The Realist Tradition: French Painting and Drawing, 1830-1900

A special exhibition organized by
The Cleveland Museum of Art

The Cleveland Museum of Art
12 November 1980 through 18 January 1981

The Brooklyn Museum
7 March through 10 May 1981

The St. Louis Art Museum
23 July through 20 September 1981

Glasgow Art Gallery and Museum, Kelvingrove
5 November 1981 through 4 January 1982

The exhibition is supported by a grant from the National
Endowment for the Humanities, by a federal indemnity from
the Federal Council on the Arts and Humanities, the Ohio
Arts Council, the Association Française d'Action Artistique,
and the Scottish Arts Council.

GABRIEL P. WEISBERG

The Realist Tradition

French Painting and Drawing 1830-1900

Published by
The Cleveland Museum of Art
in cooperation with
Indiana University Press

Curator in Charge
Gabriel P. Weisberg
Curator of Art History and Education
The Cleveland Museum of Art

©1980 by The Cleveland Museum of Art.
11150 East Boulevard, Cleveland, Ohio 44106.
Designed by Merald E. Wrolstad.
Typesetting by Square Composition Company, Cleveland, Ohio 44113.
Printing by Congress Printing Company, Chicago, Illinois 60610.

Distributed by Indiana University Press, Bloomington, Indiana 47405.

Library of Congress Cataloging in Publication Data

Weisberg, Gabriel P.
 The Realist tradition. French painting and drawing,
 1830-1900.
 Exhibition catalog.
 Bibliography: p.
 1. Realism in art—France—Exhibitions. 2. Art,
French—Exhibitions. 3. Art, Modern—19th century—
France—Exhibitions. I. Chu, Petra ten-Doesschate,
joint author. II. Cleveland Museum of Art. III. Title.
N6847.5.R4W44 759.4'074'017132 80-16579
ISBN 0-910386-60-9

Contents

Lenders to the Exhibition

Public Collections

ENGLAND

Durham, Barnard Castle, The Bowes Museum
London, The National Gallery
 The Tate Gallery
 The Victoria and Albert Museum
Sheffield, Sheffield City Art Galleries

FRANCE

Alençon, Musées d'Alençon
Arras, Musée des Beaux-Arts
Avignon, Musée Calvet
Bayeux, Musée Baron Gérard
Besançon, Musée Granvelle
Bordeaux, Musée des Beaux-Arts
Boulogne-sur-mer, Musée Municipal
Caen, Musée des Beaux-Arts
Chambéry, Musée des Beaux-Arts
Cherbourg, Musée Thomas Henry
Cognac, Musée Municipal
Compiègne, Musée National du Château de Compiègne
Dijon, Musée des Beaux-Arts
Douai, Musée Municipal
Grenoble, Musée de Peinture et de Sculpture
Jarville, Musée de l'Histoire du Fer
Le Mans, Musée des Beaux-Arts, Musée de Tessé
Le Quesnoy, Hôtel de Ville
Lille, Musée des Beaux-Arts
Lunéville, Musée de Lunéville
Marseille, Musée des Beaux-Arts
Montchanin, Mairie de Montchanin
Montpellier, Musée Fabre
Nantes, Musée des Beaux-Arts
Nice, Musée des Beaux-Arts Jules Chéret
Orléans, Musée des Beaux-Arts
Paris, Musée des Arts Décoratifs
 Musée de l'Assistance Publique
 Musée Carnavalet
 Musée J. J. Henner
 Louvre
 Louvre, Cabinet des Dessins
 Ministère des Finances
 Conservatoire National des Arts et Métiers,
 Musée National des Techniques
 Musée des Beaux-Arts de la Ville de Paris (Petit Palais)
 Sénat, Palais du Luxembourg
Pau, Musée des Beaux-Arts
Reims, Musée St. Denis
Réville, Eglise communale de Réville

Saint Etienne, Musée d'Art et d'Industrie
Saint Omer, Hôtel Sandelin and H. Dupuis
Samer, Musée Jean Charles Cazin
Senlis, Musée du Haubergier
Toulouse, Musée des Augustins
Tours, Musée des Beaux-Arts
Versailles, Musée National du Château de Versailles

HOLLAND

Amsterdam, Rijksmuseum, Rijksprentenkabinet

IRELAND

Dublin, National Gallery of Ireland

SCOTLAND

Aberdeen, Aberdeen Art Gallery
Edinburgh, The National Gallery of Scotland
Glasgow, Glasgow Art Gallery and Museum

SWITZERLAND

Geneva, Musée d'Art et d'Histoire

UNITED STATES AND CANADA

Atlanta, The High Museum of Art
Baltimore, The Baltimore Museum of Art
 The Walters Art Gallery
Boston, Museum of Fine Arts
New York, The Brooklyn Museum
Buffalo, Albright-Knox Art Gallery
Cleveland, The Cleveland Museum of Art
Denver, The Denver Art Museum
Detroit, The Detroit Institute of Arts
Montreal, The Montreal Museum of Fine Arts
New Haven, Yale University Art Gallery
Philadelphia, John G. Johnson Collection
 (Philadelphia Museum of Art)
St. Louis, The St. Louis Art Museum
 Washington University Art Gallery
Toledo, The Toledo Museum of Art
Washington, The Corcoran Gallery of Art
 (Renwick Collection)

Private Collections

Cleveland, Mr. and Mrs. Noah L. Butkin
Detroit, Frederick J. Cummings
New York, Mrs. John D. Rockefeller 3rd
 Mr. and Mrs. Herbert D. Schimmel
Santa Barbara, Mrs. Margaret Mallory

Preface

Of all the artistic movements of the French nineteenth century, Realism remains the least studied. Given the current adulation of Gustave Courbet and the increasing appreciation of the paintings and drawings of Jean François Millet, this may seem odd, but, in fact, enthusiasm for Courbet has grown only in the last fifteen years or so and a revival in interest in Millet is even more recent. Little is known of the other Realists in Courbet's circle and of those who continued the tradition after 1870. At the time, they were mentioned in the press and their works were purchased both privately and by museums, but those acquisitions have since languished in attics and basements—the victims of official neglect and changing taste. This attitude is now beginning to change. While François Bonvin, Jules Bastien-Lepage, and Léon Lhermitte, the neglected masters of the century, are not likely to topple a Manet or a Courbet from his throne, they have their place in any complete study of nineteenth-century art.

The Realist Tradition, aside from rescuing these painters from oblivion, collects together objects that reflect the way artists saw themselves and their times, so that, joined to history, sociology, and literature, a panorama of nineteenth-century French society is re-created.

The exhibition has been organized into four official Salon categories: genre, still life, portrait, and landscape—categories by which paintings were admitted by the Salon jury. The Salons, however, were not organized that way. By 1861, the works were exhibited in the galleries alphabetically, according to artist, so that, more than likely, all four categories of painting might be jammed together within the same gallery and hung without distinction of category even on the same wall. Art critics who reviewed the Salons often resolved this distraction and diversity by organizing their discussions and evaluations according to the formal entry categories. And it is their delineation by category that formed the basis for a study and comparison of the qualities that distinguished Realism. It proved advantageous to organize the exhibition in much the same way an art critic would have presented his assessment of an exhibition he actually attended, and thereby trace these categories throughout the century. The validity of a thematic arrangement of The Realist Tradition thus gradually emerged from the context of the nineteenth century itself. Genre painters could be differentiated from those who completed still lifes, although it became apparent that many painters recognized as artists of everyday scenes (e.g., François Bonvin, Théodule Ribot) were also experienced in still life, portraiture, and landscape. That is, a pattern of Realism might be demonstrated in several phases of an artist's work—a characteristic that in itself determined the ordering of the exhibition and that provided justification for a specific painter appearing in several of the four distinct categories.

Curiously, an organization appropriate for the study of the first phase of Realism proved feasible in the study of painters who followed the tradition after 1870 (an arbitrary date used to separate Realism from the later variant, Naturalism). First-generation Realism was characterized by an interest in one's time, the recording of popular culture, and a reliance on the old masters to create a style appropriate for the mid-century, while paintings by such artists as Léon Lhermitte, Jean François Raffaelli, and Jules Bastien-Lepage—even though they continued some of these very same concepts and themes—revealed a more perceptive awareness of character and possibly a reliance on photography to objectify their images. Despite these distinctions, the same categories were evident. These later artists still painted identifiable types —even though there was a lessening of interest in still life and independent landscape painting within the later group as a whole. A continuation of the Realist Tradition was thus confirmed—independent of any arbitrary vision of the material—and a unity provided for the entire exhibition that reflected the thinking of the nineteenth century.

Preparation for The Realist Tradition proceeded through several distinct phases. Extensive field research was carried out in France during a leave of absence from The Cleveland Museum of Art. Once the artists who painted in a Realist style were gradually identified, and possible locations of their works noted, on-site visits were required to determine if the works in question were actually worth retrieving, if their condition was adequate for an exhibition, or if they indeed represented a fair appraisal of a neglected artist's work. Travel to provincial museums and contacts with private collectors were, therefore, undertaken. An effort was also made to locate the descendants of each artist, in the hope of finding other works or records that might provide information on that artist's career or document his evolution.

Months of searching official government archives, Salon and exhibition records, cemetery records, and newspapers provided enough material to develop individual dossiers on many artists. These compilations included pertinent biblio-

graphic material, oral interviews with descendants, archival documents, and photographs of works that had been relocated as well as those which still awaited rediscovery but whose existence could now be documented only in old photographs or engravings. Research on some artists turned out to be fairly complete and particularly rewarding; much new information was discovered on Jules Bastien-Lepage, Jules Breton, and Alexandre Antigna. Other artists remained elusive in spite of interviews with decendants, for, in some families, little information or memorabilia had been preserved from previous generations.

Once adequate material on a given artist was accumulated, it was essential to determine whether the works located were of stylistic importance in the development of that particular artist and whether the works themselves were significant in the evolution of nineteenth-century social history. Paintings and drawings were therefore examined not only for their aesthetic importance or their relevance in the total oeuvre of an artist, but evaluated for any possible social significance or relevance to Realism. Take, for example, Alexandre Antigna's *The Fire* (Musée d'Orléans), a painting first exhibited at the Paris Salon of 1850/51 along with a number of well-known canvases by Gustave Courbet. This immense composition had been stored at the Orléans museum for a number of years before being rediscovered and shown in the retrospective exhibition dedicated to Antigna in 1978. The importance of this composition to the overall development of Realism was therefore already well known. An examination of newspaper and journal reviews of the 1850/51 Salon (the so-called Salon of Realism) also revealed its significance as a record of the terrible living conditions endured by many city workers and also as an indication of the modification of Romanticism to create a direct, moving, Realist image.

Lesser known works, for example, those by Armand or Adolphe Leleux, were more difficult to assess; there was often no record of Salon exhibition and no reviews by art critics, making it difficult to determine whether a given work had ever been exhibited or even shown to anyone outside that artist's particular circle of friends and relatives. This very "obscurity" or lack of publicity was in itself an important discovery. Realist artists, in particular, often painted for their own personal satisfaction or for a small circle of close friends in addition to completing works intended for a large audience of Salon-goers. It was concluded that even though a number of paintings remained unnoticed—even in their own time—or were small in scale, such intimate works were nevertheless often commissioned or purchased by a private collector. It was necessary to include works of all sizes and varying degrees of complexity in order to present The Realist Tradition with historical and aesthetic accuracy. The very diversity of the nineteenth-century audience thus became an important factor in the organization of the exhibition.

No exhibition can present a complete and perfect group of objects, since practical considerations invariably intervene. In this exhibition, some of the paintings and drawings by Gustave Courbet that deserve a place here are missing owing to the fragility of their supports, or their loan elsewhere. Gus-tave Caillebotte, Edouard Manet, and Edgar Degas are similarly underrepresented because of similar problems, but in the case of Manet and Degas, their works are at least familiar to most viewers.

An exhibition in preparation for over five years invariably enlists the assistance of many who will be cited elsewhere in this catalog. Some, however, deserve special consideration because of their dedication to the project and their determination to realize the exhibition in all its ramifications. The late Noah L. Butkin, a major collector of many of the painters represented in this exhibition, sought examples pertinent to the theme of the show, thereby safeguarding certain works from public auction or seclusion in private collections. It is a tribute to his tenacity that several lesser known painters are even represented at all, for his commitment to the Realist aesthetic was both heroic and enlightened. The steadfast enthusiasm and perspicacity of his wife Muriel, who entrusted a number of her own drawings to the exhibition, has continued unabated. My wife Yvonne worked with me throughout, carrying through the most arduous—at times almost impossible—aspects of research. Her understanding of the complexities implicit in the exhibition and her ability to communicate with disparate groups throughout the world enabled the organization of the exhibition to proceed unencumbered.

The determination and perseverance of Mlle. Isabel Fonseca, my research assistant in Paris, in seeking out descendants of artists or uncovering long-forgotten paintings is a testament to the kind of effort we received from many of those who worked with us. Mr. and Mrs. Edmond Jeantet and Mrs. Annette Bourrut-Lacouture were on hand for our innumerable European research trips, easing complications and providing sources and new avenues that enabled us to meet our own high expectations.

The advice and aid extended by museum colleagues in France has been enduring and gratifying: Pierre Rosenberg, Conservateur, Musée du Louvre, provided guidance and counsel; Jacques Vilain, Musée du Louvre, in charge of provincial museums, assisted on loans from many French lenders; Jacques Foucart gave valuable initial guidance in locating some neglected Realist painters; Jean and Geneviève Lacambre's enthusiasm for the scope of the exhibition reinforced my own endeavor.

The catalog itself has greatly benefited from the contributions of other scholars. Professor Petra ten-Doesschate Chu, an expert on nineteenth-century drawing provided the discussion clarifying the role of drawing within the Realist epoch. Professor Linda Nochlin and Professor Theodore Reff wrote the entries and biographies on artists with whom they are intimately familiar. Similarly, Professor Kenneth McConkey, Ms. Anne Clark James, and Mrs. Barbara Fields—art historians who have researched particular artists extensively—offered new information that few others knew about.

The period of time spent at the Institute for Advanced Study (Princeton) and the discussions generated under the tutelage of Professor Irving Lavin gave added impetus to the completion of the catalog and strengthened my own dedication to the study of Realism and many forgotten nineteenth-

century artists. Moreover, the mutual rewards of an art historian exchanging ideas with a social historian far exceeded my expectations when Theodore Zeldin, Oxford University, England, agreed to read my work. His publications and scholarship continue to warrant respect and inspiration.

The staff of The Cleveland Museum of Art—Delbert Gutridge, William E. Ward, and Merald E. Wrolstad, in particular—deserves special recognition for assistance in transportation, installation, and preparation of the catalog. My editor, Mrs. Joy H. Walworth, consistently worked to clarify the thoughts of a struggling author and to put into final form some ideas that were not originally precise. The enormous and extensive details amassed in realizing a major exhibition of this scope were entrusted to my secretary, Miss Janet L. Leonard. The rigors and triumphs of Realism have been ministrated by the rare insight and ready review and criticism of my colleague and counsellor, Dr. Sherman E. Lee. It was he who championed reconsideration of the entire movement long before the current exhibition was ever imagined.

The exhibition would not have been possible without the generous assistance of several governmental agencies. In the United States, the support of the National Endowment for the Humanities made it possible for extensive loans to come from Europe; the assistance of the Federal Council on the Arts and Humanities in providing federal indemnification further extended the possibilities. In France, the show was assisted by a grant from the French Ministry of Foreign Affairs through L'Association d'Action Artistique, making it possible for many of the French loans, from various sections of the country, to travel to the United States and Scotland. In Scotland, the exhibition received support from the Scottish Arts Council, thereby enhancing greatly the realization of a European showing. Further assistance, especially for the undertaking of initial research and for restoration of paintings, came from The Butkin Foundation. It is with deep gratitude and awareness that these grants-in-aid are acknowledged, for, without them, the show would not have been fully realized.

Two other American institutions who will share the exhibition deserve recognition. The Brooklyn Museum, its Director Michael Botwinick and Assistant Director John Lane, and The St. Louis Art Museum, represented by former Director Jim Wood and current Director James Burke, continuously supported and encouraged this undertaking. The accessibility of the exhibition to the public is due in no small measure to the imagination and perspicacity of these institutions.

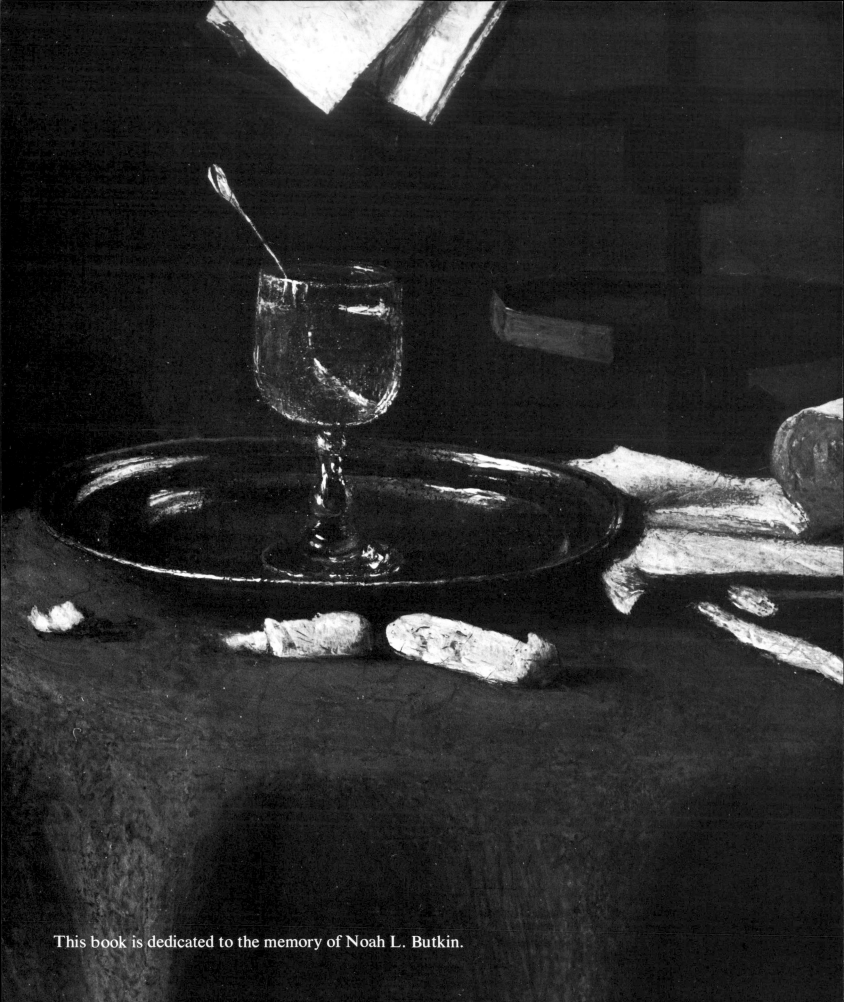

This book is dedicated to the memory of Noah L. Butkin.

Foreword

Apollo by Salomon Reinach, a distinguished classical archaeologist and scholar of the early twentieth century, was in its time probably the most widely used single-volume handbook of the history of art. Densely written and tightly packed with factual information, *Apollo* is still a significant document in any consideration of the development of introductions to the world of art. The last revised edition of 1924, issued fifty years after the first Impressionist exhibition in Paris and almost fifty years before the most popular of current introductions, H. W. Janson's *History of Art,* now seems to us most curious in its treatment of nineteenth-century painting. There is no illustration of *any* Impressionist or Post-Impressionist painting, much less of early twentieth-century works we now take for granted. There are illustrations of pictures by some of the artists represented in this exhibition, however—most notably Meissonier, Raffet, Detaille, Regnault, Bonnat, Carolus-Duran, Dagnan-Bouveret, and Henner. These were, for Reinach, the artists worth consideration. In Janson's book, despite the author's well-known interest in reevaluations within the nineteenth century, not one of Reinach's masters listed here is reproduced. The two books share only Millet, Corot, and Courbet. Why this extraordinary discrepancy in evaluations of a whole period of art? Is even so relatively long a time as a half century too short for any kind of measured and reasonably objective aesthetic judgment? Or is this simply another amusing demonstration of the vagaries of taste? The Realist Tradition is intended, among other aims, to provide an opportunity to answer these questions by presenting in depth a once-important, and then-neglected, aspect of French painting in the nineteenth century.

We say "then neglected" to imply that this very neglect is waning. There are distinct signs of a revival of interest in these Realist painters. Some museums have dusted off works in storage and restored them to admittedly lesser places in the public galleries. The annual reports of museums indicate purchases of such Realist works—few, but a sign. The auction houses show more and more such works, and new, modern record prices for previously spurned canvases have been reached in recent years. Why this exhibition? Why this growing curiosity about the "anti-modern" aspect of the century of Impressionism and Post-Impressionism?

There are many reasons for the revival, not all of equal significance. A cynic might remark that the growing scarcity of fine works by the currently accepted masters of the modern movement leads dealers and collectors to look elsewhere and to exploit a rich mother lode of Realist works located in the attics of families of lower bourgeois origins, works acquired or commissioned by the great-grandfathers or their fathers. Further, while Realist works have recently risen in value they have by no means attained the awful heights of Monet, Degas, Cézanne, and others. The Realists have what is termed "price appeal."

A more realistic reason for the revival is that these works *still* conform to the traditional understanding of what art should look like—something! The notion among advanced art historians that the battle for nonrepresentational art is over and won simply will not bear scrutiny, even when considering educated lay responses on a broad geographic basis. But if Realist art is more easily appreciated by most people, it is also more difficult to evaluate, for while it is obvious that many people can be taught to paint recognizable images, they cannot all be good because of recognizability alone. Clearly, there is a potential "elitist" problem here, leading us to a third reason for the revival.

The current enthusiasm for photography, carrying with it the application of photo-oriented techniques and appearances—"close-up realism," "photo realism," "new realism" —makes the Realist painters of the last century more acceptable to an avant-garde audience that otherwise tends to despise bourgeois tastes. The charming double image of stockbroker and hippie both lost in contemplation of Realist painting is a significant one. There is one specific connection between our craze for the photographic image and the revival of Realist painting—the interest in the historic figures of French photography: Nadar, Atget, and others who lived at the same time as most of the painters in this exhibition and whose work was influential on the painters of that time. Dagnan-Bouveret's *Horses at the Watering Trough* was as much composed by foreshortened photo techniques as any work by Degas.

Nostalgia is always a powerful force in revival and in this case it is particularly strong. History could be satirically described as systematic nostalgia, and there is little doubt that much Realist painting is valuable as a record of what has gone—mores as well as appearances. Not incidental to this nostalgia is an alliance with modern enthusiasm for conservation. Here again liberal and conservative are united in approbation of a manner of painting that indicates what could have been, or should be, conserved, as well as presenting the face of a lost past.

One of the major reasons for the revival of Realism is certainly an increased interest in quantitative, iconographic, and Marxist historical methods. The importance of the work of art as a document of human production, akin to and hardly different from a written inventory or a city birth record, implies that its *subject* is its prime indicator. Indeed, it should be noted that the arrangement of works in the exhibition and its catalog is by subject matter. The iconography of Realism proves to be the evident way to make comparisons, to order the evidence. The distinction of artistic personalities seems inappropriate in this Realist context. About this, more later.

The final reason for this particular exhibition was the major one leading to our decision to mount the show. In view of rising interest and particularly because of our ignorance of this at least historically significant movement, we felt that a contribution could be made to the knowledge of nineteenth-century French art. The systematic selection, organization, and presentation of the material would then begin to provide those immediate impressions and comparisons without which artistic evaluation would be impossible. For the work must ultimately be so judged, regardless of the current popularity of a hands-off, no-win, sociological approach.

Perhaps a look at one specific painting, frame and all, may be helpful in leading to one way of evaluation. The *Plowing Scene* by Rosa Bonheur from The Walters Art Gallery is a strong Realist work enclosed in a particularly flamboyant version of the rococo-style frame of the eighteenth century. Why does this look to us so particularly incongruous? We have been trained by generations of dealers and collectors to accept van Gogh or Gauguin framed in rococo frames and, while one can argue for incongruity, it simply is not as wildly so as in the case of the Bonheur. I believe the reason is twofold: subject and technique. Real farmers, real cobblers, real *chiffonniers* are uncomfortable in a pseudo-aristocratic environment. They are even more so when they are painted in a particular style I take to be a reinforcement of the subject matters involved. This style, seen very clearly in Breton, Bonvin, Ribot, Millet, and Carolus-Duran, emphasizes the materiality of pigment and the direct, matter-of-fact way it is applied. This is combined with a habit of forcing to our attention the images in the painting, bringing them closer to the picture plane, obstructing any effort to bypass the subject in favor of the charms of distance or vaporous space. Negatively, this is why Antigna, despite his importance in the iconography of the movement, simply cannot convince the spectator. The accoutrements of historic style—noble composition, smooth brushwork, arbitrary color—simply get in the way of his depiction of the tragic fate of the poor. In most ways, Millet can lay claim to a place beside Courbet as a master of Realism. Others are not far behind, and these are the reputations most in need of rescue, for the history of art as well as the enjoyment of art is not just a matter of the greatest masters. What seems to me important about nineteenth-century French Realism is both the appearance of a new subject matter presented in a technique both traditional and new, and the presence of some creative and fascinating artists, appreciated in their time and in need of understanding now.

The acknowledgments provide the thanks so richly deserved by all who have assisted in this project. I should like to particularly thank Dr. Gabriel Weisberg for conception and fulfillment of the idea for this exhibition and Mrs. Weisberg for her unfailing and energetic assistance. This is the kind of special loan exhitition that makes a genuine contribution to knowledge and to popular understanding.

Sherman E. Lee

Bracketed numbers in thematic essays and catalog entries signal works of art included in The Realist Tradition exhibition. Preliminary works executed by an artist in preparation for a larger composition contain a capital letter following the number within brackets. Numbers in the catalog followed by a small letter (*a* or *b*) refer the reader to illustrations that are not part of the exhibition, but that are provided for explanation or comparison.

The small superscript numbers refer the reader to sources or additional commentary that are listed in the notes at the end of each thematic essay or each catalog entry. Catalog entries contain notes and Exhibited and Published lists, where this information is known or applicable. These sources are always listed in full the first time they appear within a thematic section. Subsequent references that appear in the notes, Exhibited, or Published lists for catalog entries within one thematic section are shortened and include only the last name of the author and a short title. Thus, complete information for a shortened reference under the Published list, for example, may appear in the notes listing of a previous catalog entry. Thematic essays, however, are considered entities in themselves and will always contain the complete reference in that note section.

The Realist Tradition: Critical Theory and the Evolution of Social Themes

Gabriel P. Weisberg

TOWARD A THEORY OF REALISM

"Realism is the opposite of a school. To speak of a 'school' of realism is nonsense: realism is a frank and total expression of an individuality that attacks precisely the conventions and imitation of any kind of school. A realist is completely independent of his neighbor; he renders sensations that his nature and temperament lead him to feel when he confronts something."[1] Even if Edmond Duranty (1833-1880), the young art critic who wrote these lines in 1856, did not allow his readers to think of the Realists as an organized school of painters, they were still undeniably a recognizable group of artists. In their efforts to render their own time in images they intended to be comprehensible to the public,[2] some, such as Gustave Courbet, were attacked for impropriety in their choice of theme or of crudeness in their manner of painting, and some, for eliminating historical imagery altogether to concentrate their efforts on recording the world around them.[3] But whether they painted themes from urban or from rural life, still lifes of everyday objects, portraits of family and friends, or landscapes of their native region, they chose subjects that would touch a common chord with the largest number of viewers.[4] *Réalisme,* then, was not a term used to designate the production of artists working in a single, recognizable style; that idea was seldom mentioned—and a general aesthetic theory of Realism applicable to all members of the group was never seriously advanced. It was simply a name applied to those who sought to revitalize the centuries-old artistic tradition of accurate, truthful recording of the world and to give this tradition contemporary relevance.

In 1782 L. S. Mercier in his *Tableau de Paris* recommended Parisian life among the humble as a suitable topic from which painters should draw: "I tried to develop this *Tableau* from living models. Many others have depicted past centuries without innovation. I have occupied myself with today's generation and with the physiognomy of my century because it is more interesting for me than the vague history of the Phoenicians and the Egyptians."[5] In so doing he antici-

This essay was written during a six-month period of study on French nineteenth-century Realism at the Institute for Advanced Study, Princeton, New Jersey. The author is deeply grateful to the staff of the Institute and especially to Professor Irving Lavin for providing the opportunity to complete this undertaking. A draft of this paper was delivered at a public lecture at Princeton University in December 1979.

The author gratefully acknowledges the generous assistance of Dr. Elizabeth Holt, Belmont, Massachusetts, in the completion of this essay.

pated a nineteenth-century preoccupation with representing contemporary life rather than historical episodes, because an awareness of humanity could be seen in Parisian streets. Mercier also believed that the role of painting assisted art in effecting social improvement in a changing society. If not all painters were interested in reforming society, a sufficient number set that goal to redefine the purpose of art. Just as in Mercier's time, after the July Revolution of 1830 the inventiveness and artistic license of Romanticism seemed insufficient to the task of creating an art that would examine human needs and social symptoms. The burgeoning interest in common people, in workers, helped create the atmosphere of the July Monarchy, when Realism became an important by-product of the time.[6]

In a review of the Salon of 1833 Gabriel Laviron (1806-1849) first laid down the concepts that would later be redefined and developed by the art critics Théophile Thoré, Jules Antoine Castagnary, and others into what would become known as Realism. He called for art to be made available to all the people—a democratic viewpoint generated by his involvement in the July Revolution. This could be accomplished if artists recorded only the visible world instead of allegory and literary allusion that were accessible to only a few. On the other hand, he urged artists not to copy slavishly from nature, for "art does not consist simply in fooling the eye, but in rendering the particular character of each thing one wants to represent,"[7] and to develop a national art through the careful recording of regional characteristics. Finally, Laviron openly advocated using earlier masters as models for contemporary imagery. Many young painters sought such prototypes to make their art more direct and intelligible for both Salon audience and private collectors.

Once Laviron's article had appeared, several critics, especially Thoré and Champfleury, supported those whom they considered to be Realist painters because of style and subject matter in earlier Salons, but it was not until 1857 that they began to publish lengthy reviews propounding what they thought the conceptual content of the movement should be.[8] Of these writers, Thoré (1807-1869) became the most influential in the years just before the Second Empire. When Louis Napoleon came to power, Thoré fled to Belgium to avoid the consequences of his liberal political and social opinions. Along with Laviron, Thoré believed that art and society were closely allied and that the "new art" must shift its emphasis from allegory and history painting to the life of man if it were

1

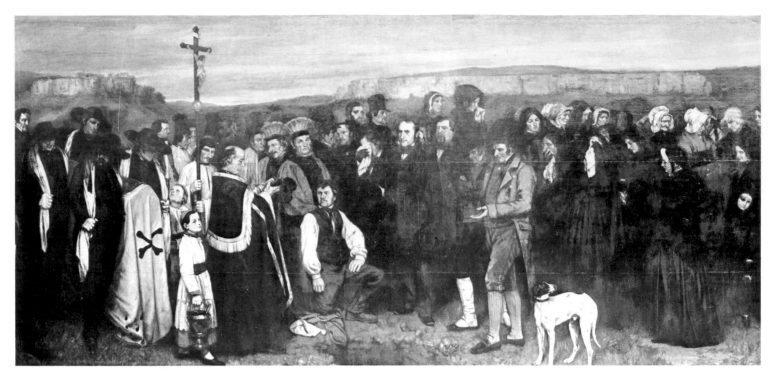

Figure 1. Gustave Courbet, *Burial at Ornans*.

to be understood by everyone. In his *Nouvelles Tendances de l'art,* Thoré applied to art some of the revolutionary ideas of 1830. An "art for man," he wrote, "should be one of the primary democratic goals of young artists: Man does not exist in the arts of the past, in the arts of yesterday; and he still has to be invented. Almost never was man, in his common capacity as man, the direct subject of painting and of the other plastic arts, not even of literature. . . ."[9] Like Laviron, Thoré sought out those artists from the past who could serve as models, for there had always been realist painters, and their work had to be studied and understood before the new art of the mid-nineteenth century could be founded.[10] Caravaggio, Ribera, Velázquez, Murillo, the Le Nains, Chardin, and, perhaps unexpectedly, such figures as Watteau and Greuze were, he thought, suitable precursors of Realism; the Dutch and Flemish painters—especially Rembrandt and, later, Vermeer—should also be emulated in their use of familiar themes and their willingness to paint the common people. His advocacy of their work influenced other artists— particularly François Bonvin [217] and Théodule Ribot [219], to whom Thoré's criticism suggested models for their images.

Champfleury's (1821-1889) contribution to the new direction of painting was his popularization of the ideas of Laviron and Thoré and writers such as Max Buchon and Pierre Dupont in a pamphlet entitled *Le Réalisme* (1857). Champfleury's dislike of art based on the historical past, his liberal viewpoint toward artists painting scenes from everyday existence, and his promulgation of the artistic possibilities in themes of humble life were one reason for the popularity of these subjects among the Realists. His enthusiastic support of Courbet

and his understanding of that painter's achievement and notoriety in his early works at a time when Realism was more often seen as a threat to Salon standards and to middle-class values also tend to obliterate Champfleury's acknowledgment at an early date of the Le Nains as the forerunners of Realism and the art of a region.[11] Champfleury also praised other Realist painters, notably François Bonvin whose early still life contained in a genre painting in the 1849 Salon he aptly described as comprised of "a pot, a jug, and a cup, . . . objects as complicated and as mysterious as any man, as strange as any woman."[12] Champfleury's emphasis on the social content in Bonvin's still lifes and family portraits introduced to the public an important new approach for the examination of art.[13]

Undoubtedly, however, Champfleury's support of Courbet's cause overshadowed his other contributions to the Realist tradition. In describing Courbet's depiction of his friends and family in regional costume in the *Burial at Ornans* (Figure 1), Champfleury wrote, "I must say that the meaning of the *Burial* is striking, intelligible to all; that it is the representation of a burial in a small town, which nonetheless stands for burials in *all* small towns. The triumph of the artist who paints individualities is seen in the way he can respond to the intimate observation of each, in the way he chooses, in this manner, a type which everyone will believe they have known and which will make them remark: 'This one is true to life; I have seen him!' "[14]

While Champfleury summed up the aspirations of the Realists, Edmond Duranty exhorted them to work directly from nature to discover truth. In his periodical *Réalisme*

(1856/57), Duranty placed landscape and portraiture in the forefront as important areas in which artists must excell. To arrive at images that were easy to comprehend he advocated simplicity in compositional design. Realism, he agreed, had a long tradition—"in France, in England, in Germany, realists have existed since books and pictures began to be made"[15]—and he, too, urged contemporary Realists to study those earlier artists.[16] Like Laviron and Champfleury, he regarded Realism as the way artists could study their own time; like Thoré, he emphasized portraying man in society, recognizing that the Realists' insistence on depicting subjects from daily life would result in an imagery accessible to most people.

In 1857 Castagnary (1830-1888), in his Salon review, noted the large number of genre paintings and remarked: "It is the human side of art which takes the place of the heroic and divine side of art and which affirms itself with the strength of numbers and the authority of talent."[17] Genre painting, he said, was the ideal artistic form, for it could emphasize the factual and at the same time depict groups in which individual action was subordinated to common customs and traditions. In 1863 Castagnary coined the term *naturalism* for this new effort that separated the younger painters from the older generation of Realists represented by Courbet and François Bonvin.[18] While the term *Naturalist* had earlier been used by Laviron to describe or analyze the Realist's pictorial style, Castagnary used it to distinguish the younger painters from both romanticists and classicists: "The naturalist school asserts that art is the expression of life in all its facets, seen from all angles, and its only goal is to reproduce nature, striving to bring it to a maximum of power and intensity. . . ."[19] This new group of Naturalists were not satisfied with reporting what they saw—they sought to reflect reality scientifically, thereby conveying the tactile, visual truth, but also mirroring the inner feelings of an individual and the influence of the milieu on that character. Contemporary painting must therefore include "all the forms in the visible world,"[20] but, like Realism, represent regional aspects of contemporary national society—for a truly national art was one based on a realistic examination of the cultures found in provincial centers.

In his *Salon of 1868,* Castagnary provided Naturalism with a historical precedent to dispel the accusations of radicalism that it continued to encounter in conservative reviews. "The word 'naturalism' that I use to designate the tendencies of today is not new in the history of art, and that is one of the reasons it is preferable to the word 'realism.' Each time we encounter a nation or, within a nation, a group of men taking the interpretation of surrounding life as the immediate object of painting and striving to make a visual reproduction of society in its natural setting, that art has been, that art is called, 'naturalist.' "[21] Castagnary also implied, however, that Naturalist painters should not simply paint in a factual, detached way like the earlier Realists, but should interpret society by finding causes of social and visual problems through a more careful rendering of the truth.[22] In this he not only anticipated the approach of the Impressionists, who would seek

to record "the impression" of every aspect of the visible world, but, more specifically, Naturalist painters such as Jean François Raffaelli who observed man in the midst of society with skepticism and a tinge of fatalism [175].

Realism and naturalism have a long tradition in literature and the visual arts going back to the seventeenth century, but the nuances and varied uses of each term were not always clearly understood. Around 1700 realism was seen to contain the truth, especially when used to describe objects; some critics also saw realism as containing a "true style." Naturalism was often used interchangeably with realism, especially, as already noted, when a writer tried to describe a "real object."

In the ninteenth century, a decided schism in the Realist camp occurred in the mid-1860s when the critic and novelist Emile Zola (1840-1902) examined the canvases of the Realists Bonvin, Ribot, and Vollon and declared them to be outdated and overly reliant on tradition.[23] His condemnation of Ribot was particularly virulent: "Ribot has added nothing to art; he has not said anything in his own words; he has revealed to us neither a heart nor a profession."[24] His refutation of Realism was, in part, simply a ploy used to establish the importance of his friend, the painter Edouard Manet, at the expense of the rest. As an avid supporter of Manet, Zola used Bonvin and Ribot as convenient foils, failing to recognize that Manet was as much a part of the Realist tradition as were some of his contemporaries.[25]

When the impassioned rhetoric associated with Zola's support of Manet is downplayed, however, it becomes apparent that he simply reiterated some of the same fundamental theories of the earlier reviewers. His insistence that the painter create "according to his own eyes and his own temperament"[26] is often quoted to establish Manet's place in the center of modernism, but it can as easily stand also as Zola's adaptation of Laviron's and Thoré's call for a painter to express his "individuality" through his own emotions and through his depiction of the moods, thoughts, and inner life of his subjects. While condemning other Realists as old-fashioned, Zola conceded that "the movement of the time is certainly Realist, or rather Positivist,"[27] even though his manufactured antagonism between Manet and other Realists disguised their actual similarity.

The demise of Realism and the rupture between the old and the new generations in the mid-1860s was essentially a figment of Zola's critical imagination. Bonvin and others shared with Manet a sincerity, an honesty of intention, and a similar choice of theme, even if they did not equal him in imagination. Zola's explanation of the conflict in the art world between the truth (*vrai*) of the Naturalists and the beautiful (*beau*) of the Realists, with Zola staunchly defending the side of the *vrai,* was also part of this fabrication.[28] Zola's "naturalism," unlike Castagnary's, also stressed the importance of the human condition without "recourse to the supernatural and with a consequent emphasis on material factors."[29] Fundamentally, therefore, and despite his protestations, Zola as an art critic was a Realist. His interest in the actual and the individual, therefore, linked him not only with

Duranty but also with the poet Charles Baudelaire, another influential critic, whose interest in modernity was incorporated into the writings of later Realist critics even though they never indulged in romanticism.[30]

The importance placed on modernity and contemporary life was reiterated by Joris Karl Huysmans in his review of the Salons of 1879 and 1880. Huysmans singled out for praise the independents (both the Impressionists and those who could be classified as Naturalists) who in 1874 organized their own annual exhibition apart from the Salon. He disparaged those painters who relied upon past masters—those who borrowed their lighting from the Dutch and Spanish painters of the seventeenth century—in favor of those painters who succeeded in capturing the light of Paris or the particular region of the country they chose to represent. Like Zola, he supported the younger Impressionists, but like Baudelaire he approved of melancholy landscapes and dismal urban scenes such as Raffaelli's *Retour des Chiffonniers*. He also supported the Naturalist aesthetic that compelled a painter to record every aspect of society:

> All of modern life has yet to be studied; scarcely a few of its multiple facets have been noticed and noted. Everything is to be done: the official galas, the salons, the balls, the many aspects of familiar life, the life of artisans and bourgeois, the shops, the markets, the restaurants, the cafés, . . . all of humanity to whatever class it belongs, no matter what function it fulfills, in the home, in hospitals, in public dance halls, in the theaters, in the squares, in the streets of the poor or on the vast boulevards.
>
> Then, if a few of the painters with whom we are concerned have, here and there, reproduced some of the episodes of contemporary life, who is the artist who will now render the imposing grandeur of factory towns? Who will follow the lead of the German painter Menzel, entering the huge forges, the halls of railway stations which Mr. Claude Monet has, it is true, already attempted to depict but without succeeding to extricate from his uncertain abbreviations the colossal proportions of the locomotives and the station? Who is the landscapist who will render the blast furnaces in the night, or the gigantic smokestacks crowned at their summit with pale fires?
>
> All of man's work, man toiling in the factories, all of this modern fever which represents industry's activity, all of the splendor of machines, all of this has yet to be painted, and will be painted as long as modernists truly worthy of the name agree not to grow less bold or to become mummified in the eternal reproduction of the same subject.[31]

Although one of the first to advocate a true image of the industrial age, Huysmans may have yet been unaware of the industrial scenes painted by François Bonhommé [42]; he also criticized Jules Bastien-Lepage [225] and Norbert Goeneutte [231] for failing to reflect the tempo and diversity of modern life in their works. More than any other later critic in the Realist tradition, Huysmans argued against perpetuating the earlier formulas, even though they were still practiced by Armand Leleux or François Bonvin [196] around 1880—advocating that younger painters such as Edgar Degas [149], Gustave Caillebotte [167], and Henri Fantin-Latour [230]

continue to use their sense of truthfulness to capture the nuances of contemporary life.

By the late 1880s changing tastes, political changes, prosperity, and social contrasts led painters to modify their style. In response to these changing modes and an increasing animosity among younger artists against traditional Realism, those critics who continued to advocate Naturalism relied upon passages extracted from Thoré, Champfleury, and Castagnary, or—like Louis de Fourcaud—simply insisted that the earlier artists were better. Maintaining the delicate relationship between democratizing art for the public and depicting mankind in all types of activity was no longer necessary. Some Realists continued to paint in regions where the newest stylistic innovations in Paris made little impact and where there was still a demand for art that was traditional and understandable to the people [187]. The remaining Naturalists became even more pointed in their social criticism, siding with the workingman in his fight against exploitation and, in the process, creating images of social realism that functioned as propaganda (Figure 2). The majority, however, changed their style to utilize decorative ensembles, pastel hues, and fashionable themes that were reminiscent of a bygone Romanticism even though they still derived their subjects from contemporary life.

They no longer wanted to paint life as it was, however. The suffering and misery around them, though no less prevalent, were not only difficult to paint but did not appeal to buyers. Collectors did not want pictures that marked the failures of progress, nor did the public who came to the Salons want to be reminded of the beggars and homeless always surrounding them. Art was supposed to be pleasurable. Social reform, as a purpose for art, therefore gave way to elegance. Pictures were no longer intended to educate the masses, and, however much they might proclaim otherwise, artists again sought to associate themselves with the wealthy of society.[32]

Thus the grand, descriptive scheme of the early critics—that art confined to actuality would improve the world through a depiction of poverty, distress, and old-fashioned virtues among the humble—had largely disappeared by 1900. Nonetheless, such works still provide a lively record of art and society in the nineteenth century and remain a document of the evolution in subject matter that took place, as well as a record of the modification of the creative process itself. Artists had clearly demonstrated that the past was not the only acceptable subject of painting; art became modern as it was brought into contact with the masses. The established hierarchy of creative values imposed by the Salon system was undermined, and the categories of painting—still life, landscape, portrait, genre—was broadened to include a variety of subjects. The theories of the critics were often in advance of the art they talked about, and this, too, encouraged artists to examine new themes. Their insistence on studying the "here and now"—a familiarity with popular imagery, literature, and folklore—helped them to humanize art for the public.

REALIST IMAGERY AND SOCIAL THEMES

The criticism of Laviron, Thoré, and Castagnary served as the basis on which Realist imagery could develop and mature, but it was the outpouring of poetry, prose, songs, social treatises on the poor, and statistical studies on urban society at the time that provided models for the artist's depiction of the social ills he felt impelled to record. Popular songwriters provided a ready store of "oral images." The composer Vinçard wrote a song called "Le Chiffonnier" (1849), for example, which immortalized a common inhabitant of the streets of Paris. Another important songwriter, Pierre Dupont (1821-1870), encouraged humanitarian instincts through verses that reflected the growing social conscience of the time.[33] Novelists such as Honoré Balzac, George Sand, and Eugène Sue used the social problems of the country as a basis for their fiction, and Champfleury provided documentation in his own novels to authenticate the scenes in which his stories were laid.[34] The novelist Gustave Flaubert in 1845 summed up the Realist attitude as "a perfect objectivity and an absolute respect for truth."[35]

Undoubtedly, the source of inspiration for these authors, and most likely for the songwriters as well, was the popular press. Mechanized production allowed the broad dissemination of books and newspapers to a growing reading public, providing a common and ready source for current events and interests.[36] Popular reading, of course, included exposés of the nation's social ills. Even if a painter did not read the newspapers, he could not remain isolated, for almost everyone else did read and talk about the news of the day. In the 1820s, the *Journal des Débats* examined the rate of suicide in the cities, a subject that later attracted the attention of such painters as Octave Tassaert.[37] Books, too, not only exposed social evils but provided the reader with the reasons for them. A. Frégier's *Des Classes dangereuses de la population dans les grandes villes et des moyens de les rendre meilleures* (Paris, 1840) offered ready explanations for social unrest and for the marked increase in urban crime. Eugène Buret's *De la misère des classes laborieuses en Angleterre et en France* (1840)[38] described the hardships under which the working class labored. Edouard Ducpétiaux's *De la condition physi-*

Figure 2. Jules Adler, *Les Las.*

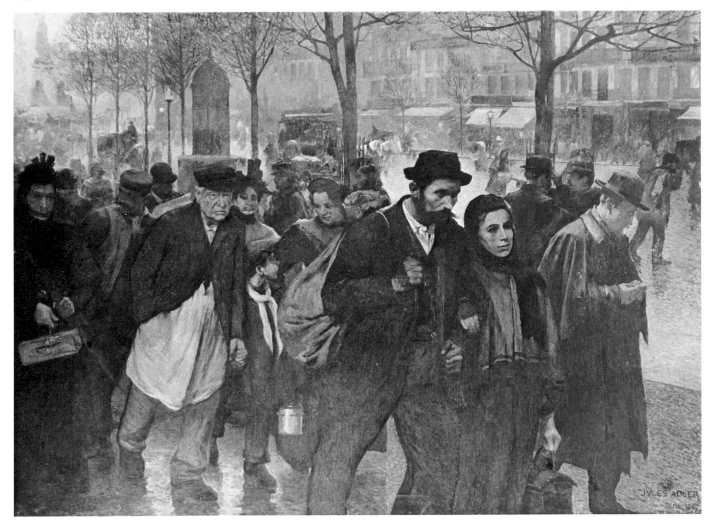

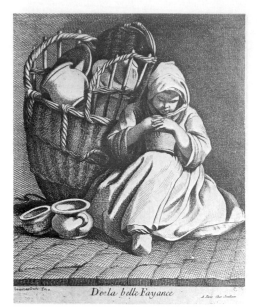 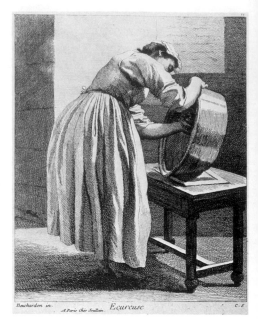

Figure 3. Edmé Bouchardon, *De la belle fayance*.

Figure 4. Edmé Bouchardon, *Revendeuse*.

Figure 5. Edmé Bouchardon, *Ecureuse*.

que et morale des jeunes ouvriers et des moyens de l'améliorer exposed the plight of child laborers and suggested ways these conditions might be alleviated. Others, from Michelet's *Le Peuple* (1846) to Eugène Bonnemère's impressive *Histoire des paysans* (1856), discussed and described regional aspects.[39]

Another widely read source was the *Physiologies* that abounded in the period—studies of nature and of various kinds of people.[40] Some, such as Louis Sébastien Mercier's *Tableau de Paris* (1782-88), were little more than written descriptions of classes of people in society. Others contained engravings as well as text and recorded certain types of people distinctive to city and countryside; such sources frequently served as guides and model books for the Realist painters. Mercier provided fairly detailed descriptions of Parisian classes—the bourgeois; workers (e.g., salt carriers, water carriers)—and locations (e.g., Pont-Neuf). When he discussed the ragpicker *(le chiffonnier)* or the studio assistant *(le rapin),* for example, Mercier also included salient characteristics that would allow a reader to understand why one or the other behaved in a certain way or dressed as he did.

In his *Essais sur les moeurs* (1823), Etienne Jouy examined such varied topics as the day school, the morgue, suicide, beggars, hospitals—adding to his account descriptions of life in the provinces (e.g., the Basques, the city of Montpellier) that Mercier had only briefly touched upon. Another popular text, Maxime du Camp's *Paris, Ses Organes, ses fonctions et sa vie* (1874), was also not illustrated, but included particulars on such modern and useful innovations as public transportation and railroads.

Another series, *Les Français peints par eux-mêmes*, appeared in Paris in fascicules published between 1 June 1839 and 6 August 1842.[41] Ultimately a nine-volume work, the first five books were devoted to descriptions of Parisian occupations and pastimes; the next three to provincial and colonial people; and the ninth, issued as a supplement free to subscribers to the series, again contained descriptions of life in Paris. The editor commissioned these essays from well-known writers, and they were illustrated by equally well known artists, including Gavarni, Philippe Auguste Jeanron, Ernest Meissonier, Louis Trimolet, Traviès, and Grandville. The subjects covered were more or less the same as those in Mercier or Jouy, but the articles were longer, more detailed, and more fully researched. Many of the illustrations were carefully rendered figures in traditional costumes, often shown performing their daily tasks. This book proved extremely popular and became a prototype of its kind. The precision and accuracy of its engravings made the volume an important influence on Realist imagery. Later publications often imitated its format, combining text with illustrations.[42]

The compilations referred to as *Cris de Paris* were another source of inspiration. They consisted of collections of pictures with only brief captions, but no text. These illustrated workbooks, occasionally used in the studio, first appeared in the thirteenth century but increased in popularity—especially from the seventeenth and well into the nineteenth centuries. Rendered by printmakers, they provided exact descriptions of street industries, vendors, and artisans that could be referred to or used as models by the artists. For example, Brebiette's *Les Cris de Paris* (1640) contained the predeces-

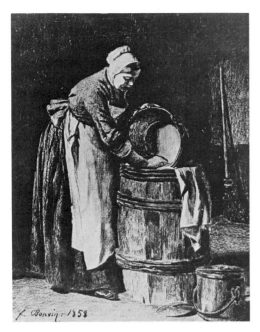

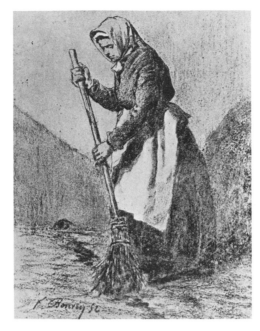

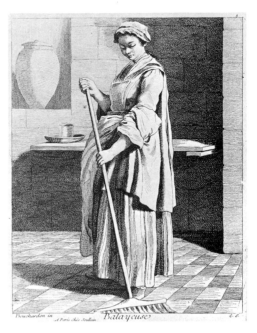

Figure 6. François Bonvin, *The Scourer*. Figure 7. François Bonvin, *Woman Sweeping*. Figure 8. Edmé Bouchardon, *Balayeuse*.

sor for numerous depictions of milkmaids in the two centuries that followed. Such illustrations were common source books used by Realists to enhance actual models or their own images.

The most famous of these books of "street criers" was Bouchardon's *Etudes prises dans le bas peuple, ou les cris de Paris,* first published in 1737 (etched by the Comte de Caylus) and undoubtedly still used by artists of the nineteenth century. It included half-page vignettes as well as full-page figures (Figures 3, 4). By the 1820s, another *Cris de Paris dessinés d'après nature* appeared—a volume which 1830s lithographers such as Gavarni and Traviès as well as painters used when they depicted urban scenes.[43] Few of these publications satirized the subjects they selected; they provided historically accurate and readily accessible details about dress, customs, and character that supplemented the vocabulary of the Realist painters.

Whether all this quasi-scientific literature and their illustrations led to true "popular images" is questionable; the encyclopedic range did, however, provide models descriptive of the urban setting[44] as well as a vast reservoir of information for artists seeking to create a new art for the common man.

Several of the early Realists—Jeanron, Bonvin, and Ribot among them—had themselves been printmakers and were undoubtedly familiar with volumes like *Les Français peints par eux-mêmes* and Bouchardon's *Cris de Paris.* In some cases, the experience they acquired as printmakers and their familiarity with these volumes can be detected in their early drawings and paintings. Bonvin's early drawing of a woman scouring a copper cauldron, for example, relies heavily on

Bouchardon's exacting engravings (Figures 5, 6). The same placement of a single figure brought dramatically close to the foreground plane is evident in both images; the figures are similarly engrossed in their work. Bonvin's drawing of a *Woman Sweeping,* 1852 (Figure 7), was suggested, in part, by Bouchardon's image of a similar model (Figure 8). The pose and the simplicity of the setting are similar, although Bonvin has emphasized the poverty of his figure by eliminating Bouchardon's elegant interior and focusing instead upon the broom made from twigs. Even though comparable in pictorial theme and pose, Bonvin's sweeper is undeniably from the lower class. Bonvin also borrowed from the fourth volume of *Les Français peints par eux-mêmes,* 1841 (Figure 9), and from Bouchardon in his portrayals of workers from the streets of Paris. Bouchardon's *Porteur d'eau* (Figure 10), dressed in work clothes and going up the steps—perhaps of a fountain—is carrying water jugs held by a strap slung over his shoulder. Bonvin depicted a similar carrier in traditional dress and cap, resting with the loose leather strap by which he would have carried the heavy containers (Figure 11).

Théodule Ribot's *Petite Laitière* is also based on traditional iconography [9]. Manet's *Ragpicker* (Figure 12) was probably influenced as much by the model found in *Les Français peints par eux-mêmes* as by the presence of contemporary *chiffonniers* in Parisian streets. When Lhermitte painted his large canvas of cobblers working at home, 1880 (Figure 13), he, too, may have made use of the cobbler's room and tools from an engraving by Meissonier that appeared in *Les Français peints par eux-mêmes.*

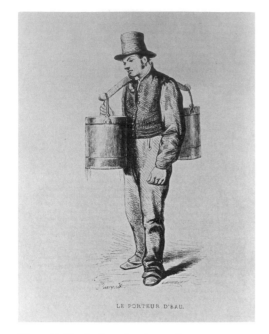

Figure 9. Illustration of watercarrier from *Les Français peints par eux-mêmes*.

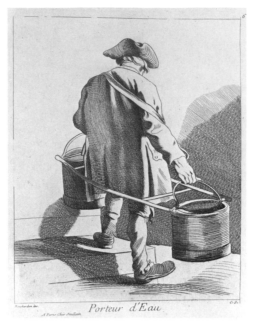

Figure 10. Edmé Bouchardon, *Porteur d'eau*.

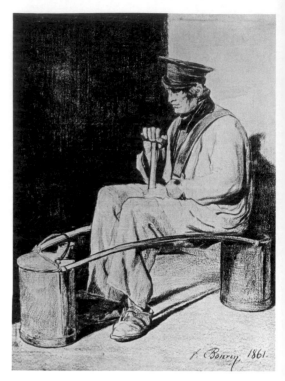

Figure 11. François Bonvin, *Watercarrier*.

Figure 12. Edouard Manet, *Ragpicker*.

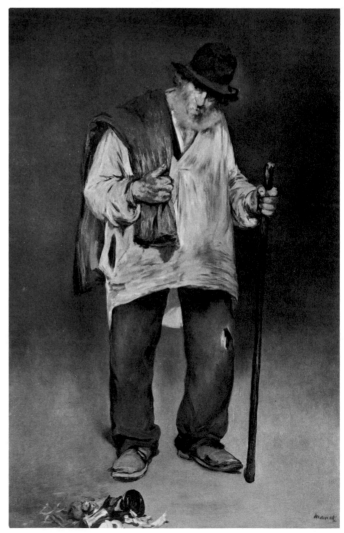

Craftsmen whose trades were handed down from generation to generation were a favorite Realist subject; the *Woodworker at His Lathe* drawn by Léon Lhermitte (Figure 14 and *The Tinker* by Alphonse Legros (Figure 15) are two examples from this *métier* tradition. In the 1840s Emile de la Bédollière published *Les Métiers,* in which a wide variety of trades were listed, illustrated with engravings after Monnier. This publication, together with a number of single-sheet images inspired by the rise of the working class as a political force, were used by the Realists, though they did not necessarily interpret the country tinker journeying from village to village or the artisan working at his lathe as harbingers of social revolution. Their workingmen, instead, reflect a somewhat Romantic view of a laborer's life, as if emulating Thoré's precept to mirror man's actual existence in their art.

If urban activities most often attracted the attention of writer and image maker, the customary ways of tilling the soil and harvesting the crops had also to be recorded before they were obliterated by the exodus of whole populations into the city in response to the massive industrial transformation then underway.[45] Even the peasants who remained behind were not immune to change; the government in Paris sought to break down their provincial loyalties and reinforce their allegiance to the central power. Suffrage was granted to the peasants and efforts made to educate their children as part of the campaign to weld a unified nation.[46] Writers and painters, recognizing the appeal on these familiar types, lamented the passing of provincial traditions, folklore, proverbs, and customs—and recorded them to save them from extinction. As a result, Realism dealt as often with traditions that were

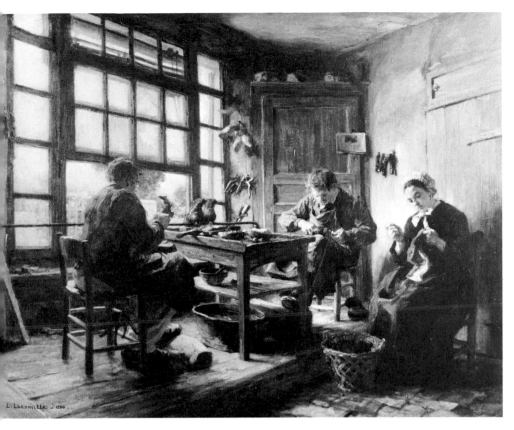

Figure 13. Léon Lhermitte, *Les Cordonniers*.

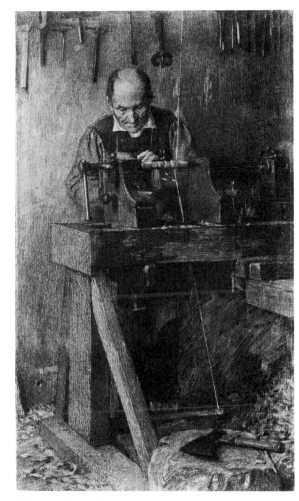

Figure 14. Léon Lhermitte,
Woodworker at His Lathe.

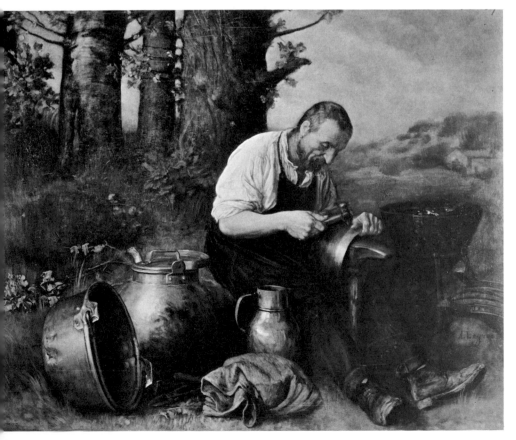

Figure 15. Alphonse Legros, *Tinker*.

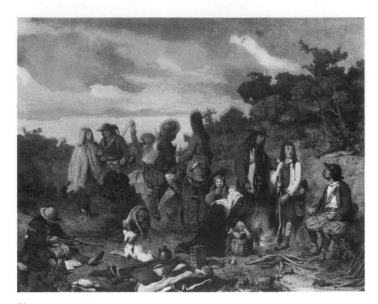

Figure 16. Adolphe Leleux,
Rendez-vous de chasseurs paysans bas-bretons.

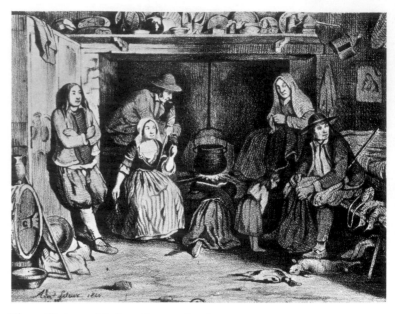

Figure 17. Armand Leleux, *Paysans bas-bretons.*

disappearing as it did with contemporary life. In the literary world, Balzac's *Médecin de campagne* (1833), *Le Curé de village* (1838/39), and *Les Paysans* (1844) and George Sand's *La Mare au diable* (1846) and *François le Champi* (1846) exemplify Romantic values combined with the Realists' accurate portrayal of peasant life. Eugène Bonnemère's *Histoire des paysans depuis la fin du Moyen Age jusqu'à nos jours, 1200-1850* (1856) provided the Realists with reasons for the peasant flight to the city and inspired migration from the countryside—another favorite Realist theme in the mid-1850s. Alexandre Antigna's *Forced Halt* [22], for example, depicts a similar wandering family threatened by storm and hunger. Bonnemère's history was followed by other publications, often privately printed, which examined village life in a quasi-scientific manner, recording the events and ceremonies that the painters of peasants depended upon to present an accurate picture of life in the provinces.

Some artists confined themselves to the condition of the worker and farmer in a particular region, and in doing so founded specific provincial schools. Gustave Brion and Gustave-Adolphe Jundt, Alsatian artists trained in Paris, painted themes from their native region. The artists of Normandy, the Pyrénées, and the Auvergne chose similar native themes. Brittany was a special favorite.[47] The romanticized versions of Breton peasant life that Armand and Adolphe Leleux (Figures 16, 17) exhibited at the Salons provided the public with views of ancient, native French traditions. Most of the paintings of the Leleux have disappeared, but the few that remain suggest that they used a proto-Realist style. Adolphe Leleux's *Cour de cabaret* (Figure 18), for all its rustic provincialism and its debt to Northern painters, reveals

the peasantry of Brittany with an earthiness that prefigures Courbet's more famous *Ornans.*

The early Realist compositions relied on landscape painting to capture the quality of a locale; the canvases of Jean François Millet, Jules Breton, and, later, Léon Lhermitte portray peasants working in the fields, housekeeping in their hovels, or battling famine, flood, and fire.[48] The numerous *physiologies* also provided information on provincial life, and art critics such as Castagnary encouraged artists to confine themselves to their own locales rather than look abroad for themes to paint. Jouy was consulted for information on provincial customs and *Les Français peints par eux-mêmes* for its studies of certain regional types (*La Femme de province, Le Braconnier, Le Franc-Comtois, Le Normand,* and *Le Limousin),* which included illustrations engraved after drawings by Jeanron, a radical Realist and advocate of the humanitarian treatment of workers in the city but who also found time to study life in the provinces. Jeanron's interest in peasant folk customs led him to complete his painting of *Les Paysans limousins,* 1834 (Figure 19), one of the earliest canvases to depict the customs of a province in proto-Realist style.

The Realist movement was at the same time a record of social protest and an expression of belief in the bourgeois society of the time,[49] and the resulting ambivalence was often apparent, whether intended or not, in the images of its painters and draftsmen. Since history painting was regarded by the Realists as an outmoded genre, as Castagnary noted in 1857, it had no choice but to disappear along with the institutions of monarchy and theocracy that it represented.[50] It was replaced with a different kind of history; all types of genre

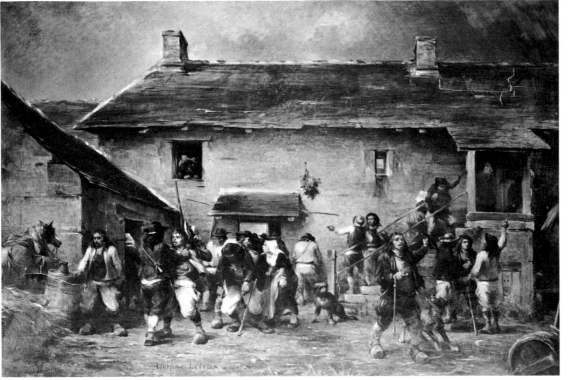

Figure 18. Adolphe Leleux,
*Cour de cabaret
(Basse bretagne).*

Figure 19. Philippe Auguste Jeanron, *Les Paysans limousins.*

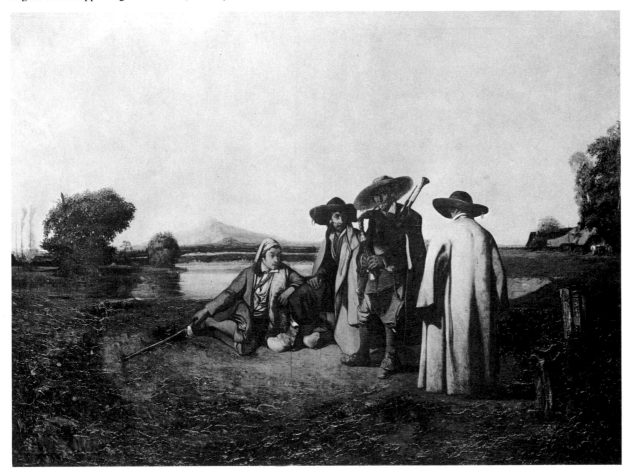

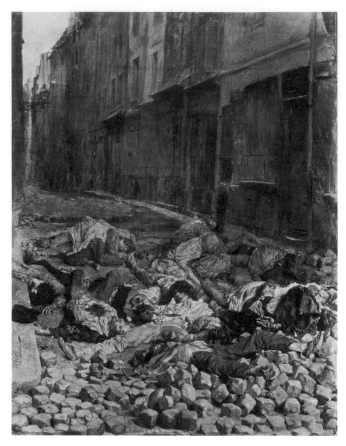

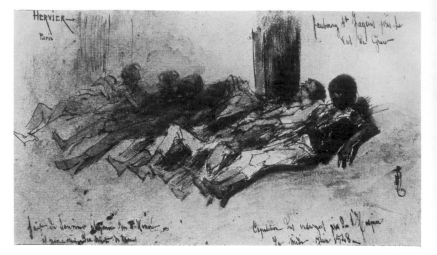

Figure 21. Adolphe Hervier, *Hôpital du Midi*.

Figure 23. Adolphe Leleux, *La Sortie, Paris*.

Figure 20. Jean-Louis-Ernest Meissonier,
Souvenir of the Civil War.

Figure 22. Adolphe Leleux, *Patrouille de nuit, Février 1848, Paris*.

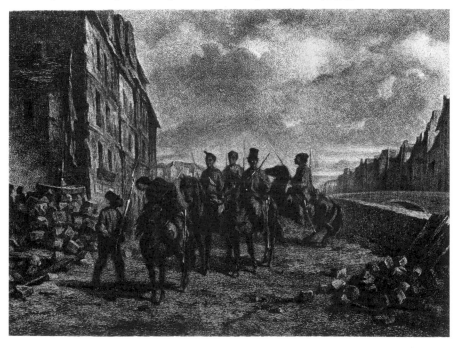

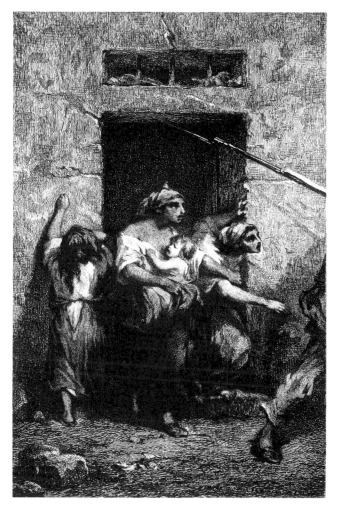

painting were declared to be history painting as long as they represented the customs and events of the time. Canvases and water colors recorded contemporary events, but, clearly, no longer favored the usual battle scenes or conquests once painted for the glorification of man and country. Contemporary works still depicted the effects of catastrophe on the humble or innocent and still glorified the common man, thereby again raising the fundamental social and political issues that were at the heart of Realist imagery. Meissonier's *Souvenir of the Civil War* (Figure 20), representing the gruesome aftermath of a battle which destroyed a civilian barricade in the Revolution of 1848, was intended to warn future rebels not to oppose authority.[51] A comparison of Meissonier's depiction with the romantic rhetoric and turmoil of Delacroix's earlier and more famous *Liberty on the Barricades* (1830) shows this change.[52]

Another artist who painted the 1848 revolution as a disaster for the common man was Adolphe Hervier, who depicted scenes of the dead and injured in the narrow streets [98, 98A] or against the wall near the Hôpital du Midi (Figure 21). At the 1850/51 Salon, where Meissonier displayed his *Souvenir of the Civil War,* Adolphe Leleux showed *Patrouille de nuit, Février 1848, Paris* (Figure 22) and *La Sortie, Paris,* 1848 (Figure 23)—both of which depicted the effects of the civil war on families. Whether Leleux's scenes were done from sketches or from memory is not known, but, whatever the case, the artist abandoned allegory for a direct, simple statement. Meissonier and Leleux were on the side of authority during the revolution. Little is known of Hervier's political allegiances,[53] but it is clear in his pictures that he grieved for the downtrodden.

Hervier's pictures were not exhibited at the Salon of 1850/51, but others of a similar persuasion were, and this Salon became not only a Realist, but a political exhibition.[54] Breton also exhibited a large canvas—unfortunately now destroyed—based on the horrors of 1848 and entitled *La Faim* (Figure 24), showing a poor family huddled together and dying of starvation in a garret after the father has returned empty-handed.[55] It was this painting that led the critics to link Breton with the Realists.

Isidore Pils, in his composition *Siege Lines at Sebastopol* [99], provides a very different view. While not as fully staged as his *Bataille de l'Alma,* which won official approval during the Second Empire, this work retains some of the contrivances of official painting, thus characterizing a Realist composition molded by state policy. He has captured the monotony of warfare in his few soldiers, but it is also known that he reconstructed his episode from the reports of soldiers active at the scene—not from his own experience. His water colors during the Franco-Prussian War are much more truthful; these are scenes he actually witnessed [102, 106]. In letters to his friend Becq de Fouquières, written between September 1870 and January 1871, Pils described the events he represented, in which "one only meets soldiers from the Garde mobile and the Garde nationale. The Garde mobile washes its clothes in our fountain, and on all our exterior boulevards barracks have been built to house these courageous

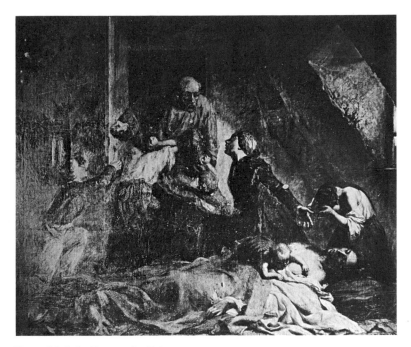

Figure 24. Jules Breton, *La Faim.*

defenders."[56] Pils's political leanings were similar to Meissonier's. From his letters, it is clear that of all that occurred during the Franco-Prussian War he most regretted the burning of the Chateau of St. Cloud.[57] His small studies show that he was a true reporter of the day-by-day events of a city under siege, but, unfortunately, few critics knew of these works. Castagnary, in particular, singled out Pils as an example of what happened to a promising painter when he fell victim to the blandishments of state patronage.[58]

Scenes of disasters were also included under the new history painting. Disaster painting had a long tradition in Europe, but once again what the Realists introduced was an emphasis on the helpless victims. A number of these canvases were commissioned by Napoleon's government, probably in an effort to show the emperor's concern for the welfare of his people. By commissioning artists such as Antigna, William Bouguereau, and Michel-Philibert Genod to paint these pictures, Napoleon III encouraged the development of a kind of official Realism. Paintings in this mode were often staged to feature Napoleon III surrounded by his applauding subjects, but occasionally one of these Realists would use a disaster itself to create a successful composition. Gustave Brion's version of the *Potato Harvest during the Flooding of the Rhine* [94], for example, records the havoc wrought by an actual flood—the destruction of a community and its very livelihood, with no reference to imperial visitation. A fire painted by Jules Breton [92] suggests the solidarity of a community resisting destruction, acknowledging the faint hope for survival that lies in united action—even though the poor are always the victims.

The Realist artists can generally be categorized into three subgroups. The first comprised those who, like Courbet,

were regarded as dangerous—in Courbet's case mainly because his works were overwhelming in scale, novel in style, and his eccentric personality abhorrent to bourgeois taste. But the use of Realist themes did not necessarily involve any overt statement of social protest, and the second group were those like Breton, who, although they might occasionally paint social themes, were never regarded as a threat to the social order. The third group included men like Antigna and Pils who used the Realist mode to paint official propaganda and, in the process, formulated an official Realism palatable to the bourgeoisie and the government.[59] Taken together, the three made one major contribution: they made legitimate as a subject for art every aspect of human life. As such, Realist art did not necessarily imply radical politics, but it did imply social consciousness.

Many of the Realist critics, most notably Champfleury, also advocated the spread of popular imagery for didactic purposes—social if not official—through mechanisms such as the painting of vast murals in railway stations and other public buildings.[60] In this way, people who might never attend a Salon or formal exhibition would be exposed to contemporary art and its message. However mutually contradictory in other respects, social conscience and industrialism would then come together in art, and, in fact, Realism undoubtedly flourished during the Second Empire as much because of its glorification of the remarkable economic expansion and prosperity generated by the growth of industry between 1850 and 1870 as for its support of the cause of the downtrodden.

This economic growth would not have been possible without the industrialization undertaken in the 1830s in response to advances in English technology. French nationalism and pride were piqued when the country was forced to import English engineers and specialists, and a deliberate effort was made to train French workers in the latest innovations. Gradually, French entrepreneurs built up French industry, especially the mining of iron ore and foundries, by utilizing new processes developed in England. Napoleon III, recognizing that he needed the support of private initiative and capital to develop France's industries, organized two world's fairs (1855 and 1867) to attract capital as well as provide a showplace for the achievements of French culture and technology. Another aspect of his economic policy encouraged the depiction of industrial themes in the arts. While few painters proved capable of recording industrial scenes, one artist—François Bonhommé—did win a medal at the 1855 International Exhibition for his accurate portrayal of industrialization and modernization. Revealing a diligent attention to detail appropriate for a Realist, his earliest drawings and paintings used the forge at Fourchambault [37A, 37B] as their subject, and his capacity to record new innovations and his association with entrepreneurs soon made him the foremost painter of industrial France. His studies for the Schneider family at Le Creusot in the mid-1850s continued this record of innovations in machinery and manufacture, but included also the beneficial effect that industrialization had on and around the village of Le Creusot [44] and nearby Montchanin [43].

Few relationships between artist and industrialist during the Second Empire are as clearly documented as that between Bonhommé and Eugène Schneider. Since Bonhommé had no particular interest in the workers' cause, he made no judgments about the conditions under which they worked and lived—as other artists were to do later in the century. Bonhommé simply recorded what he saw, painting common laborers, foremen, and owners in a series comparable to the *physiologies* used by other Realists in their depictions of urban and rural life.[61] Bonhommé's drawings did not agitate for social improvement and, when he drew a landscape transformed by factories, he painted not the destruction of nature but the triumph of man over it.

Working for Schneider at Le Creusot, Bonhommé concurred with the basic philosophy of that manufactory that science, technology, and Christian charity were equal partners.[62] As a follower of Saint-Simon, he believed the poor would be helped through a collaborative relationship between industrialist and worker. At Le Creusot this ideology was realized in a kind of paternal capitalism. A hospital was added and the water and sewerage system expanded, as Schneider transformed Le Creusot from a bankrupt, provincial town to a thriving manufactory that cared for the workers who toiled in its mines and factories. By the mid-1860s Bonhommé was at the height of his fame, and Le Creusot came to symbolize the triumph of imagination fired by the energy of an enlightened capitalist. After 1870, when the lot of the workers ceased to improve and strikes disrupted Le Creusot and other manufactories, Bonhommé's optimism was dissipated. He died embittered and impoverished, and many of his works were destroyed or hidden away because of the very changes he had helped to record. Despite his capacity for accuracy, his surviving works reflect a propaganda that can now be seen as inherent in the revitalization of French industry during that era.

Few other Realists served industrialists as faithfully as Bonhommé did (Figure 25). Those later painters who were concerned with progress dealt with it in terms of the betterment of conditions for the worker. In the 1880s and 1890s painters like Jules Adler [193] turned to the claims of the poor for a better life, as the capitalists continued to ignore their plight and the desperate workingman began to rebel. This despair became a subject for Naturalist painters.

The first Salon of Realism in 1850/51 stimulated considerable discussion about what had attracted the public to Realist painting. Some maintained that the public crowded into the Paris Salon only to see the medal winners and to examine the canvases of Courbet and others who had provoked such heated discussion in the press. Others claimed that the state had actually encouraged an audience for art by commissioning specific works or purchasing those works from the Salons that were accessible to the masses—in the process encouraging painters to turn out works that all of the people could understand.

There is no real evidence of a state policy favoring Realist painting, but many of these works were shipped to the provinces by the government. Rodez, for example, received a

Bonvin Salon painting as a gift from the emperor.[63] Policy or not, pictures that were purchased and dispersed show the state championing the masses and supporting the traditional place of the family or, as in the case of Pils's *Death of a Sister of Charity,* the official Church providing sustenance to the poor [79].

Provincial centers also purchased paintings and, like those works favored by the state, also showed a preference for paintings that documented the problems of the rural poor. For instance, Antigna's *Forced Halt,* which was purchased by the municipal government of Toulouse in 1858 after the painting had been shown in an exhibition in that city, certainly appeared to have aroused interest because of its rural theme. This work, which showed the displaced rural poor fleeing their miserable existence and which also represented a family united against adversity, was no doubt intended to provide the people of Toulouse—some of whom may well have experienced a similar situation in their own immigration to the city—with a theme for reflection. The reactions of the provincial viewers, of course, remain unknown. And the reasons a painter may have been favored by certain townspeople rather than another—Ribot, by Marseille, for example—can only be speculated.

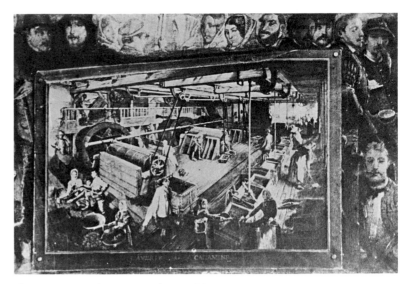

Figure 25. François Bonhommé, Mural from the Ecole des Mines.

Figure 26. Henri Gervex, *Mariage de Mathurin Moreau.*

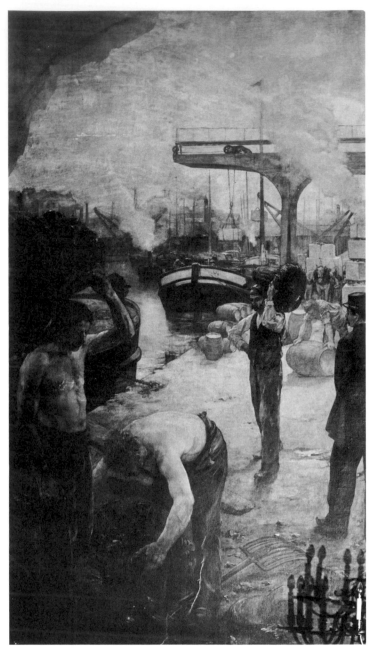

Figure 27. Henri Gervex, *Les Coltineurs*.

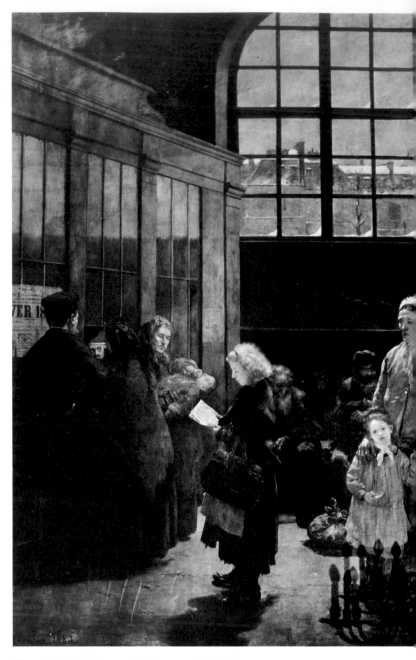

Figure 28. Henri Gervex, *Le Bureau de bienfaisance*.

The Realists could exhibit in any of three places: Paris Salons, provincial centers, or foreign countries. A work judged inappropriate for a Parisian or foreign audience might well be shown in the provinces, and it was in this way that Realist art most often fulfilled the democratic functions the early critics had proscribed. Even though Champfleury had urged the installation of art in public places, Bonhommé was the only Realist artist to have actually painted a public mural before the Third Republic.[64]

Then suddenly a host of Naturalist painters were commissioned to decorate public buildings. By 1883 Henri Gervex, an artist who had attracted considerable attention when he tried to show his *Rolla* at the 1878 Salon, completed a series of large-scale wall paintings for the town hall of Paris's Nineteenth Arrondissement. Commissioned by the mayor to decorate the *salle de mariage,* Gervex painted a marriage ceremony (Figure 26) that included among its figures such supporters of Naturalism as Zola and even the mayor him-

16

self. Another scene for the town hall showed workers from the region loading barges on the Quai de la Villette, a nearby canal. Gervex's Realist style recorded these various workers carrying out specific functions (Figure 27). A third panel symbolized the importance of public assistance for the sustenance of the poor, portraying the elderly and indigent applying for benefits from the state. The row of beggars, seated beneath a large window that provides a view of a bitter, wintry day, reveals an artist returning to social types that Realist painters had favored earlier in the century (Figure 28).

Toward the end of the 1880s Léon Lhermitte was commissioned to do a series of large paintings for the Sorbonne, to be dedicated to Claude Bernard and Henri Saint-Clair Deville, two pioneers of science from the Collège de France (Figure 29). Zola was especially attracted by the rational, experimental nature of science and may even have persuaded his close friend Lhermitte to read Bernard's *Introduction to the Study of Experimental Medicine*.[65] But Lhermitte's compositions are not so much commendations of scientific advancement as

they are monuments to contemporary history, much like Feyen-Perrin's earlier *Anatomy Lesson of Doctor Velpeau* [153] and Fantin-Latour's group portraits of his friends and colleagues. Lhermitte, with his meticulous and carefully developed official Naturalism, portrayed these thinkers as modern heroes. By singling out particular figures from society, Lhermitte and many other Naturalists thus created a new pantheon to replace standard classical and romantic heroes with workers and thinkers.[66]

While the Salons still exhibited Realist works and the provincial museums still purchased examples, the Realist-Naturalist tradition in later years retained most of its contact with the masses through commissions in public buildings, and while collectors still purchased small, intimate, nonpublic canvases, official Realism or Naturalism remained the style of those artists eager to have their works seen and appreciated by a broader public.[67] Social issues remained typical of the large-scale Realist-Naturalist pictures that dominated public spaces and were intended to inspire people to

Figure 29. Léon Lhermitte, *Claude Bernard in His Laboratory at the Collège de France.*

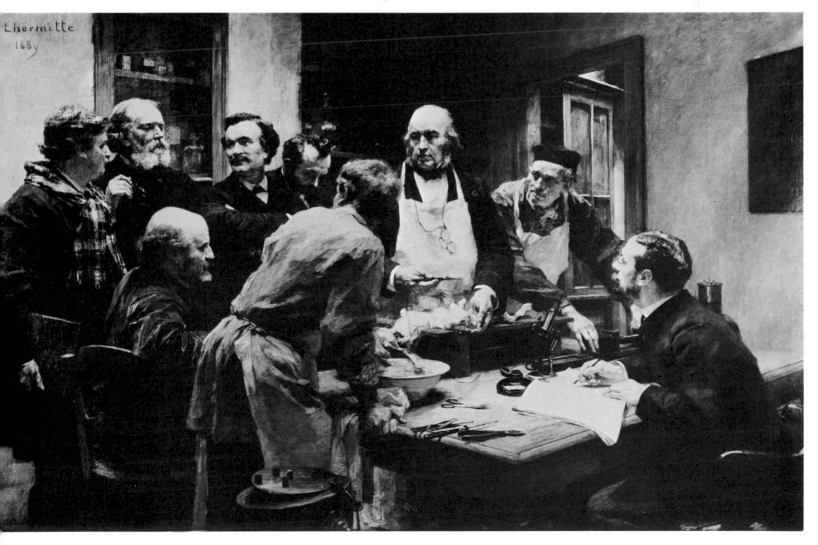

17

strive for social betterment through emulation of the successful. The blacksmith and the industrial worker were portrayed by the Realist painters in a style that elevated their common endeavors to positions comparable with the heroes of ancient Greece and Rome.

If the style used by the Realists and Naturalists was neither a revolutionary nor drastic departure from earlier art as the critics once claimed, the subjects used—especially in the category of contemporary genre—undeniably forced spectators to see and think about the world around them. Narrative painting trained the reviewer to read a picture [17] much as he read a newspaper and to think of what was happening to the various characters depicted in terms of his own personal life. Even the traditional categories of still life, portrait, and landscape—more often than not—removed the artifice of past styles and historical trappings to concentrate on the essential details. Ribot used the same care and attention in studying a clay pot [120] as Marcellin Desboutin used to characterize a sitter [163]. The Realists, and especially the Naturalists, sought to uncover truth in whatever theme they pursued.

At the heart of the Realist tradition was the belief that first Realism and, later, Naturalism could reverse a decline in art while also reflecting sympathetic changes in society. Classicism was no longer relevant to the modern world; Romanticism led to too many flights of fancy. The painter first had to focus on what he could see and, in the process, rediscover a visual tradition that linked him with the painters of reality from other times. As Edmond Duranty wrote, Realism was neither a style nor a school; it was a way of perceiving the ordinary and the commonplace that elevated it to a position of importance.

1. Edmond Duranty, "Réalisme," published in *Réalisme,* 15 November 1856, p. 1, a journal chiefly devoted to the elucidation of the Realist tradition. Duranty's journal *Réalisme* first appeared in November 1856 and continued into 1857. In a sense, he was in advance of the other critics in some of his ideas. Duranty's role in the evolution of Realist theory has not been thoroughly studied, perhaps because critics associated with Courbet—especially Champfleury—have attracted attention at the expense of younger writers like Duranty whose careers spanned the period of the Impressionists. Duranty's explanations of the Realist tradition were most likely derived from discussions with painters, since he is known to have frequented the Brasserie Andler in the late 1840s, where he became acquainted with Courbet, Bonvin, Gautier, Champfleury, the sculptor Préault, and others. See Marcel Crouzet, *Un Méconnu du Réalisme: Duranty (1833-1880), l'homme, le critique, le romancier* (Paris: Librairie Nizet, 1964).

2. The problem is discussed by T. J. Clark in *Image of the People: Gustave Courbet and the Second French Republic, 1848-1851* (Greenwich, Conn.: New York Graphic Society, 1973). The role played by private art dealers and collectors in advocating a more intelligible imagery needs further investigation. For similar aspects in England, see Howard David Rodee, "Scenes of Rural and Urban Poverty in Victorian Painting and Their Development, 1850 to 1890" (Ph.D. diss., Columbia University, 1975).

3. Discussions of Realism have concentrated on Courbet almost to the exclusion of other Realists. The vastness of his canvases, his egocentrism, and the ambiguities of his mature work—he did not concern himself exclusively with mirroring social change—continue to attract art historians. The most important writings on Courbet include Linda Nochlin, *Gustave Courbet: A Study of Style and Society* (New York: Garland Publishing, 1976); Meyer Schapiro, "Courbet and Popular Imagery," *Journal of the Warburg and Courtauld Institutes,* 1940-41, pp. 164-91; Linda Nochlin, "Gustave

Courbet's Meeting: A Portrait of the Artist as a Wandering Jew," *Art Bulletin* 49 (September 1967): 209-22; and T. J. Clark, "A Bourgeois Dance of Death, Max Buchon on Courbet," *Burlington Magazine,* April 1969, pp. 208-12, and May 1969, pp. 286-90. A comprehensive exhibition at the Louvre in 1977/78 showed Courbet's best known paintings but failed to put his work into context. Another exhibition a year later in Germany showed Courbet with the German Realists, though the juxtaposition failed to prove that the influence of Courbet on German artists was as significant in its impact as that of many other French Realists. See *Gustave Courbet: 1819-1877,* exh. cat., Grand Palais, 30 September 1977—2 January 1978, and *Courbet und Deutschland,* exh. cat., Hamburg Kunsthalle, 19 October—17 December 1978 and Stadtische Galerie, im Städelschen Kunstinstitut, Frankfurt am Main, 17 January—18 March 1979. For further reference see Linda Nochlin, *Realism* (Baltimore: Penguin Books, 1971); and idem, *Realism and Tradition in Art, 1848-1900* (Englewood Cliffs, N.J.: Prentice-Hall, 1966). For some novel, recent ideas, see Jean Luc Mayaud, *Les Paysans du Doubs au temps de Courbet* (Besançon: Les Belles-Lettres, 1979); and Aaron Sheon, "Courbet, French Realism and the Discovery of the Unconscious," *Art Quarterly,* Winter 1980, in press. For one of the few attempts to interpret the Realist movement from a broader perspective see Petra ten-Doesschate Chu, *French Realism and the Dutch Masters* (Utrecht: Haentjens Dekker and Gumbert, 1974). Literature on the other Realists includes *Jean-Pierre Alexandre Antigna (Orléans, 1817—Paris, 1878),* exh. cat., Musée des Beaux-Arts d'Orléans, 26 October 1978—3 January 1979; Gabriel P. Weisberg, "The Traditional Realism of François Bonvin," CMA *Bulletin* LXV (November 1978): 280-98; idem, *Bonvin: La Vie et l'oeuvre* (Paris: Editions Geoffroy-Dechaume, 1979); idem, "Théodule Ribot: Popular Imagery and *The Little Milkmaid,"* CMA *Bulletin* LXIII (October 1976): 253-63; and Madeleine Fidell-Beaufort, *"Fire in a Haystack* by Jules Breton," *Bulletin of The Detroit Institute of Arts* 57, no. 2 (1979): 54-63; *Léon Lhermitte (1844-1925),* exh. cat., The Paine Art Center and Arboretum, Oshkosh, Wisconsin, 21 September—10 November 1974 (text by Mary Michele Hamel).

4. Themes contrasting urban and rural life are discussed by Robert L. Herbert, "City vs. Country: The Rural Image in French Painting from Millet to Gauguin," *Artforum* VIII (February 1970): 44-55. Still-life painting in the nineteenth century is usually discussed in terms of the Chardin revival, although other trends were equally influential. See John W. McCoubrey, "The Revival of Chardin in French Still-Life Painting, 1850-1870," *Art Bulletin* XLVI (March 1964): 39-53; and Gabriel P. Weisberg with William S. Talbot, *Chardin and the Still-Life Tradition in France* (CMA, 1979). Because still-life painters often exhibited their work with private art dealers or sold directly to individuals, it is difficult to trace both the evolution of themes and the location of specific canvases. Portraiture received a notable, original treatment which still awaits examination; landscape painting, however, has been given attention from art historians at the expense of almost all other genres. See Robert L. Herbert, *Barbizon Revisited,* exh. cat. (Boston: Museum of Fine Arts, 1962); and John Rewald, *The History of Impressionism* (New York: Museum of Modern Art, 1961).

5. Louis Sébastien Mercier, *Tableau de Paris,* 8 vols. (Amsterdam, 1782—83). This work would have been well known to both critics and painters of the nineteenth century. Mercier's interest in defining different social categories may have derived from emblematic images used in Holland during the seventeenth century; that his book was published in Amsterdam makes this link a strong possibility. Mercier tried to establish *la physionomie morale* of Paris by providing the reader with descriptions similar to a painter's depiction. For a remarkable analysis of a number of the themes first examined by Mercier, see Olwen H. Hufton, *The Poor of Eighteenth-Century France: 1750-1789* (Oxford: Clarendon Press, 1974). Hufton presents considerable evidence on the importance of relief for the poor.

6. The critics who supported Realism and, later, Naturalism were the avant-garde and cannot be regarded as typical of the reviewers for daily journals. But they do represent the most cohesive body of material available on *réalisme* in the nineteenth century. Many knew each other intimately, so it is likely that their theories of Realism were debated and discussed with and among the painters who were trying to put Realist ideas into practice. See Joseph C. Sloane, *French Painting Between the Past and the Present* (Princeton University Press, 1951).

7. Gabriel Laviron and B. Galbacio, *Le Salon de 1833* (Paris: Librairie Abel Ledoux, 1833), p. 25. Laviron, a radical figure during and after the July Revolution of 1830, and his colleague, Philippe Auguste Jeanron, became leading advocates for artists' rights, reinstatement of the Salon, and Realism in painting. Laviron moved in artistic circles that favored humanitarian concerns and social improvement; painters and writers with similar attitudes, such as Théophile Thoré and Jules Antoine Castagnary, read and assimilated his art

criticism. Gustave Courbet's friend Jean Gigoux, who during the 1830s was linked to progressive ideas, painted Laviron's portrait [131]. For further information on Laviron and Jeanron, see Madeleine Rousseau, ''La Vie et l'oeuvre de Philippe Auguste Jeanron: Peintre, écrivain, directeur des Musées Nationaux, 1808-1877'' (thesis, Ecole du Louvre, 1935), vol. I, pp. 36-40.

8. For a discussion of the new conceptual basis of painting see Albert Boime, *The Academy and French Painting in the Nineteenth Century* (London: Phaidon Press, 1971). Boime correctly notes the emphasis placed on individual freedom in painting, underscoring that this was a preoccupation of both academic and independent painters of all tendencies (Romantic, Realist, and others). The importance of the sketch as a finished work in itself also affected those painters who were identified with Realism.

9. For further reference on Thoré, see Théophile Thoré, ''Nouvelles Tendances de l'art,'' in *Salons de Th. Thoré, 1844-48* (Paris, 1868), where he continued to write under the name Wm. Bürger. See also the Preface, p. xxvi. Thoré wrote this essay in 1857 while in exile in Brussels, but the theories expressed therein can be traced to the 1840s when he was actively engaged in writing for newspapers in support of radical change and artistic innovation. See Frances Suzman Jowell, *Thoré-Bürger and the Art of the Past* (New York: Garland Publishers, 1977).

10. Thoré, Preface, p. xxviii. This idea was first expressed by Duranty in the first issue of *Réalisme,* and it is likely that Thoré was inspired by Duranty's article. Duranty's review was widely circulated and helped other critics to organize their own ideas about Realism.

11. After the Revolution of 1848, the Le Nains were made heroes of the French school. Champfleury revived interest in the brothers in his *Essai sur la vie et l'oeuvre des Le Nain peintres Laonnois* in 1850. They were widely published in a series of magazines, including the *Magasin pittoresque* (1850). The Le Nains were no doubt seen as painters whose work could provide the foundation for a democratic recognition of provincial art. See Stanley Meltzoff, ''The Revival of the Le Nains.'' *Art Bulletin* 24 (1942): 259-86; on Champfleury, see Emile Bouvier, *La Bataille réaliste, 1844-1857* (Paris, 1913).

12. Bixiou [Champfleury], ''Salon de 1849,'' *La Silhouette,* 22 July 1849. The personalization of still life is the unique contribution of this particular review.

13. Ibid. Painting family life was regarded as important in 1850, and it would remain so under the Second Empire, since strong family ties were regarded as essential to the continuation of the democratic viewpoint. Bonvin was further discussed by Champfleury in 1872; see *Souvenirs et portraits de jeunesse* (Paris: E. Dentu, 1872), pp. 147-52.

14. Champfleury, *Le Réalisme* (Paris: Michel Lévy Frères, 1857), p. 281. Champfleury attributed the beginning of Realism to Courbet in 1848. He had first started his career writing in a Romantic mode, but Courbet's painting and an introduction to folk literature led him to write about life among the poor. See Schapiro, ''Courbet and Popular Imagery,'' pp. 174-75.

15. Duranty, ''Réalisme,'' p. 1.

16. Ibid., p. 2. Duranty claimed that an aesthetic definition of Realism was impossible. Basically, the terms Realism and Naturalism were both used by writers, critics, and painters for an examination of nature that did not involve the ''ideal.'' For further reference see E. Littré, *Dictionnaire de la langue française,* 4 vols. (Paris: Librairie Hachette et Cie, 1878), s.v. ''nature,'' pp. 695-97; s.v. ''réalisme, réaliste, réalité,'' p. 1496; s.v. ''vrai,'' pp. 2549-50.

17. Jules Antoine Castagnary, *Salons (1857-1870)* (Paris: Bibliothèque Charpentier, 1892), p. 3. This segment from the ''Philosophie du Salon de 1857'' was first published in *Le Présent* by Poulet-Malassis, an early and avid supporter of Realism and close friend of a number of the Realist critics and painters.

18. Nochlin, *Realism and Tradition in Art,* p. 63. The term had been used earlier by Gabriel Laviron who saw little difference between the word *Naturalism* and the word *Realism* in his analysis of a given artist.

19. Castagnary, *Salons* (1863), pp. 104-5. Reliance on ''truth'' as an aesthetic doctrine was advocated by a number of painters during the mid-1860s, among them, James McNeill Whistler, whose early paintings completed in France showed the new Naturalist strain within the Realist tradition. Eventually, Whistler gave up this position for that of ''pure painting'' and ''art for art's sake.''

20. Ibid.

21. Castagnary, *Salons* (1868), pp. 289-90. Castagnary proposed the Van Eycks and the Spanish painters of the seventeenth century such as Velázquez and Ribera as models to emulate. The influence of the earlier

Northern painters is noticeable in second-generation Realists such as Alphonse Legros [140] and Léon Bonvin [119]. The influence of the Spanish painters is even easier to document.

22. Castagnary, *Salons* (1863), p. 147. Here he emphasizes providing the key to people and the environment in which they live and seems to be suggesting that the painter should offer a moral judgment in the theme he chooses to paint.

23. F. W. J. Hemmings and Robert J. Niess, *Emile Zola—Salons* (Paris and Geneva: Librairie Minard and Librairie E. Droz, 1959), pp. 61 ff.

24. Ibid., p. 71. Zola originally wrote about the Realists for *L'Evénement,* 11 May 1866. Zola regarded himself as part of the Realist tradition because, like Duranty, he did not want to tie himself to a school. His criticism of Ribot seemed particularly harsh, since many of Ribot's canvases of the 1860s were, in fact, quite similar to Manet's; see, for example, [11].

25. For a discussion of Zola's advocacy of Manet, see Anita Brookner, *The Genius of the Future, Studies in French Art Criticism: Diderot, Stendhal, Baudelaire, Zola, the Brothers Goncourt, Huysmans* (London: Phaidon Press, 1975), pp. 91-106. Zola regarded the Impressionists as Realists in their material, or corporeal, handling of paint—another reason for his indifference to painters like Bonvin and Ribot. For further discussion, see Robert J. Niess, ''Theses and Messages,'' in *Zola, Cézanne and Manet, A Study of ''L'Oeuvre''* (Ann Arbor, Mich.: University of Michigan Press, 1968), pp. 234-49. Some art historians continue to follow Zola's lead and use Bonvin and Ribot as foils for showing the masterful, stylistic innovations of other painters or, taking these works out of context or from late in their careers, to show their dependency on Chardin or seventeenth-century Dutch and Spanish painters. Without denying the influence of these painters, it seems unfortunate that they have been spurned by art historians eager, like Zola, to put Manet forward as the forerunner of a new way of seeing and painting.

26. This is one of the fundamental aspects of Zola's art criticism. Through an understanding of the painter's and the sitter's character, Zola developed a theory of creativity which was also found in his novels. See Niess, ''Theses and Messages,'' pp. 234-49.

27. Brookner, *Genius of the Future*, p. 97. Zola may have been confused on Manet's relationship with some of the traditional, contemporary Realists.

28. Ibid.

29. Ibid. See Harry Levin, *The Gates of Horn* (Oxford: Oxford University Press, 1966).

30. Ibid. Baudelaire's complex relationship with the Realists is discussed in Schapiro, ''Courbet and Popular Imagery,'' pp. 180-83. Baudelaire rejected Realism because he saw in it a plebeian and artisan orientation that he could not accept. See Charles Baudelaire, *The Mirror of Art: Critical Studies by Charles Baudelaire,* trans. Jonathan Mayne (London: Phaidon Press, 1955), pp. 225-31, for Baudelaire's opinion of photography and Realism.

31. J. K. Huysmans, *Oeuvres complètes de J. K. Huysmans* (Paris: Les Editions G. Crès et Cie, 1928), pp. 140-42. In essence, Huysmans applied Baudelaire's theory to artists at the Salons. He noted that the artists whom the public appreciated and who initiated Salon Naturalism included Jules Bastien-Lepage, Henri Gervex, Jean Béraud, Norbert Goeneutte, and Pascal Dagnan-Bouveret. Huysmans found they lacked ''tempérament,'' or character—a distinction also made by Zola. Huysmans judged their work solely by what was shown at the Paris Salons, ignoring those works consigned to private art dealers or completed for independent patrons. He did, however, identify Degas as a painter of modern life. See Brookner, *Genius of the Future,* pp. 153-55.

32. The Art Nouveau of the 1890s proclaimed the relevancy of art for the masses, although under the Third Republic art became increasingly directed toward the tastes of an aristocratic elite; Realist tendencies had to be softened to appeal to aristocratic customers [163, 173].

33. Léon Rosenthal, ''La Genèse du Réalisme avant 1848,'' *Gazette des Beaux-Arts* X (1913): 178. Rosenthal noted that themes drawn from daily life appeared as early as 1848. Vinçard (1796-187?), an early nineteenth-century songwriter, became an apostle of Saint-Simonianism. For further information see *La Chanson française, Le Pamphlet du pauvre (1834-1851),* Introduction and Notes by Pierre Brochon (Paris: Editions Sociales, 1957), pp. 22-49.

34. Rosenthal, ''La Genèse du Réalisme,'' p. 179. For a discussion of Realism in literature see René Dumesnil, *Le Réalisme* (Paris: J. de Gigord, 1936); and idem, *L'Epoque réaliste et naturaliste* (Paris: Editions Jules Tallandier, 1945). Honoré Balzac's method is analyzed in Philippe Bertault, *Balzac and the Human Comedy* (New York University, 1963).

35. Rosenthal, ''La Genèse du Réalisme,'' p. 179. Proposed by Flaubert in his first, unpublished version of *Education sentimentale.*

36. For a discussion of the evolution and importance of newspapers in the nineteenth century, see Irene Collins, *The Government and the Newspaper Press in France, 1814-1881* (London: Oxford University Press, 1959).

37. For an early article on suicide, see *Le Journal des Débats*, 14 November 1824. Further discussion of workers' suicides is found in Louis Chevalier, *Classes laborieuses et classes dangereuses à Paris pendant la première moitié du XIXe siècle* (Paris: Librairie Plon, 1958), pp. 34, 338-59. The tragic career of Octave Tassaert, ending in suicide, will be discussed by Professor Aaron Sheon, University of Pittsburgh, in a forthcoming article.

38. See Eugène Buret, *De la misère des classes laborieuses en Angleterre et en France* (Paris: Chez Paulin, 1840), one of the more widely read volumes examining misery among the lower classes of society; see also Karl Marx, "The Class Struggle in France (1848-1850)," reprinted in *Karl Marx and Frederick Engels, Selected Works*, vol. I (Moscow, 1962).

39. See Jules Michelet, *Le Peuple* (Paris, 1846); and Eugène Bonnemère, *Histoire des paysans, depuis la fin du Moyen-Age jusqu'à nos jours, 1200-1850* (Paris: F. Chamerot-Librairie-Editeur, 1856). Michelet believed the peasant longed to own his land, and regarded it as a dangerous longing that would lead to greed and debt. Bonnemère's detailed account of peasant life was undoubtedly read by many artists looking for reasons behind the depopulation of the countryside and the backwardness of the provinces.

40. Rosenthal. "La Genèse du Réalisme," p. 180, suggested the *physiologies* as a source for the Realist imagery. Around 1840 to 1842 bookstores in Paris were flooded with these small, illustrated volumes. The themes they treated were varied and examined many societal types. Since they usually sold for a franc, were widely illustrated (with between 30 and 60 illustrations), and contained about a hundred pages, a volume could be read quickly. See Andrée Lhéritier, *Les Physiologies 1840-1845* (Paris: Service International de Microfilms, 1966). For further reference on Jeanron's involvement with *Les Français peints par eux-mêmes*, see vol. 7 and his *Le Limousin*.

41. See *Les Français peints par eux-mêmes* (Paris: L. Curmer, 1840). A pioneering article on the significance of popular imagery is Anne Coffin Hanson, "Manet's Subject Matter and a Source of Popular Imagery," *Chicago Art Institute Studies*, 1969, pp. 63-80.

42. Hanson, "Manet's Subject Matter," pp. 65 and 78, lists editions in 1853, 1860, 1861, and 1876, suggesting that dissemination of these works was widespread at all levels of society throughout much of the nineteenth century. Certain of the abridged editions (for example, 1853) or the modified volumes with new illustrations (1876-78) may have been published to keep up with particular changes in society.

43. Specific types documented in a book and their prevalence (or disappearance) need to be researched. A chronological social history could thus be established for both urban and rural locations.

44. Bouchardon's prints, first published in 1737, were undoubtedly important for the artists of the nineteenth century. They represented not only small vignettes but artistically imposing images in which the figure was prominently placed on the page. For further reference see Edmé Bouchardon, *Etudes prises dans le bas peuple ou les Cris de Paris* (Paris, 1737).

45. The best discussion of changes in rural France is Eugen Weber's *Peasants into Frenchmen: The Modernization of Rural France, 1870-1914* (Stanford University Press, 1976). Another excellent account of peasant life is found in Theodore Zeldin, *France: 1848-1945*, vol. 1, *Ambition, Love and Politics* (Oxford: Clarendon Press, 1973), pp. 131 ff.

46. Weber, *Peasants into Frenchmen*, pp. 240-77. Weber notes that "the peasantry gradually awakened to urban (that is, general) ideas, abstract (that is, not local) concerns" (p. 276).

47. Many artists went to Brittany to study the customs and dress of the region. Alexandre Antigna visited Brittany for the first time in 1857; Jules Breton was there in the 1860s. By the end of the century, Brittany had become an artist's colony. See Denise Delouche, *Peintres de la Bretagne, découverte d'une province* (Paris: Librairie C. Klincksieck, 1977).

48. For further reference see Boniface Breton, *Le Village: Histoire, morale, politique et pittoresque de Courrières* (Arras, 1837). The exact number of studies which examined provincial life in rural France is unknown, but there was a growing interest in the origins of communal life throughout the century.

49. On this aspect of Realism see Nochlin, *Realism*, pp. 45-50. Both of these aspects are delicately intertwined throughout the evolution of Realism in France, with the images often implying much more than is explicitly stated [170, 181].

50. Castagnary, *Salons*, p. 7.

51. T. J. Clark, *The Absolute Bourgeois: Artists and Politics in France, 1848-1851* (Greenwich, Conn.: New York Graphic Society, 1973), p. 27.

52. For further reference see Constance Cain Hungerford, "The Art of Jean-Louis-Ernest Meissonier: A Study of the Critical Years 1834 to 1855" (Ph.D. diss., University of California, Berkeley, 1976). Idem, "Meissonier's *Souvenir de guerre civile*," *Art Bulletin* LXI (June 1979): 277-88, points out aspects of Realism in this painting and in *The Ruins of the Tuileries* [108].

53. The works of Adolphe Hervier are scattered and many are lost; it is difficult even to locate official documents about him. See Annie Bauduin, "Recherches sur la vie et l'oeuvre du peintre français Adolphe Hervier 1819-1879) avec le catalogue des oeuvres peintes et dessinées" Université de Lille, (Mémoire de maîtrise, 1972).

54. T. J. Clark regards this Salon as representing the first concerted effort to establish Realism in France. It reflected the crises resulting from the Revolution of 1848 rather than the official attitude toward pauperism initiated by Napoleon III in 1845. See Clark, *Image of the People*, pp. 130-31.

55. The painting is no longer extant; what remains is an old photograph (kindly supplied to the author by Françoise Maison, Conservateur, Musée d'Arras). Breton never again attained the same intensity of feeling; like Millet, after 1850 he settled into a quieter existence in his native Courrières [162].

56. Isidore Pils to Becq de Fouquières, 28 September 1870, still in the possession of Becq de Fouquière's descendants.

57. Isidore Pils to Becq de Fouquières, 18 October 1870, also in the possession of descendants. Pils remained a Realist with strong loyalties to the regime in power; he was cultivated by the emperor and emerged as a major figure in the arts during the Second Empire. See Gabriel P. Weisberg, "In Search of State Patronage: Three French Realists and the Second Empire, 1851-1871," in *Essays in Honor of H. W. Janson* (New York: Prentice-Hall, forthcoming).

58. Castagnary, *Salons*, p. 253.

59. What might be emphasized about Courbet were his "associations," his friendships with men such as Proudhon and others who were considered radical and dangerous. Neither Breton, Antigna, nor even Bonvin kept such company. For more information on official Realism, see Gabriel P. Weisberg, "French Realism and Past Traditions" (Paper read at a symposium on Gustave Courbet, Städelschen Kunstinstitut, Frankfurt am Main, 1 March 1979, and to appear in proceedings of the symposium, edited by Klaus Herding, forthcoming).

60. This was noted in Schapiro, "Courbet and Popular Imagery," pp. 183-84.

61. For further discussion see Marc Le Bot, *Peinture et Machinisme* (Paris: Klincksieck, 1973), pp. 87-93. It is not really known, of course, whether or not the Realist painters actually owned *physiologies*, since little information has been uncovered about their private lives.

62. See Patrick Le Nouëne, "'Les Soldats de l'Industrie' de François Bonhommé: L'Idéologie d'un projet," *Les Réalismes et l'histoire de l'art, Histoire et Critique des Arts*, sommaire no. 4-5, May 1978, pp. 44-45.

63. See Weisberg, *Bonvin*, cat. no. 12. How the state happened to send this particular painting to Rodez is not known.

64. The paintings by François Bonhommé were destroyed after the turn of the century, but, according to Schapiro, "Courbet and Popular Imagery," were the earliest examples of Realist paintings made for public buildings.

65. For further aspects of this relationship see *Léon Lhermitte*, exh. cat., p. 18.

66. The question of heroes in Naturalist sculpture is discussed in John Hunisak, "Images of Workers: From Genre Treatment and Heroic Nudity to the Monument of Labor," in *The Romantics to Rodin: French Nineteenth-Century Sculpture from North American Collections*, exh. cat. (Los Angeles County Museum of Art in association with George Braziller, 1980), pp. 52-60. Hunisak sees workmen as unsung heroes of the modern era.

67. Hunisak also discusses the place of sculptural sketches—nonpublic art—against large-scale works. Ibid., pp. 54-55.

Into the Modern Era: The Evolution of Realist and Naturalist Drawing

Petra ten-Doesschate Chu

ORIGIN AND DEVELOPMENT

Though it is relatively simple to make broad statements about French nineteenth-century drawing, it is much more difficult to write its detailed history or part of it. This is due to the extraordinary diversity in individual drawing styles that can be perceived in every phase of nineteenth-century art, a diversity that is closely bound up with the concept of originality,[1] which played an increasingly important part in French culture from the Revolution of 1789. The heterogeneous aspect of French nineteenth-century drawings makes it nearly impossible to define period styles, such as the "Neoclassical drawing," the "Romantic drawing" or the "Realist drawing," other than in the most general terms. Accordingly, a definition of Realist drawing cannot be more specific than "a drawing of a Realist subject, done from life or from a photograph, in which faithfulness to reality has been the artist's first priority."[2] A "Realist subject," defined at length elsewhere in this catalog, might be described here briefly as a subject taken from the artist's ordinary, day-to-day life.

Thus defined, Realist drawing can be said to originate, at the latest, in the third decade of the nineteenth century, and it seems to be closely related to the early history of lithography and to the revival of landscape painting—two phenomena that were themselves closely linked.[3]

Lithography, the process patented by the German Alois Senefelder in 1799, was introduced in France in the first years of the nineteenth century, but it did not become popular until after 1815, when it began to experience a vogue that was to last until the 1860s, after which it was supplanted by photomechanical printing methods.[4] An inexpensive process, lithography was considered popular and "democratic" therefore incapable of producing great art,[5] particularly in the early decades of its existence, even though it was practiced by all the great French artists of the first half of the nineteenth century, including Gros, Géricault, and Delacroix (who, like all Romantic artists, were attracted to the lithograph for its "coloristic" possibilities). Initially, its main use, in addition to the reproduction of sheet music, programs, amateur drawing manuals, and the like, was for portraits, caricatures, and cartoons in newspapers, magazines and serials, and for popular albums of scenery prints.

Scenery prints,[6] which originated in Germany and England, became fashionable in France upon the appearance, in 1820, of the first volume of Baron Taylor's *Voyages pittoresques dans l'ancienne France*, a publication that eventually included twenty volumes and was published between 1820 and 1878. This epoch-making work was followed by numerous *Voyages pittoresques, Vues, Souvenirs,* and *Croquis,* all of them scenery albums devoted to a particular region in France or to a foreign country. For the production of these albums, young artists, such as Jacques-Raymond Brascassat, Nicolas Charlet, François Granet, Théodore Gudin, Paul Huet, Eugène Isabey, Auguste Raffet, and many of lesser talent, traveled to specific regions of France or abroad to make on-the-spot drawings of the scenery, which back in Paris would be "animated" with little figures in local costumes by professional animators *(faiseurs de bonhommes),*[7] and then reproduced by professional lithographers. The finished lithographs were published in series (each set comprising four or five plates) and sold by subscription to a primarily upper-middle-class public.

A multitude of albums were produced between 1815 and 1855, but a definite difference can be seen between the ones published during the Restoration and those issued during the subsequent rule of Louis-Philippe (1830-48). In the prints made prior to 1830, the landscapes are invariably dominated by some kind of building—a medieval church or castle, preferably in a ruinous state; a water mill; a rustic hut; a lime kiln; or, at times, even a modern factory—structures that were intended to enhance the picturesque character of the landscape.[8] In the landscape lithographs of the Bourbon period, however, the emphasis was on the natural site and though structures continued to be found in the landscape, these no longer dominated but blended with the natural setting.[9] Farms and peasant huts became particularly popular motifs, and artists executed careful studies of them—not picturesque fantasies. After 1830, an increasing number of albums were devoted to French scenery. Within France, the region around Paris, including Paris and its *banlieue*—the scenery most familiar to the vast majority of artists who resided in Paris—became most popular.[10]

The beginning of Realist drawing is closely bound up with these early landscape lithograph albums. As early as 1815,

I am thankful to the many people who have in various ways assisted me during the genesis of this paper. Its writing was greatly facilitated by a Faculty Research Grant and a sabbatical leave granted to me by Seton Hall University.

I wish to dedicate this essay to my teacher, Professor J. G. van Gelder, whose continuing encouragement has meant a great deal to me.

Figure 30. Eugène Isabey, *Two Cottages in the Woods*.

but especially after 1830, they forced young artists to explore and draw in their own country and often in their own region directly from nature and with a high standard of verisimilitude. In this way, landscape lithography, though itself a typical product of Romanticism, set the trend for a new "Realist" attitude toward subject matter that emerged with full force in the work of the painters of the Barbizon school.

Lithography not only set a trend for the subject matter of drawing but also had a strong impact on the drawing style of the 1830s generation. Whereas the "incunabulae" of lithography were generally done in pen and lithographic ink on the smooth surface of the stone, the "chalk manner," characterized by the use of lithographic crayon on a roughened surface, appeared with increased frequency from about 1804 on, until by the 1820s it was in common use.[11] Early pen as well as chalk lithographs were very graphic, drawn in a technique derived from copper engraving, with parallel hatchings and cross-hatchings to produce shading, but the perfection of the "chalk manner" and the development of various tonal techniques, such as lithographic washes, the "stump manner," and mezzotint (*manière noire*) lithography,[12] gradually made it possible to create soft, velvety tones with a nearly infinite variety of nuances, ranging from a deep black to the lightest pearl gray.

Parallel with this development in lithography, and no doubt partly under its influence, a similar evolution took place in drawing style in the late 1830s and early 1840s. In these years the linear drawing mode of the previous decades, which was marked by a preference for pen and ink, gave way to an increasingly tonal, painterly style based on the use of softer drawing instruments, such as chalk, crayon, and, above all, charcoal. It is not surprising that this new tonal style had its origin in landscape art, somewhat hesitantly at first in the works of the Romantic landscapists, such as Alexandre Decamps, Paul Huet, and Eugène Isabey (Figure 30), then more distinctly in those of the Barbizon school: Charles Daubigny, Narcisse Diaz, Jules Dupré, Charles Jacque, Théodore Rousseau, Constant Troyon, and others. It was obvious to

Figure 31. Théodore Rousseau, *A Road Leading into the Woods*.

these artists that the tonal drawing mode (*dessin de l'effet*), directed at capturing values rather than contours, was suited *par excellence* to landscape drawing, where the registration of the play of light and dark was more important than the precise delineation of forms.

Two Barbizon school works may suffice to demonstrate the new tonal style in landscape drawing and its relation to landscape lithography. Théodore Rousseau's charcoal drawing of *A Road Leading into the Woods* (Figure 31), of about 1840, is characteristic of the developments that took place in the late 1830s and early 1840s. Unlike earlier drawings by Rousseau that still tended toward the picturesque, this one is devoid of any such tendencies. Subject matter as well as composition are of a seemingly artless simplicity. The drawing calls to mind Dutch seventeenth-century landscape art in its horizontal format and motif of a road leading into the distance (Figure 32).[13] Rousseau's drawing technique, however, recalls the effects found in contemporary landscape lithography, particularly in his emphasis upon "color," the resulting wide tonal range, and the lack of precise definition of forms. Charcoal was the perfect medium to achieve these effects: it could be rubbed with the finger or the stump (*estompe*)[14] to eliminate hatching and to create a rich variety of grays and soft, graded transitions. At the same time, the use of a rough-toothed paper adds an interesting tactile quality to the drawing.

Whereas Rousseau's drawings of the 1840s show a new interest in simple landscape motifs and compositions, as well as a frankly tonal drawing technique, many of the early drawings of Charles Jacque are marked by a preoccupation with peasant themes observed from life. Jacque's work, unlike Rousseau's, rarely shows only the landscape, but mostly reveals it furnished with shepherds and their flocks, grazing cows, herds of pigs digging for truffles, or hens scratching the ground in front of a cottage. *A Man Chasing Pigs* (Figure 33), probably dating from the 1840s, shows an unidealized glimpse of peasant life that could have been realized only by direct observation. The stark realism found in this drawing is rarely seen in Jacque's paintings, which generally show a somewhat more sentimental, prettified version of country life that would have a greater appeal to the public. Like the drawings of Rousseau, Jacque's show a keen sensitivity to "color" and atmospheric effects, and this drawing evokes the bleak atmosphere and ashen color of a cold, winter landscape.

In his own time, Jacque was considered not only one of the precursors of the Realist tonal drawing mode (*dessin familier et de l'effet*)[15] that emerged around the 1840s, but also one of the major forces behind the revival of etching that started at approximately the same time.[16] The use of the etching needle as well as charcoal and stump are closely linked to the beginnings of Realism. Though apparently they led to different graphic results, both methods gave the artist the means to achieve painterly effects and a new freedom and flexibility, qualities not available to the academic drawing style and the previously popular engraving technique.

Just as lithographs of scenery had a decisive impact on the emergence of a new, artless, tonal style of landscape drawing in the late 1830s and 1840s, so figure studies in lithography contributed to the development of a new style and repertoire of subjects in figure drawing of the same period. Figure lithography, in fact, played an important role with respect to nascent Realism in that it continued, albeit as an undercurrent, the bourgeois and lower-class genre traditions of the eighteenth century, which had no place in the mainstream of the Neoclassical movement. Thus, while David and his followers were painting their large-scale scenes of Classical history and mythology, early nineteenth-century lithographers

Figure 32. Abraham Furnerius, *Forest Scene*.

Figure 33. Charles Jacque, *A Man Chasing Pigs*.

like Carle Vernet in his *Cris de Paris* (which is based on *Les Cris de Paris* by Edmé Bouchardon and similar albums by Watteau and Boucher);[17] Jean-Henri Marlet in his *Tableaux de Paris*; Horace Vernet; and Nicolas Charlet[18] extended the genre tradition of Watteau, Bouchardon, Chardin, and Greuze. At the same time, these artists created a taste for what might be called "military genre" prints that show scenes from the daily life of the common soldier, a typical nineteenth-century theme that was to remain popular until the end of the century.

Though well-received during the Restoration period, figure lithography enjoyed its first genuine popularity during the time of Louis-Philippe, when the growing appetite for illustrated newspapers and magazines brought lithography to a wider public than ever before.[19] With the emergence of newspapers and magazines came public interest in news of the highlights and trivia of day-to-day existence (*actualités*). The favorite subject matter of figure lithography during the July Monarchy thus became popular and social satire, caricature, portraits of "people in the news," themes from everyday life (*sujets de moeurs*), and pictures of popular street types. Illustrated papers and magazines, in turn, catalyzed the market for illustrated books (often published as serials), which flourished during the 1840s.[20] In the realm of the illustrated paper as well as the illustrated book, lithography soon received serious competition from wood engraving, which, because of its lower cost, gradually supplanted the lithograph, particularly in publications of wider circulation.[21]

Two important contributors to the flowering of the illustrated magazine and the illustrated book were the publishers Charles Philipon and Léon Curmer.[22] Both men owed their success to their ability to attract to their various undertakings all of the best illustrative draftsmen of their time—artists like Victor Adam, Eugène Devéria, Paul Gavarni, Grandville, Philippe Auguste Jeanron, Eugène Lami, Eugène Lepoittevin, Henri Monnier, Edmé Pigal, Joseph Traviès, Charlet, Decamps, Huet, Jacque, Raffet, and, last but most important, Daumier. With the help of these men, Philipon published his famous papers *La Caricature* and *Le Charivari*, while Curmer published book-collector favorites like *Paul et Virginie* (1838) and *Les Français peints par eux-mêmes* (1840-42), a serial publication important for its Realist subject matter.

Just as the *Voyages pittoresques* forced landscapists to explore their own country, so the illustrated magazine and book, particularly serial publications like *Les Français peints par eux-mêmes*, *Le Musée pour rire* (1839), *Le Muséum parisien* (1841), *Les Petits Français* (1842), *Rues de Paris* (1844), and others dealing with contemporary life in Paris, forced their contributors to be "of their own time," to know the celebrities of the day, and to keep their eyes open to the life around them, in the streets and the marketplace, as well as the salons, the cabarets, and the dance halls. Thus, like landscape lithography, figure lithography and—to a somewhat lesser extent—wood engraving had an impact on the development of figure drawing, which during the late 1830s and 1840s began to show a new Realist subject matter and style.

24

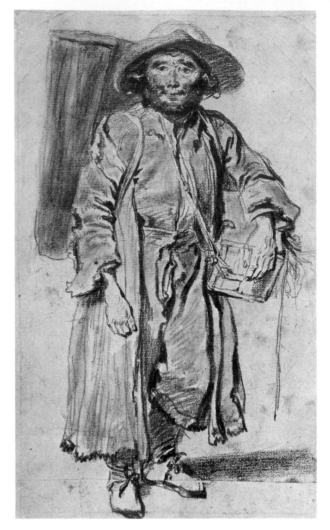

Figure 34. Antoine Watteau, *Old Savoyard*.

Figure 35. Carle Vernet, *Le Chanteur* from *Cris de Paris*.

Several examples of early Realist drawings are evident in the Realist exhibition. Jean-Jacques François Monanteuil, a provincial artist and art teacher at Alençon, produced early examples of large, finished drawings showing Realist subject matter.[23] Dating from the late 1830s and preceding the illustrations in *Les Français peints par eux-mêmes*, to which they show some resemblance, these drawings may be traced back directly to eighteenth-century prints and drawings of lower-class subjects by such artists as Watteau, Bouchardon, Lépicié, or Greuze, or to their early nineteenth-century followers, notably Carle Vernet. A drawing like the *Itinerant Musician* [18] seems closely related to the drawings of lower-class subjects by Watteau, like the *Old Savoyard* (Figure 34),[24] or to the engravings in Bouchardon's *Cris de Paris*, as well as to the lithographs of street types that are found in Vernet's early nineteenth-century *Cris de Paris* (Figure 35). Like Watteau, Bouchardon, and Vernet, Monanteuil seems to have posed his street types in the studio in order to be able to study their characteristic features better. The figures are placed close to the picture plane and rendered as *studio models*, without a street setting. This focuses attention on the carefully drawn details of dilapidated hat, wrinkled features, oversized coat, baggy trousers, and worn shoes, which seem intended to convey something about the lives of the men to whom they belong.

Although in pencil, Monanteuil's drawings show a tendency toward painterliness that this artist did not acquire in the studio of his Neoclassical teacher Girodet, but that may be attributed to his study of the prototypes just mentioned. The *Beggar* [17], which is the most tonal of all of Monanteuil's drawings in the Realist exhibit, is important as a forerunner of the full-fledged Realist figure drawing style as it developed in the late 1840s and 1850s.

While the provincial Monanteuil, following the eighteenth-century tradition, depicted the more picturesque types of lower-class life, François Bonhommé and Philippe Auguste Jeanron, ardent republicans who were active in the Revolution of 1830, confront the viewer with the period's real proletariat—the industrial worker. Their choice of this theme was a conscious one, and they treated it in a true-to-life and matter-of-fact manner. Unlike Monanteuil, both Bonhommé and Jeanron were practitioners of Romantic lithography and illustration. Bonhommé contributed to Baron Taylor's *Voyages pittoresques* (lithographs in the volume on Picardie, issued in 1835) and made a series of lithographs commemorating the Revolution of 1848,[25] for he originally intended to produce a picture album on the event.[26] In addition, he planned, but never completed, at least two more lithographic albums, both related to the mining industry, a subject that preoccupied him throughout his life. Drawings for the cover of one of these projected albums, *La Brichole*, and some of the plates it was to include are in the Realist exhibition [38].[27] Like Bonhommé, Jeanron, too, was closely engaged in illustration and printmaking. A collaborator of Philipon, with whom he shared strong republican convictions, Jeanron worked for *La Caricature*, and produced illustrations for a number of books, among them *Les Français peints par*

eux-mêmes and several leftist-republican volumes, such as *La Montagne* by Barthélémy Hauréau (1834) and *L'Histoire de dix ans* by Louis Blanc (1841).[28]

Both artists turned to Realist subject matter at an early date in their drawings and their paintings. Bonhommé's preliminary drawings for *Vue d'une grande forge à l'anglaise* [37A] show a careful observation of the different types of workers and a scrupulous rendering of characteristic details of attire, in accordance with the artist's ideas that the clothes alone were enough to indicate the different types of workers and their occupations, or, in his own words, that "the sleeve of a roller is not the same as the sleeve of a forger."[29] Despite this Realist attitude toward subject matter, Bonhommé's drawings still show a predominantly Romantic drawing style, marked by the use of pen and wash, calligraphic contours, and dramatic light and dark contrasts.

The drawings of Jeanron are more explicitly Realist in style.[30] His impressive renderings of the heroes of the July Revolution of 1830, executed in the early 1830s, and his later drawings of workers [28] show an emphatic style of drawing characterized by a bold application of charcoal with strong contours and a considerable range of values from deep black to light gray. Though most of his shades were first put in by means of hatching, rubbing with the stump has turned them into uniform areas of gray, similar to those in a tonal lithograph. Like Monanteuil and Bonhommé, the artist keenly observed his models and took pains to register characteristic details: open white shirts, worn shoes, ungainly postures, and wide slovenly trousers with intricate patterns of folds (a favorite motif of Realist draftsmen that recurs among later Realists, such as Bonvin and Lhermitte).

Jeanron's drawings, more than any of the late 1830s and early 1840s, had an impact on the evolution of the mature Realist drawing style in the years after 1848, when he became an important figure on the Parisian art scene. His influence can clearly be seen in some of Gustave Courbet's early drawings, notably the *Seated Man* (Figure 36), which was possibly executed in connection with the *After-Dinner at Ornans* of 1849 or the *Burial at Ornans* of 1850.[31] Like Jeanron's drawings, the *Seated Man* shows a common man, in a simple unaffected pose, observed in isolation in the studio, in a close-up view. The tonal style, which is still somewhat hesitant in Jeanron's drawings, has been fully developed by Courbet, who enveloped the entire figure in a shadowy veil.

In addition to the *Seated Man*, Courbet produced a number of portrait drawings in the late 1840s. These are mostly large charcoal portraits of himself, relatives, and friends. They must be related to Romantic lithography rather than to Jeanron, and notably to the popular genre of the lithographic portrait, which was brought to great height by artists like Adolphe-Félix Cals, Jean Gigoux (Figure 37), and Devéria. Cals's presumed self-portrait [132], if not actually a study for a lithographic portrait, shows the vignette format popular in lithography as well as wood engraving during the late 1830s and 1840s. Courbet's drawings such as the *Self-Portrait with Pipe* (Figure 38) and the *Self-Portrait at Easel* (Figure 39), both of 1847, have the richness of values as well as the vel-

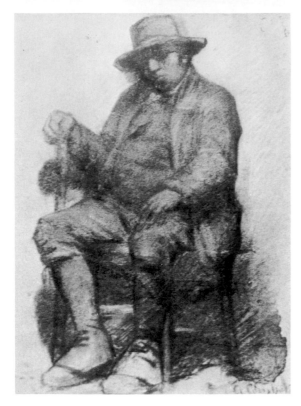

Figure 36. Gustave Courbet, *Seated Man*.

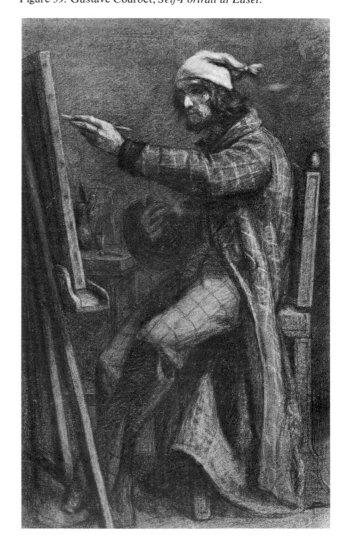

Figure 37. Jean Gigoux, *Portrait of Alfred and Tony Johannot*.

Figure 38. Gustave Courbet, *Self-Portrait with Pipe*.

Figure 39. Gustave Courbet, *Self-Portrait at Easel*.

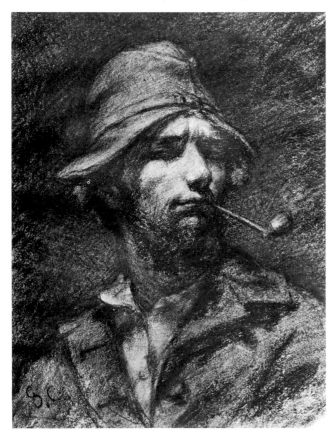

vety tones found in contemporary lithography. The technique Courbet used in these early drawings is quite unique.[32] First he blackened the entire sheet of paper with charcoal and stump to achieve a dark middle tone. Then he rubbed out the lighter areas and highlights with a lump of bread and a knife or needle, while he accented the very darkest parts with more charcoal. This process, which is not found in other Realist drawings, may have been suggested to Courbet by mezzotint lithography, which was invented in 1831 by Edmond Tudot and based on the same principle of working from dark to light.[33] A striking quality of all of Courbet's early drawings is their strong rendering of "color" and texture. This is particularly obvious in the *Self-Portrait at Easel*, in which the artist has painstakingly recorded the different checkered patterns of trousers and robe, as well as the various textures of wood, canvas, hair, and woolen materials.

Courbet's portrait drawings of the late 1840s show an interesting similarity to the contemporary charcoal portraits of Jean François Millet. Though the majority of Millet's drawings of the 1840s depict nudes and mythological subjects, between 1847 and 1850 he executed a series of large-size charcoal portraits of himself, his wife, and several close friends, such as Antoine-Louis Barye, Karl Bodmer, Louis Campredon, and Narcisse Diaz.[34] Like Courbet's portrait drawings, these are finished sheets that were not made for paintings but as works of art in their own right. Millet's *Self-Portrait* (Figure 40), though technically less original than Courbet's, shares with it a deliberate, almost defiant casualness of pose

which conveys a feeling of directness and immediacy, and a dramatic chiaroscuro that underscores the impact of the drawing. Like Courbet, Millet in the late 1840s seems to have been under the influence of Jeanron, who was one of his patrons for awhile.[35] Millet's decision to give up mythology to devote himself to peasant themes may well have been catalyzed by his contacts with the older artist.[36]

The period of the 1850s represents the heyday of Realist drawing, when artists like Courbet, Millet, François Bonvin, and Henri Fantin-Latour executed some of their most eloquent and beautiful sheets. During this decade, Courbet continued his drawing activity with a series of portraits and genre drawings that are more clearly in the Realist vein than his previous work. The portrait drawings of the 1850s, such as *Self-Portrait* (Figure 41), differ from those of the 1840s through a more objective (less Romantic) presentation of the subject: a new clarity has replaced the somewhat mysterious darkness that surrounds the sitters in the earlier portraits. Courbet's major genre drawing of the 1850s, the *Model in a Sculptor's Studio* (Figure 42), is representative of a new tendency emerging during this decade to place genre figures within a simple setting rather than isolating them as he did in his *Seated Man* or as Monanteuil, Bonhommé, and Jeanron did in their drawings of the late 1830s and 1840s. The few objects in Courbet's drawing suffice to indicate the figure's "natural habitat": a sculpture stand, some plaster casts —objects which indicate the model is not in Courbet's own studio but in the studio of a sculptor acquaintance, where she

Figure 40. Jean François Millet, *Self-Portrait*.

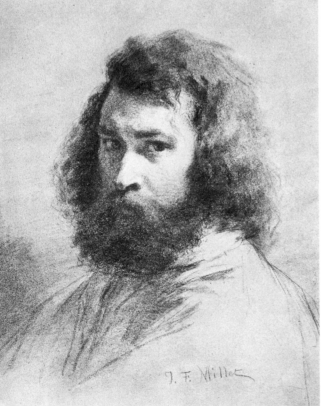

Figure 41. Gustave Courbet, *Self-Portrait*.

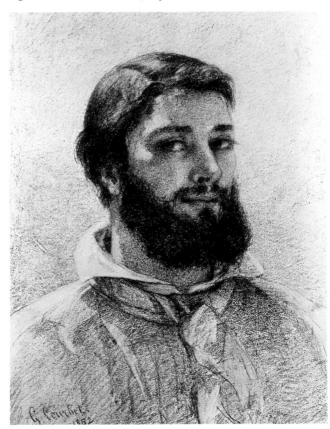

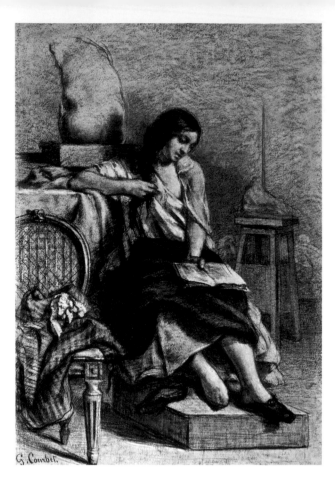

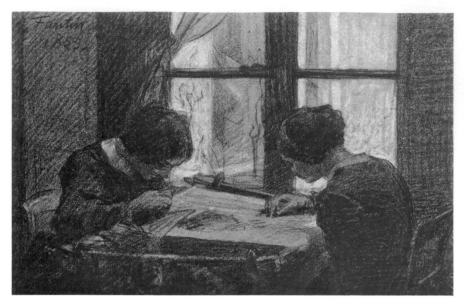

Figure 43. Henri Fantin-Latour, *Two Girls Embroidering Near a Window*.

Figure 42. Gustave Courbet, *Model in a Sculptor's Studio*.

Figure 44. Jean François Millet, *Woman at the Well*.

Figure 45. Jean François Millet, *Wood-Sawyers*.

seems caught unaware, in a brief moment of repose. In sum, Courbet's drawing exemplifies a new tendency, more legitimately Realist, to show figures in their context and in the way a casual visitor or passerby (flaneur) might have observed them. Coupled with this is the tendency to place the model farther from the picture plane, thus increasing the impression of casually observing a human being rather than closely examining a specimen.

The interest in creating an "environment" for the figure is likewise found in the drawings by François Bonvin, who was closely befriended by Courbet during the late 1840s and 1850s.[37] Like Courbet's early drawings, those of Bonvin show models (mostly lower-class types) in isolation, set closely to the picture plane. The Ragpicker [6], for example, recalling the eighteenth- and early nineteenth-century Cris de Paris as well as later Romantic serials like Les Français peints par eux-mêmes, still follows the Monanteuil-Bonhommé-Jeanron tradition. But in the course of the 1850s, Bonvin gradually began to enliven his genre types by showing them at work or at play in their natural surroundings. The drawing of the Locksmith [35] presents an interesting transitional phase, wherein the model is seen in the artist's studio (notice the stretched canvas on the floor and the palette hanging on the wall) but doing his usual chores, surrounded by the objects of his trade. In the Woman at the Spinet [72], the setting is transferred from the studio and into a bourgeois drawingroom, where the lady of the house, having casually left her hat on the spinet, is absorbed in her play, unaware of artist or spectator.

Like Courbet, Bonvin was fascinated with color and texture, and, being more patient than his younger friend, he was exceedingly successful in their rendering. Note how lovingly he lingered over details like the locksmith's tool bag with hammer and drill, the shiny leg of the spinet, and the woman's straw hat with its two silk ribbons, and how masterfully he suggested the wide variety of their textures. Emphatic light and dark contrasts, still important to him in the late 1840s and early 1850s, as indicated in The Ragpicker, gradually lose their importance as the artist becomes increasingly preoccupied with a scrupulous verisimilitude and uses his values to suggest color and texture rather than dramatic light effects.

More than any other Realist draftsman, Bonvin seems to have been influenced by eighteenth-century drawings and prints. As an art advisor to Laurent Laperlier,[38] a collector of eighteenth-century art, he had a more than common knowledge of them. The relation with eighteenth-century art is particularly noticeable in Bonvin's Woman at the Spinet, which in subject as well as tonal effects recalls contemporary engravings after Chardin and Greuze.

Next to the influence of eighteenth-century French artists, that of seventeenth-century Dutch masters—notably Rembrandt and his school[39]—can also be detected in Bonvin's drawings, foremost in his preliminary pen-and-wash sketches for paintings. The bold and free use of the pen and the loose washes in the preparatory drawing for The Girls' School [78B], for example, are strongly reminiscent of Rembrandt's pen-drawing style.

Many of the drawings of Henri Fantin-Latour, who, like Bonvin, belonged to Courbet's circle in the 1850s, also show an explicitly Realist drawing style.[40] Most of his large, finished drawings, executed between about 1854, when Fantin-Latour seems to have become seriously interested in drawing, and about 1864, when he gradually abandoned Realist subject matter to devote himself to imaginary subjects derived from mythology and music, are portraits of himself and members of his family, or genre scenes showing his sisters absorbed in quiet activities, such as embroidery, reading, and playing the piano. Like Courbet and Bonvin, Fantin-Latour preferred drawing in charcoal or black chalk on rather large sheets of paper, choosing one or two models set in a simple environment. A good example of Fantin-Latour's early Realist style is Two Girls Embroidering Near a Window (Figure 43), related to the artist's painting of The Two Sisters in the Realist exhibition [71], which shows his interest in color as well as texture in the way he has varied the tone as well as the "touch"—his handling of the charcoal.

Though the series of charcoal portraits that Millet produced in the late 1840s seems closely related to contemporary drawings of Courbet, Millet gradually developed a drawing style upon his move to Barbizon in 1849 that differed considerably from that of the other Realists, a style that occupies a unique place within the Realist movement and the nineteenth century as a whole. His drawings of the 1850s fall into two categories: rapid sketches (croquis), executed on the spot or in the studio to serve as first ideas for his paintings; and finished drawings (dessins achevés) that he sold to a small group of enlightened, but mostly impecunious collectors (amateurs) of his work. Both types of drawings show the gradual abandonment of charcoal in favor of black chalk mixed with some oil (crayon gras).[41] The change of medium was in keeping with Millet's decreased preoccupation with the subtly nuanced values that could be achieved with charcoal and the stump, and his increased fascination with the "movement of the hand," the graphic sign as the most important element of the drawing.[42] Whereas in stump drawings the individual lines are largely effaced to create areas of lighter or darker tone that imperceptibly merge with one another, in Millet's crayon-gras drawings the autonomy of each line is preserved. Line, in his drawings, especially in the rapidly executed sketch, often takes on a calligraphic aspect. A drawing like Woman at the Well (Figure 44), for example, possesses a shorthand quality akin to Oriental art, while the agitated movement of the line in the Wood-Sawyers (Figure 45) recalls the freehand sketches of Delacroix and his advice "to draw from within."[43] Even in Millet's finished drawings, in which a much greater emphasis is placed on the rendering of values, the individual line remains important and often determines the overall mood of the drawing. In Peasant Girl Watching a Cow (Figure 46), the predominant vertical tracing creates a sense of permanence and stability, while the incessant movement of the line in Twilight (Figure 47) evokes an eery and ominous feeling. It was these highly individualistic drawings by Millet in the 1850s that were so admired by the Post-Impressionists Seurat and van Gogh, at a time when the

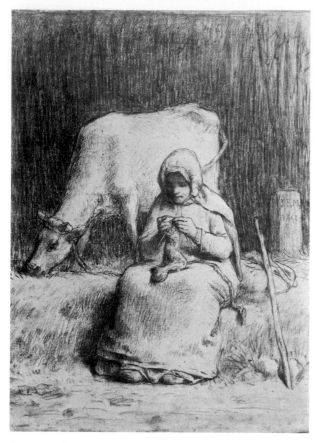

Figure 46. Jean François Millet,
Peasant Girl Watching a Cow.

Figure 47. Jean François Millet, *Twilight.*

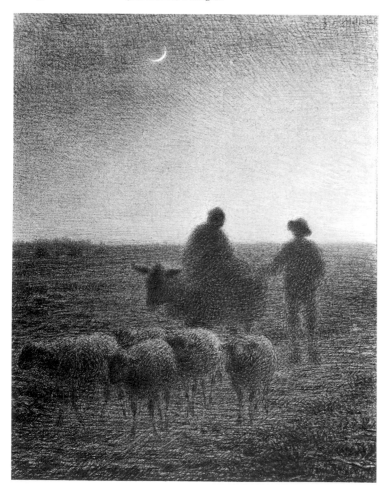

drawing style of Bonvin, Courbet, and Fantin-Latour had become obscured.

By the end of the 1850s and during the 1860s, a shift can be perceived from the decisively painterly and textural style of the previous decades toward an increasingly graphic, linear mode. This shift, though faintly perceptible in some of the works of the older Realists (such as Courbet's *Seated Girl* of 1865, Figure 48), is more clearly noticeable in the work of several younger artists (for example, Jules Bastien-Lepage, Jules Breton, Gustave Caillebotte, Edgar Degas, and Edouard Manet)—all of whom had received a thorough academic training. On the one hand, this trend must be linked to the gradual rapprochement between academicism and Realism that began during the 1860s. On the other hand, it is coupled with the decreased impact of baroque art (seventeenth-century Dutch and Spanish, as well as French rococo) and an increased interest in various forms of "primitive" art, such as Italian and French painting of the fifteenth century, German early Renaissance art (Cranach, Dürer, Holbein), and Japanese prints.[44]

The drawings of Manet and Degas of the 1860s that can be qualified as Realist—mostly portraits and figure studies— show a style that is more closely related to Ingres and his academic followers than to the portrait drawings of Courbet, Bonvin, or Fantin-Latour.[45] Manet's *Portrait of a Lady* (Figure 49) of the late 1850s or early 1860s, for example, shows an exaggerated emphasis on contour, following the example of Manet's teacher, Thomas Couture, whose notorious "black outline" was maintained even in his paintings.[46] The emphasis on line at the expense of tone may also be related to Manet's interest in quattrocento Italian painting and, subsequently, Japanese prints.[47]

Degas's *Portrait of Madame Julie Bertin* (Figure 50) of the mid-1860s and even earlier drawings, like *Marguerite Degas in Confirmation Dress* (Figure 51), at first glance seem closely related to the style of Ingres and his followers, but they differ—and this is particularly true of his later, more mature drawings—in their less subtle use of shading. Whereas in the portrait drawings of Ingres the hatched lines in the face are cobweb-thin, following the contours of the face, and maybe slightly stumped to blend into a softly modulated gray, Degas deliberately preserves the autonomy of each hatched line: the lines are not only stronger and farther apart but also consistently straight and parallel. The resulting effect is somewhat reminiscent of a drypoint, bringing to mind that Degas in the late 1850s and early 1860s was much interested in the etching and drypoint techniques.[48] This new style of drawing, with clearly visible, bold parallel hatchings and a firm outline, became very popular at the end of the century and can be seen, for example, in drawings by Jean-Louis Forain, Paul Helleu, Jean François Raffaelli, and Henri de Toulouse-Lautrec.

Whereas the drawings of Manet and Degas of the 1860s seem most akin to the academic drawing tradition, the drawings of Jules Breton of the same period as well as those by Jules Bastien-Lepage seem to have an even stronger kinship with the "primitives."[49] Holbein, in particular, is recalled in

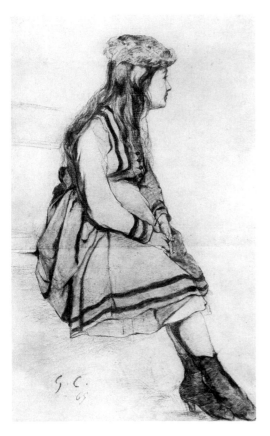

Figure 48. Gustave Courbet, *Seated Girl*.

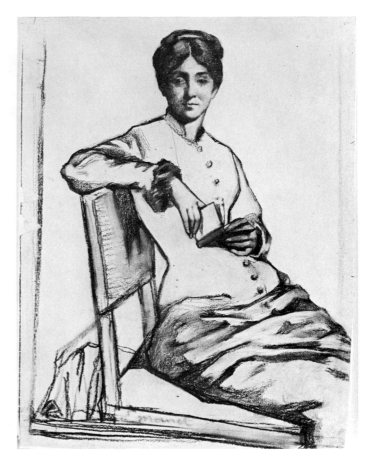

Figure 49. Edouard Manet, *Portrait of a Lady*.

Figure 50. Edgar Degas,
Portrait of Madame Julie Bertin.

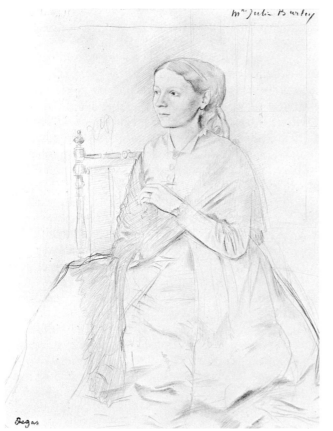

Figure 51. Edgar Degas,
Marguerite Degas in Confirmation Dress.

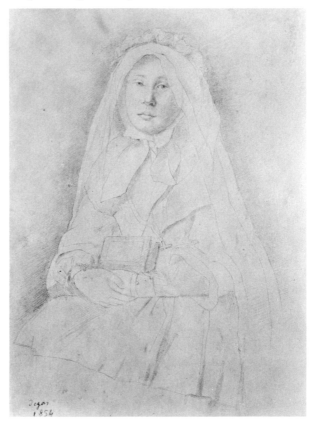

31

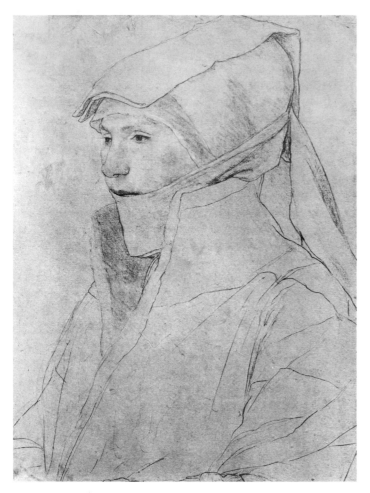

Figure 52. Hans Holbein the Younger,
Portrait of Dorothea Kannengieser.

Figure 53. Rembrandt van Rijn,
Bearded Man in Furred Oriental Cap and Robe.

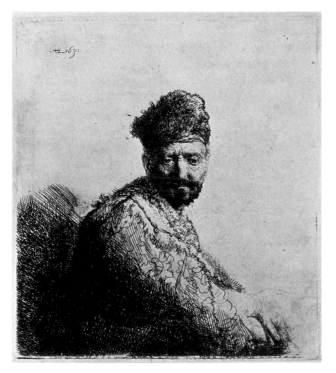

Breton's study for *The Great Pilgrimage* [89A] of 1868, which may be compared with the German artist's portrait drawing of *Dorothea Kannengieser* (Figure 52), itself a study for a larger painting. The two drawings share a seemingly objective accuracy in the tracing of the profile, a strong contrast between the pure contour drawing of body and clothing and the highly finished *(achevé)* face (in Holbein's drawing the face is worked up with water color; in Breton's, with charcoal), as well as a sense of absorption in the figures that deemphasizes the posing of the models. Jules Bastien-Lepage's drawing of a *Communicant* [224] also resembles Holbein's work in the strictly frontal pose and the overall symmetry of the figure. These qualities and the carefully wrought shading in the face also owe something to photography, which among its popular practitioners of the 1860s inadvertently exemplified the characteristics of much "primitive" art.[50]

Alongside the increased preoccupation with a "flat," more or less synthesizing graphic drawing style on the example of an Ingres or Holbein, the tonal style continued to be practiced by artists of the 1860s. It is found in many of the drawings of first-generation Realists, such as Courbet, Bonvin, Millet, and Fantin-Latour, but also in those of several of their followers. The drawings of Eugène Carrière, Jean-Jacques Henner, or Pierre Puvis de Chavannes, though obviously influenced by the older masters, notably Millet, on the whole go beyond Realism to become part of the Symbolist movement, and therefore will not be discussed. It is important, however, to realize that their drawings are the link between the graphic work of Millet and the drawings of Seurat and his followers.

The tonal style is also followed by some of the Naturalists —most important, the artist Léon Lhermitte, whose drawings, though much admired in his own time, were unjustly forgotten after his death.[51] A student of the progressive art teacher Horace Lecoq de Boisbaudran, whose mnemonic method aroused some controversy in his lifetime, Lhermitte was taught a carefully analytical approach to his subject matter. His powers of observation (aided by the study of photographs) as well as the large size and careful finish of his drawings give them a degree of concreteness and verisimilitude that often surpasses the drawings of the earlier Realists. Unlike most of his contemporaries, including Jules Bastien-Lepage and even some of his co-disciples under Lecoq, such as Jean Charles Cazin and Alphonse Legros, Lhermitte was fascinated with the play of light over irregular surfaces and with the value contrasts it created. His love of baroque light and dark effects can be seen in the drawings in the Realist exhibit. The early *Portrait of the Artist's Father* [222] at first glance recalls similar portraits by Holbein, notably his *Portrait of Erasmus,* which was much admired and frequently copied by Lecoq's students. Yet it also shows a dramatic chiaroscuro that seems more closely related to the work of Rembrandt, whose portrait etchings, such as the so-called *Portrait of the Artist's Father* (Figure 53), may well have had an impact on Lhermitte's art. Lhermitte's interest in baroque lighting continued in the next decade and can be found in his

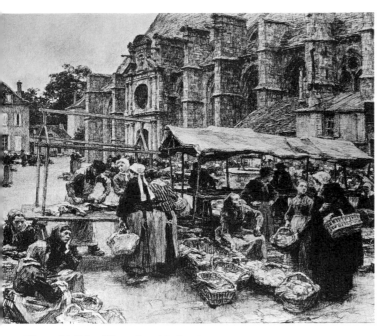

Figure 54. Léon Lhermitte, *Market Day*.

drawing of *The Butcher Shop* [176] of the late 1870s, which recalls contemporary photography, in addition to Caravagesque painting, not only in the striking against-the-light *(contre-jour)* effect but also in the zooming perspective of the interior.

The *Quartet* [169] of the next decade is unique within Lhermitte's oeuvre in its Proustian, upper-bourgeois subject matter, which sets it apart from his stock-in-trade peasant scenes. The drawing is a *tour de force* in tone, conveying the quivering play of gaslight and candlelight over walls, mirrors, and elaborate clothes. The smooth drawing style of this work is unlike the more rough-hewn style found in many of his drawings of peasant subjects. The drawings of a *Market Day* (Figure 54) of about 1878 and of *The Press House* [186] of the mid-1880s show his preoccupation with "the ways in which light seems to chisel faceted surfaces into mass."[52] These drawings with their refracted, sculptural forms and angular outlines (perhaps the result of Lhermitte's habit of first blocking out his compositions in straight lines) not only point the way to van Gogh, who was a great admirer of Lhermitte's work,[53] but also seem to forecast the art of Cézanne and the Cubists.

REALIST VS. ACADEMIC DRAWING

In order fully to understand the novel character of Realist drawing, it must be seen against the backdrop of nineteenth-century academic drawing, which, rooted in the Neoclassical style, particularly of Ingres and his school, was practiced in academic circles until the very end of the nineteenth century and beyond, and which was taught throughout the century in industrial art schools, state schools, and the private academic ateliers where beginning art students were prepared for the admission exam *(concours des places)* to the Ecole des Beaux-Arts.[54] Almost all of the Realists were taught this drawing style during at least some part of their training period. Some, like Courbet and Millet, turned away from it as soon as they realized that this kind of training was not beneficial to their artistic development; others, like Manet and Degas, stuck with it, though recognizing its shortcomings. A few artists were lucky enough to find an enlightened teacher who was willing to give a new twist to academic drawing education, for it must be realized that, although academic drawing education remained in force throughout the nineteenth century, from about 1830 on it came under close scrutiny from artists and art educators, art critics, and connoisseurs, who recognized the often-disastrous results of academic drawing practices.[55] The strongest and most enduring criticism was directed against the *pièce de resistance* of the academic curriculum, the life-drawing program. This program, which in its complete form usually took several years, consisted of a series of graded exercises leading up to the so-called *académie,* a carefully executed and properly idealized drawing after the live model.

Academic drawing instruction has often been described in detail.[56] Briefly, it consisted of the following three phases:

1. Drawing after engraved or (in the later part of the nineteenth century), sometimes, lithographed drawing models gradually increasing in difficulty. Most model books proceeded from details of the face to the face as a whole, then to parts of the body and, finally, to the body as a whole—both nude and draped. Each model was usually given in two alternate forms, as contour and as value drawing *(dessin au trait* and *dessin ombré)*.

2. Drawing of plaster casts of Classical statuary *(dessin de bosse)*. Here again, the student proceeded from the part to the whole. In this phase, he was introduced to the related concepts of relief and value *(effet* and *demi-teinte)*. The ideal academic drawing would show a delicate graduation of values, suggesting a smooth and, at the same time, variegated relief.

3. Drawing from the life model. The main challenge of this phase of training was the capturing of the model's pose. Whereas in the previous phases the student proceeded from the details to the whole, now he was forced to seize the ensemble first and to complete the details later.

Ideally, the life-drawing program was completed with an extracurricular activity—the making of free, on-the-spot sketches *(croquis)* of situations from daily life (figures, groups of figures, nature, and so forth). The choice of these exercises, however, was left up to the students and they were not supervised or controlled by the teacher. A drawing of Jean-Jacques Henner (Figure 55) combines an academic life drawing and a sketch on one and the same sheet.

The academic life-drawing program had a long and respected tradition, dating back to the seventeenth century. Though occasionally criticized,[57] it was not reviewed until the Romantic period, when the revived interest in color as well as a new anti-Classical mood led to a movement opposed to the classically idealized, engraving-like life drawing. Among the main objections raised against it were the overemphasis on detail (caused by the progression from the part to the whole during the first phases of the program), the dominance of line (both in contour and shading through hatching and cross-hatching), and the lack of naturalness, caused by the routine of the life-drawing class, where the models took stereotyped poses, generally derived from Classical sculpture, in the artificially subdued light of the studio.[58]

Figure 55. Jean-Jacques Henner, *Académie.*

From the 1830s on, a number of handbooks on drawing appeared that suggested alternative methods for teaching drawing.[59] Probably the most influential of these was a little brochure entitled *L'Education de la mémoire pittoresque,* published in 1848 by Horace Lecoq de Boisbaudran (1802-1897),[60] who more than anybody—with the possible exception of his close friend, the architect Eugène-Emmanuel Viollet-le-Duc—was devoted to nineteenth-century art education. Himself a product of the academic educational system, Lecoq developed his innovative method while teaching at the Ecole Royale et Spéciale de Dessin, or the *Petite Ecole* (as opposed to the Ecole des Beaux-Arts, the *Grande Ecole),* where he added to the existing program a series of mnemonic drawing exercises geared to develop not only the visual memory *(observation conservée)* of the students, so important for the rendering of ever changing reality, but also to increase their power of observation and to make them aware of the salient features of their subject.[61] Lecoq de Boisbaudran likewise supplemented the traditional life-drawing class, where the models stood immobile in the half-dark of the studio, by sketching models, and subsequently drawing them from memory, nude and clothed and moving around in the open air in a variety of locations (in the forest, against architectural backgrounds, and so forth).

It is understandable that Lecoq de Boisbaudran's method appealed to the artists of the Realist movement, because it presumably trained them better in the rendering of actually observed reality and also because it demanded naturalness and "naiveté" during the drawing stage.[62] (Like the academicians, however, Lecoq advocated idealization in the finished painting.) Quite a number of Realist artists, among them the painters Jean Charles Cazin, Alphonse Legros, Félix Régamey, Fantin-Latour, and Lhermitte, and the sculptors Jules Dalou and Auguste Rodin, in fact, studied with him, while others like Manet and Whistler felt his influence indirectly.[63] To more militant Realists like Courbet, however, Lecoq's method was still too traditional; for them, self-study, guided by the example of the old masters, was the only answer.[64]

Though neither Lecoq de Boisbaudran nor any other reformer was able to substantially alter the academic life-drawing program in the nineteenth century, certain minor changes did occur in the course of time. The first of these was the increased use and gradual acceptance after mid-century of charcoal in place of lead pencil as the customary medium of life drawing, with the natural result that hatching was replaced by smudging with the stump *(estompage).*[65] Though this made for a more informal result in drawing style, it could not change the artificiality of the posing and the illumination of the model. The second change was the increased emphasis placed on the sketch *(croquis),* which became a more and more important part of the artist's training, until by the end of the century it ranked in importance with the *académie.*[66] These changes, though far from radical, made for a gradual approach between Realist and academic drawing that was closely related to the development of Naturalist drawing in the later part of the century.

In the course of the period represented in the Realist exhibition, roughly from 1830 to 1900, important changes in the role of drawing and its position vis-à-vis other techniques, notably painting and printmaking, also occurred.

Throughout the Neoclassical and early Romantic periods, drawing was, for the most part, subservient to painting. Artists like David, Ingres, Géricault, and Delacroix, to mention only a few, drew primarily in preparation of their paintings, producing either compositional sketches and careful drawings for individual figures in their paintings, or filling their sketchbooks with *croquis* from life that collectively served them as a thesaurus of images to be used in their large compositions. These drawings were made for the artist's own use and, though at times they might be given away or sold, were not intended for sale. Only upon the artist's death, when the contents of his studio were liquidated, would his drawings come to light; when sold, their prices were often low.[67]

Exceptions to this, however, are two categories of drawings: portrait drawings and water colors. The portrait drawing as a genre in itself is, at least for the first part of the nineteenth century, primarily associated with Ingres, yet it was also, though with less frequency, practiced by other artists. Portrait drawings, which were generally more finished *(achevés)* than others, were often commissioned from the artist and, as in the case of the young Ingres, could constitute a considerable source of income.[68]

The water color, occupying a place midway between drawing and painting, also acquired a limited independence from an early date.[69] Neglected during the Neoclassical period, water color became popular with the early Romantics, among them Géricault, Delacroix, and Huet, who, influenced by their contacts with English watercolorists, became interested in the medium in the 1820s. Though frequently used as sketches or as preliminary drawings for lithographs or woodblock prints (as Constantin Guys used them), water colors were also often independent works of art commissioned by, or sold to, a patron. This is true, for example, of the water colors of Alexandre Decamps, which were rated as highly as the artist's easel paintings.[70]

An important purpose for the independent water color during the 1830s and 1840s was as a documentary tool. At a time when photography was still too embryonic to be used for reportage, watercolorists would join expeditions to make quick, on-the-spot "shots," which in time of leisure could be "developed" into finished, documentary pictures. Thus Delacroix, in 1832, joined the Count of Mornay on an official government trip to Morocco and produced for the count—during a quarantine in the harbor of Toulon—an album of eighteen finished water colors based on quick watercolor sketches made on the spot.[71] In the same year, Prosper Marilhat joined the scientific expedition of Baron Karl von Hügel to Egypt and Asia Minor,[72] while two years later the young Gleyre accompanied the American John Lowell, Jr., on a trip to the Near East, producing a beautiful set of quite finished water colors—a rich man's *voyage pittoresque*—for his patron.[73]

Water color continued its documentary role till the end of the nineteenth century, as can be seen in the large water colors of François Bonhommé, which record the mining industry in Le Creusot [42], as well as the lively water colors of Isidore Pils, which document the Siege of Paris in 1871 [102, 106]. Pils's *Self-Portrait* of 1853 shows how the watercolorist-reporter worked, resting his paper on a small folding table that could be set up wherever the action was [138].

With the emergence of Realism, the role of drawing gradually changed. Perhaps the most important change was that preparatory drawings were less commonly and less systematically used. From the 1830s on, landscape artists, beginning with the Barbizon-school painters and continuing with the pre-Impressionist and Impressionist painters, found less and less use for preliminary drawings as, more and more, their paintings were executed outdoors on the spot. Rather than making preparatory sketches on paper, artists drew directly on the canvas, subsequently covering these drawings with paint.[74] This does not mean that nineteenth-century landscape artists did not draw. Many of them—for example, Rousseau, Jacque, Daubigny, and Pissarro—were prolific draftsmen, but their drawings are either independent works of art or mere sketches, and are rarely direct studies for their paintings.

In the area of figure painting as well, preparatory drawings lost a good deal of their importance. Several Realists, among them Courbet and Manet, rarely made use of them at all. Others tended to make their preparatory drawings so finished that they lost their subservience to the painting and became works of art in their own right. This, for example, is the case with Bonvin's *Woman at the Spinet* [72] and his later drawing of a *Nun Holding a Letter* [88], as well as Fantin-Latour's *Two Girls Embroidering Near a Window* (Figure 42), which, though closely related to paintings of the artist, take on an independence of their own.

The preparatory drawing, as an intermediate stage between the observation of reality and the finished picture, was often aided and sometimes even substituted by photography.[75] Though in recent years much has been written on the relation between art and photography in the nineteenth century, there is relatively little demonstrable evidence of the use of photographs in the preparation of paintings, presumably because this practice was considered a trick of the trade better kept secret.[76] It is unlikely that many self-respecting artists went as far as the Realist painter-photographer Charles Nègre, who faithfully copied entire paintings after his own photographs.[77] But many artists to a greater or lesser extent relied on photographs for their compositions or for individual figures in their paintings. It is almost certain, for example, that some of Gustave Caillebotte's compositional drawings were traced from photographs taken by his brother Martial,[78] even though Caillebotte's careful preliminary studies for individual figures in paintings like the *Standing Man in Derby* [167] were probably done from life. Other artists, while inventing their own compositions or sketching them from life, used photographs for individual figures in their works. Thus

Courbet, Manet, and Degas, among others, are known to have painted portraits or specific figures in multifigured compositions directly after photographs.[79]

Though the Realists made fewer preliminary studies for paintings, they frequently made preparatory drawings for prints. These might, on occasion, be sketches for the artist's own lithographs or etchings, but mostly they were drawings for prints (lithographs, wood engravings, engravings, or etchings) that were executed by professional printmakers to be used as illustrations in books or magazines. The drawings that were submitted to these professionals were generally quite finished, as the printmaker had to be given as much guidance as possible.[80] Nearly all Realists made drawings for this purpose. Lhermitte's *Press House* [186], one of a series of drawings made for reproduction through wood engraving in André Theuriet's *La Vie rustique*, can serve as an example.

It was during the 1850s and particularly among the Realists that the practice became widespread of making large, finished, independent drawings to be sold for their own sake. Unlike earlier decades, when this tradition had involved portrait drawings and water colors almost exclusively, it was now common for drawings in various media and with various themes. The growth of this practice must be attributed to partly economic causes. In the 1850s, Realists like Courbet, Bonvin, Millet, and Fantin-Latour constituted the avant-garde. They were surrounded by small groups of enlightened middle-class admirers (mostly professionals—lawyers, doctors, architects, and government employees), generally of average means,[81] who did not have money to buy oil paintings (which represented weeks, if not months, of work and a substantial outlay of materials) but who could, with ease, afford a finished "picture drawing" that took the artist only a few days and cost him little in materials. To these progressive middle-class collectors, drawings had the advantage that they were original and—unlike prints—unique works of art that required only a moderate expenditure and, consequently, only a small investment in the somewhat risky venture of collecting avant-garde art.[82]

Drawings by Millet are a case in point. During the 1850s, they were avidly acquired by several middle-income collectors, among them the government employees Alfred Sensier and Louis Campredon, the architect Alfred Feydeau, the retired pharmacist Letrône, the small-time art dealer Beugniet, and fellow artists like Jacque and Rousseau.[83] More and more, Millet began to rely on the sale of his drawings for a living, as they provided him with a small, but steady flow of cash, while the sale of his paintings was uncertain and irregular. Thus he wrote in a letter to Sensier in 1863: "The drawings are indeed my only resource. Since picture lovers despise my paintings, I must try to find for these summary compositions people who will understand me and who can [afford to] buy them."[84] As Millet's independent drawings became more popular, he gradually added color, mostly pastel, to make them more like his paintings. To an extent, his use of color was forced upon him by his patrons. Thus the collector Emile Gavet, whom he met in 1865, "devoured" his pastels and would buy them faster than Millet could produce them.[85]

The increased use of pastel is seen not only in the drawings of Millet but also in the work of many other artists. In fact, from the 1860s on, pastel enjoyed a growing popularity that culminated in the 1880s and 1890s with artists like Degas, Lhermitte, and Pissarro. Simultaneously, water color, which during the middle of the century had fallen into some disrepute as a typical, dilettante medium—the water colors of François Bonvin's half brother Léon [77] are examples of the quality these "dilettante" works could attain[86]—regained some of its importance through its use by artists like Eugène Boudin, Johann Barthold Jongkind, and Manet.

The increasing importance of drawing, including pastel and water color, as a form of art in its own right had a number of important results. First of all, it led to an increased number of drawing exhibitions[87] as well as the publication of more albums and special magazines and books devoted exclusively to drawing.[88] Furthermore, it fostered the emergence of a class of professional draftsmen who, though they might turn out occasional oil paintings, derived their renown chiefly from their drawings. Besides some of the artists already mentioned, such as Lhermitte, Jongkind, and Boudin, other artists like Adolphe Appian, Auguste Allongé, and Maxime Lalanne, who were well known in their own time for their highly finished landscape drawings, should also be noted.

In conclusion, it can be said that the Realist movement played an important role in expanding the scope, the range of subject matter, and the stylistic and technical boundaries of nineteenth-century drawing. Realist draftsmen departed from established academic drawing practices, taking inspiration, on the one hand, from the just-invented graphic media of lithography and photography and, on the other hand, from old-master drawings from the sixteenth through eighteenth centuries—and in so doing they won for drawing the independence and freedom that twentieth-century artists would generally take for granted.

1. For the concept of originality in nineteenth-century French art, see Albert Boime, *The Academy and French Painting in the Nineteenth Century* (London-New York: Phaidon, 1971), especially pp. 173-84.

2. The definition, a priori, excludes from discussion the drawings of the "caricaturists": Honoré Daumier, Henri Monnier, Paul Gavarni, Constantin Guys, Gustave Doré, and other less important artists. Though important as pacesetters in the use of Realist subject matter in their work, these artists cannot qualify as Realist draftsmen, because they did not work from nature but without a model *(de chic),* reinterpreting nature to suit their satirical or comical purposes.

3. Cf. Boime, *Academy and French Painting,* p. 16; and Linda Nochlin, *Gustave Courbet: A Study of Style and Society* (New York: Garland Publishing, 1976), pp. 109-11.

4. For the early history of lithography in France, see, among others, H. Bouchot, *La Lithographie* (Paris: Librairies-Imprimeries Réunies, 1895); and Michael Twyman, *Lithography: 1800-1850* (London: Oxford University Press, 1970).

5. This apparently was the opinion of Théodore Géricault, who wrote from London upon completion of his famous lithograph series, the English Set: "Je me flatte que ce ne sera pour moi que l'affiche, et que bientôt le goût des vrais amateurs qui auront ainsi appris à me connaître, m'emploieront [sic] à des travaux plus dignes de moi." Quoted in Klaus Berger, *Géricault et son oeuvre* (Paris: Flammarion, 1968), p. 182, n. 76.

6. On French Romantic landscape lithography, see the excellent essay by Jean Adhémar, "Les Lithographies de paysage en France à l'époque romantique," *Archives de l'art français,* n.s. XIX (1935-37): 189-346, from which most of the material on scenery lithography in this essay was drawn.

7. The most famous among these "makers of stick figures" *(faiseurs de bonhommes)* was Victor Adam (1801-1865), who also did a great deal of independent lithographic work, much of it dealing with Parisian street life. Cf. ibid., pp. 230-32; and Henri Béraldi, *Les Graveurs du XIXe siècle* (Paris: Conquet, 1885-92), I: 15-22.

8. The picturesqueness of factories is referred to by several early Romantic authors, e.g., Raoul Rochette (1789-1854): "Aux fabriques ornementales, étrangères des tableaux d'un Salvator ou d'un Poussin, je préfère ces fabriques plus utiles et qui n'en sont pas moins pittoresques." Quoted in Adhémar, "Les Lithographies de paysage," pp. 15-22.

9. Ibid., pp. 246-48.

10. Ibid., Bibliography.

11. Twyman, *Lithography,* chap. 9, pp. 109-31.

12. For the development of lithographic tonal techniques, see ibid., chap. 10, pp. 132-70.

13. On Rousseau and Dutch landscape painting, see Petra ten-Doesschate Chu, *French Realism and the Dutch Masters* (Utrecht: Haentjens Dekker & Gumbert, 1974), pp. 23-25.

14. A short, thick roll of paper or leather cut to a point.

15. Charles Blanc, "De la gravure à l'eau-forte et des eaux-fortes de Jacque," *Gazette des Beaux-Arts,* 1st ser. IX (1861): 203.

16. Ibid., pp. 203-8; and J. J. Guiffrey, *L'Oeuvre de Ch. Jacque. Catalogue de ses eaux-fortes et pointes sèches* (Paris: Lemaire, 1866). For a general account of the etching revival in France, see especially Gabriel P. Weisberg, *The Etching Renaissance in France: 1855-1880,* exh. cat. (Salt Lake City: University of Utah, Museum of Fine Arts, 1971); and Janine Bailly-Herzberg, *L'Eau-forte de peintre au dix-neuvième siècle* (Paris: Léonce Laget, 1972).

17. For a thorough treatment of the *Cris de Paris* tradition prior to 1800—an important forerunner to the Realist tradition—see Wolfgang Steinitz, *Les Cris de Paris* (Salzburg: Verlag Galerie Welz, 1971).

18. Cf. Béraldi, *Les Graveurs du XIXe siècle,* XII: 186-210 (Carle Vernet); IX: 220-23 (Marlet); XII: 210-23 (Horace Vernet); and IV: 98-136 (Charlet).

19. A standard work on the history of the French press in the nineteenth century is Henri Avenel, *Histoire de la presse française* (Paris, 1900).

20. For a classic text on French Romantic book illustration, see Champfleury [Jules Fleury], *Les Vignettes romantiques. Histoire de la littérature et de l'art, 1825-40* (Paris: E. Dentu, 1883).

21. For the history of wood engraving in France, see Pierre Gusman, *La Gravure sur bois en France au XIXe siècle* (Paris: Editions Albert Morancé, 1929).

22. On these two important promoters of Romantic illustration, see M. Cloche, "Un Grand Éditeur du XIXe siècle, Léon Curmer," *Arts et Métiers Graphiques* XXXIII (1933): 28-36; and Howard P. Vincent, *Daumier and His World* (Evanston, Ill.: Northwestern University Press, 1968), pp. 14-23 and passim.

23. On the drawings of Monanteuil, see Léon de la Sicotière, *Monanteuil, dessinateur et peintre* (Caen, 1864), passim.

24. An engraving after this drawing is found in François Boucher, *Figures de différentes caractères . . .* (Paris: Julienne, 1726), I, no. 20.

25. Adhémar, "Les Lithographies de paysage," p. 317; and Béraldi, *Les Graveurs du XIXe siècle,* II, 155-56.

26. J. F. Schnerb, "François Bonhommé," *Gazette des Beaux-Arts,* 4th ser. IX (1913): 136-38. Also, *François Bonhommé dit le forgeron,* exh. cat. (Nancy: Musée du Fer, 1976), unpaginated.

27. A drawing for the cover of another album, *Les Gueules Noëres,* of 1848, is reproduced on the cover of *François Bonhommé dit le forgeron* (note 26 above), and in Schnerb, "François Bonhommé," p. 15.

28. Cf. Madeleine Rousseau, "La Vie et l'oeuvre de Philippe-Auguste Jeanron," oeuvre cat. (thesis, Paris, Ecole du Louvre, 1935), nos. 322-427, pp. 57-66 and passim; and Béraldi, *Les Graveurs du XIXe siècle,* VIII: 237-39.

29. Schnerb, "François Bonhommé," p. 136.

30. For a complete listing of Jeanron's drawings and water colors, see Rousseau, "La Vie et l'oeuvre," nos. 191-320, pp. 46-56.

31. Hélène Toussaint's earlier dating of the drawing (ca. 1843) is unacceptable to me. Cf. *Gustave Courbet,* exh. cat. (London: Arts Council of Great Britain, 1978), p. 200. For Courbet's drawings in general, see Louis Aragon, *L'Exemple de Courbet* (Paris: Cercle d'Art, 1952); Robert Fernier, *La Vie et l'oeuvre de Gustave Courbet* (Paris: Wildenstein, 1978), II: 265-331; *Courbet und Deutschland,* exh. cat. Essay and catalog entries by Margret Stuffmann (Hamburg, Kunsthalle, 1978), pp. 324-58.

32. For a description of Courbet's technique, see *Le Grand Larousse du XIXe siècle,* s.v. "Fusain."

33. Twyman, *Lithography,* pp. 140-45.

34. Reproduced in E. Moreau-Nélaton, *Millet, raconté par lui-même* (Paris: H. Laurens, 1921), I, figs. 38, 39, 54-58. For general accounts of Millet's drawings, see especially Léonce Bénédite, *The Drawings of Jean-François Millet* (London: William Heinemann, 1906); Roseline Bacou, *Millet dessins* (Paris: Bibliothèque des Arts, 1975); and *Jean-François Millet,* exh. cat. (Paris: Grand Palais, 1975/76), which includes updated bibliography.

35. Moreau-Nélaton, *Millet, raconté, par lui-même,* I: 71.

36. Bénédite, *Drawings of Millet,* p. 20.

37. For Bonvin's drawings and water colors, see Gabriel P. Weisberg, *Bonvin, La Vie et l'oeuvre* (Paris: Geoffroy-Dechaume, 1979), pp. 251-307.

38. For Bonvin's contacts with Laperlier, see, among others, E. Moreau-Nélaton, *Bonvin raconté par lui-même* (Paris: H. Laurens, 1927), pp. 28-29; Weisberg, *Bonvin,* pp. 36-37; idem, "François Bonvin and an Interest in Several Painters of the Seventeenth and Eighteenth Centuries," *Gazette des Beaux-Arts,* 6th ser. LXXVI (1970): 359-60.

39. On Bonvin's admiration for Rembrandt, see Chu, *French Realism and the Dutch Masters,* pp. 41-42.

40. For a complete listing of Fantin-Latour's drawings, see Madame Fantin-Latour [Victoria Dubourg], *Catalogue de l'oeuvre complet de Fantin-Latour* (Paris: H. Floury, 1911; reprint ed., Amsterdam: B. M. Israel, 1969). See also *Dessins de Fantin-Latour,* exh. cat. (Paris: Tempelaere Gallery, 1901).

41. Cf. *Jean-François Millet,* exh. cat., 1975/76, p. 127.

42. Cf. Lucien Lepoittevin, *Jean-François Millet* (Paris: L. Laget, 1973), II: 160-61.

43. See L. de Planet, *Souvenirs de travaux de peinture avec M. Eugène Delacroix,* ed. E. Joubin (Paris: Colin, 1929), p. 33.

44. Though much has been written on the influence of Japanese prints on French art since the middle of the nineteenth century (see bibliography in Gabriel P. Weisberg, et al., *Japonisme,* exh. cat. [CMA, Rutgers Art Gallery, Walters Art Gallery, 1975/76], pp. 215-18), the impact of other forms of "primitive" art has not been studied in a comprehensive manner.

45. For the drawings of Manet, see Alain de Leiris, *The Drawings of Edouard Manet* (Berkeley, Los Angeles: University of California Press, 1969). The literature on Degas's drawings is too extensive to be cited here. See recent bibliography in Jean Sutherland Boggs, *Drawings by Degas,* exh. cat. (St. Louis, Philadelphia, Minneapolis, 1967), pp. 234-35.

46. See Albert Boime, "The Uncrowned Touches of Thomas Couture," in *Thomas Couture: Drawings and Some Oil Sketches,* exh. cat. (New York: Shepherd Gallery, 1971).

47. For Manet's interest in quattrocento painting, see de Leiris, *Drawings of Edouard Manet,* pp. 7-8 and passim. The literature of Manet and Japanese prints is too extensive to be cited here. It is noteworthy, however, that a comprehensive treatment of the subject is still lacking.

48. See Loys Delteil, *Le Peintre-graveur illustré* (Paris: Author, 1906-27), IX (1919).

49. There is no special literature on the drawings of Breton and Bastien-Lepage. For numerous reproductions of Breton's drawings, see Maurice Vachon, *Jules Breton* (Paris: A. Lahure, 1919). For scattered references to the drawings of Bastien-Lepage, see William S. Feldman, "Life and Work of Jules Bastien-Lepage, 1848-1884" (Ph.D. diss., New York University, 1973).

50. For the influence of photography on nineteenth-century art, the standard work is still Aaron Scharf, *Art and Photography* (Penguin Books, 1974), bibliographical references in footnotes, pp. 327-78.

51. A recent revival of interest in Lhermitte was initiated with an exhibition of his work at The Paine Art Center and Arboretum, Oshkosh, Wisc., in 1974. The catalog was written by Mary Michele Hamel, who also wrote her Ph.D. thesis on Lhermitte (Washington University, 1974).

52. See Mary Michelle Hamel, *Léon Lhermitte*, exh. cat. (Oshkosh, Wisc.: Paine Art Center, 1974), p. 16.

53. Cf., e.g., Vincent van Gogh, *The Complete Letters* (Greenwich, Conn.: New York Graphic Society, 1959), II: 412.

54. On the subject of academic drawing education, see Boime, *Academy and French Painting*, especially chap. 2 (pp. 22-36); and idem, "The Teaching Reforms of 1863 and the Origins of Modernism in France," *Art Quarterly*, n.s. 1 (1977): 1-39. The latter article deals in depth with the organizational and pedagogical reforms at the Ecole des Beaux-Arts by the official decree of 13 November 1863. Since these reforms had comparatively little impact on drawing education, they have not been considered in this brief survey.

55. For example, Eugène Delacroix, review of *Le Dessin sans Maître* by Elizabeth Cavé, *Revue des Deux Mondes*, n.s. VII (1850): 1139-49; Eugène E. Viollet-le-Duc, *Réponse à M. Vitet à propos de l'enseignement des arts du dessin* (Paris, 1864); Philippe Burty, *Maîtres et petits maîtres* (Paris: Charpentier, 1877), pp. 1-19.

56. See Boime, *Academy and French Painting*, pp. 24-36.

57. For example, Denis Diderot, *Essais sur la peinture* (Paris: Fr. Buisson, 1795), chap. 1 (pp. 1-14): "Mes Pensées bizarres sur le dessin." Diderot warns against the dangers of academic drawing instruction and advocates that art students go out and draw reality itself. "Et ces sept ans employés à l'académie à dessiner d'après le modèle . . . voulez-vous savoir ce que j'en pense? C'est que c'est là et pendant ces sept pénibles et cruelles années qu'on prend la manière dans le dessin."

58. See note 55 above.

59. For a concise listing of several of these methods, see Boime, "Teaching Reforms of 1863," p. 29, n. 34.

60. A second, enlarged edition appeared in 1862. I have consulted the 1913 reprint edition published by Henri Laurens (Paris).

61. On Lecoq de Boisbaudran and his method, see, among others, Félix Régamey, *H. Lecoq de Boisbaudran et ses élèves* (Paris: Champion, 1903); and A. Elsen, *Rodin* (New York: Museum of Modern Art, 1963), pp. 160-62.

62. For a succinct treatment of the important concept of naïveté, see Linda Nochlin, *Realism* (Baltimore: Penguin Books, 1971), pp. 36-37.

63. Cf. Judith Wechsler, "An Aperitif to Manet's *Déjeuner sur l'herbe*," *Gazette des Beaux-Arts*, 6th ser. XCI (1978): 32-34; and Horace Lecoq de Boisbaudran, *L'Education de la mémoire pittoresque, et la formation de l'artiste* (Paris: H. Laurens, 1913), p. 3.

64. Cf. Courbet's open letter in the *Courrier du Dimanche*, 25 December 1861: "je nie l'enseignement de l'art ou . . . je prétends, en d'autres termes, que l'art est tout individuel, et n'est pour chaque artiste, que le talent résultant de sa propre inspiration et de ses propres études sur la tradition." Quoted in Pierre Courthion, *Courbet raconté par lui-même et par ses amis* (Genève: Pierre Cailler, 1950), II: 204.

65. Cf. Boime, *Academy and French Painting*, p. 32; and idem, "Teaching Reforms of 1863," pp. 12-13.

66. G. Fraipont, in his *L'Art de prendre un croquis et de l'utiliser*, discusses eight different types of *croquis*. His book, apparently very popular, appeared in numerous editions, of which I have consulted the seventh, published by H. Laurens in 1899.

67. At the auction (17-19 February 1864) of the contents of the studio of Delacroix upon his death, for example, over four hundred drawings were sold, many of which were bought by fellow artists. Cf. René-Paul Huet, *Paul Huet* (Paris: H. Laurens, 1911), pp. 370-74. For a repertoire of auction catalogs listing the contents of artists' studios upon their death, see Frits Lugt, *Répertoire des catalogues de ventes publiques* (The Hague: Martinus Nijhoff, 1933-64).

68. Cf. Hans Naef, *Die Bildniszeichnungen von J. A. D. Ingres* (Bern: Benteli-Verlag, 1977), 1: 12-15.

69. On the subject of nineteenth-century French water colors, see François Daulte, *L'Aquarelle française au XIXe siècle* (Paris: Bibliothèque des Arts, 1969).

70. Cf. Pierre du Colombier, *Decamps* (Paris: Les Editions Rieder, 1928), p. 45.

71. Daulte, *L'Aquarelle française*, p. 30.

72. See, among others, Philippe Julian, *The Orientalists* (Oxford: Phaidon, 1977), pp. 60-62.

73. Cf. Nancy Scott, *Charles Gleyre*, exh. cat. (New York: Grey Gallery, 1980), passim.

74. This practice is well illustrated by the oeuvre of Théodore Rousseau, which includes several elaborate studies in charcoal and other drawing media on canvas or panel. See *Théodore Rousseau*, exh. cat. (Paris: Louvre, 1967/68), figs. 82, 83; and Amand-Durand and Alfred Sensier, *Th. Rousseau, études et croquis* (Paris: Amand-Durand/Goupil, 1876).

75. See note 50 above.

76. Scharf, *Art and Photography*, pp. 155-56.

77. Ibid., pp. 112-13. On Charles Nègre, see also André Jammes, *Charles Nègre photographe* (Paris: Author, 1963).

78. Cf. Peter Galassi, "Caillebotte's Method," in J. Kirk Varnedoe et al., *Gustave Caillebotte*, exh. cat., (Houston, Brooklyn, 1976/77), pp. 192-93.

79. Cf. Scharf, *Art and Photography*, pp. 66-75; 131-36; 183-89.

80. There were special handbooks on how to execute these drawings, e.g., G. Fraipont, *Manière d'exécuter les dessins pour la photogravure et la gravure sur bois* (Paris: Laurens, n.d.).

81. Cf. Maurice Rheims, *La Vie étrange des objets* (Paris: Plon, 1959), p. 230.

82. Unfortunately, the literature on the collecting of drawings is scarce. To my knowledge, the only book to deal with the subject is Tito Miotti, *Il Collezzionista di disegni* (Venezia: Neri Pozza, 1962), which contains little information on nineteenth-century French drawing collections, particularly of contemporary drawings.

83. Cf. Bacou, *Millet dessins*, p. 14. For the exact make-up of these collections, consult auction catalogs listed in Lugt, *Répertoire des catalogues de ventes*.

84. Quoted in Alfred Sensier, *Jean-François Millet*, trans. Helena de Kay (Boston: James R. Osgood, 1881), p. 160.

85. Cf. ibid., pp. 185-86; and Bacou, *Millet dessins*, p. 16.

86. A special exhibition of the drawings and water colors of Léon Bonvin is on view simultaneously with the CMA Realist Tradition exhibition.

87. Though even early in the nineteenth century it was not unusual for art dealers to show drawings in their galleries and though throughout the century drawings were included in the annual Salons, special exhibitions exclusively devoted to drawing did not appear until the last quarter of the century. The Dudley Gallery in London played a pioneering role in this respect through the organization, from 1873 on, of a series of Black and White expositions, where besides English drawings and prints, the works of French artists were also frequently shown. In France this example was followed by Paul Leroi, publisher of the magazine *L'Art*, who arranged a Black and White exhibition in the magazine's gallery in 1881. His example was followed, in turn, by E. Bernard, publisher of the magazine *Le Dessin*, who was responsible for a series of shows called Du Blanc et du Noir, which took place between 1885 and 1891. Cf. Frédéric Henriet, *Les Eaux-fortes de Léon Lhermitte* (Paris: Alphonse Lemerre, 1905), pp. 26-27. In addition, the Société d'Aquarellistes Français, founded in 1879, and the Société des Pastellistes Français, founded in 1885, organized regular exhibitions, in which drawings in other media were on occasion also permitted. From the late 1870s on, one-man drawing exhibitions were also held. Thus, in 1881 a show of charcoals by Redon was on view in the editorial offices of *La Vie moderne*, while in 1887 Lhermitte's drawings for the illustrations of Theuriet's *La Vie rustique* were exhibited in the offices of that book's publisher. In order to get a more complete picture of the changing appreciation for drawing in the course of the second half of the nineteenth century, more research is needed on dealers, exhibitions, and drawing collectors during that period.

88. Among the increasing number of publications on drawing that saw the light in the second half of the century, mention should be made of *L'Autographe*, a serial publication that was issued between December 1863 and November 1865 (48 issues) and again from September 1871 to August 1872 (2d ser., 52 issues); and of the magazines *Le Fusain* (1880-83) and *Le Dessin* (1883-?).

Contributors to the catalog section, designated by initials, include:

J.F. de C. Jean-François de Canchy
B. F. Barbara Fields
A. C. J. Anne Clark James
K. Mc. Kenneth McConkey
L. N. Linda Nochlin
T. R. Theodore Reff

PART ONE

The Evolution of Realism

Genre

POPULAR TYPES
Urban Life
Provincial Life

THEMES OF LABOR
Artisans
Industrialization
Farm and Marketplace

DOMESTIC ACTIVITY

CHURCH AND STATE

CONTEMPORARY EVENTS
Natural Disasters
Revolution and War

When Castagnary wrote in 1857 that the majority of paintings exhibited at the Salon were genre, he was pointing to a major shift in the direction of French painting that had been going on over a number of years.[1] Painters everywhere began to paint scenes from everyday life, for genre lent itself well to the Realist's insistence on social content in the choice of themes. At first, many of the canvases betrayed their dependence on romanticism and anecdote, but as the movement for social change accelerated in the late 1840s painters turned more and more to themes that exposed the miseries of the common folk in both city and countryside: homeless children, suicides [5], beggars and street performers, wayfarers [21], uprooted families. Subjects like these also gave artists the opportunity to record regional customs and traditions, to chronicle the changes wrought among the working classes by the Industrial Revolution, and to immortalize the artisan, the gleaners [50], and the plowman [53] left behind by progress before these elements in the population completely disappeared. The early Realist critics, especially Champfleury, also required the painter to record the damage modern civilization had done to the family and home, and to extol the virtue of the staunch moral code, hard work, and traditions that had once supported them.

Genre also lent itself well to propaganda, and many of the Realists succumbed to melodrama and to the glorification of the Church and state in their role as alleviator of the hardships of poverty. But many acted as commentators and reporters of their times. If they still relied on disaster painting for emotional content, they did so by depicting actual storms and floods rather than mythical or historical catastrophes. Brion's *Potato Harvest during the Flooding of the Rhine* is such a *tableau historique;* Breton painted the fires that ravaged his native village of Courrières and its harvest [95]; Antigna's Romantic *Fire* shows the distress and anguish of a Parisian family as their worldly possessions are lost to the flames [92].[2]

As genre expanded to encompass new aspects of daily life, the reliance on anecdote gradually disappeared. By the 1860s genre provided the viewer with a vast array of activities and social problems to contemplate. The narrative content remained high, but it was there to make the compositions intelligible to ordinary people and to arouse in them the need for reform.

1. See Jules Antoine Castagnary, Preface to *Salons* (Paris, 1892), p. 3. Contemporary critics were aware that genre encompassed more than scenes of actuality; they used the category to study portraits, landscapes, and still lifes. In many of their reviews, however, critics separated portraits and landscapes from scenes of everyday life; some even neglected to discuss still life at all. Nonetheless, a consideration of portraits, landscapes, and still lifes as subdivisions of the genre category, and recognition of genre painting as a category that embraced a study of daily life in all aspects is appropriate.

2. The relationship between genre painting and history painting has not been satisfactorily studied or explained. If, as Champfleury expressed it, genre painting was a type of history painting that recorded a particular event or the modern conditions of a region, history painters could easily become genre painters and vice versa. See Champfleury, *Grandes Figures d'hier et d'aujourd'hui—Balzac, Gérard de Nerval, Wagner, Courbet* (Paris: Poulet-Malassis et de Broise, 1861).

POPULAR TYPES
Urban Life

François Bonvin

1 *The Young Savoyard*
(Le Petit Savoyard)

Oil on canvas, 8-1/4 x 10-5/8 inches (21 x 27 cm.).
Signed and dated upper left: F. Bonvin 1845.
Boulogne-sur-Mer, Musée Municipal.
Provenance. M. A. Bellino sale, Galerie Georges
Petit, Paris, 20 May1892. Josiah Bradlee sale,
American Art Galleries, 20-21 February 1924.
Brame Archives, no. 3812, 8 May 1925, from
Gustave Tempelaere. Sold 6 November 1925 by
Tempelaere to unknown purchaser.

Le Petit Savoyard is a significant work by
François Bonvin, but it received little recog-
nition when it was painted in 1845. This
small canvas of an urchin counting his pen-
nies typified the many homeless young chil-
dren who had been turned out of their own
households and their native regions to fend
for themselves alone or in gangs in the
streets of French cities. These beggars in-
creased the already-critical problem of
pauperism in France and dramatized the
need for some type of social welfare pro-
gram to prevent the country from being
overrun by unwanted children. While all of
the poor provinces of France bred beggars,
many of these children were native to the
outlying alpine region of Savoy, an unstable
kingdom that did not become part of France
until 1860, thus creating a growing pauper
population that the French had no chance to
remedy until well into the Third Republic.

It is difficult to understand the reason for
the hordes of children who were forced to
the roads during this period. Little is known
about the provincial families who were pro-
ducing greater numbers than they were able
to provide for at home. Whether the young
children took to begging immediately after
being turned out is also difficult to deter-
mine, since most journeyed far from home,
begging for bread one day, trying to find an
odd job the next. There was no shame or
humiliation attached to the plight of these
lonely paupers; they were simply trying to
save themselves from starvation.

The tradition of the *petit savoyard* making
his way to Paris was well established in so-
cial history, literature, and the visual arts as
early as the beginning of the eighteenth cen-
tury. The *Petit Savoyard* of Antoine Wat-
teau, who originated this tendency in paint-
ing, was completed about 1708. The pro-
gression to Paris was intermittent, with in-
tervals in certain cities or locales (e.g.,
Strasbourg, Dijon, Bordeaux) that were
known to tolerate the annual migrations.
Once in Paris, the young immigrants often
found work sweeping chimneys, assisting in
building trades, or at various seasonal jobs.
Occasionally they were exploited by cunning
entrepreneurs who forced them to turn over
whatever money they received from begging
in return for lodging and food that were—at
best—minimal.

Sometimes it was the parents who forced
these children to become street entertainers,
or who hired their children out in seasonal
jobs for a nominal fee. Once such work was
completed, the child could return home with
a portion of the funds he had earned or
begged, minus what had been deducted by
his urban "benefactor." But the child who
realized he was being coerced to his own
disadvantage might refuse to return home,
and thus become a permanent beggar or va-
grant, sometimes even being drawn into a
life of crime.

That the majority of beggars came from
Savoy cannot be proven; the region simply
provided a name (a ready cliché, if you will)
for a group of wandering, single children
found on city streets. It is equally difficult to
establish when these *savoyards*—as a group
—entered popular literature, but publi-
cations in the late eighteenth century
identified them and the pursuits associated
with them.[1] By the nineteenth century, the
savoyard had become a familiar theme for
artists. François Joseph Chatillon
(1808-1881) chose to depict a pauper posed
against a stark, blank wall (Musée de
Rouen). Artists like Alexandre Gabriel
Decamps (1803-1860) did lithographs
showing a *savoyard* street entertainer posed
with his monkey (Fogg Art Museum,
Boston). These early versions of the theme
often sentimentalized the youths, portraying
them with large, open eyes that played upon
the viewer's sympathy.

Bonvin's treatment of this traditional
theme was sympathetic, yet intimate, with
only the slightest suggestion of Romanti-
cism. The simplicity of the pose, with the
child hunched intently over his coins and
pack, the flat backdrop, and the unified
color range are qualities reminiscent of
Spanish masters, especially Esteban Murillo
(1618-1682), whose work Bonvin had studied
in the Louvre. Other Realists—even Cour-
bet—were also revealing an interest in
Spanish painters at this time. Bonvin's small
work, however, was among the first of those
created by the Realists that identified the
petit savoyard as a symbol of menial work.
In addition, Bonvin's canvas is a perfect ex-
ample of the small genre compositions that
initiated the Realist movement during the
1840s. By placing his youth in shadow and
allowing no eye contact with the viewer,
Bonvin has lessened any sentimentality that
earlier renditions might have suggested. The
possessions that Bonvin has placed within
his reach—the second pair of shoes, albeit
ill-fitting, but a luxury nonetheless; the
meager lunch of apple and a piece of bread;
and the few coins—bring into focus the in-
tent, but servile figure. In disquieting sim-
plicity, Bonvin has captured the ambience of
solitary, impoverished childhood.

1. *Tableau de Paris,* Nouvelle édition, 8 vols.
(Amsterdam, 1782), 4: 100-102.

Exhibited
1886, Paris, Galerie D. Rothschild: Exposition de
tableaux et dessins par F. Bonvin.

Published
Etienne Moreau-Nélaton, *Bonvin raconté par
lui-même (Paris: Henri Laurens, 1927), p. 25,
fig. 6.*
Gabriel P. Weisberg, "The Traditional Realism
of François Bonvin," CMA *Bulletin* LXV
(November 1978): 283, fig. 4. Idem, *Bonvin: La
Vie et l'oeuvre* (Paris: Editions Geoffroy-
Dechaume, 1979), cat. no. 3.

Pierre Edouard Frère

2 *Going to School*

Oil on panel, 12-1/4 x 9-3/4 inches (31 x 24.8 cm.).
Signed and dated lower left: Ed. Frère-53.
Baltimore, The Walters Art Gallery.

The theme of the innocence of childhood
(e.g., Courbet's *The Artist's Studio,* 1855[1])
that the Realist painters adopted in the
nineteenth century was derived from a long-
standing and popular tradition in prints and
lithographs that absorbed Pierre Edouard
Frère almost exclusively. His arrival in the
small village of Ecouen after he left Paris in
the late 1840s marks a lifelong commitment
to portray the activities of children. Frère
painted the child nursed in infancy, coddled
by elder sisters, confirmed in church, play-
ing alone in the corner of a room, or attend-
ing a playmate's birthday party. Frère's
series of small panels is a compilation of
children's pleasures and vexations.

The child bundled against the cold and de-
cisively making his way despite the chill of
the wintry day in *Going to School* was com-
posed in Frère's own studio. It was his prac-
tice to bring in several local children at one
time, dress them for his purpose, pose them,
and—once he recorded their manner—move
on to another young model. Later he devel-
oped the background or particular setting,
in this case a street corner with tall buildings
reminiscent of Paris and, just beyond, the
shadowy outline of a carriage enveloped by
the swirling snow.

Whether Frère intended his work to un-
derscore the importance of education for the
masses is difficult to ascertain. An enthus-
iastic article by the English art critic John
Ruskin early in the 1850s inspired a great
demand for Frère's popularized vision of
childhood existence. His sympathetic in-
terest in children—his ability to make them
an appealing theme—was eagerly appreci-
ated by collectors in France and England.

1. Henry Bacon, "Edouard Frère," *Art Journal* 6
(1886): 321-24.

Jean-Pierre Alexandre Antigna

3 *Young Street Singer*
(La Petite Chanteuse des rues)
Pencil drawing, 11-7/8 x 9-7/8 inches (30 x 25 cm.),
ca. 1855-60.
France, Private Collection.
Provenance. Descendants of the artist.

Like many Realist painters (e.g., Bonvin or
Ribot), Jean-Pierre Alexandre Antigna also
depicted the activities of children. Some of
his Salon canvases recorded childhood
games (*Ronde d'enfants,* 1853), while other
compositions represented sentimentalized
portraits of innocent, untarnished youth.
Some of Antigna's strongest Realist can-
vases (e.g., *L'Incendie*) also show an in-
terest centered upon the interaction of the
youngest members of a family with their el-
ders during a catastrophic moment, thereby
attributing to the young feelings and person-
alities that were not always acknowledged in
the nineteenth century.

Living on the overcrowded Ile St. Louis
during the mid-1850s, Antigna had an oppor-
tunity to observe and record numerous
scenes from daily life. Wandering urchins

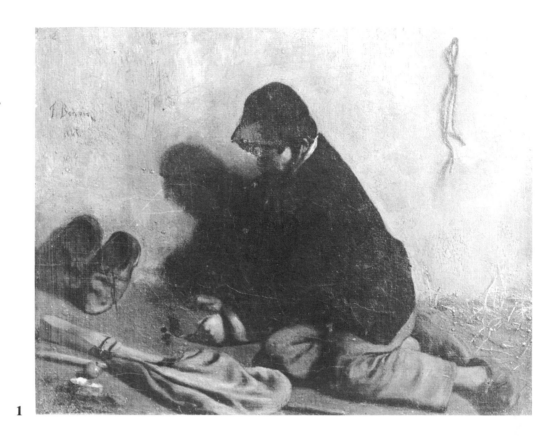

1

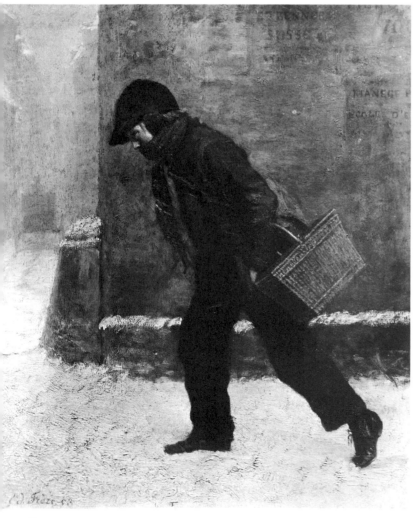

2

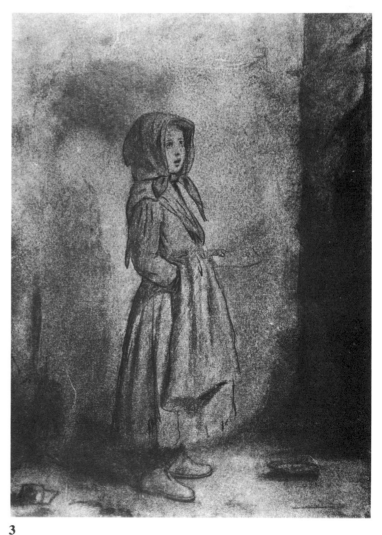

3

occasionally singing for money were a common occurrence that provided a new artistic theme for the Realists, who were seeking aspects of popular life as well as well-established traditions within urban settings. There were numerous itinerant young musicians (some with instruments, some accompanied by a pet monkey) earning money to support themselves or to sustain families that remained in the provincial regions of the country.

Antigna's innocent *Young Street Singer* was probably a popular figure in the poor sections of the city during the early evening hours, when her untrained, familiar tones provided some relief from the labors and stresses of the day.[1] The vague outlines of the street and housefronts extending the space at the right suggest that Antigna's small sketch may have been developed from an actual performance he witnessed. As one of a series or as the single sheet remaining from a lost sketchbook, this study emphasizes how important drawing was as a first step in the realization of new themes for paintings.

1. See *Tableau de Paris,* 5: 68-70, one of the many volumes French writers and painters studied to locate appropriate Realist themes.

Jean-Pierre Alexandre Antigna

4 *Hanged*
 (*Le Pendu*)
Charcoal, 11-3/4 x 9-7/8 inches (30 x 25 cm.).
France, Private Collection.
Provenance. Descendants of the artist.

Antigna, like other early Realists, was also aware of the number of suicides in Paris that were increasing at an alarming rate during mid-century. Under the stress and despair of dire poverty, it became more and more common for those who could no longer support or care for their own children—let alone themselves—to resort to the relief that only death could provide. The charcoal drawing *Hanged* registers the horror in gesture and expression of two women recoiling from the sight of a suspended, limp figure and the huddled form of a sleeping child nearby. While the specific information of this episode is not known—and may have been intended for a book—Antigna's drawing is a dramatic presentation of a serious social problem, and a singular study that unites style and message.

Octave Tassaert

5 *An Unfortunate Family* or *The Suicide*
 (*Une Famille malheureuse* ou *Le Suicide*)
Oil on canvas, 17-3/4 x 15 inches (45 x 38 cm.).
Signed and dated lower right: O. Tassaert 1852.
Montpellier, Musée Fabre.
Provenance. Alfred Bruyas Collection, 1868.
Given to the Musée Fabre by Bruyas in 1868.

The *Unfortunate Family* represents the high point of Octave Tassaert's career. It was commissioned by the state in 1849 in response to Tassaert's plea for financial assistance. The canvas was exhibited at the 1850/51 Salon and received considerable comment from the press because the theme coincided with issues then affecting the Parisian lower classes. At the close of the Salon, the painting became part of the Luxembourg Museum collection (1851). Tassaert's original painting proved so popular with collectors and art critics that he was asked to create four replicas; the one shown in the Realist Tradition exhibition was purchased by Alfred Bruyas and was included in the Bruyas collection when it was donated to the Musée Fabre in Montpellier in 1868.[1]

The theme of the *Unfortunate Family* was inspired by a literary source identified in the Salon catalog as Lammenais's *Paroles d'un croyant.* By the time Tassaert received the commission for this work, he had already completed many lithographs to illustrate Romantic novels, and his source for this particular painting was also a Romantic account that emphasized the misery of the lower classes. The literary episode by Lammenais describes the suicide of a destitute mother and daughter huddled together in their wintry-cold garret to await the death that will send their souls heavenward—a sentimental device intended to symbolize the purity of the poor whose faith remained unbroken even at the final, desperate hour. In his interpretation on canvas, Tassaert eliminated Lammenais's reference to the supernatural, capturing instead the grim reality of the moment when the carbon monoxide from the heater begins to take hold. The young girl clinging to her mother is gasping for air, while the older woman, whose pose is one of unwavering resignation, maintains her steadfast gaze upon the Madonna and Child tacked to the wall above the bed.

Aside from the melodramatic overtones of the scene and the Romantic source from which Tassaert derived his image, the canvas reveals a bitter truth: the ever increasing prevalence of suicide among the lower classes. The poor were often forced to live in cramped rooftop lodgings such as Tassaert depicted, with barely enough to live on in the long, cold, winter months.[2] During the July Monarchy, especially, and well into the Second Empire, the pauperism that increased at such an alarming rate among the working classes became a common topic for

writers such as Honoré Balzac and literary advocates of social reform. Weary of the struggle to exist without adequate food or clothing, suicide became a means by which the poor could at last find release from their misery and despair.[3] Religion, however, held fast. The lithograph of the Madonna and Child in the "holy corner"[4] remained a symbol of hope and salvation in the hereafter, a consolation even in suicide.[5] Strangely enough, the sense of religious morality, deeply inherent among the French people as a whole, gave way to public opinion, which did not castigate those members who took their own lives. Indeed, the contagious effects of self-slaughter were reported openly, and popular locations for such occurrences were documented in the press.[6]

Critics responded with sympathy when Tassaert's original composition was shown at the 1850/51 Salon. Théophile Gautier found Tassaert's style reminiscent of the figures and gestures of Proudhon. Paul Mantz, recognizing that the theme coincided with a major social problem, renamed the work *Le Suicide.*[7] Tassaert was seldom again to receive the unified praise that this work aroused in critics of several persuasions. Sadly enough, Tassaert's achievement led to an obsession with themes of death that foreshadowed his own later self-destruction by asphyxiation.

1. See Musée Fabre, Bruyas Collection, no. 112. Obviously, Bruyas wanted a copy of such an important painting for his own collection. He also secured the preliminary sketch, which Tassaert may have shown to Philippe Auguste Jeanron, before he obtained the commission from the government.

2. Louis Chevalier, *Classes laborieuses et classes dangereuses à Paris pendant la première moitié du XIXe siècle* (Paris, 1958), pp. 12, 50.

3. Louis Chevalier, *Laboring Classes and Dangerous Classes in Paris During the First Half of the Nineteenth Century* (New York, 1973), p. 280.

4. Aaron Sheon pointed out that Tassaert's suicide paintings "appear to have veiled political dimensions." The Church still forbade the burial of suicides and was supported in this by the government of Louis Philippe. This aspect may have changed under the Second Empire when Napoleon III tried to alleviate the hopelessness of pauperism at the beginning of his rule. Suicide, however, was still considered a violation of the doctrines of the Catholic Church. See Aaron Sheon, "Tassaert's Social Themes," abstract of a paper delivered at the CAA meetings, New York, 1978.

5. Information provided by Mme. Pieske in a discussion with the author in 1979.

6. Chevalier, *Laboring Classes,* p. 283.

7. Paul Mantz, "Salon de 1850/51," *L'Evénement,* 15 February 1851. For further discussion on the subject of suicide in France at this time, see Alexandre-Jacques-François Brierre de Boismont, *Du suicide et de la folie—Suicide considéré dans leurs rapports avec la statistique, la médecine et la philosophie* (Paris, 1856).

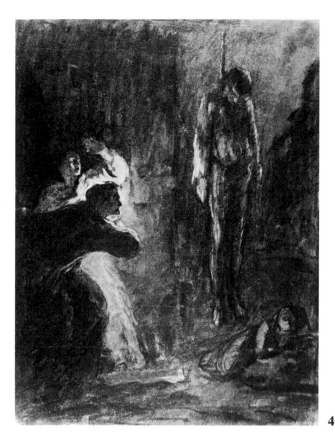

4

5

Exhibited

1953, Compiègne, Musée National de Compiègne: Le Temps des crinolines, cat. no. 243.

Published

Ernest Michel, *Galerie Bruyas,* Complément (Montpellier, 1878), p. 620, cat. no. 201.
Jules Claretie, "Octave Tassaert," in *Peintres et sculpteurs contemporains,* 2 vols. (Paris: Libraire des Bibliophiles, 1882), 1: 25-48.
Bernard Prost, *Catalogue de l'oeuvre de Tassaert* (Paris, 1886), p. 28, cat. no. 112.

François Bonvin

6 *The Ragpicker*

Chalk and charcoal, 14-15/16 x 11 inches (37.8 x 28 cm.). Signed and dated lower left: 53 F. Bonvin.
Cleveland, Private Collection.
Provenance. Charles Jacque Collection. Hazlitt Gallery, London.

The preponderance of beggars and ragpickers in Paris during the Second Empire and later [101, 164, 180] was chronicled by a number of artists in prints, drawings, and paintings. A section of *Les Français peints par eux-mêmes* appeared in 1841 devoted to the *chiffonnier* ("ragpicker"), a familiar figure that could be seen in many sections of the city collecting discards for resale at a nominal price. Unlike the beggar, the rag-

6

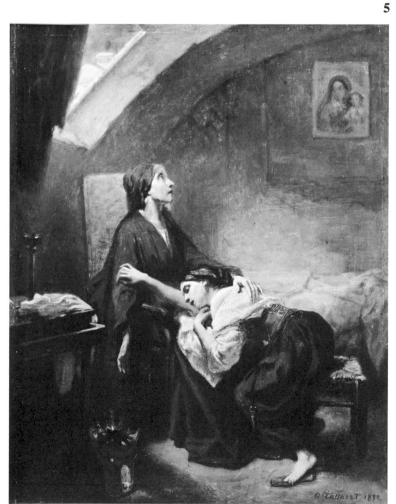

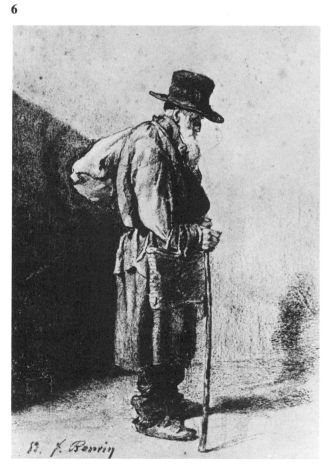

picker was a type licensed by the government so that he could legally pursue his occupation, although admittedly at the lowest level of the social spectrum.

The basic tools required for registration as a ragpicker were a lantern, a long stick, and a sack or basket in which to transport finds. He was also required to have some small reservoir of capital (no more than forty sous) and two witnesses to vouch for his honesty. As a rule, the ragpicker possessed "no furniture of his own, but [lived] in hired lodgings. . . ."[1] Exactly what he collected was difficult to document because his acquisitions ranged from bones to bits of glass; animal skins; rags of linen, wool, or cotton; scraps of food; and the shreds and shards of luxury items. This debris of civilization[2] was then brought to merchants who would sort out objects of interest from the sack or basket in another trade known as *trillage*.[3] The sale of a few items, after making his rounds of the city during the day or under cover at night, would thus enable the ragpicker to retire for a few hours.

It is difficult to pinpoint the sections of Paris with the greatest number of ragpickers, but the tally was probably proportionate to the renovation of the city under Napoleon III. The Latin Quarter near the Panthéon on the Left Bank and, later, the suburbs of the city (during the 1870s) were known to be areas that attracted great numbers of ragpickers.[4]

The tools of his trade entitled the ragpicker to a distinction never accorded the beggar who lived hand-to-mouth on a day-to-day basis, even though the ragpicker retained the symbolic brimmed hat that was familiar in the dress of the street beggars. The ragpicker was somehow separated from this class by the small dignity his gleanings and transactions provided, as well as by his sobriety and resignation—as if he recognized that he was out of step with changes that were bringing about an increasingly industrialized society. Ragpickers may have experienced former long-term employment in skills that were simply not transferable to a more modernized society. As such, ragpickers were inclined to bemoan their fate and to criticize the present conditions of society, and they were often used as symbols by writers commenting on the state of the poor.[5] Lithographs that appeared in the popular press during the 1840s immortalized the ragpicker as an outcast from society, forever condemned to exist on the refuse of a changing world. By the late 1850s, the theme of the ragpicker also appeared at the annual Paris Salons, initiated, in part, by the Realist painters' interest in readily available models that they could pose in their urban studios. The proud and resolute ragpicker was a popular type that to the Realist represented the pursuit of truth. Even in his ignorance, the ragpicker was able to chart his own course, conveying an air of freedom.

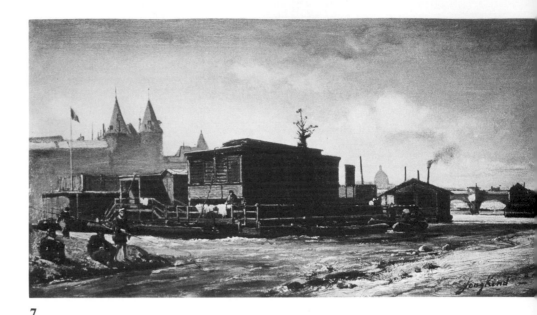

7

8

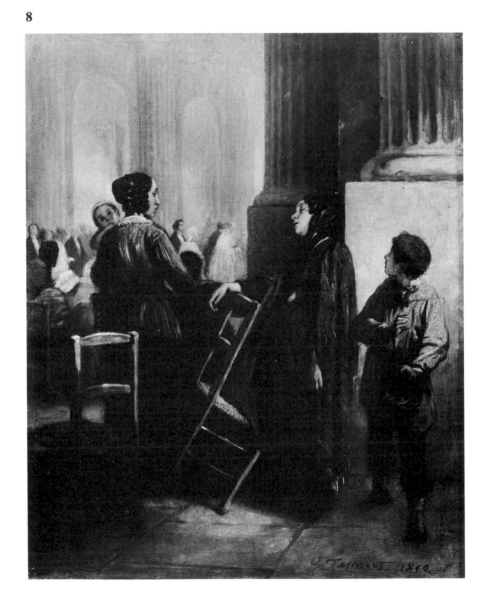

Bonvin was one of the Realists with studios on the Left Bank, and his study, *Le Chiffonnier*, in 1853 was one of several that he did using this same model.[6] As a forerunner of Edouard Manet's better-known painting of *The Ragpicker* (Norton Simon Collection, Pasadena), Bonvin's rendering distinguishes the ragpicker from the beggar, emphasizing what he knows to be the truth of this figure. The ill-fitting clothes worn by the old wanderer indicate his class; the sack, wicker basket, and wooden stick confirm his profession. By placing his figure against a simplified background, Bonvin accentuated the form, shading one section of his composition to set his figure in sharp relief. Thus, the pensive expression of the solitary figure creates a mood of dignity.

1. Albert Rhodes, "The Ragpickers of Paris," in *Galaxy* (New York, 1874), vol. XVIII, p. 194.
2. Ibid., p. 195.
3. Ibid.
4. Ibid., p. 192. Bonvin's several studios during the 1850s were on the Left Bank, often not far from the Panthéon.
5. See Charles Baudelaire, "Le Vin des chiffonniers" in *Les Fleurs du mal* (Paris, 1941), pp. 120-21. An earlier play, Félix Pyat's *Les Chiffonniers* (1847) brought the ragpicker to the attention of a Parisian-based audience. See also Anne Coffin Hanson, "Manet's Subject Matter and a Source of Popular Imagery," in *Chicago Art Institute Studies*, 1968, pp. 63-80.
6. For reference to other examples, see Weisberg, *Bonvin*, cat. nos. 244, 331.

Published
Gabriel P. Weisberg, "François Bonvin and the Critics of His Art," *Apollo*, October 1974, p. 307, fig. 3. Idem, "Traditional Realism," p. 286, fig. 11. Idem, *Bonvin*, cat. no. 244.

Johann Barthold Jongkind

7 *Bathhouses and Wash-Boat on the Seine (Bains et bateau-lavoir sur la Seine, devant la Conciergerie près du Pont-Neuf)*
Oil on canvas, 10-7/8 x 18-3/8 inches (27 x 46.3 cm.), ca. 1850s. Signed lower right: Jongkind.
Santa Barbara, Mrs. Margaret Mallory Collection.
Provenance. Private Collection, Switzerland, Galerie Schmidt, Paris.

The Parisians who lived in tenements on the Ile St. Louis or in other poorer districts often had no facilities for bathing and laundry. By mid-century, the Seine was dotted with bathhouses and washhouses where sanitary conditions could be somewhat controlled. These buildings, along with the Seine river barges, were among the most popular themes of contemporary activity that artists were then beginning to record.
When Johann Barthold Jongkind started painting river scenes in 1848/49 he established a tradition as "painter of the Seine"

that was later maintained by some of the Impressionists. Jongkind's interest in the Seine had been stimulated by the Dutch tradition of river scenes, but he transformed this native predilection into a new way of observing Paris. He contrasted barges or bathhouses with the picturesque architecture looming beyond the banks of the river, observing washhouses in brilliant light or in changing atmosphere, until he became a master of a range of environmental conditions.
Bathhouses and Wash-Boat on the Seine is one of several versions that Jongkind completed at the same time, showing wooden houses set against a panoramic cityscape. In this painting he has moved close to the *"bain"*—to the Seine itself—to reveal the effects of light on the frame structure. The potted, oversized plant abloom on the wooden roof is an unusual touch for Jongkind that dominates the central portion of the painting. The use of the plant—although seldom associated with Jongkind's early works—serves to personalize and individualize this overcrowded, bleak environment.[1]

1. Theodore Zeldin to the author, 28 March 1980, pointed out that a decree of 1851 ordered the creation of baths for the poor and that baths should be free on certain days of the week. Almost 40,000 baths were established in the course of the next couple of decades.

Exhibited
1976, Paris, Galerie Schmidt: Exposition Jongkind, cat. no. 1.

Published
Victorine Hefting, *Jongkind: Sa Vie, son oeuvre, son époque* (Paris: Arts et Métiers Graphics, 1975), fig. 74.

Octave Tassaert

8 *Abandoned (L'Abandonnée)*
Oil on canvas, 18-1/4 x 14-1/4 inches (46 x 36 cm.). Signed and dated lower right: Octave Tassaert 1852.
Montpellier, Musée Fabre.
Provenance. Alfred Bruyas Collection, 1868. Given by Bruyas to the Musée Fabre, 1868.

Octave Tassaert's interest in various aspects of contemporary life led him to comment on marriage and morals of the period in which he lived. The canvas *Abandoned* shows a young pregnant woman collapsing after witnessing the marriage of her lover to another woman. Her swoon in the side aisle of the church goes unnoticed except by the young boy and the mother holding an infant, both of whom instinctively draw back—as if to reinforce the condition that marks her as an outcast.
Even though it was Tassaert's intention to transcend the anecdotal in portraying a very real social dilemma (in the manner of such

contemporary printmakers as Daumier), the melodrama here befits a Second Empire stage presentation or a literary source rather than actual observation. A second version of this painting, completed in 1856, further exaggerated the drama and the turmoil of the episode. In that version, the wedding ceremony in the background holds the attention of every spectator, even as the deserted young mother—clutching her new little baby to her—swoons against the church pillar.

Exhibited
1953, Compiègne, Musée National de Compiègne: Le Temps des crinolines, p. 29, cat. no. 246.

Published
Michel, *Galerie Bruyas,* cat. no. 202.
Prost, *Catalogue de l'oeuvre,* p. 28, cat. no. 115.
Louis Gillet, *Les Trésors des musées de province* (Paris, 1934), p. 231.
Gustave Poulain, "Paul Valéry au Musée Fabre," *Itinéraire*, 1942, p. 29.

Théodule Ribot

9 *The Little Milkmaid*
Oil on canvas, 18-1/8 x 15-1/8 inches (46 x 38.4 cm.). Signed lower left: t. Ribot.
The Cleveland Museum of Art, Mr. and Mrs. William H. Marlatt Fund. 73.31.
Provenance. Th. Ribot. Veuve Ribot sale, 1896, no. 3 (sold for 7400 francs). M. Mir. Bernheim Jeune and Co., Paris, February 1911, no. 13. Lorenceau Gallery, Paris, 1972.

The Little Milkmaid can be dated from the mid-1860s when Théodule Ribot's paintings were sold by the independent art dealers Cadart and Luquet in Paris. Ribot's work during this decade shows an increasing awareness of popular traditions, especially those found in poems, songs, fables, and popular sources. Ribot's own family environment also served as a source of inspiration for *The Little Milkmaid*. Mignonne, his youngest daughter, is the model for the naiveté, charm, and beguiling innocence of childhood that he has captured here. The canvas, however, is not simply a portrait of his daughter. The ambience in which he has placed the young girl, the garments that she is wearing, the animals grouped around her, even the narrow milk pail reveal a narrative element as well. Mignonne has been posed by Ribot to create a popular type that was familiar in traditional folklore.
Ribot knew the ballads and songs compiled by Pierre Dupont and others, and he would have been familiar with "Il était une Bergère," a folk song typical of many about young farm girls. The first lines of the ballad are particularly fitting for Ribot's image:
> There was a small shepherdess
> Who tended her sheep.
> She made cheese
> From the milk of her sheep.
> A cat who eyes her
> Has a mischievous air. . . .

The young servant Ribot has depicted in company with her household pets reflects Ribot's awareness of popular literary investigations of the origins of French tradition in song and poem.

The Little Milkmaid is also derived from other sources. The fable by LaFontaine may have served as inspiration; La Fontaine's popular stories were frequently adapted by the Realists. The source book *Les Français peints par eux-mêmes* also served to inspire and guide many of the writers and painters of the period who were searching for motifs that they could develop to portray the iconography of the people. An essay in volume 4 (1841) is devoted to *La Laitière* and includes an engraving (Figure 9a) similar in type and pose to Ribot's milkmaid. Ribot's model is younger, revealing the beguiling nature of youth, but she retains the stance and attribute of the well-known engraved image. In addition, the history of the milkmaid provides reasons for this image's popularity. The milkmaid from the country, accompanied by her dog and cat while making her rounds in the city to sell the farm's surplus, was a customary sight. Sometimes she sold her milk, as well as butter and cheese, from a small stall; more often, however, the milkmaid wandered the streets, hawking her products, pail in hand and other containers on her back.

Like other street vendors, the milkmaid was considered one of the familiar types who bridged both country and urban life. Her picturesque role attracted the Realists, who sought immediately recognizable models that would appeal to those who understood the nature of French society at mid-century. *The Little Milkmaid* thus confirms Ribot's allegiance to the traditions of rustic life while representing a literary impression and a familiar social type that everyone would have known since his childhood.

The influence of Spanish masters of the seventeenth century is also apparent in *The Little Milkmaid*. Ribera and Velázquez were appreciated by the Realists not only because of their themes, but because of the way they painted. A preference for the rich blacks, whites, and grays evident in the works of the Spanish painters (e.g., Velázquez in his portrait of the *Maids of Honor*) can be identified in the modified tones of gray, tan, white, and black (blacks and grays in particular) that were frequently used by the Realists to effect subtle interplays between forms. The only bright color in Ribot's canvas is found in the skin tones of Mignonne. Such tonal painting can be recognized in the canvases of other painters during the 1860s, but seldom with the subtlety and directness that Ribot achieved. His brushstrokes are built upon one another to convey an immediacy of image without the aid of a preliminary drawing. Ribot allowed no sharp contrasts between areas of dark and light, so that the tones blend gently into one another. Thus, a love of the masters of the past, whether Spanish or Dutch, must be included among the traditions to which Ribot was reacting. Ribot's images, with their simple themes and earthy, tactile style, combined with well-established literary and social sources to achieve an unusual integration of visual presentation.

Exhibited

1892, Paris: Exposition Th. Ribot au Palais National de l'Ecole des Beaux-Arts, p. 38, cat. no. 51.

Published

Art et curiosité, October-December 1972, repr. p. 17.
"The Year in Review for 1973," CMA *Bulletin* XLII (February 1974): 50.
Gabriel P. Weisberg, "Théodule Ribot: Popular Imagery and *The Little Milkmaid,*" CMA *Bulletin* LXIII (October 1976): 253-63, repr. pp. 254, 260.

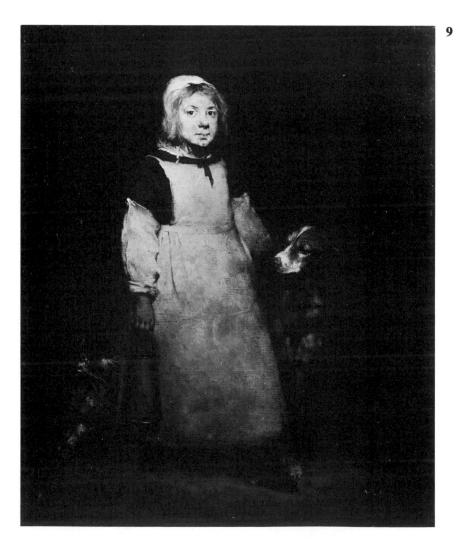

9

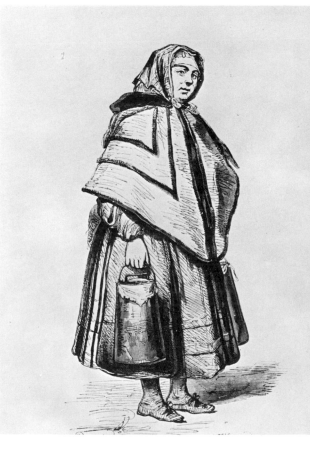

9a Illustration of *La Laitière*, from *Les Français peints par eux-mêmes*.

Théodule Ribot

10 *The Guitar Player*
(Le Joueur de guitare)

Oil on canvas, 18-3/8 x 15-1/8 inches (46.6 x 38.5 cm.). Signed and dated lower left: t. Ribot 1862.
Reims, Musée St. Denis.
Provenance. Mme. R. sale, Hôtel Drouot, Paris, 3 February 1883. Purchased by H. Vasnier. Donated to the museum by H. Vasnier, November 1907.

Although considered by some as a pastiche of the Spanish seventeenth-century painter Ribera,[1] Ribot's *Guitar Player* more precisely reflects the renewed concern during the mid-1860s on the part of many writers and artists for street performers. Ribot sensed the loss of these popular entertainers who had once earned their living from passersby, for they had become a less familiar sight since the modernization of Paris under the Second Empire. He used the theme of these street performers in several other works, such as *The Returns* [11] and *The Singers* [12], a composition which depicts cabaret performers. In other works Ribot also showed his special regard for guitar and tambourine players.

Only two years after Ribot completed his *Guitar Player,* Charles Yriarte published *Paris grotesque—Les célébrités de la rue,* a volume specifically dedicated to recording individual accounts of some of the last remaining street entertainers.[2] In much the same way, Ribot's painting documents the wandering minstrels who sang ballads for money dressed in costumes reminiscent of the *jongleurs* of the Middle Ages. Their long capes, plumed hats, and leggings designated their trade, and they provided a welcome respite for the masses confined to the bleakness of city existence.

Germain Ribot, who often posed for his father, may have served as the model for this performer. The carefully controlled light gives a theatrical quality to the canvas that is further emphasized by the romantic, picturesque mood. The wistful melancholy conveyed by his selection of this theme reflects Ribot's concern to preserve the dying tradition of the street performance.

1. For a discussion of this idea, see Hélène Toussaint, "Collection Henry Vasnier: Peintures et dessins" (MS, Musée de Reims, 1969; now at Musée du Louvre), cat. no. 300.

2. See Charles Yriarte, *Paris grotesque—Les célébrités de la rue—1815 à 1863,* ed. Dupray de la Maherie (Paris: Librairie parisienne, 1864).

Published
Vente Mme. R., sale cat. (Paris, 1883), p. 12, cat. no. 39.
Vasnier (privately printed), cat. no. 225.
Atalone, *La Galerie Vasnier à Reims* (Reims, 1909), cat. p. 36.

Théodule Ribot

11 *The Returns*
(La Recette)

Oil on canvas, 51-7/8 x 33-7/8 inches (131 x 85 cm.). Signed and dated lower right: T. Ribot 1865.
Marseille, Musée des Beaux-Arts.
Provenance. Purchased and given by the Société Artistique des Bouches-du-Rhône to the museum in 1871.

The composition *The Returns* shows Ribot's continued interest in depicting well-established social types from the streets of Paris. His portrait of this street performer, which was exhibited at the 1866 Salon, draws an obvious parallel with Edouard

10

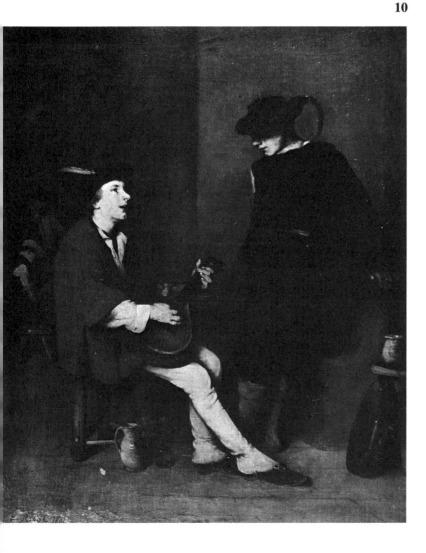

11

Manet's *The Fifer* painted about the same time in the mid-1860s, although certain characteristics distinguish each work. Ribot cast his oboe player in shadow, obscuring his outline, while Manet chose a starker presentation, silhouetting his performer against a light, flat background. Nonetheless, Ribot's musician is an imposing single figure. The dramatic lighting upon his face and hands draws attention to the coins he is carefully counting out one at a time, an absorption that emphasizes his dependence upon his day-to-day performances for his very livelihood.

Unlike Manet's *Fifer*, which is truly a product of the nineteenth century in both form and content, Ribot's composition is traditional in both subject and technique.

The dark cloak, yellow pants, white vest, and feathered cap, which are typical garb for an itinerant performer, and the somber lighting, which is based on painting techniques from the seventeenth century, serve to reinforce the age-old tradition and evoke a melancholy for a familiar figure who was gradually disappearing from the streets of Paris.

Exhibited

1866, Paris: Salon, no. 1640 (listed as *Le Flûteur*).
1892, Paris: Exposition Th. Ribot au Palais National de l'Ecole des Beaux-Arts, cat. no. 28 (listed as *Le Flûteur*).

Published

Auquier, *Catalogue du Musée des Beaux-Arts* (Marseille, n.d.), p. 269, cat. no. 488.

Théodule Ribot

12 *The Singers*

Oil on canvas, 29-1/8 x 23-7/8 inches (74.3 x 60.6 cm.), ca. 1865. Signed lower left: t. Ribot.
The Cleveland Museum of Art, Gift of Mr. and Mrs. Noah L. Butkin. 77.127.
Provenance. Cadart and Luquet, Paris, ca. 1865. Frederick P. Sears Collection, Boston.

During the 1860s, the canvases Ribot was exhibiting with independent art dealers (e.g., Cadart and Luquet) showed a departure from his tendency to use his own immediate family as models. *The Singers* was one of many canvases that continued an exploration of popular culture by concentrating on performers Ribot witnessed in the cabaret, on the Parisian street corner, or that he occasionally portrayed in the quiet of his own studio. In this composition the singers are seated on rough benches or standing, grouped around an overturned wooden barrel, singing from both memory and worn sheet music, while one member plays a stringed instrument resembling a cittern. Whether the performers were meant to suggest members of a single family, or whether they were intended to symbolize a group of itinerant street musicians is not known. Their simple dress suggests that they are singing popular ballads extolling the virtue and hard work of the masses. The discarded songbook, the pitcher, and the metal drinking vessel emphasize the simple, warming pleasures of a group whom Ribot may have become acquainted with following an encounter in a Parisian café.

The musical interlude depicted by Ribot was a well-established tradition. It was not uncommon for music to be played beneath a window when people were turning in for the night. It was an event whose only purpose was pleasure: musicians entertained to keep people happy and to create a pleasant, momentary atmosphere in which the troubles of the day could be forgotten.

During the 1840s, new songwriters, such as Pierre Dupont, appeared. Dupont's collected verse examined many of the themes then being investigated in the visual arts. His *Chants et chansons* in 1851 and his three-volume songbook in 1853 were prepared for the masses and often evoked the intimate character of peasant existence. Dupont's musical images were individualized, revealing the sincere qualities associated with hard work and honest living. He also combined an authentic appreciation for traditional folk melodies with a strong sense of actuality—an ability to capture the dialects of different regions. Therefore his songs were favored by balladeers who performed for café audiences in town and city. While it is difficult to document completely the relationship between the Realists and popular literary sources, it is clear that painters such as Bonvin and Ribot were aware of Dupont's songs and probably vis-

12

Opposite

11 Théodule Ribot, *The Returns* (detail).

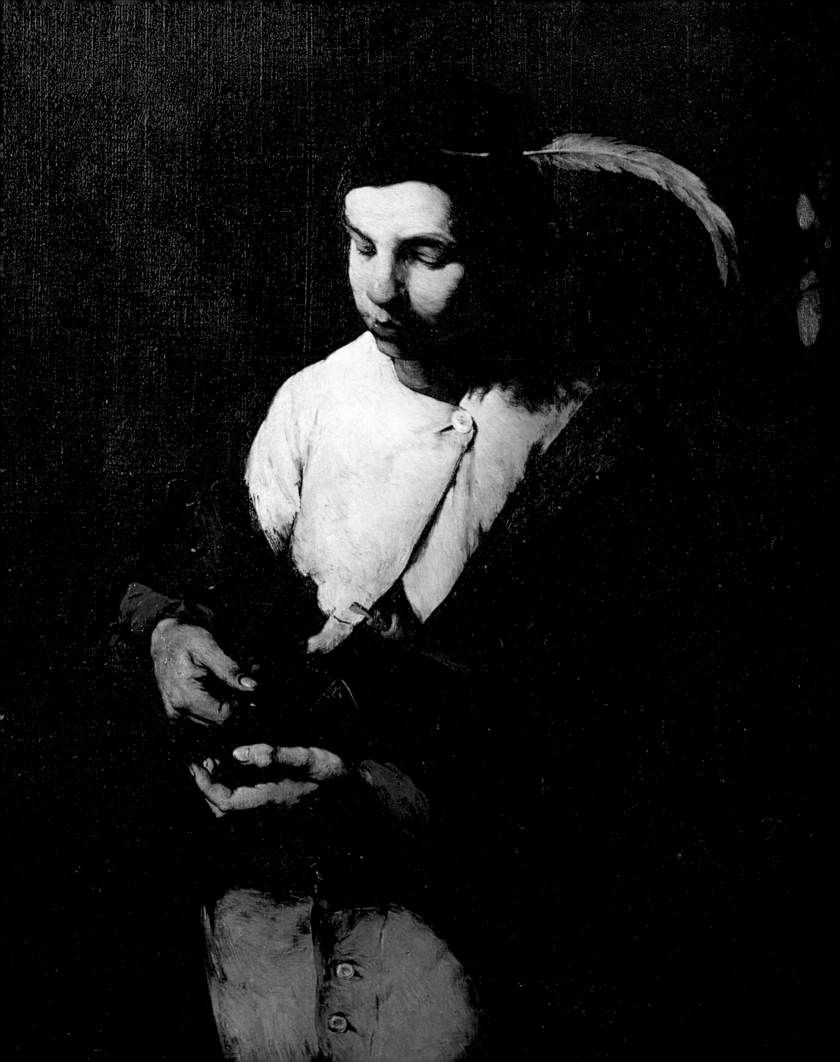

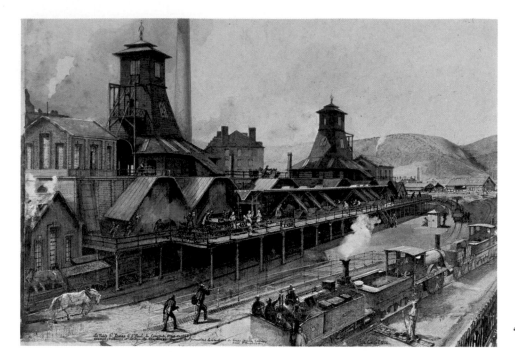

44 François Bonhommé,
St. Pierre and St. Paul Mines at Le Creusot.

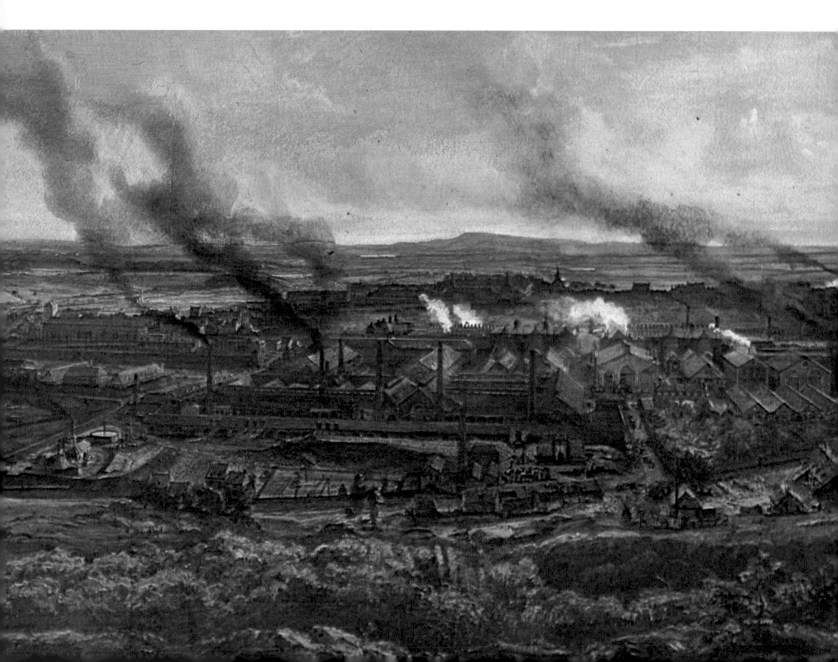

42 François Bonhommé, *The Factories at Le Creusot* (detail).

36 Théodule Ribot, *The Cook Accountant.*

Opposite
52 Jules Breton, *The Recall of the Gleaners* (detail).

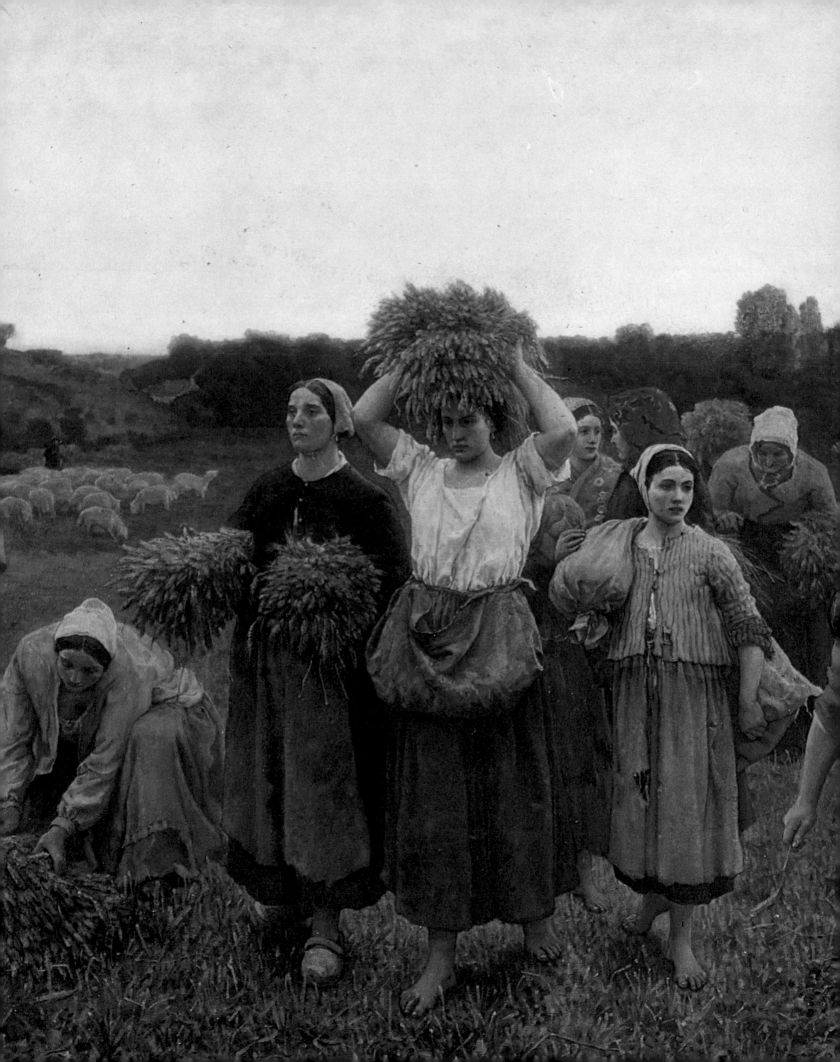

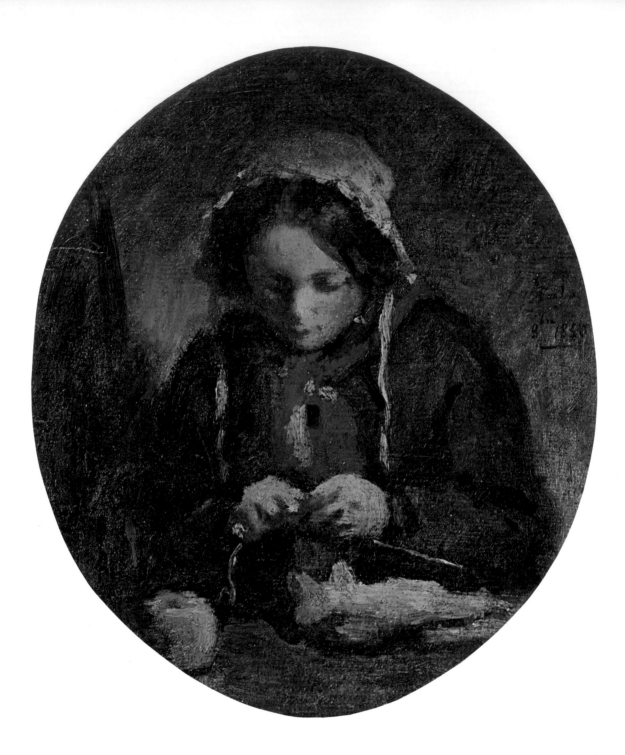

62 Adolphe-Félix Cals, *Young Girl Knitting*.

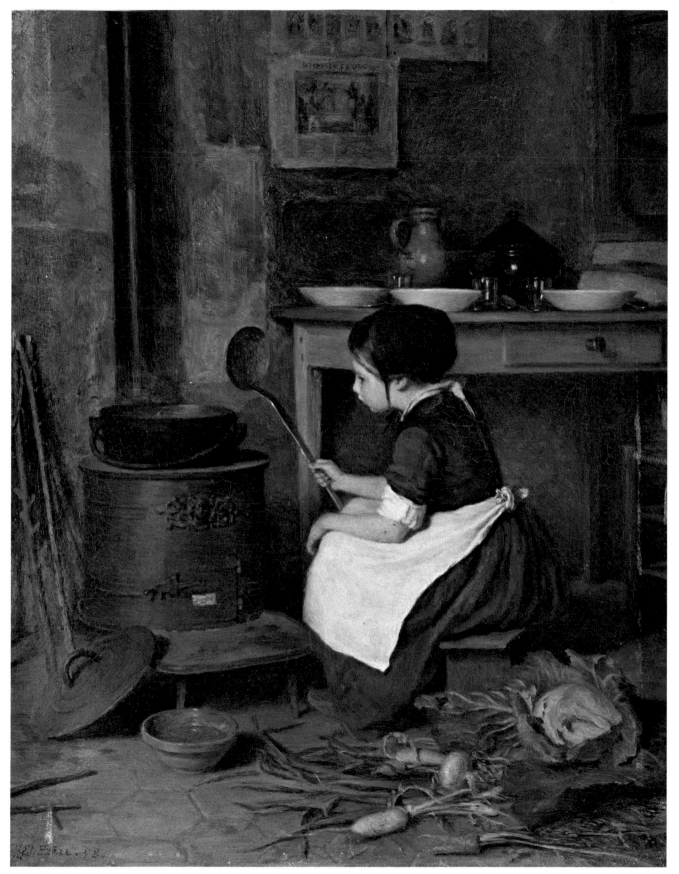

69 Pierre Edouard Frère, *The Little Cook*.

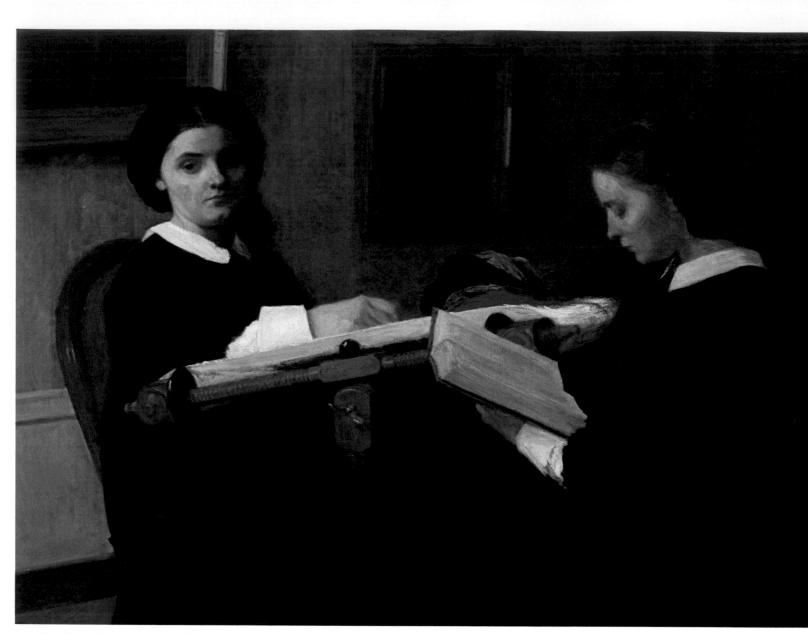

71 Henri Fantin-Latour, *The Two Sisters*.

ited cabarets where they were being performed.

The Singers is a provocative interpretation. There is no proof that Ribot's group is singing ballads. Similarly, the male instrumentalist may or may not be a well-known performer in café circles—perhaps even Darcier himself, a familiar entertainer in lower-class establishments. It is obvious, however, that this male instrumentalist and the central female vocalist are developed from types that Ribot must actually have known, for they reveal character traits that have been carefully studied. The pensiveness of the instrumentalist eyeing the viewer and the exuberance of the vocalist present a deliberate contrast of moods within a single space. Their hands and faces are brilliantly illuminated while the remainder of the canvas is dark, suggesting that Ribot spotlighted areas to achieve a theatrical effect.

Exhibited

1864, Paris: Salon.
1865, Bordeaux, Société des Beaux-Arts, no cat.
1892, Paris: Exposition Th. Ribot au Palais National de l'Ecole des Beaux-Arts, cat. no. 98.
1977/78, CMA: The Year in Review, cat. no. 4l.

Published

Raoul Sertat, "Littérature et Beaux-Arts," *Revue Encyclopédique* II (1 August 1892): 1111-12, repr. p. 1112, no. 40.
Weisberg, "Théodule Ribot," pp. 253-63, fig. 13.
"The Year in Review for 1977," CMA *Bulletin* LXV (January 1978): 4, 39, cat. no. 41.
CMA *Bulletin* LXV (June 1978), repr. back cover.

François Bonvin

13 *The Interior of a Tavern*
 (Le Cabaret flamand)

Oil on panel, 19-3/4 x 14-5/8 inches (50.1 x 37.2 cm.). Signed and dated lower right: F. Bonvin, 1867.
Baltimore, The Walters Art Gallery.

Provenance. A. Bellino sale, Georges Petit Gallery, Paris, 20 May 1892. The Charles T. Yerkes sale, American Art Galleries, New York, 5-8 April 1910. Collection of Henry Walters (purchased at the Yerkes sale).

François Bonvin was one of the Realists who continually modeled his work on "the masters of former times." This appreciation of the past was, in part, a response to the writings of the art critic Théophile Thoré, who encouraged painters to study the past to gain a foundation for observing reality in everyday themes. *Le Cabaret flamand* can be compared with a suburban cabaret theme that Bonvin had first admired in Dutch seventeenth-century compositions in the Louvre (Archives du Louvre), where he copied the works of many Dutch painters (e.g., Rembrandt's *Flayed Ox*). Bonvin was also familiar with Pieter de Hooch's *Card Players* (Louvre), a work that served as the direct compositional source for the figures

and spatial arrangement in Bonvin's *Cabaret flamand*. Despite the obvious adaptation that he acquired from his study of de Hooch, by showing his figures dressed in the garments of his own time Bonvin was also following the dictates of another Realist proponent, Champfleury.

The setting of the cabaret, derived in part from Dutch cafés Bonvin would have seen on a trip to Holland in January 1867, also held personal significance. Bonvin's father had operated a small café in an outlying district of Paris (Vaugirard) that was later managed by another son, Léon. By the mid-

1860s the growth of the city forced Léon Bonvin into competition with other, newer establishments that were then attracting a growing clientele. Unable to meet business debts and unable to realize a steady income, Léon committed suicide in the nearby forest of Meudon in 1866, leaving his wife and their four children to somehow carry on with his business.

The central figure in this painting may be a relative of Bonvin's—perhaps even Léon Bonvin's wife. There is little doubt, however, that the woman is a proprietress, since she wears the customary white apron over

13

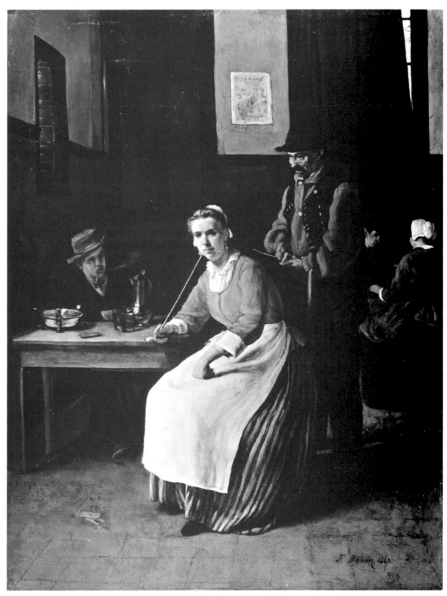

her dress. She is shown in a moment of respite from her daily chores, relaxing among her customers, smoking a long Dutch clay pipe. Her gesture is not unusual and goes unnoticed by the men nearby, for smoking (even among women) and card playing (note the cards on the floor tiles) were aspects of life common to the working class and those who frequented the cafés. Other customers, such as the two figures at the rear, are engaged in pleasant conversation. The male behind the proprietress—he may even have offered his seat to her—is dressed as an artisan, another type who commonly frequented the cabaret.

The interior is comfortable and darkened to shut out the sunlight that is suggested beyond the drawn curtains and shuttered windows. It is apparent that this is a place where people come to escape the cares of their workday, to spend a few moments in the company of others, or to relax in solitude while enjoying a glass of wine. A touch of humor is evident in the placard hung from the back wall, where Bonvin has anglicized his own name to Goodwin, thus personalizing the congenial atmosphere of this public meeting place.

As one of Bonvin's most derivative compositions, *Le Cabaret flamand* documents an effective use of the Realist theme, in which leisure activities of smoking and conversing are seen as civilizing trends for a lower-middle class who were on the threshold of modernization during the Third Republic.

Published

Moreau-Nélaton, *Bonvin raconté*, p. 69. fig. 46.
Gabriel P. Weisberg, "François Bonvin and an Interest in Several Painters of the Seventeenth and Eighteenth Centuries," *Gazette des Beaux-Arts* LXXVI (December 1970): 364, fig. 6.
Idem, *Bonvin,* cat. no. 40 bis.
Petra T. D. Chu, *French Realism and the Dutch Masters: The Influence of Dutch Seventeenth-Century Painting on the Development of French Painting Between 1830 and 1870* (Utrecht: Haertjens, Dekker & Gumbert, 1974), p. 41, fig. 63.

Honoré Daumier

14 *The Waiting Room*

Oil on paper mounted on heavy paper, 12-1/8 x 9-7/16 inches (31 x 24.7 cm.), ca. 1850s.
Buffalo, Albright-Knox Art Gallery, George B. and Jenny R. Mathews Fund, 1964.
Provenance. Paul Bureau, Paris, until 1927. Sale, Georges Petit Gallery, Paris. Purchased through Paul Rosenberg by A. Conger Goodyear.

With the expansion of transportation and railroads throughout France during the 1840s, people could afford to travel more widely and at a faster pace. The crowded waiting rooms of the train stations served a cross section of the French population. People from all walks of life were brought together here by chance, and Daumier, who often visited Corot and other artists outside of Paris, took the opportunity to study the dress, features, and pose of many an unsuspecting traveler. Daumier completed more than twenty paintings, water colors, and lithographs of this setting between 1839 and the mid-1860s. He found this location not only ripe for satire, but the travelers themselves a ready source for the accurate observation of real and recognizable social types.

Whether or not Daumier's intention was to depict a cross section of humanity, from old age to infancy, he did reveal the democracy inherent in this means of transportation. Passengers awaiting departure or arrival mingled freely together in the same, common room. To Daumier, an artist with a strong republican belief in all types of freedom, the waiting room represented a humanitarian viewpoint reinforced by a marvel of the machine age: rapid transportation.

The small painting *The Waiting Room,* despite the sketchiness of the surface and the seemingly random arrangement of individuals in a tightly controlled space, was painstakingly reworked in several areas. In a sense, Daumier arrived at a realistic informality even before Degas achieved the same effects in his portraits of the 1860s [149]. By building up carefully arranged forms with thick glazes, Daumier created a tactile paint surface which imbues his figures with an almost lifelike, sculptural quality. The taut, standing figure eyeing the wall clock provides a strong contrast to the patiently resigned old woman and her young charge crowded on the bench at the right.[1]

Dating this painting with certainty is difficult, but the 1850s seems generally acceptable.[2] The Second Empire was a key moment for increased industrialization and transportation, making travel accessible to the masses.[3]

1. See Steven Nash, *Painting and Sculpture from Antiquity to 1942: Collection of the Albright-Knox Art Gallery* (New York: Rizzoli, 1980).
2. Ibid.

3. To some, the railway station was seen as a place where Realist murals could help educate the masses who traveled.

Exhibited

1901, Paris, Ecole des Beaux-Arts: Daumier, cat. no. 19.
1928, Buffalo, Albright Art Gallery: A Selection of Paintings from the French Modern School, cat. no. 12.
1929, CMA: French Art since 1800, cat. no. 55.
1930, New York, Museum of Modern Art: Corot-Daumier. Eighth Loan Exhibition, cat. no. 75.
1930, Paris, Galerie André Weil, no cat.
1934, Paris, Musée de l'Orangerie: Daumier: Peintures, aquarelles, dessins, cat. no. 5.
1935, Museum of Fine Arts, Boston: Independent Painters of the 19th Century: Paris, cat. no. 7.
1961, London, Tate Gallery: Daumier—Paintings and Drawings, cat. no. 68A.
1961, Northampton, Mass., Smith College Museum of Art: Paintings, Drawings, Sculpture, Prints: Daumier, cat. no. 7.
1966, Buffalo, Albright-Knox Art Gallery: Paintings, Sculpture, Drawings, Prints Collected by A. Conger Goodyear, cat. no. 6.
1968, Washington, D.C., National Gallery of Art: Paintings from the Albright-Knox Art Gallery, cat. p. 11 (illus.).

Published

Erich Klossowski, *Honoré Daumier,* 2d ed. (Munich, 1923), no. 247.
Catalogue de la vente P. Bureau, Galerie Georges Petit (Paris, 1927), no. 97.
"La Collection Bureau," *Bulletin de l'Art Ancien et Moderne,* 1927, p. 170.
F. Fosca, "Les Daumier de la Collection Bureau," *L'Amour de l'Art,* May 1927, p. 150.
Eduard Fuchs, *Der Maler Daumier* (Munich, 1927), no. 46, p.48.
L. Venturi, "Quelques Dessins de Daumier," *Art Quarterly,* Winter 1938, pp. 49-52.
Raymond Escholier, *Daumier* (Paris, 1938), p. 35.
M. Sachs, *Honoré Daumier* (Paris, 1939), pl. 71.
Jacques Lassaigne, *Daumier* (Paris: Hyperion, 1938 and 1946), no. 126.
R. L. Herbert, *Seurat's Drawings* (New York, 1962), p. 68, fig. 62.
Oliver Larkin, *Daumier: Man of His Time* (New York, 1966), p. 135.
K. E. Maison, *Daumier: Catalogue Raisonné of the Paintings, Watercolours, and Drawings,* vol. 1, *The Paintings* (Greenwich, Conn.: New York Graphic Society, 1968), pp. 73-74, pl. 59.
L. Barzini, *L'Opera Pittorica Completa di Daumier* (Milan, 1971), col. pl. XIII, no. 51, illus. p. 92.

Honoré Daumier

15 *The Print Collector*
(L'Amateur d'Estampes)

Oil on canvas, 15-3/4 x 12-5/8 inches (40 x 32 cm.), ca. 1860. Signed lower left: H. Daumier.
Paris, Musée des Beaux-Arts de la Ville de Paris (Petit Palais).
Provenance. Doria Collection. Jacquette Collection.

The emergence of a new type of art collector, a member of the middle class who spent

his spare time browsing in the many small galleries, complemented the rising importance of the independent art dealer. Both gave the artist a chance to show and to sell work outside the official art spheres and the yearly Salons. Many amateur collectors had little money and they probably collected as many prints as paintings. Their eagerness to collect, both for status and for pleasure, resembled the perspicacity of their counterparts in the seventeenth century—the burghers.

When Daumier completed *The Print Collector* about 1860, he already had completed other versions of the same theme as drawings and paintings.[1] In this instance, the collector is examining a portfolio against numerous images positioned on a wall. Their number suggests the profusion of artistic

works available to a collector from such small shops as Père Martin's [141]. The theme of this composition not only indicates Daumier's own personal inclinations but also suggests in a general way the revival of interest in printmaking that was taking place in France in 1860. Indeed, private individuals were forming many collections of fine impressions, and the patience and skill of a collector often revealed a remarkable level of connoisseurship.

The figure depicted by Daumier signifies a type then becoming increasingly prevalent in the city of Paris. Collectors had already been singled out in *Les Français peints par eux-mêmes*, a source which Daumier undoubtedly knew. Posing the collector against an intense backlight accentuated both his search and his manner, bestowing

upon his solitary pursuit the dignity and absorption of a true connoisseur.

1. For further reference to other images of the same theme see K.E. Maison, *Honoré Daumier: Catalogue Raisonné of the Paintings, Watercolours, and Drawings,* vol. 1, *The Paintings* (Greenwich, Conn.: New York Graphic Society, 1968), p. 124.

Exhibited

1878, Paris, Galerie Durand-Ruel: Exposition des peintures et dessins de H. Daumier, no. 34.
1888, Paris, Ecole des Beaux-Arts: Exposition de peintures, aquarelles, dessins et lithographies de maîtres français de la caricature et de la peinture de moeurs au XIXe siècle, no. 355.
1889, Paris: Exposition centennale, no. 229.
1917, Barcelona: Exhibition of French Art, no. 1406.

15

14

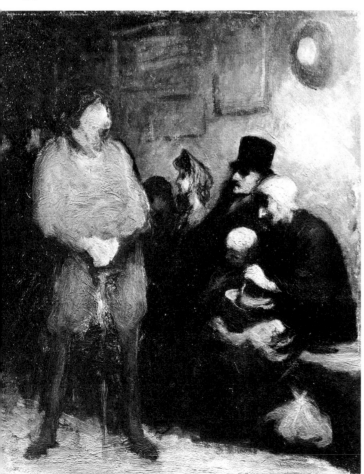

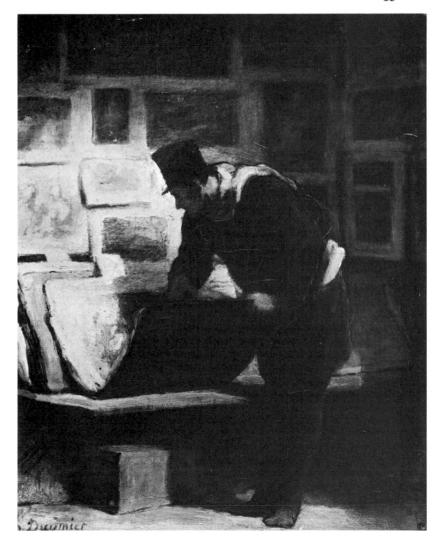

1923, Paris, Maison de Victor Hugo: Exposition
 H. Daumier et Gavarni, no. 27 repr.
1932, London, Royal Academy: Exhibition of
 French Art.
1934, Paris, Musée de l'Orangerie: Daumier:
 Peintures, aquarelles, no. 23.
1947, Zurich, Kunsthaus: Petit Palais, Museum of
 the City of Paris, no. 197.
1952, Rotterdam, Boymans Museum: French
 Masters of the Petit Palais, no. 39.
1953, Paris, Petit Palais: Un Siècle d'art français,
 1850-1950, no. 215.
1956, Poland, U.S.S.R., Czechoslovakia: Exhibi-
 tion of French Painting.
1958, Paris, Bibliothèque Nationale: Daumier—
 Le Peintre graveur, no. 171.
1960, Nice, Galerie des Ponchettes: La Réunion
 du Comté de Nice à la France, no. 120.
1963, Schaffhausen, Museum of Allerheiligen:
 World of the Impressionists, no. 34 repr.
1968, Atlanta (Ga.), The High Museum of Art:
 The Taste of Paris, not numbered, col. repr.
1971, Bucharest, Craiova, Iassi: Celebrated
 Painters of Parisian Museums, p. 46, repr. p.
 47.
1971, Budapest, no. 13 repr.
1979, Marseille, Musée Cantini: Daumier et ses
 amis républicains, no. 57.

Published

Raymond Escholier, *daumier: Peintre et
 lithographe,* La Vie et l'Art Romantiques (Paris,
 1923).
Erich Klossowski, *Honoré Daumier,* 2d ed.
 (Munich 1923), p. 375.
Michael Sadleir, *Daumier: The Man and the
 Artist* (London, 1924).
Eduard Fuchs, *Der Maler Daumier* (Munich,
 1927; see also 2d ed., 1930, containing the Sup-
 plement), p. 107.
Lassaigne, *Daumier,* 1938 ed.
Maurice Sachs, *Honoré Daumier* (Paris, 1939).
Formes et Couleurs III-IV (1945): 383.
Jean Cassou, *Daumier* (Lausanne, 1949).
Jean Adhémar, *Honoré Daumier* (Paris, 1954).
Arsène Alexandre, *Honoré Daumier–Drawings
 and Watercolours,* English ed. (New York,
 1954), p. 374.
Curt Schweicher, *Daumier,* Ars Mundi (London,
 1954).
George Besson, *Daumier*(Paris, 1959).
Claude Roger-Marx, *Daumier* (Paris: Fernand
 Hazan, 1961), col. repr. pl. 6.
R. Huyghe, "Daumier," *Jardins des Arts* 115
 (June 1964): 9, col. repr.
R. Charmet, *Musées de Paris* (Paris: Larousse,
 1965), repr. p. 59.
S. C. Burchell, *Age of Progress* (New York:
 Time, 1966), col. repr. p. 63.
M. de Michelli, *Honoré Daumier* (Milan: Fratelli
 Fabbri, 1966), col. repr. pl. VI.
A. Cacan, "Le Petit Palais," in Cogniat and Hill-
 airet, *Les Musées d'Art de Paris* (Paris: Aimery
 Somogy, 1967), p. 101.
Maison, *Honoré Daumier,* vol. l, *The Paintings,*
 p. 137, repr. pl. 92.
D. Dupré, *Courbet e il Realismo francese* (Milan:
 Fratelli Fabbri, 1969), col. repr. p. 85.
J. Richardson, *La Vie parisienne* (London:
 Hamish Hamilton, 1970), col. repr. p. 183.

POPULAR TYPES
Provincial Life

Jean-Jacques François Monanteuil

16 *Two Bell Ringers
(Les Deux Sonneurs)*

Pencil drawing, graphite; 14-1/4 x 10-1/4 inches
(35.8 x 25.8 cm.). Signed lower right: Monanteuil.
Alençon, Musée d'Ozé.

Following his trip to Brittany in the mid-
1820s, Jean-Jacques François Monanteuil
became increasingly aware of lower-class
character types. Thereafter he dismissed the
Neoclassic training he had acquired under
Girodet to turn again to his natural propen-
sity for drawing figures he observed in the
streets of provincial villages. Later, he prob-
ably positioned models in his studio at the
Alençon art school, using them for his own
painting and sketching, as well as to explain
Realist inclinations to his students. Fre-
quently, Monanteuil recorded individual vil-
lage types and their daily preoccupations at
a given hour, as seen in his sketch of *Two
Bell Ringers.* Working in pencil, Monanteuil
concentrated on dress and gait to capture the
pose and demeanor of figures he selected
from contemporary village life.

Exhibited

1977, Alençon, Maison d'Ozé: Artistes ornais du
 XIXe siècle, p. 24, cat. no. 14. Catalog by
 Claude Lioult.

Jean-Jacques François Monanteuil

17 *Beggar
(Mendiant)*

Pencil drawing, graphite; 9-1/2 x 7-1/2 inches (24 x
19 cm.). Signed lower left: Monanteuil.
Alençon, Musée d'Ozé.
Provenance. Donation Noblesse, 1906.

Beggars were prevalent not only in Paris,
but in many of the regional centers, such as
Alençon, as well. Like Bonvin in his study
of the ragpicker [6], Monanteuil also posed
his *Beggar* in the controlled light of a studio,
and modulated his pattern of light and dark,
especially about the face, to suggest a mood
of Romantic introspection. The brimmed hat
he is holding and the walking stick are attri-
butes of beggars that were described in *Les
Français peints par eux-mêmes,* but the
wooden shoes and the cloth regional cap
identify the figure as a peasant. The box or
bench that is merely suggested beneath the
man confirms that Monanteuil's rural figure
is a studio model.

Exhibited

1977, Alençon, Maison d'Ozé: Artistes ornais du
 XIXe siècle, p. 24, no. 15, repr. on cover.
 Catalog by Claude Lioult.

Jean-Jacques François Monanteuil

18 *Itinerant Musician
(Musicien ambulant)*

Pencil drawing, graphite; 14-3/8 x 10-3/8 inches
(36.2 x 26.2 cm.). Signed lower left: Monanteuil.
Alençon, Musée d'Ozé.

After he returned to Alençon (ca. 1835),
Monanteuil became a teacher at the local art
school. It is probable that he taught drawing
as much as painting, for he had placed an
important emphasis upon this medium from
his earliest days as an artist. Monanteuil did
numerous pencil portraits of his friends as
well as studies of local types. His *Itinerant
Musician,* for example, typifies the life style
of a street performer intent upon surviving
by means of the few sous he earns. Like
Bonvin in the 1850s [6], Monanteuil turned
to models he found in the streets, posing
them in his atelier to capture momentary
reality and human truths.
 Monanteuil's style in this work is adept
and meticulous, recording the rumpled over-
coat of the bedraggled musician, and reveal-
ing lines of worry and weariness under the
eyes, drawn to parallel the musician's sag-
ging mouth. The prop on the table is not in-
cidental; the musician attracts the viewer's
attention as he plays for drinks. The careful
shading and touches of detail, replete with
top hat, suggest that this musician, about to
begin his performance, is an accurate por-
trait of types that could also be found in
many village streets.

Exhibited

1977, Alençon, Maison d'Ozé: Artistes ornais du
 XIXe siècle, p. 24, no. 9. Catalog by Claude
 Lioult.

Jean-Jacques François Monanteuil

19 *Portrait of a Breton Peasant
(Portrait d'un paysan breton)*

Oil on canvas, 16-1/4 x 13-1/8 inches (41 x 33 cm.).
Signed and dated middle right: Monanteuil/1834.
Le Mans, Musée des Beaux-Arts.
Provenance. Purchased at the art exhibition in Le
Mans, 1842.

Early paintings by Monanteuil are difficult to
locate, especially those inspired by his trip
to Brittany. *Portrait of a Breton Peasant* is
one of several images that Monanteuil did of
the same theme, and which may have ap-
peared in various regional exhibitions, be-
ginning with the Caen exhibition in 1838 and
continuing until the Le Mans show in 1842.
For each of these several exhibitions
Monanteuil received an award (often a gold
medal), indicating that viewers were favora-
bly impressed with his images and his
meticulous, forthright style. While art criti-
cism that might have been written at the
time of these exhibitions has not been lo-
cated, the fact that this painting was pur-
chased by the city of Le Mans in 1842 indi-

16

17

19

18

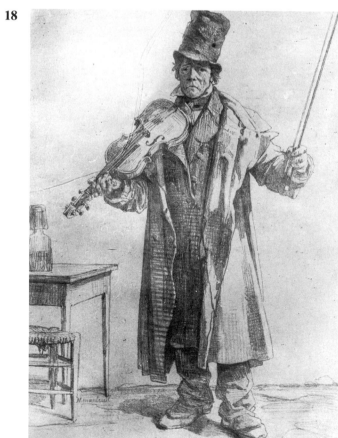

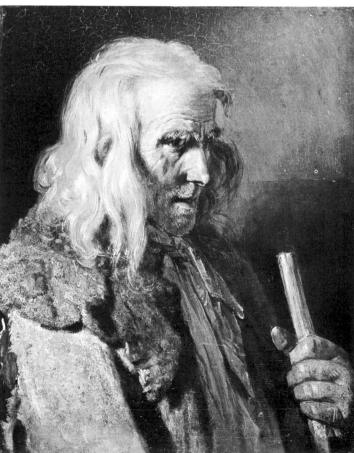

cates the recognition Monanteuil was receiving within his own region. Private collectors were eager to buy his work, and the artist completed several variations of this popular theme.

Monanteuil often selected his model from the specific region he was studying in order to capture accurately the dress and the demeanor of that area. Léon de la Sicotière, in his book on Monanteuil, noted that in each of the versions for several peasants, Monanteuil's model is either wearing a red cap (the traditional emblem of the peasants of Fougères) or, as in this canvas, is depicted with his shoulder-length white hair uncovered. The age of his model is also significant, since, in this instance, he wanted to record craggy facial features and to exaggerate for effect the graying stubble of the beard. Monanteuil has also faithfully recorded the type of garments worn by his peasant, building his paint layers in rough fashion to sug-

gest fur at the top of a coarse sheepskin coat. But the peasant's grip on the wooden staff reveals a weakness in some aspects of spatial illusionism, for the hand is somewhat too large. By bringing his peasant close to the frontal plane, Monanteuil has accentuated his physical presence, suggesting a type of realism based on an attempt to solve visual problems for himself—occasionally with naive results. The elimination of background space and the use of direct illumination further focus upon the model's facial features, intimating that Monanteuil may have been influenced by Flemish sources in his careful detailing.

Exhibited

1961, Nogent-le-Rotrou: Peintres percherons, cat. no. 38.

Published

Léon de la Sicotière, *Monanteuil–Dessinateur et peintre* (Caen, 1865), pp. 29-30.

Adolphe-Félix Cals

20 *Peasant Woman and Child*

Oil on canvas, 18-1/4 x 14-7/8 inches (46.4 x 37.8 cm.). Signed and dated lower left: Cals 1846. England, Co. Durham, Barnard Castle, The Bowes Museum.

Among themes used by the Realists during the 1840s were images inspired by an artist's personal life or those derived from abject conditions of poverty that could be witnessed in rural society. The small genre scenes that Adolphe-Félix Cals completed in the mid-1840s were imbued with a melancholy drawn as much from his own tragedies as from his profound sympathy toward the downtrodden.

Cal's miserable home life, following an unfortunate marriage, led to a clash between his humble origins and his wife's aristocratic inclinations that was further complicated by the birth of a daughter. When the young wife squandered her inheritance, the family was reduced to a life of extreme poverty. It was at this time that Cals was forced to set aside the religious themes that he hoped would bring him fame at the Salons, and he turned instead to canvases inspired by the rural poor (e.g., *Une Pauvre Femme,* 1843). Destitute financially, he often visited the outskirts of Paris (e.g., Argenteuil, Versailles, Saint-Cyr), seeking solace in nature much the same as the Barbizon painters were then doing, but driven as well by the need to depict such common types as beggars, wandering children, workers, and weary old people. He was moved by ravaged facial features and determined to record these expressions of gloom and sorrow.

Although he had been submitting scenes of impoverished peasants and beggars to the Salons since 1835, it was not until 1846 that a broader range of Cals's rural themes emerged. Like Millet [21], Cals must also have been affected by the appalling scenes of starvation after the widespread famine of 1846/47. The variety of activities he depicted reveal an understanding of daily existence.

A *Sollicitude maternelle* is known to have been included among the eleven canvases Cals exhibited at the 1846 Salon, but whether this particular work [20], dated 1846, is the same one that was actually shown at the 1846 Salon has not been established. Nevertheless, this painting is representative of the rural compositions now lost that Cals completed during this period. Some of his friends and critics considered these his best canvases, and it was anticipated that he would receive a medal. His disappointment when the 1846 Salon jury did not honor him only intensified his already depressed state.

Peasant Woman and Child imparts a mood of melancholy. The rural mother and her young son are shown resting near the foot of a twisted tree within a barren landscape. The child's doleful expression,

20

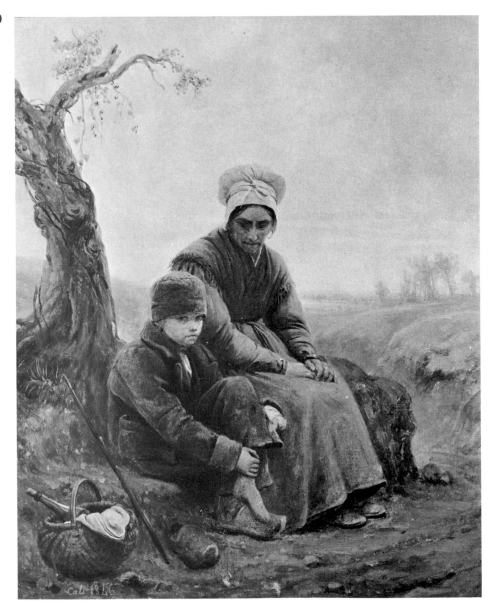

reinforced by his downcast eyes, and his mother's anxiety re-create an episode of blighted existence. Her weariness is surpassed by concern for the boy: he clutches at his ankle to lessen his pain and his other hand is bandaged. The scene is Romantic in narrative content, but the painting is restrained in its color. Cals, like other Realists, has modulated his tones to achieve a grayed ambience appropriate to the sorrowful theme of begging.

Exhibited

Probably 1846, Paris: Salon, cat. no. 293 (listed as *Sollicitude maternelle*).

Published

Handlist of French Works in the Collection (Bowes Museum, n.d.), p. 12, cat. no. 647.

21

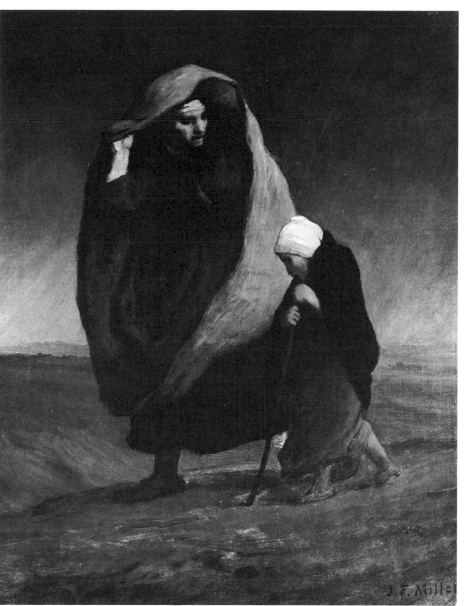

Jean François Millet

21 *The Wanderers*

Oil on canvas, 19-1/2 x 15 inches (49.5 x 38.1 cm.). Signed lower right: J. F. Millet.
Denver Art Museum.

Provenance. Gift of Horace O. Havemeyer, 1934. In memory of William D. Lippitt.

Jean François Millet's *The Wanderers* may be considered a symbolic reference to the depressed condition of the rural peasant, for it was completed at a time when this group constituted well over one-half the population of France. Much of the significance of this painting can be clarified by an understanding of the social dilemmas facing France during the 1840s, although the lasting quality of this work is not only in the history it retains, but in the interrelationship between theme and form. Popular imagery and such contemporary literary sources as Eugène Sue's voluminous novel *The Wandering Jew* must surely have influenced Millet's image of an itinerant mother and child.

Starvation was a major cause of the upheaval and migration experienced among the peasantry in the closing years of the 1840s. Although feudal ties still bound the rural population to a way of life that had remained virtually unchanged since the Middle Ages, years of bare subsistence and insecurity, aggravated by great famines in 1812, 1817, 1837, 1846/47, and 1853, led to an unrest and panic that caused overwhelming migrations throughout the countryside. Starving peasants were everywhere, most of them without any possessions other than the ragged clothes they wore, some of them even ready to enter prisons in order to obtain food.

During the period from 1848 to 1851 the hostility that existed between invading peasants and those who dwelled in towns was intensified. The peasants had always viewed with suspicion those whom they felt had more than they did, and traditional animosities—heightened by the peasants' constant state of need—led to open friction between the two groups by the middle of the century. Despite their greater number, however, misfortune and circumstance weakened any possible advantage that the peasants might have had. Many left the land permanently, migrating to villages and to Paris, where those who were able took part in the Industrial Revolution that was to revitalize a France that had once been dependent upon agriculture.

Millet's canvas conveys the mood of poverty and despair that dominated the peasants' life. The mother and child, without individualization in any way, symbolize a bereft class torn from their traditional ways and placed on a desolate plain. The forlorn expression of the child suggests that they may have been begging for food when an approaching storm perhaps threatened them. The sense of resignation and overwhelming sadness is heightened not so much by implication as by the emotionalized, sagging forms that Millet has effected. The massed shapes, almost blending into one another, convey a sense of melancholy that is similarly evident in few other paintings, except perhaps those of Honoré Daumier. In contrast to Millet's earlier idyllic scenes and his concurrent interest in Romanticism, Millet here has strengthened his theme by abstraction. Other canvases by Millet from the 1840s suggest a similar social connotation, but few convey the poignancy that is achieved by Millet's ability to simplify common types into sculpturesque, monumental forms.

Exhibited

1962/63, San Francisco, California Palace of the
Legion of Honor; The Toledo (Ohio) Museum
of Art; CMA; Museum of Fine Arts, Boston:
Barbizon Revisited, cat. no. 6l, repr. p. 158.
Catalog by Robert L. Herbert (Museum of Fine
Arts, Boston, 1962).
1966, Peoria (Ill.), Lakeview Center: Barbizon,
not numbered, repr.
1976, Paris, Grand Palais: Jean François Millet,
cat. no. 46, p. 78.

Published

D. Durbé and A.M. Damigella, *La Scuola di
Barbizon* (Milan: Fratelli Fabbri, 1969).
Peter Bermingham, *American Art in the Barbizon
Mood* (Washington, D.C.: Smithsonian Na-
tional Collection of Fine Arts, 1975), p. 144.

Jean-Pierre Alexandre Antigna

22 *The Forced Halt
(La Halte forcée)*

Oil on canvas, 55-1/8 x 80-5/16 inches (140 x 204
cm.). Signed lower right: A. Antigna.
Toulouse, Musée des Augustins.
Provenance. Purchased by the city of Toulouse at
the 1858 exhibition for 2700 francs.

Although he exhibited sixteen canvases at
the 1855 Salon, Jean-Pierre Alexandre An-
tigna received a third-class medal for only
one: *Le Lendemain, scène de nuit.* Many of
his Salon pieces that year revealed the
Romantic side of Antigna's style, but can-
vases such as *La Halte forcée* and *Le De-
nier de l'ouvrière* continued Realist themes
that were noted by critics as part of the full
emergence of the movement during the
mid-1850s. Another example of the range of
Antigna's realism was *L'Incendie* [92], a
work which had been exhibited before and
was included again at this Salon. The fact
that Antigna could work in several styles of
painting during this period undoubtedly
permitted him a far more favorable reception
from art critics and collectors than the more
innovative Gustave Courbet received.
Courbet's type of realism, in contrast with
Antigna's, provoked heated discussion and
considerable consternation among those who
came to view his canvases in his separate
Pavillon du Réalisme held the same year as
the Salon. Antigna, however, was becoming
a Second Empire favorite whose canvases
were purchased for governmental offices
while his position as an "official realist" was
also being recognized.

The exhibition of both *L'Incendie* and *La
Halte forcée* at the same Salon was a timely
revelation of one painter's interpretation of
aspects of the life of the poor in the city and
in the country. It was also an acknowledg-
ment of social implications that had carried
over since the eighteenth century.

22

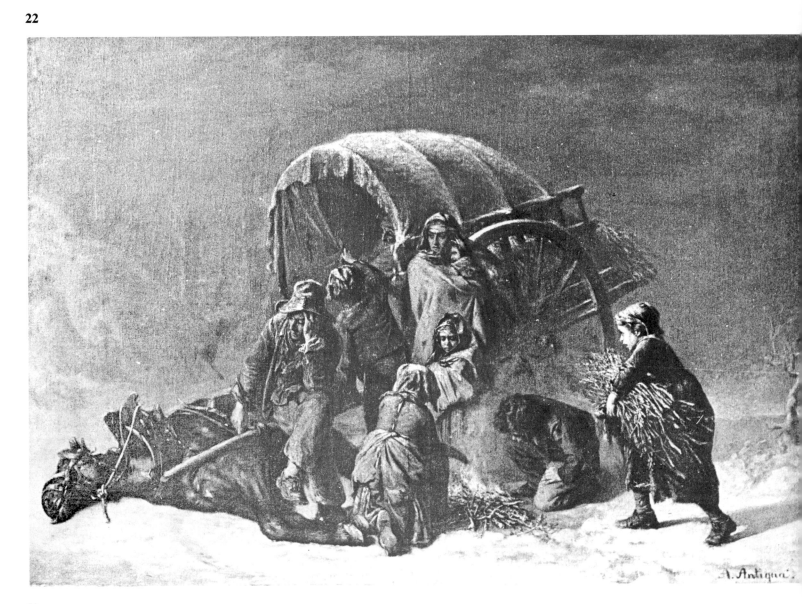

L'Incendie emphasized the vulnerability of workers living in an urban tenement; *La Halte forcée* revealed the misery of uprooted rural workers. Indeed, in showing the suffering of a family unit stranded on a provincial road during a raging winter storm, *La Halte forcée* recorded not simply an isolated incident, but acknowledged the far-reaching problem of the chronically underemployed and jobless who had left behind their rural origins in exchange for an endless and often hopeless search for resettlement and survival. During the nineteenth century, rural France was experiencing a massive and desperate depopulation during which entire families from the country were taking to the roads in search of work when conditions in provincial centers (e.g., Strasbourg or Toulouse) no longer enabled them to eke out enough for subsistence. These homeless people—moving on from one provincial center to another or being drawn finally to the "mecca" of Paris itself—were by their very transience disqualified from many job opportunities or any type of formal governmental relief that might have been available.

Thus, the crisis presented in Antigna's canvas was readily understood. The situation he depicted was all too familiar. The impoverished family stranded on the wintry road may simply have been the victims of a diminished harvest, but Antigna has chosen to modify what might have been a common—albeit ill-fated—circumstance of the poor, to focus instead upon the visual testimony of the struggle for survival itself. Antigna's figures are victims of a ruthless environment, and the all-consuming hope that this family will be able to find work in a new setting is far surpassed in Antigna's rendering by the urgency to survive the conditions of the next few hours. Several of the young children are scurrying to start a fire, and one child pulls at the curtain of the wagon opening in an effort to shelter the enfeebled eldest member within. The calamity of the dead horse—perhaps already too-weakened from hunger, but the only means by which the family could move on—affects each of them differently. While the father ponders his fate and stares forlornly at the carcass, the mother stoically draws her infant close beneath her cloak, thereby fortifying the family unit. Here, as in *L'Incendie*, the apex of Antigna's compositional triangle is dramatically underscored and developed to center upon the exemplary role of the mother as the strength and support of her family. Finally, as if to complete the inevitable in this scene of distressed immobility and hopelessness, wolves lurk on the fringes of the forced encampment.

La Halte forcée conveyed Realism with a sincerity and truthfulness that was accessible and more palatable than the vigorous palette of Courbet. The development of his figures after careful and polished study of actual models may also have enhanced Antigna's realism in this canvas. A preparatory sketch for the head of the father reveals Antigna's efforts to overcome earlier criticism directed at his inability to express a variety of human reactions in figural types.

Much as he had realized in *The Flooding of the Loire* [93], Antigna created a melancholy mood by using tonal colors. Grays and tans predominate, coinciding with the barren, wintry landscape and recording the miserable dreariness of the lives of the rural poor. The roughness of the direct application of paint, which Antigna allowed to remain rather than the usual Salon finish, identifies Antigna's intention as purely Realist in tone. Form and message were thus united in a work that was recognized by such critics as Théophile Gautier as one of Antigna's finest achievements: "*The Forced Halt*, in which dull and disagreeable color diminishes the effect, is one of Antigna's best compositions. . . . What a sorry stopping place after a long journey! And what will become of these poor people? —Will they be able to keep from freezing in their thin rags, and will daybreak with its icy chill and bluish light find them still alive?"[1] This assessment of the painting in the 1850s was to hold when it was re-exhibited in Toulouse in 1858. At that exhibition, *La Halte forcée* was purchased by the city fathers for the municipal museum—a fitting distinction for a painting that examined a severe social dilemma of the poor.

1. Théophile Gautier, *Les Beaux-Arts en Europe: 1855*, 2 vols. (Paris, 1856), 2: 102-3.

Exhibited

1855, Paris: Salon, cat. no. 2436.
1858, Toulouse: Exposition de 1858, no cat.
1979, Orléans: Jean-Pierre Alexandre Antigna.

Published

Museum cat., in 1864 edition, no. 302; in 1920, no. 1.
A. J. Du Pays, "Exposition Universelle des Beaux-Arts: Réalisme," *L'Illustration*, 28 July 1855, p. 74.
E. Loudon, *Exposition Universelle des Beaux-Arts. Le Salon de 1855* (Paris, 1855), p. 140.
J. Meyer, *Geschicte der modernen Franzosischer Malerei seit 1789 . . .* (Leipzig, 1867), pp. 632-33.
E. Loudon, Preface to *Catalogue de la vente qui aura lieu par suite du décès de Antigna, ses tableaux, études et croquis* (Paris, 1878), p. 11.
V. Champier, "Nécrologie—Antigna," *L'Année artistique 1878* (Paris, 1879), p. 475.
A. Morance, "Notice biographique sur Alexandre Antigna," *L'Avenir du Loiret*, 6 September 1882, no. 211.
P. A. Leroy, *Alexandre Antigna, Peintre* (Orléans, 1892), p. 12.
E. Roschach, *Inventaire des recherches d'art de la France: Musée de Toulouse* (Paris, 1908), cat. no. 28.
Linda Nochlin, *Realism* (Baltimore: Penguin Books, 1971), p. 252, repr. p. 47.

Jean-Pierre Alexandre Antigna

23 *The Woodcutter
(Le Fendeur de bois)*
Oil on canvas, 15-7/8 x 17-1/2 inches (40 x 44 cm.), ca. 1857-60. Signed lower left: Antigna.
Paris, Private Collection.
Provenance. Estate of the artist. See *Inventaire après le décès de M. Antigna*, 25 March 1878.

During the 1850s the search for new images led several of the Realists to travel to the provinces. Artists such as François Bonvin and Antigna chose Brittany because of the unusual regional variations and the distinctive clothing and customs of its inhabitants. Antigna's first trip to Brittany was in 1857. Here he studied the folklore of the people and observed the traditional dress of the women (which he incorporated in several canvases he later completed in Paris) and the regional attire of the men. Some of these firsthand studies were developed as idealized versions of what Antigna actually saw, because of his tendency to use academic formulas rather than observed poses in many of his compositional arrangements. Occasionally, however, Antigna chose to depict scenes that captured the activity and mannerisms of the rural people. Some of these works were quickly executed, without the careful finish given the usual Salon compositions, revealing Antigna's tendency to rely upon a spontaneous style to convey his impressions.

The Woodcutter depicts a regional scene of a worker splitting wood for his own personal use. The dwindling supply within the woodshed suggests that this was a regular chore performed at the same time each day and that the woodcutter had not taken the time to replenish his own stockpile. By positioning his figure so that a maximum force is contained within the swing of the crude ax, Antigna's work suggests an energy similar to the woodcutters painted by Jean François Millet during the same period. Unlike many of Antigna's works, the task here is not a struggle against nature, but simply a daily activity set within an interior sparsely illuminated by the natural light from the small, recessed window.

Published

Catalogue de la vente qui aura lieu par suite du décès de Antigna, ses tableaux, études et croquis (Paris, Hôtel Drouot, 14-15 June 1878), p. 20, no. 157 (listed as *Le Fendeur de bois*).

Armand Leleux

24 *A Spaniard: Interior* or *The Smuggler*
(*Le Contrebandier*)
Oil on canvas, 18-1/8 x 15 inches (46 x 38 cm.).
Signed and dated lower left: Arm. Leleux, 1849.
Tours, Musée des Beaux-Arts.
Provenance. Given by M. L. Graflin.

Although the history of *A Spaniard: Interior*
remains unknown, there is the possibility
that this painting by Armand Leleux could
be the same canvas titled *Un Espagnol,
intérieur*—the only entry Leleux submitted
at the 1849 Salon.[1] His recent trip to Spain
and his interest in exotic themes may have
inspired his choice of this theme.

 The Spaniard seated at the little table,
working on his account book, is dressed in
traditional attire, but his activity and dress
also identify him as a smuggler. Smuggling
of various goods had long been a commonp-
lace practice along the French coast, and the
theme had been used by other Salon pain-
ters. Leleux situated his model within a typ-
ical stage-space that allies his work with the
Romantic movement and exotic genre rather
than to the Realist tradition that adhered to
actual observation of an everyday scene of
the lower classes.

1. The size of the Tours painting with its frame is
67 x 58 cm. In the *Salons: Enregistrement des
ouvrages,* Archives du Louvre (under no. 1303),
Leleux's *Intérieur avec un Espagnol* was listed as
being 65 x 54 cm. If the frames were the same (the
dimensions of Salon paintings often included both
frame and canvas), there could be ample evidence
for assuming this painting to be the 1849 entry.

Jean-Pierre Alexandre Antigna

25 *A Picture Peddler*
(*Un Marchand d'images*)
Oil on canvas, 56-3/4 x 44-7/8 inches (143 x 113
cm.). Signed lower left: A. Antigna.
Bordeaux, Musée des Beaux-Arts.
Provenance. Purchased by the city of Bordeaux at
the Exposition de la Société des Amis des Arts in
1863.

Jean-Pierre Alexandre Antigna's *Picture
Peddler,* which he completed about 1862, re-
cords a well-established tradition in France.
Itinerant image vendors had worked the city
and country since the Middle Ages, hawk-
ing satirical prints intended to ridicule those
in government or religious images calcu-
lated to reinforce the piety of the peasants.[1]
Even the well-known eighteenth-century
printmaker Edmé Bouchardon included a
Marchand d'Images (Figure 25a) among his
engravings, recognizing that such efforts
served as a source for educating the people in
the cause for freedom.

24

23

The religious print that Antigna's peddler has unrolled from the sheath of prints he carries has attracted the attention of several provincial townsfolk, who have drawn closely about the worn figure. The slackness of his gaunt, wrinkled face and open jaw, and the benevolent gesture of his raised arm attest to the painter's sense of realism. The curious onlookers, however, are romantic in expression. The children and the young mother reflect a dreamy and appealing sentiment that recalls the portraits of Greuze. Antigna's accurate observation of the practice and the provincial clothing, probably inspired by a trip to Brittany in the late 1850s, has thus been modified to achieve an image more appropriate for Salon presentation.

1. The image merchants were also important as disseminators of the French national tradition. They helped formulate aesthetic sensibility and a love of national culture. For further information, see Pierre Brochon, *Le Livre de colportage en France dupuis le XVIe siècle* (Paris, 1954). Also see *Tableau de Paris,* 1: 188-91,

Exhibited

1863, Bordeaux, Galerie de la Société des Amis des Arts: 12ème Exposition, no. 9.
1975, Bordeaux, Galerie des Beaux-Arts: Pompiérisme et peinture équivoque, no. 2.
1976, Calais, Musée: Diverses tendances de la peinture française au XIXe siècle et au début du XXe siècle, no. 2.
1979, Orléans: Jean-Pierre Alexandre Antigna.

25

25a Edmé Bouchardon, *Marchand d'images,* etched by Comte de Caylus after the artist.

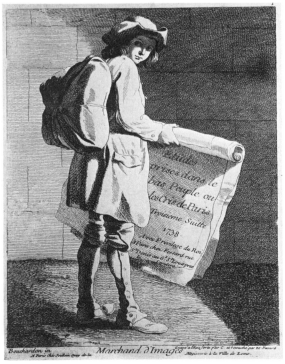

Published

Catalogue et estimation des tableaux du Musée de la Ville de Bordeaux (Bordeaux, n.d.), p. 19, no. 550.

Catalogue des tableaux, statues . . . du Musée de Bordeaux, in 1863, 1864, 1869, 1875, 1877, and 1879 editions, p. 5, no. 13 bis.

E. Vallet, Catalogue des tableaux, sculptures, gravures, dessins, exposés dans les galeries du Musée de Bordeaux (Bordeaux, 1881), p. 125, no. 349. Idem, Nouvelle édition du catalogue (Bordeaux, 1894), no. 370, p. 123.

P. Galibert, Chefs-d'oeuvre du Musée de Bordeaux (Bordeaux, 1906), repr. pl. 45.

Musée de Bordeaux, fasc., no. l8 (Bordeaux, 1909), pl. 3.

D. Alaux, Musée de peinture de Bordeaux (Bordeaux, 1910), cat. no. 306, p. 61.

Musée de peinture et sculpture de Bordeaux (Bellegarde, 1933), p. 53, cat. no. 164.

Th. Ricaud, "Le Musée de peinture et sculpture de Bordeaux de 1830 à 1870," Revue historique de Bordeaux, April-June 1937, pp. 84, 85. Idem, Le Musée de peinture et de sculpture de Bordeaux de 1830 à 1870 (Bordeaux, 1938), p. 143.

J. Vergnet-Ruiz and M. Laclotte, Petits et Grands Musées de France (Paris: Musée du Louvre, 1962), p. 225.

C. Colin, Bordeaux Sud-Ouest, 25 March 1973, repr. p. 12.

David Ojalvo, Jean-Pierre Alexandre ANTIGNA, exh. cat. (Musée des Beaux-Arts, Orléans, 26 October 1978—3 January 1979), no. 30, repr.

26

Léon Lhermitte

26 *Sportsman in a Wood*

Charcoal, 22 x 15 inches (55.8 x 38.1 cm.). Signed lower left: L. LHERMITTE [in another hand].

London, Victoria and Albert Museum.

Provenance. M. Trelat Collection. Acquired 26 June 1868 from the Ecole Impériale de Dessins.

By enrolling at the Ecole Impériale de Dessin (in 1863) in the atelier of Horace Lecoq de Boisbaudran, Lhermitte familiarized himself with the prevalent theories of memory training espoused by his teacher and his fellow colleagues, including Jean Charles Cazin and Fantin-Latour. In mastering the concept of accurate representation from memory, Lhermitte stressed a precision in the massing of his forms. Only a few of Lhermitte's memory drawings, however, have survived from his years at the Ecole Impériale, with the *Sportsman in a Wood* representing the direction of Lhermitte's later work, rather than typifying his compositions during the 1860s. The solitary gentleman paused in reverie seems integrated with the setting in which he has been posed, yet not dependent upon it as were the peasants who frequented the woods or open fields. Lhermitte's mastery of the texture of the rocks, the reflection of a segment of the environment in the pool of water, and the complexities of posing a figure amid changing patterns of light—conveyed by the bright sunspots on his pant leg, the hunting bag, and the branches of the tree at the right—all serve to intensify the reality of the hunter in the rustic forest setting.

Published

Mary Michele Hamel, "A French Artist: Léon Lhermitte, 1844-1925" (Ph.D. diss., Washington University, St. Louis, 1974), p. 19, cat. no. 3.

THEMES OF LABOR
Artisans

Jean Gigoux

27 *The Blacksmith*
 (Le Forgeron)
Oil on canvas, 17-7/8 x 14-1/4 inches (45 x 37 cm.).
Signed and dated lower right: Jean Gigoux, 1833.
Besançon, Musée Granvelle.
Provenance. Collection of Paul Lapret. Entered
the museum collection before 1902.

The Blacksmith was one of seven composi-
tions for which Jean Gigoux received a
second-class medal at the 1833 Salon. Small
in scale, inspired by his remembrance of his
own father as a village blacksmith, Gigoux's
canvas displayed an interest in intimate genre
themes that typified the early Realist move-
ment. The composition is sketchily exe-
cuted, and the smithy's stance is more con-
ventional than later Realist works. The at-
mosphere and mood also convey the

Romantic heritage from which Gigoux
evolved his style. The recollection of his
father that Gigoux adapted in this genre por-
trait (similar to his study of his mother in the
Musée des Beaux-Arts, Besançon) is
characteristic of his use of relatives as
models—a practice that became common
among the later Realists.

Published
A. Estignard, *Jean Gigoux—Sa Vie, ses oeuvres,
 ses collections* (Besançon, 1895), p. 65.

Philippe Auguste Jeanron

28 *Woodworker*
 (Ouvrier)
Charcoal, 13-1/4 x 7-3/4 inches (34.4 x 19.5 cm.).
Signed and dated lower left: Jn 1836.
Paris, Musée du Louvre, Cabinet des Dessins.
Provenance. Musée du Luxembourg, 1930.

By 1836 Philippe Auguste Jeanron had es-
tablished his career as a Realist painter of
scenes derived from the daily life of the peo-

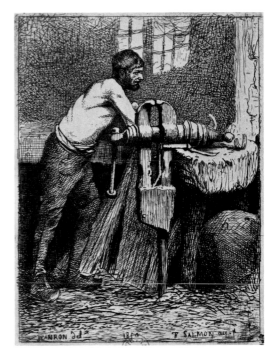

28a Philippe Auguste Jeanron,
 Worker at a Lathe, etching, undated.

27

28

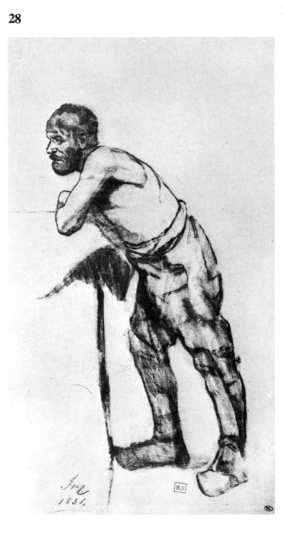

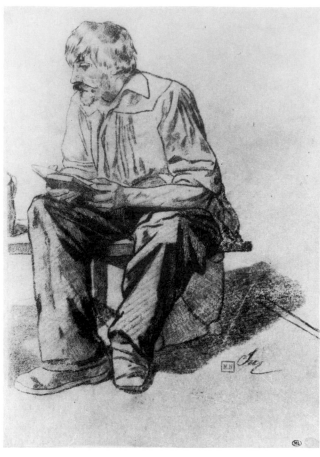

30

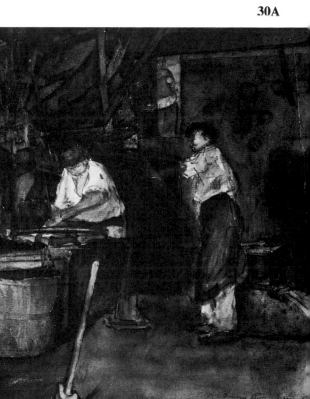

29

30A

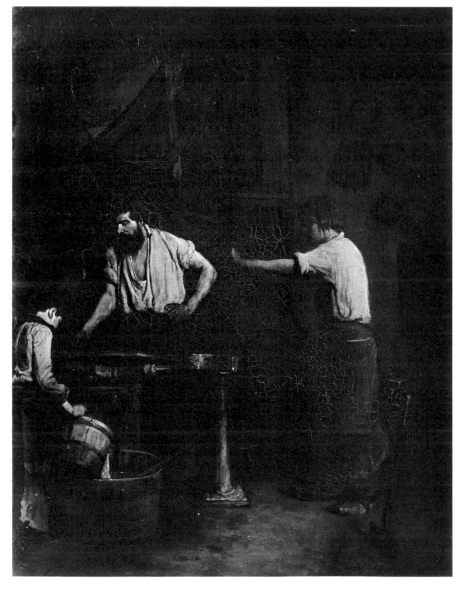

64

ple. Two years later Théophile Thoré referred to Jeanron's famous 1836 Salon painting *Les Forgerons de la Corrèze* as a key work in developing support for French workers.[1] Jeanron's success at the Salons during the 1830s, when he exhibited several works sympathetic to the cause of urban workers, was augmented by a growing interest among the critics for all his work, including the drawings he completed to develop themes he would use later in painting. The *Woodworker* that Jeanron sketched in 1836 served as a preliminary study for a painting (no longer existing) of the craftsman that was later duplicated (1850) as an etching (Figure 28a). The etching clarified the woodworker's somewhat obscure activity in the drawing, suggesting that the drawing itself was made several years before the final oil. It was not unusual for an etching to be made from the final canvas; if a work proved popular, a print was often made for art dealers, to guarantee a wide distribution of the image. Jeanron's interest in the theme of the worker, especially the manual laborer, made him a forerunner of one aspect of Realism that was later endorsed by François Bonvin [30], Jean François Millet [31], and Léon Lhermitte [186].

1. Théophile Thoré, *Journal du Peuple,* 1 April 1838. Thoré not only recognized the importance of this painting, but singled out Jeanron as a leader in the development of images that elevated everyday life.

Published

Madeleine Rousseau, "La Vie et l'oeuvre de Philippe Auguste Jeanron: Peintre, écrivain, directeur des Musées Nationaux, 1808-1877" (thesis, Musée du Louvre, 1935), p. 48, cat. no. 210.

Philippe Auguste Jeanron

29 *Seated Man Holding a Book*
(Homme assis, tenant un livre)
Charcoal on tracing paper, 11-1/8 x 8-1/8 inches (28.3 x 20.5 cm.). Signed lower right: Jn.
Paris, Musée du Louvre, Cabinet des Dessins.
Provenance. Musée du Luxembourg, 1930.

The painting *Le Philosophe campagnard* (now lost) by Jeanron attracted little critical attention when it was exhibited at the 1836 Salon. It was overshadowed by his far more dynamic *Les Forgerons de la Corrèze* (also lost), even though the little-noticed work may have revealed a more contemplative aspect than some of Jeanron's early works. As a revolutionary leader, Jeanron recognized the importance of the written word in arousing passions and in teaching the populace. His own writings in the early 1830s stressed the need to liberalize the Salons and urged adoption of a democratic process to replace the jury method by which artists were selected at the yearly Salons. This same tendency may have influenced Jeanron's

view of the worker in society, for he advocated the education of workers to assure equality and to alleviate social problems.

Similar thoughtful poses in two drawings Jeanron completed in 1842—one of workers dressed in overalls and the other of professional men in smocks—indicate that the undated drawing *Seated Man Holding a Book* may have been part of a series.[1] The rough handling of the charcoal to show the folds and shadows of the worker's trousers, however, suggests it may be dated as early as 1836. The pensive pose of this portrait conveys an introspective mood that has diverted the worker's attention from the book he has been reading. While the moment of repose recalls the more traditional paintings of a philosopher musing on his position in society, and anticipated the later pose and dress that Gustave Courbet used in portraying the writer P. J. Proudhon and his family (Musée du Petit Palais, Paris), it is also deeply indicative of Jeanron's commitment at the time. It is a study that symbolizes the liberalized citizen.

1. For further reference to these drawings see *Musée Magnin: Peintures et dessins de l'Ecole française* (Dijon, 1938), cat. no. 545.

Published

Rousseau, "La Vie et l'oeuvre," p. 4, cat. no. 214.

François Bonvin

30 *The Blacksmith's Shop:*
Remembrance of Le Tréport
(Les Forgerons–Souvenir du Tréport)
Oil on canvas, 36-5/8 x 29-1/8 inches (93 x 74 cm.).
Signed and dated lower right: F. Bonvin, 1857.
Toulouse, Musée des Augustins.
Provenance. Purchased by the state and sent to Toulouse, 1857.

With the burgeoning industrialization of France, especially under the Second Empire, artists and writers recorded the plight of the skilled workers then being replaced by new machinery[1]—an advancement occurring so rapidly that the very livelihood of many industrious, self-supporting individuals was threatened. Along with the dramatic growth of some new industries (e.g., mining), however, many of the traditional skills continued. Realist painters who chose to immortalize workers at the forge may have done so out of a refusal to accept industrialization. The increased use of this theme in the visual arts originated in the canvases and drawings of Philippe Auguste Jeanron [28, 29] as a means of "looking backward," to establish work methods which had been maintained, virtually without modification, for centuries. Some painters used the theme of the artisan to underscore the continuation of traditional jobs and individual identity in a period of

rapid change and progress. Writers like Proudhon, who glorified such artisans, also had an effect upon the realist tendency, for these craftsmen were recognized as ready models that could be observed within their own modest surroundings. To the Realists, the blacksmith thus became a symbolic personage, an artisan who refused to modify his methods of production, retaining his individuality and his independence, relying upon his own efforts and experience to provide a longstanding, traditional service to his community.

François Bonvin may have intended his *The Blacksmith's Shop: Remembrance of Le Tréport* to summarize the aspirations of the Realists and underscore the link that existed between his generation and the traditions of previous generations. This was the only painting that Bonvin exhibited at the 1857 Salon, and it was inspired by his trip to Tréport in 1854, although he had first sketched the forge theme in 1852.[2] His *Blacksmith's Shop* is based, in part, on *The Forge* by Louis Le Nain, whom the Realists recognized as an important precursor and model, and an artist whom Bonvin had studied in the Louvre. Bonvin's work also suggests the Realist as reporter, for he accurately captures the activity of the men who operate a traditional forge. With customary meticulousness, Bonvin rented an old forge and placed his models in different poses. His positioning of the figures to one side to dramatize the forge itself, however, creates the appearance of a segment of life observed as it actually happened. The work is significant because it documents Bonvin's participation in the Realists' interest in extolling the work of the independent artisan.

1. Michelle Evrard and Patrick Le Nouëne, *La Représentation du travail: Mines, forges, usines,* exh. cat., Le Creusot, September 1977—February 1978, pp. 15-17. See also J. Arrouye, "La Notion du travail créateur dans 'l'art'" in *Le Travail,* Concours d'entrée des Grandes Ecoles Commerciales (Paris: Bréal, 1978).
2. Bonvin was to complete numerous drawings and paintings with similar themes throughout his career, but few were to receive the official state sanction that his *Blacksmith's Shop* received. The painting attracted critical attention and was purchased by the state for 1500 francs.

Exhibited

1857, Paris: Salon, cat. no. 292.

Published

Maxime du Camp, *Le Salon de 1857* (Paris, 1857).
Edmond About, *Nos Artistes au Salon de 1857* (Paris, 1857).
Etienne Moreau-Nélaton, *Bonvin raconté par lui-même* (Paris: Henri Laurens, 1927), p. 49, fig. 28.
Gabriel P. Weisberg, "François Bonvin and the Critics of His Art," *Apollo,* October 1974, p. 307, fig. 4. Idem, *Bonvin: La Vie et l'oeuvre* (Paris: Editions Geoffroy-Dechaume, 1979), cat. no. 21.

François Bonvin

30A Preliminary Water Color
 for *The Blacksmith's Shop*
Water color, 8-3/4 x 10-5/8 inches (22.2 x 27 cm.).
Signed and dated lower right: f. Bonvin 1854
—Tréport.
Cleveland, Mrs. Noah L. Butkin Collection.
Provenance. Galerie Arnoldi-Livie.

A preliminary water color for *The Blacksmith's Shop* was completed on Bonvin's trip to Le Tréport in August 1854. An earlier water color of the forge theme, completed in 1852 (Musée des Beaux-Arts, Dijon), indicates Bonvin's attempt to develop a complex workshop scene utilizing a number of workmen. This second water color is a modification that depicts a simpler, country forge operated by only two men. Their status as local artisans is emphasized, although their specific responsibilities in working the forge remain unclear. Comparison with the finished oil painting, shown at the 1857 Salon [30], shows that Bonvin later added a young apprentice to assist the workmen. The later work also diminished the size and importance of the large hammer that is so prominent in the foreground of the water color.

It is not known how many preliminary studies Bonvin completed in water color for his major Salon paintings, although the existence of two for this particular theme suggests that he may have prepared an entire series, perhaps until he felt sure he had captured the right moment. Bonvin reworked these studies over a long period of time, often modifying his compositional arrangement while making observations directly from the scene before him. In this way, his water colors served as reference sources for paintings he completed at a later date in the quiet of his Parisian studio.

Published
Weisberg, *Bonvin*, cat. no. 249.

Jean François Millet

31 *The Cooper*
Oil on canvas, 18-1/4 x 15-3/8 inches (46.5 x 39 cm.), ca. 1848-52. Signed lower left: J. F. Millet.
Museum of Fine Arts, Boston. Gift of Quincy A. Shaw, through Quincy A. Shaw, Jr., and Marion Shaw Haughton.
Provenance. Constant Troyon, sold Hôtel Drouot, Paris, 22 January—27 January 1866, no. 564. Quincy Adams Shaw, Boston. Shaw family, given to the Museum of Fine Arts, Boston, 1917.

The cooper was depicted frequently in popular art and song during the eighteenth and nineteenth centuries. Edmé Bouchardon's *Etudes prises dans le bas peuple* (also called *Les Cris de Paris),* 1737, was among the first of these images that portrayed the cooper with the tools and materials of his trade, including the staves he used to bind the barrels

together.[1] Bouchardon's early image does not show the cooper actually at his work, but his print (Figure 31a) may well have inspired Millet's *The Cooper,* for the placement of Bouchardon's figure close to the frontal plane endowed his worker with a monumental scale that is not unlike the power that Millet achieved in his painting.

The familiar figure of the cooper appeared in several popular nineteenth-century illustrations, one of which was set alongside the ballad by Pierre Dupont entitled "Le Tonnelier" that was published in 1853, but written earlier. Dupont's ballads were considered significant by many of the Realists (e.g., Théodule Ribot [9]), who were probably acquainted with cabaret performances of his works that immortalized in song popular types from urban and rural settings. The cooper had long performed a valuable function, turning out barrels that were used for shipment and storage throughout the country,[2] but by mid-century the cooper had assumed mythic dimensions. He symbolized the devoted artisan and a continuity of the past into present that appealed to a generation eager to immortalize the worker and the ideals that had helped precipitate the February Revolution of 1848.

1. See Edmé Bouchardon, *Etudes prises dans le bas peuple ou les Cris de Paris* (Paris, 1737), fig. 11.
2. Robert Herbert, *Jean-François Millet,* exh. cat. (Paris: Editions des Musées Nationaux, 1975), p. 110.

Exhibited
1975/76, Paris, Musée du Louvre, Grand Palais; London, Hayward Gallery: Millet. Catalog by Robert L. Herbert.

Published
L. Soullié, *Les Grands Peintres aux ventes publiques: Jean-François Millet* (Paris, 1900).
Catalogue Quincy Adams Shaw Collection (Boston, 1918), cat. no. 58, no. 17, repr.
Etienne Moreau-Nélaton, *Millet, raconté par lui-même,* 3 vols. (Paris: Henri Laurens, 1921), 2: 124, fig. 181.
Herbert, *Millet,* pp. 110-11.

Jean François Millet

32 *The Quarriers*
Oil on canvas, 29 x 23-1/2 inches (74 x 60 cm.), 1846-47.
The Toledo Museum of Art, Gift of Arthur J. Secor.
Provenance. Millet sale, 1875, no. 3. Daniel Cottier, Paris. Ichabod T. Williams, New York (Plaza Hotel, 3-4 February 1915, no. 100). Arthur J. Secor, given to The Toledo Museum of Art in 1922.

Before his escape to nature when he moved to Barbizon in 1849, Millet painted scenes from the countryside near Paris, especially in the increasingly industrialized suburbs that were spreading out from Paris in all di-

rections. By mid-century these districts had become an overcrowded wasteland of burgeoning factories and extensive quarries amid isolated remnants of farmland and lingering village enclaves. Most of the new inhabitants were itinerant laborers who had been turned away from the capital in their search for work and had been forced into menial jobs, where their frustrations and poverty led to occasional disruptions and a political intensity that the government regarded as disloyal and dangerous. It was this desolation in the borderlands that attracted first Millet, then Cals [20] and, later, Jean François Raffaelli [164, 165].

The Quarriers by Millet is an unfinished canvas that records an industry dependent upon a migrant labor force known for its radical politics and violent unrest. These social overtones, coinciding with Millet's own beliefs[1] and the government's impetus to extend the railways during this period[2] may all have contributed to Millet's inspiration for this work. The rocky landscape near Montmartre in itself provided a certain onerous aspect to the difficult task that Millet has faithfully recorded. His positioning of the two workmen, straining their full weight together against the crowbar in an attempt to dislodge the heavy boulder, creates a tension that conveys Herculean energy. Although representative of the early Realist-Naturalist themes used by Millet, *The Quarriers* also brings to mind later compositions by Daumier that concentrate upon simplified human forms and the sculpturesque rendering of volumes.

1. T. J. Clark, *Absolute Bourgeois: Artists and Politics in France, 1848-51* (London: Thames & Hudson, 1973), p. 78.
2. Robert L. Herbert, *Barbizon Revisited,* exh. cat. (Museum of Fine Arts, Boston, 1962), p. 149.

Exhibited
1932, Buffalo, Albright Art Gallery: The Nineteenth Century: French Art in Retrospect 1800-1900, cat. no. 5, repr.
1959, London, Hazlitt: Some Paintings of the Barbizon School, no. 253.
1962/63, Museum of Fine Arts, Boston: Barbizon Revisited, no. 59, repr. Catalog by Robert L. Herbert.
1966, New York, Wildenstein: Romantics and Realists, no. 57, repr.
1975/76, Paris, Musée du Louvre, Grand Palais: Millet, no. 37, repr. p. 70.

Published
E. Wheelwright, "Personal Recollections of Jean-François Millet," *Atlantic Monthly* 38 (September 1876): 263.
Alfred Sensier, *La Vie et l'oeuvre de Jean-François Millet,* ed. P. Mantz (Paris, 1881), p. 104.
Soullié, *Les Grands Peintres,* p. 43.
Toledo Museum News 41, April 1922, repr.
P. Brandt, *Schaffende Arbeit und Bildende Kunst,* 2 vols. (Leipzig, 1928), p. 229.

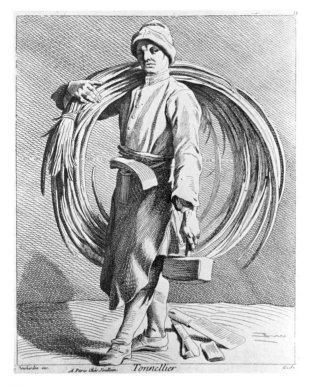

Toledo Museum News 70, March 1935, repr.
Art Digest 9, 1 May 1935, repr.
Museum cat. (Toledo, 1939), p. 176, repr.
John Canaday, *Mainstreams of Modern Art* (New York: Simon and Schuster, 1959), repr. p. 123.
Marcel Brion, *Art of the Romantic Era* (New York: Praeger, 1966), repr.
Jean Bouret, *L'Ecole de Barbizon et le paysage français aux XIXe siècle* (Neuchâtel, Suisse: Editions Ides et Calendes, 1972), repr.
Clark, *Absolute Bourgeois,* pp. 74, 78, repr.
K. Lindsay, "Millet's Lost Winnower Rediscovered," *Burlington Magazine* 116 (May 1974), repr.

32

31a Edmé Bouchardon, *Le Tonnelier*,
etched by Comte de Caylus after the artist.

31

François Bonvin

33 *Woman Ironing*
Oil on canvas, 20 x 14-1/4 inches (50.8 x 36.2 cm.). Signed and dated upper right: F. Bonvin, 1858.
Philadelphia Museum of Art, John G. Johnson Collection.
Provenance. Durand-Ruel Gallery, Paris.

Widows or wives in impoverished households often earned additional income by taking in laundry. Such washerwomen were a familiar sight in the streets of Paris, and during the nineteenth century became a popular subject among the Realists. Daumier depicted such washerwomen hauling bundles of clothes from the washhouses on the river-banks of the Seine to their homes, where the clothes would then be hung to dry or be

34

33

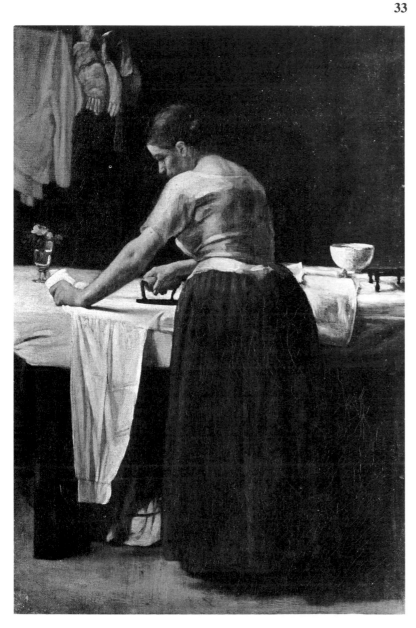

35

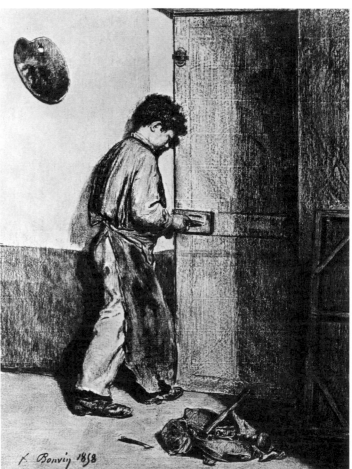

ironed before they were returned to their clients.

Bonvin's own household was undoubtedly run in this manner. His first wife, Elisabeth Dios, recorded her profession as that of laundress at the time of their marriage.[1] It was likely that she was able to support the young artist and their daughter in this fashion when Bonvin was ill, or after he left the Préfecture de Police in his determination to establish himself as a painter.[2] Bonvin's *Woman Ironing,* as well as an earlier sketch (National Museum of Wales, Cardiff), thus combined personal associations (although his model was never identified) along with his dedication to reveal the daily life of the lower classes.

Woman Ironing focuses upon the task of the woman with her back to the viewer, ironing a white shirt while other garments have been hung to dry overhead in the cramped space in which she works. Her posture suggests the series of ironers completed later by Edgar Degas during the 1870s and 1880s (e.g., Metropolitan Museum of Art, New York), which indeed may have been influenced by this earlier study by Bonvin. The single rose propped in the water glass near her work space adds a touch of color and tenderness that appears in many of Bonvin's images of women. By presenting his model larger and closer to the frontal plane of the composition—thus eliminating unnecessary environmental detail—and by placing her activity parallel to the picture plane, Bonvin created a simplified design and a sense of immediacy that were both innovative and influential in the works of other Realist painters. The subtle light that touches her shoulder and illuminates the converted kitchen table and the shirt reveal Bonvin's skill at tonal painting, especially his proficiency with a range of whites. Although he advocated the contemporary themes that Emile Zola wrote about and Degas later visualized, Bonvin's image was also deeply personal— for he had witnessed the scene many times during his first marriage. When Elisabeth died in 1859, Bonvin never again depicted this particular theme.

1. See "Préfecture du Département de la Seine, extrait du registre des actes de mariage de la Commune de Vaugirard, 23 mai 1837—Bonvin," Archives de Paris.
2. Bonvin resigned from the Préfecture de Police in 1850 to pursue his artistic career.

Published

Wilhelm Reinhold Valentiner, *Catalogue of a Collection of Paintings and Some Art Objects,* vol. 3, *German, French, Spanish and English Paintings and Art Objects* (Philadelphia: John G. Johnson, 1914), cat. no. 901.
Gabriel P. Weisberg, *Social Concern and the Worker: French Prints from 1830-1910* (Salt Lake City: Utah Museum of Fine Arts, University of Utah, 1973). Idem, "François Bonvin and the Critics," p. 308, fig. 6. Idem, *Bonvin,* cat. no. 23.

Amand Gautier

34 *The Ironer*
 (La Repasseuse)
Oil on canvas, 13-1/8 x 9-1/2 inches (33 x 24 cm.).
Signed lower left: Amand Gautier.
Caen, Musée des Beaux-Arts.
Provenance. Jaquette Bequest, 1899.

Most of the early works by Amand Gautier were either destroyed during the Franco-Prussian War or have not been located.[1] Much of his significance in the evolution of early Realism has been attributed to his 1857 Salon entry, *Les Folles de la Salpêtrière* (now lost), but without his paintings, his position and influence within the movement are difficult to assess.

He remained closely associated with the major Realists from his earliest days in Paris and may have seen the compositions that Bonvin completed of ironers during the late 1850s [33]. His friendship with Courbet (he was jailed with Courbet at the time of the Commune) and the frequent gatherings of the Realists at the Brasserie Andler must also have acquainted him with varying aspects of city and rural life that Realists were then recording to show how "the people" lived and worked.

The small, early canvas *The Ironer* (whose preservation may possibly be attributed to its purchase by a collector in the north of France) reveals characteristics that must have been paramount in Gautier's larger works. The delicate tones of white, gray, orange, and blue suggest a sensitive awareness of light and atmosphere. Gautier's ability to simplify form—suggestive of Honoré Daumier—is also apparent, for the activity is conveyed by the figure of the ironer as well as by the rectangular sweep of the table covering that directs the viewer toward the right. Gautier also completed an etching after the painting, which he included in the third portfolio of the Société des Aquafortistes, so that it is possible that Degas was familiar with the image when he began his own series of ironers in the 1870s.[2]

1. The author is indebted to André Watteau and M. Marcus for providing information on Gautier. An early still life by Gautier, from the 1850s, recently appeared on the Paris art market; see Gabriel P. Weisberg with William S. Talbot, *Chardin and the Still-life Tradition in France,* exh. cat. (CMA, 1979), fig. 28.
2. For further information, see Janine Bailly-Herzberg, *L'Eau-forte de peintre au dix-neuvième siècle: La Société des Aquafortistes 1862-1867* (Paris: Léonce Laget, 1972), no. 134.

Published

Musée des Beaux-Arts de Caen, cat., in 1907 and 1913 editions, no. 240; in 1928, no. 225.
Bulletin de la Société des Beaux-Arts de Caen 10 (1897): 437.

François Bonvin

35 *The Locksmith*
Black and brown chalk, 16-1/4 x 12-1/8 inches (41.2 x 30.7 cm.). Signed and dated lower left: f. Bonvin 1858.
London, Private Collection.
Provenance. Jonas Gallery, Paris. Stefanie Maison, London, 1975.

François Bonvin's works during the 1850s show an increasing interest in social types that he found on the streets of Paris and that he brought into his studio to pose as "true models" of these images. Occasionally, he recorded *petits artisans*—tradesmen or apprentices skilled in a specific task that he recognized as representative of the lower working class, such as a watercarrier (The Cleveland Museum of Art) or a locksmith.

The artist's palette and the rear view of a canvas positioned against the wall in *The Locksmith* denote that the young repairman intent upon his work is a study completed within Bonvin's studio. Unlike the stationary poses in many of his drawings, Bonvin has here captured the young boy at a moment of exertion on a specific part of the latch. The open sack of tools and the drill and hammer temporarily set aside suggest that the chore is not yet completed. Bonvin's concern with the momentary anticipated the interest of Manet and the Impressionists, for he, too, has preserved a "segment of life," an extemporaneous view of a young workman observed without any attempt to modify the naturalness of the event.

Along with his study of an instantaneous pose, this drawing reveals Bonvin's growing sensitivity to the treatment of light. By using a heavy chalk to suggest dark and moderate shadows and by rubbing certain sections with his fingers to blur outlines (for example, near the door), Bonvin achieved a subtle tonal gradation against the white paper that is seldom achieved in his earlier drawings. While a painting with this particular theme has not been located, it is still possible that Bonvin might have translated this black and white image into a later, finished oil painting. On the other hand, Bonvin—like other Realists—was beginning to recognize and appreciate a drawing as a work in itself.

Exhibited

1975, London, Colnaghi: French Drawings, Post Neo-Classicism, cat. no. 24.

Published

Jane Clifford, "French Drawings," *Arts Review* XXVII (7 March 1975), p. 121.
Weisberg, *Bonvin,* cat. no. 259.

Théodule Ribot

36 *The Cook Accountant*
 (Le Cuisinier comptable)

Oil on canvas, 18-1/2 x 15 inches (47 x 38 cm.).
Signed and dated lower left: T. Ribot 1862.
Marseille, Musée des Beaux-Arts.
Provenance. Deposited by the Société Artistique
des Bouches-du-Rhône, 1871.

The profession of the cook acquired new
dimensions in the nineteenth century. Cooks
were receiving increasing recognition and
responsibility, and their duties often in-
cluded supervision of the dining itself as well
as the preparation of elaborate dishes and
unusual menu accomplishments. Some re-
garded the cooking profession as a supreme
art embodying a scientific approach and
training based upon ancient traditions;
others interpreted the profession as a pleas-
ant necessity of life—a showmanship that
was as much enticement as it was fulfillment.

With an increased emphasis upon cooks,
the type of foods prepared by such specialists
was also modified. This was especially true
during the Second Empire and the Third
Republic, when the serving of individual
portions by waiters, rather than the tradi-
tional buffet or large-platter service became
popular in the many new restaurants.
Methods of preparation and the types of
food were modified to accommodate increas-
ing numbers of the middle class who were
dining out; such places usually featured sim-
pler foods that were known to appeal to a
variety of tastes.

Théodule Ribot recognized the increasing
popularity of cooks as a major visual theme
of contemporary life. Instead of concentrat-
ing on an outstanding single cook (e.g., the
famous Parisian chef Carême in the early
nineteenth century who attracted such a fol-
lowing because of his personality and culi-
nary successes), Ribot chose to depict the
kitchen process itself—those who carried
out the orders of the chef and completed the
daily tasks that made dining and restaurant
service possible.

Four of the five canvases that were ac-
cepted at Ribot's first Salon exhibit in 1861
used a kitchen theme to interpret the cook as
a hero of modern existence.[1] Ribot's interest
was in the male cooks of urban restaurants
and cafés, not the female domestic who
served in private homes. During the 1860s
when the popularity of his works increased,
Ribot depicted scenes of cooks preparing a
meal, taking a break on the back steps of a
restaurant, idly amusing the kitchen cats, or
intent upon completing the day's routine of
bookkeeping and accounting. Ribot's in-
terest in tonal painting can be discerned in
the varied shades of white and gray he
achieved in the uniform that distinguishes
his figures or the dimly lighted space in
which they are situated. Ribot may have
used his own son Germain as model (much
as he used his daughter Louise in other
works), since many of his young cooks have
similar facial features.

Occasionally, a canvas from Ribot's cook
series suggests a narrative. *The Cook
Accountant* shows a bemused young assist-
ant attempting to add up the day's receipts,
counting on his fingers and also taking into
consideration the pennies that have fallen to
the floor. The type of patron who purchased
such canvases is not known, although a
number of Ribot's series were widely exhib-
ited. In this particular case, the canvas was
secured by an art society from the prov-
inces, suggesting that Ribot's following was
widespread.

1. Paul Mantz, "Salon de 1865," *Gazette des
Beaux-Arts* XVIII (1865: 504-5. Another point
might also be considered in Ribot's depiction.
Theodore Zeldin to the author, 28 March 1980,
noted that Parisians complained of cooks spending
more time counting money than cooking; see
Théodore de Banville, "Les Restaurateurs," *Le
Gourmet Journal des Intérêts. Gastronomiques,*
18 July 1858, pp. 1-2.

36

THEMES OF LABOR
Industrialization

François Bonhommé

37A *Welsh Puddler from the First Formation of the Higher Staff— Fourchambault, 1839-40 (Puddleur gallois de la première formation du personnel chef— Fourchambault)*

Pen drawing, sepia; 5-5/8 x 2-7/8 inches (14.2 x 7.3 cm.). Signed lower right: B[e].

Jarville, Musée de l'Histoire du Fer.

Provenance. E. S. Auscher Collection. Purchased by the museum in 1972.

During the 1830s, new techniques in metallurgy modified the iron industry throughout France. The increasing number of English-style forges that produced iron and cast iron from coke resulted in more efficient production and better working conditions than the older forges, which still relied on wood to heat their furnaces.[1] These modernized forges became a genuine threat to the many smaller plants that could neither compete nor obtain financial backing from a middle class eager to invest their capital in innovative technology.[2]

One of the first iron mills to modernize was the forge at Fourchambault that had been founded in 1816. The English plan that was put into effect there under the guidance of Louis Boignes (1786-1838), president of the Royal Council of Art and Manufacture, brought about revitalization in the central section of France.[3] Proud of their achievement and eager to claim leadership over their competitors, the administrative council of Fourchambault agreed to commission a painting to commemorate their factory and its importance to the country. Recommendation of Paul Delaroche led the council to award the commission to a young contemporary artist, François Bonhommé.

In order to create an accurate painting, Bonhommé went to Fourchambault to study the forge, the processes, and the individual workers themselves. Of the finished paintings (perhaps several), *Vue d'une grande forge à l'anglaise* (Eglise Saint-Louis, Fourchambault) may have been shown at the 1840 Salon. It is didactic in format, extending from a portrayal of the directors of the factory in one section of the painting to a depiction of the machinery and workers in another.[4] In his preliminary drawings, Bonhommé was careful to note by label the many skilled workers transported from England. The study of the *Welsh Puddler*, gazing candidly at the viewer during his brief moment of respite, reveals an exactitude—apparent in all of Bonhommé's drawings—that was carefully transferred to the final oil painting.

1. Michelle Evrard and Patrick Le Nouënc. *La Représentation du travail: Mines, forges, usines,* exh. cat. (Le Creusot, 1978), p. 13.
2. For a discussion of the role of the bourgeoisie and capitalism see Patrick Le Nouëne, "'Les Soldats de l'Industrie,' de François Bonhommé: L'Idéologie d'un projet," *Les Réalismes et l'histoire de l'art, Histoire et Critique des Arts,* sommaire no. 4-5, May 1978, pp. 35-61.
3. J. F. Schnerb, "François Bonhommé," *Gazette des Beaux-Arts* 1 (January-February 1913): 20.
4. The painting was listed as no. 119 in the Salon catalog. Bonhommé's didactic manner followed a very specific plan; see Schnerb, "François Bonhommé," p. 16.

37A

37B

37C

Exhibited
1976, Jarville, Musée du Fer: François
Bonhommé dit le Forgeron, no cat.

Published
Gabriel P. Weisberg, "François Bonhommé and
Early Realist Images of Industrialization:
1830-1870," *Arts Magazine* 54 (April 1980), fig.
1.

François Bonhommé

37B *Employee with Shears, Workman—*
Fourchambault, 1839-40
(Employé aux cisailles, manoeuvre
Fourchambault)
Pen drawing, sepia; 5-3/8 x 3-3/8 inches (13.7 x 8.6
cm.). Signed lower middle: B^e.
Jarville, Musée de l'Histoire du Fer.
Provenance. E. S. Auscher Collection. Purchased
by the museum in 1972.

The images Bonhommé developed record
individuals vital to industrialization and in-
clude proprietors, visitors, and various
workers from the factory at Fourchambault.
Each of Bonhommé's figures was drawn
from direct observation and then emblematic-
ally arranged within the final composition to
symbolize specific types.[1] Whether he in-
tended his Salon painting or the individual
drawings to convey an additional meaning
beyond the documentation of historical fact
is not known. In the preparation of his pre-
liminary drawings, Bonhommé must also
have been formulating his vast plan for a
Soldiers of Industry publication [38]. The
Employee with Shears, Workman is only one
of several individuals whose separate tasks
and responsibilities made up the Fourcham-
bault oil painting. The preliminary pen draw-
ing shows a laborer holding the long shears
that cut the strips of molten metal. Each in-
dividual worker's task in sequence resulted
in the successful completion of the mill pro-
cess and intimated a harmony among classes
that might eventually—if extended outside
the factory setting—transform society.[2]

1. The emblematic scheme of the painting has
been identified by Le Nouëne, "'Les Soldats de
l'Industrie,'" p. 42.
2. Ibid., pp. 44-45. That this painting reflects
Bonhommé's political ideology is an interpretation
that must be approached with caution.

Exhibited
1976, Jarville, Musée du Fer: Bonhommé.

Published
Weisberg, "François Bonhommé and Images,"
fig. 2.

François Bonhommé

38 Frontispiece for *La Brichole*
(Frontispiece de *la Brichole*)
Pen and wash drawing, 6-1/4 x 9-7/16 inches (15.8
x 24 cm.). Signed and dated lower right: 1848 B^e.
Jarville, Musée de l'Histoire du Fer.
Provenance. E. S. Auscher Collection. Purchased
in 1972 from M. A. Fribourg.

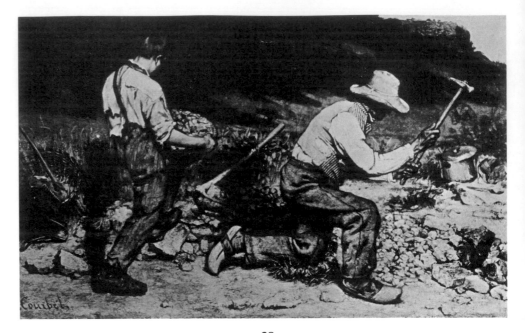

38a Gustave Courbet, *The Stonebreakers*.

François Bonhommé

37C *English Puddler from the First Forma-*
tion of the Higher Staff—
Fourchambault, 1839-40
(Puddleur anglais de la première for-
mation du personnel chef Fourcham-
bault)
Pen drawing, sepia; 5-7/8 x 2-3/4 inches (15 x 7
cm.). Signed lower right: B^e.
Jarville, Musée de l'Histoire du Fer.
Provenance. E. S. Auscher Collection. Purchased
by the museum in 1972.

Bonhommé prepared drawings for each of
the figures that he included in his finished
Salon painting. Working inside the factory,
he recorded the workers' poses, their dress,
and their concentration, capturing the mood
and detail of many distinctive types of work-
ers, such as the *English Puddler,* at their
task. Each outline drawing is exceptionally
small, suggesting that it could be easily
transferred without revision to the canvas in
the location most appropriate to the diagram-
matic scheme that Bonhommé used. In this
way, Bonhommé discerned the specific work
and the role of each individual within the
broader spectrum of types employed at
Fourchambault.

Exhibited
1976, Jarville, Musée du Fer: Bonhommé.

In addition to large-scale paintings and water
colors derived from industrial themes, Bon-
hommé also wanted to prepare books that
advocated the emergence and importance of
the worker in an industrialized society. His
volume dedicated to the "Soldiers of Indus-
try" was never published although he com-
pleted a series of drawings for the work, in-
cluding an elaborate frontispiece depicting
an industrialist juxtaposed with a group of
workers.

Similarly, Bonhommé may have intended
La Brichole as the frontispiece for a book on
child labor. Little information documents
this project, except the frontispiece itself,
which shows five "little men," possibly
from Germany, dressed and posed for the
odd, heavy tasks they performed in the
mines.[1] The young boy framing either side is
posed with a typical, long-handled tool near
the ore itself. In the foreground, another boy
stands with both arms braced, supporting a
large wheelbarrow, against which a fourth
figure is casually posed, eying the viewer,
but half-turned to indicate the oval frame
superimposed upon the setting of the four
boys.

Within the frame itself, which resembles a
letter in the word *bricole,* is a larger, com-
memorative portrait of a young child smok-
ing a pipe while resting a *bricole* (a leather
strap for carrying heavy loads) on his shoul-
ders. While in one sense *bricole* signifies the
carrying strap which the children working in
the mine used to lug heavy loads of ore or
coal, in another sense the word also con-
notes the odd jobs assigned to the young
laborers. The predominant central figure

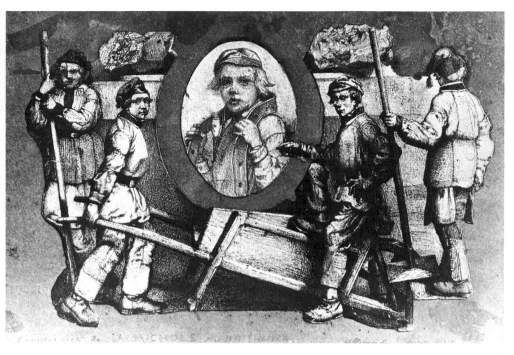

thus underscores the emblematic nature of the drawing and the play upon the word *bricole*.

It is likely that Bonhommé completed this drawing in the late 1840s. The friezelike arrangement of his figures is similar to the arrangement along the roadway in Gustave Courbet's *The Stonebreakers* (Figure 38a). The same angularity in movement and positioning of the figures is evident here, although it is the naiveté of Bonhommé's style that imposes a distinctive ruggedness upon his young workers of industry.

1. The spelling on the drawing is *brichole*. The penmanship styles discerned in the inscription suggest that Bonhommé may have received some assistance in completing this composition.

Exhibited
1976, Jarville, Musée du Fer: Bonhommé.

Published
Schnerb, "François Bonhommé," repr. p. 17.

38

39

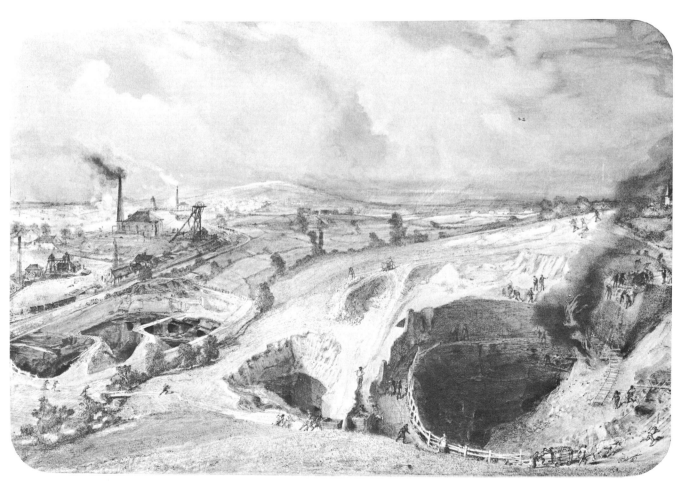

73

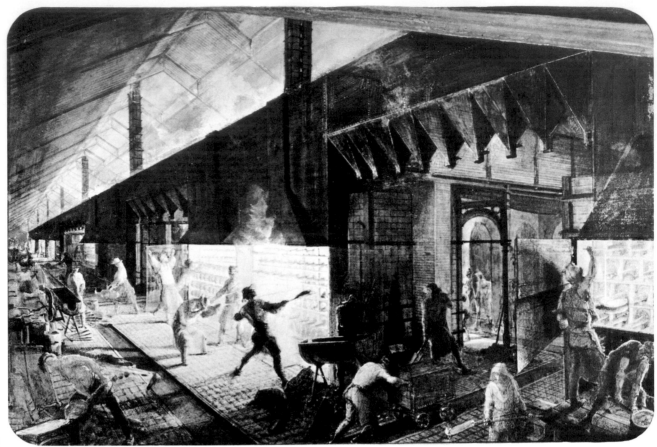

40

41

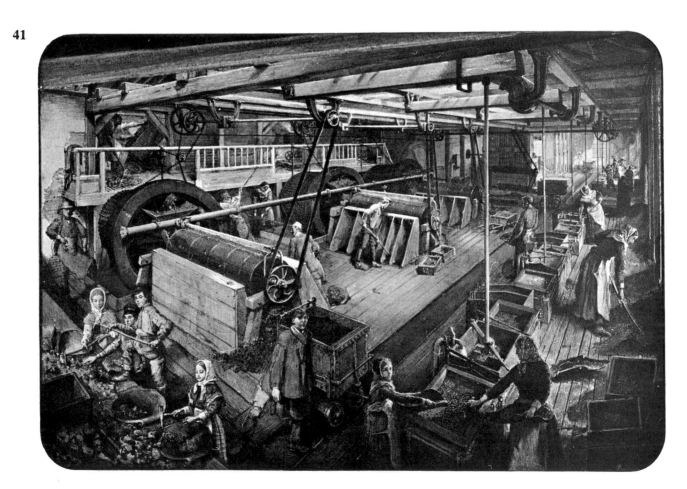

74

François Bonhommé

39 *Blanzy Mines: Open-Pit Mining at Lucy*
(Mines de Blanzy, exploitation à ciel
ouvert de Lucy)
Water color, 26-1/2 x 33-1/8 inches (57 x 84 cm.).
Signed and dated lower right: Bonhommé/1857.
Paris, Conservatoire National des Arts et
Métiers, Musée National des Techniques.
Provenance. Donated by the Minister of State to
the museum in 1862.

In 1862 Bonhommé wrote to the Ministry of
State listing in detail all the works he had
already exhibited at the Paris Salons be-
tween 1833 and 1861, reminding the head of
the art division of the many works he com-
pleted that had been placed in public build-
ings throughout Paris.[1] He had been well
supported by the Second Empire, and he
expressed the hope that the state would con-
tinue to purchase his works. Bonhommé's
success during the Second Empire was un-
doubtedly due to his ability to carefully re-
cord the rapid progress of France as an in-
dustrialized nation, and much of his recogni-
tion as an official recorder of the industrial
accomplishments of the empire must be at-
tributed to his style that combined "the pic-
turesque with the truth."[2]
 It was Bonhommé's ambition to record
the history of mining and the rapid expan-
sion of mining techniques and processes
(seen, for example, in his studies of Le
Creusot) that were occurring in many of the
regional areas throughout France. His let-
ters to the Ministry of State compared his
own endeavors with other artists who
specialized in specific images of labor, for
example, Joseph Vernet who did shipbuild-
ing scenes; Géricault who did studies of
horse-shoeing; Léopold Robert who re-
corded the activities of fishermen; or Gus-
tave Brion who depicted a locomotive haul-
ing wood. Bonhommé believed that all of
these painters had merely been captivated
by the Romantic qualities of such scenes.
Bonhommé saw himself as the only artist to
directly observe and confine his composi-
tions to the actual work—specifically, to the
activity of mining itself, and to the ma-
chines, the interiors of the mines, and the
factories that were included in an accurate
depiction of that work.[3]
 The water color *Blanzy Mines: Open-Pit*
Mining at Lucy was part of Bonhommé's
series dedicated to mining that was exhibited
at the 1857 Salon. It is an accurate descrip-
tion of the technological process that was
preempting man and his landscape in re-
gional France. The individuals here are
dwarfed by a panoramic perspective that
serves to encompass the belching chimneys
and a countryside drastically altered by
open-pit mining techniques. Despite the
ever-present threat of fire that has sent the
workers scurrying from one of the mines,
operations at the other mines continue un-

abated, for nothing can halt the newly
mechanized era.[4]

1. See François Bonhommé, 4 April 1862, dossier
40, F 21/120, Archives Nationales.
2. Ibid.
3. Ibid.
4. This water color shows coal extraction in its
primary phase—with pits open to the sky. The
pits here are shallow, indicating that only enough
coal was extracted for local consumption.

Exhibited
1857, Paris: Salon, cat. no. 273.

François Bonhommé

40 *Belgian and Silesian Ovens at the*
Factory of La Vieille Montagne
(Fours belges et fours silésiens de
l'usine de La Vieille Montagne)
Water color, 30-1/4 x 36-1/4 inches (76 x 91 cm.).
Paris, Conservatoire National des Arts et
Métiers, Musée National des Techniques.
Provenance. Purchased by the state 9 August
1862. Sent by the state to the museum in 1862.

When Bonhommé received the commission
from the government to do the murals at the
Ecole des Mines in 1851, he continued to
make water colors for themes that he in-
tended to include in the series or that he
might have seen as part of his vast scheme
for a history of ore extraction. Although he
was able to finish only two themes for the
history—one on the extraction and use of
iron, and another on zinc—plans for this un-
dertaking are found in a series of water col-
ors that the state purchased in 1862. These
water colors, which reveal Bonhommé's re-
markable grasp of the new technological
processes being utilized in France just prior
to the Franco-Prussian War, include a vast
panorama of Le Creusot [42] and two views
of the works at La Vieille Montagne from
the same region.
 Bonhommé's description of the processing
of the zinc ore at the *Belgian and Silesian*
Ovens at the Factory of La Vieille Mont-
agne, which had been exhibited at the 1861
Salon, was also among the water colors the
state purchased. As the raw ore was melted
down in the ovens, workers using long-
handled dippers transferred the liquid zinc
from the ovens into larger, standing troughs,
like the one depicted in the lower left corner.
The Mannerist quality that Bonhommé
achieved by the slightly elongated figures ef-
fectively intensifies the perspective here, al-
though the accuracy with which he detailed
their tasks and the degree to which he re-
corded all aspects of the machinery demon-
strate his Realist style.[1]

1. The rapidly receding perspective, borrowed
from late Renaissance prototypes, and the elon-
gated figures suggest that Bonhommé used art his-
torical references to strengthen the drama of his
scene.

Exhibited
1861, Paris: Salon, no. 321, with the following title
and description: *Histoire de la métallurgie—*
Fonderie de calamine: Vue intérieure d'une
halle de traitement des minerais préparés pour
la fonte—Fours belges, chambres de condensa-
tion des vapeurs de zinc. Travail des fondeurs.

François Bonhommé

41 *Workshop with Mechanical Sieves at the*
Factory of La Vieille Montagne
(Atelier des cribles à secousse de l'usine
de La Vieille Montagne)
Water color, 30 x 35-7/8 inches (76 x 91 cm.).
Signed lower right: Bonhommé.
Paris, Conservatoire National des Arts et
Métiers, Musée National des Techniques.
Provenance. Purchased by the state 9 August
1862. Sent by the state to the museum in 1862.

Among the water colors that the state
purchased from Bonhommé in 1862 was a
composition reproducing a scene that he had
completed earlier in oil for the Ecole des
Mines.[1] The factory interior entitled
Workshop with Mechanical Sieves shows the
steam-operated troughs (ore-buddles) that
washed and sorted the zinc before it was
taken to the ovens to be melted. To expedite
production, many of the workers who as-
sumed specific functions as engineers or
foremen (such as the figure at the left rear)
were brought in from Belgium and Ger-
many, already trained and experienced in
the operation of the new machinery. The
women and children working together in the
foreground were assigned the less-skilled
tasks—sorting ore on screens or splitting
larger chunks in readiness for the sorting and
washing cycle.
 Like his view of the Belgian-style foundry
[40], Bonhommé probably completed this
water color before the middle of 1859. In a
letter to the Directeur des Beaux-Arts that
year he referred to his drawings as the prod-
uct of "intensive study" and expressed the
hope that their purchase by the government
would provide him with additional assign-
ments from private industrialists.[2] When he
received no reply from the Directeur des
Beaux-Arts by August 1861, he wrote di-
rectly to Napoleon III, conceding that in
spite of the series of awards and official
commissions he had already received, this
appeal was his last resort. He acknowledged
the famous battles and courageous acts that
many artists chose to recount, but noted that
these same heroes, once they resumed their
jobs as foremen, engineers, or leaders of in-
dustry, were seldom glorified. He flattered
Napoleon, admitting that the emperor's
theory of industrial progress and advance-
ment had inspired his own desire to record
battles of men over nature and to recognize
the aspirations of industry for the betterment
of mankind. Napoleon's own concern for
workers[3] was further complemented by

Bonhommé's request for support in his endeavors to record and glorify the working class—a request which was realized in 1862 when the state finally purchased nine of his water colors for 3000 francs.[4]

1. The murals at the Ecole des Mines were destroyed sometime after 1900. A painting of the same subject is reproduced in Schnerb, "François Bonhommé," p. 23.
2. François Bonhommé, dossier 42, F 21/120, 7e série, Archives Nationales. See letter from Bonhommé, stamped at the time of its arrival on 8 August 1859.
3. Ibid., François Bonhommé to Emperor Napoleon III, 8 August 1861. Bonhommé's position during the Second Empire was overlooked in the 1978 *Second Empire* exhibition dedicated to this period.
4. Several were shown at the London exhibition in 1861. Chef des Beaux-Arts to François Bonhommé, 12 August 1862, noted that the water colors were to be purchased with frames. Because of the cost of framing these works, Bonhommé probably realized little profit from this official purchase.

Exhibited

1861, Paris: Salon, cat. no. 321, with the following title and description: *Histoire de la métallurgie —Laverie de calamine:* Vue intérieure d'une laverie mécanique mue par la vapeur; trummels de séparation, de classement; cribles à secousse. Travail des femmes et des enfants. Dessin des types allemands et belges choisis dans le personnel des ingénieurs, contre-maîtres, ouvriers, femmes et enfants d'un grand établissement métallurgique spécial au minerai de calamine dans les provinces rhénanes. Répétition des compositions peintes dans l'une des salles de l'Ecole des Mines.

François Bonhommé

42 *The Factories at Le Creusot (Usines du Creusot en 1848)*
Gouache on paper mounted on wood, 14-3/4 x 51-1/2 inches (37 x 1.30 cm.). Signed and dated lower right: Bonhommé 1855.
Paris, Private Collection.
Provenance. Given by the artist to the Schneider family.

Once in power, Napoleon determined to bring about sweeping changes and innovations—such as he had witnessed in England during his exile—that would make France a great industrial nation.[1] Inspired by the social philosophy of the Saint Simonists who advocated scientific organization and public control of the means of production, his own official policies became focused upon the need to increase production and to develop credit for the expansion of industry. Generous assistance to entrepreneurs, extension of the railway into the outlying regions, and establishment of the Free Trade agreement with other European nations (1860) were all directed toward the realization of a new, industrialized France. The Paris Fair in 1867 with its emphasis upon the newest of

machinery and industrial advances thus served to document and to celebrate the achievements of France in comparison with other nations.

Bonhommé exhibited two water colors at the Paris Fair. Both were views of the Schneider manufactory at Le Creusot, one he completed about 1857 and another finished almost ten years later, after the Free Trade treaty was in effect.[2] In his own way, Bonhommé thus participated in the celebration of the expansionist policies of Napoleon III, since the later painting—in contrast to its companion view—revealed the scope and magnitude that the Schneider works attained under Napoleon III.

Whether this painting may have been the earlier view exhibited at the Paris Fair is not known.[3] It does, however, document Bonhommé's close association with the Schneider manufactory during the same year that he received a third-class medal at the Paris Salon (1855). The publicity generated by the Salon award may have prompted his initial assignment from Eugène Schneider and resulted in a relationship—much like his commissions from Fourchambault—that continued throughout the Second Empire.[4]

Like the large views of Le Creusot completed for the Ecole des Mines, the water color *Factories at Le Creusot* documents the buildings and surrounding countryside in analytic detail. The smoke that moves upward from the active manufactory tends to drift over the large, flat plain, recording the encroachment of the industrial era upon the natural setting even though the plant has not yet grown to the size it would attain in 1866/67 [44]. The homes, the church, and the school already established indicate Schneider's concern for the well-being of his workers.[5] A water color of this size could not have been completed out-of-doors and must have involved a series of exacting, preliminary sketches made on location to achieve the reality of atmosphere and site that has already transformed the once-static view of the countryside.

1. Evrard and Le Nouëne, *La Représentation du travail,* pp. 17-18.
2. See *Explication des ouvrages de peinture . . . au Palais des Champs-Elysées, le 15 avril 1867* (Paris, 1867), p. 25, nos. 1634 and 1635. Both works were listed in the drawing section of the catalog.
3. There may, however, be no connection between the composition here and the work which appeared at the Paris Fair. *The Factories at Le Creusot* does not correspond completely with no. 1634 in the Salon catalog. Similarly, the early work from the Paris Fair was dated 1856—not 1855—although the possibility of an error in the catalog cannot be dismissed.
4. No letters or correspondence between Bonhommé and Schneider have been located to establish the relationship between the artist and his second private industrial patron.

5. In 1855 Schneider began modifications that included a sanitary water source (1862/63); a hospital (1863); and a new church (1864). For further information see *Le Creusot: Usine, ville, et environs—Guide du visiteur* (Le Creusot: G. Martet, n.d. [ca. 1890]).

Published
Weisberg, "François Bonhommé and Images," fig. 9.

François Bonhommé

43 *Coalpits and Clay Quarries at Montchanin (Houillères et carrières d'argile à Montchanin)*
Oil on canvas, 46-3/8 x 62-3/4 inches (117 x 158 cm.).
Montchanin, Mairie de Montchanin.
Provenance. Mr. Avril. Avril Collection sale. Gift of the Tuileries, ca. 1950.

Compositions that Bonhommé completed for private patrons (e.g., *Forge at Fourchambault*) often included a portrait of that individual within the industrial setting. *Coal Pits and Clay Quarries at Montchanin,* near Le Creusot, shows the industrialist Avril in the foreground, discussing the location of his mines with his colleagues, within a landscape that shelters remnants of the traditional pastoral setting, but that champions the new, vibrant industrial age. The small, fenced gardens still maintained at the left and the rustic chateau in the distance at the far right provide a serene contrast to the imposing steam-powered machinery and belching chimneys that now preempt the setting. In the broad plain beneath the mining area is a clay quarry and a series of structures in which the coal is prepared before it is transported out of the region on the nearby rails. At the far left, a number of railway cars lead to another mining area just visible in the distance.

Bonhommé's meticulously observed landscape provides a bird's-eye view of industrial transformation. The irreversible nature of progress substantiated within the panoramic landscape here (trees have been cleared, hills opened) was already forcing the flight of some Barbizon painters, thus endowing Bonhommé's image with additional significance for the 1850s.

Exhibited
1977/78, Le Creusot, Ecomusée de la Communauté Le Creusot-Montceau, Château de la Verrerie; Chalon-sur-Saône; Grenoble, Maison de la Culture: La Représentation du travail: Mines, forges, usines. Catalog by Michelle Evrard and Patrick Le Nouëne.

Published
Weisberg, "François Bonhommé and Images," fig. 10.

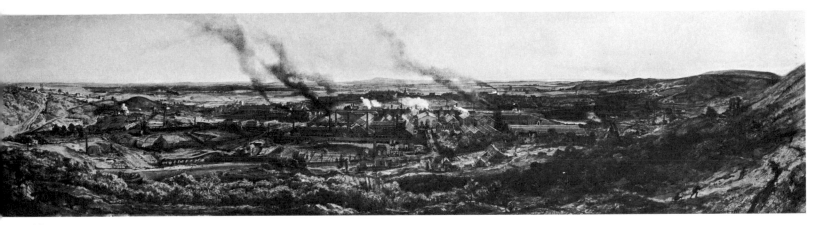

42

43

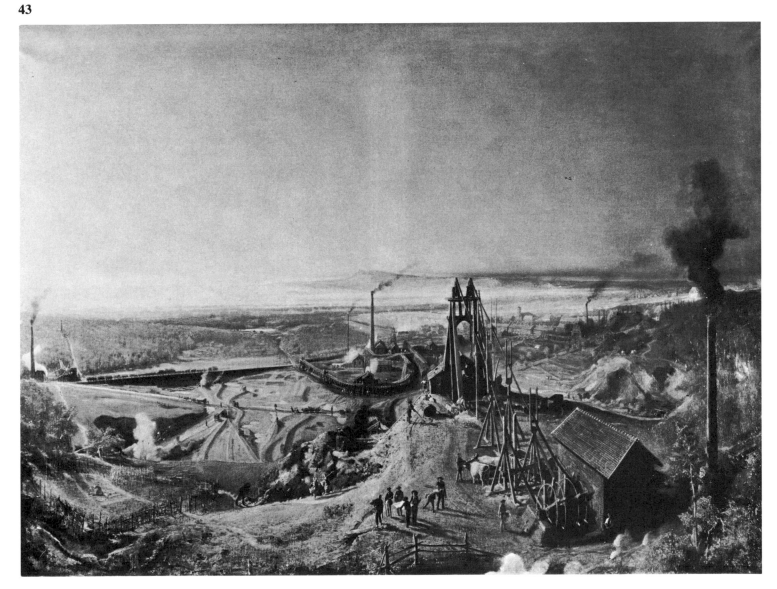

François Bonhommé

44 *St. Pierre and St. Paul Mines at Le Creusot*
(Les Puits St. Pierre et St. Paul au Creusot)

China ink and gouache on paper, 13-7/8 x 19 inches (35 x 48 cm.). Signed and dated lower right: Bonhommé 1866. Inscription at the left: Les Puits St. Pierre et St. Paul du Creuzot [Le Creusot was often spelled with a *z* in the nineteenth century.] (état de 1866) lavage, criblage et triage du charbon. Départ des premières locomotives du Great Eastern Railway pour l'Angleterre.
Paris, Private Collection.

Provenance. The artist to the Schneider family, Le Creusot.

When Bonhommé did his first studies of Le Creusot in the mid-1850s [42], he recorded the mining activity in this region. By 1866, when he completed his drawing of the *St. Pierre and St. Paul Mines,* the works at Le Creusot had been expanded to include not only the extraction of coal and iron ore but also the manufacture of machinery, cast iron, armaments (cannon), and by the mid-1860s the production of locomotives as well.[1]

Capitalizing on the ready availability of credit and the Free Trade policy under Napoleon III, Eugène Schneider (1805-1875) and his brother Adolphe[2] transformed the small manufactory at Le Creusot into one of the most important industrial complexes in France. *St. Pierre and St. Paul Mines* documents the extraction of the coal, its washing and sorting, and its preparation for transport in horse-drawn cars.[3] The line of new locomotives that Bonhommé has depicted being readied for shipment in the foreground were the first French engines to be delivered to the Great Eastern Railway in England, marking France's successful competition with foreign markets in the manufacture of heavy machinery. Therefore, Bonhommé's image is as much a record of this specific event as a document of the daily operations at Le Creusot.

1. For further information see Joseph-Antoine Roy, *Histoire de la famille Schneider et du Creusot* (Paris: Marcel Rivière et Cie., 1962).
2. Adolphe was killed in a riding accident in 1845.
3. No finished paintings have been located which correspond to this preparatory study. Exactly when Bonhommé began his assignments with the Schneider family has not been determined, but he is known to have completed a series of preliminary studies (in ink and water color) that may later have been transferred to oil paintings of Schneider's plant and workers.

Published
Weisberg, "François Bonhommé and Images," fig. 11.

44

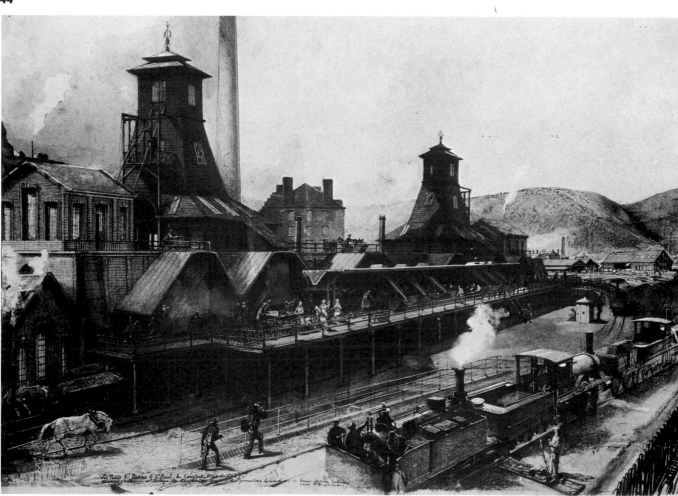

François Bonhommé

45 *The Master Miner Galoisy*
(Le Maître-mineur Galoisy)

Wash drawing, 6-5/8 x 5 inches (16.9 x 12.7 cm.).
Signed and dated lower right: Creuzot 1866/Bé.
Inscription lower left: Le Maître mineur Galoisy.
Jarville, Musée de Histoire du Fer.
Provenance. E. S. Auscher Collection. Purchased in 1972 from M. A. Fribourg.

Just as he made a series of sketches in preparation for his painting of the Fourchambault works, Bonhommé studied the different types of workers at Le Creusot, recording their actions and their responsibilities. Each figure was drawn from life and described in the dress and with the equipment appropriate to his work. Some workers were portrayed in semi-official poses, such as *The Master Miner Galoisy,* who has been placed near the coal carrier, with his foot raised on the wheel, his left arm resting on the carrier itself, his lantern ready for the descent into the mines. The date and the small inscription identifying each figure provides an accurate record of a number of specific individuals who worked at Le Creusot during 1866.

Exhibited
1976, Jarville, Musée du Fer: Bonhommé.

François Bonhommé

46 *La Brichole—German Student*
(La Brichole . . . élève allemand)

Gouache and wash drawing, 7-1/4 x 4-3/4 inches (18.4 x 12.2 cm.). Signed lower right: Bé/La Brichole. Inscription: Elève Allemand.
Jarville, Musée de l'Histoire du Fer.
Provenance. E. S. Auscher Collection. Purchased in 1972 from M. A . Fribourg.

As the title *La Brichole* suggests, the numbers of young children hired to work in the mines were a ready source of cheap, unskilled labor for a variety of odd jobs imposed by the space limitations within the mines. The young boy from Germany depicted by Bonhommé appears unusually well-dressed[1] in spite of the type of labor indicated by the hammer and the lamp he is holding. His formal posture, casually resting his arm against the raw ore, suggests that he has been given permission to pose for Bonhommé, so that the artist's record of the various types of workers observed at Le Creusot would be as accurate and complete as possible.

1. Whether the uniform is a cast-off, an indication of his position in the mine, or an attire peculiar to his own German background is not known.

Exhibited
1976, Jarville, Musée du Fer: Bonhommé.

45

46

François Bonhommé

47 *The Subterranean World—Lowering a Horse into the Mine (Le Creusot) (Le Monde souterrain. Descente d'un cheval dans la mine, Le Creusot)*

Gouache and wash drawing, 9-1/8 x 6-5/16 inches (23.2 x 16.1 cm.). Signed lower right: B^e; dated lower left: Le Creuzot 1866.
Jarville, Musée de l'Histoire du Fer.
Provenance. E. S. Auscher Collection. Purchased in 1972 from M. A. Fribourg.

During the late 1850s, Bonhommé became associated with the mining activities carried out at Le Creusot. As an official artist for the Schneider family [42, 44], Bonhommé recorded all aspects of mining activity. The small drawing *The Subterranean World —Lowering a Horse into the Mine (Le Creusot),* showing a view of the enclosure over the mine shaft, documents the means by which horses were lowered into the mines to pull the heavy carts of coal. To prevent shock, the horses were tied and blindfolded during the fearful descent.

Exhibited
1976, Jarville, Musée du Fer: Bonhommé.

Published
Schnerb, "François Bonhommé," repr. p. 21.

47

THEMES OF LABOR
Farm and Marketplace

Louis Cabat

48 *Farm in Normandy (Ferme en Normandie)*

Oil on canvas, 12-3/4 x 21-3/4 inches (32 x 55 cm.). Signed lower left: Cabat.
Nantes, Musée des Beaux-Arts.
Provenance. Purchased in 1849 from the artist for 450 francs.

Well into the middle of the nineteenth century, the peasant in the rural sections of France continued to observe a life style that had been maintained for centuries virtually without change. He tilled the soil according to seasonal planting and harvesting, living as his ancestors before him, in a simple dwelling constructed from readily available, local materials. Even at mid-century, regional customs and illiteracy continued to isolate the peasant, although the life he led was romanticized by such writers as George Sand and certain artists attracted by the picturesqueness of "life on the farm."[1] Others, especially the leaders of the Realist movement (e.g., Millet and Courbet), perceived the oppressed desolation of the peasant confined to his timeless labors, unable to overcome his meager existence.

While Louis Cabat was involved with the development of Realism in its earliest phases, by the late 1840s, when *Farm in Normandy* was completed, he had already modified his work to conform to the dictates of an official style. His composition shows a typical rural homestead in Normandy, with its large thatched-roof cottage, connecting workshed, and large poultry yard with a well nearby for water and a trough for feeding the farm animals. Cabat's interest in rustic peasant scenes and his careful observations from earlier trips to Normandy are retained in this broad, panoramic vista of rural life that avoids any reference to the individual peasant or his plight. The genre details that he has suffused in light and atmosphere convey only the heritage of the Low Countries and a picturesque view of country life.

1. Theodore Zeldin, *France: 1848-1945,* vol. 1, *Ambition, Love and Politics* (Oxford: Clarendon Press, 1973), p. 133.

Published
Marcel Nicolle, *Catalogue, Musée des Beaux-Arts* (Nantes, 1913), cat. no. 851.

48

Jean François Millet

49 *Harvesters Resting* or
The Harvesters' Meal
(Le Repas des moissonneurs)

Oil on canvas, 27-1/8 x 50-3/4 inches (69 x 129 cm.). Signed and dated lower right: J. F. Millet 1853.

Museum of Fine Arts, Boston, Gift of Mrs. Martin Brimmer.

Provenance. Purchased at the Paris Salon of 1853 by Martin Brimmer. Given to the Museum of Fine Arts, Boston, by Mrs. Martin Brimmer, 1906.

The Harvesters Resting was regarded as the most important of the three paintings Jean François Millet exhibited at the 1853 Paris Salon.[1] It became the subject of avid discussions among the critics, and it was unanimously awarded a second-class medal. Even the academic critics, who were usually severe and disapproving in their appraisal of Millet's work, were enthusiastic. Paul de Saint-Victor described the composition as "the idyls of Homer translated into dialect."[2] The primitive strength of the figures, the ugliness of some of the field hands (according to Saint-Victor) even suggested an influence from Egyptian art. Staunch Millet

49

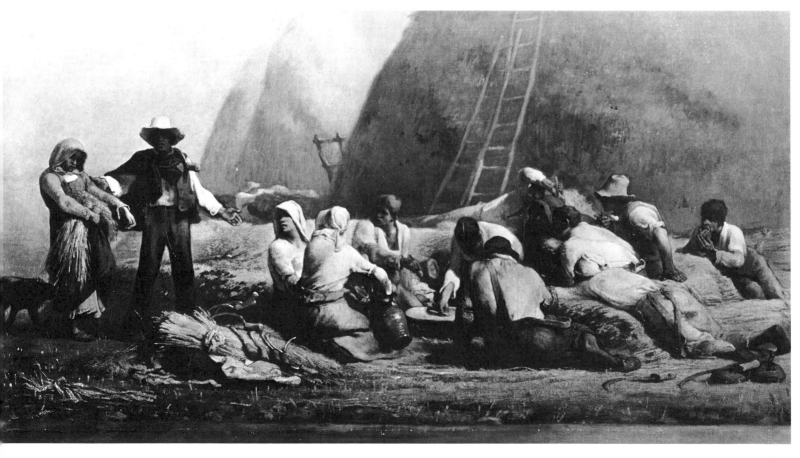

supporters, like Théophile Gautier, also noted Millet's primitivism, but attributed a lack of detail and simplification to the directness of his style. Gautier compared Millet's powerful, dominant figures with the sculpture of Michelangelo.[3] Thus, more than many of Millet's paintings up to this time, the canvas revealed his indebtedness to the grand tradition in painting and sculpture—an aspect which especially gratified those critics eager to find a contemporary work based on a solid foundation from the past.

More evident even than the influence of Michelangelo is Millet's dependence upon Poussin.[4] He derived his arrangement of the field hands on the right from Poussin's composition of the *Last Supper*. The influence of other traditional masters is also apparent: the arrangement of the standing figures on the left in Millet's work echoes Dürer and Rubens; the central group recalls sixteenth- and seventeenth-century painters. Even the theme itself is traditional, and the circle of harvesters similar enough to Breugel's *Harvest* (Metropolitan Museum of Art, New York) to document Millet's close affinity to the Northern artist.[5] Millet may also have studied Léopold Robert's *Arrival of the Harvesters* (Louvre), which had been part of the Louvre collection since it was first exhibited in 1831. Millet's interest in Robert, which was shared by many of the early Realists (e.g., Jules Breton [50]), also links this work with a contemporary Romantic painter whose interests reflected an earlier master.

The Harvesters Resting is significant for another reason. It documents Millet's shift from a strictly religious composition to an integration of this intent within a traditional theme. Millet had intended to entitle this painting Ruth and Boaz, but after he completed the figures in contemporary dress and by the time of the Salon itself, he changed the definitive title. Even though the critics were quick to notice the relationship between this composition and the biblical text, Millet's modification of the religious significance classifies his work as an observation of a common rural event and the customary break in the day's work. Like Millet's *Angelus* (ca. 1855-57),[6] in which he at first intended to depict an angel hovering over the two praying field laborers, the acknowledgment of the biblical source in the *Harvesters* remains less apparent than the field theme itself.

1. The other paintings exhibited in 1853 were *Tondeuse de moutons* and *Un Berger, effet de soir.* Because all three works were purchased by Bostonians, Millet's reputation was established in the United States at an early date.

2. Paul de Saint-Victor, as quoted in Robert L. Herbert, *Jean-François Millet,* exh. cat. (Paris: Editions des Musées Nationaux, 1975), p. 95.

3. Théophile Gautier, as quoted in Herbert, *Millet,* p. 95.

4. Ibid. Herbert notes the relationship between the Sacrament paintings by Millet and Poussin in the collection of Lord Ellesmere.

5. For further information about this relationship see Margaret Ann Sambi, "Jean-François Millet and Mid-Nineteenth-Century Revivals" (M.A. thesis, University of Cincinnati, 1974), especially the chapter on Millet and the Breugel revival. More research is needed to locate the earliest articles that note the importance of Breugel in the nineteenth century.

6. This drawing, which the author saw several years ago, was preserved in a collection owned by the daughter of Etienne Moreau-Nélaton. Its present location is unknown.

Exhibited

1853, Paris: Salon, no. 857.
1854, Boston, Athenaeum: Twenty-seventh Exhibition, no. 120.
1859, Boston, Athenaeum: Thirty-third Exhibition, no. 166.
1860, Boston, Athenaeum: Thirty-fourth Exhibition, no. 71.
1866, Boston, Allston Club: First Exhibition, no. 21.
1945, Andover (Mass.), Addison Gallery. no cat.
1949, Fort Worth (Texas): Fort Worth Centennial, no. 5, repr.
1950, Los Angeles (Calif.) County Fair Association: Masters of Art, 1790-1950, not numbered, repr.
1959, Houston (Texas), Museum of Fine Arts: Corot and His Contemporaries.
1963, Hartford (Conn.), Wadsworth Atheneum: Harvest of Plenty.
1970, Tokyo, Kyoto, Fukuoka: Jean-François Millet et ses amis.
1975/76, Paris, Grand Palais: Jean-François Millet.

Published

Salons (Paris, 1853), see J. Arnoux, L. Clément-Ris, H. Delaborde, Théophile Gautier, Paul de Saint-Victor, C. Tillot.
P. L. Couturier, *Millet et Corot* (Saint-Quentin, 1876).
E. Wheelwright, "Personal Recollections of Jean-François Millet," *Atlantic Monthly* 38 (September 1876): 257-76.
E. Strahan, *Art Treasures of America,* 3 vols. (Philadelphia, 1879/80).
Alfred Sensier and Paul Mantz, *La Vie et l'oeuvre de Jean-François Millet* (Paris, 1881).
H. Knowlton, *William Morris Hunts Talks on Art* (Boston, 1884).
E. Durand-Greville, "La Peinture aux Etats-Unis," *Gazette des Beaux-Arts* XXXVI (July 1887): 65-75.
C. H. Stranahan, *A History of French Painting* (New York, 1888).
Jules Breton, *La Vie d'un artiste,* English ed. (New York, 1890), pp. 224-25.
W. J. Mollett, *The Painters of Barbizon* (London and New York, 1890).
D. C. Thomson, *The Barbizon School of Painters* (London and New York, 1890), p. 226.
Anonymous [Bénézit-Constant], *Le Livre d'or de J. F. Millet par un ancien ami* (Paris, 1891).
J. M. Cartwright, *Jean-François Millet: His Life and Letters* (London, 1896).
H. Naegely, *J. F. Millet and Rustic Art* (London, 1898), p. 73.
Jules Breton, *Nos Peintres du siècle* (Paris, 1899), pp. 150-52.
W. Gensel, *Millet und Rousseau* (Bielefedl and Leipzig, 1902), p.38.
H. Marcel, *J.-F. Millet* (Paris, 1903).
Arsène Alexandre, Frederick Keppel, and C. J. Holme, *Corot and Millet,* special no., *Studio,* 1902-3.
N. Peacock, *Millet* (London, 1905).
A. Tomson, *Jean François Millet and the Barbizon School* (London, 1905).
J. Cain, *Millet* (Paris, n.d.).
R. J. Wickenden, "Millet's Drawings in the Museum of Fine Arts," *Print Collector's Quarterly* 4 (1914): 3-30.
L. M. Bryant, *What Pictures to See in America* (New York, 1915).
Etienne Moreau-Nélaton, *Millet, raconté par lui-même,* 3 vols. (Paris, 1921), 1: 99, 100, 104-5, 110-14, fig. 86; 2: 1, 122; 3: 115.
P. Gsell, *Millet* (Paris, 1928).
Museum of Fine Arts, Boston, cat. (Boston, 1932), repr.
A. Tabarant, *La Vie artistique au temps de Baudelaire* (Paris, 1942), p. 200.
London, Aldeburgh, Cardiff: *Drawings by Jean François Millet,* exh. cat. (1956).
Robert Herbert, "Millet Reconsidered," *Museum Studies* (Chicago, 1966) I: 29-65.
Robert L. Herbert, "City vs. Country: The Rural Image in French Painting from Millet to Gauguin," *Artforum,* 8 February 1970, pp. 44-55.
W. Whitehill, *Museum of Fine Arts, Boston: A Centennial History* (Cambridge, Mass., 1970), 1: 370.
Jean Bouret, *L'Ecole de Barbizon et le paysage français au XIXe siècle* (Neuchâtel, Suisse: Editions Ides et Calendes, 1972), p. 177, col. repr.
Herbert, *Millet,* pp. 95-96.

Jules Breton

50 *The Gleaners*

Oil on canvas, 36-1/2 x 54-1/4 inches (92.7 x 137.8 cm.). Signed and dated lower left: Jules Breton 1854.

Dublin, National Gallery of Ireland.

Provenance. Collection of Sir Alfred Chester Beatty. Given to Irish nation, 1950. Transferred to National Gallery, Ireland, 1978.

The success of his exhibition of *The Petite Glaneuse* in Brussels inspired Breton to develop a much larger and more intricate composition of the same familiar activity. When he returned home in 1854 Breton began working on "a more complete scene of poor women, young girls and boys" gleaning the remnants of the wheat harvest—a scene he had witnessed many times in Courrières.[1] His earliest sketches [50A, 50B] demonstrate the care with which he prepared each of the many figures in his arrangement, and the final canvas represented the most complex composition he had yet attempted. Of the three paintings Breton exhibited at the 1855 Salon, *The Gleaners* was the work favored by the critics and, because of this, he was awarded the first of his Salon prizes, a third-class medal.

Aside from Breton's own personal interests and the biblical significance of the

theme itself, the choice of *The Gleaners* appeared at an opportune moment in the nineteenth century. The time-honored tradition of the gleaner was itself under question. In 1854 the rights of the gleaners as opposed to a firm rural code was debated in the French Senate. The question itself was not resolved until April 1856, but the problems surrounding the tradition of gleaning were discussed in the press and in parliamentary debate.[2] The practice of gleaning dated back to the origins of the country, but the controversy concerning the gleaners had recurred with growing frequency since the eighteenth century.[3] On the one hand, landowners objected to gleaning as an infringement of their own personal property, feeling that the practice encouraged the poor to steal as much as they could under the protection and pretext of fulfilling "inalienable rights." On the other side, traditionalists recognized the benefits of gleaning, feeling that outlawing the custom would undermine the oppressed and deny a "basic patrimony of the poor."[4]

The rights of the gleaners were upheld in 1856 (as they had been several times earlier), but this time the growing number of landowners were also placated in some of their demands. Even though agrarian reform was still in its infancy, the issue of gleaning actually hastened mechanization, for the rights of private landholders could not coexist with feudal doctrines.

During the 1850s the official government policy required that gleaning be done only by hand; that the activity take place only in non-enclosed fields; and that gleaning occur only between dawn and dusk (not into the evening hours).[5] In addition, gleaners were permitted to enter a given field only after the entire harvest had been gathered—a delay that assured supervision by local authorities against any encroachments by the gleaners. Without such a stipulation, gleaners might have mingled with the harvesters or worked the areas where the sheaves were already stacked, making it impossible for local authorities to police the charitable activity or

to eliminate the theft of the crop already secured.

The types of individuals who were entitled to glean, however, remained unresolved. In general, the right of gleaning was reserved for the poor, the handicapped, and women and young children. It was left to the *garde-champêtre* ("field-keeper") stationed in the midst of the gleaners to enforce these restrictions, and to prevent able-bodied men from entering the grain fields. In some provincial areas, however, gleaning was still observed as a traditional communal activity. At the close of the harvest, villagers who wished to participate were permitted in all the open fields. Those who worked quickly or who had several younger relatives working with them could gather enough to pay for a few pleasures beyond mere subsistence, and even "sufficient to provide girls with Sunday dresses." But gleaning was hard work, and the gleanings were becoming less plentiful, for the growing number of small landowners were more diligent when they

50

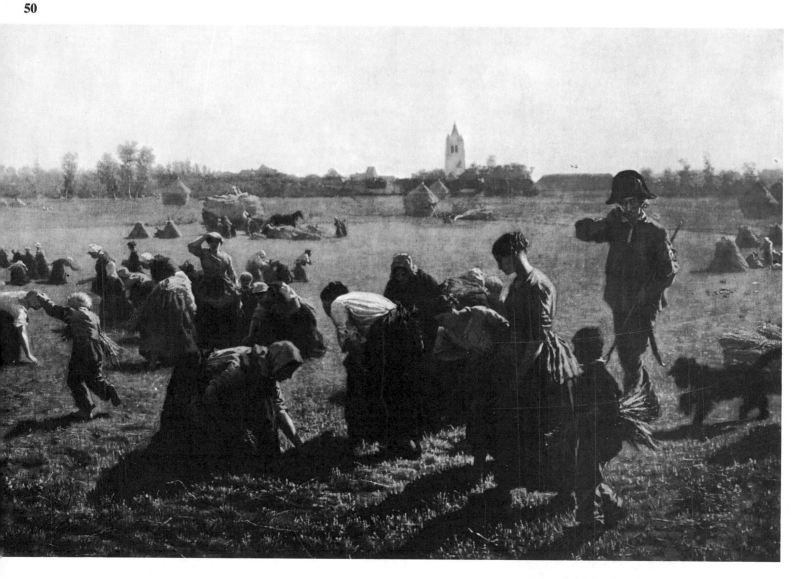

harvested their own crops. Thus, the collective approach gradually gave way as private landowners increased; more and more fields were closed to gleaning, and communal gleaning from an open parcel of land declined.[6]

Breton's composition shows several members of different families busily at work, while some of their small children frolic about in the fields. The atmosphere is free of anxiety or hardship, and it is obvious that the industrious wives and families working here under the watchful eye of the *garde-champêtre* and his faithful dog are gleaning for the extra benefits it will provide. The haywagon in the background and the resting harvesters at the right indicate that the gleaners have been admitted before the field is completely harvested and that the time-honored tradition of these particular

51

gleaners poses no threat to either the harvesters or the landlord.

The peaceful atmosphere which dominates Breton's scene appealed to the Salon critics and jury, and they acknowledged the classic nobility Breton had conferred upon the tradition. His ability to capture the subtle movement of workers, the varied poses of his models, and a naturalness based on observation of light, atmosphere, and harmonious balance of complex groupings marked him as an official painter of the fields.

The young woman given the position of honor in the foreground, near the small boy with the sheaves, is Breton's future wife Elodie. He has portrayed her as one of the villagers, already participating in the communal life of Courrières.[7] Her stately pose exemplifies the quiet harmony and dignity of the traditional field activity.

Breton was one of the first of the nineteenth-century painters to treat the theme of gleaners. Jean François Millet, who also began painting gleaners in the early 1850s, must have known about Breton's composition, but Breton should be credited with being the first to exhibit a large-scale painting of this theme at the Salon.[8]

1. Jules Breton, La Vie d'un artiste (Paris: Alphonse Lemerre, 1890), p. 225.

2. Paul Degrully, Le Droit de glanage, grapillage, ratelage, chaumage, et sarclage patrimoine des pauvres (Paris: V. Giard et E. Brière, 1912), pp. 121 ff.

3. Ibid., pp. 54 ff.

4. Ibid., p. 121.

5. Ibid. It was thought that gleaning at night would only encourage dishonesty.

6. Marc Bloch, French Rural History: An Essay on Its Basic Characteristics (Berkeley and Los Angeles: University of California Press, 1966), pp. 22 ff. See also Degrully, Le Droit, pp. 58 ff, for a discussion of collective possession as an aspect of the eighteenth century. In many provincial regions of France these traditions of "community" action continued without change even at the middle of the nineteenth century.

7. Breton met Elodie in the mid-1840s. A small study dated 1851, in the possession of the Breton family, documents Breton's use of Elodie as a model at an early date.

8. For further discussion, see Herbert, Millet, pp. 101-3. Breton's painting did not engender the critical attacks that were directed at Millet's Gleaners in 1857.

Exhibited

1855, Paris: Exposition Universelle, cat. no. 2628 (listed as Les Glaneuses; Courrières [Pas-de-Calais]).

Jules Breton

50A Study for *The Gleaners* (figure in center foreground)

Oil on cardboard, 9-3/4 x 11-5/8 inches (24.8 x 29.5 cm.). Signed and dated lower right: J. Breton, 1854.
France, Private Collection.
Provenance. Descendants of Jules Breton.

At the close of the 1853 Salon, Breton had returned to Courrières, where he dedicated his career to studies of rural activity. His growing interest in agrarian life and the toilers of his homeland led him to do a series of oil sketches in preparation for *The Gleaners* [50]. Working directly from models he observed in the open fields, Breton completed a number of small oil studies that capture various figures—often wearing a traditional hood and apron—collecting the remaining grain from the wheat fields. Resolving the effects of brilliant illumination by moderating his shadows and relying upon general massing of his tones to define the shape of a field laborer, Breton thus instinctively evoked a geometric abstraction of his model. From this traditional *ébauche* stage which generalized form, Breton was then able to rearrange and group his images in the larger composition.

Jules Breton

50B Study for *The Gleaners* (figure in the middle-distance at the left)

Oil on cardboard, 11-7/8 x 9-1/4 inches (30.2 x 23.5 cm.). Signed lower right: Jules Breton.
France, Private Collection.
Provenance. Descendants of Jules Breton.

The existence of an oil sketch depicting an isolated gleaner bent to her task amid the field of golden wheat can be identified in the middle-ground of the final composition of *The Gleaners,* suggesting that Breton must have prepared detailed studies for many of the figures.[1] The brilliance reflected off the white of her cap and the illumination dissolving against the folds of her skirt reveal Breton's growing sensitivity to the effects of light. In the final canvas, the clothing of the heavy-set woman was altered to a white blouse more appropriate for a field worker in the heat of the day.

1. Only two sketches for this painting have been found. It is possible, however, that others were done. They suggest the importance of the *ébauche* in the evolution of a major painting; see Albert Boime, *The Academy and French Painting in the Nineteenth Century* (London: Phaidon Press, 1972).

Jean François Millet

51 Study for the *Gleaners,* or *Summer*

Oil on canvas, 15 x 11-5/8 inches (38 x 29.5 cm.), ca. 1852/53. Signed bottom center: Jean François Millet.
New York, Mrs. John D. Rockefeller 3rd.
Provenance. Purchased from the artist by Alfred Feydeau, Paris, before February 1853. Alfred Sensier until 1873. Ernest Hoschede Collection, purchased from Hôtel Drouot, 20 April 1875, cat. no. 54 repr. Prince Dutz. Tretiakoff. Defoer (Georges Petit, 22 May 1886, cat. no. 29). Willy Blumenthal. Mme. W. Blumenthal. M. et Mme. L. C. Cotnareanu? Palais Galliera, 1 December 1960, cat no. 209, repr.

Jean François Millet began working on the theme of the *Gleaners* as early as 1850/51 in a series of drawings and small paintings.[1] While many of these early works were inspired by his observation of peasants working in the fields, Millet had another objective in mind. He wanted to create a series of compositions in which the labor of the fields at a specific time of the year could symbolize one of the four seasons, in this case, summer.

The small painting entitled *Gleaners (Summer),* thought to have been executed after Millet finished his large *Gleaners* (Musée du Louvre), was actually completed in 1853 as part of four works for one of the artist's principal patrons, Alfred Feydeau. By 30 March 1853 Alfred Sensier wrote to Millet that Feydeau had received two paintings from the projected series and that he was "quite happy with the *Gleaners*. . . ."[2] The series demonstrates Millet's early awareness of the the theme, but also reveals he had not yet firmly utilized the theme with all of its social implications. This was to occur later, after he had seen Jules Breton's impressive *Gleaners* [50] at the 1855 Salon, when he became captivated by the social implications of gleaning and the impact such an image could have on the Salon audience.

1. For some of these drawings see Herbert, *Millet,* cat. nos. 99-101.

2. Quoted by Herbert, *Millet,* p. 148. Herbert makes a careful study of the evolution of the series for Feydeau and places the theme of the gleaners within the context of the evolution of Millet's work. The allegorical basis of this early painting and its delicate tones are more suggestive of the eighteenth century.

Exhibited

1887, Paris, Ecole des Beaux-Arts, no. 31.
1892, Paris, Galerie Georges Petit: Cent chefs-d'oeuvre des écoles françaises et étrangères.
1975, Paris: Jean François Millet, cat. no. 102.
1978, Minneapolis: Millet's Gleaners, cat. no. 12.
1980, Tokyo, Kobe, Sapporo, Hiroshima, Kitayushu: Millet, Corot and the School of Barbizon in Japan.

Published

Yuzo Iida, *Millet* (Japan: Kodansha Ltd., forthcoming).

Jules Breton

52 *The Recall of the Gleaners*
(Le Rappel des glaneuses)

Oil on canvas, 35-7/8 x 69-7/8 inches (90 x 176 cm.). Signed and dated lower right: Jules Breton Courrières,/1859.

Arras, Musée des Beaux-Arts.

Provenance. Purchased by the Emperor at the 1859 Salon for 8000 francs. Given to the Musées Impériaux for the Luxembourg Museum in 1862, entering the Luxembourg in 1862. Transferred to the Louvre 21 February 1920. Deposited at the Museum in Arras 20 November 1926.

Of the paintings completed in the 1850s dedicated to the re-creation of a work cycle, *The Recall of the Gleaners* was Jules Breton's most famous. Appearing two years after Jean François Millet's *Gleaners* (Musée du Louvre), Breton's composition received favorable attention at the 1859 Salon from public and critics alike. The canvas was so highly regarded that it was placed in the *Salon carré,* a singular honor for a Salon entry, and Breton was awarded a first-class medal. *The Recall of the Gleaners* was purchased by the emperor at the Salon, exhibited at the Luxembourg Museum in 1862, at the Paris Fair in 1867, and the Vienna Fair in 1873, ostensibly because it provided an accurate and sympathetic response to the traditions of field labor. The fervent support by art critics for this canvas, more than any other work Breton painted, established him as the foremost artist of genre scenes in France.[1]

Breton had used the theme of the gleaners before, in a small, unlocated canvas in 1853 and, later, in the large-scale *Gleaners,* 1855 [50]—both of which focused upon field laborers at midday. His *Recall of the Gleaners,* however, depicted the orderly departure of the gleaners at the end of the long workday. Although based upon observation, Breton's depiction conveyed the privilege of the tradition, and bestowed a stoic dignity to the irregular procession of women gathering their final sheaves and departing from the fields.[2]

This use of the theme was inspired during a trip to Marlotte where Breton observed a peasant returning from the fields at dusk.[3] Instead of focusing his large composition on one field worker, however, Breton selected a variety of types, portraying very young as well as elderly women dutifully withdrawing from the field at the call of the *garde-champêtre* (seen leaning against the field marker at the left).

The acclaim Breton received as a result of *The Recall of the Gleaners* and his response to this success is recorded in letters written to his young wife Elodie who remained in Courrières to await the birth of their first

The author is indebted to Françoise Maison for some information in this entry and for the location of some bibliographic material on *The Recall of the Gleaners.*

child.[4] Each Salon review increased Breton's excitement and he saved the articles not only as testimony of his achievement but to keep Elodie and his relatives in Courrières informed.[5] Breton visited some of the critics personally to thank them for supporting his work and also to learn more about their views on art. It was during one of these discussions that the critic Maxime du Camp, who had referred to Breton as France's first genre painter, encouraged Breton to establish a purely French style of painting that would mirror the life of France and the traditions of the nation.[6]

In addition, Breton was nominated for a medal of honor, a recognition that received the support of such diverse artists as Eugène Delacroix, the dean of the Romantic movement, and the well-known academician and traditionalist Robert Fleury.[7] Despite warm endorsement, the Salon jury rejected Breton's nomination, partly because he was considered too young for the prestigious award, and further, because such a commendation specifically in response to *The Recall of the Gleaners* would limit the definition of the already-controversial category of history painting.[8] Despite this rejection, the popularity of the composition continued. At the end of June, the work was reproduced on the cover of *L'Illustration,* an honor that increased Breton's standing among his peers and that also ensured wide popular appeal for the work itself.

Breton was present when *The Recall of the Gleaners* was removed from the Salon early in July and sent to the imperial residence in St. Cloud.[9] During another visit to the Salon galleries, Breton met Philippe de Chenevières, an important official of the Second Empire who discussed with Breton his contribution to the development of French painting and indicated Breton would be awarded the Légion d'honneur at the next Salon.

The insights and opinions of the Salon critics were undoubtedly responsible for some of the attention Breton's work received at the 1859 Salon. Zacharie Astruc, although critical of Breton's *Seamstress* that was also exhibited that year, found *The Recall of the Gleaners* "permeated with color and light. Happy, poetic and warm—executed in half-tones that capture the dying rays of the sun, giving the canvas a surprising truth."[10] He recognized that Breton's ability to concentrate not only on the figures of the gleaners but to achieve an accurate landscape ambience distinguished his method from other genre painters who relied solely upon studio props and models. Another critic, Alexandre Dumas, noted that Breton's preference for true peasants, "robust [types]—used to their work,"[11] actually intensified the reality of his theme. Others felt that Breton's figures echoed the peasants of Léopold Robert, but many praised his composition as an accurate de-

piction of what he observed. Le Marquis de Belloy, writing in the prestigious *L'Artiste,* commended Breton's forceful style, recognizing the truthfulness of "his rigorous portraits, because evidently these are portraits. . . ."[12] Like the faithful portraits of Van Eyck in the fifteenth century, Breton had indeed demonstrated his ability to capture the physiognomy of the peasants of his own region as well as the landscape itself.

1. Jules Breton to Elodie Breton, 7 June 1859, now in the possession of the Breton descendants. Also see 26 June 1859.

2. It is curious that after a full day's labor in the fields many of the women are carrying away only small bundles. The grazing sheep in the background augment the serenity of the composition, but may also suggest that this field was not an extensive one; hence the small return for a day's labor.

3. Breton, *La Vie,* p. 241.

4. Virginie was born 26 July 1859.

5. Apparently Breton's Uncle Boniface accompanied the young painter to Paris. Breton's sensitivity to the comments made by critics in their Salon reviews is not unusual. Jules Bastien-Lepage and Jean-Jacques Henner also clipped each press article for future reference and faithfully preserved the reviews, thus providing an accurate and extensive record of their Salon notices.

6. Jules Breton to Elodie Breton, 7 June 1859.

7. Jules Breton to Elodie Breton, 15 June 1859, now in the possession of the Breton descendants, France.

8. Ibid. The debate still raged among jury members over the importance of history painting and other categories, especially landscapes and genre scenes. Eventually, history painting was dismissed as being irrelevant for modern tendencies, but in 1859 the jury was not ready to issue the proclamation that awarding Breton a medal of honor would have provoked.

9. Jules Breton to Elodie Breton, 14 July 1859, now in the possession of the Breton descendants, France. The painting was purchased through the support of the Empress Eugénie who, during this decade, patronized the careers of many artists, including Isidore Pils [81].

10. Zacharie Astruc, *Les 14 Stations du Salon, 1859, Suivies d'un récit douloureux* (Paris, 1859), pp. 228-29.

11. Alexandre Dumas, *L'Art et les artistes contemporains au Salon de 1859* (Paris, 1859), pp. 51-54.

12. Le Marquis de Belloy, "Le Salon de 1859," *L'Artiste,* 24 April 1859, pp. 5-6.

Exhibited

1859, Paris: Salon, cat. no. 409.
1867, Paris: Exposition Universelle, cat. no. 84.
1873, Vienna: Exposition Universelle, France
—Oeuvres d'art et Manufactures Nationales), cat. no. 90.
1918, Madrid, Barcelona: Exposition d'art français.
1968/69, Paris, Petit-Palais: Baudelaire, cat. no. 471.
1974, Paris, Grand-Palais: Le Musée du Luxembourg en 1874, no. 34.
1977, Arras: Jules et Emile Breton, peintres de l'Artois, no cat.

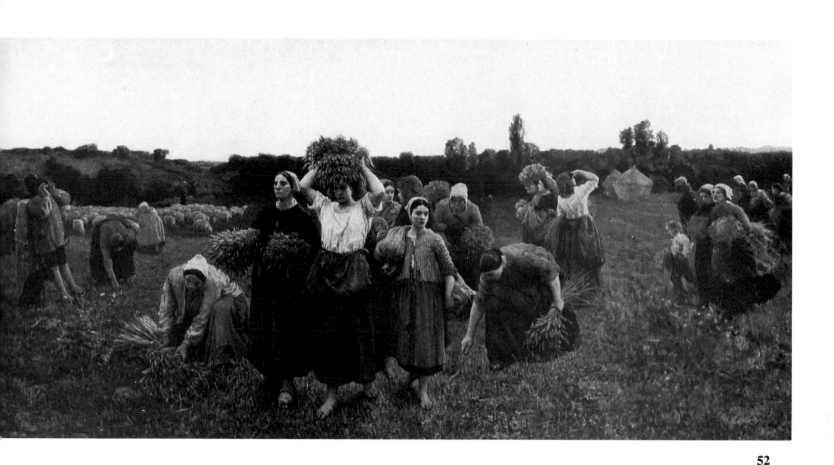

52

1977, Paris, Musée des Arts et Traditions
 Populaires: Boutiques d'hier, no. 234.

Published

Astruc, *Les 14 Stations du Salon,* pp. 228-29.
M. Aubert, *Souvenirs du Salon de 1859* (Paris,
 1859), pp. 179-80.
L. Auvray, *Le Salon de 1859* (Paris, 1859), p. 41.
Marquis de Belloy, "Salon de 1859," in *L'Artiste,*
 1 May 1859, p. 59.
Maxime du Camp, *Le Salon de 1859* (Paris, 1859),
 p. 37.
E. Cantrel, "Voyage en zig-zag à travers
 l'exposition," *L'Artiste,* 26 June 1859, p. 132.
Dumas, *L'Art et les artistes,* pp. 51-54.
A. Nettement, *Poètes et artistes contemporains
 au Salon de 1859* (Paris, 1862), p. 361.
Catalogues du Musée du Luxembourg, editions
 from 1863 to 1912 (in 1912 edition, p. 10).
M. de Montifaud, "Salon de 1867 et Exposition
 Universelle," *L'Artiste,* 1 May 1867, p. 246.
R. Ménard, *Le Monde vu par les artistes:
 Géographie artistique* (Paris, 1881), p. 979.
Richard Heath, "Jules Breton, Painter and Poet,"
 Art Journal 10 (1884): 291, repr.
E. Montrosier, "Le Musée du Luxembourg," in
 Les Chefs-d'oeuvre d'art au Luxembourg
 (Paris, 1881), p. 189. Idem, "Jules Breton," in
 Les Artistes modernes (Paris, n.d.), p. 51.
Catalogue of the Luxembourg Museum (1884,
 1887, 1892), illus. repr. p. 31.
M. Chaumelin, *Portraits d'artistes, E. Meis-
 sonier, J. Breton* (Paris, 1887), p. 91.
A. Hustin, "Jules Breton," *L'Estafette,*
 1 November 1888.

Breton, *La Vie,* pp. 226-33.
P. Lefort, *Les Chefs-d'oeuvre de l'art au XIXe
 siècle,* vol. 3, *La Peinture française actuelle*
 (Paris, n.d.), p. 60.
Jules Breton, *Un Peintre paysan* (Paris, 1896), pp.
 105-9.
M. Vachon, *Jules Breton* (Paris, 1899), p. 142,
 repr. facing p. 76.
Henry Marcel, *La Peinture française au XIXe
 siècle* (Paris, 1905), p. 28.
Gabriel Mourey, "Jules Breton, 1827-1906," *Les
 Arts,* 1906, p. 36.
F. E. Cluit, "The Art of Jules Breton," *Brush
 and Pencil,* 1906, p. 110.
M. Gabriel-Ferrier, *Notice sur la vie et les
 travaux de M. Jules Breton, lue dans la séance
 du 12 décembre, 1900 de l'Académie des
 Beaux-Arts* (Paris, 1910), p. 9.
G. Brière, *Catalogue des peintures exposées dans
 les galeries. Musée du Louvre, école française*
 (Paris, 1924).
Charles Baudelaire, *Oeuvres complètes,* texte
 établi et annoté par Y. G. Le Dantec; édition
 complétée et présentée par C. Pinchois (Paris,
 Bibliothèque de la Pleiade, 1961), p. 1077.
Henri Perruchot, "La Gloire et le néant," *Jardin
 des Arts,* June 1966, p. 44, repr. p. 45.
A. Calvet-Serullaz, "A propos de l'exposition
 Baudelaire: L'Exposition du Bazar Bonne-
 Nouvelle en 1846 et le Salon de 1859," *Bulletin
 de la Société de l'Histoire de l'Art Français,*
 1971, p. 128.

Rosa Bonheur

53 *Plowing Scene*
Oil on canvas, 19-1/2 x 31-3/4 inches (49.5 x 80.5
cm.). Signed and dated lower left: Rosa
Bonheur/1854.
Baltimore, The Walters Art Gallery.
Provenance. Acquired before 1931.

The success of *Labourage nivernais, le
sombrage* at the 1849 Salon and *Marché aux
chevaux de Paris* at the 1853 Salon estab-
lished Rosa Bonheur as one of the foremost
Realist painters of animals. Art dealers and
private collectors sought her work, and the
demand for her compositions in England,
Scotland, Belgium, and other countries be-
came so great that after 1855 Bonheur no
longer participated in the Salon exhibitions
in France. She preferred to work indepen-
dently, devoting her career to her newly
found private patrons.
 Plowing Scene, one of the works Bonheur
completed in 1854 soon after she achieved
recognition at the Salons, is similar to the
theme and arrangement of forms in
Labourage nivernais. This composition,
however, is confined to a single field laborer
and a small team of oxen—a less affluent
farm than Bonheur depicted in her larger
Salon canvas. The implements of work are
the same, but the season here, indicated by

the fresh haystacks nearby, is after the harvest, when the remaining stubble of vegetation is being worked back into the soil. The flat, blue sky and the lengthy shadows cast by the farmer and his oxen suggest an atmosphere both brisk and clear. Bonheur's grasp of the field cycles and the accuracy of her recording demonstrate a Realist acumen, while the quality of intense light she has captured reveals her ability as a pre-Impressionist.

Exhibited

1972, Baltimore, The Walters Art Gallery: Old Mistresses: Women Artists of the Past, handlist, cat. no. 22.

Published

Anna Klumpke, *Rosa Bonheur: Sa Vie, son oeuvre* (Paris, 1908), repr. (detail) on back cover.

Constant Troyon

54 *Four Oxen Pulling a Plow*

Black chalk and gouache on squared beige paper, 13-3/16 x 22-1/16 inches (33.5 x 56.1 cm.). Signed lower right: C. Troyon/Paris [?59 or 39].
Cleveland, Mrs. Noah L. Butkin Collection.
Provenance. Professor Adam Politzer Collection, Vienna. Sotheby's sale, London, 12 October 1977. Shepherd Gallery, New York.

Constant Troyon's preparatory drawings are extremely rare. The version *Four Oxen Pulling a Plow* has been squared off for transfer, probably in preparation for a Salon painting.[1] While focusing on the plow and the team of oxen led by the field hand, the artist has detailed the musculature of the animals and the regional clothes of the field workers. In the foreground are tufts of grass and furrows left by the first passage of the plow; in the distance, rolling hills and filmy trees detail the countryside against which this rural activity unfolded. The number of works Troyon completed in this vein remains unknown, since he often eliminated human beings in his finished compositions—choosing

to concentrate his skill as an *animalier*,[2] in a manner that suggests similar themes and compositions by Rosa Bonheur. Artists in countries throughout Europe admired his style—a consideration that suggests he was often closely imitated.[3]

1. The squared lines are underneath the animals and figures and suggest the artist may have been working from an already completed composition rather than struggling to develop his sketch.
2. Troyon completed a painting with a similar theme in the 1850s. For a reproduction see Walter Gensel, *Corot und Troyon* (Bielefeld und Leipzig: Velhagen und Klasing, 1906), reproduced as no. 12.
3. The date at the lower right has been read as both 1839 and 1859. This drawing does not correspond to Salon entries close to either date and may have been done for an unexhibited work. A German inscription on the drawing's verso notes that this was a study for a Troyon painting in the Louvre dated 1839. No such composition with that date has been located. The paper sticker with no. 1052 on it does not correspond to any Paris Salon entry submitted by Troyon during his lifetime.

53

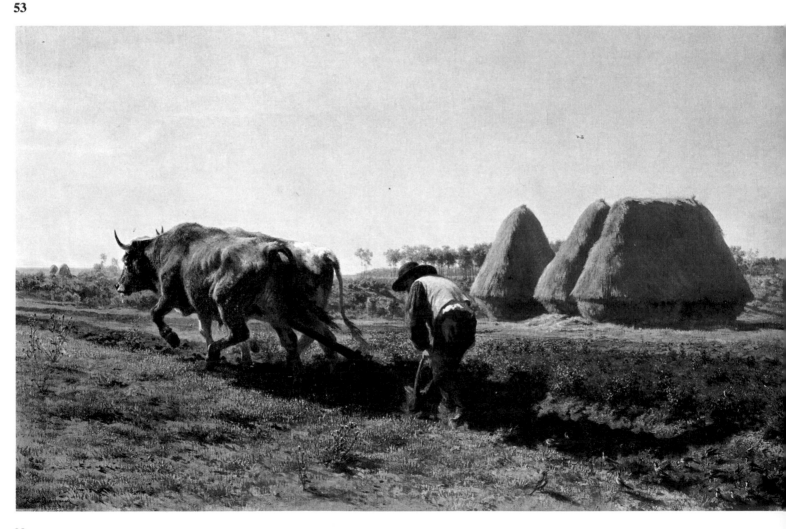

Gustave Brion

55 *The Cattle Tenter*

Oil on canvas, 31-3/4 x 25-1/2 inches (80.6 x 64.8 cm.). Signed and dated lower left: G Brion 1857.
York City Art Gallery.

Provenance. George Taylor sale, Christie's, 14 May 1860, no. 218 (listed as *Returning from the Pastures*). John Burton Bequest, 1882.

Following his arrival in Paris in 1850 Gustave Brion studied the Realist canvases of Gustave Courbet and, for a short period of time, had a studio in the same building (53 rue Notre Dame des Champs) as Bonvin and Jules Breton, then two of the leading Realist painters. After his first Salon success in 1853 when he received a second-class medal, Brion became convinced that no money could be made painting canvases in a purely Realist style (e.g., *Une Récolte des pommes de terre* [94]). Therefore, he selected other themes to paint and moved his studio from the house where he had first shared ideas about Realism with Bonvin and Breton and eventually found lodging in another building on rue Notre Dame des Champs (70 bis). There he devoted his time to depicting anecdotal genre themes of his Alsatian homeland.

Jules Breton was to emphasize this dramatic shift in Brion's style some years later in recalling the celebration for Brion's first Salon medal. He remembered Bonvin teasingly cautioning Brion during the gathering at a local tavern to "beware of . . . success." Brion's friends in the Realist camp had been duly impressed with his earliest work, but Breton's later interpretation was that Brion had fallen prey to the demands of private collectors who implored him to paint Alsatian scenes.

Brion was not the only painter in Paris who turned to Alsatian themes. During the Second Empire the government encouraged the documentation of provincial customs as a means of increasing public awareness of different regions as well as promoting governmental favor within a particular area. In 1864 an exhibition comprising the works of all painters who used Alsatian themes was held in Paris and, later, in Strasbourg.

The Cattle Tenter is typical of the type of work that Brion completed to satisfy newly found patrons, some of whom were from England. He first completed a composition using this particular theme in 1856, but after it had been sold, Brion was asked to do a second version, the one shown here that he finished in 1857. While the first version has not been located, this *replique* indicates how Brion modified his manner to suit the tastes of a clientele eager to obtain scenes of rustic life devoid of disturbing political or social implications.

The pastoral setting in a rural mountain village depicts two peasants returning from the fields, carrying the attributes of their

54

55

labor. A long horn, which would have been used to summon cows or sheep from the mountain pastures, rests on the father's shoulder. The boy carries a young kid, still too weak for the long walk, that he is returning to the farm. He is also holding a long ladle. The regional dress of these figures suggests that Brion must have made extensive notes on local costumes during trips to visit his family in Strasbourg. He had other recourse in reconstructing the reality of his rural village also, because his parents often sent Alsatian costumes that he then used for his Parisian models when he posed them in his studio. Like the painters of ancient history, Brion researched his themes thoroughly, dressing his figures accurately to create a rustic ambience for regional types that he recalled from his childhood. The spatial organization of his studio composition, however, suggests a theatrical setting, with buildings serving as a backdrop for peasants whose dress and demeanor convey Alsace and its customs.

Published

René Ménard, *L'Art en Alsace-Lorraine* (Paris, 1876), p. 126.
York Catalogue (1907), cat. no. 91.
Hans Haug, "Un Peintre alsacien sous le Second Empire—Gustave Brion (1824-1877)," *La Vie en Alsace* (Strasbourg, 1925), p. 48.
York City Art Gallery, *Catalogue of Paintings (English and European 19th-20th Centuries)*, vol. 3 (York, 1974), p. 9, no. 300.

Jules Breton

56 *Two Women Resting in the Fields*
Charcoal and chalk drawing, 9-7/8 x 7-3/8 inches (24.5 x 18.5 cm.), ca. 1860s. Signed lower left: J B.
France, Private Collection.
Provenance. Descendants of Jules Breton.

Jules Breton, like many of the Realists, also used drawings to develop his preliminary concepts. Often these were studies of figures intended for large-scale group canvases, although some of his intimate studies were finished works in themselves. *Two Women Resting in the Fields* is similar to many of the works Breton completed in the mid-1860s (e.g., *The Rest,* Musée d'Arras) that depict workers having paused from their labor.

The head covering draped to protect her from the sun, the rolled-up sleeves, and the wide skirt and apron of the figure with the rake recall other field workers by Breton.[1] Her momentary respite, holding the rake in one hand while grasping the jug, and the crouched position of her companion, kneeling before the wicker basket, indicate that they have stopped to refresh themselves.

The specific dress and attitude of these harvesters reflect the provincial life of northern France. Breton faithfully recorded

the familiar harvest activity that he observed many times in the fields near his home in Courrières, but the background here intimates that Breton's intention was more than a re-creation of a natural setting. He may have sketched this scene as part of a wall mural—perhaps in preparation for an emblematic scene for a public building.[2] The figure with the rake may also have been the source for a similar figure Breton later portrayed in *The Close of the Day* (The Walters Art Gallery, Baltimore), a work whose tranquil atmosphere and reflective pose recall the canvases of Jean François Millet.

1. Geneviève Lacambre, catalog entry for *The Rest,* in *The Second Empire: Art in France under Napoleon III* (Philadelphia Museum of Art, 1978), p. 261.
2. There is no record that Breton was commissioned to work on murals for public buildings at this stage in his career. Other painters of the time, however, were being attracted to this type of work (e.g., Puvis de Chavannes). It was generally believed that Realist imagery could be used in railway stations and other public buildings, although little came of these suggestions.

Exhibited

1976/77, Arras, Musée des Beaux-Arts: Jules et Emile Breton: Peintres de l'Artois, no cat.

Auguste Herlin

57 *Threshing at Colza on the Lille Plain (Battage de colza dans la plaine de Lille)*
Oil on canvas, 47-1/4 x 82-11/16 inches (120 x 210 cm.). Signed lower left.
Lille, Musée des Beaux-Arts.
Provenance. Given to the museum by George Herlin, 1928.

Both Jules Breton and Auguste Herlin exhibited paintings of a grain harvest at the 1861 Paris Salon.[1] Breton's composition, *Le Colza* (Corcoran Gallery of Art, Washington, D.C.), focused on a group of figures sifting grain and filling canvas bags in the foreground, but Herlin created a more episodic scene. In the foreground are a group of field workers momentarily at rest. In the background are other groups busily threshing and moving straw. Both sections of the composition are united by the women gathering bundles of wheat. Romantic in sentiment and inspired by peasant scenes painted by Léopold Robert as well as actual observation, the composition accurately depicts the various phases of grain harvesting. The aura of elegance achieved by his idealized portrayal of the timeless theme separates the work of Herlin from Breton, who presented more realistic field laborers in his earliest period.

Both Jules Breton and Herlin unified their compositions, but Herlin followed the older pattern of using narrative to bring together various harvest activities in a single work. Although little is known about Herlin's

career, he can be considered typical of the regional painters who retained more conservative conceptions of painting. Fascinated by the life of his region near Lille, Herlin spent all his life in the north of France (he never went to Paris), maintaining a Realist's interest in contemporary themes while painting in a partly sentimentalized, romantic style.

1. Although they shared a common interest, whether Jules Breton and Herlin knew one another is unknown. Since Breton worked and lived in Courrières—not far from Lille—Herlin may have known Breton's work when he completed his own paintings for the 1861 Salon.

Exhibited

1861, Paris: Salon, cat. no. 1498.

Camille Flers

58 *Poultry Yard (Basse-cour)*
Oil on cardboard, 10-1/8 x 15-1/2 inches (25.5 x 39 cm.). Signed lower left: Flers; dated lower right: 1863.
Alençon, Musée d'Ozé.
Provenance. Jacquette Donation, 1880.

The theme of the farmyard was used frequently by the Barbizon painters, most notably by Charles Jacque. By examining the types of farm implements, recording the huts that peasants had built, and enumerating the number of poultry in a yard, it was possible to convey a sense of rustic life. The composition *Poultry Yard* that Camille Flers completed late in his career shows a sensitivity to light suggestive of still life in its careful illumination of everyday objects. The minimal reference to persons captures only a glimpse of a common rural activity.

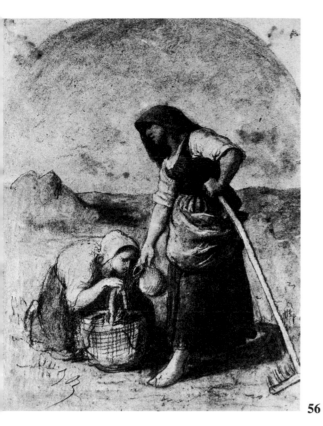

56

58

57

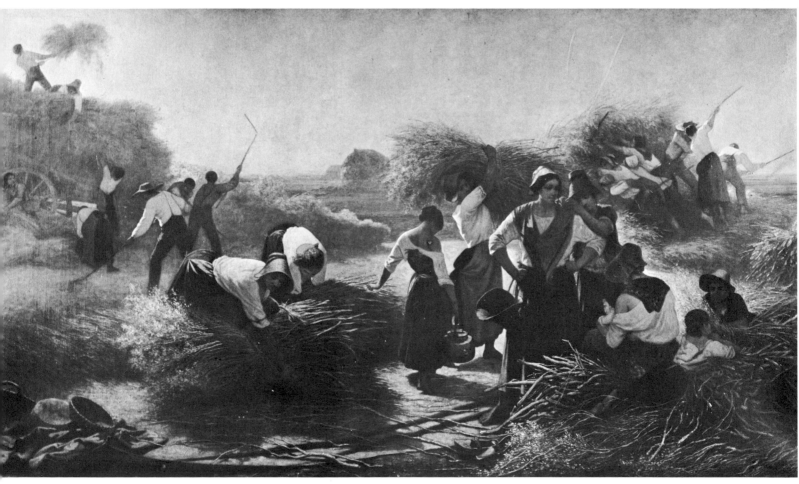

91

Adolphe Hervier

59 *The Market at Caen*
(Le Marché à Caen)

Oil on wood, 14-3/4 x 9-1/2 inches (37 x 24 cm.),
ca. 1860. Signed lower left: HERVIER.

Dijon, Musée des Beaux-Arts.

Provenance. Given to the Museum in the
G. Joliet Bequest, 1928.

Throughout his career, Adolphe Hervier did
numerous water colors of picturesque sites
he witnessed during his travels throughout
the French countryside. Often he studied
mothers and children in the streets of a rural
village; at other times he recorded market-
day scenes of a specific region. Although
these observations were recorded in outdoor
pencil sketches and water colors, oil paint-
ings based on these same themes were fre-
quently completed later in his studio. These
later works, usually small wood panels like
The Market at Caen, often exaggerated cer-
tain details, such as the mother nursing her
child, thus creating small vignettes of scenes
he had witnessed earlier (for example, the
painting of a similar nursing scene, Private
Collection, Cleveland).

Hervier composed this genre scene like
his landscapes—from a similar high vantage
point that reveals the diversity of rural activ-
ity but also (because of the bird's-eye per-
spective) imbues his panel with an animation
found only in a panoramic vista. This small
panel includes such diverse details as chick-
ens searching for grain on the ground as well
as various women and children bargaining
for wares. His ability to caricature common
types links Hervier with Honoré Daumier, a
relationship further substantiated since Her-
vier, as a major printmaker, was well aware
of Daumier's contribution to lithography.

Published

Catalogue des peintures françaises (Dijon: Musée
des Beaux-Arts, 1968), p. 126, cat. no. 672.

Philippe Auguste Jeanron

60 *Fishermen*
(Pêcheurs)

Oil on canvas, 63-3/8 x 91-1/8 inches (160 x 230
cm.). Signed lower left: Jeanron.

Douai, Musée Municipal.

Provenance. Purchased by the state and sent to
Douai in 1852-53. Gift of the Minister of State.

Even before his removal as director of the
National Museums in 1851, Philippe Au-
guste Jeanron was encouraged to continue
his painting through official commissions
from the state, acceptance of his work at Sa-
lons, and purchase of his work for provincial
museums.[1] *Fishermen* is representative of
the type of painting by which Jeanron sup-
ported himself in the years prior to his ap-
pointment as director of the art school and
curator of the museum in Marseille (1863).[2]
Organized in the traditional manner of
seventeenth-century Dutch prototypes and
Romantic seascapes of the 1830s and 1840s
(e.g., works by Eugène Lepoittevin), it was
exhibited at either the 1852 or 1853 Salon,
and later sent by the state to the museum in
Douai.[3]

The canvas records provincial industri-
ousness of fishermen returning after their
day's activity, hauling in their nets, and pre-
paring their catch for market while two
young girls look on. A figure at the left is
already cleaning and readying his fish for the
basket nearby. While some details of the
composition, such as the village background,
were drawn from observation, Jeanron de-
veloped his poses from studio models, and
his atmosphere from his remembrance of
scenes along the coast of France. The
stiffness of the figures and the traditional
organization of space represent Jeanron's
subjugation to create theatrical compositions
suitable for state consumption.

1. See 15 January 1851, F 21/89, Archives
Nationales, for a record of Jeanron's first official
commission. A second commission was granted in
1852. By 1854 records show that the government
was also buying his paintings after the Salon ex-
hibition. This practice continued in 1856, 1857,
1858, 1859, and 1860. Since these commissions
and purchases each involved no less than 3000
francs, they represent a type of official state sup-
port, or pension, after Jeanron was removed as di-
rector of the National Museums.
2. For further information concerning this period
in Jeanron's life, see Madeleine Rousseau, "La
Vie et l'oeuvre de Philippe Auguste Jeanron:
Peintre, écrivain, directeur des Musées
Nationaux, 1808-1877" (thesis, Musée du Louvre,
1935).
3. Rousseau identified this painting as the one
shown at the 1852 Salon (vol. 3, pp. 25-26, cat. no.
87). The museum in Douai, in records transmitted
to the author, cites this painting as being exhibited
at the 1853 Salon.

59

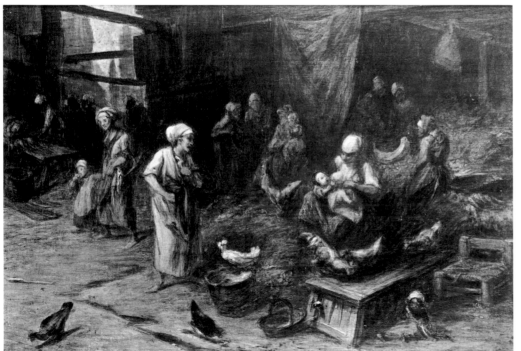

Exhibited

Either 1852, Paris: Salon, cat. no. 692 (listed as
 Les Pêcheurs, vue prise au Creux-Nazeux) or
 1853, Paris: Salon, cat. no. 650 (listed as *La
 Morte eau).*
1975, Douai: Douai au temps de la Seconde
 République, 1848-1852, p. 35, cat. no. 242.

Published

Le Magasin Pittoresque, 1853, p. 269, repr.

60

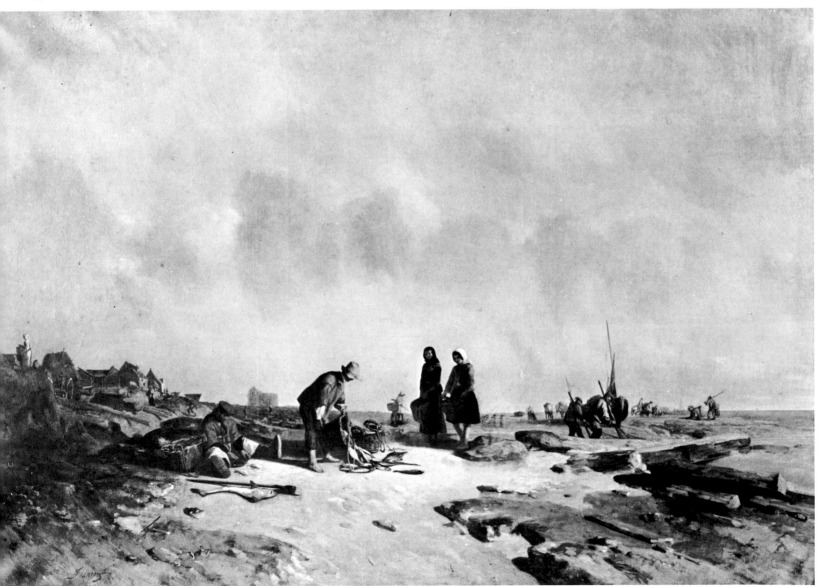

DOMESTIC ACTIVITY

Eugène Lepoittevin

61 *A Farm Girl at Her Toilet*
Oil on canvas, 17-1/2 x 16 inches (44.4 x 40.7 cm.).
England, Co. Durham, Barnard Castle, The Bowes Museum.
Provenance. Probably purchased by Lepautre for 300 francs at Paris sale, 9 April 1872.

Few Realist painters seem to have depicted the huts and primitive dwellings that sheltered the peasants in rural areas. Eugène Lepoittevin's *Farm Girl at Her Toilet* —although an unusual subject for an artist known for his picturesque landscapes of the French coast and seldom associated with the Realists—is an accurate description of a common rustic setting. Like many of the peasant families for whom they worked, hired help and working girls lived in ill-heated, foul-smelling, scantily furnished hovels, and in the cold of the winter often took advantage of the body heat provided by the cattle or sheep with whom they shared cramped quarters.

The young farm girl carefully arranging her dress before the mirror propped against the lantern, which probably lighted her way to bed the night before, is somewhat suggestive of Greuze's eighteenth-century models. The earthenware pitcher, the broom fallen to the floor, and the careless disarray of clothing about the room are characteristics of the rural dwelling that provide an amusing contrast to the young girl's concern.[1] The tightly constricted space—made even smaller because of the cow in the background—is an accurate reminder of a way of life common to many people in rural areas.

1. This also suggests remnants of the eighteenth-century interest in chastity symbolism. For a detailed inventory of the kind of possessions a farm girl might own, see F. Le Play, *Les Ouvriers européens* (Paris, 1877); 4: 390; 5: 323.

Published
Handlist of French Works in the Collection (Bowes Museum, n.d.), cat. no. 313.

Adolphe-Félix Cals

62 *Young Girl Knitting*
(Jeune Fille tricotant)
Oil on wood, 7-1/4 x 6-1/4 inches (18.3 x 15.7 cm.). Signed and dated middle right: Cals 9bre 1850.
Reims, Musée Saint Denis.
Provenance. Kasparek Bequest, 10 July 1893.

During the 1840s, Adolphe-Félix Cals's life was marred by his unfortunate marriage to Ermance de Provisy, a young art student whom he had met through his teacher Léon Cogniet. The disparity between Cals's humble parentage and her wealthy, aristocratic origins was further aggravated by her shrewish personality and extravagances that soon reduced the Cals's household to penury. The birth of a daughter Marie Adolphine Elisabeth on 24 April 1844[1] must have only increased Cals's concern. It was at this time, with his marriage already failing, that Cals recognized tendencies of insanity in his wife's behavior (a disease that was later to afflict Marie also). Taking charge of his young daughter, Cals left his wife, and he and Marie lived together in a succession of Parisian apartments. She became a ready model, accompanying him on his trips to the outskirts of Paris and posing during their evening hours at home.

Cals did small, intimate studies of Marie in her white bonnet, seated in a chair reading by lamplight or knitting at a small table. These compositions, often completed on wood panel because Cals seldom had enough money for canvas, were intended only for himself. They captured quiet moments from daily life, suggesting the same quality of pervasive stillness and pensive involvement in a simple task that is often found in Dutch paintings of the seventeenth century. No known record exists of Cals's study of previous painting traditions, but Salon critics such as Théophile Thoré were then advocating Dutch masters as a source the Realists should study if the intimacy of home life were to be fully understood.

By the 1850s, Cals had broadened his study of family life to include themes of childhood: children playing with cutouts, dining at their own miniature table, or learning to read under the careful tutelage of a parent (e.g., *L'Education maternelle,* Salon of 1859). These domestic themes suggest that Cals had the opportunity to see similar works of family life by Chardin, which were then being rediscovered. Other nineteenth-century painters were also completing canvases or panels with similar themes (e.g., Edouard Frère [64, 69]), contributing to the growing tradition of children as participating members of a family. These studies focused upon the naiveté and innocence of childhood by observing emotions, moods, and personalities. Occasionally they revealed overtones of sentimentality—qualities that were considered representative of family virtues and childhood charms (e.g., Jules Bastien-Lepage [182]).

The *Young Girl Knitting* is an example of Cals's preference for the quick sketch rather than a finished work. A few brushstrokes suggest the hands, cloth, and the ball of yarn. The red dress and the white bonnet are summarily brushed in; even the face has been rendered simply and quickly, with far less detail than the features in his earlier *Peasant Woman and Child* [20]. Here Cals modulated his shadows softly, using more pigment to build up the tactile quality of highlighted areas. This type of study anticipated his interest in effects quickly perceived and recorded—a tendency that was to lead him to exhibit with the Impressionists during the 1870s.

1. See Acte de Naissance, 24 April 1844, Mairie 3e Arrondissement de Paris.

Exhibited
1961, Vichy: D'Ingres à Renoir, cat. no. 40.

Octave Tassaert

63 *Reading the Bible*
(La Lecture de la Bible)
Pencil drawing, 8-3/4 x 9-7/8 inches (22.3 x 25.1 cm.). Signed and dated lower left: O. Tassaert 1851.
Montpellier, Musée Fabre.
Provenance. Alfred Bruyas Donation, 1878.

The familiar routine of the daily Bible reading for educational and religious instruction within the family unit was both a privilege and a responsibility often reserved for the eldest member.[1] The intense absorption of the grandmother in *Reading the Bible* appears to be tolerated patiently by her young listeners. She seems unaware of the gesticulations and the exaggerated exhaustion of the older boy. The smallest child has fallen asleep on his sister's lap, while she and the young boy on the window ledge are similarly preoccupied with their own thoughts. The anecdotal quality of this drawing indicates a likeness in Octave Tassaert's style to Edouard Frère's. Aside from the theme itself, Tassaert reveals an interest in facial expressions and gesture derived from his early training as a printmaker.

1. Theodore Zeldin to the author, 10 April 1980, notes that reading the Bible was more common among Protestants than Catholics. But attributing this work or Tassaert's interests to a specific faith cannot be documented.

Published
Ernest Michel, *Galerie Bruyas* (Montpellier, 1876), no. 209.
Bernard Prost, *Catalogue de l'oeuvre de Tassaert* (Paris, 1886), no. 402.

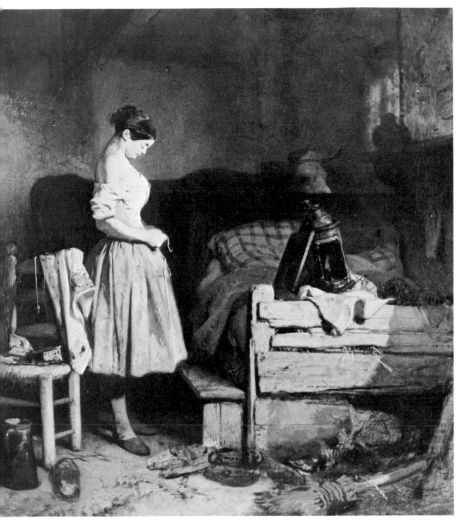

61

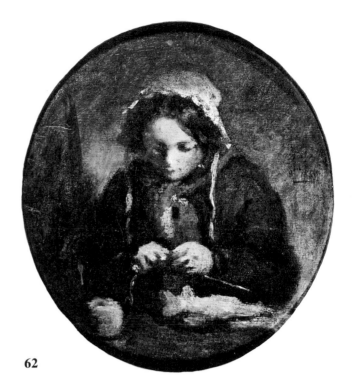

62

63

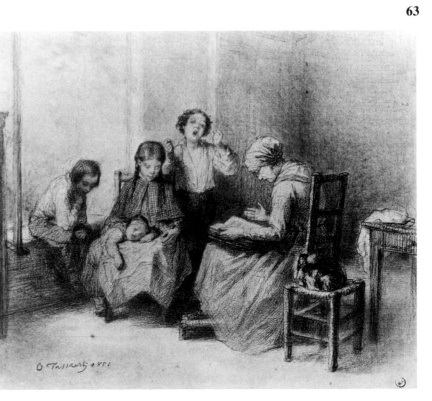

95

Pierre Edouard Frère

64 *Preparing for Church*
Oil on canvas, 22 x 29 inches (55.4 x 73 cm.).
Signed and dated lower left: Ed. Frère. 53.
Washington, D.C., The Corcoran Gallery of
Art—Renwick Collection.
Provenance. Sale of the J. Taylor Johnston Collection, New York. Acquired 21 December 1876
(for $2400).

The innumerable details of running a household appealed to Edouard Frère, and he did variations of this theme throughout his career.[1] By portraying dedication to hard work, the daily activity of people living in modest surroundings, and a love of family, Frère underscored ideals that writers and popular printmakers were advocating for the people.[2] If the poor and the middle class followed these examples—if they instilled in their own children a knowledge of ethical traditions—then the children would develop into leaders whose knowledge and respect for past traditions and customs were assured. Compositions such as *Preparing for Church* inspired and reinforced democratic principles,[3] presenting amusing didactic lessons that idealized members of a community or revealed the family's role in training young children.

Frère emphasized narrative, using his familiarity with the commonplace to dramatize—like a journalist—moments or episodes that were familiar to the masses. On a Sunday morning, nothing was more important than preparation for church, where the youngest children—especially a boy—served in the choir. Dressed in their finest clothes, the children epitomize this common Sunday ritual. The young girl stands in ready attendance, while her brother holds himself stiff and erect, enduring his mother's last-minute inspection. Frère's facility to idealize the role of motherhood and his ability to convey a comfortable mood of understanding are characteristic of Frère's many family scenes.

Preparing for Church was completed on canvas and is one of Frère's largest early paintings. The broad implications of the scene must have assured Frère a wide marketability, once he began consigning his works to art dealers by 1852.[4]

1. Frère's interests were shared by many other "sentimental" painters and printmakers in several countries. John Ruskin, Frère's first supporter in England, encouraged similar attributes in many of his published articles.
2. The role of popular printmakers in Germany, England, and France in emphasizing these common ideas has not been adequately studied. For an introduction, see *Burgerliches Wandbild, 1840-1920, Populaire Druckgraphik aus Deutschland, Frankreich und England* (Göttingen, 1975); cat. by Christa Pieske.
3. The democratic outlook influenced the way popular image-makers evolved throughout the nineteenth century—and became a guiding princi-

ple in the Third Republic, the time when Frère's images increased in popularity.
4. Beginning in 1852 Frère sold many paintings through the Parisian art dealer Beugniet. See "Edouard Frère," Carton 13, Documents originaux, Bibliothèque d'Art et d'Archéologie, Paris, for letters from Frère to Beugniet in the 1850s and 1860s.

Exhibited
1952, Washington, D.C., George Washington
 University: Tribute to W. W. Corcoran.

Jean-Jacques Henner

65 *The Artist's Mother Praying before the
 Body of Her Daughter Madeleine (La
 Mère de l'artiste priant devant le corps
 de sa fille Madeleine)*
Oil on canvas, 18-1/8 x 26 inches (46 x 66 cm.), ca.
1852. Signed lower right: J. henner
Paris, Musée J. J. Henner.

As a provincial painter working in Paris during the 1840s, Jean-Jacques Henner had ample opportunity to observe genre canvases recording rural life. These works coincided with his own humble origins, reminding him of the sacrifices his parents made to send him to art school in Strasbourg and, later, in Paris to the studio of another Alsatian, Michel-Martin Drolling. While Henner won a few prizes at the Ecole des Beaux-Arts from 1846 to 1858, the most coveted award, the Prix de Rome, consistently eluded him during this same period. Unable to fully adapt his classical training to scenes of actuality, Henner turned to Realist themes inspired by the intimate life of his family, often returning to his home in the village of Bernwiller (in Alsace).

The interest of the Realists in religious genre was not to become pronounced until Alphonse Legros painted his *Angelus* in 1859 and *Ex-Voto* [83] in 1861. In *The Artist's Mother Praying before the Body of Her Madeleine*, however, Henner found a means to suggest the finality of death without recourse to the supernatural. By depicting the grief of his mother at the death of his sister (1852), Henner invented a new category of painting using the emotionalism of the event to show the customs of the province. Henner's sincerity was also combined with a stylistic naiveté that resulted in distorted shapes to express the piety of a bitter moment which had deeply moved him.[1] Henner used an unidealized figure style. The body, wrapped in a white shroud, is rigidly laid out in the quiet of a simple, unadorned room. Only the head of the deceased is visible, and her face has been enlarged to magnify the impact on the grieving mother. The slightly off-balance perspective, the oversized figure of the kneeling mother contrasting with the tiny furniture, and the compelling position of the crucifix and memorial candle reveal an uncomplicated spatial arrangement. The holy objects are symbolic

and traditional; even the customary twig of boxwood soaking in the container of holy water denotes the blessing of the dead. The landscape beyond the rear window reveals a barrenness in its leafless trees that reinforces the solemnity of the moment. The use of muted tones and distorted forms here indicates Germanic and expressive sources—origins that Henner later subsumed in his formularized Symbolist manner.

1. The naive quality of this work is noted in "Nécrologie, Jean Jacques Henner," *Chronique des Arts*, 1905, p. 222.

Published
Léon Lhermitte, "Notice sur la vie et les travaux
 de J. J. Henner, membre de l'Institut,"
 Catalogue, Musée J. J. Henner (Paris, n.d.), p.
 1 and no. 52.
S. Rocheblave, "La Jeunesse d'Henner," *Revue
 de l'Art Ancien et Moderne* 19 (1906): 161-76,
 repr. p. 165.
Albert Soubies, *J. J. Henner (1829-1905), Notes
 biographiques* (Paris, 1905), p. 4.
Léonce Bénédite, "Artistes contemporains—J. J.
 Henner," *Gazette des Beaux-Arts* XXXVIII
 (1907): 315-32, repr. p. 317.

Jean-Jacques Henner

66 *Alsatian Interior—Marie-Anne Henner
 Churning Butter
 (Intérieur alsacien—Marie-Anne-Henner
 baratant le beurre)*
Oil on canvas, 18-1/8 x 13-3/8 inches (46 x 34 cm.).
Signed and dated lower right: henner/1854.
Paris, Musée J. J. Henner.

Henner completed a series of studies in the village of Bernwiller during the mid-1850s that recorded other episodes from rural life. For this series, Henner used members of his family as models, working from the scene in front of him without inventing or idealizing his figures. These works show a similar preference for reality in color, revealing harmonious, subtle tones of the locale, rather than the brilliant palette of the romantics that Henner had seen earlier at the Paris Salons. Significantly, these small, intimate canvases are recognized as among his earliest painted images that convey—through the development of a series—activities drawn from the everyday life of a region.

The same direct, naive style that is evident in Henner's canvas of his dead sister Madeleine [65] prevails in *Alsatian Interior—Marie-Anne Henner Churning Butter*, even though the central figure of his sister Marie-Anne was carefully drawn from life. Marie-Anne is depicted churning butter while two village children keep her company. The face of the sister is sensitively detailed, indicating that while Henner was composing a genre scene he was also nurturing a latent interest in portraiture. By centering all of his figures (which curiously include a study of his elderly mother) near the

64

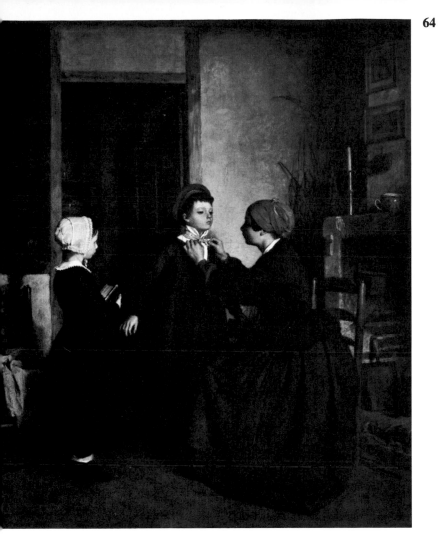

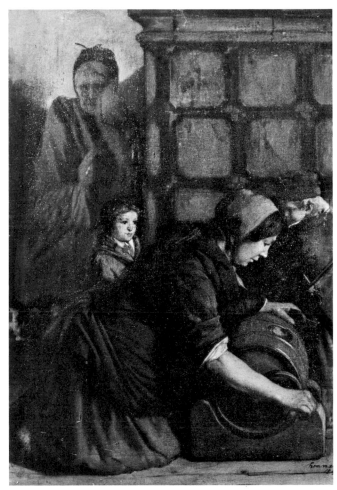

66

65

warmth generated by the large stove, Henner has further strengthened a composition of an early-morning household activity.

Published

Lhermitte, "Notice . . . J. Henner," p. 1, no. 12.
Bénédite, "Artistes contemporains," p. 321, repr.

Adolphe-Félix Cals

67 *Woman Plucking a Duck*

Oil on canvas, 18 x 15-1/8 inches (45.7 x 38.4 cm.). Signed and dated upper left: Cals 1854.
England, Co. Durham, Barnard Castle, The Bowes Museum.

Provenance. Purchased from Charles Pillet through the art dealer Lepautre, 4 March 1868, sale no. 10 for 130 francs (entitled *Cook with a Duck*).

Paintings with the theme of the family cook proliferated during the 1850s after François Bonvin received a third-class Salon medal (1849) for his *Cuisinière* preparing bread (Musée de Mulhouse).[1] Champfleury, a friend of the Realists and an important art critic, had favorably reviewed Bonvin's painting, extolling the quality of the still-life section and, in general, praising Bonvin's ability to capture aspects of family life.

The still-life section of Adolphe-Félix Cals's work of 1854, *Woman Plucking a Duck*, suggests a similarity with Bonvin's earlier version. The second dead bird, the bottle of wine, the celery, and the cabbage on the wooden table, however, anticipate the preparation of an elaborate meal that is an obvious contrast to the plainly dressed cook herself. Her position at one side of the crowded interior draws equal attention to her presence, so that the work becomes one of mood and introspection as well as a careful study of a still-life arrangement.

The types of food associated with the peasantry during the nineteenth century emphasized how close to misery these people often were. The peasant existed on the barest minimum, a common diet that might include bread (or sometimes pancakes), which was usually baked in batches and carefully doled out to accompany the staple of the peasants' meal—a soup prepared by the woman of the household. While meat quickly became a regular part of the middle-class diet in urban areas, it was a rarity at the peasants' table. Indeed, the peasant who ate fowl for dinner probably obtained it by poaching, a genuine resource for the peasant, but uncommon at his table. Even the small landowners and tenant farmers, who had access to a more varied and adequate food supply, often denied themselves the very foods that might have alleviated their malnutrition. Instead, they preferred to market birds, rabbits, eggs, and fish in order to pay their rent or to provide sorely needed clothing for their families.

The wine and meat in Cals's composition signify the pleasures of good dining, especially in the rural regions—but they could hardly be considered peasants' fare. Cals's painting also provides social commentary about the role of cooks in some Realist canvases. This cook is not a mother in a humble family setting, but rather a domestic servant, perhaps of rural origin, attending to chores in the corner of her employer's kitchen. The copper and ceramic utensils and the location of the kitchen itself—away from the main section of the house—and even her pensive expression indicate her role as a servant.

While little is known of Cals's life at the time of this painting, Arsène Alexandre, his first biographer, noted that he did a landscape during this same period on the outskirts of Paris near Colombes, a small town where he may also have observed this kitchen scene.[2] After Cals had made the acquaintance of the enthusiastic art dealer Père Martin, his career improved considerably, and such a middle-class kitchen scene may indeed even have been requested by one of Martin's clients. In addition, Cals's work suggests an awareness of Dutch seventeenth-century painters who positioned servants near still-life arrangements in market-day scenes. Finally, Cals's commitment to paint domestic servants might also have been inspired by similar works of Chardin, who depicted cooks preparing meals or tending to similar daily chores. The even illumination entering the scene from the right not only intensifies the orange of the cook's scarf and the white of her cap, but also mitigates the severe gray of the rear wall. It is a harmonious setting with social implications that suggest a change in Cals's fortune as well as a new direction in the type of composition that was attracting patrons to his work.

67

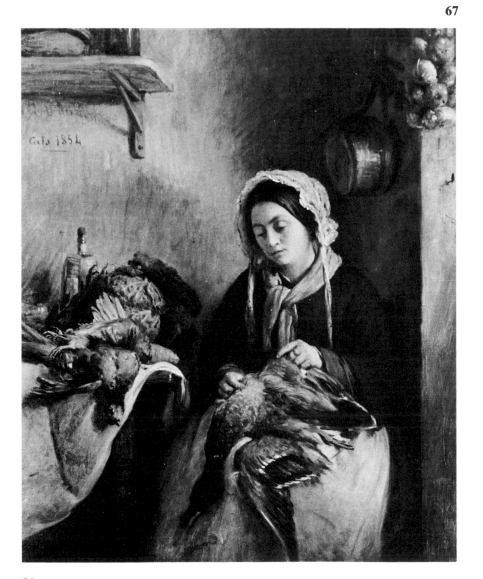

1. François Bonvin's painting in the Mulhouse museum is probably not the same work he exhibited at the 1849 Salon. The exhibited work and this smaller study are different sizes. See Gabriel P. Weisberg, *Bonvin: La Vie et l'oeuvre* (Paris: Editions Geoffroy-Dechaume, 1979), p. 36, n. 52.

2. Arsène Alexandre, *A.-F. Cals, ou le bonheur de peindre* (Paris, 1900), p. 203.

Published
Handlist of French Works in the Collection
 (Bowes Museum, n.d.), p. 6, no. 360.

Pierre Edouard Frère

68 *Children Looking at Perspective Prints*
Oil on panel, 13 x 11 inches (32.9 x 27.8 cm.).
Signed lower left: Ed. Frère.
New York, The Brooklyn Museum.
Provenance. Bequest of William Herriman.

Edouard Frère's small paintings preserved familiar activities and endearing scenes that typified family life. During the middle decades of the century, one of the popular pastimes at home was viewing perspective prints through a special apparatus known as a zograscope (commonly referred to in Paris as an *optique*).[1] Inexpensive prints especially made for this device assumed a heightened sense of depth and vista (for example, of an expansive courtyard or road) when viewed through such a glass.

These optical devices, even though they had been invented in the eighteenth century, became exceptionally popular in England during the mid-1850s after they had been displayed at the famed Crystal Palace exhibition in 1851.[2] *Children Looking at Perspective Prints* shows the young boy about to place the perspective print in a horizontal position near the base of the tabletop apparatus.[3] The print held by the girl and those set aside on the floor in Frère's work were cheaply reproduced, poorly colored versions. Inexpensive, ready availability in dealers' shops throughout Paris, however, encouraged their widespread popularity as a leisure-time amusement among the growing number of middle-class families in France.

1. J. A. Chaldecott, "The Zograscope or Optical Diagonal Machine," *Annals of Science* 9 (December 1953): 315-22.
2. Ibid., p. 320.
3. Ibid., p. 319.

Exhibited
Possibly 1857, Paris: Salon, no. 1075 (listed as *Les Images*).

Pierre Edouard Frère

69 *The Little Cook*
Oil on panel, 11-1/4 x 8 inches (28.3 x 20.2 cm.).
Signed and dated lower left: Ed. Frère '58.
New York, The Brooklyn Museum.
Provenance. Bequest of Robert B. Woodward.

Frère's small compositions proved increasingly popular under the Second Empire. In 1851, 1852, and 1853 he received Salon medals; in 1855, after the World's Fair, he received the Légion d'honneur. His panels

<div align="center">

68 **69**

</div>

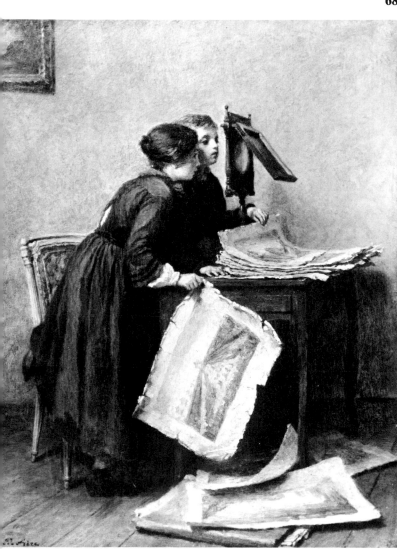
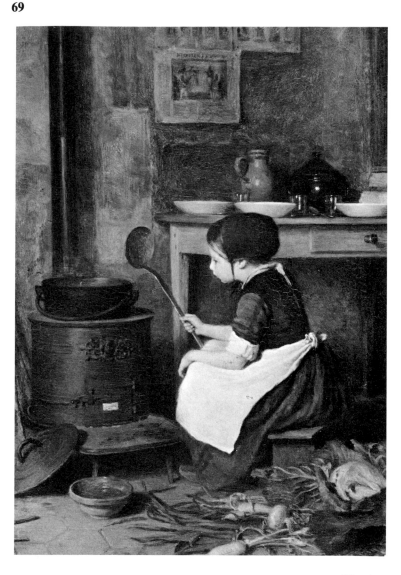

were well represented at both the 1857 and 1859 Salons, where he exhibited a variety of daily rites from a young child stepping out of the bath to the observance of morning prayer. In 1859, as part of his interest in themes of childhood, Frère exhibited an *Enfant malade* and another composition showing one of his little cooks—perhaps the very one seen here.

The young girl minding the stove shows only too well that Frère's popular appeal lay in the quality of naiveté with which he infused such themes. The innocence of the *Young Cook* intent upon her chore is underscored by the simplicity of Frère's style, which suggests his indebtedness to the genre compositions of Chardin that were then re-

ceiving considerable notice. Frère's interior emphasizes as well his exacting sense for the careful placement of inanimate objects, and reveals his mastery of subtle modulations in the light that plays on the tableware and his accuracy in depicting the vegetables scattered about on the tile floor that still await preparation. The placard and the *images d'Epinal* he included on the rear wall are typical of the cheaply reproduced representations that were often found in lower-class households.

Frère painted several versions of young cooks (another is in The Walters Art Gallery, Baltimore), but seldom achieved the atmosphere of dignity and restraint that are evident in this particular work. It was not

surprising that clients from England and the Low Countries sought his sentimental images. He represented the lower classes with a purity and wholesomeness that in the Victorian age alleviated the very real misery and struggle that other Realists dedicated themselves to revealing.

Exhibited
1859, Paris: Salon, no. 1143.
1921, Brooklyn Museum: Paintings by Modern French Masters Representing the Post Impressionists and Their Predecessors, cat. no. 116.

Published
Flor O'Squarr, "Edouard Frère né à Paris en 1819," *Galerie Contemporaine Littéraire et Artistique* I (1876), no. 18.

70

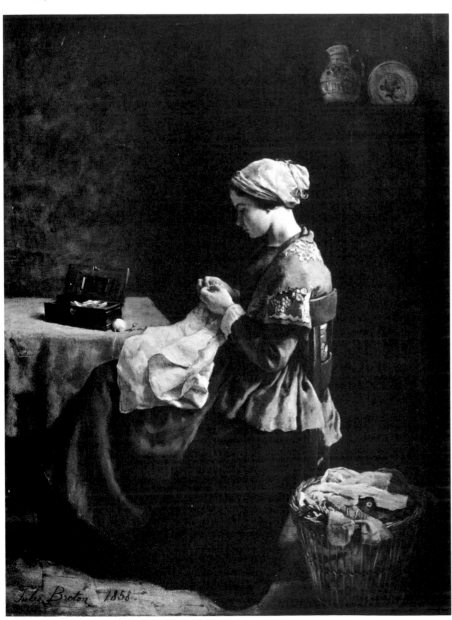

70a Edmé Bouchardon, *Apprentisse Couturière*, etched by Comte de Caylus after the artist.

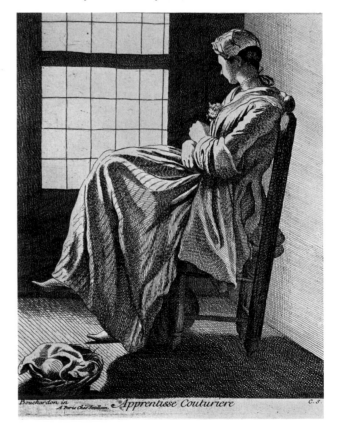

Jules Breton

70 *The Seamstress*
(La Couturière)

Oil on canvas, 21-7/8 x 17 inches (55.5 x 43.2 cm.). Signed and dated lower left: Jules Breton, 1858.

Paris, Private Collection.

The Seamstress, the smallest of four works Jules Breton exhibited at the 1859 Salon, may have remained part of a private collection for a number of years, but its early history is unknown, except for a document found in the Archives du Louvre. The painting was purchased by the National Lottery Commission for 1500 francs on 20 April 1859[1] and was thus probably secured by a successful lottery participant as part of the Second Empire's campaign to make art works accessible to collectors.[2] The intimate canvas received only slight favor by Salon critics. The comments of Zacharie Astruc are typical of the generally derogatory tone of the reviewers: "A young girl is seated near a table. We should praise here the effect of light, which is graceful, and the coloring, which is pleasing. But the theme is too slight—this isolated child is lost in the expanse of the canvas; she has the stiff appearance of a daguerreotype. M. Breton is more successful in his complicated groupings. In summation, in spite of its relative charm, this canvas is weak."[3] A similar attitude by other Salon critics makes it hard to understand why *The Seamstress* was even selected by the Lottery Commission—except for the broad appeal of the theme itself.[4]

Breton developed his image from a longstanding tradition. In the seventeenth-century, Dutch painters frequently depicted a woman sewing or making lace, although they rarely isolated their figures as dramatically as Breton. During the eighteenth century, Chardin and Edmé Bouchardon completed similar themes. The same placement of the model in a simplified setting that Bouchardon used in *Apprentisse Couturière*, 1742 (Figure 70a), is apparent in Breton's *Seamstress*. In Breton's work, however, the corner of the room is free of distracting furniture, so that the activity of the model remains the focus. By placing his young model near a low table with only her sewing kit and the mending basket nearby on the floor, Breton thus transformed a well-established theme into a more personal interpretation. *The Seamstress* is his new wife Elodie (they were married 29 April 1858), and the canvas reflects the growing tranquility of his home life.[5] In keeping with the recognition of domestic virtues that Realist theorists such as Théophile Thoré were then advocating, the canvas also signifies the dedication and dignity with which Breton embraced Elodie's everyday activity.

1. See "Enregistrement des ouvrages," Salons 1859, Archives du Louvre.
2. The importance of the Lottery Commission in the distribution of art work to collectors has not been studied. The type of individuals involved in the process should be examined to determine what level of society they represented. That the lottery was well established and heavily publicized in Paris is documented by the existence of wall posters now kept in the Archives du Louvre. The current owner of *The Seamstress* (in a letter to the author) noted that the painting was once owned by M. Teste.
3. Zacharie Astruc, *Les 14 Stations du Salon —1859: Suivies d'un récit douloureux* (Paris, 1859), pp. 226-27.
4. Another painting by Jules Breton was selected by the National Lottery Commission in 1859: *La Plantation d'un Calvaire* [82]. The organizers of the lottery selected this theme of a well-known rural event because it was one way to popularize a work for collectors. If collectors recognized the event, or its significance, they would be more likely to appreciate these same qualities in a composition won through the national lottery.
5. François Maison, Conservateur, Musée d'Arras, in unpublished notes shown to the author (1978), pointed out that Ernest Chesneau and Maxime du Camp recognized the model in *The Seamstress* as the same young woman, in profile, dressed in yellow and holding two children by the hand in *La Plantation d'un Calvaire*.

Exhibited

1859, Paris: Salon, no. 412.
1977, Arras, Musée des Beaux-Arts: Jules et Emile Breton, peintres de l'Artois, no cat.

Published

Astruc, *Les 14 Stations*, pp. 226-27.
Ernest Chesneau, *Le Salon de 1859* (Paris, 1859), p. 56.
Maxime du Camp, *Le Salon de 1859* (Paris, 1859), p. 39.
Alexandre Dumas, *Le Salon de 1859* (Paris, 1859), pp. 54-55.
A. Hustin, *L'Estafette,* 1 November 1888.

Henri Fantin-Latour

71 *The Two Sisters*

Oil on canvas, 38-7/8 x 51-1/2 inches (98 x 130 cm.). Signed lower left: Fantin 59.

The St. Louis Art Museum.

Provenance. Mme. Victor Klotz, Paris. M. Victor Klotz, Paris. Jacques Seligman and Company, New York. Purchased by the Museum.

Like James McNeill Whistler's *At the Piano*, Henri Fantin-Latour's *Two Sisters* was rejected by the 1859 Salon jury, but selected for display in the exhibition François Bonvin held in his atelier that year. Since the number of paintings that Bonvin selected exceeded the space in his small studio, Fantin-Latour's painting may never have been formally exhibited.[1] Nevertheless it was undoubtedly known and appreciated by other painters who gathered at Bonvin's studio, for it mirrored the same themes of intimacy and domestic life that Realist artists during the mid-1850s had also chosen to paint. In particular, this canvas resembles two compositons, which Bonvin himself completed after 1855, that portray a solitary figure in a restricted space absorbed in her needlework.[2] Whether Fantin-Latour had actually seen these paintings by Bonvin is not known, although his professed advocacy of Realist theory and his friendship with Gustave Courbet after Courbet's exhibition at the Pavillon du Réalisme in 1855 linked Fantin-Latour with the Realists from this time. Fantin-Latour's use of a second figure absorbed in her reading, like the theme of the woman embroidering, was also familiar to the Realists. Both themes represented an interlude apart from usual domestic activities and reflected a contemplative aspect of contemporary life that Realists were then interested in depicting. Bonvin's affinity for these subjects and his appreciation of Fantin-Latour's treatment are thus easy to understand.

The placement of the two sisters close to the frontal plane was also advocated by the Realists, who were interested in endowing individuals with a presence and a sense of actuality that would include the spectator. This same type of spatial organization with the figure brought close to the frontal plane had already been used by both Bonvin and Ribot, and was to remain characteristic of such second-generation Realists as Alphonse Legros [83] and Antoine Vollon [86]—artists with whom Fantin-Latour was associated at that time. The placement of the two sisters across from one another in Fantin-Latour's composition also provides an informality that heightens the intimacy of his presentation. These are his two sisters: Nathalie, poised with her needle still in place on her embroidery, looking absent-mindedly away from her work, her reverie a foreshadowing of the derangement that will soon preclude any normal activity; and Marie, relaxed and completely absorbed in

her book although seated close enough to be attentive to her sister's needs.

Fantin-Latour's spatial setting also enhances the casualness of this glimpse into the daily life of his family. The composition is at an angle, with the border of the floor and the pictures on the wall placed on a slight perspective line that infers spatial recession. This sense of slightly distorted space is contrasted with a frontality of the sitters that emphasizes the interplay of diagonals in the restricted space. The picture frames on the rear wall become space markers, dividing the background plane asymmetrically. Fantin-Latour's use of frames within a painting to structure the composition anticipates Edgar Degas's adoption of the device in his own early compositions.

Fantin-Latour has also followed the direction of the Realists in his use of muted tones to achieve a tonal harmony in which all sections of the composition are wedded. This is amply demonstrated by Fantin-Latour's ability to depict in tones of black and white—similar to a draftsman—the restrained garments worn by his two sisters. Even the color harmonies are muted, with the only bright color emanating from the bundle of yarn on top of the frame on which Nathalie works.

Aside from the formal aspects of the work, the painting also reveals an underlying Symbolist mood. Soon after the work was completed, Nathalie was committed to the insane ward at Charenton. Her gaze and her inability to concentrate on her work imply

the mental illness that was soon to isolate her from her sister. Marie, whose demeanor reflects the calmness of the Fantin-Latour family, remained in Paris only a short time after this. She soon married and moved to Russia, so that the succeeding years (before his own marriage some time later) were a period of great loneliness for Fantin-Latour.

Fantin-Latour idolized his sisters and completed other variations of this composition (Birmingham Museum, England) as well as a series of charcoal drawings (Cabinet des Dessins, Louvre). Several were undoubtedly preparatory studies for this composition; others may have been completed later in Fantin-Latour's career when he again was able to reflect on this theme from his early years. Few of Fantin-Latour's later compo-

71

sitions, however, were as carefully realized as this work. His attentiveness to tonal painting suggests his underlying debt to Whistler, but his choice of subject matter was inspired by similar works of such Realists as François Bonvin. The portrait paintings that he completed later reveal this same indebtedness to his contemporaries, but a style modified in its detachment and organization to conform to the rational structuring advocated by some of the Impressionists.

1. *From Realism to Symbolism: Whistler and His World*, exh. cat. (New York: Wildenstein & Co., 1971), p. 76. No catalog of Bonvin's exhibition exists and the show was not covered in the press. It is unclear which paintings Bonvin finally exhibited in his small studio.
2. See Weisberg, *Bonvin*, cat. nos. 19, 20.

Exhibited

1859, Paris, Bonvin's studio (selected).
1903, Paris, Musée du Luxembourg.
1906, Paris, Palais des Beaux-Arts: Exposition rétrospective de l'oeuvre de Fantin-Latour, cat. no. 23.
1958, New York, Wildenstein: Fifty Master Works from the City Art Museum of St. Louis, cat. no. 42.
1963, New York, Wildenstein: Birth of Impressionism, cat. no. 43.
1966, Northampton (Mass.), Smith College Museum of Art: Henri Fantin-Latour, 1836-1904, cat. no. 3.
1971, New York, Wildenstein; The Philadelphia Museum of Art: From Realism to Symbolism, Whistler and His World, p. 75, cat. no. 68, pl. 68.

Published

Léonce Bénédite, "Un Tableau de Fantin-Latour," *Revue de l'Art Ancien et Moderne* II (1902): 95-101, illus. facing p. 100.
Jules Meier-Graefe, *Entwicklungeschicte der modernen Kunst* (Stuttgart, 1904), 1: 345.
Léonce Bénédite, *La Peinture au XIXe siècle* (Paris, n.d.), p. 141, illus. p. 139.
F. Gibson, *The Art of Fantin-Latour: His Life and Works* (London, n.d.), pp. 35-36, pl. 22.
Mme. Fantin-Latour, Catalogue de l'oeuvre complet de Fantin-Latour (Paris, 1911), p. 18, no. 114.
G. Kahn, *Fantin-Latour* (Paris, 1926), p. 25, pl. 2.
M. R. R. [Meyric R. Rogers], "The Two Sisters," *Bulletin of the City Art Museum of Saint Louis* XXII (April 1937): 14-16.
John Rewald, *The History of Impressionism* (New York: Museum of Modern Art, 1946), p. 29; in 2d edition (1961), illus. p. 33.
Frank A. Trapp, "Fantin-Latour at Smith College," *Burlington Magazine* 108 (July 1966): 393, fig. 78.
T. Prideaux, *The World of Whisler, 1834-1903* (New York, 1970), p. 30, illus.
"New York," review of Whistler and His World, *Artforum* IX (May 1971): 79, illus. p. 81.
William J. Chiego, "Two Paintings by Fantin-Latour," *Museum News: The Toledo Museum of Art* 17 (1974): 35, repr. p. 36, fig. 9.
St. Louis Art Museum, *Handbook of the Collections* (1975), p. 154.

François Bonvin

72 Woman at the Spinet

Charcoal on brownish paper, 16-1/4 x 11-15/16 inches (41.1 x 30.3 cm.). Signed and dated bottom left: f. Bonvin, 1860.
Rijksmuseum, Amsterdam, Rijksprentenkabinet.
Provenance. Gift of Mrs. L. Thurkow van Huffel.

François Bonvin's use of the complex concert theme was ultimately related to his own personal life as much as it was influenced by a willingness to record varied aspects of domestic life. During the 1850s, even before the death of his first wife Elisabeth Dios (1859), Bonvin was encouraged by his friends—Courbet, Champfleury, and others—to free himself from domestic restrictions and responsibilities and concentrate solely on his artistic career. Despite this carefree existence, Bonvin undoubtedly led a lonely life that was relieved only by hard work and, for a brief interval, by a second marriage.

It is not known exactly when Bonvin met Céline Prunaire, the beautiful sister of a contemporary printmaker, but by November 1860 Bonvin had remarried. Céline was tempestuous, independent, and singularly committed to becoming a musician and actress. Perhaps Bonvin was too infatuated to realize their incompatibility; at any rate the marriage was doomed to failure. The belief that Céline would complement Bonvin's artistic talents was far outweighed by Céline's own aspirations and their twenty-two-year age difference. Bonvin's friends enviously eyed the marriage, and Courbet's pointed remark that many young men were now eager to become Bonvin's students caused a final break in their long friendship. The marriage, beset by financial difficulties as well, lasted less than three years—despite Bonvin's return to the police department as a meat inspector. This unfortunate marriage, and the fact that Céline never divorced Bonvin, troubled the painter the rest of his life.

72

During their brief marriage, however, Bonvin completed images that used the concert theme to demonstrate affection. *Woman at the Spinet* was first completed as a charcoal drawing and, sometime later, in 1862, as a finished painting (Glasgow Art Museum, Scotland). Even though these two works do not reveal her face, they were prompted by Céline's ability to play the instrument. The theme reflects Bonvin's commitment to follow the Dutch painters from the seventeenth century whose image of a woman in concert, playing to an unseen admirer, represented a prelude to seduction. The arrangement of the forms in *Woman at the Spinet* recalls similar compositions by Terborch and de Hooch, both of whom Bonvin studied in the Louvre. The drawing (and the oil painting as well) can also be compared with James McNeill Whistler's *At the Piano*, a work that had been rejected at the 1859 Salon. While Bonvin and Whistler had been acquainted earlier, their friendship developed when Bonvin opened his studio for an exhibition of the works of those artists who had been rejected at the Salon. It is more than likely, therefore, that *Woman at the Spinet* was as much inspired by Whistler as by the masters of former times.

The charcoal drawing indicates that Bonvin occasionally completed a highly finished composition in black and white first, rather than using such sketches simply as a preliminary study for an oil painting. The drawing reveals a subtlety in the handling of tones and overall design that Bonvin would later translate into a work on canvas. In the drawing, Bonvin worked from the model, carefully recording such differences in light as the shadow cast by Céline against the spinet—achieving a degree of delineation that was not developed in the later colorful oil.

There is another curious difference between the drawing and the painting. Whereas the bouquet of flowers in the black-and-white version intimate a romantic atmosphere, the several red petals that have fallen to the floor from the vase of poppies on the spinet in the canvas might, indeed, symbolize consolation and melancholy—perhaps Bonvin's way of commemorating his already strained relationship with Céline.

Published

Weisberg, *Bonvin,* cat. no. 265.

Jules Breton

73 *Peasant Woman Threading a Needle*
(Paysanne enfilant une aiguille)
Oil on panel, 16-3/4 x 11-7/8 inches (42 x 30 cm.).
Signed and dated lower right: Jules Breton 1860.
Geneva, Musée d'Art et d'Histoire.

Even though most of Jules Breton's early themes were derived from life in the village of Courrières, his participation in the Realist movement remained less controversial than that of some of his contemporaries. Breton was assessed as calmer, quieter, and secure from the vulgar social issues or themes that critics found so provoking in Courbet's canvases and opinions. Some critics cautioned Breton against exaggerated realism, while others—Zacharie Astruc among them—reproached Breton for not following Courbet's direction.[1] As the movement developed, however, Breton showed a growing preference for traditional rural themes (e.g., religious processions [82]) and a style that was accurate but devoid of the vigorous, daring brushwork of Courbet. His intimate studies of young peasant women (e.g., *The Seamstress* [70]) indicate that Breton could have pursued a more direct style. Such occasional studies, however, remain the least known of his early work.

In *Peasant Woman Threading a Needle*, Breton concentrated on the tranquility of domestic life while simplifying his compositional organization even further than his similar, earlier depiction of *The Seamstress* (1859). Here the woman dominates her setting; she is positioned close to the frontal plane so that attention focuses on her activity: an attempt to rethread the needle so that she can finish mending the maroon shawl that rests in her lap. Her blue apron and brown jacket are painted loosely, more naturally—a modification that suggests the influence of the freer manner of François Bonvin, an artist Breton had known since his first days in Paris.

1. For a discussion of this attitude see Geneviève Lacambre, entry entitled *Monday,* in *The Second Empire: Art in France under Napoleon III,* exh. cat. (Philadelphia Museum of Art, 1978), pp. 260-61.

Armand Leleux

74 *The Message*
(Le Message)
Oil on canvas, 32-1/8 x 26-1/8 inches (81 x 66 cm.).
Signed lower left: Armand Leleux.
Dijon, Musée des Beaux-Arts.
Provenance. Gift of M. A. Joliet, 1928.

Armand Leleux's use of the theme of the letter to increase the mood of introspection recalls the Dutch paintings of the seventeenth century that similarly recorded the momentary interruption of the mistress of the household at her daily tasks by a servant bearing a message.[1] The expression of the young girl who has set aside her sewing in *The Message* suggests her pleasure in the note—an absorption that is reinforced by the placement of the solitary figure in a corner of the well-furnished room. Whether the model for this painting was Leleux's wife is not known, although the canvas was undoubtedly completed in the late 1850s and may have been the same painting identified in the 1859 Salon as *Le Message (Intérieur suisse).*[2]

The composition reveals Leleux's sensitivity to light and atmosphere, an aspect of his painting style that led critics such as Maxime du Camp to regard Leleux as an "eminent painter and observer."[3] Paul Mantz included Leleux among the painters of interior scenes that impressed him at the 1859 Salon, approvingly noting that "several interiors that he [Leleux] exhibits today reveal a clarity of form and an exacting light which are a pleasure to observe. . . ."[4] Referring specifically to *Le Message,* Mantz praised Leleux's delicate touch and his ability to suggest sketch qualities in a finished composition. Leleux had mastered tonal painting, achieving subtleties of color in the bluish tint of the girl's apron that reflected the soft sunlight entering from the window at the right. The still life on the table—especially the vase with flowers—in full light from the window reinforces a romantic mood appropriate for the theme. As a painter interested in effects of light and mood, Leleux deserves a place in the Realist movement, although he confined himself to themes with few social implications.

1. Leleux's interest in Dutch painting should be further examined.

2. The lack of information on the Dijon painting makes exact identification of the 1859 Salon canvas difficult.

3. du Camp, *Le Salon de 1859,* pp. 113-14.

4. Paul Mantz, "Salon de 1859," *Gazette des Beaux-Arts* 1 (1859): 288.

Published

Catalogue des peintures françaises, Musée des Beaux-Arts de Dijon (Dijon, 1968), no. 728, p. 134.

73

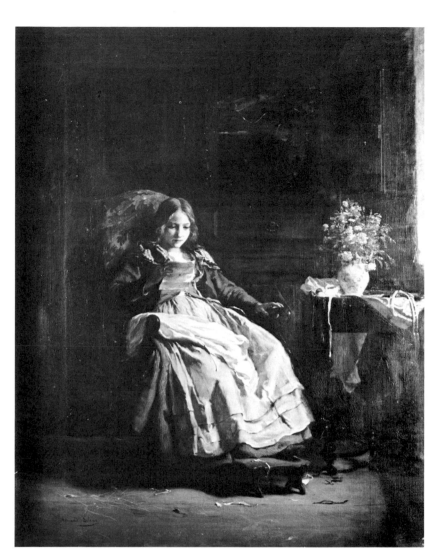

74

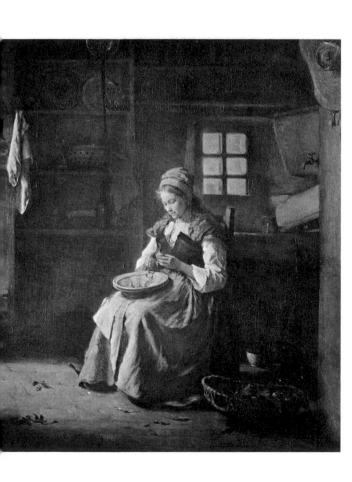

75

Armand Leleux

75 *The Servant Girl*
Oil on canvas, 18-1/8 x 14-1/2 inches (45.6 x 36.5 cm.). Signed lower right: Armand Leleux.
The Baltimore Museum of Art.
Provenance. Lucas Collection, on indefinite loan from The Maryland Institute, College of Art.

Armand Leleux's *The Servant Girl* became part of a United States collection because of an unusual circumstance. During the 1860s, the American collector and connoisseur George A. Lucas lived in Paris, where he served as a special agent for several American collectors and dealers—among them William T. Walters of Baltimore.[1] Many of the objects which Walters eventually gave to the gallery that bears his name were secured through the perspicacious contacts of Lucas, who was somehow able to locate unusual

works at reasonable prices. Lucas also maintained a collection of his own, which he willed to his friend Henry Walters (William's son). *The Servant Girl* was among the paintings owned by Lucas that were thus placed on loan to the Walters gallery.[2]

A notation in Lucas's personal diary for Wednesday, 15 November 1865, records his purchase of a single figure by Armand Leleux for 200 francs.[3] This must have been *The Servant Girl*, since there is no other known painting by Armand Leleux in Lucas's collection.

It is an unusual work for Leleux to have completed during the mid-1860s, since Leleux had already given up painting themes of the lower classes and by that date was considered a well-established member of the Second Empire. In this work, however, Leleux returned to a common genre theme that other Realists had used (e.g., Bonvin), depicting a domestic seated in a modest kitchen peeling vegetables. The model for this composition may have been a servant from Switzerland that he had seen during his travels. Leleux's sensitive use of light emphasizes her activity, while the remainder of the interior is deeply shadowed. The cloth hanging from the rear shelf in the direct light cast by the open doorway is the only other area of brightness. Tranquil in mood, this composition continues a rustic theme based on Realist prototypes.

1. For further information see Lillian M. C. Randall, *The Diary of George A. Lucas: An American Art Agent in Paris 1857-1909,* 2 vols. (Princeton University Press, 1979).
2. See *The George A. Lucas Collection,* exh. cat. (Baltimore Museum of Art, 1965), pls. 5-18.
3. Randall, *Diary*, 2: 206.

Published
George A. Lucas Collection, p. 44.

Pierre Edouard Frère

76 *Preparing Dinner*
Oil on canvas, 16-1/8 x 21-1/8 inches (40.8 x 53.5 cm.). Signed and dated lower left: Edouard Frère, 1868.
Baltimore, The Walters Art Gallery.

Life in the village of Ecouen gave Edouard Frère an opportunity to observe and select episodes of daily household life. Preparation of the large midday meal, such as that depicted in *Preparing Dinner*, was a major daily task in even the simplest households. Although Frère more often illustrated popular themes for the sentimental taste of the middle class, this type of canvas reveals his awareness of Dutch seventeenth-century prototypes—particularly the work of Rembrandt. The subtle lighting Frère has created in the interior, with the only illumination entering through the solitary window, conveys a mood of melancholy and a painterly effect that is seldom discerned in Frère's more popular images. The figure, intent upon her meal-time chores with her back to the viewer, is partially dwarfed by her environment (a motif reminiscent of early paintings by Rembrandt). The composition also points out Frère's ability to capture the reality of such a rustic home: the textures of the various vegetables, the coarseness of the wall surfaces, the sturdinesss of the sparse furnishings. One other aspect of the interior is

77

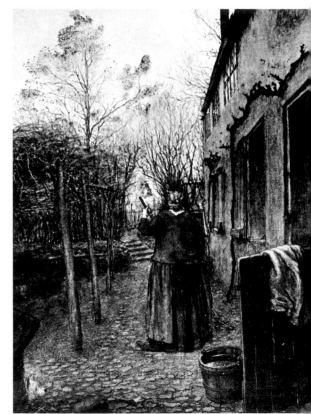

76

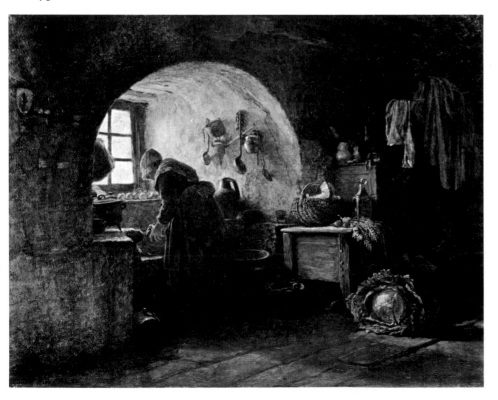

the huge cabbage on the floor at the right that dominates the setting—and provides some indication of the abundance of natural staples available to those who lived in the country.[1] Although not typical, this work suggests Frère's capacity to compose canvases which have aesthetic quality based on a sincere appreciation of past masters whose guidance was well acknowledged as a foundation for nineteenth-century Realism.

1. It was not until the end of the century that crop production and the marketing of surplus began to benefit the country as a whole. See Eugen Weber, *Peasants into Frenchmen: The Modernization of Rural France, 1870-1914* (Stanford University Press, 1976), pp. 115-29.

Léon Bonvin

77 *Woman Sweeping*
Water color, 11-1/4 x 8-3/8 inches (28.8 x 21.3 cm.). Signed and dated lower right: Léon Bonvin, 1865.
Baltimore, The Walters Art Gallery.
Provenance. Collection of Mr. Walters.

By 1865 Léon Bonvin was recording watercolor scenes of Vaugirard, including garden studies, views of distant Paris [159], or vistas of open fields with a profusion of wildflowers scattered in the foreground. By painting in early morning or evening—the only time he was able to get away without disrupting his business—Léon recorded varying atmospheric conditions (fog, mist, sunrise, moonlight). *Woman Sweeping* shows his wife at her daily morning task, tidying the inn yard and entranceway with a broom of branches, which she would dampen frequently from the bucket nearby to keep the dust down. The dog alerted in the foreground—Bonvin's own pet and a favorite subject in earlier charcoal studies—adds a note of personable benevolence to her commonplace chore.[1] The early hour is suggested not only because she is bundled against the autumn chill but also by the bleak light beginning to break low beyond the already leafless trees.

Léon Bonvin used his preliminary ink drawing as a grid before he applied water color—a practice that reveals his methodical technique and his capability as a watercolorist only a few years before his death. Influenced by his brother François (also a capable watercolorist) and by his own study of Netherlandish painters of earlier centuries, Léon's realism was based on a meticulous observation of country existence.

1. See Gabriel P. Weisberg, *The Water Colors and Drawings of Léon Bonvin,* exh. cat. (CMA, 1980).

CHURCH & STATE

François Bonvin

78A *Three Little Girls*
Oil on panel, 8-25/32 x 8-15/16 inches (22 x 22.7 cm.). Signed and dated upper left: F.B./46.
Cleveland, Collection of Mr. and Mrs. Noah L. Butkin.
Provenance. André Watteau Gallery, Paris.

At the 1849 Salon François Bonvin was referred to as "the painter of family life" by his friend and art critic Champfleury. The epithet was substantiated not only by Bonvin's paintings for the Salon but by a series of drawings and oil sketches of women and children absorbed in a variety of everyday activities that had preoccupied the painter since earlier in the decade.

The small sketch *Three Little Girls* shows three classmates (perhaps even Bonvin's daughter Françoise) reading in a corner of a schoolroom. The finished painting (Musée de Langres) that was anticipated by this sketch was not shown until the 1850/51 Salon, where it received a second-class medal from the state. This preliminary sketch reveals that Bonvin had already been working on the theme of *Ecole des Orphelines* since 1846. Bonvin, like Ribot in the 1860s [87], was dedicated to themes derived from his own personal experience, and the classroom theme was inspired by the enrollment of his young daughter in a community school. Bonvin has captured the children's momentary poses—even the distraction of the one girl. In the preliminary water color that followed [78B], before the final painting, this child was moved to the other side of her two attentive companions, so that the importance of the lesson being conducted by the Sister of Charity is strengthened.

Published

Gabriel P. Weisberg, "Théodule Ribot: Popular Imagery and *The Little Milkmaid,*" CMA *Bulletin* LXIII (October 1976): 256, fig. 7. Idem, *Bonvin: La Vie et l'oeuvre* (Paris: Editions Geoffroy-Dechaume, 1979), cat. no. 5.

François Bonvin

78B Preparatory Water Color for *The Girls' School (Ecole des Orphelines)*
Brown ink with brown wash and water color, 9-3/8 x 12 inches (23.6 x 30.5 cm.). Signed and dated lower left: F. Bonvin, 1850. Inscribed lower left: approuvé Charles Blanc.
Paris, Louvre, Cabinet des Dessins.
Provenance. Given to the Louvre by Gaston Mélingue in 1919.

Of all the paintings that Bonvin exhibited at the annual Salons, the *Ecole des Orphelines* proved his most popular and enduring. When it was shown at the 1850/51 Salon, critics were quick to praise Bonvin's approach, elevating him into the highest ranks of genre painting because his theme reflected many of the main educational concerns of the time. Charles Blanc, the Minister of Fine Arts in 1849 under the short-lived Republican government, had approved Bonvin's preliminary water color. The jury at the 1850/51 Salon awarded the work a second-class medal (the highest award, incidentally, that Bonvin ever received), and the state under the Second Empire purchased the painting for the provincial Langres museum. The canvas was also engraved at the close of the Salon exhibition, thus assuring it a widespread popularity even outside of Paris. Throughout his career Bonvin later received several requests to duplicate the composition, either in small studies or as large-scale replicas.[1]

The popularity of this particular theme is not difficult to understand. Following the Revolution of 1848 and throughout the remainder of the century, there was an increasing urgency to educate the masses, both in the city and in rural regions. If France were to emerge as a unified country—without separate regional divisions —it was essential that all children be instructed in at least the rudiments of reading and writing and that the same national spirit be instilled throughout the provinces.[2] From 1833 various French governments tried to reform public education, at first by providing primary education for boys. From 1867, districts of over five hundred individuals were required to provide separate schools for girls as well.[3] At the beginning of this massive effort by the government, whenever schools were established, education was often conducted by members of religious orders. When Charles Blanc asked Bonvin to develop the theme of a girls' school, it was undoubtedly intended to underscore the more liberal interest in encouraging education for the lower classes.

Standards of teaching in many of these primary schools were low. Nuns or Sisters of Charity worked with the children, helping them to master the alphabet or memorize certain biblical verses.[4] These religious orders often instructed the young not out of a

feeling for national unity but because of their strong conviction that all children be able to read in order to receive the important Sacrament of Holy Communion at an early age.[5] Those children who attended primary schools run by the Church did not have to pay for instruction, for it was still the responsibility of the Church to indoctrinate as many as possible.

Whether Bonvin anticipated the propagandistic impact of his painting is difficult to ascertain. It is more likely that the theme evolved simply from his own familiarity with the training given his young daughter Françoise, who may have remained with her mother during the 1850s even though she was probably educated in a Church school. Nonetheless, the fact that the state was encouraging similar educational opportunities may have increased Bonvin's interest in this theme.

Aside from the theme itself, this preliminary water color demonstrates Bonvin's dependency upon the work of Rembrandt for his own early drawings. The calligraphic lines by which Bonvin quickly sketched the young girls that are seated on the benches or standing to recite their lessons suggests a strong acquaintance with the drawings of the seventeenth-century master. The orderly, yet relaxed atmosphere, sensed in the young child moving toward the center of the classroom and the deep absorption of the others in their studies, was appreciated by art crit-

ics and government leaders alike, who found Bonvin's evocation of "truth" appropriately representative of the ideals of education as well as of the dignity inherent in the lower classes.

1. For further reference to these studies, see Weisberg, *Bonvin*, cat. no. 87.
2. Eugen Weber, *Peasants into Frenchmen: The Modernization of Rural France, 1870-1914* (Stanford University Press, 1976), p. 314.
3. Ibid., 319.
4. For further reference see C. S. Phillips, *The Church in France 1848-1902* (London, 1936).
5. This was also done because of a more self-serving desire: to continue the teachings of the Church and to make certain that religion and Church influence maintained a hold on the minds of the young—and on the population as a whole. The Church wanted to make sure that the individuals under their control would not be corrupted by new scientific ideas which might take them away from the Church doctrines. For further reference see Phillips, *Church in France*.

Exhibited
1886, Paris, Galerie D. Rothschild: Exposition de tableaux et dessins par F. Bonvin.

Published
Etienne Moreau-Nélaton, *Bonvin raconté par lui-même* (Paris: Henri Laurens, 1927), p. 34, fig. 18.
Weisberg, *Bonvin*, cat. no. 238.

Isidore Pils

79 *The Death of a Sister of Charity (La Mort d'une Soeur de Charité)*
Oil on canvas, 95-1/2 x 120-7/8 inches (241 x 305 cm.). Signed and dated lower left: I. Pils 1850.
Toulouse, Musée des Augustins.
Provenance. Purchased by the government for 4000 francs. Sent by the state to Toulouse in 1852.

Critical acclaim and the purchase by the state of his *La Mort d'une Soeur de Charité* for 4000 francs at the 1850/51 Salon marked the first time Isidore Pils had received the support of the French government.[1] It also marked a turning point for French Realism: it was the first time the government had recognized the category of religious genre.

Pils's development as a painter indicates his awareness of the social changes taking place in France that enabled him to sympathetically record the misery of the poor classes. His first exhibition, at the 1846 Salon in which he received a second-class medal, used models from contemporary life. As his biographer L. Becq de Fouquières later described it, "the world became for him a living museum where God's hand created types with an infinite variety; this became his territory—it was from here that he selected his models."[2]

Pils memorialized an event that he had actually witnessed, and *La Mort . . .* demon-

78A

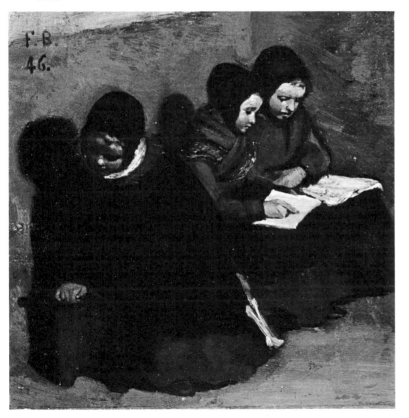

78B

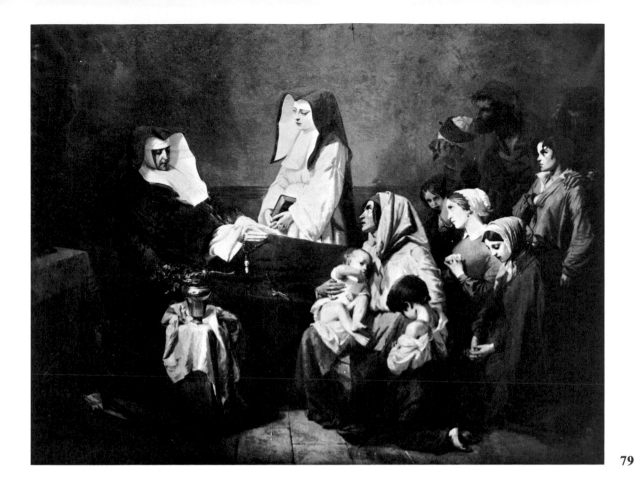

79

79B

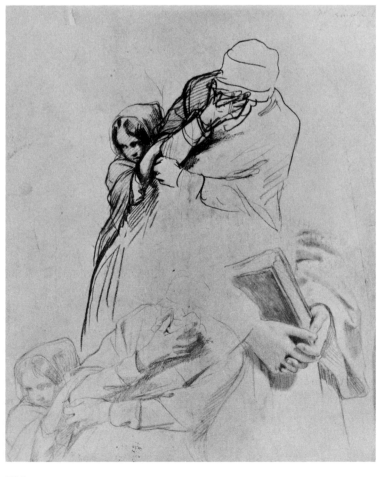

79A

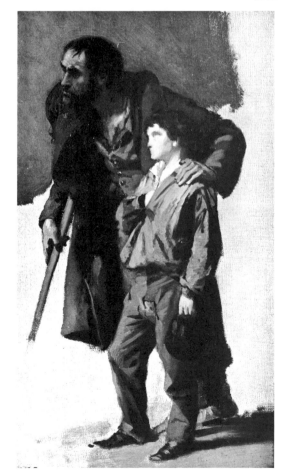

strates how Pils used his own experience to create a canvas with symbolic and social implications for the poor. The last illness of Saint Prosper, the mother superior of Hôpital Saint-Louis brought many—including Pils—to her bedside. The hospital, which had been established in 1802 as a center for the treatment of skin and venereal diseases, had become an excellent general clinic with a widespread reputation because of the care provided by its nuns under the direction of Saint Prosper.[3] Pils himself, in his longstanding struggle with tuberculosis, had been hospitalized there in 1845, 1846, and again in 1848, so that he knew the staff well.

Confining his composition to the impact of Saint Prosper's death upon the very segment of society she had touched the most enabled Pils not only to document the sad condition of the downtrodden, but also to pay homage to the friend and benefactor of the poor. In addition to his significant contribution to Realism, *La Mort . . .* represents Pils's separation from traditional history painting, in which images were based on events from the past. He chronicled a contemporary event —an aspect of history painting, but one in which he was able to use his skill as an artist to record what he saw much as a reporter would do for a newspaper or magazine. Salon critics in 1850/51, 1852, and 1853 recognized Pils's sense of reality and his ability to recast historical painting within a contemporary mode: "this serenity in appearance is produced by an excessive moderation of execution. The subject is calm and touching. A Sister of Charity from the Saint Louis Hospital has just passed away. . . . This painting fits into the realm of moral ethics, which the painter symbolizes through a simple action, in a way that is understandable to all. By all rights, it belongs to history painting; it has in itself the means of teaching; it represents the virtues of the people in a way which is both interesting and moralizing. . . ."[4] De la Fizelière realized the advantage of Pils's composition in teaching the masses because of his ability to convey uplifting sentiments of the poor. The dignity portrayed by Pils despite the obvious oppression and poverty served as a model for other Realists. After the Salon exhibition, no less aware of the value of a message of nobility inherent in the downtrodden and of the importance of the Church that it also contained, the government sent the painting to Toulouse.[5]

Pils relied upon previous artistic tradition in the development of his composition. The graphic realism of the dying Saint Prosper[6] recalls the work of Philippe de Champaigne, the seventeenth-century master whose earlier image of a dying mother superior was in the Louvre. The faces of the poor and the portrait of the young nun emphasize benevolent qualities that suggest Pils's awareness of eighteenth-century artists, especially Greuze. Little is known about the revival of

Greuze in the mid-nineteenth century, although renewed interest in eighteenth-century contemporaries such as Greuze and Oudry undoubtedly followed in the wake of the growing popularity of Chardin.[7] The subdued supplication of the mothers at the right, the downcast eyes of the young nun, and the upward gaze of the mother in the center indicate Pils's ability to convey emotions and a range of expressions which could not have been unfamiliar to Salon viewers. Pils's inclination toward Romantic painters is also suggested in the similarity of the dress, pose, and demeanor of the mother in the foreground to models of Delacroix (e.g., *Massacre at Chios*). While Pils's style was not dependent upon the freer paint application that typified so many Romantics, his color tones imply a close study of certain Romantic canvases.

Even though some critics found the canvas inappropriately large or considered the poses of the figures theatrical, the success of the painting accorded Pils distinction as an apostle of Realism without endangering his respected position as a chronicler of history under the Second Empire.

1. See dossier Isidore Pils, F 21/103, Archives Nationales, Paris. The painting was acquired by the state 23 May 1851.

2. L. Becq de Fouquières, *Isidore Alexandre Auguste Pils—Sa Vie et ses oeuvres* (Paris, 1876), p. 25.

3. See Pierre Vallery-Radot, "Chroniques, en l'honneur de l'internat et de l'hôpital Saint-Louis," *La Presse médicale*, 3 December 1952.

4. Albert de la Fizelière, *Exposition Nationale —Salon de 1850/51* (Paris, 1851), p. 12.

5. Education in the provinces became an important concern of the Second Empire. Toulouse may have been selected for religious as well as political reasons, although the exact reason for the canvas being sent there is not known.

6. Pils's study of Saint Prosper, who died 30 August 1846, is in Musée Magnin, Dijon.

7. For further information on artistic revival at mid-century, see Gabriel P. Weisberg with William S. Talbot, *Chardin and the Still-Life Tradition in France*, exh. cat. (CMA, 1979).

Exhibited

1850, Paris: Salon, no. 2475.

Published

Explication des ouvrages . . . exposés au Palais National, le 30 décembre, 1850 (Paris, 1850), p. 204, no. 2475.

M. I. Peisse, "Feuilleton du Constitutionnnel —Salon de 1850," *Le Constitutionnel*, 1 April 1850.

Louis de Geoffroy, *Le Salon de 1850* (Paris, 1850), p. 945.

De la Fizelière, *Exposition Nationale*, p. 12.

Paul Mantz, "Feuilleton de l'Evénement—Le Salon," *L'Evénement*, 15 February 1851, p. 2.

Louis Gonse, "Exposition de Pils à l'Ecole des Beaux-Arts," *Paris Chronique des Arts*, 1876, p. 25.

W. Bouguereau, "Notice sur M. Pils," *Institut de France—Académie des Beaux-Arts* (Paris: Typographie de Firmin-Didot, 1877), p. 6.

L. Becq de Fouquières, *Exposition des oeuvres de Pils à l'Ecole des Beaus-Arts*, exh. ca. Paris, 1876), p. 3. Idem, *Isidore Pils*, p. 25.

Jules Claretie, "Isidore Pils," in *Peintres et sculpteurs contemporains*, 2 vols. (Paris: Librairie des Bibliophiles, 1882), 1: 157.

Catalogue, Musée des Augustins (Toulouse, n.d.), p. 109.

Gabriel P. Weisberg, "In Search of State Patronage: Three French Realists and the Second Empire—1851-1871," in *Essays in Honor of H. W. Janson* (New York: Prentice-Hall, forthcoming).

Isidore Pils

79A Preparatory Drawing for Two Figures in *The Death of a Sister of Charity*

Pencil and charcoal, 15-1/8 x 12-1/4 inches (38 x 31 cm.).

Paris, Private Collection.

In preparation for his *Death of a Sister of Charity*, Pils did a series of charcoal sketches for many of the figures. Rapidly recording his ideas, and possibly working from models he posed in his studio, Pils tried to capture the emotional range necessary for his final canvas. He repeated his figures in several different sketches and often concentrated on only a portion of a figure, such as the hands of the young nun at the right holding a Bible. This drawing establishes the importance of preliminary studies in Pils's development of a composition: he used the charcoal sketch to capture first impressions that he later modified in oil sketches.

Isidore Pils

79B Oil Sketch of Two Figures in *The Death of a Sister of Charity*

Oil on canvas, 17 x 10-1/2 inches (43 x 26.5 cm.). Stamped lower left: I. PILS. Pils estate seal, in wax, on the verso.

Cleveland, Collection of Mr. and Mrs. Noah L. Butkin.

Provenance. Sale, Hôtel Drouot, Paris, March 1876, no. 419, p. 43. Galerie André Watteau, Paris.

Whether Pils did oil sketches for all of the figures in *The Death of a Sister of Charity* remains unknown, although studies were done of other figures for the composition, especially Saint Prosper (Musée Magnin, Dijon). In completing these works, Pils may have relied on models that he posed in the studio. The old beggar, grasping his crutch but supporting himself on the shoulder of the young boy, seems to have been drawn from life, for his face has a taut expression far removed from traditional idealized formulas. One critic, Paul Mantz, in writing about the painting when it was shown at the Salon, commented that Pils used models with crim-

inal implications.[1] There is no evidence to suggest that Pils relied on criminal types, but the critic was correct in recognizing the accuracy of Pils's lower-class models to heighten his reality. Like Bonvin, Pils sought his models in the streets for a work he wanted to appear convincingly sympathetic and accurate. Pils used the small oil sketch to work out color and form relationships and to achieve a tangible street beggar, even though he later lessened the intensity of the gaze and dress in the finished composition.

1. Mantz, "Feuilleton de l'Evénement," p. 2.

Published

Catalogue de tableaux, études, esquisses, aquarelles, dessins par I. Pils (Paris, 1876), p. 43, no. 419.

Isidore Pils

80 Sketch for *Soldiers Distributing Bread to the Poor*

Oil with some graphite on tan paper, 13-1/4 x 19-5/8 inches (33.7 x 27 cm.). Inscribed lower left in red chalk: Victor Boisse/Passage St. Maur no. 4/Chez M. Moret.

Cleveland, Mrs. Noah L. Butkin Collection.

Provenance. Sale, Hôtel Drouot, Paris, March 1876, no. 297, p. 32. Galerie Fischer-Kiener, Paris. Shepherd Gallery, New York.

Soldiers Distributing Bread to the Poor, an image of the people of Paris interacting with the army in 1849, was the second of Pils's canvases to document his sympathy toward the poor. It was commissioned by the state, exhibited at the 1852 Salon, and recognized by the art critics as a subject appropriate for the times.[1] It was the first of many works to reflect a growing interest that would lead to Pils's fame as a portrayer of military events.

Pils had observed a similar scene at the Camp des Invalides in the center of Paris, which he then reconstructed in a series of preparatory drawings for the major figures and in this oil sketch of a youth reaching expectantly, with his arms outstretched and openhanded.[2] Pils recognized that it was "in the streets . . . among the people that one could find types and models; and in this way historic painting could become true and human."[3] In studying young children, such as those gathered around the soup container in the foreground of the large canvas (Figure 80a), Pils humanized history painting, making it not only factual but understandable.

Because the painting was commissioned by the government of the Second Empire (and hung in the Ministry of the Interior), it is clear that Napoleon III intended the painting to elevate his own image of concern for his people as well as to document the actual event itself.[4] The eagerness of the people straining for the bread and soup—leaning over a railing or reaching from the vantage of a tree—reinforced the image of suffering of the masses that Pils observed.

Pils probably completed oil sketches for many of the key figures, working from models he found in the poorer sections of Paris.

80

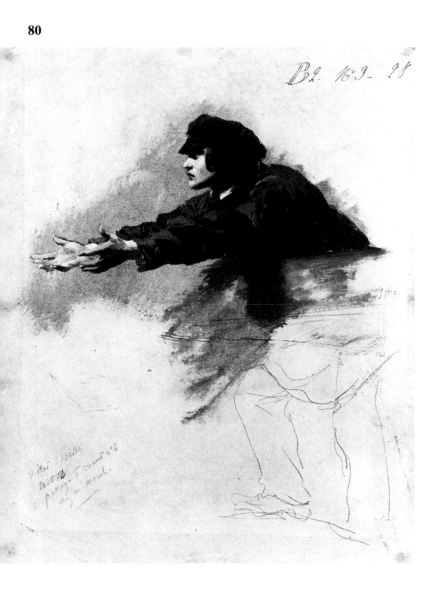

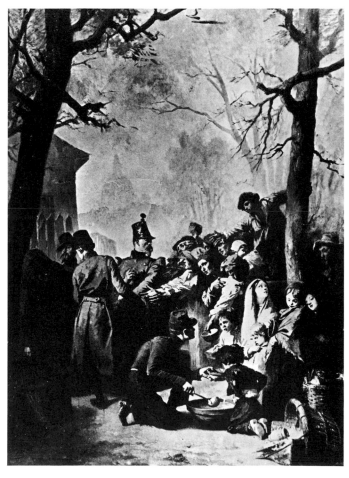

80a Isidore Pils, *Soldiers Distributing Bread to the Poor*, oil painting.

The study of the young boy is freely painted and carefully developed from accurate observation, and bears a notation at the left, which may record the name of the model and the street where Pils found him. The numbering system at the top suggests that the sketch was one of a series executed in preparation for the finished composition.

1. See dossier I. Pils, F 21/103, Archives Nationales, Paris, recording the commissioning of the composition and the eventual payment of 4000 francs in two installments (February 1853 and January 1854).
2. See *Explication . . . exposés au Palais Royal, le 1er avril, 1852* (Paris, 1852), p. 167, where the site is identified as "*14e de ligne; Camp des Invalides, 1849.*"
3. Becq de Fouquières, *Isidore Pils*, p. 26.
4. See dossier I. Pils, F 21/103. Despite the painting's fame (it was engraved in *L'Illustration* in 1852), the canvas itself has not been located.

Published
Catalogue de tableaux, p. 32, no. 297.

Isidore Pils

81 *The Prayer in the Hospice*
 (La Prière à l'hospice)
Oil on canvas, 103-7/8 x 78-1/8 inches (262 x 107 cm.). Signed and dated lower left: I. Pils 1853.
Paris, Musée de l'Assistance Publique.
Provenance. Purchased at the 1853 Salon by the Empress Eugénie. Given to the Hospital for "Enfants trouvés," Paris. Transported to the Hôpital St. Louis, 1902. Transferred to the Musée de l'Assistance Publique, 1934.

For the 1853 Salon, Pils completed a large canvas entitled *The Prayer in the Hospice*, repeating a theme which he had first used in *The Death of a Sister of Charity* [79]. Using the Hôpital Saint-Louis, which had become a Parisian center for child care, as his setting, Pils focused on young children with their heads shaved and bandaged, closely gathered around the kneeling figure of Sister Marie-Jeanne François (also known as Sister Isidora—later Saint Isidora).[1] The sympathy that Pils always demonstrated in his images of children is evident here, for he captured them in a variety of expressions, some affecting the posture of the nun, others, distracted, but reflecting her demeanor.

During the time he was convalescing at Saint-Louis late in the 1840s, Pils made a series of drawings of the young patients in various poses and attitudes, many of which he preserved in his notebooks.[2] Thus from observations, where he worked on each figure separately, Pils later developed his composition. His knowledge of the treatment provided to those children whose poverty-stricken parents were unable to care for them; his own childhood affliction with the same scalp disease;[3] and his awareness of the generosity and concern of Sister Isidora—to himself as well as to others—

undoubtedly influenced his decision to memorialize the deeds of the nun.

The painting, therefore, contains several levels of interpretation. On a personal side, the canvas records the care given to children and to Pils, a personal testimony that permitted him to create an autobiographical image in the youth at the feet of Sister Isidora who tenderly and longingly looks out at the viewer.[4] On a second level, the canvas memorializes Marie-Jeanne François who continually prayed for the welfare of the children in her keeping and who tried to continue their education during the period they were hospitalized (notice the readers scattered on the tile floor).[5] Pils began his painting in 1852, a date corroborated by some of the preliminary sketches that have been preserved. Sister Isidora became ill late in 1852 and died 28 January 1853.[6] His composition thus became a timely tribute to Saint Isidora and the endeavors which the state was then attempting to achieve through the Sisters of Charity.

81

1. Vallery-Radot, "Chroniques," pp. 1657-58.
2. Pils's notebooks, preserved in private collections, reveal his method of working and suggest that he drew from models in the completion of this composition.
3. See Yvonne Saint-Geours, Nicolas Sainte-Fare-Garnot, and Nadine Simon, *Trésors et chefs-d'oeuvre de l'Assistance Publique,* exh. cat. (Paris, 15 June—31 December 1977), pp. 3-4. Pils's biographer, Becq de Fouquières, also documents that Pils suffered as a child from this skin disease.
4. Saint-Geours, *Trésors et chefs-d'oeuvre,* p. 4.
5. The work of individual nuns in continuing the education of young children undoubtedly helped to establish the more formalized school at Saint-Louis in 1885. See notes, typescript, Musée de l'Assistance Publique, Paris.
6. *Explication . . . des artistes vivants exposés aux Menus-Plaisirs, le 15 mai 1853* (Paris, 1853), p. 168. Marie-Jeanne François, of the Augustinian order, was born in 1795.

Exhibited

1853, Paris: Salon, no. 933.
1876, Paris: Exposition des oeuvres de Pils à l'Ecole des Beaux-Arts, p. 9, no. 11.
1977, Paris, Musée de l'Assistance Publique: Trésors et chefs-d'Oeuvre de l'Assistance Publique, pp. 3-4, cat. no. 4. Catalog by Yvonne Saint-Geours, Nicolas Sainte-Fare-Garnot, and Nadine Simon.

Published

Becq de Fouquières, *Isidore Pils,* pp. 25-26, 53.
Gonse, "Exposition de Pils," pp. 17, 25.

81A

Bouguereau, "*Notice sur M. Pils,*" p. 6.
Claretie, *Peintres et sculpteurs,* 1: 157.
Dr. L. Butte, "La Teigne à Paris, Les Hôpitaux et les écoles de teigneux," *L'Assistance,* July 1891.
Vallery-Radot, "Chroniques," cat. no. 77, pp. 1657-58, repr.
Weisberg, "In Search of State Patronage."

Isidore Pils

81A Album of Preliminary Sketches

Pencil, 5-1/2 x 3-1/2 inches (14 x 9 cm.), ca. 1850-52.
Paris, Private Collection.
Provenance. Collection of the artist.

Pils carried with him small sketchbooks in which he recorded scenes from direct observation. Occasionally, these quickly perceived annotations were dated so that the evolution of some of his major Salon compositions are thus documented. Several of the free sketches he made in mid-June 1852 show a praying nun surrounded by her small charges in a Parisian hospital for the poor and thus document his preliminary efforts for the later oil *La Prière à l'hospice.* Other sketches dated 1852 and contained within the same album preserve his impressions of a variety of different themes, from large structures, such as factories, to simple sketches that capture the stance of farm animals.

Jules Breton

82 *The Dedication of a Calvary (La Plantation d'un Calvaire)*

Oil on canvas, 53-1/2 x 99-1/4 inches (135 x 250 cm.). Signed and dated lower right: Jules Breton/Courrières, 1858.
Lille, Musée des Beaux-Arts; deposited at the Musée des Arts et Traditions Populaires, Paris.
Provenance. Purchased by the "Commission de la Loterie," on 20 April 1859 for 8000 francs. Purchased in 1866 from M. Pereire by the "Commission de l'Exposition des Beaux-Arts," Lille.

The installation of a religious monument in a provincial village was an important ceremony in which villagers and church officials alike participated. Monks, nuns, local clergy, and village elders all were assigned specific tasks, some to bear the wooden effigy of Christ on their shoulders, others to chant hymns as the procession moved from the steps of the local church to the site where the cross would be erected. *The Dedication of a Calvary* was inspired by a ceremony Jules Breton recalled from his own childhood, but he did not develop his theme until some years later, after he returned to Courrières and after his career as a painter of provincial themes was already established.[1]

Although influenced, no doubt, by Courbet's innovative use of models for *The Burial at Ornans* (a composition of major significance in the evolution of early Realism), Breton's rendering was highly personalized. He not only chose to record a ceremony of particular significance to his own village, but also included family relatives who would not have been present at the original dedication.[2] His young wife Elodie is the Virgin dressed in white carrying Christ's crown of thorns, and she is portrayed again, in the foreground, as the peasant mother of the two children straining to join the procession.[3] Breton's elder brother Louis served as the model for the parish priest leading the chanting curates, and Jules Octave de Vigne, his young brother-in-law, posed as the intent young boy with the prayer book accompanying the old woman.[4]

The pious solemnity of the episode is reinforced by other participants and spectators. At the right is a cripple seeking the blessing of the priests as they leave the church. The older women nearby, their heads bowed in reverence to the passing effigy, represent devotion and piety—a quality reiterated in the gestures of the other villagers that accompany the procession. Some village elders (wardens of the church) carry memorial tapers; others in the procession—in particular, the young girls approaching the cross who are dressed in white to signify their role as Virgins of the Church—hold aloft banners dedicated to Christ's Passion and the Virgin. As the stately pageant proceeds toward the crucifix in the background, workmen make ready the ladders to attach the wooden

statue. Once in place, the monumental figure will dominate the graveyard and, by implication, all of those in His keeping—both villagers and the departed.

This painting was one of four that Breton exhibited at the 1859 Paris Salon following a favorable reception in Antwerp. While similar in theme to his *Bénédiction des blés* (1857 Salon), *The Dedication of a Calvary* is more unified in style and detail. Critics commented on Breton's mastery of facial detail, noting a resemblance to Flemish old masters.[5] Breton's use of somber tones of gray, tan, and white, augmented by his choice of an overcast day, however, led some reviewers to disparage the solemnity as more appropriate for a funeral cortege than a ceremonial processional (an allusion to Christ's death that Breton may indeed have intended).

On the whole, the work was well received by most of the Salon critics, who identified the setting as a "peasant atmosphere" rather than a religious environment. Some, such as Alexandre Dumas, recognized the influence of Gustave Courbet upon Breton's style: "It is evident to us that Breton is . . . a student of Courbet's school; Courbet, however, was

a teacher and not a model. Breton has reflected the true side of the master. When one invents a style as Courbet did, he is a master; Breton has assimilated the true side of the master without retaining any of the side that is always ugly—often ridiculous. Like Courbet, he has not only studied directly from nature, but he has also learned—without copying—the lessons of the old masters."[6] Dumas designated Breton's composition as an expression of truth and commended the painter's preference for village types rather than studio models. Breton's use of "naive types"—the villagers of Courrières—thus underscored the authenticity of his canvas.[7]

1. Jules Breton, *La Vie d'un artiste* (Paris, 1890), pp. 84, 92-93.
2. This was a method that Courbet had utilized in his *Burial at Ornans,* since members of his family would have been dead at the time the ceremony actually took place. Whether Breton knew about this detail from discussions with Courbet is difficult to document.
3. Information provided by the descendants of Jules Breton to the author. Documentation of the role played by Elodie in the painting is further established by the existence of a sketch for the

young girl holding the crown of thorns which has an inscription on its back identifying the model as Mme. Jules Breton. For further reference see *Study of the Head of the Young Woman Holding the Crown of Thorns* (Lille museum).
4. The identity of this model has been provided by the descendants of Jules Breton in correspondence with the author. In addition, another sketch, *Study of the Head of a Young Boy* (Lille museum), has an inscription on its back identifying the model for this figure as Jules Octave de Vigne. Two other sketches for the painting are also preserved in the Lille museum, although they do not provide evidence for identifying the other models. Still other sketches done for the painting are documented in the catalog of the sale of Breton's atelier, although a *Fillette* (no. 51) and a *Paysanne* (no. 150) have not been located.
5. Alexandre Dumas, *L'Art et les artistes contemporains au Salon de 1859* (Paris, 1859), pp. 51-53. While Dumas does not specify which old masters he has in mind, it seems clear that Breton was familiar with Netherlandish painters of the fourteenth and fifteenth century, especially after his training in Antwerp.
6. Ibid.
7. Maxime du Camp, *Salon de 1859* (Paris, 1859), pp. 35-37.

Opposite
80 Isidore Pils, Sketch for *Soldiers Distributing Bread.*

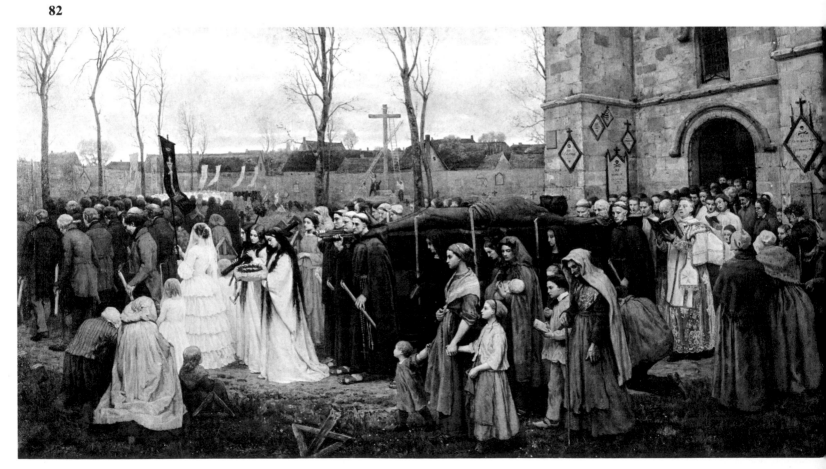

B2. N°3 - 28

Victor Boillé
[illegible] n°4
passage St mart
au 4° [illegible]

87 Théodule Ribot, *A Children's School*.

Opposite
83 Alphonse Legros, *The Ex-Voto* (detail).

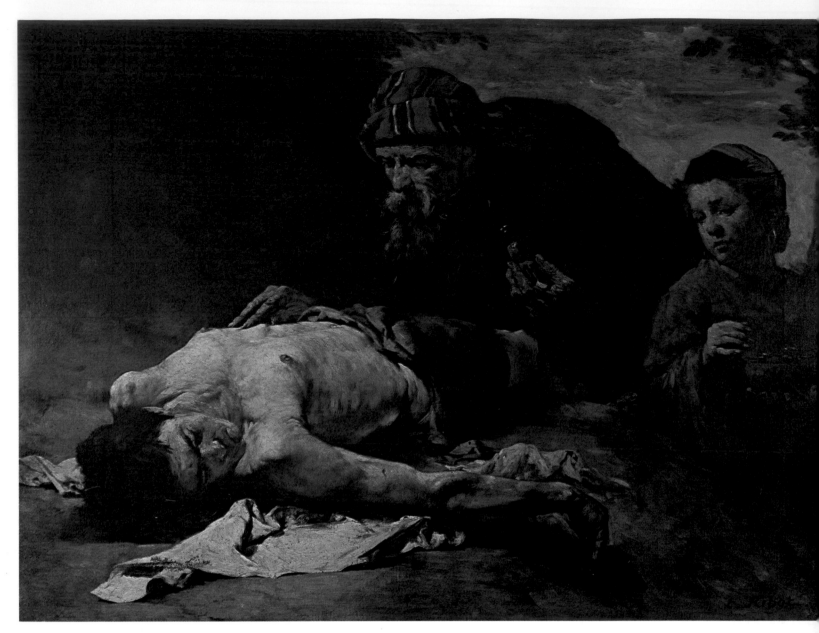

91 Théodule Ribot, *The Good Samaritan*.

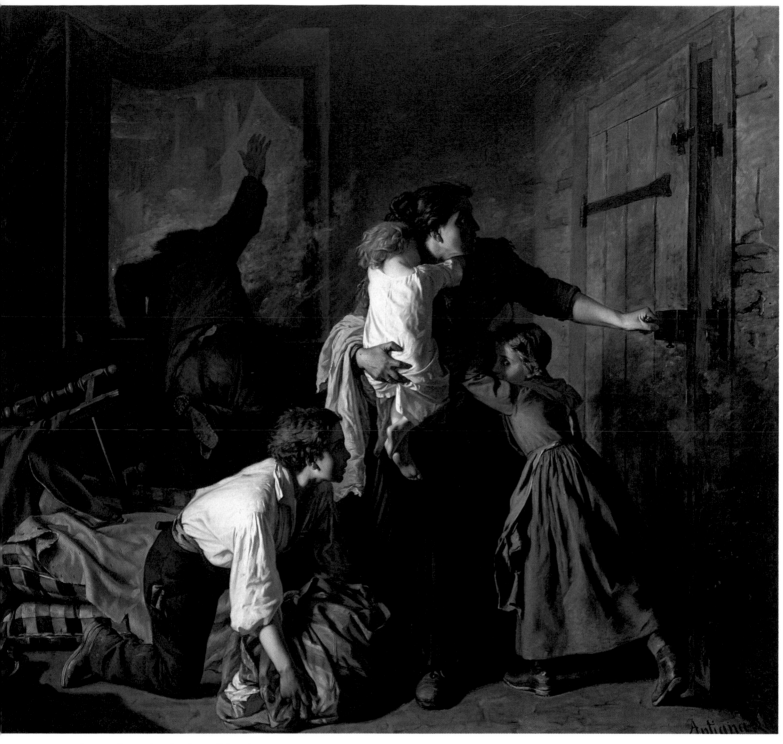

92 Jean-Pierre Alexandre Antigna, *The Fire*.

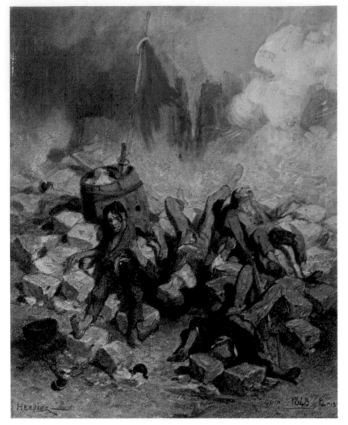

98 Adolphe Hervier, *The Barricade*.

Opposite
95 Jules Breton, *Fire in a Haystack* (detail).

107 Isidore Pils,
The Vendome Column Destroyed.

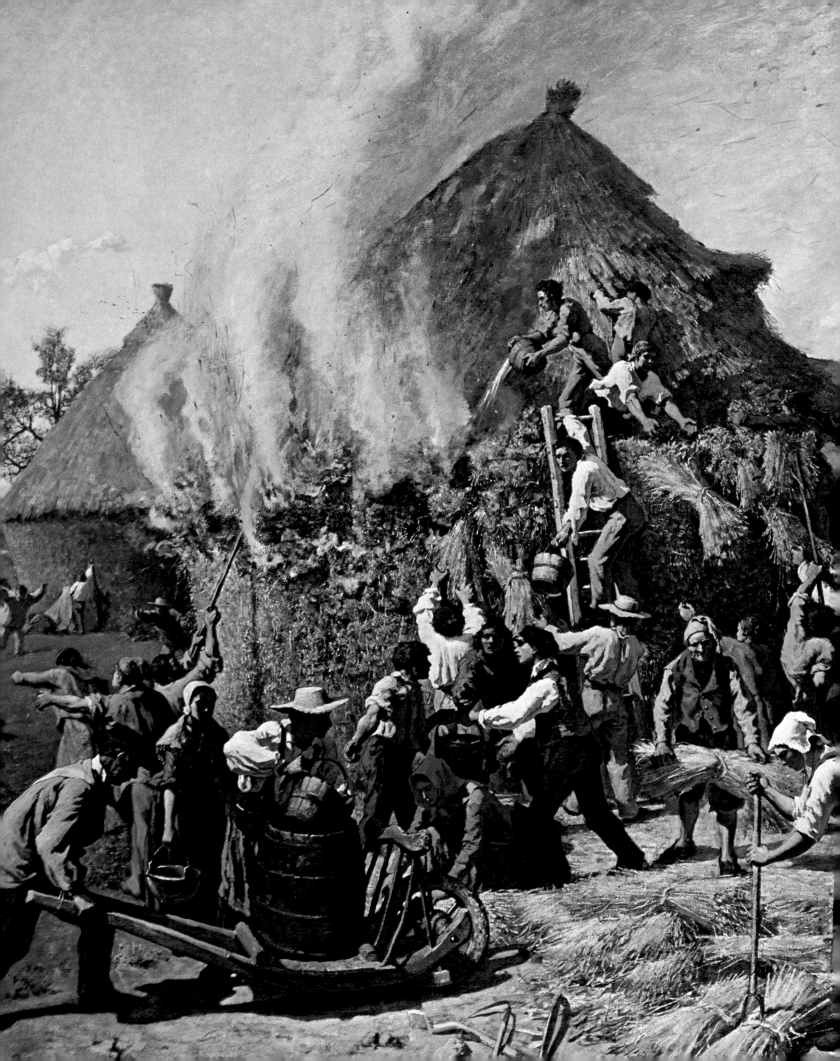

108 Jean-Louis-Ernest Meissonier, *The Ruins of the Tuileries*.

Exhibited

1858, Antwerp: Salon.
1859, Paris: Salon, no. 410.
1973, Paris, Musée des Arts Décoratifs: Equivoques: Peintures françaises du XIXe siècle.

Published

Dumas, *L'Art et les artistes,* pp. 51-54.
Paul Mantz, "Salon de 1859," *Gazette des Beaux-Arts* 1 (1859): 286-87.
L. Jourdan, *Les Peintres français—Salon de 1859* (Paris, 1859), pp. 26-27.
Zacharie Astruc, *Les 14 Stations du Salon —1859—Suivies d'un récit douloureux* (Paris, 1859), pp. 227-28.
Marquis de Belloy, "Le Salon de 1859," *L'Artiste,* 24 April 1859.
Marius Vachon, *Jules Breton* (Paris, 1899), pp. 66, 96, 99, 101.
François Monod, *Art et Décoration,* supp., August 1906, p. 2.

Alphonse Legros

83 *The Ex-Voto*
 (L'Ex-Voto)

Oil on canvas, 68-7/8 x 78-1/8 inches (174 x 197 cm.). Signed and dated lower left: A. Legros. 1860.

Dijon, Musée des Beaux-Arts.

Provenance. Gift of Alphonse Legros in 1868.

When Zacharie Astruc praised the work of Alphonse Legros in his 1863 Salon review, he pointed out that the painter's *Ex-Voto,* a canvas which Legros had shown at the 1861 Salon, had been changed by the painter prior to its initial exhibition.[1] Astruc recalled Legros's original rendering in his description of the final version:

> This painting has undergone . . . an important change which it is significant to record. The canvas originally represented a death chamber. The bed is empty; the drapes hang like funerary hangings enclosing the alcove. . . . On benches a coffin

has been placed, covered with a white sheet on its lowest section. A woman has run toward the coffin desperately crying. A child near her looks on without understanding what is occurring. To the right are invited mourners. . . . In the foreground a few women are murmuring prayers.[2]

The finished scene, however, is quite different. The room interior, in which figures were holding prayer books before a funerary bier, was changed to record, instead, individuals before a wayside shrine, which was composed of a crucifixion and four golden tears against a dark background.[3] While Astruc's perceptive review is the only published account of how the painting initially looked, recent x-rays of the canvas have confirmed that the painting was originally an indoor death scene.[4]

Given the nature of the Realists' interest in moving themes and in recording figural types with a truthful objectivity, it is easy to understand Legros's first inclination to paint

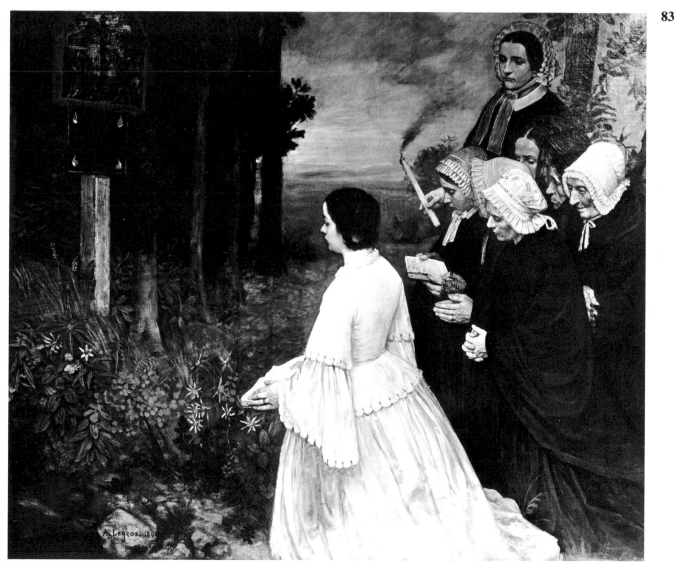

a scene with unpleasant connotations. As a fervent admirer of the works of Gustave Courbet, Legros may even have known the Realist master's *La Toilette de la morte*,[5] a canvas that could have inspired his commitment to paint these aspects of daily existence.

Nevertheless, before Legros's canvas was shown at the 1861 Salon, he modified the composition that Astruc described, to win favor with the jury and the Salon public.[6] Without knowing the changes involved in the development of the painting, one critic, nonetheless, pinpointed the discrepancy in Legros's composition when it was exhibited at the 1861 Salon: "the heads contain the powerful strength of the first inclinations of the Venus of realism. But why does this canvas lack air and perspective? And why are the plants which cover the ground and which are of a normal size not studied with the same accuracy as the individuals?"[7] The accuracy of Legros's realism had indeed been compromised by his desire for success; the decorative flowers, the bank of trees are studio props that he added to disguise the original nature of the scene.

Despite that critic's perceptive analysis, the painting won considerable praise. Hippolyte Flandrin, a member of the Salon jury, advocated that Legros be awarded a second-class medal; he received only an honorable mention. *The Ex-Voto* was also shown at the Galerie Martinet that year, enabling members of the Realist school to study the precise detail of the hands and faces of the women in black that revealed Legros's ability to suggest Spanish painting, and his command of tonal painting—evident in the somber palette of blacks and whites to which he confined his figures.[8] Shown at the Royal Academy in London in 1864, this canvas promoted Legros's stature as a major artist in England, where he taught young art students aspects of Realism.[9]

Even though the painting was widely shown during the 1860s, Legros was unable to sell it. By 1868, in the belief that it would finally be properly honored, he donated the work to the museum in his native Dijon. Concerned when the work was not hung, Legros asked his uncle to visit the director.[10] Despite such prompting, the painting was badly placed, suggesting that the provincial director, Célestin Nanteuil—himself a Romantic painter and printmaker—was uninterested in Realist compositions.

1. Zacharie Astruc, "Le Salon de 1863," *Feuilleton quotidien* (Paris, 1863), vol. 2, pp. 2-3.
2. Ibid.
3. The use of en ex-voto was unusual in Realist painting of this period, although Legros does not seem to have depicted a particular one from a provincial region. The ex-voto (in this case, a roadside shrine) helped protect the faithful, and a prayer here demonstrated gratitude as well as assured protection. By selecting this motif, Legros was able to retain his original compositional for-

mat without changing his figural grouping. For further information see Jean Arrouye, *Sémiotique de l'Ex-Voto,* Communication au 1er congrès de la Société des Sciences de l'Information et de la Communication, Compiègne, May 1978.
4. See Monique Geiger, "Alphonse Legros, l'Ex-Voto, Etude radiographique," *Bulletin du Laboratoire de Recherches des Musées de France,* 1971, pp. 18-23.
5. For a discussion of this painting see *Gustave Courbet (1819-1877),* exh. cat. (Paris: Editions de la Réunion des Musées Nationaux, 1977), pp. 107-9; and Linda Nochlin, "Gustave Courbet's 'Toilette de la mariée,'" *Art Quarterly* 34 (1971): 31-54.
6. Astruc, "Le Salon de 1863," pp. 2-3.
7. Léon Lagrange, "Le Salon de 1861,"*Gazette des Beaux-Arts* XI (1861): 52.
8. Some have noted that the old woman at the right was a portrait of Legros's mother. See Alexander Seltzer, "Alphonse Legros: The Development of an Archaic Visual Vocabulary in the 19th Century" (Ph.D. diss., State University of New York at Binghamton, 1980), p. 123.
9. The painting was reviewed in the *Spectator* and the *Athaenaeum,* as cited in Papiers Clément-Janin, carton 74, dossier 3 bis, résumé des coupures de journaux, depuis 1863, Bibliothèque d'Art et d'Archéologie, Paris.
10. Legros to Ludovic Barrié, 29 November 1869.

Exhibited
1861, Paris: Salon no. 1900.
1861, Paris, Galerie Martinet.
1864, London: Royal Academy Exhibition, no. 230.
1900, Paris: Centennale de l'art français, cat. no. 417, repr. p. 72.
1932, London: Exposition d'art français, cat. no. 498.
1936, Paris: Souvenirs artistiques et littéraires recuellis sur la Bourgogne, no. 87.
1957, Dijon: Alphonse Legros, p. 1, no. 2.
1968, Paris, Petit Palais: Baudelaire, no. 528.
1973, Paris, Musée des Arts Décoratifs: Equivoques: Peintures françaises du XIXe siècle.

Published
Roger Marx, *L'Art français à l'Exposition centennale de 1900* (Paris, 1900), repr.
Léonce Bénédite, "A. Legros," *Revue de l'Art Ancien et Moderne,* 1900, pp. 337, 341, 348-50; repr. p. 339. Idem, "A. Legros, Painter and Sculptor," *Studio,* June 1903, p. 12, repr. p. 3. Idem, *L'Art au XIXe siècle—1800-1900* (Paris, n.d.), pp, 213, 216.
J. K. Huysmans, *L'Oblat* (Paris, 1903), p. 219.
Fyot [Onyx], "L'Ex-Voto de A. Legros," *La Revue de Bourgogne,* 1911, pp. 96-98, repr.
Louis Réau, "La Peinture française de 1848 à nos jours," in *Histoire de l'Art,* ed. André Michel (Paris, 1926), VIII: 564, fig. 353.
Henri Focillon, *La Peinture aux XIXe et XXe Siècles* (Paris, 1928), p. 163.
H. David, *Le Musée de Dijon et le romantisme* (Dijon, 1930), p. 23.
L. Hautecoeur, *Littérature et peinture en France* (Paris 1942), pl. XXIV.
P. Quarré, "L'Art en Bourgogne," *Visages de la Bourgogne* (Paris, 1963), repr. p. 146.
Catalogue des peintures françaises, Musée des Beaux-Arts (Dijon, 1968), pp. 132-33, no. 717, repr. pl. XLI.

Alphonse Legros

84 *The Vocation of St. Francis (La Vocation de St. François)*

Oil on canvas, 55-1/8 x 76-7/8 inches (140 x 195 cm.). Signed and dated lower left: A. Legros, 61. Musées d'Alençon.
Provenance. Gift of the artist to the Musées d'Alençon in 1862.

Legros's religious genre compositions form a distinct thematic group and perhaps his largest single category. His preoccupation with religious genre extended throughout his career (e.g., *Le Manège,* 1855; *Femmes en prière,* 1888). The monks he often depicted recall those he had first seen in Spanish and Flemish paintings of earlier centuries, although he frequently visited a monastery in Paris to observe dress and attitudes practiced there.[1]

Legros's interest in religious genre is hard to understand. Other Realists who had used this theme, such as Bonvin in *Ecole des Orphelines* [78B], had been inspired by the increasing involvement of the Church with society. Legros's *Vocation of St. Francis,* however, contains little specific political or ecclesiastical connotation and may perhaps be regarded simply as a means for Legros to express the piety of worshipers. The unidealized figure style, his bold brushwork, and his objectivity suggest a debt to Courbet's Realist compositions as well as to some by Spanish seventeenth-century painters. The praying monks closely positioned within the constricted space appear larger than life and assume a grandeur comparable to that of Courbet in figural types such as *The Stonebreakers.* The *memento-mori* still life in the foreground serves to reinforce the attitude of the praying figures, emphasizing their commitment to a life of poverty and self-denial.

When it was exhibited at the Galerie Martinet, Charles Baudelaire noted that the work recalled "the most solid Spanish compositions" and compared the canvas with works by Eugène Delacroix. A latent Romanticism, which was discernible in some Realist works, was perceived by Baudelaire in Legros's composition. This quality must also have appealed to Poulet-Malassis, the publisher of Baudelaire's *Fleurs du mal* and a supporter of early Realism.[2]

1. The art critic Philippe Burty noted that Legros often visited a monastery in Paris.
2. Poulet-Malassis's relationship with the Realists awaits further examination, especially since he called upon some of them (including Félix Bracquemond—then a Realist) to do designs for his home. For further reference to Legros's early work, see Seltzer, "Alphonse Legros."

Exhibited
1861 or 1862, Paris, Galerie Martinet.
1957, Dijon, no. 5.
1968/69, Paris, Petit Palais, no. 529.

1978/79, Philadelphia Museum of Art, Detroit Institute of Art, and Grand Palais: The Second Empire 1852-1870: Art in France under Napoleon III, no. VI-75.

Published

Zacharie Astruc, *Le Salon,* 14 May 1863 (Paris: Cadart, 1863).

A. Poulet-Malassis, *Monsieur Alphonse Legros au Salon de 1875; note critique et biographique* (Paris and London, 1875), p.12.

Denys Sutton, "The Baudelaire Exhibition," *Apollo,* March 1969, pp. 177-78, repr. p. 180, fig. 9.

Odile Sebastiani, entries on Alphonse Legros, in *The Second Empire: Art in France under Napoleon III* (Philadelphia Museum of Arts, 1978), p. 324.

François Bonvin

85 *The Poor's Bench: Remembrance of Brittany*
(Le Banc des pauvres, Souvenir de Bretagne)

Oil on canvas, 21-21/32 x 15-3/8 inches (55 x 39 cm.). Signed and dated lower right: F. Bonvin, 1864.

Montpellier, Musée Fabre.

Provenance. M. Marmontel sale, Hôtel Drouot, Paris, 11-14 May 1868. Gift of Alfred Bruyas, 1868.

François Bonvin's *The Poor's Bench: Remembrance of Brittany* was purchased by Alfred Bruyas at the sale of the Marmontel collection in 1868; later it was included in the Bruyas bequest to the city of Montpellier, and thus became part of the Musée Fabre collection when it was formed.[1] When it was first exhibited at the 1865 Salon, Théophile Thoré approvingly described it as a church interior in which two women, seated against a wall of an outer aisle, were reading their prayers. The composition was listed in the Salon catalog as a remembrance of a scene from Brittany, and the attire of the women, with their white bonnets, suggests the regional dress of that province, a section of France that Bonvin visited during the 1850s. The church interior, however, is similar to St. Germain des Prés in Paris.

Critical acclaim and appreciation for this canvas during the 1860s by private collectors overlooked the way Bonvin developed his composition or the significance of the theme. The existence of a preliminary charcoal drawing confirms that Bonvin positioned two models dressed in regional garments on a bench in his studio. His preliminary study carefully recorded their facial features, especially the wrinkled skin of the older woman, and various aspects of illumination that he then transferred to this finished composition. Bonvin thus maintained his tradi-

84

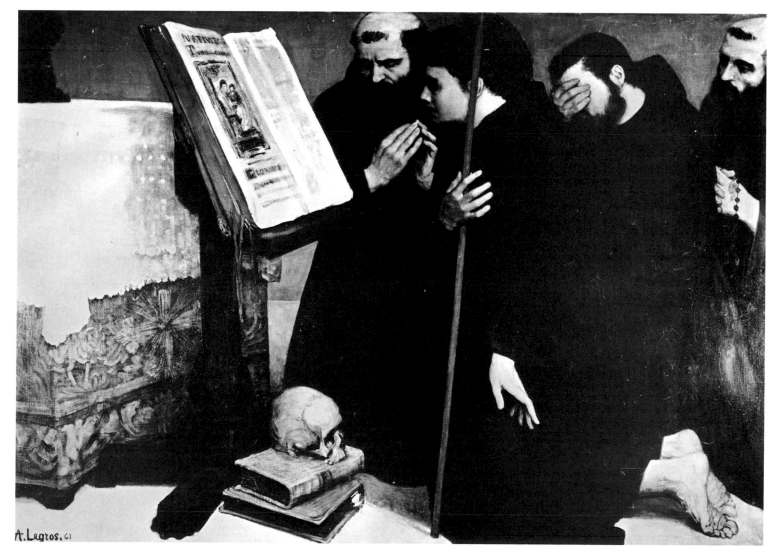

A. Legros. 61

tional method in the development of this work.

The significance of the two women intent upon their missals, the reason for their placement at the side aisle of the church, or the function of the container safeguarded at the feet of the older woman have never been fully explained.[2] The women are dressed alike in heavy capes to ward off the damp, musty chill of the dimly lit side aisle, so that only their hands and physiognomy—a contrast of age and youth—distinguish the figures.

1. See *Catalogue de la Galerie Bruyas* (Montpellier, 1868), p. 128. *The Poor's Bench* was one of two paintings by Bonvin that Bruyas owned.
2. The pail has been misidentified as a foot warmer. It has been suggested that the woman

and her youthful assistant may have been charged with holding the container of holy water for incoming worshipers to touch with their fingertips before making the sign of the cross upon entering.

Exhibited

1865, Paris: Salon, no. 238 (listed as belonging to Marmontel).
1939, Paris, Musée de l'Orangerie; Berne, Kunsthalle: Les Chefs-d'oeuvre du Musée de Montpellier, p. 20, cat. no. 9.

Published

Théophile Thoré, *Salons de W. Bürger, 1861 à 1868* (Paris, 1870), vol. 2, p. 199.
Moreau-Nélaton, *Bonvin*, pp. 64-65, fig. 43.
Weisberg, *Bonvin*, cat. no. 36.

Antoine Vollon

86 *The Altar Boys*
Oil on canvas, 12-7/8 x 9-9/16 inches (32.5 x 24.5 cm.). Signed lower left: A. Vollon.
U.S.A., Private Collection.

Pure genre scenes are unusual in Antoine Vollon's work. His occasional studies of children or women going to market, however, reveal an absorption of Realist themes that are reminiscent of the series of poses by Bonvin in which his daughter Françoise or her friends served as models [78A]. Ribot, who has been recorded as Vollon's mentor, also painted similar scenes of young children (also using his own daughter), either as milkmaids [9] or as musicians [11]. Vollon's *The Altar Boys* shows two young children in ill-fitting garments, perhaps choirboys, par-

85

86

ticipating in a prayer service. The restlessness of the seated boy, who is scratching his foot, preserves a gesture that earlier painters would have dismissed as too commonplace to record." Vollon heightened the "naturalness" of the event he had witnessed by presenting only the backs of the young boys, so that their expressions are not seen, rather than recomposing the scene according to established academic dictates.

Unlike other early works by Vollon or the muted, somber tones of other Realists, Vollon here has broadened his color range to emphasize the brilliant red of the standing boy's vestment and to intensify the contrasting black coat worn by the other child. Light is more evenly distributed than in Vollon's other early compositions, and the paint application is varied: a thick texture in some places, a thin layer in other areas that creates a watery surface. Vollon's technique reveals a love of paint and texture that Delacroix, as much as Courbet, may have inspired—and an achievement that anticipates the spontaneity of the Impressionists.

Exhibited

1966, Paris, Galerie M. Bénézit: Hommage de Paul Gadala à Antoine Vollon, no. 7 repr.

Published.

Gabriel P. Weisberg, "A Still Life by Antoine Vollon, Painter of Two Traditions," *Bulletin of The Detroit Institute of Arts* LVI, no. 4 (1978), repr. p. 224, fig.3 (with incorrect caption).

Théodule Ribot

87 *A Children's School*

Oil on canvas, 28-1/2 x 23-1/4 inches (72.4 x 59.1 cm.). Signed lower left: t. Ribot.

The Montreal Museum of Fine Arts.

Provenance. Cadart and Luquet, Paris 79, rue de Richelieu. W. J. Learmont Collection, Montreal, 1903. Given to the Museum by Lord Strathcona and family (1927).

While the bleak and impersonal regimen of a state orphanage is implied, Théodule Ribot's painting of the young girls may more accurately describe activity in one of the many *salles d'asiles* ("hospices") or, as they were later called, *écoles maternelles*—schools that were established by the state to provide training in moral instruction and rudimentary skills for children of the poor.[1] Salon critics at the time the work was exhibited in 1863 under the title *La Toilette du matin* took no notice of the school setting, however, but commented only upon the early morning activity of bathing and dressing.[2]

The function of the *école maternelle* was not clearly defined until 1881, when Jules Ferry referred to it as a "home for children," but efforts had been underway in the large cities for decades to develop special schools for the children of the poor. Instead of merely providing care for young children while their parents were at work, the young

women who supervised these schools taught singing, drawing, moral ethics, and simple reading and writing.[3] By the middle decades of the century, *écoles maternelles* were recognized as a transitional stage where children still too young to attend primary school became acquainted with the educational system.[4]

During the mid-1860s, when this painting was completed, the educational system underwent a series of reforms.[5] Most of the educational changes concerned higher levels of training, but the *école maternelle* was also modified and its disciplinary emphasis relaxed to stress the development of personal freedom and to provide an atmosphere of sharing and cooperation such as that evident in Ribot's composition.

Little is known about Ribot's personal life during the 1860s, so that it is difficult to document for certain the location of this *école maternelle* or the ages of the children he depicted. The girl in the center of the composition being dressed by a companion is known to be Ribot's daughter Louise (born September 1857). When the painting was exhibited, probably at the 1863 Salon, Louise would have been five—the age when young children were commonly enrolled in such a school. In the background, waiting for the girls, is the teacher who will accompany the children into the classroom to begin the day's instruction.

Paul de Saint-Victor, writing in *La Presse*, compared this composition with Velázquez's *infantas*, noting the similar painterly quality

87

in the faces of the children.[6] He failed to carry his observations any further, although the spare setting and the bleak, grayed colors create an atmosphere appropriate to the poverty of the lower classes.

1. The identification of this painting as a *Children's Home* remains unknown, although this is how the painting is now regarded by the Montreal Museum. In an exhibition in Montreal in 1912 it was entitled *The School*.

2. Ribot exhibited three paintings at the 1863 Salon, among them *La Toilette du matin* (no. 1580).

3. For further information on the *écoles maternelles*, see M. de Savigny, *Le Magasin des écoliers, encyclopédie illustrée* (Paris: Didier), pp. 235-42.

4. Ibid. Guizot urged that these *écoles maternelles* be considered as the first stage of the primary school education. During the middle decades of the century, however, this type of school remained a separate institution.

5. For further information see Alexis Léaud, *L'Ecole primaire en France* (Paris: La Cité Française, 1934), p. 269 ff.

6. See Paul de Saint Victor, "Variétés—Salon de 1863," *La Presse,* 13 June 1863, p. 3.

Exhibited

1863, Paris: Salon.
1880, Paris: Galeries de "l'Art" (listed as *La Toilette des petites filles*).
1912, Montreal, Art Association of Montreal: Inaugural Loan Exhibition of Paintings, no. 145 (listed as *The School*).
1960, Montreal, Montreal Museum of Fine Arts: Canada Collects: European Painting, no. 63.

Published

John H. Steegman, *Catalogue of Paintings: Montreal Museum of Fine Arts* (Montreal, 1960), p.102, no. 381.

François Bonvin

88 *Nun Holding a Letter*

Drawing in black, white, and colored crayons on blue paper, 15-3/16 x 9-7/8 inches (38.5 x 25 cm.). Signed lower left: f. Bonvin.
The Cleveland Museum of Art, donated by friends of Moselle Taylor Meals in her memory. 79.24.
Provenance. Mme. Paul Brodin, Paris. Fischer-Kiener Gallery, Paris.

In 1866, seeking relief from the depression that followed the suicide of his half brother Léon and his own brief, ill-fated second marriage, François Bonvin made a short trip to Brittany after which, instead of returning to Paris, he moved to Saint-Germain-en-Laye. The quarters he rented in the little village were not far from the convent, and his association with the order became both personal and professional. In addition to the care he received from members of the convent during periods of illness, his strong commitment to subjects and themes he observed there led to a continuing series of works with nuns as models.

Bonvin was not alone in choosing the theme of a religious order as a subject. During the Second Empire, other Realist painters (e.g., Amand Gautier [34]; Henriette Browne), recognizing the increasing amelioration of relations between Church and state, also turned to the theme of nuns. Bonvin's own interest in this theme emerged in 1858 when he painted *The Letter of Recommendation* (Musée de Besançon). Another painting, also entitled *The Letter of Recommendation* (Musée de Saint-Germain-en-Laye), 1867, shows two novitiates standing before a mother superior and her staff, awaiting approval of their official letter of presentation into the order. Bonvin completed at least two drawings for this second painting, one of them probably derived from his association with the religious order in Saint-Germain-en-Laye, since the mother superior is a specific model that he had used before. Her work apron is another indication of Bonvin's accuracy, but a detail that Bonvin changed in the final painting to the more traditional habit befitting the dignity and status of her position in the religious community.

Exhibited

1980, CMA: Year in Review, cat. no. 20.

Published

Moreau-Nélaton, *Bonvin*, fig. 82.
Weisberg, *Bonvin*, cat. no. 341.

88

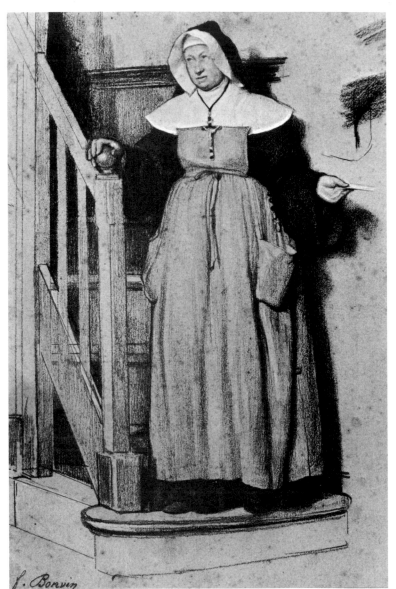

l. Bonvin

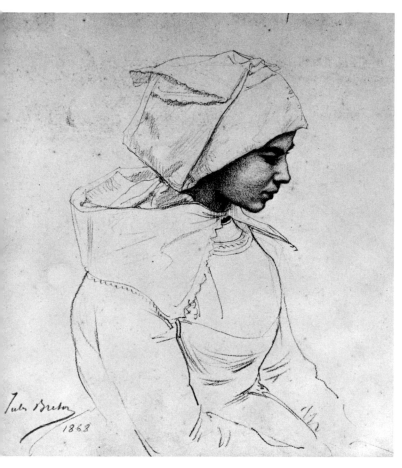

89A

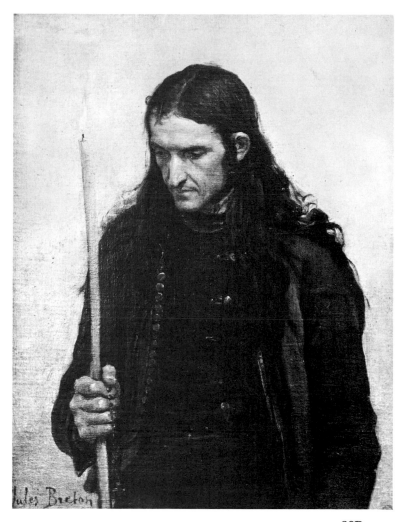

89B

Jules Breton

89A Study for *The Great Pilgrimage*
(Etude pour *Le Grand Pardon*)
Charcoal drawing, 9-1/2 x 9-1/2 inches (24 x 24 cm.). Signed and dated lower left: Jules Breton/1868.
France, Private Collection.

The customs and daily activities that Jules Breton observed during his stay in Brittany inspired some of his most complex themes depicting unrecorded aspects of regional life.[1] One of the most moving of these events was the annual pilgrimage of the peasants to receive general absolution.[2] This massive assembly that took place in front of a local church was the subject of Breton's monumental canvas *Le Grand Pardon* at the 1869 Salon.[3] In preparation for this large-scale painting, Breton did a series of studies in both charcoal and oil of men, women, and children dressed in regional garments. The preliminary charcoal of a young girl carrying a candle, which he would re-create in the left foreground of his finished oil, provides a description of her traditional garments and reveals Breton's meticulous care in capturing her pensive expression.

89a Jules Breton, *The Great Pilgrimage,* oil on canvas.

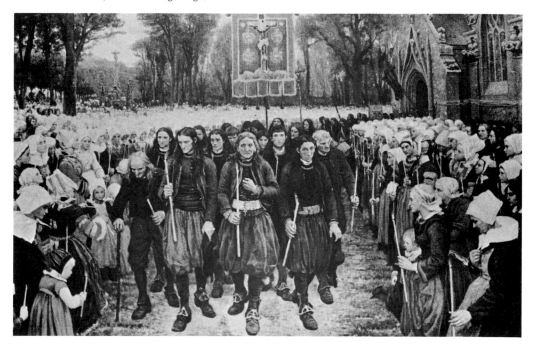

121

1. Other Realists (e.g., Antigna) had travelled to Brittany, and may have inspired Breton's trip, although his Uncle Boniface (who was considered an expert on regional life and had published a book on Courrières) may also have served as the inspiration for Breton's choice of this region.
 See Boniface Breton, *Le Village: Histoire, morale, politique et pittoresque de Courrières* (Arras, 1837). Boniface's interests and his close relationship with his nephew make it easy to see why Jules Breton was immersed in the life of his native village.
2. The observance of *Le Grand Pardon* in Brittany can be compared with the Jewish Day of Atonement (Yom Kippur).
3. The Salon painting is now believed to be in the National Museum of Cuba in Havana.

Jules Breton

89B *Breton with a Church Candle* (Study for The Great Pilgrimage)
Breton avec chandelle d'église—
Etude pour *Le Grand Pardon)*

Oil on canvas, 13-3/4 x 10-5/8 inches (35 x 27 cm.).
Signed lower left: Jules Breton.
France, Private Collection.
Provenance. Included in the atelier sale of Jules Breton on 2-3 June 1911 as cat. no. 63 but not sold.

The Great Pilgrimage was one of the most complex of Jules Breton's Salon compositions, and he included in it numerous individualized portraits of Breton peasants. The theme of the canvas had its origins in feudal times, and served as both a documentary of the popular religious ceremony and a reminder of the annual mass congregations of peasants from surrounding villages who came to receive official forgiveness for their sins—or, occasionally, as in this pilgrimage at Kergoat—to observe the healing of the sick.[1] Breton's canvas (Figure 89a) gives the impression that thousands came for the ceremony; rows of women and children extend from the church as far as the eye can see to witness the main event, the procession of the men of Brittany with their long ceremonial candles. Among the spectators, Breton included a contemporary self-portrait, but also portrayed Elodie and Virginie dressed in the traditional peasant garb.[2]

The series of oil sketches drawn from life in preparation for the larger composition include the candle bearer heading the central procession. The single portrait with its reflective pose conveys the distinctive atmosphere and dress of the region as well as the solemnity of the occasion.

1. See Jacques Duchemin, *Pardons bretons du temps passé* (Brussels: S.P.R.L., 1979), unpaginated.
2. Breton included members of his family or himself in this scene just as the Netherlandish masters of the fifteenth century had done; many of his works thus bring to mind "donor portraits" of earlier periods. Elodie appeared in earlier canvases by Breton [50, 82].

Published
Catalogue de vente des oeuvres de J. Breton, Atelier (Paris, 1911).

Théodule Ribot

90 *The Philosophers*
(*Les Philosophes*)

Oil on canvas, 40-1/8 x 35 inches (102 x 89 cm.), ca. 1869. Signed lower right: t. Ribot.
St. Omer, Hôtel Sandelin and H. Dupuis.
Provenance. Given by the state in 1869.

Théodule Ribot's success at the 1865 Salon, when the state acquired his *Saint Sebastian,* led to a series of official purchases by the state. Critics often compared Ribot's canvases with Spanish masters, especially Ribera, recognizing that Ribot's type of realism was based upon a study of former masters. In 1866, Ribot's *Christ among the Doctors* (Musée d'Arras) was selected by the government, indicating that his official sanction under the Second Empire was somehow particularly related to his religious themes of service to the people. The direct placement of his figures in the forefront of large canvases resulted in readily understood, forceful presentations devoid of supernatural effects. Another work, *The Oyster and the Litigants* (Musée de Caen), was purchased by the state in 1868. *The Good Samaritan* (1870 Salon), which was acquired by the state in 1871, received acclaim also, since its theme underscored the virtue of Christian charity. *The Philosophers* was secured by the state after the 1869 Salon and probably sent to the Munich exhibition that year. Here, along with other canvases by Ribot, German painters had an opportunity to see another aspect of Realism as well as the more famous canvases of Gustave Courbet.

90

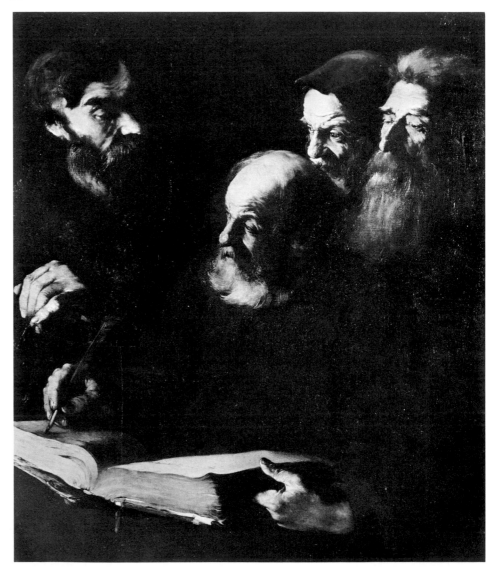

While the theme of *The Philosophers* cannot be fully defined, it is a significant work that reveals Ribot's mastery of old age as represented by village elders. By positioning his figures in the frontal plane of the canvas Ribot brought out the interplay of personalities through questioning gazes and hand gestures. As in many of his later canvases, Ribot used dramatic lighting effects, illuminating only sections of faces or the expressive hands, leaving other areas of the composition in shadow to enhance the sense of mystery. This composition is less suggestive of purely Spanish sources and reminiscent of the portraits of Rembrandt. The strength and subtlety of the characterizations and Ribot's ability to capture age without trivializing his sitters marks this as an important transitional work whose distinctive use of "common types"[1] was perceived by few of the critics of the time.

Ribot's version is a popularized Realism, showing that—in a religious sense—the elders' positions as scribes and educators were based as much upon experience as upon innate wisdom. The caution that halts the central figure, who is just about to record their decision, acknowledges the foresight and determination of men who think before they act.

1. Paul Mantz, "Salon de 1869," *Gazette des Beaux-Arts* I (1869): 501.

Exhibited

1869, Paris: Salon, no. 2025.
1869, Munich: Exposition Internationale.

Published

Eugène Muntz, "Exposition Internationale de Munich," *Gazette des Beaux-Arts* II (October 1869): 308.
F 21/176, 7e série, purchased by the state on 28 May 1869 for 3000 francs, Archives Nationales.

Théodule Ribot

91 *The Good Samaritan*
 (Le Bon Samaritain)

Oil on canvas, 38-5/8 x 51-5/8 inches (98 x 131 cm.), ca. 1870-75. Signed lower right: t. Ribot.
Pau, Musée des Beaux-Arts.
Provenance. Purchased in 1875 by the Société des Amis des Arts, Pau.

Although much of Ribot's previous work had been small canvases of musicians or cooks, during the 1860s he began to paint larger canvases with religious themes. His exhibit at the 1865 Salon depicting women caring for the martyred *Saint Sebastian* was a popular work that the state purchased for 6000 francs (Musée du Louvre).[1] The following year Ribot exhibited a young *Christ among the Doctors* (Musée d'Arras), a canvas that critics found more appealing than the unclothed, wounded nude of the previous year. At the 1867 Salon, however, Ribot again completed a study of the naked figure, using stark lighting and distorted poses in *Torture by Wedges* (also called *The Torment of Alonso Cano,* Musée de Rouen).

91

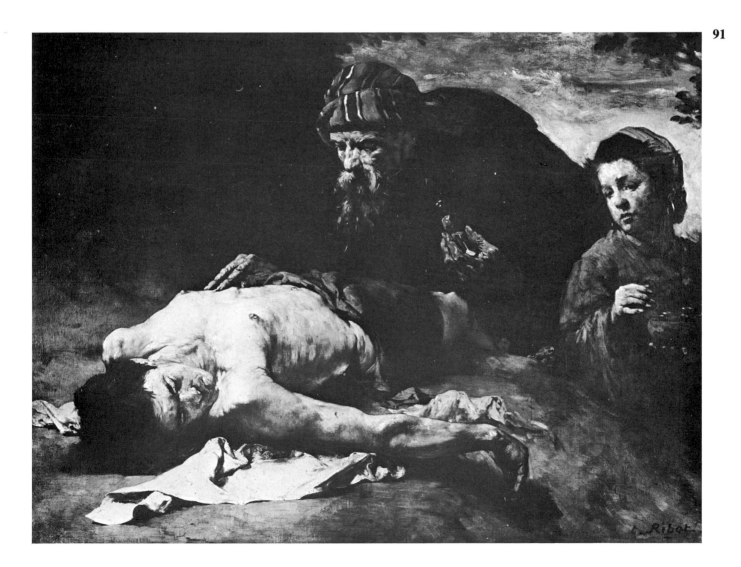

This canvas, similar in organization—especially in the central figure—to his *Saint Sebastian*, depicted the death of the Spanish seventeenth-century painter Alonso Cano who had been unjustly accused of murdering his wife. Two years later, Ribot painted his first version of the parable of the *Good Samaritan* (1870 Salon), a theme related to his previous religious themes in that it, too, stressed a humanistic attitude toward suffering.

Ribot's predilection for these themes differed from other artists of the Realist tradition, and was prompted as much by his fondness for the painters of the seventeenth century as by his own personal religious convictions and his regional background. Even before he came to Paris, Ribot had studied a similar painting of the Samaritan in his native Rouen that at that time was attributed to Ribera (although it is now recognized as a work by Luca Giordano).[2] Ribot regarded the seventeenth-century painters as masters of the human body, recognizing in their distorted, exaggerated poses a technical skill founded upon a solid knowledge of anatomy. While Giordano's work may have inspired Ribot's first version of the Good Samaritan, Johann Carl Loth (1632-1698) also depicted a scene of the Good Samaritan that is similar in compositional organization to Ribot's second version of the theme.[3]

Changing religious practices and policies under the Second Empire and Third Republic must also have influenced Ribot's choice of theme. The cooperation of Church and state during the Second Empire, especially during the 1850s and early 1860s, emphasized humanistic concerns and a renewal of efforts to alleviate the miseries of the poor—efforts intended to keep the masses in subordination.[4] A theme such as the *Good Samaritan* that stressed salvation through service to others was both timely and appropriate. The Church's stand against industrialization, capitalism, urbanization, and virtually every progressive innovation that threatened to compromise the Catholic stronghold in the minds and hearts of the people, and the Church's renewed emphasis upon a return to the fundamental teachings of the Bible thus received increasing support—especially in the poorer outlying provinces and rural villages where a tradition of religious dependency was already longstanding.

Like Jean François Millet, whose workers of the field represent the chosen people of God, Ribot also created images that hold a profound message. In the New Testament parable (Luke 10:30-37), when the lawyer asks, "Who is my neighbor?" Christ recounts the story of the traveller on his way from Jerusalem to Jericho who is attacked by robbers. Left to die by the side of the road, the traveller's plight is ignored by first one and then a second passerby—both of them learned religious leaders. Finally, a Samaritan—himself an outcast from society—stops to aid the injured man, soothing his wounds with wine and oil, assisting the helpless traveller onto his own donkey, and arranging for him to be cared for at a nearby inn until he is able to continue his journey.[5]

Other artists who portrayed the Good Samaritan traditionally featured the moment of abandon after the passersby have ignored the wounded traveller, or showed the Samaritan leading the injured man to the inn. Ribot's first version of this theme (which was purchased by the state in 1870, but is now lost and presumably destroyed in Warsaw during World War II) also emphasized the moment when the other travellers bypassed the injured man. Ribot's second version, which he completed after the terrors of the Franco-Prussian War, was an unusual presentation of the familiar theme. Ribot depicted the Samaritan kneeling by the side of the road and treating the stranger's wounds —a representation that focuses upon the Samaritan as a healer, perhaps Christ himself.[6]

The illumination in the second version is both compelling and profound, centering upon the traveller's bared and wounded torso, touching upon the bright turban and wizened features of the foreigner, and encircling the head and lighting upon the face of the child, who has turned from assisting the Samaritan to fix his attention upon the viewer. The directness and intimacy of the large composition—so that the viewer is fully part of the scene—and Ribot's ability to unite a biblical source with contemporary social implications make this canvas one of the most significant of his early paintings.

The work was never exhibited at a Salon. The city of Pau acquired the painting directly from the artist for 4000 francs after it was shown at the Société des Amis des Arts exhibition in 1875.[7] The specific reasons for the selection of a painting with this theme by the city fathers are not known. Ribot's moving rendition underscores Christian virtue and charity, suggesting that a model of humanitarianism was important to the provincial areas during the Third Republic.

1. See dossier Théodule Ribot and *Saint-Sébastien, martyr,* 15 May 1865, F 21/176 Archives Nationales.

2. For reference to this work, see *The Second Empire,* exh. cat., p. 350.

3. It is not known whether Ribot could have seen Johann Loth's version of *The Good Samaritan* in the Herzog Anton Ulrich Museum, Braunschweig, Germany. Paintings attributed to Loth were also hung in the Eglise de Bilettes in Paris—along with another version of the *Good Samaritan* by Loth. The turbaned Samaritan and the single young assistant in the Braunschweig composition, however, seem a stronger potential source for Ribot than the Loth paintings in Paris.

4. Theodore Zeldin, *France: 1848-1945,* vol. 2, *Intellect, Taste and Anxiety* (Oxford: Clarendon Press, 1977), pp. 983-1037. Zeldin to the author, 10 April 1980, stressed the political nature of this alliance.

92A

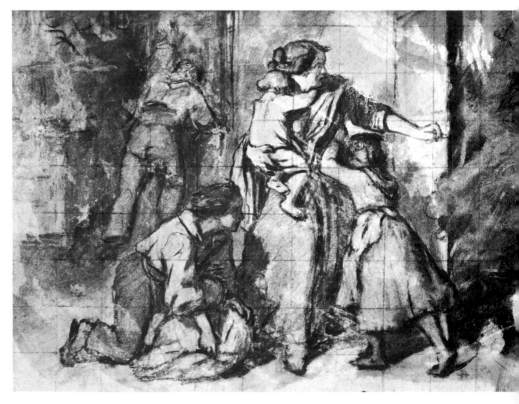

5. The symbolism of the story is well established. The traveller epitomizes humanity in general; the passersby (a Levite and a priest) symbolize the Judaic heritage; and the Samaritan can be interpreted as a Christ figure who binds the wounds of the suffering while conducting mankind into the Church (i.e., the inn). See "Sermon 13," *Select English Works of John Wyclif,* edited by Thomas Arnold (Oxford: Clarendon Press, 1869), 1:31-33.

6. Ibid.

7. Th. Ribot to the curator of the Pau museum, 19 February 1875. In the letter, Ribot acknowledges that he is ready to sell his painting for 4000 francs, and adds that he is honored that the work is destined for Pau. Copy of Ribot's letter included in communication from the present Curator, M. Ph. Comte, to the author, 1979.

Published

L. Fourcaud, *Théodule Ribot, Sa Vie et ses oeuvres* (Paris, n.d.), p. 11.

Raoul Sertat, *Exposition Th. Ribot au Palais National de l'Ecole des Beaux-Arts* (Paris, 1892), p. 15.

Bénédite, *L'Art au XIXe siècle,* p. 221.

Henri Marcel, *La Peinture française au 19e siècle* (Paris, 1905), p. 212.

CONTEMPORARY EVENTS
Natural Disasters

Jean-Pierre Alexandre Antigna

92 *The Fire*
 (L'Incendie)

Oil on canvas, 103-3/4 x 111-7/8 inches (262 x 282 cm.), 1850. Signed lower right: Antigna.

Orléans, Musée des Beaux-Arts.

Provenance. Acquired through purchase from the artist under authorization from the Minister of the Interior on 23 May 1851 (5000 francs). Entered the Luxembourg Museum in 1851. Transferred to the Louvre in 1879. Deposited at the Musée d'Orléans in 1886.

During the period between 1845 and 1860, Jean-Pierre Alexandre Antigna dedicated part of his work to revealing the oppressed conditions of honest workers. Except for a few major examples, many of his canvases from this period are lost, so that it is only through Salon titles such as *Pauvre Famille* (1847) or *Pauvre Femme* (1857) that Antigna's social commitment can be judged. Although critics censured the painter for working on too grand a scale, the immensity of his canvases in itself attracted the attention of some Salon critics. Such large-scale works can be regarded as manifestos, permitting Antigna to emphasize his position, thereby investing genre with considerable social significance.

When *L'Incendie* was first exhibited at the 1850/51 Salon, the fatalism of its drama aroused public and critics alike. Coinciding with a similar evocation of the commonplace by Gustave Courbet (e.g., *The Stonebreakers*), *L'Incendie* brought recognition and status to the long-neglected city workers. The critic I. Peisse in *Le Constitutionnel* noted:

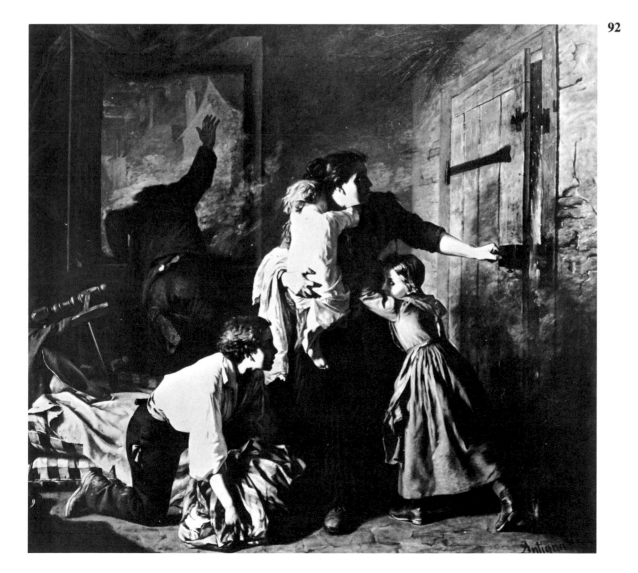

Antigna is one of the first followers of this taste, which claims to raise to the seriousness of history the intimate dramas of the garret, the street and the atelier. Such is, this year, among other paintings inspired by the same feeling, his *Fire,* a scene of terror rather vigorously treated. The fire is about to engulf a room occupied by a poor family. . . . The woman, standing in the middle of the room, has taken her youngest child in her arms. . . . The anguish caused by her terror and her despair is energetically expressed in her features and her attitude. . . . In the back, a man, his back turned, leans out of the window. . . . [He] seems to cry for help. I must say that this good man takes, involuntarily no doubt, a pose which would do credit to Daumier's pencil. . . .[1]

Peisse stressed Antigna's sentiment, for the attempt to imbue a commonplace event with a profound meaning bordering on ancient tragedy was an important quality for early Realism. It was a difficult aesthetic to achieve, because the noble passions thus revealed often jarred with simple genre details. Peisse criticized *L'Incendie* because he believed the young boy hastily gathering together a bundle of prized family possessions distracted from the purity of the emotional range established between the mother and her other children.

The theme of fire in itself was notable. Fires had been painted by earlier artists (e.g., Raphael) and were used by other nineteenth-century painters (e.g., Jules Breton [95]). Few, however, centered the effects of a fire on a single group confined within a restricted space. Antigna constructed his grouping to emphasize the vulnerability of the poor, showing that—for them—the threat of total deprivation and the immediacy of death was ever present. For some, Antigna's canvas was restrained, underscoring the hardship of existence while ennobling the actions of the poor in the face of calamity. Appearing immediately after the disastrous events of the 1848 revolution, Antigna's dramatic canvas was a strong and timely proclamation of the little that had been done for the city worker. Far from showing them as a dangerous, unruly element, he conveyed the need to help this suppressed, threatened class.

Aside from the purely social implications of the theme, some critics—notably Paul Mantz in *L'Evénement* (1851)—felt that it was important for a painting to capture all aspects of contemporary life. Mantz wanted artists to appeal to a broad public, to be easily understood, and to capture the humanity of "the people." Even though Mantz's quest to find a great painter at the 1850/51 Salon remained unfulfilled, he praised Antigna, acknowledging him as a qualified painter who unfortunately might never attain the highest goals.

There is some terror in *The Fire,* a composition ingeniously conceived, in which one sees, in the midst of despair, caused by extreme emotion, a worker's family whose poor lodgings are threatened and almost engulfed by flames. . . . But, nevertheless, *The Fire,* which could be as moving as a drama, is no more moving that an anecdote skillfully narrated. That results especially from the exaggerated dimensions which Antigna has given his canvas. His painting, like those of Breton, has the notable fault of being executed in a style which does not suit it. Enlarge your frames, multiply your volumes in vain; you will never make of genre painting a heroic painting [picture], and of a simple Parisian happening an epic. . . . In spite of the animation they attempt to convey, the huge canvases of Antigna and of his rivals will always seem empty and brutally cold.[2]

In his search for an artist to capture the heroism of modern life by transcending anecdotal genre, Mantz overlooked what Antigna actually had achieved in *L'Incendie.* The painter did come close to imbuing the commonplace with heroism in choosing a moment of distress. Mantz, however, found Antigna's painting overworked, deliberate, since the passion observed in the preliminary drawing appeared forced in the completed canvas. What Mantz and almost all of the Salon critics failed to perceive was that Antigna had deliberately simplified his preliminary forms to concentrate on the essential shapes themselves. For the most part, he limited the details, obscuring the interior in semidarkness and emphasizing only the figures in the foreground frieze. The atmosphere of terror is thus augmented by the mysterious, encroaching gloom. Curiously, the classic pyramidal arrangement of his protagonists, focusing on the mother as head of the family, suggests the traditional, academic training Antigna received. Although he worked in a genre category, he was trying to re-create classical elements that would confer upon his figures a solemn, tragic presence.

Other than considering the theme of *L'Incendie,* critics also tried to establish similarities between Antigna and other Realist painters exhibiting at the Salon. They were able to identify and isolate similar tendencies in several artists. Albert de la Fizelière was prompted to note the contrast between Gustave Courbet and Antigna: "After Courbet, we arrive . . . at M. Antigna. This one, just as the other, has painted the dramas of the life of the poor. The *Stonebreakers* of the former exhaust their life in murderous labour which hardly suffices the most basic needs. . . . It is life's struggle without help against nature's strength. *The Fire,* by the second [artist], shows us man struggling with unexpected calamities, contending with disaster for the

love of his life and the fruit of his labour. This painting is conceived and summed up in action at once simple and poignant."[3]

The history of this painting also reflects changes in artistic taste. Antigna received a first-class medal for it, and after the Salon the government purchased *L'Incendie* for 5000 francs.[4] At first the painting was hung in the Luxembourg Museum, but was transferred to the Louvre in 1879. In 1886 it was again moved, this time to the Orléans museum, where it has since remained. For a period of time the painting was not exhibited in Orléans because of its size. Only recently has it been fully restored.

The Antigna family was not happy when the painting was moved from the Louvre. Madame Antigna wrote (14 March 1899) to the Minister of the Beaux-Arts that she hoped the canvas would be returned to Paris.[5] With support from the painter Félix Barrias and Deputy Minister Louis Marchegey, pressure was exerted to bring about her request. In his reply, 22 April 1899, the Minister expressed his regrets that the painting had been moved, but noted that lack of space prevented the painting from being shown in the Louvre.[6] Thus, even late in the century, Antigna's canvas suffered because of its excessive dimensions.

1. I. Peisse, "Salon de 1850," *Feuilleton du Constitutionnel,* 1 April 1850, pp.1-2.
2. Paul Mantz, "Le Salon," *Feuilleton de L'Evénement,* 15 February 1851.
3. Albert de la Fizelière, *Salon de 1850/51* (Paris, 1851), pp. 25-26.
4. See Alexandre Antigna, payment schedule from 26 August 1851 to 13 June 1852, dossier 55, F 21/61, Archives Nationales.
5. Ibid. Madame Antigna to the Minister of the Beaux-Arts, 14 March 1899.
6. Ibid. Minister of the Beaux-Arts to Madame Antigna, 12 April 1899, following the instructions of A. Kaempfer, Directeur des Musées Nationaux, who had said that the Louvre is "déjà très à l'étroit pour abriter ses collections. . . ."

Exhibited
1850/51, Paris: Salon, no. 40.
1855, Paris: Exposition Universelle, no. 2439.
1873, Vienna: Exposition Universelle, no. 12.
1889, Paris: Exposition Universelle, no. 2.
1978/79, Orléans, Musée des Beaux-Arts: Jean-Pierre Alexandre Antigna (Orléans 1817—Paris 1878), retrospective exh. Catalog by David Ojalvo.

Published
Musée du Luxembourg, cats. from 1852 to 1879.
Dossier 55, série 61, F 21/61, Archives Nationales.
E. J. Delécluze, *Exposition des artistes vivants,* 1850 (Paris, 1851), pp. 54-55.
Du Pays, 1851, 3e art., p. 73.
Clément de Ris, "Le Salon de 1851," *L'Artiste,* February 1851, p. 6.
Cl. Vignon, *Le Salon de 1850-51* (Paris, 1851), p. 100.
E. and J. de Goncourt, "Salon de 1852," *Etudes d'Art* (Paris, 1852), pp. 5-6.

Cl. Vignon, *Salon de 1852* (Paris, 1852), p. 94.
E. About, *Voyage à travers l'exposition des Beaux-Arts (peinture et sculpture)* (Paris, 1855), p. 208.
E. Loudun, *Exposition universelle des Beaux-Arts. Le Salon de 1855* (Paris, 1855), p. 140.
Ch. Perrier, "Exposition universelle des Beaux-Arts," *L'Artiste,* 20 May 1855, p. 30; 8 July 1855, p. 133.
Th. Gautier, *Les Beaux-Arts en Europe 1855* (Paris, 1856), p. 102.
Th. Pelloquet, *Guide dans les musées de peinture et de sculpture du Louvre et du Luxembourg* (Paris, 1851). Idem, *Dictionnaire de poche des artistes contemporains. Les Peintres* (Paris), pp. 14-15.
Z. Astruc, *Les 14 Stations du Salon de 1859* (Paris, 1859), p . 7.
H. de Callias, "Salon de 1861," *L'Artiste,* 15 May 1861, p. 223.
J. Castagnary, *Les Artistes au XIXe siècle. Salon de 1861, gravures par H. Linton, Notices par Castagnary* (Paris, 1861), pp. 27-28.
A. Baignères, "Journal du Salon de 1866," *Revue contemporaine,* 1866, p. 353.
F. Jahyer, *Deuxième étude sur les Beaux-Arts, Salon de 1866* (Paris, 1866), pp. 16-17.
J. Meyer, *Geschichte der modernen Französischer Malerei seit 1789* . . . (Leipzig, 1867), p. 632.
Th. Véron, *Mémorial de l'art et des artistes de mon temps. Le Salon de 1876* (2e annuaire) (Poitiers et Paris, 1876), p. 181.
E. Loudun, Preface to *Catalogue de la vente qui aura lieu par suite du décès de ANTIGNA, ses tableaux, études et croquis* (Paris, 1878), pp. ii, iii.
L. de Lora, "Le Peintre Antigna," *Journal du Loiret,* 1 March 1878.
Véron, *Dictionnaire Véron ou Mémorial de l'art et des artistes de mon temps. Le Salon de 1878 et l'Exposition universelle* (Paris, 1878), p. 20.
Anonymous, *Journal du Loiret,* 1 March 1878.
V. Champier, "Nécrologie—Antigna," *L'Année Artistique 1878* (Paris, 1879), p. 475.
A. Morancé, "Notice biographique sur Alexandre Antigna," *L'Avenir du Loiret,* 6 September 1882, no. 211.
P. A. Leroy, *Alexandre Antigna, peintre* (Orléans, 1892), p. 11.
Anonymous, *Dictionnaire Larrousse, XIXe siècle,* p. 442.
A. Roux, "Antigna," *Dictionnaire de biographie française* (Paris, 1936), 2: 151.
A. Tabarant, *La Vie artistique du temps de Baudelaire,* 2d ed. (Paris, 1963), pp. 160, 167, 178.
Linda Nochlin, *Realism* (Baltimore: Penguin Books, 1971), p. 252.
Le Musée du Luxembourg en 1874, exh. cat., 1974.
Esnault, *Le Salon de 1852* (n.d.), p. 13.
Musée des Beaux-Arts d'Orléans, *Jean-Pierre Alexandre ANTIGNA (Orléans, 1817—Paris, 1878)* (Orléans, 1978), cat. no. 7.
Gabriel P. Weisberg, "French Realism and Past Traditions" (Paper read at a symposium on Gustave Courbet, Städelschen Kunstinstitut, Frankfurt am Main, 2 March 1979, and to appear in proceedings of the symposium, edited by Klaus Herding, forthcoming), fig. 1.

Jean-Pierre Alexandre Antigna

92A Study for *The Fire*
(Etude pour *L'Incendie*)
Charcoal on paper, squared for transfer, 13-5/8 x 17-3/4 inches (34.5 x 45 cm.), ca. 1850.
Orléans, Musée des Beaux-Arts.
Provenance. Descendants of the artist.

Despite criticism for his large-scale scenes depicting everyday life and poverty, it is significant that many of Antigna's canvases were first conceived as small charcoal drawings. In preliminary, intimate scale, Antigna visualized and orchestrated groups of figures [92] that were to be finalized as vast, panoramic disaster scenes. He planned his interrelationships so that his composition was fully organized even before he worked in color.

Antigna used a standard academic procedure: his ideas were initiated in drawings; his color arrangements were then developed in oil sketches (e.g., Private Collection, France); and the theme ultimately completed on a large, finished scale. He was among the first of the Realists to transform black-and-white preliminary studies into an intensification of the graphic horror in a given theme. For *L'Incendie,* Antigna abbreviated facial expression in the preliminary drawing so that he could concentrate on the gestures of his main figures. His impulsive, blunt line was crudely applied in some areas to accentuate the dark and light pattern. Occasionally he deliberately blurred the edges of his forms (note the outline of the door) to capture the penetration of the smoke into the threatened mansard apartment. The atmospheric effect prevails around the entrapped family and continues into the background, encroaching upon the man signaling at the rear window.

A significant revision is apparent between the preliminary drawing and the final version. In the finished composition, Antigna modified the subsidiary figure at the window, so that his pose became far more frenzied, thus increasing the action and heightening the distraught overtones of the terrified family.

The vigorous manner in Antigna's preliminary study produces an effect of momentary reality and an emotional element that is not always to be found in his more carefully finished, final paintings.

Exhibited
1978, Orléans, Musée des Beaux-Arts: Jean Pierre Alexandre Antigna (Orléans, 1817—Paris, 1878).

Jean-Pierre Alexandre Antigna

93 Study for a Scene from *The Flooding of the Loire*
(Etude pour le tableau: Une Scène de *L'Inondation de la Loire*)
Charcoal on paper, 13-7/8 x 17-1/8 inches (35 x 42.5 cm.).
Orléans, Musée des Beaux-Arts.
Provenance. Descendants of the artist.

When *The Flooding of the Loire* was exhibited at the 1852 Salon, critics were uniformly antagonistic toward the scale and manner in which it had been painted. Using classic French masters as a comparison, Alphonse Grün discredited Alexandre Antigna for painting a flood "ten times as large as the *Flood* of Poussin."[1] He went on to disparage Antigna for his inability to differentiate between figural types, noting, "M. Antigna gives to all his personages almost the same expression, to all the objects the same color, and he shows too much the technique of his brush, which consists of opposing a few very luminous tones with brown and dirty colors. . . ."[2] Other critics chose to compare *The Flooding of the Loire* with Antigna's earlier *The Fire,* pointing out the similar quality of the terror in the two canvases.

Because this large painting is lost, Salon reviews of the period and a preliminary drawing provide the only means of now assessing the canvas. The drawing shows a frightened rural family clinging precariously atop the straw roof of their cottage as onrushing waters are beginning to inundate the countryside. The primitive charcoal lines and the intense blackness of this expressionistic study capture the frenzied courage forced upon this family by impending disaster. Flaws in compositional organization are apparent: the upper portion of a cow intrudes in the lower center of the drawing. The general overall effect of terror, however, countermands any suggestion of spatial inconsistencies, which may, indeed, have been resolved in the final painting.

While the flood theme conveys traditional connotations of destruction within a gloomy atmosphere, Antigna has altered the subject to dramatize the peril inflicted upon the rural peasantry by a natural disaster. Since the paint application in his Realist canvases was becoming increasingly sketchy and less finished (see, for example, *The Forced Halt* [22] from the same period), the observation by Grün that Antigna had left the canvas of *Flooding of the Loire* in a deliberately rough, unfinished state is convincing. Antigna may have recognized that a polished finish necessitated a typical Salon entry, and that his conventional resolution of the final version of *The Fire* was not in keeping with a scene derived from the iconography of the lower classes. He was showing an increasing tendency during this period to maintain the expressionistic power and spontancity of a

preliminary drawing in his completed Realist canvases that may well have carried over into *The Flooding of the Loire*.

He also limited his tonal range; the browns and tans that the Salon critics referred to as creating a "grimy" effect predominated in the painted version. By restricting himself to these dark tones, however, Antigna created a symbolic atmosphere which united theme and technique to convey the dreary, blighted environment of the poor.

1. Alphonse Grün, *Salon de 1852* (Paris, 1852), pp. 64-65.
2. Ibid.

Exhibited (painting only)

1852, Paris: Salon, no. 21.
1978/79, Orléans, Musée des Beaux-Arts d'Orléans: Jean-Pierre Alexandre Antigna (Orléans, 1817—Paris, 1878), cat. no. 78. Catalog by David Ojalvo.

93

94

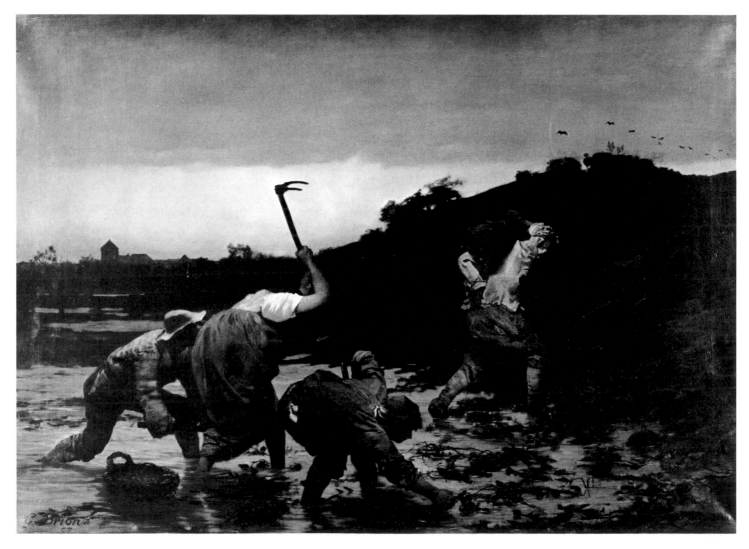

Published (painting only)
M. Bechet, "Le Salon pour rire," *Le Journal pour Rire,* May 1852, p. 4.
A. J. Du Pays, "Le Salon de 1852," *L'Illustration,* 22 May 1852, p. 346.
Giram, *Examen critique des principaux ouvrages en peinture et sculpture de l'exposition de 1852* (Paris, 1852), p. 41.
Goncourt, "Salon de 1852," pp. 5-6.
Vignon, *Salon de 1852,* pp. 94-97.
Meyer, *Geschichte der modernen Französischer Malerei,* pp. 632 ff.
Lora, "Le Peintre Antigna."
Morancé, "Notice biographique sur Alexandre Antigna."
Leroy, *Alexandre Antigna,* p. 11.
Esnault, *Le Salon de 1852.*
Tabarant, *La Vie artistique,* p. 182.

Gustave Brion

94 *The Potato Harvest during the Flooding of the Rhine in 1852, Alsace*
(La Récolte des pommes de terre pendant l'inondation du Rhin en 1852, Alsace)
Oil on canvas, 39-5/8 x 52 inches (98 x 132 cm.).
Signed and dated lower left: G. Brion/52.
Nantes, Musée des Beaux-Arts.
Provenance. Purchased by the museum in 1858.

Gustave Brion received his first Salon award, a second-class medal, at the 1853 Salon, at which time he exhibited three canvases. One of these paintings, *Schlitteurs de la Forêt-Noire,* was destroyed in 1870, so that Brion's style in that particular work—or an overall generalization about his style when he was first patronized by the government—cannot be fully determined.[1] Another work, *Batteurs en grange (Alsace),* has never been located.[2] Only *La Récolte des pommes de terre pendant l'inondation du Rhin en 1852, Alsace* remains of the three canvases that critics of the time perceived as closely related to the Realist works of Millet and Courbet.

When he first arrived in Paris in mid-1850, Brion was certainly aware of the entries of Millet and Courbet, and he followed their lead in compositions which glorified field labor. By 1853 he had also become acquainted with two other members of the Realist group, Jules Breton and François Bonvin, even sharing a building with these artists at 53 rue Notre Dame des Champs. Brion's new friends were encouraged by his Realist style, believing that he would become an active participant in the new movement. Brion's canvases in 1853 were inspired by conditions of the peasant that he had witnessed, scenes remembered from Alsace. He developed a style which placed little attention on anecdote or compulsive detail, however, favoring a generalized manner in which the drama of an event contrasted the peasant with nature in a struggle for survival.

The Potato Harvest during the Flooding of the Rhine in 1852 is a heartrending scene depicting an actual flood of the Rhine which threatened to undermine the existence of the Alsatian peasant. Four figures struggle to save the remnants of their potato crop by salvaging tubers from an already flooded field. Their effort to save the crop is heightened by the drudgery and futility of their labor. One bent figure strains to haul a loaded basket from the mud to the safety of the cart waiting on higher ground. The others are ankle-deep in the flood water, foraging to rescue the few remaining plants. Without individualizing the figures (an effect similar to Millet's images), Brion has captured the anguish and despair of their last efforts. The upraised hoe of the one woman in the group indicates frenzied endeavor. Silhouetted against the gray, low, cloud-filled sky, her primitive hoe represents the battle with elemental forces that had been waged by similar tools many times before—and further reinforces the futility of the peasants' efforts to preserve their mainstay. The potato, a symbol of dire poverty, had become a crucial food by the 1850s. Any failure or loss, even a partial crop failure, meant starvation. The significance was clearly understood when Brion's stark canvas was exhibited at the Salon. Like Millet and Breton, he invested the peasant with a sense of nobility and purpose that immortalized heroism in the fields.

Some critics made note of this particular canvas in their reviews of the 1853 Salon, although recognizing the work as little more than an unfinished study. Charles Tillot, writing in *Le Siècle,* found the work "truly sad, truly somber, but more a study than a finished painting."[3] His opinion typified general reaction, and the painting did not sell immediately, leading Brion to write his parents in 1857 that "scenes of the poor in torn clothes will decidedly not sell and I will not do any more until I get rich. I am convinced that, in spite of the public, the *Flood* and the *Showmen* of this year are my two best works—but this is not enough of a reason for buyers to want them."[4] Although *The Potato Harvest* was finally purchased by the museum in Nantes in 1858, Brion seldom turned again to such images of strength and sympathy for the poor.

1. See Hans Haug, "Un Peintre alsacien sous le Second Empire—Gustave Brion (1824-1877)," *La Vie en Alsace* (Strasbourg, 1925), p. 46. The painting was destroyed 24 August 1870.
2. Ibid. *Batteurs en grange,* which may have influenced Courbet in choice of theme, was sold to an English collector, and has not been found.
3. Charles Tillot, "Exposition de 1853—Revue de Salon," *Le Siècle,* 25 May 1853, pp. 1-2.
4. Gustave Brion to his parents, 1857, Archives of the library of the Strasbourg museum.

Exhibited
1853, Paris: Salon, no. 180.
1973, Paris, Musée des Arts Décoratifs: Equivoques: Peintures françaises du XIXe siècle, cat. not numbered.

Published
H. de la Madeleine, *Salon de 1853* (Paris, 1853), p. 75.
A. de la Fizelière, *L'Union des Arts,* 2 July 1864.
René Ménard, *L'Art en Alsace-Lorraine* (Paris, 1876), pp. 126 ff.
Jules Breton, *La Vie d'un artiste* (Paris, 1890), p. 261. Idem, *Nos Peintres du siècle* (Paris, 1899), p. 152.
Haug, "Un Peintre alsacien," fig. 8, pp. 46, 48, 50.

Jules Breton

95 *Fire in a Haystack*
Oil on canvas, 55 x 82-1/2 inches (139.7 x 209.6 cm.). Signed lower right: Jules Breton.
The Detroit Institute of Arts, Founders Society Purchase, Robert H. Tannahill Foundation Fund.
Provenance. Samuel P. Avery, Jr., New York, by 1890. Tanenbaum, 1902. Loyola University, Los Angeles. Sale, Christie's London, 1976. P. D. Colnaghi, Ltd., London, 1976. The Detroit Institute of Arts, 1976.

Reminiscences of his family, the writings of his Uncle Boniface,[1] and his own observations served as the basis for two compositions by Jules Breton that evoked the terror and devastation of fire, one in the fields and a second composition in the rural village itself.[2] Referring to *Fire in a Haystack,* which he completed in 1856, Breton commented: "I had seen a haystack on fire, under a full, mournful sun, on which groups hurled themselves—desperate to salvage bundles that had not yet caught fire. Later, the black-red mass that was soon left sent forth—in certain places—bursts of sulfur-colored smoke; flaming fragments blazed again in the slightest wind and crackling sparks sent up burning debris that was carried away toward the next haystack."[3]

Breton captured the effect of a fire in an open field, burning out of control under the intense heat of a midday sun. The silence of the suddenly deserted fields from which workers had come running contrasted with the surge of activity directed at the flames themselves. It is obvious from the efforts of those in the foreground and the townspeople rushing to assist in the background that the fire has just been discovered and that there is still hope of protecting nearby stacks from the conflagration. Men at the left are carrying a large wooden tub and extra buckets to douse the flames, while others are intent upon the stack itself, using their hay hooks in an attempt to save some of the crop. A few brave young men have mounted the stack itself, perhaps to determine the extent of the blaze and to direct the buckets of water into the heart of the fire. A cross section of the village is present, from the old man trudging with the single sheaf toward the pile already retrieved (which a young woman in the foreground is cautiously rechecking) to the mother and children at the right warily skirting the fury of the fire. In the left foreground, an older workman

—whose distinctive hat and extra equipment perhaps mark him as the "fireman" of the village—balances his wheelbarrow to steady the rain barrel already in use by the hastily formed brigade spiraling the ravaged stack. One little boy strains under the weight of his filled bucket, while another, his eyes fast upon the flames, races empty-handed toward the burning stack.

The reality of the scene is further heightened by the expressions of fear and trepidation mingled with stoic reserve among the various villagers in spite of the stirring breezes, the intense flames, and the billowing smoke—all of which foreshadow the eventual engulfment of the harvest. The futility of the fire itself—even in the distance where a canvas is being spread to protect another stack—is contrasted with Breton's sweeping panoramic landscape, which not only captures the brilliant light of the hot summer day but creates a carefully observed backdrop. The single straw hat that has been forgotten in the empty field in the right corner of Breton's scene reinforces what might

have been a routine day in the fields. Despite the peasants' eternal struggle with their environment, nature is conveyed here as a calming influence.

This canvas reveals none of the stately classical rhythms that pervade Breton's later works, suggesting that the origins of his style were derived from observations of his contemporaries and taken directly from the life of rural Courrières. There are obvious references here to other works "of art done in the Realist style toward which Breton leaned."[4] The figure pushing the wheelbarrow in the foreground recalls a similar form in Gustave Courbet's The Stonebreakers (a significant work in the evolution of early Realism, and a painting with which Breton would have been familar). The man helping to steady the tub of water is reminiscent of Millet's Winnower, and the woman and children at the right resemble similar poses by Daumier. Breton's subject may also have been influenced by the use of the theme of fire by other Realists; like Alexandre Antigna's singular focus upon a poor family's ef-

forts within a burning Parisian tenement building in L'Incendie [92], Breton also concentrated on personal reactions.[5]

Breton's intentions in creating this canvas are not known. There is no record that the painting was ever exhibited at the Paris Salon. It was included in Breton's exhibition of the life of rural France that was shown at the French Gallery, 120 Pall Mall, London, in 1856, but the extent of Breton's relationship with English dealers and art critics is not known. A critic for Art Journal noted that: "Haystacks on Fire at Midday is a large picture by Breton. The fact of the fire is clearly stated; but in the numerous figures there is a want of energy and spirit—many are very skillfully drawn and lighted but they will never subdue the fire."[6] While he recognized the fatalism of Breton's interpretation, this critic overlooked Breton's ability to convey the reaction of the different villagers. Energy and excitement have been superseded by diligence, efficiency, and determination to save whatever is possible in the face of a terrible calamity.

95

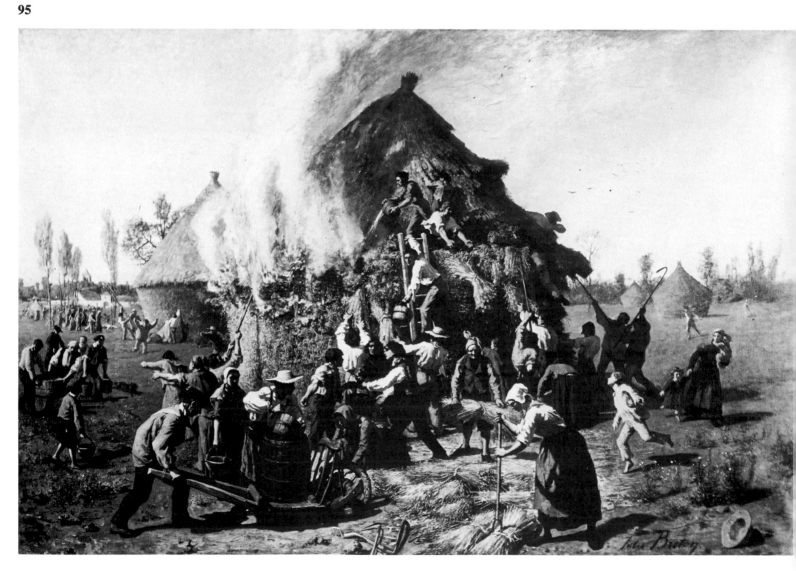

An account which appeared in the catalog of the London exhibition, however, treated the theme with more understanding: "M. Breton has a subject also novel in character: it is *Haystacks on Fire at Midday*. This is a case of spontaneous combustion, and a stack on one side is in a light, breezy flame. Busy groups are endeavoring to save the remainder and are tearing away with much vigour. Women, children, and old men toilsomely moving to the rescue, or running away in alarm, help to give bustle and motion to the scene, which, as a transcription of real country life was certainly worth painting."[7]

1. The influence of the writings of Boniface Breton in formulating Jules Breton's earliest interests cannot be underestimated. For further information see Boniface Breton, "Un Grand Incendie au village," *Le Village: Histoire, morale, politique et pittoresque de Courrières* (Arras, 1837), pp. 385-89.

2. The second painting has not been located. An old photograph, preserved in the archives of the Bibliothèque Nationale, Paris, reveals that the same figure with a barrel of water on a wheelbarrow was situated in the foreground. The village fire was devastating, and a young girl is depicted being removed from the wreckage of a home at the right.

3. Jules Breton, *Un Peintre paysan: Souvenirs et impressions* (Paris, 1896), pp. 112-13.

4. Dewey F. Mosby, *The Figure in Nineteenth-Century French Painting: A Loan Exhibition from The Detroit Institute of Arts*, (Detroit Institute of Arts, 1979), p. 51. This is an important discovery which should be examined in other paintings by Breton, because it mitigates the misconception that carried over from critics of the time who viewed Breton as less radical in style than Courbet.

5. Breton lived in Paris at the time Antigna's work was exhibited, but there is nothing to document that he actually saw or was inspired by Antigna's work.

6. Anonymous, "The Exhibition of French Pictures," *Art Journal*, 1 June 1856, p. 193. The author is indebted to Dewey F. Mosby for sharing this information with him.

7. *Third Annual Exhibition of the French School of Fine Art at The French Gallery* (London, n.d.). The author is indebted to Madeleine Fidell-Beaufort for this information. The person who wrote the catalog entry for the London exhibition remains unknown. Breton obviously exhibited other paintings at the same exhibition and may have been selling works to private English collectors. Ernest Gambart, a Belgian art dealer, also supported Breton at this time; see Jeremy Maas, *Gambart: Prince of the Victorian Art World* (London: Barrie & Jenkins, 1975).

Exhibited

1856, London, Gallery 120 Pall Mall, no. 58.

Published

Third Annual Exhibition of the French School of Fine Art at the French Gallery, 120 Pall Mall (London, n.d.).

Madeleine Fidell-Beaufort, "*Fire in a Haystack* by Jules Breton," *Bulletin of The Detroit Institute of Arts* 57, no. 2 (1979): 55-63.

CONTEMPORARY EVENTS
Revolution and War

Philippe Auguste Jeanron

96 *Man in a Top Hat*
(Homme en chapeau haut de forme)
Charcoal drawing, 13 x 5-1/4 inches (32.5 x 13 cm.). Signed lower left: Jeanron 1831 or 1832. Paris, Musée Carnavalet.

The misery and poverty that affected Philippe Auguste Jeanron's early childhood[1] must also have influenced his association with radical secret societies that advocated social change after the July Revolution in 1830. Jeanron's liberal social beliefs were also apparent in his artistic effort, for Jeanron showed an early preference for direct realism based upon observation of urban social types. While it is now difficult to assess the views of nineteenth-century art critics about his work because his canvases have unfortunately not survived, it is likely that such works as *Scène de Paris* (1833 Salon) demonstrated a "profound sympathy for the discomfort of the working class."[2] Critics noted his ready capacity to select episodes or types from Parisian street life that the prevailing Romanticism of the time—with its emphasis upon literary and anecdotal connotations—preferred not to acknowledge.

Even though few facts are known about Jeanron's paintings and drawings from the early 1830s, it is likely that he did a number of sketches similar to *Man in a Top Hat* that depict types from revolutionary and urban environments. The staunch figure in the large top hat wears his cape flung over one shoulder so that the knife tucked handily into the waist of his leather apron is disclosed.[3] The clenched fist and determined

96

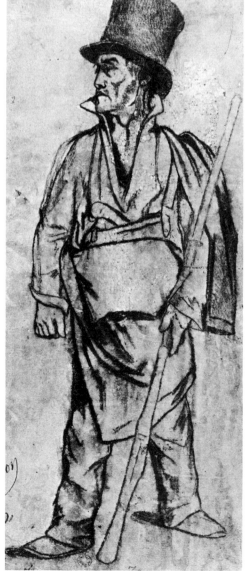

thrust of his jaw convey an attitude of serious commitment that links Jeanron's image with the growing democratization of the lower classes. Jeanron's style is direct; he has abandoned traditional methods of draftsmanship for a rough, crude application of thick charcoal that achieves a forthright description of the personal truths he championed.

1. See Madeleine Rousseau, "La Vie et l'oeuvre de Philippe Auguste Jeanron, Peintre, écrivain, directeur des Musées Nationaux, 1808-1877" (thesis, Ecole du Louvre, 1935), pp. 2-11. Jeanron's father was imprisoned on an English ship for seven years. Jeanron's mother must have tried to keep the family together nearby, for Rousseau has written: "Sans doute Marguerite Jeanron et ses enfants s'étaient—ils logés dans le voisinage des pontons aucune certitude n'est donnée à ce sujet" (p. 6).
2. Gabriel Laviron, "Salon de 1833," pp. 255-57. Almost all of Jeanron's early Realist paintings have disappeared. His *Petits Patriotes* is in good condition and can be seen in the Musée de Caen.
3. This drawing was not listed in Rousseau's catalog of known works by Jeanron. The exact nature of the figure's work is not known; his long pole and top hat suggest he may be a type of chimney sweep. His aggressive stance, however, suggests he may be a guard or revolutionary policeman. The drawing appears to be a fragment and may have been a part of a series that Jeanron intended to illustrate a popular book, such as *Les Français peints par eux-mêmes,* a volume for which some of Jeanron's drawings were engraved.

Adolphe Leleux

97 *The Password*
(*Le Mot d'ordre*)

Oil on canvas, 36-5/8 x 22-7/8 inches (93 x 58 cm.).
Signed and dated lower left: Adolphe Leleux/ 1848.
Versailles, Musée National du Château de Versailles.
Provenance. Purchased by the government in 1886 for the Luxembourg Museum. Sent to Versailles in 1923.

Of the paintings originally intended for the Salon exhibit in 1849, Adolphe Leleux's *The Password* and Ernest Meissonier's *The Barricade* both reflect the terrible events that came to be called the June Days of 1848.[1] The June insurrection, in which the workingmen of Paris rose up in opposition to the new Republic, had been savagely and quickly suppressed by the Garde Mobile, and the barricades of the people systematically annihilated by heavy cannon bombardment. By the end of June, the uprising of the workingmen was over, and many of its supporters had fled the city, in fear of reprisals by the newly reinstated government. While some historians consider the June Days a battle between classes, the groups who were fighting one another were not clearly defined, and the lines between these groups continually changed.[2] It was, therefore, not a true class war, because the object of the workers' attack was not the employer or the capitalist; the revolt of the workers was essentially against the whole middle class of small landlords and bankers.

The mood of the June Days was one of fear and trepidation. Both sides were confused. The black pall of death and destruction that had erupted portended the very collapse of the social fabric of the country. With the defeat of the workers, however, the bourgeois again assumed power, and repressive policies were instituted that would enable Napoleon III to become first president of the new Republic (December 1848).

The specter of the barricades remained. It was here that the country had almost collapsed; and it was the confrontation at the barricades that formed new class allegiances. The versions of the June Days depicted by Meissonier and Leleux both preserved the anxiety and terror of the period. While Meissonier's *The Barricade* objectively reported the horror of the massacre in the streets of Paris, Leleux's scene of the checkpoint suggested the camaraderie established among colleagues defending their beliefs. Both paintings, however, reveal an intimacy and a knowledge of the barricades and its defenders that could only have been inspired by a sense of compassion toward the cause itself. The compositions are unique "episodes in their authors' careers. They were doubtless begun with exemplary thoughts in mind. . . . "[3] Leleux's *Password* is not as searing as Meissonier's because, like many of his Salon entries during the 1840s, Leleux's treatment of the theme is closer to anecdote than tragedy. The episode that Leleux depicted was the moment of confrontation, when the armed compatriot relays the secret word or phrase that distinguishes him from the enemy and that permits him to pass beyond the barrier. The drab, dishevelled figure at the right leans on his rifle, staring vacantly into space, oblivious to the exchange taking place. Thus, the password has been reduced to a common —and perhaps hopeless—ceremony that holds little meaning for the surviving members of the insurrection.

Leleux selected specific types for his revolutionary figures: an unkempt figure with ruffled beard and uncropped hair; a street urchin; and a youth with a Spanish-looking face. These portrayals characterize the lower classes in Paris who have taken to the barricades to protest their position in society. Their features are gaunt and their makeshift, soiled and ragged "uniforms" —perhaps relegated, in part, from skirmishes with the Garde Mobile—indicate their poverty. The gesture of the unkempt figure is clumsy, and the face of his youthful companion drawn with the fatigue of fighting. It is the image of the street urchin, however, that fixes one's attention: here is a face hardened by travail, a youth grown old amid the rubble of his environment.

By posing his street figures against a grimy wall, where a yellowing notice is still posted, Leleux realistically suggested the urban revolt. Here the people have been intimately identified, depicted alongside the barricades of their insurrection, and treated as identifiable types by an artist sensitive to the often-anonymous rabble of the streets.[4]

1. At the last moment Meissonier's *The Barricade* was withdrawn from the Salon. It was exhibited two years later. For a discussion see Constance Cain Hungerford, "The Art of Jean-Louis-Ernest Meissonier: A Study of the Critical Years 1834-1855" (Ph.D. diss., University of California at Berkeley; Ann Arbor, Mich.: University Microfilms, 1976), pp. 257-71. Leleux's *The Password* was engraved by Hédouin.
2. For a discussion see T. J. Clark, *The Absolute Bourgeois: Artists and Politics in France, 1848-1851* (London: Thames & Hudson, 1973), chap. 1.
3. Ibid., p. 27.
4. Hungerford, "Art of Meissonier," pp. 256-57, notes that there are few scenes dealing sympathetically with revolutionary action.

Exhibited
1849, Paris: Salon, no. 1310.

Published
Explication des ouvrages de peinture, sculpture, architecture, gravure et lithographie des artistes vivants, exposés au Palais des Tuileries le 15 juin 1849 (Paris: Imprimeur des Musées Nationaux, 1849), no. 1310.
Louis de Geoffroy, "Le Salon de 1850," *La Revue des Deux Mondes* (Paris, 1851), p. 938.
Jules Claretie, *Peintres et sculpteurs contemporains: L'Art français en 1872* (Paris, 1873), p. 284.
Léonce Bénédite, *L'Art au XIXe siècle 1800-1900* (Paris, n.d.), repr. p. 187; see also p. 182.
Clark, *Absolute Bourgeois,* fig. 16.

Adolphe Hervier

98 *The Barricade*
(*La Barricade*)

Oil on wood, 8-3/8 x 7 inches (21.2 x 17.8 cm.).
Inscribed lower right: Juin 1848, Paris. Signed lower left: HERVIER.
Paris, Private Collection.
Provenance. Given to Georges Bardon by the artist and now possessed by Bardon's descendants.

The small oil panel *The Barricade* and the accompanying water color of the same theme [98A] depict the anguish of June during the 1848 revolution. Although similar in intensity to Jean-Louis-Ernest Meissonier's *Souvenir de la guerre civile* (Musée du Louvre), Adolphe Hervier portrayed the aftermath of the bloody battle for the streets of Paris in which workers were savagely suppressed by the Garde Mobile.[1] Focusing on the destruction of one of many street barricades which had been hastily constructed throughout eastern Paris, Hervier captures the moment after the

bombardment annihilated the insurgents. The smoke and dust hanging over the area slowly recedes into the background to reveal the bodies of four men haphazardly strewn amid the cobblestone rubble. In the center of this shattered barricade is a wooden barrel with a torn and tattered red flag, symbolizing the revolutionary cause of the dead men.

Little is known about the history of this painting or about its exhibition during Hervier's lifetime. Judging from the painter's inability to exhibit his work, the panel may have entered the collection of Georges Bardon, a friend of the artist, at an early date.[2] How Hervier actually did this small work is difficult to determine since little documentation substantiates his activities during the revolutionary period of

98

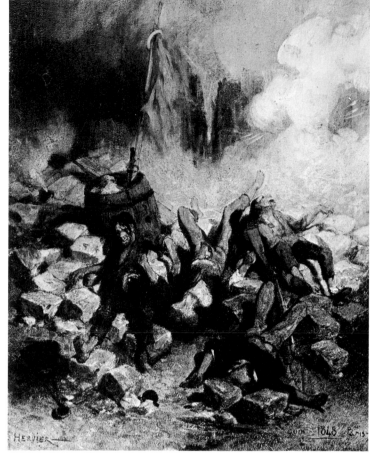

97

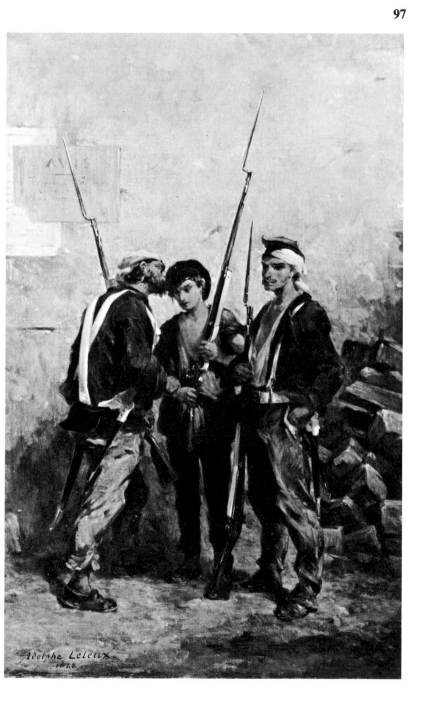

98A

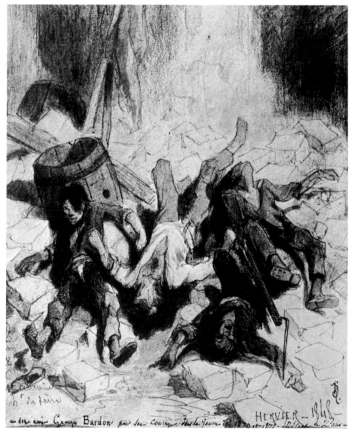

1848. In all likelihood, Hervier actually witnessed such a scene of destruction and did the painting shortly thereafter. Since he focuses on a contemporary event, this work documents his Realist inclinations, albeit in a violent scene.

1. The confusion surrounding the complexity of the sides in June, 1848, is discussed in Clark, *Absolute Bourgeois*, pp. 12-13. Hervier provides no evidence as to the location of this barricade in the streets of Paris. This is unusual since quite often he provides an inscription with further information on the accuracy of his observations and his method of transcribing reality exactly.
2. This painting has remained with Georges Bardon's descendants for many years. It is not known when the work was first acquired from Adolphe Hervier, but it may have been given to Bardon in 1870/71 when Hervier inscribed the water color [98A] for his friend.

Published

Annie Bauduin, "Recherches sur la vie et l'oeuvre du peintre français Adolphe Hervier (1819-1879) avec le catalogue des oeuvres peintes et dessinées" (Mémoire de maîtrise, University of Lille, 1972), cat. no. 201.

Adolphe Hervier

98A *The Barricade*
(La Barricade)

Pencil and water color, 5-3/4 x 4-5/8 inches (14.5 x 11.7 cm.). Signed and dated lower right: HERVIER — 1848. Inscribed upper left: triste souvenir; lower left: 24 juin 1848 [illegible word] faub St. Antoine 6 h. du soir.
Paris, Private Collection.
Provenance. Given by the artist to Georges Bardon and now possessed by Bardon's descendants.

Similar in compositional organization to the oil panel of the same theme [98], the water color of *The Barricade* focuses on the dead insurgents of the destroyed barricade, eliminating effects used in the oil panel such as background buildings or the suggestion of smoke or dust. Inscribed at the upper left with the words *triste souvenir,* this image may have been completed after the oil panel.[1] The inscription at the lower left documents the date of this event as 24 June 1848, the location of the barricade as the Faubourg St. Antoine, and the time as six o'clock in the evening. The preciseness with which Hervier annotated this work is similar to inscriptions found on his other water colors from the same period. Thus he recorded impressions of a specific event in much the same way other artists prepared their compositions.

The ink dedication at the bottom documents that Hervier gave this work to his friend Georges Bardon with the notation *Offert à mon ami Georges Bardon pour son courage dans la guerre de 1870 et 1871. Defanse* [sic] *de Paris.* Hervier may have thought this work an appropriate theme for

evoking the tribulations of Paris in 1848 and also for mirroring the devastation that took place during both the siege of the city and the Commune in 1870 and 1871.[2]

1. Bauduin, "Recherches sur la vie," p. 66. Hervier's working methods are not clear. He may have completed water colors after an oil painting.
2. The work may reflect the tragic coincidence that Hervier discerned between the Paris of 1848 and of 1870/71. The work may have been given to Bardon after the Commune, perhaps as an ironic reminder, suggesting that fundamentally nothing had changed—that Frenchmen still died on barricades in the streets of Paris.

Isidore Pils

99 *Siege Lines at Sebastopol*
(La Tranchée devant Sébastopol)

Oil on canvas, 53-1/2 x 87-1/4 inches (135 x 220 cm.). Signed and dated lower right: I. Pils 1855.
Bordeaux, Musée des Beaux-Arts.
Provenance. Gift of the Société des Amis des Arts, 1857.

When Napoleon III came to power, he realized that one effective way he could fully reestablish French supremacy in Europe was by resorting to war.[1] A large part of his foreign policy was thus determined by military campaigns in the Crimea, Italy, and Mexico—each designed to enhance his position with European powers. The first opportunity to demonstrate the rebuilt French military might came in the spring of 1853 when France joined forces with the English and Turks against the Russians in the Crimea. The prolonged siege of Sebastopol (the main port city in Turkey) during the winter of 1854/55 placed the French troops in key positions on the outermost siege lines, where they were significant in forcing the retreat of the Russians and bringing about the eventual peace treaty (1856)—and a victory for the allies that was widely publicized by the presses in both England and France.

The Crimean War marked the first time that newspapers in both countries provided daily coverage of military events. Not only first-hand accounts of field reporters, but descriptions of front-line artists and photographers that were engraved in such newspapers as the *Illustrated London News* enabled the reading audience to experience both the immediacy and the effect of remote battles and campaigns.[2]

Aware that the success of his reign was dependent upon the support of the masses, Napoleon III encouraged French painters to glorify his victories. The Salons of the late 1850s, therefore, exhibited an increased number of military themes—few of them as successful as the works of Isidore Pils.[3] Already favored by the court for his Realist paintings that emphasized the problems of the poor, but in moderate terms that did not

indict the state, Pils was also able to achieve scenes of military action which were acceptable to officials of the government. His style of painting, although contemporary, nonetheless retained much of the Romantic preoccupation with military exploits.

A supreme example of Realist history painting that glorified the achievements of Napoleon III was Pils's *Siege Lines at Sebastopol* that was shown at the 1855 Salon. Its exhibition at the time of the World's Fair, which attracted additional visitors to Paris that year, helped Pils earn a second-class medal;[4] later it was purchased by the Société des Amis des Arts for the Bordeaux museum (1857).

Because of his delicate health, Pils never traveled to the Crimea, so that the battle scene he depicted was adapted from what he heard and saw during his visits at Vincennes, a major military encampment near Paris. His discussions with officers and infantrymen who had actually taken part in the campaign, as well as his sketches of military preparations, attitudes, and dress all contributed to the image he recorded of what he envisioned to be the routine of the siege line at Sebastopol.[5] Whether Pils had access to French photographs taken in the Crimea is unknown; he may also have seen engravings in the *Illustrated London News,* some of which came from drawings done by Constantin Guys at the battlefront.[6]

In Pils's conception, the soldiers are making the best of the temporary lull in the battle—some trying to sleep, others nursing wounded comrades, while those standing guard at the improvised wall are conversing with one another. Their gloves and winter uniforms denote chill winds that swept across the high plateau surrounding Sebastopol. Their posture and the expression of those facing the viewer convey both the tedium and the tenseness of a moment of respite during the constant exchange of fire that was maintained for many weeks before the French succeeded in subduing the Russians.

1. Charles Guignebert, *A Short History of the French People* (London: George Allen & Unwin, 1930), 2: 685. Napoleon III recognized that he could never defeat England, learning the lessons of history appropriate to the reestablishment of Bonapartism.
2. For reproduction of several, see *The Camera Goes to War: Photographs from the Crimean War, 1854-56* (Scottish Arts Council, n.d.), figs. 6-8.
3. Contemporary history painting, essentially of the military and its campaigns, was widespread under the Second Empire. Since it was essentially a modernization of standard historical painting derived from Greece or Rome, the theme has little lasting relevance for the Realist movement. It was largely an invention of the academy as a means for promoting a type of "pseudo-realism" that was best practiced by Pils and Meissonier.

4. L. Becq de Fouquières, *Isidore Alexandre Auguste Pils: Sa Vie et ses oeuvres* (Paris, 1876), p. 57.

5. W. Bouguereau, "Notice sur M. Pils," *Institut de France—Académie des Beaux-Arts* (Paris: Typographie de Firmin-Didot, 1877), p. 7.

6. For further information see Karen W. Smith, *The Crimean War Drawings of Constantin Guys*, exh. cat. (CMA, 1978).

Exhibited

1855, Paris: Salon, no. 3801.
1876, Paris: Exposition des oeuvres de Pils à l'Ecole des Beaux-Arts, pp. 3, 10, no. 13. Introduction by L. Becq de Fouquières.
1975, Bordeaux, Galerie des Beaux-Arts: Pompiérisme et peinture équivoque, no. 46.
1976, Calais, Musée: Diverses tendances de la peinture française au XIXe siècle et au début du XXe siècle, no. 41.

Published

Explication des ouvrages . . . des artistes vivants étrangers et français exposés au Palais des Beaux-Arts, Avenue Montaigne, le 15 mai 1855 (Paris, 1855), p. 409, no. 3801.
Th. Guédy, *Musées de France* (Paris, n.d.), p. 104, no. 587.
Maxime du Camp, *Les Beaux-Arts à l'Exposition Universelle de 1855* (Paris, 1855), p. 235.
Catalogue et estimation des tableaux du Musée de la ville de Bordeaux (Bordeaux, n.d.), p. 16, no. 458.
L. Clément de Ris, "Musées de province, Musée de Bordeaux," *Revue Universelle des Arts* XII (1860): 32.
P. Lacour and J. Delpit, *Catalogue des tableaux, statues. . . du Musée de Bordeaux,* rev. ed. by O. Gue (Bordeaux, 1862), p. 196, no. 327.
Catalogue des tableaux, statues . . . du Musée de Bordeaux, in 1863, 1864, 1875, 1877, 1879 editions, p. 49, cat. no. 327.
L. Clément de Ris, *Les Musées de province* (Paris, 1872), p. 99.

L. Becq de Fouquières, *Exposition des oeuvres de Pils à l'Ecole des Beaux-Arts* (Paris, 1876), p. 3, no. 13, p. 10. Idem, *Isidore Pils*, p. 26.
E. Vallet, *Catalogue des tableaux, sculptures, gravures, dessins exposés dans les galeries du Musée de Bordeaux* (Bordeaux, 1881), p. 187, no. 591. Idem, *Nouvelle Edition du catalogue* (Bordeaux, 1894), p. 201, no. 733.
D. Galibert, *Chefs-d'oeuvre du Musée de Bordeaux* (Bordeaux, 1906), repr., pl. 34.
B. Alaux, *Musée de peinture de Bordeaux,* cat. (Bordeaux, 1910), p. 102, no. 546.
Ch. Saunier, *Bordeaux* (Paris, 1925), p. 126.
Musée de peinture et de sculpture de Bordeaux, cat. (Bellegarde, 1933), p. 85, no. 329.
Th. Ricaud, "Le Musée de peinture et de sculpture de Bordeaux de 1830 à 1870," *Revue Historique de Bordeaux,* March-April, 1936, pp. 78-79. Idem, *Le Musée de peinture et de sculpture de Bordeaux de 1830 à 1870* (Bordeaux, 1938), pp. 72-73.
J. Vergnet-Ruiz and M. Laclotte, *Petits et grands musées de France* (Paris: Editions Cercle d'Art, 1962), p. 248.

99

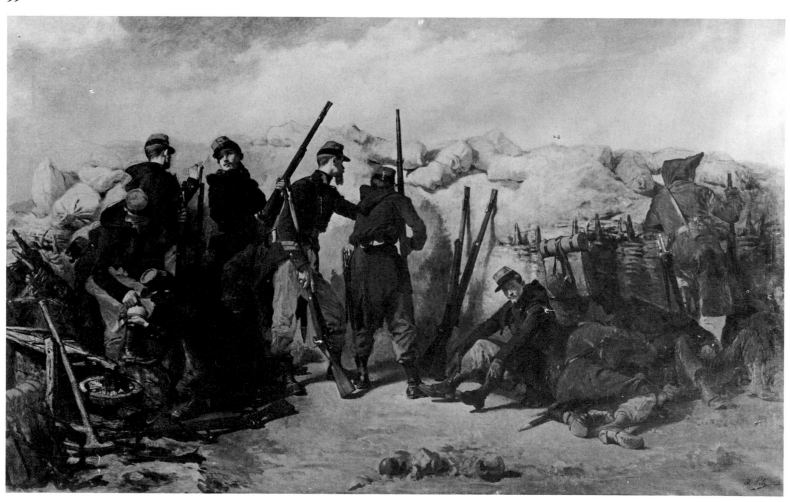

Gustave Brion

100 *Vosges Peasants Fleeing
 before the Invasion*

Oil on canvas, 43-3/8 x 68-5/16 inches (105 x 173.5
cm.). Signed and dated lower right: G. Brion,
1867.
St. Louis, Washington University Art Gallery.
Provenance. Charles Parsons Pettus Collection.

During the 1860s artists completed canvases
of episodes from the history of Alsace or
scenes documenting the daily life of that re-
gion. Napoleon III had initiated a program
to stimulate French awareness of Alsatian
customs, culture, and history, and in 1864
sponsored an exhibition in Paris (later
shown again in Strasbourg) displaying the
works of the nation's Alsatian painters. For
the first time, many now had the opportunity
to observe provincial life, and interest in the
region became widespread. Some Alsatian
artists emphasized Napoleonic themes, be-
cause Alsace was a region where the Na-
poleonic cult still flourished. During the
First Empire, Alsace had contributed a large
number of soldiers to the emperor's army
and provided an exceptional proportion of
its generals. Alsatian loyalty to France con-

tinued to be strong, and Napoleon III
capitalized on this continued allegiance by
encouraging artists to follow a policy of
glorification of their homeland.

By the late 1860s Gustave Brion had al-
ready established himself as an Alsatian
folklorist. His *Invasion*, which was exhib-
ited at the World's Fair in 1867, was derived
from the last days of Napoleon I's empire,
for it was during the late 1860s that Brion
had turned to actively documenting past
episodes from the life of the people. Brion's
scene of the villagers, fleeing after being
turned out of their homes by the invading
Prussians, commemorates the perseverance
of peasants who took to the roads rather
than be dominated by a foreign power. Al-
though completed in his Paris studio, Brion
carefully reconstructed the attitudes and
costumes of individuals carrying their infants
in wicker baskets and their household pos-
sessions in their arms. Smoke from their
burning homes already pervades the air—an
effect Brion achieved by carefully muted
tones. Moving stoically forward, Brion's
peasants recall the nobility of similar peasant
types painted by Jules Breton [52], who also
tried to convey the personalities of a rural
population.

Although Brion had already relinquished
his interest in contemporary events or works
with strong social implications, this painting
provides an illusion of reality through the
re-creation of history. The authenticity of
the costumes and the documentary impact of
the composition reinforce the stagelike
drama. Such a painting reveals a similarity
between the Realist movement and official
history painting as it was practiced by the
academics (e.g., Jean Léon Gérôme or
Ernest Meissonier), suggesting that even a
painter closely connected with the core of
the movement, as Brion certainly had been,
could adapt his convictions to the tempta-
tions of success that were offered during the
Second Empire. Brion's *Invasion* was com-
pleted to satisfy the policies of Napoleon
III, and for his efforts he received a
second-class medal at the 1867 Salon and a
grand medal in 1868.

Exhibited

1867, Paris: Salon, cat. no. 220.
1884, St. Louis, Exposition and Music Hall, no.
 64.
1912, St. Louis, City Art Museum of St. Louis:
 An Exhibition of Paintings Owned in St. Louis,
 p. 37, no. 7 (painting lent by Mr. Charles P.
 Pettus).

100

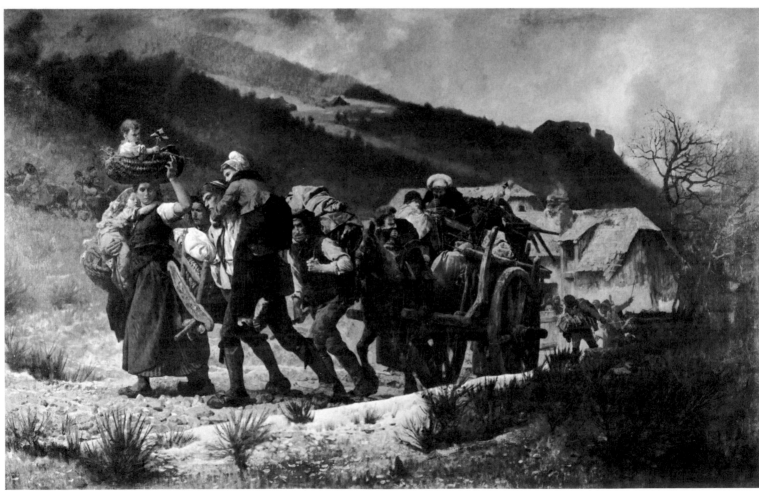

Published

René Ménard, *L'Art en Alsace-Lorraine* (Paris, 1876), p. 128, repr. after p. 128.

Edward Strahan, ed., *Art Treasures of America* (Philadelphia, 1879), II: 65.

Jules Breton, *The Life of an Artist* (New York: D. Appleton & Co., 1890), pp. 269-72.

John D. Champlin and Charles C. Perkins, *Encyclopedia of Painters and Paintings* (New York, 1913), I: 206.

Jill Johnson, *Charles Parsons Collection of Paintings* (St. Louis: Washington University, 1977), p. 21.

Marie François Firmin-Girard

101 *The Beggar*

Oil on canvas, 15-1/2 x 10-1/2 inches (39.3 x 26.2 cm.). Signed and dated lower right: FIRMIN-GIRARD/Paris Xbre 1870.

Cleveland, Collection of Mr. and Mrs. Noah L. Butkin.

Forced to take to the streets, bereft of shelter or food because of the continuous Prussian bombardment that reduced whole sections of the city to rubble during the siege, countless numbers of Parisians became beggars. Whether this small canvas, *The Beggar*, may be the same work by Marie François Firmin-Girard that was shown at the 1870 Salon under the title *Charité* is not known. But it is a moving image undoubtedly inspired by reality. The destitute, middle-aged veteran stands lost in his own thoughts, his hat patiently extended.[1] The artist's careful observation of the gaunt figure, and his ironic placement against the proclamations offering assistance to the poor commemorate the tenuous existence of many of the citizens of Paris during the dire winter of 1870/71.

1. It is unlikely that the figure is a veteran of the Franco-Prussian War. His uniform may represent earlier Second Empire campaigns in the Crimea or Italy and, thus, symbolize a military veteran of the Second Empire reduced to destitution.

Isidore Pils

102 *Soldiers in the Ruins of the Chateau of St. Cloud (Soldats dans les ruines du Château de St. Cloud)*

Water color, 14-3/4 x 11-1/8 inches (37 x 28 cm.). Signed and dated lower right: I. Pils/St Cloud 1871.

Paris, Musée Carnavalet.

Provenance. Purchased by Carnavalet from M. Bergnier, 1900.

The German invasion of France and the bombardment of Paris destroyed the lavish imperial chateau, for St. Cloud was directly in the line of fire from the advancing Prussians who had set up artillery batteries on the cliffs in order to shell Paris. Once the armistice had been arranged in mid-winter 1871, Isidore Pils went to St. Cloud, where he examined the remains of the imperial residence and mingled with the French soldiers

101

102

stationed on the grounds. His water color *Soldiers in the Ruins of the Chateau of St. Cloud* depicts the troops bivouacked in the courtyard—mindless of their setting—preparing their meal over the central fire amid what had once been the splendor of France. Pils's interest in genre detail was combined here with an appreciation for the aura of grandeur still emanating from the once-elaborate structure.

Exhibited
1876, Paris: Exposition des oeuvres de Pils à l'Ecole des Beaux-Arts, p. 47, cat. no., 309. Introduction by L. Becq de Fouquières.

103

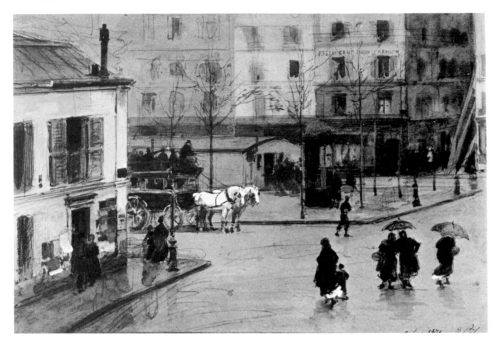

104

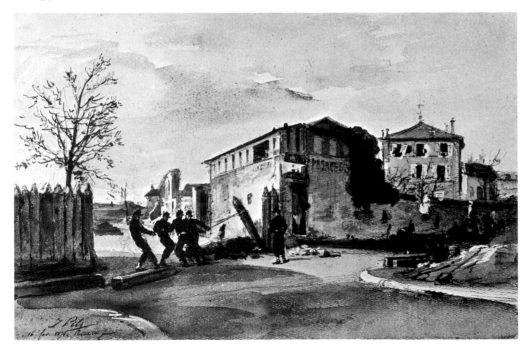

138

Isidore Pils

103 *Scene in the Streets of Paris, February 2nd (Scène dans les rues de Paris)*

Water color and gouache, 10 x 14-7/8 inches (25 x 37 cm.). Signed and dated lower right: 2 fév. 1871 I. Pils.
Paris, Musée Carnavalet.
Provenance. Acquired at the sale after the death of A. Hartmann, Paris, 1899.

The fall of Paris and the armistice 28 January 1871 enabled the weary, oppressed inhabitants of the city to move about without constant fear of bombardment, but it was some time before work routines were reestablished and food supplies and provisions restored. The National Guard that had taken over the city became a familiar sight everywhere, and the provisional government (organized to formulate a peace treaty with the Germans) was helpless to disarm them, for the guard had unified their strength, forming a *Fédération* that opposed both the capitulation and the new French government.[1]
It was this time of uncertainty and unrest that Pils recorded in a series of water colors that he completed from the windows of his Parisian apartment near the Place Pigalle. Pils depicted the groups that gathered to talk on the street corners and the mothers and children that scurried about to find food, arranging his figures against a rain-drenched street to suggest the sweeping expanse of the bleak mid-winter, and reserving his bright colors for the gaudy billboards and placards posted on the sides of the buildings. Studies of urban existence such as *Scene in the Streets of Paris, February 2nd* document the city trying to come back to life and provide an accurate description of the times. Prohibited from exhibiting these scenes as a series at the 1872 Salon because of the limited number of entries that any one artist could submit, Pils thereafter withheld many from public view during his lifetime.

1. The National Guard retained their arms, thereby assuring themselves a role in Parisian decision-making. For further discussion see Guignebert, *Short History*, p. 626.

Isidore Pils

104 *The Gate at Point du jour (Point du jour)*

Gouache and China ink, 12 x 18-1/4 inches (30 x 46 cm.). Signed and dated lower left: I Pils/ 16. fev.1871. Point Du jour.
Paris, Musée Carnavalet.
Provenance. Sale, Tableaux, études, esquisses, aquarelles, dessins par I. Pils (peintre d'histoire) . . . , Hôtel Drouot, Paris, 20 March 1876. Exh. cat. by L. Becq de Fouquières.

One of Pils's closest friends was an officer in an artillery battery at the Point du jour, and the artist visited the troops in this sector fre-

quently. During the siege itself he completed a series of water colors of soldiers in action.[1] After the armistice he recorded the National Guard removing the barricades, pulling down wooden posts which had sealed off this outpost on the fringe of the city. Working in ink and gouache, Pils freely sketched the episode in *The Gate at Point du jour*, adding washes of color to capture the atmosphere of the low-lying clouds or a blasted building.

1. The exact number of water colors Pils completed in 1870/71 is not known. Some were sold in 1876 after his death. See L. Becq de Fouquières, *Catalogue de tableaux, études, esquisses, aquarelles, dessins par I. Pils (peintre d'histoire) . . . , Hôtel Drouot, 20 March 1876* (Paris, 1876).

Exhibited
1876, Paris: Exposition, p. 45, cat. no. 299.

Isidore Pils

105 *Soldiers of the Thirty-seventh Front Line Regiment Camping on the Boulevard de Clichy*
 (Soldats du 37e régiment de ligne campent au Boulevard de Clichy avant l'entrée des Prussiens)
Gouache, 10 x 14-1/2 inches (25 x 36.5 cm.).
Signed and dated lower left: I Pils/22. fev 1871.
B^d. Clichy. 37^e de ligne.
Paris, Musée Carnavalet.
Provenance. Acquired at the sale after the death of A. Hartmann, Paris, 1899.

During February and March, 1871, troops that had seen action in the front line during the siege of Paris remained camped throughout the city. The scene Pils depicted in *Soldiers of the Thirty-seventh Front Line Regiment Camping on the Boulevard de Clichy*, with wagons, makeshift barracks, and open campfires juxtaposed amid the newly constructed buildings of the Second Empire, had become a common sight during this period of uncertainty when the soldiers warily awaited further instruction from the provisional government. The atmosphere was tense and somber as Pils wandered the streets of the city, documenting the soldiers biding their time on a cold mid-winter's day.

Exhibited
1876, Paris: Exposition, p. 46, cat. no. 305.

Isidore Pils

106 *Soldiers Washing Their Clothes: Place Pigalle*
 (La Lessive, Place Pigalle)
Gouache, 14-1/2 x 20 inches (36.5 x 50.5 cm.).
Signed and dated lower left: I. Pils/Place Pigalle mars 1871.
Paris, Musée Carnavalet.
Provenance. Purchased at the sale after the death of A. Hartmann, Paris, 1899.

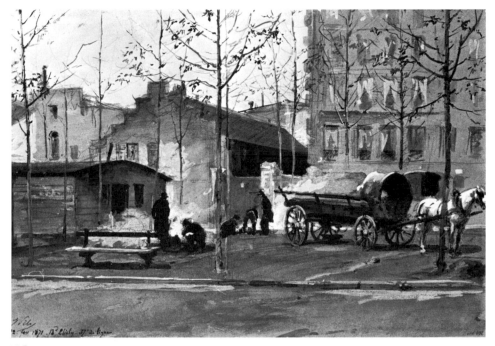

105

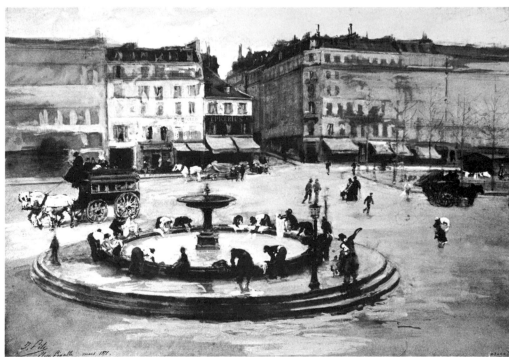

106

The warming March weather and the cease-fire gave the soldiers encamped near the Place Pigalle an opportunity to attend to their own personal needs. Against a backdrop of Parisian shops, horse-drawn carriages, and supply wagons, the soldiers washed their uniforms in the public fountain. Pils's high vantage point surveyed the realities of daily existence among the remnants of the French army and transcended description to convey the excitement of contemporary street life. The sweeping panorama and immediacy that he captured in *Soldiers Washing Their Clothes: Place Pigalle* anticipates the Impressionist works of Pissarro and others who recorded the teeming life of Paris streets later in the century.

Exhibited

Isidore Pils

107 *The Vendome Column Destroyed*
 (La Colonne Vendôme renversée)
Gouache on ochre paper, 14-1/4 x 22 inches (36 x 55.5 cm.). Signed and dated lower left: 29 mai 1871. I. Pils.
Paris, Musée Carnavalet.
Provenance. Sale, Tableaux, études, esquisses, aquarelles, dessins par I. Pils . . . , Hôtel Drouot, Paris, 20 March 1876, no. 171, p. 24.

The interest of Pils in the ruin of the Vendome column had been conditioned by his involvement with the Second Empire and, conversely, by his awareness of the hatred the column engendered as a symbol of Napoleonic imperialism.[1] For over sixty years republicans had despised the column. Fashioned in imitation of the Trajan column in Rome but constructed of bronze instead of marble, the original column erected in 1803 was to have been crowned with a statue of Charlemagne. When the column was finished in 1806, however, it was a statue of Napoleon himself that looked down over the city of Paris. During the Bourbon restoration, this statue of Napoleon was melted down and replaced with a white royalist flag. Under Louis Philippe, a new statue of Napoleon appeared, this time dressed in a modern uniform. During the revolutionary period of 1848, there was much agitation to demolish the column, but too little time to effect the change. When Napoleon III came into power, he removed the statue of Napoleon in contemporary dress, and substituted a likeness of Napoleon I in the garb of imperial Rome. By the time of the Franco-Prussian War, and especially after the humiliation and routing of Napoleon III's army in Sedan, many leading figures (perhaps even Gustave Courbet)[2] called again for the demolition of the column and its recycling for military purposes.[3]

In the midst of the takeover of the Parisian government by revolutionary groups, the Vendome column continued to represent a symbol everyone hated. As the conflict escalated between troops loyal to the provisional government of Adolphe Thiers and the insurrectionary forces of the Commune, a second bombardment of Paris ensued.[4] On 12 April 1871 the Commune ordered the demolition of the column without making any provisions to preserve the less controversial reliefs on the base. After several postponements, the column was completely destroyed on 16 May 1871 before a large crowd gathered on the square to witness the event. Ironically, the destruction of the column occurred almost at the same time the troops from Versailles were preparing to surround Paris.

Unsympathetic to the insurrectionary forces who had thrown the city into turmoil, Pils visited the Vendome column on 29 May, the day after the fall of the Commune. He recorded the broken segments of the monumental column where they had fallen, with the statue of Napoleon I lying face downward on the street beside it. Even toppled and broken, the memorial still dwarfed the single spectator seated amid its battered stones.

Pils used white and gray gouache only to outline the stone blocks and the bronze of the column's reliefs, leaving the ochre color of the paper itself untouched to convey the somber mood of the composition. The tricolor placed triumphantly at the base is the only bright color in an otherwise solemn setting—as if to anticipate the return to normalcy under the new republican government. *The Vendome Column Destroyed*, with its sparing use of color and asymmetrical arrangement of shapes, is an abstract composition. It remains one of the most moving images Pils ever created.

1. For a discussion of the history of the Vendome column, see Jack Lindsay, *Gustave Courbet: His Life and Art* (New York: Somerset, Adams and Dart, 1973), pp. 248-51.
2. Courbet maintained that he was never involved in early decisions to raze the column. Ibid., p. 249.
3. The Commune planned for a new figure symbolizing the revolution to replace the entire column. See Lindsay, *Courbet*, p. 259.
4. See Guignebert, *Short History*, p. 628, for an analysis of the factions within the Commune. Parisians also feared that Paris might not continue as the capital of the country, which further precipitated the problems of 1871.

Exhibited

107

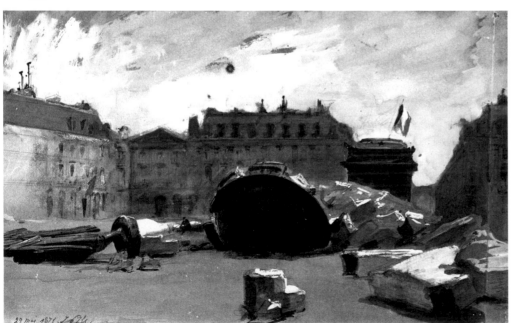

Jean-Louis-Ernest Meissonier

108 *The Ruins of the Tuileries*
(Ruines des Tuileries)

Oil on canvas, 53-1/2 x 37-3/4 inches (136 x 96 cm.). Inscribed: GLORIA MAIORUM PER FLAMMAS USQUE SUPERSTES/MAIUS MDCCCLXXI.
Compiègne, Musée National du Château de Compiègne.
Provenance. Given to the museum by Mlle. E. Meissonier, 1903.

Among Jean-Louis-Ernest Meissonier's most popular paintings was his *Barricade rue de la Mortellerie* (June 1848), which realistically recorded death and destruction in a Parisian street during the 1848 revolution. In 1871, inspired by the destruction of the Tuileries, Meissonier returned to a similar theme when he graphically showed the splendor of the Napoleonic reign in ruins.[1]

During the Second Empire, Meissonier became a popular artist whose genre paintings were eagerly collected and whose military scenes from Napoleonic history were much appreciated. A supporter of the emperor, Meissonier enjoyed being a court favorite.[2] The *Barricade* can be considered Meissonier's most arresting work because of its reality and tragedy. The *Ruins of the Tuileries* continued this same type of painting and also memorialized the end of the Second Empire for an artist who was one of its glittering devotees.[3]

Like the Realists, Meissonier relied on his interest in contemporaneity to help him create this canvas. Whether he was familiar with photographs of the ruins of the Tuileries is unknown. Views taken of similar sections of the building still exist.[4] But, unlike a photographer, Meissonier rendered all sections of his composition in an intense, meticulous style. The Triumph of Peace in the background, situated atop the Arch of Triumph erected by Napoleon I, seems as sharply in focus as the crushed stones and plaster in the foreground. Pitiless in its photographic objectivity, the composition becomes a Romantic allegory of the fallen glory of France. This is made evident by the Latin inscription on the stone slab in the front: "The glory of our ancestors survives the flames, May 1871." The collapse of the Second Empire so moved Meissonier that he was determined to preserve his impression of a contemporary disaster.

By comparing the victories of Napoleon I (those immortalized by the reliefs at the top of the building dedicated to Marengo and Austerlitz) with the destruction inflicted upon France by Napoleon III, Meissonier underlined the irony of the country being ruined by Napoleonic campaigns. Similarly, the Triumph of Peace looming so prominently from the long vista and against the stark blue sky suggests that (like the restoration after Napoleon I)[5] peace can only return when rule by kings is reestablished. Far

108

more than an artist's dispassionate recording of actual details, the symbolic overtones of the ruined monument (which was not cleared away until well into the Third Republic) stood as a moving commentary on French society.

1. For a discussion see *Courbet und Deutschland*, exh. cat. (Köln: DuMont, 1978), no. 189, pp. 159-60.
2. See *The Second Empire: Art in France under Napoleon III* (Philadelphia Museum of Art, 1979), pp. 332-33.
3. For a discussion of this concept and *The Barricade* see Hungerford, "Art of Meissonier," pp. 241 ff.
4. Some of these photographs are reproduced in *Courbet und Deutschland*, p. 260.
5. The Triumph of Peace was erected during the restoration. Constance Cain Hungerford, "Meissonier's Souvenir de guerre civile," *Art Bulletin LXI* (June 1979): 277, notes that the victory sculpture "seemed to move away into the distance, turning her back on a defeated France." For further information on Meissonier see Constance Cain Hungerford, "Ernest Meissonier's First Military Paintings: I: *The Emperor* Napoleon at the Battle of Solferino" and "II: 1814, the Campaign of France," *Arts Magazine* 54 (January 1980): 89-107.

Exhibited
1953, Compiègne, Château de Compiègne: Le Temps des crinolines, no. 202.
1978/79, Hamburg, Frankfurt: Courbet und Deutschland, cat. no. 187. Catalog (Köln: DuMont, 1978).

Published
Octave Gréard, *Jean-Louis-Ernest Meissonier— Ses Souvenirs, ses entretiens* (Paris, 1897), pp. 247-50, 404.
Gaston Brière, *Catalogue des peintures du Louvre* (Paris: Musées Nationaux, 1924), no. 2968.

109

Isidore Pils

109 *The Ruins of the Tuileries (Ruines des Tuileries)*
Water color, 19-3/4 x 14-7/8 inches (49.5 x 37 cm.).
Signed and dated lower right: I. Pils/1871/ Les Tuileries 7 juillet.
Paris, Musée Carnavalet.

Provenance. Sale, Tableaux, études, esquisses, aquarelles, dessins par I. Pils, Hôtel Drouot, Paris, March 1876, no. 177, p. 24. Acquired at the sale after the death of A. Hartmann, Paris, 1899.

The contemporary ruins of Paris which attracted Isidore Pils remain one of the most accurate accounts of the war's aftermath. The ransacking and burning that occurred just prior to the dissolution of the Commune and even as the oncoming troops were making their way into Paris from Versailles destroyed a number of official buildings in Paris.[1] The Tuileries, which housed the imperial treasures—including murals and paintings—was among them. Ernest Meissonier's record of the interior section of the destroyed building [108] was probably based on a photograph. The eyewitness account of *The Ruins of the Tuileries* that Pils completed in July showed an encampment of soldiers in the midst of the gutted ruin, after the stones and bricks had been cleared away. The soldiers lounging on their weapons in the heat of a bright summer day provided the necessary foil against which the majesty of a contemporary ruin could be assessed. Despite the accuracy of his reporting and his Realist inclinations, the illumination and the vista, with the victory monument inviolate in the rear, evoke a reverence for the grandeur of the imperial court and the arts that had flourished under Napoleon III.

1. Legend has persisted that the Communards systematically destroyed Paris.

Exhibited
1876, Paris: Exposition, p. 49, cat. no. 325.

Published
Becq de Fouquières, *Catalogue de tableaux*, p. 24, no. 177.

Still Life

FORMS IN A SETTING

TABLETOP STUDIES

As painters abandoned subjects from the classical past and returned to a study of their surroundings, they began to favor landscapes and—even though the Salon critics continued to regard these categories as inferior—still lifes as well.[1] Despite the persistent claim that still-life painters were no more than talentless copyists, their numbers continued to grow, and their works became increasingly sought after by art dealers. They found a ready market for such works in their clients from the middle class, who appreciated a realistic rendering of familiar objects. As a result, still-life painters from earlier times whose work provided a useful model also enjoyed a new vogue. The interest in Jean Siméon Chardin was only part of a more general enthusiasm that involved many painters, collectors, and critics.[2]

In 1833 Gabriel Laviron discussed the history of still life as an art form in his review of the Salon and denounced the antipathy with which many approached it.[3] He claimed that the first painters to render nature truthfully were the still-life painters.[4] His spirited defense of the genre led some painters to recognize that Caravaggio (1573-1610), Géricault (1791-1824), and others among the masters had also painted still lifes and that this form provided an opportunity for painters to create according to their own will and feeling.[5] Laviron's views not only influenced young painters like Philippe Rousseau [115], but later critics such as Castagnary who, rephrasing some of Laviron's thoughts, passed them off as his own.

Art critics could hardly fail to notice the growing number of Realist still lifes or the variety of their approaches, but, for the most part, still-life painting remained without substantial critical examination in the press. Aside from Castagnary, who observed that still-life painters were "multiplying like rodents"[6] and might eventually undermine the entire academic system, no one even commented on the loss in 1862 when the many Realist studies of cabbages, oysters, and onions were rejected by the Salon. The precedent of Chardin's still lifes failed to save them, for the Salon arbiters of taste agreed that when it came to subject matter even Chardin lacked judgment.

The still-life painters used themes similar to those in earlier periods, but they particularly favored the depiction of familiar objects associated with a working-class or peasant kitchen: cabbages, turnips, carrots, oysters, onions, earthenware dishes, and pots and pans. By choosing unadorned earthenware jugs because of their geometric shapes, Ribot was able to concentrate on purely formal ends, thereby anticipating the abstract rhythms found in later, more progressive still-life painters like Cézanne. But despite their profusion, the still life presented none of the opportunities for debate that genre painting engendered and remained a category devoid of a critical champion. It endured as a medium for the personal expression of the painter and for the consumption of the private patron of modest means.

1. John W. McCoubrey, "Studies in French Still-Life Painting, Theory and Criticism: 1660-1860" (Ph.D. diss., New York University, March 1958; Ann Arbor, Mich.: University Microfilms, MIC58-7755), p. 111. Still life was disparaged by such critics as Paul Mantz and Edmond About during the 1850s and 1860s.
2. A preference for previous still-life masters can be detected in the work of François Bonvin, a principal member of the still-life revival. For further information on Bonvin's revivalism, see Gabriel P. Weisberg, "François Bonvin and an Interest in Several Painters of the Seventeenth and Eighteenth Centuries," *Gazette des Beaux-Arts* LXXVI (December 1970): 359-65.
3. See Gabriel Laviron and B. Galbacio, *Le Salon de 1833* (Paris, 1833), pp. 367-74.
4. Ibid., p. 367.
5. Ibid., p. 373.
6. Quoted in McCoubrey, "Studies in French Still-Life Painting." By promoting humble themes, still-life painters threatened history painters.

FORMS
IN A SETTING

Philippe Rousseau

110 *The Fish Market*

Oil on wood, 9-3/4 x 13-5/8 inches (24 x 34.5 cm.). Signed lower right: Ph. Rousseau.

London, The Trustees of The National Gallery.

Provenance. Thomas McLean Gallery, London. Presented by H. L. Florence, 1909. Transferred from The Tate Gallery in 1956.

When *The Fish Market* was first presented to The Tate Gallery in 1909, it was identified as the combined effort of both Eugène Isabey and Philippe Rousseau.[1] There is no evidence, however, that Rousseau actually worked with Isabey, although little is known about Rousseau's early career. It is, of course, possible that he studied the Romantic painter's genre and seascape compositions and adapted Isabey's method of painting for this small, market-scene panel, since Rousseau was a highly eclectic painter. His ability to imitate the works of others brought him fame as a "new Chardin" and suggests a close assimilation of Oudry, Desportes, and the Flemish and Dutch still-life painters of the seventeenth century. He often submerged his own independent style and the characteristics that qualified him as a participant in the new Realist movement, in deference to the tastes and inclinations of his traditionally oriented patrons.

Fish Market reveals the intimacy that can typify Isabey's work, but the arrangement of the fish on the wooden plank directly in the center of the composition is reminiscent of Flemish market scenes of the seventeenth century. Much of the interior is in darkness, and the forms of the attendants only sketchily rendered, so that the drama of the scene is concentrated on the brilliantly illuminated array of fish in the central section. By combining a still life of fish with a genre market scene, Rousseau thus maintained the Flemish tradition, achieving the ambience, light, and arrangement that these artists of previous centuries had mastered.

1. Martin Davies, *French School—Early 19th Century, Impressionists, Post-Impressionists* . . . (London: National Gallery, 1970), p. 125, cat. no. 2480.

110

Antoine Vollon

111 *Interior of a Kitchen (Intérieur de cuisine)*

Oil on canvas, 79-1/4 x 51-3/4 inches (200 x 130 cm.). Signed lower right: A. Vollon.

Nantes, Musée des Beaux-Arts.

Provenance. Purchased by the state (1865) and sent to Nantes.

In May 1864 when Antoine Vollon badly needed money to finish his large painting for the 1865 Salon, he wrote to Count Nieuwerkerke, asking him to buy one of his canvases that had been exhibited at the Salon the previous year, noting: "I am at present working on a very large painting for the upcoming Salon. But, if it is to be properly brought to completion, I need funds which are beyond my resources. I ask you, Monsieur le Comte, to take into consideration both my situation and my efforts to date, and to give me the support of the Minister of Fine Arts. I earnestly request that one of my two paintings be acquired. By granting me this favor, you will enable me to provide for the demands of my profession and for the necessities of everyday life. . . ."[1] As a result of his direct appeal, the state purchased one of Vollon's 1864 Salon paintings for 1800 francs. This was his first sale to the government, and it enabled the painter to continue his *Intérieur de cuisine* for the 1865 Salon. In April 1865, when the large canvas was still not completed, Vollon again wrote to Count Nieuwerkerke, this time asking him to examine an unfinished work personally, so that he might be assured that his painting was satisfactory for the Salon competition.[2] Vollon thus solicited recognition well before the canvas was officially accepted—an unprecedented procedure that could not have been without some influence upon his receipt of the Salon medal that year as well as the purchase of his entry by the state for 2000 francs on 2 June 1865.

Intérieur de cuisine combined the activity of a kitchen maid with still-life objects used in the preparation of a meal. The traditional interior indicates Vollon's use of motifs derived from the Dutch, Spanish (e.g., Murillo), and Flemish masters of the seventeenth century, but the controlled atmosphere shows the influence of the Realists (e.g., Bonvin and Ribot), who often showed cooks or servant girls preparing meals or washing utensils. The young painter's mastery of still life is also evident in this early work, extending from the arrangement of mussels and fish in the foreground, to the dead rabbit and ceramic on the wooden barrel at the right, and finally to the calf lights (lungs) hung from the rear wall. To the left, beyond the entrance to a second room, a straw broom and an array of domestic utensils provide another study in still life.

The canvas was well received at the Salon. Théophile Thoré, writing under the pseudonym of W. Bürger, drew parallels be-

tween Vollon's kitchen and similar works by Velázquez, Snyders, Teniers, and Rembrandt. Thoré must certainly have exaggerated, however, when he referred to the composition's "ragout of color,"[3] because the only intense colors are the vermillion of the servant girl's blouse and the brilliant emerald green of the ceramic atop the wooden barrel. All else, as noted by Paul Mantz, a second critic writing about the Salon in *Gazette des Beaux-Arts*, creates a "rusty and smokcy atmosphere that, above all, gives the painting unity. . . ."[4]

Both critics recognized the awkwardness of the figure of the servant girl. Thoré dismissed her as a robust type reminiscent of the figures of Jordaens and other Flemish masters, rather than the more demure servants of Chardin. He criticized Vollon for his larger-than-life scale, believing that the theme required a smaller canvas. Mantz was even more outspoken, identifying the girl as "uglier than nature itself." This harsh criticism may have been aimed at the Realists in general, rather than specifically at Vollon's canvas, since some of the critics were having difficulty with the then-increasing tendency to represent ordinary figures. Mantz's remark, however, contains an astute observation (although Mantz could not have realized the implications of what he sensed): Vollon was by no means trying to duplicate the charming, more appealing models used by earlier masters, but attempting to characterize the earthy manner and ungainly robustness of a simple country woman scouring a copper cauldron.

It is unlikely that Vollon ever again attempted to integrate a servant girl or cook with a still life. In fact, Vollon seldom depicted the figure at all, preferring instead to examine inert objects and study landscape and its atmosphere.

1. Vollon to Nieuwerkerke, 10 May 1864, Antoine Vollon dossiers, F 21/189, Archives Nationales, Paris.
2. It is likely that Vollon was working on another painting for the 1865 Salon and switched to the *Intérieur de cuisine*. See Vollon to Nieuwerkerke, 26 April 1865, Archives Nationales, for this reference. Geneviève Lacambre, *The Second Empire: Art in France under Napoleon III* (Philadelphia Museum of Art, 1978), pp. 356-57, notes that the other painting could have been *Curiosités*.
3. W. Bürger, *Salons, 1861-1868* (Paris, 1870), II: 198. Cleaning of the painting (1980) may yet reveal more color.
4. Paul Mantz, "Salon de 1865," *Gazette des Beaux-Arts* XIX (1865): 8-9.

Exhibited
1865, Paris: Salon, no. 2196.

Published
Gabriel P. Weisberg, "A Still Life by Antoine Vollon, Painter of Two Traditions," *Bulletin of The Detroit Institute of Arts* 56, no. 4 (1978): 225, fig. 5 repr.

111

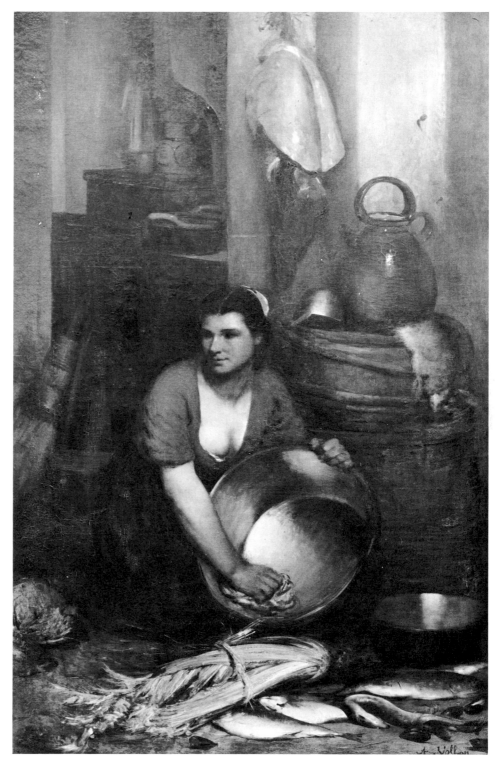

112

Below left
113a Illustration of *Le Gniaffe*,
from *Les Français peints par eux-mêmes*.

113

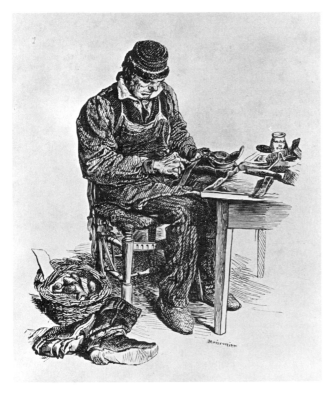

146

Théodule Ribot

112 *Corner of a Kitchen*
Water color and ink, 10-1/4 x 7-1/8 inches (26 x 18.1 cm.). Signed lower left: t.R.
London, Private Collection.

A series of drawings completed early in his career indicate Théodule Ribot's interest in interior structure and architecture.[1] Many of these simple charcoal studies achieve a sense of scale by emphasizing relationships between sections of a room or by the placement of utensils within a particular environment. The rows of frying pans in descending order in some of his drawings (e.g., Private Collection, Cleveland) attest to his well-known predilection for restaurant kitchens. The wash drawing *Corner of a Kitchen* is confined to an oblique view into a small kitchen, where the dimly lit storage wall of covered cooking pots opens into a narrow strip of bright sunlight emitted from the single window. The unusual vantage point, further heightened by the large, open doorway, preserves a commonplace segment of reality.

1. It has been suggested that Ribot began his career as an architectural draftsman—a training which undoubtedly influenced the way he composed his interior scenes.

Jean Alphonse Duplessy

113 *The Cobbler's Quarters*
Oil on canvas, 24 x 20 inches (60 x 51 cm.).
Cleveland, Collection of Mr. and Mrs. Noah L. Butkin.
Provenance. Private dealer, London 1978.

The activity of the cobbler was treated by several Realist painters, including François Bonvin and Léon Lhermitte (see page 7), whose similar themes focused upon the significance of that workman's trade. Jean Alphonse Duplessy, however, omitted the shoemaker from his description of *The Cobbler's Quarters*, concentrating instead upon the disarray of objects that are contained in the small apartment. Duplessy's composition is similar to Dutch seventeenth-century still-life paintings, which show an unfinished meal interrupted for an instant or an arrangement of objects momentarily set aside, for it is obvious that the cobbler has just been called away.

The cobbler's role in French society is also evident. This shoemaker works at home, with a corner of the room set aside for his tools and the boots that are to be repaired. From the extent of his workspace, it is obvious that he has no shop other than his home, so that perhaps he has taken on this trade to earn extra money rather than retaining a commercial location to attract clients. The stove in the center of the room provides not only heat but cooking facilities, for the pot has already been tended and, in the far

corner, a table has been readied. The small paintings on the wall, the newspaper propped open on the bureau, and the familiar plaster statue of Napoleon I on the shelf over the work area all qualify this as the room of one of the small, independent workingmen who earned an honorable living while upholding the traditional values of Napoleonic France.[1]

The theme of the shoemaker was already well established in popular iconography of the country, since *Les Français peints par eux-mêmes,* published in 1841, contained a section devoted to this social type (Figure 113a). A description of a cobbler's interior from this publication may even have provided the inspiration for Duplessy's representation, for the writer carefully detailed the shoemaker at his work, surrounded by his tools "in front of his lamp on a small square table. . . . [Here] are tools made from wood, awls, nails and wooden bowls; at his left is *le baquet de science* [a bucket filled with water to moisten the hard leather], and at his right a hammer, pliers and a straw basket called a *caille-bottin* for holding threads."[2] This is an apt description for Duplessy's composition, where similar objects are placed in nearly the same location.

Duplessy displays a meticulous ability to capture actual appearances, using dark tones to convey the dimmed interior. His mastery of still life conveys the casualness of living quarters converted into a workspace. Although the last known record of Duplessy shows that he participated in the Salon in 1871, other than his "successful rendering" of *The Cobbler's Quarters* few works by his hand have yet been located.

1. The significance of the plaster statue of Napoleon I should not be minimized. The painting was completed during the Second Empire and this detail attests to the allegiances of both the household and the artist.

2. *Les Français peints par eux-mêmes* (Paris, 1841), 4: 373-85.

TABLETOP STUDIES

Eugène Boudin

114 *Still Life with Lobster on a White Tablecloth*
Oil on canvas, 22-1/2 x 32-1/4 inches (50.6 x 80.1 cm.), ca. 1853-56. Signed lower right: E. BOUDIN.
Atlanta, The High Museum of Art, Gift in memory of Lena B. Jacobs.
Provenance. Mme. A. Popoff, Paris (purchased by Alexander Popoff from a "relative of the Rothschilds"). Richard L. Feigen and Co., New York City. High Museum of Art, Atlanta, 1970.

Eugène Boudin began painting still lifes in the early 1850s as part of the general revival of interest in this category. Among his earliest works are traditional compositions of game in which a wild rabbit has been placed on a wooden tabletop along with dead birds to represent trophies of the hunt.[1] Based, in part, on the widespread appreciation of the canvases of Chardin, Boudin probably painted these works after he had seen earlier canvases by Chardin in Paris. As early as 1847 he is known to have studied alone in Paris, spending days copying masters of previous times in the Louvre. In 1851, after receiving a subsidy from the town of Le Havre, he remained in Paris for three years, completing works that he often sent to the Le Havre museum.

In the early 1850s Boudin exhibited paintings in regional shows, among them Le Havre in 1852 and 1858, Bordeaux in 1852 and 1859, and Rouen in 1856. As part of the art program for the provinces, these exhibitions gave artists an opportunity to show canvases to an increasingly interested provincial public. Occasionally, painters who had previously exhibited only in Paris sent works to these locations. When purchases were made by an active Société des Amis des Arts, Realists often received regional praise even before they achieved renown in Paris.

Little is known about Boudin's still-life compositions. Regional collectors commissioned him to do canvases for their homes as early as 1855; perhaps these were still lifes, since the middle class usually appreciated smaller studies. His own regard for the still life as an art form can only be assumed by his entry of a still life in the Rouen exhibition in 1856.[2] In 1858 he exhibited three still lifes in Le Havre, including one titled *Still Life with Lobster*, which may indeed be the same work shown here. Boudin often studied fish or dead birds that he placed in direct light, so that little of the background is detailed. By placing his objects close to the

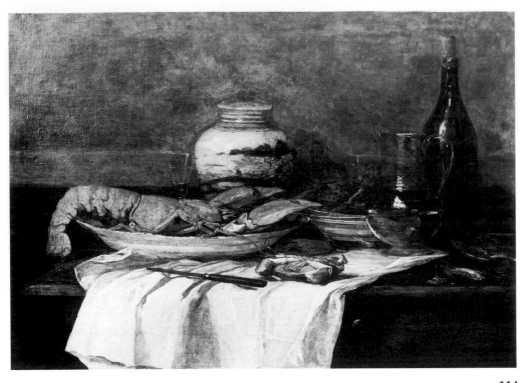

frontal plane he was able to depict the iridescent coloration of the feathers or the tactile quality of fruits and vegetables.

Still Life with Lobster on a White Tablecloth is more intricate than many of Boudin's early still lifes. The numerous objects in this mealtime composition are placed on a white tablecloth, with a knife obliquely situated to suggest space, in a manner similar to the still lifes of Chardin that Boudin probably studied earlier in the Louvre.[3] Boudin's interest in light effects is revealed by the glass pitcher that is used to cast reflections of light as well as to provide a transparent view of the other container and the wine bottle. This translucency suggests that Boudin was studying Flemish masters as much as native French still-life painters. The glazed ceramic with its scenic detail and the presence of both a wine bottle and a small drinking glass suggest that this is a meal to be enjoyed in a middle-class household. This work was probably commissioned by one of Boudin's new patrons. As such, it shows the regional painter's transition from rustic setting and simple peasant meals toward the cultivation of finer tastes.

114

115

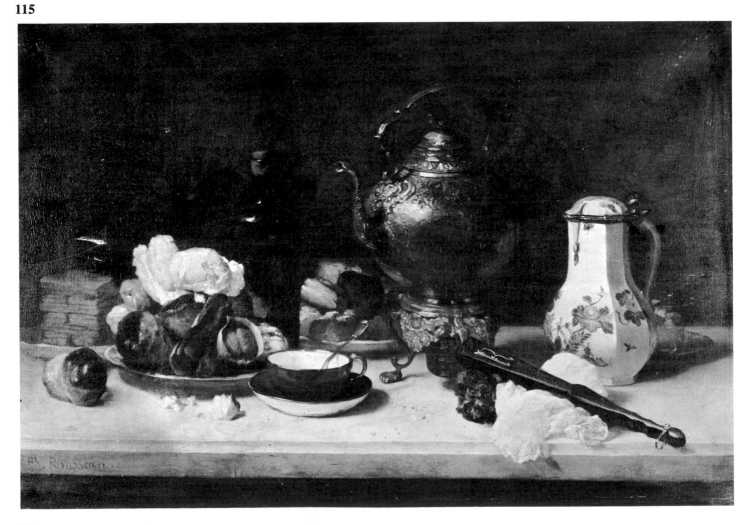

1. For reproductions of these paintings see Robert Schmit, *Eugène Boudin: 1824-1898* (Paris: Imprimerie Union, 1973), figs. 20, 21.

2. Charles C. Cunningham, *Jongkind and the Pre-Impressionists: Painters of the Ecole Saint-Siméon,* exh. cat. (Williamstown, Mass.: Sterling and Francine Clark Art Institute and Smith College Museum of Art, 1977), pp. 69-70, has suggested that *Still Life with Paté and Fruit* (Wadsworth Atheneum, Hartford) was the painting shown in 1856 at Rouen.

3. For an examination of the Chardin still lifes that would have been available to Boudin, see Pierre Rosenberg, *Chardin: 1699-1779* (CMA, 1979).

Exhibited

1958, Paris, Galerie Charpentier: Cent tableaux d'Eugène Boudin.

1976/77, Santa Barbara (Calif.) Museum of Art; Corpus Christi, Art Museum of South Texas; St. Petersburg (Fla.), Museum of Fine Arts; Columbus (Ohio) Gallery of Fine Arts; Fine Arts Gallery of San Diego (Calif.): Louis Eugène Boudin: Precursor of Impressionism, cat. no. 1. Catalog by Mahonri Sharp Young (Santa Barbara Museum of Art, 1976), illus.

Philippe Rousseau

115 *Still Life—Five O'clock*
(*Nature morte—Five O'clock*)

Oil on canvas, 22-1/2 x 34 3/8 inches (56.8 x 86.7 cm.). Signed lower left: Ph. Rousseau.

Reims, Musée St. Denis.

Provenance. Purchased by H. Vasnier at the Merline sale, Paris, 1900 (2100 francs). Donated to the museum by H. Vasnier, 1907.

Because he was a deft practitioner in several revival styles and because he was skilled in all the categories of still life, Philippe Rousseau represents important characteristics of the nineteenth-century still-life revival that are often overlooked. It is important to understand that he was not dependent upon one master, although at his death his obituary proclaimed, "French art has just lost its modern Chardin."[1] The resemblance of a given work by Rousseau to the way in which Chardin composed his canvases, with a feeling for studying shapes on an intimate scale, must be tempered by the acknowledgment that nineteenth-century critics were often comparing the general accomplishments of a given painter with the merits of a past master. By comparing Rousseau with Chardin, therefore, writers were placing Rousseau in a preferred historical context, recognizing that many of his canvases rivaled the quality of Chardin's finest achievements—even though many of Rousseau's works show little influence from known examples by Chardin.

The similarity between Rousseau's *Five O'clock* and Chardin's paintings (which Rousseau would have known from the La Caze collection even before they were acquired by the Louvre in 1869) seems apt.

The genteel arrangement of delicate pastries and biscuits; fine, decorative china; and the tea server demonstrate his mastery of the tactile qualities of these forms. His deft touch has preserved the look of pastry and the creamy resiliency of chocolate éclairs. The monogrammed fan at the right symbolizes the elegance of this upper-middle-class environment and contrasts with the delicate lace of the handkerchief upon which it rests. The arrangement, viewed at eye level on the smooth marble tabletop, is also similar to Chardin. This tour de force of style and appearance was indeed appropriate for the Chardin revival and the wealthy patrons who supported the movement during the Second Empire.[2]

1. "Nécrologie," *Courrier de l'Art*, 1887, p. 392.

2. The painting is not dated (like the majority of Rousseau's compositions), but the type of objects selected suggest the opulence associated with the Second Empire.

Exhibited

1970, Reims, Musée de Reims: L'Art de recevoir.

Published

Sale Merlin, cat. (1900), no. 35.

Sartor Vasnier, cat. (1907), no. 228.

Atalone, *La Galerie Vasnier à Reims* (Reims, 1909), p. 51.

Hélène Toussaint, "Collection Henry Vasnier: Peintures et dessins" (MS, Musée de Reims, 1969; now at Musée du Louvre), cat. no. 315.

Adolphe-Félix Cals

116 *Still Life with Cabbage, Cauliflower, Onions, and Dead Bird*

Oil on canvas, 17-3/4 x 24 inches (45.1 x 61 cm.). Signed and dated upper left: Cals 1858.

Cleveland, Collection of Mr. and Mrs. Noah L. Butkin.

Provenance. François Delestre Gallery, Paris.

The painting of still lifes was a lifelong interest of Adolphe-Félix Cals, and he often positioned dead game or vegetables near a cook in his kitchen genre scenes, or completed simpler studies of vegetables or fruit alone. One of his earliest still lifes, *Still Life with a Cucumber and a Pitcher* (Private Collection, Paris), was completed on wood panel in small dimensions in 1847, a time when the painter had little funds to purchase canvas,[1] and it may even have been included among the first still lifes Cals exhibited at the 1848 Salon.

Like other Realists, Cals used the still life as a category to convey truths derived from observation, favoring simple rustic objects, such as earthenware jugs or ceramic plates, to call attention to the fare or setting of a humble meal, and concentrating on such common foods as cabbages, cauliflowers, oysters, eggs, bread, or asparagus. These were the staples most often used in the still lifes that proliferated during the 1850s, and Cals's *Still Life with Cabbage, Cauliflower,*

116

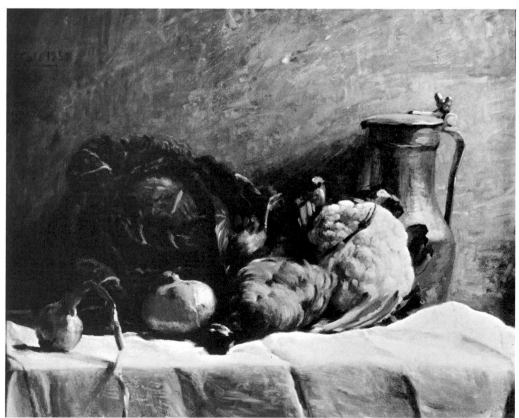

Onions, and Dead Bird is typical of this period. The natural atmosphere, which Cals (and other Realists) achieved through direct study of light on stationary objects, is also characteristic of the pre-Impressionists.

Cals placed his forms on a white table-cloth and against a muted, gray background. The space is limited, compelling the viewer to study the variety of textures: the soft plumage of the dead bird, and the silvery reflection cast by the surface of the metal container. Cals's composition shows a careful balance of shapes that indicate his awareness of the still lifes of Chardin, whose work was affecting almost all of the Realist still-life painters. Cals's work, dated 1858, was probably intended for middle-class buyers who, in effect, encouraged the still-life revival because of their desire to acquire familiar images for their own dining rooms.

1. For a reproduction of this painting see Cunningham, *Jongkind and the Pre-Impressionists*, fig. 46. The painting was owned by Jacques Daber, an art dealer in Paris.

Exhibited
1979, CMA: Chardin and the Still-Life Tradition in France, cat. no. 15. Catalog by Gabriel P. Weisberg with William S. Talbot.

Philippe Rousseau

117 *Still Life with Asparagus*
Oil on canvas, 14 x 25-1/2 inches (36 x 65 cm.).
Signed lower left: Ph. Rousseau./à son ami A. Arago.
Cleveland, Collection of Mr. and Mrs. Noah L. Butkin.
Provenance. Brame and Lorenceau Gallery, Paris.

Throughout the 1850s Philippe Rousseau was favored by a series of commissions and awards from the imperial court, including the highly prized Légion d'honneur as well as the sponsorship of Count Nieuwerkerke, from whom he received many lucrative painting opportunities.[1] As a result, many of Rousseau's canvases must be dismissed as overly contrived pastiches, derived from the masters of the seventeenth and eighteenth centuries, that only served to satisfy the demands of his many patrons. Some of his works, however, reveal a direct way of painting based upon actually observing objects in an interior setting or in the Normandy countryside. These observations reveal a close affinity with the Realist tradition and, especially, with the works of François Bonvin, since such compositions were not simply the re-use of forms learned from memory. The Realists' and Chardin's preference for foods and forms in and of themselves, rather than displays and accouterments that signified aristocratic pretensions,

led to the depiction of simplified still lifes of familiar objects.

Early in the movement Rousseau was also attracted to the tendency to paint still life. The supple bundle of cooked asparagus standing in the ceramic platter near the brown jug in *Still Life with Asparagus* affirms his interest in natural, uncontrived compositions. The stalks that have fallen onto a second platter and the serving tongs casually left nearby underscore an informality that is often lacking in Rousseau's other works. The naturalness of this presentation, the accuracy with which each stalk has been painted, and the summary treatment of the background provide an integrity that confines the viewer's attention to the asparagus itself.

Dedicated to A. Arago, a relative of Emmanuel Arago, director of the Beaux-Arts, the painting documents Rousseau's official ties as well as his ability to paint in a free manner suggestive of the still lifes of Bonvin or Edouard Manet.

1. For further information see dossiers on Ph. Rousseau listed under numbers P 30, P 21, D 8, P 5, P 6, Archives du Louvre.

Exhibited
1979, CMA: Chardin and the Still-Life Tradition in France, cat. no. 26.

François Bonvin

118 *Still Life with Oysters*
Oil on canvas, 37-1/8 x 29 inches (94.3 x 73.7 cm.). Signed and dated lower right: F Bonvin, 1860.
Yale University Art Gallery, Stephen Carlton Clark, B.A. 1903 Fund.
Provenance. M. A. Bellino sale, Georges Petit Gallery, Paris, 20 May 1892. Public sale, Sotheby's, London, 7 May 1973. Shickman Gallery, New York. Purchased by Yale University Art Gallery, 1976.

By the mid-1850s, although François Bonvin was a well-established painter who enjoyed support from the government of the Second Empire for such large works as *Les Forgerons—Souvenirs du Tréport* [30], his still lifes were becoming increasingly popular among private collectors. A cartoon in *Journal pour Rire* in 1852 satirized his success, showing him with a huge eye in his head, seated among an assortment of still life objects.[1] Some of Bonvin's smaller still lifes were spontaneously executed, but he also completed larger canvases that suggest a more deliberate painting technique and a careful assimilation of compositional devices absorbed from the Dutch seventeenth-century masters and from Chardin.

Still Life with Oysters was probably hung in a dining room as a single decorative piece or as part of a series of similar compositions by several different still-life painters. In this painting, Bonvin organized his objects on

117

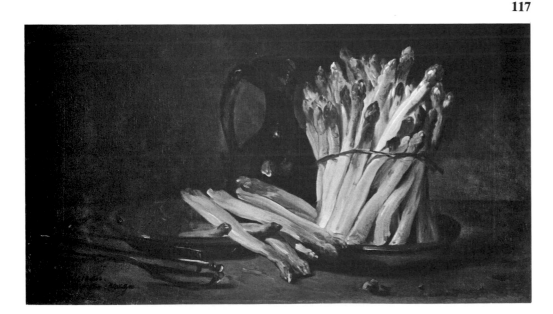

the soft folds of a white tablecloth, a traditional motif that he used in many of his still-life studies. A knife positioned precariously near the table edge recalls Dutch motifs as well as the influence of Chardin, and directs the viewer toward the serving tray of oysters and the partially peeled lemon—focal points in an arrangement that Bonvin depicted several times during that decade (e.g., *Still Life with Lemon and Oysters*, 1858, Tanenbaum Collection, Toronto). Similarly, Bonvin's large-scale still lifes show the same carefully modulated color scheme in tones of brown, white, bluish green, ochre, and black that were consistent with his attempt to paint objects as he saw them. The highlights on the wine bottle and the glass, entering from a light source at the left, reveal Bonvin's adaptation of a Netherlandish treatment of light reflections; the harmony of these muted colors reveals subtle nuances of light and atmosphere. Unlike some of his smaller still lifes, where freer paint application is often evident, this canvas exhibits a smooth surface. When he thus chose to follow Salon practice and to limit his personal freedom, Bonvin demonstrated a type of Realism intended to appeal to the middle class of the Second Empire, who responded more readily to such traditional sources.

1. Gabriel P. Weisberg, *Bonvin: La Vie et l'oeuvre* (Paris: Geoffroy-Dechaume, 1979), p. 44, cat. no. 117. For discussion and a reproduction of the cartoon, see John W. McCoubrey, "The Revival of Chardin in French Still-Life Painting, 1850- 1870," *Art Bulletin* XLVI (March 1964): 39-53.

Published
Art Journal XXXVI (Spring 1977): 252, repr.

Léon Bonvin

119 *Still Life: Containers and Vegetables*
Water color on paper, mounted on cardboard, 6-1/2 x 8-3/8 inches (16.5 x 21.2 cm.). Signed and dated lower right: Léon Bonvin. 1863.
Baltimore, The Walters Art Gallery.
Provenance. Collection of Mr. Walters.

It is uncertain when Léon Bonvin began his interest in still life, although many of his water colors on this theme are dated in the early 1860s. His still lifes suggest that an examination of objects from the kitchen—perhaps inspired by the general interest in this type of theme—led Léon to record exactly what he saw in the environment around him. Sensitivity to light, to textures of a variety of fruits and vegetables, and interest in light reflections from glass and ceramics led Léon to create still lifes of meticulous accuracy. Often he outlined his forms first in pen, then added color. The clarity of his spatial arrangements, his careful selection of objects, and the informality of the setting suggest that Léon Bonvin had studied Chardin as well as the still lifes of his contemporaries.

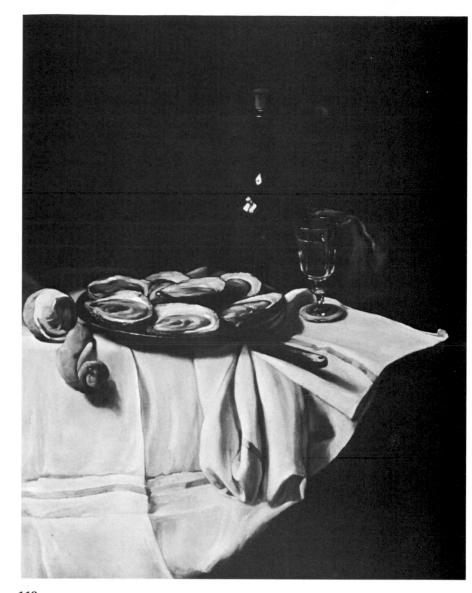

118

119

Of the still-life painters active during the 1860s, Léon Bonvin was the only one who worked solely in water color. In addition, he never exhibited during his lifetime, since he found little support from his family or friends aside from the assistance of his half brother François—an artist who excelled in still life [118]. Perhaps Léon was too poor to afford large canvases and costlier oil paints. Nonetheless, his small water colors, such as *Still Life: Containers and Vegetables,* that depict objects readily available from his garden or inn (e.g., onions, leeks, celery) capture the same intimacy associated with better known still-life artists (e.g., Cals). Working alone in Vaugirard on the outskirts of Paris, Léon shunned the public eye, developing—without preconceptions—a purely intuitive response to nature.

Published

Private Collections: A Culinary Treasure (Baltimore: The Walters Art Gallery, 1973), p. 19.

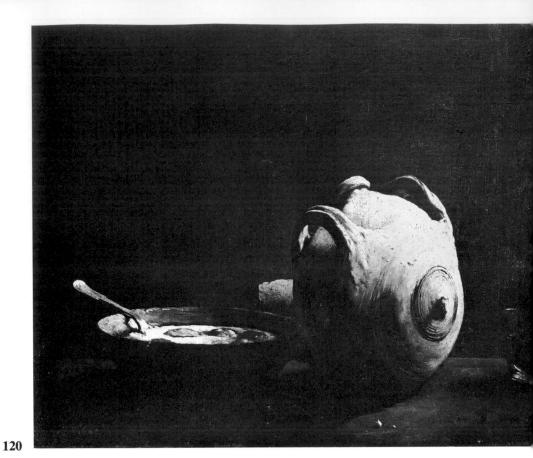

120

121

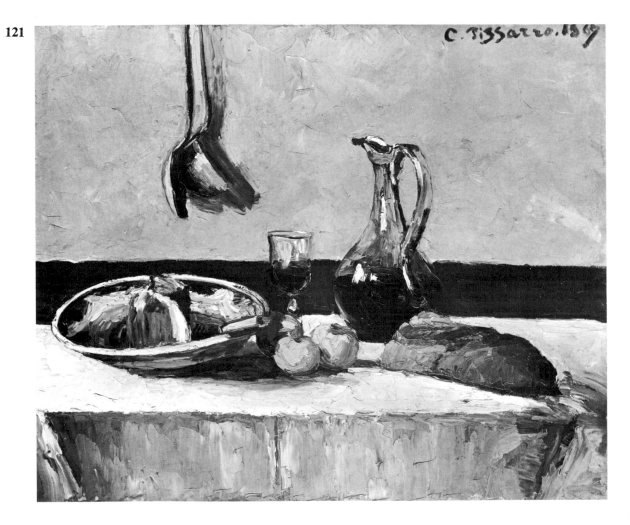

Théodule Ribot

120 *Still Life with Eggs*
 (*Nature morte aux oeufs sur le plat*)
Oil on canvas, 23-1/4 x 29-1/8 inches (59 x 74 cm.),
ca. 1865-75. Signed lower left: T. Ribot.
Senlis, Musée du Haubergier.
Provenance. Given to the museum by M. Reyre,
1939.

Théodule Ribot turned to still lifes in the
1860s after an intense period of historic and
religious compositions that could well be
termed successful, since they were exhibited
at the Salons and often purchased by the
state [90]. His interest in large religious can-
vases continued, but his preference for rus-
tic themes increased, perhaps because of the
general tendency of the time for painters to
complete studies of simple, everyday ob-
jects. During the latter part of his career he
is known to have concentrated on simple ar-
rangements of fruit—using a much looser
paint style, but it is not known how many
still lifes he completed, or even who pur-
chased them. One still life, *Science et Arts*,
was exhibited at the 1870 Salon, but many of
his works simply disappeared into private
collections. Interestingly, both of Ribot's
children, Louise (1857-1916) and Germain
(1845-1893), became painters who favored
the same still-life themes their father had
studied.
 Still Life with Eggs was a theme Ribot had
used in a number of canvases. His arrange-
ments were usually similar: a container of
eggs grouped together with a large ceramic,
and other objects such as onions or a glass
placed on a dark, spare shelf or tabletop.
The eggs, symbolizing a simple peasant
meal, are contrasted in this work with a
glass of wine, a piece of bread, and the large
earthenware container. The light that enters
at the right dramatically illuminates one side
of the jug and touches upon the surface of
the eggs, so that the edges of each object are
modulated to suggest their structure. Like
the Spanish masters—artists whom Ribot
revered and studied in French collections—
Ribot diverts the viewer from the work as a
whole to focus again upon the rugged, grainy
surface and the striated detail of the un-
glazed earthenware jug, thereby heightening
the sense of realism. The painter imparts an
atmosphere of dignity to the individual ob-
jects through his spare arrangement of these
humble shapes.
 Ribot's interest in simplification trans-
cended still-life painting from its established
reliance upon Chardin (and Flemish mas-
ters) toward a fuller assimilation of the
Spanish seventeenth-century painters (e.g.,
Velázquez). An earlier attempt at a still-life
composition beneath the present image of
Still Life with Eggs reveals that Ribot
worked without preliminary drawings, mod-
ifying and refining his still-life compositions
directly on the canvas.[1] It is probable that
Ribot painted over this still life in order to
re-use a canvas at a time when he had little
money to buy new materials. The painter's
tendency to bring out tactile qualities of the
objects he studied attracted other artists,
perhaps even Cézanne, whose search for the
intrinsic structure of apples or oranges paral-
leled Ribot's own dedication to these ob-
jects.

1. Beneath the present composition is a chicken—
a fact which was revealed in an x-ray of the com-
position. This suggests that Ribot, early in his
career, modified still-life compositions as he
worked on them. Andrée Jouan, "Notes sur quel-
ques radiographies," *Bulletin du Laboratoire du
Musée du Louvre* 11 (Paris: Réunion des Musées
Nationaux, 1966): 20, repr. pp. 21, 22-23.

Camille Pissarro

121 *Still Life*
Oil on canvas, 31-7/8 x 39-1/4 inches (81 x 99.6
cm.). Signed and dated upper right: C. Pissarro.
1867.
The Toledo Museum of Art, Gift of Edward
Drummond Libbey.
Provenance. Madame Pissarro (Georges Petit
sale, Paris, 3 December 1928, lot 33 repr.).
Georges Viau, Paris, 1928 (sale, Galerie Charpen-
tier, Paris, 22 June 1948, lot 5). Wildenstein and
Co., New York.

The number of still lifes Camille Pissarro
painted is difficult to estimate since many of
his early paintings were destroyed during the
Franco-Prussian War. Though still-life paint-
ing was probably not his major preoccupa-
tion, Pissarro's familiarity with the works of
Edouard Manet and Realist painters such as
François Bonvin, Théodule Ribot, or Gus-
tave Courbet perhaps led him to see still life
as one of the most important categories. In
still life, an artist could follow his inclina-
tions in the arrangement of objects, study of
form, and manner of painting.
 In a study of commonplace objects enti-
tled *Still Life*, Pissarro placed a glass of
wine, a decanter, several apples, a half-loaf
of bread, a ceramic bowl, and a knife on a
tabletop in a time-honored arrangement.
While placing the bread and knife at an angle
to create an illusion of space, Pissarro mas-
terfully balanced verticals and horizontals.
The shadow alongside the two ladles sus-
pended against the neutral back wall further
suggests space. Because of the sparing use
of brilliant color, especially in the dish and
the three apples, the composition remains
essentially neutral in tone, conforming to the
harmonious still-life arrangements painted
by Realists.
 This painting differs from other Realist
still lifes in its bold handling of paint, applied
with a palette knife. The palette-knife tech-
nique, undoubtedly learned from Courbet's
landscapes, enabled Pissarro to create a tex-
ture of roughness and achieve an appro-
priately Realist directness. The success Pis-
sarro achieved in his rough still life indeed
rivaled Courbet's studies of apples and fish.
Courbet's more traditional surfaces, how-
ever, contrast with Pissarro's structured,
layered textures. The closest parallels to this
still life are the early works of Paul Cézanne
from the 1860s in which Cézanne used a
similar facture. Cézanne's darker color
range conforms to the Realists, but his paint
surface (*Still Life*, Cincinnati Art Museum)
suggests a relationship between Pissarro and
Cézanne, which perhaps began in 1861 when
they are first known to have met.[1]

1. John Rewald, *Camille Pissarro* (New York:
Harry N. Abrams, 1963), p. 63.

Exhibited
1930, Paris, Musée de l'Orangerie: Centenaire de
 la naissance de Camille Pissarro, no. 6.
1937, Paris, *Gazette des Beaux-Arts*: Naissance
 de l'Impressionnisme, no. 73.
1938, Amsterdam, Stedelijk Museum: Honderd
 Jaar Fransche Kunst, no. 186.
1945, New York, Wildenstein: Camille Pissarro:
 His Place in Art, no. 1.
1955, Paris, Musée de l'Orangerie: De David à
 Toulouse-Lautrec: Chefs d'oeuvre des Collec-
 tions Américaines, no. 24, repr.
1965, New York, Wildenstein: C. Pissarro, no. 3
 repr.

Published
Charles Kunstler, "Camille Pissarro," *La Re-
 naissance de l'Art Français* XI (December
 1928): 504, repr. p. 498.
L. R. Pissarro and L. Venturi, *Camille Pissarro,
 Son Art—Son Oeuvre* (Paris, 1939), I: 20, no.
 50; II, pl. 9.
John Rewald, *The History of Impressionism*, 1st
 ed. (New York: Museum of Modern Art, 1946),
 pp. 139-40, repr. p. 138; 4th ed., 1973, pp.
 157-58, repr. p. 156.
H. L. F. [Henry La Farge], "Ruisdael to Pissarro
 to Noguchi," *Art News* XLIX (March 1950): 32,
 repr. p. 33.
Rewald, *Camille Pissarro*, pp. 19, 69, repr. p. 69.
Charles Kunstler, *Camille Pissarro* (Milan:
 Fratelli Fabbri, 1972), p. 14, repr.
Kermit Champa, *Studies in Early Impressionism*
 (New Haven, Conn.: Yale University Press,
 1973), pp. 74-75, pl. 18.
The Toledo Museum of Art, European Paintings
 (1976), pp. 127-28, pl. 248.
Franz Schulze, "A Consistently Discriminating
 Connoisseurship," *Art News* 76 (April 1977):
 64.

Antoine Vollon

122 *Still Life with Eggs*
Oil on panel, 8-7/8 x 10-7/8 inches (22 x 27 cm.).
Signed lower right: A. Vollon.
U.S.A., Private Collection.

The majority of Antoine Vollon's still lifes are difficult to date. In the compositions he completed after the 1870s, however, Vollon seems to have used a more random placement of objects—perhaps to heighten the impression of immediacy by minimizing the sense of prearrangement. Earlier paintings were usually completed in a tighter style that carefully delineated each object. Regardless of when a given work was accomplished, Vollon concentrated on the textures of his forms and used a broad spectrum of color. Often, as in *Still Life with Eggs*, the light is centralized, impelling the viewer to focus on the major objects without absorbing the surroundings in which they have been placed.

It was as a still-life painter that Vollon earned his reputation and his living. Critics who examined his canvases compared him with Chardin—a great compliment—since the still-life revival at mid-century was urging the discovery of a modern master whose achievements could equal those of their ideal. Vollon was also compared with Bonvin, Ribot [120], and Rousseau [115], for they were all considered eligible for the title "new Chardin." Undoubtedly, the comparison affected the way in which Vollon completed his early still lifes: he often placed his arrangements on a tabletop where the ceramics or food containers contrasted with a white tablecloth. Vollon's ability to suggest the shiny surface of metals or the reflective translucency of glass amazed his critics, who recognized in him a technical proficiency that would lead to his distinction as the foremost painter of still life during the nineteenth century.

Vollon's earliest canvases were done on a small scale and depicted the humble meals and modest utensils advocated by other Realists. Eventually, however, Vollon modified his kitchen still lifes, using silver decanters and Oriental rugs that reflect the tastes of the upper-middle class. At the beginning of his career, when *Still Life with Eggs* was completed, Vollon was still intent upon perfecting a simple array of objects, rather than attempting to satisfy the growing demand for his works that increased his haste and spontaneity after he became famous.

Exhibited
1937, Paris, Galerie Raphaël Gérard: Antoine
 Vollon, no. 5.
1966, Paris, Galerie M. Bénézit: Hommage de
 Paul Gadala à Antoine Vollon, no. 9.

122

123

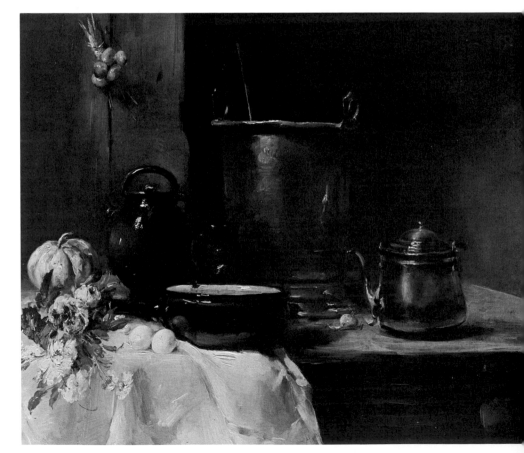

Antoine Vollon

123 *Still Life with Copper Cauldron*
Oil on canvas, 15-1/8 x 18-1/16 inches (38.4 x 46.3 cm.). Signed lower right: A. Vollon.
U.S.A., Private Collection.

Vollon adopted Jean Siméon Chardin's propensity for common themes to help expand the possibilities of using everyday objects. In the composition *Still Life with Copper Cauldron* Vollon centered a copper water urn (one of his favorite studio props) amid a series of familiar objects which he carefully arranged on a shallow tabletop. The contrasting textures of the metallic containers and the earthenware ceramics show the painter's continuing debt to Chardin although Vollon's freer method of paint application is apparent in the tablecloth and flowers. The use of the flowers also strikes a romantic chord, making Vollon's still life less somber than other Realists (e.g., François Bonvin) and demonstrating that he retained strong ties with several traditions in his work.

Exhibited
1966, Paris, Galerie M. Bénézit: Hommage de Paul Gadala à Antoine Vollon, no. 26.
1979, CMA: Chardin and the Still-Life Tradition in France, pp. 73, 87, 90, cat. no. 32 and col. cover (detail).

Henri Fantin-Latour

124 *Still Life with Paper Cutter*
 (Nature morte au coupe-papier)
Oil on canvas, 7-1/4 x 12 inches (18 x 30 cm.).
Signed and dated upper right: Fantin, 60.
Alençon, Musée d'Ozé
Provenance. Gift of Poulet-Malassis in 1861.

The extent of Henri Fantin-Latour's relationship with the editor Auguste Poulet-Malassis awaits further clarification, but it is known that Poulet-Malassis—the publisher of Baudelaire's *Les Fleurs du mal*—was linked with Realist painters (including Gustave Courbet) and critics as early as 1859.[1] Poulet-Malassis may have requested prints for his book projects, or may have commissioned paintings for the decoration of his home near Alençon.[2] Félix Bracquemond, the etcher and decorative designer, is known to have helped Poulet-Malassis coordinate these efforts, but how the projects originated or by whom a particular work was contributed has not been fully determined.[3]

The size and subject of Fantin-Latour's *Still Life with Paper Cutter* that was purchased by Poulet-Malassis suggests that it may have been intended as part of the decoration for Poulet-Malassis's home. All that is known, however, is that Poulet-Malassis presented the still life to the museum in Alençon in 1861. The remarkably simple, intimate composition—consisting of an ink

well, an empty container for pens and pencils, and the letter opener—symbolizes the preoccupation of a man of letters and attests to Fantin-Latour's ability to paint directly from observation. The understatement inherent in the ordinary objects that Poulet-Malassis must have kept at hand and the color harmonies of the grays and whites, highlighted only by the red object in the center (possibly sealing wax), recall works by James McNeill Whistler, Fantin-Latour's close friend during the 1860s—and reveal the influence of this artist on Fantin-Latour during that period.

1. For further reference see the letters of Poulet-Malassis to Félix Bracquemond noted in Jean Paul Bouillon, ''La Correspondance de Félix Bracquemond—Une Source inédite pour l'histoire de l'art français dans la seconde moitié du XIXe siècle,'' *Gazette des Beaux-Arts* LXXXII (December 1973): 373-77. The letters are found in the Bibliothèque Nationale; those for the years 1859-1861 are of specific interest.
2. One letter, dated 19 May 1860, notes that a contribution by Fantin-Latour was being framed. It does not specify whether it was a print or this painting.
3. For future information on Bracquemond and Realism, see Jean Paul Bouillon, "Félix Bracquemond, les années d'apprentissage," *Nouvelles de l'Estampe,* December 1979, pp. 12-17.

Henri Fantin-Latour

125 *Fruit and Flowers*
Oil on canvas, 23-5/8 x 17-3/8 inches (60 x 44 cm.).
Signed and dated lower left: Fantin 66.
England, Co. Durham, Barnard Castle, The Bowes Museum.

The traditional categories of still life and flower painting experienced a strong revival during the Second Empire, stimulated by renewed interest in Chardin and by the insatiable collecting tastes of a middle class eager to acquire objects of art they could understand. The still lifes of Fantin-Latour were derived from an examination of Chardin's compositions as well as from an awareness of the French still-life tradition. But his interest in a variety of fruits and flowers in their containers recalls the paintings of Alexandre-François Desportes as much as it does the works of Chardin.[1] The renewed interest in these types of paintings during the nineteenth century brought financial and artistic success to Fantin-Latour, and he devoted much of his artistic energy to still life.

Although he used the same elements in many of his compositions, *Fruit and Flowers* epitomizes a style Fantin-Latour developed during the 1860s. He carefully observed the texture of fruit, allowing his color to seep through, building up the shape of an

124

apple or a pear from repeated glazings of color and creating a crumbly texture similar to Thomas Couture's style. The succulence and freshness evident in the fruit is contrasted with an exquisite brilliance in the flowers that recalls the meticulous observations of fifteenth-century Flemish painters. His restrained presentation on a simple tabletop, however, distinguishes his composition from technical virtuosity alone. As a recent writer noted, the "essential chasteness of the arrangement suggests a fundamentally watchful aspect of his nature."[2]

1. For further information see Gabriel P. Weisberg with William S. Talbot, *Chardin and the Still-Life Tradition* (CMA, 1979).
2. *The Second Empire 1852-1870: Art in France under Napoleon III* (Philadelphia Museum of Art, 1978), entry by Joseph Rishel, p. 300.

Published

Edward Lucie-Smith, *Fantin Latour* (Oxford: Phaidon Press, 1977), repr. pl. 55.

Albert Lebourg

126 *Still Life by Candlelight*
Black conte crayon heightened with white on tan laid paper, 11-9/32 x 8-3/4 inches (28.7 x 22.3 cm.).
Signed in black conte crayon, lower left corner: A. Lebourg.
Detroit, Collection of Frederick J. Cummings.
Provenance. Galerie Fischer-Kiener, Paris.

Recognized primarily as a landscape painter who exhibited with the Impressionists in 1879 and 1880, Albert Lebourg also drew a series of still lifes. Completed early in his career, probably before 1870, these simple arrangements of everyday kitchen utensils reveal Lebourg's ability to examine the effects of internal light sources. The burning candle in *Still Life by Candlelight* provides the only illumination, subtly highlighting some of the ceramics while casting shadows on the flat rear wall. Like some of the early drawings by Léon Bonvin from the late 1850s, this small study reveals a young artist perfecting his ability to observe by studying simple forms from his environment.

125

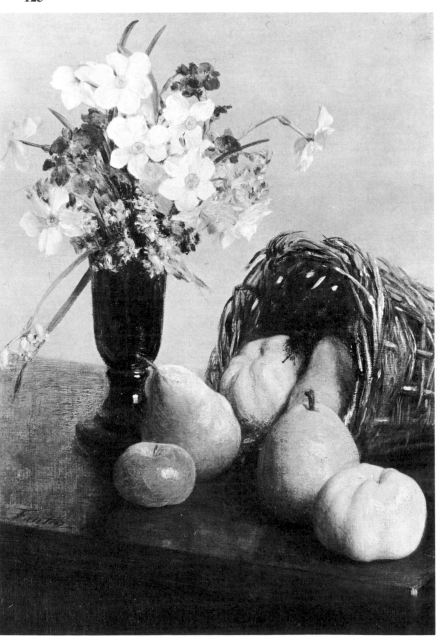

126

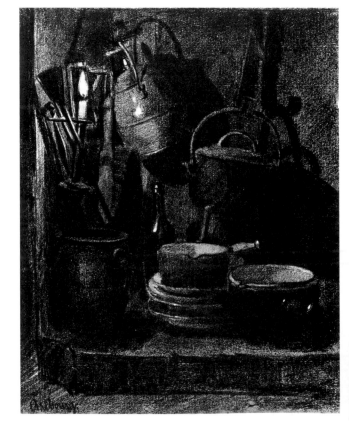

Portraits

For the early critics of Realism, portraiture required more than simple recording of outward appearances; a portrait should reveal the character of the sitter, express his individuality,[1] render his specific qualities, and, in this way, move away from standard poses and conventional attitudes. Most of the early Realists (Jean Gigoux [131], François Bonvin [134], Alphonse Legros [140], Octave Tassaert [137], and Jean-Jacques Henner [146]) painted self-portraits or depicted their friends and family. By using models they knew personally, they were able more easily to reveal character, often depicting the sitter in his familiar surroundings, though many still relied on Romantic props, especially dramatic lighting to emphasize the face and create an aura of poetic introspection [131, 134].

The few paintings that placed figures in a more accurately rendered milieu (e.g., Manet's *Portrait of Emile Zola,* 1867) helped portraiture advance toward Realism because of those artists' acknowledgment of environment and its influence, until such a later "genre portrait" as Adolphe-Félix Cals's *Portrait of Two Men Playing Cards* [141] showed how life molded the activities and thoughts of two individuals. Realist artists portrayed all sorts of people, not just those who could afford to commission a formal composition. The Realist portrait eventually became informal and relaxed. More often than not, portraits were not painted on commission but, instead, remained in the possession of the painter or were presented as gifts to his friends. They were also rarely shown at the Salons and, consequently, rarely subjected to the scrutiny of the critics.

1. For further reference see G. Laviron and B. Galbacio, *Le Salon de 1833* (Paris, 1833), pp. 26, 143-49; Théophile Thoré, "Les Portraits," *Le Salon de 1847* (Paris, 1847), pp. 111-27; and Jules Antoine Castagnary, *Salons* (1857) (Paris: Bibliothèque Charpentier, 1892), II: 35-41.

THE ARTIST'S STUDIO

Octave Tassaert

127 *A Corner of His Atelier*
 (Un Coin de son atelier)
Oil on canvas, 18-1/8 x 15 inches (46 x 38 cm.).
Signed and dated lower right: O. t. 1845.
Paris, Louvre.
Provenance. Collection of Gustave Arosa, sale, Paris, 1891, cat. no. 31. Given to the Louvre by Ernest May in 1923. Entered the Louvre in 1926.

The mid-1840s were a difficult time for Octave Tassaert. He was trying to complete paintings in the Romantic mood for the Salon and also to work on a number of exquisite drawings for art dealers (and possibly book publishers) who paid him little for his efforts.[1] Tassaert's poverty is recorded in *A Corner of His Atelier*, a painting that he completed in 1845.

It is difficult to determine with certainty the identity of the young painter, but it is obvious that Tassaert intended the young man to symbolize the struggling bohemian artist that was described in many of the popular novels of the time.[2] Seated on the floor of his atelier, surrounded by his empty paintbox, his clean wooden palette, and empty easel, the young artist is preparing the simplest of repasts for the ceramic pot already waiting on the fire. His attitude suggests that he is both undernourished and exhausted, for the simple task of peeling a potato seems to require all his effort.

The barren interior of his temporary quarters accentuates the isolation and poverty of the struggling young artist. Everything is in disarray—as if to underscore the artist's idleness—from the cat at his feet to the pipe and empty tobacco pouch discarded on the floor to the water pitcher, the book, the lamp, and the stale portion of bread within reach on the mantel. The painter's red vest and rich gray trousers provide the only touches of color in a setting developed from grayed tonalities. Tassaert's meticulous attention to the various objects and their placement in the composition makes this an accurate depiction of a young painter struggling to keep alive.

After the 1848 revolution, Tassaert's own existence worsened. In February 1849 he wrote to the Directeur des Beaux-Arts, requesting any kind of work in order to make ends meet. His plight attracted the attention of Philippe Auguste Jeanron, director of the National Museums at that time, who received Tassaert in his offices, and then probably visited Tassaert to check on his condition. From notes kept in the Archives

Nationales, Paris, it is apparent that Jeanron discovered Tassaert living and working in a dilapidated shed, exploited by art dealers, and without money to even buy food—a scene not unlike that Tassaert depicted in 1845.[3] Tassaert's timely request for assistance and the liberal policy of the new republican government led to a commission on 18 May 1849 for 2000 francs to complete the painting of *An Unfortunate Family* (Musée de Poitiers).[4] In addition, even though this commissioned painting was not exhibited until the 1850/51 Salon, Tassaert received preferential treatment at the 1849 Salon, where six of his paintings, including *A Corner of His Atelier*, permitted others to observe the conditions under which young Realist painters were then working.

Tassaert's studio scene is significant for another reason. It reveals an interest (e.g., Cogniet or Boilly) continued by the Realists in painting their own studios. They were no longer fascinated by depictions of studios of famous painters from the past, but were recognizing—and recording—a use of models, studio props, and imagery that differed from the creations of former Romantic painters.

1. At the 1846 Salon Tassaert exhibited six canvases of which three works (*Le Juif, Erigone,* and *Le Marchand d'esclaves*) were Romantic in quality. The other canvases included *La Pauvre Enfant, Les Enfants malheureux,* and *Les Enfants heureux*—themes which suggest the development of Realism and its interest in childhood existence.

2. The relationship with Murger, *Scènes de la vie Bohème*, has been suggested by Hélène Toussaint, *Le Romantisme dans la peinture française* (Moscow, 1968), no. 95.

3. Notes from a letter dated 18 May 1849, Octave Tassaert, dossier 8, F 21/57, Archives Nationales.

4. Ibid.

Exhibited

1849, Paris: Salon, cat. no. 1876.

1885, Paris, Galerie Georges Petit: Exposition O. Tassaert au bénéfice de la Société des Artistes, peintres, sculpteurs, graveurs, cat. no. 71.

1923, Paris, Galerie Charpentier: L'Art et la vie romantique, cat. no. 425.

1958, Agen, Grenoble, Nancy: Romantiques et réalistes, exposition circulante, cat. no. 40.

1963, Bordeaux: Delacroix, ses maîtres, ses amis, ses élèves, cat. no. 349.

1968, Moscow, Leningrad: Le Romantisme dans la peinture française, cat. no. 95. Catalog by Hélène Toussaint.

Published

Bernard Prost, *Catalogue de l'oeuvre de Tassaert* (Paris, 1886), p. 12, cat. no. 69; p. 67, cat. no. 51 bis.

Charles Sterling and Hélène Adhémar, *La Peinture au Musée du Louvre, l'Ecole française, le XIXe siècle* (Paris, 1961), vol. IV, cat. no. 1766, pl. 703.

Romantiques et réalistes, cat., L'Institut pédagogique national (Paris, 1958), no. 40.

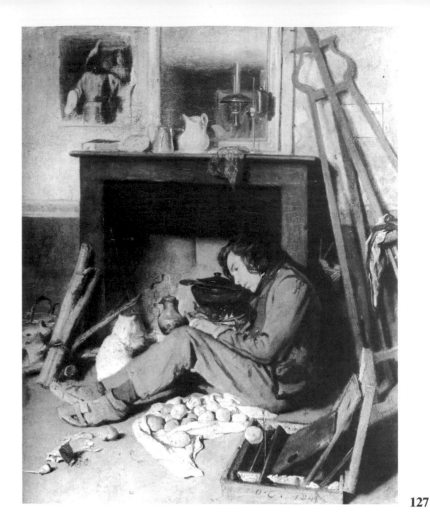

127

128

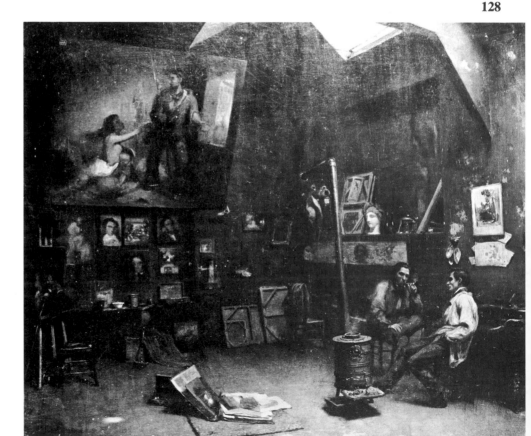

Jules Breton

128 *The Atelier of Jules Breton and Ernest Delalleau*
(L'Atelier de Jules Breton et Ernest Delalleau)
Oil on canvas, 18-1/4 x 22 inches (46 x 55.5 cm.).
Signed and dated lower left: Jules Breton/1849.
France, Private Collection.

When Jules Breton returned to Paris in 1859 he shared a studio at 53 rue Notre Dame des Champs with his colleague and longtime friend, Charles Joseph Ernest Delalleau (1826-1864).[1] Both young men were studying painting (Delalleau was then working in the studio of Drolling [1786-1851], although he had first studied under the architect Henri Labrouste).[2] Breton's description of their lodging, written to his Uncle Boniface in Courrières who supported Breton after the death of his father, relates the sincerity and enthusiasm with which both young men were embracing their careers. "Our atelier is an indication of its character. Nothing in it is sham extravagance: no skeleton strangely attired or holding a pipe between its teeth, no bats nailed on the wall, no palette painted on the door, etc., but some little things which might seem silly to many people: some pearly shells taken from the pond at Versailles, a string of chestnuts, some sycamore fruits . . . , each of these objects recalling for us a happy day spent in the sun or in the shade in the woods. . . ."[3] Breton's letter to his uncle also anticipates the canvas he was preparing to acquaint his relatives back home with his Parisian quarters and his style of painting.

The result, *The Atelier of Jules Breton and Ernest Delalleau*, shows the two artists seated near a small stove, Breton with his pipe and Delalleau, in profile, turning to him in conversation. The wallspace that dominates their rooftop studio serves to document the work of both men and contains portrait studies, descriptions of nature, and, possibly, still lifes.[4] The largest canvas suspended overhead is Breton's *Misère et Désespoir*, the only reference now remaining to a composition Breton exhibited at the 1849 Salon using a theme inspired by the social distress and revolutionary turmoil he witnessed in Paris. The easel in the corner displays a reproduction of *La Faim*, another painting that has since disappeared (presumably destroyed in World War I when the painting was housed in the Arras museum).[5] When *La Faim* was shown at the 1850/51 Salon, some critics interpreted it as qualifying Breton for membership in the Realist camp, for it was inspired by Breton's growing awareness of misery and poverty.[6] The loss of both of these primary works makes it difficult to reconstruct Breton's early style of painting and the type of Realism that was then attracting him to the works of Alexandre Antigna [92] or Gustave Courbet.

While *The Atelier* can only hint at the scope of Breton's lost compositions, the simply furnished lodging does establish the interests and the ambience of the two young artists. Breton's earlier preoccupation with historical themes is retained in only one reference to classical tradition, an antique plaster bust on the mantel that has been fittingly modified by the addition of a republican cap and laurel leaves.[7] The open portfolio on the floor, the small sketches tacked to the wall, and the personal mementos that Delalleau and Breton collected on their trips outside of Paris (notice the bundle of shells hanging at the right)[8] all present a comfortable, but honest appraisal that Uncle Boniface would have taken much pleasure in studying.[9] Moreover, as one of the first Realist studio compositions, the canvas characterizes and reinforces the sincerity and naturalness that Breton was trying to achieve in these early years.

1. Little is known about the career of Delalleau except that he was a history painter and writer who studied with Drolling in the 1840s. His interest in architecture has not been documented beyond his association with Henri Labrouste during his student years.
2. Henri Labrouste must have had many students throughout his career. He became one of the most important architects during the Second Empire.
3. See letter dated 6 November 1849, "Choix de lettres adressées à Breton jeune," vol. 2, in the possession of the descendants of Jules Breton.
4. Breton did one known still life when he studied in Ghent under Félix de Vigne. The arrangement of objects on the rear wall, near the easel, suggests a still-life grouping. Breton's still life is in the possession of his descendants.
5. *La Faim* was given to the Arras museum in 1863 and was destroyed in 1915. As Françoise Maison has noted (in her unpublished notes on *L'Atelier*), *La Faim*, in different editions of the museum's catalog, was mistaken for *Misère et Désespoir*. The description of the painting in the 1880 edition of the catalog corresponded exactly to *La Faim*, documenting that even during Breton's lifetime both paintings were confused with one another.
6. See Paul Mantz, "Le Salon, MM. Adolphe Leleux, Eugène Lacoste et Breton," *L'Evénement*, 12 February 1851. Mantz noted that *La Faim* was a lugubrious theme derived from the life of a poor family, "une famille sans nom."
7. The Realist painters were aware of the classical tradition, although there are seldom references to this in their work. Breton, however, infused his work with the classical Italian Renaissance tradition and never lost sight of the classical past that is suggested by this amusing detail. Even Fantin-Latour, in his *Studio in the Batignolles* composition, referred to the classical heritage when he used a plaster of Minerva on his tabletop. For further reference see Gabriel P. Weisberg, "Fantin-Latour and Still-Life Symbolism in 'Un Atelier aux Batignolles,'" *Gazette des Beaux-Arts* XVI (December 1977): 205-15.
8. Letter dated 12 October 1849, "Choix de lettres adressées à Breton jeune."
9. The painting was in Courrières by 7 December 1849 according to a letter from Jules to Uncle Boniface, "Choix de lettres adressées à Breton jeune."

Exhibited
1977, Arras, Musée des Beaux-Arts: Jules et Emile Breton, peintres de l'Artois.

Published
Marius Vachon, *Jules Breton* (Paris, 1899), repr. p. 18.
Virginie Demont-Breton, *L'Art*, 1929, repr. p. 29.

Jean Antoine Bail

129 *The Artist's Studio*
(L'Atelier de l'artiste)
Oil on canvas, 29-1/8 x 36-5/8 inches (74 x 93 cm.).
Signed and dated lower left: Bail/1856.
Saint-Etienne, Musée d'Art et d'Industrie.

Although the provenance of Jean Antoine Bail's *The Artist's Studio* is not known, the painting is similar in theme and subject to *Intérieur d'atelier*, a work Bail exhibited at the 1854 Salon in Lyon.[1] The continuation of the antique tradition is suggested here in the relief sculpture of the Bacchic figure on the wall at the right and the plaster casts of anatomical limbs hanging from the ceiling, but the scene Bail has depicted—especially the friendly dog in the center foreground—denotes an atmosphere of casual, relaxed activity rather than formal pursuit. The elderly model, seated on the straight-backed chair with a skull at his feet, suggests the Realists' interest in Romantic allegory. The casual disregard for order (the large, open can at the right, the open sketch pad abandoned where it has fallen to the floor, the cutter, the discarded broom, and the drapery flung on the vacant chair) may be props for still-life arrangements, but also indicates the spontaneity and informality of a studio that has been organized for the convenience of a group of bohemian artists rather than under the rigidly meticulous, classically oriented supervision of the Ecole des Beaux-Arts.

Whether this studio represents the actual atelier when Jean Antoine Bail painted in Lyon has not been determined. It does, however, provide a glimpse of what an ordinary atelier would have looked like in the provinces, where many of the Realists received their first training in the company of one another rather than under the direction of an academic master. The free exchange of ideas and the desire to draw inspiration from everyday life rather than classical dogma were aspects of early Realist training—no matter where the studio was located.[2]

1. The archives of the Musée St. Etienne (from 1946) reveal nothing about the history of this painting. There is no record of the work that Bail exhibited in Lyon in 1854.
2. It is doubtful that Bail knew of Courbet's large-scale atelier in 1856 since his ties were still confined to the provinces at that date. He did not move to Paris until 1870.

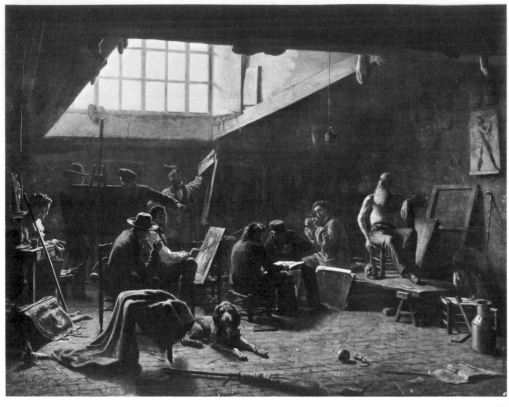

129

130

Armand Leleux

130 *Interval in the Studio*
Oil on canvas, 9-3/4 x 12-3/4 inches (24 x 32 cm).
Signed lower left: Arm. Leleux.
Geneva, Musée d'Art et d'Histoire.

Armand Leleux exhibited several compositions during his career using the theme of the artist's studio, one at the 1846 Paris Salon and others at the 1850 and 1861 Salons. There is no documentation describing the appearance of these canvases, but *Interval in the Studio* might be the version he exhibited at the 1850 Salon. The acquisition of this painting by the museum in Geneva as early as 1855 documents Leleux's work in Switzerland before this date, and his ability to secure interested patrons for his work there.[1]

The well-dressed young woman seated within the studio (probably Leleux's own studio) also suggests the Swiss setting and the early dating of this composition. The sitter is perhaps Leleux's future wife, Louise Emilie Giraud (1824-1885), for her absorption in the sketchbook in her lap indicates more than a passing interest in this aspect of an artist's activity. The large canvas of the washerwomen at the stream that is propped on the easel facing her and the smaller landscape at the base of the easel may both be works that Leleux was also preparing at that time and offer evidence for identifying this composition with the 1850 Salon. The Salon that year included titles by Leleux that are similar: *Lavandières (Suisse Allemande)* and *Bords d'une mare (Suisse)*. These 1850 Salon compositions all suggest Leleux's growing interest in Switzerland, its customs, and dress, although the exact date of his first trip to that country remains undocumented.

The assumption that *Interval in the Studio* was completed early in Leleux's career suggests the importance he placed on the artistic environment. Not only was it possible to reveal the setting in which a painter worked—a theme other artists were using (e.g., Jules Breton [128])—but it was also possible to expand the theme itself to include close friends, collectors, and patrons who were also part of the world of art. What had thus long been regarded as a mysterious place of creation became—when painted—a locale that showed how the interior may have actually looked. Delicately painted in tones that suggest his interest in lightening his color range, this composition also reveals the harmonious balance of light and color that Leleux could achieve when he painted from direct observation.

1. The inventory number on the painting, 1855-8, suggests that the museum acquired the work at an early date. No documentation or information on the early provenance of the work have been located.

160

SELF, FAMILY, AND FRIENDS

Jean Gigoux

131 *Portrait of Gabriel Laviron*
(Portrait de Gabriel Laviron)
Oil on canvas, 33-3/8 x 25-7/8 inches (84 x 65 cm).
Signed and dated lower left: J. Gigoux, 1834.
Besançon, Musée Granvelle.
Provenance. Gift of the artist, 1860.

Jean Gigoux's *Portrait of Gabriel Laviron* was completed at the height of the art critic's fame, during the period when Gigoux had already received some recognition at the Salon. The two men had studied painting together in their native Besançon, and it was Laviron who encouraged Gigoux to continue his career in painting. Laviron, however, gave up his own desire to become an artist, and continued his interest in art as a critic and writer. Their friendship continued during the early days when both were becoming established in Paris, and they even made a trip through the Normandy countryside together.[1]

Laviron's Salon reviews provided the earliest support for still-life painting in the nineteenth century. At the 1833 Salon, Laviron emphasized still life as an art form with a recognizable history. He denounced the general lack of sympathy many held for still life at that time and encouraged young artists to return to older masters, pointing out that earlier artists like Caravaggio and Géricault who had rendered nature successfully had also been accomplished still-life painters. Laviron also stressed scenes of actuality, advocating an art that mirrored changes in society.[2] He was among the first of the critics to emphasize the necessity for a "truthfulness" in representation that would enable art to reach a broader audience.[3]

Gigoux worked directly from his model, capturing Laviron's moody and intense personality. Romantic in spirit, the painting reveals the latent Realism that Gigoux often obscured in his effort to win official recognition.[4] When the canvas was exhibited in Cambrai, Théophile Thoré noted that the portrait was both serious and modern. He compared Gigoux with Titian, discerning similarities in lighting and background that permitted the personality of Laviron to forcefully emerge.

1. While Laviron was successful as an art critic, he followed a bohemian life style, and his friendship with Gigoux gradually waned.
2. Gabriel Laviron and B. Galbacio, *Le Salon de 1833* (Paris, 1833), p. 30. Laviron also tried to distinguish between Realism and Naturalism in his early criticism, although few painters were able to fully grasp his point of view at this early date.
3. Believing in the cause of the masses, Laviron participated in the Italian revolution of 1848, and died in battle during the siege of Rome in 1849.
4. For further reference see Théophile Thoré, "Peintres modernes. M. Jean Gigoux," *L'Artiste* II (series 2, 1839): 204.

Exhibited
1834, Paris: Salon, no. 841.
1838, Cambrai.

Published
A. Estignard, *Jean Gigoux—Sa Vie, ses oeuvres, ses collections* (Besançon, 1895), pp. 39, 66.
Henry Jouin, *Jean Gigoux—Artistes et gens de lettres de l'époque romantique* (Paris, 1895), pp. 39, 55.
Gabriel P. Weisberg with William S. Talbot, *Chardin and the Still-Life Tradition in France* (CMA, 1979), fig. 18.

131

132

133

134

162

135

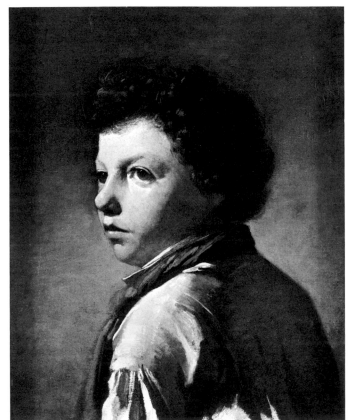

Adolphe-Félix Cals

132 *Self-Portrait*
(Auto-Portrait)

Charcoal drawing, 10-1/4 x 8-1/2 inches (26 x 21.5 cm.). Signed and dated lower right: Cals 1840. France, Private Collection.

Although more frequently associated with themes depicting the life of the poor that he exhibited at the Parisian Salons during the 1830s, Adolphe-Félix Cals also made several studies of his own face, among them the *Self-Portrait* that he completed in 1840. Cals developed an intimate relationship through his experimental use of the medium, blending the charcoal with a stump to blur the background and soften the facial features.[1] The effect is both personal and painterly. This vignette, with only a segment of the background suggested, adds to the intensity of the introspective study.

1. In earlier drawings Cals relied on hatching to suggest the background, creating a colder, more impersonal quality.

Jean François Millet

133 *Portrait of Madame Roumy*
(Portrait de Madame Roumy)

Oil on canvas, 28-5/8 x 23-3/8 inches (72.8 x 59.3 cm.). Signed lower left: Millet.
Cherbourg, Musée Thomas Henry.
Provenance. Ono Collection, St. Malô. Gift to the Museum in 1915.

Among the early portraits of Jean François Millet (ca. 1842), this representation of Madame Roumy, the grandmother of Pauline Ono (his first wife) displays the strongest Realist qualities.[1] Millet sympathetically posed the old woman in a three-quarter position, allowing her facial characteristics—her sunken lips, deep-set eyes, bulging forehead, and shrunken features—to underscore her advanced age.[2] This is one of the most observant of Millet's early portraits, for he has also captured her mood of resignation and her vacant stare. The dramatic lighting of Madame Roumy's face and hands offset by her dark, simple clothing demonstrates Millet's ability to convey the character of his sitter.

1. Several years before (1836), Millet did a front-view drawing of Madame Roumy, but the present location of this work in unknown. See L. Lepoittevin, *Jean François Millet portraitiste* (Paris, 1971), cat. no. 2.
2. There is the possibility that Madame Roumy suffered from a disease that left her with these pronounced facial characteristics.

Exhibited

1887, Paris, Ecole des Beaux-Arts: Exposition J. F. Millet.
1949, Paris, Galerie Charpentier: Cent Portraits de femmes.

1964, Cherbourg, Musée Thomas Henry: J. F. Millet, no. 31.
1964/65, Paris, Musée Jacquemart André, no. 6.
1975, Cherbourg, Musée Thomas Henry: Jean François Millet et le thème du paysan dans la peinture française du XIXe siècle, no. 2.

Published

Etienne Moreau-Nélaton, *Millet, raconté par lui-même*, 3 vols. (Paris: Henri Laurens, 1921), 1: 45, fig. 19.
Léandre Vaillat, "Vingt Toiles de Millet dans un grenier," *L'Illustration*, 11 March 1922.
Lepoittevin, *Jean François Millet portraitiste*, no. 60 repr.
Paul Vergne, "J. F. Millet au Musée National des Beaux-Arts d'Alger," *Etudes d'Art* 6 (1951): 113-24.
J. M. Gaudillot, "Un Aspect peu connu de Millet," *Art de Basse-Normandie* v (1957): 33-35.
Lucien Lepoittevin, "J. F. Millet, mythe et réalité," *L'Oeil,* November 1964, repr. Idem, "Le Cotentin et ses artistes," *La Presqu'île du Cotentin* (Saint-Lô, 1968), repr. p. 101.

François Bonvin

134 *Self-Portrait*

Oil on canvas, 25-3/4 x 21-1/2 inches (65.4 x 54.6 cm.).
Signed and dated lower right: F. Bonvin/1847.
England, Co. Durham, Barnard Castle, The Bowes Museum.
Provenance. Laperlier sale, Hôtel Drouot, Paris, 11-13 April 1867. M. Lepautre. John and Josephine Bowes, purchased from M. Lepautre, 23 May 1872.

The first painting by François Bonvin that was accepted for Salon exhibition (1847) was a portrait, suggesting that many of his earliest works were actual presentations of people rather than genre scenes and still-life studies for which he later became well known. A *Self-Portrait* from this early period reveals a painting style that combined the Romantic tradition with particular qualities that Bonvin must have adopted from his friend Gustave Courbet. Bonvin had met Courbet during the 1840s, perhaps at one of the many gatherings in Paris which brought together private collectors, artists, and writers. Before Bonvin attempted his self-portrait, he is known to have sat for a portrait by Courbet.[1] Undoubtedly, during these sessions, Bonvin studied Courbet's methods and techniques, as well as a number of self-portraits by Courbet that had been accumulated in his studio. The same self-assuredness that Courbet conveyed in his own self-portraits is evident in Bonvin's work, too. The dramatic spotlighting of the head confers an intensity and fervor to his figure that typified Courbet's work and that all the young Realists would have aspired to achieve.

In 1849, in return for Bonvin's guidance in the acquisition of paintings by Chardin, Bonvin's friend and patron Laurent Laperlier purchased several of his still lifes, a series of his drawings, and this self-portrait.

The self-portrait is perhaps more a tribute to their friendship than an indication of their business association, for Laperlier kept the portrait until 1867, when he was forced to leave for Algeria because of his health. The art dealer Lepautre purchased the portrait at the Laperlier auction, and it was eventually secured by John and Josephine Bowes. By the time of the Bowes's purchase in 1872, Bonvin was a well-known artist—a factor which undoubtedly added to its value.

1. This painting was onced owned by Louison Köhler, who sold it in 1893. An old photograph, presumably of Courbet's portrait of Bonvin, is reproduced in Robert Fernier, *La Vie et l'oeuvre de Gustave Courbet*, 2 vols. (Lausanne-Paris: Bibliothèque des Arts—Fondation Wildenstein, 1977-78), 1, cat. no. 72; there is no reference to the location of the painting now.

Published

Gabriel P. Weisberg, *Bonvin: La Vie et l'oeuvre* (Paris: Editions Geoffroy-Dechaume, 1979), cat. no. 6.

Constant Troyon

135 *Portrait of a Young Man*

Oil on canvas, 18-3/4 x 15-1/4 inches (47.5 x 38.5 cm.). Signed with initials: C. T.
Cleveland, Collection of Mr. and Mrs. Noah L. Butkin.
Provenance. Sale, Nineteenth-Century European Paintings, Sotheby, Parke-Bernet, Inc., New York, 12 May 1978, no. 270.

When Constant Troyon found the weather too difficult to permit him to work directly from nature, he would spend time profitably doing studies of figures either from models in his studio or from sketches done in the fields. Troyon completed several large drawings in his studio of laborers plowing [54] or handling animals. But when it came time to use these studies in a finished painting, Troyon preferred to concentrate on animals or on the environment.[1] Therefore, Troyon's preliminary studies of field workers and portraits of young farmhands have never been examined. His fame rests solely on his landscapes and on his innumerable canvases of cows or sheep.

The small *Portrait of a Young Man* reflects the Romantic origins of the Barbizon painters. In emphasizing a momentary expression, a glance outward, Troyon suggests that he could complete studies of individuals from observation in a style that was both theatrical and realistic.[2]

1. For reference to this practice, see Philippe Burty, "Nouvelles du jour, Mort de Troyon," *La Presse,* 22 March 1865, and "Nouvelles du jour, Funérailles de Troyon," 23 March 1865. Troyon's work awaits systematic study. Little is known of his studies based on the human figure.
2. Nothing is known of the history of this particular painting or of the model's identity.

163

Jean-Jacques François Monanteuil

136 *Self-Portrait*
(Auto-Portrait)

Oil on canvas, 29 x 23-3/4 inches (73 x 59.5 cm.).
Le Mans, Musée des Beaux-Arts, Musée de
Tessé.

The title of professor at the Art School in
Alençon during the period between 1843 and
1851 provided Jean-Jacques François Mon-
anteuil and his family with some sense of
status. Because of his reputation as a stu-
dent of Girodet and because of the medals
he had been awarded at regional exhibitions,
he may well have been considered one of the
most famous citizens of the town. It is not
known how many private patrons Monan-
teuil attracted either in Alençon or later in
Le Mans, but it is certain that he would have
preferred instead to receive a curatorship at
the Caen museum. That position would have
allowed him more time for his own work as
well as permitted him to cultivate ties that
might have led to further commissions as a
portraitist working in oils.

In this *Self-Portrait,* Monanteuil has de-
picted himself both in good health and in
good spirits, suggesting that this canvas was
completed after he returned to Alençon but
prior to his move to Le Mans. The painting
may well be regarded as his official portrait,
since his image is that of a well-dressed
member of a middle-class community. Simi-
lar to his other portraits, he has brought his
image close to the viewer by eliminating
background space and by confining his study
to a three-quarter pose. His relaxed manner,
with one arm positioned across the back of a
chair and the formal posture of the other
hand, placed in his pocket, animates his
character and identifies him as a man of ac-
tion as well as meditation. His keen gaze,
heightened by small wire glasses, intensifies
the atmosphere and provides vigor to his
character.

Octave Tassaert

137 *Portrait of Alfred Bruyas*
(Portrait d'Alfred Bruyas)

Oil on canvas, 24-3/8 x 20-1/4 inches (61 x 51 cm.).
Signed and dated lower right: Oct. Tassaert/1852.
Montpellier, Musée Fabre.
Provenance. Alfred Bruyas Collection, 1868.
Given by Bruyas to the Museum, 1868.

Alfred Bruyas, born in Montpellier in 1821,
was the son of a wealthy local financier.
After a trip to Italy at the age of twenty-five,
he dedicated himself and his family fortune
to the defense and protection of the arts and
to patronage of specific artists. Several
painters flourished under his support, includ-
ing Gustave Courbet, who visited him at
Montpellier, and Octave Tassaert, who was
eventually cared for by Bruyas in Montpel-
lier when he was attempting to overcome al-

coholism. Bruyas himself was a frail, hyper-
sensitive individual suffering from tuber-
culosis and, more than that, a peculiar
hypochondria which actually enhanced his
support of the arts. Bruyas was given to
periods of self-evaluation and introspection
that he was convinced were mirrored in his
facial features. He became obsessed with
the way in which painters saw him. During
his lifetime he commissioned thirty-four por-
traits by both notable and lesser known art-
ists. Courbet painted Bruyas four times. Oc-
tave Tassaert, Bruyas's favorite artist, re-
corded his patron's face six times, including
one canvas showing Tassaert and Bruyas
conversing in Tassaert's own study amid
other canvases by the artist.[1]

Bruyas's support of Tassaert came at an
opportune time in the artist's career, for dur-
ing the 1850s, despite a major success at the
1850/51 Salon, the painter encountered much
financial difficulty. Bruyas purchased a
number of Tassaert's canvases, and com-
missioned others, which he brought together
in his private art gallery in Montpellier.
Bruyas's collection included not only his
studies of himself (portraits by Alexandre
Cabanel, Glaize, Eugène Delacroix, Ricard,
and Thomas Couture), but a number of
paintings, drawings, and sculptures by dif-
ferent artists that were eventually presented
to the Musée Fabre in 1868. Bruyas's dona-
tions to this museum, including purchases
made after 1868, established a major art col-
lection in Montpellier that represented a
range of Romantic and Realist tendencies in
the nineteenth century.

Few of Tassaert's works are as elegant or
as noble as his *Portrait of Alfred Bruyas*. By
carefully capturing the sensitive features of
Bruyas, Tassaert revealed the introspective
qualities of his intense personality. The pen-
sive gaze and the decisive, raised hand dis-
close a capacity for observation Tassaert
seldom revealed, making this portrait one of
the most direct and realistic canvases in
Tassaert's oeuvre.

1. The portrait in Tassaert's study is dated 1853
and is found in the Musée Fabre collection. The
early 1850s marked a period of close friendship
between Tassaert and Courbet, possibly fostered
by the relationship both men had with Bruyas.

Published

Ernest Michel, *Galerie Bruyas,* Complément
 (Montpellier, 1878), p. 621, cat. no. 206.
Bernard Prost, *Catalogue de l'oeuvre de Tassaert*
 (Paris, 1886), p. 28, no. 114.
André Joubin, "Les Dix-sept Portraits d'Alfred
 Bruyas ou 'chacun sa vérité,' " *La Renaissance
 de l'Art Français* 9 (1926): 552.

Isidore Pils

138 *Self-Portrait*
(Auto-Portrait)

Water color, 13-3/4 x 10-1/2 inches (34.2 x 26.7
cm.). Signed and dated lower right: I. Pils, 23 oct
1853.
Paris, Musée Carnavalet.
Provenance. Given to Carnavalet in 1907 by
Madame Auguste Boulard.

Isidore Pils did his first water colors of
military themes in the early 1850s, when he
became increasingly interested in military
movement and began visiting Vincennes, the
large encampment near Paris where Napoleon
III reviewed his troops. Pils did water col-
ors whenever possible, capturing entire
scenes as well as individual figures. He re-
corded the passing movement in studies that
are a combination of accurate observation
and Romantic mood and color.

Pils often sketched at a portable table near
his subject, from which he completed
sketches that filled innumerable small al-
bums. As a Realist reporter, Pils's first
military themes were studies of uniforms
(1853 Salon), which he later developed into
images of military encampment (1857 Salon)
in preparation for his large-scale Salon com-
positions. Following in the tradition of his
father, who had also studied the military,
Pils became a welcome visitor in the military
camps where he may have completed his
own, keenly attentive *Self-Portrait.*

Léon Bonnat

139 *Portrait of Joseph Sarvy*
(Portrait de Joseph Sarvy)

Oil on canvas, mounted on wood, 10-1/4 x 5-1/2
inches (26 x 14 cm.). Signed lower right: L. B. 53.
Paris, Private Collection.
Provenance. Given by the artist to Dr. Barnetche,
Saint-Jean-de-Luz. Private Collection, Paris.

In 1846 Léon Bonnat moved with his family
to Spain, beginning formal studies in paint-
ing at Madrid's Academy of San Fernando
in 1847 under the history and portrait painter
José Madrazo and, subsequently, his son
Federico Madrazo. Bonnat's days were
spent helping his father in their bookstore,
but evenings were devoted to painting. Al-
though his first known painting was a self-
portrait in 1849 (Private Collection, Paris),
during the 1850s Bonnat painted portraits of
his own family almost exclusively. These
delicate, small-scale pictures are charac-
terized by their quiet mood and almost still-
life qualities.

Bonnat's maternal uncles, Joseph and
Charles Sarvy, must have influenced
Bonnat's choice of career. There is little
documentation concerning the Sarvy
family—mostly personal recollections. Of
Portuguese-Jewish origin, the Sarvys were
originally goldsmiths who immigrated to

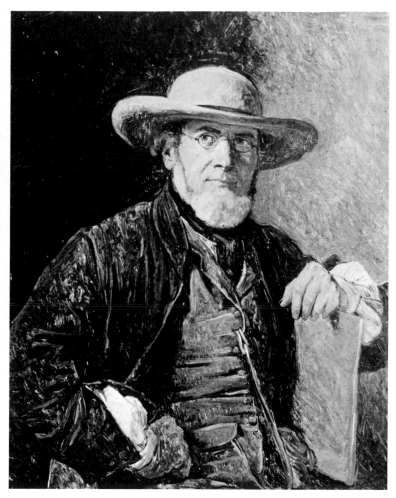

136

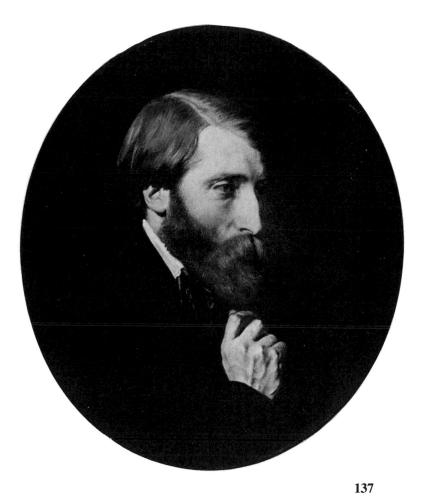

137

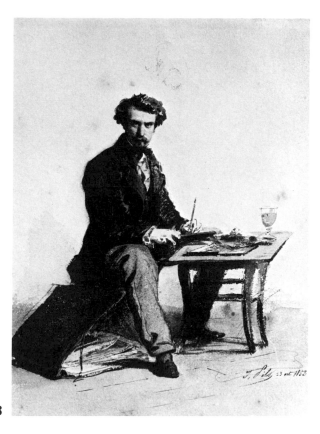

138

139

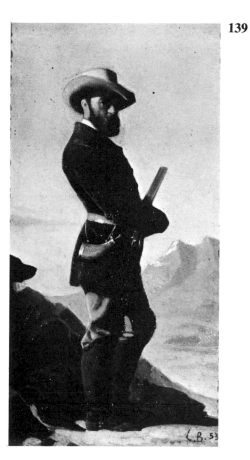

165

Bayonne during the eighteenth century. Bonnat's uncles had moved to Pamplona, the northern Basque city in Spain, by the time Bonnat and his family returned to Bayonne from Madrid. Both the Sarvy uncles appear to have been painters, although only Charles devoted constant time to painting. This is revealed by a wood screen of painted wild game—realistic studies of dark muted colors based on nature which they did in collaboration—and now in a private collection in France. Charles Sarvy painted predominantly landscapes, all of which are privately owned by families closely linked to Bonnat, and these are naturalistic, competent landscapes of subjects taken from life in the Basque provinces of France and Spain, and places recognizable even today. Bonnat, although he painted numerous and sympathetic portraits of his Uncle Charles in his painter's smock or at his easel during the 1850s, made only one known written reference to his Uncle Charles in a letter from Rome to his former teacher in Bayonne, Bernard-Romain Julien,[1] and then rather apologetically, for at the age of thirty-five, although then in Paris, Charles appeared to have had no success.

Portrait of Joseph Sarvy is the first of three variants (the others are located in the Musée Bonnat, Bayonne). Joseph Sarvy stands in profile dressed in full shooting regalia, arrogantly catching the spectator's eye, high above the backdrop of mountain scenery around Pamplona, and he is contained in his space by the two dogs at his feet. The clear, bright colors are unusual in Bonnat's oeuvre, whose palette is more usually composed of muted colors.

Greatly impressed by the Velázquez hunting portraits in his frequent visits to the Prado, Bonnat adapted some of their compositional devices, but in small scale. The figure set against mountain scenery, and the division of the picture plane into varying diagonals, as in Velázquez's portrait of *Prince Balthasar Carlos in Hunting Dress with Two Dogs* (1635/36, Prado), is an unsophisticated interpretation of a sitter naturalistically integrated in landscape. Federico Madrazo's similar and accomplished hunting portraits were also dependent on Velázquez's models.

Bonnat actually reworked many of his family portraits. His masterpiece of this group, the *Portrait of the Artist's Family* (1853, Musée Bonnat), was only achieved after awkward preliminary attempts at placing his own family in relation to each other.[2] In the other variants on the portrait of this uncle, Bonnat drops the background scenery and returns to his more usual technique for portraiture of placing his figure against a neutral brown background. The portrait variant of 1853, which was given by Bonnat to his museum, was also painted in Pamplona. The other portrait of his Uncle Joseph was painted in 1855, probably in Paris, and not

from life. It appears to be a somewhat-enlarged copy of the 1853 portrait in the Musée Bonnat. In his single, full-length portrait studies—Bonnat usually posed the figures alone without additional ornamentation—the lighting is generated by the tiny figures themselves. Again, the prototype for these portrait arrangements is Velázquez, as seen in his *Portrait of Pablillos de Vallodolid* (1630s). Bonnat's intimate portrait studies, however, in their quiet, detached mood, are in a world of their own —far removed from Velázquez's extrovert portraits. The two individual paintings of his brother Paul and his sister Marie (Musée Bonnat) are Bonnat's most enduring works in this genre. Their faces are impressionistically portrayed, and the still-life quality bears a resemblance to some of Whistler's abstract portrait studies before he turned away from ''ce damné réalisme,'' studies also strongly dependent on the Velázquez prototype.

Bonnat's origins are important for an understanding of the evolution of his artistic style. Bonnat was born into a talented, provincial family in modest circumstances. His father, during his childhood, bankrupted the family by numerous unsuccessful enterprises and, when he died in Madrid in 1853, he left his family impoverished. Returning to Bayonne, Bonnat's mother and sister Marie were taken on as companions by the women of the Détroyat family while Bonnat pursued his artistic studies. The pension awarded by the city of Bayonne enabled Bonnat to provide for his family in Paris, but when he decided to pursue further training in Rome, his family returned to Bayonne. Even in Rome, Bonnat kept only a small studio outside the Villa Medicis, for as a second-prize winner, he was not accorded the comfortable accommodation of the Villa. Public and financial success became all-important to Bonnat, for unlike some of the more avant-garde painters of his age—notably Manet and Degas—Bonnat had no private means and, because he evolved by the 1880s a successful formula for representing fashionable Parisian society, he rarely changed his format and slowly left behind the sensitive Realism of his youth.

It is in these paintings of Bonnat's youth that the strongest artistic similarities are to be found between the Realist painter François Bonvin and Bonnat. Bonnat must have met Bonvin in the 1860s in Paris, for the two painters appear to have been friends; a water color of a *Porc écorché* (Musée Bonnat) inscribed to Bonnat with the dedication ''à mon cher Bonnat, son reconnaissant f. Bonvin 1874'' indicates this. Bonvin's genre paintings—often of the simplest subjects—in their still concentration, muted colors, and domestic calm, parallel Bonnat's own family portrait that was actually painted well after Bonvin's style was formed. The two artists shared a common

spiritual bond of seventeenth-century genre painting. Unlike Bonvin, Bonnat successfully integrated himself into the Parisian artistic community based around the academy, but he nevertheless must have admired Bonvin's work, for in 1886 he contributed works to be sold to aid the older painter.[3] A.C.J.

1. Léon Bonnat to Bernard-Romain Julien, 14 October 1858, Bibliothèque Municipale de Bayonne.
2. Two small oil paintings leading up to the *Portrait of the Artist's Family* survive and are both in France, privately owned.
3. For Bonnat and Bonvin, see Weisberg, *Bonvin*, pp. 111, 136, 146.

Published

Achille Fouquier, *L. Bonnat: Première Partie de sa vie et de ses oeuvres.* (n.p., 1879).
L. Bonnat, ''Velasquez,'' *Gazette des Beaux-Arts* XIX (1898): 177-82.

Alphonse Legros

140 *Portrait of the Artist's Father (Portrait du père de l'artiste)*
Oil on canvas, 28-3/4 x 24 inches (73 x 61 cm.).
Signed and dated lower middle: 1856/A. Legros.
Tours, Musée des Beaux-Arts.
Provenance. Given by the artist to the museum in 1875.

Of the early paintings by Alphonse Legros, none combined so effectively his dependency on previous masters along with his study of an actual model than the *Portrait of the Artist's Father* (1857 Paris Salon). Like a number of young painters, when Legros was a student of Horace Lecoq de Boisbaudran (ca. 1854), he and his friend Fantin-Latour copied old master paintings in the Louvre from several traditions, including Rembrandt and Hans Holbein. Legros did drawings of some of these well-known paintings, following the dictates of his teacher by working from memory.[1] Following the arrangement of the original composition, Legros would then try to recapture the relationship between all parts of the figure and the placement of the form in space.

Portrait of the Artist's Father is a rephrasing of Holbein's small panel portrait of *Erasmus*. The Netherlandish format also appropriately conveys Legros's symbolic intention: keys, a sharpened pencil, a wax stamp, an inkwell, and a book provide a still-life arrangement that documents his parent's occupation as a clerk and an accountant. His clothing also suggests the Holbein portrait, although Legros's father is most likely wearing a dressing gown. The placement of his model in front of a sectional background is a traditional Netherlandish device; like an open window, which extended perspective and offered variety within an interior, Legros and other early

Realist painters during the 1850s and 1860s made use of framed paintings to provide spatial divisions in their compositions.

The compact composition and the somber lighting are in keeping with Legros's usual propensity for direct portrait observation, although the placement of the figure close to the frontal plane suggests that Legros also studied Courbet's early portraits. More than any of his other early paintings, this portrait typifies the tendencies of the Realists as portrait painters, because it conveys the personality of Legros's father at a serious, everyday task. Since Legros was a close companion of Jean Charles Cazin—also a student of Lecoq de Boisbaudran—it is not surprising that the painting was eventually presented to the Tours museum (1875) to commemorate the relationship between Cazin and Legros and to honor Cazin's term as curator of that museum.

1. For a description of Legros's study of the Holbein portrait see Léonce Bénédite, "Alphonse Legros," *Revue de l'Art Ancien et Moderne* VII (1900): 340.

Exhibited

1857, Paris: Salon, no. 1684.
1957, Dijon, Musée des Beaux-Arts: A. Legros peintre et graveur, no. 1, pl. 1.
1957, Vienna. Chefs d'oeuvre du Musée de Tours, no. 48.

Published

Catalogue du Salon de 1857 (Paris, 1857).
A. Poulet-Malassis, *M. A. Legros au Salon de 1875* (Paris-London, 1875), p. 6.
E. Fyot, "Le Portrait du père de A. Legros," *La Revue de Bourgogne* (Dijon, 1922), pp. 132-35.
Louis Decamps, "Exposition d'oeuvres d'art exécutées en noir et blanc," *L'Art,* 1876, pp. 199, 202.
Léonce Bénédite, "Alphonse Legros, painter and sculptor," *Studio* 29 (1903): 7-8.
Denys Sutton, "The Baudelaire Exhibition," *Apollo,* March 1969, pp. 177-78.

Adolphe-Félix Cals

141 *Portrait of Two Men Playing Cards*

Oil on canvas, 18-3/4 x 23-1/4 inches (47.7 x 59 cm.). Signed and dated upper left: Cals 1859.

Cleveland, Collection of Mr. and Mrs. Noah L. Butkin.

Provenance. Madengue Collection (inscribed on the back of the canvas). Delestre Gallery, Paris.

Adolphe-Félix Cals made the acquaintance of Pierre Firmin-Martin in 1848 when Martin first became an art dealer. Père Martin, as he was affectionately called by the painters and collectors who became his friends, rendered the same service for the Barbizon painters and the pre-Impressionists that Durand-Ruel was later to achieve for the Impressionists. He exhibited and purchased their work for his galleries, sold their canvases to collectors, and gave painters encouragement when they needed it most—at

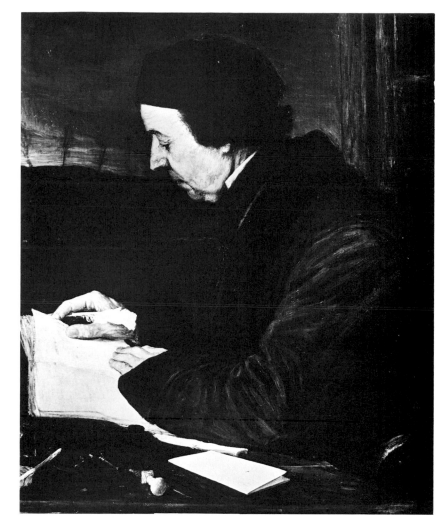

140

141

the beginning of their careers. According to the biographer Arsène Alexandre, Martin had not always envisioned himself as an art dealer. He started his career as an actor, performing at various Montmartre theaters. After that, he operated a saddle shop, which he converted into an art gallery about the time Cals first made his acquaintance. In these first galleries on the outskirts of Paris and then on the rue Mogador, Martin interspersed paintings with saddle equipment and accessories, but it was not long before Martin became a full-time art dealer. Later, he relocated his gallery on the more fashionable rue Laffitte.

Père Martin's role as a patron of independent tendencies in the art world was not unlike that of other art dealers such as Alfred Cadart in the 1860s or Père Tanguy in the 1870s. By encouraging and supporting such painters as Jean François Millet, Camille Corot, Théodore Rousseau, Johann Jongkind, Eugène Boudin, and Adolphe-Félix Cals, Père Martin aided progressive tendencies in landscape and genre painting. Later, he championed Théodule Ribot, Alfred Sisley, Victor Vignon, and Stanislas Lépine. Martin did more than exhibit their works. He welcomed the artists themselves, and his gallery became a refuge where artists were free to talk with one another, mingle with patrons and private collectors, or simply relax over a game of cards. Martin's group eventually became known as *le cercle Mogador* since the gatherings took place in the gallery itself.

Among the connoisseurs who came to his shop were Count Armand Doria, the Rouarts, Fernand Hazard, Jean Dollfus, Gustave Arosa, as well as many other ardent admirers of new tendencies and more progressive trends in art. Interestingly enough, though, Martin never overpriced his canvases, selling them for as little as forty and never more than three hundred francs, thereby encouraging sales and strengthening an appreciation for even those painters whose careers were not yet fully established. The support Martin bestowed assured a painter not only of contact with wealthy patrons, but of individual care and concern that sprang from Martin's genuine affection for his consignors. For example, it was Martin who entrusted Cals with the task and provided the funds for him to rescue the ailing and destitute Jongkind from his disastrous interval in Holland (1855-1860).

It was also through Père Martin that Cals met Count Doria, an individual who became a purchaser of Cals's canvases several years before actually meeting him at Martin's shop. In recognition of Cals's talent, Count Doria invited the painter to live at his Château d'Orrouy, thus providing the financial encouragement and incentive that Cals needed to continue painting during the 1860s.

Like other Realists, Cals derived his images from friends and family. *The Card Players,* which shows two men seated at a small table playing cards by lamplight, is undoubtedly set within the rue Mogador gallery, for the rear wall is crowded with framed compositions. The canvas is dated 1859, the same year Cals met Doria, suggesting that Cals painted this work not simply to portray two artists inside an art gallery, but perhaps to commemorate the relationship between Père Martin and Count Doria. The figure at the left has long been assumed to be Martin, while the familiar posture of the gentleman on the right may well be the count himself, who frequented Martin's gallery to talk, relax, and buy canvases.

Aside from the personal connotations, this portrait is important for other reasons. The Realists during this period were becoming increasingly interested in artificial and natural light, and practiced the methods of previous masters to convey a modulated light intensity. Similarly, in *The Card Players,* in a manner recalling Northern baroque sources (e.g., Honthorst or Rembrandt), Cals has relied upon internal illumination as his single light source. The theme of the cardplayers was known to other Realists (e.g., Bonvin)—having originated in Dutch seventeenth-century paintings—and was probably inspired by Cals's study of old masters in the Louvre collection. By posing his friends in the guise of a familiar theme, Cals was making use of traditional sources in a new way, continuing a theme that was to be significant late in the century in the work of Paul Cézanne.

Charles-Emile Carolus-Duran

142 *The Convalescent*
(Le Convalescent)
Oil on canvas, 39 x 49-5/8 inches (99 x 126 cm.), ca. 1860. Signed lower right: Carolus-Duran.
Grenoble, Musée de Peinture et de Sculpture.
Provenance. Paris, Luxembourg Museum. Transferred by the government to Grenoble, 1933.

The Convalescent is probably one of the fragments remaining from what was titled *The Visit to the Convalescent* when it was exhibited in Lille in 1860. The canvas was highly regarded by local art critics who, despite controversy among some of the jury members, awarded Charles-Emile Carolus-Duran a first-place prize that entitled him to study in Rome.

The date when Carolus-Duran's canvas was destroyed or the reason he saved only two fragments of the composition are not known.[1] It is assumed that the portion now titled *The Convalescent* is a self-portrait of the painter in his own studio during the late 1850s (ca. 1858), when he was in dire financial and physical straits. Only through the generosity and support of his friend, the art critic Zacharie Astruc, did Carolus-Duran regain his health and continue his career.[2]

Carolus-Duran was encouraged in his Realist inclinations not only by his friendship with Astruc but with such painters as Fantin-Latour and Alphonse Legros as well. He is known to have seen Courbet's 1855 exhibition, and the similarity of the sleeping, introspective pose here suggests that he may have studied Courbet's *Wounded Man*.[3] The brilliant red of the sick man's shirt and the vigorous application of the paint also indicate an attentive assimilation of Courbet's methods. The figure propped against the pillow with quiet anguish evident in his features is placed in the frontal plane close to the viewer. The water containers, the book within easy reach, and the glimpse of the unfinished canvas on the easel to the right impart an unaffected directness that suggests the personal nature of this segment of the original canvas.

1. There is no record of the compositional format or arrangement of *The Visit to the Convalescent*. The two fragments that were saved by Carolus-Duran include this section of the sickly artist and a study of a small dog. See Arsène Alexandre, "Artistes contemporains—Carolus-Duran," *La Revue de l'Art Ancien et Moderne* XIV (1903): 192, reproduced as *The Sleeping Man* (Lille museum). Alexandre discussed the Grenoble painting in this text, but mistakenly used a photograph of *The Sleeping Man* from Lille as a reproduction.

2. See Jules Claretie, "Carolus-Duran," in *Peintres et sculpteurs contemporains,* 2 vols. (Paris: Librairie des Bibliophiles, 1884), 2:156-59. Astruc brought Carolus-Duran into his own home where he was cared for by a neighboring student of medicine.

The relationship between Astruc and Carolus-Duran is worth examining further. They had been friends since their student days in Lille. Astruc undoubtedly encouraged Carolus-Duran's Realist inclinations and may have been a catalyst in urging him to go to Spain to visit the museums and study the Spanish masters. Astruc made a trip to Spain in 1864, and his interest in the Spanish masters at an early date infused his own writings and his discussions with such painters as Edouard Manet and Carolus-Duran. See Sharon Flescher, *Zacharie Astruc: Critic, Artist and Japoniste* (New York: Garland Publishing, 1978), pp. 95 ff. Astruc's regard for Carolus-Duran's paintings is noted as early as 1859 (see Flescher, p. 284).

3. See *Gustave Courbet (1819-1877),* exh. cat., Grand Palais, 30 September 1977—2 January 1978 (Paris: Editions des Musées Nationaux, 1977), fig. 35.

Published
Catalogue, Paris, Luxembourg Museum (1924), repr. p. 5.
Geneviève Lacambre, entry on *The Sleeping Man* in *The Second Empire: Art in France under Napoleon III* (Philadelphia Museum of Art, 1978), p. 266, no. VI-19.

Antoine Vollon

143 *Portrait of a Man*
Oil on canvas, 9-5/8 x 7-1/2 inches (24.6 x 19 cm.).
Signed lower right: A. Vollon.
U.S.A., Private Collection.

When he arrived in Paris in 1859, Antoine Vollon made friends with several Realist painters, including François Bonvin and Théodule Ribot. It is not known if Vollon tried to submit paintings to the 1859 Salon, but it is likely that he visited the exhibit held in Bonvin's studio (called at that time the *atelier flamand),* where canvases of such artists as Whistler, Fantin-Latour, Alphonse Legros, and Ribot that had been rejected by the 1859 Salon jury were exhibited. Several writers of the time suggest that it was Ribot who urged Vollon to study old masters, but there is no record that Vollon ever studied with Ribot and no definitive information as to the extent of his influence. Nonetheless, Vollon did turn to the old masters, including the Dutch and Spanish painters of the seventeenth century—artists that Ribot considered important.

Although the wooden palette in the foreground of *Portrait of a Man* indicates that Vollon's intention was to portray a traditional view of an artist at work, the influence of the Realists is discernible in the muted environment in which only the face is illuminated. The somber color tones and the similarity to Dutch portrait painting reveal that Vollon's earliest style was not unlike that of his Realist friends and the sources they studied.

The identity of the young man has not been determined with certainty. A self-portrait (Musée du Louvre) that Vollon completed somewhat later reveals provocative similarities. There is no proof, however, that this early study of an artist is Vollon himself. The painting may indeed be the very same *Portrait of M. S.* that was shown at the Salon des Refusés[1] in 1863 when Vollon was mourning the loss of his close friend and fellow artist Joseph-Paul-Marius Soumy (1831-1863). Soumy had supported Vollon's early painting efforts, and his suicide after contracting an eye disease moved Vollon to paint a commemorative portrait—now lost —of his colleague. Only further research on the provenance of this canvas will establish the true identity of the attentive sitter.

1. Vollon exhibited three canvases at the Salon des Refusés: *Amazone,* no. 590; *Portrait de M. S.,* no. 591; and *Paysage (Charenton),* no. 592. For further information see *Catalogue des ouvrages de peinture, sculpture, gravure, lithographie et architecture, refusés par le jury de 1863 et exposés, par décision de S. M. l'Empereur au Salon annexe,* Palais des Champs-Elysées, le 15 mai, 1863 (Paris, 1863).

Published

Gabriel P. Weisberg, "A Still Life by Antoine Vollon, Painter of Two Traditions," *Bulletin of The Detroit Institute of Arts* LVI (1978): 223, repr. p. 224, fig. 2.

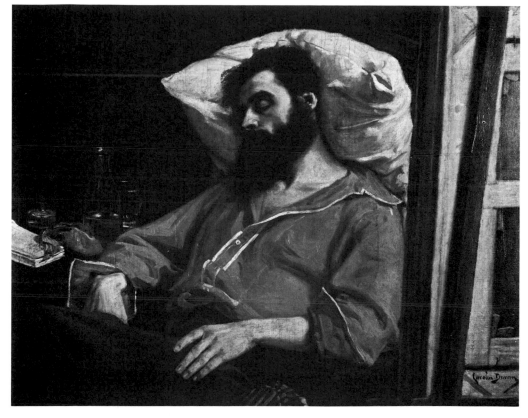

142

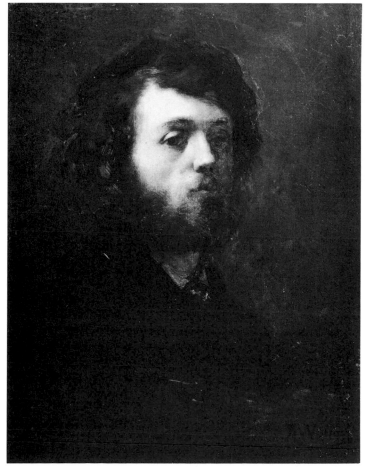

143

Léon Bonvin

144 *Portrait of His Father*
(Portrait du père de l'artiste)
Charcoal drawing, 8-5/8 x 6-11/16 inches (22 x 17 cm.). Signed lower right: L. Bonvin.
Paris, Louvre, Cabinet des Dessins.

Léon Bonvin began his career as an artist by drawing a series of charcoal studies of his surroundings near Vaugirard. These sketches depicted the interior of the family inn, arrangements of still-life objects on a counter, exterior stone walls, or the inn itself isolated against a barren landscape. They are bleak and melancholy expressions that impart the bereft environment that was Léon's existence. Occasionally, Léon did studies of household pets (the family cat or dog) warming themselves behind a stove or waiting in the sunlight for the return of their master. Most of these little studies are signed and dated 1855 or 1856, and they reflect Léon's earliest attempts to record what he saw. They are often primitively executed, awkward in their handling of perspective, unsure in their modeling of forms—suggesting the trial-and-error attempts of an artist learning on his own. Whether Léon was ever assisted by his half brother François is unknown; these early efforts, however, give little indication of his later achievement as a draftsman and watercolorist.[1]

In contrast to these undeveloped sketches, Léon Bonvin's *Portrait of His Father* displays an increased assuredness and a heightened awareness of recording visual truth, a significant aspect of early Realism. Léon depicted his father during a moment of repose, his head lowered. But the pose is not submissive. His position in the family, his strength, is shown by the subtle gradations of dark and light, an indication that Léon's understanding of his subject was not hindered by any lack of formal training. This moving, accurate study is the only known portrait in Léon Bonvin's oeuvre.

1. A series of Léon Bonvin's early charcoal studies, many of them small in size, are preserved in the Cabinet des Dessins, Louvre.

Published
Etienne Moreau-Nélaton, *Bonvin raconté par lui-même* (Paris: Henri Laurens, 1927), fig. 32.

Jules Breton

145 *Portrait of His Daughter Virginie*
(Portrait de sa fille Virginie)
Pencil drawing, 11-1/2 x 7-5/8 inches (29.2 x 19.4 cm.). Signed and dated lower right: J. Breton/25 février 1860. Inscription lower left: Virginie née le 26 juillet 1859.
France, Private Collection.

One of Jules Breton's favorite subjects was his daughter. A series of small vignettes that remain in the family collection—some of them studies made on succeeding days—suggest that, like a proud parent of any generation, Breton wanted to capture the moods, gestures, and personality of his daughter. These small sketches reveal Breton's sensitivity and spontaneity as a draftsman whose intention was to preserve his observations of this new family member. Breton's *Portrait of His Daughter Virginie* is inscribed with her date of birth, so that, when compared with the date the drawing was completed, Virginie's age could easily be recalled.

Jean-Jacques Henner

146 *Portait of the Sculptor Chapu*
(Portait du sculpteur Chapu)
Oil on canvas, 12-3/16 x 9-7/8 inches (31 x 25 cm.). Signed and dated lower left: J. Henner/Rome 1861. Inscription middle left: à mon ami Chapu.
Paris, Musée J. J. Henner.

Jean-Jacques Henner won the Prix de Rome in 1858 and spent the next few years (between 1859 and 1864) in Italy studying from the classical masters and developing a style that was to be heavily dependent on Romantic-Classical sources. While in Rome he also became acquainted with a number of other Prix de Rome winners, including the sculptor Henri Chapu (1833-1891). Henner spent considerable time with Chapu, impressed by the young sculptor's diligent determination to succeed and by his abiding love of nature. In 1861, when Chapu returned to Paris to continue his career (having stayed in Rome since 1855), Henner painted his *Portrait of the Sculptor Chapu*, a work that reveals the sturdy, provincial personality of this artist from the small village of Le Mée.

Using a method which was increasingly favored by the Realists in the 1860s, Henner sought to portray the personality of his subject by posing Chapu against a flat backdrop and directly illuminating his face. The bust-length oval format conveys a surprising frankness derived from actual observation that neither follows a preconceived formula nor idealizes Chapu's features. The study is formal, but Henner's sensitive awareness of light and personality convey latent Realist inclinations that would not become fully apparent in Chapu's own work until the 1870s.

For at the time of this portrait, Chapu still worked mostly in an allegorical format; only such sculptures as *Monument to Schneider* (1878), the *Galigniani Brothers* (1880), and *Le Verrier*[1] evince the straightforward manner of some Realist sculptors.[2]

1. The author is grateful for the assistance of Professor June Hargrove, Cleveland State University, in providing information on the career of Chapu and his relationship with J. J. Henner.
2. For further information on Realist sculpture in France, see *The Romantics to Rodin: French Nineteenth-Century Sculpture from North American Collections* (Los Angeles County Museum of Art in association with George Braziller, 1980), pp. 172-73.

Published
Musée J. J. Henner, cat., p. 11, no. 194.

Jean-Jacques Henner

147 *Portrait of Joseph Tournois,*
Son of the Sculptor
(Portrait de Joseph Tournois)
Oil on canvas, 18-1/4 x 15-1/8 inches (46 x 38 cm.). Signed and dated lower right: J. J. Henner/1864.
Paris, Musée J. J. Henner.

While a student in Rome, Henner became acquainted with Henri Chapu [146], Joseph Tournois (1830-1891), and other Prix-de-Rome winners. Tournois had been in Rome since 1857, but probably had already returned to Paris by the time Henner painted the portrait of Joseph Tournois, son of the sculptor, in 1864. The portrait may even have been commissioned by Tournois, but all that is known about the painting is that Henner cherished it, keeping it as part of his own collection throughout his career. After his death it was included among the paintings presented by his family to establish a museum in his honor.

Like many of his portraits, Henner posed his model against a flat, maroon background that silhouetted the young boy's facial features and, appropriately for a sculptor's son, simulated the cameo portrait of a sculptural frieze. The muted tones here—which typify many of the Realists' works—successfully capture the innocence of the child.

Even though Tournois's son was posed in a formal manner and studied in the studio, Henner's ability to grasp the personality of the child intimates a capacity as a portraitist that became less evident as Henner's career developed. Despite close association with Léon Bonnat and Edgar Degas, early indications of his interest in direct study of the model gave way to the prearranged placement of his figures in shallow space—a conventional manner derived from Italian and northern Renaissance prototypes.

Published
Musée J. J. Henner, cat., p. 18, no. 342.

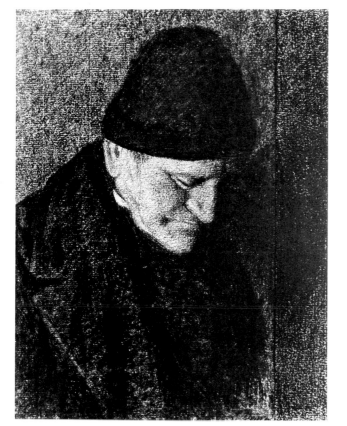

144

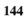 145

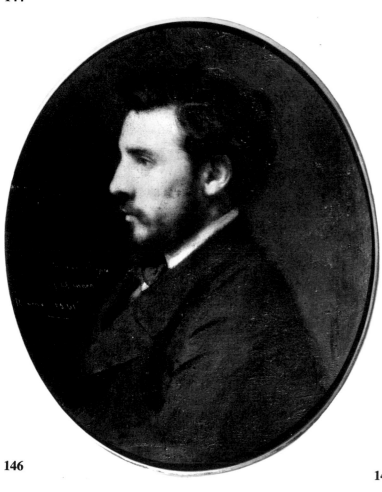

146

147

Edouard Manet

148 *The Reader*
(Le Liseur)

Oil on canvas, 38-1/2 x 31-1/2 inches (97.8 x 80 cm.). Signed lower left: Ed Manet.

The St. Louis Art Museum.

Provenance. Durand-Ruel, Paris, 1872. Jean-Baptiste Faure, Paris. Durand-Ruel, Paris, 1907. Durand-Ruel, New York, 1909. City Art Museum, Saint Louis, 1916.

Le Liseur (The Reader) is that familiar form of Realist hybrid, a genre figure that is at the same time a portrait of someone in the artist's circle. The model was Joseph Gall (1807-1888), a painter of historical subjects, landscapes, and animals, who exhibited at the Salon from 1842 until shortly before his death; his studio was on the rue Guyot, near the one Edouard Manet occupied in 1861, the year he painted this picture. *Le Liseur* is thus the earliest of a trio that includes *Le Fumeur* (1866), for which Gall served again, and *Le Bon Bock* (1873), for which the printmaker Emile Bellot posed.[1] Clearly it was the dignified, gray-haired, bearded appearance of his neighbor, rather than his reputation as an artist, that attracted Manet. He had already depicted similar types in the *Tête d'homme* (1856) and the portrait of his parents (1860), and he was to do so again, in a monumental form, in the central figure of *Le Vieux Musicien* (1862), using as a model the Parisian gypsy Jean Lagrène.[2]

In this interest in the strongly defined features and expressions of old men, the young Manet was like the young Rembrandt, who often chose aged beggars, gypsies, and scholars as his models. Among the pictorial sources of *Le Liseur* must, in fact, be counted Rembrandt's two pictures of scholars in the Louvre, deeply meditative figures in shadowy interiors before whom lie open large volumes.[3] Even closer in format and in the figure's posture and scale is the *Portrait of a Man Reading* (now at Williamstown), though whether Manet would have known one of the many versions is less certain.[4] In his etching of *Le Liseur* (a replica of the painting, also of 1861), the influence of Rembrandt's prints is equally apparent—not so much that of Jan Cornelis Sylvius, which has been mentioned as a source, but the *St. Paul in Meditation* and the *Portrait of Jan Uytenbogaert,* which are closer to Manet's print in composition.[5] He had already relied on a print that was then considered a portrait of Rembrandt's father as a model for the image of his own father in the double portrait of his parents and the etchings related to it.[6] In *Le Liseur* Joseph Gall, who was fifty-four at the time, is seen as an equally paternal figure, bearded, dignified, and wise, one who may indeed have represented for Manet an ideal father, since he was also an artist. In fact, the other probable source for *Le Liseur* in older art, Jacopo Tintoretto's *Self-Portrait,* which Manet had copied in the Louvre, is also an image of an artist as a gray-haired, half-length figure seen against a dark background; and the treatment of its bearded head, especially in Manet's copy, is very similar to that of Gall's head in *Le Liseur*.[7]

The "old master" aspect of *Le Liseur,* its evident debt to traditional portraits in composition and lighting, has long been recognized. But it is usually Velázquez, whom Manet did admire and copy in these years, who is mentioned rather than Rembrandt or Tintoretto, particularly with regard to the Spanish master's handling of paint.[8] Actually, Manet did not imitate the technique of any of these artists: a careful examination of the surface of *Le Liseur* reveals that the dark background was not developed from a previously toned canvas in the traditional manner, but rather was painted over a white ground—and the same was presumably true of the figure.[9] Already at this early date, then, Manet had abandoned the procedure advocated by his teacher Couture and, anticipating his own and the Impressionists' later practice, had painted directly on a white canvas. The final effect may be similar to that of an old master portrait, but the process was very different. And this suggests that what Manet sought in earlier works such as those of Rembrandt and Tintoretto was a specific pictorial quality, at

148

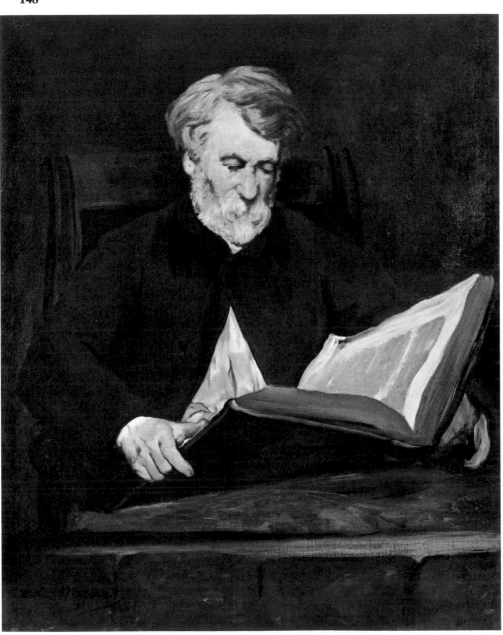

once stylistic and expressive, rather than a formula or recipe that he could follow easily.

Manet was not alone among the Realists around 1860 in seeking to imitate such specific effects in Rembrandt's genre paintings and prints. In its subject as well as its strongly contrasting light and dark, *Le Liseur* and, especially of course, the related etching belong to a group of works that include Whistler's *Reading by Lamplight* (1858), Seymour Haden's *A Lady Reading* (1858), and Ribot's *La Lecture à la lampe* (ca. 1863), all of which look back to prints such as Rembrandt's *Student at a Table by Candlelight*.[10] The Reader was, in fact, a common theme in Realist art, and pictures of solitary figures absorbed in this silent activity—some of them also influenced by Rembrandt—occur frequently in the work of Bonvin, Courbet, Daumier, and others in this school.

For Daumier, whose Realism is strongly tinged with Romantic sentiments, reading was a means of escape from the mundane world into that of the imagination, and Don Quixote, whom he represents poring over an ancient tome, was thus his ideal reader.[11] But Daumier also depicts anonymous, aged men reading aloud to each other or to children or silently to themselves, their postures and faces mirroring their utter absorption.[12] The same is true for Courbet, at least in his early years; his portrait of Baudelaire bent over the book he reads by candlelight in a garret and that of Marc Trapadoux hunched over the album of prints he examines in a studio are important examples.[13] Courbet's later *Liseuse d'Ornans,* lying half-dressed in a pleasant grove, seems more occupied with her sense of physical well being than with the small volume she holds.[14] Bonvin's readers, on the other hand, are generally humble people, domestic servants or lower-class workers, whom he shows in an earnest, unself-conscious attitude that ennobles them; usually elderly women or young servant girls, occasionally poor schoolchildren, they seem deeply aware of the value of reading both as a respite from their labors and as an avenue to education and culture.[15] Ribot, too, depicts elderly people of modest means reading intently to themselves; and like Manet he clearly draws on Rembrandt's pictures of such subjects for inspiration, working within a narrow range of black, white, gray, brown, and tan.[16] By contrast, Fantin-Latour's readers are distinctly middle class in dress and comportment; members of his immediate family, they read as virtuously and seriously as they embroider or draw or play the piano in his other domestic genre scenes.[17] Manet's *Liseur,* though it lacks any indication through costume or setting of the sitter's social status, belongs in the tradition of readers represented by Daumier, Bonvin, and Ribot, all of whom were also indebted to Rembrandt stylistically. Within Manet's own work, it belongs to a group of early genre subjects whose strongest affinities are, as already pointed out, with contemporary or slightly earlier Realist pictures of similar subjects.

When Manet took up the Reader theme again in 1879—the *Liseuse* of 1866 now attributed to him seems banal in composition, weak in expression, and rather dry in execution, and the feeble copy of his *Torero mort* in the background is more disconcerting than reassuring[18]—the result was very different. *La Lecture de "L'Illustré"* (Figure 148a) shows a well-dressed young woman in a café reading an illustrated magazine with a bland expression perfectly suited to its contents.[19] And both in this conception and in its broadly painted, brightly colored surface, it is closer to Renoir's pictures of attractive young women reading slim volumes or illustrated newspapers than it is to his own earlier version of the subject.[20] T. R.

1. Denis Rouart and Daniel Wildenstein, *Edouard Manet, Catalogue raisonné* (Lausanne: La Bibliothèque des Arts, 1975), nos. 112, 186. Anne Coffin Hanson, *Edouard Manet: 1832-1883* (Philadelphia Museum of Art, 1966), no. 81.

2. Rouart and Wildenstein, *Edouard Manet,* nos. 11, 30, 52. M. R. Brown, "Manet's *Old Musician:* Portrait of a Gypsy and Naturalist Allegory," *Studies in the History of Art* 8 (1978): 77-87.

3. A. Bredius, *Rembrandt: The Complete Edition of the Paintings,* rev. H. Gerson (London, 1969), no. 431; the other version, no longer attributed to Rembrandt, is mentioned on p. 588.

4. Ibid., no. 238; probably not by Rembrandt. See also the *Evangelist Matthew* in the Louvre, no. 614.

5. C. White and K. G. Boon, *Hollstein's Dutch and Flemish Etchings, Engravings, and Woodcuts* (Amsterdam, 1969), 19: 126, 230. J. C. Harris, *Edouard Manet Graphic Works* (New York, 1970), no. 13.

6. T. Reff, " 'Manet's Sources': A Critical Evaluation," *Artforum* 8 (September 1969): 42.

7. Rouart and Wildenstein, *Edouard Manet,* no. 6.

8. Julius Meier-Graefe, *Edouard Manet* (Munich: R. Piper, 1912), p. 69. E. Moreau-Nélaton, *Manet raconté par lui-même* (Paris, 1926), 1: 32-33.

9. Anne Coffin Hanson, *Manet and the Modern Tradition* (New Haven, Conn.: Yale University Press, 1977), pp. 159-60.

148a Edouard Manet, *La Lecture de "L'Illustré."*

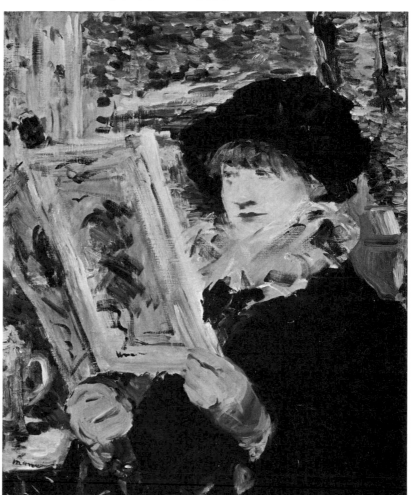

10. The Whistler and the Haden are illustrated in *From Realism to Symbolism: Whistler and His World* (New York: Wildenstein & Co., 1971), nos. 5, 75; the Ribot, in *Paris-New York, a Continuing Romance* (New York: Wildenstein & Co. 1977), no. 111; the Rembrandt, in White and Boon, *Hollstein's Dutch*, p. 125.

11. K. E. Maison, *Honoré Daumier: Catalogue Raisonné of the Paintings, Watercolors, and Drawings* (Greenwich, Conn., 1968), nos. I-124, I-193.

12. Ibid., nos. I-99 to I-102.

13. Fernier, *La Vie et l'oeuvre*, I, nos. 96, 98, 115. See also the portrait drawing of Francis Sabatier reading, ibid., II, no. 39.

14. Ibid., I, no. 287.

15. Weisberg, *Bonvin*, cat. nos. 5, 47, 48, 62, 93, 94, 233, 241, 242, 268, 271, 320, 324.

16. L. de Fourcaud, *Théodule Ribot* (Paris, 1885), p. 9. L. d'Argencourt and D. Druick, eds., *The Other Nineteenth Century* (Ottawa, 1978), no. 60.

17. Mme. Fantin-Latour, *Catalogue de l'oeuvre complet de Fantin-Latour* (Paris, 1911), nos. 42, 105, 112, 114, 166, 174, 215, etc.

18. Rouart and Wildenstein, *Edouard Manet*, no. 114. See Theodore Reff, review of Rouart and Wildenstein, *Art Bulletin* 58 (1976): 636.

19. Rouart and Wildenstein, *Edouard Manet*, no. 313.

20. F. Daulte, *Auguste Renoir: Catalogue raisonné de l'oeuvre peint* (Lausanne, 1971), I, nos. 106, 235, 300, 333.

Exhibited

1861, Paris, Galerie Martinet.
1863, Brussels: Exposition Générale des Beaux-Arts.
1867, Paris, Avenue de l'Alma: Manet, no. 27.
1872, London, 168 New Bond Street: Third Exhibition of the Society of French Artists, no. 72.
1873, Vienna: Exposition Universelle, no. 472.
1884, Paris, Ecole Nationale des Beaux-Arts: Exposition des oeuvres d'Edouard Manet, no. 28.
1889, Paris: Exposition Universelle, no. 497.
1906, Paris, Galerie Durand-Ruel: Exposition de 24 tableaux et aquarelles de Manet formant la collection Faure, no. 9.
1906, London, Sulley and Co.: Exhibition of Paintings and Water-Colours by Manet (Faure Collection), no. 8.
1908, London, The Art Palace: Franco-British Exhibition, no. 329.
1931, Saint Louis, City Art Museum: Loan Exhibition of French Painting: 1800-1880, no. 18.
1937, New York, Wildenstein: Edouard Manet, A Retrospective Loan Exhibition for the Benefit of the French Hospital and the Lisa Day Nursery, no. 4.
1944, Richmond, Virginia Museum of Fine Arts: XIXth-Century French Painting, no. 11.
1948, New York, Wildenstein: Loan Exhibition of Manet for the Benefit of the New York Infirmary, no. 9.
1958, New York, Wildenstein: Fifty Masterworks from the City Art Museum of Saint Louis, no. 41.
1958, Munich, Haus der Kunst: München 1869-1958, Aufbruch zur Modernen Kunst, no. 80.
1962, Baltimore Museum of Art: Manet, Degas, Berthe Morisot, and Mary Cassatt, no. 3.
1966, Philadelphia Museum of Art: Edouard Manet 1832-1883.
1967, Art Institute of Chicago: Edouard Manet 1832-1883, no. 22.
1968, Baltimore Museum of Art: From El Greco to Pollock: Early and Late Works by European and American Artists, no. 75.

Published

E. Spuller, "Edouard Manet et sa peinture," *Le Nain Jaune*, 6 June 1867.
Emile Zola, *Edouard Manet: Etude biographique et critique* (Paris: Dentu, 1867), p. 30.
Armand Silvestre, *Galerie Durand-Ruel*, vol. 1 (Paris: Maison Durand-Ruel, 1873), pl. 35.
Louis Gonse, "Manet," *Gazette des Beaux-Arts* 29 (1884): 133-52.
Josephin Péladan, "Le Procédé de Manet," *L'Artiste* 54 (1884): 106-8.
Théodore Duret, *Histoire d'Edouard Manet et de son oeuvre* (Paris: H. Floury, 1902).
H. Von Tschudi, *Edouard Manet* (Berlin: B. Cassirer, 1902), p. 67.
Camille Mauclair, *L'Impressionnisme: Son Histoire, son esthétique, ses maîtres* (Paris: Librairie de l'Art Ancien et Moderne, 1904), p. 57.
Etienne Moreau-Nélaton, *Manet: Graveur et lithographe* (Paris: L. Delteil, 1906), no. 57.
George Moore, "Erinnerungen an die Impressionisten," *Kunst und Künstler* 5 (January 1907): 153.
Meier-Graefe, *Edouard Manet*, p. 310, pl. 37.
Antonin Proust, *Edouard Manet: Souvenirs* (Paris: A. Barthélemy, H. Laurens, 1913).
John Quinn, "Modern Art from a Layman's Point of View," *Arts and Decoration* 3 (March 1913): 158.
Bulletin of the City Art Museum, St. Louis 1 (March 1916): 2-3.
Catalogue of Paintings (Saint Louis: City Art Museum of St. Louis, 1924), p. 101.
Léon Rosenthal, *Manet Aquafortiste* (Paris: Goupy, 1925), p. 268.
Moreau-Nélaton, *Manet raconté par lui-même*, I: 32-33, fig. 20.
Saint Louis: City Art Museum, *Masterpiece of the Week*, 8 November 1931, no. 7.
Paul Colin, *Edouard Manet* (Paris: Librairie Floury, 1932), p. 75, pl. 4.
Paul Jamot and Georges Wildenstein, *Manet*, vol. 1 (Paris: Beaux-Arts, 1932), no. 4.
Robert Rey, *Manet* (Paris: Hyperion Press, 1938), pl. 46.
Adolphe Tabarant, *La Vie artistique au temps de Baudelaire* (Paris: Mercure de France, 1942), pp. 367, 488.
Marcel Guérin, *L'Oeuvre gravé de Manet* (Paris: Floury, 1944), no. 18.
Adolphe Tabarant, *Manet et ses oeuvres* (Paris: Gallimard, 1947), pp. 44-45, no. 93.
Nils Gösta Sandblad, *Manet: Three Studies in Artistic Conception* (Lund: C. W. K. Gleerup, 1954), pp. 17, 27.
George Heard Hamilton, *Manet and His Critics* (New Haven, Conn.: Yale University Press, 1954), p. 28.
Sandra Orienti, *The Complete Paintings of Manet* (New York: Harry N. Abrams, 1967), no. 36.
Hanson, *Edouard Manet*, no. 22.
Melvin Waldfogel, "Manet's Smoker," *Minneapolis Institute of Arts Bulletin* 57 (1968): 17-18.
Jean C. Harris, *Edouard Manet Graphic Works, A Definitive Catalogue Raisonné* (New York: Collectors Editions, 1970), p. 55.
Rouart and Wildenstein, *Edouard Manet*, no. 35.

Edgar Degas

149 *Portrait of a Man*
(Portrait d'homme)

Oil on canvas, 33-1/16 x 25-3/8 inches (85 x 65 cm.), ca. 1866. Signed lower right: Degas [stamp]. New York, The Brooklyn Museum, Museum Collection Fund.

Provenance. Edgar Degas Atelier sale, Galerie Georges Petit, Paris, 6-8 May 1918, no. 36. Jacques Seligmann Collection of Degas sale, Plaza Hotel, New York, 27 January 1921, no. 35. Purchased by The Brooklyn Museum, 1921.

Nothing is known about the subject of *Portrait of a Man* other than what can be learned from the picture itself, and its heavily revised, yet unfinished state prevents us from learning very much. Nowhere else in Edgar Degas's portraiture does this man appear, though his melancholy expression, enhanced by a broad, deeply furrowed brow and wide-set, somber eyes, would be difficult to overlook. Nor does the setting shed light on his profession or interests. It is apparently an artist's studio, in which he has come to pose. Yet even this is uncertain, for the things around him are hard to identify and harder still to make sense of together in their sketchy, unfinished state. On the wall at the right—it once extended across the background before the white curtain was added—there is a large frame containing several small prints, such as might be found in a studio. On the floor at the left there seems to be a woman's hat like some of those in Degas's later pictures of milliners;[1] but this room is clearly not a milliner's shop and the hat is better understood as a painter's property. In the same way, the still life on the table—a platter of food and two almost transparent bottles—is more likely a subject for painting than a meal in a private dining room, despite the white tablecloth; for neither the framed group of prints nor the carelessly disposed hat suggest a restaurant. The white curtain was evidently added, without much regard for either the restaurant or the millinery shop, simply as a foil for the dark figure. It must be assumed, then, that the sitter was a friend of Degas's who shared his artistic interests and posed in his studio. But if his identity and profession are unknown, much is implied by his relation to the things around him and by his deliberately informal posture.

In the development of Degas's portraiture, it was only about 1866—when this picture was most likely painted—that setting and posture began to acquire this degree of realistic detail and expressive force. In the *Femme aux chrysanthèmes*, begun in 1858 as a floral still life and radically transformed in 1865 by the addition of a female figure, her tense, distracted mood is subtly evoked not only by her gesture but by the brilliant, almost overwhelming bouquet.[2] In the memorable image of Manet sprawling on a sofa with one leg drawn up, listening to his

wife play the piano, both his authority and his confident ease are conveyed,[3] whereas in portraying himself with De Valernes, an older colleague, Degas holds one hand timidly before his face and appears boxed in by the other man, whose crossed legs and arm akimbo suggest an almost haughty confidence.[4] Perhaps the most relevant of these contemporary portraits to this painting are those of the painter Victoria Dubourg, whose concentrated pose with hands folded in her lap resembles that of the unidentified sitter, and of the collector of prints who is shown surrounded by objects that speak in a similar way of his interest in art.[5]

This distinctive form of Realist portrait also emerged in the mid-1860s in the work of some of Degas's colleagues, for example, in Manet's images of the writers Zacharie Astruc (1866) and Zola (1867) and in Legros's image of Manet himself (1863), all of which reveal a comparable concern for the informally posed figure and fully described setting.[6] In prints and photographs, this concern appeared even earlier, perhaps because of their smaller scale and greater spontaneity of execution. In Whistler's etching *The Music Room* (1858), a scene of domestic comfort and contentment, his brother-in-law Seymour Haden is seen slumped down in his chair, his legs stretched out, holding his newspaper before him.[7] And in Disdéri's *carte-de-visite* photographs of about 1860, to which Degas alluded in a notebook sketch, people are often shown in unconventional attitudes, seated astride their chairs or turning away from the camera.[8] These features occur still closer to home in a small brown photograph, probably of a fellow artist, that Degas pasted into the same notebook about 1860.[9] Such images influenced his drawn and etched portraits of Manet a few years later, and these in turn prepared the way for his more ambitious painted portraits of the print collector, the artist James Tissot, and of course the *Portrait of a Man.*[10]

In Realist portraits of the decades before 1860, the background is generally a single plane or void with, at most, a few indications of an interior, and the sitter assumes a relatively formal pose in frontal or three-quarter view, largely filling the available space. Among examples in the Realist tradition are Bonvin's *Self-Portrait,* 1847 [134]; Gigoux's *Gabriel Laviron,* before 1849 [131]; Courbet's *Hector Berlioz,* 1850; Bonnat's *Charles Sarvy,* 1854; and Manet's Joseph Gall as *The Reader,* 1861 [148]. It is true that in Courbet's portraits of Baudelaire and Marc Trapadoux (both ca. 1849) the attic or studio setting is more fully described, if still somewhat shadowy, and the subject is seen unself-consciously absorbed in reading;[11] but such images are exceptional in their time. One important part of the later theory of modern portraiture was, in fact, formulated only in 1876, in Duranty's pamphlet *La Nouvelle Peinture:* "Since we embrace nature closely," he declared, "we will

no longer separate the personage from the apartment or street that forms the background."[12] The other part was first stated by Degas himself in a notebook about 1868-70: "Make portraits of people in familiar and typical attitudes, above all give to their faces the same type of expression that you give to their figures. Thus, if laughter is the characteristic of a person, show him laughing."[13] Or, he might have added, apropos the *Portrait of a Man,* if a brooding melancholy is his chief characteristic, show

him slumped sideways in his chair, wedged against a corner of the table, with legs outstretched and hands clasped between them; then add a baleful expression in his eyes and furrowed brow. T.R.

1. See especially P.-A. Lemoisne, *Degas et son oeuvre,* 2 vols. (Paris, 1946-49), I, nos. 681-683, 832.
2. Lemoisne, *Degas,* no. 125. See T. Reff, *Degas: The Artist's Mind* (New York, 1976), pp. 48-49, 62-65.
3. Lemoisne, *Degas,* no. 127.

149

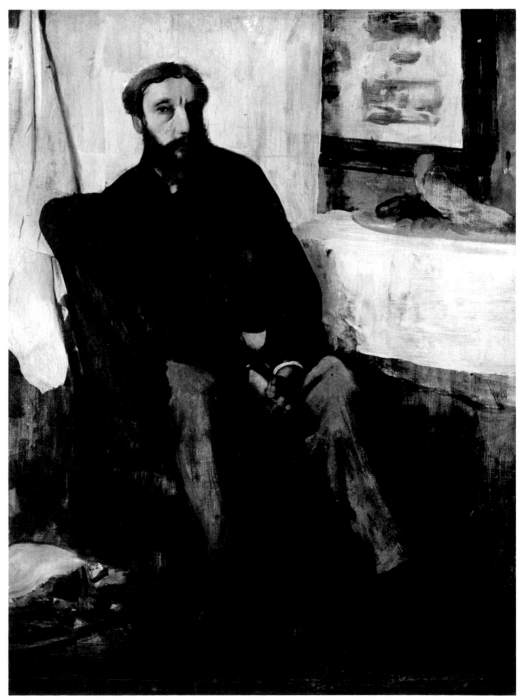

4. Lemoisne, *Degas*, no. 116. See J. S. Boggs, *Portraits by Degas* (Berkeley, 1963), pp. 18-19.

5. Lemoisne, *Degas*, nos. 137, 138. See Reff, *Degas*, pp. 98-101.

6. Rouart and Wildenstein, *Edouard Manet*, nos. 92 (wrongly dated 1864), 128. J.-P. Bouillon, "Manet vu par Bracquemond," *Revue de l'Art* 27 (1975): 37-38.

7. E. G. Kennedy, *The Etched Work of Whistler* (New York, 1910), no. 33.

8. B. Newhall, *The History of Photography* (New York, 1964), p. 53, several examples repr. T. Reff, *The Notebooks of Edgar Degas* (Oxford, 1976), Notebook 18, p. 31.

9. Ibid., Notebook 18, p. 104.

10. J. Adhémar and F. Cachin, *Degas: The Complete Etchings, Lithographs, and Monotypes* (London, 1974), nos. 18, 19 (wrongly dated ca. 1861).

11. Fernier, *La Vie et l'oeuvre*, nos. 96, 98, 115.

12. L. E. Duranty, *La Nouvelle Peinture*, ed. M. Guérin (Paris, 1946; 1st ed. 1876), p. 45.

13. Reff, *Notebooks*, Notebook 23, pp. 46-47.

Exhibited

1921, New York, The Brooklyn Museum: Paintings by Modern French Masters, no. 72.

1923, New York, The Brooklyn Museum: Paintings by Contemporary English and French Painters, no. 159.

1924, New York, The Brooklyn Museum: Loan Exhibition of Brooklyn Art Treasures and Original Drawings by American Artists, no. 90.

1934, New York, Marie Harriman Gallery: Degas, no. 12.

1936, Iowa City, University of Iowa: Masterpieces of Figure Composition.

1940, San Francisco, Palace of Fine Art: Golden Gate International Exposition: Art, no. 260.

1945, New York, The Brooklyn Museum: European Paintings from the Museum Collection.

1947, CMA: Work by Edgar Degas—Loan Exhibition, no. 6.

1949, New York, Wildenstein: A Loan Exhibition of Degas, no. 11.

1950, Richmond, Virginia Museum of Fine Arts: Paintings by the Impressionists and Post-Impressionists.

1953, Vancouver Art Gallery: French Impressionists, no. 50.

1954, New Orleans, Isaac Delgade Museum of Fine Arts: Louisiana Purchase Sesquicentennial Commission Loan Exhibition, Masterpieces of French Art through Five Centuries, 1400-1900, no. 72.

1955/56, New York, The American Federation of Arts; Iowa, Des Moines Art Center; Lubbock, Texas Technological University; California, Art Center of La Jolla; Columbus (Ohio) Museum of Arts and Crafts: Picture of the Month.

1968, New York, The Brooklyn Museum: The Triumph of Realism, no. 6.

1970, New York, Wildenstein: One Hundred Years of Impressionism, A Tribute to Durand-Ruel for the Benefit of the New York University Art Collection, no. 4.

1978, New York, Acquavella Galleries, Inc.: Edgar Degas, 1834-1914, no. 5.

Published

Catalogue des tableaux, pastels et dessins par Edgar Degas et provenant de son atelier, vol. 1 (Paris: Galerie Georges Petit, 1918), p. 23, no. 36.

Lemoisne, *Degas et son oeuvre*, II, no. 145.

Hertha Wegener, "French Impressionist and Post-Impressionist Paintings in The Brooklyn Museum," *Brooklyn Museum Bulletin* 16 (Fall 1954): 7-8.

Mahonri Sharp Young, "The Delights of Collecting," *Apollo* 92 (July 1970): 64-68.

150

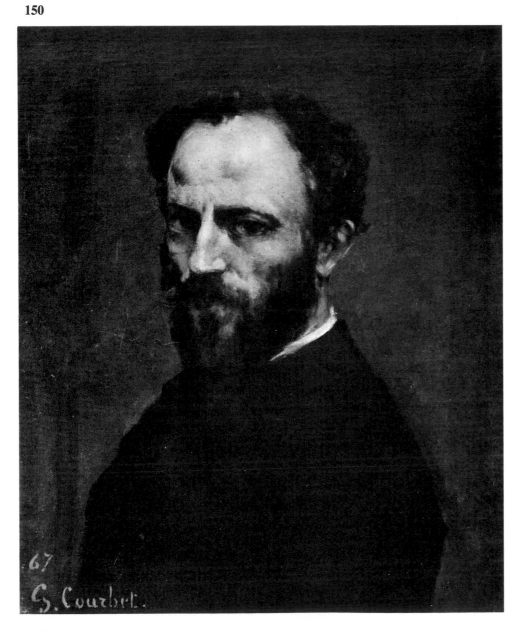

Gustave Courbet

150 *Portrait of Amand Gautier (Portrait d'Amand Gautier)*

Oil on canvas, 21-7/8 x 18-5/16 inches (55.5 x 46.5 cm.). Signed and dated lower left.

Lille, Musée des Beaux-Arts.

Provenance. Given to the Museum by Paul Gachet, 1952.

Gustave Courbet included twenty-five portraits in his private exhibition of about one hundred fifteen works that took place on the pont de l'Alma in 1867. The fine *Portrait of Amand Gautier* was the only new portrait he exhibited in this show, and it must have been finished just in time, since it was painted in Paris immediately before the opening of the exhibition.

The painter Gautier, born in Lille (1825-1894), was a friend and admirer of Courbet's, a member of the Brasserie Andler group, who shared Courbet's political convictions. Like Courbet, he participated in the political activities of the Commune and was a member of the Federation of Artists. He, too, suffered imprisonment after the fall of the left-wing regime. A painter of modest abilities, Gautier was dubbed "the painter of Sisters of Charity" because of his attachment to this theme. He also produced such

genre subjects as an *Ironer* [34], various landscapes, and several still lifes.

Courbet's image of Gautier is marked by certain defining qualities of simplicity, sympathy, and seriousness—even intensity—of approach that characterize a group of bust-length portraits created in the decade of the 1860s of fellow-artists and writers, especially those who shared his political and social outlook. This group includes the portrait of the *Sculptor Leboeuf* (1863, now in the Bührle Collection in Zurich); that of the *Chansonnier Pierre Dupont* (1868, Staatliche Kunsthalle, Karlsruhe); that of the "philosophical" painter from Lyon, *Paul Chenavard* (1869, Musée des Beaux-Arts, Lyon); and the intense and moving portrait of the radical novelist and journalist *Jules Vallés*, author of the major novel of the Commune, *L'Insurgé* (1861, Musée Carnavalet, Paris). L.N.

Exhibited
1867, Paris, Pavillon de l'Alma, no. 73.
1952, Besançon: Courbet, no. 39.
1954, Paris: Van Gogh et les peintres d'Auvers sur Oise, no. 26.
1955, Lille: Bicentenaire de l'Ecole des Beaux-Arts de Lille, no. 203.

Léon Bonnat

151 *Portrait of a Man*

Oil on canvas, 31-1/2 x 25-1/2 inches (80 x 65 cm.).
Signed top left: Ln Bonnat/1868.
Cleveland, Collection of Mr. and Mrs. Noah L. Butkin.

Provenance. Public auction, Paris. Seligmann Antiquités, Paris. Cyril Humphris, London, 1976.

In 1868 Léon Bonnat accompanied the ethnographic painter Jean-Léon Gérôme and others on a painting trip to the Middle East. He returned by way of Bayonne to undertake the commission of an altarpiece, the *Ascension of the Virgin* for the church of Saint André, and to visit his family. There is evidence that the *Portrait of a Man* and its companion piece, although their sitters have not yet been identified, were painted in Bayonne during this visit.

Bonnat often painted double portraits of husband and wife, and *the Portrait of a Man* and its companion illustrate the fusion of the two apparently dissimilar influences on Bonnat's painting: Spanish art and Rembrandt. The companion piece, *Portrait of a Woman* (Seligmann Antiquités, Paris, Figure 151a), is more subdued, its contrasts of light less emphatic than the *Portrait of a Man,* and in style it is perhaps closer to the Dutch than to the Spanish influence in Bonnat's painting. Bonnat had at this time become thoroughly familiar with Dutch painting from his studies in the Louvre, and particularly admired Rembrandt, on whose late *Self-Portrait at His Easel* (1660, Louvre)

151a Léon Bonnat, *Portrait of a Woman*, oil on canvas, 1868.

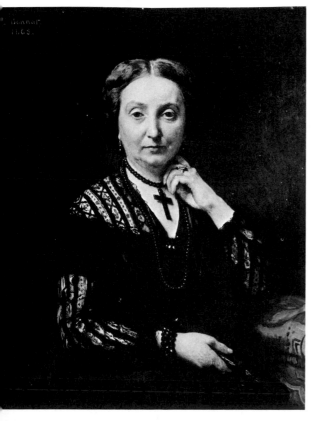

151

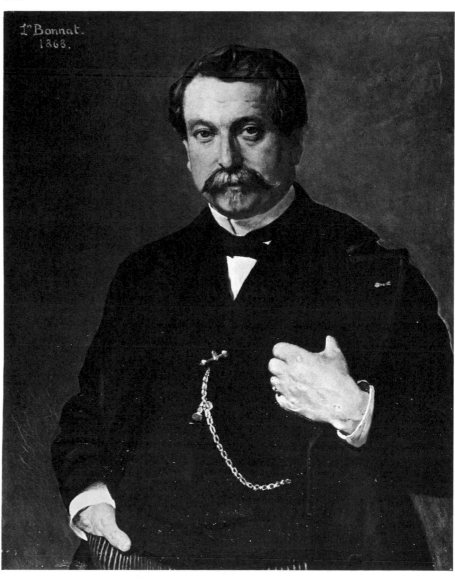

Bonnat clearly based his *Portrait of the Painter Joseph-Nicolas Robert-Fleury* (1865, Louvre). (Bonnat's respect for Rembrandt was to increase on his journey to Holland in 1872.) The portrait also bears comparison with his *Portrait of His Aunt Elisa* (1860s, Musée Bonnat).

In the *Portrait of a Woman,* Bonnat concentrates on the sitter's face, heavily building up the layers of paint to achieve an almost introspective expression. The sitter is dressed completely in black, the fashion of the Basque provinces, as though in mourning. Her dress is ornamented with lace, and she wears a heavy cross around her neck and holds a fan in her lap. The sitter could be the wife of a notable from Bayonne, close to the Spanish border. As in Bonnat's *Portrait of His Sister, Mme. Mélida* (1866, Musée Bonnat), who holds a sprig of lavender in her hands, the only touch of color here is a lavender ribbon near her fan. The heavily modeled features of the unknown subject of *Portrait of a Man,* the solid bourgeois prosperity of his conservative dress, and the ribbon of a Commander of the Légion d'honneur in his buttonhole all point to a local figure of considerable esteem. Bonnat had not yet won renown as the fashionable society portraitist he was later to become, and the majority of his known portraits of the 1860s are of other artists, his own family, and various friends. Could these Establishment figures, rare at this time in his work, be portraits of Jules Labat—the collector of Spanish painting and mayor of Bayonne who earlier had made possible Bonnat's scholarships to Paris and Rome—and his Spanish wife?

These more literally realistic portraits are typical of the stylistic evolution of Bonnat's work throughout the decade, a departure from the earlier, more naturalistic portraits that were strongly dependent on Velázquez. By the late 1860s, Bonnat, influenced also by Gérôme's realism, had evolved a style which was both realistic and sculptural—the sitters are compellingly solid—and these two portraits, painted almost life-size against warm but neutral backgrounds, are strongly modeled in the round. Bonnat's palette, too, has here intensified toward the darker tones and stronger chiaroscuro of seventeenth-century Spanish masters other than Velázquez, notably Ribera. In 1867 Bonnat expressed his admiration for Ribera by painting *Ribera Drawing at Rome* (1867, Musée Bonnat), and in later works he actually introduced figures from Ribera's paintings into his own work.[1] It was for this realism that Bonnat was sometimes rebuked by the critics and considered avant-garde.[2] The intensely Spanish *Portrait of His Sister, Mme. Mélida* and the Rembrandtesque *Portrait of Robert-Fleury* are Bonnat's other noteworthy portraits of this period.

In 1865 Bonnat opened his own *atelier indépendant* in Paris, where he stressed to his students, as did Manet, the value of simplicity in art. Compared with Manet's highly original portraits of this period—*Emile Zola* (1868, Louvre), *Théodore Duret* (1868, Petit Palais)—Bonnat's realism could be labeled of the *juste-milieu* school, a compromise between the avant-garde artists and academic painting. Bonnat's English pupil, Barclay Day, who described the purpose of Bonnat's teaching studio, reveals the philosophy behind Bonnat's realism: "The Atelier-Bonnat was started in 1865 with the wholesome purpose of studying nature as closely as possible, avoiding on the one hand the vagueness of the Impressionists, and on the other the conventionalism of the academical style of work, upon which the followers of Bonnat look with undisguised contempt."[3] Both Bonnat and Manet drew on seventeenth-century Spanish painting for inspiration, and Bonnat in the *Portrait of a Man*—in such details as the free, broad painting of the hands, shirt collar, and sleeves of the sitter—has used the loaded brush considered innovative in Manet's technique, and has omitted his usual, careful building up of depth by halftones. This is powerful and original painting by Bonnat, but the portrait as a whole differs strongly from Manet's more innovative painting. Although in their small-scale works—notably their flower pieces, and in some of the details of their portraits—Bonnat's painting resembles that of Manet, their general interpretation of Spanish painting was, in Manet's case, avant-garde, and, in Bonnat's, essentially conservative. Manet revivified Spanish painting with his own brilliant technique of almost total omission of halftones, but Bonnat adopted the values of his revered masters, retaining the use of strong chiaroscuro, heavy modeling, and academic drawing.

Manet's thorough modernization of Spanish art set him apart from his contemporaries, but also strongly influenced them. Bonnat's *Portrait of a Man* can also be closely allied to the work of other Realists of his age. Fantin-Latour and Carolus-Duran were influenced both by the work of Manet as well as by Spanish painting, and during the 1860s both their formal paintings and their more intimate portraits bear similarities to Bonnat's. Fantin-Latour's worldly *Portrait of Manet* (1867, Chicago Art Institute), which established his reputation as a leading portrait painter, and Carolus-Duran's own freely painted *Self-Portrait with Palette and Brushes* (1869, Sotheby's sale 1977) also have the physical intensity and objective realism of Bonnat's portrait. Of Bonnat's numerous American pupils, it was Thomas Eakins, who studied at his *atelier indépendant* in 1869, absorbing the Realist tradition of Bonnat's teaching, and who continued this vein of his master in the United States even more closely than Bonnat did himself. Bonnat's brother-in-law, the Spanish portrait painter Enrique Mélida had, like Bonnat, a successful career as a society portraitist, but his known work has none of

the powerful realism of Bonnat during this period.

Later in his career Bonnat, like so many French portrait painters of the age, reduced the number of sittings required by having his sitters photographed.[4] Although he often made preliminary oil sketches for his portraits which were remarkably free interpretations, practically no drawings for his portraits are known. He was said, however, to have used Velázquez's technique of drawing directly onto the canvas, a method which he most certainly later combined with the use of photography. The new medium of photography first affected portrait painting as early as the 1840s, and this directly representational style of portraiture was preferred by the public to Manet's highly personal interpretations of his sitters as more truthful in artistic expression. By the 1860s Bonnat was certainly familiar with the new medium of photography, for Gérôme, who advocated the use of photography in his realistic representations of an idealized world, brought along his own photographer to make accurate records on their Middle Eastern trip of 1868.[5] Many of these photographs were later used by Gérôme and Bonnat for their finished Orientalist paintings, completed much later and exhibited in the Salon well into the 1880s. Bonnat's lifelong friend from Bayonne, Antonin Personnaz, was a photographer as well as a superb collector.[6] Clearly, Bonnat kept in touch with experiments in photography. Photographs might well have been used by Bonnat in the initial stages of painting these portraits. The sitters, although placed in standard poses against neutral backgrounds—conventions commonly used by portrait painters who relied on photography—are strongly lifelike, sculptural, and freely painted. Bonnat's later, painstaking portraits, undoubtedly dependent on photographs, earned him the title *roi de la ressemblance* and were considered so real that Salon caricaturists depicted the sitters in his portraits stepping right out of their frames! *Portrait of a Man* from the oeuvre of Bonnat during the 1860s, however, places him closer to the more expressive and forceful painting of Carolus-Duran and Fantin-Latour, and to his own earlier and better paintings. A.C.J.

1. In his *Martyrdom of Saint Andrew* (1876, Musée Bonnat), Bonnat reused actual figures from Ribera's altarpieces.

2. *St. Vincent of Paul Taking the Place of a Galley Slave* (1865, St. Nicolas-des-Champs, Paris), Bonnat's first decorative commission, was generally considered controversial. See A. Personnaz, "Léon Bonnat," *Notice de la Société des Amis du Louvre* (Paris, n.p., 1923), for its realism and the critical reaction, pp. 18-19.

3. Barclay Day, "The Atelier-Bonnat," *Magazine of Art* V (1882): 138.

4. Bonnat's use of photographs for portrait sittings was recounted by his goddaughter. The ground floor of his own house in Paris, 48 rue Bassano, was a photographic studio.

Opposite
114 Eugène Boudin, *Still-Life with Lobster on a White Tablecloth* (detail).

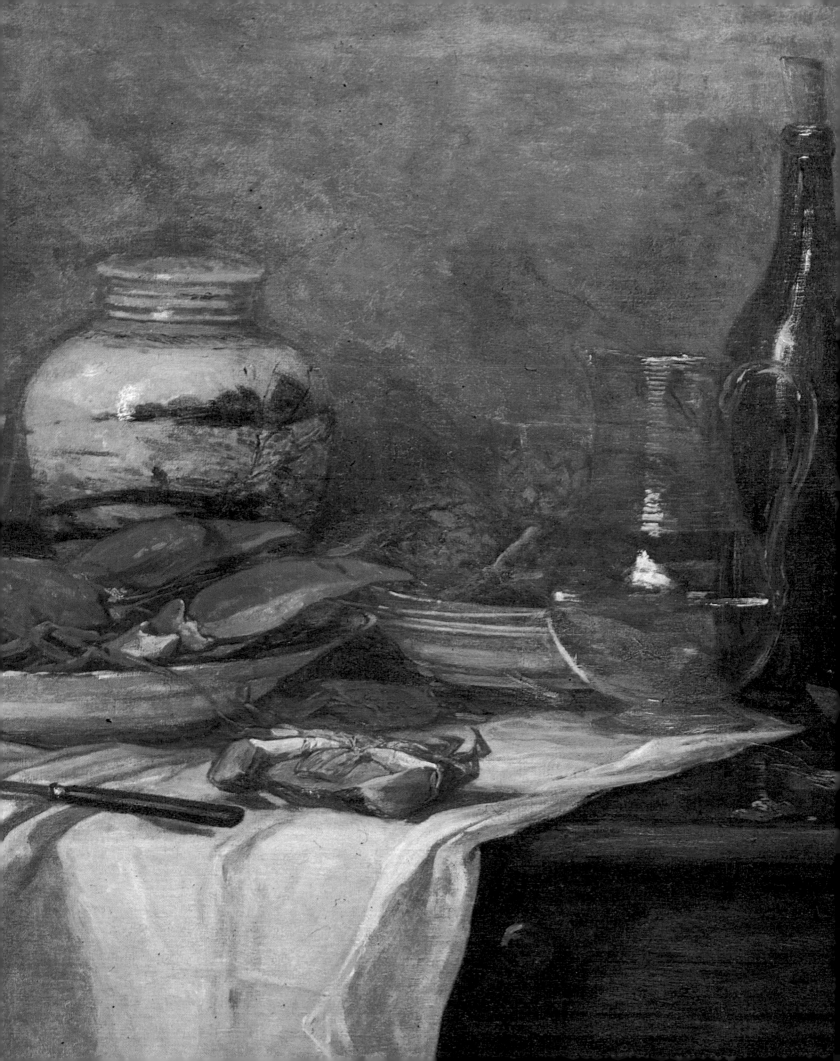

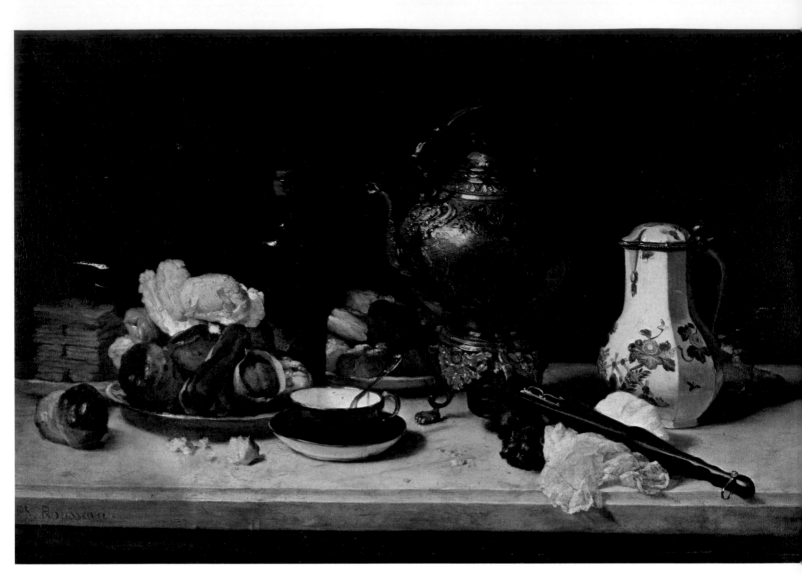

115 Philippe Rousseau, *Still-Life—Five O'clock.*

122 Antoine Vollon,
Still Life with Eggs.

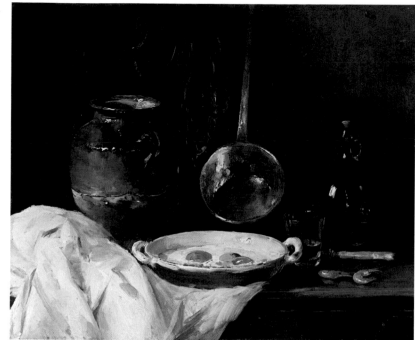

120 Théodule Ribot,
Still Life with Eggs.

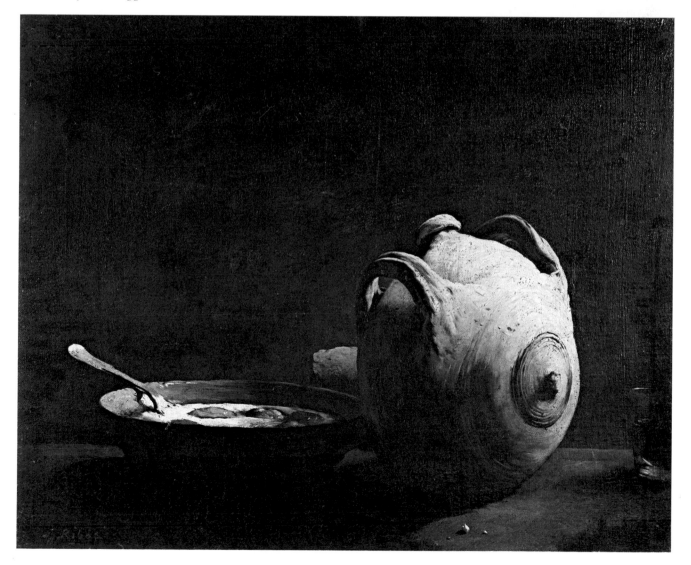

112 Théodule Ribot, *Corner of a Kitchen*.

127 Octave Tassaert, *A Corner of His Atelier.*

151 Léon Bonnat, *Portrait of a Man.*

Opposite
149 Edgar Degas, *Portrait of a Man.*

159 Léon Bonvin, *Street in Front of Léon Bonvin's House.*

5. Paul Lenoir, *Le Fayoum, le Sinai et Pétra, expédition dans la Moyenne Egypte et l'Arabie Petrée, sous la direction de J. L. Gérôme* (Paris: Editions Plon, 1872), recounts that the photographer Gautier Saint-Elme accompanied them.

6. Antonin Personnaz was a member of the Société Française de Photographie.

Léon Bonnat

152 *Portrait of Aimé Millet*
(*Portrait d'Aimé Millet*)

Oil on canvas, mounted on wood (?), 18-5/16 x 15-3/8 inches (46.5 x 39 cm.). Signed left-hand side: à Aimé Millet/Ln Bonnat/1869.
Musée de Lunéville.

Provenance. Willed by the artist to the Louvre. Now in Lunéville.

The sympathetic *Portrait of Aimé Millet,* the sculptor and occasional painter, is close to the intimate painting of Bonnat's youth. Little is known about the relationship of Bonnat to Aimé Millet. Born in 1817, the son of the Parisian miniaturist painter Frédéric Millet, Millet won a first-class medal in the Salon of 1857 with his mythological sculpture of *Ariane,* the same year Bonnat made his Salon début. A pupil of the classicizing sculptor David d'Angers, whose medallions Bonnat assiduously collected for his museum, Aimé Millet's career was devoted to sculpture rather than painting, and he received numerous portrait commissions, the most notable, his statues of George Sand, Edgar Quinet, and Châteaubriand. He also sculpted a large-scale group, *Apollon,* for Garnier's Opera. His *Jeunesse effeuillant des roses,* which ornaments the tomb of Henri Mürger, author of *La Vie de Bohème,* links him to the group of Montmartois, far removed from Bonnat and the prosperous academic community. Millet, however, was highly regarded in academic circles, made president of the Société Nationale des Beaux-Arts in 1866, served on most of the Salon juries from 1877 to 1889, and had, like Bonnat, a successful professional career.

Strongly differing from much of Bonnat's increasingly conventional portraiture in which his realism had evolved from the earlier naturalistic style to more robust, sculptural painting, this portrait bears a close affinity to Bonnat's paintings of his own uncle, the painter Charles Sarvy. Bonnat's paintings of his artist contemporaries are often his most sensitive. Here, the sitter looks out at the viewer from the shadows of the background, where on the left side of his face no divisions of line are made. The portrait is painted with a full and heavily loaded brush and with the bold highlighting more usual in Bonnat's portrait sketches than in his finished works. The technique recalls his use of the compositional sketch in his *atelier indépendant* and in his own work, an impressionistic method used to catch the essence

of a subject and transmitted to Bonnat from his academic teacher, Léon Cogniet.

During the 1860s and early 1870s, Bonnat worked in a wide variety of styles, varying from official portraits and highly academic large-scale paintings commissioned by the state to more intimate portraits, still lifes, and landscapes. This particular portrait recalls Bonnat's own teaching methods, methods practiced in academic studios in a limited fashion, which appear to be close to techniques advocated by the Impressionists. As Bonnat's American pupil E. H. Blashfield described it: "Instead of sitting or standing before his canvas with his model at a distance, he placed the latter close beside the canvas, and then went away from his subject to the very end of his studio. There dropping upon one knee to bring the point of sight to the proper level, and half-closing his eyes, he carefully compared model and picture, then going quickly to his easel, painted a few strokes, and repeated his journey."[1] This method of painting is completely different from Bonnat's more popular, formal portraiture which relied on an almost photographic technique, for here Bonnat is advocating the importance of an impressionistic view of his sitter, close to the transitory effects the Impressionists sought, although the results are, of course, widely different.

It is in this *Portrait of Aimé Millet,* strongly Romantic in mood, that Bonnat appears to be closest to the sober, but intensely Romantic self-portraits of his contemporary, Fantin-Latour. Both Bonnat and Fantin-Latour admired the Romanticism of Delacroix,[2] and Fantin-Latour painted a *Self-Portrait* (1860, Sonnenberg Collection, on loan, Baltimore Museum) very similar to Bonnat's later portrait of Aimé Millet, in which his own darkened face, painted with a

152

loaded brush and strong highlighting, disappears into the background. Another closely related *Self-Portrait*[3] by Fantin-Latour was rejected by the Salon, but exhibited in the first Exposition des Refusés of 1863, along with paintings by Manet and the Impressionists. The similarity of Bonnat's painting to Fantin-Latour's work reveals the complexity of Bonnat's vaguely termed style of "academic realism." Bonnat's *Portrait of Aimé Millet*, left to the state in his will, to be hung in the Louvre's gallery of famous artists, was highly regarded by his artist contemporaries, although such an intimate and Romantic portrayal of a sitter is unusual in Bonnat's later oeuvre. One other known, finished portrait of this decade by Bonnat truly bears comparison with this sensitive interpretation, and that is the portrait of the minor genre painter *Edmond Lebel* (Amiens). Bonnat's various oil sketches, many done in the Middle East, also attain similar freedom of artistic expression; these sketches, however, were never publicly exhibited.

Bonnat appeared to have few relations with the Impressionists, although his contemporaries Fantin-Latour and Carolus-Duran retained close links with the group. Carolus-Duran, the "modern Van Dyck," who had also an immensely successful career as a society portraitist, painted many portraits similar to those in Bonnat's more intimate vein as well as finished society paintings, and was aware of the Impressionists' work, notably the paintings of Bonnat's close friend Monet, whose portrait he painted in 1867 (Musée Marmottan). This portrait bears similarities to Bonnat's portrait of Millet. Carolus-Duran and Bonnat constantly crossed paths during their careers, and Bonnat kept a pen-sketch portrait of himself by Carolus-Duran as an *homme du monde* complete with top hat (Musée Bonnat). Bonnat's freer and unexhibited works are a special category of his oeuvre. They are similar only to paintings by Carolus-Duran and Fantin-Latour, of whom Courbet said, "This is no painting for a bourgeois."　A.C.J.

1. J. C. Van Dyke, ed., *Modern French Masters* (London: T. Fischer Unwin, 1896), p. 51.
2. Bonnat bought both drawings and paintings by Delacroix for his collection, and his admiration for the Romanticism of the sculptor Barye knew no bounds. See L. Bonnat, "Barye," *Gazette des Beaux-Arts* I (1889): 374-82.
3. Location now unknown.

Published

H. Dumesnil, *Souvenirs intimes, Aimé Millet* (Paris, 1891).

Auguste Feyen-Perrin

153 *The Anatomy Lesson of Doctor Velpeau*
(*La Leçon d'anatomie du Docteur Velpeau*)

Oil on canvas, 67 x 91-3/4 inches (170 x 233 cm.).
Signed middle bottom: A. Feyen-Perrin.
Tours, Musée des Beaux-Arts.
Provenance. Purchased by the state from the artist in 1879. Sent by the state to Tours in 1896.

Of the early paintings by Auguste Feyen-Perrin, *The Anatomy Lesson of Doctor Velpeau,* first exhibited at the 1864 Paris Salon, was the one work which epitomized his interest in Realist trends and his study of people. Léon Lagrange, writing in *Gazette des Beaux-Arts* in 1864, compared the painting with Fantin-Latour's *Hommage to Delacroix* (ca. 1863, Musée du Louvre) since both artists tried to accurately record personalities from their period. Lagrange also pointed out the similarity between this work and Rembrandt's *Anatomy Lesson of Dr. Tulp;* in both, the surgeons are beginning the study and dissection of a corpse in the presence of colleagues, friends, and hospital students. The review in *Gazette* also raised some questions about Feyen-Perrin's use of the two figures in the foreground: "Why was he forced to add two other figures to the foreground? One is an assistant in the amphitheatre, the other a student who holds a list of names on which is found the word Charité. . . ."[1] Lagrange was calling attention to an awkward placement of individuals in the foreground of the composition. Actually, the assistant, dressed in a blue hospital gown, has just pulled back the sheet and revealed the corpse, and the student establishes the exact location, la Charité, the hospital where Doctor Velpeau (1795-1867), the most famous surgeon then in Paris, performed surgery and held discussions for students and colleagues.

Each observer, from left to right, can be identified: Dr. H. Liouville, a colleague; Armand Silvestre, an art critic; and, at the far right, the artist. Like other Realist painters, notably Feyen-Perrin's friend Jules Breton, the artist included his own portrait to substantiate that he actually was present when Doctor Velpeau conducted this class.[2] Painted in somber, dark tones, the composition creates a serious, scholarly atmosphere as all eyes focus on Velpeau and the movement of his hands over the corpse. The solemnity of the composition and the directness of the lighting suggest a classical frieze as much as the heritage of Realism from seventeenth-century Northern painters.

The composition memorialized a category the Realists would use. When asked to paint similar scenes for the Sorbonne, Léon Lhermitte kept this painting in mind; similarly, after being shown at the Philadelphia Centennial Exhibition in 1876, this work in-

fluenced Thomas Eakins (who may have seen it in France before it was shown in Philadelphia) in developing *The Gross Clinic,* a composition of broader drama and scope.[3] Given the period when this painting was completed, its significance as a reminder of Realism cannot be overstated.

The history of the canvas's acquisition by the state requires some clarification since Feyen-Perrin kept the painting to himself after the 1864 Salon. While he wanted the state to purchase his work, and even requested that the government purchase a work after the 1878 Salon, he himself probably would not ever have suggested the purchase of this painting. Instead, he had his friend Ph. Jourde, manager of the newspaper *Le Siècle,* write to the under secretary of state. Jourde's letter urged that the state purchase the *Anatomy Lesson* since it rightfully belonged in either the Ecole de Médecine or la Charité. In December 1879, the state purchased the work for 6000 francs, but the painting was not exhibited until 1889 at the retrospective exhibition after the painter's death.[4]

1. Léon Lagrange, "Salon de 1864," *Gazette des Beaux-Arts* XVI (1864): 523.
2. Jules Breton and Feyen-Perrin were close friends since their training together in Drolling's studio in the late 1840s. Breton played an important role in organizing the retrospective exhibition following Feyen-Perrin's death. See Charles Frémine, "Feyen-Perrin à l'Ecole des Beaux-Arts," *Le Rappel,* 10 March 1889. Theodore Zeldin to the author, 10 April 1980, pointed out that Dr. Velpeau's lessons were published. In the painting, Dr. Velpeau looks eminently successful.
3. For further information see Elwood C. Parry, " 'The Gross Clinic' as Anatomy Lesson and Memorial Portrait," *Art Quarterly* 32 (1969): 373-91. Lhermitte was commissioned to begin his Sorbonne portrait series in 1886.
4. For further information see dossier on Feyen-Perrin, F 21/216, Archives Nationales.

Exhibited

1864, Paris: Salon, cat. no. 709
1876, Philadelphia: Universal Exhibition, cat. no. 123.
1936, Tours: Exposition rétrospective, "La Médecine en Tourraine à travers les siècles," cat. no. 263.

Published

Henri Marcel, *La Peinture française au 19e siècle* (Paris, 1905), p. 220.
Paul Vitry Catalogue (Paris, 1911), cat. no. 76, pl. 71.

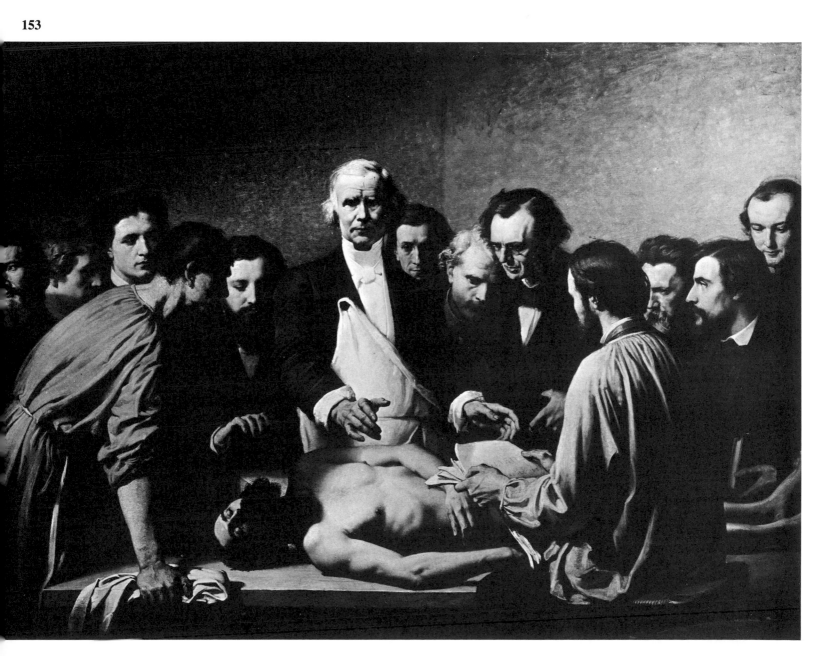

Landscapes

Critics and artists were often locked in bitter debate over the type of images that reflected social change. Landscape was not involved in the dispute until it became a favored subject for the Impressionists. By the mid-1860s, it was regarded as a form of art equal to other categories that had formerly been considered superior in the Salon hierarchy.[1] Writing in 1868, Castagnary could remark that landscapists had revolutionized the genre by removing it from abstract conceptualization to the realm of concrete, immediate, visual sensation.[2]

Landscapists often specialized in particular locales (Flers [154] and Philippe Rousseau [155] painted Normandy—Théodore Rousseau and others, Barbizon), and they became expert in depicting the light of that locale.[3] To be identified with a specific region became the goal of many of them, for it rooted them in the community and allowed them to merge their creative expression with pride in a region.[4]

Thoré identified innovative landscape painters as those who maintained a "naive feeling" for nature.[5] While this could mean dominance of personal responses over preconceived reactions, Thoré's intention was broader; he was actually beginning to formulate the technique that the forerunners of the Impressionists endorsed: to paint truthfully a painter had to remain receptive to what nature could reveal to him; he did this by registering his first impressions and thereby retaining his spontaneity. These qualities can be seen in the pictures by Léon Bonvin, who used water color to record breathtaking studies of atmosphere in countryside and village street [159]. Breton painted the garden at Courrières in a way that showed his awareness of the possibilities of light [162].[6] Both artists demonstrate the triumph of landscape at the hands of the Realist painters.

1. Joseph Sloane, *French Painting Between the Past and the Present: Artists, Critics and Traditions from 1848 to 1870* (Princeton University Press, 1951), p. 104.

2. Jules Antoine Castagnary, *Salons, 1857-1870* (Paris, 1892), p. 263.

3. Thoré had attacked earlier landscapists in the Ingres school because they painted the landscape only at dusk. See Théophile Thoré, *Le Salon de 1844, précédé d'une lettre à Théodore Rousseau* (Paris: Alliance des Arts et chez M. Masgana, Galerie de l'Odéon, 1844), p. 133. For a discussion of the new landscape, see Emile Bouvier, *La Bataille réaliste* (Paris: Fontmery and Cie, 1913), pp. 219-20.

4. Linda Nochlin noted that Gustave Courbet's painting of the great oak at Flagey revealed his historical ties to the region of the Franche-Comté. Paper read at a public lecture at Princeton University, October 1979.

5. Théophile Thoré, *Le Salon de 1845, précédé d'une lettre à Béranger* (Paris: Alliance des Arts et chez M. Masgana, Galerie de l'Odéon, 1845), p. 27.

6. Jules Breton completed a number of independent landscapes on a small, intimate scale. In this, he reflected the interests of other Realists with whom his early work should be compared. See Sloane, *French Painting*, pp. 142-43, for an opposing view of Breton's place in the movement.

Camille Flers

154 *Thatched-Roof Cottages at the Edge of a River with Laundresses*
Oil on canvas, 11-3/4 x 18 inches (29.8 x 45.7 cm.). Signed and dated lower right: Flers 1832 [or 1852].
Cleveland, Collection of Mr. and Mrs. Noah L. Butkin.
Provenance. Galerie Claude Marumo, Paris.

The development of scenes of the French countryside emerged as a popular theme among artists in the early decades of the nineteenth century, some years before the landscape studies Barbizon painters were to achieve. Those artists who did watercolor studies directly from nature as well as those who did small oil sketches out-of-doors created a veritable movement in landscape composition that became widespread in the 1830s.

Camille Flers was among the early landscapists who devoted themselves to a particular region. Flers remained associated with Normandy throughout his career. He often did preliminary compositions of trees and figures outdoors from which he then developed his final composition in his atelier. The soft light that is characteristic of his early landscapes, the grayed atmosphere, and the delicacy of his brushwork are apparent in the details of the foliage and the bank shown near the isolated pond in *Thatched-Roof Cottages at the Edge of a River with*

Laundresses. Such critics as Théophile Thoré commended the Romantic mood that he achieved by adapting direct observation to convey a harmonious environment.

Published
Barbizon au temps de J. F. Millet, 1849-1875 (Barbizon: La Municipalité, 1975), no. 178. Text by Guy Isnard.

Philippe Rousseau

155 *A Valley*
Oil on canvas, 31-7/8 x 39-1/8 inches (81 x 99.5 cm.). Signed lower left: Ph. Rousseau.
London, The Trustees of The National Gallery.
Provenance. Mrs. van Wisselingh sale, 13 April 1928 (lot 41). Bought by Francis Howard. Presented to The Tate Gallery by Mr. Francis Howard, 1936. Transferred from The Tate, 1956.

Philippe Rousseau is recognized today as a still-life painter and an imitator of Chardin, but he was also one of the first of the new-generation Realists to work in the other "lower" category: landscape. As early as 1834 Rousseau was completing landscapes

154

155

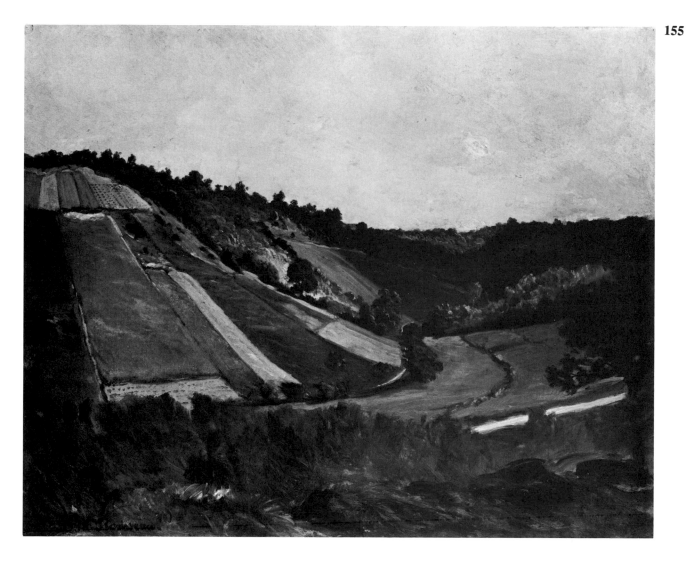

183

based on actual observation of the Normandy countryside, and he continued this interest throughout his career—an indication that despite his major acclaim as a still-life artist, contemporary collectors must also have appreciated his landscapes.

Exactly when Rousseau completed *A Valley* is difficult to determine because the work is undated. The stamp of J. Bovard, 15 rue de Buci, Paris, on the back documents where Rousseau purchased the canvas, but even a detailed search of all the Paris *Bottin*[1] would probably not bring to light any information on the date of Rousseau's purchase. J. Bovard is recorded at this address in 1860,[2] but there is no documentation for the length of time that he had already maintained this address. Thus, Rousseau may even have made his purchase and completed this landscape long before 1860.

The *Valley* is not typical of Barbizon landscapes. The rolling hills of the French countryside and the sweeping panoramic vista convey a sense of magnitude that is unusual. Brilliantly illuminated central fields, recorded at the moment when the light was most intense, provide a contrast to the darkened foreground area and recall similar atmospheric light effects that earlier Dutch painters captured across a broad expanse. The loosely painted composition, particularly the sketchy foreground, however, forecast a scope and vibrancy that may have inspired Impressionist landscapes. Works of later artists such as Camille Pissarro reveal the same brilliant illumination against a carefully organized, sweeping landscape space.

1. Martin Davies, *French School—Early 19th Century Impressionists, Post-Impressionists. . .* (London: National Gallery, 1970), p. 126. The Paris *Bottin* for the early years of the century should be examined year by year to see when the first mention of J. Bovard at 15 rue de Buci appears.
2. Ibid. Davies notes that in 1867 and 1875 the name of the firm at the same address was Chabot.

Published

John Rothenstein, *Modern Foreign Pictures in The Tate Gallery* (London, 1947), pl. 14.

Adolphe Hervier

156 *The Storm*
 (Paysage d'orage)
Oil on canvas, 13-7/8 x 19-1/2 inches (35 x 49 cm.).
Signed lower left: HERVIER.
Dijon, Musée des Beaux-Arts.
Provenance. Joliet Collection. Gift of Mlle. Pourprix, 1931.

Although *The Storm* is not clearly dated, it is likely that Adolphe Hervier completed it during the late 1840s. His work was repeatedly excluded by the Salon jury for a number of years, and it was not until 1849—during this same period—that a similar theme, *Un Effet d'orage, étude d'après*

nature, was accepted as his first Salon entry.[1]

Hervier spent many years traveling throughout the French countryside before he finally joined a number of Barbizon artists and settled near the Fountainebleau Forest. His work during this period reflects a similar sensitivity to aspects of light and atmosphere. His ability to capture changes of light in the swift movement of low-lying clouds across the sky was appreciated by a number of critics, including Théophile Gautier and

Philippe Burty [220]. Often working from memory rather than actual observation, in his oil paintings Hervier explored the landscape from a series of unusual vantage points. In this composition, the view is of the countryside below, from a bird's-eye perspective that makes the small village appear nestled among the foliage. The two figures moving along the narrow, winding path and the logs stacked at the left, however, denote a sense of actuality that distinguishes Hervier's interlude from the total

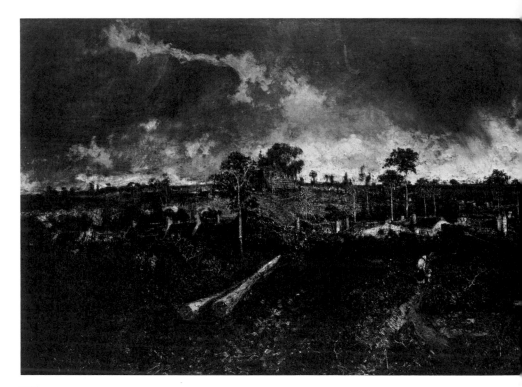

156

157

immersion with nature achieved by some of his Barbizon colleagues.

The brooding atmosphere, which is typical of Hervier's muted color range, and the sketchy execution of this composition in the middleground establish Hervier's position in the evolution of Realism. His works serve as a link between the Romantic artists, whose imaginative landscapes were often composed in the studio, and the Realists, who studied details and light from actual observation.

1. Little is known about Hervier's contributions to the Salon. While he received occasional notice by friendly critics, few collectors seem to have purchased his works and he remained little known to the general public. The date on this painting, which is barely visible at the lower left, can be read as either 1847 or 1849.

Exhibited

1900, Paris: Exposition Centennale de l'Art français, cat. no. 362.

Published

Catalogue des peintures françaises, Musée des Beaux-Arts de Dijon (Dijon, 1968), p. 125.
Georges Pillement, Les Pré-Impressionnistes (Zoug, Suisse: Les Clefs du Temps, 1974), p. 324.

Adolphe Hervier

157 *Village Scene: Barbizon*
Oil on wood, 5 x 12 inches (12.7 x 30.5 cm.), ca. 1850-60. Signed lower right: HERVIER.
Glasgow Art Gallery and Museum.
Provenance. McInnes Bequest, 1944.

Like many of the Realists, Hervier derived his themes from the daily life of the common people. Attracted to the solitude of small villages like Barbizon, Hervier did many studies in the Fontainebleau forest region. He was an inveterate wanderer, and an artist who lived an impoverished life—partly because of his own aloofness. Few artists knew him well, although Théodore Rousseau, Constant Troyon, François Bonvin, and Jean François Millet were undoubtedly impressed by the quality of his work.

Like many of Hervier's works, *Village Scene: Barbizon* is intimate in scale—a characteristic perhaps necessitated by the only size panel he could afford to buy. The sweep of the low-lying countryside that Hervier recorded from a high vantage point recalls settings depicted by the Dutch painters of the seventeenth century, and imparts a sense of monumentality to this view of the village street. The intense light and brilliant tones denote a mid-summer vista whose serenity is maintained even by the gentle breeze that sways the pair of solitary trees alongside the roadway. Hervier's light, airy palette—completed at a time when most landscape painters worked in dark tones—anticipated the achievements of the pre-Impressionists.[1]

1. Hervier has been considered a pre-Impressionist. See Pillement, *Les Pré-Impressionnistes,* pp. 317-23.

Published

Jean Bouret, *L'Ecole de Barbizon, et le paysage français au XIXe siècle* (Neuchâtel: Editions Ides et Calendes, 1972), p. 86.

Gustave Courbet

158 *The Rivulet of Puits Noir*
 (Le Ruisseau du Puits noir)
Oil on canvas, 31-1/2 x 39-3/8 inches (80 x 100 cm.). Signed lower right: G. Courbet.
Toulouse, Musée des Augustins.
Provenance. Given to the Museum by Mme. Béraldi in 1912.

The canvas *The Rivulet of Puits Noir* is one of at least ten versions of the theme, the best known of which is in the Louvre. It was the Louvre painting that Gustave Courbet's biographer, Georges Riat, singled out as a "magnificent poem of nature, green and solitary." The Toulouse version has a more abrupt, diagonal emphasis in its composition than many of the others, which are marked by a calm, vertical harmony of cliffs and foliage, contrasting with the dark, shimmering, rock-marked surface of the water of the stream. The Puits Noir is a spot near Ornans where the Brème River runs through a channel between lofty cliffs; thus, surrounded by dense foliage, little light ever penetrates to illuminate the water beneath.

Like so many of Courbet's numerous landscapes of the 1860s (it might be dated about 1865, close to the time of the Louvre version), *The Rivulet of Puits Noir* is marked by a characteristic sense of specific place, an affectionate and knowing response to the particular qualities of the various unique sites offered by his native countryside around Ornans. Reaction to mood, form, and color are recorded with forceful palette-knife work modulated by delicate, and sometimes transparent brushstrokes. L.N.

Exhibited

1952, Besançon: Courbet, no. 31.
1969, Rome, no. 22, repr.

Published

Hélène Toussaint, *Gustave Courbet (1819-1877),* exh. cat. (Paris: Editions des Musées Nationaux, 1977), cat. no. 92.
Robert Fernier, *La Vie et l'oeuvre de Gustave Courbet,* catalogue raisonné, 2 vols. (Lausanne-Paris: Bibliothèque des Arts—Fondation Wildenstein, 1977-78), 1: 254, cat. no. 465.

158

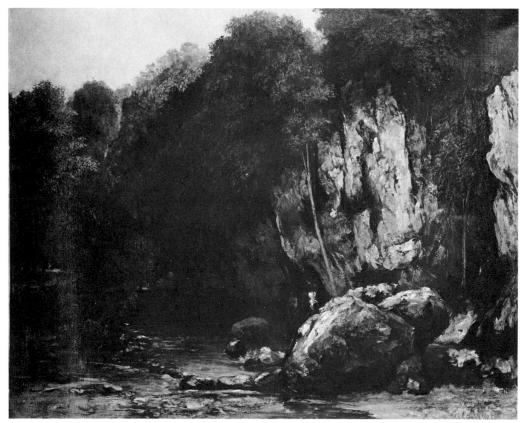

159

Léon Bonvin

159 *Street in Front of Léon Bonvin's House*
Water color, 6-15/16 x 6-5/16 inches (17.6 x 16 cm.). Signed and dated lower right: Léon Bonvin 1863.
Paris, Private Collection.

The tradition of using water color to record the immediate environment was well established by mid-nineteenth century. Many painters used the medium to prepare first impressions of a scene, later referring to the water color when they were working on a more detailed oil painting of the same theme. Unlike many artists of the period, Léon Bonvin never attempted to translate his impressions into another medium; the water color itself was his final statement. He painstakingly completed each of his scenes, rising early in the day to observe mists or the light that shrouded an outlying valley or the inner streets of a distant city.

Léon Bonvin often used his own home and the fields nearby as themes. He was unable to travel because of family responsibilities and the obligations entailed in running an inn. The *Street in Front of Léon Bonvin's House* shows the view of the roadway with a glimpse of Léon's home beyond the fence at the right. The single remaining tall tree stands in sharp contrast to the row of homes that line the receding road and the otherwise barren expanse of grayed sky. Despite the rapidly encroaching city in the distance, the lone lightpost creates a mood of rural isolation and solitary existence. The luminous atmosphere, with the geometric clarity of the outlines of the buildings, anticipates the Impressionists in its depiction of subtly observed light within a city context.

160

Jules Breton

160 *Farmyard at Souchez—Pas-de-Calais*
 (Une Cour de ferme à Souchez—
 Pas-de-Calais)
Oil on canvas, glued to cardboard, 13-1/8 x 18-1/4 inches (33 x 46 cm.). Signed lower left: Jules Breton.
Lille, Musée des Beaux-Arts.
Provenance. Donated by Ed. Reynart, 1879.

Like the Barbizon painters, Jules Breton was inspired by rural buildings. Since he spent considerable time in northern France, he had the opportunity to see the thatched buildings indigenous to the region. The small field cart and the domestic fowl in *Farmyard at Souchez* convey a reality that recalls the compositions of Charles Jacque, the Barbizon master of the farmyard scene.

Exhibited
1972, Seoul (Korea), Musée du Palais Duksoo: Millet et les peintres de la vie rurale en France au 19e siècle.

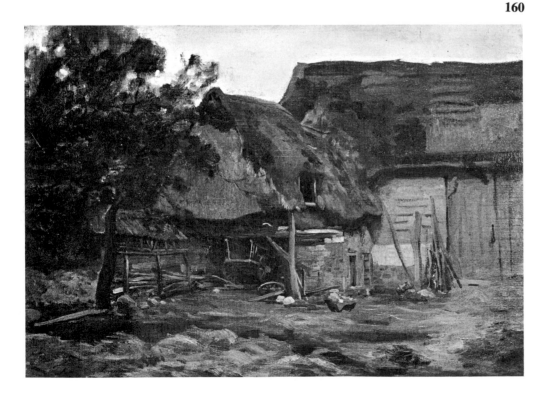

Jules Breton

161 *Landscape: Courrières*
Oil on board, 9 x 13 inches (22.8 x 33 cm.). Signed and dated lower left: Jules Breton 1854.
England, Sheffield City Art Galleries.
Provenance. Gift of Mr. Graves in 1937.

During the early 1850s, Breton returned to his native village of Courrières where he devoted himself to studies of the countryside and scenes of rural activity. While the small *Landscape: Courrières* was not intended as a preparatory study, the same location appeared again in the distant background of Breton's later (1855) Salon entry, *The Gleaners* [50]. The same stand of trees and the spire of the local church are also noticeable in the larger Salon canvas. The inspiration Breton derived from the Barbizon painters, especially Théodore Rousseau, is evident in his choice of an isolated country road and his attention to the effects of light on trees and fields. He signed and dated this work, suggesting that he considered it as a sketch perhaps intended for exhibition.

Exhibited
1959, Arts Council.

Jules Breton

162 *The Garden of "The Brewery" at Courrières*
 (Le Jardin de la Brasserie à Courrières)
Oil on canvas, 11-1/2 x 16-1/8 inches (29 x 41 cm.).
Signed and dated lower left: Jules Breton, 1861.
Paris, Private Collection.
Provenance. Descendants of the artist.

Under the direction of his Uncle Boniface, a studio was constructed for Breton in the garden of the family brewery in Courrières, and as Breton undertook larger canvases the studio was remodeled so that the workroom remained convenient and pleasant. The view from Breton's studio in 1861 has been preserved in the small canvas, *The Garden of "The Brewery" at Courrières,* which shows the approaching figures of his wife Elodie and their young daughter Virginie (b. 26 July 1859) on the central pathway near the covered arbor leading to his studio.[1]

The garden itself enabled Breton to work directly from nature. His study of the espalier of fruit trees positioned against the walls of the buildings, the pear trees lining the central walkway, and the parts of the garden given over to vegetables and flowers provided Breton with considerable coloristic detail—a characteristic most evident in the personal, small canvases retained for his own recollection and as memoirs by his family. His attention to light and shadow in this work, and the brilliance of the lighting he achieved indicate his sensitivity to natural effects and confirm his pre-Impressionist inclinations.[2]

1. Members of the Breton family identified the two figures as Elodie and Virginie in discussions with the author (1979).

2. Breton has not been considered a pre-Impressionist, but his landscape studies, with their increasingly light-colored tonality, show that during the 1860s he was moving in this direction.

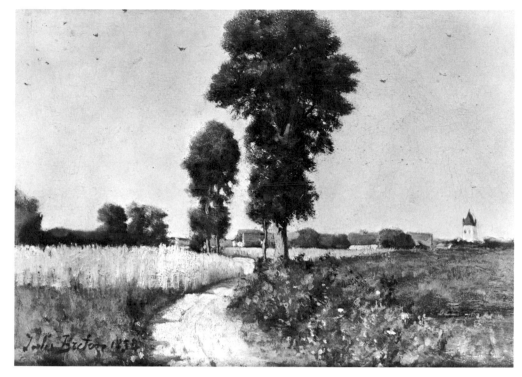

161

162

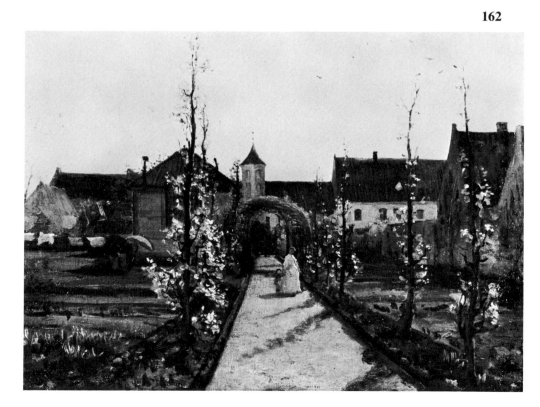

PART TWO The Emergence of Naturalism

Genre

URBAN EXISTENCE
REGIONAL EXISTENCE
URBAN LABOR
RUSTIC ACTIVITY

In the late 1870s a split occurred between painters such as Breton, Ribot, and Bonvin, who followed the older tenets of Realism, and the younger Impressionists (who received this appellation at the time of their first group exhibition in 1874). The Impressionists were influenced by Realist concepts but were divided between the pure landscape painting and color theory advocated by Claude Monet and Auguste Renoir and the Naturalism espoused by Edgar Degas and Jean François Raffaelli, a painter then regarded as the perfect Naturalist.[1] Between these factions were artists like Jean Charles Cazin and Lhermitte who exhibited in the official Salon but whom Degas was also willing to admit into the Impressionist circle,[2] and those like Jules Bastien-Lepage and, later, Jean Béraud, who modified the intensity of their Naturalism to please a Salon audience and who tempered their darker palettes because of their attraction to the lighter tones of Edouard Manet and the Impressionists.[3] Between 1879 and 1882 the confusion between these groups was compounded as the Naturalist Raffaelli exhibited with the Impressionist group in independent exhibitions, while the stalwarts of Impressionism, including Renoir and Monet—in quest of commissions—returned to the official Salon to exhibit their portraits.

In 1866, Zola advocated a form of Naturalism which was interpreted at the time to mean that it was not sufficient to represent surface reality; the painter needed to understand the nature of the subject portrayed and to understand his own artistic temperament and the ways it governed his perceptions. Recognizing the importance of psychological and physiological analysis, Zola placed his faith in science as the tool for examining reality through the study of man. Those artists who succeeded in painting truly modern themes he called actualists. He was not enthusiastic about landscape painting because it did not lend itself well to conveying the artist's personality, but he did acknowledge the achievement of the Impressionists in their willingness to select contemporary themes—the streets of Paris, shops, workers at work and at play. It was the Impressionists that he believed were revolutionizing the course of French painting. But he also selected a group of Naturalists from the Salon—Bastien-Lepage, Gervex, Ulysse Butin, Jean Béraud, and Raffaelli—whom he designated suitable portrayers of modernity. In particular, he regarded Bastien-Lepage as the heir of Courbet and Raffaelli. Although aware of the influence of the Impressionists in Bastien-Lepage's use of delicate tones [226], he pointed out that Bastien-Lepage "is carried along by his temperament, and the open air does the rest. His superiority over the Impressionists rests precisely in this ability to realize his impressions."

Huysmans, also writing in 1879, applauded the Impressionists—or more precisely the "independents," the term he used for the group—for their "true concern for contemporary life." Both of these critics, however, still awaited a "genius of the future" who would join the virtues of Impressionism with the strengths of Naturalism.[4] Huysmans believed, correctly as it turned out, that this conjunction would be based on the earlier innovations of the Realists, that Naturalism would coexist with Impressionism in the form of landscape painting—to create an art that would depict all aspects of modern life.

188

In his search for painters who were fulfilling the sociological role of art, Huysmans examined the work of Bastien-Lepage, Béraud, and Goeneutte,[5] but concluded that the only truly modern painter among them was Raffaelli, an artist enthusiastically supported by Degas in the Impressionist camp and an artist who had developed in his own writings a fully thought-out theory of Naturalism.[6] Raffaelli, along with Lhermitte, documented two of the strongest cases for Naturalism in genre painting during the 1870s. Both painters tried to paint life as it was—Lhermitte in the countryside, and Raffaelli in the lower depths of the city.[7] They tried not only to copy nature, but to convey the very thoughts of their figures. The starkness and fatalism of Raffaelli's paintings of ragpickers differed from the softer Naturalism of Butin and Gilbert [179, 189], who depicted the depressing aspects of life and the hardships produced by industrial change with a Naturalism comparable to the literary achievements of Guy de Maupassant and Alphonse Daudet, but who never sustained the bleak vision of misery exemplified by Raffaelli.

After the Franco-Prussian War, emphasis shifted from the Realist dedication to types, to the representation of man as a figure conditioned by society and the modern world. By the end of the century the factory workers depicted by Adler [193], the strike scenes by Roll, and the other contemporary themes painted by the adherents of Naturalism were inclined not simply to record but to "comment" upon the environment in which man worked and struggled to make a living.

1. For a discussion of Raffaelli see the excellent dissertation by Barbara Schinman Fields, "Jean-François Raffaelli (1850-1924): The Naturalist Artist" (Ph.D. diss., Columbia University, 1978). The situation in Paris during the 1870s has not been completely assessed. The tragic effects of the Franco-Prussian War were compounded by martial law that prevailed in the city until 1874. The rebuilding of the city was expedited by the 1878 World's Fair, which did much to reestablish France competitively among European nations. The need to create a new type of painting helped foment the crisis atmosphere that continued in the Impressionist exhibitions. For a discussion of these matters see *The Crisis of Impressionism: 1878-1882*, exh. cat., with a text by Joel Isaacson (Ann Arbor: University of Michigan Museum of Art, 1979).

2. To what extent Degas advocated these painters is unknown. Neither painter ever exhibited with the Impressionists. For further information on Lhermitte see Mary Michele Hamel, *Léon Lhermitte (1844-1925)*, exh. cat. (Oshkosh, Wisc.: Paine Art Center and Arboretum, 1974), p. 27.

3. See F. W. J. Hemmings and Robert J. Niess, *Emile Zola—Salons* (Geneva: Librairie Droz, 1959), pp. 62 ff. Zola disliked the work of Bonvin and Ribot.

4. For further reference, see Anita Brookner, *The Genius of the Future, Studies in French Art Criticism: Diderot, Stendhal, Baudelaire, Zola, the Brothers Goncourt, Huysmans* (London: Phaidon, 1971).

5. Works by Jean Béraud are difficult to locate. A recent sale in New York of twenty-six views of Parisian life provided a cross section of Béraud's themes. For further reference see *La Belle Epoque: Twenty-Six Paintings of Parisian Life by Jean Béraud,* catalog of a public auction, Sotheby Parke Bernet, 25 January 1980.

6. This aspect of Raffaelli's career is discussed in Fields, "Jean-François Raffaelli."

7. Lhermitte's early work depicts rural life quite accurately. Later paintings and pastels reflect a Romantic nostalgia for the lost innocence of rural existence.

URBAN EXISTENCE

Marcellin Desboutin

163 *Mother and Child*
Oil on canvas, 18 x 14-3/4 inches (45.7 x 37.5 cm.). Signed lower right: M. Desboutin.
The National Gallery of Scotland.
Provenance. Purchased at a sale at Dowell's in Edinburgh, 1 March 1913.

When Marcellin Desboutin returned to Paris in 1872, he lived poorly in a small apartment on the rue Bréda. His wife had just died, and Desboutin was left to care for his children the best way he could.[1] Perhaps relying on neighbors to stay with his children, who were very young, Desboutin tried to earn a living as a professional artist, for he had squandered his considerable personal fortune. The paintings that he exhibited in the Salons beginning in 1869 were often portraits of his friends from the art world or the theater, but Desboutin did other small studies which reflected his personal plight. One of these might have been *Mother and Child,* a work which suggests the cramped quarters Desboutin lived in on rue Bréda. Its dark, almost monochromatic tones reflect an atmosphere of sadness and poverty. Like other Realist painters, Desboutin emphasized the effects of environment upon his personality at an early time in his career when he was only beginning to establish his friendships with Impressionists.

1. The date of his wife's death or the number of children he had is unknown.

Jean François Raffaelli

164 *The Ragpicker*
(Le Chiffonnier)
Oil on panel, 8-3/8 x 3-1/2 inches (21.2 x 9 cm.).
Signed lower right: J. F. RAFFAËLLI.79.

Reims, Musée Saint-Denis, Bequest of Henry Vasnier (1907).
Provenance. L. Guyotin. Vente Rougé, Paris, 1887, cat. no. 42.

The Ragpicker, typical of Jean François Raffaelli's portrayal of suburban types at the time, depicts a single figure standing casually in front of a wintry landscape, his right hand holding a wicker basket and hooked stick and his left hand in his pant's pocket. Feet planted on the ground, he casts a pale gray shadow. The figure is dressed in brownish black clothing with only a hint of the red shirt and green vest that he wears underneath. His face, aged and weather-beaten, is framed by curly, gray hair and a beard.

163

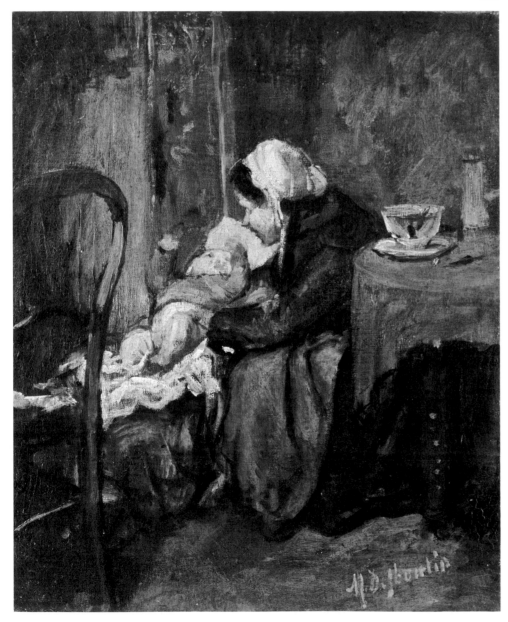

164

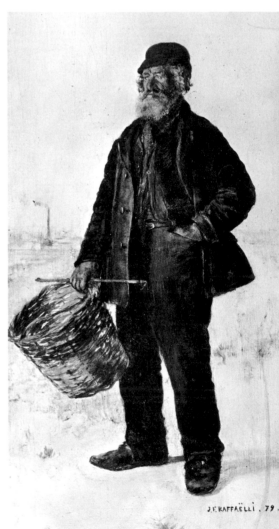

190

The small, narrow format of this painting, a favorite size of Raffaelli's in the early years, may have been influenced by the illustrations found in the *physiologies*. These entertaining albums or illustrated essays on human types were extremely popular throughout the nineteenth century in France. For example, Gavarni's series, *Physionomies parisiennes* (1857/58), illustrating various social "types," depicts each figure standing full-length against a landscape setting.[1]

Raffaelli treated the figure and the landscape in entirely different ways. Modeling and details of the figure were painted in miniaturist fashion.[2] Carefully delineated wrinkles in the forehead and cheek and the red brown, varied coloring of the face and hands create the impression of strongly modeled flesh. The artist meticulously highlighted the edges of the jacket and outer vest, the buttons, and the wrinkles of the clothing to give the forms weightiness. The contours of the figure are not simple curves but, as in the sleeves and trousers, convey a rumpled effect.

The landscape behind the figure, basically cream white, is thinly painted. Sketchy tufts of yellow green and brown blades of grass appear scattered along the ground. A greenish river flows at the left; beyond, a gray smokestack rising from a brown building emits swirling gray smoke. Gray horizontal dashes indicate roofs at the horizon. No trace of blue appears in the cream white sky.

The summary treatment of the landscape and its light tonality emphasize the silhouette of the dark, modeled figure to such an extent that it seems to be set out in relief. This ragpicker emerges above the horizon line, which is seen behind his waist, increasing his detachment from the environment. This objectivity, together with his upright stance and the vertical space he occupies, give an impression of monumentality to a figure only thirteen centimeters high.

For Raffaelli, *The Ragpicker* was more than a picturesque feature of the suburban landscape. Standing alone against the barren industrial landscape, he embodies the poverty and illusory independence of mankind that Raffaelli sensed in himself. The alienation of the ragpicker's marginal existence symbolized the artist's detachment from the community, both physically and psychologically. B.F.

1. J. Armelhaut and E. Boucher, *L'Oeuvre de Gavarni: Catalogue raisonné* (Paris: Librairie des Bibliophiles, 1873), nos. 1850-1899. *Au Coin de la Borne,* no. 1895, represents a ragpicker.

2. In his review of the 1881 Impressionist exhibition, the critic Gustave Geffroy commended Raffaelli's discovery of new subject matter, but warned the artist not to succumb in his "miniatures" to the facile charms of Meissonier. See "Exposition des artistes indépendants," *La Justice,* 19 April 1881, p. 3.

Published

A. Atalone, *La Galerie Vasnier à Reims* (Reims, 1909), p. 66.
Sartor, *Musée de Reims: Catalogue sommaire de la Collection H. Vasnier* (Reims, 1913), cat. no. 220.
Hélène Toussaint, "Collection Henry Vasnier: Peintures et dessins" (MS, Musée de Reims, 1969; now at Musée du Louvre), cat. no. 295.

Jean François Raffaelli

165 *The Merchant of Garlic and Shallots*
Oil on canvas, 31-1/8 x 19-1/4 inches (72 x 49 cm.). Signed lower right: J. F. RAFFAËLLI.
Museum of Fine Arts, Boston.
Provenance. Albert Wolff Collection, Paris. Hazelton, Philadelphia. Henry C. and Martha B. Angell Collection, Boston.

A category of suburban character treated by Raffaelli is that of the workers and *petits industriels* who are most frequently seen plying their trade or relaxing in a neighborhood tavern. The occupations recorded by Raffaelli were, for the most part, not those practiced in the factories situated along the Seine but, rather, individual labors observed in the streets and worksites of the suburbs. Among these laborers are blacksmiths, road menders, sand shovelers, woodcutters, scissors grinders, chair menders, cobblers, chimney makers, and sellers of chestnuts, chickweed, garlic, old clothes, and the like. Few of these figures are actually shown at work. Instead, they are seen resting or posing for the artist. It is not the act of labor itself or even the specific social problems of the working

165

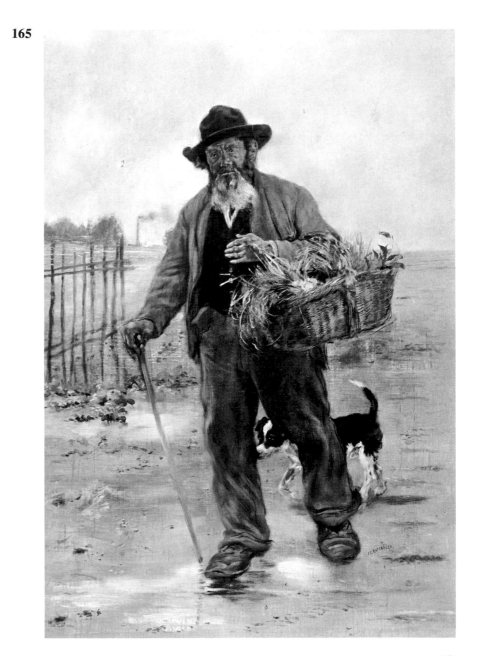

class—as seen for example in the painter Alfred Roll's *Grève* (1880) and *Travail: Chantier de Suresnes, Seine* (1885)—that interest Raffaelli. Beyond a basic sympathy for the hardships of the lower classes, the artist offers no large statements on the condition of man, such as could be inferred from Courbet's *Stonebreakers* or Millet's *Man with a Hoe*. Rather, Raffaelli seeks to record their individual physiognomies and to suggest the diverse milieus.

The Merchant of Garlic and Shallots, executed around 1880 and exhibited as one of his *Portraits—Types de gens du peuple,* shows, in Raffaelli's words, "an old man, a little paralyzed, with his black and white mutt always in the way—he holds a wicker basket on his arm and in it are some garlic and shallots, some thyme and laurel— suburban landscape, rainy weather."[1] Typically, this garlic seller's leathery face and hands are strongly modeled, the rest of his body left relatively flat. The dark figure is silhouetted against a gray foreground touched with white, yellowish fields, and pale gray sky. He looms above the horizon, dwarfing the Seine and the factory in the distance—a compositional format often chosen by Raffaelli to depict suburban types. A refreshing addition to the generally gray tonality of the canvas is the delicately painted still life of garlic, shallots, and herbs. As in the portraits of ragpickers and vagabonds, the barren land and inhospitable weather reflect the downtrodden state of the sitter. These objectively portrayed *déclassés* stand firm, dominating the landscape as if to confirm their ability to survive in the face of hardship; they rarely are placed in a sunny, colorful setting, for it was Raffaelli's desire to describe, as neutrally as possible, their drab, worn, and weather-beaten appearance.

B.F.

1. Raffaelli to Mallarmé, 28 August 1888, describing Raffaelli's illustrations for Mallarmé's prose poems to be included in Raffaelli's album *Les Types de Paris* (Paris, 1889). See Stéphane Mallarmé, *Correspondance,* vol. IV, ed. Henri Mondor and Lloyd James Austin (Paris: Gallimard, 1973), p. 532, n. 3.

Exhibited

1881, Paris: Sixth Impressionist Exhibition, cat. no. 96 (owned by Albert Wolff).
1885, Paris, Galerie Georges Petit: Exposition internationale de peinture, cat. no. 87.
1895, Boston, Museum of Fine Arts: Jean-François Raffaelli, cat. no. 108.
1966, Manchester (Mass.), Essex Country Club: no cat.

Published

Stéphane Mallarmé, "Types de la rue," *Les Types de Paris* (Paris, 1889), p. 106, repr.
Lloyd James Austin, "Mallarmé and the Visual Arts," *French 19th Century Painting and Literature,* ed. Ulrich Fincke (University of Manchester, 1972), p. 249, repr. p. 248.

166

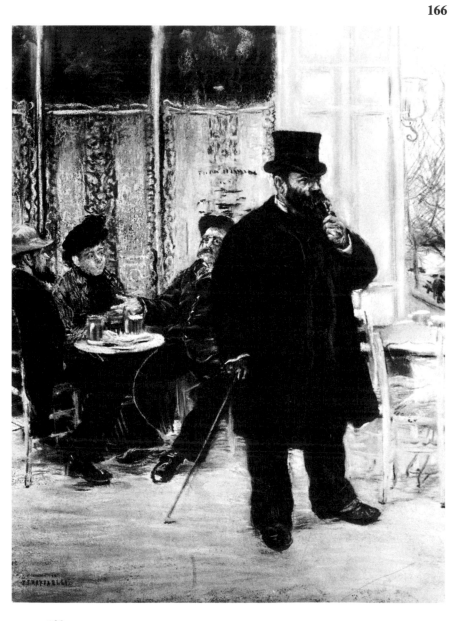

167

Jean François Raffaelli

166 *Bohemians at the Café*
(Bohèmes au café)

Pastel on canvas, 21-7/8 x 17-5/16 inches (55.5 x 44 cm.). Signed lower left: J. F. RAFFAËLLI.

Bordeaux, Musée et Galerie des Beaux-Arts.

Provenance. Purchased by the city from the artist in 1897.

The figures depicted in *Bohemians at the Café* may well be personal acquaintances of Raffaelli, a subject not often depicted by the artist. They are shown characteristically in their everyday milieu just as, in other Raffaelli works, the downtrodden or the *petits industriels* were portrayed in their ordinary environments—along the exterior boulevards of Paris, for example. Although this pastel is not dated, its subject matter and style place it in the first half of the 1880s. Two men and a woman are seated at an outdoor café engaged in conversation. On the small, round, marble table are set three mugs of beer. Dominating the scene is a corpulent, well-dressed man smoking a pipe and carrying a walking stick, who stands in the foreground. The clarity and distinctiveness of the individuals invite speculation as to their identity.

In the early 1880s following his participation in the Impressionist shows of 1880 and 1881, Raffaelli's circle of acquaintances widened. His studio in Asnières became a meeting ground for artists and writers. In the first exhibition of the Société des Pastellistes Français held at the Galerie Georges Petit in April 1885, Raffaelli showed a pastel entitled *Contemporains: Un Café, à Asnières*—which seems a more fitting title for the Bordeaux pastel than its own title: *Bohèmes au café*. Unfortunately, not one of these figures in the pastel has been positively identified. The gesticulating, seated man may be Léon Hennique, one of the young Naturalist writers with whom Raffaelli was friendly.[1]

As in his depictions of ragpickers and *petits industriels*, Raffaelli in *Bohèmes au café* clearly delineates the features of his subjects, incisively recording the smallest details of their physiognomy and clothing. Typically, the dark forms of their figures stand out sharply against a light, sketchy background. The repetition of geometric shapes is reminiscent of other works of this period such as *Les Forgerons buvant* [200]. Against a strong pattern of verticals and horizontals formed by the café windows and chairs, the soft diagonals created by the contours of the figures emphasize their organic nature. In subtle ways Raffaelli avoids monotony. He playfully repeats certain angles, such as the cane and the leg of the spectacled man seated in the rear, and counters them with the stripes of the woman's dress. The seated figures, framed by the café windows, seem totally isolated from the heavy-set man standing in the foreground. The clarity and detail of the foreground contrast sharply with the painted impression of the pedestrians and the bare trees in the background at the right. By closing off the background, the café focuses attention on the figures. B.F.

1. The author is grateful to Miss Sherry Goodman, a doctoral candidate at Columbia University, for this suggestion.

Exhibited

1885, possibly exhibited in Paris, Galerie Georges Petit: Société des Pastellistes Français, cat. no. 213.
1947, Bordeaux, Musée des Beaux-Arts: La Vie au Musée de 1939 à 1947, cat. no. 186.

Published

Gustave Geffroy, "Impressionnisme," *Revue Encyclopédique* III (December 1893): 1235 (repr. only).
P. Galibert, *Chefs-d'oeuvre du Musée de Bordeaux* (Bordeaux, 1906), repr. pl. 71.
Arsène Alexandre, *J.-F. Raffaëlli* (Paris, 1909), repr. p. 49.
D. Alaux, *Musée de peinture de Bordeaux: Catalogue* (Bordeaux, 1910), p. 104, cat. no. 557.
Ch. Manciet, *Le Musée de Bordeaux* (Paris, 1931), p. 12, cat. no. 57, repr.
J. Vergnet-Ruiz and M. Laclotte, *Petits et grands musées de France* (Paris: Editions Cercle d'Art, 1962), p. 249.
J. P. Crespelle, *Les Maîtres de la Belle Epoque* (Paris: Hachette, 1966), repr. p. 134, pl. 210.

Gustave Caillebotte

167 *Standing Man in Derby: Hands in Pockets* (Study for *In the Café*)

Charcoal, 17-1/2 x 12-1/4 inches (42.7 x 30.9 cm.), 1880. Signed lower left: G Caillebotte.

New Haven, Yale University Art Gallery, Bequest of Edith Malvina K. Wetmore.

Provenance. Edith Malvina K. Wetmore Bequest.

Almost all of Gustave Caillebotte's drawings are studies for completed paintings. The drawing *Standing Man in Derby* is a preliminary study for *In the Café* (Rouen museum), painted in 1880.[1] Unlike Caillebotte's early drawings of laboring floor scrapers or house painters done in a closely observed, specific style, this drawing is looser and more spontaneous. This is especially noticeable in the background details: the reflection of the figure in the mirror, the table he leans against, and the suggestion of the still life at the left. This Parisian type, a habitué of the café, emphasizes the importance of the café itself. The café had become a center for Parisian life, where men escaped from daily cares or boredom into drinking, dreaming, talking, or card playing. The figure in casual pose is one of several portrayed in Caillebotte's finished painting.

1. J. Kirk T. Varnedoe and Thomas P. Lee, *Gustave Caillebotte: A Retrospective Exhibition* (Houston, Tex.: Museum of Fine Arts, 1976), pp. 183 ff.

Published

E. Haverkamp-Begemann and Anne Marie Logan, *European Drawings and Watercolors in the Yale University Art Gallery* (New Haven, Conn.: Yale University Press, 1970), p. 46, cat. no. 82.

Jean Béraud

168 *The Banks of the Seine* (*Les Berges de la Seine*)

Oil on canvas, 18-1/4 x 21-7/8 inches (46 x 56 cm.), before 1880.

Paris, Musée Carnavalet.

Provenance. Gift of the Friends and Admirers of Jean Béraud, 1935.

During the 1870s, Jean Béraud turned from portrait painting to the depiction of scenes of Parisian city life. His studies of the movement of people on city streets and in cafés, or of sights along the banks of the Seine qualify Béraud as a reporter of contemporary life. His attraction for fashionable society led him to focus on the upper-middle class and to record amusing scenes he often observed.

The banks of the Seine were frequented not only by fishermen. Many of the well-dressed Parisians with their coterie of carefully manicured dogs were also drawn to the shores in their leisure hours. The particular outing Béraud recorded in his painting *The Banks of the Seine* shows a well-attired gentleman at the water's edge, his arm raised in a playful gesture, and the pose of his dogs expectant, ready to retrieve what he is about to toss into the water. The umbrella carried by his fashionably dressed companion, who is holding the dogs' empty leashes, calls attention to the overcast day. Béraud's composition recalls similar outings recorded by the Impressionists, except that he focused upon a different aspect of urban life. The landscape, the barge in the river, the bathhouse, and the belching smokestacks in the distance provide an accurate rendering of the Seine before it became fully industrialized—when people were still able to stroll along the riverbanks on the outskirts of the bustling inner city. The grayed environment contrasted with the dark clothing worn by the well-bred couple reveals Béraud's ability to capture subtle nuances within a limited color range. His interest in this seemingly unimportant activity extends the repertoire of scenes used by Naturalist painters eager to record all aspects of urban life and all levels of society.

Exhibited

1936/37, Paris, Musée Carnavalet: Jean Béraud—Peintre de la vie parisienne, p. 8, no. 9. Catalog by J. L. Vaudoyer (1936).
1978, Paris, Mairie Annexe du XVIe Arrondissement: Collections du Musée Carnavalet: Un Témoin de la Belle Epoque—Jean Béraud (1849-1935), p. 22, cat. no. 15.

168

169

Léon Lhermitte

169 *Quartet—Musical Evening at Amaury-
 Duval's
 (Quatuor)*

Charcoal, 31-7/8 x 44-1/2 inches (82 x 115 cm.).
Signed and dated lower left: L. Lhermitte/1881.
Paris, Musée du Louvre, Cabinet des Dessins.
Provenance. Charles Hayem Collection, 1881-98.
Gift to the Luxembourg Museum, Paris. Given to
the Louvre in 1931.

By the mid-1880s Louis de Fourcaud cor-
rectly assessed the drawings of Léon Lher-
mitte when he characterized them not as
preparatory studies meant to design a paint-
ing but rather as "paintings in charcoal"
which displayed all the subtleties and care
that would be given to a finished oil paint-
ing.[1] No drawing demonstrates this better
than the most unusual *Quartet,* a work exhi-
bited at the 1881 Salon. Critics continually
credited this drawing with revealing the
aesthetic significance that Lhermitte had
been trying to achieve in his drawings since
the mid-1860s.

 Aside from Lhermitte's mastery of distrib-
uted light and reflected images (noticeable in
the mirrors embellishing the room), this
finished drawing reveals his ability to accu-
rately detail the physiognomy and character
of musicians and audience. To create the in-
timate ambience of a fashionable chamber
concert attended by well-known guests,
Lhermitte studied some of the same sitters
(e.g., Amaury-Duval) as Edgar Degas, who
wanted Lhermitte to exhibit with the
Impressionists.[2] In the foreground Lher-
mitte portrayed a young woman (possibly his
wife, Héloise Goudard) listening attentively
to the musicians. Behind her sits an older
woman, perhaps a relative, whose face is
lost to the viewer but whose pose helps
frame the outer limits of the group listening
to the performance.

 This drawing makes understandable
Degas's interest in Lhermitte. Lhermitte
used compositional means similar to Degas's
to suggest a room full of guests. By cutting
his figures at the edge of the paper (note the
gentleman seated in a chair at the left),
Lhermitte conveyed a sense of the composi-
tion continuing beyond its actual confines.
Similarly, his study of diffused light, with
lamps providing the illumination in the in-
terior, enabled him to reveal interests which
some Impressionists had already made their
hallmark. The poses of the musicians and of
the invited, high-society celebrities are
lifelike, creating an easy, natural effect
which is quite different from Lhermitte's
usual work.

1. Louis de Fourcaud, "Le Salon de 1884,"
Gazette des Beaux-Arts XXX (1884): 106.
2. The individuals in the drawing, aside from
Amaury-Duval and the woman in the front, have
not been identified. Nor have exact reasons why
Lhermitte did this drawing been established.

Exhibited
1881, Paris: Salon, cat. no. 3074.
1883, Paris: Exposition Nationale, cat. no. 819.
1908, London.
1915, San Francisco.
1921, Strasbourg: Exposition de peintres de
 l'Ecole française de 1870 à 1920, cat. no. 86.

Jules Bastien-Lepage

170 *The London Bootblack*
 (Petit Cireur de bottes à Londres)

Oil on canvas, 52-1/8 x 35-1/4 inches (132.5 x 89.5
cm.). Signed and dated lower left: J. Bastien-
Lepage/Londres 1882.

Paris, Musée des Arts Décoratifs.

Provenance. The artist, sale, J. Bastien-Lepage,
Galerie Georges Petit, 11-12 May 1885, cat. no. 7.
M. Soubiron Collection, n.d. Donated by his son,
M. Albert Soubiron, May 1939.

He turned out a restless, troublesome lit-
tle fellow, and was quite unconscious of
the honour done him. Bastien Lepage ex-
pected long hours and very great quiet
from his models. This the shoeblack found
irksome, and it was with the greatest
difficulty we prevailed on him to return,
though he was munificently paid and
feasted.[1]

Thus Mrs. H. M. Stanley described the
model in Jules Bastien-Lepage's *Petit Cireur
de bottes à Londres.* Dorothy Tennant (as
Mrs. Stanley was known in 1882) had acted
as Bastien-Lepage's hostess in London, and
the picture was painted in her studio, 2
Richmond Terrace, Whitehall.[2] On this par-
ticular visit to London—incidentally, his
last—the artist concentrated upon finding a
type très anglais. His search led him to
Cheapside and Charing Cross, respectively,
where he found a bootblack and a flower
seller. Before looking at either of the result-
ing canvases, however, it is worth examining
the artist's intentions in the quest for a
"very English type."

On successive visits to London from 1879
onward, Bastien-Lepage conceived an affec-
tion for the British capital. Not only had he
produced portraits of its leading person-
alities, but he had also painted scenes of
the London docks [235]. His interest in typi-
cal street characters, however, was a clearer
statement of Realist affiliations. Having al-
ready declared himself a "re-a-liste" before
a group of London admirers in 1880, it was
to be expected that he should turn his atten-
tion to individuals in whom the quality of
"Englishness" was concentrated.[3] He
selected from the lowest strata of society,
not simply because similar characters—
street singers and ragpickers—were part
of the French Realist heritage, but because
he must have been aware of the contempor-
ary interest in these types sparked off in
London by the researches of Henry
Mayhew and by the illustrations of Gustave

Doré.[4] He may well have found inspiration
in images of the London poor by Luke
Fildes, Frank Holl, and Hubert von Her-
komer. These artists, working for the illus-
trated weekly paper *Graphic,* functioned
partly as reporters, pursuing good subjects
as pieces of investigative visual journalism,
and the paintings that they exhibited at the
Royal Academy were often simply enlarged
from their illustrations.[5] The series of Lon-
don Sketches, begun in 1872 with blocks like
Frank Holl's *A Flowergirl,* continued inter-
mittently until the early 1880s with such
scenes as C. J. Staniland's *Feeding the
Hungry—A Sketch at a London Soup
Kitchen* and J. C. Dollman's *An Opium Den
at the East End.*[6] These records of Lon-
don's vices and its vagrants were supple-
mented in the 1870s by the appearance of
photographs of typical characters in *Street
Life in London* by John Thomson and
Adolphe Smith,[7] which conveyed a sense of
actuality that had been missing from the
portrait studies of the poor by O. G. Rejlan-
der. There photographers did succeed in
bringing the condition of the poor into public
focus. When Rejlander's study of *A London
Street Arab* was engraved for the *Graphic* in
1872, it was accompanied by a text that re-
minded the reader: "There are thousands of
children in London to whom the word home
conjures up no delightful memory of cosi-
ness and warmth, but of cold and desolation,
varied by parental violence and brutality.
Such homes . . . are numerous enough to
produce a stock of children who regard the
streets as their sole place of refuge."[8]

Bastien-Lepage's bootblack and flower
seller were, therefore, by-products of "the
unfavourable conditions of life in great
cities" and, of the two, the flower seller was
already a popular subject with artists.[9] She
continued to provide painters with an obvi-
ous opportunity for Romantic renderings of
fallen women, even after illustration had lost
its mawkish Dickensian sentimentality.[10]
The important factor in this development
was the increasing awareness of photog-
raphy.[11] Bastien-Lepage's sophisticated
Naturalism contributed to, and derived
from, this changing milieu, and while he
might have set out to find an English type,
he actually returned to the studio with an in-
dividual. This fascinating equivocation bet-
ween the general and the particular comple-
ments the mental impression of a self-
declared Realist who produced pictures that
are, by definition, Naturalist.[12]

A comparison of these two London works
of 1882 suggests that Bastien-Lepage was
more innovative with his *Petit Cireur de bot-
tes* than with his *Marchande de fleurs.*[13] The
flower seller is seen standing at the corner of
a drab building which takes up most of the
background. The only suggestion of city life
going on around her is contained in the view
of the narrow passage on the left of the pic-
ture. A bootblack, by contrast, would stand
at the edge of the footpath and, as contem-

porary photographs confirm, would often
station himself by one of the posts at a street
corner.[14] This vantage point has given the
artist an unprecedented opportunity to con-
vey the background bustle of a busy London
thoroughfare. Traffic statistics presented in
Henry Mayhew's survey reveal that Cheap-
side, after London Bridge, was the busiest
road in the British capital.[15] Connecting St.
Paul's with Mansion House and the Bank of
England, the street remains at the center of
London's commercial world.

Bastien-Lepage responded to the chal-
lenge of painting this rush-hour throng in a
novel way. He had carefully considered the
problem of depicting figures in motion. As
he indicated to the young Irish painter John
Lavery, when they were introduced to one
another on the Pont des Arts, "Always
carry a sketchbook. Select a person—watch
him—then put down as much as you re-
member. Never look twice. At first you will
remember very little, but continue and you
will soon get complete action."[16] While he
was prepared to adopt the arbitrary cropping
of figures and deliberate blurring that charac-
terized the work of the Impressionists,
Bastien-Lepage seems to have been anxious
in the bootblack picture to convey a sense of
the movement and flashing color of the set-
ting. Areas of white priming on the canvas
were left exposed and others were scraped
down "according to a new method." As
Mrs. Stanley described it, "His idea was to
lay on the colour rather more than an eighth
of an inch thick, and when it was quite dry
he would shave off the surface, and thereby
obtain beneath a delightful quality of
surface."[17] At this point Bastien-Lepage added a few
cursory strokes of drawing in order to en-
hance the general effect of hansom cabs
swaying to and fro under the direction of the
traffic policeman at the top right.[18] Such a
form of selective focus was a consistent fea-
ture of Naturalist painting and is usually re-
garded as the painter's approximation of the
random focus of instantaneous photog-
raphy.[19] Here Bastien-Lepage has clearly
defined the wheel of the cab to the left of the
boy's head and has imitated the crude sign-
writing on his brush box; such details not
only indicate his early predisposition for the
heraldic painting of Holbein and Clouet, but
also provide a necessary air of authenticity.

The treatment of these focal points con-
trasts with the relatively free handling of the
figure. The boy's body has been brushed in
with the speed and confidence of a master of
"premier coup" painting. Bastien-Lepage's
manner has much in common with contem-
porary accounts of Whistler and Sargent at
work. As his hostess recalled, "I . . . was
much surprised to see how very near
Bastien-Lepage stood to his model, who was
not even raised on a platform. The boy was
only six feet from the canvas. Bastien-
Lepage walked backwards and forwards a
great deal, using very long brushes, which

he held at the extreme end."[20] It is evident, therefore, that Bastien-Lepage used a variety of techniques in painting *The London Bootblack*, and that some of these were purely experimental. No single method predominated.

Among Bastien-Lepage's oeuvre this painting is unusual, but not simply because of the bustling activity of its setting. The format, though similar to that of his full-length peasant pictures, contains an entirely novel arrangement of hues, reflecting the artist's particular attraction for the light and color of the London streets. He discovered that in the British capital there was an even light which enabled foreground objects to stand out more clearly than in Paris. For

him, the color red denoted London. As he put it, "You cannot look down a street but you see a strong bit of red somewhere. The wheels of a cab, a postbox, the letters on a shop, the uniform of a soldier, the touch of red in the streets would suffice to show me I am in England."[21] Bastien-Lepage therefore contrasted the blue blouses of Paris with the boy's red jacket and cap band—not to mention incidental details like the wheel of the cab and the postbox discernible on the far side of the street at the top right.[22] Bastien-Lepage must have been aware of the chauvinistic associations of a scarlet uniform. In a few years the boy might exchange his red jacket for that of an infantryman. Visiting the Royal Academy in 1880 and

1881, Bastien-Lepage would have seen a number of street scenes with soldiers departing for, or returning from, some distant battle. The two most prominent works in this group were undoubtedly Frank Holl's *Ordered to the Front* and *Home Again*.[23] In this connection, Herkomer's *Missing*, a bustling Portsmith street scene of sailors embracing their wives, which contains a large foreground post, could also be cited.[24]

The boy's livery, as well as the brass disk worn on his chest, suggests that he was a member of the Shoe Black Brigade. He may even have been sponsored by Carr's, the "blacking" manufacturers advertised upon his brush box. Shoeblacks were a relatively recent introduction to the London streets. They had not been sufficiently numerous in the mid-century to merit inclusion in Mayhew's monumental survey *London Labour and the London Poor*.[25] Their origin as a significant section of street traders goes back to 1851 when one of the "Ragged school" teachers, a certain "Rob Roy" MacGregor, was inspired to employ vagrant boys to clean the shoes of visitors to the Great Exhibition. This led to the founding of a charitable organization known as the Shoe Black Brigade. During the Exhibition the original twenty-five boys cleaned 101,000 pairs of shoes. As a result, "the success of the scheme was ensured; from year to year improvements and extensions were made, and [by 1886] the Shoe Black Brigade [was] one of the permanent institutions of the land."[26]

The members of this Brigade were encouraged to be politely solicitous, and a virtuous, hard-working example of the trade was immortalized in a painting presented by the "Ragged school" staff to their benefactor, Lord Shaftesbury, in 1860.[27] The boy in Bastien-Lepage's Cheapside, however, was obviously confident of earning his living. He could more readily be identified with the cheeky shoeblack who had appeared in *Punch* six months earlier.[28] Despite the melee surrounding him, he could afford to lounge at his post. His casual pose, taken from a quick watercolor sketch (reproduced in Mrs. Stanley's article), aptly expresses the character of the London libertine who preferred the familiarity of the streets to the studio, even though he was "munificently paid and feasted."[29] K.Mc.

1. Mrs. H. M. Stanley, "Bastien-Lepage in London," *Art Journal,* 1897, p. 56.

2. Dorothy Tennant (d. 1926) was the daughter of Charles and Gertrude Collier Tennant. Dorothy inherited her francophilia from her mother. Gertrude Collier had flirted with Flaubert at Trouville in 1842 and retained the friendship of the famous author until the 1870s (see Enid Starkie, *Flaubert: The Making of the Master* [London: Penguin Books, 1971], pp. 10, 72, 85-89, 91-92, 295). At her fashionable home in Richmond Terrace, she established what was described as "a salon in the time of Louis Philippe" (see Frank Hird, *H. M. Stanley: The Authorized Life* [London, 1935], p.

170

279). It was here that Bastien-Lepage, along with many of the leading artistic and literary figures of the day, was entertained. Gertrude herself was moved to write a touching letter of condolence to the artist's brother, Emile, at the time of Jules Bastien-Lepage's death (M. et Mme. C. Médard Collection, Paris). Dorothy Tennant therefore grew up in an atmosphere in which the arts were appreciated. She herself became the friend and model of Millais and G. F. Watts. She states that she and Bastien-Lepage were introduced by Watts at the Grosvenor Gallery in 1880 (see Stanley, "Bastien-Lepage," p. 55); it should also be noted that J. E. Blanche, Portraits of a Lifetime (London, 1937), p. 68, suggests—probably inaccurately—that Dorothy encouraged Bastien-Lepage to come to England in the first place. The effect of Bastien-Lepage's visits to the Tennant household in 1880, 1881, and 1882 was probably to dislodge the Classical tendencies in her own painting, which had been the result of instruction at the Slade School of Fine Arts in London and under J. J. Henner in Paris. In the years which followed Bastien-Lepage's depiction of the London bootblack in her studio, she increasingly turned to painting pauper children, and she published a collection of illustrations of such children under the title London Street Arabs (London: Cassell & Co., 1890). Although in the accompanying text she stated her preference for the "happy-go-lucky urchin"—like the beggar boys of Murillo—she does not illustrate a bootblack. In calling for a "modern Murillo," a painter of "our parks, our streets, our Embankment . . . ," Mrs. Stanley must have thought back to the days when she sketched the London Bootblack by Bastien-Lepage's side. During the year in which her book was published, she had married the explorer Henry Morton Stanley and their wedding at Westminster Abbey was attended by children from the pauper schools (see J. G. Millais, The Life and Letters of Sir John Everett Millais [London, 1899], vol. 2, p. 69). Seven years later she set down her vivid recollections of Bastien-Lepage in an article, which appeared in the Art Journal, entitled "Bastien-Lepage in London." In its general tone, this memoir confirms the impression discerned in her letter to Emile Bastien-Lepage (M. et Mme. C. Médard Collection, Paris) shortly after the artist's death. At that time she confessed, "Pour moi, ses conseils, son exemple, son amitié sont quelque chose que je posséderais toute ma vie."

3. Bram Stoker, Reminiscences of Henry Irving (London, 1906), vol. 11, p. 164, quoted in Kenneth McConkey, "The Bouguereau of the Naturalists: Bastien-Lepage and British Art," Art History III, no. 3 (1978): 373.

4. Henry Mayhew, London Labour and the London Poor (London, 1861; Dover reprint, 1968); and G. Doré and B. Jerrold, London (London: Grant & Co., 1872).

5. Luke Fildes, for instance, recalled that he had chanced upon the scene of his most famous illustration Houseless and Hungry (Graphic, 4 December 1869) when he was returning from a dinner party: "I saw an awful crowd of poor wretches applying for permits to lodge in the Casual Ward. I made a note of the scene, and after that often went again, making friends with the policeman and talking to the people themselves." See David Croal Thompson, Luke Fildes, R.A., The Art Annual (London: J. S. Virtue & Co., 1896), p. 4. Like Courbet and Ford Madox Brown, Fildes became sufficiently intimate with his subject that he

could record the individual personalities and life histories of the London vagrants. The picture was so closely studied that it could sustain enlargement to become Applicants for Admission to a Casual Ward (R.A. 1874, no. 504). For an excellent survey of illustrated periodicals of the period in the context of van Gogh's early influences, see Arts Council, English Influences on Vincent van Gogh (1974-75), catalog by Ronald Pickvance.

6. Frank Holl, A Flowergirl, Graphic, 22 June 1872, cover illus. C. J. Staniland, "Feeding the Hungry—At a London Soup Kitchen," Graphic, 13 March 1880, p. 277. J. C. Dollman, "An Opium Den at East London," Graphic, 23 October 1880, p. 401.

7. John Thomson and Adolphe Smith, Street Life in London (London: Sampson Low, Marston, Searle & Rivington, 1877-78), published in monthly parts.

8. Graphic, 16 November 1872, p. 455.

9. Ibid.

10. Flower sellers were, in fact, associated with prostitution (see Henry Mayhew, London Labour and the London Poor [London, 1861; reprint ed. Dover, 1968], vol. 1, p. 136; and G. Doré and B. Jerrold, London [London: Grant & Co., 1872], p. 126).

11. The evolution of more naturalistic representation in English illustration in the 1870s must owe something to the development of photography. John Thomson (see note 7) actually declared, "The precision and accuracy of photography enables us to present true types of the London poor and shields us from the accusation of either underrating or exaggerating individual peculiarities of appearance." Quoted in Valerie Lloyd, Photography, the First Eighty Years (London: P. & D. Colnaghi & Co., 1976), p. 188.

12. For the artist of the 1870s it was hardly important to make semantic distinctions between Realism and Naturalism. Many of Bastien-Lepage's predecessors and contemporaries thought of themselves as Realists. Perhaps the most notable of these was Degas, who in a famous letter to Tissot in 1874 referred to what is now regarded as the first Impressionist Exhibition as "a salon of the realists." See Edgar Germain Hilaire Degas, Letters, ed. Marcel Guerin (Oxford: Bruno Cassirer, 1947), p. 39.

13. The comparison of these two works must necessarily be rather limited because the Marchande de fleurs à Londres remains untraced. It was reproduced by Richard Muther in The History of Modern Painting (London: Henry & Co., 1896), p. 16, and described as "that beautiful picture" of a "pale delicate child upon whose faded countenance, love and hunger have so early left their traces" (p. 27). Possibly because the picture was felt to be more resolved than its companion piece, Bastien-Lepage declared that "he would return in '83 to paint a group of London flower girls. 'For I have done nothing yet compared with which I can do—what I shall do' " (Stanley, "Bastien-Lepage," p. 56). In Victorian painting, flower girls are sometimes difficult to distinguish from the floral portraits favored at the time; they occur commonly, however, in the work of Bastien-Lepage's British followers, for example, in pictures by Clausen (1881 and 1883), Wilkinson (1887), Logsdail (1887), and Lavery (1888).

14. See, for example, William Sanson, Victorian Life in Photographs (London: Thames & Hudson, 1974), pl. 44.

15. Mayhew, London Labour, vol. 2, pp. 282-83.

16. John Lavery, The Life of a Painter (London: Cassell & Co., 1940), p. 57.

17. Stanley, "Bastien-Lepage," p. 56.

18. Hansom cabs, unique to London, were introduced in the 1850s and remained a feature of street life until the turn of the century. They appear often in contemporary painting, most notably perhaps in Tissot's Victoria Station and Going to the City (both ca. 1879).

19. Compare, for example, Degas's method of recording city life in works such as Place de la Concorde (ca. 1875). Indeed, one might transpose Valéry's estimation of Degas's aims as a way of summing up Bastien-Lepage's intentions in the London Bootblack. Degas wished, according to Valéry, "to combine the snapshot with the endless labour of the studio, enshrining his impression of it in prolonged study—the instantaneous given enduring quality by the patience of intense meditation" (Paul Valéry, Degas, Manet, Morisot, trans. David Paul [London: Routledge & Kegan Paul, 1960], p. 55). For a general discussion of these issues, see A. Scharf, "Painting, Photography and the Image of Movement," Burlington Magazine, May 1962, pp. 186-95.

20. Stanley, "Bastien-Lepage," p. 56; quoted in Kenneth McConkey, "Bouguereau of the Naturalists," p. 373.

21. Stanley, "Bastien-Lepage," p. 54.

22. Julia Cartwright, Jules Bastien Lepage (London: Seeley & Co., 1894), p. 59, records that the figure and setting appeared so realistic that "a visitor to his studio remarked, you seem to hear the sound of the wheels all around him."

23. Frank Holl's Ordered to the Front (R.A. 1880, no. 366) and Home Again (R.A. 1881, no. 401) should be seen in context with P. R. Morris's Sons of the Brave (R.A. 1880, no. 20), Charles Green's The Girl I Left Behind Me (R.A. 1880, no. 1072), and F. E. Cox's The King Breaks Many Hearts (R.A. 1881, no. 1382). All of these works, selected from the military subjects on display in 1880 and 1881, were no doubt produced as a direct consequence of the Zulu War and the Indian Mutiny.

24. Herkomer, Missing (R.A. 1881, no. 373).

25. Shoeblacks were classified by Mayhew as "street servants," and therefore considered part of the huge "nomadic" tribes of vagrants and casual labourers" (Mayhew, London Labour, vol. 1, p. 4); he does not discuss them as a separate group.

26. Edwin Hodder, The Life and Work of the Seventh Earl of Shaftesbury, K.G. (London: Cassell & Co., 1886), vol. 2, p. 342.

27. See Georgina Battiscombe, Shaftesbury (London: Constable, 1974), opposite p. 274. This picture is entitled The Shoeblack's Lunch; the artist is not cited. For a further illustration of the typical "Ragged school" shoeblack, see J. Wesley Bready, Lord Shaftesbury and Social-Industrial Progress (London: Allen & Unwin, 1926), opposite p. 152. One further well-known image—reproduced in Battiscombe—is a picture by William MacDuff entitled Shaftesbury or Lost and Found, which shows a virtuous shoeblack drawing the attention of a less fortunate pauper boy to the likeness of his benefactor in a printseller's window. See Arts Council, Victorian Paintings (1962), catalog by Graham Reynolds, no. 42.

28. Punch, 26 November 1881, p. 241.

29. Stanley, "Bastien-Lepage," repr. p. 54. This water color remains untraced.

197

Jean Béraud

171 *The Editorial Office at the Journal des Débats*
(La Salle de rédaction du Journal des Débats)

Oil on panel, 15-1/8 x 21-1/4 inches (38 x 53.5 cm.). Signed lower left: Jean Béraud.

Paris, Musée Carnavalet.

Provenance. Gift of the Friends and Admirers of Jean Béraud, 1935.

Just as a stage designer studies the locale in which to place his actors, Jean Béraud visited the main editorial office of the *Journal des Débats,* 17 rue des Prêtres in Saint-Germain l'Auxerrois, in preparation for the canvas that he would exhibit at the Salon in 1889. Georges Seurat had made small-scale studies on location before painting his *Sunday Afternoon on the Grande Jatte,* and the canvas Béraud planned required a similar, realistic recording of the location itself so that the finished work would be an accurate description of his setting. The preliminary studies that Béraud made at the journal's offices established not only the accuracy of the setting, but helped him to determine the natural placement of the thirty-nine figures requested for the portrait and to visualize the scale on which to develop his complex composition. The meticulous, small-scale panel studies, such as the office interior, provided a valuable reference for the Salon composition Béraud was to finish in his studio, serving much the same purpose as a writer or reporter's notebook.

The finished painting, which is now lost, provided a higher vantage point than the preliminary panel, for Béraud, in his final version, expanded the interior space so that the rafters and supporting beams became a dominant part of the spatial organization.[1] The single chair isolated near the frontal plane in the sketch was also placed to the left, and upon it—as if to indicate that they would be claimed within the next moment or two—were placed a walking stick and an upturned top hat containing a copy of the journal.

The table seen in the center of the sketch was hidden in the final version by a group of men conversing with the journal's sponsor, Ernest Renan, and an editor, J. J. Weiss. The chimney at the left and the tall desk at the right were obscured in the canvas by a number of figures. Details of the room overhead, however, remained largely unchanged, including the room divider at the back, the rear window, and the map on the wall at the right.

1. The final painting was well received by the critics—among them Roger Ballu in the *Salon Illustré,* July 1889—who praised the Naturalism achieved by Béraud.

171

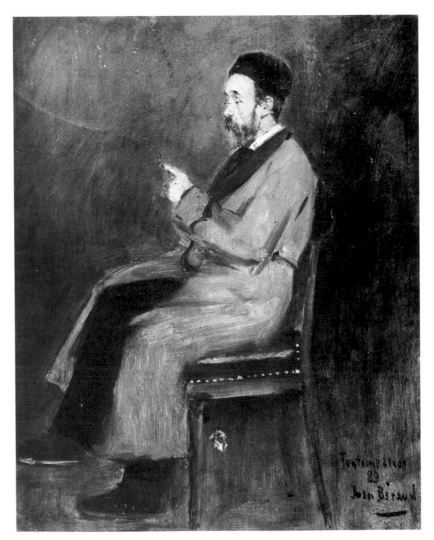

172

Exhibited

1936/37, Paris, Musée Carnavalet: Jean Béraud—
Peintre de la vie parisienne, p. 12, cat. no. 32.
Catalog by J. L. Vaudoyer (1936).

1978, Paris, Mairie-Annexe du XVIe Arrondissement: Collections du Musée Carnavalet: Un
Témoin de la Belle Epoque—Jean Béraud
(1849-1935), p. 17, cat. no. 4.

Jean Béraud

172 *Portrait of J. J. Weiss*
(Portrait de J. J. Weiss)

Oil on panel, 18-1/4 x 15-1/8 inches (46 x 38 cm.).
Signed and dated lower right: Fontainebleau/
89/Jean Béraud.

Paris, Musée Carnavalet.

Provenance. Donated to the Museum by Mlle.
Iznaga in 1934.

As part of the commemoration of their one-hundredth anniversary, the *Journal des
Débats* commissioned Béraud to do a large
painting of their editorial staff. The group
portrait that Béraud completed in time for
the 1889 Salon was similar to the interior
scenes painted earlier by Henri Fantin-Latour and Edgar Degas. Unlike Fantin-Latour and Degas, however, who chose
their own models and arranged friends according to their own personal artistic inclinations, Béraud confronted a more difficult
situation. There were thirty-nine editors on
the staff of the *Journal des Débats,* each of
whom needed to be fully identified, yet
posed together within a single scene. Béraud
confined his composition to the magazine's
main office, carefully composing his groups
so that the more important figures were
positioned near Ernest Renan in the center,
to provide an accurate description of the interior and the man in charge of the influential periodical. Although his final portrait
does not reveal the innovative placement of
figures in space that Béraud achieved in later
works (e.g., *Interior of a Bank),* it does provide a sense of actuality and observation
based on his naturalistic inclinations.

Many of the key figures—for instance, the
Portrait of J. J. Weiss, a chief contributor to
the magazine[1]—were first done in small
sketches observed from life. This enabled
Béraud to achieve a lifelike representation
on an intimate scale, which he later reworked into the general scheme of the final
composition. In this case, the sense of spontaneity in the quickly executed oil study is
enhanced by the unfinished quality of the
surface. Following the tradition established
by the Realist painters who relied upon the
actual tonal colors they observed, Béraud
recorded his preliminary study of Weiss in
grayed tones, with mauve and black predominating. This characterization of the introspective critic reveals Béraud's capacity
to capture a sitter's depth of personality in a
manner similar to Edgar Degas, an artist he
undoubtedly admired.[2]

1. Weiss was born in Bayonne in 1827 and died in
Fontainebleau in 1891. Theodore Zeldin to the author, 10 April 1980, pointed out that Weiss was an
important political as well as literary figure.

2. The number of small studies for the figures in
the finished painting remains unknown. Béraud
also did studies of Hippolyte Taine, Ernest
Renan, and John Lemoine.

Exhibited

1936/37, Paris, Musée Carnavalet: Jean Béraud—
Peintre de la vie parisienne, p. 13, cat. no. 37.
Catalog by J. L. Vaudoyer (1936).

1979, Paris, Mairie-Annexe du Ve Arrondissement: Collections du Musée Carnavalet, p. 18,
no. 6.

Jean Béraud

173 *The Pastry Shop "Gloppe"*
(La Pâtisserie Gloppe)

Oil on wood, 15-1/8 x 21 inches (38 x 53 cm.).
Signed and dated lower left: Jean Béraud 1889.

Paris, Musée Carnavalet.

Provenance. Donated by Armand Dorville, 1944.

The same year Béraud received a gold medal
at the Paris World's Fair he completed a
painting epitomizing the cosmopolitan atmosphere of that fashionable city. By the
1880s, promenading along the boulevards of
Paris—in groups or in the company of a
husband or companion—had become a popular amusement for women and men of the
leisure class. *The Pastry Shop "Gloppe,"*
located on the Champs Elysées, became one
of the most popular gathering places for
Parisian high society,[1] and it seemed only
fitting that Béraud, as an official painter of
the wealthy middle class during the Third
Republic, would select it as the subject for
one of his compositions. Women with their
children or older gentlemen who had been
strolling on the boulevards and in the parks
often stopped in at the pastry shop at 6
Avenue Champs Elysées in the late afternoon to enjoy the rich pastries along with a
cup of coffee or tea or a glass of wine. The
young women Béraud depicted seated at one
of the many small tables or poised against
the long counter in their large, stylish hats
and full-length jackets reflected the latest
fashions.

Béraud's composition records the renewed interest in light and space that was
then influencing contemporary decor. The
tall mirrors that panel the walls and the delicate pastel colors provide an ambience of
elegance that characterized society of that
period. This work also suggests Béraud's interest in Edouard Manet (e.g., *The Bar at
the Folies Bergères)* and Edgar Degas, for
he has conveyed a similar aura of "modernity" that—although less concerned with individual portraiture and personality—presents an image appropriate for the fashionable
woman of the *belle époque.* Echoes of
Béraud's interest in Naturalism are also ap-

173

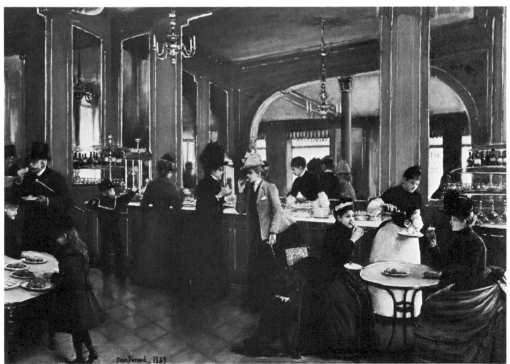

parent, even in the way he suggests the continuation of the scene at the left by cutting off a figure at the border of the canvas.

The Pastry Shop ''Gloppe'' marks a turning point in Béraud's career, however, for this is the last of his paintings based on observation. Like other Realist painters (e.g., Jules Breton or Jean Charles Cazin), Béraud turned to symbolic images—confining his later compositions to social types he perfected in his imagination.

1. For a discussion on places to congregate, including the café, see Philippe Aries, ''The Family and the City,'' *Daedalus* 106 (Spring 1977): 227-35.

Exhibited

1933, Paris, Pavillon de Marsan: Décor de la vie de 1870 à 1900, cat. no. 25.
1936/37, Paris, Musée Carnavalet: Jean Béraud—Peintre de la vie parisienne, p. 11, cat. no. 28. Catalog by J. L. Vaudoyer (1936).
1950, Paris, Galerie Charpentier: Autour de 1900, cat. no. 8.
1978, Paris: Collections du Musée Carnavalet: Un Témoin de la Belle Epoque—Jean Béraud (1849-1935), p. 23, cat. no. 18, repr. p. 23.

Published

''Journal d'un jeune parisien en Décembre, 1899,'' *Réalités,* 1949, p. 42, repr.
''Musée Carnavalet—Trente Ans d'acquisitions 1941-1972,'' *Bulletin,* 1973, cat. no. 1.
Chastenet, ''Images de la Belle Epoque,'' *Jardin des Arts* 122 (January 1965): 25 repr.
Jacques Wilhelm, ''Life in Paris under the Second Empire and the Third Republic,'' *Apollo* 106 (December 1977): 495 (repr.), 498, fig. 8.

Charles Maurin

174 *Dance Hall on the rue Coustou (Bal Musette de la rue Coustou)*

Pastel, 18-1/2 x 24-1/8 inches (46.9 x 61.3 cm.).
Signed lower left: Maurin/Bal Musette de la rue Coustou.
New York, Collection of Mr. and Mrs. Herbert D. Schimmel.
Provenance. André Deveche Collection, Paris.

Nowhere did popular entertainment find a better setting than in the small dance halls and cabarets of Montmartre. During the 1880s and 1890s, artists flocked to these sites to record performers and customers in drawings, pastels, prints, and posters. While most of these images reflect a shift toward an Art Nouveau or Symbolist style, the theme originated in the Realist interest in street characters and popular performers [12].

Dance Hall on the rue Coustou is a transitional work. Using an amateur musician, a sad old man playing bagpipes, Charles Maurin created the same ambience found in his earliest charcoal drawings of provincial life. In this case, dancers, serving girls, talking men, or military officers pay little attention to the entertainer. Maurin seems to have depicted a scene from observation of the musician, but he was perhaps more concerned with developing an image in accordance with avant-garde theories. The café is suggestive of works by Toulouse-Lautrec, a close friend of the artist at the time, but Maurin is preoccupied with compositional devices absorbed from Degas which create an abstract interplay of verticals and horizontals.

Exhibited

1978, New York, Lucien Goldschmidt Gallery: Charles Maurin, 1856-1914, p. 42, cat. no. 49. Essay by Phillip Dennis Cate.

174

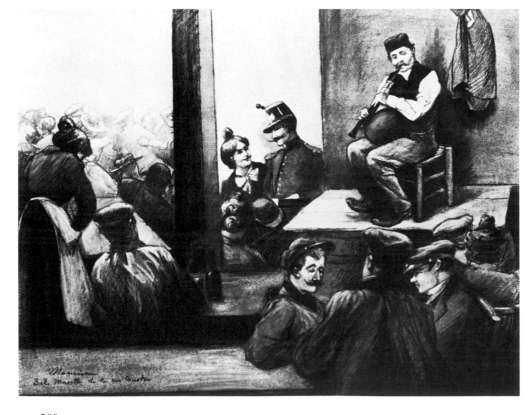

REGIONAL EXISTENCE

Jean François Raffaelli

175 *The Family of Jean-le-Boîteux, Peasants from Plougasnou—Finistère (La Famille de Jean-le-Boîteux, paysans de Plougasnou—Finistère*
Oil on canvas, 59-7/8 x 74 inches (152 x 188 cm.).
Signed lower right: J F RAFFAËLLI 1876.
Le Quesnoy, Hôtel de Ville.
Provenance. Bought by the state in 1910 and sent to Le Quesnoy in 1924.

A new phase in Jean François Raffaelli's art commenced with *The Family of Jean-le-Boîteux, Peasants from Plougasnou,* a large canvas painted in Brittany in the summer of 1876. Scenes from peasant life had a long tradition in the arts, and even as late as the nineteenth century, peasantry still formed the largest element of the French population. Raffaelli's choice of this theme was thus perhaps the obvious availability of such a subject for any artist championing Realism.[1] *The Family* originally depicted five figures, but Raffaelli later deleted one figure and part of another at the left. The friezelike disposition of the figures in front of an interior wall seems to have been done purposely to avoid academic convention. Stiff horizontals, verticals, and diagonals formed by the rustic furniture and the limbs of the figures accentuate a rigid format that was probably square before the canvas was cut.[2]

No communication among the figures, either physical or psychological, is conveyed. Despite some overlapping, each stands alone. Instead of lining up his figures frontally, the artist chose to capture each in his characteristic pose as if he had sketched each figure individually and later incorporated them into a group portrait. Within the shallow space, the figures are arranged by generation—young daughter (cut off),[3] father, mother, grandfather, grandmother—with the females placed slightly forward of the males.

The individual poses reveal the psychological states of each family member. The old woman, seated frontally and leaning forward, rests her heavy, swollen hands—witness to years of toil—wearily in her lap. The white kerchief framing her weather-beaten face droops down onto her chest. The eyes, staring out and down, bespeak resignation to age and to her station in life. Her silhouette is closed, her body compact. The younger woman is also seated, but she is turned sideways to the left toward her husband and child, her wedding ring bearing witness to her family ties. Her head is also kerchiefed and bent forward, but in concentration on the task at hand rather than in weariness. She is working with three needles and appears to be knitting a sock. Blue veins protruding conspicuously from the back of her left hand indicate that she will not escape the fate of her elders. The grandfather is seated between and slightly back of the two women, his arms folded across his chest. Although positioned in a three-quarter view, his head is turned toward the viewer. The determined expression on his leathery face, which engages the viewer, pushes him forward and further compresses the space. The other male figure, the father, is also forceful. He stands frontally with hand on hip, his eyes staring forward. The space between him and the other three figures emphasizes his role as the breadwinner for the family.

The somber coloring and rendering of details reinforce the stark, humble existence of these peasants.[4] The sparse setting attests to the plainness of their lives. The once-white wall is stained and cracked. Although each figure casts a shadow onto the wall, the area which immediately surrounds the three seated figures is lightened like a halo, further emphasizing their grimy appearance.[5] The chairs, wooden shoes, and floor are a dull gray brown, while skin tones resemble tanned leather. Unidealized, harsh drawing

175

delineates each feature. For example, Raffaelli closely observed the white lace floral trim on the mother's blue cape as well as the tear in her striped, brown skirt. Each fold, dirty nail, and weather-beaten wrinkle is carefully and harshly recorded.

This objective portrayal is devoid of sentimentality or social propaganda. The stiff drawing and the arrangement stress the primitive quality of these proud, hardworking Breton peasants. The literalness and intensely hard manner represent a break from academic modes and a commitment to close observation and to the treatment of all elements equally in an objective sense, thus avoiding a universal statement of hierarchical structure. The brutal frankness and the large scale of the image force the viewer to confront these figures on their own terms. They are neither the rustic peasants of Bastien-Lepage nor the monumental laborers of Millet, but simply the family of Jean-le-Boîteux from Plougasnou.[6]

Raffaelli's approach and choice of subject recall the work of the leader of the Realist movement, Gustave Courbet, who in his sincere, direct depiction of the lower classes "rejected traditional coherence, dramatic unity, and imposed psychological focus in favor of a loosely additive pictorial structure."[7] Just as Courbet's work bore comparison with that of the Le Nains, so critics such as Arsène Alexandre related the spirit and force in Raffaelli's picture to seventeenth-century Fench genre painters.[8] Indeed, Louis Le Nain's *Famille de Paysans* (Louvre) is strikingly similar in its stiff, stark realism, inwardness of character, and friezelike composition, although it is devoid of the personal caricature identified with Raffaelli's work. In his comments upon the later Realist works of Raffaelli included in the 1881 Impressionist exhibition, Huysmans claimed that Raffaelli had taken up where the Le Nain brothers left off, augmenting their work by his depiction of miserable creatures from the city that he dared to show in their true environment.[9] B.F.

1. Why Raffaelli chose this particular family to portray is unknown, but Brittany attracted many artists throughout the century to study peasant life.

2. A significant number of Raffaelli's early Realist works used a square format, a shape he abandoned because it did not attract buyers. J.-F. Raffaelli, "Caractère des lignes," *La Revue Indépendante* VI (February 1888): 176-77.

3. Gustave Geffroy, "Jean-François Raffaelli," *Gazette des Beaux-Arts* X (1924): 180, identifies the missing figure as a young daughter.

4. There is no evidence that Raffaelli relied upon photographs in creating his paintings. Only in his graphic activity, executed mainly between 1893 and 1911, did Raffaelli seem to depend on photographs of his earlier Realist paintings in order to copy their compositions.

5. The colors are basically medium blues for the father's shirt and women's capes; black for the grandfather's hat and jacket; browns for the pants and mother's jacket and skirt; and various shades of white for the old woman's sweater, skirt, and kerchief, and the younger women's kerchief and knitting.

6. A close parallel might be Wilhelm Leibl's *Three Women in Church* (1878-82, Kunsthalle, Hamburg), yet Raffaelli's work does not portray any religious ritual or folk custom nor does he represent such a pristine view of peasants.

7. Linda Nochlin, *"The Development and Nature of Realism in the Work of Gustave Courbet"* (Ph.D. diss., New York University, 1963; New York: Garland Publishing Co., 1976), pp. 225-26.

8. Arsène Alexandre, *Jean-François Raffaelli* (Paris: H. Ploury, 1909), p. 56.

9. J. K. Huysmans, *Oeuvres complètes* (Paris: G. Crès, 1928-34), VI: 269; from *L'Art Moderne,* 1883.

Exhibited

1877, Paris: Salon de la Société des Artistes Français, cat. no. 1755.
1884, Paris, 28 bis, avenue de l'Opéra: Oeuvres de J. F. Raffaelli, cat. no. 18.

1889, Paris: Exposition Universelle Internationale de 1889: Exposition Centennale de l'Art français (1789-1889), cat. no. 565.
1893, Chicago: World's Columbian Exposition, French Section, cat. no. 652.
1894, Paris, 202 rue de Courcelles: Oeuvres de J.-F. Raffaelli, cat. no. 8.
1899, Venice: France: Biennale, cat. no. 38.
1909, Paris, Galerie Georges Petit: Exposition J. F. Raffaelli, cat. no. 10.

Published

Edmond Duranty, "Réflexions d'un bourgeois sur le Salon de peinture," *Gazette des Beaux-Arts* XV (June 1877): 552, repr. of drawing of grandmother on p. 557.
Pierre Laurent, "Les Conseillers municipaux," *Les Beaux-Arts Illustrés* XI (1879): 83.
Georges Lecomte, "L'Oeuvre de J.-F. Raffaelli," *La Grande Revue* XLV (25 September 1907): 458, 471.
Arsène Alexandre, *Jean-François Raffaelli,* pp. 53-57, repr. p. 55.

176

Léon Lhermitte

176 *Interior of a Butcher Shop*

Charcoal, black and white chalk drawing, 20-3/4 x
22-1/2 inches (53 x 57 cm.). Signed lower left: L.
Lhermitte.
The Cleveland Museum of Art, Gift of Muriel S.
Butkin. 78. 131.
Provenance. Shepherd Gallery, New York.
Cleveland, Mrs. Muriel S. Butkin Collection.

Léon Lhermitte's continuous interest in
drawing first was established publicly in the
mid-1860s when he sent fusains to the Salon.
His figural style was often meticulous and
exceptionally precise, virtually photo-
graphic. Whether Lhermitte utilized photo-
graphs in these years is unknown, although
his appreciation of seventeenth-century
Dutch painters, a tendency other Realist art-
ists shared, is noticeable in certain works,
including his study *Interior of a Butcher
Shop*.

Carefully arranging his figures in a tightly
controlled space, Lhermitte organized his
forms as a series of interlocking geometric
shapes. The recession of the countertop is
accentuated by the perspective arrangement
of the doors being opened at the left. The
customer's entrance through the half door
accents the momentariness of her pose, an
impression reinforced by the gesture of the
woman behind the counter who is holding a
piece of meat, offering either to give it to the
woman or to weigh it for her. In the subtly
observed patterns of light, from the bril-
liance of the street which silhouettes the en-
tering customer to the diffused light from the
windows that illuminates the shop interior,
Lhermitte reveals a mastery seldom found in
later drawings.

This work was completed early in Lher-
mitte's career after trips to Brittany in 1874
and 1876. Etched and published in the En-
glish periodical *The Etcher,* the drawing
helped establish Lhermitte's fame in
England.[1] By the early 1880s, using themes
from provincial daily life, Lhermitte had be-
come a leading master of black and white
drawing on both sides of the English Chan-
nel.

1. For a discussion of this work as an etching see
Frédéric Henriet, *Les Eaux-fortes de Léon Lher-
mitte* (Paris: Alphonse Lemerre, 1905), p. 82, no.
36. *La Boucherie (The Butcher Shop)* was repro-
duced in *The Etcher* in 1881.

Exhibited
1978, CMA: The Year in Review.

Published
"Year in Review," CMA *Bulletin* LXVI (January
1979): 44, cat. no. 68, repr. p. 20.

Eugène Carrière

177 *The Young Mother*
 (La Jeune Mère)

Oil on canvas, 58 x 45-3/4 inches (146 x 115 cm.).
Signed and dated upper right: EUGENE CAR-
RIERE 1879.
Avignon, Musée Calvet.
Provenance. Purchased from the artist for 800
francs.

Eugène Carrière's *intimiste* themes origi-
nated in his appreciation of first-generation
Realist painters. Carrière's early paintings

reuse Jean François Millet's family themes.[1]
Later in his career, after developing a Sym-
bolist style of painting in which forms dis-
solved into one another and a monochroma-
tic tonality predominated, Carrière derived
inspiration from other Realist painters, no-
tably Théodule Ribot.[2]

The art critic Roger Marx briefly com-
mented on Carrière's *Young Mother* when it
was shown at the 1879 Salon. Few other crit-
ics mentioned the work, and no one placed
the theme directly in the Realist painting
tradition that examined family life. His

177

method was also traditional, for he developed his composition from a preliminary sketch (Figure 177a). Like Théodule Ribot, Carrière derived the theme from his family circle, using his wife and infant son as models. The simple kitchen interior referred to his own modest living quarters. Painted in muted tones, with strong emphasis on subtle distinctions in the use of white, the painting is similar in tone to Ribot's work. Carrière's study of still-life objects, including the ceramic pitcher on the wooden table and the towel and container on the floor, accent the simplicity of design and his appreciation of diffused light.

This painting incorporates Symbolist qualities since Carrière created a mood of solemnity and devotion not unlike a religious icon.[3] The purity of the event, emphasized by the towel and water container and the swaddling clothes of the infant, suggests the religious counterpart. By focusing on the mother nursing her child, leaving the rest of the room in semidarkness, Carrière created an atmosphere of genuine affection and tenderness. Since Carrière completed numerous *Maternité* scenes with his wife and children as models, this theme especially expressed Carrière's devotional attitude as a Symbolist of family life.[4]

After the 1879 Salon, where the painting received little attention, Carrière put the large canvas on sale in various provincial centers in the early 1880s. Finally, he learned that the Musée Calvet wanted to acquire the work. Whether the museum purchased the painting in 1882 (as documented by the current museum staff) or after it was shown at the 1883 Avignon exhibition where Carrière received a silver medal remains a moot point.[5] The painting, at the time of its purchase, had been well received in provincial cities because it upheld traditional home-life values fundamental to rural France.

1. The parallel with Millet's compositions is apparent. Perhaps Carrière also knew Jules Breton's small studies recording similar moments from family life.

2. The relationship with Ribot was suggested by Denys Sutton, "Carrière and the Symbolists at the Orangerie," *Burlington Magazine* XCII (March 1950): 81.

3. The theme suggests a Madonna and Child composition, but the religious significance of Carrière's themes needs further study.

4. For further discussion see Andrew J. Stillpass, "Eugène Carrière: Symbolist of Family Life" (M.A. thesis, University of Cincinnati, May 1974).

5. As part of the continuing development of regional exhibitions bringing art to the people during the last half of the century, the Avignon exhibition of 1883 invites further examination.

Exhibited
1879, Paris: Salon, cat. no. 528.
1883, Avignon.

178

177a Eugène Carrière, Sketch for *La Jeune Mère*, oil on canvas, undated.

Published

Paul Desjardins, "Artistes contemporains—
Eugène Carrière," *Gazette des Beaux-Arts*
XXXVIII (1907): 21.
Stillpass, "Eugène Carrière," p. 20, pl. 4.
Robert J. Bantens, "Eugène Carrière—His Work
and His Influence" (Ph.D. diss., Pennsylvania
State University, 1975; Ann Arbor, Mich.:
University Microfilms, 1976), pp. 96-97.

Jean Antoine Bail

178 *A Member of the Brass Band*
(Un Membre de la fanfare)

Oil on canvas, 28-1/2 x 23-1/2 inches (72.5 x 59.5
cm.), ca. 1880/81. Signed lower right: ABail [*A*
superimposed on *B*].

Cognac, Musée des Beaux-Arts.

Provenance. Given to the Museum by Gabriel
Cor in 1904.

At the Paris Salon of 1880 Jean Antoine Bail
exhibited a painting entitled *Un Membre de
la fanfare* which may indeed be the same
painting now belonging to the Cognac
museum, although the provenance of this
canvas before 1904 is not known. This oil
study, possibly from the 1880 Salon,[1] later
was used (although in a modified pose) for
one of the musicians in Bail's more elaborate
figural composition *La Fanfare de Bois-le-
Roi*, a painting now in the collection of the
Musée de Lyon.[2]

During summers in the late 1870s and
early 1880s, Jean Antoine Bail, accompanied
by his two sons Frank and Joseph, often vis-
ited the region near Fontainebleau to study
and record the rustic scenes and customs
that were already fast disappearing from tra-
ditional village life in France.[3] It was proba-
bly on one of these occasions that they ob-
served preparations for the street concert in
the village at Bois-le-Roi, although there is
no record of the exact number of paintings
Jean Antoine Bail did of these local musi-
cians with their instruments. The pleasure
provided in the few spare moments of prac-
tice set aside from daily chores in order to
prepare for the anticipated concert is obvi-
ous in the portrait Bail recorded of the vil-
lager seated near his hearth.[4] The French
horn he plays was a popular instrument that
had only recently become fashionable (since
the 1870s), augmenting more traditional in-
struments such as flutes and bagpipes. In-
terestingly enough, in the nearby country vil-
lages that surrounded the larger cities, the
latest instruments and new tunes that had
become popular in the city were welcomed
much more readily than changes in social
customs or dress.

Jean Antoine Bail's placement of his
model within the rural interior conveys a
sense of the provincial environment. The
comfortable, but simple setting, replete with
kettles and cauldrons, provides an accurate
ambience for his solitary performance. A
sense of anticipation is evident in the inten-
sity of this last-minute rehearsal, for the
young man depicted by Bail is already
dressed for the concert (the cap is part of his
uniform). The brass band undoubtedly pro-
vided a sense of official community impor-
tance as well as cultural achievement in the
small village, although the influence of the
larger city is evident in this young man's
dress and his instrument. The modification
of traditional rustic customs by the last quar-
ter of the century, especially in the regions
near Paris, was captured in Jean Antoine
Bail's realistic portrayal of contemporary
rural life.

1. See the 1880 Salon catalog, no. 73, for refer-
ence to the painting.
2. The painting is now housed in a municipal
building in Lyon, but is not available to the public.
3. Léon Riotor, "Les Artistes de l'Ile Saint
Louis," *Bulletin de la Ville de Paris* VIII-IX,
(n.d.): 445-50 no. 234.
4. Eugen Weber, *Peasants into Frenchmen: The
Modernization of Rural France, 1870-1914*
(Stanford University Press, 1976), pp. 429-51.

Ulysse Butin

179 *The Ex-Voto*
(Ex-Voto)

Oil on canvas, 57-5/8 x 92-1/4 inches (145 x 232
cm.). Signed and dated lower right: Ulysse Butin
— 1880.

Lille, Musée des Beaux-Arts.

Provenance. Purchased by the state in 1880 for
3000 francs. Sent to Lille in 1880.

Ulysse Butin's *The Ex-Voto*, which was
purchased by the state for 3000 francs and
then sent to the museum in Lille,[1] is a didac-
tic canvas that focuses on a devotional ser-
vice held by fishermen to commemorate
their safekeeping from shipwreck or death at
sea. The young woman in the center of the
work is dressed in regional attire and carries
a model of a sailing vessel that will be placed
inside the church. To her right, leading the
processional of fishermen and their families,
are elders bearing commemorative candles.
Butin's composition underscores the human
and supernatural qualities inherent in such
an event. The vista of the sea in the back-
ground provides a glimpse of the danger and
destruction that the fishermen encountered
each time they left the peace and security of
the port, which can also be glimpsed at the
base of the hill. The religious sanctuary it-
self, which is probably a likeness of the
church of D'Hennequeville (Calvados), pre-
dominates over the nearby village, the port,
and the sea. The penitential and pious at-
mosphere of the procession making its way
toward the church is further enhanced by the
supernatural quality of the large crucifix in
the churchyard in full sight of the fishermen
and their families reverently bearing their of-
fering, the ex-voto, that is intended to assure
the aid and intercession of the local saint in
troubled times at sea. The fresh flowers
borne by the young boy and the model of the
ship both emphasize the importance of phys-
ical and religious salvation to the fishermen
of this region.

Butin used an appropriately Naturalistic
style to record types from northern French
coastal villages. The customs of the region
and the traditional ceremonies were care-
fully studied in order to re-create the scene
exactly. Butin's descriptive manner—similar
to that of a reporter—relied heavily upon
narrative to convey the message of the
image to a Parisian audience that may not
have been familiar with traditions in the
provinces.

1. See dossier Ulysse Butin, 23 June 1880,
F 21/199, Archives Nationales.

Exhibited

1880, Paris: Salon, cat. no. 562.
1883, Paris: Exposition Nationale.

Published

L'Art, 23 December 1883, p. 235.
Chronique des Arts, 15 December 1883, p. 318.
E. Montrosier, *Les Artistes modernes* (Paris,
1883), III: 75.
Ex-Voto, marins du ponant (offerts à Dieu et à ses
Saints par les gens de la Mer du Nord, de la
Manche et de l'Atlantique), exh. cat., Nantes,
Caen, Dunkerque, November 1975—May 1976,
repr.

Jules Bastien-Lepage

180 *The Beggar*
(Le Mendiant)

Oil on canvas, 15-3/4 x 12-5/8 inches (40 x 32 cm.).
Signed lower left: J. BASTIEN-LEPAGE.

Paris, Private Collection.

Provenance. Sale, Ancienne Collection Besson-
neau d'Angers et à divers amateurs—Tableaux
modernes, Hôtel Drouot, Paris, 23 June 1954, cat.
no. 16.

Like Jean François Millet, Jules Bastien-
Lepage, as a Realist interested in the study
of appearances, was committed to recording
his own particular region, the Meuse coun-
tryside in northern France. The slower pace
of his rural homeland served as a restful an-
tidote to the frenzied activity of Paris and
the involvement with private collectors and
theatrical performers that marked his career
as a portrait painter during the late 1870s.
Beginning in 1876, whenever he traveled in
the countryside, Bastien-Lepage carried a
sketchbook to record impressions of the
Meusian landscape and images of daily ac-
tivity in the region, in anticipation of a series
of works intended to extol nature and pro-
vincial life.

Although he exhibited both portraits and
genre scenes in the 1878 and 1879 Salons,
Bastien-Lepage concentrated much of his ef-
fort on a monumental canvas of *Joan of Arc*
(1880 Salon), a work that embodied his artis-
tic philosophy and for which he hoped to

win a coveted medal of honor. When this Symbolist painting received only mixed reactions, Bastien-Lepage was bitterly disappointed and, for a brief time after the 1880 Salon, consoled himself by traveling in Belgium and England.

By August 1880, however, he returned to Damvillers and began preparations for another large-scale painting, this time a genre painting entitled *The Beggar*, which he exhibited at the 1881 Salon.[1] His original conception of the theme depicted a beggar stopping at a home within a village setting (Musée Marmottan, Paris). The compositional problem that resulted from the placement of the beggar within the receding perspective of a village street, and the attention diverted to the large spotted dog in the foreground caused Bastien-Lepage to discard this initial plan.

The final image developed somewhat differently, although little is known about its progress other than the fact that he discussed his plans with his brother Emile. A letter written to Emile on 17 November 1880 included a quick ink sketch of the final conception and discussed his ideas for revising the original composition.

I haven't forgotten the flowers. They are, with the head of the child, the only smile in the midst of sadness. The flowers synthesize the beauties of nature and are a reminder of a joyful, carefree life. These same joys are represented by the child who sympathizes somewhat with the sadness of the miserable beggar. Among all the great artists only those who have seriously learned from and studied nature and humanity, those who have been able to substantiate their observations—sad or happy . . . , those who have accomplished something durable, free from passing taste or fashion, and those who have remained close to the unchanging aspects of nature will remain youthful and strong.[2]

His explanation of the philosophy behind the composition of *The Beggar* suggests an emerging symbolism that was then beginning to inspire a number of Realist painters.[3] His focus upon the problem of beggars, which continued to plague France, not only reiterated the social phenomenon, but also, because of his depiction of the young girl at the doorway, showed the concern for this segment of society felt by members of the middle class. The younger figure represents a note of hope without vitiating the social implication of the composition.

Bastien-Lepage carefully developed his ideas for the canvas, doing a small pencil drawing (Cabinet des Dessins, Louvre) that examines the expressions of both the beggar and the young girl.[4] Skillfully done, the drawing contrasts the sorrowful expression of the haggard beggar with the innocence of the young child, revealing Bastien-Lepage's Naturalist inclinations. Once the initial drawings were completed, Bastien-Lepage began his first oil sketch, a work which closely corresponds to the final painting as it was exhibited in 1881. Only the cat, which Bastien-Lepage perhaps added to serve as an anecdotal counterpart to the itinerant beggar on the steps, was eliminated from the final version. Completed in monochromatic colors, the sketch retains the time-worn expression of the beggar's face. A small flowerpot (that Emile suggested he add) pro-

179

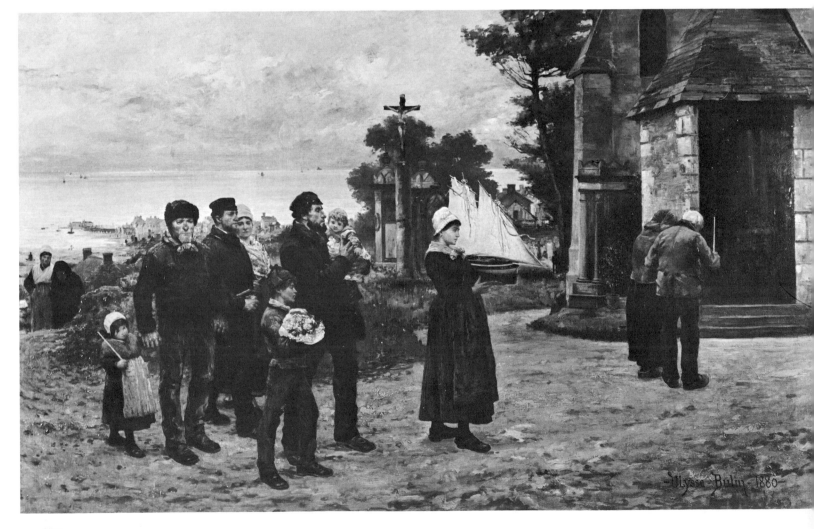

vides a bright note of color in the otherwise limited tonality of the composition.

By the time the monumental oil composition (Copenhagen) was sent to the 1881 Salon, Bastien-Lepage had made additional changes. In the doorway behind the young girl, he included her mother absorbed in her reading. This detail identified the middle-class household and emphasized the beggar as a social outcast, resigned to spend his days wandering in search of food and lodging.

Critical response to the final work was favorable. Unlike *Joan of Arc*, the theme of the wandering beggar was well established in Realist iconography and, despite its social overtones, Bastien-Lepage's composition upheld a "traditional theme" in a strikingly detailed style.[5] Salon critics were impressed with the lifelike strength conveyed by the figure of the old man in his worn, wooden sabots. *L'Art* called *The Beggar* a "superb realist canvas. . . ." Another writer referred to Bastien-Lepage's work as "one of the best examples at the Salon."[6]

As a provincial genre painting with strong narrative content, *The Beggar* indeed underscored the sense of humanity that Bastien-Lepage conveyed in his letter to his brother in November 1880. By contrasting the earthy realism of the wanderer with the ethereal sentimentality of the young girl, Bastien-Lepage emphasized even further the accuracy of his description. The candor of his presentation[7] must not be overlooked, for although he used a popular Salon theme, he also recorded an honest view of a social type common in many regions of France, including the Meuse.[8] Begging had become a way of life, and the ability to survive by such means led to a shrewdness that dispelled any fondness for these itinerants who had once been regarded as picturesque. Beggars were viewed with distrust and fear by many villagers, and Bastien-Lepage's solemn figure, hardened by years of travail, documents the very real social blight that then existed.

While the oil sketch with the cat does not bring the beggar as close to the frontal plane as the final canvas, the positioning of the figure with his clumsy, oversized sabots near the edge of the canvas confers the same sense of immediacy to his person. Bastien-Lepage—even in this small sketch—was trying to create an impression of reality suggesting that the beggar was actually a living person.

1. The finished painting measures 199 x 181 cm. The size of the work made it difficult to obtain for the Realist Tradition exhibition.

2. Jules Bastien-Lepage to Emile, 17 November 1880, archives of the Bastien-Lepage descendants.

3. The modification of Realist iconography by Symbolist associations should be studied. It influenced the imagery of many of the later artists, including Dagnan-Bouveret, Léon Lhermitte, and others.

4. See RF 1870-12242, Cabinet des Dessins, Louvre.

5. The wandering beggar had been treated by others, most notably by Alphonse Legros in numerous water colors and drawings during the 1860s and 1870s.

6. J. Buisson, "Le Salon de 1881," *Gazette des Beaux-Arts* II (1881): 38-39.

7. William Steven Feldman, "The Life and Work of Jules Bastien-Lepage" (Ph.D. diss. New York University, 1973), p. 146.

8. Noted by Louis de Fourcaud in "Exposition des oeuvres de Bastien-Lepage à l'Hôtel de Chimay," *Gazette des Beaux-Arts* XXXI (1885): 261.

Published (Salon painting only)

Louis de Fourcaud, *Exposition des oeuvres de Jules Bastien-Lepage* (Paris, 1885), pp. 21-22.

André Theuriet, "Jules Bastien-Lepage," in *Catalogue des tableaux, esquisses, etc., laissés dans son atelier* (Paris, May 1885), p. 6.

Gustave Larroumet, *Discours prononcé à l'inauguration de la statue de Jules Bastien-Lepage à Damvillers* (Paris, September 1889), p. 11.

Henri Amic, *Jules Bastien-Lepage—Lettres et souvenirs* (Evreux, 1896), p. 38.

Anonymous, "Bastien-Lepage," *La Liberté,* 13 December 1884.

Paul Mantz, "Bastien-Lepage," *Le Temps,* 23 December 1884.

S. Rocheblave, "Les Salons de Louis de Fourcaud," *Gazette des Beaux-Arts* XIII (1926): 50.

Feldman, "Life and Work," pp. 142-53, figs. 48-50.

Kenneth McConkey, "The Bouguereau of the Naturalists—Bastien-Lepage," *Art History* III (September 1978): 375.

180

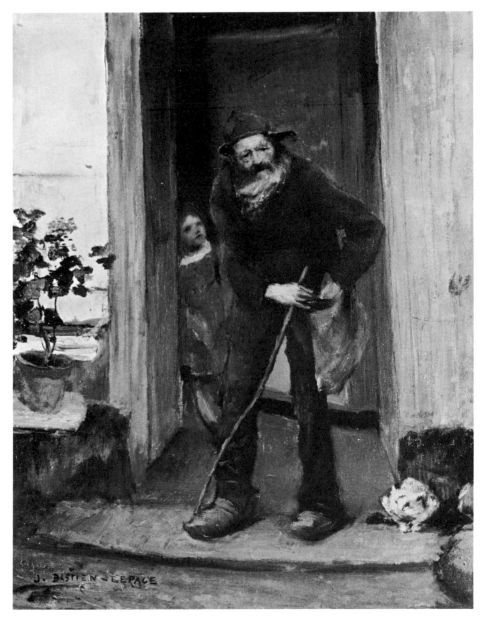

Jules Bastien-Lepage

181 *Nothing Doing*
(Pas Mêche)

Oil on canvas, 52 x 34-3/4 inches (132.1 x 88.3 cm.). Signed bottom right: J. BASTIEN-LEPAGE/Damvillers/82.
The National Gallery of Scotland.

Provenance. Tooth and Sons, 1882. Tooth's sale, 28 February 1885 (cat. no. 119), repurchased. H. J. Turner, Stockleigh House, Scotland, before 1888. G. McCulloch, 184 Queen's Gate, London, ca. 1897-1903. McCulloch sale, 23 May 1913 (cat. no. 10), bought in. Acquired through Wallis and Sons for The National Gallery of Scotland, 1913.

The common feature in all of Jules Bastien-Lepage's pictures of single figures in full-length portrait format is their high horizon. Bastien-Lepage clearly wished to differentiate his peasants from the *belles caryatides* of Breton who stand out against the sky.[1] His intentions on this point were quite clear. "There is a great deal of routine and prejudice in that criticism of the perspective of my pictures done in the open air. It is the criticism of people who have never looked at a landscape, except crouching down or sitting. Sitting you see more sky and you have more objects—trees, houses, or living beings standing out sharply in silhouette against the sky, which gives the illusion of a greater distance and a wider atmosphere. But it is not in this way that we generally see a landscape. We look at it standing, and then the objects, animate or inanimate, that are nearest to us, instead of being seen in profile against the sky, are silhouetted upon the trees, or upon the fields, gray or green. They stand out with less clearness, and sometimes mix with the background, which then, instead of going away, seems to come forward."[2] By insisting upon the landscape and figure as they are normally seen, Bastien-Lepage in some ways diminishes the spectator's sense of encounter with his figures. In a very literal way they emerge from the world in which they live. The spectator meets them as he would have done in real life.

The extent to which the boy in *Pas Mêche* projects his personality is due largely to Bastien-Lepage's desire—as a Naturalist painter—to establish a new kind of relationship with his audience. Even the picture's title, a slang expression, challenges the viewer to find his own way of reacting to the boy's air of defiance. *Pas Mêche* is a shortened version of *il n'y a pas mêche,* which is usually translated as "there is nothing doing."[3] This in itself suggests that the boy has been depicted in the act of responding to provocation. The painting therefore says much about the subtle shift of emphasis between Realism and Naturalism in the late nineteenth century. At first sight this might simply be regarded as another *métier*-type subject, a painting derived from popular illustrations of typical working men and

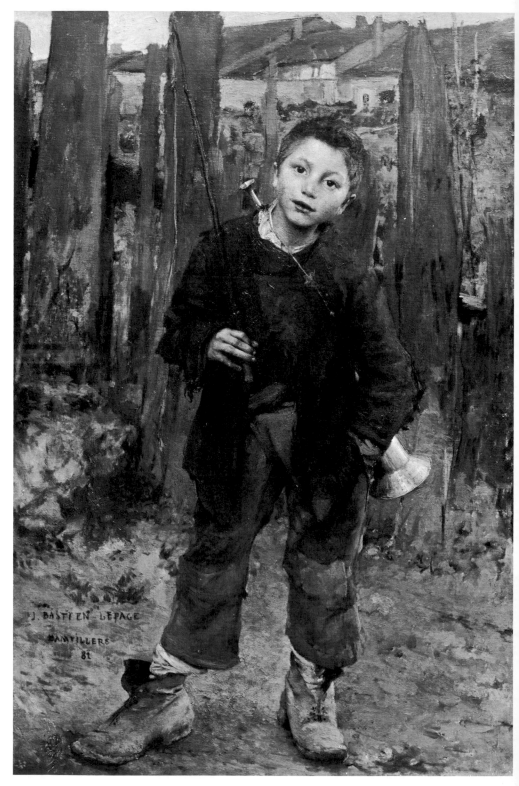

181

women which bring to mind earlier full-length figures by Courbet and Manet, or the heroic peasants of Millet.[4] And yet the differences in such comparisons are as instructive as the similarities. In his isolation of the figure, the Realist creates a type, while, by his insistence on *mise-en-scène,* the Naturalist produces a painting of an individual.[5] The problems inherent in the picture are therefore very specific ones, and while it is possible to understand in artistic terms why such a picture looks the way it does, its exact relationship with its social environment has yet to be explored.[6]

After his abortive attempt to paint a picture of Ophelia during the summer of 1881, Bastien-Lepage took a brief holiday in Switzerland and nothern Italy before going back to Damvillers at the end of the autumn, "pour revenir à ses paysans."[7] Much of his time during the following winter must have been spent on *Le Père Jacques* (Milwaukee Art Center), the large painting exhibited at the 1882 Salon. At the same time Bastien-Lepage completed a number of smaller canvases, among them *Pauvre Fauvette* (Glasgow City Art Gallery) and *Pas Mêche.* Both of these pictures of children, dressed in "handed-down" clothes, are more than they at first seem. The very literal rendering of the boy's baggy trousers and tattered jacket was just the type of painting which led the critic George Moore to make rueful allusion to Bastien-Lepage's followers as those who paint "seam by seam, patch by patch," as if the artist wished to applaud the unseen generations which had passed through this same peasant's garb![8] In this instance, the boy's disregard for his appearance is carried down to the unlaced boots, which are too big for him and are even worn on the wrong feet. All of these details support the impression of a young libertine who stares out at the viewer defiantly, waiting for a response. It was this penetrating and hypnotic gaze which baffled and enraged contemporary reviewers of Bastien-Lepage's peasant pictures.[9] The boy's head in this work is tightly defined, his clothing more broadly handled, and the paling in the background with the kitchen gardens beyond is summarily painted.[10]

The picture was painted for Arthur Tooth and Sons, a London art dealer. Immediately after it had been exhibited at the Cercle Artistique in Paris, it was included in Tooth's Spring Exhibition which opened at the end of March 1882. Of the 123 works on display by British and foreign artists, the *London Times* critic was convinced that "the palm of interest is borne off by M. Bastien-Lepage, with an impudent . . . gamin whom he has christened *Pas Mêche.* Like the *Mendiant*, he is taken in full front view; and like him seems almost to breathe, so vigorous and exact are the finished head, the pose of the irrepressible little body, the whip and the trumpet."[11] The life-likeness of Bastien-Lepage's figure carried with it something enigmatic. When the picture had passed into a Scottish collection only to reappear later at the Glasgow International Exhibition in 1888, many critics and artists were puzzled by the ambiguity surrounding Bastien-Lepage's relationship to his subject matter. Was he, as Alexander Roche declared, "virtually a mechanical reflector of the things in nature he chooses to depict . . ."?[12] Or did he possess, as Patrick Geddes suggested, "a fullness of vision, far more than photographic, but selected and unified with the firmest artistic hand . . ."?[13] While followers might posthumously debate whether Bastien-Lepage's quality of observation was intuitive or consciously contrived, Roche and Geddes would both agree that *Pas Mêche* was a unique achievement. It was "a remarkable example of scientific realism, reaching, perhaps, as high artistic achievement as may be reached by such a method. Alike in its characteristic pose of the boy's figure, so well caught and expressed by the fine drawing and modelling; in the placing of the subject on the canvas; in the subtle gradations of tone and colour, so faithfully realizing the appearance of open-air effect; in the ensemble, and no less in the deft and capable handling, *Pas Mêche* proved its accomplished painter to be at once a man of refined artistic perceptions, and also a craftsman of a high order."[14] A fitting compliment to Roche's eulogy might be his own line illustration of *Pas Mêche* that appeared in a memorial volume of the Glasgow Exhibition published in 1888.[15]

As might be expected, it was the technical aspect of the work which attracted younger artists. Indeed, according to Bastien-Lepage's friend Dorothy Tennant (Mrs. H. M. Stanley), it was an easel made from "a stout piece of wood with three notches" and anchored by whipcord that enabled him to achieve the open-air Naturalism of *Pas Mêche.*[16] As he worked down the figure, Tennant reported, Bastien-Lepage dug a hole to stand in, for he was convinced that "the nearer the feet came to the bottom of the canvas the greater was the impression of reality." It was with such tactics that Bastien-Lepage forced his urchin upon the spectator's attention. An English reviewer remarked, "everything passes within a yard of your nose."[17]

And thus, it was Bastien-Lepage's remarkable ability to convey the impression of his peasant's physical presence that exerted such a powerful fascination in those who looked upon his work. K. Mc.

1. Maxime du Camp, *Le Salon de 1859*, p. 37, quoted in the catalog *Le Musée du Luxembourg en 1874*, Grand Palais, 31 May—18 November 1974, p. 40.

2. André Theuriet, *Jules Bastien-Lepage and His Art. A Memoir* (London: T. Fisher Unwin, 1892), pp. 73-74. Bastien-Lepage's original statement was first quoted in the French version of Theuriet's text. See André Theuriet, "Jules Bastien-Lepage, l'homme et l'artiste," *Revue des Deux Mondes*, 15 April 1885, p. 827: "Il y a beaucoup de routines et de préjugés dans ce reproche qu'on fait à la perspective de mes tableaux de plein-air. C'est de la critique de gens qui semblent n'avoir jamais contemplé un paysage qu'accroupis ou assis. Quand vous vous asseyez pour peindre, vous voyez naturellement un site d'une tout autre façon que si vous êtiez debout. Assis, vous apercevez plus de ciel et vous avez plus d'objets: arbres, maisons ou êtres animés se découpant en silhouettes sur ce ciel, ce qui donne l'illusion d'un recul plus considérable et d'une aération plus large. Mais ce n'est pas ainsi que le paysage s'offre ordinairement à nos yeux. Nous le regardons debout, et alors les objets animés ou inanimés des premiers plans, au lieu de se profiler sur le ciel, se silhouettent sur les arbres, sur des champs gris ou verts. Ils se détachent avec moins de netteté, et, par places, se mêlent confusément avec les fonds, qui alors, au lieu de reculer, semblent venir en avant." This important statement also appears in Julia Cartwright, *Jules Bastien-Lepage* (London: Seeley and Co., 1894), p. 63; and in Feldman, "Life and Work," p. 157.

3. See Olivier Leroy, *A Glossary of French Slang* (London, 1922), p. 107. Taken by itself the word *mêche* can refer to the wick in a candle or the lash on a whip. See *Petit Larousse*, 1905, p. 604. At least one French critic was aware of Bastien-Lepage's possible wordplay in the title. Writing in *L'Artiste* XXIII (1885): 393, Emmanuel Ducros referred to "*Pamêche* [sic], ce Jeune garçon du village qui tient une mêche de fouet. . . ." ("this little boy from the village who holds a whip with a string on the end").

4. Much has been written about the popular image of the worker, which occupies a central position in Realist iconography. While it is unnecessary to refer to this extensive literature in detail, one might simply cite Meyer Schapiro's seminal "Courbet and Popular Imagery," *Journal of the Courtauld and Warburg Institutes* 4 (1941): 169. Feldman, "Life and Work," p. 168, makes an apposite comparison between *Pas Mêche* and Manet's *Le Fifre*.

5. The phrase *mise-en-scène*, a piece of theatrical language, was frequently used in connection with the art of the late nineteenth century. It was particularly useful in dealing with Naturalist paintings in which figure and setting were mutually supportive. More than once it was applied to Bastien-Lepage's work, in an effort to describe the ingenuity, comparable to that of a stage director, with which he maneuvered his characters and backgrounds into the right relationship.

6. There are a number of possible explanations for the boy's activity. His ragged clothing and the straight tin horn he carries suggest that he is unlikely to be associated with hunting. A plowboy, as in George Clausen's *Ploughing*, might be expected to carry a whip, but not a horn. A number of successive editions of The National Gallery of Scotland catalog—e.g., 49th (1936), 50th (1946), and 51st (1957)—describe the protagonist as a bargeboy, posing on a towpath. While there is no evidence upon which to base this suggestion, it is plausible. He presumably used his whip to drive the horses which pulled the barge, and he alerted lockmasters with the horn. Even if one were to positively identify the boy's occupation, a consequential relationship between it and the picture's title seems unlikely.

7. Theuriet, "Jules Bastien-Lepage, l'homme et l'artiste," p. 823.

8. George Moore, *Modern Painting* (London: Walter Scott, 1893), p. 116.

9. Feldman, "Life and Work," quotes many examples. A number of others are contained in

McConkey, "Bouguereau of the Naturalists," p. 374.

10. Close examination of the canvas reveals a confident, speedy execution. Overpainting is evident along the line of the rooftops and, perhaps, around the boy's right heel. The weight, solidity, and texture of the figure is conveyed by generally thicker paint than that found in the surroundings. In places, surface pattern is incised into the impasto—probably by using the handle of the brush. The formality of the arrangement is apparent in the slope of the boy's shoulders, which echo the tilt of the crosspiece in the fence. This upward movement to the left is, of course, held in check by the strong horizontal in the roofs.

11. *London Times*, 6 April 1882, p. 3.

12. Alexander Roche, "Of Finish in Art," in *Transactions of the National Association for the Advancement of Art*, Edinburgh meeting, 28 October—1 November 1889 (London, 1890), p. 339.

13. Patrick Geddes, *Every Man His Own Art Critic,* (Glasgow and Edinburgh, 1888), p. 35.

14. Roche, "Of Finish in Art."

15. W. E. Henley, *A Century of Artists: A Memorial of the Collection of Painting and Sculpture at the Glasgow International Exhibition* (Glasgow, 1889), p. 4.

16. Mrs. H. M. Stanley, "Bastien-Lepage in London," *Art Journal*, 1897, p. 54.

17. *Academy*, 2 June 1883, p. 389.

Exhibited

1882, Paris: Cercle de l'Union Artistique et le Cercle St. Arnaud.
1882, London: Tooth's Spring Exhibition.
1885, Paris: Exposition des oeuvres de Bastien-Lepage à l'Hôtel de Chimay.
1888, Glasgow International Exhibition, cat. no. 675.
1900, Paris: Exposition Centenniale de L'Art Français.
1906, London: Tooth's Spring Exhibition, cat. no. 30.
1909, London: Royal Academy Winter Exhibition, cat. no. 89.

Published

"Art Notes," *Magazine of Art* 5 (1882): xxiii.
Le Roy de Sainte Croix, *Journal des Arts*, 9 June 1882.
Theuriet, "Jules Bastien-Lepage, l'homme et l'artiste," p. 822.
de Fourcaud, "Exposition des oeuvres," pp. 265, 267.
Scottish Art Review 1 (June 1888), p. 4.
Marie Bashkirtseff, Entry for 27 February 1883, *Journal* (London 1890), p. 326.
Cartwright, *Jules Bastien-Lepage*, p. 57.
Academy, 21 April 1906, p. 384.
Sir James L. Caw, *Sir James Guthrie, P.R.S.A., LL.D., a Biography* (London, 1932), p. 25.
Colin Thompson, *Pictures for Scotland: The National Gallery of Scotland and Its Collection* (Edinburgh, 1972), p. 78.
Elizabeth Bird, "International Glasgow," *Connoisseur* 183 (August 1973): 252.
Feldman, "Life and Work," pp. 168-70.
Lucien de Chardon, *Damvillers et son canton*, 1973, p. 129.
David Irwin and Francina Irwin, *Scottish Painters at Home and Abroad, 1700-1900* (London, 1975), p. 376.
McConkey, "Bouguereau of the Naturalists," p. 377.

210

Jules Bastien-Lepage

182 *Going to School*
(Allant à l'école)

Oil on canvas, 31-1/2 x 23 inches (80 x 58.4 cm.), 1882. Signed and dated bottom right: J. Bastien-Lepage/Damvillers/1882.

Scotland, Aberdeen Art Gallery.

Provenance. James Staats Forbes, n.d. Sir James Murray, ca. 1916-19. Murray sale, 29 April 1927, no. 26, purchased through Wallis & Sons for the Aberdeen Art Gallery, 1927.

A painting of a little girl walking to school with a satchel over her arm appears self-explanatory, and yet Jules Bastien-Lepage's *Allant à l'école* caused considerable confusion when it was exhibited at the Royal Academy in 1896 where it was mistakenly entitled *Portrait of Marie Bashkirtseff*.[1] At that time—six years after the publication of her *Journal*—the flamboyant Russian artist's infatuation for Bastien-Lepage was well known and this, no doubt, gave the painting false notoriety. Its mistaken title, however, did not deceive everyone who saw it. One reviewer, who regarded the picture as "an excellent piece of work," expressed his uncertainty by saying that "Whether, as the catalogue states, it is a portrait of Marie Bashkirtseff, is open to question, for it was painted when the artist was thirty-two years of age, and the girl is apparently not more than thirteen."[2] Though this same point was also made by the writer E. G. Halton in the *Studio* in 1906, the legend persisted, and the picture still carried a reference to Marie Bashkirtseff in its title when it appeared in the Murray sale in 1927.[3] While all reference to the Russian artist might now be deleted, the task of researching the picture's early history still remains.

Allant à l'école must undoubtedly be similar to another of Bastien-Lepage's works which was exhibited in London in 1882 and entitled *La Petite Coquette*. This work, which remains unlocated, was shown along with the larger *Pauvre Fauvette* (Glasgow City Art Gallery) at the United Arts Gallery, and they were both described by one reviewer as "works of astounding force. . . . They both represent a little girl in a hood (Is it the same little girl?), one arch and happy, with pink tassels on her hood, the other melancholy, and without any tassels. One at first sight appears to be pasted against a street, the other against a field; but it is only fair to say that the longer you look at his [Bastien-Lepage's] work the more atmosphere seems to come between his figures and his backgrounds."[4] Other reviewers confirm the points of contrast between these two canvases. There is never quite enough evidence, however, to prove that the unlocated *La Petite Coquette* and *Allant à l'école* are one and the same work.[5] Yet no other picture by Bastien-Lepage depicting a child wearing a hood with pink pom-poms has survived.[6]

Ultimately, it has to be admitted that André Theuriet's title *Petite Fille allant à l'école* is perfectly acceptable.[7] Pictures of children going to school were common enough [2, 87], and it seems likely that Bastien-Lepage would have discussed this aspect of village life with the writer Theuriet. They may even have decided that an illustration of the long winter marches to school would be appropriate for their joint publication, which was to be called *Les Mois rustiques*. Following Bastien-Lepage's death, Theuriet completed this project in collaboration with Léon Lhermitte, and when it was finally published in 1888, it contained a chapter on village childhood. According to Theuriet, formal education started at the age of eight and, while in the past it had been a semi-serious activity, "now that education has become obligatory, schools for boys and girls are taken more seriously and are regularly attended. From 8 o'clock in the morning, winter and summer alike, one finds the children from the hamlets and outlying farms of the district on the roads leading to the market town. Clad in clogs and stout hobnailed boots, the boys and girls trudge along noisily, with their text books and exercise books in folios under their arms."[8] Theuriet also observed the street urchins who scampered off noisily when the bell sounded, while girls like Bastien-Lepage's model, "so quiet and reserved, leave without making a great noise and cross themselves reverently as they pass the church."[9] Thus, the *Petite Fille*'s coyness might easily be equated with that of the *communiantes,* who were also such a popular subject at the time. Her hands are folded into the sleeves of her gown, imitating, no doubt, the attitude adopted by her devout instructress. Her walk assumes the air of a religious processional.

Bastien-Lepage's *infant* has none of the robustness and rugged health of the boys and girls in James Guthrie's *Schoolmates* (Museum of Fine Arts, Ghent). Yet Guthrie and Bastien-Lepage share a quality of observation which cannot be found in Marie Bashkirtseff's own depiction of schoolchildren, entitled *A Meeting*.[10] As a Naturalist painter, Guthrie provided an appropriate setting for his figures and did not lapse into narrative like the Russian artist, who retreated into the genre of "gamins" and "urchins" derived from the Dutch old masters. Thus, from the long shadows crossing the street in *Allant à l'école,* it is easy to determine that the young girl is making an early morning expedition. She is watched by an old man leaning on a stick, who stands in the doorway of one of the buildings in the background. Whether he is a *Mendiant* or a *Père Jacques* is uncertain. From the gutter of the building in which he has taken shelter fall trickles of rainwater which, together with the grim sky, indicate that a storm is passing.[11] Shafts of sunlight and bluish shadows

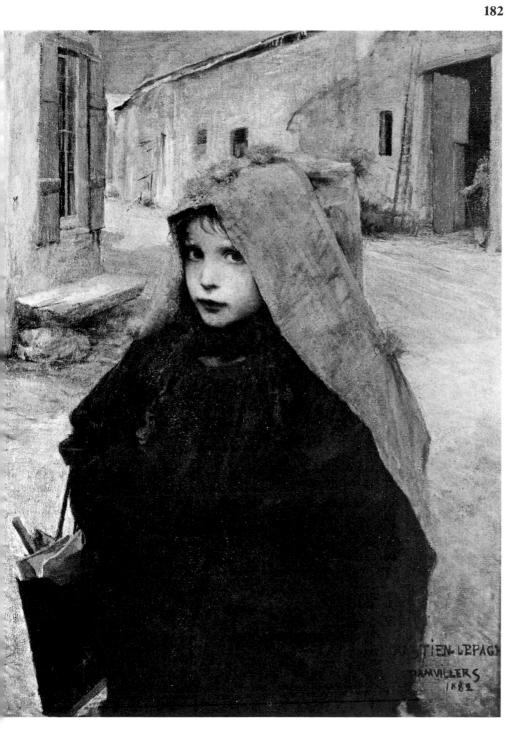

describe an interesting space around the girl. As in *Pas Mêche,* Bastien-Lepage makes use of diagonals that lead the eye up the canvas from the immediate foreground, but in this particular work there is more obvious depth and recession. Figure and setting relate as accurately to one another as if the artist had painted down to the girl's feet and then placed them literally in the space of the street. It is apparent that Bastien-Lepage carefully orchestrated the narrow range of chalky hues with which his setting has been realized, and they are concentrated in the blue blacks of the girl's tunic and the greenish brown of her hood. The artist must have thought a great deal about the way in which the sharp edge of the hood frames the child's face. It is painted very thickly with a square-stroke brush. Indeed, this paint is so thickly laid that it may cover an earlier, less satisfactory working.[12] The almost sculpted texture of a dull fabric partly conceals the delicate features of the blue-eyed schoolgirl. No doubt, Bastien-Lepage felt he must emphasize the fabric's angularity to distinguish his pretty young girl from the sacred, but sentimental sweetness of virgins and shepherdesses by William-Adolphe Bouguereau.[13] In such a comparison, justice must be done to Bastien-Lepage's accurate eye. The fact that he succeeds in expressing the demeanor of the child, that he conveys so much of her provincial *petit-bourgeois* personality in an everyday activity suggests that—for him—a picture of a little girl walking to school was motivated less by desire to appeal to his viewers than to accomplish this effect. K.Mc.

1. Marie Konstantinowna Bashkirtseff was born on 11 November 1860 at Gawronzi, near Poltawa in Russia. She was taught initially by her grandfather, before she embarked on a European tour at the age of ten. In 1877 she entered the atelier of Tony Robert-Fleury and, like many of the impressionable art students of her generation, was deeply affected by Bastien-Lepage's *Jeanne d'Arc* at the 1880 Salon. Marie confessed in her *Journal* that she had difficulty holding back tears, so powerful was the emotion aroused by the figure (entry for 30 April 1880). On 21 January 1882 Mme. Coquelin took her on a visit to Bastien-Lepage's studio where she and the artist met for the first time. Their relationship developed to such an extent that she confessed herself continually "preoccupied with Bastien-Lepage" (*Journal* entry for 24 February 1883), and the extent of her artistic reliance may be seen in *The Meeting* (1883 Salon, purchased by the state), in which a group of schoolboys are gathered in front of a wooden paling. Marie was distraught to hear the news of Bastien-Lepage's illness (*Journal* entry for 12 May 1884) and she reported his deterioration in her *Journal* during the last few months of her own life. Marie died on 31 October 1884, six weeks before Bastien-Lepage's death.

2. *Graphic,* 11 January 1896, p. 39.

3. E. G. Halton, "The Staats Forbes Collection," *Studio* 36 (1906): 221, describes the picture thus: "the so-called *Marie Bashkirtseff* by Bastien-

Lepage is an interesting picture. It is impossible to connect this child dressed in the garb of a peasant . . . with the accomplished and famous young lady who was one of the central figures of Parisian society.'' By 1927 these points were acknowledged by the catalogers of the Murray sale, who entitled the picture *Going to School: Marie Bashkirtscheff* [sic] *When a Girl.* Even supposing that the picture had been painted from a childhood photograph of Marie, it is unlikely that she would have failed to mention the occurrence in her *Journal.* A *Head of a Girl (Marie Bashkirtseff),* 16-1/2 x 13-1/2 inches by Bastien-Lepage, appeared in a sale at Christie's on 7 February 1930, but remains unlocated.

4. *Academy,* 6 May 1882, p. 328.

5. For example, *Art Journal,* 1882, p. 221, liked the *Coquette's* ''expressiveness,'' while ''Art Notes,'' p. xxx, found it ''more pleasing'' but ''feebler'' than *Pauvre Fauvette.* Purely because they both represent little girls wearing sackcloth hoods, the Aberdeen and Glasgow paintings were compared by Halton, ''Staats Forbes Collection,'' p. 221, when he expressed his preference for the ''pathetic'' *Pauvre Fauvette,* concluding that the girl in the Aberdeen picture ''is not a child of the soil, but rather a daughter of the village on her way to school.'' It should be noted that both the Aberdeen and Glasgow paintings and the Edinburgh *Pas Mêche* had been owned at various times by James Staats Forbes, but since Forbes was a dealer-collector it is difficult to establish when pictures entered and left his collection. *Allant à l'ecole* passed to Sir James Murray at one of three sales between 1916 and 1919, at which Staats Forbes's collection was dispersed.

6. One might dispute the use of the word ''tassel'' by the *Academy* reviewer (see n. 4) to describe the tufts on the hood of the *Petite Fille;* it must be stated, however, that Victorian reviewers sometimes used words casually. One final note on the original companion of *Pauvre Fauvette* is that a picture described as *La Coquette* (1882), owned by E. Grey, appeared in three Christie's sales between 1882 and 1885, being ''bought-in'' on all three occasions. After this date the title disappeared.

7. Theuriet, ''Jules Bastien Lepage, l'homme et l'artiste,'' p. 822.

8. André Theuriet, *La Vie rustique* (Paris 1888), pp. 199-200: ''maintenant que l'instruction est devenue obligatoire, les écoles de filles et de garçons sont plus sérieusement et plus assidûment fréquentées. Dès huit heures du matin, hiver comme été, on rencontre, sur les chemins qui mènent au bourg, les enfants des hameaux et des fermes éparpillés sur le territoire de la commune. Chaussés de sabots ou de gros souliers à clous les garçons et les filles cheminent bruyamment, avec leurs livres et leurs cahiers enfermés dans des cartons ou portés sous le bras.''

9. Ibid., p. 201: ''plus paisibles ou plus réservées déjà, sortent sans mener grand bruit et se signent dévotement en passant devant l'église.''

10. Between 1875 and 1885, communicants were painted by Bastien-Lepage, Jules Breton, Dagnan-Bouveret, James Charles, Weldon Hawkins, P. R. Morris, and many others. One could produce an equally long list of painters attracted to the subject of children going to school during this period. That it was an accepted part of the rustic canon is confirmed by P. G. Hamerton, *The Present State of the Fine Arts in France* (London, 1892), p. 46, who concurs with Theuriet by observing, ''the

country child had a few years of blissful existence, light work and much play, with much enjoyment of nature—not aesthetic, but after his own fashion. This has lately been interfered with by compulsory education and long marches to school.'' For an excellent survey of the state of primary education in the French provinces during this period, see Theodore Zeldin, *France: 1848-1945,* vol. 2, *Intellect, Taste and Anxiety* (Oxford: Clarendon Press, 1977), pp. 139-204.

11. Alternatively, these touches of white could be read as icicles. Cartwright, *Jules Bastien-Lepage,* p. 57, no doubt recalling the cold light and the girl's heavy clothing, goes so far as to describe this as a ''snowy winter's morning.''

12. Close scrutiny of the pentimenti around the crown and outer edge of the hood reveal that it has been painted on top of strokes that make up the receding street.

13. Feldman, ''Life and Work,'' p. 175, compares this picture to the ''smooth delicacy'' of Bouguereau and follows Halton in seeing this as a bourgeois pendant to *Pauvre Fauvette.* While this picture might seem to justify the use of the term *juste-milieu,* its application should not detract from Bastien-Lepage's calculated intentions in the work. For Bastien-Lepage, this child's circumstances are as unique as those of *Pauvre Fauvette;* she is not the product of an artistic treadmill.

Exhibited
1896, London: Royal Academy Old Masters Exhibition (listed as *Portrait of Marie Bashkirtseff*).
1949, Royal Scottish Academy, cat. no. 271.

Published
Magazine of Art XIX (1896): 163.

Théodule Ribot

183 *The Old Women of Brest (Vieilles Femmes de Brest)*
Charcoal drawing, 7-1/2 x 6-1/4 inches (19 x 16 cm.). Signed lower right: t. Ribot.
Cognac, Musée Municipal.
Provenance. Given to the Museum in 1892 by the Bernheim Gallery, Paris.

During the mid-1870s, Théodule Ribot exhibited paintings at the Paris Salon inspired by trips to Brittany.[1] Attracted to this region by other Realists (e.g., François Bonvin), Ribot completed paintings and drawings of peasant women seated on the steps of buildings on market day. An 1884 painting—now lost—that depicted two elderly women in regional costume, one holding flowers in her

183

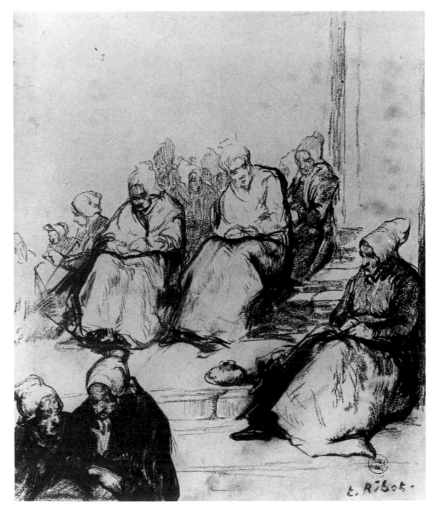

lap, was dedicated to Ribot's friend and fervent supporter, the art critic Louis de Fourcaud.[2]

Whether the drawing *The Old Women of Brest* was once owned by Fourcaud is not known, although it was reproduced in his volume on Ribot published in 1885. The drawing was presented by The Bernheim Gallery (the Parisian establishment that promoted Ribot's later works) to the Cognac municipal collection when it opened in 1892.

While it is not known how many drawings Ribot completed during trips to Brittany, this example suggests a deepening interest in studying provincial types. The thickly applied charcoal captures the craggy features of the old women in the foreground. The evidence of caricature here—leaving some forms incomplete and exaggerating the pose of others—reveals a development of intentional distortion by Ribot that owes much to the strong influence of the more innovative works of Daumier.

1. Raoul Sertat, Introduction to *Exposition Th. Ribot, au Palais National de l'Ecole des Beaux-Arts* (Paris, 1892), p. 16, notes that Ribot left for Brittany before 1875.
2. A photograph of this painting is in the Wildenstein archives, Paris.

Published

Louis de Fourcaud, *Théodule Ribot: Sa Vie et ses oeuvres* (Paris, 1885), p. 20, repr.

Pierre Edouard Frère

184 *In Front of the School*
Oil on panel, 21-1/2 x 18 inches (54 x 45.2 cm.).
Signed and dated lower left: Edouard Frère 1881.
Sheffield City Art Galleries.
Provenance. Presented to the Art Gallery by J. N. Mappin.

Edouard Frère established ties with a number of younger artists who worked near the village of Ecouen. In time, the region became an artists' colony, and Frère by the early 1860s emerged as a local master whose canvases influenced such followers as George H. Boughton (1833-1905), an English-born artist trained in America who eventually settled in London.[1] Frère gave friendly advice to his young protégés, recommending their work to art dealers, who, in turn, recognized a ready market for such small genre scenes.[2] Frère also visited his students after they left Ecouen to settle in Paris or London; it was Boughton's London flat that Frère used when he visited England to offer his paintings to art dealers there. In addition to these later visits, Frère originally received support from the art critic John Ruskin (1851), so that it is not surprising that a number of his paintings are found in English and Scottish collections.[3]

The panel *In Front of the School,* which Frère exhibited at the Royal Academy in 1881, continues a theme the artist popu-

larized.[4] He frequently depicted children going to school [2] or at play outside before the school day began. His interest in childhood activity remained throughout his career, even well into the 1880s when many of his former students had become widely recognized for using similar themes.

1. W. D. Conway, "Edouard Frère, and Sympathetic Art in France," *Harper's New Monthly Magazine* XLIII (November 1871): 801-14. A work by Boughton, *The Little Helper,* is reproduced on page 808. Even though Boughton was born and died in England, he is listed as an American painter because of his early training in the United States. Records show that he worked with Frère beginning in 1860. For further information, see Sidney Colvin, "English Painters, George H. Boughton," *Portfolio,* 1871, pp. 67-70.

2. Henry Bacon, "Edouard Frère," *Art Journal,* November 1886, p. 323. A list of the painters who worked in the Ecouen region or who studied with Frère has never been compiled.
3. A small panel is located in the Aberdeen Art Gallery, Scotland.
4. Frère was a regular contributor to exhibitions at the Royal Academy between 1868 and 1885, indicating the ready market for his work in Great Britain.

Exhibited

1881, Royal Academy, cat. no. 1429.
1967, Nottingham University (England), Fine Arts Department.

184

Jules Breton

185 *Woman at the Spinning Wheel*
(Study for *The Last Ray
of Sunshine*)
(Etude pour *Le Dernier Rayon*)
Charcoal drawing, 20-1/4 x 13-3/4 inches (51 x 35 cm.), ca. 1884. Signed lower right: Jules Breton. France, Private Collection.

Spinning was one of the "cottage industries" that had persisted in the provinces for generations. Even the older women who were no longer able to work in the fields thus continued to contribute to the well-being of the family, either by providing clothing or income from the sale of the yarn itself. *Woman at the Spinning Wheel*, the image of the older woman that Jules Breton depicted seated in the dooryard busy at her wheel until the "last rays of sunshine," was a common enough scene in Artois, for it was a way of life that continued in the provinces well into the nineteenth century, virtually without change.

Even late in his career, Breton maintained the same methods of working as in his earliest compositions. He still prepared a series of drawings from life of individual figures, which he then used as the basis for preliminary oil sketches.[1] After he studied and portrayed each figure carefully—both in black and white and in color—he was ready to sketch the entire composition, integrating the many individual scenes into the whole. The preliminary charcoal sketch of the local model Colette that was begun 24 March 1885 documents one of Breton's preparatory efforts for the oil canvas *The Last Ray of Sunshine: Evening in an Artois Village*. The oil painting, which he completed in March 1885,[2] appeared in the 1885 Salon and later reached America through the joint efforts of Goupil and Company in Paris and Knoedler and Company of New York.[3]

1. Elodie recorded the exact date when this drawing was begun, early in the morning on 24 March 1884. See Diary of Elodie Breton, March 1884, now in the possession of the Breton descendants, France.

2. Ibid.

3. The painting remained in the collection of the Walker Art Center until 1970, when it was sold at auction.

Published

Marius Vachon, *Jules Breton* (Paris, 1899), repr. p. 87.

185

186

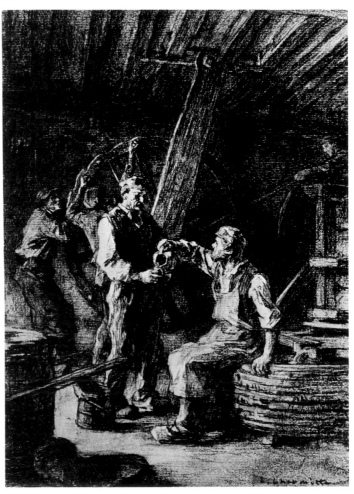

Léon Lhermitte

186 *The Press House*
(Les Tonneliers)

Carbon pencil on paper, 14-3/4 x 10-3/4 inches (37 x 27 cm.). Signed lower right: L. Lhermitte. Paris, Private Collection.

Léon Lhermitte's knowledge of rural life, nurtured by his early years at Mont-Saint-Père, served as a fundamental guide when he was commissioned to prepare the illustrations for André Theuriet's book *La Vie rustique* in 1886. Theuriet ambitiously discussed numerous activities of provincial life, ranging from the potato and wheat harvest and the plowing and sowing of the fields, to the making of bread and the preparation of wine. But for his text to be as instructive as possible, he needed to have illustrations accompanying the commentary. Thus, he formed a close relationship with Lhermitte, who prepared a series of charcoal drawings, such as *The Press House,* which were engraved as illustrations once the book was published in 1888.

By 1887, Lhermitte had completed enough of the drawings to enable the publisher, H. Launette and Company, to hold an exhibition from 25 to 30 November in their office at 197 Boulevard St. Germain. This showing, both as advance publicity for the book and as a one-man exhibition of Lhermitte's drawings, was successful. Lhermitte's Exposition des fusains et dessins showed the artist could work closely with a writer and a publisher to create informative images that also could stand on their own as works of art.[1]

In *The Press House,* Lhermitte depicted men working in shade, or perhaps at night, crushing grapes by turning the large windlass shown in the background. The must trickles into a huge vat as two workmen pause to taste it. While focusing on the activities of rural wine makers in the dusky press house, Lhermitte revealed his mastery of interior light. Clear in its contrasts, Lhermitte's drawing was easily adapted for engraving.

1. These drawings are widely dispersed in many private collections and museums.

Exhibited

1887, Paris: Exposition des fusains et dessins de Léon Lhermitte.

Published

Theuriet, *La Vie rustique,* engraving no. 17, between pp. 106-7.
Mary Michele Hamel, "A French Artist: Léon Lhermitte (1844-1924)" (Ph.D. diss., Washington University, St. Louis, May 1974), cat. no. 127.

Guillaume Fouace

187 *A Baptism at Réville*
(Baptême à Réville)

Oil on canvas, 71-1/2 x 49-3/4 inches (180 x 125 cm.). Signed lower right: G. Fouace.
Réville, Eglise communale de Réville.

Provenance. Mrs. Guillaume Fouace Collection. Gift of Mrs. Fouace to the town of Réville, 23 February 1919.

Guillaume Fouace not only used models from his native village of Réville; he also situated several genre scenes in buildings in the town. In *A Baptism at Réville,* the church of Réville functions as a backdrop for the young choirboy holding the prayer book overhead for the old village priest reading the service. In the background stand the godparents and the proud mother in a white

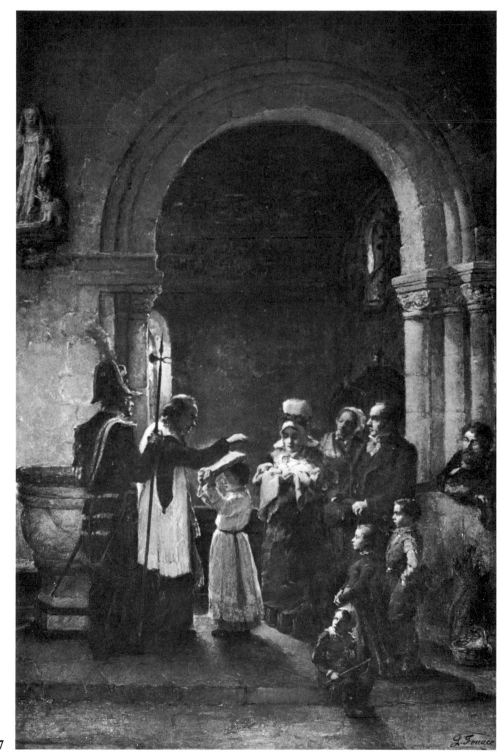

187

bonnet holding her infant. A Swiss guard and three village children witness the ceremony. At the right, standing apart, is an older man, perhaps a village fisherman, but more likely a portrait of the artist.

Fouace's presence in the church might explain why his wife kept this painting in her private collection before donating the work to the church in Réville. Another possibility is that the painting might commemorate the baptism of Fouace's first child with his god-parents, his wife's parents who lived nearby.

Exhibited
1895, Paris: Exposition posthume des oeuvres de Guillaume Fouace à l'Ecole Nationale des Beaux-Arts, cat. no. 224. Introductory essay by Gustave Larroumet.

Alexis Vollon

188 *Young Boy with a Bowl*
 (L'Enfant à l'écuelle)
Oil on canvas, 57-7/8 x 48 inches (147 x 122 cm.). Signed and dated lower right: Alexis Vollon 1901 (?).
Paris, Ministère des Finances.
Provenance. Deposited at the Administration Centrale des Finances by the Direction des Musées de France.

Even though he was trained by his father, Alexis Vollon's earliest style reflects much of a traditional Realism that suggests the influence of genre scenes by Chardin[1] as well as an awareness of the works of Jules Bastien-Lepage. The romantic mood conveyed in many of his early compositions, however, suggests the influence of his father. *Young Boy with a Bowl,* which was probably shown at a Parisian Salon, is a meticulous study of a young workman enjoying a simple meal.[2] A mood of melancholic detachment is suggested by the boy's posture and pose, for his spoon rests over his bowl and he is lost in his own thoughts. The precision of Alexis Vollon's Realism is emphasized not only by his subtle use of light, but also by the descriptive accuracy of his textures, as seen in the glaze of the ceramic bowl contrasted with the grain of the wooden tabletop. Although a turn-of-the-century composition, the canvas is painted in the limited tonal range—essentially tans and browns—that confines Alexis Vollon's image to the Realist tradition.[3]

1. Alexis Vollon's close relationship with his father is documented in a series of letters dating from the early 1880s, now in the Institut Néerlandais, Paris. Alexis Vollon was also a collector of works by Chardin. For further reference see Pierre Rosenberg, *Chardin* (Paris: Editions de la Réunion des Musées Nationaux, 1979).

2. Little information is available on this composition. A second painting, *Breton Interior* (1903), is also found in the Ministère des Finances, Paris. Here the quality of Vollon's figures and his smooth painting style suggest the academicism of Bouguereau.

3. Vollon continued exhibiting in the Salons of the Société des Artistes Français until the 1930s. He died in 1945.

188

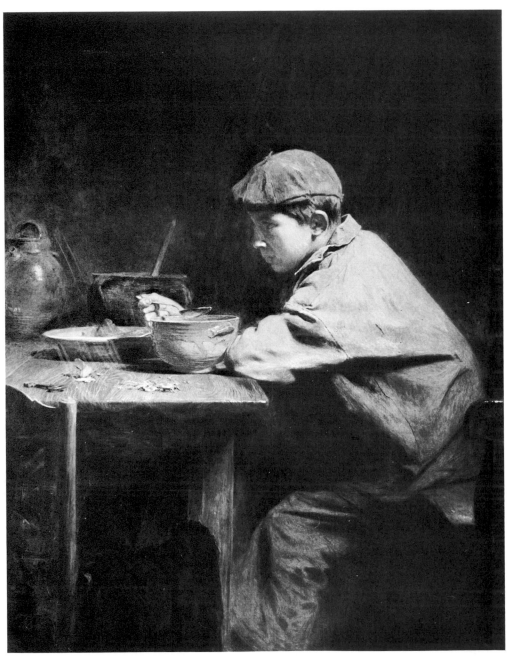

URBAN LABOR

Victor Gabriel Gilbert

189 *A Corner of the Fish Market: Morning (Un Coin de la Halle aux poissons, le matin)*

Oil on canvas, 71-1/4 x 55-1/8 inches (181 x 140 cm.). Signed and dated bottom right: Victor Gilbert/1880.

Lille, Musée des Beaux-Arts.

Provenance. Purchased by the state at the 1880 Salon and sent to Lille.

189

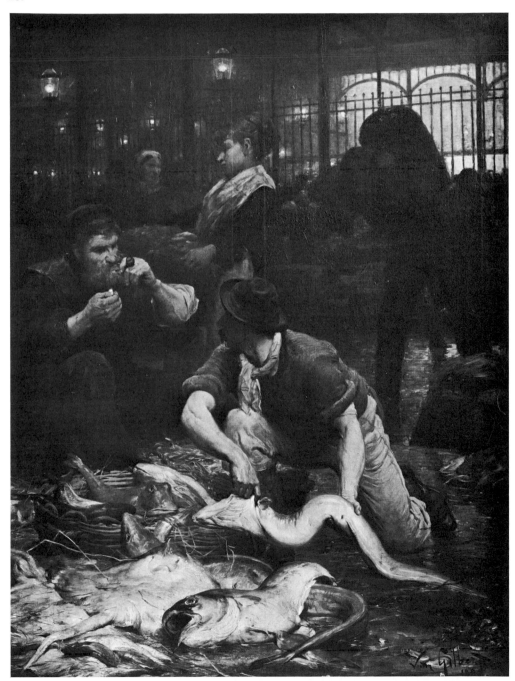

At the 1880 Salon Victor Gilbert achieved a major triumph when he received a second-class medal and the state purchased his painting *Un Coin de la Halle aux poissons, le matin* for 2500 francs.[1] Emerging in the early 1880s as the primary Realist painter to record the Parisian marketplace, Gilbert had been interested in the theme of the street vendor and the market for several years. In selecting this theme Gilbert may have been inspired by the career of François Bonvin, who for many years served as meat inspector in les Halles to earn a living, as well as by the long tradition of the marketplace as a lively center of urban life.

Since Gilbert was familiar with Naturalist literature, specifically with the novels of Emile Zola, he was aware of the author's view of les Halles as a symbol of the dynamism and energy of Paris.[2] The variety of odors and the differing social types also inspired Gilbert to paint a series of large canvases based on different sections of les Halles. The fish market, one of his first themes, recorded the traditional sorting and selling of fish in an open market well established since the eighteenth century. Fish were transported daily from the coast to Paris and arrived in the early morning at les Halles. Here inspectors examined each basket, spreading the catch on the ground and checking each fish to assure freshness. Then the fish were placed in baskets to be auctioned to retail merchants eagerly awaiting their daily supply.

An early record of this activity is found in a lithograph published in the 1820s illustrating the *Nouveau Marché au poisson* as part of the *Tableaux de Paris*.[3] As in Gilbert's painting, the day's delivery is spread out on the ground so that three inspectors, one a woman, can determine if the fish meet the standards established for public auction (Figure 189a). At the left, a tray of fish already approved is being carried to the bidding area where fishwomen are gathered.

In Gilbert's painting, rather than recording the bidding process itself, Gilbert focuses on two men appraising the catch spread before them.[4] Conversation determines if the fish are good enough to be carted to the nearby auction area as the woman in the middle ground is doing. At the right, in front of the glare of lights, another

189a Lithograph of *Nouveau Marché au poisson* from *Tableaux de Paris*.

189b Victor Gilbert, Oil sketch for *Fish Market: Morning,* oil on canvas.

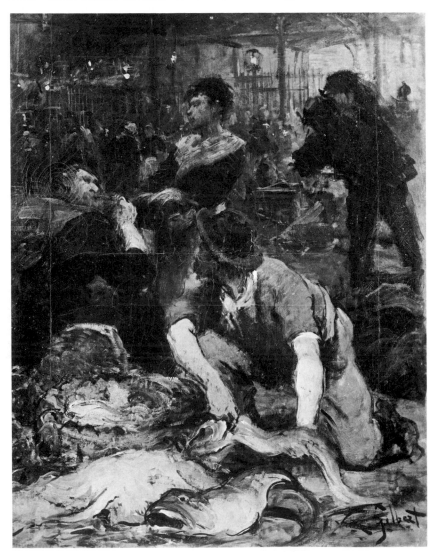

workman is bringing a basket for the inspectors to check. Besides Victor Gilbert's canvas, other works exhibited in the 1880s were also based on the fish market at les Halles. At the 1881 Salon, Norbert Goeneutte exhibited *La Criée,* which depicted the market interior after the fish were approved for sale.[5] By completing the cycle originated by Gilbert, Goeneutte returned to the theme used in the lithograph published in the 1820s.

Gilbert's large-scale painting proved one of the most impressive examples of Naturalism at the 1880 Salon. Gilbert based his painting style on his study of the early masters of Realism. His color range in both a preliminary sketch (Figure 189b) and the final composition was dark, mirroring the muted tones of Bonvin—his acknowledged, first Realist master. A still life similar to those by Antoine Vollon is also suggested in the arrangement of the fish,[6] although Gilbert painted the foreground in lighter tones. The ambience, caused by the early morning light, is accentuated by Gilbert's use of light sources within the composition, such as the street lamps and the interior of another market in the rear. In later compositions Gilbert lightened his color range throughout, modifying his style under the influence of the Impressionists.

1. See ''Un Coin de la Halle aux poissons,'' 23 June 1880, dossier Victor Gilbert, F 21/221, Archives Nationales. Gilbert may have initiated the official request that led to the state acquiring his painting.

2. Zola's novel, *Le Ventre de Paris,* which examined les Halles, was first published in 1873.

3. For further information see Jean Henri Marlet, *Tableaux de Paris* (Paris: Chez Marlet, 1821-24 [?]).The *Marché au poisson* was considered a *tableau de Paris* and hence had a long tradition in the pictorial arts with which many painters at the end of the century were undoubtedly familiar.

4. For a discussion of the different types of men working at the fish market at les Halles, see Maxime du Camp, *Paris: Ses Organes, ses fonctions et sa vie* (Paris: Librairie Hachette et Cie, 1874), pp. 167-71.

5. For a reproduction of this painting see *Album artistique et biographique, Salon 1881* (Paris, 1881), unpaginated. This painting has not been located. It was listed as no. 1011 in the official Salon catalog.

6. Since Gilbert began his career as a painter of still life he would have been familiar with the major contemporary still-life painters, including Antoine Vollon.

Exhibited

1880, Paris: Salon, cat. no. 1609.
1883, Paris: Exposition Nationale.

Henri Gervex

190 Preliminary Sketch for *Quai de la Villette à Paris*

Oil sketch on canvas, 45-5/8 x 28 inches (116 x 71 cm.). Signed and dated lower left: H. Gervex. 82. Lille, Musée des Beaux-Arts.

Provenance. Given to the Museum by Mme. R. Trachet, 1949.

Between the rejection of Henri Gervex's *Rolla* by the 1878 Salon and the completion of his large-scale canvas of *Dr. Péan opérant à l'hôpital Saint-Louis,* Gervex received a commission to do a series of paintings for the Salle de Mariage of the town hall of the Nineteenth Arrondissement in Paris.[1] The commission's conditions stipulated that Gervex should include some scenes appropriate to that section of Paris, such as the "town dock" and other themes reflecting the activities occurring within the building itself. While the history of social-naturalist images in public buildings in France remains to be researched, Gervex's method indicates how other painters during the Third Republic reacted to the opportunity to decorate public buildings with scenes that the people entering could easily understand.

Between 1881 and 1883 Gervex completed the project with the assistance of E. Blan-

190a François del Pech after Carle Vernet, *Coal Hauler,* colored lithograph, undated.

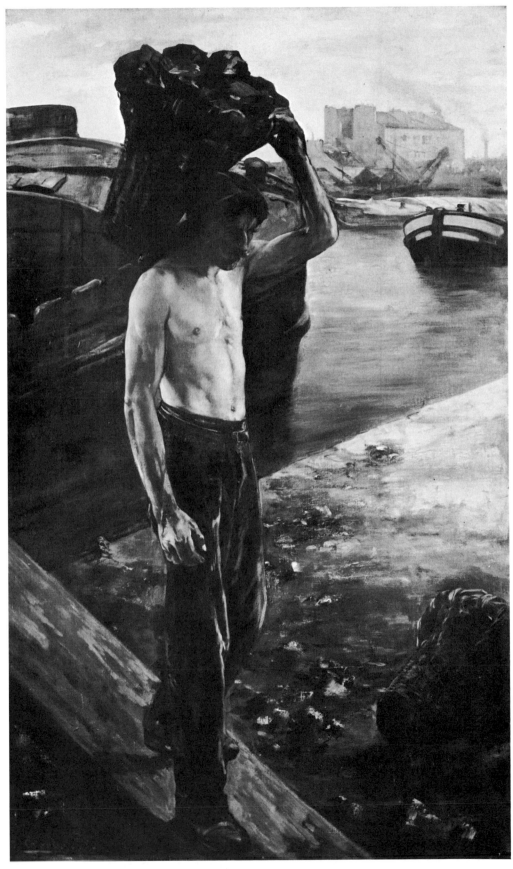

219

chon, who did some subsidiary paintings for the Salle de Mariage. Gervex's first painting recorded a marriage ceremony taking place inside the town hall in the very room he was commissioned to paint. Thus, using illusionism, Gervex painted the same official desk and chairs in his canvas that were actually found in the room. The marriage itself was that of the son of Mathurin Moreau, the mayor of the Nineteenth Arrondissement from 1879 to 1912 and the chief organizer of the plan to hire an artist of Gervex's stature to paint scenes in the public building.[2] Recognizing Moreau's importance to this scheme of patronage, Gervex imagined the guests attending the marriage ceremony to include Emile Zola, the staunch supporter of Naturalism; Camille Pelletan, an important journalist and Minister of the Marine; Edward VII, then Prince of Wales, who was placed next to Emile Zola; and the future Czar of Russia, Nicholas II. Mathurin Moreau, who was also a practicing sculptor, was depicted reading the marriage ceremony from his position at his desk in the Salle de Mariage.[3]

Other scenes included the *Salle de l'Assistance* (1883), in which the foreground treatment of a young girl in tattered clothes, a maid with a young child, and an old woman receives as much attention as the depiction of the cold, wintry day, reinforcing the bleakness of these figures' lives and the significance of public assistance for the poor and the elderly. The remaining paintings in the series, *The Market* and the *Quai de la Villette,* stressed activities occurring within this section of Paris over which the mayor of the Nineteenth Arrondissement presided. The entire series presented social realism recording the glories of the local municipality and made the Nineteenth Arrondissement's town hall one of the most decorated in Paris.

In preparing his large, mural-like wall canvas of the *Quai de la Villette,* Gervex prepared drawings (Private Collection, France) and the sketch of a workman unloading coal from a barge in the canal. The grayed tonal painting was in keeping with the autumn day when Gervex visualized this man working on the canal. While Gervex's naturalism is based on academic models posed in a contemporary urban scene, his use of a coal carrier as a major urban figure can be traced back to popular lithographs from the 1820s (Figure 190a).[4] Like Victor Gilbert, Gervex represents a Naturalist painter who returned to traditional imagery as a source for his work.

In all the murals, Gervex used few bright colors, relying on the themes to give the viewer a sense of place, actuality, and well-being, thereby underscoring the spirit of democracy which dominated the Third Republic and that led a municipal government to this expression of interest in the productivity of its people and the welfare of the underprivileged.

191

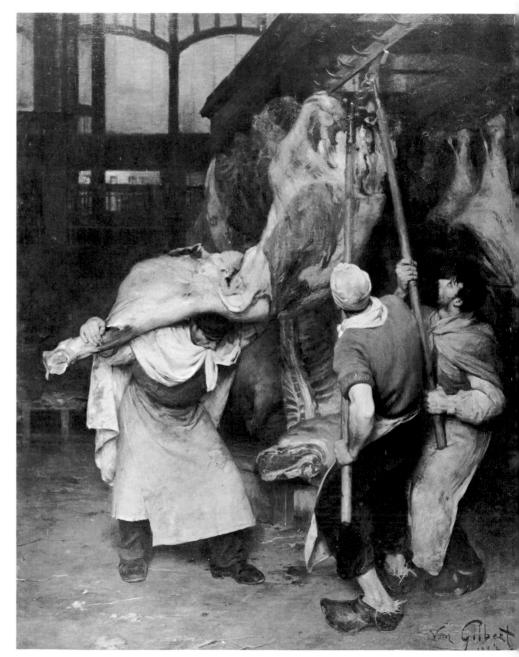

1. A competition was held to decorate the Mairie and other buildings in Paris. No papers could be located in the archives of the municipal government.

2. Gervex, along with his assistant Blanchon, received 57,000 francs. Information supplied by the descendants of Henri Gervex in discussions with the author in Paris (1979).

3. Naturally these distinguished guests did not attend the marriage of Moreau's son, but they were becoming Gervex's patrons.

4. See Carle Vernet, *Cris de Paris, dessinés d'après nature* (Paris: Chez Delpech, 182 [?]).

Exhibited

1951, Lille: Growth of the Collections, cat. no. 23.

Victor Gabriel Gilbert

191 *Meat Haulers*
(Porteurs de viande)

Oil on canvas, 78-3/4 x 62-3/16 inches (200 x 158 cm.). Signed and dated lower right: Victor Gilbert/1884.

Bordeaux, Musée et Galerie des Beaux-Arts.

Provenance. Purchased by the state at the 1884 Salon and sent to Bordeaux in 1885.

Victor Gilbert's ability to capture different work activities and social types is another aspect of his style. The large canvas *Meat Haulers* shows two men in les Halles hooking a large side of beef to a rack while a fellow worker supports the slab of meat on his back. Straining at their work, struggling with their hooks, the swarthy, muscular men provide a sense of the tension and energy expended in moving the huge carcasses. Dressed in traditional long white aprons, the men are immersed in a job which Gilbert depicted as another episode from daily Parisian life.

Gilbert's frequent visits to les Halles enabled him to witness this activity. Stressing the actuality of the scene, his visual description helped make him the renowned master of les Halles by 1885. Following the 1884 Salon, the state purchased the painting for 1800 francs and sent it to the Bordeaux museum, where it was regarded as a major work of contemporary Realism.[1]

1. See "Porteurs de viande," 11 June 1884, dossier Victor Gilbert, F 21/2083, Archives Nationales.

Published

Catalogue et estimation des tableaux du Musée de la Ville de Bordeaux (Bordeaux, n.d.), p. 25.
E. Vallet, *Nouvelle Édition du catalogue* (Bordeaux, 1894), p. 170, cat. no. 586.
P. Galibert, *Chefs-d'oeuvre du Musée de Bordeaux* (Bordeaux, 1906), pl. 66.
D. Alaux, *Musée de Peinture de Bordeaux,* cat. (Bordeaux, 1910), p. 85, no. 447.
Ch. Manciet, *Le Musée de Bordeaux* (Paris, 1931), p. 14.
Musée de Peinture et de Sculpture de Bordeaux (Bellegarde, 1933), p. 72, cat. no. 267.

Charles Paul Renouard

192 *Out of Work*
(Sans Travail)

Pencil with black ink wash and touches of black chalk or crayon, 12-3/4 x 19 inches (32.2 x 48.3 cm.). Signed and dedicated lower right: à Monsieur Depaepe/souvenirs affectueux/P. Renouard.

New York, Private Collection.

Provenance. Fischer-Kiener Gallery, Paris.

The drawing *Sans Travail,* reproduced as a wood engraving by Albert Bellenger, appeared in the 25 October 1884 issue of *L'Illustration* with the caption: "La Crise industrielle à Lyon" and the subheading "Dessin d'après nature de M. Renouard, envoyé spécial de *L'Illustration.*" *Sans Travail (Out of Work)* was the second in a series of three eyewitness reports by Charles Renouard on the contemporary crisis in the weaving industry of Lyons. The first of the series, *Un Canut à son métier (A Weaver at His Loom),* had appeared in the 18 October issue of the same journal; the third, *Une Réunion d'ouvriers aux Folies-Bergère (A Meeting of Workers at the Folies-Bergère),* did not appear until 15 November.

Sans Travail represents a scene of enforced idleness in one of the domestic workshops that were the individual units of Lyon's important weaving industry. Fairly large in scale, the drawing is rich in the type of graphic detail that seems to guarantee documentary accuracy, as well as lending itself admirably to the medium of the wood engraving. It is dedicated in the lower right-hand corner to a "Monsieur Depaepe." This is probably César de Paepe, a Flemish printer and prominent socialist who founded the Belgian Labor Party in 1885. In 1884, the year Renouard completed this drawing, de Paepe had signed an important manifesto in praise of Belgian republicanism.

The scene depicted in Renouard's drawing, which was much admired by Vincent van Gogh in a letter of 1885, would seem to represent the head of the workshop surrounded by members of his family, with one of the *compagnons,* or hired laborers who assisted in the home workshops of the weavers, to the left of the seated old man. The text which accompanied the published drawing was fairly explicit about the situation depicted: "No work anywhere, and the scene, drawn from nature, which our engraving represents, is to be seen on almost every floor of the houses of the populous quarters of the city, which is being so sorely tried. . . . We are in a poor room where a whole family of old weavers live: the father, the mother and the widowed daughter with her child, a little girl. . . . No more resources; soon no more bread. . . . To think that the house in which this family lives has 370 windows, that each of these windows illuminates a room, and that in each room . . . a scene like this is taking place!" L.N.

192

Exhibited
1977, Paris, Jacques Fischer-Chantal Kiener: Visages du Dix-Neuvième Siècle.

Published
Linda Nochlin, ''Van Gogh, Renouard and the Weavers' Crisis in Lyon: The Status of a Social Issue in the Art of the Later 19th Century,'' *Essays in Honor of H. W. Janson* (New York: Prentice-Hall, forthcoming).

Jules Adler

193 *An Atelier for the Cutting of False Diamonds at Pré-Saint-Gervais (Intérieur d'usine)*
Oil on canvas, 18-1/4 x 21-1/4 inches (46.5 x 54 cm.). Signed and dated lower right: Jules Adler.93.
Bayeux, Musée Baron Gérard.
Provenance. Given to the Museum by Baron Gérard in 1898.

Jules Adler was among the later Realist painters who concentrated on the life of the urban poor. In many canvases exhibited at Salons in the 1890s, Adler examined the plight of workers exhausted by continual misery. He also recorded the monotonous activities of workers in small factory shops.

An Atelier for the Cutting of False Diamonds shows two women seated on wooden benches at a low table, cutting stones for use in costume jewelry. These women, using mass production techniques, are earning money for their families.[1] The painting reflects the increasing reliance on mechanization. Adler's use of pastel hues suggests the influence of Impressionist painting, which enabled artists to use a more delicate range of colors even for scenes documenting urban work.

1. The use of women in factories often weakened the family unit. Women were favored over men because they did not have to be paid as much. For further information see Friedrich Engels, *The Condition of the Working Class in England* (1844; reprint ed., Moscow: Progress Publishers, 1973), pp. 185 ff. Although published in 1844, it outlines conditions which persisted throughout the century.

Exhibited
1894, Paris: Salon, no. 7.

RUSTIC ACTIVITY

Léon Lhermitte

194 *Oxen Plowing*
Oil on canvas, 23-5/8 x 40-1/2 inches (60 x 102.9 cm.). Signed lower right: Léon Lhermitte.
Glasgow Art Gallery and Museum.
Provenance. J. J. C. sale, Hôtel Drouot, Paris, 31 March 1911, cat. no. 28. Sale, Galerie Georges Petit, Paris, 4-5 December 1918, cat. no. 85. Eugene Cremetti (art dealer), London. The Reverend H. G. R. Hay-Boyd, Bequest, 1941.

One of the traditional tasks of rustic life was the preparation of fields. As a boy, Léon Lhermitte often witnessed oxen pulling a plow across fields under low-lying clouds, and he relied upon his memory as a starting point when he painted *Oxen Plowing,* a work which conveyed the continuous, timeless quality of rural labor.

Possibly inspired by earlier Barbizon painters such as Rosa Bonheur [53] or Constant Troyon [54], Lhermitte captured the solemnity of the activity by posing his lonely group against a stark, sweeping plain. The furrows cut into the earth by the plow are the only change in the rolling terrain. The mood of the composition is dour, even melancholy. The accuracy of Lhermitte's understanding of this traditional labor scene is revealed in his ability to convey the slow, stately rhythm of the oxen which permitted the blade of the plow to cut the soil in even furrows.[1] The team of animals were kept in unison under the prodding of the cowherd and the direction of the plowman surveying the opened furrows.

Lhermitte's realism is evident not only in the way he caught the attentiveness of the field workers and the methodical pace of the animals but also in smaller details. The cut earth exhibits a rich, humid quality, and the flank of the lighter oxen is caked with the newly turned earth. This image documents the affinity of workers and animals to the land they till.

1. For a description of this activity see André Theuriet, *La Vie rustique* (Paris: H. Launette and Cie, 1888), pp. 44-47.

Exhibited
1872, London: Royal Academy, cat. no. 27.
Possibly 1901, London: Lhermitte at the Goupil Gallery, cat. no. 73.

Published
Mary Michele Hamel, ''A French Artist: Léon Lhermitte, 1844-1925'' (Ph.D. diss., Washington University, St. Louis, 1974), p. 23, cat. no. 20; p. 34, n. 43.

193

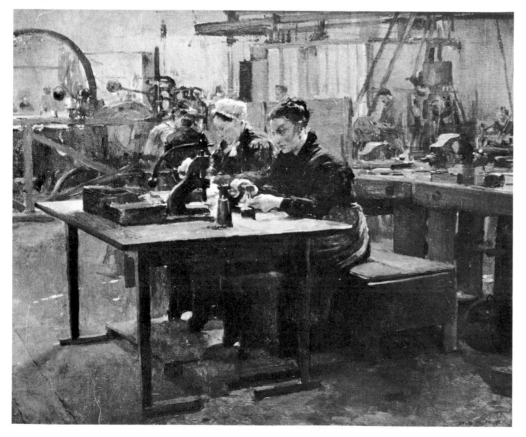

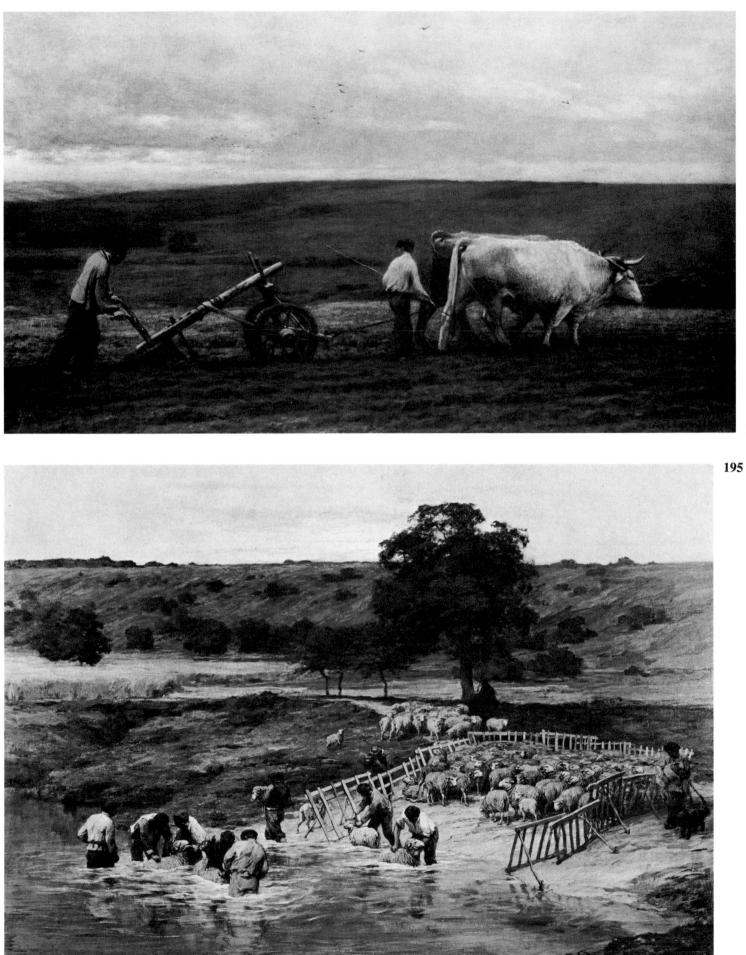

194

195

Léon Lhermitte

195 *Sheep Washing*

Oil on canvas, 33-1/2 x 46-1/2 inches (85.9 x 118 cm.). Signed lower left: L. Lhermitte.

Aberdeen Art Gallery.

Provenance. Hilton Philipson Collection. Sale, Christie's, London, 14 February 1947, cat. no. 27. Williams Gallery (Williams and Son, London). Ian MacNicol, Glasgow. Romney Gallery, Southport. Purchased from the Gallery in 1948.

Lhermitte's early exposure to farm life at Mont-Saint-Père served him well in a series of paintings based on rustic activity that were exhibited in either London or Paris during the 1870s. Among these works was *Sheep Washing,* a canvas shown at the 1876 Paris Salon.

Using the theme of sheepshearing, Lhermitte accurately depicted an activity he must have witnessed frequently. Each year, when merchants came to a rural village or farm to buy wool, the sheep were washed before the shearing ceremony could take place. Taken to a river or a pond (as suggested here), the unwashed sheep were enclosed in a temporary pen constructed nearby, so that workmen could pull out and wash each sheep one at a time. Under the midday sun the workers actually wade into the pool to bathe the animals, while the clean sheep, white and fresh, wander the countryside under the watchful eye of a herdsman (seated under the large central tree).[1]

In a style revealing the meticulousness of his early oil paintings, before he freed his brushstroke under the influence of the Impressionists, Lhermitte placed the activity of the farm laborers against a broad, sweeping landscape. Accurate in detail, the painting reveals Lhermitte's Naturalism in a manner only vaguely suggestive of the Barbizon tradition.[2]

1. The activity is described in Theuriet, *La Vie rustique,* p. 9.
2. Hamel, "A French Artist," p. 24, cat. no. 32, has incorrectly noted an influence from Corot's style in this composition.

Exhibited

1876, Paris: Salon, cat. no. 1327.
1894, St. Louis: St. Louis Exposition and Music Hall, cat. no. 233.

Published

Theuriet, *La Vie rustique,* p. 7, engraving repr.

François Bonvin

196 *The Pig*
(*Le Cochon, cour de charcutier*)

Oil on canvas, 24-1/4 x 19-3/4 inches (61.4 x 50 cm.). Signed and dated lower right: F. Bonvin, 1874.

Reims, Musée St. Denis.

Provenance. Lefebvre Collection. Jules Warnier-David Collection. Jules Warnier-David Bequest, 26 June 1899.

The theme of a carcass hanging in a butcher shop was not new in 1874 when François Bonvin completed *The Pig.* Ever since 1857, when the Louvre first exhibited Rembrandt's *Slaughtered Ox,* major painters such as Daumier, Decamps, and Delacroix had copied or interpreted the theme. Bonvin, directly inspired by Rembrandt's work, received permission in 1858 to copy the seventeenth-century painting.[1] By the late 1860s, other painters were also using the theme. Amédée Elie Servin's *My Butcher Shop* at the 1869 Salon showed the head and lungs hung alongside the carcass of a pig within a contrasting arrangement of stark furnishings and cooking utensils. The same subject was treated by Albert Aublet in the 1873 Salon in a work entitled *Ducourroy's Butcher Shop, Tréport.* Because of Bonvin's natural predilection for the use of Dutch sources, as well as his earlier absorption with the work of Rembrandt, it was not surprising for him to paint a similar motif. In much of his later work, Bonvin was also absorbed in influences from his younger contemporaries, and his work suggests a likeness to Servin's in its choice of subject and setting. Bonvin's inspiration to paint this theme was not confined to the art world. At the time of his marriage to Céline Prunaire, and in order to make enough money to keep their household going, Bonvin resumed working for the Préfecture de Police as a meat inspector—an early morning routine that would have provided him with many opportunities to observe and absorb the scene he later depicted.

When *The Pig* was exhibited at the 1875 Salon it was compared with Antoine Vollon's *Hanging Pig* (Tanenbaum Collection, Toronto, Canada) that was shown at the same exhibition. Writing about the Salon, the art critic Jules Antoine Castagnary, a strong advocate of Naturalism, judged Bonvin's canvas "less flashy than the work by Vollon; . . . more studied and honest. In Vollon there are some touches of joyous colors; in Bonvin there is a perfect painting."[2] He noted that Bonvin had provided a natural setting for his carcass that was relevant to the subject. If "one suppresses the pig," Castagnary explained, "you will still sense that you are in a butcher shop. In Vollon, suppressing the pig will leave you without any indication of where you are."[3] Bonvin's truthfulness in representation, achieved through the depiction

of the actual environment, was an important quality in the shift toward Naturalism during the 1870s.

Bonvin's image was developed from a preliminary water color (Musée de Bayonne) that Bonvin gave to his friend Léon Bonnat. In it, Bonvin massed his forms, developing dark and light arrangements that would be modified in the final oil painting. The sunlight in the painting softens the somewhat-shaded interior of the courtyard, lighting only one section in brilliance, and illuminating the hanging carcass only slightly. Because of the subtle differences in light qualities, this work represents one of the most highly developed studies of atmosphere that Bonvin was to achieve. The dripping blood splattered on the ground, awaiting the attendant's broom propped against the wall, is a Naturalistic tendency that indicated Bonvin's dedication even late in his career to honestly record his environment.

1. "Enregistrement des Copies de Tableaux, 1851-1871," 9 July 1858, LL 22, Archives du Louvre.
2. Jules Antoine Castagnary, "Salon de 1875," in *Salons: 1857-1879* (Paris, 1892), II: 163.
3. Ibid.

Exhibited

1875, Paris: Salon, cat. no. 251.
1938, Paris, Orangerie: Trésors de Reims.

Published

Frédéric Henriet, "Au Musée de Reims," *Journal des Arts,* 11 November 1899, reprinted in *L'Indépendant Reinais,* 20 November 1899.
Etienne Moreau-Nélaton, *Bonvin raconté par lui-même* (Paris: Henri Laurens, 1927), pp. 90-91, fig. 73.
Trésors de Reims, cat. (Paris: Musée de l'Orangerie, 1938), no. 3.
Gabriel P. Weisberg, "François Bonvin and an Interest in Several Painters of the Seventeenth and Eighteenth Centuries," *Gazette des Beaux-Arts* LXXVI (December 1970): 365, fig. 7.
Petra Ten Doesschate Chu, *French Realism and the Dutch Masters* (Utrecht: Haentjens Dekker & Gumbert, 1974), p. 42, fig. 69.
Gabriel P. Weisberg, *Bonvin: La Vie et l'oeuvre* (Paris: Editions Geoffroy-Dechaume, 1979), p. 190, cat. no. 59.

Antoine Vollon

197 *Peasant Woman Carrying Baskets*

Oil on wood, 22-7/8 x 17 inches (57.6 x 42.5 cm.), 1874. Signed and dated lower left: A. Vollon.74.

U.S.A., Private Collection.

At the time of the 1868 Salon when Antoine Vollon exhibited *Curiosités* (Musée Municipal, Lunéville), faith in his ability to convey the substance of precious objects was obvious, for Count Nieuwerkerke had placed at the painter's disposal not only his own private collection of *objets d'art,* but those of the Louvre as well. By 1875, Vollon continued to record precious objects, exhibiting

a study of *Armures* in which his technical facility in light reflections reigned supreme. At the same Salon, Vollon submitted his hanging *Pig* (Tanenbaum Collection, Canada), a work which reiterated in Naturalist terms a theme which had first been treated by the Dutch masters of the seventeenth century. The *Pig* canvas, moreover, documents a style by Vollon that is coarse, more direct; it suggests the vigorous brushwork found in some of Edouard Manet's compositions, although Vollon eliminated detail to concentrate on an expressionistic use of paint—as he also did in *Peasant Woman Carrying Baskets*—that is rare in the nineteenth century.

The following year, Vollon exhibited *Femme du Pollet, à Dieppe,* a work inspired by trips to northern France, specifically to the seacoast villages of Dieppe and Le Tréport—sites that were popular for other painters also.[1] Although a finished Salon painting has not been found, *Peasant Woman Carrying Baskets* suggests that Vollon may have completed a series of studies intended for a larger composition. Like his earlier *Pig* (1875 Salon), this work is one of Vollon's more powerful genre studies. The distortion of the body and the predominant, oversized hands convey a primitive strength that is unencumbered by detail and reduced to the simplest representation, so that the lone peasant with her load assumes a monumental scale against the loosely painted, indistinct sea and sky. The determination inherent in the pose reinforces the simplification of a style that achieves a dramatic intensity unequalled in Vollon's previous examples of genre painting or still life. Although the expressionists (e.g., Vlaminck and Soutine) of the twentieth century may not have been familiar with Vollon's work, strangely enough his studies forecast their similar free use of paint.

1. This painting is housed in the Stedilijk Museum, The Hague.

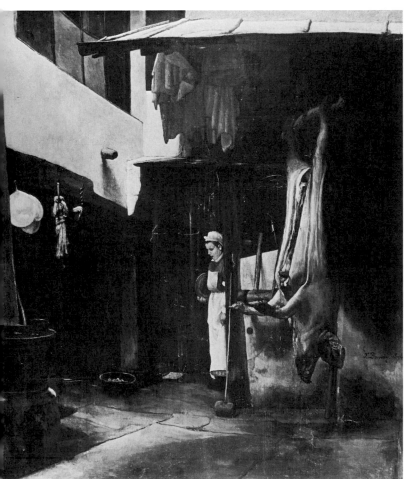

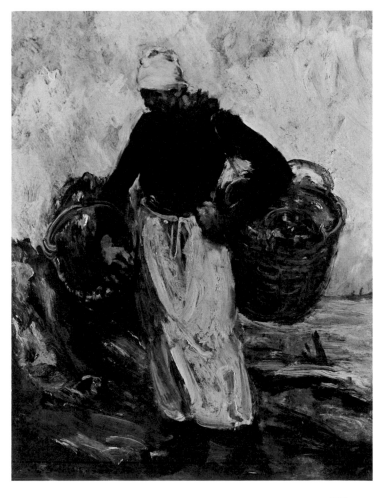

Jean Charles Cazin

198 *The Bakery of the Coquelin Family at Boulogne-sur-mer (La Maison natale des frères Coquelin)*

Oil on canvas, 45-3/4 x 37-7/8 inches (115 x 95 cm.). Signed lower right: J C CAZIN.
Samer, Musée J. Charles Cazin.
Provenance. Gift of Mme. Henry Mory.

Jean Charles Cazin's friendship with the Coquelin brothers began when they were classmates in Boulogne and continued well into the 1880s. By that time, Cazin was well established as an artist, and the two actors[1] were among the many famous guests he entertained at his summer home in Equihen.

Cazin and the Coquelin brothers undoubtedly reminisced about their childhood and the Coquelin bakery that was familiar to Cazin and known throughout the region for the delicacy of its pastries.[2] *The Bakery of the Coquelin Family at Boulogne-sur-mer* must have been commissioned by the brothers—perhaps as a gift to the Coquelin family—for it was completed late in the 1870s when Cazin was less interested in genre scenes and more preoccupied with biblical history and large-scale Salon canvases.[3]

Through the method of "memory painting," Cazin reconstructed the environment of the bakery in one preparatory drawing and in his mind before he actually began painting. It is unlikely that Cazin used oil sketches or detailed black and white studies that many Realists traditionally depended upon, for he relied on his first impression to maintain the freshness of his image. The strength of the finished painting was thus less dependent upon the figures placed within the environment than upon the arrangement of elements to re-create the space and the ambience. The only suggestion of activity is the glimpse through the open doorway of the baker with his back to the viewer.

The atmosphere in the courtyard of the bakery, with its array of delivery baskets and assorted buckets and utensils, is softly modulated, a characteristic of the subtle gradations of tone which Cazin blended to create a harmonious canvas. His use of chalky tans, grays, and ochres suggests the tonal paintings of James McNeill Whistler,[4] especially Whistler's early genre compositions and his occasional oblique vistas in space. The interior arrangement, however, is more indicative of Cazin's interest in the seventeenth-century Dutch painters. Even though the thin application of paint and occasional areas of bare canvas convey the immediacy of having studied the scene directly—like the Impressionists—in actuality Cazin recomposed the bakery scene from his own memory.

198

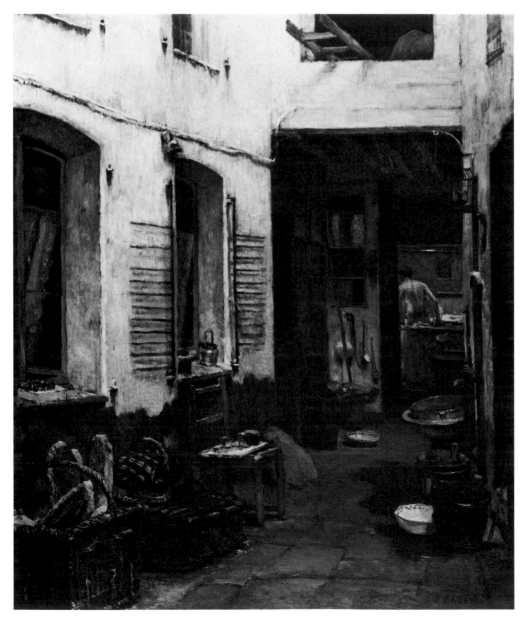

1. After leaving Samer and Boulogne, both Ernest and Constant Coquelin became famous actors in Paris, especially known for their performances of Cyrano de Bergerac and the Barber of Seville. See "Deux Illustres comédiens boulonnais," *Boulogne Magazine: La Voix du Nord,* 16 March 1966.

2. Information supplied by Madeleine Adam in "Articles sur les lettres de Cazin et souvenirs d'enfance," and made available to the author by descendants of friends of the Cazin family.

3. The early history of this painting remains unknown. The canvas was saved from destruction during World War II only through the courageous actions of local villagers. For information on Cazin's interests during the 1880s, see Adam, "Articles." Cazin's fame during this period emerged from his interest in history painting, even though his temperament was suited to other types of painting—a fact noted by some critics of the time.

4. Cazin undoubtedly saw Whistler's work in the Paris Salons of the 1860s.

Published

Nicolas d'Enquin, "Richesses de nos campagnes, Le Musée Cazin de Samer," *Boulogne Informations* (Boulogne, France, n.d.).

Opposite
168 Jean Béraud, *The Banks of the Seine* (detail)

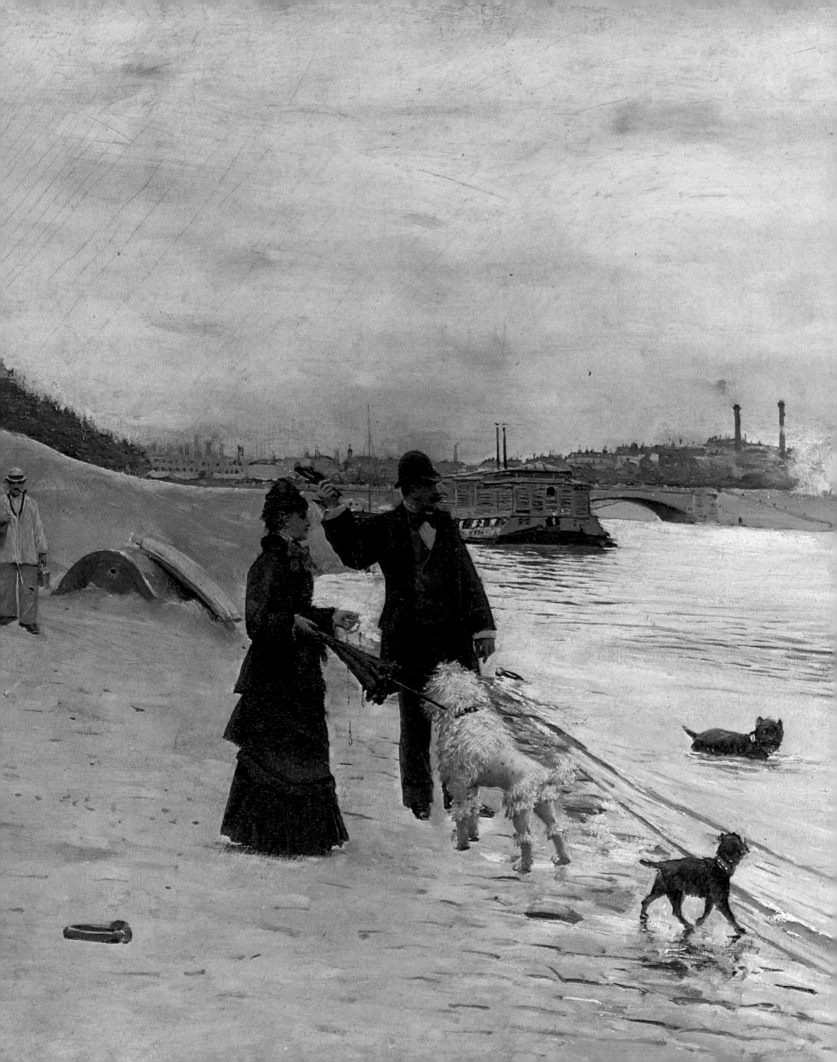

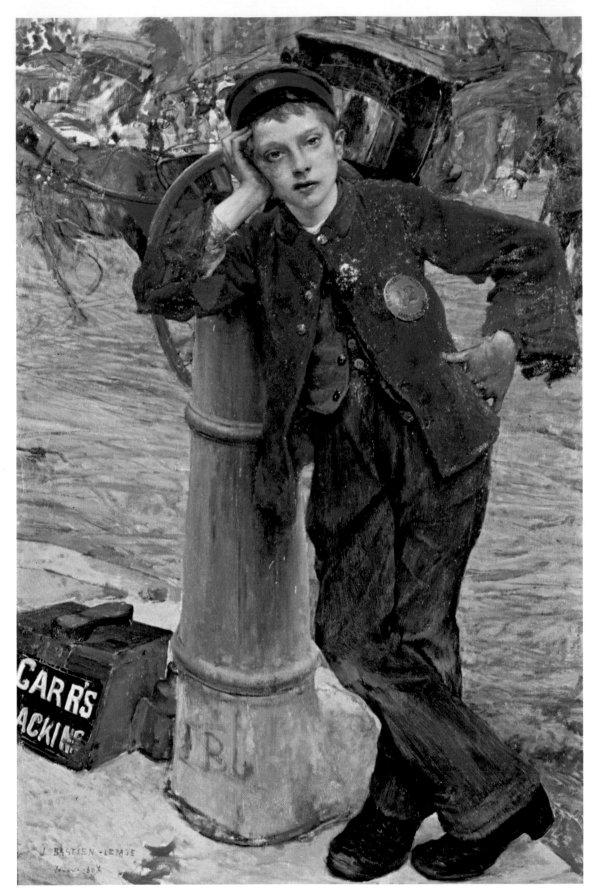

170 Jules Bastien-Lepage, *The London Bootblack*.

Opposite
173 Jean Béraud, *The Pastry Shop "Gloppe"* (detail).

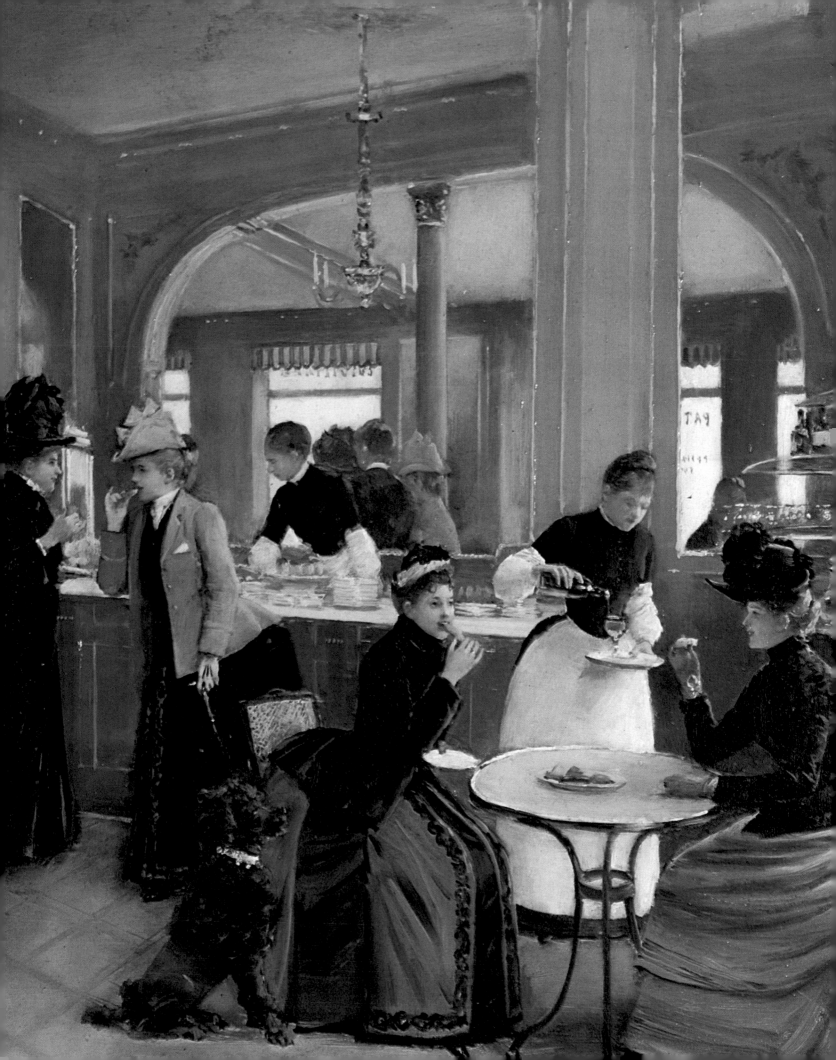

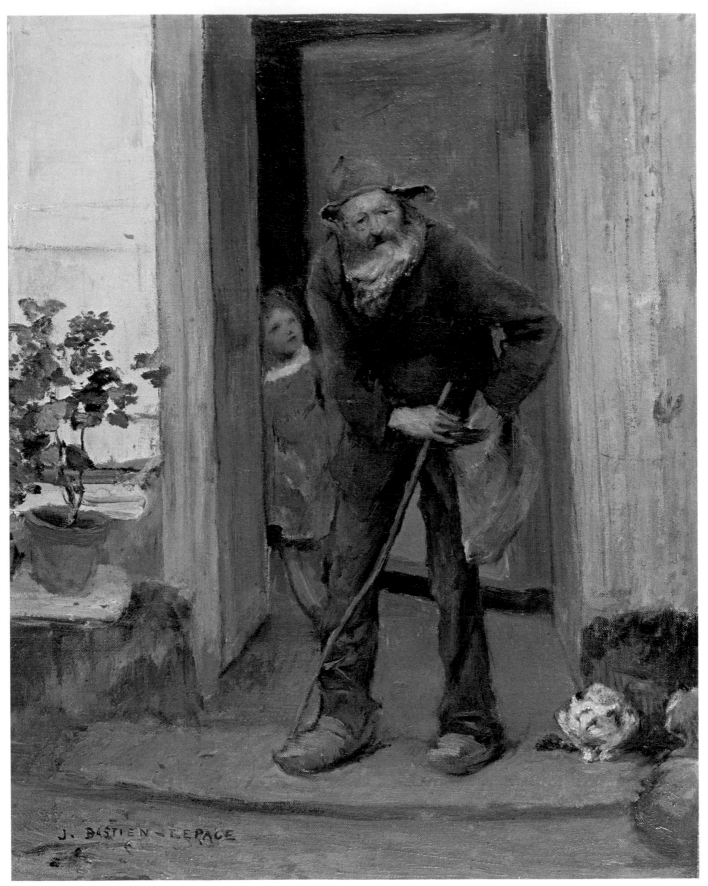

180 Jules Bastien-Lepage, *The Beggar*.

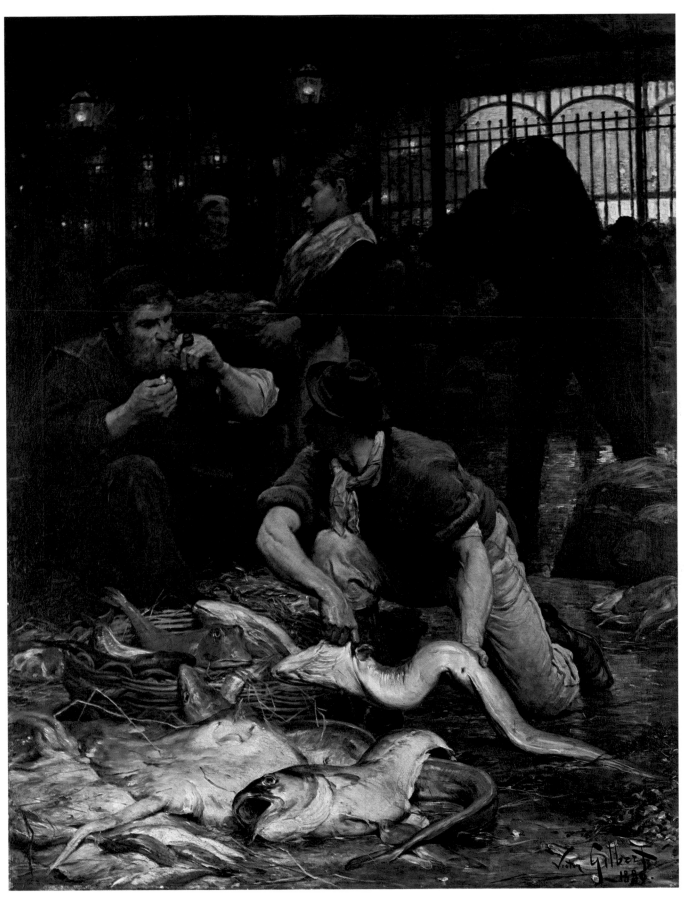

189 Victor Gabriel Gilbert, *A Corner of the Fish Market: Morning*

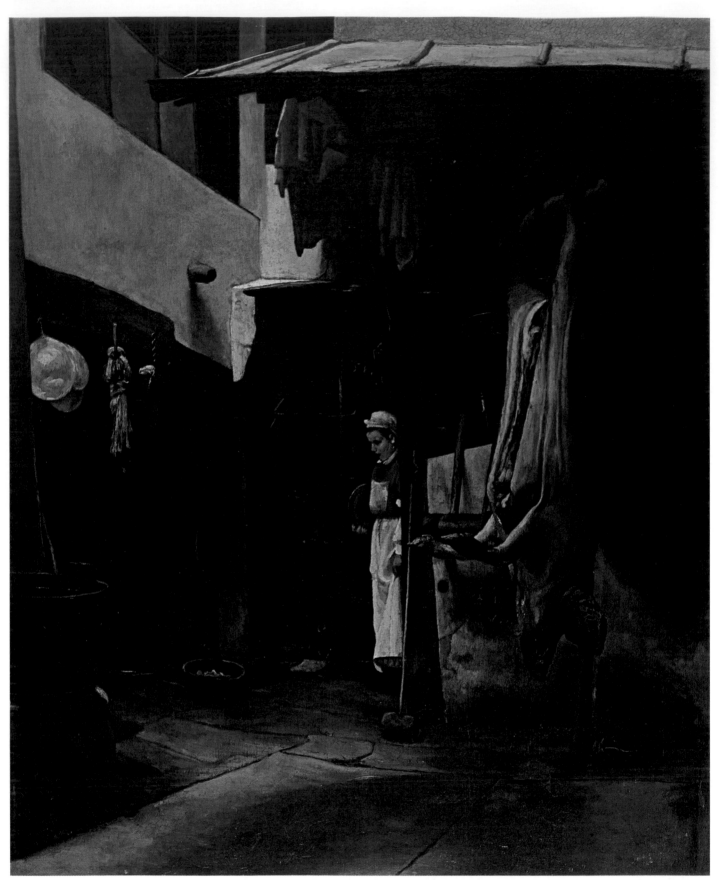

196 François Bonvin, *The Pig*.

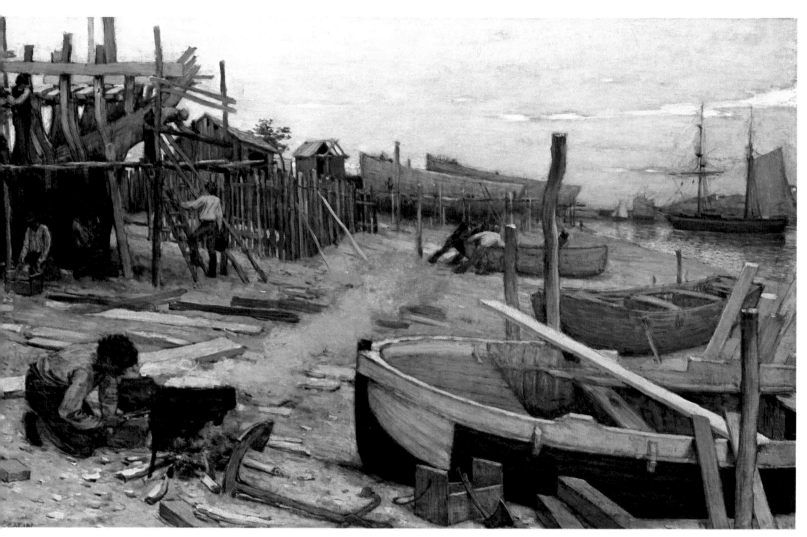

199 Jean Charles Cazin, *The Boatyard*.

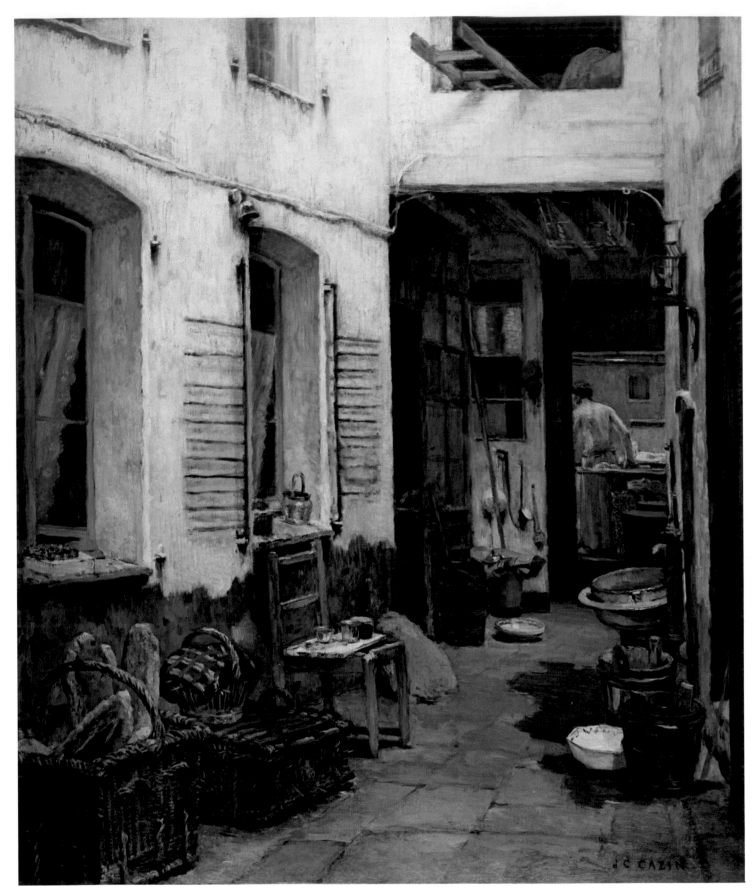

198 Jean Charles Cazin, *The Bakery of the Coquelin Family at Boulogne-sur-mer*.

Jean Charles Cazin

198A *Ernest-Alexandre-Honoré Coquelin*
Black chalk heightened with white chalk, 16-1/2 x 12-1/2 inches (41.9 x 31.7 cm.), ca. 1875. Signed lower right: J. C. CAZIN.
New Haven, Yale University Art Gallery, Gift of Mrs. William Polk.
Provenance. Gift of Mrs. William Polk.

Preliminary drawings by Cazin for genre scenes or landscapes are extremely rare. Cazin seldom prepared study drawings for individual figures or a segment of a composition, preferring to paint directly on his canvas without the elaborate preparation that other Realists (e.g., Bonvin) depended upon. An exception is the drawing of the youthful *Ernest-Alexandre-Honoré Coquelin* (b. 1848) that was perhaps intended as a preliminary study for the oil painting *The Bakery of the Coquelin Family*.[1]

Ernest and his elder brother Constant (b. 1841), who remained close friends with Cazin long after their childhood days together in Boulogne, had helped in the family bakery during the late 1860s, before they left for Paris to make their name in the theater. But it is unlikely that Cazin completed this drawing early in his career. Instead, by working from memory—a practice he had learned as a student of Horace Lecoq de Boisbaudran, Cazin rephrased a scene that recalled his earlier familiarity with the Coquelin bakery. The later date for this drawing is also implied by the book and pose that suggest Ernest is preparing for one of his theatrical performances rather than actively participating in the bakery environment for which he is dressed. In the finished painting [198], however, the figure of Ernest Coquelin was omitted from a prominent role in the foreground.

198A

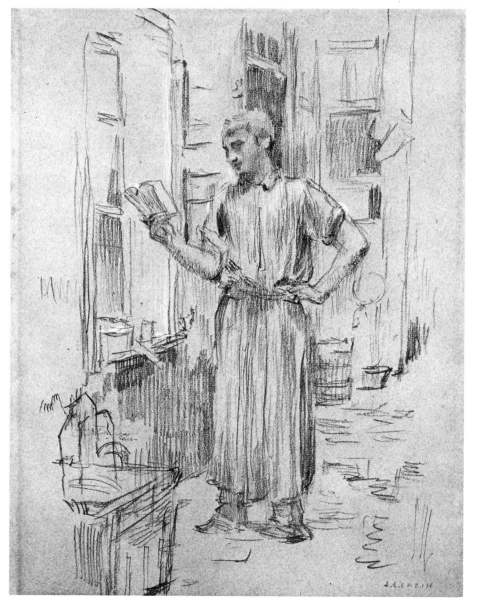

1. It is difficult to date the drawings and paintings of Cazin; he seldom dated his own works, and his style did not change dramatically over the course of his career.

Published
E. Haverkamp Begemann and Anne-Marie Logan, *European Drawings and Watercolors in the Yale University Art Gallery* (New Haven, Conn.: Yale University Press, 1970), p. 47, cat. no. 83.

Jean Charles Cazin

199 *The Boatyard*
　　(Le Chantier)
Oil on canvas, 30-1/8 x 48-1/2 inches (75.7 x 121.9 cm.). Signed lower left: J. C. Cazin.
The Cleveland Museum of Art, Gift of Mr. and Mrs. Noah L. Butkin. 77.123.
Provenance. Gregoire Galleries, New York. Vente X . . . , 19 June 1933 (1850 francs). Mr. and Mrs. Noah L Butkin Collection.

After his return to France (ca. 1875), Cazin settled in his native region near Boulogne-sur-mer. There he returned to painting landscapes and again prepared for Salon exhibits for the first time in ten years. (His last exhibitions had been *études* at the 1865 and 1866 Salons.) His entry at the 1876 Salon was *Le Chantier,* a work described in the Salon catalog as completed in oil and wax as a preliminary study for a room decoration.[1] Even though this composition has frequently been mentioned in the literature on Cazin as being his most significant early canvas, it was never reproduced or engraved, making it difficult to determine the actual canvas that was exhibited at the 1876 Salon. In addition, Salon reviewers did not discuss Cazin's entry, so that identification of this particular canvas is not firm.[2] The 1876 Salon entry may, indeed, have been *The Boatyard*.

Cazin's use of the theme of the boatyard corresponds to his earlier works combining genre themes with landscape. The painting was completed solely in oil pigment—not wax—and the sweep of the composition and its horizontal format suggest that a private patron may have requested the scene as part of a room decor.[3] Early patrons of Cazin's work have not been identified, although it is possible that one of the shipbuilding families in the Boulogne area might have wished to commemorate the well-established community activity. The probability that it was commissioned—like the canvas immortalizing the Coquelin bakery [198]—suggests an interest by Cazin in themes of personal significance that should not be underestimated.

Inspired by the Nocturnes of James McNeill Whistler, a painter he would have known since the Salon des Refusés in 1863, Cazin used a tonal range in *Boatyard* that was characteristic of numerous compositions throughout his career. Unlike the stark con-

227

trasts between colors or the dramatic dark and light arrangements of many painters, Cazin harmoniously graded his chalky tans, grays, and ochres, offsetting them by darker grays and blacks, so that each color was modulated and softened to create a tonal environment. This graying of colors to create a harmonious balance also suggests the work of Puvis de Chavannes, an artist Cazin admired and with whom he became good friends.[4]

Whether Cazin composed *The Boatyard* from actual observation is doubtful. He is known to have maintained the method he learned as a student of Horace Lecoq de Boisbaudran throughout his career, painting a previous observation from memory in the tranquility of his studio. This process dismissed reliance upon preliminary studies in deference to maintaining the freshness and spontaneity of the initial inspiration. If Cazin were dissatisfied with his results, he would scrape down and remove his earlier image, and begin again.

Each section of the composition has been carefully organized according to the type of work being done. In the foreground, a workman at the fire is readying the caulking compound to mold the wood or to seal the joints of the small boat at the right. In the middle ground, laborers have erected a scaffolding for the construction of a larger boat, and, beyond them, a group of men are preparing to water-test a smaller craft. The careful inclusion of the details and accessories of the work scene is unusual, for Cazin seldom used such a Naturalistic theme. The sketchily painted forms and figures in the background areas, however, rely upon evocation and suggestion to complete the boatyard environment.

1. The documents on the Salons of the 1870s that would establish the size of a given Salon entry have not been located in the Archives du Louvre. It is possible that the Salon catalog was incorrect or that another version of this theme was submitted to the 1876 exhibition.

2. The conservation report of The Cleveland Museum of Art, after the work was relined and cleaned, made no mention of wax mixed with oil. See Ross Merrill, "Report on Cazin's *Shipyard* to Noah Butkin," 16 July 1976, Conservation Department, CMA.

3. Since room decorations of all types proliferated during the last half of the century—from elaborate dining room still-life ensembles to landscape images for bedrooms—it is possible this could have been part of another commission.

4. See H. Reveillez, "Le Peintre Jean-Charles Cazin," *Revue de Boulogne-sur-mer* (n.d.), p. 13, in which Cazin's visits from Puvis de Chavannes at Equihen are recorded.

Exhibited

1876, Paris: Salon, cat. no. 372 (listed as "*Le Chantier; — peinture à la cire. Fragment d'un projet de décoration*").

Published

"Nécrologie, Jean Charles Cazin," *Chronique des Arts et de la Curiosité,* 29 March 1901, p. 102, cat. no. 13.
Paul Desjardins, "En Mémoire de Jean-Charles Cazin," *Gazette des Beaux-Arts* XXVI (1901): 182.
Léonce Bénédite, "Jean Charles Cazin," *Revue de l'Art Ancien et Moderne* X (July-December 1901): 21.
A. M., "Charles Cazin," *Le Bulletin de l'Art Ancien et Moderne,* 30 March 1901.
Léonce Bénédite, *L'Art au XIXe siècle—1800-1900* (Paris, n.d.), p. 295.

199

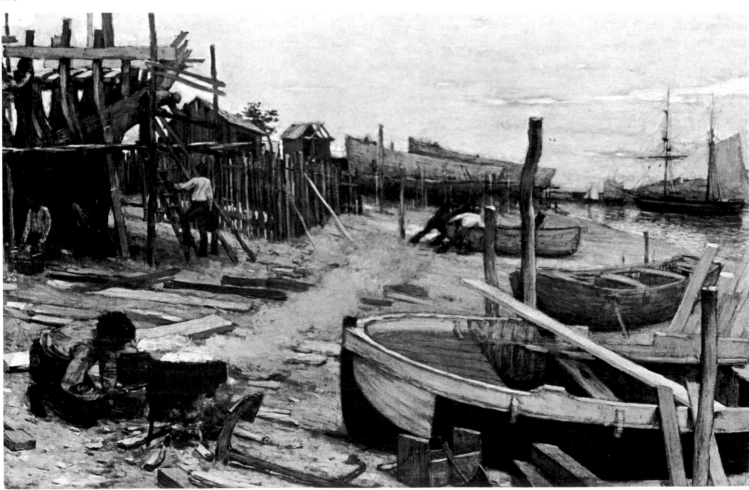

Henri Marcel, *La Peinture française au 19e siècle* (Paris, 1905), p. 315.

Léonce Bénédite, "Jean-Charles Cazin," *Les Artistes de tous les temps*, Série D—Le XXe siècle (Paris, n.d.), pp. 21-23.

Georges Eggenberger, "Jean Charles Cazin," *Revue de Boulogne-sur-mer* (n.d.), p. 3.

Burlington Magazine, June 1973, repr. pl. XLIX.

Jean François Raffaelli

200 *Blacksmiths Drinking*
(*Les Forgerons buvant*)
Drawing heightened with oil on cardboard laid down on panel, 30-5/16 x 22-7/16 inches (77 x 57 cm.). Signed lower right: J. F. RAFFAËLLI.
Douai, Musée de la Chartreuse.
Provenance. Georges Bernheim, Paris. Fernand Crouan, Nantes.

One of Jean François Raffaelli's most successful depictions of the suburban worker is *Les Forgerons buvant*, executed in 1884. Two men standing before a table situated outside a suburban tavern reach simultaneously for their glasses of wine. The composition itself is made up of a zone of strong verticals and horizontals in the still-life details. The rectangular geometry of this design is dramatized by the placement of the workers' arms, stretching diagonally in parallel lines toward the table, and by their upper trunks, bent forward and also parallel, as part of the reaching gesture. This repetition of geometric forms lends strength to the composition. Except for some difficulty with the hands of the older man (there are pentimenti in the thumb of the right hand), the drawing is fresh and vigorous. Unlike Raffaelli's vagabonds and ragpickers, these men are healthy and strong.

The coloring is somewhat lighter than in earlier works, but the values are low key. The brightness of the day is conveyed by the whitened sky and whitish waves in the river, in which are reflected the pale salmon roofs of the homes. The cardboard provides the basic brownish shade of the ground, over which pale gray-green patches are laid. Even though these figures wear dark aprons, one blue black and the other brownish green, the open, light-colored shirt of the younger man and the light skin tones of their arms lack the dark contrast of figure and landscape characteristic of Raffaelli's earlier works.

Les Forgerons buvant was well received by the Belgian critics at the February 1885 exhibition of Les XX.[1] Although these reviewers expected something more revolutionary from an artist associated with Impressionism, they were pleased with a subject matter which they could relate to the works of their own Belgian Realist painter and sculptor, Constantin Meunier (1831-1905), who depicted puddlers, dockers, and the working class in general. But, as the Belgian critic Octave Maus pointed out, there was a great difference in the approach of these two artists: Raffaelli pursued the character of each individual, while Meunier generalized him into a type representing all the dignity and honesty of a Millet peasant.[2] B.F.

1. See, for example, M. W., "L'Exposition des XX," *La Réforme*, 3 February 1885, p. 1; and 4 February 1885, p. 1.
2. [Octave Maus], "Les Vingt: 3e article," *L'Art Moderne*, 22 February 1885, p. 58. When the picture was shown a few months later in the Paris Salon, it was placed in the drawings section and was largely ignored, overshadowed by Raffaelli's controversial portrait of Clémenceau with which he sought to reenter official circles after a six-year absence.

Exhibited
1885, Brussels: IIe Exposition annuelle des XX, cat. no. 5.
1885, Paris: Salon de la Société des Artistes Français, cat. no. 3131.
1889, Paris: Exposition Universelle de 1889: Exposition Décennale, cat. no. 1599.
1900, Paris: Exposition Universelle de 1900: Exposition Centennale de l'Art français de 1800 à 1889, cat. no. 541.

200

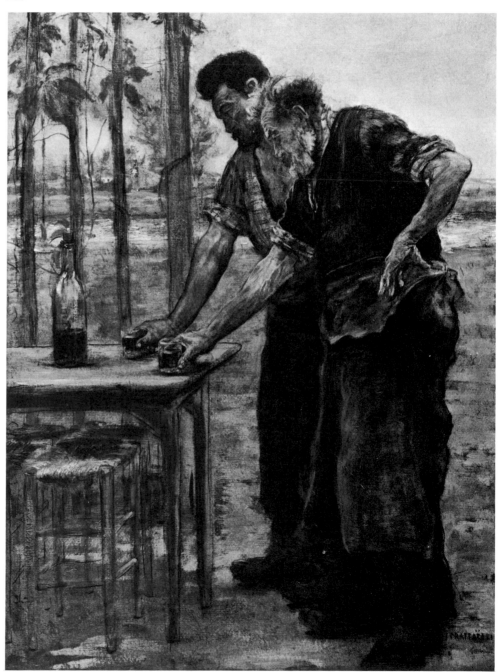

1957, Geneva, Musée d'Art et d'Histoire: Art et Travail, cat. no. 284.

1979/80, London, Royal Academy of Arts: Post-Impressionism: Cross-Currents in European Painting, pp. 117-18, cat. no. 162.

Published

Stéphane Leroy, *Catalogue des peintures, sculptures, dessins et gravures exposés dans les galeries du Musée de Douai* (Douai, 1937), p. 95, cat. no. 526.

Julien Dupré

201 *Haying Scene*

Oil on canvas, 48-1/2 x 49 inches (123.2 x 149.8 cm.). Signed and dated lower right: JULIEN DUPRE 1884.

The St. Louis Art Museum, Gift of Mrs. Daniel Catlin.

Provenance. Mr. and Mrs. Daniel Catlin, St. Louis.

Establishing the specific region of France depicted in *Haying Scene* is difficult. Julien Dupré probably thought of the field worker as continuing traditional work methods. Like Jean François Millet, Dupré saw little change in rural work methods during the 1880s. Progress was slow, and many agricul-

tural regions of France were still untouched except for modifications in cattle raising.[1] Labor conditions were hardly affected, and the peasants continued to use the same tools they had used for centuries.

The sense of vigor Dupré's field worker conveys is achieved through artistic devices. Dupré monumentalized his young woman gathering hay, thus conferring an aura of heroism to her labor.[2] In this sense, like other painters of the field laborer (e.g., Léon Lhermitte or Jules Breton), Dupré created a mythical, romantic model rather than a figure solely observed from reality. Included among those painters creating a "cult of the peasant" at the turn of the century, Dupré divorced the peasant from political connotations. His workers symbolize the purity of

201

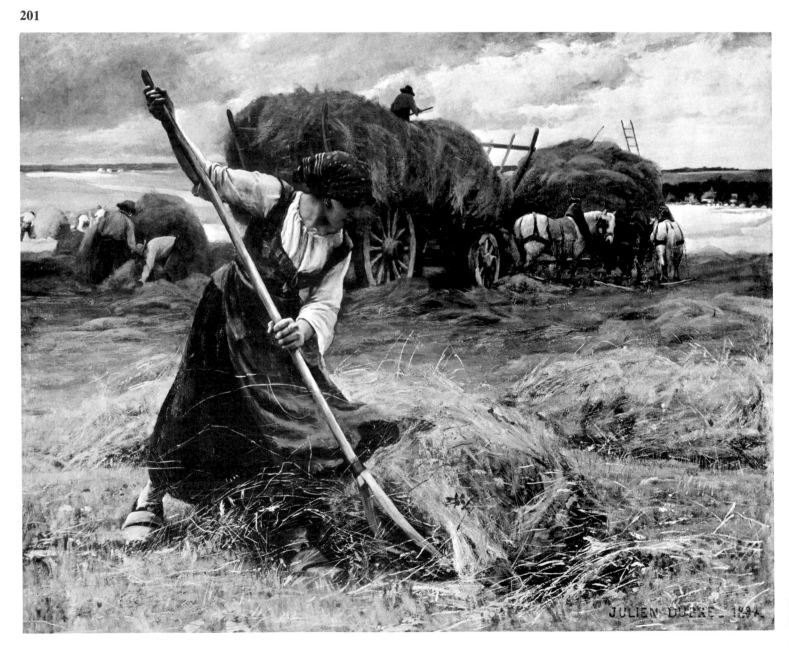

hard work. By emphasizing time-honored traditions, Dupré perhaps was attacking rural depopulation and the lure of easy money for work in the larger cities.

Continually working in large scale and plotting his space carefully, Dupré integrated all elements to arrive at a harmonious composition. His freely brushed foreground area, where the cut hay falls across the field worker's garment, suggests he studied Vollon's compositions; the carefully modeled features and subtle use of light, however, betray his academic discipline as well as acknowledge a study of the works of Jules Breton and William Bouguereau.

1. Eugen Weber, *Peasants into Frenchmen: The Modernization of Rural France, 1870-1914* (Stanford University Press, 1976), p. 118.
2. For a discussion of this device in the work of Léon Lhermitte, see Hamel, "A French Artist." Hamel identified this quality of monumentality as "the grand manner."

Pascal Adolphe Jean Dagnan-Bouveret

202 *Horses at the Watering Trough*
 (Chevaux à l'abreuvoir)
Oil on canvas, 90-1/4 x 69-1/2 inches (225 x 175 cm.). Signed and dated lower middle: PAJ Dagnan-B 1884.
Chambéry, Musée des Beaux-Arts.

Provenance. Acquired by the state following exhibition at the 1885 Salon. Exhibited at the Luxembourg Museum. Sent to the Museum in Chambéry, 4 May 1892.

Attracted to the Franche-Comté region after his artistic companion Gustave Courtois took him there in 1878, P. A. J. Dagnan-Bouveret did a series of paintings inspired by regional activities and field workers. Among these canvases was his *Horses at the Watering Trough,* completed in 1884 and exhibited at the 1885 Paris Salon. Because of this work, Dagnan-Bouveret was named Chevalier of the Légion d'honneur. The canvas was purchased by the state for exhibition at the Luxembourg Museum. When Dagnan-Bouveret received notification where he was staying in the Franche-Comté that the painting was being considered for acquisition by the government, he responded to the Under Secretary of State: "I am most flattered by your intention to purchase my painting, 'Chevaux à l'abreuvoir,' but I am unable to visit your office as you have asked since I have been in the Franche-Comté for fifteen days already. Thus I hope that you will be able to send me a letter noting how much you will offer me for this painting."[1] Dagnan-Bouveret sold the work to the state for an unknown amount. The painting was sent in 1892 to the museum in Chambéry.

Regarded at the time as a painting of "great importance," the work was also deemed one of Dagnan-Bouveret's more impressive canvases.[2] Roughly painted, with the raw canvas appearing in several areas of the forms and background, the composition was sketched at least once before Dagnan-Bouveret completed the larger canvas.[3] In the version in Chambéry, the young worker, dressed in regional garb, is bringing two horses to a watering trough at the close of the working day. Holding a small pipe in one hand and securing a whip to his forearm, the young man looks at the spectator as if captured in a momentary gaze. In the previous sketch, only one horse (in exactly the same pose as the middle horse in the final work) stands near the watering trough. The attendant, at the right, assumes a stiffer, more formal posture with one hand on his left hip, as if he had been captured in a photograph.[4] The driver's identity is unknown, but he is different in the two compositions. Dagnan-Bouveret apparently changed his mind not only about the pose but also about the specific model for the horses' attendant. The assumption that Dagnan-Bouveret worked from a photograph, or several photographs, might account for the way he cropped certain of his forms, such as the white horse.

Dagnan-Bouveret accurately transcribed what he actually witnessed and thus rendered a Naturalist's view of an event from the Franche-Comté region.

202

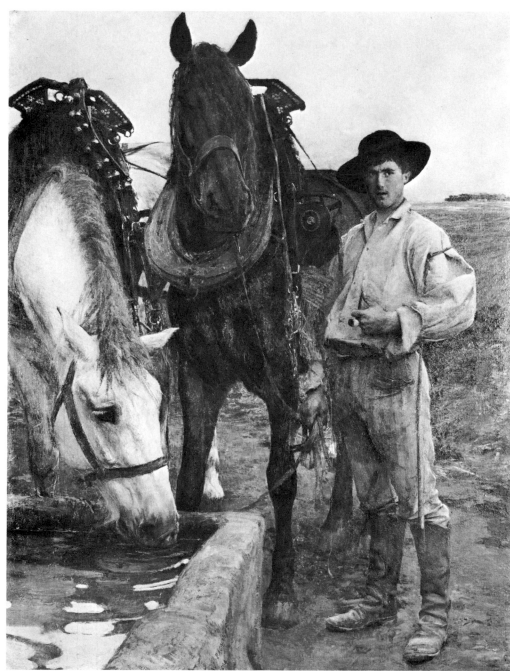

1. Dagnan-Bouveret to the Sous-Secrétaire d'Etat, 27 July 1885. The letter is preserved in the archives of the Institut Néerlandais, Paris (1973—A 313).

2. See "Les Echos de Paris," *Les Annales Politiques et Littéraires,* 9 June 1889. The painting was praised by André Charles Coppier, "Regards sur l'oeuvre de Dagnan," in *Catalogue des oeuvres de M. Dagnan-Bouveret—Peintures* (Paris: Maurice Rousseau, 1930), pp. 14, 24.

3. A photographic reproduction of a variant of this composition was found in the Rijksbureau photo archives. Dating this variant is difficult, but its size (31 x 19 inches) suggests it was a preliminary study for the larger canvas. The American Art Galleries sold the variant on 3 February 1905.

4. Whether Dagnan-Bouveret worked from photographs in unknown. Henri Lerolle, in some of his genre paintings of the 1880s, worked from photographs taken at farms or inside buildings. In discussions with the author (1979), Professor Van Deren Coke, a noted photographic historian, said the poses of the horses and their flattened perspective suggested a photographic source.

Exhibited
1885, Paris: Salon, cat. no. 667.

Published
Jules Carotti, *Musée de Chambéry, catalogue raisonné* (Chambéry, 1911), p. 179, repr. pl. 13.

203

Guillaume Fouace

203 *The Stonebreaker's Lunch*
(Le Déjeuner du casseur de pierres)

Oil on canvas, 86-5/8 x 70-7/8 inches (220 x 180 cm.). Signed and dated lower right: G. Fouace/1885.

France, Private Collection.

Provenance. Guillaume Fouace Collection. Auguste Lebrun Collection. Mlle. Sorrensen Collection.

After the appearance of Courbet's *The Stonebreakers* and Millet's *Man with a Hoe* (1863 Salon), some provincial Realist painters kept alive the image of the desolate worker slaving at a menial job and living on a pittance. By the 1880s, this tradition was best found in regions where painters such as Guillaume Fouace relied on an earlier generation's style. Although Fouace's paintings were exhibited at the Paris Salon, they were seldom appreciated by a Parisian public and were only collected by those in the artist's native region.

By showing his large-scale *Stonebreaker's Lunch* at the 1885 Salon, Fouace perhaps revealed an interest in regional literature. The poet Charles Frémine (1841-1906), active in northern France, had described a similar downtrodden old peasant seated on a rock having a bowl of soup.[1] But whether Fouace actually knew Frémine's writings before he painted this picture is unknown. That Fouace's models were from Réville reinforces the local nature of the composition. In fact, the young girl mending the stonebreaker's socks is Esther Guérin, the daughter of a fisherman and a friend of the painter.[2]

By the latter decades of the century, this theme, which earlier incited strong social interpretations, was modified to reveal quaintness of character. The geniality of the old stonebreaker is contrasted with the benevolent kindness of his youthful companion—without any harsh suggestion of the realities of life.

1. Information supplied by the present owner of the painting in a letter to the author (1979).
2. Jean Le Jeune, *Guillaume Fouace, 1837-1895* (Coutances: Editions O.C.E.P., 1977), pp. 58-59.

Exhibited

1885, Paris: Salon.
1895, Paris: Exposition posthume des oeuvres de Guillaume Fouace à l'Ecole Nationale des Beaux-Arts, cat. no. 156.

Published

Gustave Larroumet, Introduction to *Catalogue des oeuvres de G. R. Fouace exposées à l'Ecole Nationale des Beaux-Arts* (Paris, 1895), cat. no. 156.
Le Jeune, *Guillaume Fouace,* pp. 92, 108, 121, 128, repr. p. 79.

Jules Breton

204 *The Shepherd's Star*
(L'Etoile du Berger)

Oil on canvas, 40-1/2 x 31 inches (102.8 x 78.8 cm.). Signed and dated lower right: Jules Breton/87.

The Toledo Museum of Art.

Provenance. Gift of Arthur J. Secor, 1922.

Late in his career, even though he continued to use themes of peasants at work, Jules Breton modified his Naturalism to reflect his writings (e.g., *Les Champs et la mer,* 1880) and the thoughts of others. The more expressive style of his early years became increasingly tempered by an underlying classicism that the traditional academicians favored. Such later compositions as *The Shepherd's Star* combined a romanticism and classicism that led to his election into the prestigious Institut de France in 1886.[1] Sentimentalized versions of peasant life[2] found a ready market in the United States, and it was Breton's intention to sell *The Shepherd's Star* through his usual dealer, Knoedler. He substituted another work to meet Knoedler's expectations, however, and kept *The Shepherd's Star* for himself.[3]

204

233

Later, after the work was exhibited at the Paris Salon (1888) and shown at the World's Fair of 1889, Breton finally agreed to part with it for the substantial amount of 20,000 francs.[4]

Perceptive critics noticed the change in Breton's style, even though he maintained his usual selection of a common theme. The departure of a young girl after a day in the fields, balancing the day's yield on her head, is a more romantic image—unlike his earlier portraits of strenuous labor. This larger-than-life figure is posed in a heroic manner against a tranquil landscape, and she is assured and unweary. Working directly from a model, Catherine Bibi of Courrières, Breton maintained the accuracy of a portrait, but he relied upon memory and association—not observation—to achieve the lyric, reflective quality of the setting.

The critic Arsène Houssaye acknowledged Breton's enduring aptitude for reality, but recognized also the heroism inherent in Breton's rendering: "With an admirable alliance of the real and the ideal, this daughter of the fields has become a true peasant; but imagine that she carried on her back a sheaf of wheat instead of a sack of potatoes, and then she could be the personification of harvesting. She would be a modern Ceres."[5] It was through such traditional associations with mythological figures that Breton's peasants were warmly accepted in France and in the United States.

1. Breton received the highest awards—even at an early stage in his career. He was eminently successful, and each award precipitated others.
2. For a discussion of the types who worked the land in France, see Weber, *Peasants into Frenchmen,* pp. 115-29. The number of individuals in agriculture actually increased by the end of the century and contributed to the continuing popularity of peasant themes in the visual arts.
3. Diary of Elodie Breton, 19 September 1887.
4. Ibid., July 1889.
5. Arsène Houssaye, *Salon de 1888* (Paris, 1888), p. 52.

Exhibited
1888, Paris: Salon.
1889, Paris: Exposition Universelle.

Published
Eugène Montrosier, *Salon de 1888* (Paris, 1888), p. 51.
Georges Lafenestre, "Salon de 1888," *Revue des Deux Mondes,* 1 June 1888.
René Doumic, *Le Correspondant,* 10 May 1888.
M. Duthil, *La Dépêche,* 7 June 1888.
Aylieson, *Le Pas de Calais,* 13 May 1888.
Léon Hee, *Le Parti National,* 18 August 1889.
Dranerl, *Le Charivari,* 10 May 1888.
François Monod, "Chronique," *Art et Décoration,* supp., August 1906, p. 2.
F. E. Cluit, "The Art of Jules Breton," *Brush and Pencil* XVIII (1906): 110.

Louis Paul Henri Sérusier

205 *The Breton Weaver*
(Le Tisserand breton)
Oil on canvas, 28-3/8 x 22-7/8 inches (72 x 58 cm.).
Signed and dated lower left: P. Sérusier/1888.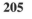
Senlis, Musée du Haubergier.
Provenance. Given by Alphonse de Rothschild to the Museum.

Paul Sérusier has never been linked with the Realist movement because he is always seen as a founding member of the Nabis, who rebelled against the strictures of actual observation in their pursuit of abstract art. Sérusier's style, however, originated from Realist imagery, as witnessed by his first Salon entry in 1888: *The Breton Weaver.*[1]

The members of the Nabis group with whom he was then associated castigated this painting as both somber and banal, but despite their disapproval, the composition merits inclusion in any complete review of the Realist movement, for it represents a phase of Sérusier's work long neglected.[2] When visiting Brittany in 1887, Sérusier saw similar instances of home labor, but he also may have been inspired by André Theuriet's *La Vie rustique,* which contained a description of a weaver much like the one Sérusier portrayed.[3]

During the 1880s, weaving remained the one cottage industry that enabled field laborers to earn money during the cold winter months. Hence, the theme carried suggestions of social significance. A solitary weaver, intent upon his work, could produce enough linen in a few days to earn money for a few weeks' food. Working at his loom in a corner of his small cottage, the weaver could

205

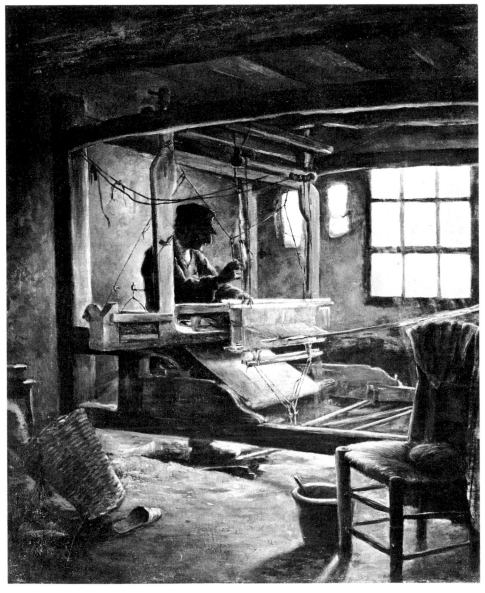

continue his labor night or day. Sérusier characterized the weaver as a pale, dejected individual whose basic sadness created a sullen impression. Perhaps aided by Theuriet's text, Sérusier documented the weaver's painstaking activity in the corner. Using dull, earthy colors, Sérusier achieved a realistic effect which the Salon jury rewarded with an honorable mention.

Few other Realist works by Sérusier are known. He quickly discarded this style of painting after he met Paul Gauguin in October 1888.[4]

1. The painting was listed as *Atelier de tisserand breton*, no. 2284, in the 1888 catalog of the Société des Artistes Français.
2. See Maurice Denis, *Paul Sérusier—ABC de la Peinture* (Paris: Librairie Floury, 1942), p. 42. Denis denigrates this composition.
3. See Theuriet, *La Vie rustique*, pp. 135-40.
4. Perhaps Sérusier was familiar with similar themes Vincent van Gogh used during the 1880s, although this has not been determined.

Exhibited

1888, Paris: Salon, no. 2284.
1979/80, London, Royal Academy of Arts: Post-Impressionism: Cross-Currents in European Painting, pp. 127-28, cat. no. 186.

Published

Marcel Guicheteau (with the assistance of Paule Henriette Boutaric), *Paul Sérusier* (Paris: Editions Side, 1976), pp. 17-18.

206a Joseph Bail, Oil sketch for *La Ménagère*, oil on wood.

Joseph Bail

206 *The Housewife (La Ménagère)*
Oil on canvas, 54-1/2 x 45-1/8 inches (138.5 x 114.5 cm.). Signed bottom right: Bail Joseph. Paris, Sénat, Palais du Luxembourg.

When it was exhibited at the 1897 Paris Salon,[1] Joseph Bail's *La Ménagère* reflected an interest in recording once-traditional household activities that by the turn of the century were already becoming less and less familiar to Salon audiences. Joseph Bail's canvas depicted a young woman, possibly his sister Amélie,[2] pickling gherkins by pouring vinegar into a large glass jar containing small cucumbers. The darkened interior of the large copper kettle nearby on the floor at the left and two additional glass jars on the low wooden stool dramatize the household chore that routinely took place in the fall of the year. The painting also suggests a latent use of the Naturalistic aesthetic, focusing on a scene from rural life and a timeless tradition far removed from the innovative pace and circumstances that increasing contact with larger cities had provided to alter the rural setting. The young woman wearing the white bonnet and apron and a red blouse dominates her environment —a rustic kitchen typical of the many simple house-

206

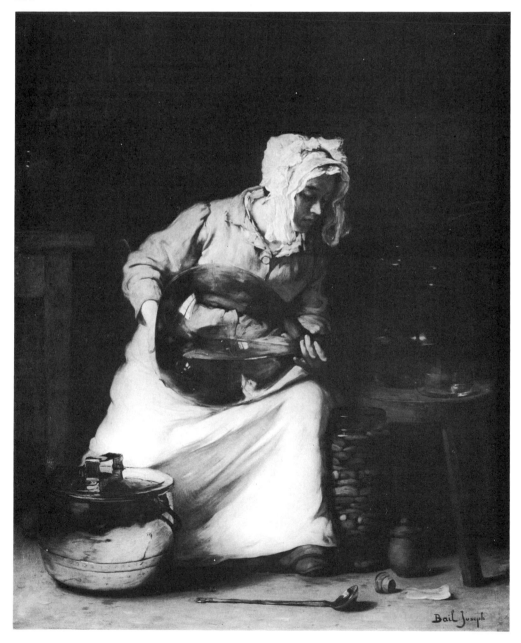

235

holds near Bois-le-Roi where the Bail family for many years spent the summer and early fall.

Stylistically, the painting is also traditional. The use of reflective surfaces, notably the copper kettle at the left, and the translucency of the vinegar in the glass container suggest that Bail had studied Northern masters closely, especially Van Eyck, to increase his sense of visual reality. The predominance of white and the use of a kitchen servant as a subject denote the influence of Chardin upon the painter. The impact of the first-generation Realist painters (e.g., François Bonvin and Théodule Ribot)— unusual this late in the century—is also evident here in the placement of the model as the central focus, as well as in her posture and her activity.

The existence of a small oil sketch for the figure (Figure 206a) also suggests that Joseph Bail worked on his composition in a traditional manner, first preparing a drawing and later an oil sketch, to arrange his color harmonies.

1. For further reference see the 1897 Salon catalog, which lists the painting as no. 61. It was acquired by the state and exhibited at the Luxembourg Museum prior to being transferred to its present location at the Sénat.

2. In the preliminary drawing of this theme, Bail carefully rendered the portrait quality of the woman. See J. Valmy-Baysse, "Joseph Bail," *Peintres d'aujourd'hui* (Paris, 1910), unpaginated. The identification of the model was made by Bail descendants in discussions with the author (fall 1979).

Published

J. P. Crespelle, *Les Maîtres de la Belle Epoque* (Paris: Hachette, 1966), p. 84, fig. 114.

Emile Bastien-Lepage

207 *The Young Craftsman*
Oil and gouache on panel, 24 x 24 inches (61 x 61 cm.). Signed and dated: Emile Bastien-Lepage 1901.
England, Sheffield City Art Galleries.
Provenance. Graves Gift to the Gallery, 1943.

207

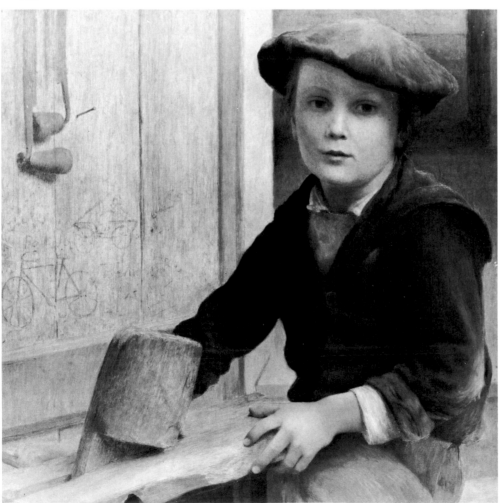

Since Emile Bastien-Lepage received his training in the tradition of genre painting [227] that his brother Jules probably taught him, *The Young Craftsman* was not an unusual theme for him to choose. By 1901, however, when this panel was painted, Emile was already an exceptionally successful architect whose commissions included homes in fashionable sections of Paris (e.g., Neuilly-sur-Seine). His name by that time was more often associated with friezes of flowers or mythological scenes than with the Realist themes that distinguished his brother.

The panel, which may have been created at the request of one of his patrons, reveals a modification of Realism that recalls the academicism practiced by William Bouguereau.[1] Unlike similar titles rendered earlier in the nineteenth century, however, Emile's popular image of the young apprentice is somewhat romantic in mood. Interest in Chardin's genre paintings was already well established, and touching scenes of sentimentality—devoid of oppressive social overtones—were favored, especially by English collectors. Edouard Frère, who is often considered a continuator of the genre tradition, found a ready audience for these themes in Great Britain, and it is likely that Emile Bastien-Lepage, in occasional easel paintings such as this, satisfied a similar clientele. His image is a mythical presentation of what a typical apprentice should look like. The direct gaze and pleasant countenance of the engaging youth, dressed in an oversized cap and posed at his workbench, reflect an atmosphere of purity and innocence that was sure to win the viewers' favor. The details of the environment, although meticulously observed, include wall graffiti of a bicycle and a carriage—intimating the pursuit of other pleasures perhaps more appropriate for the young model than the setting in which he has been placed.

Painted in pastel tones that suggest its use as a study for wall decoration, this panel presents a delicate quality in keeping with both the refined sensibilities of the painter and—although he remains unknown—a patron who desired to acknowledge the poor without any reminders of troublesome social issues.[2] This sentimentalized image at the turn of the century remains apart from the fundamental issues of the Realists and marks the decline of truthful representations of the lower classes.

1. His brother Jules has also been compared with Bouguereau. The brothers worked together in Cabanel's studio, and both retained certain academic qualities in their later work.

2. Emile Bastien-Lepage's architectural achievements would suggest the upper-middle class and the aristocracy—those who could afford fashionable new homes. Further research is necessary to establish the names of his patrons.

Still Life

Until the truly modern innovations of Cézanne and later of the Cubists, still-life painting changed little during the nineteenth century. Painters continued to study Chardin and the masters of Dutch seventeenth-century realism. They also learned from each other, painting the same objects on similar tabletops. Some of the later still-life painters paid less attention to detail and concentrated more upon light and quickly perceived textures; others tried to simplify their compositions to convey the casualness of objects in disarray [210], an effect probably best exemplified in the still lifes of Edouard Manet.

While landscape painting was often mentioned by avant-garde critics, still life does not seem to have attracted much notice. When Zola or Huysmans discussed an individual painter, they might examine a still life by that artist at the Salon, but they did not write long essays on the importance of still life and modernism. That Vollon and Ribot continued to paint like Chardin or a particular Dutch painter mattered little, and the critics—if they noticed at all—certainly did not condemn still-life painters for following past traditions. Modernity of subject matter (fruit, utensils, flowers) was, in this case, apparently not required; still life was one theme that could maintain the past in the present.

Later, formalistic qualities became paramount, and still-life painting reflected these innovations. When Huysmans wrote about the work of Antoine Vollon in 1880, he placed him squarely in an art-historical tradition, but he also praised him for painting in "true light." Unlike Ribot and Bonvin, whose still lifes remained somber, Vollon had managed both to maintain past tradition and to adopt the technical innovations of Manet and the palette of the Impressionists.

Pierre-Denis Bergeret

208 *Still Life*
 (Nature Morte)

Oil on canvas, 24 x 35-7/8 inches (61 x 91 cm.),
ca. 1876. Signed lower right: D Bergeret.
Bordeaux, Musée des Beaux-Arts.
Provenance. Gardère Donation, 1903.

As one of the more popular still-life painters
of the Third Republic, Pierre-Denis
Bergeret did numerous small canvases of
seafood and shellfish, such as this *Still Life*
depicting the contents of an overturned
wicker basket on a tabletop, or stone ledge.
His compositions emphasize the trophies of
the day displayed in the market or collected
in readiness for meal preparation. The hank
of straw and the slate slab on the rear wall

(marked with the date and number of fish
caught) are careful details from reality that
Bergeret retained to heighten the rusticity of
his setting. The rich, Romantic color range
of his compositions and his freely conceived
style were often compared with Antoine
Vollon. Bergeret remains singularly noted
for one still-life theme: the glorification of
fish and fishing.

Published

D. Alaux, *Musée de peinture de Bordeaux,
 Catalogue . . .* (Bordeaux, 1910), p. 62, no. 317.
Musée de peinture et de sculpture de Bordeaux
 cat. (Bellegarde, 1933), p. 54, no. 173.

Antoine Vollon

209 *Still Life with Peonies and
 a Slice of Pumpkin*

Oil on canvas, 19-13/16 x 24-1/8 inches (50.5 x
61.4 cm.). Signed lower right: A. Vollon.
U.S.A., Private Collection.

The provenances of Antoine Vollon's still
lifes are difficult to trace. The names of
specific collectors remain unknown, even
though there was always considerable in-
terest among middle-class collectors for
Vollon's work because of his success at the
Salons. After the Exposition Universelle in
1878, when Vollon won a first-class medal
and he received recognition as an outstand-
ing painter of the Third Republic, the de-
mand for his canvases undoubtedly in-
creased—so much so that the number of
commissions Vollon received during the
1880s and 1890s often made it necessary for
him to work on several still lifes at the same
time, thereby making it difficult to determine
the dates of these canvases. The most

208

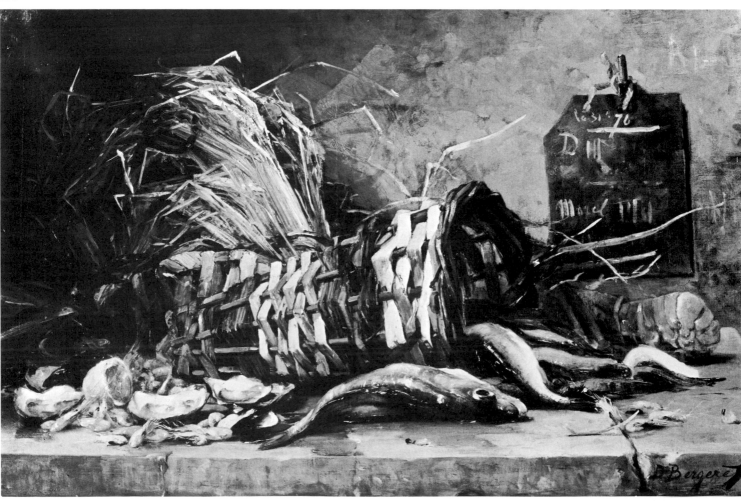

significant factor, however, was Vollon's preference for certain objects that had long remained part of his studio collection. Unlike other painters whose changing interests or choice of objects aid in establishing the date of their works, Vollon, like Chardin, continued to paint the same objects throughout his thirty-year career.

The obvious freedom evidenced in many of Vollon's later works was the product of examination, study, and familiarity with objects that he continually kept at hand. Whether it was a plate that he enjoyed painting or a vase that provided a comfortable shape, Vollon continued to favor these same objects, achieving variation by the accessories he added from the garden or the type of flowers he randomly arranged on a tabletop, rather than by the particular ceramics themselves. The green and brown glazed ceramic in *Still Life with Peonies and a Slice of Pumpkin* was a piece that Vollon cherished and used in other works [122]. In this canvas, Vollon selected a wedge of pumpkin not only because it was an available shape, but because the intense orange provided a necessary brilliance to the painter's color range that contrasted with the emerald green of the glazed ceramic.

Vollon was an exquisite flower painter, sharing with Fantin-Latour a preeminent position in this Romantic-Realist thematic category that can be discerned in his casual positioning of the showy head and satiny buds. Aside from the colorful blooms Vollon concentrated on the meaty pulp of the pumpkin, the smooth tactility of the cardoon, the dull chalky-white of the eggshells —characteristically disregarding the background. Vollon's tendency to imply abstraction was perhaps the result of reusing forms that he knew intimately—re-creating by familiarity until descriptive recording was transcended.

Published

Gabriel P. Weisberg, "A Still Life by Antoine Vollon, Painter of Two Traditions," *Bulletin of The Detroit Institute of Arts* LVI (1978): 226 repr., fig. 8.

Antoine Vollon

210 *Still Life with Ceramic Jug, Basket of Fish, and Cooking Utensils*
Oil on panel, 16-1/8 x 12-11/16 inches (41 x 32.2 cm.). Signed lower right: A. Vollon.
U.S.A., Private Collection.

After his return to France from Brussels (ca. 1871), Vollon spent more and more time away from Paris. During the late 1880s he lived in Bessancourt and Saint-Prix, where he worked directly from nature. Occasionally he would visit the village church to paint an interior view of the empty building. Sometimes he would set up his work within the shelter of the doorway of a rustic hut, to

209

210

paint the farmyard scene before him or a few still-life objects that he set up just outside.

When Vollon arranged still-life objects out-of-doors, such as near the barn door that is visible in *Still Life with Ceramic Jug, Basket of Fish, and Cooking Utensils,* he combined an interest in rural environment with a dedication to objects native to that particular locale. The paint surface in this later still life reflects Vollon's interest in spontaneity. In some areas, such as the wall of the building, the paint appears to have been splashed on the surface so that the qualities of masonry and wood are merely suggested. As one critic noted, "Vollon, coming at the end of Romanticism and the blossoming of Realism, simultaneously shows the influence of both."[1] This still life united a Realist's concern for observation and attention with a paint application that creates an atmosphere of Romanticism.

1. Etienne Martin, *Antoine Vollon: Peintre, 1833-1900* (Marseille, 1923), p. 25.

Published
Weisberg, "A Still Life by Antoine Vollon," p. 225, repr. p. 226, fig. 6.

Germain Ribot

211 *Oysters and Partridges*
Oil on canvas, 18-1/4 x 21-7/8 inches (46 x 55.5 cm.). Signed lower left: Germain Ribot.
Cleveland, Collection of Mr. and Mrs. Noah L. Butkin.
Provenance. K. Wyndham sale, Christie, Manson and Woods, Ltd. Nineteenth-Century Impressionist and Modern Paintings and Drawings, London, 1 April 1977, cat. no. 105, pl. 2.

Dead game continued as a theme throughout the nineteenth century. Well after 1875, the theme was still used by artists of traditional orientation, who positioned birds in spatial arrangements that not only suggested the paintings of Chardin but which also echoed the French heritage of the eighteenth century (e.g., Desportes). Germain Ribot's small canvas of *Oysters and Partridges* is a rare example of his work that shows the combination of traditional influences on the development of his style. The illumination effected in the muted tones of the plumage and the light glistening on the surface of the oysters indicate his mastery of his father's achievements.

Exhibited
1979, CMA: Chardin and the Still-Life Tradition in France, p. 56, cat. no. 54. Catalog by Gabriel P. Weisberg with William S. Talbot.

Victoria Dubourg (Madame Henri Fantin-Latour)

212 *Still Life (Nature Morte)*
Oil on canvas, 25-7/8 x 32-1/2 inches (65 x 82 cm.). Signed and dated upper right: V. Dubourg/1884.
Grenoble, Musée de Peinture et de Sculpture.
Provenance. Gift of V. Dubourg in June 1899.

Fantin-Latour's late marriage to the beautiful, young Victoria Dubourg provided not only the stabilizing comfort and support of a second family, but also encouraged his commitment to his art. For Victoria was a professional artist herself. She sustained Fantin-Latour's efforts, and continued her own—achieving a Salon medal in 1895.

Little is known about Victoria's still-life painting. She may have worked alongside her husband in her country studio, because many of his late flower paintings were completed in the quiet of her country property at Buré in Lower Normandy. Her own still lifes were traditional, suggestive of the influence of Chardin and the still-life revival at mid-century (e.g., Cals [116]). *Still Life,* an arrangement of objects at eye-level on a wooden table, reveals her ability to paint different textures, to capture shimmering light effects, and to compose a work that is not original in format, but competent in composition and form. She epitomizes many still-life painters active throughout the latter part of the century who resolved none of the formal problems encountered by the innovative, but continued a traditional arrangement of forms.

Exhibited
1977, Grenoble: Fantin Latour—Une Famille de peintres au XIXe·siècle, Collection du Musée de Grenoble, p. 18, cat. no. 30.

211

Guillaume Fouace

213 *Still Life with Roquefort Cheese*
(Nature Morte au Roquefort)
Oil on canvas, 16-1/8 x 12-5/8 inches (41 x 32 cm.).
Signed and dated lower left: G. Fouace/1885.
Cherbourg, Musée Thomas Henry.

From the moment he arrived in Paris from
Réville, in the north of France, Guillaume
Fouace found numerous collectors eager to
purchase his still lifes. At the 1873 Salon he
exhibited two canvases, *Femmes* and *Pot-
au-feu,* revealing his diversity in a genre that
provided him with a lucrative income. His
still lifes stress a simple arrangement of
everyday objects or foods (a slice of meat, a
cup, leeks, or a container on a plain table-

top) reminiscent of the early still lifes of An-
toine Vollon from the 1860s. Later canvases
often utilized a bottle of wine arranged with
a platter of oysters, a cut melon, grapes, or,
as in *Still Life with Roquefort Cheese,* a
slice of Roquefort under a glass cover.

Using a palette knife in his later works,
Fouace created a heavily built up surface
texture to capture subtle nuances of color
and light on the surface of objects. Often his
forms were spotlighted against a dark back-
ground, thus revealing the density and struc-
ture of his shapes. Compared by some cri-
tics with Chardin, because of the simplicity
of his arrangements, Fouace maintained the
tradition of Realist still lifes for middle-class
collectors.

Dominique Hubert Rozier

214 *Still Life—Game*
(Nature Morte, Gibier)
Oil on canvas, 45-1/4 x 57-1/8 inches (115 x 145
cm.), ca. 1886. Signed lower left: Dominique
Rozier.
Lille, Musée des Beaux-Arts.
Provenance. Given to the Museum in 1886 by
Mme. E. Denneville.

Still Life—Game may be the painting with
the same title (*Gibier*) exhibited by Domini-
que Rozier at the 1886 Paris Salon. This
canvas could more appropriately be entitled
After the Hunt, another still-life theme
widely used in the eighteenth century by
Desportes and others that became a tradi-
tional compositional organization in the
nineteenth century.

Large-scale, still-life paintings were used
to decorate middle-class dining rooms and
salons. Perhaps the private individual who
gave this work to the Lille museum in 1886
used it decoratively.[1] Randomly placing his
dead game in apparent disarray, Rozier por-
trayed a doe, hares, pheasants, and other
birds. The wicker baskets into which the
animals were stuffed after killing create an
atmosphere of rusticity which reinforces the
Realism of Rozier's composition. Working
in dull, earthen colors, and placing the dead
game close to the foreground, Rozier analyti-
cally studied his forms in direct light. Al-
though his painting technique was not as free
as that of his teacher, Antoine Vollon,
Rozier enjoyed a good following among col-
lectors, who appreciated meticulous style
and directness in large-scale still lifes.

1. A private donor gave this canvas to the Lille
Museum in 1886.

Exhibited
Possibly 1886, Paris: Salon.

213

242

Portraits

Although the Realists sought to revise interest in portraying the character of a sitter, the achievements of the first-generation Realists such as Bonvin and Ribot continued a Romantic heritage. Even after 1870 their portraits continued to be staged [217], although both painters broadened the types of individuals they immortalized; intended these studies of family and friends for the home and not for public spaces; and depicted their subjects in surroundings that would suggest character and occupation. Desboutin, for example, placed Madame Tribes in an elegant chair to suggest her aristocratic lineage [229]. Bastien-Lepage painted informal portraits that retain some of the qualities of a sketch, suggesting both the influence of the Impressionists and the warmth of the friendships within this closely knit artistic community. What differentiated later paintings from their predecessors was the attempt to respond to the new concern with psychology—to portray a state of mind. For example, compare Jean François Millet's *Portrait of Madame Roumy* [133] with the portraits by Lhermitte or Bastien-Lepage. Millet shows his sitter's advanced age through description; Lhermitte's *Portrait of the Artist's Father* [222] and Bastien-Lepage's drawings of a *Communicant* [224] suggest what each figure is thinking. The differences between the portraits of the earlier decades and these later ones are not dramatic, however. The shift is one of degree, a subtle change to increasing informality.[1]

1. Some Realists, including Carolus-Duran and Léon Bonnat, did return to the staged, formal portrait. Bonnat painted numerous portraits as artificial icons for members of the Third Republic.

Théodule Ribot

215 *Woman Looking Down*
Black wash on buff paper, 14-3/8 x 10-13/16 inches (36.5 x 27.5 cm.). Signed twice: top right-hand corner and bottom left: t. Ribot/1872.
London, Private Collection.
Provenance. Pelisson Collection.

Théodule Ribot used members of his family as models in his paintings and water colors. His interest in studying the human figure was supported by this dedication to his family, since he could not afford to hire studio assistants. During the 1860s, Ribot used his daughter Louise (b. 1857) in a series of genre scenes, and his son Germain (b. 1845) in several canvases showing theatrical performers [10, 11].

The wash drawing *Young Woman Looking Down* is one of perhaps several personal studies that Ribot did of Louise. Dated 1872, after the destruction of Ribot's studio in Argenteuil by the Prussians, this work marks Ribot's increasing subtlety as a portraitist—a new phase in Ribot's career that was to lead to his fame as a major psychological portraitist. The subtle shading of black and white reflects his study of similar washes and tonal gradations in Rembrandt's drawings, for along with his interest in seventeenth-century baroque art, Ribot absorbed the lighting techniques of Dutch and Spanish masters. The introspective quality of the closely viewed features was probably also inspired by Rembrandt's portraits, although only the fully illuminated face emerges. It is impossible to speculate if the downcast eyes are intent upon a book or if Ribot has simply captured Louise in a thoughtful moment of repose.

Exhibited
1972, London, Faerber and Maison Ltd.: Drawings, cat. no. 31.

Théodule Ribot

216 *Double Portrait: Reading the Bible*
 (*La Lecture de la Bible*)

Oil on canvas, 16-1/4 x 9-1/2 inches (41 x 24 cm.).
Bordeaux, Musée des Beaux-Arts.
Provenance. Given to the Museum by M.
Gardère, 1903.

The *Double Portrait* marks a transitional phase in the career of Théodule Ribot. It is a small, unsigned canvas that continues his interest in genre themes, but redirects his emphasis toward the faces of his models and eliminates all details of the interior. By concentrating on the reactions of the two women, contrasting the features of age and the older woman's apparent reverence for the little Bible with the receptive countenance of her listener, Ribot transcended the small genre themes derived from the streets of Paris, to realize an intimate study of personalities he knew well.

His practice of using his wife, his daughter, or other relatives as models may have inspired this new direction toward portraiture. The monochromatic range of tones that he continued to prefer, combined with his tendency to highlight only the faces and hands of his models, allowed his sitters to emerge as forceful presences whose gazes —often directed toward the viewer— capture their melancholy personalities.

Completed during the mid-1870s, this canvas anticipates Ribot's later, monumental portraits.

Exhibited

1947, Bordeaux, Musée des Beaux-Arts: La Vie du Musée de 1939 à 1947, cat. no. 149.

Published

D. Alaux, *Catalogue, Musée de peinture de Bordeaux* (Bordeaux, 1910), p. 104, cat. no. 560.
Charles Saunier, *Bordeaux* (Paris, 1925), p. 128.
G. Mahe, *Etude sur Louis-Richard-François-Dupont* (Caen, 1931), p. 13, cat. no. 53.
J. Vergnet-Ruiz and M. Laclotte, *Petits et Grands Musées de France* (Paris: Editions Cercle d'Art, 1962), p. 249.

216

215

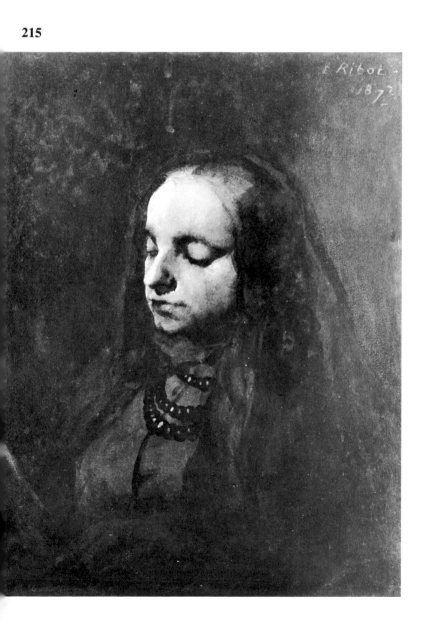

François Bonvin

217 *Portrait of Louison Köhler*

Oil on canvas, 21-5/8 x 18-1/8 inches (55 x 46 cm.).
Signed lower left: F. Bonvin.
The Cleveland Museum of Art, Gift of Mr. and
Mrs. Noah L. Butkin. 77.124.
Provenance. Hôtel Drouot (sale, 19 December
1973, no. 213). Vachet Collection. Mr. and Mrs.
Noah L. Butkin Collection.

François Bonvin was among the first-generation Realists who continued—even in the last decades of the century—to use the same themes and way of painting that had been established by the movement during the 1850s. The canvases Bonvin exhibited in the Salons or privately indicate a staunch dedication to the masters of previous generations, even though an awareness of innovations occurring in the younger Impressionist camp is also sometimes evident.

The *Portrait of Louison Köhler,* which Bonvin exhibited at the 1874 Salon, repeats a theme he had first used in the early 1850s when he painted *Young Woman Playing a Mandolin* (L. H. van Baaren Collection, Utrecht). At that time his compositions were influenced by concert performances he had studied by Terborch and Vermeer. He reused the concert theme many times in the years that followed, and his reliance upon Dutch painters as his prototypes never diminished.

The theme of a woman musician, however, was closely linked to Bonvin's personal life. Céline, his tempestuous second wife, was often depicted as a model with a mandolin, and she also posed for *Woman at the Spinet* [72]. The artist's companion in later years, Louison Köhler, is portrayed in the same traditional guise that Bonvin had used earlier—a young woman intent upon her musical performance. Bonvin had met Louison in 1870, probably at her father's shoemaker shop in St. Germain-en-Laye. Although they could not marry, they remained together for eighteen years (even during the Franco-Prussian War when Bonvin lived in England), until the painter's death in 1887. It is not surprising then that this was the last time Bonvin used the concert theme. His *Portrait of Louison Köhler* was a happy resolution, for Louison's dedication to the aging Realist remained constant.

The work shows a development in Bonvin's realism to convey allusions (a tendency toward Symbolism also evident in the later works of other Realists such as Jules Breton [204]). Posed in a period chair, Louison is about to play the cittern. In front of her, on a music stand, is an open music book. A disarray of other sheet music set to one side suggests that the concert has been in progress for some time. The bits of delicate pastry that have not been cleared away and the glass of wine on the silver tray serve to enhance the charms of the music. Louison seems oblivious to the blank sheets before her, her mouth open in song. Bonvin thus conveys a concert in progress that is similar to his earlier concert images, except that the details in this work are more specific and the symbolic suggestions heightened.

The difference is most apparent in the framed picture of the tempting nude placed on the back wall between Louison and the open sheet music. Bonvin did not incorporate such details in his earlier concert images, even though Dutch painters used such motifs to deepen the scope of a scene. This suggestive detail is also related to Bonvin's awareness of similar room embellishments used by his contemporaries. During the 1860s, Bonvin had ample opportunity to see the works of younger artists such as Edouard Manet and, to a lesser degree, Edgar Degas that were exhibited at the Salons. Both of these painters had perfected the device of using "pictures within pictures" to expand the narrative in a portrait setting and to provide allusions to other aspects of a sitter's life or career. Degas, in his *Portrait of the Belleli Family* (1859, Musée du Louvre), used a framed drawing on the back wall both to suggest one of his previous works and also to provide an image of a family ancestor who was still exerting his influence upon his heirs. Similarly, Manet, in his *Portrait of Emile Zola* (1868, Musée du Louvre), used a series of smaller pictures in the framed area on the back wall to suggest Zola's and Manet's mutual interest in Japanese art, to acknowledge Manet's previous work as an artist, and to suggest his interest in an earlier work by Diego Velázquez.

217

The variety of meanings thus conveyed by his colleagues in the structuring of additional pictures within pictures and his own awareness of seventeenth-century Dutch heritage enabled Bonvin to adapt the complex tradition either to develop a "contrived" image of his own or to copy a previous work. Bonvin's nude print, with its tones of gray and black, is similar to a reclining nude in the front plane of a *Bacchanale* by Titian, or some works from the eighteenth century. Bonvin's free adaptation of a single figure and the elimination of the rest of the composition, however, indicate that the alluring pose itself was all that Bonvin was interested in copying.

The painting of Louison has an air of an official portrait that must have satisfied Bonvin's sense of humor when it was exhibited at the Salon in 1874. Louison is wearing her best finery, including a black Spanish-style veil that is draped to cover her hair and one shoulder. Her fancy white blouse is ill fitting. Her apparel and her composure confirm Bonvin's intention to create an official portrait within a theme that he had been able to accentuate with personal symbolic allusions. The sensual overtones of the nude above, the choice of sitter, the long-standing interpretation of the concert theme combine to convey the devotion and beauty implicit in true love. The painting is transitional in treatment, representing an important shift in Bonvin's work—reflecting a modification from a purely visual response to a sitter to a specific and symbolic portrayal of the musical interlude.

Exhibited

1874, Paris: Salon, no. 218 (listed as *Portrait of Mlle. L. De K.*)

Published

Gabriel P. Weisberg, "The Traditional Realism of François Bonvin," CMA *Bulletin* LXV (November 1978): 280-98. Idem, *Bonvin: La Vie et l'oeuvre* (Paris: Geoffroy-Dechaume, 1979), cat. no. 95.

Théodule Ribot

218 *Self-Portrait*
 (Auto-Portrait)
Oil on canvas, 29-1/8 x 23-7/8 inches (73.5 x 60 cm.). Signed lower right: t. Ribot.
Lille, Musée des Beaux-Arts.
Provenance. Given to the Museum by Paul Engrand, 1935.

Théodule Ribot's *Self-Portrait* is similar to many of the large portraits that the painter completed during the 1880s that were shown at the retrospective exhibition of his work near the end of his career. During this later period, Ribot devoted his painting to studies of Breton peasants and large portraits of studio models, friends, and family. He continued to use the same somber palette that

had predominated in his genre scenes and childhood studies during the 1860s, but modified his later canvases by a more dramatic focus of the lighting upon the model's face. His increasing interest in psychological portraiture is evident in this intense study of his own features.

Dressed in a protective, hooded garment reminiscent of provincial fishermen, and posed with his paintbrush and palette, Ribot recorded his own gaze. He built up his face carefully with several layers of paint, but left the clothing of his upper torso sketchy. The resulting *Self-Portrait* is a rare examination of Ribot's personality and a document that provides one of the few opportunities to note the temperament of this mysterious painter.

Exhibited

1887, Paris, Galerie Bernheim-Jeune: Exposition T. Ribot, cat. no. 45.

218

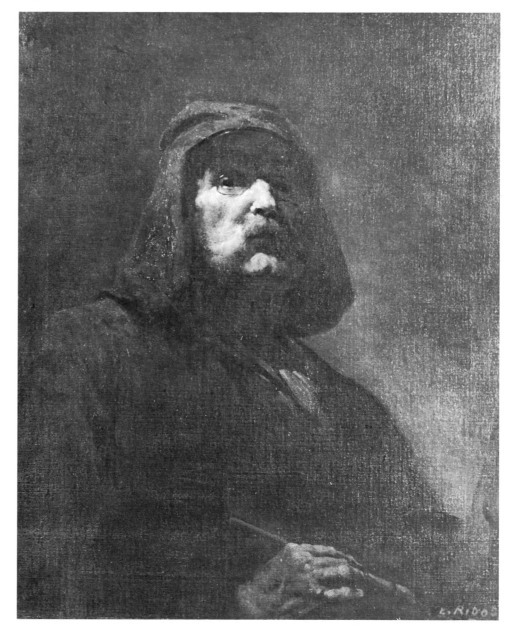

219 *Portrait of His Daughter*
 (Portrait de sa fille)

Oil on canvas, 36-1/2 x 25-5/8 inches (92.5 x 65.1
cm.). Signed lower left: t. Ribot.
Reims, Musée St. Denis.
Provenance. Purchased by H. Vasnier from Ribot
in 1884, 7000 francs. Donated by H. Vasnier to
the Museum, November 1907.

219

By the mid-1880s Théodule Ribot was a
well-established portraitist whose canvases
reveal a careful attentiveness to Rembrandt.
The same dramatic lighting of the face and
the same intensity of expression create a dis-
tinct impression of the model's tempera-
ment. The background of the *Portrait of His
Daughter* remains dark, so that only the face
of Louise is brilliantly illuminated. The
young model reflecting this emphasis directs
her gaze toward the viewer—a traditional
method in Ribot's later portraits.

Ribot completed several large paintings
with his daughter as model (e.g., *Portrait of
a Young Woman,* Tanenbaum Collection,
Canada), so that these compositions provide
not only a description of his own interests
and tendencies but an accurate record of his
family as well. The portrait tradition was
well established in Realist circles, but as the
movement developed it was modified from a
study of faces to full-length poses with the
model positioned against a flat, grayed back-
ground. Amand Gautier, Léon Bonnat,
Edouard Manet, James McNeill Whistler,
and most of the later Realists portrayed the
model interacting with the environment or
showed their models in natural, relaxed at-
titudes. Ribot, however, maintained a more
static, traditional approach.[1] The portraits
that he completed late in the movement con-
vey the psychological intensity of the sitter,
but belong to an earlier tradition, which sel-
dom conveys the animation of contemporary
life that other portrait painters were then
achieving.

Ribot's technique, with the face emerging
out of total darkness, forecasts later Sym-
bolist icons,[2] especially Eugène Carrière's
monochromatic themes of family and mater-
nal care. The success of this portrait, which
was purchased in 1884 after its exhibition at
the Paris Salon, helps document Ribot's
transition from genre to portraiture and his
growing appeal among private middle-class
patrons eager to acquire his portraits at sub-
stantial prices.

1. The static Realism of Ribot and Bonvin differs
from the movement and contemporary life found
in the paintings of Manet, Legros, or Fantin-
Latour. See Henri Focillon, *La Peinture aux
XIXe et XXe siècles* (Paris: Librairie Renouard,
1928), p. 162.
2. Louis de Fourcaud believed that Ribot cap-
tured the essence of humanity in his portraits by
"imprisoning a soul in his canvas." This concept
is similar to the Symbolist painters' desire to re-
veal states of mind in their portraits. See Louis de

Fourcaud, "Le Salon de 1884," *Gazette des Beaux-Arts* XXIX (1884): 480-81.

Exhibited

1884, Paris: Salon, no. 2036.
n.d., Paris: Exposition rétrospective du Salon de la Société Nationale des Beaux-Arts.
1906, Bagatelle.

Published

Drawing by Ribot, *Gazette des Beaux-Arts* XXX (1884): 50, repr.
Paul Lefort, "Th. Ribot," *Gazette des Beaux-Arts* VI (October 1891): 309.
Atalone, *La Galerie Vasnier à Reims* (Reims, 1909), p. 36.
Vasnier (privately printed), cat. no. 224.
Hélène Toussaint, "Collection Henry Vasnier: Peintures et dessins" (MS, Musée de Reims, 1969; now at Musée du Louvre), cat. no. 302.

Charles-Emile Carolus-Duran

220 *Portrait of Philippe Burty*
Oil on canvas, 18-3/4 x 15-3/4 inches (47.5 x 40 cm.). Signed and dated upper right: Carolus-Duran/1874. Inscribed upper left: AP. Burty.
Paris, Private Collection.

Philippe Burty, one of the most progressive critics of his generation, actively supported the changes that were taking place in print-making, decorative arts, and painting during the 1870s and 1880s. He was an early enthusiast of *japonisme* (the taste for Japanese art and culture then taking place in France) and an ardent early advocate of Impressionism. As chief art critic for Léon Gambetta's *La République Française,* he revealed an astute knowledge of the new painting tendencies manifested by the first Impressionist exhibition (1874)—and an intimate awareness of these painters' approaches that he had acquired from conversations with friends and visits to artists' studios.

As well as championing independent painting, Burty also sought modern tendencies in the traditional Salon exhibitions. At the 1874 Salon, Charles-Emile Carolus-Duran's fashionable portraits of women were harshly criticized by Emile Zola, and especially by Jules Antoine Castagnary, who believed Carolus-Duran had forsaken his Realist inclination for intimate portraits to produce, instead, paintings that pandered to popular taste or recorded only the superficialities of fashion and attitude.[1] Burty, however, did not join this criticism. He praised Carolus-Duran's freer style of painting, recognizing his move away from Realism as a mastery of subtle tones and drawing. Despite similar criticism of Carolus-Duran at the 1876 Salon, Burty maintained his support, commending the *Portrait of M. de Girardin* as "the major work"[2] at that Salon and designating it a legitimate success.

The *Portrait of Philippe Burty* justifies the strong regard Burty held for Carolus-Duran. It was completed in 1874 during the period when Carolus-Duran was receiving much criticism from proponents of Naturalism (such as Zola), but the relationship between the two men is not fully known. The accuracy of his likeness, conveyed with a bravura brushstroke, undoubtedly appealed to Burty, whose own Romantic inclinations are substantiated by the painters he chose to favor in his published reviews.

1. For further reference see Jules Antoine Castagnary, *Salons 1872-1879* (Paris, 1892), I, 24-25, 90-91, 115-16, 163-64, 238.
2. See Philippe Burty, "Le Salon de 1874," *La République Française,* 28 May 1874 and "Le Salon de 1876," *La République Française,* 17 May 1876.

Published

Gabriel P. Weisberg, "Philippe Burty: A Notable Critic of the Nineteenth Century," *Apollo* XCI (April 1970): 296, fig. 3.

220

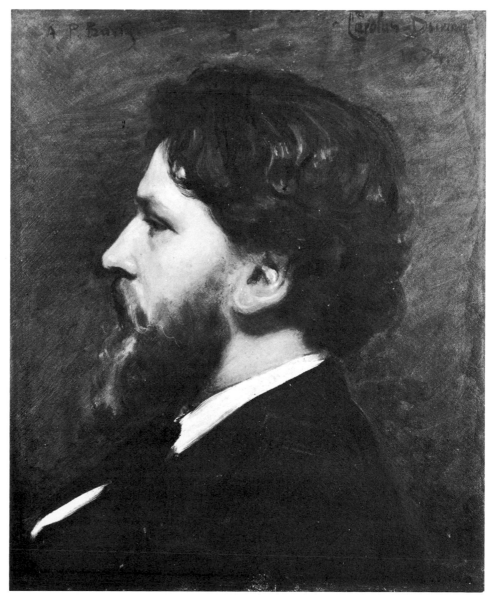

Jules Bastien-Lepage

221 *The Artist's Mother*
(La Mère de l'artiste)

Oil on canvas, 40-5/8 x 30-3/8 inches (103 x 77 cm.). Signed lower left: BASTIEN-LEPAGE. Nice, Musée des Beaux-Arts Jules Chéret.
Provenance. Emile Bastien-Lepage. Musée du Louvre (Gift of Emile Bastien-Lepage).

The composition *Mes Parents* that Jules Bastien-Lepage exhibited at the 1877 Salon revealed his intimate home life and the pro-vincial world of Damvillers. The companion portraits of his parents had been painted some years earlier, in 1874 and 1875, so that his decision to combine the two portraits and exhibit them at the 1877 Salon was probably based on his intention to become established as a painter of provincial themes.

Some time prior to the exhibition, the in-dividual portraits were united to form a dip-tych. When the Salon jury discovered the two sections were actually separate paint-ings, however, they requested that the dip-tych be sewn together.[1] Although Bastien-Lepage complied with the Salon require-ment, after the Salon closed he again sepa-rated the works and they have since been considered individual, but companion en-tities.

Just as an earlier *Portrait of His Grand-father* established his concern for recording his origins, he intended his portraits of his parents to attest to their effect upon his life and career as a painter. He undoubtedly wanted to reveal the peasant stock from which he was born, and to make his portraits equal to the more aristocratic studies exhib-ited by other portrait painters at the annual Salons. His parents' garden in Damvillers, which served as the original background for both portraits,[2] was modified to a dull, earthy background in the diptych that effec-tively relates these figures to the soil. The heavy use of pigment in the background and throughout the composition demonstrates a type of realism that is characteristically as-sociated with Courbet, the prime exponent of the Realist movement. While some crit-ics, notably Duranty, did not like the por-traits, the diptych provided a forceful pre-sentation of both figures. From her posture, *The Artist's Mother* was probably placed to the left. Whether Bastien-Lepage was aided by the use of photographs remains un-documented, although the unembellished di-rectness and immediacy of his mother—her unassuming pose and her lips parted as if about to speak—suggests a photographic source (Figure 221a).[3]

221

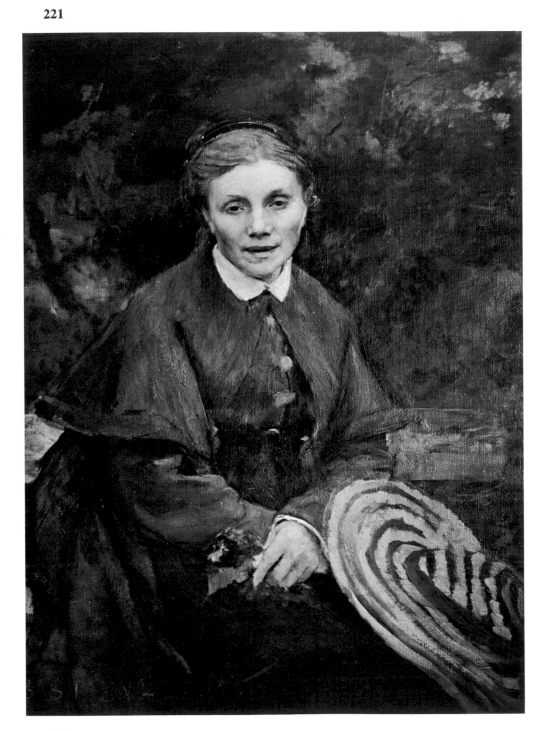

221a Photograph of Mme. Bastien-Lepage.

1. Information supplied by the Musée des Beaux-Arts Jules Chéret, Nice. Bastien-Lepage also submitted a more aristrocratic *Portrait of M. L. . . .* that year.

2. William Steven Feldman, "The Life and Work of Jules Bastien-Lepage" (Ph.D. diss., New York University, 1973), p. 191.

3. Feldman, "Life and Work," p. 193. Although no direct borrowings from photographs have been found in Bastien-Lepage's work, the possibility remains that he did utilize photographs in several works. The descendants of Bastien-Lepage in 1978 showed the author a series of photographs made by Bastien-Lepage in Venice (near the end of his life) that testify to his familiarity with this medium. Figure 221a is a similar (but not exact) photograph of his mother taken by Hermet (45 rue Jacob) and preserved in the family collection, which documents that photographs existed from which Bastien-Lepage could have worked.

Exhibited

1877, Paris, Cercle Artistique et Littéraire: Exposition de peinture et de sculpture, no. 8.
1877, Paris: Salon, no. 118 (listed as *Mes Parents).*
1885, Paris, Ecole Nationale des Beaux-Arts, Hôtel de Chimay: Exposition des oeuvres de Jules Bastien-Lepage, pp. 17, 36, no. 33.
1939, Nice, Musée Jules Chéret: Exposition rétrospective—Bastien-Lepage, 1848-1884; Louise Breslau, 1854-1927; Marie Bashkirtseff, 1860-1884, p. 16, no. 3.

Published

Le Voltaire, 12 December 1884.
La Marseillaise, 14 December 1884.
Louis de Fourcaud, "Exposition des oeuvres de Bastien-Lepage — à l'Hôtel de Chimay," *Gazette des Beaux-Arts* XXXI (1885): 266.
Julia Cartwright, "Jules Bastien-Lepage," *Portfolio,* 1894, p. 29.
H. Amic, *Jules Bastien-Lepage—Lettres et Souvenirs* (Evreux, 1896), p. 3.
J. Joseph Saqui and M. G. A. Mossa, *Exposition rétrospective—Bastien-Lepage 1848-1884; Louise Breslau, 1854-1927; Marie Bashkirtseff, 1860-1884* (Nice, 1939), pp. 14, 16, no. 3.
Louis-Emile Duranty, "Réflexions d'un bourgeois sur le Salon," *Gazette des Beaux-Arts* XVI (1877): 79.
Feldman, "Life and Work," pp. 189-96, fig. 80.

Léon Lhermitte

222 *Portrait of the Artist's Father (Portrait du père de l'artiste)*
Charcoal on squared paper, 13-3/8 x 12-3/8 inches (34 x 31 cm.). Signed upper left: L. Lhermitte. Inscription on reverse: Portrait de mon Père.
Paris, Private Collection.

Perspicaciously discerning his son's ability, Léon Lhermitte's father, a schoolteacher, actively supported Léon's interest in art. Léon sketched in his father's classroom at Mont-Saint-Père, and both parents encouraged him to develop his talent, doing everything they could to enable Léon to continue his education in a Parisian art school. Léon's father showed the boy's earliest drawings to Count Alexandre Walewski,

with the result that Léon received a stipend to study art in Paris. Such parental guidance was unusual in the nineteenth century and helps explain Léon's affectionate relationship with his father.

Early in his career, when Lhermitte was establishing himself as a major proponent of black and white drawing, he did a meticulous portrait of his father.[1] Depicting Jacques-Augustin Lhermitte leafing through a book at his reading table in his familiar classroom setting underscored his studious nature. Devoted to the primary education of children, Jacques-Augustin Lhermitte symbolized the dedication of the local schoolteacher as one who regarded the continuation of his students beyond the primary years as reward enough. Among Lhermitte's earliest charcoal portraits, *Portrait of the Artist's Father,* exhibited at the 1877 Salon, demonstrates Lhermitte's fidelity to appear-

ance while yet retaining the warm, sensitive personality of his father.

1. The date of this drawing remains unknown. Lhermitte did a number of portraits of friends during the 1870s that are comparable with this work, notably studies of Edwin Edwards, Jean Charles Cazin, and his own wife. See Mary Michele Hamel, "A French Artist: Léon Lhermitte (1844-1925)" (Ph.D. diss., Washington University, St. Louis, May 1974), cat. nos. 36-38.

Exhibited

1877, Paris: Salon, cat. no. 3065.
1881, Paris: First Exhibition of Works in Black and White, cat. no. 116.
1924, Paris, Salon: Rétrospective, Société Nationale des Beaux-Arts, cat. no. 705.

Published

Hamel, "A French Artist," cat. no. 35.
L. Roger Milès, "Léon Lhermitte," *Le Figaro Illustré* 18 (1907): 150, repr. p. 147.

222

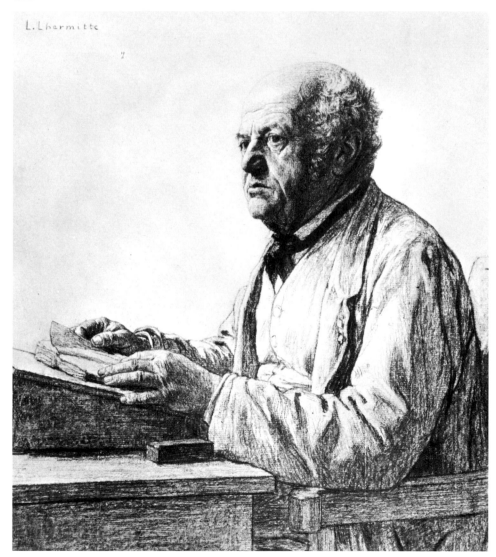

L. Lhermitte

Jean-Louis-Ernest Meissonier

223 *Portrait of Alfred Lachnitt*
Oil on wood, 9-7/8 x 6-1/8 inches (25.1 x 15.5 cm.), 1877. Initialed [reversed *E* superimposed on first stroke of *M*] and dated lower left: 1877. Inscription on back: M. Alfred Lachnitt (artiste-peintre à lithographe) peint par M. Meissonier dans son atelier Bl. à place Malesherbes en 1877.
Cleveland, Collection of Mr. and Mrs. Noah L. Butkin.
Provenance. Private Collection, Belgium. Shepherd Gallery, New York.

Portrait of Alfred Lachnitt, with the figure posed informally against a large worktable, suggests that Jean-Louis-Ernest Meissonier perhaps did other small studies of artists and acquaintances that document his friendships.[1] The apparent sense of momentariness is heightened by Lachnitt's outward gaze—and his relaxed, but mannered post-

ure (with one hand in his pocket and the other resting in a belt loop) adds to the impression of ''captured'' casualness. The artist Lachnitt's dedication to his work is documented by the disarray of business folders and books on the table. As an example of Naturalist portraiture, this panel reveals Meissonier's ability to capture fashionable types as well as scenes from contemporary history [108].

1. Whether the two men knew one another well is not known.

Jules Bastien-Lepage

224 Drawing for *The Communicant* (*La Communiante*)
Drawing, 10 x 8 inches (25 x 20 cm.).
Paris, Private Collection.
Provenance. Descendants of the artist.

The discovery of a small drawing in the possession of the descendants of Jules Bastien-Lepage raises significant questions about the painter's manner of working during the formative stages of his career. The preciseness of the line and the descriptive accuracy in the face and dress of the young girl in a drawing for *The Communicant* reveal his ability as a miniaturist. His knowledge of the Northern painters who worked on a small scale and showed a similar interest in preciseness cannot be verified, although the clarity and fineness of this drawing suggest

223

224

his indebtedness to painters and draftsmen from the fifteenth and sixteenth centuries (e.g., Holbein or Clouet).[1]

There may be another explanation for the exquisite detail that distinguishes this drawing. The drawing is small enough (10 x 8 inches) to correspond to a photographic glass negative. The model, his godchild Lucie Bastien, is depicted at the time of her First Communion, an event that may well have been commemorated by a professional photographer.[2] The simple, flattened, iconic pose and the minute detail may thus have been transcribed by Bastien-Lepage from the photographer's glass negative or positive print.

Bastien-Lepage also made an oil sketch of his godchild before he proceeded to complete the final Salon canvas (Musée de Tournai), indicating that he worked for some time in order to perfect the pose, detail, and the simple, tonal color range.[3] When the finished canvas was exhibited at the 1875 Salon, it was hung with the *Portrait of M. Hayem,* which some have also identified as derived from a photograph.[4]

Whether or not the work was derived from a photograph, it indeed reflects Bastien-Lepage's increasing ability to achieve simplification. The plain young girl dressed exclusively in white is stiffly posed to look directly at the viewer. Within her hands she holds a small prayerbook, and her veil is crowned with blossoms. Referring to the social as well as religious significance of the solemn occasion in the provincial town of Damvillers in 1894, the art critic Julia Cartwright thus described Bastien-Lepage's young godchild as a "portrait of [a] little peasant girl robed in white for her First Communion. . . . The little dark-eyed maid is seated erect in her chair, wearing a frock of thick white muslin and a stiff white veil. . . . She holds her missal before her, and her rough hands are stuffed into white gloves cracked at the seams, in her efforts to pull them on. Yet every line of her figure, every detail of her dress, the conscious primness of her quaint little person, the very awkwardness with which she wears her new clothes, helps us to realize the importance and solemnity of the occasion."[5] The drawing, which served as the starting point for a series of works that culminated in the Salon entry, effectively captured the awkward innocence of the young girl. Unlike some of Bastien-Lepage's other early work, the little portrait synthesizes both his interest in Northern painters and his indebtedness to photographic Naturalism.

1. The relationship with Northern Renaissance masters was suggested by Theuriet and Mantz when the finished painting was exhibited at the Paris Salon. See André Theuriet, *Jules Bastien-Lepage, l'homme et l'artiste* (Paris, 1885), p. 33; Paul Mantz, "Bastien-Lepage," *Le Temps,* 23 December 1884.

2. The flat, blank background in both the drawing and the painting are similar to the backdrop used in a photographer's studio. There is no currently available photographic source with which to compare this work even though the author had access to the photo albums of the Bastien-Lepage family. (Of course, this does not preclude the possibility that a photographic negative was made and subsequently either lost or destroyed.)

3. The oil sketch is in the possession of the descendants of Bastien-Lepage. It is inscribed at the lower left "bon souvenir à ma petite Lucie."

4. Feldman, "Life and Work," p. 74. Professor Van Deren Coke, a noted photographic historian, in discussions with the author, reiterated the belief that Bastien-Lepage—like other painters of the period—worked from photographs. Such photographs were then either destroyed (to hide any trace of the artist's use of a reproductive medium) or hidden by descendants who feared that revealing how an artist worked would impugn his originality. On the contrary, to work from a photographic source (as Gustave Caillebotte and Edgar Degas did in the late 1870s) heightened the descriptive Naturalism and enabled a simplification of design that often enhanced the painting.

5. Cartwright, "Jules Bastien-Lepage," pp. 22-23. Although Cartwright's description refers to the Salon painting, the same qualities are also evident in the drawing.

Published (Salon painting only)

Catalogue des tableaux, esquisses, etc., laissés dans son atelier, Sale (Paris, 1885), p. 31, no. 173 or p. 33, no. 198.
de Fourcaud, "Exposition des oeuvres de Bastien-Lepage," p. 226.
Exposition des oeuvres de Jules Bastien-Lepage, cat., Ecole Nationale des Beaux-Arts, Hôtel de Chimay (Paris, 1885), p. 36, no. 32.
Gustave Larroumet, *Discours prononcé à l'inauguration de la statue de Jules Bastien-Lepage à Damvillers, le 29 septembre 1889* (Paris, 1889), p. 9.
"Jules Bastien-Lepage," in *Masters in Art* IX (Boston, 1908): 26.
Léonce Bénédite, *L'Art au XIXe siècle— 1800-1900* (Paris, n.d.), p. 286.
Feldman, "Life and Work," pp. 74-80, fig. 21.

Jules Bastien-Lepage

225 *Portrait of Marie Samary of the Odéon*
Oil on canvas, 21-1/8 x 18-1/4 inches (53 x 46 cm.). Signed upper left: A ma bonne Marie Samary/ BASTIEN-LEPAGE.
Cleveland, Collection of Mr. and Mrs. Noah L. Butkin.
Provenance. Galerie André Watteau, Paris.

By the late 1870s, Jules Bastien-Lepage's fame as a portraitist was well established and he attracted a large following. The few paintings that have been located from this period provide an impressive list of the artist's fashionable acquaintances during the peak years of his career. Contemporary reviews noted his attendance at the salon gatherings of Edmund Adam, where he mingled with politicians (including Léon Gambetta), authors, and artists.[1]

Women especially found him charming, despite his small stature, and his friendships included a number of famous actresses of the period. His friendship with Sarah Bernhardt, whose portrait he exhibited at the 1879 Salon, gained him access to many theatrical circles. The portraits he completed of stage performers and art critics thus range from the actor Henry Irving (National Portrait Gallery, London), the dancer Rosita Mauri (Musée Jules Chéret, Nice), to the important art critic Albert Wolff (Mr. and Mrs. Noah L. Butkin Collection, Cleveland). Writers recalled evenings spent with Bastien-Lepage when he dined with Marie Samary and her sister Jeanne—both involved with the Comédie-Française. Relationships with such individuals refute the impression held by many about Bastien-Lepage's distaste for glamorous city life and his preoccupation with dour provincial scenes. He was not an isolated artist, and he very carefully cultivated his contacts with the socially prominent in order to assure his livelihood as a portrait painter.

Like Edgar Degas, Bastien-Lepage shared a sense of involvement with his sitters that is apparent in many of his portraits from 1879. In *Portrait of Marie Samary of the Odéon,* which shows Marie about to speak, Bastien-Lepage conveyed an impression of animation and liveliness that makes this one of his most lifelike portraits. The tilt of Marie's head and neck and her forthright upward glance (as if in reaction to something the painter had just said) suggest a candor worthy of the best Impressionist portraits.

Bastien-Lepage considered the portrait complete, although the relaxed pose, with details of dress, hat, and environment quickly brushed in and only the face itself somewhat more detailed, conveys a spontaneity usually confined to a sketch. His success in capturing gestures, similar to Edgar Degas, is achieved not only in the angle of the head, but also in the way in which the lace ruffles of the dress accent Marie's body and direct the viewer to her

animated expression. The rich, but muted range of colors also demonstrates his mastery of tonal painting.

1. Amic, *Jules Bastien-Lepage*, p. 2.

Exhibited
1939, Nice: Exposition rétrospective— Bastien-Lepage, 1848-1884; Louise Breslau, 1854-1927; Marie Bashkirtseff, 1860-1884, p. 17, no. 5, repr. Preface by Gabriel Hanoteaux.

Jules Bastien-Lepage

226 *Young Woman in Bed*
 (Jeune Femme dans un lit)
Oil on canvas, 15 x 18-1/4 inches (38 x 46.5 cm.).
Signed and dated lower right: Jules BASTIEN-LEPAGE/1880.
Paris, Private Collection.
Provenance. Gift of Emile Bastien-Lepage to the present owner in 1936/37.

An unusual study entitled *Young Woman in Bed* was completed by Jules Bastien-Lepage around 1880 at the height of his distinction as both a portraitist and a painter of large-scale Salon compositions. Like the sketchy portraits of Edgar Degas, an artist whom Bastien-Lepage admired at the time, the work attempts the dissolution of form found in classic Impressionism and the symbolic

atmosphere of restfulness and idyllic quietude associated with sleep.[1] The delicate tones of lavender, blue, and white reveal Bastien-Lepage's ability to complete a tonal painting that is also suggestive of James McNeill Whistler. As an intimate close-up of a companion, this reposing figure[2] suggests his ties with the Naturalists who were then studying aspects of life seldom seen in contemporary painting.

1. Feldman, "Life and Work," pp. 227-28.
2. His model remains unknown.

Emile Bastien-Lepage

227 *Portrait of His Grandfather*
 (Portrait de son Grand-Père)
Oil on wood, 8-3/8 x 11 inches (22 x 28 cm.).
Signed lower right. Dated on the back: 1880.
Paris, Private Collection.
Provenance. Inherited by the present owner from Emile Bastien-Lepage.

Between the year 1874 when Jules Bastien-Lepage submitted his *Portrait of His Grandfather* to the Salon until 1880, the eldest member of the Bastien-Lepage family appeared often as a model in the compositions of both Jules and Emile. A series of sketches by Jules includes descriptions of the elderly figure holding an open book, or asleep in his comfortable chair, and studies only of his head that portray him wearing his black skullcap. Such informal poses gave Jules the opportunity to study the personality of an individual he deeply loved, but they also reveal the artist's reliance upon observation as the basis for his portraits.

Like his brother, Emile was also interested in portraiture and completed a small oil painting of his grandfather with his chair drawn directly before an open fire (ca. 1880). The aging figure wearing the familiar skullcap and worn jacket is gazing pensively into the flames, as if unaware of his role as model. The intimate scene, which Jules may have helped Emile to achieve, emphasizes the close-knit relationship among all members of the family.[1] It also documents the ability of Emile Bastien-Lepage to complete Realist portraits in muted tones.

1. Descendants of Bastien-Lepage attribute the painting to both Jules and Emile (discussions with the author, 1978).

225

226

227

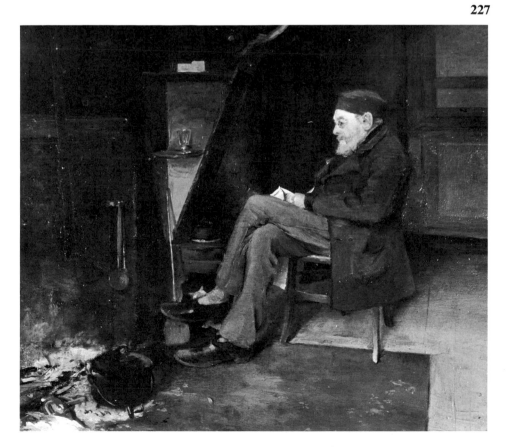

Jean Charles Cazin

228 *Gambetta's Death Chamber*
(La Chambre mortuaire de Gambetta)
Oil on canvas, 15 x 18-1/2 inches (38 x 47 cm.).
Signed lower right: J. C. CAZIN.
Versailles, Musée National du Château de Versailles.
Provenance. Purchased from Cazin 18 November 1887 for 3500 francs for the Luxembourg Museum. Deposited by the Louvre at Versailles.

The premature death of the politician Léon Gambetta in 1882 deeply shocked his many close friends in the art world. Jean Charles Cazin had often entertained Gambetta in his summer home at Equihen and had frequently discussed the politics of the country with him. The loss of this vigorous young friend in the prime of his life moved Cazin to journey to Gambetta's home in Paris to paint *Gambetta's Death Chamber,* a melancholic substitute portrait of his friend.

Gambetta was prime minister for only a brief period, from November 1881 to January 1882, but he holds a major place in the history of France, for he is regarded as one of the main founders of the Third Republic. His strength came from his appeal to a wide spectrum of social classes (peasants as well as workers and lower bourgeoisie) and from his opposition to clericalism.[1] He used his newspaper *La République Française* to voice his democratic outlook and his policies for a new social order within the country. In the world of art, Gambetta played a curious role, for his independent views were best expressed through the liberal reviewer Philippe Burty (1830-1890), the primary art critic of the newspaper. Burty, in turn, championed Cazin and other artists of the Impressionist mold, and took a firm stand against the Academy and the professors of the Ecole des Beaux-Arts. The success of *La République Française* in reaching the middle class was so effective that the paper became financially independent, providing Gambetta, by the time he became prime minister, with a substantial income that permitted him to live fashionably and luxuriously.[2]

When Cazin's *Gambetta's Death Chamber* was exhibited at the 1883 Salon, it had a particularly sobering effect upon both critics and public. The atmosphere of the room suggests that the composition was completed from actual observation, for the bed is strewn with laurel leaves, and the tricolor and memorial wreath resting at the foot of the bed underscore the tragedy. The works of art and the disarray of unfinished business indicated by the books and papers strewn about the room convey both the importance of the man and the tragic abruptness with which his life was interrupted.

Reviewing the reaction to Cazin's tribute, Léonce Bénédite wrote: "See, in *Gambetta's Death Chamber,* all this tragic grandeur which Cazin knows how to convey

255

through the use of some torn papers, some scattered sheaves . . . some yellow books, red sealing wax, a hat left on a chair, and the poignant and touching note of the colored flag placed at the foot of the chair. It is all the banal furnishing of an ordinary room with its low ceiling, its engravings, and its gray, flowery wallpaper. But nothing is more moving than the silent eloquence of all the inanimate witnesses that speak of one who will not return. In Hobbema, so profoundly endowed with a feeling for life, those vulgar accessories only accentuate the verisimilitude, the sense of nature and reality. Remembering Millet who, in turn, using them with great power, imbued them with a kind of religious and symbolic meaning, Cazin reused them, looking at the Dutch master in order to achieve a character even more expressive—a moving and gently pathetic role."[3]

The only similar canvas Cazin completed was a small study late in the 1850s of his father's office (Musée d'Arras). While the brushstrokes in the earlier canvas are not as free, in it Cazin revealed the same sense of internal order and observation of detail. *Gambetta's Death Chamber* suggests the influence of Impressionism, but, with the exception of the intense color of the flag, the tonal range is more subdued. The composition was purchased by the government in 1887 for the Luxembourg Museum, and thus promoted Cazin's standing as a leading artist during the Third Republic.

1. Theodore Zeldin to the author, 10 April 1980. For information on Gambetta's concern about clericalism, see Eugen Weber, *Peasants into Frenchmen: The Modernization of Rural France, 1870-1914* (Stanford University Press, 1976), p. 359.
2. Gambetta's relationship with the newspaper *La République Française* is discussed in Theodore Zeldin, *France: 1848-1945*, vol. 2, *Intellect, Taste and Anxiety* (Oxford: Clarenden Press, 1977), pp. 502-3.
3. Léonce Bénédite, "Jean Charles Cazin," *Les Artistes de tous les temps,* série D, le XXe siècle (Paris, n.d.), pp. 22, 55.

Exhibited
1883, Paris: Salon, cat. no. 147.

Published
Catalogue du Salon de 1883 (Paris, 1883).
Léonce Bénédite, *Le Musée National du Luxembourg, Catalogue raisonné et illustré des peintures, sculptures, dessins . . . des écoles contemporaines* (Paris, 1896).
Linda Nochlin, *Realism* (New York and Baltimore: Penguin Books, 1971), repr. p. 68, pl. 30.

Marcellin Desboutin

229 *Portrait of Mme. Aldonce Tribes (Portrait de Mme. Aldonce Tribes)*
Oil on canvas, 90-1/2 x 70-7/8 inches (230 x 180 cm.). Signed upper left: M. Desboutin 1885.
Nice, Musée des Beaux-Arts Jules Chéret.
Provenance. Given to the Museum by M. Edouard Tribes, 1951.

Between 1880 and 1888 Marcellin Desboutin lived in Nice. Little is known about his stay there except that his propensity to study individuals he knew continued and resulted in a number of portraits. Some of these canvases were of wealthy, local individuals, for example, *Portrait of Mme. Aldonce Tribes*.

During this happier period, the warmth of the south of France brightened Desboutin's color, which led him toward a luminous study of light. His ability to capture the personality of a fashionable sitter echoes the upper-class Naturalism of the major Salon portraits by Auguste Renoir, Fantin-Latour, and Albert Besnard. Using dark blue or black to heighten the richer, romantic tones in setting and dress, Desboutin created a mood of opulence which contrasted with the drab, stark paintings he had completed earlier in Paris. He had become a fashionable portrait painter of the well-to-do families of the Côte d'Azur.

Exhibited
1967, Nice, Galerie des Ponchettes: Marcellin Desboutin, cat. no. 52.
1976, Tokyo, Osaka, Kobe: Promenade dans les Musées et Fondations de la Côte d'Azur, cat. no. 55, col. repr.

228

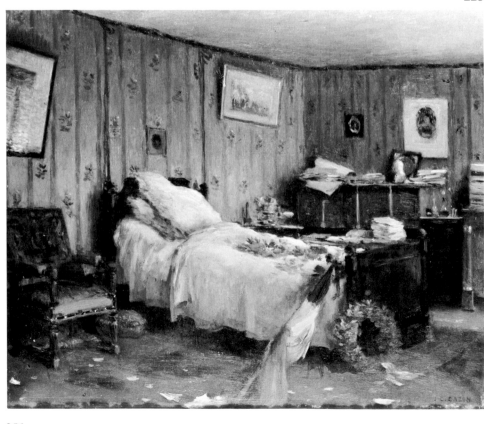

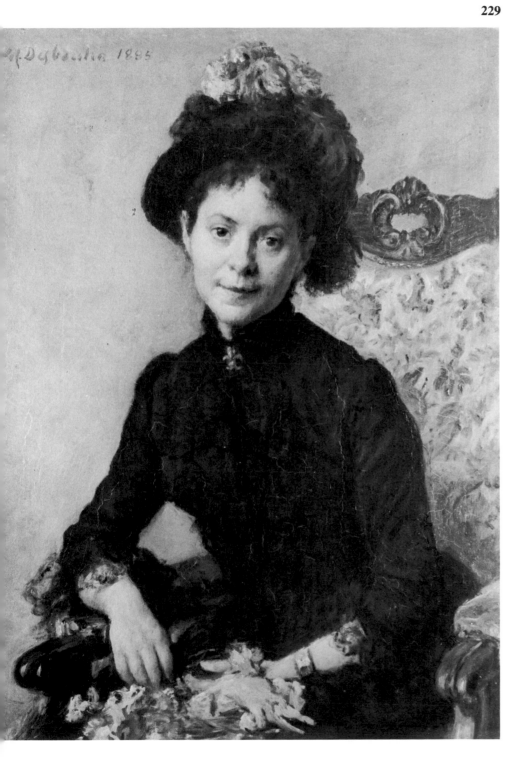

229

Henri Fantin-Latour

230 *Portrait of Louise Riesener*
(Portrait de Louise Riesener)
Oil on canvas, 39-3/4 x 31-3/4 inches (100 x 80
cm.). Signed and dated lower left: Fantin-86.
Grenoble, Musée de Peinture et de Sculpture.
Provenance. Mme. Léouzon-Leduc Collection.
Donated by Mme. Escholier, 1969.

Fantin-Latour found it difficult to reveal the
personalities of sitters whom he did not
know intimately.[1] Even though he painted
numerous self-portraits that recorded his
own inner life, other than members of his
own family or close friends (for example,
Adolphe Jullien or Léon Maitre), he rarely
attempted formal portraits of single indi-
viduals.

The early group portraits that he com-
pleted of artistic colleagues manifest a clar-
ity and objectivity that is not unlike contem-
porary nineteenth-century photography, but
the arrangement of his figures can be traced
back to seventeenth-century Dutch group
compositions. His depictions of individuals
(both male and female) that he posed in his
studio, however, are reminiscent of studies
of single figures from earlier times. These
individual portraits, unlike some of the popu-
lar portraits completed by studio assistants
after the primary artist (e.g., Léon Bonnat)
rendered the likeness of the model, convey a
strained, unnatural pose. This tense awk-
wardness in Fantin-Latour's portraits was
not the result of any expediency of produc-
tion, but was founded in his own aloof per-
sonality and his inability to make his sitters
feel at ease.

The portrait he completed of Madame
Lerolle in 1882 (CMA) and his *Portrait of
Louise Riesener* are typical of his late por-
traits of women. While the Lerolle portrait
was painted within a limited tonal range of
whites and grays that indicate the influence
of James McNeill Whistler, the portrait of
his friend Léon Riesener's daughter was de-
veloped in tones of gray, blue, and black.[2]
Her pose against a flat, grayed background
and her upright position in the hard-backed
chair bring the sitter close to the viewer. But
her proximity is neither intimate nor infor-
mal. Her stare is fixed and her expression
blank. This same inhibition in rendering
feminine models is evident in many of
Fantin-Latour's portraits of women, and
conveys a reserve somehow appropriate for
the late Victorian period.

1. Edward Lucie-Smith, *Fantin-Latour* (Oxford:
Phaidon Press, 1977), pp. 27-28.
2. Léon Riesener was a well-known portrait
painter who died in 1878, several years before
Fantin-Latour painted this portrait of his daugh-
ter. After the death of Riesener, Fantin-Latour
organized two exhibitions of that painter's work.
The first took place in Riesener's atelier (in Paris)
and the second (which was followed by a sale), at
the Georges Petit Gallery, Paris. For further in-
formation on Riesener see Geneviève Viallefond,

Le Peintre Léon Riesener 1808-1878: Sa Vie, son oeuvre avec des extraits d'un manuscrit inédit de l'artiste (Villeneuve-Saint-Georges, Editions Albert Moranée, 1955). Little is known about the career of this sitter.

Exhibited
1977, Grenoble, Collection du Musée de Grenoble: Fantin-Latour—Une Famille de peintres au XIXe siècle, p. 19, repr. p. 12, cat. no. 47.

Published
Exposition de l'oeuvre de Fantin-Latour au Palais de l'Ecole Nationale des Beaux-Arts quai Malaquais, mai-juin (Paris, 1906), p. 46, no. 40.
Mme. Fantin-Latour, *Catalogue de l'oeuvre complet de Fantin-Latour* (Paris: H. Floury, 1911), cat. no. 986.

Norbert Goeneutte

231 *Self-Portrait in His Studio*
Oil on panel, 24 x 18-1/2 inches (61 x 47 cm.).
Signed and dated lower right: NORBERT GOENEUTTE/Paris 25 Juillet 1888.
London, Private Collection.

As a fashionable member of the Impressionist circle whose friendships included some of the most well-known artists of that period,[1] Norbert Goeneutte established himself in a comfortable Parisian atelier during the 1880s, where he worked on sketches, water colors, etchings, and oil paintings that reflected his fascination with unusual views of Paris. His *Self-Portrait in His Studio* shows him turned momentarily from the sketchboard propped against the table to look at the viewer, while the chalk still in hand directs attention to the portfolio resting against his chair. The elegance of Goeneutte's atelier forms a sharp contrast to the poverty that beset a number of other artists of the Realist tradition. The setting here conveys the aura of a dilettante whose interest in art was cultivated by his family's ability to indulge his talent. The momentary informality of the portrait follows in the tradition established by Degas [149] and reveals the cosmopolitan outlook that coincided with the development of Naturalist inclinations in the later phases of the movement.

1. Auguste Renoir and Edgar Degas were among Goeneutte's circle of close friends.

Exhibited
1965, London, Hazlitt Gallery: The Tillotson Collection, cat. no. 51, pl. 41.

230

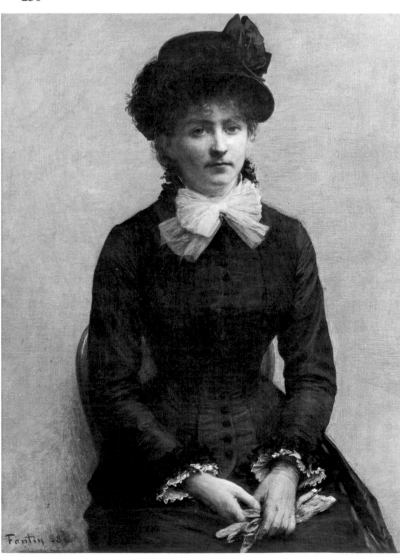

231

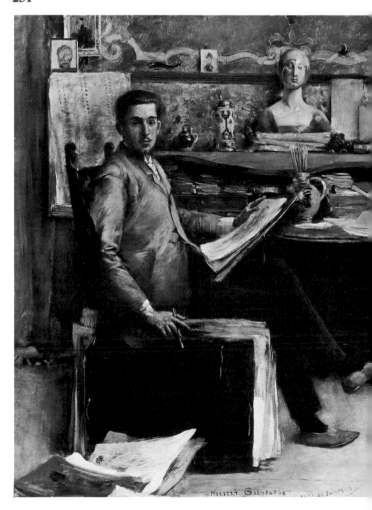

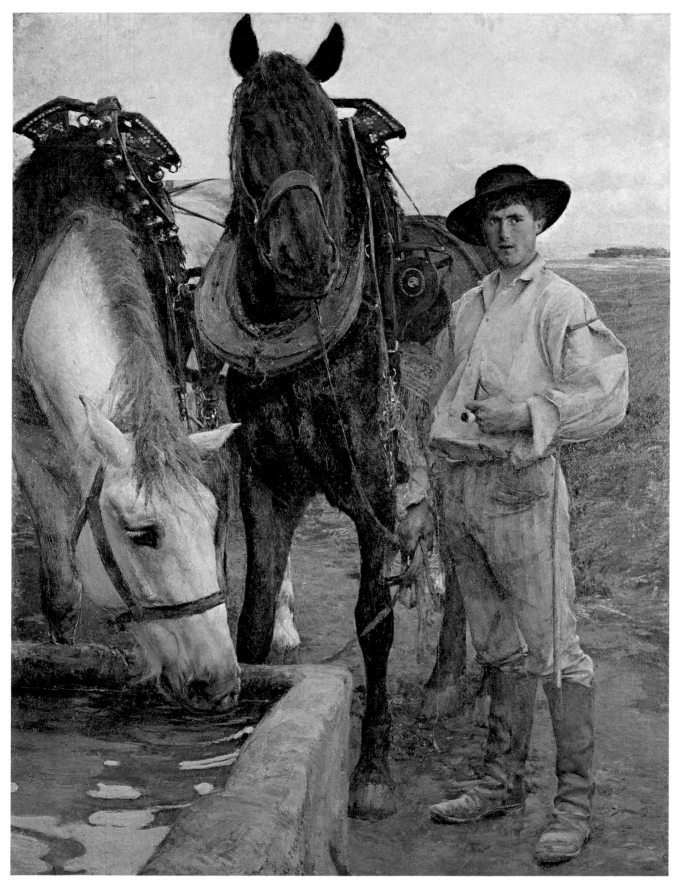

202 Pascal Adolphe Jean Dagnan-Bouveret, *Horses at the Watering Trough*.

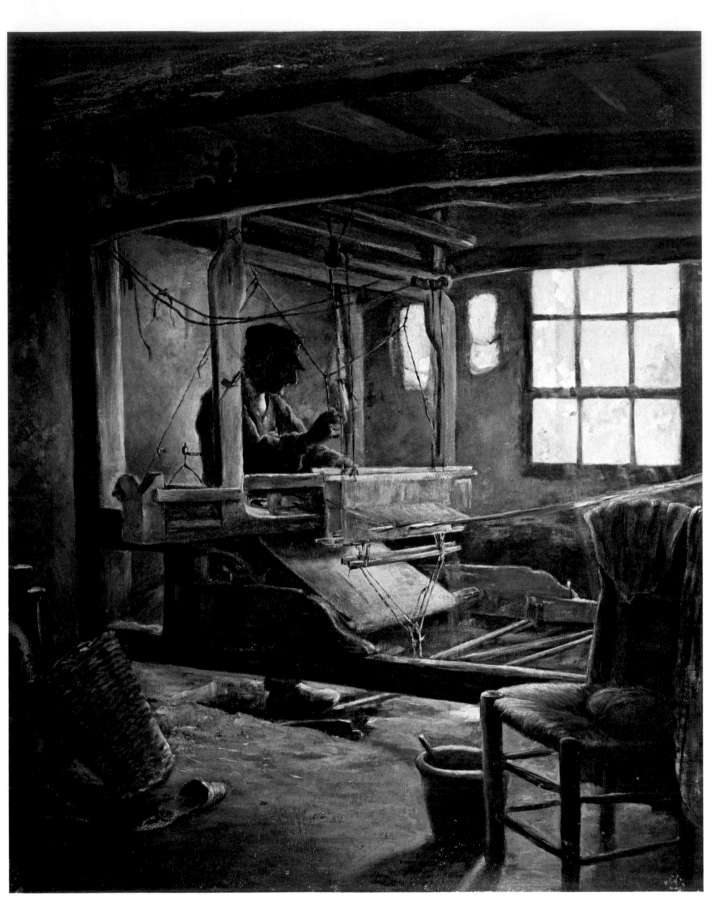

205 Louis Paul Henri Sérusier, *The Breton Weaver*.

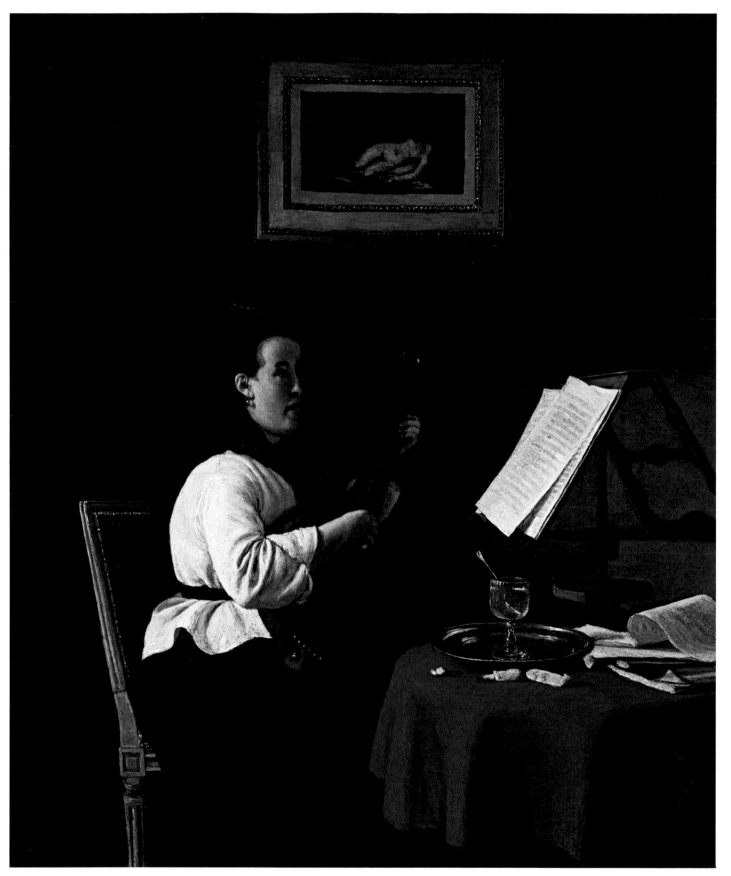

217 François Bonvin, *Portrait of Louison Köhler*.

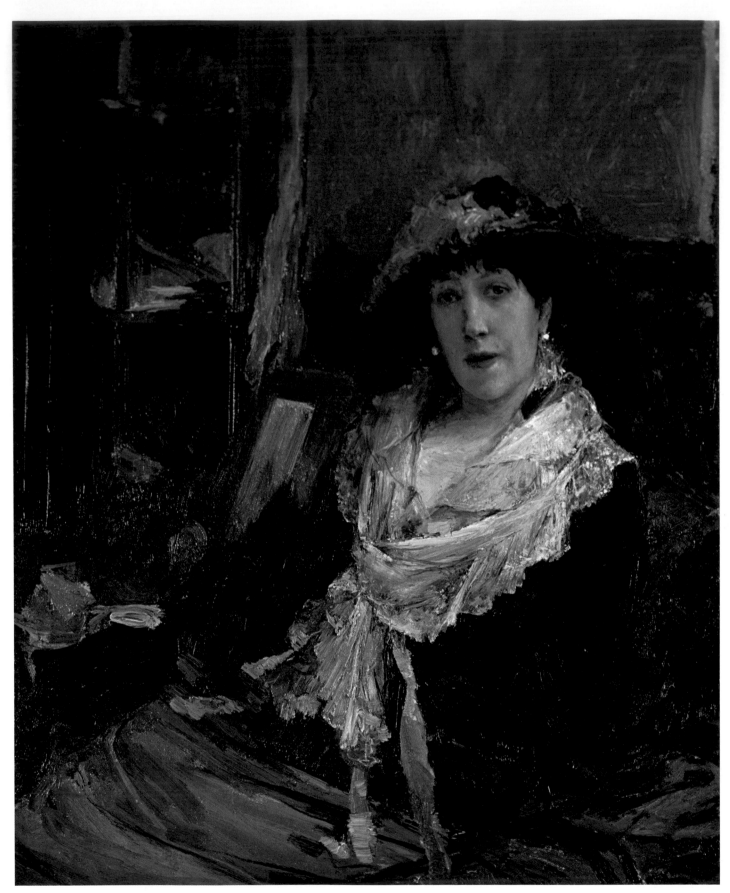

225 Jules Bastien-Lepage, *Portrait of Marie Samary of the Odéon.*

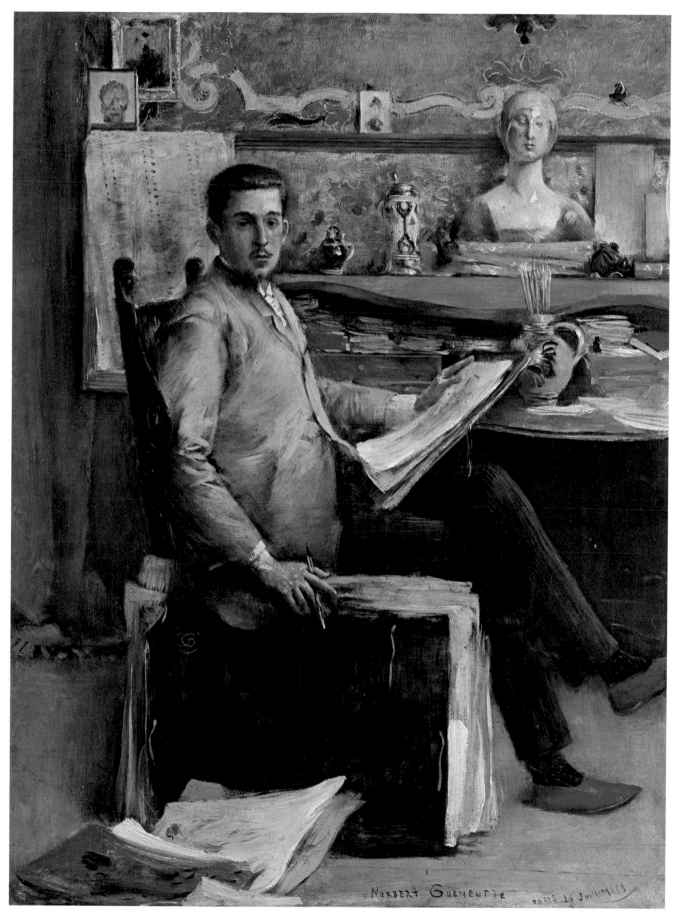

231 Norbert Goeneutte, *Self-Portrait in His Studio*.

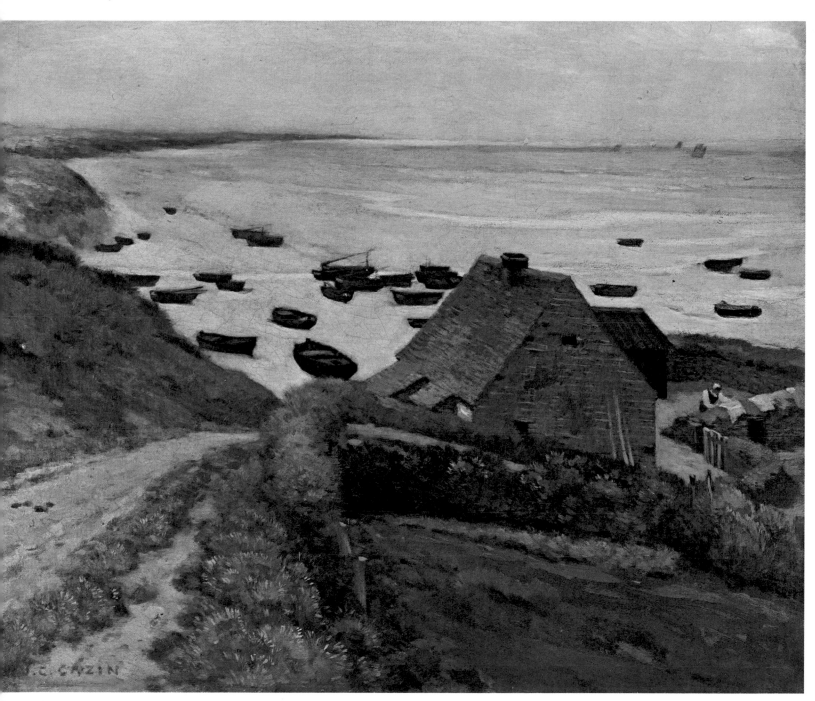

234 Jean Charles Cazin, *The Beach at Equihen.*

Opposite
233 Antoine Vollon, *The Pont-Neuf* (detail).

Landscapes

While some landscapists broke with academic tradition and the requirements of the heroic landscape to follow the innovations in color and composition of the pre-Impressionists and the Barbizon painters, after 1870 a new type of landscape painting began to appear in both private and public exhibitions. Artists continued to paint rural scenes with renewed energy, concentrating on the light and atmosphere of the fields—but more often they turned to cityscapes.[1] The Impressionists and the Naturalists both painted canvases showing the bridges and streets, the Seine running through Paris, and places in provincial centers such as Avignon, Marseille, Rouen, and Le Havre—often adding figures to the fields and city streets to convey a sense of energy.[2] Late nineteenth-century landscape painting merged the themes used by the Naturalists with those of the Impressionists[3] until those artists who painted landscapes without including the now-obligatory human figures were criticized for being old-fashioned. Artists were no longer content to show nature alone; they tried to integrate man with his environment or to show how man interacted with nature. In the process, the very distinction between "pure" landscape and genre was vitiated.

1. The writings of Charles Baudelaire and J. K. Huysmans emphasized modernity. Modernity was readily accepted by several painters and inspired changes in landscape painting after 1870.

2. Linda Nochlin, *Realism* (Baltimore: Penguin Books, 1971), p. 137. The use of figures in landscapes was one of the major innovations of post-1870 modernism.

3. This compromise was noticed by Léonce Bénédite, *L'Art au XIXe siècle—1800-1900* (Paris, n.d.), p. 285. Bénédite identified the *plein-air* school whose members appeared simultaneously with the Impressionists and formed a *juste-milieu* for artists who wanted to appear liberal without adopting revolutionary theories.

Opposite
237 Alfred Casile,
The Bank of the Rhône at Avignon.

Norbert Goeneutte

232 *The Boulevard de Clichy under Snow*
Oil on canvas, 25-5/8 x 28-7/8 inches (60 x 73.5 cm.). Signed lower left: N Goeneutte.
London, The Tate Gallery.
Provenance. M. Cherfils, Paris. Gustave Tempelaere, Paris, 1895. Aimé Diot, Paris. Diot sale, Hôtel Drouot, 8-9 March 1897 (lot 109, 380 francs). Herbert Coleman, London. Purchased from Herbert Coleman through Arthur Ruck (Clarke Fund) in 1930.

As a student of Isidore Pils, Norbert Goeneutte may have been inspired by his teacher's water colors that recorded the panoramic street scenes of Paris at the time of the Franco-Prussian War and the Commune. Even if these water colors were not available in Pils's studio where Goeneutte studied from about 1872 to 1875, Goeneutte may have seen them during the Pils retrospective exhibition held at the Ecole des Beaux-Arts in 1875 after the painter's death.[1] Goeneutte's contacts with the young Impressionists, Auguste Renoir and Edgar Degas in particular, may also have influenced his interest in recording vistas and impressions of an active modern life in the center of Paris.

Many of Goeneutte's early works are lost (possibly destroyed by the painter himself), but *The Boulevard de Clichy under Snow* (along with a work entitled *En Classe*) was exhibited at the 1876 Paris Salon. The two paintings seem to have gone unnoticed in Salon reviews even though the winter street scene that still exists captures subtle nuances in color and reflects the newer tendencies of the Impressionists to capture the effects of certain seasons. Goeneutte had worked on *The Boulevard de Clichy under Snow* during the winter of 1875/76 in the company of another artist and new friend, Jean Béraud, who also exhibited a painting of the same vista at the 1876 Salon. Béraud's *The Return from the Funeral* records a group of mourners making their way home within a somber wintry setting only a few yards beyond Goeneutte's boulevard scene.[2]

Goeneutte's composition reveals one of the newest tendencies: his off-center composition with the figures on the right balanced by the wide expanse of snowy street was inspired by the asymmetrical compositions of Japanese prints. This same influence accounts for the slightly elongated silhouettes carefully arranged against a flattened backdrop. His indebtedness to Degas is also

evident; the vista appears realistic—as if Goeneutte carefully observed the effects of the dismal wintry day even though it is the design elements that predominate.

This Parisian boulevard was a favorite of Goeneutte. He did a series of studies in preparation for the final canvas, and from the left section of the composition made an etching in which he added several additional figures.[3]

1. See *Exposition des oeuvres de Pils à l'Ecole des Beaux-Arts,* cat. (Paris, January 1876), nos. 277-328. The diversity of these water colors undoubtedly influenced those artists who had studied with Pils.

2. The current location of this painting remains unknown. For further reference see *L'Art* VI (1876): 42.

3. For reference to sketches, see *Collectors Choice* (London: Gimpel fils, November 1953), cat. no. 9, repr. The sketch measures 6-1/4 x 3-1/2 inches. Also see Palais Galliera, 27 November 1968 sale, for reference to another sketch on wood: *Boulevard de Clichy sous la neige,* 1875, measuring 7-1/2 x 9-7/16 inches.

Exhibited

1876, Paris: Salon, no. 924 (listed as *Le Boulevard de Clichy, par un temps de neige).*
Probably 1895, Paris, Ecole des Beaux-Arts: The Goeneutte Memorial Exhibition (two paintings, nos. 57 and 119, were listed as *Le Boulevard de Clichy).*
1932, Bristol Museum and Art Gallery: French Paintings and Drawings, cat. no. 20.

Published

Ronald Alley, *Foreign Paintings, Drawings and Sculpture,* The Tate Gallery catalogue (London: Tate Gallery, 1959), pp. 91-92.

Antoine Vollon

233 *The Pont-Neuf*
Oil on canvas, 31-7/8 x 35-7/8 inches (80 x 90 cm.).
Signed lower right: A. Vollon.
U.S.A. Private Collection.
Provenance. Raphael Gérard Gallery, Paris. Charpentier Gallery, Paris.

The Pont Neuf represented a particular segment of popular Parisian culture and life throughout much of the seventeenth and eighteenth centuries.[1] Throngs of pedestrians made their way each day among the crowded stalls of the minor tradesmen and hawkers that lined the bridge, crossing over the Seine amid the cries of flower vendors, water carriers, and an assortment of comedians, jugglers, and street performers bidding for their attention and their francs. In the late 1840s, when the last stall was removed from the bridge, a vibrant part of Parisian life was abruptly and drastically changed. In a sense, however, the long-familiar heritage of the Pont-Neuf (Figure 233a) continued to stir subsequent generations of Parisians. Artists continued to use the bridge and its populace as themes for new compositions,[2] evoking a nostalgia and a fondness for a setting that provided timeless appeal.

During the 1870s Auguste Renoir and Claude Monet painted similar views of the bridge, as if seen from the window of a nearby café.[3] Their compositions capture the pattern of fluctuating traffic, making the Pont-Neuf once again a center of activity and urban excitement. Using the same Realist theme, and essentially the same location chosen by Renoir, Antoine Vollon—at a somewhat later date—also completed a view of *The Pont-Neuf.* His composition includes more people and carriages than did either Renoir's or Monet's, thus reinforcing the tempo and pace that made the bridge such a vital causeway. Wisps of smoke and dust billow across the bridge, conveying a sense of momentariness that, like his use of light, atmosphere, and color, was more characteristic of the avant-garde painters than the traditional Realists. His canvas thus represents an outgrowth of the Realist interest in this type of theme, and denotes an Impressionist view of the urban landscape.

1. The literature on the Pont-Neuf is extensive. See *Tableau de Paris* (Amsterdam, 1782), 1: 156-63; Charles Simond, *Paris de 1800 à 1900 d'après les estampes et les mémoires du temps* (Paris: E. Plon, Nourrit et Cie, 1900), p. 290; Victor Fournel, *Les Cris de Paris* (Paris: Librairie Firmin-Didot et Cie, 1889), pp. 176 ff.

2. The Pont-Neuf could be compared with les Halles as a center of urban activity.

3. For a reproduction of both paintings see John Rewald, *The History of Impressionism* (New York: Musuem of Modern Art, 1961), pp. 280 and 281.

Exhibited

1937, Paris, Galerie Raphael Gérard: Antoine Vollon—1833-1900, cat. no. 9.
1943, Paris, Galerie Charpentier: Scènes et figures parisiennes, cat. no. 22.

Published

Gabriel P. Weisberg, "A Still Life by Antoine Vollon, Painter of Two Traditions," *Bulletin of The Detroit Institute of Arts* LVI (1978): 227, repr. fig. 11.

232

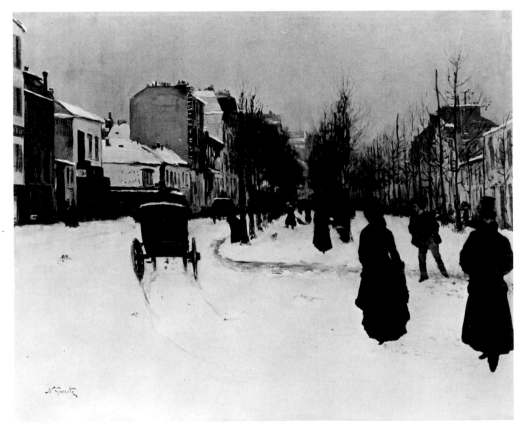

233a *View of Paris from the Place du Pont-Neuf,* oil on canvas, ca. 1665-69.

233

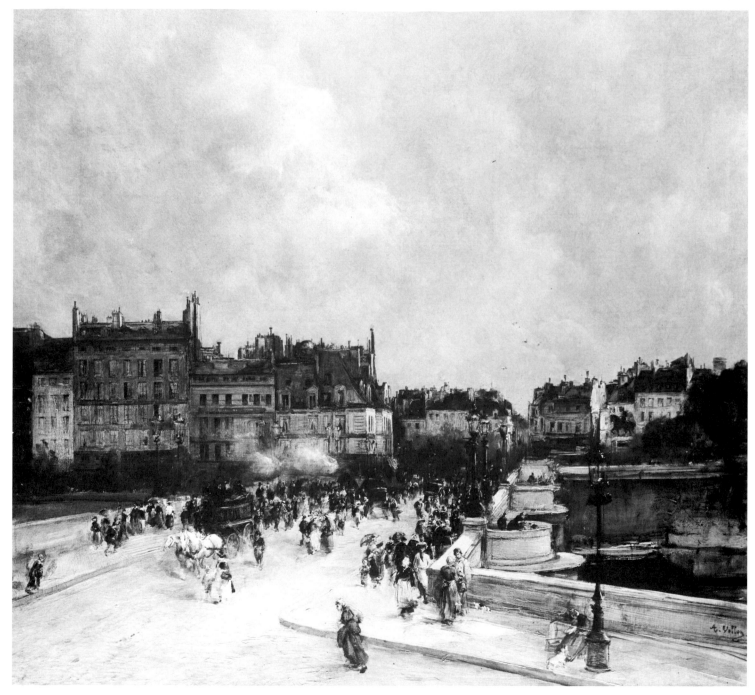

Jean Charles Cazin

234 *The Beach at Equihen*
(La Plage d'Equihen)
Oil on canvas, 18-7/8 x 22-7/8 inches (48 x 58 cm.).
Signed lower left: J. C. CAZIN.
Paris, Private Collection.

After his return to France in the mid-1870s,
Cazin spent his summers at Equihen, at first
in a house he rented near the beach. Later,
when he became more successful, he pur-
chased his own home and, from his studio
windows, he was probably able to view the
beach, the surrounding countryside, and the
shimmering sand and dunes which reflected
the light of northern France.

In addition to his larger Salon contribu-
tions, Cazin worked on landscapes that re-
veal his ability as a tonalist to integrate color
and light. He used a subdued palette and a
grayed light so that even his midday scenes,
such as *The Beach at Equihen,* appear filmy
and moderated by a slight haze. The light
colors and sketchy application of paint in
this composition explain why he is often
compared with the Impressionists, although
the arrangement of his forms—the boats on
the white beach—connote abstract rhythms
and a carefully designed composition. This
canvas originally belonged to a close friend
(a family relative by marriage), suggesting
that many of Cazin's landscapes may have
been given as gifts, or purchased for a very
moderate price.

Published

Henri Frantz, "A Great French Landscape
 Painter: Jean Charles Cazin," *Studio* 45
 (November 1911): 16 repr.

Jules Bastien-Lepage

235 *Thames, London*
Oil on canvas, 22-5/16 x 30-1/4 inches (56.7 x 76.8
cm.). Signed and dated lower left: J. BASTIEN-
LEPAGE/LONDRES 82.
Philadelphia, John G. Johnson Collection.
Provenance. Sale, Paris, May 1885 (after
Bastien-Lepage's death). Cartier (26 rue Mon-
ceau) for 860 francs. Georges Petit Gallery, Paris.
John G. Johnson Collection, Philadelphia.

During his trip to London in 1882, Jules
Bastien-Lepage did a series of canvases that
evoke the river life of that city. His views of
the *Thames, Backfriar's Bridge;* of *London
Bridge;* or of *Thames, London* all emphasize
the life-giving force of the river[1] and its con-
tinued impact upon the city. The apparent
calmness of Bastien-Lepage's urban sea-
scape *Thames, London,* however, belies the
social implications that may underlie his ob-
servations.

The urban setting that Bastien-Lepage re-
corded along the upper Thames in the 1880s
was a dramatic contrast to the bustling scene
of rapid unloading and immediate sale that

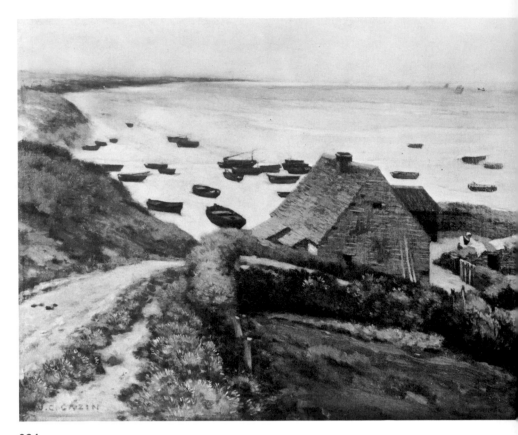

234

235

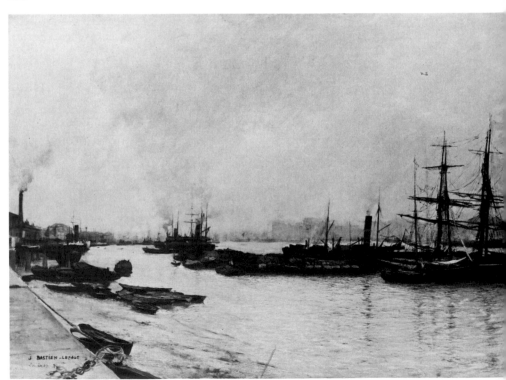

had characterized the riverfront some twenty years earlier. The number of storage facilities and warehouses that lined the waterway had increased, but the twenty-six miles of dock system,[2] which had long served great numbers of shipping vessels, by the 1880s was inadequate and too shallow to accommodate the new, larger steamships.[3] Much of their cargo had to be removed and brought into the upper Thames dock area by smaller boats. The overtly tranquil transition captured by Bastien-Lepage in his depiction of modern steamships docked together with conventionally rigged sailing craft along the right central foreground may have been, in truth, an uneasy juxtaposition. The "modern" loading and unloading methods necessitated by the larger vessels having to anchor further from the old riverfront, where the goods were then transferred to smaller craft to be brought into the city, also meant less work for the number of stevedores who had once manned the docks. The London urban problems inherent in such progress are thus contained within Bastien-Lepage's peaceful image of the waterfront tradition.[4]

In addition to the social impact implied by his painting, there is no doubt that the older tradition of Realist art focused upon the river as a setting for the observation of modern life could not have eluded him. Like Whistler, Monet, and even Antoine Vollon before him, Bastien-Lepage, too, saw the river as a focal point of urban energy. An abandoned lumberyard in full view of the Thames provided the ideal place to work, and there he made preparatory drawings that served as reference for his several waterfront canvases, although at least one scene, *Thames, Backfriar's Bridge*, was painted on the spot.[5]

Despite the painter's interest in an even, overall distribution of light, *Thames, London* provides a detailed record of watercraft and their rigging. Bastien-Lepage's Naturalistic fascination with minutiae is apparent in his attention to areas of the canvas which, in actuality, must have been too indistinct —because of their remoteness and the overcast atmosphere—to observe with the naked eye. The Thames itself is recorded with a bluish gray light that conveys a continuity of movement receding into the distance. The overall effect is one of silvery illumination —not unlike the Nocturnes that Whistler completed in the 1870s. Thus, *Thames, London*—and the other Thames compositions in Bastien-Lepage's series— are as suggestive of Impressionism as his academic training would permit.[6]

Another Realist-Romantic device also deserves mention. Like the studies of single, empty boats depicted by François Bonvin and Antoine Vollon, Bastien-Lepage created a melancholy atmosphere of loneliness that for him provided an effective contrast to the complexity and bustling activity of modern riverfront life.

1. The *Thames, Backfriar's Bridge*, 1881, is found in the John G. Johnson Collection, The Philadelphia Museum of Art; *Pont à Londres* is in the Musée des Beaux-Arts, Tournai.
2. The word *dock*, in describing the Thames dock system, refers not to single landing piers or wharves, but rather to the large, excavated basins or enclosures equipped with floodgates that were used to receive ships between voyages.
3. See Gareth Stedman Jones, *Outcast London: A Study in the Relationship Between Classes in Victorian Society* (London: Penguin Books, 1976), p. 118.
4. Ibid., pp. 120-24, discusses the changes in employment figures and requirements that were directly related to the introduction of steam.
5. Noted in William Steven Feldman, "The Life and Work of Jules Bastien-Lepage (Ph.D. diss., New York University, 1973), p. 232, although the information is derived from Dorothy Stanley, "Bastien-Lepage in London," *Art Journal* 59 (1897): 53-54.
6. Feldman, "Life and Work," p. 232.

Exhibited

1885, Paris, Hôtel de Chimay: Exposition des oeuvres de Jules Bastien-Lepage, Ecole Nationale des Beaux-Arts, p. 61, cat. no. 177.

Published

Louis de Fourcaud, "Exposition des oeuvres de Bastien-Lepage à l'Hôtel de Chimay," *Gazette des Beaux-Arts* XXXI (1885): 267.
Catalogue des tableaux, esquisses . . . laissés dans son atelier, sale, May 1885 (Paris, 1885), p. 17, no. 56.
Georges Duval, "Bastien-Lepage intime," *L'Evénement,* 13 December 1884.
Paul Mantz, "Bastien-Lepage," *Le Temps,* 25 December 1884, pp. 232-33, fig. 126.
Wilhelm Reinhold Valentiner, *Catalogue of a Collection of Paintings and Some Art Objects,* vol.

3, *German, French, Spanish and English Paintings and Art Objects* (Philadelphia: John G. Johnson, 1914), p. 78.
Feldman, "Life and Work," pp. 232-33, fig. 126.
Kenneth McConkey, "The Bouguereau of the Naturalists: Bastien-Lepage and British Art," *Art History* III (September 1978): 380.

Gustave Colin

236 *The Castillo and the Inlet of Pasages at High Tide (Le Castillo et le Goulet de Pasagès à marée haute)*
Oil on canvas, 10-7/8 x 16-1/4 inches (27 x 41 cm.).
Signed lower left: Gust. Colin.
Lille, Musée des Beaux-Arts.
Provenance. Rouart Collection. Purchased in 1972, Pavillon des Arts, for 2000 francs.

While painting in the south of France, Gustave Colin studied the intense light and brilliant colors of a region which aptly suited his late Romantic-Realist style. Painting in either a freely and thinly brushed manner or with a heavy impasto inspired by the palette-knife technique of Gustave Courbet, Colin did a series of canvases that captured the ruggedness of the unspoiled terrain near the Spanish border, for example, *The Castillo and the Inlet of Pasages at High Tide.* While Colin was recognized as a major colorist at the Paris Salons, most of his sketches and smaller canvases remained unknown until exhibition at the Société Nationale des Beaux-Arts in 1906, when he achieved distinction as one of the significant regional landscape painters of the last half of the nineteenth century.

236

Alfred Casile

237 *The Bank of the Rhône at Avignon*
(Quai du Rhône à Avignon)
Oil on canvas, 56-1/4 x 100 inches (143 x 254 cm.).
Signed lower right: alf. Casile.
Marseille, Musée des Beaux-Arts.
Provenance. Purchased from the artist in 1886.

When Alfred Casile arrived in Paris in 1880, he met several Impressionist painters, including Claude Monet, Camille Pissarro, and Alfred Sisley. Advocates of "open-air" painting, they encouraged Casile to study changing atmospheric conditions, effects of climate, and differing light caused by low-lying clouds. Under the influence of these painters and Boudin and Jongkind, Casile returned to his native south of France to paint locales that other landscapists had overlooked. *Quai du Rhône à Avignon,* shown at the 1883 Salon, is among his larger canvases from the early 1880s, when he was regularly exhibiting at the Paris Salons.

Casile selected an atypical day for his composition, for this region of France is characterized by blazing sunlight and few clouds. Casile, however, much like a Dutch seventeenth-century painter, filled his panoramic expanse with low-lying clouds to create a dull, overcast illumination. The muted light enhances the earthiness of the browns, greens, and yellows which Casile used to complete the landscape and the houses along the quay. Painting with an accuracy that suggests he worked from small studies made while in Avignon, Casile undoubtedly completed the canvas in a Paris studio. River barges, horses, and workers provide Naturalistic detail to a landscape that is innovative, yet not Impressionistic.

No letters between the artist and museum administration have survived to indicate how the Marseille Musée des Beaux-Arts received this work. It was purchased directly from Casile in 1886 for 1500 francs, which suggests that his success in Paris and the purchase of his works by other museums encouraged Marseille to obtain one of their native son's best works. Although they received *Vue de Paris—L'Estacade* after the 1885 Salon, they undoubtedly also wanted a work depicting the south of France rather than the city of Paris.[1]

1. Regionalist concepts were maintained even in landscape compositions. For further information on *Vue de Paris—L'Estacade,* see dossier Alfred Casile, 6 July 1885, F 21/2062, Archives Nationales.

Exhibited
1883, Paris, Salon: no. 465.

Published
Bulletin du Musée du Vieux Marseille, June-July 1936, pp. 73-80, repr. p. 77.
André M. Alauzen, *La Peinture en Provence du XVIème siècle à nos jours* (Lausanne: Editions La Savoisienne, 1962), col. repr. p. 161.

237

Biographies

JULES ADLER

Jules Adler
1865 Luxeuil — 1952 Paris

Jules Adler's career as an artist was governed by chance. His parents were cloth merchants who had five children and little interest in the visual arts. They did, however, see that Adler attended school, where his artistic interests attracted the attention of local teachers. In 1879, while Adler was working on his own and exhibiting his art work in a school exhibition, a regional administrator visiting Luxeuil singled Adler out for commendation and encouraged him to draw on his own even while enrolled in traditional academic classes. Other professors, recognizing this unusual gesture, convinced Adler's parents of the importance of additional training for Jules. With two older sons already working in the capital, the family liquidated their business and moved to Paris in April 1882.

Adler was enrolled in the Ecole des Arts Décoratifs without any preliminary examination; his work from Luxeuil was judged as testimony enough. Although Adler won medals in his classes, he found the teaching at the Ecole dull, showing a preference even then to become a painter rather than a decorator. He tried to enroll in the Ecole des Beaux-Arts, but, after passing preliminary tests, he was rejected because he lacked training in studying the nude. He resigned himself to continue at the Ecole des Arts Décoratifs until he was accepted at the Académie Julian despite his background. Here his work was judged by two well-established painters, William Bouguereau and Tony Robert-Fleury (1837-1912), and he worked very hard, taking special courses in anatomy so that he could obtain a license as a drawing teacher. In 1884, after passing his test, Adler met Jean Gigoux, one of the older Romantic-Realists still active in Paris and an artist who perhaps influenced his choice of theme more than has been generally recognized.

Until being drafted into the army in 1885 Adler studied at the Académie Julian. He also entered the Ecole des Beaux-Arts, where he frequented the studio of the history painter Yvon (1817-1893) and there won a third-class medal, which entitled him to be called an *étudiant définitif* and further encouraged him to become a painter rather than simply a teacher. Recognizing the young artist's talent and modest means, the administration at the Académie Julian waived his fees, and the position he maintained at the Ecole des Beaux-Arts saved him from a lengthy period in the army.

After one year of military service at Mayenne, Adler returned to Paris to resume his classes at the Académie Julian and the Ecole des Beaux-Arts. But he soon became convinced that his training in the ateliers was inadequate and that he needed a more direct contact with nature. In August 1887 Adler spent some time in the Limousin, observing the life and work of peasants. By 1889,

gradually freeing himself from the restrictions of academic teaching, Adler rented a studio in the center of Paris.

In the early 1890s Adler began exhibiting his paintings in the annual Salons in order to achieve recognition.[1] In 1892 he received a commission for a large painting entitled *La Transfusion du sang de chèvre par le Docteur Bernheim*. His negotiations with the patron specified Adler was to receive 1500 francs if the painting were shown at the Salon and 1200 if it were not. The painting was not only exhibited in the 1892 Salon but also received supportive comment in the daily press. At about this time, Adler met Dagnan-Bouveret, who befriended and advised the young painter. Thus, in the 1892 Salon catalog, Adler included Dagnan-Bouveret with Bouguereau and T. Robert-Fleury in his list of teachers.

After he left the Ecole des Beaux-Arts, Adler was increasingly moved by scenes of poverty and destitution he witnessed in the streets of Paris. He became a social reporter of Realist imagery much like earlier English painters (e.g., Herkomer). Using models from the streets, Adler painted *La Rue* (Musée de Castres), shown at the 1893 Salon. The work marked Adler's first genuine Salon success; he received an honorable mention and the government purchased the canvas for 1200 francs. Adler continued exhibiting Realist themes at the Salon. In 1894 he showed *An Atelier for the Cutting of False Diamonds at Pré-Saint-Gervais* [193] along with a portrait. In 1895 he exhibited *Au Faubourg Saint-Denis, le matin*, a work depicting the Parisian marketplace. For this painting he received a third-class medal and a travel grant which permitted him to visit Italy, Holland, and Belgium. These countries provided ample opportunity to observe other Naturalist painters who were examining themes of regional existence.

Adler's depiction of worn-out workers, *Les Las*, which was shown at the 1897 Salon, achieved a sympathetic Naturalism that underscores his commitment to the poor, and also reveals his indebtedness to Emile Zola's *L'Assommoir*. Despite its significance, the work was not recognized by the Salon jury. The next year, however, Adler received a second-class award at the Salon for his paintings of *Joies populaires* and *L'Homme à la blouse*. By the turn of the century, Adler was a most prolific painter of social-realist themes in France; *Les Haleurs, La Soupe des pauvres* (1906), *L'Accident*, and others established his place in the art world. Surpassed in talent and diversity by his rival and friend Théophile Steinlen (1859-1923), Adler nonetheless remained staunchly committed to the cause of workers, a dedication epitomized in his 1900 painting *La Grève au Creusot* (Ecomusée, Le Creusot).

1. Adler first exhibited in the 1889 Salon, showing a portrait. For further reference see L. Barbedette, *Le Peintre Jules Adler* (Besançon: Editions Séquania, 1938).

Jean-Pierre Alexandre Antigna
1817 Orléans — 1878 Paris

Alexandre Antigna remains an important figure in the evolution of Realism because of his relationship with independent painters such as Bonvin and Courbet and because of the patronage he received from the government of the Second Empire. Like other first-generation Realists, Antigna used themes that reflected contemporary social problems in canvases that reveal an appreciation of old masters and the Romantic school. Antigna's mature style was a combination of actual observation with studio poses and mannerisms gleaned from other painters.

Because his father was a successful wine merchant and his mother the daughter of a well-established Parisian architect, Antigna was spared the privations that affected other painters of his generation (e.g., Bonvin).[1] His middle-class parents were familiar with the tradition of the arts, and nurtured Antigna's inclination toward an artistic career, enrolling him in a drawing class taught by François Salmon (1781-1855) at the Orléans Art School. By 1837 Antigna was accepted in the atelier of Sébastien Norblin at the Ecole des Beaux-Arts in Paris,[2] where he remained less than a year before transferring to the atelier of the Romantic painter Paul Delaroche (1797-1856) and competing unsuccessfully for the Prix de Rome.

Antigna's first Salon exhibition after leaving Delaroche's studio was in 1841, where his *Naissance de Jésus-Christ* established him as a painter of religious compositions as well as of portraits. Antigna continued these themes until the 1845 Salon, when he expanded his interests to include beggars and ragpickers—displaced individuals who were attracting increasing attention because of the growing urbanization within France.

During the 1840s Antigna lived on the Ile St. Louis, one of the poorest, most overcrowded sections of Paris. His awareness of the poverty around him undoubtedly affected the themes he selected; *Enfants de Paris, Enfants égarés, Enfants de Savoie,* and *Pauvre famille* were exhibited at the 1847 Salon, where he received a third-class medal. At the Salon the following year, Antigna received a second-class medal, and the government purchased *L'Eclair* for 5000 francs. In this work, Antigna created a sense of Romantic

ALEXANDRE ANTIGNA

melodrama by focusing on the facial features of a poor family terrorized by nature.

Of the three paintings exhibited by Antigna at the 1849 Salon, one particularly romantic, sensual, and richly colored composition called *Après le bain* was purchased by the government for 3000 francs. This painting, which was sent to the Orléans Museum, shocked local sensibilities. The director of the museum ordered one of the nudes partially covered in pastel in an effort to modify the impact of the painting; finally, under still further pressure from municipal officials, the work was removed from public view in 1854 and placed in a museum storeroom.[3] The scandal provoked by this painting, which continued despite the efforts and support of Antigna's friends, provides some indication of the prevailing attitudes toward the arts at the beginning of the Second Empire.

The Salon of 1850/51 is considered the official beginning of the Realist movement. Antigna exhibited seven canvases at this Salon and was awarded a first-class medal. *The Fire* [92], in particular, was acclaimed be the critics; it was purchased by the government on 23 May 1851 and hung in the Luxembourg Museum until 1886, when it was transferred to Orléans. *The Fire* served as a rallying point for other Realists and must be judged an integral part of the new movement along with such better known canvases as *The Stonebreakers* and *Burial at Ornans* by Courbet, which were also shown at the same Salon.

During the 1850s Antigna exhibited at the Salons and continued to receive favorable support from the government of the Second Empire. His type of Realism was useful to the state because of his ability to adapt contemporary events to further the cult of hero worship then emerging around the personality and deeds of Napoleon III. This capacity to reflect changing circumstances can be seen in two similar works from this period. His 1852 *The Flooding of the Loire* records a regional disaster; his 1857 *Visite de S. M. l'Empereur aux ouvriers ardoisiers d'Angers pendant l'inondation de 1856* (Musée d'Angers) features Napoleon III in a similar flood scene. At the Exposition Universelle held in 1855 Antigna received considerable notice, exhibiting a total of sixteen canvases.

He received a third-class medal for *Le Lendemain: Scène de nuit*. Some of his works at this exhibit, such as *L'Hiver* and *L'Eté*, reveal a latent Romanticism. Others were studies in Realism: *The Fire*, which was exhibited again for this show, revealed a disaster befalling an impoverished city family; *The Forced Halt* [22] presented a contrasting pictorial account of the misery of the country poor.

By the end of the 1850s, Antigna's career as an artist was well established. He exhibited and won further awards in regional shows (Rouen, 1858; Besançon and Troyes, 1860). His financial future assured, he married Hélène-Marie Pettit on 5 February 1861. Napoleon III continued to favor Antigna, recognizing his importance in the visual arts and naming him Chevalier of the Légion d'honneur on 2 July 1861. In 1861 he was also awarded a diploma of honor in Nantes and commissioned by the Minister of State to complete a work for the government.[4]

The decade of the 1860s was a congenial one. Antigna travelled to Spain in 1863 and there gathered ideas for canvases he would complete over the next ten years. His family by this time included a daughter, Cécile-Marie-Yvonne, and a son, André-Marc.

Antigna's involvement in Realist themes remained limited [25]. For the most part he preferred themes of sentimental anecdote or romantic melodrama. An exhibition (Hôtel Drouot, 14-15 June 1878) after his death displayed the diversity of his tastes as well as his interest in past masters.

1. See "Extrait des registres servant à constater les naissances dans la ville d'Orléans pendant l'année 1817," *Ville d'Orléans*, 7 March 1817.
2. Musée des Beaux-Arts d'Orléans, *Jean-Pierre Alexandre ANTIGNA (Orléans, 1817–Paris, 1878)*, exh. cat. (Orléans, 1978), exhibition organized by David Ojalvo.
3. Ibid.
4. Antigna's original request to paint a *Scène de guerre civile de 1859* was denied by the state; instead he was permitted to paint *Filles d'Eve*.

Jean Antoine Bail

1830 Chasselay, Rhône — 1919 Nesle-la-Vallée

As the father and teacher of two children who also had important careers as painters, Jean Antoine Bail almost outlived his two sons (Frank Antoine died in 1924; [Claude] Joseph died in 1921).[1] Largely self-taught, Jean Antoine received some instruction at the Ecole des Beaux-Arts (Lyon) before his first regional Lyonnais Salon (1854), where he exhibited *The Artist's Studio* [129]. His earliest paintings remain largely unlocated, but critical reviews note that he painted scenes from regional life as he observed it—in the cottages of his family and friends. Although he utilized his native region for many of his themes, he also painted still lifes influenced by the general vogue for Chardin, exhibiting *Les Cerises* at his first Parisian Salon in 1861. He continued to exhibit at the yearly Société des Artistes Français Salons until 1898 but seldom dated his canvases. During the 1890s he lived with his son Joseph, submitting works to the Salons from Joseph's address.[2]

Jean Antoine developed a reputation as a painter immersed in studying subtle qualities of light in many of his Dutch-inspired interior scenes. These same effects were also discernible in single and group portraits, for example, *A Member of the Brass Band* [178] shown at the 1880 Paris Salon. Living on the Ile St. Louis, he and his sons were considered supreme genre pain-

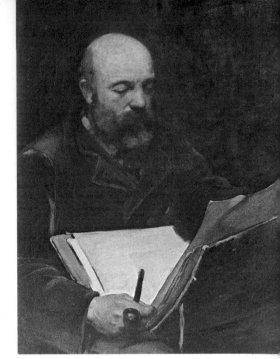

JEAN ANTOINE BAIL

ters who understood the life of the provinces as well as the daily activity of the cooks and maids they observed in Paris. As the elder statesman of the Bail family, and an artist dedicated to provincial themes and subjects at an early date, Jean Antoine was recognized as a major influence in the development of regional Realism.

1. Little is known of the career of Jean Antoine Bail despite the existence of descendants who recognize his contribution to the development of early Realism. His paintings have largely disappeared, and the few that can be found are located in small provincial museums. Jean Antoine Bail had one daughter, Amélie, who married the painter Emile Boulard in May 1889.
2. See the Salon catalog for 1892 in which Jean Antoine Bail gave his address as "chez M. Joseph Bail."

Joseph Bail

1862 Limonest, Rhône — 1921 Paris

As the youngest son of the painter Jean Antoine Bail (1830-1919), Joseph Bail was introduced to the artistic Romantic heritage that characterized painting in Lyon as well as to the development of Realist art that he observed in the canvases of his father [178]. He received his early training from his father and later in the academic studios of Jean Léon Gérôme and Charles-Emile Carolus-Duran. Although little is known about his first Salon exhibition in 1878,[1] the compositions he painted throughout the 1880s—portraits (such as those of his parents), genre scenes of cooks, studies of animals, and still lifes—reveal a knowledge of previous painters, such as Chardin, as well as those in the Realist tradition.[2] His best known canvases included a series of cooks (preparing food, cleaning utensils, smoking, playing cards), suggesting that Bail was familiar with the work of Théodule Ribot and perhaps attempted to achieve the same degree of popularity with a similar theme.[3]

Joseph Bail's Salon compositions were favorably received during the Third Republic, and he was awarded an honorable mention (1885), a third-class medal (1886), a second-class medal (1887), a silver medal at the World's Fair (1889),

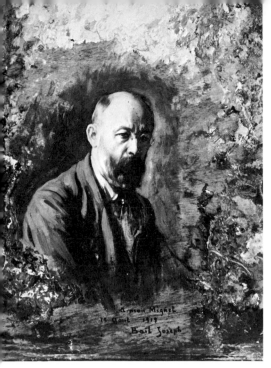

JOSEPH BAIL

and a gold medal (1900). Because Bail practiced a traditional type of painting based on earlier models, the middle class found his canvases attractive and appealing. His works show a subtle knowledge of light, for he often posed figures in silhouette against a brilliant light source—although he showed no interest in abstracting his form further. In 1902 he received a medal of honor at the Salon for his continued dedication to the Realist aesthetic at a time when newer modes of painting were capturing the allegiances of younger painters.

1. Some descendants of the Bail family, contacted by the author, could provide little specific information on the life and career of individual members of the family. They could provide no letters or other documents, and possess only a few paintings by each member of the group. Recently, a still life with a lobster and paté, dated 1878, was sold through the firm of Brame and Lorenceau, Paris. It is possible that this work may have been the still life that Joseph Bail exhibited at the 1878 Salon. Other descendants have been located—but too late to make use of their material.
2. The portraits of *Jean Antoine Bail* and *Mme. Jean Antoine Bail*, 1883, reveal another facet of Joseph Bail's personality and talent. Both paintings are forceful, accurate representations of his parents. They are owned by the descendants of the family and have been exhibited only once. See *Catalogue E. Boulard, 1863-1943* (L'Isle-Adam: Musée Louis-Senlecq, 19 May—4 June 1979).
3. The relationship between Joseph Bail and Chardin, Vollon, and Ribot was noted in Yveling Rambaud, "Joseph Bail," *Le Journal*, 17 July 1894. The largest collection of paintings by Joseph Bail is found in the Musée Lombard, Doullens. For further information see J. Valmy-Baysse, "Joseph Bail," *Peintres d'aujourd'hui* (Paris, 1910).

Emile Bastien-Lepage
1854 Damvillers, Meuse — 1936 Paris

Although better known as an architect, Emile Bastien-Lepage (the younger brother of Jules) also enjoyed a productive career as a painter. He made up his mind early in life to become an architect, and after studying in the college at Verdun, entered the Ecole des Beaux-Arts in 1874 as an architectural student working under André (1840-

1896). At the same time, he studied drawing and painting with his brother, who captured his intense personality in a portrait of him in 1879 (Musée du Louvre). He also studied in the atelier of Cabanel.[1]

In 1880, Emile received his diploma in architecture. He exhibited in the 1887 and 1888 Salons and contributed frequently to the new Société Nationale des Beaux-Arts during the 1890s. His 1892 entries *La Rentrée au village, Portrait of Mme. E. B. L.*—and similar compositions suggest that many of his themes were similar to his brother's. By 1893, however, his entries of projects for decorative frescoes reflect his greater interest in architecture. Even after the turn of the century, when living in the Parisian suburb of Neuilly-sur-Seine, he continued to send designs for frescoes to the Salon.[2]

As an architect, Emile worked in fashionable sections of Paris, including Neuilly. Here, as early as 1883, he completed a private hotel, where sculptures by Rodin and paintings were integrated with the final decoration.[3] He also completed a private swimming pool (1894), country villas with frescoes, and the monuments for both his brother and Marie Bashkirtseff (Passy Cemetery, 1886).

1. Most of the information on the life and career of Emile has been provided by his descendants.
2. There is no accurate description of the frescoes; family descendants possess no photographs of the work of Emile Bastien-Lepage.
3. This building was located on rue de la Ferme at Neuilly.

Jules Bastien-Lepage
1848 Damvillers — 1884 Paris

In the comparative detachment provided by the pages of an English periodical, the *Art Journal* critic of the 1882 Salon observed, "this year a noticeable feature is the many, and often clever, imitations of the style of Bastien-Lepage. . . ."[1] Exactly ten years later, when the mood of European art seemed to have changed, another critic woefully declared in the columns of the *Speaker:* "Poor Bastien! time has dealt hardly with you. Only a few years ago your name was on every lip, and now—at least, among artists—it is nearly forgotten."[2]

The swift reversal of Jules Bastien-Lepage's fortunes in the ten years following his death indicates how quickly his work was assimilated by the artists of his time. While the latter writer's motives might appear suspect, it remains true that by 1892 many of those young painters who had so admired Bastien-Lepage in the 1880s had outgrown their youthful enthusiasm. Because Bastien-Lepage died amid a host of temporary imitators, he has until recently been lost to art historians.

Jules Bastien-Lepage was born on 1 November 1848, the son of Claude and Marie-Adèle Bastien.[3] The artist's parents cultivated a few fields around Damvillers, a village in the Meuse district of northeastern France. Bastien-Lepage's earliest efforts in drawing were encouraged by his family and by M. Fouquet, his professor at the *lycée* in Verdun. When he expressed his artistic ambitions, however, they conflicted with his parents' wish that he should become a civil servant. He therefore worked for a short period as a postal clerk in Paris, studying part-time at the Ecole des Beaux-Arts. His future was finally resolved in 1868 when he entered the atelier of Cabanel as a full-time student under a modest grant from the

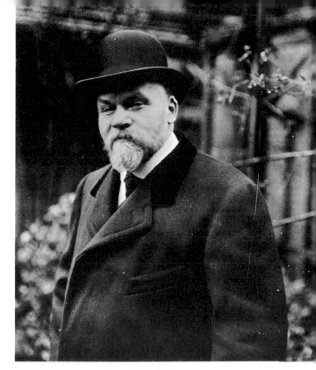

EMILE BASTIEN-LEPAGE

Department of the Meuse, and during this training received two prizes in drawing. He made his Salon debut in 1870 with a portrait that went unnoticed. When the Franco-Prussian War broke out, he joined a regiment of sharpshooters *(franc-tireurs)*, and was wounded in the chest by a shell that exploded nearby. After the war, when he had fully recovered, Bastien-Lepage unsuccessfully sought employment as an illustrator, but returned to the Salon in 1873, showing a Watteau pastiche. The moderate success of this work encouraged him to submit two pictures, a *Portrait de mon Grand-père* (Musée Jules Chéret, Nice) and an allegory, *Chanson du printemps* (Musée de la Princerie, Verdun), to the 1874 Salon. His open-air portrait was a critical success, and it drew the artist into contact with his future biographer André Theuriet. The precise character of Jules Bastien-Lepage's Naturalism was further defined by his principal work at the 1875 Salon, *La Communiante* (Musée des Beaux-Arts, Tournai; see [224]). Despite its superficial resemblance, in the style of the dress, to Whistler's *Symphony in White No. 1*, it also establishes his allegiance to Northern European masters such as Holbein and Clouet. Since the earlier days of Realism at Bonvin's *atelier flamand*, Northern masters had been studied for their close observation of nature, and, in an obvious way, painters like Tissot, Stevens, the students of Baron Leys, and even Whistler in the early 1870s were producing work of "Holbeinlike" gravity. It was the spirituality revealed in the precision of Holbein's likenesses that appealed to Bastien-Lepage. As he remarked to Theuriet, "underneath their ugliness and vulgarity, we find the thought and feeling that glorified everything."[4]

The degree of Bastien-Lepage's stylistic eclecticism may be further measured by his 1875 Prix de Rome entry, *L'Annonciation aux bergers* (The National Gallery of Victoria, Melbourne). This remarkable work, which borrows its formal arrangement from Ingres and Ribera, conveys the full extent of Bastien-Lepage's study of the art of the past.[5] The baroque gestures of the shepherds, their Caravaggesque realism, contrasts with the sophisticated quattrocento calm of the angel. In all of this, Bastien-Lepage's borrowings, like

267

those of Degas, are experiments in style rather than in iconography. No doubt, because of its erudition, everyone expected Bastien-Lepage to win the Prix; for reasons of expediency, however, it was awarded to Léon Commerre. During the following years, Bastien-Lepage rejected all pretensions to official success in favor of peasant subjects and in the summer of 1877 he wrote to the engraver Charles Baude of his resolve to "give myself up to a debauch in pearly tones: half dry hay and flowering grasses. . . . The clumps of trees on the banks of the stream and in the meadow will stand out strongly with a rather Japanese effect. . . ."[6] After such a declaration, Baude must have been surprised to come upon *Les Foins* (Musée du Louvre) in the 1878 Salon. Its uncompromising Realism of technique stunned spectators. As Bastien-Lepage himself reported, "The country people say it is alive." At the same time, a full appreciation of Bastien-Lepage's intentions in the work must recognize his patient notation of even tones, which convey the heat haze of a midsummer hay harvest.

The following year Bastien-Lepage sent a companion picture, *Saison d'octobre, récolte des pommes de terre* (National Gallery of Victoria, Melbourne), to the Salon. Here the mood was one of tense activity on a blustery autumn day. It must have been the light and air in the picture which led Zola to observe that while Bastien was "nearly the grandson of Courbet and Millet, . . . the influence of the impressionist painters is also obvious."[7] Generally, critics felt less challenged by *Saison d'octobre* than they had been by *Les Foins*. The poet Théodore de Banville wrote, "Bastien-Lepage is the King of this year's Salon."[8] It was therefore with some confidence in his position that the artist embarked upon the long-cherished project of painting a picture of Joan of Arc. It is said that the legendary and patriotic associations of the subject stirred a deep sense of conviction in the artist.[9] Bastien-Lepage visited Domrémy to research the picture, and he chose several models from his own village to help him visualize the character and facial expression of Saint Joan. His first intentions were to show the Maid kneeling in prayer before the altar, but this conventional pose was quickly rejected in favor of a picture of the girl seated at her spinning wheel in her father's orchard. Finally, he depicted Joan wandering away from her work, straining in an effort to hear the message of the voices more distinctly. After some discussion with Theuriet, Bastien-Lepage decided to paint in the apparitions behind the head of the protagonist. This somewhat-unconventional rendering of the subject provoked a mixed reception in the press, when the painting appeared in the 1880 Salon. The contradiction implied in the realistic representation of the voices was commented upon, and, as a result, there was great divergence in critical opinion.

Bastien-Lepage found consolation in a visit to London, where he already had a considerable following among artists and where a small retrospective of his work had been arranged at the Grosvenor Gallery. Up to this point in his career, Bastien-Lepage had received the least equivocal praise for his portraits. He had made it a regular practice to send his large pictures of subjects to the Salon accompanied by at least one portrait; he had also shown portraits at the Cercle Artistique in Paris and at the Royal Academy in London; no less than seven of the nine pictures at the Grosvenor Gallery were portraits.

Though he might have found temporary solace in London society, Bastien-Lepage never fully ac-

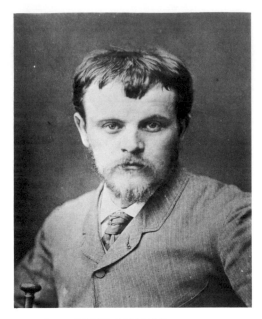

JULES BASTIEN-LEPAGE

cepted the criticism which *Jeanne d'Arc* (Metropolitan Museum of Art, New York) received. It is significant that a further attempt at a similar theme, the *Ophélie* (Musée des Beaux-Arts, Nancy) should have been abandoned in a state of uncertainty. During the remaining years of his life, Jules Bastien-Lepage concentrated on peasant subjects. He exhibited two contrasting works, *Le Mendiant* (Ny Carlsberg Glyptotek, Copenhagen) and *Le Père Jacques* (Milwaukee Art Center) at the Salons of 1881 and 1882. These pictures of aged peasants both incorporate the theme of youth and age by introducing a child as a foil to the main character. Of the two, *Le Mendiant* was perhaps more successful, not simply because it restored the artist to full critical favor, but because it also extended the ideals of the Naturalist in the presentation of a complete physical and psychological apprehension of the character of the subject. When it was shown in London, these qualities were warmly acknowledged by the *Magazine of Art*, which stated, "brilliantly drawn, excellently painted, good as character and good as gesture; the expression of a frank, sincere, discreet, intelligent naturalism. . . ."[10]

Bastien-Lepage was now at the height of his powers. His great Salon paintings were supported by many smaller studies which combine to form an impressive gallery of country types. In this brief heyday, he painted *Pas Mêche* [181] and *Going to School* [182]. His work was also enriched by regular visits to London, and his range of subject matter was extended in 1882 to include the *London Bootblack* [170] and the *Marchande de fleurs à Londres* (unlocated). Bastien-Lepage's attitude toward life at Damvillers was greatly affected by his contact with British art and this can be deduced from a remark he made to his hostess, Dorothy Tennant, on what was to be his last visit to the British capital: " I am going to paint a picture which shall satisfy you sentimental English with all your *sensiblerie*. I will paint a Village Tryst—Lovers Meeting; even the sky shall be sentimental."[11]

The resulting picture, *L'Amour au village* (1883 Salon, Pushkin Museum, Moscow), shows a pair of rustic lovers conversing over a fence, in a setting similar to that of the boy in *Pas Mêche*,

though more clearly defined. As if to prove the accuracy of Bastien-Lepage's calculations, the *Magazine of Art* found the painting, "a canvas which is completely a picture. . . ." Having discussed the Naturalism of the girl's pose,[12] it continued, "But there is another quality—most important in every form of art, but seldom seen in the art of Bastien-Lepage—the quality of sentiment."[13] *L'Amour au village* was completed amid growing difficulties. Bastien-Lepage's stomach cancer, which would eventually prove fatal, was becoming more virulent. Bastien-Lepage had begun the winter by exhibiting seven works at the Société Internationale des Peintres et Sculpteurs at the Galerie Georges Petit. He was then commissioned to design the funeral car for the statesman Léon Gambetta in January 1883. The strain involved in making sketches for a canvas of Gambetta on his deathbed forced Bastien-Lepage to return to Damvillers at the end of February. After *L'Amour au village* was installed at the Salon, Bastien-Lepage spent the summer months at Concarneau, where he was besieged by British and American followers who wanted to study his method of painting. The death of Grandfather Lepage hastened his return to Damvillers in October, where he remained for the winter.

Unable to exhibit a new work at the 1884 Salon, Bastien-Lepage spent his last months contemplating uncompleted projects, among them the *Enterrement d'une jeune fille*—his Salon exhibit for 1885. This work extends further the rustic Naturalism which had begun with *Les Foins*. Like *Le Mendiant* and *Le Père Jacques*, it shows the subtle shift toward inexorable themes, with their concomitant Symbolism. After a period of reprieve in the spring months of 1884, Bastien-Lepage's health quickly worsened, and on 10 December 1884 he died in the arms of his friend, Prince Bojidar Karageorgevitch.[14] K. Mc.

1. *Art Journal*, 1882, p. 217.
2. *Speaker*, 20 February 1892, p. 227, from a review of Theuriet's *Jules Bastien-Lepage and His Art, A Memoir* (London: Fisher Unwin, 1892), signed with the initials G. M., identifying the author as George Moore.
3. The main sources of information on Bastien-Lepage are: Louis de Fourcaud, "Artistes contemporains, Jules Bastien-Lepage," *Gazette des Beaux-Arts* XXXI (1885): 105-20; Louis de Fourcaud, "Exposition des oeuvres de Bastien-Lepage à l'Hôtel de Chimay," *Gazette des Beaux-Arts* XXXI (1885): 251-67; André Theuriet, "Jules Bastien-Lepage, l'homme et l'artiste," *Revue des Deux Mondes*, 15 April 1885, reprinted in translation as *Jules Bastien-Lepage and His Art: A Memoir* (London: Fisher Unwin, 1892); Julia Cartwright, *Jules Bastien-Lepage* (London: Seeley and Co., 1894); William Steven Feldman, "The Life and Work of Jules Bastien-Lepage: 1848-1884" (Ph.D. diss., New York University, 1973).
4. Quoted by Cartwright, *Jules Bastien-Lepage*, p. 27. Bastien-Lepage was nicknamed by his friends "le Primitif," and his devotion to Holbein and Clouet is a study in itself. It must suffice to quote Jules Breton's verdict. In the closing pages of *The Life of an Artist*, trans. Mary J. Serrano (London: Sampson Low, Marston & Co., 1891), p. 346, he states, "France, in Bastien-Lepage, has lost her Holbein."
5. Bastien-Lepage had recently copied Ingres's *Apotheosis of Napoleon I*. He was also influenced by Ribera's *Adoration of the Shepherds*; see Mace de Charles, "La Jeunesse de Bastien-Lepage d'après sa correspondance inédite," *Le Figaro*, 17 December 1884, quoted in Feldman, "Life and Work," pp. 81-82.
6. Theuriet, "Bastien-Lepage, l'homme," p. 45.
7. Emile Zola, *Le Bon combant, de Courbet aux Impressionnistes* (Paris: Collection Savoir, 1974), p. 206.
8. Cartwright, *Jules Bastien-Lepage*, p. 48.
9. See C. Sterling and M. M. Salinger, *French Paintings: A Catalogue of the Collection of the Metropolitan Museum of Art*, vol. 2 (New York, 1966), pp. 207-10.

JEAN BERAUD

10. "Art Notes," *Magazine of Art* V (1882): xxvi.
11. Mrs. H. M. Stanley, "Bastien Lepage in London," *Art Journal*, 1897, p. 56.
12. The pose might almost be a textbook illustration of Duranty's precept that temperament, age, and social status could, in Naturalist painting, be accurately conveyed in a backview.
13. *Magazine of Art* VI (1883): 380.
14. See Prince Bojidar Karageorgevitch, "Personal Reminiscences of Jules Bastien Lepage," *Magazine of Art* XIII (1890): 88.

Jean Béraud

1849 Saint Petersburg, Russia — 1935 Paris

Scenes of daily life painted by Jean Béraud reveal his interest in Naturalism. Such diverse themes as the crowds observing the funeral of Victor Hugo (Musée Carnavalet, Paris) or studies of the interior of a Parisian Bank reflect aspects of French society during the Third Republic.

Béraud was born of wealthy French parents in Saint Petersburg, Russia, where his father's career as a sculptor introduced him to the arts at an early age. After his father's death the family moved to Paris (1853). Béraud thus received his early education at the Lycée Bonaparte. Studious and talented, he finished his degree in law before the Franco-Prussian War. During the siege of Paris, he served in the army's Garde mobile de la Seine.

It was not until after the war and the dissolution of the Commune that Béraud decided to become an artist. He entered the studio of Léon Bonnat (one of the leading painters of the Third Republic), and received training as a portraitist for the next two years. The six entries he exhibited at the 1873 Salon document his interest for portraits during the early part of his career. He entered the official Salons regularly until 1889, receiving a third-class medal in 1882 and a second-class medal in 1883. The late 1870s, however, show a change of focus in Béraud's work, for he began recording scenes from Les Halles (1879 Salon) or the streets of Montmartre (1880 Salon). During the mid-1880s he completed two paintings that reveal social consciousness, a quality inherent in some aspects of the Naturalist movement. *Les Fous* (1885 Salon)

and *La Salle des filles au dépot* (1886 Salon) are compositions that graphically convey the personality of his figures as well as his adeptness at capturing anecdotal gestures. His depiction of a young prostitute yawning or another tying her shoe demonstrates his indebtedness to similar works by Degas.

Tiring of the academic Salon, Béraud became an enthusiastic founding member of the Salon of the Société Nationale des Beaux-Arts, serving as vice-president, and exhibiting at their annual Salons from 1890 until 1929. During the 1890s Béraud modified his Naturalist style to create religious compositions in a contemporary mode.[1] The symbolic implications of these canvases, which he exhibited in 1892 and 1894, evoked considerable discussion among critics: although his context was historic, he depicted his subjects in contemporary dress. These compositions were not his most successful, but they nonetheless document his continued participation in the Naturalist circle. His frequent choice of worldly events and public personalities reflects a similar "modernity" because of his ability to capture the personality of his models and to record their active participation.

In addition, Béraud was highly successful at creating an image of the fashionable Parisian woman of the 1890s. These compositions convey a stereotype of femininity, but the French and Russian aristocracy who were his clients were more than satisfied with his superficial representations of reality. Although he received the Légion d'honneur in 1887 and a gold medal at the Paris Fair in 1889, Béraud's later work was less serious than the Naturalist themes that he completed during his middle years. After his death, the Société Nationale des Beaux-Arts honored his work with a retrospective exhibition at the 1936 Salon; a second exhibition was also held that year at the Musée Carnavalet, Paris.[2]

1. Like James Tissot, whose later works were religious in theme, Béraud may have reflected the end-of-the-century attitude of disinterest and doubt toward religion. These paintings created a stir because Béraud used realistic portraits of contemporary figures dressed in clothing typical of the nineteenth century.
2. See *Jean Béraud, peintre de la vie parisienne*, Musée Carnavalet, November 1936—January 1937. The same museum held a similar exhibition in 1978/79; see *Un Témoin de la Belle Epoque—Jean Béraud (1849-1935)*, Collections du Musée Carnavalet, 5 June—29 July 1979. Information on Béraud's life and career remains sparse, since no descendants have been located.

Pierre-Denis Bergeret

1846 Villeparisis — 1910 Paris

Pierre-Denis Bergeret became one of the most popular and prolific painters of still life during the Third Republic. Trained under Eugène Isabey, Bergeret combined an intense Romantic coloring with a Realist's interest in carefully observed form. Undoubtedly, he was influenced by the canvases of Antoine Vollon [209, 210], since he used a similarly thick paint impasto applied with a vigorous brushstroke. Bergeret first exhibited a still life at the 1870 Salon and regularly thereafter until 1908, completing compositions of standard genre (e.g., cooks preparing a meal) and still-life themes that included flowers and fruit, asparagus, plums, fish, rabbits, and shrimp. He received a third-class medal (1873) for his painting *Lobster*; a second-class medal (1877) for *Shrimp*; and, as a commendation for his artistry in general, a medal of honor at the World's Fair in 1889 and another at the Paris Fair in 1900. In a small artist's colony

PIERRE-DENIS BERGERET

in Montmartre (26 rue Victor Massé), where he lived during the 1890s, Bergeret's works attracted the attention of collectors. He devoted the later part of his career to the popularization of still life.[1]

1. Bergeret's death date is not generally known, but is recorded in "Actes de décès," 28 February 1910, 9e arrondissement, Ville de Paris.

Rosa Bonheur

1822 Bordeaux — 1899 By, Seine-et-Marne

Rosa Bonheur's parents were both talented in the arts: her mother was a musician and her father, Raymond Bonheur, was a sculptor. All four children were well acquainted with the visual arts, but Rosa Bonheur asserted her individuality and independence at an early age. Her family moved to Paris in 1829, with the hope that their income, largely derived from her father's drawing classes, would be increased by the new clientele, but they remained a family of modest means.

During the 1830s, Bonheur's father joined the Saint-Simonians, a group of French socialists interested in the scientific reorganization of the existing social order.[1] Because of their desire to create a Utopian existence on earth, the Saint-Simonians also advocated equality for women—a concept so basic to their revolutionary outlook that a female Messiah was even sought. Bonheur's independent spirit was nurtured by this atmosphere, for she undoubtedly visited her father when he lived with the community of Saint-Simonians during her formative years. While the effect of this group upon Bonheur's life has not been fully examined, her early contact with their ideas and her decision to live with her father after 1833 must have led her to adopt some of their basic beliefs.

After her mother died in 1833, Bonheur was first sent to live with an aunt, who, in turn, arranged for her to be cared for in a *pension*. The unhappy, young girl rebelled and returned to her father. She was not a good student, and when his plan for her to learn sewing as a trade was unsuccessful, she was sent to live with artistic friends who designed heraldic images—probably for books. It was here that Bonheur discovered her true inclination.

269

Finally convinced of her artistic ability, her father agreed to teach her to paint, providing lessons for her at home and emphasizing the study of the old masters in the Louvre. For a time she also studied with Léon Cogniet, but the extent of her training in his atelier remains unknown.

Between 1841 and 1849, Bonheur spent much of her time with her father and his new wife. Their lodgings on rue Rumford, near the Monceau Plain, provided the opportunity for Bonheur to study and paint both wildlife and farm animals. She spent part of her time in other locations, such as Neuilly, where she continued to study animal anatomy and movement, concentrating upon depicting the muscles of cows, sheep, and goats, familiarizing herself with "the rapid movement of animals."[2] In 1841, two of her works were accepted for Salon exhibition: the painting *Deux Lapins*, and a drawing, *Chèvres et moutons*. Although the works may have attracted little notice, they signaled her career as an artist and provided her the first real opportunity to exhibit the kinds of themes she preferred.

Rosa did not confine her study of animals to the fields or nearby farms. She also visited the slaughterhouses and marketplaces to further her understanding of the traits and actions of animals. Her aim was more than scientific, factual presentation, and she did innumerable studies of the same subject, trying to capture the true spirit of the animal. Her preference for animals did not limit her interest in other aspects of nature. She studied zoology texts, but she also studied botany, and became an avid student at the Jardin des Plantes.[3] Some of the compositions she completed during this period also demonstrate an ability as a landscapist in the Barbizon tradition (e.g., *Effet du soir sur un pâturage*, 1842 Salon).

Bonheur exhibited at the Salons from 1841 until 1855. In 1845 she received favorable notice from Théophile Thoré in his Salon review[4] and received a third-class medal for her six entries. It was not until the 1848 Salon, however—when she exhibited eight works and was awarded a first-class medal—that her reputation as an artist was established and she was able to exhibit freely. It was during these years that Bonheur frequently travelled to the provinces, searching for new themes to paint, and her Salon canvases from this period often reflected the previous year's trips.

Bonheur's success at the 1848 Salon led the government to commission a work from her for 3000 francs.[5] The canvas, *Labourage nivernais: Le Sombrage* (Fontainebleau, Musée National du Château), was originally intended for the Lyon Museum, but after the close of the 1849 Salon, where it was exhibited, it entered the Luxembourg Museum. Bonheur's choice of theme for this composition may have been influenced by a passage from George Sand's novel *La Mare au diable*, but her accurate characterization of animals also reveals her affinity with the Realist movement. *Labourage nivernais* marked Bonheur's success as an artist and signified her rank among the most important *animaliers* of the period.[6]

In 1849, after the birth of her half-brother Germain, Bonheur left her father's home and the communal atelier they had been sharing. Needing a larger space for her own work, she rented the atelier at 56 rue de l'Ouest that was to remain her studio until 1853. The location provided the opportunity to get to know other painters in the same building: she became acquainted with the history painter Yvon (1817-1893) and the fashionable, Romantic portrait painter Signol (1804-1892).

ROSA BONHEUR

She continued her studies of animals, frequenting the Parisian slaughterhouses to observe animals both before and after they were killed.

Bonheur's fame as a painter began to attract art dealers such as Tedesco, who also sold paintings by François Bonvin, and Bourges, a private collector and linen merchant who favored her animal studies. It was the 1853 Salon, however, that brought her international fame. Her huge canvas *The Horse Fair (Marché aux chevaux de Paris)* was an immediate success, attracting considerable press attention, although—because of its size—no buyers. At the close of the Salon, the painting was exhibited in Ghent and, later, in Bonheur's native Bordeaux, where she hoped the city would buy it.[7] The painting was finally purchased by the English art dealer Gambard, and—through the intervention of the perspicacious art dealer Samuel P. Avery—eventually became part of the collection of Cornelius Vanderbilt.[8]

At the close of the 1853 Salon, Bonheur had a studio built on rue d'Assas. She transformed the garden into an area where animals could be kept but, because it was difficult to feed and quarter large animals within the city, also obtained a second atelier in Chevilly, near Fontainebleau, where she raised sheep and goats.

During the Second Empire, Bonheur also became a teacher. After her father's death in 1849, she became director of the Ecole de Dessin, a position she maintained until 1860, when she informally retired to her Château of By (Thomery). Her paintings were well appreciated in France and her compositions favored by the Second Empire. The Empress Eugénie came to Bonheur's chateau in person in 1865 to present her the Légion d'honneur. More than that, she became the idol of the English. A leading English art dealer invited Bonheur to come to London (probably to accompany *The Horse Fair* when he purchased it). This enabled her to meet a number of English painters, including the animal painter Edwin Landseer, and to travel in Scotland as well. Her interest in England, especially the Scottish countryside, not only inspired the *Fenaison en Auvergne* that she exhibited at the Paris World's Fair in 1855, but served as the source for the ten Scottish works shown at the 1867 Paris Fair.[9]

Except for the London Exhibition in 1862, the 1867 Paris Fair remained her only international exhibition until the 1890s. After 1855, Bonheur declined to send canvases to the annual Paris Salons. Only twice—at the Chicago Fair in 1893 and the Paris Salon of 1899—did she again participate in international shows. Nevertheless, her fame extended far beyond the French borders. She was decorated by both the Spanish and Belgians. Her works became so popular among the English that French critics began to regard her lack of participation in the Salons as disdain for her French audience. Nonetheless, she was made an officer of the Légion d'honneur in 1894, the first French woman so honored, even though she continued to withhold her works from the Salon exhibitions.

Although Bonheur's studies of animals and landscapes rank her among the Realists, the extent of her contribution remains somewhat elusive because of her personality. She fiercely guarded both her privacy and her independence. Her unconventional mannerism (her preference for men's clothing) and her aloofness from her French audience shocked many of her countrymen. Her passion for animals, which suggests the Romantic tendencies of Géricault and Delacroix, inspired thorough, scientifically accurate descriptions of goats, sheep, and cows. Some of her paintings achieve a primitive strength, such as that seen in *The Horse Fair*, which combines the energy and spirit of the animals with a Realist's dedication to recording the observable.

1. For further information see L. Roger-Milès, *Rosa Bonheur: Sa Vie—son oeuvre* (Paris: Société d'Edition Artistique, 1900), pp. 19-20.

2. Ibid., p. 28.

3. During a visit to Bonheur's studio at the Château of By, it was revealed that she studied from C. Cuvier, *Le Règne animal, distribué d'après son organisation* (Paris, 1817), a book which is prominently displayed in Bonheur's atelier as it is presently maintained.

4. Roger-Milès, *Rosa Bonheur*, p. 42.

5. Noted in Geneviève Lacambre, *Le Musée du Luxembourg en 1874*, exh. cat., Grand Palais, 31 May—18 November 1974, p. 34.

6. Roger-Milès, *Rosa Bonheur*, p. 50.

7. For the history of this painting see Roger-Milès, *Rosa Bonheur*, pp. 50 ff.

8. Vanderbilt, who paid $52,000 for the work in 1887, eventually gave the painting to the Metropolitan Museum of Art, New York.

9. Bonheur received a first-class medal in 1855 and a second-class medal in 1867.

François Bonhommé

1809 Paris — 1881 Paris

François Bonhommé was one of the early protoRealists who specialized in images of the workers of industry, and it is unfortunate that his works are now difficult to locate.[1] Even at the time of his death in 1881, Bonhommé's works had already been completely forgotten, and his type of Realism dismissed as no more than archival recording of a specific, dated activity.

His background was humble, and it was assumed that Bonhommé would become a *petit artisan* like his father, who painted scenes on carriages for a number of the wealthy aristocrats of the Restoration. In 1829, however, Bonhommé was accepted at the Ecole des Beaux-Arts, ranking ninety-third out of one hundred fourteen entrants. Despite the training he received from Horace Vernet and Paul Delaroche, Bonhommé soon tired of the classical tradition and began recording scenes from daily life in Paris, undoubt-

FRANÇOIS BONHOMME

edly motivated by Delacroix's imagery of the July Revolution of 1830 and "le peuple."

During the early 1830s, Bonhommé became increasingly aware of the inadequacy of his academic training. He exhibited a modest study of a dog at his first Salon in 1833, but he also worked on a series of pastel portraits,[2] some of which were acquired by Alexandre Dumas the Elder, a staunch advocate of Bonhommé throughout his career.

There are two versions that explain Bonhommé's predilection to chronicle nineteenth-century industrial activity. A singular experience visiting a factory where he witnessed the interaction between man and fire may have prompted Bonhommé's fascination with mechanization and modernization.[3] His complete dedication to this theme may also have been nurtured by Paul Delaroche, a teacher known to have been deeply concerned for the well-being of his students, who helped Bonhommé obtain a commission to paint the industrial activity at the Fourchambault mills.[4] In any event, by 1836 the entrepreneurs of Fourchambault became his patrons, and Bonhommé devoted his efforts to portraying individual workmen and their specific tasks. Bonhommé's entry at the 1840 Salon, *The Forge at Fourchambault*, confirmed his reputation as a recorder of the industrialization of the French mills and the men who worked them, and he received further commissions as industrialists, including leading mill owners such as M. Aubertot, eagerly responded to his specialty. In 1848 Bonhommé conceived his series Soldiers of Industry, a compilation of the various efforts and activities describing labor and industry. A depiction of child labor in the mines [38] was intended to serve as a frontispiece for another undertaking. Bonhommé's ability to record contemporary scenes also led to his first acknowledgment by the government, which designated him to document the events of the February Revolution of 1848. He continued to receive governmental support when the Second Empire was established, despite his republican desire to reconcile all classes. Napoleon III needed artists to promote his aspirations, and he recognized Bonhommé's ability to relate the process of industrialization to the peo-

ple. In 1851 Bonhommé was commissioned to complete a series of paintings for the Ecole des Mines, a reflection of his continued appreciation by the provisional government and the Minister Ledru-Rollin. The Second Empire maintained its support in later years; in addition, he received a third-class medal at the important 1855 Salon.

The wall murals for the Ecole des Mines were among the most significant commissions Bonhommé received. Each of these large works was intended to identify a different field of the metal industry and presented not only the entire view of a given factory but included gigantic images of that industry's particular workers. The entire series was to be dedicated to the history of metal extraction, but only two themes were completed: the extraction and the use of zinc and iron.[5] Unfortunately, none of these canvases, which consumed a large part of Bonhommé's career during the late 1850s, have survived. They were destroyed sometime after 1900 by a director of the Ecole des Mines who failed to recognize their artistic merit or their historical value.

Aside from these examples, Bonhommé received other important commissions. Under Napoleon III he recorded the industrial activity of the country in a series of impressive, detailed water colors [41] that were exhibited in the 1860s at the Paris Salons. The success he experienced from themes in industry was transitory, and his later years were overcome by misery and poverty. Two of his oldest friends, Félix Bracquemond (the etcher and industrial designer) and Champfleury, did their best to look out for him. When Champfleury became director at Sèvres, he was able to obtain a professorship of drawing for Bonhommé at Sèvres for a salary of 250 francs a year. When he died, however, Bonhommé was nearly destitute.

1. For information on Bonhommé as a proto-Realist, see Linda Nochlin, *Gustave Courbet: A Study of Style and Society* (New York: Garland Publishers, 1977), pp. 111-14. Bonhommé's works are scattered in industrial museums and private collections, making it difficult to obtain an overview of his work as a Realist.
2. These early portraits have not been located; some may still be in private collections.
3. For a discussion of Bonhommé's influence in the development of industrial imagery, see Michelle Evrard and Patrick Le Nouène, *La Représentation du travail: Mines, forges, usines*, exh. cat. (Le Creusot, 1978).
4. For a reproduction of a Fourchambault painting, see Evrard and Le Nouène, *La Représentation du travail*, p. 14.
5. Ibid., p. 23, shows a reproduction of one of these murals.

Joseph-Florentin-Léon Bonnat
1833 Bayonne — 1922 Bayonne

Joseph-Florentin-Léon Bonnat, France's most fashionable portraitist during the Third Republic, was born in 1833 in Bayonne, a city bordering the Basque region of France along the Spanish frontier.[1] In his own lifetime, he was accorded every possible artistic and social recognition (among them, member of the Institut de France in 1881, grand officer of the Légion d'honneur in 1900, and director of the Ecole des Beaux-Arts in 1905), and his career exemplified that of the successful nineteenth-century French academic painter. His numerous pupils in his own private studio and later at the Ecole des Beaux-Arts included such distinguished painters as Dufy and Matisse, Toulouse-Lautrec (whom he disliked),[2] and the great American Realist painter Thomas

Eakins, as well as a school of painters known as the *Ecole bayonnaise* who continued his *vériste* tradition.[3] Closely associated from the 1870s with the official French art establishment noted for its conservatism, Bonnat won many public commissions,[4] obtaining—along with Puvis de Chavannes, Cabanel, Baudry, and others—the commission for the most important decorative scheme of the nineteenth century: the interior of the Panthéon. Bonnat's conventional later career, however, was at variance with his unusual artistic beginnings. Today he is remembered for his own superb art collection, housed in the Musée Bonnat in Bayonne, and for society portraits of photographic verisimilitude, but Bonnat's early oeuvre bears closer examination, for these works reveal an individual painter independent of the Parisian academic artistic community.

Bonnat spent his childhood in Bayonne, often accompanying Charles Sarvy, his maternal uncle and an accomplished landscape painter, on open-air sketching trips in the Pyrénées. Although their styles were never similar, Bonnat's most vivid, single portraits are oil sketches of this uncle.[5] Bonnat received his first drawing lessons from a family friend, Antoine Clergel de Sète, in Bayonne, and his first signed and dated work, a self-portrait of 1849 (Private Collection, Paris), is dedicated to this teacher.[6] In December 1846 Bonnat abandoned his formal schooling and left Bayonne to join his family in Madrid where they had emigrated for financial reasons, Bonnat's father having opened a French bookstore in the capital. Encouraged by his father to make frequent visits to the Prado, he was especially struck by the paintings of Velázquez and the seventeenth-century Spanish school, and made numerous, careful sketches and exact copies of their works. The following year he began formal studies in painting in Madrid, attending classes at the Royal Academy of San Fernando in the evenings, for a short time in the studio of José Madrazo (a dedicated classicist and former pupil of David) and then in the studio of his son, Federico Madrazo, who had been a protégé of Ingres. Throughout his career, Bonnat remained strongly influenced by the tradition of formal court portraiture, dependent on Velázquez and able to call on Ingriste technique.

During the 1850s in France, Realism was considered the most controversial issue in the arts, and Bonnat's paintings of these years reveal a proximity to the temperate Realism of such artists as Bonvin, Carolus-Duran, and Fantin-Latour. Modern rather than anecdotal in their depiction of life, these Realists knew Courbet's work, but their approach was at variance with his emphatic and political Realism. Bonnat, developing his early style independently in Spain, painted a series of intimate portraits of his own family similar to this group for which seventeenth-century genre painting often provided the model. These remain among his most expressive works. Bonnat's *Portrait of Joseph Sarvy* [139], his uncle, was painted the same year as his masterpiece, *Portrait of His Family* (1853, Musée Bonnat)—and the same year as his father's death. This family portrait bears comparison with Degas's painting of his relatives, the *Belleli Family* (Louvre), painted six years later in Italy when he was a fellow student with Bonnat, and reveals in these two apparently dissimilar artists close artistic links at the outset of their careers. Degas's portrait, however, lacks the genre feeling of Bonnat's painting and concentrates on the individual sitters and their complex spatial relationships. In this work, Bon-

271

LEON BONNAT

nat appears to be in advance of his exact contemporary, Manet. Bonnat and Manet shared an affinity for Spanish painting, but even before Bonnat knew Manet's work, his family portrait had in the background an impressionistic portrayal of their servant. This same family portrait also parallels Fantin-Latour's *Two Sisters* [71]. Bonnat never publicly exhibited his family portraits, although he always displayed them in his studio.

The Bonnat family left Madrid, returning 17 November 1853 to Bayonne. Bonnat, decided upon an artistic career, was assisted by the Bayonne painter and lithographer Bernard-Romain Julien, a former pupil of Gros and the director of the Bayonne Academy of Drawing, whose copybooks of lithographs flooded the academic ateliers of France. Julien, enormously impressed by Bonnat's family portraits, interested the mayor of Bayonne, Jules Labat, a connoisseur and collector of Spanish painting, in Bonnat's case. The artist obtained a triennial pension of 1500 francs from the Municipal Council in accordance with the popular practice during the nineteenth century of provincial cities sponsoring their own talented painters for further studies in Paris. Parisian training changed the course of Bonnat's artistic career, and it can only be speculated that had Bonnat returned to Spain for further artistic studies rather than migrating to the great magnet of Paris, his work might have remained within the Realist tradition of Spanish painting.

Bonnat left Bayonne for Paris accompanied by his mother and sister, supporting all of them on his meager pension, and they settled in the Cité Gaillard by January 1854. Recommended by Julien, Bonnat enrolled in the large and active studio of Léon Cogniet, a Prix de Rome winner who had been a pupil of Guérin. In the studio of this accomplished, if highly traditional, painter, Bonnat met his lifelong friends: the academic painters Jules Lefebvre, Pierre-Auguste Cot, and Tony Robert-Fleury—all of whom, although minor painters artistically, were to have successful Salon careers. It must be emphasized that Bonnat retained closer ties to this group of academic painters than to other more avant-garde artists, although he did have close links at various times in his career with Bonvin, Degas (whom he

knew in Rome and later in France), and Manet, whose work he often voted for on Salon juries.[7]

In Paris, Bonnat followed a full training program. As well as studying with Cogniet, he also attended anatomy and perspective classes at the Ecole des Beaux-Arts under Paul Delaroche and received advice from the history painter Joseph-Nicolas Robert-Fleury. Cogniet, who had begun his career with historical compositions of contorted complexity, was exhibiting only portraits in the Salon when Bonnat began his studies with him, and he encouraged his pupil's natural aptitude for portraiture.

Bonnat's Salon debut in 1857 with three portraits went unremarked by the critics, but in the same year he competed for the Prix de Rome. Bonnat, taking second place, had his pension renewed by the city of Bayonne and, with additional help from Bayonne friends,[8] set out for three years of study at the Villa Medicis, the French Academy at Rome then under the directorship of Jean-Victor Schnetz.

During his stay in Rome, Bonnat received the standard academic training, making many copies after High Renaissance masters, notably Michelangelo, Giulio Romano, and Daniel Volterra. There were few academic stipulations for the Villa Medicis students—only the compulsory annual works to be sent to the Paris Salon. From Rome, Bonnat sent back only three paintings to the Salon, none particularly notable, although his *Death of Abel* (1861, Musée de Lille), an academic nude study reminiscent of Jean-Jacques Henner's Prix de Rome painting of the same subject of 1858, won him a second-class medal in the Salon.

At the Villa Medicis, Bonnat was surrounded by a diverse group of painters—Jules Lefebvre, Jean-Jacques Henner, Elie Delaunay, Gustave Moreau, and Degas—all of whom had successful Salon careers, except Degas who moved rapidly away from academicism.[9] Bonnat did many oil sketches of contemporary Italian life and also practiced open-air sketching as a pastime. His more successful landscapes follow the tradition of Valenciennes and Michallon and concentrate on evoking the atmosphere of a particular time of day, as in his sketchy *View of Rome* (Musée Bonnat) in early evening that captured the hazy outlines of the buildings and soft, subdued coloring. He was later fascinated by the picturesque qualities of Venice's misty lagoon, making a visit there in 1883. Only two oil paintings are known from this visit,[10] but the parallel to Whistler's views of Venice is striking, and the American is known to have been in Venice at the same time. In contrast, Bonnat's rare landscape drawings appear to be rational reconstructions of nature in their ordered and geometrical composition. Bonnat's only Salon-exhibited landscape of half-a-century later, *La Route de Sainte-Anne* near Saint-Jean-de-Luz (Salon 1899, Musée Bonnat), was firmly within the classical tradition.

After three years in Italy, Bonnat returned in 1861 to his *pays*, visiting his mother and sister in the fishing port of Saint-Jean-de-Luz, near Bayonne. He never married and was most discreet about his complex personal life, dividing his time between Paris and the house on the port where he kept a studio until 1904.[11] Professionally, the 1860s were interesting years for Bonnat. In his letters to a friend in Bayonne, Bonnat confessed his disillusionment with the Paris art establishment, but like Manet he considered the Salon a battleground, and rather enjoyed it: "It is there that one has to compete, and it will be a pleasure."[12] By

1865, following the exhibition of his controversial and overtly Realist *Saint Vincent of Paul Taking the Place of a Galley Slave*, Bonnat opened his own teaching studio to promote the academic study of Realism. Bonnat's own style was formed slowly, and his years of study in Rome, while classicizing, never entirely supplanted the austere Realism of Spanish art in his work.

During the 1860s, successful French artists were making voyages to the Orient, bringing back exotic subjects to the insatiable, fickle Parisian public, and Bonnat made the required mid-Eastern journey with Jean-Léon Gérôme, now regarded as a pillar of the academic artistic establishment but in his own lifetime acclaimed as a Realist, ethnographic painter. Gérôme's group, which included Paul Lenoir,[13] Frédéric Masson, and several other painters, left Marseille's *porte d'Orient* on 18 January 1868 and visited Egypt, the Sinai, Palestine, and parts of Turkey and Greece. Bonnat's landscape sketches from this trip are among his more interesting works,[14] and in these he approaches the sophistication of Eugène Fromentin's delicate and abstract studies. The Orientalist paintings for exhibition, which Bonnat continued to show in the Salon well after his trip and reconstructed with the aid of photographs, are essentially in the *fini* tradition set by Gérôme. Bonnat's studio in Saint-Jean-de-Luz was to serve him well in later Orientalist paintings for, "slave to truth" as he described himself, he made actual reconstructions of the desert on the beach at Saint-Jean.[15]

The numerous landscape studies which Bonnat made on this trip had but little effect on his style for large-scale, commissioned compositions. On his return to France he painted an *Ascension of the Virgin* (Saint André, Bayonne) so artistically archaic that the avant-garde critic Castagnary, a supporter of the Realist movement and of modernity in art, put in a despairing plea to Salon painters for art based on real life.[16]

Although large-scale decorative paintings formed the basis of academic art in the nineteenth century, the demand for them was only occasional. In the late 1870s, Bonnat turned almost entirely to exhibiting portraits, and these won praise for their contemporary approach, so unlike his large-scale decorative work. Most successful artists were obliged to rely on portraiture and, in this field, academic painters kept their lead. Bonnat's portrait of the actress *Madame Pasca* (1874, Louvre) and his portrait of the former president of the Republic, *Adolphe Thiers* (1877, Louvre) were unanimously acclaimed by the critics, launching his career as the leading portraitist of the Third Republic and also winning for him an international reputation. Bonnat's portrait of Thiers, with all the solidity of Ingres's earlier portrait of *Monsieur Bertin* (1832, Louvre), lacks its prototype's psychological realism but remains important as a historical document. Bonnat painted portraits of most of the important men of his age—including Victor Hugo (twice), Carnot, Dumas, Pasteur, Renan, and Taine—and these form a veritable encyclopedia of influential personages.

Many of Bonnat's later portraits were painted with the aid of photographs[17] and, in their definite lines, dark tonality, and emphasis on detail, the verisimilitude often seems unpleasant to modern eyes. Paintings resembling the quality of photographs were the vogue in fashionable portraiture from the 1880s, and Bonnat was renowned for this achievement, especially popular among bejewelled and elegant society ladies. The desire for finish in painting parallels to some extent other tastes of

the society of the prosperous, new France in a period of rapid, economic expansion. Parisians, although shocked by the vulgarity of Courbet's paintings and rejecting *la bande à Manet*, admired the polished frivolity of Offenbach's operas, the eroticism of Gérôme's works in the Salon, and the opulence of Haussmann's boulevards that were transforming Paris. Bonnat's society portraits were a reflection of this new materialism. Forsaking his earlier style, Bonnat held a mirror to his age and, as he prospered, he also became the product of the new France he portrayed. Emile Zola, the defender of Manet and the Impressionists, although he disliked the paintings of Bonnat and any paintings resembling photographs, argued that meticulous observation by such established artists as Bonnat would change the academic approach and create a movement toward Naturalism.[18] In fact, when Impressionism became an established movement, Bonnat actually made concessions to the new style. Many of his late portraits were lighter in color and reveal broken, multicolored brushwork. Conventional portraiture provided for Bonnat an agreeable and financially rewarding living, and Bonnat—very much a man of the world—clearly enjoyed the society he painted.

The high prices Bonnat commanded for his effigies enabled him to found the first museum in his native Bayonne. His wish to form an art collection was long-standing, and he planned his museum primarily as a teaching collection spanning all epochs in the history of art. Bonnat's general collection was acquired through dealers and various friends, but his personally formed collection of old master drawings remains one of the world's best.[19] His collection is richest in drawings by the Renaissance masters, second in drawings by Rembrandt. Of his artist contemporaries he sought out those by Millet, for he was closely drawn to this type of spiritual Realism.[20] Although his collection shows a sympathy with many types of art—in part because of the contributions of Impressionist and Post-Impressionist paintings by his friend, the photographer and collector, Antonin Personnaz—Bonnat never appeared to have questioned the validity of the academic system for himself.

Bonnat's painting career spanned a period of over seventy years until his death in 1922, and he was witness to the major artistic movements of the nineteenth and early twentieth centuries. Never an advocate of artistic change, Bonnat became in later years an eloquent opponent of modern art under the auspices of the Académie des Beaux-Arts. In a long essay devoted to the critical devastation of Cézanne,[21] Bonnat's approach was clearly outdated. Bonnat's paintings prior to his Parisian success, however, have yet to be seriously appraised, for in these works Bonnat proved his talent as an artist of the Realist tradition and a spiritual contemporary of the *atelier flamand*.

A. C. J.

1. Joseph Catherine François Bonnat (b. 1798 Madrid) married Anne-Marie Florentine Serval dit Sarvy (b. 1812 Bayonne) in 1830 in Bayonne. Three children survived into adulthood: Léon, Paul (d. 1870), and Marie. Archives Municipales, Bayonne.

2. Toulouse-Lautrec was a pupil of Bonnat during 1882. Bonnat refused Toulouse-Lautrec's *Portrait of M. Delaporte* for the Luxembourg in 1905; see H. Jeanpierre, "Bonnat et l'art moderne," *Société des Sciences, Lettres et Arts de Bayonne*, 1973. For letters of Toulouse-Lautrec referring to Bonnat, see *Unpublished Correspondence of Henri de Toulouse-Lautrec in the Collection of Herbert Schimmel* (New York: Phaidon, 1969), pp. 64, 67-70; and Maurice Joyant, *Correspondance de Toulouse-Lautrec*, vol. I, pp. 56-57.

3. The *Ecole bayonnaise* was comprised of the painters Gabriel Deluc, Eugène Pascau, Denis Etcheverry, Georges Bergès, and Henri Zo—most of whom became curators of the Musée Bonnat in accordance with Bonnat's wishes.

4. Major public commissions: *Saint Vincent of Paul*, 1865 (Saint-Nicolas-des-Champs, Paris); *Ascension of the Virgin*, 1869 (Saint-André, Paris); *Christ Crucified*, 1872 (Palais de Justice, Paris); *Job*, 1880 (Luxembourg, Paris); *Martyrdom of Saint-Denis*, 1886 (Panthéon, Paris); *Triumph of the Arts*, 1894 (Hôtel de Ville, Paris).

5. Musée Bonnat and private collections in France.

6. Dedication on this portrait reads: "L. B. à son ami Ant. Clergel 1849." Contemporary label states: "Portrait par lui-même par Bonnat donné à Ant. Clergel de Sète qui lui donna ses premières leçons à Bayonne."

7. See Gabriel P. Weisberg, *Bonvin: La Vie et l'oeuvre* (Paris: Editions Geoffroy-Dechaume, 1979), pp. 111, 136, 146. Degas first knew Bonnat at the Villa Medicis in Rome where he painted his portrait (Musée Bonnat) and then later in Paris in the 1860s (*Portrait of Bonnat* by Degas, Private Collection, U.S.A.). They met again in Biarritz in the 1880s. Degas always considered Bonnat a good, if conservative, painter. Manet and Bonnat were acquainted from the 1860s through the Paris Salons, and Bonnat—like most of his contemporaries—was somewhat influenced by Manet's innovatory technique.

8. The Détroyat family in Bayonne helped to finance Bonnat's Rome years, and Bonnat's mother and sister were their dependants during this time. Family papers, Saint-Jean-de-Luz.

9. Phoebe Pool, "Some Early Friends of Degas," *Apollo* LXXIX (May 1964): 391-94.

10. Venetian oil sketches: *View of S. Maria della Salute and the Grand Canal* (1883, Mairie, Bayonne) and *Night View of S. Maria della Salute* (Private Collection).

11. Bonnat-Baita was given by Bonnat to his goddaughter, Jacqueline de Verneuil, in 1904.

12. Bonnat to Bernard Romain Julien, Rome, 19 October 1858, Bibliothèque Municipale, Bayonne.

13. Paul Lenoir, *Le Fayoum, le Sinai et Pétra, expédition dans la Moyenne Egypte et l'Arabie Petrée, sous la direction de J. L. Gérôme* (Paris: Editions Plon, 1872).

14. Achille Fouquier, *L. Bonnat, première partie de sa vie et de ses oeuvres* (privately printed, 1879) states that Bonnat brought back seventy-two oil sketches from this trip, many of which he gave to Madame Robineau-Dailly, although few are known today.

15. Bonnat to Bernard-Romain Julien, quoted, in part, in Henri Jeanpierre, *Guernika* (1950): "Je ferai poser le tout, de six à sept heures du soir derrière l'établissement des bains. . . ."

16. Castagnary, "Salon de 1869," *Salons 1857-1870* (Paris: Bibliothèque Charpentier, 1892), 1: 329-30.

17. Like many nineteenth-century portrait painters, Bonnat made no mention of using photography for painting, although in his house, 48 rue Bassano, Paris (built for him by Stanislas Louis Bernier in the 1880s), a professional photographer occupied the ground floor.

18. Emile Zola, "Le Naturalisme au Salon" in "Salon de 1880," *Salons*, with notes by F. W. J. Hemmings and Robert J. Niess (New York, 1959), p. 254.

19. In 1865 Bonnat met a Parisian neighbor, the great collector His de la Salle, who gave him the Rembrandt drawing which began his collection, according to information Bonnat reported to a woman friend in 1893 and published in "Comment je suis devenu collectionneur," *La Revue de Paris*, 1926, pp. 751-64.

20. See *Les Dessins de la collection Léon Bonnat au Musée de Bayonne*, exh. cat. (Paris, 1925); and Vincent Ducourau and Maurice Sérullaz, *Dessins français du XIXe siècle du Musée Bonnat à Bayonne*, LXIXe exposition du Cabinet des Dessins, exh. cat. (Paris: Editions de la Réunion des Musées Nationaux, 1979).

21. Essay concerning Cézanne, Bibliothèque Municipale, Bayonne.

FRANÇOIS BONVIN

François Saint Bonvin

1817 Vaugirard, Paris —
1887 Saint-Germain-en-Laye

François Saint Bonvin was largely a self-taught artist. His earliest known oil painting (1839) forecasts a lifelong dedication to still life. He was recognized by contemporary critics and collectors as a leader in both the revival and the development of this theme. Bonvin's first still life was painted while he was still working for the Paris Préfecture de Police, when financial difficulties prevented him from devoting much time to his painting except in the evenings. What little training Bonvin obtained, first as a printer and, later, on his own at the Gobelins and the Académie Suisse, was augmented by contact with François Marius Granet (1775-1849), the artist Bonvin considered his master. During the early 1840s, Bonvin advocated themes of everyday life, especially scenes inspired by family and close friends.

In an effort to win recognition, Bonvin exhibited his drawings and water colors under the arcades of the Institut de France from 1844 to 1846, where his first patron, Laurent Laperlier, purchased some drawings. He was first accepted at the Paris Salon in 1847, when he exhibited a portrait; after that he continued sending works to the Salons until 1880.

Bonvin was committed to the Realist movement early in his career when he became acquainted with the novelist and art critic Champfleury and the artist Gustave Courbet. While the extent of Bonvin's relationship with Courbet remains unknown, they often held lengthy discussions together at the Brasserie Andler, which also attracted Amand Gautier, Jean Gigoux, Max Buchon, and, probably after 1860, Castagnary. It was here that Courbet set forth his theories on the development of Realism. Bonvin remained a member of this group until the 1860s, when he terminated his friendship with Courbet, ostensibly over an insult Courbet made concerning Bonvin's second wife Céline Prunaire. Champfleury, another frequent visitor at the Brasserie Andler, championed Bonvin's still lifes. At the 1849 Salon he singled out *The Cook* (Musée de Mulhouse) as sharing affinities with the work of Jean Siméon

Chardin (1699-1779), a master whose works Bonvin admired at the Louvre and in private Parisian collections. This painting received a third-class medal, and the artist was awarded 250 francs, which helped alleviate his poverty.

Bonvin's small compositions never generated the fervent critical attacks by conservative critics that were directed against Courbet's new Realist imagery. For this reason Bonvin received an official state commission to complete *The Girls' School* (1851 Salon), for which he received a second-class medal—the highest award he was ever to receive.

During the Second Empire, Bonvin obtained considerable official support, and he continued to produce genre scenes, still lifes, portraits, and an occasional landscape. Commissions and purchases of his images of contemporary themes helped establish him as an important figure in the Realist movement. In 1859, when a number of younger painters were rejected at the Salon, Bonvin exhibited their works in his own studio, thereby actively supporting Alphonse Legros [140], Henri Fantin-Latour [71], James McNeill Whistler, and Théodule Ribot in spite of conservative opposition to increasingly naturalistic images.

Because Bonvin avoided the violent stylistic modifications that Courbet pursued, many critics supported his type of Realism. Bonvin maintained a sympathetic understanding of the painters from former times, especially the Dutch masters of the seventeenth century, Chardin, and the Le Nains —painters that critics were eager to link with the contemporary movement. Bonvin's examination of these earlier themes also helped to reinforce the "art for man" theory advocated at that time by his friend, the art critic Théophile Thoré. In 1866, following the suicide of his talented stepbrother Léon, Bonvin made his first trip to the Low Countries, visiting Holland in 1867 and thus fulfilling a lifelong admiration for painters he had first studied in the Louvre.

At the time of the Franco-Prussian War, Bonvin traveled to London accompanied by Louison Köhler (1850-1935). During the year he remained there, his financial problems worsened. Returning to France in 1871, he again settled in Saint-Germain-en-Laye (a small town outside Paris) and continued to submit paintings to the Salons, often using Louison as his model. Failing health eventually forced him to curtail his travels—he made one last trip to Holland in 1873—but he continued to paint the scenes and subjects of his own familiar setting, showing tendencies in light and local color that mark him as a forerunner of the Impressionists.

He received official recognition in 1870, when he was awarded the Légion d'honneur, but despite continued support by the able young art dealer Gustave Tempelaere, interest in Bonvin's work diminished. By the 1880s his paintings attracted little notice except from the most fervent advocates of the traditional Realist aesthetic. His financial and physical condition also deteriorated, and the special charity exhibition and sale organized and held by his friends in 1887 occurred only a few months before his death.[1]

1. For a study of Bonvin, see Gabriel P. Weisberg, *Bonvin: La Vie et l'oeuvre* (Paris: Editions Geoffroy-Dechaume, 1979). Recent research has located an article by Gustave Geoffroy on Bonvin published in *La Vie artistique* (Paris: H. Floury, 1903), pp. 173-90. A handwritten manuscript of this article is in the Institut Néerlandais, Paris.

Léon Bonvin
1834 Vaugirard, Paris — 1866 Meudon

During his impoverished youth, learning to draw was Léon Bonvin's only pleasure. Léon was the half brother of François and the fourth of nine children from the marriage of François Eustache Bonvin to his second wife Adelaïde Beurier. Timid and introspective, Léon was never able to break away from the oppressive domination of his father, and he was destined at an early age to serve as a waiter and gradually assume responsibility for the family tavern in Vaugirard. It was Léon's admiration for François and the supplies that François generously shared with him that encouraged Léon to enroll for a time in classes at the Ecole de Dessin in Paris; this was the only formal training Léon ever experienced.

Despite his obligations to the family business, Léon continued sketching and painting in his spare time. He worked directly from nature, recording the fields and flowers near his home or interior views of the family inn. He readily accepted the direction of his self-taught older brother François, who urged him to study the meticulous realism of the Dutch and Flemish masters and encouraged him to use pen and ink first to outline his water colors. Most of his earliest works are black and white [144], it was not until the early 1860s that he fully turned to water colors, using pen and ink in another way to heighten the color contrasts.

Léon's marriage in 1861 brought further complications. His wife did not appreciate the time he spent drawing and painting; their several young children made it hard for him to pursue his work at home. The winter of 1865 was a difficult time for business; other taverns had opened near the new inn that Léon had built in Vaugirard, forcing him into debt in order to stay in business.

On 29 January 1866, Léon—desperate for funds—went to Paris to sell some of his water colors. When an art dealer refused to buy his work, Léon assumed that his paintings were worthless and could see no escape from his problems. He hanged himself in the forest of Meudon the next day. Ironically, a sale of the water colors and drawings of Léon Bonvin and other artists—organized at the Hôtel Drouot on 24 May 1866 under the auspices of the art dealer Boussaton to benefit Léon Bonvin's family—grossed over 8000 francs. Many of these works were purchased by private collectors. Others entered The Walters Art Gallery, which eventually became the largest repository in the world for Léon Bonvin's work.

Eugène Boudin
1824 Honfleur — 1898 Deauville

Eugène Boudin occupies an important place in the development of pre-Impressionist painting because he influenced several artists in choice of locale and preference for painting out-of-doors. What is often misunderstood about Boudin is that he began his career in a Realist tradition, developing images of familiar regional customs (e.g., *Pardon of Saint-Anne-la-Palud, Gulf of Douarnenez [Finistère]*, 1858) or completing still lifes that demonstrate his knowledge of Chardin, who was then receiving attention as one of the founding fathers of the French school.

Like many of the Realists, Boudin's origins were regional. He was the son of Léonard Boudin, a ship's captain, and served for a time as a cabin boy on a ship which sailed from Le Havre

EUGENE BOUDIN

to the West Indies. Reluctant to follow the same career as his father but still maintaining close ties to his native region, Boudin, with a partner, opened a framing and stationery shop in Le Havre in 1844. Here he also exhibited works by artists living in the area, including Constant Troyon and Jean François Millet, two young painters who convinced Boudin to try his own hand at painting. By 1851, with the support of a subsidy from the Société des Amis des Arts of Le Havre, Boudin was able to continue his training in Paris. After the subsidy expired, however, he returned to the Normandy Coast, where he painted directly from nature, making studies of sky, sea, and countryside.

In 1858 Boudin was attracted to the caricatures of Claude Monet in a shop in Le Havre, and, after meeting the artist, encouraged Monet to also paint outdoors in the "open air." The following year Boudin met Gustave Courbet and Charles Baudelaire when they were visiting Le Havre; like Boudin they had also been guests at the Saint-Siméon farm in the 1850s.[1] Baudelaire was already familiar with Boudin's works, and when Boudin's pastels of clouds were shown at his first Salon in 1859, Baudelaire praised his entries. This exhibition marked the first time Boudin had shown in Paris, although his works had been exhibited in earlier regional shows.

From the middle of the 1860s, Boudin submitted landscapes of Normandy and Brittany to the Salons regularly. After he moved to Honfleur (ca. 1860), he became associated with a group of regional landscape and seascape painters who often met at Saint-Siméon, which was nearby. Although he accepted the advice of Troyon and Isabey about his landscapes, it was Jongkind who influenced Boudin the most. During the 1860s Boudin also began a different series of paintings that reflected the mores of the Second Empire. Deauville and Trouville had become fashionable seaside resorts, and Boudin became the official recorder of the well-dressed gentlemen and ladies who promenaded near the sea.

Boudin's canvases became more spontaneous, and he relied upon his first impressions with increasing assuredness. His works were among those exhibited with the first Impressionists in

1874 and thus represent a link between this younger generation and earlier landscape artists whom they idolized as living masters. Boudin's reputation continued to grow, and by the 1870s he was making frequent trips to Belgium, Holland, Bordeaux, and, later, to the Midi and Venice. In 1883 Durand-Ruel organized a successful retrospective exhibition of Boudin's work and was given exclusive rights to his paintings. This arrangement left Boudin free from further financial anxiety. Although he traveled frequently, Boudin always returned to his native region, showing a partiality in his works for the picturesque sights of Normandy and Brittany until his death in 1898.

1. Boudin first visited Saint-Siméon farm in 1854. Thereafter he introduced many of his friends to its charms. Courbet and Baudelaire probably visited the farm in 1859, the same year Courbet is recorded as having painted it. For further reference see Charles C. Cunningham, *Jongkind and the Pre-Impressionists: Painters of the Ecole Saint-Siméon*, exh. cat. (Williamstown, Mass.: Sterling and Francine Clark Art Institute and Smith College Museum, 1977), pp. 16-19.

Jules Breton
1827 Courrières, Pas-de-Calais — 1906 Paris

Jules Breton spent the greatest part of his life in the village of Courrières, where he immersed himself in the life and customs of the rural environment. He was the second child in a family of four, and, after his mother's death when he was four years old, was reared for various periods by his father, his maternal grandmother, and an uncle, Boniface Breton (1789-1867).[1] His father supervised the land of the duke of Duras and held other positions as a landowner, manager of the family brewery, tax collector, and assistant judge. Both his father and his uncle served terms as mayor of the village.

When he was ten, Breton was enrolled in the College St. Bertin (near St. Omer) where he stayed three years, and it was here that he received his first drawing lessons.[2] Félix de Vigne (1806-1862), a professor of art at the Ghent Academy, met Breton in 1842 and, impressed by his sketches, asked Breton to study with him in Belgium.[3] Breton went to Ghent in 1843, where he not only studied in De Vigne's studio, but also at the Royal Academy. He remained in Belgium during the mid-1840s, and by 1846 was working at the Art Academy in Antwerp in the atelier of Wappers (1803-1874). According to his own memoirs, he remained in Antwerp only a few weeks and spent most of this time in the museums studying the work of Rubens, Memling, and Van Eyck.[4] In poor health in 1847, he was forced to return home to Courrières, where he found his father already quite enfeebled from an illness.

After his own recovery, Breton was sent to Paris by his family to finish his training in the atelier of Michel-Martin Drolling (1786-1851), where he became acquainted with Jean Jacques Henner [66] and Feyin-Perrin [153], talented painters who remained friends throughout his career. Breton settled in the section of Paris where the Realists lived (at 5 rue Dragon) and eventually became acquainted with François Bonvin and Gustave Brion. Later (1849) he shared a studio at 53 rue Notre-Dame-des-Champs [128] with his classmate from boarding school and college days, Ernest Delalleau.

During the February Revolution of 1848 both Delalleau (who had been studying architecture) and Breton joined the liberal republicans. Unfortunately, business reverses in Breton's family and the death of his father (11 May 1848) forced Breton to return to Courrières, where he, Uncle Boniface, and the family were faced with financial difficulties for the first time.

Breton returned to Paris in 1849, where he again shared the studio with Delalleau. His return to the capital signaled his first Realist composition, *Misère et désespoir,* a work shown at the 1849 Salon and a theme inspired by his own deprivations and the disastrous effects of political change on the poor. (Although now destroyed, a version of this work appears as the large canvas Breton included on the wall of his *Atelier . . . ,* completed in 1849.) For the 1850/51 Salon Breton painted *La Faim* (also destroyed) which—like Antigna's *The Fire*—was inspired by the social distress of the time and focused on the struggles of a poor, starving family. Because of his ties with Félix de Vigne, after the close of the Salon, this painting was also exhibited in Ghent and Brussels, where it received favorable attention in the press. Breton found a sympathetic audience in Ghent and returned to live in that city early in 1851, continuing to paint themes based on village life in Courrières and using De Vigne's daughter Elodie as a model.

By 1852 Breton returned to Paris, where he shared a studio at 85 boulevard de Montparnasse with De Winne (1821-1880), another student of De Vigne's. He continued his association with the Realists, renewing his friendship with Brion and becoming acquainted with the printmaker Traviès and the sculptor Bartholdi. In trips with his friends to the outskirts of Paris (e.g., Meudon, Clamart), Breton developed the concept for *Le Retour des moissonneurs* (Private Collection, Belgium), a work he exhibited at the 1853 Salon. It was the first of a large series of canvases on rural life based on his own observations, even though he used professional models to complete the painting in Paris.

At the close of the 1853 Salon, Breton returned to Courrières and continued his sketches of rural life. His Uncle Boniface, who was always sympathetic to Breton's career, had a small atelier constructed in the garden of the family brewery so that Breton would have a place to work while staying in the village. Here, Breton completed *Un Campement de bohémiens,* which he exhibited in Brussels along with *La Petite Glaneuse*—the first of several works dedicated to this theme.

In August 1853, when Elodie de Vigne visited Courrières with her father, Breton asked her to marry him. They became officially engaged and were married 29 April 1858. During this period (1853-1858), Elodie appeared in many of Breton's canvases, including *The Gleaners* [50], a work begun in 1854 and stimulated by seasonal traditions in Courrières. *The Gleaners* was one of three paintings for which Breton received a third-class medal at the 1855 Salon. It was exceptionally well received and was carefully studied by other painters, probably even Jean François Millet.

Boniface Breton, impressed by Breton's official recognition, responded by enlarging the atelier at Courrières to accommodate such large compositions as *La Bénédiction des blés* (Musée de Compiègne), a work exhibited at the 1857 Salon. Breton received a second-class medal and the painting, championed by Count Nieuwerkerke, was purchased by the state.

With his career going well and his acceptance by the officials of the Second Empire established, Breton again returned to Courrières to work on other themes for the next Salon. His interest in

JULES BRETON

provincial life and the recording of time-honored episodes in rural France was maintained in other works: *The Recall of the Gleaners* [52] *Dedication of a Calvary* [82], *Le Lundi* (Washington University, St. Louis), and *The Seamstress* [70]. All these compositions were well placed at the 1859 Salon, and they assured Breton's success with public and governmental officials. As in many of his earlier works, Breton continued to use Elodie as a model; she appeared as one of the young virgins in *Dedication of a Calvary,* even though the theme itself was inspired by ceremonies Breton witnessed in his youth.

After his marriage and the birth of his daughter Virginie (26 July 1859), who also became a painter, Breton continued to extol the virtues of work and field labor. His style, influenced by Italian Renaissance sources, became more classical in derivation, although he still developed themes based on daily life, such as *Le Colza* (Corcoran Gallery of Art, Washington D.C.). For this canvas and others, Breton received a first-class medal in the 1861 Salon and received the Légion d'honneur.

Breton was invited to go to the south of France (Médoc) and traveled there in the autumn of 1862, and again in the fall of 1863. While there, he began doing studies for *Les Vendanges,* his first composition of a grape harvest (The Joclyn Art Museum, Omaha). Throughout 1863, Breton continued his travels, visiting Toulouse, Montpellier, Nîmes, and Arles. At the 1864 Salon, *Les Vendanges* revealed a modification of his tonal range toward brilliant light and deeper colors.

Tiring of southern France, Breton made his first trip to Brittany in 1865. Like other regional painters, Breton wanted to know more about the lesser known provinces of France, and he found in Brittany much that reminded him of his native Courrières. He developed a keen interest in folklore and ethnography—qualities which were highly valued by other members of the Realist tradition.

Breton exhibited ten paintings at the Paris Fair in 1867 and was awarded a first-place medal and made a commander of the Légion d'honneur. Breton continued to exhibit works derived from pro-

vincial life, especially scenes of Brittany, retaining his position as an important painter of rural life throughout the Third Republic. In 1875 Breton also began to write, publishing a volume of poems, *Les Champs et la mer;* in 1880 he published another volume of poetry, a single, long poem entitled *Jeanne.*

Breton was instrumental in his later works in modifying the Realist position in order to create images with a Symbolist orientation. This shift from Realism toward a poetic Naturalism was especially evident in such works as *Le Chant de l'alouette* (Chicago Art Institute) and *The Shepherd's Star* [204]. His compositions became increasingly popular, especially in the United States, where they entered numerous private collections.

Breton considered himself a serious writer, and in 1890 published *La Vie d'un artiste: Art et nature.* In 1896 he wrote *Un Peintre paysan,* and in 1899, *Nos Peintres du siècle.*[5] He was the first Realist painter to be appointed to membership in the Institut de France, an indication that his traditional style was well understood by governmental officials and private collectors. His last exhibition was in 1905 at the Salon of the Société des Artistes Français.

1. Jules Breton, *La Vie d'un artiste: Art et nature* (Paris: Lemerre, 1890), p. 6.
2. Ibid., p. 110.
3. Ibid., pp. 132-34.
4. Ibid., pp. 188-97.
5. Breton's works were published in Paris. For further reference, see Jules Breton, *Un Peintre paysan* (Paris: Lemerre, 1896); and *Nos Peintres du siècle* (Paris, [1904]). Jules Breton was also quite popular in France as a writer.

Gustave Brion

1824 Rothau, Vosges — 1877 Paris

As a representative of the Alsatian school which flourished during the Second Empire, Gustave Brion turned increasingly to painting the life and customs of his native region. Linked thematically with German and Swiss Romantic painters (e.g., Ludwig Knaus and Benjamin Vautier), Brion illustrated episodes from peasant life and folklore tradition during a period when Alsace was slowly becoming French.[1] Many of Brion's canvases achieve the same degree of pseudo-accuracy as history paintings of Greece and Rome, since he made a study of traditional costumes and local events. Brion was not the only Alsatian painter living in Paris who examined native customs; Eugène Beyer (1817-1893), Félix Haffner (1818-1893), Louis Schutzenberger (1825-1903), and Gustave-Adolphe Jundt (1830-1884) were among others who extolled provincial life. But Brion, perhaps more so than his colleagues, was influenced by Parisian trends. The social implications found in the works of Millet and Courbet are apparent in the early canvases of Brion; the works he completed at that time transcend purely regional interest and are directly related to the evolution of Realism.

Gustave Brion was the youngest of four children born to a businessman from Rothau. After his father moved to Strasbourg in 1831, Brion revealed artistic inclinations that led his parents to place him in the atelier of Gabriel Christophe Guérin (1790-1846), a local painter of historical scenes and portraits. Here he met other young painters (e.g., Félix Haffner) who would later also represent Alsatian customs during the Second

GUSTAVE BRION

Empire. Brion exhibited *Les Pipaux* in Strasbourg in 1843, and *Deux Enfants* in 1845. His progress in Guérin's studio was so rapid that by 1847 Brion was able to exhibit in the Paris Salon (*Intérieur de ferme à Dombach, Alsace*). During the Revolution of 1848 Brion served as a *garde national* while continuing to paint semi-Romantic genre scenes such as a *Famille de mendiants,* a theme inspired by the increasing number of outcasts and wanderers of that time. After he left Guérin's atelier in the late 1840s, Brion made a living giving drawing lessons and copying works by Eugène Isabey, Jules Dupré, and Camille Roqueplan. He arrived in Paris in the summer of 1850, convinced that it was the only place to succeed as an artist. Whether Brion reached Paris in time for the 1850 Salon is unknown; if, indeed, he did, he would have received a full indoctrination to Realist painting and to the large-scale canvases of Gustave Courbet that were to influence his own work during the 1850s.

From the moment of his arrival in Paris, Brion corresponded frequently with his family and friends in Alsace. At first he shared a studio with Félix Haffner, but soon he moved in with other Realist artists at 70 bis rue Notre-Dame-des-Champs, a location he retained throughout the Second Empire.[2] Whether Brion studied with a master in Paris is not clear, although the most likely artist would have been Michel-Martin Drolling, a painter from his own region and an artist who understood the importance of genre painting. Brion's major concern at this time was to succeed at the Salon, for he knew that success as an artist was dependent upon the recognition that only a Salon medal could confer. By 1852, Brion exhibited one canvas at the Salon, *Le Chemin de halage.* While it did not win a medal, it was purchased by the Goncourt brothers, his first Parisian patrons. The following year Brion fared better, receiving a second-class medal for three canvases: *Schlitters de la Forêt-Noire,* a work purchased by the government, but unfortunately destroyed in 1870; *The Potato Harvest during the Flooding of the Rhine in 1852, Alsace* [94]; and *Batteurs en grange.* His canvases received the support of such critics as H. de la Madeleine, who wrote: "The

paintings of M. Brion belong as much to genre painting as to landscape painting. The figures which animate them have as much importance as the trees, the water, and the sky which surrounds them. The *Schlitters* ("wood haulers") of the Black Forest are vigorous and of a good color. The rugged peasant—on the downhill slope holding back the clumsy handcart loaded with branches, on which the pretty, young Bavarian girl is reclining—is well composed. The men who ascend in the background are lively and agile. The unity of the composition is solid, but air seems to be lacking in the thick foliage. *The Potato Harvest* and *The Threshers in a Barn* are [both] strong and energetic paintings. M. Brion is a little coarse, but I do not hold that against him."[3]

During his early years in Paris, Brion tried many themes: genre (both rustic and historic), landscape, and portraiture. His four canvases at the 1855 Salon included *Un Train de bois sur le Rhin, Un Enterrement dans les Vosges, La Fête Dieu,* and *La Source miraculeuse,* paintings which attracted international attention when some were sold to an English collector. In 1857 Brion again sold a replica of an Alsatian theme, *The Cattle Tenter* [55], to a private patron in England.

By the end of the 1850s Brion was less interested in depicting the social struggle that had earlier attracted him to the canvases of Courbet and Millet. Instead, following numerous visits to Strasbourg, his compositions revealed an increasing preoccupation with local detail. Brion now saw himself as capable of documenting the folklore of his provincial region. This tendency was not a new one in his work; all his life Brion had immersed himself in local customs and collected objects which he could use in his paintings to establish an atmosphere of authenticity. After his death, the sale of his studio listed ceramics from Alsace as well as many regional costumes (for both men and women), which his models wore when he worked on canvases in his Parisian atelier. During the 1860s Brion won further honors. In 1863 he received a first-class medal at the Salon and was awarded the Légion d'honneur. When he exhibited *Vosges Peasants Fleeing before the Invasion, 1814* [100] at the World's Fair in 1867, he received a second-class medal. He also received a medal of honor at the 1868 Salon. His fame and fortune now assured, Brion enjoyed new status, traveling to Italy where he completed *Un Enterrement à Venise* in 1868.

While a strong element of anecdotal narrative is evident in many of Brion's Salon canvases, it was not until he painted *Siège d'une ville par les Romains sous J. César. Batterie de ballistes et catapultes* (1861 Salon) that he received recognition as an illustrator of ancient history. The painting proved popular, and it was purchased by Napoleon III. Brion's talents as a narrative artist were further enhanced in 1862 when he did illustrations for Victor Hugo's *Les Misérables,* one of the most popular books of the time. Brion was not content to confine himself to reproductions within Hugo's book; he had these studies photographed and sold them for 25 centimes each. The success of this enterprise led to requests for other illustrations. Brion did studies for Hugo's *Notre-Dame de Paris,* but these later works lacked the skill of those he completed for *Les Misérables.*

After the Franco-Prussian War, Brion was not able to overcome his despondency at the loss of Alsace-Lorraine. Many of his compatriots remained in Paris, but Brion could no longer paint symbolic canvases of his lost homeland. Instead, his last works reveal an air of romantic melan-

ULYSSE BUTIN

Enterrement d'un marin à Villerville (Calvados) in 1878 marked his official acceptance into the art world; he was awarded a second-class medal and the work was purchased by the state for 3000 francs.[3] Another work, *The Ex-Voto,* was purchased by the government in 1880 and sent to the Lille museum. He received the Légion d'honneur in 1881 and continued to exhibit regularly in the Salons. His death in 1883 cut short the recognition he might have attained and which his few remaining works indicate he merited. A special sale was held by his colleagues after the artist and his wife died, to raise funds for his two orphaned children.[4]

1. *Chronique des Arts,* 15 December 1883.
2. See "Ulysse Butin," 22 December 1869, P 21, Archives du Louvre.
3. See "Enterrement d'un marin à Villerville," 5 August 1878, dossier Ulysse Butin, F 21/199, Archives Nationales, Paris. No document in this file, however, specifically explains this purchase by the state.
4. See *Catalogue de tableaux, études et dessins par Ulysse Butin* and *Tableaux, aquarelles, sculptures, bronzes, terres cuites . . . , offerts par les artistes à ses deux orphelins dont la vente aura lieu Hôtel Drouot,* salles nos. 8 et 9, 19-21 May 1884 (Paris, 1884). No record of Butin's children has been found.

NICOLAS LOUIS CABAT

choly at variance with the folkloric events that he had achieved earlier in painting the daily life of Alsace. He died prematurely in 1877.

1. For a discussion of Alsace in the nineteenth century see Theodore Zeldin, *France: 1848-1945,* vol. 2, *Intellect, Taste and Anxiety* (Oxford: Clarendon Press, 1977), pp. 77-83.
2. Brion's house was called "Boîte à thé." For further information see Hans Haug, "Un Peintre alsacien sous le Second Empire, Gustave Brion, 1824-1877, " in *La Vie en Alsace* (Strasbourg, 1925), p. 45.
3. Hans Haug Papers, Archives, Library of the Musée des Beaux-Arts, Strasbourg. H. de la Madeleine wrote this review at the time of the 1853 Salon.

Ulysse Butin

1838 St. Quentin — 1883 Paris

Ulysse Butin came from a poor family in St. Quentin and in his first job served as an apprentice designer in a muslin factory, but he spent his free time attending drawing classes at the Ecole Latour (in St. Quentin). A drawing prize of 300 francs that he won in a local art competition enabled him to leave for Paris to continue his training at the Ecole des Beaux-Arts, even though he continued to earn his living as an industrial designer for a manufactory which produced curtains.[1]

Butin received his training from François Picot, [?] Lemale, and Isidore Pils. He excelled at drawing the human figure—studies which were appreciated by his teachers (especially Picot) —although few of these works were acquired by collectors. His first exhibit at the Salon in 1870 attracted little notice and it was only through a position he obtained as a teacher in drawing in the municipal schools of Paris that he was able to eke out a meager living.[2] A visit to Villerville in 1874 inspired him to study seascapes and scenes of a seaside village. The life of fishermen struggling against the elements and the sea thus became a continuous source for the canvases he completed during the remainder of his short career.

Butin received his first Salon medal (a third-class award) in 1875 when he exhibited *L'Attente—Le Samedi à Villerville* (Calvados).

Nicolas Louis Cabat

1812 Paris — 1893 Paris

Nicolas Louis Cabat's paintings represent a blending of two traditions: classical idealism and Realism. His earliest landscapes, completed when he worked directly from nature during the 1830s, were well appreciated by progressive critics such as Théophile Thoré. His later works, many of them completed after trips to Rome, promoted Cabat's career and received the support of academic critics and collectors, although they disappointed his progressive friends, including several members of the Barbizon tradition.

Raised in modest surroundings in Paris, Cabat received training as an apprentice decorator in the atelier of Gouverneur during the 1820s. It was there that he was introduced to Camille Flers, the first real master to encourage him to paint from nature. On weekends the two often traveled together to the Buttes-Chaumont near Paris and to the forest of Romainville where Cabat sketched trees and rocks, perfecting his keen sense of observation under the watchful eye of his teacher and friend.

Shortly before the July Revolution of 1830, Cabat traveled to Normandy with Gouverneur, where he completed compositions of the Aumale valley that reveal the continued influence of Flers upon his painting. When he returned to Paris, he exhibited these studies with several art dealers (particularly Mme. Hulin) and became acquainted with two of the most important progressive artists of the period, Philippe Auguste Jeanron and Jules Dupré.

Early in the 1830s he gave up his intention to support himself as a decorative painter of porcelains to pursue a career as a serious painter of the French countryside. His travels included a trip to Picardie, where he prepared a landscape that was exhibited—along with four other compositions—at his first Salon in 1833. He also began to paint in the Forest of Fontainebleau, where his growing friendship and admiration for members of the Barbizon circle inspired him, along with Jules Dupré, to spend two months of solitude at an isolated inn, immersing himself in the study and appreciation of nature. Reviewing

the 1833 Salon and Cabat's first Salon entries, one of the most important early critics of Naturalist tendencies, Gabriel Laviron [131], commended the sincerity of Cabat's work, recognizing his unpretentious capacity for understanding nature.[1] Noting the similarity between Cabat's landscapes and Flemish and Dutch scenes, he identified the tradition from which some of Cabat's work developed and with which Cabat could favorably be compared.

Cabat's work continued to be well received by the critics throughout the 1830s. His compositions were often pure landscape studies that he completed in various sections of the country, and he was praised for the harmony of his tones and his "truthful" capacity to depict such details as rocks or trees. Younger artists praised him, and established members of the Romantic tradition, such as Victor Hugo, Gustave Planche, and Théophile Gautier, acknowledged his individualism and supported his efforts. At the height of his popularity, however, Cabat relinquished this dedication to pure landscapes.

In 1835 he met Lacordaire and converted to Catholicism, a decision that had a profound effect on the type of paintings he completed. Under the stimulus of academic critics, Cabat began to modify his style and to aspire to "higher" themes, although he also continued to paint compositions derived from pure observations of the country. In 1836, after a trip to Dieppe, Cabat joined Lacordaire in Rome. Supported by the French government (a grant of 2000 francs from the Ministry of the Interior), Cabat studied Italian Renaissance painting and classical seventeenth-century trends. It was here that Cabat, under the influence of Lacordaire, tried to join the *Frères prêcheurs* ("preaching monks"), artists with strong religious convictions who devoted themselves to Christian themes. Along with such fervent Catholics as Flandrin and others, Cabat most likely joined the society of "Saint John" whose goal was the regeneration of art through Christianity.[2] After his return to Paris in 1840, Cabat continued to paint landscapes from nature, but his Salon entries during this period reveal two different aspects in his style: a predilection for the ideal, which inspired the religious compositions that endeared him to

the Academy, and a Realist attitude, which prompted scenes of provincial villages and lakes that attracted painters such as Jules Breton and Léon Bonnat.

The change in Cabat's style won him official recognition. He received a second-class medal in 1835. In 1843 he was awarded the Légion d'honneur. He received membership in the Institut de France in 1867 and served as the director of the French Academy in Rome from 1878 until 1885. Although he continued to exhibit at the Salon until 1892, he was never able to resolve the two divergent tendencies in his art.

1. Gabriel Laviron and B. Galbacio, *Le Salon de 1833* (Paris: Librairie Abel Ledoux, 1833), pp. 365-66.
2. Little is known about this society or the increasing interest in religious painting in nineteenth-century France. For recent information, see *Religious Imagery in Nineteenth-Century France* (New York: Shepherd Gallery, 1980).

Gustave Caillebotte
1848 Paris — 1894

The son of a wealthy textile manufacturer, Gustave Caillebotte grew up in comfortable affluence. Trips to the countryside near Donfort in Normandy and life in a fashionable Parisian townhouse on rue de Miromesnil provided a leisurely existence for the Caillebotte family and their four children.[1]

Unfortunately, Gustave Caillebotte's early years are not well documented. The first mention is his army registration in 1868, attaching him to infantry units in Cherbourg and Rouen. Caillebotte is known to have studied to become a lawyer, and by 1869 he received his *Diplôme de bachelier en droit*. He paid a military replacement to serve on his behalf from June 1869 to June 1870, but at the time of the Franco-Prussian War, he was called to active service in the Garde mobile de la Seine, and served with them until March 1871.

Caillebotte made the change from a conventional professional career to art with parental approval and enrolled in Léon Bonnat's studio in 1872. Under Bonnat's tutelage, Caillebotte was admitted to the Ecole des Beaux-Arts in March 1873. His early painting (e.g., *A Road near Naples*, Private Collection) reveals an interest in exactitude—perhaps achieved by working from photographs. The most important event marking Caillebotte's early development was the first Impressionist exhibition of 1874, where he was introduced to a number of the painters, including Edgar Degas. These Impressionists became the masters to whom Caillebotte apprenticed himself.

The death of his father reinforced Caillebotte's dedication to the avant-garde. His father's will left him a sizable fortune that enabled him to be financially and artistically independent. When the jury rejected his Salon entry in 1875, he abandoned "the official art system,"[2] although he continued to adhere to Bonnat's instruction; tight draftsmanship, somber tonal range, and interest in contemporary themes mark his work at this time. Ties with other Bonnat pupils, especially Jean Béraud, may also have encouraged Caillebotte to continue his academic training with contemporary Parisian themes.

The year 1876 denoted Caillebotte's artistic "arrival" when he exhibited eight works at the second Impressionist show, among them *Les Raboteurs de parquet* (Musée du Louvre), a work of "unflinching proletarian realism."[3] Other

GUSTAVE CAILLEBOTTE

works from this period—*Homme nu-tête vu de dos à la fenêtre*, *Jeune homme au piano*, and *Le Déjeuner*—reveal painstakingly detailed, bourgeois interiors combined with an audacious placement of scene. Caillebotte's unusual angles and unconventional arrangements of objects or people linked him with Degas and caused some criticism.

Caillebotte's importance to the Impressionist movement, however, cannot be measured solely by his own work. At a time when few were purchasing the works of his colleagues, Caillebotte used his family money to acquire, at high prices, significant works. Thus, he emulated his teacher, Léon Bonnat, whose collection of his own and contemporary drawings was unparalleled in the nineteenth century.[4] Perhaps foreseeing his own early death, Caillebotte willed his collection to the Musée du Luxembourg, assuring the Impressionists a place in a national museum at a time when they were still neither accepted nor acclaimed.

As a chief promoter and organizer of the group, Caillebotte financed the Impressionist exhibitions in 1877 and 1878. His own paintings continued his Realist interest in family life, although *Rue de Paris: Temps de pluie* (Art Institute of Chicago) revealed a new direction and a contemporary exploration of a common Parisian theme. By 1878, Caillebotte was painting in a much looser style, becoming less structured and following the spontaneous innovations of Monet, Renoir, and Sisley. He heightened his range of colors and expanded his themes to include views of boaters and bathers on the Yerres. The death of his mother in 1878 ended the first phase of the artist's work. The grieving artist achieved little in 1879, a year of crisis in Impressionism.[5]

Caillebotte was able to complete some impressive city- and landscapes during the early 1880s, but his greater concern for unity among the Impressionists was also apparent. He opposed Degas for censuring Monet and Renoir, who chose to exhibit in the Salon. His own work began to reveal a direct Realism (e.g., *Standing Man in Derby* [167]) and an originality that led the art critic Joris-Karl Huysmans to praise him. Problems within the group, and his own awareness that

Degas was causing much of the difficulty, however, led the painter to abstain from that group's 1881 show.

Caillebotte tried to reshape the Impressionist coalition for the 1882 exhibition, but Degas now abstained, and Monet and Renoir participated. This exhibition ended Caillebotte's "public" role as painter; he withdrew to his garden and home at Petit-Gennevilliers near Argenteuil, although he still supported friends (e.g., Renoir) by adding their works to his own collection. He also made a new circle of colleagues among the Neo-Impressionists. He still participated in an occasional exhibition (e.g., the United States, 1886; Brussels, 1888) but his name faded into obscurity even as recognition for the Impressionists increased. His paintings in 1893 and 1894 suggest a brief self-renewal before his death in 1894. Durand-Ruel organized a retrospective which received some favorable comment, although, in general, Caillebotte's work was viewed as a continuation from the Realist past.

1. For further information, see the excellent essay "Gustave Caillebotte: A Biography," in J. Kirk T. Varnedoe and Thomas P. Lee, *Gustave Caillebotte: A Retrospective Exhibition* (Houston, Tex.: Museum of Fine Arts, 1976), pp. 33-46.
2. Ibid., p. 34.
3. Ibid., p. 35.
4. For further reference, see Vincent Ducourau and Maurice Sérullaz, *Dessins français du XIXe siècle du Musée Bonnat à Bayonne*, LXIXe exposition du Cabinet des Dessins, exh. cat. (Paris: Editions de la Réunion des Musées Nationaux, 1979).
5. For further information see Joel Isaacson, *The Crisis of Impressionism: 1878-1882* (Ann Arbor, Mich.: University of Michigan Museum of Art, 1979).

Adolphe-Félix Cals
1810 Paris — 1880 Honfleur

While it is not known exactly when Adolphe-Félix Cals began his interest in art, his earliest training came from little known printmakers, who taught Cals engraving, drawing, and how to work from plaster casts in the studio. After working for such men as Anselin, Ponce, and Bosc (copying the works of François Boucher or Achille Devéria in lithographs), Cals was introduced by another young student to the academic painter Léon Cogniet (1794-1880) and entered his atelier at the Ecole des Beaux-Arts during the late 1820s.

It is not surprising that Cogniet would expect Cals to study the masters, for that was the tradition of the atelier, but although Cogniet recognized the talents of his young pupil, he was not pleased with Cals's independent turn of mind. Perhaps the only qualities Cals acquired from Cogniet were interest in painterly detail and use of Romantic color, although even in this early period Cals maintained his determination to depict themes which stressed the miserable existence of the lower classes.

After Cals left Cogniet's atelier and served a brief period in the military, he painted landscapes on the outskirts of Paris (ca. 1833) in preparation for exhibiting his work at the Salon. Three of his works were accepted at the 1835 Salon, including one with strong social implications (*Une Pauvre Femme*). From that time on until 1870, he exhibited regularly at these yearly shows. Often, however, his works were poorly placed and, thus, overlooked by those who attended. Admittedly, contemporary academic critics found little to interest them because of the social overtones in his genre scenes and landscapes.

ADOLPHE-FELIX CALS

Cals made friends with several young painters when he lived in Paris, including Ed. Cousin, who became the subject of one of Cals's early portraits.[1] During this period, Cals also married Ermance de Provisy, a young art student from an aristocratic family that he had met through Cogniet.[2] When his irascible young wife showed signs of insanity, he left her, taking his small daughter [62] to live with him at numerous locations in Paris. She often accompanied him on his painting excursions to the outskirts of the city (e.g., Argenteuil, Saint-Cyr). It was not a happy existence, and the themes that Cals completed during the 1840s mirrored his personal preoccupation with poverty. Many of these early works show an interest in peasant life that anticipates the later works of Jean François Millet but which at the time only served to disturb a Salon public ill-prepared for anything but the classicism of Ingres. In 1846, when Cals exhibited eleven works at the Salon, the assurance of his many Realist friends that he would win a medal for his genre studies convinced him of the success he felt he deserved; his failure to receive official recognition only added to his disillusionment.

His struggles as an artist were finally alleviated by his friendship with the art dealer Père Martin. In 1848 Martin, a man of passionate dedication and a firm supporter of the direct and contemporary way of examining the environment and themes of humanity, opened his first shop on rue Mogador. Here and later on rue Laffitte, Martin was able to sell works by Cals, as well as paintings by Millet, Corot, and others. Among the patrons who came to Martin's shop were private collectors such as the Rouart brothers and Gustave Arosa. With Martin's help, Cals's paintings may have entered private collections of the middle and upper classes, who were attracted to his small-scale humble themes and who appreciated the still lifes that Cals began exhibiting in 1848.

Père Martin was not the only individual to come to Cals's assistance. In 1858, at Martin's gallery, Cals met Count Doria and formed a lifelong friendship with this patron of the arts. Count Doria invited Cals to work at his private villa (until 1869) and there Cals was able to achieve

some of his purest studies of light and atmosphere. During the 1850s, Cals also completed a number of studies of family life, many of which were perhaps inspired by a growing appreciation of Chardin, but were based, in part, also upon studies of his own daughter Marie absorbed in her daily activities. This type of painting was popular among other artists (e.g., Edouard Frère and Octave Tassaert), for it was a time when the Realists were studying the ramifications of childhood as part of their widespread appreciation of family life.

Cals enjoyed the friendship of many of the Realists, but his relationship with the Dutch pre-Impressionist Jongkind was probably his closest. By the late 1850s, word had already reached Paris that Jongkind was in poor health; in 1861 Cals was sent by Père Martin and other friends to Holland to settle Jongkind's debts and to bring him back to Paris where he could be cared for. Cals and Jongkind remained good friends, and in 1873 Cals went to live with Jongkind at Honfleur, a region where others as early as the mid-1850s had been studying effects of light. Undoubtedly, Cals's awareness of the landscapes of Charles Daubigny and the seascapes of Eugène Boudin, depicted at differing times of the day and under changing atmospheric conditions, inspired him to follow other pre-Impressionists. He became increasingly interested in painting landscapes.

During the 1860s, when many of his canvases were rejected at the Salon because of their disturbing social themes, Cals gained increasing respect from other traditional Realists (e.g., Bonvin and Ribot), for his participation in the Salon des Refusés classified him as one of the vocal, revolutionary figures in French painting. His entry of a lower-class genre painting, depicting the work of a shoemaker, typified the honest, hard work by lesser artisans that the Realists were then studying (see also Bonvin [35]).

By 1874, six years before his death, Cals had become associated with the new movement of the Impressionists, a generation of Realists who emerged as a force on the art scene with their first independent exhibition.[3] Cals's growing interest in newer tendencies in French art and his friendship with young painters (e.g., Claude Monet) thus conditioned him to modify his style according to innovative theory and painting techniques. These later works that Cals exhibited with the Impressionists reveal a freer brushstroke and a lightened color range.

Cals's home life was never easy and, like other Realists (e.g., Bonvin and Ribot), he was often afflicted by poverty and personal problems. In 1868 his daughter became insane, and he placed her in Charenton.

Many of Cals's earliest canvases merit further examination, since it was in a variety of genre themes that he first attracted attention. His interest in still life [116], while apparently not extensive, began in the late 1840s and indicates that he had an opportunity not only to study domestic genre compositions by Chardin, but also Chardin's still lifes when they were first being rediscovered. Although he surrendered his expectation of further Salon exhibitions when he chose to exhibit with the Impressionists in 1874, his participation was characteristic of the independent position that he first established in the mid-1830s. Altogether, his career embraces the full extent of the Realist movement, from the first generation to the final modification of the tradition.

1. For a reproduction of this painting see Arsène Alexandre, A. F. Cals, ou le Bonheur de peindre (Paris, 1900), p. 29. Little is known about Cousin's career.

2. Cals painted a portrait of his wife. For a reproduction see Alexandre, Cals, p. 31. Cogniet may have introduced Ermance de Provisy to Cals with the hope of alleviating Cals's destitution. Apparently, Cals gave his future wife drawing lessons.

3. Cals exhibited with the Impressionists in 1874, 1876, 1877, 1879.

Charles-Emile Auguste Durand
Carolus-Duran
1838 Lille — 1917 Paris

As one of the most prolific portrait painters of the last half of the nineteenth century, Charles-Emile Auguste Durand attracted many students and exerted a lasting influence on the development of Salon portraiture. Although he was trained in Lille, his native city, he developed an early interest in Spanish painting—especially the canvases of Velázquez—that influenced the way in which he composed his works.

He received his first drawing lessons when he was about eight from Augustin Phidias Cadet de Beaupré (1800-?), a little known sculptor at the local art academy in Lille. Despite the young boy's artistic abilities, Cadet de Beaupré offered him little encouragement, and in 1851 his family placed him in the atelier of François Souchon (1787-1855), a former student of Jacque Louis David. By the time he left Souchon to study on his own in Paris in 1853, Carolus-Duran was well trained in the academic arts and had received his first award. Two years later, because of his father's illness and financial distress, his parents also came to Paris. After his father's death, when Carolus-Duran was unable to support his mother and sister, he resolved to seek employment in Algeria, but the financial support of a friend (who paid for his studio the next two years) permitted him to remain in Paris, where he painted from the old masters in the Louvre, and, during the summer months, landscapes out-of-doors.

Financial worries continued to plague him during the late 1850s. In 1858 friends found him in his studio dissipated and near death. Only through the generosity of the art critic Zacharie Astruc, his colleague and friend from Lille, did Carolus-Duran regain his health and return again to his painting.[1] After his recovery, Carolus-Duran returned to Lille where living costs were less, and it was there, in his native setting, that his career began to develop; the number of portrait commissions that he began to receive locally assured him a regular income. In 1859 he won a city-sponsored painting competition (1200 franc stipend) that enabled him to return to Paris to study from live models at the Académie Suisse. He also became acquainted with other young painters enrolled there; Fantin-Latour became a close friend and they often copied from the old masters in the Louvre. During this period he also became interested in the work of Edouard Manet, and records show that Carolus-Duran, along with Fantin-Latour, Alphonse Legros, Amand Gautier, and Félix Bracquemond, actually went to congratulate Manet after his exhibition of the Spanish Guitar Player in the 1861 Salon.

About 1860 or 1861, Carolus-Duran entered his Visit to the Convalescent in the competition sponsored by the city of Lille from the proceeds of the sale of the house left by the painter Jean-Baptiste-Joseph Wicar (1762-1834). This canvas (most of which Carolus-Duran later destroyed except for two fragments [142]) was selected by the judges for the first prize in painting. The municipal

CAROLUS-DURAN

EUGENE CARRIERE

council of Lille, which had previously denied Carolus-Duran a first prize (1859) because it found his Realist style of painting unwarranted, was again opposed to him, but finally ratified the judges' selection, enabling him to leave for Italy in 1862.

He traveled throughout the country, stopping in Rome, visiting Venice (1863) and Pompeii (1864). In 1866 he returned to Paris, where he was again beset by financial concerns. For a period of time, he again returned to Lille, where his local reputation provided him with many commissions for portraits and enabled him to live less expensively. In the 1866 Salon, he received a medal for *L'Assassiné*. Although the general public showed little interest in this composition, it was sold for 5000 francs—enough for a trip to Spain.[2] The enthusiasm of his Parisian colleagues for Spanish art had long inspired him, and he remained in Spain for some time, absorbing the traditions of the old masters and doing copies of work by Murillo and Velázquez.

He did not return to Paris until 1868. By the end of the Second Empire, his career finally more secure, he married the artist Pauline-Marie-Charlotte Croizette, a pastelliste and a painter of miniatures. His portrait of her, called *Portrait of Madame XXX* and later entitled *La Dame au gant*, resulted in his first genuine success when it was shown at the 1869 Salon. This work, which received a second-class medal and was purchased by the Luxemburg Museum, established Carolus-Duran as one of the young *indépendants* and assured his reputation as a fashionable portrait painter of young women during the Third Republic.

Carolus-Duran remained in Paris and joined the National Guard during the Franco-Prussian War. He later received a Salon medal (1870) for his moving painting entitled *Glory*, which depicted his reminiscences of the battle of Champigny.[3]

He did not experience the upheaval that affected some of the other Parisian artists during the next year, for even before the Commune he left for Brussels and there continued his interest in portraiture. His studies of fashionable young women were enthusiastically received at the 1872 Salon, and he received the Légion d'honneur. In-

spired by this success and also by the request of Robert Hinckey, an American painter, he then opened a large, spacious studio for young painters on the Boulevard Montparnasse. His students, many of them American, included John Singer Sargent, who under Carolus-Duran's tutelage was to become a master American portraitist by the end of the century. Carolus-Duran trained his students to rely on direct painting exclusively—a method by which form and color were conceived and executed simultaneously.

He also maintained an interest in landscape painting and visited Trouville in 1873. A portrait of his sister-in-law Sophie Croizette (a comedienne at the Comédie-Française) that was painted in Trouville was called *Au bord de la mer* and was shown at the 1873 Salon.

Throughout the 1870s, his fame continued to increase. While a large retrospective exhibition of his work in the Parisian galleries during 1874 or 1875 testified to his earlier propensity for Realism, he now became more interested in effect. The public rushed to see his paintings and he became closely associated with several of the leading critics of his day, including Philippe Burty [220]. His superficial portraits and his desire to please the public, however, alienated the Impressionists and a number of critics, including Zola and Castagnary, who found his style exaggerated. To them, he symbolized an insincerity in which "spirit . . . was sacrificed to dress." Nonetheless, he remained good friends with some of his contemporaries, including Edouard Manet.

In 1879 he received a medal of honor, which assured his continued prestige throughout the Third Republic. He was promoted to a commander in the Légion d'honneur in 1898, made a grand officer in 1900, and elected to the Institut de France in 1904. In 1905 he became director of the French Academy in Rome. His was a story of success and exceptional wealth. His facility at portraiture assured him a clientele and a following among younger students.

1. For a discussion of the relationship with Zacharie Astruc see Sharon Flescher, *Zacharie Astruc: Critic and Artist* (New York: Garland Publishing Co., 1978). Astruc knew Carolus-Duran in Lille, was supportive of his painting, and may have encouraged the painter's trip to Spain since Astruc himself made a similar trip in 1864.
2. The painting is now in the Lille Museum; it may have been purchased directly from the artist.
3. There is no record of this painting in the 1870 Salon catalog. Further research is needed to locate this composition and establish the date of its exhibition.

Eugène Carrière
1849 Gournay, Seine-et-Marne — 1906 Paris

Eugène Carrière, the son of a poor insurance salesman, was reared in Strasbourg and given art training in preparation for a practical career in lithography. Although members of his family had been artists, Carrière's parents were not happy with his own decision, in 1868, to become an artist. He enrolled in the Ecole des Beaux-Arts in the atelier of Alexandre Cabanel (1823-1889), where he received his first formal education as a painter just before the Franco-Prussian War. After the war, Carrière resumed his studies in 1871, but also supported himself by working in the lithographic shop of his friend Jules Chéret (1836-1932), a printmaker he had met earlier in Strasbourg.

In 1877 Carrière finished his studies under Cabanel, married, and continued to paint on his

own. His earliest works, influenced in theme by Théodule Ribot, reflect a similar Realist style. His first *La Jeune Mère* [177] (1879 Salon), reveals an indebtedness to Jean François Millet that established for Carrière a basic interest in family themes. He was to continue to use his wife and children as models throughout his career. But despite these early exhibitions, success eluded him. Between 1880 and 1885, to earn money for his growing family, he worked at the Sèvres Porcelain Manufactory where he met and became associated with the sculptor Auguste Rodin (1840-1917).

Carrière received his first honorable mention at the 1884 Salon, followed in 1885 by a second-class medal and, in 1889, a first-class award at the Paris Fair. By the mid-1880s his work showed a markedly dense atmosphere created by the use of a monochromatic brown tone from which his figures only partially emerged. Recognized as a Symbolist because of the quiet tone of reverie he created, some critics detected his influence in the work of many of the younger painters. He was designated a Chevalier of the Légion d'honneur in 1889 and went on to occupy a position of esteem in the Paris art world that was further enhanced by his participation in the Salons of the Société Nationale des Beaux-Arts. After his death, this group, in 1906, and the Ecole Nationale des Beaux-Arts and Libre Esthétique (Belgium), in 1907, held major retrospectives of his work.[1]

1. For further information see Robert James Bantens, "Eugène Carrière—His Work and His Influence" (Ph.D. diss., Pennsylvania State University, 1975; Ann Arbor, Mich.: University Microfilms, 1976).

Alfred Casile
1848 Marseille — 1909 Marseille

Alfred Casile can be considered a true *Provençal*, for he spent most of his career painting landscapes in the south of France and sending work to the Salons. He received his first training under Philippe Auguste Jeanron when Jeanron directed the Ecole des Beaux-Arts in Marseille. Jeanron may have instilled in his pupil a desire to paint directly from nature (something Jeanron failed to maintain in his own later canvases) and to study

ALFRED CASILE

JEAN CHARLES CAZIN

light accurately. Although he studied at the Ecole during the 1860s, Casile only painted on week-ends, for, following his parents' wishes, he trained for a more conventional career, first as a railway clerk, and later as an assistant in the offices of the Compagnie des Docks. Exactly how long Casile was employed or what he did for each firm is unknown. Shortly after the Franco-Prussian War, however, Casile resolved to devote himself only to painting. Casile probably spent the 1870s near Marseille or traveling to other provincial regions, developing his style, until in 1879 he felt qualified to send a landscape, *Une Falaise en Normandie*, to the Paris Salon. The painting won attention from the critics and public and enabled Casile to gain his family's blessing to study in Paris.[1]

In 1880, Casile met a former student of Corot's the landscapist Jean-Baptiste-Antoine Guillemet (1843-1918), who provided a continual source of inspiration. Through Guillemet, Casile was introduced to the Impressionist circle, meeting Emile Zola, Camille Pissarro, Alfred Sisley, Claude Monet, Eugène Boudin, and Jongkind. During his Parisian period, Casile also admired the canvases of Gustave Courbet and probably saw the large, retrospective exhibition of the works of Manet after this painter died in 1883. Casile painted with Impressionist friends along the Seine near the Marne and may have journeyed with them to regional cities such as Honfleur. Casile also traveled elsewhere, sending back to the Paris Salon such landscapes as *Sous les falaises à Puys* in 1881, *The Bank of the Rhône at Avignon* [237] in 1883, and *Les Démolitions à Marseille, effet d'hiver* in 1891. With his friend Paul Sain, from Provence, Casile also traveled to Naples and the smaller villages in the south of France.[2] Casile thus represents another itinerant landscapist who continually sought new sites to paint and naturalistically recorded the effects of light and atmosphere perhaps bypassed by other landscapists.

Casile received few official awards at the Paris Salon; in 1881 he obtained an honorable mention, and in 1885 he received a third-class medal for his painting *Vue de Paris—l'Estacade* (Musée de Marseille). The state purchased several of Casile's paintings, including *Les Terrains du Lazaret, à Marseille* (1880/81), *Vue de Paris*

(1885), *La Durance* (1888), and *L'Abbaye de Montmajour* (1889).[3] By the late 1880s, Casile tired of Parisian life and the changeable tastes of Parisian Salon audiences. He returned to Marseille, where he married Belgian-born Constance Dutoit in 1891.[4] He later traveled with his wife and two small daughters to Belgium and from 1900 until 1903 painted in cities such as Ghent, Bruges, and Brussels.[5] He returned to Marseille after this sojourn and continued to paint despite health problems brought on by alcoholism.

1. For a discussion of this problem see Bernard Plasse, *42 Oeuvres du peintre A. Casile, 1848-1909* (Paris: Galerie Jean Saint-Georges, 15-30 April 1964), pp. 9-16.
2. Ibid., p. 12.
3. See dossier A. Casile, from 1881 to 1889, F 21/2062, Archives Nationales. Casile sold his first painting to the state in 1881 for 2000 francs.
4. See "Acte de l'Etat-Civil, Mariages," Ville de Marseille, 19 December 1891, a document given to the author by Madame Verdihan, daughter of the painter.
5. Madame Verdilhan possesses several sketchbooks with scenes of Bruges from Casile's later trips.

Stanislas Henri Jean Charles Cazin
1841 Samer — 1901 Lavandou

Jean Charles Cazin occupies an unusual position in the development of the Realist movement. His earliest paintings display the accuracy of an observer of contemporary life, but his later canvases were strongly influenced by Impressionism and remembrances of his native region in the north of France. Although he is mainly recognized as a landscapist, his earliest compositions included genre studies of his friends [198] or interiors of his home. Unfortunately, many of these compositions have disappeared because much of the region where Cazin lived—near Boulogne—was destroyed during the wars of the twentieth century.[1]

Cazin's father (François Joseph Cazin), a doctor, moved his family from Samer to Boulogne-sur-mer in 1846, so that his children could continue their education. At first it was thought that Jean Charles would become a doctor also, but the young boy displayed a talent for drawing at an early age. His parents did not discourage him because another son, Pierre Joseph Henri Cazin, continued the family medical tradition. It was also in Boulogne that Cazin first became acquainted with the Coquelin brothers—lifelong friends, who were then helping in their parents' bakery but who later became well-known Parisian actors. Cazin's education was completed in England, where he had been sent for health reasons, and he finally passed his *baccalauréat* in Lille.

By 1862 or 1863 Cazin was in Paris. He exhibited a landscape, *Souvenir des dunes de Wissant* (a theme based on his observations of the seashore in the north of France), at the Salon des Refusés in 1863. Cazin also enrolled in the Ecole Gratuite de Dessin, where he studied under the independent teacher Horace Lecoq de Boisbaudran. It was during this period that Cazin made friends with a number of painters including François Bonvin, Henri Fantin-Latour, Alphonse Legros, Théodule Ribot, and Léon Lhermitte. Lecoq de Boisbaudran's method of painting and drawing from memory inspired Cazin and other Realists to recall and depict individuals and locations while in the tranquility of their studio; Boisbaudran's training also heightened their perceptions, forcing them to observe nature accurately and intensely. It was during this same period that Cazin met his future wife, Marie Guillet, who was studying in the studio of Rosa Bonheur [53] and who also became a serious painter and ceramist.

Lecoq de Boisbaudran recommended Cazin for a teaching position at the Ecole Spéciale d'Architecture in Paris, where he taught for three years during the mid-1860s.[2] While teaching, Cazin moved from Paris to Chailly, near Barbizon, where he most likely did the series of studies that were accepted at the 1865 and 1866 Salons, marking the first time that Cazin had exhibited in an official capacity.[3] Continuing to receive the support of Lecoq de Boisbaudran (who encouraged his most capable and promising students), Cazin was nominated for the post of director of the Ecole de Dessin and curator of the museum in Tours, and there, in 1868, following his marriage to Marie, Cazin reorganized the school in accordance with Lecoq de Boisbaudran's theories of memory training. Tours was the center of a number of local industries dependent upon trained artisans, and it was an important position for a young, struggling artist. It was probably here that Cazin developed an interest in the industrial arts, since both he and his wife made and enjoyed decorating pottery. As curator of the local museum, Cazin became aware of changes in other villages and traveled to Holland, Belgium, and England to study other collections. At the time of the Franco-Prussian War, Cazin's concern for the objects under his care led him to remove and put into hiding many of the local treasures (including a work by Mantegna).[4]

In 1871, discouraged by the ravages of war and disagreements with local authorities in Tours about the direction of his program, Cazin left for England. He had long been interested in moving out of the city and his friendship with Alphonse Legros (who moved to England in 1863) convinced him of that country's receptiveness to French artists.[5] Legros's suggestion that Cazin organize a school in England—perhaps based on the theories of Lecoq de Boisbaudran—was premature and never fully materialized. Without an official post to support him, Cazin turned to the industrial arts, making a living through the production and decoration of ceramics in the Oriental and *Japonisme* style.[6]

Cazin had received some training in ceramics at Sèvres and had worked on his own at Tours. While in London, he made an agreement with the

281

owner of the Fulham Pottery (C. J. C. Bailey and Company) for several artisans to work for him, at an hourly wage, so that he would have pieces to decorate. Cazin's ceramics included a series of stoneware vases and platters, mostly decorated with geometric patterns. In 1875, Cazin returned to France, settling in Equihen near Boulogne-sur-mer. Later, he and his son Michel continued to fire ceramics in the kilns at Equihen during the summer months, even though the family lived in Paris. Cazin's contribution to the revitalization of decorative art in France was recognized in 1882 when his large pieces of *grès* exhibited at the Union Centrale were acclaimed as precursors of the renaissance in French pottery.

At the same time that Cazin was working on the decoration of ceramics, he resumed painting. The region near Boulogne inspired him to do landscapes and, in 1876, he submitted his first important entry to the Salon: *The Boatyard*, a study of a boatyard in Boulogne [199].[7] His interest in landscape and studies of light and atmosphere was soon superseded by more traditional historical compositions which he exhibited at the Salons between 1876 and 1883. His *Voyage of Tobias* and the *Departure of Judith*, depicting figures in modern clothing enacting biblical scenes, were influenced by the compositions of his friend Puvis de Chavannes and display a light, delicate pastel tonality. Such compositions that combined classical themes with contemporary aspects were not always well received by the critics, indicating that Cazin, despite his inclinations, was not as effective as a history painter.

During the summer months Cazin rented a house for his family at Equihen. Later they bought a home and Cazin built his own studio where he translated nature through the use of values that muted his color range. Cazin did a series of studies overlooking the dunes: impressive seascapes which designate him as an important landscapist. He made friends with a number of famous people who often visited him at Equihen, including the political activist Léon Gambetta (whose death chamber he painted in 1883 [228]) and the painters Bastien-Lepage and Puvis de Chavannes. In 1880 Cazin received a first-class medal at the Salon for his composition of *Ishmael*, which eventually entered the Luxemburg Museum.

Following the 1882 exhibition of his ceramics at the Union Centrale, and because of his position as painter-decorator, Cazin was awarded the Légion d'honneur. At the World's Fair in 1889, he received a gold medal; in 1900, he received a *Grand Prix* at the World's Fair. Despite his widespread acceptance by the traditional art world, Cazin continually sought new inspiration for his landscapes. Like the Dutch painters of the seventeenth century, he rediscovered the beauties of his country—a region in northern France that inspired his most subtle landscapes. His Realist inclinations—evident in his early genre studies—resurfaced in these later poetic interpretations of the French countryside. Because he is linked to several traditions at the same time, Cazin's oeuvre is varied and complex.

1. In a visit to the Cazin Museum in Samer, local authorities reiterated that a number of Cazin's paintings were used for target practice by the German army and destroyed, despite efforts at the time to hide objects in barns or basements.
2. The exact dates of Cazin's teaching at the Ecole are not known.
3. In 1865 and 1866 Cazin exhibited works under the general title of *Etude;* these could have been figural studies or landscapes.
4. A judicious move that only reinforces the irony of the later destruction of Cazin's own works.
5. Legros's relationship is further documented by *Portrait of the Artist's Father* [140], which Legros donated to the Tours Museum in 1875. The specific reason for the contribution at that time remains unclear, since Cazin was no longer associated with the museum in 1875.
6. See Gabriel P. Weisberg et al., *Japonisme: Japanese Influence on French Art 1854-1910* (CMA, 1975), p. 164.
7. The painting exhibited at the Salon was described as painted in wax and listed as a section for a decorative project.

Gustave Colin
1828 Arras — 1910 Paris

Gustave Colin represents a particular region in the development of Realist landscapes. The rich, evocative color and luminous sense of light he achieved in his descriptions of the Basque country qualify some of his best works as pre-Impressionist. While his themes also include descriptions of daily life and large Romantic melodramas with historical overtones, his freely sketched landscapes that combine the influence of Romanticism with the palette-knife technique of Courbet remain his most significant works.

Colin's family was well established in the city of Arras in northern France, where his uncle served as mayor from 1837 to 1848; his father was both an assistant judge and a distinguished entomologist and numismatist. Both men also served on the municipal council of the local museum so that an interest in the arts was a familiar part of Colin's childhood. He entered school at seven and, at first, did exceptionally well in his studies. His rapid physical growth, however, left him enervated, and he spent most of his time developing caricatures of colleagues and family rather than attending to his studies. Recognizing Colin's artistic ability, one of his teachers, Auguste Demory, persuaded his family to allow Colin to study drawing. After only a brief period with Demory, in 1847 Colin entered the atelier of a well-established local painter, Constant Dutilleux (1807-1865). In spite of his obvious progress and Dutilleux's encouragement, Colin's family was concerned that he receive a practical means of earning a living, and in 1850 he was sent to Paris to study law. By 1853, however, he was again pursuing his first interest, studying in Paris with Wagrez, a former student of Dutilleux. In the spring of 1854 Colin became a student of the Romantic painter Ary Scheffer (1795-1858) but, preferring a less academic atmosphere, moved to the studio of Thomas Couture (1815-1879), where he remained for the next three or four years. During this time, he maintained his contact with his early teacher Dutilleux, and in the fall of 1855 both men spent time painting together out-of-doors near the Forest of Fontainebleau.

While it is possible that Colin may have exhibited in the Salon as early as 1853, the first complete records appear only in 1857.[1] It was during this period that he became interested in the lesser known regions of France, and in the late 1850s he made the first of many trips to the Pyrénées. His interest in this area was reflected in his 1859 Salon entry, *La Sortie de la messe à Cèdre—Hautes-Pyrénées,* a work which Zacharie Astruc described as "filled with light and air."[2] Captivated by the region, he made a second trip to this part of France in 1860. He married Marie Carmier, a native of the Basque region on 21 November 1860,[3] and became a permanent resident of southern France, settling in Ciboure, although he continued to

GUSTAVE COLIN

maintain a small apartment and studio in Paris throughout the rest of his career.[4]

Younger painters were enthusiastic about his work when he exhibited in the Salon des Refusés in 1863, but his participation generated hostility among the academic critics. As a result, he received little official government recognition throughout the remainder of his career.[5] It was not until 1880 that he was able to sell any of his paintings to the government, even though he sold one to the Arras Museum in 1867, and another to the museum in Pau in 1870. He continued to exhibit at the Salons throughout the 1880s, but was not awarded the Légion d'honneur until 1899, and only promoted to the rank of Chevalier in 1907 —far later than most of the membership.

Although he was ostracized by some for the freedom of his style, Colin's preoccupation with the unusual and the exotic nonetheless intrigued others. His trip to Spain in 1864, where he was enthralled by the paintings of Velázquez at the Prado, only increased his obsession with the Basque country. He invited some of his Parisian friends to visit him in the picturesque southern setting where he continued to make his home. Among his guests were Camille Corot, who visited him in 1875; Colin's article after Corot's death later that year remains an eloquent tribute of his special regard for the Barbizon master.[6]

Colin's landscapes during the 1870s were devoted to a variety of scenes from the south of France, a seascape of the port of St. Jean-de-Luz, or a view of the tree-lined streets of Ciboure observed in the intense heat of the day. His main patron, Count Armand Doria, continued to support him, even during the time when few admired his work. Throughout his career, he remained an active regional painter, but only belatedly (except for the continued support of such friends as Castagnary)[7] did he receive distinction as a major artist. His work was recognized at the retrospective of the Société Nationale des Beaux-Arts in 1906 and, after his death in 1910, the well-deserved designation of "major colorist, and one of the most delicate painters of light that we have had in our French school of painting" was finally conferred upon him.[8]

1. Colin is recorded as exhibiting three paintings in the 1853 *Enregistrement des ouvrages*, Archives du Louvre. (nos. 2578-2580) In the official Salon catalog, however, there is no mention of these works.
2. Zacharie Astruc, *Les 14 Stations du Salon* (Paris, 1859), pp. 288-89.
3. *Gustave Colin, 1828-1910*, exh. cat. (Musée d'Arras, 1967), p. 10. The Musée du Petit-Palais, Paris possesses a drawing of Marie Carmier (1860).
4. Ibid.
5. Ibid., p. 10. No mention of works by Colin can be found in the official published catalog of the Salon des Refusés.
6. Gustave Colin, "C. Corot," *L'Evénement*, 23 March 1875, pp. 1-2.
7. See Jules Antoine Castagnary, *Salons (1857-1870)* (Paris: Bibliothèque Charpentier, 1892), p. 366.
8. André Nède, "Nécrologie, Gustave Colin," *Le Figaro*, 30 December 1910.

Gustave Courbet

1819 Ornans, Franche-Comté—
1877 La Tour de Peilz, Switzerland

The controversial figure of Gustave Courbet was a focus for the major issues of the Realist movement in the middle of the nineteenth century. Born in the Franche-Comté in the little town of Ornans of a prosperous farming family, Courbet, in both his work and manner laid great stress on his provincial, rustic background. After his arrival in Paris in 1839, he made friends with the painter François Bonvin, who guided the young Courbet through the Louvre, especially emphasizing those modest recorders of everyday reality, the seventeenth-century Dutch little masters, as well as the French painters of reality, Chardin and the Le Nain brothers. Both young artists, in addition, reacted favorably to the work of Spanish painters like Murillo, Velázquez, and Zurbarán. Courbet's participation in the Revolution of 1848 seems to have been confined to the drawing of a frontispiece for the short-lived journal *Le Salut public*. He also consorted with a group of writers who frequented the Brasserie Andler and who formed the nucleus of the Realist circle: Champfleury, Max Buchon, Baudelaire, and painters like Daumier and Decamps. Although Courbet participated in several Salons before the 1848 Revolution—contributing a *Classical Walpurgis Night* among other offerings to the Salon of 1848—it was not until the Salon of 1849, with the *After Dinner at Ornans,* a striking, sober, large-scale representation of the intimate life of his friends and family, that he may be said to have created a work related to the aims and attitudes of Realism. The work was well received by the liberal jury of 1849 and Courbet was awarded a coveted medal for it, an honor which carried with it the privilege of automatic acceptance in future exhibitions. It was not until the 1850/51 Salon, in a climate of political reaction, that Courbet may be said to have created a scandal and, at the same time, to have raised the issue of Realism as a controversial movement, with three major, large-scale and startling direct works: *The Burial at Ornans; The Peasants of Flagey,* and *The Stonebreakers.* Courbet's contribution to the 1852 Salon, the *Young Ladies of the Village,* representing his three sisters giving alms to a little cowherd on an upland pasture outside of Ornans, was savagely attacked in caricature and on the stage, even though the work had been purchased by the Comte de Morny, a prominent member of the Imperial government and a relative of Emperor Napoleon III himself. By 1855, the year of the

GUSTAVE COURBET

great Universal Exhibition in Paris, Courbet decided to take matters into his own hands. With the aid of his friend and supporter Alfred Bruyas, the wealthy and eccentric collector from Montpellier whom he depicted stepping forward to greet him in the famous *Meeting* of 1854, Courbet opened his own private Pavilion of Realism in which he showed forty of his paintings, including his documentary *Painter's Studio,* provocatively subtitled: "a Real Allegory Summarizing Seven Years of My Artistic Life." This private exhibition was accompanied by a catalog containing a definitive statement of Courbet's position, in which the artist declared that "the title of Realist" had been thrust upon him and that he had wished to "draw forth from a complete acquaintance with tradition the reasoned and independent consciousness" of his own individuality. The concluding passage of his catalog statement constitutes a brief summary of Courbet's Realist intentions and achievements: "To be in a position to translate the customs, the ideas, the appearance of my epoch, according to my own estimation. . . ."

After this point, although Courbet remained individualistic and often combative in his approach to both his art and his public, he focused less exclusively on recording aspects of contemporary rural life and increasingly turned to less controversial subjects like the nude, the portrait, and, most of all, the landscape. Although major works like the *Young Ladies on the Banks of the Seine* (1857) or the *Portrait of P.-J. Proudhon and His Children* (1865) might occasionally raise the hackles of conservative critics and public because of their unidealized directness of form or purportedly vulgar subject matter, Courbet's contributions to the Salons of the 1860s were often enthusiastically greeted. Such was the case with the *Woman with a Parrot* (1866 Salon), about which the leftist critic Théophile Thoré ironically remarked: "Well, my dear Courbet, you are done for now; your palmy days are over! Here you are accepted, bemedalled, decorated, glorified, embalmed!" Nevertheless, despite a certain degree of public acceptance, Courbet decided to organize another private exhibition, even more ambitious in its range and scale than the previous one, in competition with the Universal Exhibition of 1867. Like that of

1855, this show, which listed 115 items in its catalog, could be considered only a qualified success, although cartoonists of the day found ample material for their own art in the occasion.

When the Franco-Prussian War broke out in 1870, Courbet, who had recently and publically refused the Légion d'honneur offered him by the government of Napoleon III, became chairman of the Arts Commission, whose duty it was to protect works of art in the Paris area. When the Commune seized power in the capital, Courbet took an active part in political and administrative affairs, both as chairman of the Artists' Federation and as representative from the Sixth Arrondissement to the Commune government itself. After the fall of the Commune, Courbet was imprisoned in Sainte-Pélagie, a misfortune which he later commemorated in the well-known *Self-Portrait in Sainte-Pélagie* (now in the Musée Gustave Courbet in Ornans) and was only narrowly saved from execution by the intervention of friends, chiefly that of the critic Jules Antoine Castagnary. Under the government of Marshall MacMahon, in 1873, Courbet was declared responsible for the destruction of the Vendôme Column and forced to go into exile to avoid paying the enormous costs of reconstructing this monument. He crossed the border into Switzerland, where he settled in La Tour de Peilz, near Vevey. There, he continued to paint—landscapes for the most part—often assisted by his pupil Pata and, according to the testimony of friends like Dr. Marcel Ordinaire, to "drown himself" in the local white wine. In 1877, Courbet developed dropsy, and died on the morning of 31 December 1877. He was buried in the cemetery of La Tour de Peilz. It was not until the time of the centenary of his birth, in 1919, that the body of the exiled artist was transferred to his beloved birthplace of Ornans. L.N.

Pascal Adolphe Jean Dagnan-Bouveret

1852 Paris — 1929 Quincey, Haute-Saône

Although born in modest surroundings in Paris, Pascal Adolphe Jean Dagnan-Bouveret established ties with provincial regions of France, especially the Franche-Comté, from which his wife came. He was brought up by his grandfather in Melun, a small city near Paris, because his father moved to Brazil to make a living as a tailor. At sixteen, when his father asked Dagnan-Bouveret to join him in his business in Brazil, Dagnan-Bouveret rebuffed his parent and refused to leave France,[1] for he had already decided to become a painter. He later took the name Dagnan-Bouveret in memory of the kind support his grandfather gave him at a crucial stage in his career.

In 1869, Dagnan-Bouveret entered the Ecole des Beaux-Arts. First he studied in the atelier of Cabanel, and after a few months he joined the studio of Jean Léon Gérôme.[2] Renting a small room on the rue Faubourg-Poissonnière, he was supported by funds sent weekly by his grandfather. While in this apartment, Dagnan-Bouveret met Gustave Courtois (1853-1923), the painter who became his lifelong friend.[3]

Dagnan-Bouveret's work first appeared at the Salon in 1875 when he exhibited a painting entitled *Atalante* and two drawings. The latter affirmed the importance he placed on draftsmanship in the development of compositions. The painting was purchased by the state and sent to the Melun Museum. In 1876, still working in Gérôme's studio, Dagnan-Bouveret received the second

Prix de Rome for a painting entitled *Priam demandant à Achille le corps de son fils.* He also won first prize for painting the human figure at the Ecole. But, by 1878, Dagnan-Bouveret realized he must establish himself on his own and, with his friend Courtois, left the Ecole. During vacation periods Dagnan-Bouveret and his friend went to the Franche-Comté, Courtois's native region, where Dagnan-Bouveret met Courtois's cousin Maria Walter (ca. 1878), who eventually became his wife.[4]

During the late 1870s, Dagnan-Bouveret, like his good friend Jules Bastien-Lepage, submitted mythological paintings to the Salon in addition to portraits of his friends and family.[5] But in 1879, he changed his style and themes and exhibited *Une Noce chez le photographe* (Musée de Lyon), a work based on actual observation and Realism.[6]

Dagnan-Bouveret received a third-class medal at the 1878 Salon, but only in 1880, after he exhibited *Un Accident* (The Walters Art Gallery, Baltimore) at the Salon, did he receive a first-class prize. This theme, which Dagnan painted at least twice, was based on an incident he may have witnessed in the Franche-Comté or read about in Naturalist literature.[7] Evincing firsthand observation, Dagnan recorded a village doctor's visit to a poor peasant family's home to care for the hand of a boy injured while hunting for birds. The drama achieved in his portrayal of the incident and its effect on members of the boy's family demonstrated his talent for accurate observation using themes derived from daily life in this region.[8]

He also continued to record his own family, submitting a portrait of his grandmother to the 1882 Salon. His *Bénédiction des jeunes époux avant le mariage-coutume de Franche-Comté,* also exhibited at the 1882 Salon, reinforced his growing position as a regionalist intent on reporting the customs of an area which he had adopted—a locale that, since Gustave Courbet left, had been overlooked.

Not all of Dagnan-Bouveret's early canvases were exhibited at the Salon. Landscapes of the Franche-Comté and still lifes demonstrate that he tried many themes. Other studies drawn from the life of Franche-Comté explored not only popular themes but also light and value, somewhat in the manner of the seventeenth-century Dutch masters. In 1885, Dagnan-Bouveret achieved an important success at the Paris Salon when he exhibited his large canvas, *Horses at the Watering Trough* [202].[9] Following this, he was named Chevalier of the Légion d'honneur, and the painting was purchased by the state and sent in 1892 to the Musée de Chambéry.

After the 1885 Salon, Dagnan-Bouveret made his first trip to Brittany. The region had already attracted a number of Realist painters, from François Bonvin to Jules Breton, and became the theme of many of Dagnan-Bouveret's Salon paintings in the late 1880s. In 1887 he exhibited *Le Pardon—Bretagne* which stressed the peasants' piety and their regional celebration. He painted the same theme again in 1889 and did other Brittany themes even after 1900. In 1887 he was elected to the Salon jury and between late 1887 and 1888 made his first trip to Algeria. In 1889 he received a medal of honor from the Société des Artistes Français, another medal of honor at the 1889 Paris Fair, and gold medals from exhibitions in Munich and Ghent. Throughout the latter part of his career, Dagnan-Bouveret devoted himself to official portraits for which he received numerous prestigious awards. In 1900, at the Paris World's Fair, Dagnan-Bouveret received a grand

P.A.J. DAGNAN-BOUVERET

prize and was named a member of the Institut de France (27 October).

1. See J. Dampt, "P. A. J. Dagnan-Bouveret, 1852-1929," in *Catalogue des oeuvres de M. Dagnan-Bouveret (Peintures)* (Paris: Maurice Rousseau, 1930), pp. 3-7.
2. How long Dagnan-Bouveret studied with Cabanel is unknown. Ibid., p. 19.
3. Ibid., p. 4.
4. The exact date of their marriage is unknown. Dagnan-Bouveret did a portrait of Maria Walter in 1878. No trace of the location of this composition exists. For a list of paintings he completed in 1878, see *Catalogue des oeuvres* (1930), p. 22.
5. Dagnan-Bouveret made a drawing of Bastien-Lepage on his deathbed. See Georges Lafenestre, "Exposition d'études, dessins et pastels de M. Dagnan-Bouveret, à la Société Nationale des Beaux-Arts," *Gazette des Beaux-Arts* 1 (1909): 465-80, repr. p. 475.
6. See André-Charles Coppier, "Regards sur l'oeuvre de Dagnan" in *Catalogue des oeuvres* (1930), p. 8.
7. This painting was judged too fragile to be included in the Realist exhibition. A photograph of a variant of this composition was found in the Rijksbureau photo archives, The Hague. The variant was sold through Goupil and Co. in Paris, and its present location remains unknown.
8. For an account of the incident see E. Montrosier, "Dagnan-Bouveret," *Les Artistes modernes,* vol. 1 (Paris, 1881), p. 111.
9. He also showed *La Vierge* at this Salon.

Honoré Daumier
1808 Marseille — 1879 Paris

Honoré Daumier occupies an unusual place in the evolution of modern painting and lithography, but the origins of Daumier's imagery are often overlooked in the tendency to elevate his work above the work of his contemporaries. He frequently used Realist themes and was the friend of Philippe Auguste Jeanron, François Bonvin, and several early Realists as well as some of the Barbizon landscapists.

Daumier was born into a modest family in Marseille. Daumier's father, a glassmaker, had his own shop where the boy was introduced to painters and artisans, including his godfather, Joseph

Lagrange. Modest success as an amateur poet convinced Daumier's father to give up his trade; with the support of his friends, he left for Paris, determined to establish himself in literary circles. Arriving in the capital shortly after the fall of Napoleon in 1815, he published a small book of poetry, *Un Matin de printemps,* which received considerable attention, although he soon realized he could not earn a living with this interest. In July 1816 he became *commission-agent* at the Caisse d'Arbitrage, which enabled him to send for his wife and children in September 1816. He continued, however, to write poetry, received an audience with Louis XVIII in 1818, and wrote a play that was performed in a Parisian theater in 1819.

His father found work for Daumier as a messenger boy in the law courts from 1820 until 1821, when he became a clerk in a bookstore. This apprenticeship was significant since the shop's location on the Palais Royal introduced Daumier to many aspects of contemporary Parisian life. By 1822, however, Honoré found his calling as an artist. His father again assisted by placing him with a friend, the painter Alexandre Lenoir, who became Daumier's first teacher.

The sixty-year-old Lenoir introduced his pupil to the works of Rubens and Titian in the Louvre. He also encouraged Daumier's interest in sculpture. After leaving Lenoir, Daumier enrolled at the Académie Suisse, where drawing from models sharpened his sense of observation. In 1822, Daumier also did his first lithographs—the medium which was to provide his livelihood. Aided by the lithographer Ramelet, Daumier produced prints in the style of Charlet. Daumier increased his knowledge of lithography by entering the shop of Belliard, a publisher of contemporary portraits.

During the mid-1820s Daumier did his own lithographs. Many of these were caricatures of political figures, and Belliard refused to circulate them. By 1830 Daumier's prints attacking Charles X, the Jesuits, or the police appeared frequently in *La Silhouette.* At the same time, he was also completing sculpture inspired by his training with Lenoir and his friendship with the Realist sculptor Préault. Daumier was obsessed by physiognomies and his obvious emphasis in portraiture led Charles Philipon (1806-1862), the influential editor, to ask Daumier to sculpt a series of these small-scale caricatures.

With lithographs in *La Caricature* and later in *Le Charivari,* Daumier's success as a caricaturist emerged in the early 1830s. While working for *La Caricature,* Daumier met Honoré Balzac, who admired Daumier's portrait caricatures and urged him to continue. Daumier's lithographs, however, were too radical. He was arrested for attacking the state, fined, and sentenced to six months in prison. While in Sainte-Pélagie, Daumier did studies and some paintings of his fellow inmates. After his release, he lived in an apartment on rue Saint-Denis near artists with similar political views, including Cabat, Préault, and Jeanron, and was hired by a local newspaper, *La Liberté, Journal des Artistes,* where he collaborated with Jean Gigoux and Célestin Nanteuil.

The painter Daumier most wanted to emulate was Jeanron, the leader of these radical young artists.[1] In the early 1830s, the paintings of Alexandre Decamps also influenced Daumier. Decamps's interest in contemporary genre and his increasing popularity led Daumier to closely study his work. By 1833, Daumier was still regarded as a political caricaturist, but he was careful to guard

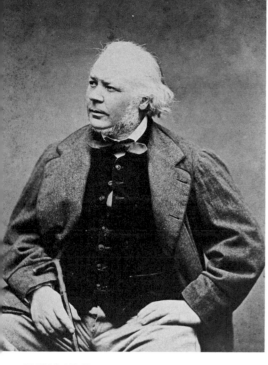

HONORE DAUMIER

himself—governmental censorship had taken hold, and Daumier recognized that political caricature could not focus upon the government. After Louis Philippe suppressed *La Caricature,* Daumier created images that satirized the contemporary customs and manners for *Le Charivari.* By the end of the decade, Daumier had become a leader in French caricature.

In 1845 Daumier moved to the Ile St. Louis where, with artists and writers such as Charles Daubigny, Trimolet, and Charles Baudelaire, he turned some of his efforts to the depiction of contemporary life. His marriage on 16 April 1846, to Alexandrine Dassy, a dressmaker, stabilized his life and provided the tranquilty he needed to continue his work during the frenzied revolutionary period that began in 1847. At that time, Daumier's republican views led him and others to demand reforms, especially a liberalized Salon system. In 1848 Daumier became one of the twenty finalists selected in the competition to create a symbol of the new republic, but the republic was shortlived and Daumier never finished his sketch. The trauma of 1848 led to a bourgeois reaction in which thousands were either killed or deported—themes which Daumier used in paintings such as *Les Emigrants* and *Les Fugitifs.*

In 1849 Daumier broadened his painting themes to include literary and mythological subjects, such as *Le Meunier, son fils et l'àne.* Inspired by "open-air" painting, he also did a number of small compositions of Parisian life, including images of little girls dancing or of children sitting under trees. When Napoleon III appeared, Daumier again turned to political caricature in *Le Charivari* to warn the populace of the dangers of a dictatorship. Once Napoleon III gained full control of the press, however, Daumier again avoided direct political comments and resumed his social comment. His lithographs and sculptures of *Ratapoil,* a secret agent of Napoleon III, were considered subversive, and Daumier was forced to hide them in his home. His inflammatory political views at this time again affected his career, for the state would not purchase his paintings. By 1852 Daumier was no longer exhibiting at the Salons.[2]

In the early 1850s, he prepared lithographs for *Le Charivari,* but also spent considerable time near Valmondois on the outskirts of Paris. By the late 1850s, Daumier was no longer content to be called an "amusing" caricaturist. He became increasingly interested in the Barbizon painters, especially Théodore Rousseau, Jean François Millet, and Camille Corot. Through contact with François Bonvin, Daumier became acquainted with recent trends in painting and was aware of the works Gustave Courbet exhibited in the Salons or at the private pavilion Courbet constructed in 1855.

In 1860, *Le Charivari* asked him to stop sending lithographs and cut him from their staff. A number of Daumier's friends, including Baudelaire, tried to console him. Others urged him to paint new themes, such as the waiting rooms of train stations [14], the interiors of trains, or people traveling by rail. Other themes drawn from life in the Ile St. Louis, such as *Bain dans la Seine* or *l'Abreuvoir,* satisfied Daumier's Realist predilection for contemporary life. In 1862, when the Salon accepted his *Blanchisseuse,* Daumier began to emerge from his depression. The *Blanchisseuse,* badly hung and denounced by critics, was supported only by Daumier's friends, who also tried to alleviate the destitute artist by buying some of his work. With changing Salon restrictions in 1863, however, Daumier received a commission from the government for a drawing, *La Marche de Silène*—the first time during the Second Empire that the state supported Daumier.

Daumier's fortunes improved in 1864. He did one hundred lithographs for *Le Charivari.* Financially secure now, Daumier had little time to draw or paint because of publishing deadlines. He became closely associated with the critic Champfleury, who was working on a book on caricature. After 1866, Daumier did fewer prints. In his later years, several major themes fascinated and preoccupied him. These included *The Print Collector* [15], a figure he often painted or drew, and a series on *Don Quixote and Sancho-Panza.* Another theme, the life of the itinerant performer, also took hold in his later years and provided Daumier with Romantic-Realist themes decidedly autobiographical in content.

Still republican in his views, Daumier continually tried to liberalize the art exhibitions and Salon juries. An opponent of Napoleon III, Daumier refused the Légion d'honneur and continued his outspoken imagery during the Franco-Prussian War. The last years of his life became most difficult when his eyesight failed and he was again penniless. Although his work interested a few art dealers and a retrospective of his paintings and drawings was held in 1878, Daumier died in debt and was buried in a pauper's grave.

1. Daumier's first painting is reported to have been a signboard he worked on with Jeanron.
2. No record exists of Daumier submitting works which were rejected by the Salon. Nevertheless, this remains a distinct possibility during the 1850s.

Hilaire-Germain-Edgar Degas

1834 Paris — 1917 Paris

Hilaire-Germain-Edgar Degas, who later signed himself simply Degas, was born in Paris in 1834. His mother, of the Musson family of New Orleans, died when he was thirteen; his father, of a noble Languedoc family recently settled in Naples, was a banker who interested himself in art and music. He urged his son to study law but did

not object strenuously to his studying art and continued to support him. After working briefly with Félix Barrias, in 1855 Degas entered the Ecole des Beaux-Arts and the studio of Louis Lamothe, a pupil of Ingres; his meeting with the master himself that year was an event he never forgot. In 1856 he traveled to Italy, where he remained for three years, making many copies after ancient and Renaissance art in Naples, Rome, and Florence. In this he was unlike most of the Realists, who no longer considered an Italian voyage necessary, and closer to conservative artists such as Gustave Moreau, who met and befriended him there. On his return to Paris he continued to paint portraits and historical subjects but showed one at the Salon only in 1865; this was the *Scène de guerre au Moyen Age,* the last such subject he treated.[1] The following year he showed instead a *Scène de steeplechase,* and in subsequent years a theatrical subject and portraits of women.[2] By now he was a member of a group of modern artists that included Manet and most of the future Impressionists, as well as writers such as Duranty and Zola, who met at the Café Guerbois.

After the Franco-Prussian War, in which he served with Manet in an artillery unit, Degas stayed first in Normandy with his friend Valpinçon, painting racehorses, then in New Orleans with his brothers, whose cotton business office he also painted.[3] In 1874 he helped organize the first Impressionist exhibition, and he continued to play an important part in almost all the later ones, including the last in 1886. Paris was now his primary source of inspiration, providing scenes of modern business operations—the office, bank, and stock exchange; of middle-class entertainment—the opera, theater, and racetrack; and of urban culture—the museum, private collection, and domestic concert. Although he returned often to Naples, visited London a few times in the 1870s, and in the following decade traveled in Spain, Switzerland, and Morocco, his subjects remained exclusively Parisian.

By the early 1890s Degas was well established and successful enough financially to begin forming what eventually became one of the finest artist's collections of his day; especially strong in Ingres and Delacroix, who remained his idols, it also contained many Impressionist and Post-Impressionist works and Japanese prints. By this time, too, his failing eyesight—an affliction he had struggled with for thirty years—forced him to work on a larger scale and in a bolder style and to turn increasingly to sculpture to realize his ideas. In the same years he took up two other art forms that had long interested him, poetry and photography, producing sonnets that Mallarmé and other literary friends admired and strikingly original portraits of relatives and friends. But apart from a gradually decreasing circle of old acquaintances, further decreased by the tensions of the Dreyfus affair, he lived in virtual isolation. In this solitary world, darkened by his worsening eyesight, he continued to work until near blindness forced him to cease entirely about 1910. He died in 1917, already a legendary figure, and the sales of the contents of his studio consecrated his reputation throughout the world.

Degas's place among the Realists is as difficult to define as his place among the Impressionists; he belongs fully to neither and to both movements. He was acquainted with several of the Realist artists and writers and was undoubtedly familiar with the work of others; but the same could be said of many of the academic artists of his day. His first contact with monumental Realist

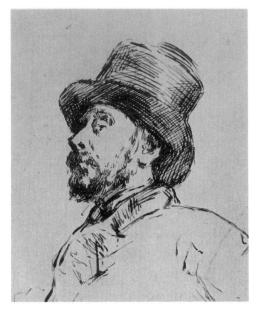

EDGAR DEGAS

art must have been in 1855 at Courbet's retrospective exhibition outside the World's Fair, where he is also reported to have met Fantin-Latour.[4] His only explicit mention of Courbet in these years was a note on the coloristic effect of the *Dame au chapeau noir,* which he recalled seeing at the 1863 Salon,[5] but he may already have been influenced by such effects in boldly juxtaposing black and white in *La Famille Belleli* (1859-60), his first major work.[6] In any event, he came close in it to realizing the kind of domestic group portrait that some of Courbet's followers were painting, among them Fantin-Latour (*The Two Sisters,* 1859) and Whistler (*At the Piano,* 1859).[7] He himself later pointed to their common source in Dutch seventeenth-century realism: "At the beginning we were on the same path, Whistler, Fantin, and I, the road from Holland,"[8] and in this group he might have included Bonvin, Ribot, and many other Realists. In the company of Fantin-Latour he must also have met Alphonse Legros, who was later to befriend him on visits to London, and Amand Gautier, a follower of Courbet, although Gautier's address appears in his notebooks only about 1870.[9] In that decade, too, Degas was certainly acquainted with Adolphe-Félix Cals, who exhibited with him in the early Impressionist shows. There is no evidence, however, of his contact with Bonvin, Ribot, Vollon, and other Realist artists, though he did know intimately such writers as Duranty, Edmond de Goncourt, and Zola.

Only certain of the subjects Degas treated, and those only in the first half of his career, can be considered characteristically Realist. The sketches he made in France and Italy in the late 1850s of urban genre scenes—crowds gathered in markets and streets, religious services in churches[10]—resemble those of Bonvin, Fantin-Latour, and their colleagues at the time. But Degas's paintings of old beggarwomen in Rome,[11] despite their realistic technique, stress the picturesqueness of their subjects' poverty without the social criticism implicit in contemporary pictures of the urban and rural poor by Courbet, Ribot, and Antigna. A decade later Degas began to depict the world of Parisian entertainment and spectacle with an eye for its ironic contrasts of the artificial and the natural, the brilliant illusion, and

the mundane reality—an eye educated by Gavarni and Daumier, whose prints he admired and collected in large numbers.[12] His café-concert pictures of the mid-1870s are especially close to Daumier's in design, but Degas comments more sharply on the vulgarity of the singers and their clientele, and records more fully the charm of the nocturnal setting and artificial illumination.[13] His café interiors, too, are at once within the Realist tradition of Courbet, Bonvin, and Daumier and outside it—more penetrating in their observation of character and class, more complex in pictorial structure; the most famous example, *L'Absinthe* (1876), makes of a subject already treated by Manet and Daumier a profoundly pessimistic statement of urban alienation.[14]

It was above all in the Laundress that Degas found a major Realist theme and made it entirely his own. Whereas Bonvin and Antigna stress the young working girl's inferior status and drudgery, and Gavarni hints at her moral vulnerability, Degas depicts her as a skilled worker in a shop hung with linens silhouetted brilliantly against the light.[15] If at times he shows the physical discomfort she must endure, pressing down on her iron or yawning in exhaustion, at others it is a moment of conversation or amusement; he never dwells on the social injustice of her plight, whereas in Daumier's paintings and prints the laundress struggles heroically to maintain herself and her child in the indifferent city.[16]

Although Degas continued to represent laundresses well into the 1880s, increasingly in that decade he concentrated on the daily life of middle-class women, whom he shows in intimate conversation, in visits to the dressmaker, the milliner, and the Louvre galleries, and above all in scenes of bathing, drying themselves, combing their hair, and having coffee served. In the millinery shop, he professed to be fascinated by the red hands of the little pin girl, but what he painted was the wealthy client trying on hats, and from a viewpoint that played ingeniously with their fanciful forms and colors.[17] By the end of his career, he had withdrawn entirely into this bourgeois world of private comforts and public pleasures, one that had little rapport with his earlier images of the harsher realities of modern urban life. T.R.

1. P.-A. Lemoisne, *Degas et son oeuvre* (Paris: Paul Brame and C. M. de Hanke, 1946-49), no. 124.
2. Ibid., nos. 140, 146, 165, 271.
3. Ibid., nos. 281, 289-91, 320, 321.
4. John Rewald, *The History of Impressionism,* 4th ed. (New York: Museum of Modern Art, 1973), p. 25.
5. Theodore Reff, "Further Thoughts on Degas's Copies," *Burlington Magazine* CXIII (1971): 540. Robert Fernier, *La Vie et l'oeuvre de Gustave Courbet* (Lausanne-Paris: Bibliothèque des Arts—Fondation Wildenstein, 1977-78), no. 358.
6. Lemoisne, *Degas,* no. 79. On Courbet's influence, see J. S. Boggs, *Portraits by Degas* (Berkeley, 1963), pp. 2, 8, 13, 20, 30, 32.
7. Illustrated in Rewald, *History of Impressionism,* pp. 32-33.
8. E. Degas, *Lettres,* ed. M. Guérin (Paris, 1945), p. 256.
9. Theodore Reff, *The Notebooks of Edgar Degas* (Oxford, 1976), Notebook 24, p. 112; Notebook 26, p. 98; Notebook 32, p. 1B.
10. Ibid., Notebook 3, pp. 42, 44; Notebook 4, pp. 1, 2; Notebook 8, pp. 53, 60, 69v-70. Gabriel P. Weisberg, *Bonvin: La Vie et l'oeuvre* (Paris: Editions Geoffroy-Dechaume, 1979), nos. 11, 16.
11. Lemoisne, *Degas,* nos. 28, 29.
12. *Catalogue des estampes anciennes et modernes composant la collection Edgar Degas,* sale cat., Hôtel Drouot, Paris, 6-7 November 1918, lots 61-103, 129-96.
13. See, for example, Lemoisne, *Degas,* nos. 380, 404, 405. On Daumier's influence, see Theodore Reff, *Degas: The Artist's Mind* (New York, 1976), pp. 79-80.
14. Lemoisne, *Degas,* no. 393. Denis Rouart and Daniel Wildenstein, *Edouard Manet, Catalogue raisonné* (Lausanne: La Bibliothèque des Arts, 1975), no. 19. L. Delteil, *Honoré Daumier (Le Peintre-graveur illustré, XIXe et XXe siècles)* (Paris, 1925-30), no. 3256.
15. Lemoisne, *Degas,* nos. 356, 685, 846. Weisberg, *Bonvin,* nos. 19 bis, 25. *Jean-Pierre Alexandre ANTIGNA (Orléans, 1817—Paris, 1878)* (Orléans: Musée des Beaux-Arts, 1978), nos. 38, 39. *The Cult of Images* exh. cat. (University of California, Santa Barbara: Art Museum, 6 April—8 May 1977), no. 44.
16. Lemoisne, *Degas,* nos. 686, 687, 776, 777, 785, 786. K. E. Maison, *Honoré Daumier: Catalogue Raisonné of the Paintings, Watercolors, and Drawings,* vol. 1, *The Paintings* (Greenwich, Conn.: New York Graphic Society, 1968), nos. I-85, I-86, I-121, I-159, I-160.
17. Degas, *Lettres,* p. 147, n. 1. Lemoisne, *Degas,* nos. 681-83, 693, 729.

Marcellin Desboutin

1823 Cérilly, Allier — 1902 Nice

That Edgar Degas selected Marcellin Desboutin as model for a dissipated figure in his *L'Absinthe* (Musée du Louvre), painted in 1876, is not surprising. Desboutin spent a number of years in Italy and returned to Paris in August 1872, a ruined man, having squandered his considerable inheritance collecting paintings and enjoying a bohemian life. Obliged at last to earn a living, Desboutin found lodging in a miserable section of Paris and became a printmaker. The misery and sadness that now surrounded him led Degas and others to regard him as unofficial president of the meetings of the young Impressionists (and Naturalists) who gathered at the Café de la Nouvelle Athènes during the 1870s.[1]

Despite Desboutin's forlorn condition in the 1870s, he had already produced a considerable oeuvre by the time he returned to Paris late in 1872. The son of a wealthy landowner, Desboutin came from an aristocratic background and was exceptionally well educated.[2] He received three years at law school, registered at the bar, but apparently never practiced. By 1845 he had entered the Ecole des Beaux-Arts, where he worked in the studio of Louis-Jules Etex (1810-1889). Tiring of his academic master, however, he worked in 1847 under Thomas Couture, but he soon preferred to work and study alone. With a fortune to support him, Desboutin then traveled to England, Holland, Belgium, and finally Italy. He spent seventeen years in Florence where he purchased a home called Villa del'Ombrellino and there developed an art collection and also trained himself as an etcher. He continued to paint, and also wrote many plays, but only one, *Maurice de Saxe,* seems to have been performed in a Parisian theater (1870). Indifferently producing etchings, paintings, and plays, Desboutin eventually found himself unable to pay his debts, and when he returned to Paris, he determined to work as a professional artist, his profligate days behind him.

Desboutin first exhibited portraits at the 1869 Paris Salon. These studies of friends, including actors from the theater and critics from the art world, often went unnoticed; they were dark, monochromatic studies that no doubt reflected the sadness of his own life at that time. He also completed a series of remarkable etchings—portraits of his friends such as Philippe Burty or the critic's

MARCELLIN DESBOUTIN

daughter Madeleine—which captured the sitters' personalities with psychological insight. Collectors and friends avidly purchased these works.

Despite some success at the 1879 and 1880 Salons, when his young son fell ill in 1880, Desboutin decided to move to Nice. A sale of his paintings at the Hôtel Drouot brought him a large amount of money and enabled him to live in Nice for eight years, until an earthquake in 1888. He then moved to Geneva but soon returned to Paris and entered his most productive years as a painter. In 1890 he was among the founding members of the Société Nationale des Beaux-Arts and continued to contribute to the new Salons until his death in 1902. He received state commissions for his work. In 1895 he was named Chevalier of the Légion d'honneur in recognition of his entire career as an artist. Tired and dissipated, after 1896 Desboutin spent the remainder of his life in Nice, returning to Paris only to accept a grand prize in 1900 at the World's Fair.

1. For a brief discussion see Ronald Pickvance, *Degas 1879*, exh. cat. (Edinburgh: National Gallery of Scotland, 1979), no. 39.
2. For further information on Desboutin, see Marcellin Crépin-Leblond, ''Sur Marcellin Desboutin,'' *Société d'Emulation et des Beaux-Arts du Bourbonnais*, 1902, pp. 120-36.

Victoria Dubourg
1840 Paris — 1926 Buré, Orne

As the young wife of Henri Fantin-Latour, Victoria Dubourg shared her husband's passion for still-life painting. She met the painter early in her own career, when as an art student she was copying in the Louvre. Interestingly, she and Fantin-Latour were copying the same picture: Correggio's *Mystic Marriage of St. Catherine*. She was extremely shy, however, and their friendship did not begin until some time later when she was introduced to the painter by a mutual friend.

Her marriage to Fantin-Latour in 1876 marked the turning point in his career. As an artist, she understood and supported his endeavors. More than that, her own family became his. In these

later years he was to experience again a close family circle that alleviated the grief and loneliness he had carried with him after his sisters' departure shattered his home life some years before.

Both Victoria and her husband enjoyed painting still lifes. During the summer months, they stayed at Victoria's country property in Buré (Lower Normandy), where Fantin-Latour had a choice of numerous summer blooms for his compositions. Although Victoria was never as innovative, she also completed a number of highly competent still lifes [212] that reflect a familiarity with Chardin and those nineteenth-century painters who revived the still-life category during mid-century (e.g., Cals). Victoria exhibited at the Salons beginning in 1869, won an honorable mention in 1894, and a medal in 1895. Her portraits and still lifes were often inspired by her husband's compositions, suggesting that she worked very closely with him throughout the latter part of his career.

Jean Alphonse Duplessy
1817 Paris — ?

Although Jean Alphonse Duplessy was among the numerous painters of still life who emerged during the revival of this theme at mid-century, his career remains largely unrecorded. He was trained by an obscure artist named Dubouloz (1800-1870), and made his first appearance at the 1865 Salon when he showed two still lifes. His career may have been brief; the fact that he is not recorded in the Salons after 1872 suggests that he either gave up painting or that he died at about this time. The titles of his works from the 1860s suggest that there may have been moral overtones to his compositions, although the works themselves—for example, *Les Bibelots de la jeunesse* or *Les Bibelots de la vieillesse*—have never been located. Interior scenes such as *The Cobbler's Quarters* [133] or *Une Loge de portier: Ancien Paris* (1868 Salon) indicate that Duplessy was also a genre painter. Although his designation as a member of the Realist movement is now established, the observations he recorded in interior scenes have been lost to posterity.

Julien Dupré
1851 Paris — 1910 Paris

Among the painters associated with the Realists, several, including Constant Troyon, Rosa Bonheur, and Julien Dupré, were noted for their ability to paint animals.[1] These artists were also linked with the Barbizon painters. Underscoring a continuing dedication to the traditions of rustic life even during the latter decades of the century, Dupré concentrated on field workers harvesting hay or tending their flocks of sheep.

Trained in the academic studios of Isidore Pils, Laugée, and Henri Lehmann, Dupré developed an impeccable draftsmanship which he maintained in his finished oil paintings and in independent drawings which he also exhibited at the Salons.[2] First exhibiting an oil painting (*La Moisson en Picardie*) at the 1876 Salon, Dupré submitted similar scenes to the Salons until his death.[3] In 1880 Dupré received a third-class medal for his *Faucheurs de luzerne* (now in a private office in the Sénat, Paris), and in 1881 he obtained a second-class medal for his *La Récolte des foins*.[4] At the Paris Fair of 1889 Dupré was singularly honored with a gold medal for his dedication to field labor and rustic life.

JULIEN DUPRE

In almost all his paintings, Dupré's peasants loom large—whether milkmaids, girls feeding chickens or geese, harvesters, or women guarding flocks of sheep. While maintaining the Barbizon heritage initiated by Jean François Millet, Dupré achieved in his figures a presence usually associated only with Léon Lhermitte or Jules Breton. He proved a most popular painter in other countries, and many of his works entered public and private collections in the United States.[5]

1. While Troyon and Bonheur were essentially known as *animaliers*, a significant part of their work was figural studies, with occasional efforts in pure landscapes. Both painters have yet to be fully researched.
2. At the 1894 Salon Dupré exhibited a gouache of *L'Orage s'approche* and a pastel of *Vache au soleil*, which suggests that, like Lhermitte, he worked in many mediums.
3. Little information is available to document Julien Dupré's personal life; he may have died without descendants.
4. Karl Cartier, ''Silhouettes d'artistes—Julien Dupré, peintre,'' *Le Journal des Arts*, 9 May 1903.
5. Dupré's *Haying Scene* (1882) is in the collection of Washington University, St. Louis. The carefree attitude of Dupré's peasants perhaps contributed to his considerable popularity at the end of the nineteenth century.

Ignace Henri Jean Théodore Fantin-Latour
1836 Grenoble — 1904 Buré, Orne

The son of a portrait painter and pastellist, Ignace Henri Jean Théodore Fantin-Latour first studied with his father and then in 1850 enrolled at the Ecole de Dessin, where he spent the next six years studying with Horace Lecoq de Boisbaudran (1802-1897). During this same period he was also, briefly and unsuccessfully, a student at the Ecole des Beaux-Arts. While studying in Lecoq de Boisbaudran's atelier, Fantin-Latour made the acquaintance of a number of younger painters, including Alphonse Legros, Guillaume Régamey (1837-1875), and Otto Scholderer, a German painter (1834-1902) who moved to Paris in 1858. Fantin-Latour was influenced by Lecoq de Boisbaudran's theories of memory painting and working directly from nature, but he combined

HENRI FANTIN-LATOUR

these practices with the formal approach advocated by the Ecole des Beaux-Arts, making copies after old masters in the Louvre and working from plaster casts.

His first entries to the Salon, submitted in 1859, were refused, but a number of compositions by other artists (Alphonse Legros, James McNeill Whistler, and Théodule Ribot) were also rejected that year. These rejected compositions so impressed the well-established Realist artist François Bonvin, however, that he held an exhibition in his *atelier flamand*, to enable a number of the leading avant-garde artists (among them Courbet) to see and appreciate these works by younger painters. Bonvin's support undoubtedly helped to stimulate Fantin-Latour's career at a critical time.

Fantin-Latour made his first visit to England that same year, at the urging of his friend Whistler. This and subsequent visits in 1861, 1864, and 1881, and the contacts he made there, such as Edwin and Ruth Edwards who helped place his work on the English art market, established patronage and a stable income from portraits and still lifes that would continue throughout his career.

His first success at the Salon came in 1864, and during the 1860s his reputation as a portraitist (e.g., *Hommage à Delacroix* and *The Studio in the Batignolles*) and a painter of flower pieces continued to increase. While he frequently exhibited portraits at the Salons, he also completed many romantic compositions inspired by the music of Brahms, Schumann, Wagner, and Berlioz. His skill as a printmaker (he joined the Société des Aquafortistes in 1862) enabled him to produce lithographs of these romantic compositions, and by the end of the century, in addition to his other achievements, he was recognized as a master of lithography.

Fantin-Latour maintained an enthusiasm for the work of Eugène Delacroix, Camille Corot, and Jean François Millet throughout his career. His interest in contemporary painters of his own generation—especially Gustave Courbet—was short-lived. The two men met in 1859 and Fantin-Latour attended classes taught by the painter in 1861, but by 1865 Fantin-Latour was no

longer intensely allied with the Realist movement. By the end of the 1860s, he also became disillusioned with Alphonse Legros and James McNeill Whistler, once his close friends. His long-standing admiration for Edouard Manet was also tempered when this painter became increasingly involved with the Impressionists—a group Fantin-Latour disliked. His early predilection to paint nature and the everyday life he observed was thus superseded by a belief that art and contemporary life must never by united.[1]

Disenchanted with his colleagues and dissatisfied with his own personal life, he isolated himself from others and even lost interest in his own career. He was saved from total egocentricity by his late marriage in 1876 to Victoria Dubourg, a beautiful young painter who brought into his life not only the encouragement to continue painting but the stability of a close family circle he had been denied during the early part of his career. He continued to exhibit regularly at the Salons until 1899, and his portraits and still lifes from this later period retained the same high aesthetic quality, although Fantin-Latour ceased to evolve as a painter. He completed many of these later works in the solitude of his wife's summer home at Buré, and continued to remain apart from the stylistic changes and innovations of the Paris art world —preferring to paint only for his own pleasure.

1. Douglas Druick, entries on Fantin-Latour, in *The Other Nineteenth Century: Paintings and Sculpture in the Collection of Mr. and Mrs. Joseph M. Tanenbaum* (Ottawa: National Gallery of Canada, 1978), pp. 90-96.

François-Nicolas-Augustin Feyen-Perrin
1829 Bey-sur-Seille — 1888 Paris

François-Nicolas-Augustin Feyen-Perrin revealed an interest in art at an early age, but his father wanted him to study another field. With the perseverance and assistance of his older brother Eugène Feyen, who also was a painter, Feyen-Perrin was allowed to study art. He received his early training in his brother's studio in Nancy and later at the Ecole de Nancy. Later he went to Paris where he worked at the Ecole des Beaux-Arts in the studios of Drolling, Léon Cogniet, and Adolphe Yvon. While studying with Drolling, Feyen-Perrin established a lifelong friendship with Jules Breton that mutually benefited the two painters.

During the troubled days of the Revolution of 1848, the two young artists observed people in the streets and developed the theories that are found in their early works. Unlike many contemporary artists, Feyen-Perrin worked in many different media and used a variety of themes: from historical scenes, to landscape, to genre studies. According to some sources, his work first appeared at the 1848 Salon under the name of Auguste Feyen.[1] In 1853, still using the name Auguste Feyen, he exhibited a *Portrait* and listed himself as a student of Léon Cogniet and Adolphe Yvon.[2] Some of these early paintings, such as *Retour à la chaumière* (1855 Salon), reflect Realist inclinations, but Feyen-Perrin aspired to create "great art." By 1857 he was exhibiting historical and academic themes (e.g., *La Barque de Caron*), which he hoped would receive honors from the Salon jury. Feyen-Perrin did not abandon his Realist inclinations, however, and at the 1864 Salon exhibited *The Anatomy Lesson of Doctor Velpeau* [153], which depicted the famous surgeon about to perform a dissection. Although it failed to win a Salon medal, Feyen-Perrin's friends regarded this

FRANÇOIS-NICOLAS-AUGUSTIN
FEYEN-PERRIN

work as a major composition and it was later purchased by the government. In 1865, Feyen-Perrin received his first Salon medal for a historical theme. In 1867, he received a medal for *Vanneuse, souvenir de Cancale*, a Romantic landscape inspired by a trip to the Cancale in 1866, a region that he depicted in many later works.

Feyen-Perrin continued to exhibit allegorical themes at the yearly Salons, somehow convinced that these themes would provide lasting success. In 1875 he received another medal, and in 1878 he became a Chevalier of the Légion d'honneur. Although Feyen-Perrin fluctuated between several styles, his best work indicates a Realism influenced by the advent of photography.[3] Combining a sense of poetry with visual images, the painter's late work suggests a continuing relationship with Jules Breton, who often similarly combined literary associations and visual metaphors.

1. According to Bénézit and *Chronique des Arts* (1888), p. 254, Feyen-Perrin exhibited in 1848. Possibly he exhibited under the name Auguste Feyen, although the entry about this artist in the 1848 Salon catalog lists a different birthplace than the one normally associated with Feyen-Perrin.
2. See *Explication des ouvrages de peinture, sculpture, gravure, lithographie et architecture des artistes vivants, exposés aux Menus-Plaisirs, 15 May 1853* (Paris, 1853), p. 100, no. 455.
3. René Ménard, "Feyen-Perrin," *L'Art en Alsace-Lorraine*, 1876, pp. 413-414.

Marie François Firmin-Girard
1838 Poncin — 1921 Montluçon

Coming to Paris in the mid-1850s, Marie François Firmin-Girard entered the Ecole des Beaux-Arts about 1854, where he studied in the atelier of Charles Gleyre (1808-1874). He must have received several years of training by the time his *Saint Sebastian*, along with another history painting and a genre composition, was accepted by the Salon jury in 1859. During the 1860s, Firmin-Girard continued to exhibit at the Salons and in 1863 received a third-class medal. Inspired by fashionable themes that were appreciated by the middle class, Firmin-Girard completed innumera-

MARIE FRANÇOIS FIRMIN-GIRARD

ble Romantic themes and sentimental portraits. At the 1874 Salon he received a second-class medal; at the World's Fair in 1900, a bronze medal. Except during the Franco-Prussian War, when he was moved by the events he witnessed in Paris, he seldom displayed Realist inclinations.

Camille Flers

1802 Paris — 1868 Annet-sur-Marne, Seine-et-Marne

Camille Flers, like Philippe Auguste Jeanron and François Bonhommé, has been regarded as a proto-Realist.[1] Like other regional painters, such as the Leleux brothers, who dedicated their efforts to studying the effects of light and atmosphere in a particular region of the countryside, Flers devoted his career to landscapes of Normandy.

Flers's parents came from a comfortable middle-class background in Paris, where his father was a director of a porcelain manufactory (for the Nast brothers). At an early age, Flers was sent to boarding school, but when he showed little inclination for his studies, his parents encouraged his interest in art, apprenticing him to an elderly portrait painter named Demarcy, who had received traditional instruction from the pastellist Quentin de la Tour. (Some years later, in 1846 when his career as an artist was well established, Flers published an article in *L'Artiste* on how to complete pastels.) Flers then worked for his father at the porcelain manufactory and, later, under Ciceri, who assigned Flers to do theater decorations. Flers, however, was not ready to settle into a traditional mode in Paris. In 1818 he began studying with the landscapist Joseph François Paris. In 1820/21 he signed on as a cook on a boat bound for Brazil, and remained out of the country until 1823/24, visiting different locations in South America, especially Rio de Janeiro. When he returned to Paris, Flers resumed his career as a decorator of porcelains, working—like his father—for the Nast Manufactory. On weekends, possibly accompanied by his teacher and friend Joseph François Paris, Flers continued his painting, making trips throughout the countryside, vis-

iting St. Cloud, Belleville, and Montmorency, completing studies of trees and valleys and perfecting his interest in light and atmosphere. Sometime near the end of the 1820s, Flers traveled to Switzerland, and there he completed *Vue du village de Pissevache-Bas-Valais*, his first entry accepted at the Salon (1831).

The immediate enthusiasm his landscapes received from critics encouraged Flers to find new locales and inspired him to seek out lesser known regions where he could record his impressions. He began exhibiting landscapes of Normandy (e.g., *Vue prise à Moulinot, Normandie*) in 1834, and became an expert on the scenes of this region, specifically of the Aumale valley. Critics noted two important contributions in his work: he was the first to recognize the beauty that could be found in the study of a single tree; and he discovered "virgin forests of a new world," forecasting an appreciation of deeply secluded nature that would be fully realized only by the Barbizon painters in the Forest of Fontainebleau.[2] While Flers's compositions suggest that they were painted directly on the scene, numerous preliminary drawings that have been found of his major compositions reveal that many of his landscapes were carefully developed—and often reworked in the studio.[3] Supported by such critics as Théophile Gautier, Théophile Thoré, and—later—Philippe Burty, Flers achieved some official success as early as the 1840s. At the 1840 Salon he received a third-class medal; at the 1847 Salon, a second-class medal. He was awarded the Légion d'honneur in 1849 and continued to exhibit at the Salons until 1863. Flers remains a significant regional landscape painter whose small canvases were collected by many of his colleagues, including Eugène Delacroix.

1. Linda Nochlin, *Gustave Courbet: A Study of Style and Society* (New York: Garland Publishing Co., 1976), p. 115. Flers was seen as a painter interested in contemporary life because of his use of provincial landscape vistas.
2. Flers's influence as a precursor of the Barbizon movement has not been fully studied.
3. Philippe Burty, "Camille Flers," in *Maîtres et Petits Maîtres* (Paris, 1877), p. 107. This article was first published in 1868, at the time of Flers's death.

Guillaume Fouace

1837 Réville, Manche — 1895 Paris

Salon juries and critics regarded Guillaume Fouace as another of the many still-life painters who had been influenced by Chardin.[1] A number of Fouace's genre paintings [187], portraits, and landscapes, however, also establish him as a Realist affected by the life of northern France, especially the region near his native village, Réville.

Fouace's parents were simple, untutored farmers, and they reared Guillaume and his brothers, Pierre, Jean and Benjamin, to be farmers. Hence, Guillaume enjoyed little formal education and few opportunities to draw or paint. While proud of his native talent, his parents were not ready to accept the idea that Fouace might make a career as a painter. In 1841, his brother Benjamin died. His two older brothers soon married. After a long illness, Fouace's father died in 1861, leaving only the young artist and his mother to maintain the family farm. With even less time to devote to his art, Fouace, nevertheless, continued to paint, eventually becoming known even beyond his small, regional community.

CAMILLE FLERS

Bringing his paintings to Cherbourg, Fouace met François Henry, a town councilor, bookseller, and collector of paintings. Recognizing Fouace's ability, he discussed with the painter's mother the need for Fouace to study in Paris, despite her concern for the farm and her fear that Paris would corrupt him. Finally, under the firm persuasion of François Henry, she accepted the idea. In a request dated 13 May 1867, Henry then asked the Municipal Council of Cherbourg to provide the money, noting as proof of Fouace's talent copies of several paintings he had done from the local museum.

On 15 July 1867, the town council voted to award Fouace a subvention of 600 francs, similar to the amount they had given Jean François Millet at an earlier date. To this small sum, Fouace's mother added 200 francs.

Arriving in Paris, perhaps in time to see part of the World's Fair of 1867, Fouace found lodging at 141 rue de Sèvres. He spent much of his time studying the collections in Parisian museums; at Versailles he also copied two portraits. After five months of frugal living, his funds depleted, Fouace was forced to return to Cherbourg. To make a living, he painted portraits, in particular, one of Thomas Henry, founder of the Cherbourg Museum, who died in 1836. The city, once again recognizing his ability and willingness to work, gave him another subvention to return to Paris.

In Paris, Fouace entered the atelier of Adolphe Yvon (1817-1893), a well-established history and portrait painter of the Second Empire. To perfect his draftsmanship, Fouace also studied at the Ecole de Dessin. After two years with Yvon, Fouace submitted works, including a *Portrait of Thomas Henry* (possibly the canvas Fouace completed earlier in Cherbourg) and a *Portrait of M. D. . . .* to the 1870 Salon. The number of votes in favor of accepting Fouace's canvases is unknown; that Jean François Millet was an elected member of the 1870 Salon jury may have enhanced Fouace's chances of Salon acceptance, since the painter had also come from Cherbourg. Fouace's Salon entries established his name in Paris, and he began to attract a few collectors who purchased his work.

GUILLAUME FOUACE

Following army service in the Franco-Prussian War, Fouace opened an atelier on rue Neuve Saint-Méry in Paris. Here Fouace painted other portraits, including that of *l'Amiral Ducrest de Villeneuve* (1872 Salon), and added still life, landscape, and seascape to his repertoire of themes. Each summer Fouace returned to Réville and Cherbourg to find new themes for his genre paintings and to renew acquaintances. Recognizing his own talent for still-life painting, and knowing that collectors were eager to pay good prices for them, Fouace exhibited *Pommes* and *Pot-au-feu* at the 1873 Salon. His success in this genre may have led Fouace to paint directly for collectors, for he did not submit works to the Salons in 1874, 1875, and 1876.

In 1874, well-established in his career, Fouace married Adèle David.[2] His wife's parents had a country home near Réville and had always hoped that Fouace would marry their daughter, who was eleven years younger than the painter. Once married, Fouace moved into new Parisian quarters at 130 rue d'Assas where he opened an even larger atelier, although Adèle's parents reserved part of their home in Réville as a summer studio for Fouace. A daughter, Béatrix, was born in 1875, and another, Catherine, arrived in 1879. Fouace began to do portraits of his children and sent a study of Béatrix to the 1879 Salon.

Although Fouace was most interested in doing portraits, he found collectors wanted his still lifes. At the 1878 Salon, he exhibited two: *Lapin domestique* and a *Still Life*. The same year, Fouace received an unusual commission from the Abbé Goutière to decorate the interior of the church at Montfarville. Working in an academic style, Fouace began in 1878 and completed in 1881 a cycle of nineteen paintings representing the life of the Virgin and Jesus. From the money he received, Fouace was able to purchase a new home on rue Jonville, Réville.

Regularly exhibiting at the Salons, Fouace submitted *La Bernière fileuse de mon village,* a portrait of his aged mother, to the 1881 Salon. With his children growing up and his status as a painter improving, Fouace moved to a larger Parisian apartment at 18 rue Vavin. In the early 1880s he continued to send portraits and genre

scenes to the Salon, but he also turned to new themes. In 1883, attracted by the sea he loved, he completed six paintings in Jersey including *Un Convive inattendu*. This painting brought him his first official Salon award, an honorable mention in 1884. Unaffected by the lack of governmental patronage, Fouace found support among numerous private collectors and remained free to send many types of work to the Salon. In 1885 he submitted another still life and his impressive *The Stonebreaker's Lunch* [203], a large canvas based on rural life, utilizing models from Réville.

Unhappy events overtook Fouace in 1886 when his mother died, and in July 1888 when his first daughter Béatrix passed away. Frustration grew late in his career because the Salon jury still considered him only a still-life painter and remained unimpressed by his genre paintings. Hoping for wider recognition, he became a member of the Société des Artistes Français. He did, however, receive another honorable mention at the Salon in 1889 for *Le Déjeuner de carême*, a painting purchased by the state and later sent to Cherbourg.

After 1890 Fouace exhibited only still lifes at the Salon, receiving a gold medal in 1891, his highest award. His paintings were widely sold outside France, but official recognition (even receipt of the Légion d'honneur) came too slowly and often too late. In spite of this, Fouace enjoyed a good reputation, was able to sell his paintings to private collectors, and achieved fame as a staunch still-life painter and regional Realist.[3]

1. Noted by Gustave Larroumet in *Catalogue des oeuvres de Guillaume R. Fouace exposées à l'Ecole Nationale des Beaux-Arts* (Paris, 1895).
2. For further information on Fouace see Jean Le Jeune's excellent monograph *Guillaume Fouace, 1837-1895* (Paris: Editions OCEP, 1976).
3. Ibid., p. 104.

Pierre Edouard Frère
1819 Paris — 1886 Ecouen

Some critics of the nineteenth century recognized Edouard Frère as the typical example of an anecdotal painter who succeeded in attracting a large public.[1] The art critic Albert de la Fizelière, writing in 1864, acknowledged Frère's fame: "Edouard Frère has for a long time been a favorite of collectors and one of the artists whose work brings high prices in the sales rooms [of Paris]. . . . Collectors in Holland and England purchase his little interiors . . . painted with a profound sentiment for reality and with a charm that characterizes the masters of Flanders. . . ."[2]

Frère's popularity was largely due to his ability to select themes which recorded the commonly shared incidents of daily existence and especially the activities of children. While Frère had been trained in the Parisian atelier of Paul Delaroche and his works were first accepted at the Salon in 1842, unlike most artists—who equated Paris with success—Frère found Paris intolerable. He moved his family to the small rural village of Ecouen and remained there the rest of his life.

By the 1840s Frère posed models against the simple backgrounds of peasant cottages, giving interest to the humblest themes and the most traditional activities. During the 1850s Frère was awarded medals at the 1851, 1852, and 1855 Salons.[3] After the 1855 exhibition he also received the Légion d'honneur, becoming one of the most popular painters to attract the general public during the Second Empire. Frère's acclaim was fos-

PIERRE EDOUARD FRERE

tered by his ties with art dealers and critics who sponsored his work in France, England, and Holland. Recognition of Frère's work by John Ruskin, the English critic, inspired an adulation for Frère's work that further encouraged collectors in Great Britain.[4] By 1868 he was exhibiting annually at the Royal Academy, and he continued to participate in these shows until 1885.

Frère painted the history of childhood from babyhood on, creating small compositions that were avidly collected by the middle class. By the early 1860s he also attracted a number of students, who came to work near Ecouen. Among them was George Boughton, a friend whose own paintings reveal a close affinity with Frère in compositional arrangement and formulation of an anecdotal type of painting. While the names of many of the painters of the Ecouen school remain unknown, Frère influenced many of the later painters who created popular images for a widespread audience. By the 1880s Frère's paintings were being collected in the United States, where the same interest in sympathetic portrayals of the commonplace found a ready market.

1. Paul Mantz, "Salon de 1863, peinture," *Gazette des Beaux-Arts* XIV (June 1863): 505. Frère's brother, Charles-Théodore Frère, was a well-known painter of Oriental subjects.
2. Albert de la Fizelière, "Salon, 1864," *Union des Arts*, 2 July 1864.
3. Frère received a third-class medal in 1851 and second-class medals in 1852 and 1853. See "Edouard Frère," *Chronique des Arts*, 1886, p. 172.
4. Jules Claretie, *Peintres et sculpteurs contemporains* (Paris, 1873), p. 269. In 1873 Frère exhibited at Agnew's Gallery in London. For further reference to Frère's support in England see John Ruskin, "1856-1859," and "1876," in *The Works of John Ruskin*, ed. E.T. Cook and Alexander Wedderburn (London: George Allen, Layman's, Green and Co., 1904).

Amand Désiré Gautier
1825 Lille — 1894 Paris

As an active participant in the Realist movement during the 1850s, Amand Gautier made the acquaintance of a number of the key painters who commonly gathered at the Brasserie Andler and who exhibited in the annual Salons.[1] His closest friendship, however, was not with a painter, but with Dr. Paul Gachet (the famed surgeon who cared for Vincent van Gogh during his last years), who, like Gautier, came from Lille and shared his quarters with Gautier in Paris.[2]

Gautier came from a modest background. His parents struggled to make ends meet, for his father was a tailor. After attending school at the Frères d'Ecoles Chrétiennes, Gautier was apprenticed to a lithographer, so that he could have the security of a practical trade. Here he designed labels for a variety of products, such as coffee or thread, but his obvious abilities convinced his parents that he deserved artistic training. He entered the Ecole Académique in Lille in 1845, where he took drawing lessons from Cadet de Beaupré and, because of his talent, was awarded a municipal grant of 600 francs to pay for his instruction. He then worked in the atelier of François Souchon (1787-1857), a student of the Davidian tradition.[3] By the late 1840s, Gautier's work was well recognized by the Academy; he received medals in 1847, 1848, and 1850. He also studied in the Lille Museum, where he became acquainted with Louis and Paul Ferdinand Gachet. In 1850, with the support of another financial grant from the regional government, he left Lille to study in Paris. He entered the studio of Léon Cogniet in April 1852 and became friends with Adolphe-Félix Cals and Alexander Schanne (a friend of the critic Champfleury and the writer Mürger), who were also studying there.

His closest companion and strongest influence, however, remained Paul Gachet, who had come to Paris in 1848 to continue his medical training. Gautier shared Gachet's small apartment for a time. But the friendship extended much further. It was Gachet who introduced him to the medical staff at the hospital for Enfants Trouvés where he was receiving his own training, and where Gautier received permission to observe and make studies of the patients. Gautier also accompanied Gachet in 1854 during the cholera epidemic in the Jura Mountains where he made a series of detailed sketches of the sick. Later, in the mid-1850s, he met Doctor Trousseau, who permitted him to study the inmates at the La Salpêtrière hospital. Like the Romantic painters (Géricault, in particular), Gautier became interested in studying various mental disorders and attitudes, and completed a series of drawings and oil sketches that were probably intended as preparation for the large-scale Les Folles de la Salpêtrière he exhibited at the 1857 Salon.

Even though Gautier began exhibiting in 1853 and continued to do so until 1888, his composition Les Folles de la Salpêtrière established his importance in the Realist movement—and remained the most impressive of his works. The canvas—now lost—attracted considerable comment, for it revealed all the concepts and techniques upheld by the Realists, specifically Gustave Courbet. Maxime du Camp, in his review of the 1857 Salon, commented on Gautier's ability to render the truthfulness of the pathetic situation of those incarcerated in an insane asylum. Théophile Gautier, in his review, found the work far more moving than any image inspired by imagination,

"sadder than reality itself." Even Charles Baudelaire, who usually reserved his commentary for the Romantics, discerned in Gautier's canvas "a faithful and intelligent amount of observation." Gautier's success with this theme led some critics to wonder why other Realists did not also paint the deranged, because these models never assumed artificial poses, but were continually dominated by their actual impressions and inner thoughts. While he never again achieved the overall success he experienced with Les Folles, Gautier maintained his dedication to the Realist movement, and remained closely allied with Courbet and those who gathered at the Brasserie Andler. His close friendship with the dean of Realism was acknowledged in 1866 when Courbet painted his portrait [150].

Gautier counted on Doctor Gachet to contact Alfred Bruyas, the local patron of nineteenth-century painting, when he traveled to Montpellier in the late 1850s. Bruyas was purchasing paintings and commissioning many painters to do works specifically for him, and Gautier hoped to establish a similar arrangement.[4] While there is no record of Bruyas's patronage, Gautier was successful in receiving the support of M. Gaudibert of Le Havre.[5] Gaudibert was a wealthy shipowner whose purchases had helped provide financial support for several French artists, including Eugène Boudin and Claude Monet. When Gautier traveled to Le Havre in 1858, he did portraits of the Gaudibert family as well as many seascapes and still-life compositions. The exhibition of Les Folles in Le Havre in the summer of 1858 also contributed to Gautier's success in that city, even though at this period in his career he was receiving more renown—and displaying considerable assuredness—as a portraitist.

Gautier missed Paris and his Realist colleagues too much to remain away from the capital, although he continued to return to Le Havre each year to renew his contacts and to exhibit his work in local shows. While he received an honorable mention for his portrait of Doctor Gachet at the 1861 Salon, his recognition was slight and his financial position never secure. His only real support was provided by his friendship with Gaudibert and his yearly visits to Le Havre. He joined his colleagues in their efforts to free art from the confines of official control, and his entry at the Salon des Refusés (1863), La Femme adultère, was praised by the art critic Castagnary as an important composition, although the work is unfortunately now lost.[6]

Gautier also made friends with many of the younger painters, and by the early 1860s knew Claude Monet, visited the studio of Camille Pissarro [121] and, as a member of the Société des Aquafortistes (the group instrumental in the revival of etching), met Charles Méryon and did a series of prints published by the editors Cadart and Chevallier (1862).[7] During the 1860s he continued to support himself by completing portraits, some as official commissions, which he regularly exhibited at the Paris Salons.[8] His career improved, and critics noted that his work rivaled Carolus-Duran, then one of the most popular portrait painters of the Second Empire.[9]

Even though this was a period of some financial stability, two national events affected him personally and disastrously. Most of his early paintings were destroyed in the Franco-Prussian War, despite the efforts of his friends to save them. Like Théodule Ribot and Camille Pissarro, whose studios were also vandalized by the Prussians,

AMAND DESIRE GAUTIER

Gautier's position in the development of Realism, remains largely unknown due to a paucity of works.

A second event, his association with the Paris Commune, also affected his career and his position in French art. In April 1871 Gautier and Courbet were both elected to membership in the Fédération des Artistes, a loosely aligned group of independent artists who supported the insurrection of Paris. When the Commune was dissolved in June 1871, Gautier was arrested, charged by the Préfecture de Police with usurping public interest, and imprisoned. Unlike Courbet, who had also been arrested, Gautier was eventually acquitted. His loyalty to Courbet during this period, however, did not waver—even when his more famous colleague was unjustly persecuted. Like Claude Monet and Eugène Boudin, he continued to visit Courbet (ca. 1872) until the painter fled to Switzerland. For Gautier, it was a time of depression and discouragement, and he almost gave up his work, for he saw his closest friends disappearing and found himself excluded from many of the old circles because of his association with the Commune.

He did not exhibit again until the 1874 Salon. The enthusiasm evident in his earlier works was now gone, and critics who saw him at the exhibitions commented on his premature aging. He continued to participate in the Salons throughout the 1880s, usually still lifes and scenes of nuns, although he moved out of Paris and settled in the more remote village of Ecouen, where he may even have become acquainted with Edouard Frère. During the 1880s he received a third-class medal (1882 Salon), but he could not earn enough money from his paintings to pay his bills. A friendly supporter, the critic Armand Silvestre, solicited the aid of the well-established printmaker Félix Bracquemond and the sculptor Dalou, in an unsuccessful attempt to obtain a commission for Gautier. His last years were confined and impoverished. When his few remaining friends discovered his deplorable state, he was placed in an old-age home, where he died in 1894. Poor and forgotten, he was buried in a common grave in the Pantin cemetery.[10]

1. Gautier has been identified as both *Armand* and *Amand*. The correct identification—and the one used by Gautier's close friends such as Dr. Paul Gachet—is Amand. This spelling is found in the Salon catalogs during the 1850s and 1860s.

2. The author is indebted to Paul Marcus for providing information on the life of Amand Gautier. The documents prepared by Dr. Paul Ferdinand Gachet—and preserved by M. Marcus—contain the most detailed and accurate account of Amand Gautier's career.

3. Souchon also trained Narcisse Diaz and Charles-Emile Carolus-Duran when they worked in Lille.

4. Amand Gautier to Doctor Gachet 22 March 1858, now in the possession of M. Marcus, Paris.

5. Noted in the documents on Amand Gautier preserved by M. Marcus, Paris.

6. Jules Antoine Castagnary, *Salons (1857-1870)* (Paris: Bibliothèque Charpentier, 1892), vol. 1, pp. 168-69.

7. The edition included six etchings: *Chaumières, La Repasseuse, Le Rat blanc mort, Le Repos, Le Travail,* and *Les Soeurs de Charité*.

8. The names of many of the sitters remain unknown. Some of Gautier's still lifes from this period were owned by private collectors.

9. Léonce Bénédite, *Art et Décoration* XXIII (1908): 141.

10. Gautier's daughter Marie was also an artist. Little is known about her life or her relationship with her father except that she may have moved to Algeria. She was married to the painter F. Antoni.

HENRI GERVEX

Henri Gervex
1852 Paris — 1929 Paris

Henri Gervex, son of Henri Alexandre Gervex, was born in Paris on 10 September 1852.[1] In 1867 the painter Pierre Brissot, a recipient of the Prix de Rome, noticed the young man's talent and gave him his first lessons. Soon after that, Gervex was accepted in the atelier of Cabanel for five years. (Cabanel's was one of three ateliers installed in the Ecole des Beaux-Arts at the request of the Emperor; the other two were run by Jean-Léon Gérôme and Isidore Pils.) During the five years he remained with Cabanel, he became acquainted with Henri Regnault, Bastien-Lepage, Jean Louis Forain, among others, and, with them, often went to the Louvre to copy antiques. It was Carrier-Belleuse, the sculptor, who influenced him most directly and who finally dissuaded him from copying the old masters.

Gervex first exhibited at the Salon des Artistes Français in 1873 with a painting entitled *Baigneuse endormie*. At the time, artistic life revolved around the Salon and a medal indicated not only Salon recognition but assured commissions from the state as well. The next year, at the same Salon, he exhibited *Satyres jouant avec une bacchante* (Musée de Montluçon) and received a second-class medal and a favorable review in *Gazette des Beaux-Arts*: "[It is] a brilliant and highly colored piece by a young beginner, for whom we predict a wonderful future if he continues to nurture carefully the gifts that nature has given him."

In 1875 Gervex continued at the same Salon, exhibiting *Diane et Endymion* (Musée d' Angers). In 1876, he exhibited *Autopsie à l'Hôtel Dieu* (formerly in Limoges), a painting now lost and possibly destroyed in World War II, for which he received another medal (*Rappel de médaille*). The work, depicting a modern theme, further established his reputation. As Gervex explained it, "This Realist subject par excellence had not been my choice; it had been suggested to me by chance. I had discovered, during my strolls, the autopsy room at the old Hôtel Dieu just as Parisians discover the picturesque or little known

corners of their city. . . . What a scene! I told myself, 'If I can manage to capture the principal characteristics and if I am able to treat them as Granet would have, while keeping what is modern about the scene and all the details, I will have created a work of art.'"

In 1877, at the Salon des Artistes Français, he exhibited a *Portrait de mon ami Brispot*, a representation of a fellow artist. This painting was sent to the Beauvais Museum and later destroyed during a fire which devastated the museum in World War I.

At twenty-six, Gervex created the major work of his career, *Rolla* (Musée de Bordeaux), a composition inspired by the writing of Alfred de Musset. Gervex wrote: "It's daybreak, but on the table a lamp is still lit, and it is precisely this contrast between the artificial light of the lamp and the cold light of morning which had seduced me. . . . I confess that I placed a great deal of hope on the effect of this light and also on such details as the disarray of clothing near the bed close to the naked skin of the woman—which seemed quite daring at the time. My expectations were not betrayed and all my comrades who came to see me predicted the greatest success. Among them were Manet, Degas, Stevens, the young, and the more mature, all of them passing in front of a painting, which was famous even before the Salon. . . . Nonetheless, as soon as my painting was hung in one of the [Salon] rooms, the superintendent of the Beaux-Arts, M. Turquet, gave the order to remove it under the pretext of immorality. This was done with the tacit complicity of the Salon jury. . . . It was then that a dealer offered to exhibit *Rolla* in his gallery on the Chaussé d'Antin. . . . I accepted, as one can imagine, with gratitude, and for three months it received an uninterrupted succession of visitors and a line of cabs parked as far as the Opéra. This exhibition was an excellent thing for me."

Rolla brought to Gervex immediate notoriety —in spite of semi-adverse commentary in the *Gazette des Beaux Arts*: "Oh to be young, to have the honor of being an artist, to feel the talent in oneself, and to create such a work! But to use a sacred art to excite unhealthy thoughts, this is a profanation. While we recognize the first-rate

qualities of the work, we hope that it is but an accident in the life of the artist—perhaps only a youthful indiscretion. We thank those strong minded individuals who refused to compromise the Universal Exhibition of 1878 by its presence."

In 1879, Gervex's paintings for the Salon were entitled *Retour de bal* and *Portrait de Mme. Valtesse de la Bigne* (Musée du Louvre). Mme. de la Bigne was a product of the Third Republic; she was the mistress of a rich banker who lived in a hotel he had acquired at the Boulevard Malesherbes and the rue de la Terrasse. She entertained frequently and since she took an interest in literature, art, and politics, her gatherings included representatives from all these different worlds. She particularly sought out painters. Manet did her portrait, Détaille was an intimate friend, Gervex was often invited to her fancy dinner parties, and it was he who first brought Zola, then writing *Nana*. Zola had never been in the company of such a high-class courtesan and was eager to record this milieu.[2]

In 1880, Gervex exhibited *Souvenir de la nuit du 4* (Musée de St. Etienne), a work subtitled in the Salon catalog with Victor Hugo's words: "L'Enfant avait reçu deux balles dans la tête." Many interpreted this as an allusion to Napoleon III's coup d'état, and after this, the painter did not dare show his face at Princess Mathilde's salon, even though they were on intimate terms.

At the 1881 Salon, Gervex exhibited *Le Mariage civil*, a decorative panel for the town hall of the Nineteenth Arrondissement in Paris. It was one of the panels presented at a competition, the first organized by the City of Paris, for the decoration of four town halls and two schools. The entrants of registered projects totaled 154 and amounted to 383 studies. The exhibition took place at the Ecole des Beaux-Arts from 28 January to 11 February 1881. Gervex, with the painter Blanchon as his partner, won first prize, and his work was designated for the most important and extensive of the commissions. His part in the project, which was to decorate the Salle des mariages, included three panels and a ceiling. Gervex, commenting on this commission, said: "I had gone into partnership with a friend, Blanchon, and together we had imagined something quite original. Instead of representing the eternal mythological subjects in the style of David, we walked around the neighborhood of that particular *Mairie*, noting all the picturesque details, all the amusing places that distinguished this particular corner of Paris."

Edmond About wrote on *Le Mariage civil* (see Figure 26) in 1881, in *L'Année Artistique*: "as for this wedding by M. Gervex, don't you think as I do that in spite of the touch of the artist, the panel will be a foolish duplication in the Mairie of the XIXth arrondissement since it merely repeats the types, the dress, the grimaces, and the banalities which pass through this 'civil temple' three or four times a week."

In 1881, at the Cercle de l'Union Artistique, Gervex also exhibited *Femme en soirée*. At the Salon in Brussels, he received a medal for his entry *Le Retour du bal*, a work which had been exhibited the previous year in Paris. At the 1882 Salon des Artistes Français, Gervex exhibited *Les Bouchers de la Villette*, the second decorative panel planned for the town hall of the Nineteenth Arrondissement; and it was for this work that Gervex received the Légion d'honneur.

Manet and Gervex became close friends because of the support Gervex had given the older painter in Brussels, and this friendship is reflected

in Manet's painting *Nana*, which was exhibited at the Cercle de l'Union Artistique in 1882. The identity of the model for Manet's painting has frequently been debated. It has been thought that Manet's painting was inspired by Zola's *Nana*, but the painting was completed before the book was published. The painting, which portrayed a young woman at her toilet, is a study of Gervex's model Anna. Manet called his work *Nana* in honor of this young woman from Montmartre because—despite his friendship with Gervex—at the same time, he could not refrain from being a little envious of the luck of this young artist. Manet, already in his fifties, still found his talent contested and he had received none of the official awards.[3]

In 1884, Gervex exhibited *Portrait de M. Alfred Stevens* at the Salon des Artistes Français. He also became a member of the committee which organized the Manet retrospective at the Ecole des Beaux-Arts and for which Emile Zola wrote the preface for the catalog. At the 1885 Salon Gervex showed *Une Séance du Jury de peinture* (Reims), depicting a number of other painters, among them Cabanel, Carolus-Duran, Harpignies, Bouguereau, Henner, Bonnat, Benjamin Constant, Puvis de Chavannes, Détaille, and de Neuville. In that same year, Gervex went on a trip to Italy with the novelist Guy de Maupassant, with whom he remained friends and of whom he painted the only known portrait.

Gervex exhibited *La Femme au masque* in 1886, a work which resulted in a duel with a Parisian gentleman who was convinced—wrongly—that he had recognized the visage of his wife in the unclothed depiction of the woman in the painting, even though her face was covered with a veil. In 1887, Gervex continued his contemporary themes with *Avant l'opération* (Musée de l'Assistance Publique, Paris), a portrait of Doctor Péan, a famous surgeon of the time.

By 1889, Gervex and Alfred Stevens undertook the panorama of the luminaries of the century represented in the 1889 Exposition Universelle. The panorama measured 120 meters in length and 20 meters in height, and was done with the help of perhaps ten collaborators. When no buyer could be found for this huge work, it was cut and sold in pieces. That year Gervex was made an officer of the Légion d'honneur and named a member of the jury for the World's Fair. In 1890 Gervex exhibited *Les Fondateurs de la République française* (Versailles)—joining the many artists who were now exhibiting at the Société Nationale des Beaux-Arts.

The following year he exhibited *La Musique*, a decorative ceiling for the Hôtel de Ville. Gervex exhibited *Village de Villeray* at the Société Nationale des Beaux-Arts in 1893. In this same year he married Henriette Fauche, a figure who appeared in many of his genre paintings. The village of Villeray and its environs—where his wife's family owned property—is the setting in many of his landscapes.

By 1896 Gervex made his first trip to Moscow, where he was officially invited to reproduce the crowning of the Tsar; a second trip was made in 1897 to paint the portraits of the Imperial family. He exhibited *La Distribution des récompenses au Palais de l'Industrie* at the 1897 Salon. His *Yachting sur l'Archipel* was exhibited at the 1899 Salon, a work he completed on the yacht *Lysistrata,* which belonged to Gordon Bennett, director and owner of the *New York Herald*. The *Lysistrata* was the largest private yacht in the world at this time and Gordon Bennett had equip-

ped it with all the modern conveniences. When he was not in Paris or New York, he would take friends, such as Gervex, on cruises. Gervex also received assignments to do illustrations for the *New York Herald* from Bennett.

In 1900, at the Russian Pavilion at the Trocadéro, Gervex exhibited *Le Couronnement du Tsar*, a work which was purchased by Russia in 1901 and which Gervex accompanied to Moscow to present to the Tsar. He also completed *La Fête des fleurs*, one of the panels for the decoration of the ceiling of the restaurant of the Gare de Lyon.

Gervex continued to exhibit at the Société Nationale des Beaux-Arts, showing *Banquet des maires* and *Portrait de S. A. I. le prince Victor* in 1902. Following the Salon, Bennett asked Gervex to paint his portrait, a work which was exhibited in 1903. *Louis XVI et Parmentier dans la plaine des Sablons*, a panel destined to decorate the Mairie of Neuilly, was exhibited at the 1904 Salon; he also exhibited *Vue de Venise, le Palais des Doges*, another work he had painted on Bennett's yacht.

In 1905 Gervex exhibited *Etude pour le plafond de la mairie du XIXe arrondissement*, and an exhibition of his work was held at the Georges Petit Gallery (Paris). Ensuing years saw Gervex completing themes of art, industry, and agriculture for the decoration of the private hotel of M. Dufayel, a rich industrialist. Gervex also continued doing such themes as *Naissance de Venus* (Musée du Petit Palais) and *Le Cercle de Puteaux*, which was the first of his three large paintings depicting the fashionable society of the time (others were entitled *Armenaville* and *Le Pré Catelan*). A painting on the ceiling of the Elysée was called *La France recevant les nations*. In 1911 he became a commander of the Légion d'honneur, and in 1913 a member of the Institut de France. From 1914 to 1921, he exhibited paintings and illustrations inspired by the war. In 1924, four years before his death, he held his last exhibition at the Galerie Charpentier, largely an exhibition of portraits and landscapes. Adapted from J. F. de C.

1. Biographical information and quotes on Gervex have been supplied by Jean-François de Canchy, Musée National d'Art Moderne, Paris.
2. Jules Bertaut, *Les Belles Nuits de Paris* (Paris: Ed. Tallandier, 1956).
3. Georges Rivière, *Renoir et ses amis* (Paris: Flourey, 1921).

Jean Gigoux
1806 Besançon — 1894 Besançon

Like Philippe Auguste Jeanron and François Bonhommé, Jean Gigoux is considered a proto-Realist.[1] Gigoux's earthiness, his dedication to genre themes, the simplicity of his style, and his natural compatibility with the Realists who met at the Brasserie Andler in the early days to discuss left-wing sympathies make him a beloved figure in the early Realist movement. These endearing aspects, combined with his interest in painting his native countryside and his dedication to the history of Besançon, confirm the belief that his talent was expansive and based upon actual observation. Gigoux's artistic abilities, however, ceased to mature after the 1840s, and the rest of his career was confined to the painting of history in a style lacking in both scope and imagination.

Although he came from an uneducated family (his father was a blacksmith), Gigoux was determined to become an artist. His first lessons were

JEAN GIGOUX

with a painter named Mlle. de Fauveau, who encouraged his efforts when he was no more than thirteen. He also attended the free drawing school of Besançon, where he received an award in 1823 for a landscape after an engraving. In spite of this modest recognition, his father wanted Gigoux to become a veterinarian. Because of the local commissions Gigoux received for church murals, however, he was able to follow his own inclinations and he soon left for Paris, where he received the encouragement and guidance of his close friend, the art critic Gabriel Laviron. His previous training as a printmaker in Besançon enabled him to publish a series of lithographs in 1828 (soon after his arrival) entitled *Etudes de paysages près de Besançon* that emphasized his deep commitment, even at that time, to his native region.[2]

Although Laviron and Gigoux had both studied painting in Besançon under the artist Flajoulot (1774-1840), it was not until Gigoux entered the Ecole des Beaux-Arts in April 1829 that his academic training really commenced. In order to support himself, Gigoux continued to do prints, lithographing the works of Raphael and producing images for the periodical *L'Artiste*. He also earned enough to enable him to travel with Laviron to Normandy, where he did his first studies "after nature" in Rouen, Jumièges, Le Havre, and other rural locations. These early years also provided the opportunity to meet many of the Romantic painters (e.g., Delacroix, Signalon, Delaroche) who were to remain his friends throughout his career.

In 1830 Gigoux became an active participant in the revolution. His letters to his parents record the events in Paris, and at the end of the conflict he went to England, where he remained for two months, returning to France in January 1831. Eager for Salon competition and official recognition, Gigoux exhibited several pencil drawings and lithographs in the 1831 Salon. In 1833 he exhibited five paintings, four of them portraits. His entries that year, which probably included *The Blacksmith* [27], impressed the critics and he received a second-class medal.[3] For the 1834 Salon he submitted eight compositions, four of them portraits—among them his *Portrait of Gabriel Laviron* [131]. Both *The Blacksmith* and his por-

293

trait of Laviron reflect aspects of Realism because they were based on direct observation, were simple in color tone, and were small in format.

In addition to an extensive number of Salon entries during the 1830s, Gigoux was also an industrious printmaker. In 1835 he illustrated *Gil Blas*, a work for which he received recognition as a master printmaker ranking with Achille Devéria or Eugène Delacroix.

Even though some of Gigoux's works contain Realist qualities, Gigoux was not considered a Realist. His greatest composition, *Les Derniers Moments de Léonard de Vinci* (1835 Salon), must be classified as a Romantic historical composition, although it does embrace some of the characteristics that Paul Mantz outlined in his essay on Realism in 1889.[4] For *Les Derniers . . .* Gigoux was awarded a first-class medal in history—a recognition so important to Gigoux that it set the course for the remainder of his career. Gigoux's success as a painter continued, first under Louis Philippe and, later, during the Second Empire. He received a number of official commissions for murals, and the government paid lavish prices for his work.[5] His desire for official recognition predominated, and he continued to exhibit at the Salon until 1894, five years after he received a grand prize at the 1889 World's Fair.

Despite his eminence in the art world and his membership in the Légion d'honneur in 1842, he was nevertheless severely censured by the more progressive critics. Arsène Houssaye, Paul Mantz, and others found his history painting so weak that he was forced to give up this category by 1860 and to return to genre painting and portraiture. The harshness of such criticism did not deter him, and Gigoux continued to receive the support of each succeeding French government, most likely because he was congenial enough to maintain friendships that would promote his career. While Gigoux is most often associated with the first-generation Romantic painters, he was also close friends with Jean-Jacques Henner and Léon Bonnat, both influential figures under the Third Republic and artists who may have helped Gigoux obtain commissions and honors late in his career.

1. Linda Nochlin, *Gustave Courbet: A Study of Style and Society* (New York: Garland Publishing Co., 1976), pp. 119-20.
2. See Henri Béraldi, *Les Graveurs du XIXe siècle* (Paris, 1892), VII: 109.
3. This is probably the same painting entitled *Le Forgeron*, now in the museum in Besançon. It was an additional work accepted at the 1833 Salon and appeared as no. 3048 in the supplement to the official catalog.
4. See Paul Mantz, "La Peinture française," *Gazette des Beaux-Arts* II (1889): 358.
5. For a discussion of these commissions, see Henry Jouin, *Jean Gigoux: Artistes et gens de lettres de l'époque romantique* (Paris: Aux Bureaux de l'Artiste, 1895), pp. 74-90.

Victor Gabriel Gilbert

1847 Paris — 1935 Paris

Reared in Paris, Victor Gilbert suffered a sickly childhood that prevented his following his father's career as a woodworker for Pleyel and Wolf.[1] His natural propensity for drawing was nurtured by his family, but they were too poor to enroll him in the Ecole des Beaux-Arts. Instead, Gilbert at thirteen learned the trade of an artisan, working for the painter-decorator Eugène Adam by day, and in the evenings attending an art school organized by Père Levasseur at the Ecole de la Ville de

VICTOR GILBERT

Paris.[2] This was the only official artistic training he received.

Working on his own, Gilbert eventually exhibited still lifes at the Salon. In 1873 he showed two compositions, and again in 1874 two canvases, one entitled *Le Pot-au-feu* that a private collector purchased. During the mid-1870s Gilbert received some financial support from Père Martin, whose art shop on rue Laffitte had been a center of artistic activity since the 1850s. Martin secured many of Gilbert's early works for himself; in return the painter completed the *Portrait of Mme. M. . . .* (1875 Salon), which assured him enough success as a painter to renounce his decorative work for textile manufacturers.

In the late 1870s, Gilbert turned to scenes that genuinely attracted him: street markets, vendors, café scenes, and especially views of Les Halles. In effect, Gilbert became the visualizer of life at Les Halles just as Emile Zola was the recorder of this locale in segments of his Rougon Macquart series.[3] The sorting of fish in early morning hours or the carrying of meat by men straining under heavy loads [191] reiterated themes of work that Zola perceived as the energy and dynamism of contemporary Paris. The colors Gilbert used in some of his early works were often dark, suggestive of Bonvin, and in keeping with the atmosphere of the early Realists. Gradually, under the influence of the Impressionists, Gilbert softened his palette and turned his attention to effects of light.

At the 1880 Salon, Gilbert achieved his first major triumph when he received a second-class medal and the state purchased *A Corner of the Fish Market: Morning* [189]. The exhibition of two more paintings of Les Halles at the 1881 Salon suggests that Gilbert was considered the official painter of this section of Paris. He continued to paint themes of the street life of Paris (e.g., *Le Marchand de chanson*, 1886; *L'Heure du repas—Quartier du Temple*, 1891), maintaining a naturalist style well into the twentieth century. Although he obtained a silver medal at the Paris Fair of 1889, it was not until 1926 when he won the Prix Bonnat that Gilbert again received an official award.[4]

1. Yveling Rambaud, "Victor Gilbert," *Le Journal*, 7 August 1898.
2. Ibid.
3. Eugène Montrosier, "Victor Gilbert," *Les Artistes Modernes* IV (1884): 25-27.
4. The date of Gilbert's death, which is not generally known, is recorded in "Actes de décès," 21 July 1935, 9e arrondissement, Ville de Paris. Gilbert apparently died without descendants. He is buried in the Montmartre cemetery, Paris.

Norbert Goeneutte

1854 Paris — 1894 Auvers-sur-Oise

As a third-generation Realist, Norbert Goeneutte was closely linked to the Impressionist movement because of his themes of Parisian life, but he also represents a transitional place in the evolution of the Realist tradition in his later themes, which were inspired by the Naturalist novels of Emile Zola. Goeneutte was trained as a printmaker, and he maintained an avid interest in this medium, which he shared with other members of the Impressionist circle, including Marcellin Desboutin and Jean François Raffaelli. But the majority of his works are now lost or retained by family descendants, so that few of the details about his life or works can be documented.

Little is known about his early years. His father was a member of an insurance company in Paris (Assurances Générales), and his mother a professional milliner. Together, they earned enough to care for a family of six children and to live a comfortable middle-class existence on the rue Richelieu not far from the Bibliothèque Nationale. Norbert, the oldest son, and a sister Suzanne were sent to boarding school in Villiers-le-Bel near Pontoise, but Goeneutte showed little inclination for any of his studies. He was homesick and unhappy with his new surroundings, and only his newly developed interest in art sustained him. After several years at Villiers-le-Bel, Goeneutte returned to Paris and enrolled in the Lycée Condorcet, although his parents also arranged for him to take drawing lessons.

During the Franco-Prussian War, Goeneutte's elder sister was sent to Belgium along with three of the younger children. Goeneutte refused to leave Paris, and remained in the city during the siege and throughout the frightening aftermath of the Commune. When his father, who had been in poor health since a trip to Algeria, died (probably in May 1871), Goeneutte assumed responsibilities as head of the household. He completed his baccalauréat during this trying period and, even though he still wanted to become an artist, tried to fulfill his father's more practical wishes, apprenticing as a clerk to a notary for a short time. He soon enrolled in the Ecole des Beaux-Arts, however, and by 1872 was studying under Isidore Pils. Even though he may have found Pils's teaching methods restricting, he probably admired the views of the city that Pils completed during the siege. After Pils's death in 1875, Henri Lehmann assumed Pils's position. Lehmann was unsympathetic to the younger generation, and his students asked Edouard Manet to become their professor. When Manet refused, many of the students left Lehmann's atelier; Goeneutte was among the few who remained. As soon as he was able to find an atelier of his own, however, Goeneutte left the Ecole des Beaux-Arts.

Working in his studio during the mid-1870s, Goeneutte made the acquaintance of Marcellin Desboutin, who helped train Goeneutte as an etcher. He gradually made friends with a number

NORBERT GOENEUTTE

Jean-Jacques Henner
1829 Bernwiller, Haut-Rhin — 1905 Paris

Only the earliest of Jean-Jacques Henner's compositions are linked with the Realist movement. Those works completed while he was still in Alsace suggest Realist themes and a color range that is somber and grayed. His later reputation as a portraitist with Symbolist tendencies, and his election to membership in the prestigious Institut de France (1889) did not diminish his regard for the Realists, however, and Théodule Ribot, Léon Bonnat, Dagnan-Bouveret, Jean Charles Cazin, and Jean François Raffaelli were among his close friends.

Henner was one of six children cared for in the village of Bernwiller in Alsace by an older sister and a brother, Séraphin, after his father died in 1843. Despite his simple background, his early interest in drawing was recognized by his family and they encouraged his talent. Like many of the Realists, his early works often portrayed members of his own family [65, 66], and he remained close to his relatives throughout his career, frequently returning to Bernwiller even after he settled in Paris.

He started upper school in 1841 at Altkirch near Bernwiller, where his first art teacher was Charles Goutzwiller, a capable draftsman and portraitist who obviously encouraged Henner's abilities in this direction, too, for Henner won two prizes in draftsmanship there. In 1844, Henner's family sent him to Strasbourg to study under Gabriel Guérin. The Guérin art academy was well known in the region; a number of local artists, such as Gustave Brion, had been trained there. When his father died in 1831, Gabriel Guérin continued to run this private "art academy," teaching his students in a traditional manner that included scrupulous adherence to classical modes. When Guérin died in 1846, Henner went to Paris and became a student of Michel-Martin Drolling (1786-1851), an artist who provided academic training for a number of young Alsatian painters who had come to the capital.

Henner's apprenticeship with master painters in Paris lasted twelve years. From the fall of 1846 until September 1858, when he finally won the Prix de Rome, Henner worked diligently in Paris, spending only enough time in Alsace to paint portraits that provided enough money for him to continue his instruction. His progress was slow: in 1847 he placed thirty-eighth in the Prix de Rome competition, and in 1851 he still ranked tenth. In May 1852, however, he was awarded a third-class medal in drawing at the Ecole des Beaux-Arts. Even by 1854, still earning little money of his own and completing the last year of a departmental subvention (500 francs per year) that enabled him to study in Paris, Henner was still unable to sell his paintings to the government. His attempt to find patrons to purchase his canvases or provide other projects for him was so unsuccessful that, even though his subvention was renewed at the end of 1854, he began to study lithography so that he could earn a living from book publications.

After a two-year stay in Alsace (1855-1857), he returned to Paris and enrolled in the studio of the painter Picot. He continued to compete for the Prix de Rome. Although his 1857 entry, *The Resurrection of Lazarus*, did not receive the prize, both Picot and Horace Vernet were impressed with his work. At last, in 1858, he received the award. His *Adam and Eve Discovering the Body of Abel* enabled him to spend the next five years in Italy at the Villa Medici, where he was inspired by a number of Italian Renaissance

JEAN-JACQUES HENNER

masters, including Giorgione, Titian, and Correggio. While in Italy, he continued to submit paintings to the Ecole des Beaux-Arts, and in 1863 was accepted at the Salon for the first time with his entry *Young Bathers Asleep*, a work which received a third-class medal. During his stay in Rome, Henner became acquainted with a number of other Prix winners, including the sculptors Chapu and Tournois, and he completed several paintings inspired by these friendships [146, 147]. When he returned to Paris in 1864, Henner moved into the same building on Place Pigalle where Théodore Rousseau, Isidore Pils, and other artists were also living, and he remained there for the rest of his life. He continued to exhibit regularly at the Salons until 1903. He was a prodigious painter and completed many portraits, although he frequently repeated the theme of nudes in a landscape setting.

He won all the official honors. In 1878 he was made an officer of the Légion d'honneur. The same year he won a first prize at the Paris World's Fair, and in 1889 he became a member of the Institut. As a student of traditional old masters, from both the northern and southern schools, Henner maintained significant links with the past. The purest of his Realist paintings were achieved only early in his career when his ties with Alsace were strongest, and in some of the portraits he completed during the mid-1860s. He remained a friend of some of the more progressive, independent painters of his time, but, in his own works, relinquished his early Realist tendencies in deference to conservative art traditions.

Auguste Herlin
1815 Lille — 1900 Lille

Little is known about the career of Auguste Herlin except that he exhibited at the Paris Salons from 1861 until 1876. His themes were often regional, stressing landscapes of the countryside near Lille or genre scenes of washerwomen.[1] During the mid-1870s he succeeded Reynard, who had been a practicing artist, as curator of the Lille Museum. Whether he continued painting after assuming administrative duties is unknown, but he did receive the Légion d'honneur in 1891.

of the young Impressionists, too, including Edgar Degas, Auguste Renoir, and, later, Henri Rivière. They met together at the Parisian cafés, in particular La Nouvelle Athènes. The several times Goeneutte served as a model for Renoir during the 1870s (e.g., *Le Moulin de la Galette*) also document his close relationship with the Impressionists. In 1876 Goeneutte completed *The Boulevard de Clichy under Snow* [232], one of the few works to have survived from his early years and a composition he exhibited at his first Salon in 1876.

Goeneutte was also attracted to themes of urban work and attempted to infuse compositions like *L'Appel des balayeurs* (1877 Salon) or *La Soupe du matin* (1880 Salon) with a social consciousness. Such Naturalist themes as his depiction of the distribution of soup to the poor in front of the restaurant Brebant in Paris were an unusual choice for a painter linked with the Impressionists.

Throughout the 1880s Goeneutte continued to paint themes derived from Parisian life: portraits of members of his family, views of Parisian boulevards and landmarks (e.g., *Gare St. Lazare*), and studies of popular places (e.g., *La Bourse*). In 1881 he made his first trip to Normandy, where he completed a series of landscape studies. In 1889, following his successful exhibition of five paintings at the World's Fair, he made a second trip to Normandy, this time traveling as far as Bordeaux (*Le Port de Bordeaux*, 1889). His compositions were selected for exhibition at the first Salon of the Société Nationale des Beaux-Arts in 1890. His continued success in the art world enabled him to travel to Venice, Holland, and London. Following his return to Paris and a period of ill health, Goeneutte settled in the country in Auvers-sur-Oise. Here, cared for by his brother Charles, he met Doctor Gachet (1891) who became a close friend; his portrait of Doctor Gachet (Musée du Louvre) was exhibited at the Société Nationale des Beaux-Arts in 1891. Goeneutte's works were never widely known, however, and his death in 1894 received little general notice.[1]

1. A recent book on Norbert Goeneutte does little to clarify his place in French art or analyze his style. See Gilbert de Knyff, *Norbert Goeneutte: Sa Vie et son oeuvre ou l'Art Libre au XIXe Siècle* (Paris: Editions Mayer, 1979).

AUGUSTE HERLIN

1. The compositions Herlin exhibited in 1863 included *Blanchisseuses* (*Washerwomen*).

Louis-Henri-Victor-Jules François [Adolphe] Hervier
1818 Paris — 1879 Paris

Adolphe Hervier began painting scenes of Parisian life and provincial existence in the early 1830s, but he remains one of the least known members of the Barbizon generation. Because of his repeated rejection by the Salon jury— twenty-three times according to his first biographer Philippe Burty—he found few early patrons to support his work, and his water colors and paintings thus received little notice.

After training with his father, an artist who had studied in the Neoclassic style under Jacques Louis David, Hervier worked in the atelier of the painter Léon Cogniet. In 1838 Hervier left Cogniet's studio, for he wanted to paint provincial life and to study nature. His work—especially his early landscapes—reveals the influence of Alexandre Decamps and Eugène Isabey in both genre detail and attention to light, atmosphere, and climactic conditions. His landscape *The Storm* [156] is characteristic of these qualities and may have been the first of his efforts finally accepted for exhibit in a Salon in 1849.[1]

Between 1849 and 1855, Hervier exhibited at the Salons four times using the name of Adolphe Hervier. Between 1864 and 1870 he exhibited under his real name, Louis-Henri-Victor-Jules François Hervier, suggesting that as he became better known, he may have wanted collectors and critics to become aware of his true identity.[2] There were few, however, who fully appreciated Hervier's work during the 1850s, and only an occasional critic recognized the significance of his work. Théophile Gautier wrote in 1856: "We are surprised not to find M. Hervier better known than he is; he has everything that one should have: lively color, an original technique, and the ability to observe nature in a particular way. He often suggests [Théodore] Rousseau. . . ."[3] This praise from a well-established critic and favorable comparison of his work with the leading land-

scapist of the Barbizon tradition resulted in little public attention. Discouraged, Hervier did not exhibit in the Salons during the late 1850s, and returned to active competition again only in 1864 after several collectors—among them Philippe Burty—had selected his work for their own collections. Few of Hervier's works, however, entered public collections; he was seldom able to sell even his water colors, and he lived an impoverished existence.

Hervier was also a printmaker. His lithographs and etchings reveal a sense of caricature and an awareness of the picturesque derived from the daily life of the people in both Paris and provincial villages.

Because Hervier is linked with the Barbizon landscape painters, it is often assumed that he painted directly from nature. Many of his landscapes, however, were "remembrances"—studies completed at a later date and recalled in the tranquility of his studio. Hervier can be regarded as an intermediary between the Romantic generation and the early Realists: he derived many of his themes from daily life, even though he did not always work from actual observation.[4]

1. The complete provenance of *The Storm* is not known.
2. The change in Hervier's name is difficult to explain. The relative obscurity of his work even by the mid-1860s may have encouraged him to seek more accurate acknowledgment.
3. Théophile Gautier, *Les Beaux-Arts en Europe—1855* (Paris, 1856), pp. 158-59.
4. Hervier's work has been studied by two contemporary art historians. Their efforts have remained unpublished because they have found it difficult to locate documents (letters, photographs, etc.) on Hervier's life and career. See Annie Bauduin, "Recherches sur la vie et l'oeuvre du peintre français Adolphe Hervier (1819-1879) avec le catalogue des oeuvres peintes et dessinées" (Mémoire de maîtrise présenté par Mademoiselle Annie Bauduin sous la direction de Monsieur le Professeur François Souchal à l'Université de Lille III, 1972). The research of Professor Jan van der Noort, in The Hague, also establishes the significance of this artist in French nineteenth-century studies. Van der Noort is preparing a catalogue raisonné of Hervier's prints and water colors.

ADOLPHE HERVIER

Philippe Auguste Jeanron
1808 Boulogne-sur-mer — 1877 Comborn

The significance of Philippe Auguste Jeanron in the emergence of proto-Realism in the 1830s and 1840s has long been overlooked.[1] Even before the Revolution of 1848 when he became director of the National Museums of France, Jeanron completed paintings which sympathetically mirrored the life and hardships of common people. His advocacy of *le peuple*, a commitment he maintained throughout the 1830s, made him a popular choice to oversee the Louvre.

Most of Jeanron's early canvases are lost and many of his later works are inaccessible because they are located in provincial collections. In the 1831 Salon, his first exhibited work, *Les Petits Patriotes* (Musée de Caen), portrayed a group of street urchins playing soldier, and its theme is comparable with Delacroix's *Liberty on the Barricades* in its characteristic use of younger models—a type of figure which would attract many of the Realists. Throughout the 1830s Jeanron continued to reveal the harsh and direct reality of common types in such canvases as *Scène de Paris* (1833 Salon), balancing his sympathetic interest in urban life with scenes of country existence. While some critics of the 1834 Salon felt that *Paysans limousins* (Musée de Lille)[2] lacked a strong social message, others linked the group of wanderers and their simple musical entertainment with the customs of the provinces. At the same Salon Jeanron also exhibited two versions of a blind beggar. His continued interest in themes of everyday life remained evident in *Death of a Young Child, Poor Family*, and *Hunter* that were shown at the 1836 Salon. His most important painting at the 1836 Salon, *La Charité du peuple* (also called *Les Forgerons de la Corrèze*), depicting workers at a forge, is now lost.[3] Théophile Thoré recognized this canvas extolling simple work as a prime example of the use of everyday life for thematic material.

At the time of the 1848 revolution, Jeanron's position as both a painter and a critic enabled him to become the people's apostle for the Louvre and the national museums. Under Jeanron's short term as director, the Louvre was regarded as the "Palace of the People," and a series of reforms were planned. Salon exhibitions were not held at the Louvre for the first time; a national library was to be organized; workers were to be hired so that the buildings of the Louvre could be expanded and put to use.

Not all of the reforms Jeanron intended were carried out, but his term represents significant achievements and a new direction for art in France. For the first time, recognition was accorded neglected French painters from the past; such masters as Chardin and the Le Nains emerged from relative obscurity when their works were put on public view in the Louvre. Jeanron also initiated the rearrangement of galleries into a historical framework that provided chronological continuity and strengthened the relationship between the central museum and those in the provinces. Dedicated to democratic principles, Jeanron sought to exhibit a great number of works in order to broaden the base of visible art and to increase public awareness of the many different past masters. The provisional republican government under which Jeanron served in 1848 also sponsored art contests. One of these competitions that he was unable to complete was the selection of an appropriate symbol of the new Republic. Even though Jeanron was dismissed after Napoleon III

PHILIPPE AUGUSTE JEANRON

gained control of the government, some of his liberal reforms continued, especially his reorganization of the Louvre collections. Jeanron's effectiveness as a proponent of democratic tendencies in the art world was silenced by providing him a sinecure in a far-distant location: he became director of the School of Art and curator of the provincial museum in Marseille. Since Jeanron was not a wealthy man, he had to be content with a "pension" in the provinces that permitted him to continue to exhibit at the annual Salons for the remainder of his career in a relative obscurity that satisfied the new leaders of the Second Empire.

The later works by Jeanron [60] are inconsequential landscapes or seascapes, which he produced in his peaceful isolation. Support by the state meant that many of these later canvases were acquired by state museums—an arrangement that assured a plentiful number of far less significant canvases than he had earlier created.[4]

1. Linda Nochlin, *Gustave Courbet: A Study of Style and Society* (Ph.D. diss., New York University, 1963; New York: Garland Publishing Co., 1976), p. 120.
2. The painting is now in much too fragile a condition to be exhibited. See Nochlin, *Gustave Courbet*, p. 121.
3. This painting is discussed in Madeleine Rousseau, "La Vie et l'oeuvre de Philippe Auguste Jeanron: Peintre, écrivain, directeur des Musées Nationaux, 1808-1877" (thesis, Musée du Louvre, 1935). Rousseau's study is the only major work on Jeanron and contains a catalog of many of his known works.
4. A number of Jeanron's paintings from the 1850s and 1860s can be found in the provincial museums (e.g., Tours, Bayeux, and Marseille). Many were purchased by the government directly from the artist.

Johann Barthold Jongkind
1819 Lattrop — 1891 Côte Saint André

Johann Barthold Jongkind was educated in Holland and received his early artistic training from Andreas Schelfout at the Drawing Academy in The Hague. In 1843 Jongkind applied to the Dutch government for official support, and was granted a subsidy of 200 florins that enabled him to continue his training. During the 1840s he was considered one of the most promising Dutch

painters of his generation, and Schelfout requested a grant from the government that enabled Jongkind to further his training in the Paris atelier of Eugène Isabey (1803-1886), a noted seascape painter. Jongkind left for Paris in March 1846 and, through his work in Isabey's studio, became acquainted with other young painters, such as Théodore Rousseau, Isidore Pils [79], and Eugène Boudin [114]. Jongkind also studied from the model in the atelier of F. E. Picot. Late in the 1840s Jongkind made his first trip to Normandy and Brittany, during which time he completed *Un Port de mer* for the 1848 Salon. He also studied life on the Seine, depicting scenes of barges, bridges, and bathhouses—scenes that distinguish him as one of the first painters in France to concentrate on themes derived from direct observation of river activity.

In 1850 Isabey invited Jongkind to join him on his trip along the coasts of Normandy and Brittany, where they stopped at the villages of Le Tréport (then an artists' haven), Fécamp, Saint-Valéry-en-Caux, Brest, and Douarnenez. Jongkind's watercolor studies capture his first impression of these scenes; he later used these firsthand observations to complete large oil paintings for exhibition at the Salons. During the early 1850s, when Jongkind was still working in Paris, he met Pierre Firmin-Martin (known as Père Martin), the art dealer who befriended and supported him through several difficult periods. Père Martin's gallery on rue Mogador was then attracting many of the younger Realist and Barbizon painters, including Jean François Millet, Constant Troyon, François Bonvin [30], Charles Jacque, and Adolphe-Félix Cals [141]. Jongkind developed a close friendship with Père Martin; his extensive correspondence with the art dealer provides information on the activities and personalities of both men.[1]

During the 1850s Jongkind received increasing recognition at the Paris Salons. The government of the Second Empire's admiration for Jongkind's seascapes and cityscapes is revealed by their purchase of a *View of the Port of Harfleur* (Musée de Picardie, Amiens) at the 1851 Salon and *Le Pont de l'Estacade* (Musée d'Angers) at the 1853 Salon.[2] Both of these canvases were of major proportions, and the accuracy of each scene is no little indication of the time-consuming preliminary studies that they entailed. In 1852 Jongkind received his first official award, a third-class medal, at the Salon. Unfortunately, just as Jongkind's reputation was increasing in the Parisian art world, the subsidy he had been receiving from the Dutch government was withdrawn. Even though some of his friends purchased his paintings and he received financial help from such art dealers as Père Martin and Adolphe Beugniet, he could not support himself by his painting and he began to drink heavily.

The three paintings he exhibited at the Exposition Universelle in 1855 attracted little attention. In comparison with Alexandre Antigna, who showed sixteen canvases, Jongkind's entries seemed paltry. His failure to receive the continued support of the Second Empire and the sudden death of his cherished mother in August 1855 caused severe depression. He left Paris, precipitously, in November of that year and, except for a very brief visit to Paris in 1857, remained in Holland for the next five years.

In Holland, Jongkind's problems continued; his paintings did not sell and he was unable to become established with Dutch art dealers. Again, he became dependent on the generosity of others. In

JOHANN BARTHOLD JONGKIND

March 1856 Jongkind's financial plight became known to his friends in Paris, and Père Martin organized a sale of the 100 paintings and 117 water colors that Jongkind had left behind in his Parisian studio. Many of the buyers were Jongkind's friends and fellow artists who were similarly strapped for funds, so that it is understandable that only 2848.25 francs were realized through this effort. Sometime later, in 1857, Jongkind is known to have returned to Paris, where he met briefly with Gustave Courbet, but he left again immediately for Rotterdam.

Jongkind's Dutch paintings from this period reflect an interest in landscapes: canal scenes, studies of windmills, views of solitary country roads. In 1858 he sent eight of these scenes to Père Martin; in 1859, ten. Few were sold. (One of the buyers was Achille Arosa, a collector of Romantic compositions who had visited Jongkind in Rotterdam in 1858.) Jongkind was awarded a silver medal for his works at the Dijon exhibition in 1858, and in 1861 his Dutch view of a sunset was exhibited at the Salon. Official recognition, however, was insignificant; his patrons were minimal and his depression continued.

Early in 1860 Jongkind wrote to Père Martin asking to return to France. Again, Martin, with the assistance of Count Doria (a collector of pre-Impressionist works), arranged a benefit—this time, a sale of works by fellow artists—to resolve Jongkind's debts and pay for his return to France. Among those who donated their work for the sale were François Bonvin (a drawing), Isidore Pils (a water color), Adolphe-Félix Cals (a painting of a *Young Girl Reading*), Edouard Frère (a painting of an *Interior*), Jean François Millet (a sculpture), and Philippe Rousseau (an allegorical painting).[3] A total of 6046 francs, minus the expenses for the sale, was raised, and Cals was designated as the group representative to take care of Jongkind's affairs and bring him back to Paris, where Martin had even located a room for him.

Jongkind was deeply touched by the friendship and generosity of his colleagues. Soon after his return to Paris, and again through the influence of Martin, an event occurred which was to change his life. At one of the evening gatherings at Martin's home, where lively discussions usually

ensued between artists and friends on the state of the art world, Jongkind met Madame Josephine Fesser-Borrhee, a Dutch drawing teacher in a Parisian girls' school. Madame Fesser and her husband became most interested in Jongkind and welcomed him into their own home, where they nursed him back to health. The relationship with the Fesser family restored Jongkind's spirit, and his paintings from this time on became surer, more sensitive atmospheric studies.

During the 1860s, Jongkind became increasingly interested in outdoor painting. In 1862 he returned to Normandy, this time becoming acquainted with Claude Monet, the painter who idolized Jongkind, referring to him as his "real master." For the Salon des Refusés, Jongkind exhibited three canvases, including a winter scene with skaters. Late in 1863 he returned to Honfleur, where he became reacquainted with Eugène Boudin. The years 1864 and 1865 were peak ones for Jongkind. His canvases demonstrated a freshness and spontaneity that the budding Impressionsists admired; Jongkind joined their gatherings at the Saint-Siméon farm (a popular rendezvous for artists, writers, and collectors)[4] and was stimulated by discussions with Cals, Alfred Sisley, Frédéric Bazille, Albert Lebourg, Troyon, Daubigny, Boudin, and Monet. By the end of the decade, Jongkind was making trips to Holland frequently. While his working habits improved somewhat, periods of depression persisted that often subdued his creativity for weeks on end.

During the remainder of his career, he alternated his time between Paris, the Channel coast, the south of France, and the Dauphiné. In each region he produced varied landscape studies. In the 1880s his paintings were acquired by a number of important collectors of Barbizon and Impressionist paintings (e.g., George Lutz, de Bellio), and his reputation was secure. In his later years he became part of the informal group of landscape painters who worked near Le Havre.

Despite Jongkind's ties with the younger avant-garde generation, his own predilections were formed by the tradition of Dutch seventeenth-century marine and cityscape scenes. Like many of the Realists, he worked within a limited color range, but he differed from most Realists in his use of higher intensity tones that convey a greater luminosity. His traditional approach to landscape composition—developing the final image in the quiet of his studio was dependent upon free, spontaneous drawings and water colors that were completed on location. He became the idol of younger French painters who recognized his canvases and water colors (as well as those by his friend Eugène Boudin) as the point of departure for their own examination of light and atmosphere.

1. For further reference see Victorine Hefting, *Jongkind, d'après sa correspondance* (Utrecht, 1969).
2. For reproductions of these paintings see Victorine Hefting, *Jongkind: Sa Vie, son oeuvre, son époque* (Paris: Arts et Métier Graphics, 1975), figs. 89 and 118.
3. For a complete list of the artists contributing to the benefit sale, see Etienne Moreau-Nélaton, *Jongkind raconté par lui-même* (Paris, 1918), pp. 58-59.
4. For a discussion of the role played by the Auberge Saint-Siméon, see Charles C. Cunningham, *Jongkind and the Pre-Impressionists: Painters of the Ecole Saint-Siméon*, exh. cat. (Williamstown, Mass.: Sterling and Francine Clark Art Institute and Smith College Museum of Art, 1977), pp. 7-24.

Albert Lebourg
1849 Montfort-sur-Risle — 1928 Rouen

Albert Lebourg was born in Normandy in the small, country village of Montfort-sur-Risle, where he spent his youth painting the landscape near his home. Interestingly enough, though living near peasants and field laborers, he never chose to paint regional types. Artistic connections with one of his mother's relatives, Charles Gueulette, who was an art critic for *Gazette des Beaux-Arts*, may have influenced the boy to pursue an artistic career.

Until the age of twelve Lebourg attended the Ecole Communale in Montfort. His parents then decided he should attend the Lycée at Evreux. Since Lebourg was not a good student, it was anticipated that he would seek work for the railway, but when he expressed an interest in architecture, his parents sent him to study with a local architect named Drouin. Here Lebourg was introduced to an artistic milieu which included the drawings of Victor Delamarre, an artist living in Lebourg's native village who admired Lebourg's ability and encouraged the youth to work on his own. Even though Lebourg never studied formally with him, Delamarre has long been considered Lebourg's first major art teacher. Drouin also aided Lebourg's pursuit of an independent career by introducing him to Gustave Morin (1819-1886), director of the Ecole Municipale de Peinture et de Dessin in Rouen. Morin found Lebourg's work substantial and urged him to continue painting the countryside of Normandy.

In 1867 Lebourg attended the large exhibition of painting that coincided with the Paris World's Fair, and saw the separate exhibition of Gustave Courbet's works, which included some of the major canvases of Realism. Lebourg maintained a strong Romantic inclination in his landscapes, although his series of still-life charcoal drawings reveal the careful study of common utensils that might have typified a Realist [126].[1]

After the Franco-Prussian War, Lebourg brought his paintings to the Rouen art dealer Legrip, where they were discovered by Laurent Laperlier, a supporter of Bonvin and collector of Chardin's paintings who had returned from Algeria to be treated at Forges-les-Eaux for an illness.[2] Impressed with his work Laperlier offered Lebourg a position as drawing professor at the Société des Beaux-Arts in Algiers, which he assumed in October 1872. Lebourg taught children and, through contacts with Laperlier, also gave private lessons to adults. His friendship with Laperlier also enabled him to study the collection Laperlier had brought with him from France.[3] After a year in Algeria, Lebourg returned to France to marry Marie Guilloux on 27 September 1873. They returned to Algiers where Lebourg gave art lessons for three more years. As his painting style matured, Lebourg found a private patron, M. Daudre, who purchased many of Lebourg's works.

In 1877, Lebourg and his wife returned to France to renew contacts with contemporary French painters. At first he was assisted by an art dealer named Portier, who had sold many works by Corot and who introduced Lebourg to collectors of Impressionist paintings.[4] This contact undoubtedly brought Lebourg into the Impressionist camp, and he was invited to exhibit with them in 1879 and 1880. In 1883, Lebourg exhibited in his first Salon by showing *Matinée à Dieppe*. In 1890 still painting landscapes of provincial regions, Lebourg exhibited with the newly formed

ALBERT LEBOURG

Société Nationale des Beaux-Arts. Normandy and the environs of Paris (e.g., Sèvres, St. Cloud, Bas-Meudon) became his favorite painting sites. By 1900 he had traveled to Holland and Belgium in search of new landscapes. In all of Lebourg's work a Romantic interest in brilliant color and personal sensation predominates. Only occasionally can he be linked with Realist genre concepts.

1. See Léonce Bénédite, *Albert Lebourg* (Paris: Editions Galeries Georges Petit, 1923), p. 389.
2. Laperlier's illness is undocumented. He died in 1878.
3. Laperlier owned works by Ribera, Goya, Bonington, and Michel,
4. Bénédite, *Albert Lebourg*, p. 91.

Alphonse Legros
1837 Dijon — 1911 Watford, near London, England

Alphonse Legros occupies an important place in the evolution of nineteenth-century printmaking and painting because of his reputation and influence in both England and France. His role in nineteenth-century painting has long been underestimated, however, because few of his paintings have been located and little published information exists that would reestablish his position or provide a systematic chronology.[1] Legros was strongly influenced by Courbet and developed a personal style that led some, including Charles Baudelaire, to call him a religious painter. His association with Fantin-Latour, Edouard Manet, James McNeill Whistler, and others, along with the influence of memory-training theories by his teacher Horace Lecoq de Boisbaudran led him to retain a somber, Romantic style—even during the 1860s, so that like the static Realism that Théodule Ribot and François Bonvin depicted, his compositions also expressed contemporary life, and a new understanding of man.

Legros came from a modest background in Dijon; because he was one of seven children, it was difficult for him to receive an education. When he was eleven, he was apprenticed to a house painter, but was also enrolled at the Ecole des Beaux-Arts in Dijon for drawing lessons.[2] He

did not become a full-time student at the Ecole des Beaux-Arts until 1849, when he probably studied in the atelier of Philippe Boudair. When his family moved from Dijon to Lyon (ca 1850), he worked for the decorator Beuchot, helping him with the murals for the chapel of the local cathedral. In 1851 he left the provinces for Paris, realizing that this was the only way to progress as an artist. It was probably in the atelier of Cambon, a theater decorator in Paris, that he may have acquired the simplification of style—perhaps imposed by the restrictions of stage backdrops—that was noticeable in his early paintings.[3] In 1851 he also enrolled in the Petite Ecole de Dessin (equivalent of the present-day Ecole des Arts Décoratifs), where he trained as an artisan for the decorative and industrial arts under Jean Hilaire Belloc, the director. This provided him with a sound education that prepared him for the Ecole des Beaux-Arts, and, at the same time, enabled him to earn enough to live on by hand-coloring lithographs.

It was not long before he became a student of Horace Lecoq de Boisbaudran at the Petite Ecole, who unlike most atelier instructors, refused to permit his pupils to copy his own style, but urged them to follow their personal inclinations. By stressing memory training, which emphasized an artist's first responses, Lecoq de Boisbaudran's approach challenged the official academic tradition and distinguished his particular students, for they developed an unusual visual recall that many of them remained dedicated to throughout their careers.[4] Many of the Petite Ecole students that Legros came in contact with (Auguste Rodin, Jules Dalou, Jean Charles Cazin, Léon Lhermitte, and, for a short time, Carolus-Duran) eventually became highly respected artists. Fantin-Latour became Legros's closest friend at the Petite Ecole, and it was probably through him that Legros met James McNeill Whistler, one of the most revolutionary and influential young artists of the late 1850s.

Legros became one of Lecoq de Boisbaudran's favorite pupils. Impressed with his ability to work from memory, Lecoq de Boisbaudran set up a separate atelier to provide the special attention that he felt Legros and several of his other pupils (probably Fantin-Latour also) deserved. Part of Lecoq de Boisbaudran's curriculum for this group included the copying of old masters in the Louvre. Working from paintings by Poussin, Géricault, and Rembrandt trained Legros's eye and his memory. While studying under Lecoq de Boisbaudran and working in his master's atelier at 39 rue du quai des Grands-Augustins, Legros passed his examinations for admission into the Ecole des Beaux-Arts and enrolled in their night school in October 1855. In the late 1850s, while still working with Lecoq de Boisbaudran on outdoor landscape studies, Legros moved to the less expensive village of Montrouge on the outskirts of Paris.

In 1857, one of Legros's two entries, *Portrait of the Artist's Father* [140] was shown at the Salon. His ability to combine an interest in old masters with his newly developing Realist inclination to work from nature is evident in this copy of Holbein's *Erasmus*. Critics such as Champfleury began to notice his paintings, and Charles Baudelaire, reviewing the 1859 Salon entries, praised Legros's *Angelus*.

During this time when he was first receiving recognition at the Salons, Legros's friendship with James McNeill Whistler and Fantin-Latour was so constant that the three became known as *Les Trois*. Their common interest in printmaking,

their admiration for Dutch and Spanish seventeenth-century art, and their alliance as disciples of Courbet benefited each of their careers at a crucial moment.

Legros's second *Portrait of His Father,* Whistler's *At the Piano,* and all three of Fantin-Latour's entries were refused by the 1859 Salon jury, and the rejection that *Les Trois* faced resulted in a close union. Their canvases, along with works by Théodule Ribot, were shown in Bonvin's atelier, and there attracted the attention of Courbet.[5] The small exhibition in Bonvin's atelier also led to Legros's acquaintance with Louis Martinet, the art dealer who exhibited works by Chardin during the early 1860s. During the next few years Martinet showed a number of works by members of the Realist circle, including Legros, giving these young artists the opportunity to show and sell their canvases and etchings in a setting that imposed none of the atmosphere or the restrictions that the Salon then so rigidly maintained.

Nevertheless, he continued to exhibit at the Salons. In 1861 his *Ex-Voto* [83] was strongly supported by such critics as Duranty, but despised by others (e.g., Louis Lagrange) who believed Legros was attempting to rekindle the same kind of scandal that Courbet's *Burial at Ornans* had provided. Despite the controversy, Legros received an honorable mention, and the work still remains the most important composition from the early phase of his career.

Some success in Paris and exhibition of his work at the Salon des Refusés in 1863 did not alter Legros's decision to emigrate to London. He had first visited there in 1860, when he posed for Whistler's painting *Wapping*. The sale of some of his works through contacts with Whistler and Francis Seymour Haden (in particular the purchase of the *Angelus* by Seymour Haden for his own collection) encouraged him, but, even though he moved to England, he continued to paint French themes throughout his career.

He also continued to exhibit, more or less regularly, in the Paris Salons until 1880. In 1867 he received a third-class medal for two works: *La Lapidation de St. Etienne* and *Une Scène d'inquisition*; in 1868 he received a medal for *L'Amende honorable*.[6] Some of his works were purchased by the state (*Lapidation* for 3000 francs) and by the Luxembourg Museum. In 1869 his *Le Réfectoire* received critical support.

During this same period, Legros also exhibited at the Royal Academy in London (1868, 1869, 1870). His style continued to baffle some of the critics. Champfleury considered Legros a Realist. Jules Antoine Castagnary found suggestions of the Spanish masters (Legros had probably visited Spain in 1861) as well as hints of the modern French tradition that Courbet had initiated. Despite this recognition from several of the major critics, Legros's paintings remained unknown except for a small, intimate circle of friends who admired his work.

Legros's move to England resulted in impressive official posts that sapped both his time and his commitment to his work. He served as a drawing teacher at the South Kensington Museum and later, from 1876 until 1892, as Slade Professor at the Slade School of Art at University College, London. He maintained his associations with French artists throughout the 1870s and 1880s, but he remained apart from the artistic changes occurring in France. He preferred to ally himself with English painters and printmakers, and devoted himself to his own distinctive, historically-minded style.

ALPHONSE LEGROS

1. A number of research projects by several art historians during the last fifty years that were never completed or published seem only to have compounded Legros's obscurity. A print catalog begun by Harold Wright is only now being completed by Professor Jean Harris of Mount Holyoke College. Noel Clément-Janin, Conservateur at the Cabinet des Estampes, Doucet Library, Paris, prepared a monograph on Legros that was ready for publication in 1925; work progressed on the English and French version (assisted by Legros's eldest son Lucien), but individuals closest to the project died and World War II halted the project completely. In 1958, another art historian began to study Legros. Monique Geiger, Conservateur, Musée de Dijon, wrote a thesis "Alphonse Legros" (Ecole du Louvre, 1958) which was never published. Much material is thus available, but stored in inaccessible archives in various parts of the world. Alexander Seltzer completed his doctoral dissertation on Legros for the State University of New York at Binghamton in 1980; his study "Alphonse Legros: The Development of an Archaic Visual Vocabulary in 19th Century Art," places Legros in a broader context.
2. Clément-Janin notes that Legros entered the Ecole des Beaux-Arts in 1848. See Papiers Clément-Janin, Bibliothèque d'Art et d'Archéologie, Paris.
3. Alexander Seltzer, State University of New York at Binghamton, has suggested that the crudeness and naiveté in Legros's style may be attributed to his training in theatrical devices and his familiarity with popular imagery.
4. For further discussion, see Geiger, "Alphonse Legros."
5. While the work of all three painters impressed Courbet, it was Whistler's *At the Piano* (Taft Museum, Cincinnati, Ohio) that Courbet especially praised.
6. This painting was acquired by the state in June 1868 for 3000 francs and is part of the collection of the Tribunal de Commerce in Niort. See *Le Musée du Luxembourg en 1874*, exh. cat. (Paris: Musée Nationaux, 1974), pp. 122-23.

Adolphe Leleux

1812 Paris — 1891 Paris

Adolphe Leleux and his brother Armand were regional painters who specialized in scenes of rural life in the provinces. Seeking a "truthful provincialism" in the mid-1840s, their scenes of contemporary life rank them—along with Philippe Auguste Jeanron—as proto-Realists.[1] Critics related

ADOLPHE LELEUX

Adolphe Leleux's naive depiction of types from Brittany and his interest in recording the brilliant colors of Spain to the new school of painting that was then developing. In fact, the term Realist was often used to describe his work, especially his *Les Cantonniers* when it was shown at the 1844 Salon.[2]

Leleux was an artist who discovered Brittany; that area of the French countryside became his special interest. As a provincialist, he is linked with other regional painters: Camille Flers [154], who specialized in Normandy; Camille Roqueplan, who did scenes of the Pyrénées; and Elmerich, who limited his painting to Alsatian peasants even before Gustave Brion's themes of that region began to appear. Some critics were especially appreciative of Adolphe Leleux, for they believed that he was discovering something new, even though the picturesqueness of his themes and the sentimentality of his types preclude a pure, forceful Realist style.

Adolphe Leleux's background was not typical. Unlike many artists, whose artistic abilities were encouraged by lessons at an early age, Leleux was twenty-five before he decided to become a painter, and he received no formal training in the arts. Even his preference for provincial scenes was unusual, for he was raised in Paris. At first, in order to make a living, Adolphe Leleux did engravings and lithographs, studying with the printer Sixdeniers (1795-1846). In 1835, however, he began exhibiting at the Salon with scenes from Picardie, and in 1838 he showed genre themes depicting the life of the poor, *Bas breton* and *Un Mendiant*.

After the 1838 Salon, Leleux left Paris to study in Brittany—to observe local types and to increase the truthfulness of his scenes. The year 1839 marks the beginning of his dedication to Breton themes. By the early 1840s, Salon critics, including Théophile Gautier, commented on his *naifs rustres*, noting that this way of life and type of frugality no longer existed in the urban environment. Critics discerned Realist qualities in these early compositions and referred to the "sincerity" that he conveyed in scenes that were "almost real."[3] Gautier watched the development of Leleux's career carefully and in 1844 designated

Les Cantonniers "one of the major works of the realist school"—exceptionally high praise for any young artist to receive.[4]

Adolphe Leleux exhibited regularly at the Salons from 1835 until 1881. In 1842 he received a third-class medal; in 1843 and again in 1848 he was awarded a second-class medal; and in 1855, the Légion d'honneur. The majority of his themes were derived from life in Brittany, although a trip to Spain in 1843 provided another locale for some of his rustic themes. Like some of his contemporaries, Leleux took an active part in the Revolution of 1848, completing a series of compositions (e.g., *The Password* [97]) that recorded episodes from that transitional period. During the Second Empire, the Emperor's interest in artists who faithfully recorded provincial scenes and life increased Leleux's prestige. In 1855 his painting *Champ de foire de St. Fargeau* was purchased by the government for 3000 francs.[5]

His later works were less often praised by the critics. Even Théophile Gautier, a staunch advocate of Leleux in his first years, discerned a lack of strength, a lack of definition in his work during the mid-1850s. He concluded that Leleux was no longer painting from observation and urged him to return to the method advocated by the Realists: to paint in front of the subject itself. Like Philippe Auguste Jeanron, whose period of significance was confined to his early years, Leleux is another painter who merits attention because of the compositions he completed in his early period—even though the number of paintings that have been located are sparse.

1. Linda Nochlin has identified the Leleuxs as proto-Realist. See her *Gustave Courbet: A Study of Style and Society*, (Ph.D. diss., New York University, 1963; New York: Garland Publishing Co., 1976), pp. 115 ff.
2. Léon Rosenthal, *Du Romantisme au réalisme: Essai sur l' évolution de la peinture en France de 1830 à 1848*, (Paris, 1914), pp. 383-86.
3. H. Robert, "Salon de 1841, Portrait—Oublis," *Le National*, 20 April 1841.
4. Théophile Gautier, "Salon de 1844," *La Presse*, March 1844.
5. Comte Nieuwerkerke to Adolphe Leleux, 14 November 1855, P 30, Archives du Louvre.

Armand Leleux
Ca. 1818 — 20 Paris — 1885 Paris

Armand Leleux is often compared and confused with his brother Adolphe, for both are considered proto-Realists. Armand was trained by his brother and, like Adolphe, his early compositions were of Breton themes (e.g., *Paysans bas-bretons revenant de la chasse*, 1840 Salon) that he depicted without actually traveling to the provincial region. These works display the slight disproportion in scale that is indicative of a largely self-taught painter. Although some information suggests that Armand spent two years in Rome studying under Ingres, his style does not show Ingres's influence, and the date of his stay in Rome has not been documented.

Despite his limited artistic training, Armand Leleux was an avid traveler, and he had the opportunity to visit many museums and to observe actual scenes during his travels that he later used in his own canvases. In 1846 he was sent by the French government to paint in Spain; the same year he also visited Switzerland, developing a fondness for the people and the countryside that led him to return to Geneva and that part of the country many times. His letter of gratitude in 1852 to an unidentified collector who purchased his

ARMAND LELEUX

Swiss theme *Guide du St. Gothar, intérieur* notes his intention to stay longer in a country which had proven most hospitable to him.[1] By April 1854, through Count Nieuwerkerke, he received payment for another work, *La Tricoteuse*, which had been purchased by the Empress.[2] His earlier letter to the government requesting payment soon because he would be away for some time reinforces the belief that Armand traveled extensively during these early years.

Armand Leleux began exhibiting in the Salons in 1839, just four years after his brother Adolphe. His themes, some of them derived from folklore, were popular with the public and the Salon jury, and he received a third-class medal in 1844, second-class medals in 1847 and 1848, and a first-class medal in 1859. He was awarded the Légion d'honneur in 1860. His success at the Salons and among private collectors made it possible for him to travel frequently. In September 1863, when the state purchased *Intérieur de la pharmacie du couvent des Capucins à Rome*, he wrote from Rome to thank Count Nieuwerkerke.[3] By 1865, a letter he wrote to Nieuwerkerke documents that he was back in Switzerland again. That he enjoyed traveling is also indicated by his appointment to serve on a committee for the 1867 World's Fair.[4]

Leleux's continuous interest in Switzerland was undoubtedly nurtured by his marriage to the Swiss painter Louise Emilie Giraud (1824-1885), who had been a student of Léon Cogniet in Paris. When or where they met, or when they were married, is not known. Throughout his life, Armand Leleux continued to exhibit in Switzerland, as well as Germany, where he also traveled.

While much of Leleux's success and patronage was due to his support by the Second Empire, unlike many of the artists who were receiving encouragement during this regime, he was associated with the Realist movement. His work themes (e.g., *Le Sabotier* depicting the poor; a version of a *Woman with a Lamp;* and the *Forge*), completed during the mid-1850s, suggests a familiarity with the canvases and drawings of François Bonvin. His early canvases of rural Spanish themes, developed after preliminary studies in that country, indicate an interest in light and reg-

EUGENE LEPOITTEVIN

ional exactitude that is similar to that of his brother Adolphe. Other compositions, however, are devoid of social implications, showing Armand Leleux's preference in later work for intimate scenes of home life that were perhaps inspired by his family ties in Switzerland, but were prepared solely for the upper-middle-class market.

1. Signed by Armand Leleux 16 August 1852 from Geneva, P 30, Archives du Louvre.
2. Count Nieuwerkerke to M. Gautier, 20 April 1854, asking that Leleux be given 1400 francs for his painting *La Tricoteuse*, P 30, Archives du Louvre.
3. Letter dated 21 September 1863, P 30, Archives du Louvre. For reference to this painting see *Le Musée du Luxembourg en 1874*, Grand Palais, 31 May—18 November 1974 (Paris, 1974), pp. 126-27.
4. Nieuwerkerke to Leleux, 28 August 1865, P 30, Archives du Louvre. Leleux was asked to serve on a commission to study the popular dress of various countries, an assignment that obviously appealed to him since he replied that he would assume his duties with "zeal."

Eugène Modeste Edmond Lepoittevin

1806 Paris — 1870 Auteuil

Eugène Modeste Edmond Lepoittevin is one of the least known painters of the second-generation Romantic school that matured during the 1830s. Trained under Hersent (1777-1860) and Le Prince, Lepoittevin was known primarily as a painter of seascapes and small genre scenes. He first exhibited at the 1831 Salon with eight works. Like many of the artists who traveled the coast of France, Lepoittevin revealed Realist inclinations in drawing seascapes and studying atmospheric conditions. He also worked in England, producing small, picturesque studies of fishing villages and coastal inlets and a few, rare portraits of friends or patrons. By the mid-1840s Lepoittevin's career was well established. He received medals in numerous Salons (1831, 1836, 1848, and 1855) and was awarded the Légion d'honneur in 1843. Further travels to Italy and the Netherlands led to an increased interest in landscape, especially scenes that capture the mood of rivers and waterways.

While Lepoittevin cannot be classified as a Realist, he occasionally did small genre studies which examined aspects of the Realist aesthetic observed in rustic settings. In spirit, these compositions resemble Gavarni's work, for they are anecdotal in theme and often view life humorously [61].

Léon Lhermitte

1844 Mont-Saint-Père, Aisne — 1925 Paris

As one of the most prolific nineteenth-century artists, Léon Lhermitte contributed significantly to the evolution of Realist drawing and painting. Born at Mont-Saint-Père (near Château-Thiérry), Lhermitte was a sickly child who spent considerable time doing portraits of his parents and copying illustrations from popular periodicals, including *Le Magasin Pittoresque*. In his classroom, Lhermitte's father, a primary school teacher, encouraged his son's interest in drawing by having him sketch. These drawings were so impressive that his father showed them to the Minister of State and Fine Arts, Count Alexandre Walewski, who helped Lhermitte obtain a renewable award of 600 francs to study art. This recognition so impressed the regional district encompassing Mont-Saint-Père that it added a small stipend to the amount already given by the national government.

In the early 1860s, Lhermitte's father enrolled him in the Ecole Impériale de Dessin (called the Petite Ecole) in the atelier of Horace Lecoq de Boisbaudran and, in either April or May, 1863—in time to attend the Salon des Refusés—Lhermitte left his family and went to live with friends in Paris. Working in "Lecoq's" atelier meant that Lhermitte was introduced to theories of memory training that sharpened his perceptions and made him even more acutely aware of value drawing, where subtle comparisons are the most important. Here Lhermitte established a number of friendships with colleagues such as Jean Charles Cazin [228]. Later he met both Alphonse Legros and Henri Fantin-Latour, former students of Lecoq de Boisbaudran.[1]

By 1864, Lhermitte had progressed enough to enter his *fusain* entitled *Les Bords de la Marne près Alfort* in the Paris Salon. Although not recorded in the Salon catalog as trained by a specific teacher, the next year Lhermitte listed himself as a student of Lecoq de Boisbaudran. At the 1865 Salon, Lhermitte exhibited two other landscape drawings. In 1866 he showed his first painting, a still life of Chinese and Japanese objects which were then a vogue in Paris. Maintaining his regard for the significance of drawing, Lhermitte always exhibited in this category; *fusains* became a continuous part of his Salon contributions until 1889. He considered his drawings fully developed compositions and submitted several, including *Les Roches d'Etretat au soleil couchant* and *The Lathe*, to the Salons of the 1860s. These works, in the subtlety of their handling of light, their preciseness of detail, and their emphasis on observation are among the earliest major "black and white" drawings establishing the medium as suitable for exhibitable work, not just for preparatory studies.

At the end of the 1860s, Lhermitte made his first trip to London, intending to meet with Alphonse Legros. He may have hoped to find work in England with Legros's assistance. When this did not materialize, he returned to France to work as an illustrator for scientific publications and art

LEON LHERMITTE

magazines.[2] During 1871, when the Franco-Prussian War and the Commune were disrupting Parisian life, Lhermitte returned to London. With Legros's assistance, he worked as a printmaker doing etchings for a book entitled *Works of Art in the Collections of England* by Edouard Lièvre. Legros also introduced the young artist to the French art dealer Durand-Ruel (then in London to escape the problems caused by the fighting in Paris), who, excited by Lhermitte's *fusains*, accepted several for his London gallery.

Lhermitte's earliest oil paintings emphasize rustic scenes observed near Mont-Saint-Père. Some were shown in the Paris Salon; others, like *Oxen Plowing* [194], were exhibited at the London Royal Academy (1872). While still in London, Durand-Ruel took it upon himself to send a number of Lhermitte's drawings to the first annual "Black and White" exhibition in 1873 at the Dudley Gallery. These drawings met with considerable success, convincing Lhermitte to travel frequently to London in future years. Simultaneously, Lhermitte saw his etchings being reproduced in France by Alfred Cadart, and his *fusains* being depicted in the Galerie Durand-Ruel's *Recueil d'estampes gravées à l'eau-forte* (1873).[3]

Lhermitte's success in England and his support by private art dealers in France may have influenced the 1874 Salon jury to award him his first Salon medal, a third-class award for *La Moisson*.[4] The government also purchased the painting for 1800 francs and gave it to the Musée des Beaux-Arts, Carcassone. Maintaining ties with England, Lhermitte exhibited ten charcoal drawings at the second London Black and White exhibition and received additional critical esteem.

By 1875, Lhermitte was devoting considerable time to completing charcoal drawings. He had extended his interest from landscape and genre studies to include portraits, completing one of the painter Charles Daubigny. Nine charcoals were exhibited at the third annual London Black and White exhibition, where, for the first time, Lhermitte served as a member of the jury. In Paris, Lhermitte continued to show Realist paintings such as *Pèlerinage à la Vierge-du-Pilier* (Trinity College Collection, Toronto) that emphasized the

impact of both Alphonse Legros and Jules Breton on the development of his style.

In 1876, with his career well established on both sides of the English Channel, Lhermitte married his cousin from Mont-Saint-Père, Héloïse Goudard (1850-1916). Traveling to Brittany for the second time since 1874, Lhermitte, accompanied by his bride, found in provincial life a new theme for a painting, *Le Pardon de Plourin, Brittany* (Victoria and Albert Museum, London), which he exhibited in the 1877 Salon. Also in 1877, Lhermitte's first son, Jacques-Jean, was born.

By the end of this decade, Edgar Degas noted in one sketchbook an intention of proposing Lhermitte as an invitee to the fourth Impressionist exhibition in 1879; although this did not occur, it does signify Lhermitte's appreciation by avant-garde painters. At the same time, the state purchased another canvas, *Le Pardon de Ploumanach, Finistère* (1879), for 1100 francs.

In 1880, Lhermitte's worries of rejection by a Salon jury were over: by winning a second-class medal for *L'Aïeule* (Musée des Beaux-Arts, Ghent), he was *hors concours*. The government, recognizing the importance of Lhermitte's *fusains*, purchased *La Vieille Demeure* from the 1880 Salon for 400 francs. Following the birth of a second child, Charles-Augustin, in 1881, Lhermitte completed *Le Cabaret*, the first of a series of paintings detailing the life of agricultural workers. In 1882 Lhermitte achieved widespread fame from both critics and public when he exhibited *La Paye des moissonneurs*. This work was purchased by the state for 5000 francs, a large sum at the time, and exhibited at the Luxembourg Museum until transferred to the Hôtel de Ville at Château-Thiérry.[5]

Lhermitte's work also impressed other painters, including Vincent van Gogh, who referred to the artist as the "Millet and Jules Breton of Black and White." In 1883, the Exposition Nationale (the Salon) honored Lhermitte by showing thirteen of his works, including ten charcoal drawings and *La Paye des moissonneurs*. In the middle years of this decade, Lhermitte traveled widely in the French provinces, visiting Béthune, Le Tréport, and Bordeaux. He also began to work in pastel— a medium he would help revolutionize. His fame as a recorder of the purity of rustic life led to a commission to do drawings for André Theuriet's *La Vie rustique*, published in 1888. Following an exhibition of the drawings for this publication in 1887, Lhermitte showed a series of his pastels at the *Société des Aquarellistes Français* and, there-after, contributed regularly to these shows.

An interest in portraiture, first shown in a series of small drawings, culminated in Lhermitte's being commissioned in 1886 to do two large group portraits as decorations for the Sorbonne. By 1889, Lhermitte sent the first of these Sorbonne panels, *Claude Bernard,* to the Salon, thus establishing himself as a major portraitist in the Naturalist vein. Tiring of the official Salon, Lhermitte and a number of his friends, such as Jean Charles Cazin, became charter members of the Société Nationale des Beaux-Arts founded in 1890. In their first Salon that year, Lhermitte served as a jury member and exhibited five drawings and four paintings.

The decade of the 1890s marked a period of independence for Lhermitte, who no longer felt obliged to sell paintings directly to the state. Continuing to travel widely, Lhermitte was decorated by other countries. He received the Bavarian Chevalier of the Order of St. Michael following the 1892 Munich International Exhibition of Fine Arts. In 1893, the French government further recognized Lhermitte's stature by purchasing his only Salon entry that year, *La Mort et le bûcheron* (Musée de Picardie, Amiens), for 5000 francs. Working on large-scale paintings and panoramic wall murals, Lhermitte in 1895 finished his largest composition, *Les Halles*. Originally destined for the Hôtel de Ville in Paris, the work is now in storage in the Musée Petit Palais.

Lhermitte's productivity did not diminish with time. He was still exhibiting at the Salons in the 1920s, well after his election in 1905 to the Institut to fill the vacancy caused by the death of Jean-Jacques Henner. With his paintings entering private and public collections throughout the world, Lhermitte remained a staunch member of the Realist tradition until his death in 1925.

1. These two artists were not working under Lecoq de Boisbaudran when Lhermitte first met them.
2. For further information on Lhermitte's career, see Mary Michel Hamel, *Léon Lhermitte*, exh. cat., an international exhibition organized by The Paine Art Center and Arboretum, 21 September—10 November 1974, The Paine Art Center, Oshkosh, Wisconsin. Hamel also did her doctoral dissertation on Lhermitte (Washington University, St. Louis, May 1974).
3. By this date Durand-Ruel had reestablished his gallery in Paris.
4. This painting suggests the influence of Jules Breton's field scenes on Lhermitte's development.
5. A series of preliminary drawings for this painting are found in the collection of the Lhermitte descendants.

Edouard Manet
1832 Paris — 1883 Paris

Born in Paris in 1832, Edouard Manet was brought up in a solidly bourgeois family of the July Monarchy. His father was a high official in the Ministry of Justice; his mother, the daughter of an influential diplomat. His own interests ran in a different direction: toward liberal politics (he followed the events of 1848 eagerly and endorsed the new Republic) and a career in art. Resisting his father's wish that he study law and failing twice to pass the entrance examination for the naval academy, he was allowed at last in 1850 to enroll in Thomas Couture's studio. There Manet remained for six years, absorbing his teacher's unconventional ideas and enthusiasm for the old masters; twice in this period Manet traveled widely, visiting most of the major European museums. His first submission to the Salon, *Le Buveur d'absinthe*, was rejected in 1859, but two years later his *Chanteur espagnol* was awarded an honorable mention and praised by Théophile Gautier. Baudelaire, with whom Manet had recently become friendly, also supported his efforts and discussed with him his ideas on modernity. By now Manet had begun to exhibit with other Realists of his own and previous generations at Martinet's gallery, but he continued to submit pictures to the Salon as well. In 1863 all his entries, including the *Déjeuner sur l'herbe,* were rejected and later shown at the notorious Salon des Refusés. The following year his pictures were accepted but harshly criticized, and, the year after, his *Olympia* was the object of almost universal derision. Fleeing from his defeat, Manet traveled in Spain and was able at last to study the great Spanish masters, above all Velázquez, whom he had long admired. At the World's Fair of 1867 he displayed fifty works in a private pavilion near Courbet's, but he found little public or critical approval; only Zola, whom he had met the previous year, openly championed his art.

After the Franco-Prussian War, in which he served in the National Guard, and the devastating civil war that followed—scenes of which he recorded in prints—Manet resumed his earlier efforts to gain public approval. He continued to exhibit regularly at the Salon or in his own studio, with steadily growing success; yet he refused to participate in the group shows organized by his Impressionist colleagues from 1874 on. In 1873 he met Mallarmé, the third great writer who was to befriend him and write perceptively about his work; and two years later he revisited Venice, this time to paint the Grand Canal in an Impressionist manner calculated to please Mallarmé. By the end of the decade Manet began to suffer from locomotor ataxia (then diagnosed as rheumatism), a condition that afflicted his last years, but he remained active and in 1880 held an important exhibition in the offices of the magazine *La Vie Moderne*. By the end of the following year he was seriously ill and his production declined. By the spring of 1883 he was bedridden, and on 30 April he died. Now at last a widely respected artist, he was given a posthumous retrospective exhibition at the Ecole des Beaux-Arts.

Manet's connections, both personal and artistic, with the Realists were largely restricted to the years before 1866, yet they were surprisingly extensive. Although he learned much in Couture's studio, including an appreciation of the heroism and dynamism of modern life, it was not there that he developed an interest in street musicians, rag-pickers, and beggars. His teacher's attitude is indeed summed up in *Le Réaliste,* a satire on the vulgarity he disliked in such subjects, and his disdain for Manet's *Buveur d'absinthe* led to a permanent break between them.[1] Meanwhile, however, Manet was becoming acquainted with the younger Realists who exhibited together in Bonvin's studio in 1859. At Martinet's gallery and Cadart's print shop he must also have met Bonvin, Bracquemond, Ribot, and Vollon, who likewise exhibited there and belonged to Cadart's Société des Aquafortistes. At the Salon des Refusés he was in the company of Fantin-Latour, Whistler, Vollon, and Amand Gautier, who was also close to Courbet. Courbet's work had a strong influence on Manet throughout the decade, and though there is no evidence of their direct contact, they were certainly aware of each other and at times in direct competition.[2] As late as the 1880s Ribot was admired by Monet, Stevens, and others in Manet's circle, just as Ribot considered Manet a master equal to Corot, Courbet, and the Barbizon painters.[3]

Unlike most of these artists, whose humble origin and struggle for survival naturally disposed them to represent impoverished and marginal types, Manet did so deliberately, almost in defiance of his upper-middle-class background. This was especially true in his early years, when he painted *Le Buveur d'absinthe* (1858-59), a subject also treated in a Daumier lithograph;[4] *La Chanteuse des rues* and *Les Gitanes* (both 1862), familiar subjects in the illustrations of *Les Français peints par eux-mêmes* and similar publications;[5] and above all *Le Vieux Musicien* (1862), a subject described by Realist writers such as Champfleury and Victor Fournel.[6] Despite Manet's turn in that year to scenes of bourgeois diversion and pleasure—a troupe of Spanish dancers, a concert in the Tuileries Gardens, an elegant and risqué picnic, a fashionable courtesan in her boudoire—he did not abandon his early interest in Realist themes. Witness the monumental *Philosophes* (1865), beggar-philosophers in the

EDOUARD MANET

CHARLES MAURIN

3. Gabriel P. Weisberg, "Théodule Augustin Ribot," in *The Other Nineteenth Century,* ed. L. d'Argencourt and D. Druick (Ottawa: National Gallery of Canada, 1978), p. 157. L. de Fourcaud, *Théodule Ribot* (Paris, 1885), pp. 2, 8-9.

4. Denis Rouart and Daniel Wildenstein, *Edouard Manet, Catalogue raisonné* (Lausanne: La Bibliothèque des Arts, 1975), no. 19. L. Delteil, *Honoré Daumier (Le Peintre-graveur illustré, XIXe et XXe siècles)* (Paris, 1925-30), no. 3256.

5. Rouart and Wildenstein, *Edouard Manet,* nos. 41, 50. Hanson, *Manet,* pp. 60-66.

6. Rouart and Wildenstein, *Edouard Manet,* no. 52. Theodore Reff, " 'Manet's Sources': A Critical Evaluation," *Artforum* VIII (September 1969): 42-43.

7. Rouart and Wildenstein, *Edouard Manet,* nos. 99, 100, 137, 244; Hanson, *Manet,* pp. 64-65.

8. Rouart and Wildenstein, *Edouard Manet,* nos. 112, 186.

9. Emile Zola, "Les Réalistes du Salon," *L'Evénement,* 11 May 1866, quoted in Zola, *Le Bon combat,* ed. J.-P. Bouillon (Paris, 1974), pp. 65-69.

10. Robert Fernier, *La Vie et l'oeuvre de Gustave Courbet* (Lausanne-Paris: Bibliothèque des Arts—Fondation Wildenstein, 1977-78), no. 101. Rouart and Wildenstein, *Edouard Manet,* no. 272.

tradition of Velázquez; the still larger and more imposing *Chiffonnier* (1869); and the touching portrait of Marcellin Desboutin as a bohemian outcast (1875).[7] Other images of popular types in the Realist vein in his later work include *Le Fumeur* (1866) and *Le Bon Bock* (1873), both of which represent the same type, and one of them the same model, as *The Reader* (1861).[8] In his treatment of such subjects, too, Manet—like the other Realists—employed a sober palette based on black, white, and neutral tones inspired by those of seventeenth-century Dutch and Spanish art, a taste he shared with Bonvin, Ribot, and others at the time.

Increasingly in the course of the 1860s, however, Manet's conception of Realism differed from theirs, and despite his acquaintance with them and his occasional choice of a subject dear to them, his work came to resemble theirs very little. Zola, who became his champion and to some extent his spokesman in 1866, emphasized the distance between Manet and these artists in reviewing their works at the Salon that year; in criticizing their lack of vigor, truth to nature, and strong personal accent, whether he was entirely justified or not, he was in effect stressing the very qualities he admired most in Manet.[9] By the following decade Manet was working in a sophisticated, elliptical, Impressionist style that especially appealed to the Symbolist poet Mallarmé and that further removed him from the Realists. Nothing marks the distance between Manet's later work and theirs more clearly than a comparison between his luminous, broadly painted, coolly detached *Rue Mosnier aux Paveurs* (1878) and Courbet's grimly down-to-earth, grittily realistic *Casseurs de pierres* (1850).[10] In the interval, the very definition of Realism as an advanced style had changed profoundly. T.R.

1. Anne Coffin Hanson, *Manet and the Modern Tradition* (New Haven, Conn.: Yale University Press, 1977), pp. 9, 14, 128, 157. A. de Leiris, "Couture, The Painter," *Thomas Couture: Paintings and Drawings in American Collections* (University of Maryland Art Gallery, 5 February—15 March 1970), p. 23.

2. Theodore Reff, "Courbet and Manet," *Arts Magazine* LIV (March 1980): 98-103.

Jean Baptiste-Joseph-Antonin Charles Maurin
1856 Le Puy-en-Velay — 1914 Paris

For a large part of his career Charles Maurin was linked with both the Naturalists and the Symbolists as he tried to forge a connection between the movements. Although compared with Henri de Toulouse-Lautrec (1864-1901), Mary Cassatt (1845-1926), and occasionally Edgar Degas, Maurin is best known as a printmaker.[1]

First trained at the Lycée du Puy, Maurin excelled at drawing. From 1875 to 1879, supported by a fellowship from his town, he studied in Paris under Jules Lefèbvre (1836-1912) and Gustave Rodolphe Boulanger (1824-1888) at the Académie Julian. From 1882 until 1890 Maurin exhibited at the annual Paris Salons, receiving an honorable mention in 1882 and in 1884 a third-class medal for two portraits, *Jeune Fille* and *Portrait de Rodolphe Julian,* a study of a teacher at the Académie Julian. By the mid-1880s Maurin was well established as a teacher, holding sessions at the Académie Julian. Here, in 1885 or 1886, he met the young Swiss artist Félix Vallotton and became both his teacher and his friend.[2] Exhibiting at the Salon des Indépendants for the first time in 1887, Maurin enjoyed considerable success. Critics regarded him as a draftsman in the tradition of Goya and Daumier, and his paintings were admired by other artists, especially Edgar Degas. His works at the same Salon the following year were studied by a number of younger painters, for he was considered a member of the avant-garde.

Maurin became friends with Toulouse-Lautrec (1890), and made frequent visits to the cafés and nightspots of Montmartre. Eager to travel, Maurin visited Holland, Belgium, and England but only rarely returned to his native region of Le Puy. He completed large decorative paintings that were often symbolic in content, and in 1892 exhibited for the first time with the Rose-Croix group. The following year he held a two-man exhibit with Toulouse- Lautrec at the Boussod-Valadon Gallery, which resulted in the sale of his *Prélude de Lohengrin* to the city of Le Puy. Established as a major artist in Paris, Maurin also sent paintings to exhibitions in other countries, including La Libre Esthétique, Belgium (1896 and 1897), and the Exhibition of International Art, London (1898).

The 1890s were Maurin's most prosperous period. From 1900 to 1914 his production declined and his imagination weakened. His death went almost unnoticed.

1. For further information on Maurin see *Charles Maurin 1856-1914* (with an essay by Phillip Dennis Cate) (New York: Lucien Goldschmidt, 2-29 November 1978); and *Charles Maurin, 1856-1914,* essai sur le peintre et catalogue de l'exposition de 1978 par Roger Gounot (Le Puy: Musée Crozatier, 1978).

2. *Charles Maurin* (Le Puy), p. 9.

Jean-Louis-Ernest Meissonier
1815 Lyon — 1891 Paris

As a staunch supporter of academic history painting, Jean-Louis-Ernest Meissonier often regarded the Realists as antagonists. In 1872, he played a leading role in preventing Gustave Courbet from exhibiting works painted while imprisoned for his activities during the Paris Commune (March-May 1871). Yet, occasionally Meissonier painted a Realist-inspired composition such as *Remembrance of the Civil War* (1848, Musée du Louvre) or *The Ruins of the Tuileries* [108] (1870)—works which demonstrated his meticulous style could be used for a contemporary scene when he was personally moved by the event.

Meissonier's father, a dye merchant, selected a commercial career for Jean-Louis. Rebelling, Meissonier became one of the most influential and prosperous nineteenth-century painters. Raised in Paris since the age of three, Meissonier lived and worked there, although he later acquired property in suburban Poissy (ca. 1846-47) and made occasional trips to Grenoble, Antibes, and, after 1859, Italy. After spending only four or five months in the studio of Léon Cogniet (1794-1880), where he believed he learned little, Meissonier followed an independent course, studying Dutch and Flemish genre painters in the Louvre. His work was deeply influenced by Dutch artists such as Gerard Terborch (1617-1681) and Gabriel Metsu (1629-1667), and by the French master Jean-Baptiste Greuze (1725-1805). Most important for Meissonier's development was his work as a book illustrator for editors such as Léon Curmer and

JEAN-LOUIS-ERNEST MEISSONIER

1. For further information on the early part of Meissonier's career, see Constance Cain Hungerford, "The Art of Jean-Louis-Ernest Meissonier: A Study of the Critical Years 1834-1855" (Ph.D. diss., Berkeley, University of California, 1977).

Jean François Millet

1814 Gruchy — 1875 Barbizon

Jean François Millet occupies a significant place in the development of nineteenth-century painting, and much of his work exemplifies the Realist tradition. Millet did the majority of his mature works in the village of Barbizon, near the Fontainebleau Forest, away from the pressures and problems of Paris. Along with several colleagues, most notably Théodore Rousseau, Millet became absorbed in depicting peasant life.

Millet was born in the small village of Gruchy, near Cherbourg, to respectable, landowning parents who recognized his artistic ability and sent him to Cherbourg, seventeen kilometers to the east, to study with Mouchel, a local painter who specialized in portraiture. Millet often returned home to Gruchy to help with farm work. By 1835, Millet was studying in Cherbourg with L. Langlois (1803-1845), a student of Gros, and had decided upon a career as a painter, While in Cherbourg, Millet studied works by earlier Spanish, Dutch, and French painters in Thomas Henry's collection (later given to found the local museum).

Local authorities regarded Millet so highly that they recommended him for financial assistance to study in Paris. In March 1837, he enrolled in the studio of Paul Delaroche (1797-1856) at the Ecole des Beaux-Arts in Paris. Failing to win awards in Delaroche's atelier, Millet left the Ecole, an act which so angered the city fathers of Cherbourg that they rescinded his fellowship. Millet continued to paint on his own, however, submitting works to the Salon until finally, at the 1840 Salon, his *Portrait de M. L. P.* (Lefranc) was exhibited.

When Millet returned to Cherbourg, the City Council in the winter of 1840 commissioned a portrait of the former mayor, Colonel Javain. But once Millet completed the canvas, the Municipal Council rejected it. Though Millet painted other portraits in Cherbourg [133], he remained depressed and returned to Paris at the end of the winter. Many of these early portraits were of members of the family of Pauline-Virginie Ono, Millet's first wife, and reflected his highly eclectic, early portrait style and, in the most successful of these works, a deep understanding of character combined with intense observation (e.g., *Portrait of Madame Roumy* [133]).

The early 1840s were a period of deprivation and struggle. Pauline Ono, whom Millet married in 1841, was sickly and eventually died of consumption in 1844. Still struggling to achieve Salon acceptance, Millet returned to Cherbourg to try to overcome his grief.

After a short stay in Cherbourg, Millet left for Le Havre accompanied by Catherine Lemaire, a servant whom he met earlier. In late 1845, he painted portraits and pastoral scenes which he sold at public auction in Le Havre to raise money to return to Paris. In Paris in 1846 Millet met Troyon and Diaz (1807-1876) who helped place his canvases with art dealers, including Durand-Ruel. Millet's work sold for exceedingly low prices that provided only a subsistence level for the artist, Catherine, and their first child. During the late 1840s, Millet met a number of young, vigorous, republican artists, including Théodore Rousseau

JEAN FRANÇOIS MILLET

(1812-1867), Daumier, and Charles Jacque (1813-1894). He began examining the life of the French peasant in a direct style that suggested that an uncompromising Realism was affecting his imagery.

During the Revolution of 1848, the friends Millet associated with—Daumier, Jacque, and Jeanron—and the themes Millet painted (e.g., *Le Vanneur*) suggest an awareness of contemporary issues, if not a commitment to republicanism. After taking part, along with Daumier, in the contest in 1848 to determine the new image of the Republic, Millet reflected the tensions of 1848-49 in increasingly somber paintings. Prodded by powerful republican friends, the state commissioned Millet, and he began work on *Agar et Ismael*. Unable to finish this painting, Millet substituted another work, *Le Repos des faneurs* (Musée du Louvre). The 1800 francs he received enabled Millet to flee from Paris and establish himself at Barbizon, where he remained the rest of his life.

Alfred Sensier, a civil servant Millet met in 1847, gave Millet canvas and paint in return for some paintings and drawings. By selling Millet's compositions to dealers and an occasional client, Sensier became Millet's first agent. By 1850 Millet's paintings were receiving recognition; his *Sower*, in the 1850 Salon, was widely appreciated by republican colleagues and critics of the left. In 1851, thanks to Sensier's efforts, Millet's first painting to be shown abroad, *La Broyeuse de lin* (The Walters Art Gallery), was exhibited in London and served to influence contemporary English art. As Millet's works became widely known through lithography and engraving, many came to regard him as an important artist of the peasant class. His paintings at the 1853 Salon, such as *The Harvesters Resting* [49] and *Une Tondeuse de mouton*, enhanced this position and won Millet a second-class medal.[1]

While Millet was progressing as a painter, selling works to a number of private collectors of modest means, his family affairs were complicated. His grandmother died in 1851 without ever knowing of Millet's liaison with Catherine Lemaire or their four children that had already been born. His mother passed away in 1853, and although the last of Millet's nine children was born in 1863, Millet did not marry Catherine until 1875.

Jules Hetzel in the 1830s and 1840s. In illustrations for such well-known novels as *Paul et Virginie*, Meissonier developed a style employing diminutive, painstaking detail.

Exhibiting in the Paris Salons from 1834 until 1877, Meissonier received numerous awards for his genre and historical compositions. He received a third-class medal in 1840, a second-class award in 1841, and first-class medals in 1843 and 1848. His genre compositions of sixteenth- and seventeenth-century cavaliers and eighteenth-century smokers, readers, chess players, or connoisseurs were very popular and led to his receiving medals of honor in 1855 and 1867, at the height of the Second Empire. With the exception of his experience of the street barricades during the Revolution of 1848 that led him to do a water color and a small painting based on these contemporary, gruesome events, throughout the Second Empire he maintained a preference for glorifying the military campaigns of Napoleon I in paintings such as *1814, The Campaign of France* (1864) (Musée du Louvre).[1]

Meissonier became one of the leading figures in the Paris art world. He was also appointed or elected to Salon juries and art sections of the Paris World's Fairs. He was elected to the Institut de France in 1861, and twice served as its president. In 1884, his works were shown in a major retrospective organized by the Galerie Georges Petit to commemorate the fiftieth anniversary of his first Salon. In 1889, besides receiving a second medal of honor to match the one he received in 1878, Meissonier in conjunction with Puvis de Chavannes (1824-1898) helped organize the Société Nationale des Beaux-Arts, and became that group's first president in 1891. That same year he also became the first artist to receive the Grand Cross of the Légion d'honneur, an award attesting to his fame and dominance in the art world. He exhibited at the Salons of the Société Nationale des Beaux-Arts until his death. The sale of his atelier took place in 1893, after which his paintings quickly fell into disfavor.

Millet's friendship with other Barbizon painters helped his career. Théodore Rousseau purchased Millet's *L'Homme répandant du fumier* and *Le Greffeur* in 1855 at a high price but under a false name, thereby helping to further secure Millet's name on the art market. Millet continued to work in Barbizon (near Rousseau), and left only to go to Cherbourg in 1854, to Vichy in the summers of 1866 to 1868, and again to Cherbourg in 1870-71. Millet fully embraced the rural environment, painting innumerable scenes based on memories of his upbringing in Normandy. If Millet did find middle-class collectors, his paintings at later Salons were perhaps indicative of class problems, since Millet stressed the moral superiority of hard labor in his peasant themes.

By 1857, when Millet exhibited his *Gleaners* at the Salon, he had gained a number of adherents. One of his major "champions" in France, Jules Antoine Castagnary vehemently defended Millet's work. But in 1859, conservative critics still attacked Millet and his controversial painting *La Mort et le bûcheron* (Copenhagen Glyptothek) was rejected at the Salon. This painting, with its overtones of peasant oppression, reinforced his colleagues' opinion that Millet's familiarity with Milton, Virgil, and, here, La Fontaine made him one of the most cultured, contemporary painters. Critics again violently attacked Millet at the 1863 Salon for his *Man with a Hoe*, but the postcard reproduction Millet authorized assured widespread popularity for the work.

After 1863, encouraged by Théodore Rousseau, Millet became more interested in landscape painting. His work was received more favorably by the public, but his serious financial problems were alleviated only in 1864 when he received a first-class Salon medal despite art critics' unanimous condemnation of his painting, *La Naissance du veau*. In general, however, Millet's position improved during the decade of the 1860s. *The Angelus* was exhibited for the first time at the 1865 Salon. The 1867 World's Fair became a retrospective exhibition of a number of Millet's works, thus helping consolidate his reputation. The following year he received the Légion d'honneur.

During the Franco-Prussian War and the Commune, Millet remained in Cherbourg, absorbed in painting realistic seascapes. He was commissioned by the government to do a chapel of the Pantheon in 1874, but died before he could fulfill the request. While many of his works suggest a biblical quality, and critics often attributed a scriptural significance to his paintings, Millet was not religious. He simply saw his themes as traditional ones that emphasized the fundamental continuation of customs from one century to the next.

1. Because of Millet's fame at the 1853 Salon, William Morris Hunt, a young American painter who wanted to discuss art theories, contacted Millet. Subsequently, Hunt's friend from Boston, Martin Brimmer, purchased *Le Repas des moissonneurs*.

Jean-Jacques François Monanteuil
1785 Mortagne — 1860 Le Mans

Jean-Jacques François Monanteuil occupies an unusual position in the evolution of Realism since he remained largely unknown during the nineteenth century, and his paintings that remain today are found only in two small museums in Alençon and Le Mans, within the provincial region where he spent much of his life. Nevertheless, his Realist canvases (and more often his drawings) were occasionally acquired by private collectors, probably as a result of his participation in regional exhibitions. As a provincial painter who desired to succeed in Paris and at the Salons, Monanteuil at first developed a style in accordance with Davidian principles and the aesthetics of Neoclassicism. Later, tiring of these qualities, he gave up a lucrative academic career to return to his native region, where from the late 1820s he worked alone, evolving a naive Realist style.

Because of the modest surroundings in which he was raised (his father was a wool merchant), Monanteuil's earliest artistic training was limited. Fresnais d'Albert (1763-1816), a painter of still lifes, was Monanteuil's first teacher at the art school in Alençon. While studying there, Monanteuil excelled as a draftsman, a skill he maintained in his later pencil drawings of street musicians and beggars [17, 18]. Monanteuil's abilities were also recognized by a local patron of the arts, Louis-Joseph Poissonnier (Baron de Prulay), who sent the young artist to Paris. Under the sponsorship of Poissonnier, Monanteuil was accepted into the atelier of Girodet (1767-1824), a painter well known for pre-Romantic themes completed in a Neoclassic style. This was a distinguished honor for an unknown provincial artist, and Monanteuil made the most of this singular opportunity. He excelled as a student, and his natural propensity for drawing coincided with Girodet's reliance on line. During the opening years of the First Empire (ca. 1805-6), Monanteuil also gained invaluable experience and completed his first oil paintings.

Girodet favored the young artist, and Monanteuil posed for the figure of Chactas in *The Entombment of Atala*.[1] Monanteuil also served as model for a peasant (along with his wife) in Girodet's *Napoleon Receiving the Keys of Vienna*. Even when others began to find the aging Girodet's personality increasingly intolerable, Monanteuil continued to work as his assistant on decorations for the Château de Vincennes. From 1810 until 1828, when he finally left Paris, Monanteuil also completed many canvases independently, which were exhibited at the Salons (e.g., *Une Baigneuse*, 1819; *Etude de paysan normand*, 1824; *Pêcheuses des côtes de Dunkerque*, 1827). The many portraits that he also painted during this period were the result of his contacts with aristocratic families.

Despite his success, Monanteuil became increasingly uneasy about the style of painting in which he had been trained—perhaps because of the growing popularity of the Romantic school then emerging under Géricault and Delacroix. Similarly, when Girodet died in 1824 leaving no mention or recognition of his faithful service in his will, Monanteuil was deeply disillusioned. Monanteuil had been under the domination of a strong master for too long.

No longer duty-bound, Monanteuil was free to travel. He went to Flanders, then on to Brittany, where he again began sketching what he observed. He completed innumerable studies of people—popular types, figures in regional costumes, portraits—revealing individual characteristics that would never have been considered acceptable under the constraints of the Neoclassic doctrine in which he had been trained.

By 1825 Monanteuil had changed his way of painting. He discarded the doctrine of classical tradition that he had earlier acquired, to follow, instead, a decidedly Realistic predilection. The themes he selected reflect this change; old fishermen and blind beggars singing in the streets became his new subjects. Monanteuil continued his drawing, recording what he saw as quick translations of reality.

JEAN-JACQUES FRANÇOIS MONANTEUIL

By 1828, Monanteuil left Paris—never to return—and moved back to his provincial home town of Alençon (1831). Here he continued the direction initiated by his earlier trip to Brittany, increasingly studying local types and finishing portraits of friends dressed in contemporary garments. During the late 1830s, Monanteuil's preference for drawing increased. His portraits in pencil are among his finest works. Here, the freshness of his manner combined with a purity of vision derived from working directly from a model.

Monanteuil was also named a professor at the Alençon art school, but by 1835 he realized that he was not suited to run an atelier and that he wanted to free himself from administrative duties. He applied for appointment as curator at the Caen Museum, a post which would have given him time to work but also would have enabled him to maintain contacts with influential people. The position, however, was given to another artist, who had been born in Caen. The need for a fixed income forced Monanteuil to return to the Alençon art school in 1843, where he remained as a teacher until he moved to Le Mans in 1851.

Monanteuil's proto-Realist paintings were never shown in Paris. Nonetheless, his provincial exhibitions helped to establish an important regional basis for Realism.

1. Léon de la Sicotière, *Monanteuil, Dessinateur et peintre* (Caen, 1865), p. 8.

Isidore Pils
1813 Paris — 1875 Douarnenez

Unlike the impoverished working-class background common to many of the Realist painters, Isidore Pil's home life was enriched by family ties that remained close throughout his life. His early fascination with contemporary military scenes and campaigns that continued throughout his career may perhaps be traced to his own father's participation as a soldier during the First Empire and the interest in art he shared with both of his sons. Like his brother, a promising artist who died when he was only twenty-nine, Pils also

ISIDORE PILS

suffered from ill health throughout his life and was hospitalized several times for treatment of tuberculosis.

After studying for a short time with Guillaume-Guillon Lethière (1760-1832), Pils enrolled in 1834 in the atelier of Picot (1786-1868). Picot quickly recognized the young artist's aptitude and recommended Pils for work on the Gallery of Henry II, an assignment that established an interest in large-scale paintings and wall decorations that would culminate some years later in the murals Pils completed for the new Paris Opera House. In 1838, after a stay in the hospital, Pils won the coveted Prix de Rome with his composition *St. Peter Healing a Cripple*, a sympathetic depiction that forecasts Pils's transformation within the next few years into a Realist especially concerned with the treatment of the poor.

The Prix de Rome enabled Pils to spend the next five years in Rome studying Renaissance painters and improving his use of color. When he returned to Paris in 1843, he exhibited at the Salons and continued to paint religious themes (e.g., *Christ Preaching*) and eventually received a second-class medal. Pils exhibited *The Death of Magdelene* at the 1847 Salon and *An Episode in the Passage of the Beresina* (most likely a semi-historical composition) at the 1848 Salon. At the 1849 Salon Pils exhibited a work which would have assured his fame had it been his only composition, for his singular depiction of *Rouget de Lisle Singing the Marseillaise* appealed to the patriotic sentiment then prevailing.

It was at this time that Pils's innate predilection for compassion toward the poor became evident, an interest that signaled his participation in the emergence of Realism. *The Death of a Sister of Charity* [79], exhibited at the 1850/51 Salon, continued his commentary on the poor that he hoped to establish as a new category of "religious genre." In the 1852 Salon, his concern for the poor was revealed by another large-scale composition, *Soldiers Distributing Bread to the Poor*. His 1853 entry, *The Prayer in the Hospice* [81], combined his personal feelings with his own memories of being cared for by Sisters of Charity in the hospitals of Paris. This painting so impressed Empress Eugénie that Pils became a well-known

figure among the several young artists then being championed by the Second Empire.[1]

Established as an official Realist and favored by the Imperial family, Pils began to chronicle the military campaigns of the Emperor. He accompanied the army on expeditions, rapidly recording sketches and watercolor observations in notebooks that became original drafts for his later paintings. The water colors that Pils introduced at the Salon in 1855 established him as one of the foremost artists in this medium in France.[2] Throughout the remainder of the Second Empire, Pils was well rewarded for his dedication to the goals of the government. After his exhibition of the *Battle of Alma* at the 1861 Salon, Pils received a grand medal, and in 1864 he was named professor at the Ecole des Beaux-Arts, a position that marked the height of his fame and popularity; he was the first of the Realists to receive such honors.

During the 1860s, military scenes consumed Pils's interest. He did innumerable studies of different army units and detailed studies of men in uniform. He was fascinated by the color and the spirit portrayed by these events and individuals. With the fall of the Second Empire and the siege of Paris (1870/71), the training that Pils had acquired as a Realist reporter was put to use. His water colors provide a moving record of the destruction of Paris and the military siege. While these images are not devoid of Romantic sentiment, they also reveal an accurate account of the tragedy he witnessed. These studies can also be designated Impressionist because of the freshness and spontaneity of their execution, even though they pre-date the first Impressionist exhibition.

Pils was awarded the Légion d'honneur in 1867 and received membership in the Institut in 1868. During the 1870s his health began to fail and, although he continued to exhibit at the Salons until 1875, he was not able to undertake new projects or commissions. Throughout his life, his openness and fairness were respected by his contemporaries, for he maintained his personal dedication to frankly Realist predilections, even under state domination.

1. Surprisingly, Pils was omitted from the recent Second Empire exhibition—a serious oversight since Pils was one of the foremost artists of the period and his historical scenes were balanced by an interest in portraiture, contemporary genre, and military studies. See *The Second Empire: Art in France under Napoleon III*, exh. cat. (Philadelphia Museum of Art, 1978).

2. A recent exhibition, *From Delacroix to Cézanne: French Watercolor Landscapes of the Nineteenth Century* (College Park: University of Maryland, 1977), failed to include any examples of works by Pils. While some of Pils's water colors could be considered urban in theme, many of his works would have been appropriate in this exhibition.

Camille Pissarro
1830 Saint Thomas, Virgin Islands — 1903 Paris

Although many of Camille Pissarro's early paintings were destroyed during the Franco-Prussian War, the few that remain reveal the influence of Courbet and other Realists in modifying Pissarro's early Romantic style. Arriving in Paris as an impressionable young artist in 1855, Pissarro followed the dictates of Corot until sometime in the mid-1860s, when his inclinations allied him with the vigorous, painterly innovations of Courbet. Emerging as a stalwart of the Impressionist movement in the 1870s, Pissarro painted adventurously in a natural manner based on visual perceptions that chronicle contemporary life and landscape.

Born in the Danish West Indies, Pissarro was sent to school in Paris by his parents. From 1841 until 1847, at a boarding school in Passy, Pissarro indulged his penchant for art. In 1847, returning to the West Indies to clerk in his father's store, he continued to draw, spending all his spare time doing sketches of life around him. He struggled to fit his art work into his official responsibilities for five years, but, finally, in 1852, without parental permission, accompanied the Danish painter Fritz Melbye to Caracas, Venezuela, where he remained until 1855. His new friend taught him the rudimentary skills of painting, and Pissarro's works from this period were mainly water colors —usually annotated in Spanish.

Pissarro's parents eventually accepted their son's chosen career and sent him funds to return to Paris in 1855. Arriving in time for the World's Fair, Pissarro saw paintings from many countries and Realist canvases by Alexandre Antigna and Gustave Courbet. Indeed, Corot, Courbet, Millet, and Daubigny all strongly influenced the young painter. Pissarro also met other artists, including Anton Melbye, the brother of his friend Fritz, who introduced him to the Ecole des Beaux-Arts and the Académie Suisse. Pissarro preferred the Académie Suisse, where he could work at his own pace without interruption by a teacher.

Solely to appease his father, Pissarro studied briefly with several academic painters in the 1850s. He sought advice from Camille Corot and, with his encouragement, did landscapes from 1856 to 1858 of the outskirts of Paris, especially at Montmorency and La Roche-Guyon. A view of Montmorency was his first painting accepted at the Salon in 1859. In the Salon catalog, Pissarro listed himself as a student of Melbye, but his conventional interest in landscape disappeared when Salon juries in 1861 and 1863 rejected these works.

By 1860, Pissarro had become friends with Antoine Chintreuil (1816-1873), who is often considered a precursor of Impressionism, and Ludovic Piette (1826-1877), another landscape painter who exhibited with the Impressionists in 1877 and 1879. Pissarro continued to work at the Académie Suisse, where he met Paul Cézanne and Armand Guillaumin (1841-1927).

Pissarro fell in love with his mother's maid, Julie Vellay, and when a child, Lucien, was born in 1863, his father wanted to stop his son's allowance, but his mother continued to send him money. Pissarro struggled to make ends meet and soon moved with his mistress and child to La Varenne Saint-Hilaire, on the Marne. Rejected by the 1863 Salon jury, Pissarro exhibited in the Salon des Refusés. Jules Antoine Castagnary noticed his work and found it comparable with Corot's. By 1864, Pissarro was listed as Corot's pupil in the 1864 and 1865 Salon catalogs. But in 1866, there is no mention of Corot with Pissarro, possibly because Pissarro had quarreled with his teacher about becoming a Realist. Corot abhorred Realism. His 1866 Salon painting praised by Emile Zola, clearly underscored Pissarro's intention of following Courbet rather than Corot.

After his father's death in 1866, Pissarro settled in Pontoise, where he did many landscapes and possibly some still lifes [121]. Along with other young avant-garde painters (e.g., Renoir, Sisley), Pissarro petitioned for another Salon des Refusés when the jury rejected his work in 1867. Though nothing came of this request, the Salon the follow-

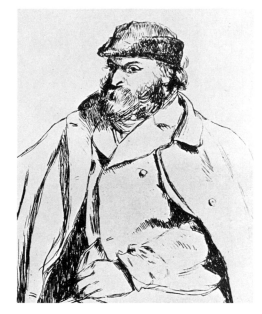

CAMILLE PISSARRO

ing year admitted two Pissarro landscapes, which
were praised by Emile Zola and Odilon Redon.
This acceptance finally established Pissarro as a
painter, and he never again listed himself as the
student of another artist.

Dogged by financial difficulties, Pissarro man-
aged to sell a few paintings to Père Martin at low
prices. He went to England, thus escaping the
ravages of the war with Prussia, and was intro-
duced by Daubigny to the art dealer Durand-
Ruel. London proved successful in another way:
Pissarro formed a friendship with Claude Monet,
then also in England, that lasted until Pissarro's
death in 1903.

Defending the right of painters to exhibit where
they pleased, Pissarro championed independent
exhibitions outside the Salon system. The first
Impressionist shows became his personal call for
artistic freedom. Pissarro's efforts continued to
hold the loosely knit group together. In 1883,
Durand-Ruel selected Pissarro for a one-man ex-
hibition that recognized him as the dean of
Impressionist painters, but his show aroused little
public interest.

In the mid-1880s Pissarro moved away from
Realism. Influenced by both Seurat (1859-1891)
and Signac (1863-1935), these later composi-
tions—shown at the last Impressionist exhibition
in 1886—reflected a "divisionist" style. Pissarro
gradually began to receive public attention, mostly
because of promotion by Durand-Ruel. For the
first time in his career, his financial position was
secure. By the late 1880s, Pissarro suffered from a
chronic eye infection which prevented him from
working outdoors. Although one aspect of his
productivity ceased, Durand-Ruel is recorded as
having purchased a large number of canvases in
1889.

In the decade of the 1890s, Pissarro was active
as a printmaker as well as painter. He also fol-
lowed the political events of the time, and a
number of activists shared his anarchist
philosophy. Most of Pissarro's work in oils con-
tinued the Impressionist style he had adopted in
the early 1880s; the somber, structured, Realist
paintings of the late 1860s were completely super-
seded by a study of light and color for their own
sake.

Jean François Raffaelli
1850 Paris — 1924 Paris

Raffaelli's importance in nineteenth-century art
comes from his unique portrayals of the industrial
suburban landscape of Paris and its inhabitants.
His works display a segment of humanity hidden
from public view and largely overlooked by other
artists. Like his friend Huysmans and other con-
temporary Naturalist writers of fiction, Raffaelli,
with rare acuity of vision, depicted downtrodden
or work-weary figures, carefully individualized in
their accustomed milieu.

In paintings such as *The Ragpicker* [164], and
The Merchant of Garlic and Shallots [165], Raf-
faelli documents contemporary society and men's
individualized roles within it. These pictures dem-
onstrate a utilitarian aspect of art and, in keeping
with the positivist notions of that time, parallel the
work of the literary Naturalists.

Unlike previous nineteenth-century artists who
depicted the Parisian industrial suburbs and its in-
habitants only occasionally, Raffaelli focused
upon this subject matter for a substantial part of
his career—the period of his residence at
Asnières—from the late 1870s until his return to
Paris in the early 1890s. Attentive to the sociolog-
ical role of his art, he categorized these suburban
figures not only pictorially but also explicitly by
the descriptive labels he provided for exhibitions,
such as *Portraits—Types de gens du bas peuple,
Portraits—Types de petits bourgeois, Scènes de
moeurs, Sur Paris* and *Caractères de banlieue*.
His sociological endeavor to analyze particular
segments of society through detailed investigation
is applicable to the positivist philosophy that per-
meated the latter decades of the nineteenth cen-
tury. Not surprisingly, Raffaelli's compositions
reminded critics more often of the work of writers
such as Zola, the Goncourt brothers, Balzac, and
Paul de Kock, rather than the work of artists.

Raffaelli's theories of art, expressed primarily
in his late 1884 essay *Etude des mouvements de
l'art moderne et du beau caractériste* and in his
1885 lecture *Le Laid dans l'art*, offer a general
view of the importance to Raffaelli of sociology
and philosophy in art. In these essays, Raffaelli
conceived of the artist not as an impulsive, roman-
tic, creative spirit but rather as a rational being
duty-bound to reveal the essential character of
various aspects of reality and, in particular, of
man. Just as history had progressed from idolatry
to individual liberty, art had progressed from ad-
miration of idols to critical examination. The role
of art, at that time demythologized, was to repro-
duce and draw attention to the various aspects of
modern life.

Art fulfills its descriptive and analytical function
through the portrayal of what Raffaelli termed
caractère: "Character, in effect, is that which
constitutes the moral physiognomy in its constant
and complete expression. Character is the
physiological and psychological constitution of
man. . . . Character is man's distinctive trait."[1] In
seeking out in nature and creating in his art the
necessary *caractère*, the artist must analyze the
behavioral and physical laws which determine in-
dividuality and natural phenomena.[2] Unfortu-
nately, most artists at that time, Raffaelli com-
plained, were handicapped by their training at the
Ecole des Beaux-Arts, which emphasized techni-
que and was indiscriminately tied to tradition; ac-
cordingly, they lacked the philosophical spirit to
engage in such a critical inquiry.[3]

By the adoption of his theory of *caractérisme*,
appropriated in part from Taine's philosophy of

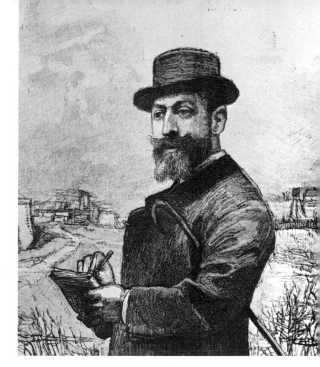

JEAN FRANÇOIS RAFFAELLI

art, Raffaelli set himself apart from the "realists"
who, in his judgment, merely copied nature with-
out concern for depicting the predominant aspects
of individuals.[4] Taine's views had previously been
embraced wholeheartedly by Zola and indeed had
contributed greatly to the basic philosophy of the
Naturalist movement in literature. While at first,
Raffaelli seems to have accepted the term
"Naturalist" as used by Zola in his art criticism
to describe his work and that of his Impressionist
friends, by 1884, with the publication of his theory
of *caractérisme*, Raffaelli rejected this
epithet—for the express reason that it connoted
Zola's brand of Naturalism, which was too "sci-
entific" for the plastic arts.[5] Nonetheless, it was
probably not any doctrinal difference but rather
his desire not to be regarded as a mere follower of
Zola that prompted this decision.

In any event, his affinities with literary Natu-
ralism remained close, as, for example, in his
choice of contemporary subject matter. While
Zola concentrated on the plight of the industrial
worker, Raffaelli turned his attention to those
without status either as industrial worker or
bourgeois—the individuals for whom modern so-
ciety had no place. Raffaelli contended that, de-
spite the public attention that had been focused on
these *déclassés*, they had been ignored by art. For
him, this vagabond class, these social outcasts,
served as unexplored territory.[6] Just as Millet had
raised the peasant to a status meriting artistic
portrayal,[7] so Raffaelli established the artistic
worthiness of the *déclassés*.

For Raffaelli, the choice of this subject matter
was not simply novelty or *reportage*. Rather, it
was a subject matter that was the inevitable pro-
duct of focusing an artistic sensibility on the new
urban industrial society. In such a society, Raf-
faelli observed, the new powers and respon-
sibilities that democracy thrust upon the indi-
vidual created a psychic despair, which was, of
course, all the more keenly experienced by the
artist—and in particular by the Realist artist: "It
is evident that the writers and artists who belong
to the Realist and Naturalist movements are suf-
fering, unhappy, restless men, who contain in
themselves the anxieties and melancholy of our
society."[8] If modern society had brought about

this state of nervous exasperation, so had it disrupted established social and economic patterns, creating classes of individuals without function or place. No small coincidence, then, that the artist, painfully sensitive to his social environment, would choose as the subject matter of his expression the exemplary victim of this social upheaval and the rubbish-strewn land which he inhabited.

The painter of ragpickers and Parisian industrial suburbs was born in Paris on 20 April 1850 and raised amid the trappings of a comfortable nineteenth-century French bourgeois life, including several country homes, parties, trips, and music.[9] Raffaelli's father was a successful chemist who manufactured silk dyes. In Raffaelli's fourteenth year or so, financial reversals in his father's business forced him to seek employment. For several years he held a series of jobs—as a salesman of lace, assistant in a dentist's office, and as a jewelry worker—and at the age of sixteen was placed unwillingly in a commercial house as a bookkeeper.[10] Timidly at first he would visit the Louvre during his lunch breaks and soon thereafter spent Sundays at the Musée du Luxembourg.[11] Work became the means of support that enabled Raffaelli to pursue his developing interest in drawing. As his artistic aspirations grew, he supported himself by singing in theaters and churches.[12] In 1870, a landscape of his was accepted for exhibition at the Paris Salon, despite his lack of formal training. In October 1871 Raffaelli finally enrolled in the Ecole des Beaux-Arts, where he entered Gérôme's painting studio. Serious in his devotion to the arts and priggish in his bourgeois ways, the young artist was offended by the vulgar behavior of his fellow students and the lack of intellectual stimulation.[13] He left within three months.[14]

As models for his own pictures, Raffaelli turned during these early years (1870-1877) to the works of established, successful painters such as Corot, Gérôme, Roybet, and Fortuny. Together with a few landscapes, the major part of his production consisted of *tableaux costumés*, primarily of subjects in Louis XIII dress. Suddenly in 1876, and without explanation, Raffaelli produced a powerful, stark, realistic portrait of a Breton peasant family (*The Family of Jean-le-Boiteux* [175]) that drew praise from Emond Duranty during its exhibition at the 1877 Salon and signaled a new direction in Raffaelli's art.

Raffaelli's career as a Realist artist was launched late in the 1870s with the support of such critics as Duranty and Joris-Karl Huysmans. Through Degas's insistence, Raffaelli became a member of the Impressionist group and eventually, though unwittingly, played a leading role in the dissolution of the group. In the late 1870s and 1880s, Raffaelli concentrated on depictions of the newly expanding suburbs of Paris where he had settled, and it was the work done here that forms his major contribution.

In the early 1890s Raffaelli moved back from the suburbs into Paris, and his work shifted in focus to more public views of the capital. Enjoying increased prosperity, Raffaelli turned out picture-postcard views of Parisian monuments and boulevards and, in later years, picturesque views of the French countryside and seaports. He died in 1924.

Although Raffaelli thought of himself primarily as a painter, he was active as a printmaker, sculptor, and draftsman. While not a professional illustrator, Raffaelli provided material from time to time (primarily in the 1880s and early 1890s) for newspapers, reviews, and books. His subjects,

drawn for the most part from the industrial suburban milieu, popular city entertainments, and street life accompanied texts by Huysmans, the Goncourts, and Victor Hugo, among others. His most ambitious project, *Les Types de Paris* (1889), a profusely illustrated album of lighthearted articles written by his literary friends, serves as a retrospective of Raffaelli's activities as an illustrator of Parisian life. B.F.

1. J. F. Raffaelli, "Etude des mouvements de l'art moderne et du beau caractériste" in *Catalogue illustré des oeuvres de J. F. Raffaëlli exposées 28 bis, Avenue de l'Opéra, 15 Mars au 15 Avril 1884* (Paris, 1884), pp. 66-67.
2. Ibid., pp. 23-24.
3. Ibid., p. 27.
4. J. F. Raffaelli, *Conférence faite par M. Jean-François Raffaëlli au Palais des Beaux-Arts de Bruxelles au Salon Annuel des XX, le 7 Février 1885* (Paris, 1885), p. 22.
5. Raffaelli, "Etude des mouvements," pp. 39-41.
6. Raffaelli, *Conférence faite*, pp. 7-9.
7. Ibid., pp. 8-9.
8. Ibid., p. 9.
9. J. F. Raffaelli, *Mes Promenades au musée du Louvre*, 2d ed., rev. (Paris: Editions d'Art et de Littérature, 1913), p. 1.
10. [Jules Claretie], "Chronique: Un Peintre indépendant, M. Raffaëlli," *Le Temps*, 21 July 1880, p. 2.
11. Raffaelli, *Mes Promenades*, p. 2.
12. Arsène Alexandre, *Jean-François Raffaëlli* (Paris: H. Ploury, 1909), p. 26.
13. J. F. Raffaelli, "L'Art dans une démocratie," *La Nouvelle Revue*, 15 October 1896, p. 706.
14. Alexandre, *Jean-François Raffaëlli*, p. 46.

[Charles] Paul Renouard

1845 Cour-Cheverny, Loir et Cher — 1924 Paris

Paul Renouard, born in Cour-Cheverny (Loir et Cher), was one of that group of cosmopolitan reporter-draftsmen who made their living and their reputation working for the illustrated journals of the day. This group (which included the Englishmen Hubert Herkomer, Frank Holl, Luke Fildes, E. J. Gregory, and John Nash; and the Frenchmen Gustave Doré, Paul Gavarni, Félix and Guillaume Régamey, Auguste Lançon, and Jules Férat) produced drawings that, skillfully reproduced by wood engravers, appeared in such publications as the *Illustrated London News*, the *Graphic*, *Harper's Weekly*, *Le Monde Illustré*, and *L'Illustration*—the journal with which Renouard was most consistently connected.

Renouard's production during the course of his long career was enormous and wide-ranging: fourteen volumes of his work are filed in the Cabinet des Estampes at the Bibliothèque Nationale in Paris and they contain literally thousands of wood-engraved illustrations. His work was admired by such figures as Huysmans, who wrote enthusiastically about the artist in his *Salon* of 1879 and by van Gogh, who referred to him frequently in his letters.

Although he studied with Pils, who entrusted him with a portion of the ceiling painting for the Paris Opera, and made his debut as a painter in the 1877 Salon, Renouard owed his reputation almost exclusively to his graphic work. He dealt with all kinds of subjects, traveled to many countries—one critic dubbed him "the Wandering Jew of illustration"—and depicted all kinds of physical and national types and a broad spectrum of social milieus.

His oeuvre included numerous sketches of the world of entertainment—most notably that of the

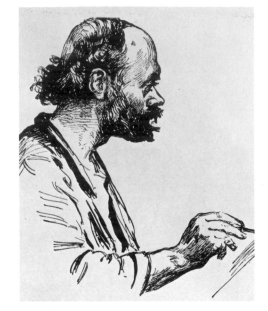

PAUL RENOUARD

opera, which he also commemorated in an album of etchings, *Le Nouvel Opéra*, in 1881; various aspects of public life—the Bourse, the courts, the navy, the Chamber of Deputies, and the American Congress; eyewitness reports of famous trials of the time—most notably, the Dreyfus Case; and all sorts of "miscellaneous" subjects—children playing, guests at a working-class wedding, fashionable ladies taking tea, participants and observers at Queen Victoria's funeral, orchestra leaders in action, animals in motion. Yet the realm of documentation he preferred above all others was perhaps that of the poor and the marginal, whether it be the milieu of the working poor (miners, fishermen, artisans, and factory workers) or that of the inhabitants of the "Lower Depths" —ragpickers, drunkards, or slum-dwellers in general. He also devoted several of his series to those whose existence was marginal—members of the Anarchist Club, inmates of the Foundling Hospital, old soldiers at the Invalides, and the mad people at La Salpêtrière.

His culminating masterpiece *Mouvements, Gestes, Expressions* appeared in 1907. This series of two hundred etchings conveyed an almost cinematic effect of dynamic immediacy, representing animals and humans in action. The many plates of rabbits, chickens, pigs, beetles, tigers, and kangaroos reveal the influence of Japanese prototypes; human beings engaged in gymnastics, music-making, fishing, and bathing; children playing, jumping, giggling, or dancing; fashionable ladies in incredible hats strolling and gossiping; heads of state glimpsed behind the scenes; lawyers and their clients captured with a photographic veracity in the courtroom; the Salvation Army; scenes of London life.

Renouard was admired as much for his graphic innovations and formal daring as for the range of his subject matter. Indeed, almost from the start, form and content were viewed as inseparable features of his modernity, his inimitable grasp of the spirit, and substance of modern life. Considered a master of the "snap-shot" sketch and the synoptic drawing style it demanded, he was appointed *professeur de croquis* at the Ecole des Arts Décoratifs in 1903. His final collection, executed in 1917, was devoted to scenes from World War I. L.N.

Germain Ribot

1845 Paris — 1893 Argenteuil

Little is known about the career and life of Germain Ribot, except that he first studied with his father and then with Antoine Vollon. Neither the exact period of time he spent working with these teachers nor the type of training he received is known. It is generally thought that Germain worked in still life, preferring this category to genre scenes, although there are examples of cooks (York Art Gallery, England) painted by Germain that were once attributed to his father.

Even though his work appeared in several exhibitions during the 1870s, his individual characteristics and preferences are difficult to distinguish; a number of works attributed to his father may one day be reexamined. He remains a shadowy figure who, along with his sister Louise (1857-1916), may even have had a hand in completing some of Théodule Ribot's canvases.

Théodule Augustin Ribot

1823 Saint-Nicolas-d'Attez, Eure —
1891 Colombes

Despite a difficult life burdened by many family hardships, Théodule Ribot managed to train himself as an artist.[1] After his father died in 1840, he found a low-paying job as a bookkeeper for a textile firm in Elbeuf (near Rouen) in order to support his mother and sisters. In 1845, after his marriage and because he wanted a better job, Ribot went to Paris. At first, even though he worked for a mirror manufacturer, decorating gilded frames, the serious interest in art that had begun when he was a young boy persisted. Somehow he finally managed to work in the atelier of Auguste-Barthélémy Glaize (1807-1893), his only recorded master. Here he studied the nude and assisted his teacher by perfecting architectural backgrounds in Glaize's paintings.

The exact chronology of Ribot's activities during the late 1840s cannot be determined because this period was interrupted by a three-year stay in Algeria, where Ribot worked as a foreman. Both before and after his return to Paris in 1851, Ribot struggled to make ends meet. He colored lithographs, decorated window shades and curtains, painted trade signs, and copied the work of Jean-Antoine Watteau (1684-1721) for American export. These commercial projects provided him with enough money to live on, but did not permit him to express his own talents.

The canvases Ribot completed in the late 1850s were painted by lamplight in the evenings at his home and were derived from his own environment. These works emphasize dark and light contrasts, aspects of his style imposed by inadequate lighting conditions, but a style he continued to perfect throughout his career. In his later works, Ribot often accented areas in bright light, leaving other sections in darkness.

Ribot found a supporter in François Bonvin who exhibited Ribot's canvases along with those of Antoine Vollon, Henri Fantin-Latour, and James McNeill Whistler in his atelier in 1859.[2] In 1861 Ribot was finally accepted at the Salon, and several of his canvases of cooks were shown, a theme also used by Bonvin that was then attracting Parisian collectors. Public awareness of his work increased as Ribot exhibited at the annual Paris Salons, at international exhibitions (e.g., Amsterdam in 1865, Munich in 1869, Vienna in 1873), and provincial shows (e.g., Bordeaux, Lille, Rouen, Grenoble, Lyon, and Le Havre).

During this period, some artists and collectors recognized his still lifes, genre scenes, and portraits as furthering the tradition of Realism. Ribot was also accepted by the official art establishment with two Salon medals he received at the more liberal exhibitions in 1864 and 1865. The purchase of his *Saint Sebastian* by the Second Empire for 6000 francs in 1865 demonstrated that peasant types could be used in a religious scene if the work suggested those of the masters of the seventeenth century—and, in Ribot's works, especially the Spanish painter Jose de Ribera (1591-1652).

Ribot also exhibited paintings in Parisian galleries such as the shop of Louis Martinet, a sympathizer with the independent Naturalist artists, and the gallery of Alfred Cadart, a patron of etching and painting during the 1860s. In both locations, Ribot's works were hung with those by Bonvin and Edouard Manet. Ribot undoubtedly influenced some German Realist painters also, when his works were shown in Munich (1869) and Vienna (1873), although the full extent of his impact upon German art has not been examined.[3]

Besides selecting themes from everyday life and popular literature, Ribot helped establish tonal painting. By using modulated tones of tan, gray, white, and black, Ribot created canvases of nuance reminiscent of the works of Frans Hals (1581/85-1666), in whom interest was then being revived. In modulating his dark and light scheme, Ribot worked within a limited color range that also suggests another source, the Spanish painters of the seventeenth century.

During the Franco-Prussian War in 1870, Ribot had a studio in the Parisian suburb of Argenteuil. When the Prussians invaded this village and found his atelier, they destroyed many of his works. This may account for the difficulty in locating a wide range of Ribot's early canvases. Also, in the late 1870s, after he had moved to Colombes, Ribot suffered a severe illness which prevented him from painting. Later, supported by a friend who eased some of his financial worries, Ribot continued to paint genre scenes and numerous portraits of family and close friends in a style suggestive of Rembrandt.

In 1878, Ribot was inducted into the Légion d'honneur and received a third-class medal at the Paris World's Fair. At a special dinner held in 1884, a group of friends recognized his artistic contribution and presented him with a medal of honor inscribed: *A Théodule Ribot, le peintre indépendant*. That this award was presented by such well-known figures as Henri Fantin-Latour, Jules Bastien-Lepage, Jean Charles Cazin, Jèan François Raffaelli, and Claude Monet documents Ribot's link with other painters.

Several important exhibitions of his work also took place during his lifetime: the first, in the gallery belonging to the periodical *L'Art* (1880) and two others at the Gallery Bernheim-Jeune (1887, 1890). He was honored again in 1887 when he was made an officer of the Légion d'honneur. Ribot died in 1891 in the small village of Colombes. A year later, a large retrospective exhibition held at the Ecole des Beaux-Arts continued to support Ribot's contribution at a time when many younger painters were repudiating artists of the Realist tradition because of their dark tones and gloomy themes.

1. Little of Ribot's personal life is known. There are no descendants and letters and other documentary material are sparse. This makes reconstruction of his career difficult, especially since he seldom dated his paintings. Thus, most of the information on Ribot's life and work has been provided only by standard sources. In addition, the archives of André Watteau (Paris) are invaluable in

THEODULE RIBOT

establishing a visual chronology for Ribot's oeuvre.
2. Raoul Sertat, "Théodule Ribot." *Revue Populaire des Beaux-Arts*, 18 February 1899, p. 98.
3. A recent exhibition on the impact of French Realism in Germany stressed only the influence of Courbet. See *Courbet und Deutschland*, exh. cat., Hamburg Kunsthalle, 19 October—17 December 1978 and Stadtische Galerie, im Städelschen Kunstinstitut, Frankfurt am Main, 17 January—18 March 1979.

Philippe Rousseau

1816 Paris — 1887 Acquigny

Little is known about the life and works of Philippe Rousseau. Some biographers mention that he studied under Gros and Bertin, but others say that, like his friend François Bonvin, he was largely self-taught. At his first Salon, in 1834, he exhibited a series of landscapes from actual observation of the Normandy countryside, but his still lifes from the same period (Musée de Louviers, 1836) show an appreciation of past masters such as Jean Baptiste Oudry (1686-1755) and Jean Siméon Chardin (1699-1779).[1] Thus Rousseau established himself as one of the first painters of his generation to work in both of the "lower" types of Salon categories: still life and landscape. He maintained a staunch interest in the masters from earlier periods, and he eventually acquired two major still lifes by Chardin for his own private collection. Rousseau's still lifes were often linked with Chardin by nineteenth-century critics, and late in life he affirmed that Chardin had been "his god."

As a favorite under the Second Empire, Rousseau received commissions from the court of Napoleon III and distinction as a decorator, utilizing standard still-life motifs he had observed in the works of Desportes and other eighteenth-century painters. To this interest in flowers and animals, however, Rousseau often added literary associations to create large canvases that recalled the pleasures of the eighteenth century and were appropriate to the courtly tastes of Napoleon III.

He continued to exhibit at the Salons until 1877 with a series of still lifes and allegorical images derived from the fables of La Fontaine. It was not

PHILIPPE ROUSSEAU

until 1845, however, that Rousseau won his first medal—a third-class award for his *City Rat and Country Rat*. He received a first-class medal in 1848, and another as late as 1878. His interest in Chardin continued throughout his career, and by 1867 he completed *Chardin and His Models*, a work shown at the Salon but which unfortunately is now lost.

Rousseau was patronized throughout his career by wealthy families, including Baron J. de Rothschild, Mme. Grandin, and the Princess Mathilde. Many of his paintings were purchased for country homes throughout the provinces (from the south of France and in the region near his village of Acquigny). During the 1850s, when Rousseau was at the height of his popularity, he joined the Société Française de Photographie. Whether he used photographs in the creation of his still lifes or landscapes, however, is not known.

The critic Théophile Gautier in 1861 recognized Rousseau as a member of the Realist circle, but also praised his intense Romantic color. Rousseau's highly eclectic style, however, had been formulated by other interests, especially the masters of Holland and Flanders from the seventeenth century; Pieter Claesz, Jan de Heem, and Wilhelm Kalf were painters he appreciated for their rich textures and reflected light. Despite these influences, it was always with Chardin that Rousseau was compared, especially at his death, when the press referred to him as the modern incarnation of the eighteenth-century painter.[2]

1. Early works by Rousseau are difficult to locate. The painting in Louviers is in poor condition and the date on the canvas difficult to decipher.
2. "Nécrologie," *Courrier de l'Art*, 1887, p. 392.

Dominique Hubert Rozier
1840 Paris — 1901 Paris

Beginning his official career at the 1869 Salon just at the end of the Second Empire, Dominique Rozier established himself as a decorative flower painter.[1] By 1874, Alexandre Dumas was collecting Rozier's paintings, including *Roses et azalées*. Probably other members of the upper-middle class

collected his paintings, too. When he began to study with Antoine Vollon is unknown, but by the mid-1870s he had changed his still-life themes, preferring the large compositions of fish, rabbits, birds, and the fashionable buffet that Vollon favored. In *Fishmonger Dieppe*,[2] for example, Rozier's naive, almost awkward painting of figures is secondary to his lifelike rendering of squirming fish, which, recalls his training with Vollon.[3] In theme, his works suggest the continuation of the Chardin revival into the 1880s as well as the influence of the contemporary still lifes of Philippe Rousseau.

Rozier received a third-class medal at the 1876 Salon, a second-class medal in 1880, and bronze medals at the 1889 and 1900 Paris World's Fairs. Rozier often utilized his talent for still life in large scenes of picturesque activity.

1. Little is known of Rozier's career. Bénézit's statement that Rozier began to exhibit officially with the 1879 Paris Salon is incorrect.
2. A reproduction of this lost painting is in the Rijksbureau Photo Archives, The Hague. The painting was sold in Chicago in 1893.
3. During the 1880s, Rozier noted in the official Salon catalogs that he was Vollon's student. How many students Vollon actually had at any given time is unknown.

Louis Paul Henri Sérusier
1864 Paris — 1927 Morlaix

Born into a wealthy middle-class family, Paul Sérusier was educated in Paris. He entered the Lycée Fontanes (later known as the Lycée Condorcet) in 1876. His father, who had been trained in glove manufacturing, succeeded in business and, in 1878, became the owner of the famous Maison Houbigant. Without financial worries, Sérusier was free to spend his time reading and musing on philosophy at the Lycée Condorcet. In June 1883 he passed his second baccalauréat examination. He also made friends who would become his artistic colleagues, including Maurice Denis and the Nathanson brothers.

After a brief period of military service, Sérusier worked in his brother-in-law's stationery shop. Finding this work boring, he amused himself by doing portraits of his brother-in-law's children (ca. 1884) that so impressed his family that he soon found support for a career as an artist,[1] and entered the Académie Julian in 1885.

In May 1888 after spending a short time in late 1887 in Brittany, Sérusier exhibited his first canvas at the Paris Salon; his *Breton Weaver* [205] received an honorable mention. Despite its success, it remains the only fully Realist composition by Sérusier that can be located. In July 1888 Sérusier again traveled to Brittany. By October he had met Paul Gauguin at Pont-Aven and this relationship completely changed Sérusier's painting style. At the end of the month Sérusier left Pont-Aven to impart Gauguin's theories to his young friends, Maurice Denis, Pierre Bonnard, Paul Ranson, and H. G. Ibels. Inspired by Gauguin's ideas, all these artists revolted against Realist perceptions and devoted themselves to two-dimensional design and abstract painting. Sérusier thus rejected what he now considered restricting approaches and never returned to the Realist aesthetic. The remainder of his career was devoted to the formulation of another way of observing and painting.[2]

1. These early paintings are lost. Sérusier is also believed to have completed a Realist theme in 1884 entitled *Une Ménagère récurant un bassin de cuivre*.
2. For further information on Sérusier's career see Charles Chassé, *Les Nabis et leur temps* (Paris: La Bibliothèque des Arts, 1960).

Octave Tassaert
1800 Paris — 1874 Paris

As a member of an older generation, Octave Tassaert developed a type of Realism derived from his training in printmaking and influenced by the Romantic tradition. Tassaert's family had contributed to the arts of Antwerp for several generations before his father moved to Paris. His grandfather, Jean-Pierre-Antoine Tassaert, was a sculptor, and his father, Jean-Joseph-François Tassaert (1765-ca. 1812) was an etcher noted for his historical scenes and portraits. The uncertainties of such a career often provided the family with only enough for bare subsistence, so that, like François and Léon Bonvin, Tassaert's early childhood was a time of poverty and uncertainty. He received little formal education other than what he and another brother, Paul, learned of the art of engraving while working in their father's atelier. At the age of twelve, Tassaert, like the other five children, was forced to earn his own living—a circumstance that was not unusual for a family of humble means. Nonetheless, there was little opposition to his decision to become an artist.

As a teenager, Tassaert visited the studios of the printmakers Alexis-François Girard (1787-1870) and Guillaume Guillon-Lethière (1760-1832). In 1817 Tassaert enrolled in the Ecole des Beaux-Arts to devote himself to painting. He worked hard, often into the evening hours, but his paintings received little notice. Although he was designated as a finalist several times, he never won the prestigious Prix de Rome. At the 1827 Salon, however, Tassaert finally received recognition by exhibiting a historical canvas derived from the life of Louis XI. If this particular painting, now lost, can be considered typical, Tassaert's early work followed the tradition of elaborate historical episodes—sources that were quite different from the early works of many of the Realists.

By the early 1830s, Tassaert had increased the range of his work, exhibiting portraits and even a contemporary historical subject, *Fighter in the July Revolution* (1831 Salon). At the 1834 Salon, Tassaert's *Death of Correggio* received critical acclaim when it was purchased by the Duke of Orléans, and the conservative critic Delécluze noted the relationship between Tassaert's canvases and the works of the Romantic painter Prud'hon. Tassaert was inspired by heroes from former times—those who seemed larger than life, a basic tendency that he reiterated in such melodramatic themes during the 1830s as a deathbed scene of Héloise or Magdalene in the Desert. Works such as these increased Tassaert's fame, and at the 1838 Salon he was awarded a second-class medal. Curiously, though, toward the close of the 1830s, when the Salon canvases of other painters (such as Philippe Auguste Jeanron and François Bonhommé) revealed an increased awareness of visible reality, Tassaert unexpectedly renounced history painting.

Even though he exhibited in the Salons from the mid-1820s until 1849 and won several awards, Tassaert earned barely enough to live on. His miserable existence, perhaps even his own studio, is recorded in *A Corner of His Atelier* [127], a scene of poverty that was common to many struggling young painters. From 1825 until 1849, he managed to get by on the fees he received from publishers (Osterwald, Julien, and the firm of Bes and Dubreuil) for drawings that were later lithographed. His themes in these drawings varied, but many were illustrations for the novels of contemporary Romantic writers such as Alexandre

Dumas, Victor Hugo, and Chauteaubriand. Tassaert spent the meager income he received on food, lodging, and paint supplies. But he also indulged in drinking. He is known to have frequented taverns where he enjoyed singing with the workers who gathered there after hours.

By the end of the 1840s, Tassaert's physical and financial condition was distressing. Dressed in his usual tattered clothes, he appeared one day in the office of Jeanron, director of the National Museum, and begged for employment. Jeanron, who had seen Tassaert's work at the Salons, secured a commission (ca. 1849-1850) that provided the struggling artist with money to live on. The painting he completed, *An Unfortunate Family (The Suicide)*, was shown at the 1850/51 Salon and became his most famous work [5].

Tassaert concentrated on troubling themes with social implications: starvation, misery in the garrets of Paris, suicide, abandoned mothers, urban overcrowding, and city pauperism—and thus became associated with the Realist movement during the reign of Louis Philippe and later during the Second Empire. Critics did not always regard his canvases kindly. Some found his work sentimental; others, monotonous. Michelet called him the "Correggio of Suffering" and Paul de Saint-Victor referred to him as "a working-class Prud'hon." Significantly, others compared Tassaert's genre scenes with those of Chardin. His women, with their sentimental gazes and poses, were also compared with Greuze (an apt comparison most apparent in a series of Romantic drawings now in the Musée Bonnat, Bayonne).[1]

During the 1860s, Tassaert was in a dire state of poverty. Alcoholism forced him to give up painting. He sold the contents of his studio in 1863 to the art dealer Père Martin for 2400 francs and a single cask of wine. Writing to his old friend Alfred Bruyas, the art collector in Montpellier, Tassaert said he now considered himself a poet and that his career from then on would be dedicated to the writing of verse. Although he is known to have written comedy, tragedy, and epic poems throughout his life, none of his literary compositions have been located. Théodule Ribot, another friend, possessed some of Tassaert's manuscripts, but these, too, have disappeared.

By 1865, when he was almost blind, Tassaert was sent by his doctor for treatment to the south of France. He stayed at the villa of Bruyas in Montpellier, and although he quickly improved when he stopped drinking, he became increasingly homesick for Paris. Before long, he returned to the capital and his old ways. He became known as "Père Octave," because of his considerable weight and his scraggly, long white beard, but he spent his days as usual at his customary seat in a local café.

In April 1874, faced with starvation and with no hope of earning a living, Tassaert committed suicide, using the same type of coal stove he had depicted in his genre scenes of the garrets of the poor. His death brought acclaim for his work from numerous Parisian journals. In 1878, seventeen of his paintings were exhibited at the Durand-Ruel galleries, fourteen from the collection of Alexandre Dumas the Younger. A number of contemporaries, especially painters from the Barbizon group (e.g., Troyon, Rousseau, Diaz) and Delacroix appreciated Tassaert's artistic contribution. He assumed a symbolic importance for them and for other Realists as a painter driven to his grave by personal tragedy—and perhaps in protest of the disdain in which many held his work while he was alive.

1. These drawings, mostly executed in pastel, are among the most impressive of Tassaert's works. His studies of women emphasize facial features and reveal the same romantic pensiveness and dreamy detachment that he also depicted in his paintings. They were collected by Léon Bonnat, who was interested in other contemporary artists as well. For further information on Bonnat's drawing collection, see Gustave Geffroy, *La Vie artistique*, vol. 7, *Tassaert* (Paris: E. Dentu, Editeur, 1892-1903).

Constant Troyon
1810 Sèvres — 1865 Paris

Constant Troyon's career marks the first time a Barbizon artist was able to win general acceptance. Following receipt of the Légion d'honneur in 1849, Troyon enjoyed a period of financial success in which his works were exhibited and collected outside of France more often than any other artist associated with the Barbizon circle. By 1860 Constant Troyon's works had been shown in London, Manchester, Vienna, Brussels, Antwerp, and The Hague. In almost every center of European art, numerous young artists tried to paint like Troyon, the foremost animal painter in Europe.[1] Coming from a family of porcelain painters at Sèvres, Troyon began his career by doing pure landscapes. At the 1833 and 1835 Salons he exhibited canvases of the Sèvres countryside as well as views from Brittany and the Limousin. Troyon received his first Salon medal in 1838 for landscapes such as the *Vue du Château de St. Cloud* and *Une Foire champêtre dans le Limousin*. These works suggest that his early work included a series of scenes based on direct, realist observation of the countryside. By 1843, Troyon had met Théodore Rousseau (1812-1867) and Jules Dupré (1811-1889), and accompanied Dupré on a trip to the Landes. He also began painting in the Forest of Fontainebleau, sharing his impressions of light and atmosphere with his artistic colleagues. In 1846 Troyon received a first-class Salon medal, a mark of growing appreciation for his imagery by the jury.

A trip to Holland in 1847 became the artistic event of his career. He fell under the full influence of Dutch animal painters, especially of Albert Cuyp. Changing his themes, Troyon soon became known as the painter who integrated animals with the natural landscape. In 1852, turning his attention to seascapes, Troyon traveled throughout Normandy. In 1859 he exhibited for the last time in Paris, thereafter sending his works only to provincial exhibitions and abroad. During the last years of his life, Troyon spent time in Normandy, Tourraine, and near Paris. He died in March 1865 after a brief period of insanity.

1. For further information on Troyon see Louis Soullié, *Peintures, pastels, aquarelles, dessins de Constant Troyon relevés dans les catalogues de ventes de 1833 à 1900*, précédés d'une notice biographique par Ph. Burty (Paris, May 1900).

Antoine Vollon
1833 Lyon — 1900 Paris

When Antoine Vollon died in August 1900, numerous artists and critics attended his funeral at Père Lachaise cemetery in Paris. Many important critics reviewed his career, including Arsène Alexandre, who evaluated Vollon's place among his contemporaries and who discussed his work as part of the tradition of regional artistic development in Lyon:

LOUIS PAUL HENRI SERUSIER

OCTAVE TASSAERT

CONSTANT TROYON

ANTOINE VOLLON

ANTOINE (ALEXIS) VOLLON

M. Vollon was above all a popular painter. The public gathered in throngs before his paintings at the Salon, since the artist managed to achieve a successful composition solely through the vigor and the depth of his execution. . . .

As a "painter of objects," M. Vollon had few rivals among the Establishment artists. His talent, marked by a rare candor and much good humor, involved no ambiguity whatsoever. . . .

M. Vollon belonged to that remarkable mid-century Lyonnaise school whose role and importance we are only now beginning to grasp and which has produced such masters as Vernay, Ravier, Bail the Elder, and others, masters who have since died, and some who are still alive—an extremely fine group that is both honest and unaffected.[1]

As an exponent of the Romantic tradition of painting, Vollon became one of the most successful painters of his generation. His fame rested largely on his still lifes, a category which he continued to paint for official patrons and private collectors throughout his career. These compositions often depict vessels and materials from his own studio, objects which Vollon used again and again to fulfill the insatiable demand for canvases with his signature. Undoubtedly, his popularity hampered the completion of first-rate canvases that he might otherwise have realized; it cannot detract, however, from his proficiency and vitality as a painter who combined strong Realist and Romantic qualities.[2]

Vollon grew up in Lyon, where he was introduced to the industrial arts by his father; after his father's death in 1847, Vollon served as an apprentice to an engraver. Between 1850 and 1852, he studied at the Ecole des Beaux-Arts in Lyon, winning awards in printmaking.[3] At the same time, he continued his family's tradition of working in the industrial arts, copying masters of the eighteenth century for decorative art pieces. By 1858, he was exhibiting oil paintings in Lyon, revealing an already-broad knowledge of previous painters from the seventeenth and eighteenth centuries. In addition, he contributed etchings to the *Revue du Lyonnais* (1858-1859), revealing an awareness of the growing interest in independent printmaking that was developing during the 1850s.[4] By 1859, realizing that he would have to leave provincial Lyon in order to pursue a serious career as an artist, Vollon moved to Paris.

Life in Paris was difficult for the struggling artist; Vollon had little money even to buy supplies for painting. He did, however, make friends with two of the Realist painters, Bonvin and Ribot; somber portraits of himself or fellow Realists are among his earliest canvases. During the late 1850s, Vollon made the acquaintance of other painters outside the Realist group, establishing ties that eventually led to his membership in the Institut des Beaux-Arts (1897). He also sought assignments from the government of the Second Empire, requesting the opportunity to copy the masterpieces in the Louvre; his letter to the Ministère d'Etat in July 1860 was endorsed by the artists Charles Daubigny (1817-1878), Hippolyte Flandrin (1809-1864), and Joseph Soumy (1831-1863). His willingness to copy any painting that would allow him to follow "the difficult path of serious art" reveals the intensity of his commitment to become an artist. Finally, after two years of negotiation, Vollon received authorization to copy a work by the Spanish master Ribera (21 June 1862).

In 1863, when the Salon jury rejected some 2800 paintings that had been entered in the annual Salon, Vollon joined such artists as Jean Charles Cazin, Johann Barthold Jongkind, Adolphe-Félix Cals, James McNeill Whistler, Edouard Manet, and Henri Fantin-Latour in the Salon des Refusés. That same year Vollon married Marie-Fanny Boucher; they had two children, a son Alexis in 1865 [188] and a daughter Marguerite in 1868.

In 1864, two of Vollon's genre works were finally accepted at the Salon: One of these, a *Kitchen Interior,* was purchased by the state for 1800 francs. These early works, including another *Interior of a Kitchen* [111] for which Vollon received his first Salon medal in 1865, reveal Vollon's knowledge of both Dutch sources and the still lifes of Chardin. Vollon received exhibition awards again in 1868, 1869, and 1878. At the World's Fair of 1878, when Vollon was named an officer of the Légion d'honneur, he was also awarded a first-class medal that marked the peak of his artistic career.

The purchases by the state that Vollon obtained throughout the 1860s (*Curiosities*, 1868; *Fish of the Sea*, 1870) document his rapid rise to success. Vollon's fame under the Second Empire led him to complete still lifes of similar themes, and these no doubt found their way into the private collections of the wealthy middle class. After the collapse of the Empire, Vollon moved to Le Havre and from there to Saint-Gilles, the suburb of Brussels that became a haven for many members of French art circles. During this time, Vollon met Eugène Boudin [114], whom he assisted financially, for his own paintings were now selling quite well. After the Franco-Prussian War and the siege of Paris, Vollon returned to the city and was accorded the support of the new government. He received permission to copy paintings by Ribera and Frans Hals that were located outside of France, and this enabled him to visit Italy and Holland.[5] Although copying works of art may no longer have interested him, such requests, in addition to another state purchase in 1875, provided Vollon with a substantial income.

During the latter part of his career, Vollon painted a diversity of themes unequaled among members of the Realist tradition. His color range varied; sometimes he used light, pastel hues and, at other times, he resorted to rich reds and oranges. Still lifes became his consuming passion [209, 210], although he completed many landscapes and drawings of country [197] and city life. During this period (ca. 1885-1890), Vollon maintained close ties in the city, but chose to live much of the time outside of Paris, completing many

studies of the countryside that reflected his growing absorption with Barbizon and Impressionist tendencies.

Vollon continued to exhibit at the Salons until 1880. His contribution to the evolution of nineteenth-century painting joins a Romantic temperament with a Realist sensitivity to light and form. In 1898 he was made Commander of the Légion d'honneur. He was awarded the medal of honor at the World's Fair in 1900.

1. Arsène Alexandre, quoted in Lyon *L'Express*, 30 August 1900.
2. For further discussion see Gabriel P. Weisberg, "A Still Life by Antoine Vollon, Painter of Two Traditions," *Bulletin of the Detroit Institute of Arts* LVI, no. 4 (1978): 222-29.
3. See *Procès-verbal de la distribution des prix pour l'année 1852 aux élèves de l'Ecole Nationale de Dessin et des Beaux-Arts* (Lyon, 1852), pp. 5, 14. Vollon studied with Victor Vibert, who taught printmaking at the Ecole from 1833 until 1860.
4. His *Chazay d'Azergues* appeared in *Revue du Lyonnais* (Paris, 1858), p. 272. See also in the 1859 issue of the same publication: *Aqueduct de Chaponost (près Lyon)*, p. 81; *Souvenirs de Genève*, p. 456.
5. See dossiers on Antoine Vollon, specifically dossier dated 11 June 1872, F 21/189, Archives Nationales.

Antoine (Alexis) Vollon

1865 Paris — 1945 Paris

Antoine Vollon, the son of the famous artist who bears the same name, was called Alexis and received his training from his father. He exhibited for the first time at the 1885 Salon, winning an honorable mention — the first of several official awards he was to receive during his lifetime. In 1888 he was given a third-class medal, in 1889 a second-class award. As a painter of intimate family scenes, domestic genre [188], still lifes, and landscapes, Alexis painted many of the same themes his father had used, but he received none of the attention from critics and public that distinguished his father's career. He participated regularly at the Salons of the Société des Artistes Français, and in 1900 was made Chevalier of the Légion d'honneur and presented a silver medal for compositions exhibited at the Paris Fair that year. He continued to paint until the 1930s, devoting himself to traditional themes, even at a time when formal avant-garde changes dominated painting.

1. For further information on his correct name see Extrait des minutes des actes de décès, 13 April 1945, Mairie du 16e Arrondissement, Paris.

Chronological Synopsis for the Realist Period 1830-1900

Historical Events

1830 • Charles X is deposed 29 July after six-year reign. Louis-Philippe, proclaimed "citizen-king" by Thiers, begins eighteen-year reign • Industrial Revolution makes paupers out of English peasants and destroys rural skills • Stendhal's *The Red and the Black* blends eighteenth-century rationalism with Romantic fervor

1831 • Outbreaks at Modena and Parma, inspired by Paris Revolution of 1830, are unsuccessful, but intensify growing desire in northern Italy for freedom • Louis Philippe creates French Foreign Legion • Bristol Riots of 29-31 October raise fears of riot and revolution throughout England • Insurrection by French workers in Lyon is crushed • In France, secret societies proliferate among workers • Hugo publishes *Notre Dame de Paris*. His depression over failure of July Revolution of 1830 increases • Pushkin: *Boris Godunov*

1832 • Italian unification movement fails in March. Similar movement in Germany quelled in July by Prince von Metternich • Number of voters in England doubles, as upper-middle class receives right to vote under First Reform Bill, 4 June • Cholera epidemic, which spread through Russia and Europe in 1830, reaches Scotland • George Sand's *Indiana* asserts woman's right to love and independence • Death of Goethe

1833 • Slavery abolished throughout British Empire • Factory Act, passed by British Parliament on 29 August, forbids employment of children under age of nine and establishes mandatory schooling for all children • Abolition movement reaches crusading proportions with founding of American Anti-Slavery Society in Philadelphia • New education law in France delegates extensive control to the Church over that nation's primary schools • Sand: *Leila* • Balzac: *Eugénie Grandet* • Théophile Gautier: *Les Grotesques*

1834 • The Grand National Consolidated Trades Union, organized by Robert Owen and John Doherty in England, pledges to strike for eight-hour day • New British Poor Law establishes workhouses for able-bodied paupers • Fire destroys London's Houses of Parliament and part of city • Blind French educator Louis Braille invents system of printing and writing for the sightless • London's National Gallery established • Balzac: *Le Père Goriot* and *La Recherche de l'absolu*

1835 • First German railway opens • Tocqueville: *Democracy in America* • Gautier's *Mademoiselle de Maupin* espouses doctrine of "art for art's sake" • Lamartine: *Voyage en Orient*

General Artistic Events

1830 • Birth of Pissarro

1831 • Delacroix: *Liberty on the Barricades* • Achille Devéria: *Sermon of Louis Philippe* • Many landscapists who will revolutionize French landscape school exhibit at their first Salon: Corot, Aligny, Marilhat, Huet, Flers, Brascassat, Théodore Rousseau, Diaz, Jules Dupré

1832 • Birth of Manet • Daumier portrays Louis Philippe as Gargantua, gorging himself on earnings of working class. Sentenced to six months in prison • Salon cancelled because of cholera epidemic

1833 • Ingres: *Mr. Bertin* • Delacroix: *Charles Quint at the Monastery of Saint-Juste* • Courbet studies in Ornans with "père Baud," a Gros student

1834 • Birth of Whistler, Paul Guigou, Degas • Corot makes second trip to Italy • Ingres, appointed director of Villa Medici, exhibits *The Martyrdom of Saint Symphorian* • Delacroix: *The Women of Algiers* and *The Battle of Nancy* • François Marius Granet: *The Death of Poussin* • Charles Daubigny restores paintings in Louvre under Granet

1835 • Death of Gros • Delacroix: *The Prisoner of Chillon* • Paul Delaroche: *The Assassination of the duc de Guise* • Daumier: *The Rue Transnonain* • Corot: *Hagar in the Desert* • Turner: *Burning of the Houses of Lords and Commons* • Millet studies in Cherbourg with L. Langlois, a Gros student

Realist Events

1830 • Birth of Jean Antoine Bail • Cabat decides to become painter • Gigoux arrives in Paris, participates in July Revolution, and makes friends with Gabriel Laviron, critic supporting Naturalism • Jeanron, leader of dissident artists, writes *Petition nationale* to deputies, proposing an allocation of 2% of art funds to help needy artists

1831 • Brion studies in Strasbourg with Guérin • Flers's first Salon • Gigoux exhibits drawings and lithographs at Salon • Jeanron: *Young Patriots* • Monanteuil accepts teaching post at Alençon art school • Tassaert exhibits contemporary historical scene: *Fighter in the July Revolution*

1832 • Jeanron joins editors of *La Liberté* and *Journal des Arts* in advocating changes in the arts

1833 • Birth of Antoine Vollon, Bonnat • Cabat's first Salon • Laviron: *Salon de 1833* • Gigoux exhibits five works, receiving second-class Salon medal for *The Blacksmith*

1834 • Birth of Léon Bonvin • Laviron: *Salon of 1834* • Flers exhibits views of Normandy • Gigoux exhibits eight works, including *Portrait of Gabriel Laviron* • Jeanron exhibits *Limousin Peasants* • Meissonier's first Salon • Pils studies with Picot at Ecole des Beaux-Arts • Philippe Rousseau's first Salon

1835 • Cals's first Salon: three works, including *A Poor Woman* • Gigoux illustrates *Gil Blas* • Adolphe Leleux's first Salon

1836 • Galvanized iron invented in France • Iron-works at Le Creusot, operated by French industrialists Joseph and Eugène Schneider, mark beginning of gigantic steelmaking and munitions enterprise • Arc de Triomphe, first ordered by Napoleon in 1806, finally completed • Alfred de Musset's autobiographical novel *Confession d'un enfant du siècle* reflects the disillusion of his contemporaries • Edgar Allan Poe: *Maelzel's Chess Player* • Gogol's satirical drama *The Government Inspector* is performed in Saint Petersburg

1837 • Economic depression begins in Britain • French attack and capture Constantine from Turks • First railway opens to link Paris with Le Pecq near Saint-Germain-en-Laye • Friedrich Froebel opens world's first kindergarten in Germany • Tiffany and Company opens in New York City • London's Buckingham Palace becomes royal residence of the new Queen Victoria • First installments of Charles Dickens's *Oliver Twist* describe widespread poverty and hunger in Britain • Thomas Carlyle: *The French Revolution* • Dickens: *The Posthumous Papers of the Pickwick Club* • Balzac: *Le Curé de village* • Hugo: *Les Voix intérieures* • Sand: *Mauprat* • Death of Pushkin

1838 • First transatlantic crossing of ships powered entirely by steam • First Russian railway opens to link Saint Petersburg with czar's summer palace at Tsarskoe Selo • People's Charter, published by British workingmen's movement, calls for universal suffrage without property qualification • Britain applies Poor Law of 1834 to Ireland and subsequent hardship kills thousands • Dicken's *Oliver Twist* reinforces growing indictment of Poor Law • Balzac: *Mercadet* • Lamartine: *La Chute d'un ange*

1839 • French journalist Louis Blanc's *Organisation du travail* outlines social order based on "From each according to his abilities, to each according to his needs" • Invention of steam hammer by Scottish engineer James Nasmyth facilitates large-scale forgings without loss of precision • Photographic reproduction, discovered by Louis Daguerre in 1829, is finally presented to French Academy of Arts and Sciences, although Englishman Talbot claims to have produced photographs earlier using camera obscura • Stendhal: *La Chartreuse de Parme*

1840 • Queen Victoria marries her cousin Albert • Death of Prussia's Friedrich Wilhelm III and succession of his son Friedrich Wilhelm IV • Pierre Joseph Proudhon's pamphlet *What Is Property* condemns private property and advocates anarchy • Another insurrection by Prince Louis Napoleon (nephew of Napoleon I) fails at Boulogne • Liberal premier Louis Adolphe Thiers falls from power and François Guizot becomes minister • Napoleon I's remains returned to France and entombed in Invalides in Paris • Birth of Emile Zola • James Fenimore Cooper: *The Pathfinder* • Poe: *Tales of the Grotesque and Arabesque*

1841 • *Punch* begins publication in London • Irish agriculture falls into decay: tenant farmers, dependent on potato crop for food, raise grain and cattle to pay for rent, and whiskey becomes cheaper than bread • Population of London, 2.24 million; Paris, 935,000 • Sand: *Le Compagnon du tour de France*

1836 • Birth of Stanislas Lépine • Delacroix: *Saint Sebastian* and paints Salon of the King in Chamber of Deputies • Rude: *The Marseillaise* • First long stay of Théodore Rousseau at Barbizon • Daubigny leaves for Italy

1837 • Death of Constable, Baron François Gérard • Turner paints in Paris • Inauguration of Galleries of Versailles • Courbet goes to college in Besançon and works in studio of painter Flajoulot • Millet, with assistance from town of Cherbourg, studies with Delaroche

1838 • Delacroix refused membership in French Institute • Delacroix: *Medea* • Corot: *Silenus* • Duban designs Palais de l'Ecole des Beaux-Arts • Musée Espagnol opens at the Louvre • Théodore Rousseau rejected at the Salon

1839 • Birth of Cézanne, Sisley • Delacroix: *Hamlet* • Chassériau: *Suzanna at the Bath* • Courbet arrives in Paris in the fall to work in the studio of Steuben

1840 • Birth of Monet, Rodin • Ingres: *Stratonice* • Daubigny: *Saint Jerome in the Desert* • Corot: *Flight into Egypt* • Hittorff reworks Place de la Concorde

1841 • Birth of Renoir, Bazille • Delacroix: *Entry of the Crusaders into Constantinople* (commissioned by the state in 1838) and *Jewish Wedding* • Chassériau: *Father Lacordaire* • Thomas Couture: *The Prodigal Son* • Delaroche paints the Hémicycle of the Ecole des Beaux-Arts • Salon rejects Courbet's *Portrait de MM. UC.* (Urbain Cuénot) and *A.M.* (Adolphe Marlet)

1836 • Birth of Fantin-Latour • Cabat receives stipend from government to study in Italy • Jeanron's *The Charity of the People* (also called *The Blacksmiths from Corrèze*) designated "a new art in form and content" by Thoré

1837 • Birth of Butin, Carolus-Duran, Firmin-Girard • Hervier leaves Léon Cogniet's studio • Adolphe Leleux travels to Brittany • Pils wins Prix de Rome with *St. Peter Healing a Cripple* and goes to Rome • Troyon receives first Salon award for *View of the Château of St. Cloud* and *A Rural Fair in the Limousin*

1839 • Adolphe Leleux dedicates himself to Brittany scenes • Armand Leleux's first Salon • First volume of *Les Français peints par eux-mêmes*

1840 • Birth of Victoria Dubourg (Mme. Fantin-Latour), Rozier • Flers receives third-class medal • Armand and Adolphe Leleux exhibit scenes of Brittany • Meissonier receives third-class medal

1841 • Breton studies with Félix de Vigne in Ghent • Frère's first Salon • Gigoux receives Légion d'honneur

1842 • Treaty of Nanking ends Opium War and opens China to exploitation by Western powers. Hong Kong is ceded to Britain • Strikes and riots erupt in northern England • English reformer Edwin Chadwick's report to Poor Commissioners exposes terrible working conditions in milltown slums and leads to establishment of Health of Towns Association to provide health, cleanliness, enlightened self-interest, and "the simple blessings of Air, Water and Light" for everyone • French government passes Railway Act and undertakes the building of roadbeds, bridges, tunnels, and stations • Queen Victoria makes first railroad journey from Windsor to Paddington, London • *Illustrated London News* begins publication • Death of Stendhal • Birth of Stéphane Mallarmé • Gogol: *Dead Souls*

1843 • Congress appropriates funds for Samuel F.B. Morse to build world's first long-distance telegraph line • Dickens: *Christmas Carol* • Hugo: *Les Burgraves* • Eugène Sue's *Les Mystères de Paris* reflects Socialist ideas of day

1844 • Suppression of his newspaper *Reiische Zeitung* by Cologne authorities causes Karl Marx to flee to Paris • British author Samuel Laing's *National Distress* reveals effects of machinery on country's working class • Treaty of Tangier ends French war in Morocco • Invention of wood pulp process by German Gottlob Keller reduces price of newsprint and facilitates cheap mass media • Birth of Nietzsche, Anatole France, Paul Verlaine • Balzac: *Les Paysans* • Dickens: *The Life and Adventures of Martin Chuzzlewit* • Sand: *Jeanne*

1845 • Potato crops fail throughout Europe and 2.5 million starve to death as famine extends from Moscow to Ireland • Potato famine in England spurs free trade • Wars with Sikhs plague British control in India • German socialist Friedrich Engels, who had worked in his father's English textile mill, becomes friend of Marx in Paris and publishes *The Condition of the Working Class in England*, an account of exploitation of labor by capital • Feminist Margaret Fuller: *Woman in the Nineteenth Century* • Sand: *Les Maîtres mosaïstes* and *Le Meunier d'Angibault* • Sue: *Le Juif errant*

1846 • Great Potato Famine continues in Ireland, and Irish immigrate to England, Canada, Australia, and America • Louis Napoleon, disguised as a worker, escapes from fortress of Ham and flees to England • Britain adopts standard gauge to facilitate expansion of national rail system • French-American art dealer Michel Knoedler purchases gallery of Goupil and Cie in Paris and opens another at Broadway and 9th Street in New York City • French historian Jules Michelet's *The People* calls for French people to unite, to eliminate class division created by Industrial Revolution, and to return to ideals of 1789 Revolution • Sand: *La Mare au diable* • Balzac: *La Cousine Bette*

1847 • Karl Marx and Friedrich Engels: *Communist Manifesto* • Economic depression continues in England • Charlotte Brontë: *Jane Eyre* • Emily Brontë: *Wuthering Heights* • Balzac: *Le Cousin Pons* • Michelet and Louis Blanc each publish an *Histoire de la Révolution* • Sand: *Le Péché de M. Antoine*

1842 • Inauguration of La Madeleine church in Paris • Musée Standish opens at the Louvre • Visconti executes La Fontaine Molière • Viollet-le-Duc begins restoration of Notre Dame • Ingres: *Odalisque as Slave* • Salon rejects two paintings by Courbet

1843 • Birth of Henri Regnault • Death of Georges Michel • Corot makes third trip to Italy • Turner: *The Sun of Venice Going to Sea* • Delacroix works on Bibliothèque of the Chambre des Députés • Ingres starts work at Dampierre • Charles Gleyre: *Lost Illusions* • Salon rejects two paintings by Courbet

1844 • Edwin Landseer: *Shoeing the Mare* • Turner: *Rain, Steam and Speed* • Courbet's first Salon painting accepted, two others rejected

1845 • Corot makes first engravings • Delacroix works on the Pieta at Saint Denis du Saint Sacrement, and exhibits *Abd-el-Rhaman* and *Marcus Aurelius* • Ingres: *Mme d'Haussonville* • Baudelaire reviews the Salon • Salon accepts Courbet's *The Guitarrero*, rejects four others

1846 • Delacroix works on cupola of the Bibliothèque du Luxembourg • Hippolyte Flandrin begins work on the choir of Saint-Germain-des-Prés • Chenevard: *Hell* • Courbet makes first trip to Holland • Millet, in Paris, meets Troyon and Diaz • Salon accepts Courbet's *Portrait of M. XXX* (known as *The Man with the Leather Belt*), rejects his other seven entries

1847 • Théodore Rousseau moves to Barbizon • Couture: *The Romans of the Decadence* • Jean Léon Gérôme: *The Cock-Fight* • Delacroix: *Jewish Musicians of Mogador* • New British Museum opens in London • Salon rejects all three of Courbet's works

1842 • Cabat receives Légion d'honneur • Adolphe Leleux travels to Spain and adds Spanish scenes to repertoire • Meissonier receives first-class medal • Pils returns to Paris

1844 • Birth of Lhermitte • Henner and Brion study with Guérin in Strasbourg • Adolphe Leleux's exhibit *The Roadmen* earns him the designation of Realist by critics

1845 • Birth of Germain Ribot • Antigna exhibits Realist themes for first time • Gautier enters Ecole Académique in Lille • Théodule Ribot arrives in Paris • Philippe Rousseau wins first award, a third-class medal

1846 • Birth of Bergeret • Bonnat joins family in Madrid • Breton studies in Art Academy in Antwerp • Cals exhibits eleven works at Salon • Henner studies with Drolling in Paris • Jongkind arrives in Paris • Armand Leleux accepts government trip to Spain and also travels in Switzerland

1847 • Birth of Gilbert • Bonnat studies in Madrid with José Fernando at Royal Academy • Colin studies with Constant Dutilleux in Arras • Antigna wins first award, exhibits several Realist scenes • François Bonvin's first Salon • Brion exhibits Alsatian scene at first Paris Salon • Troyon travels to Holland and studies Dutch animal painters

1848 • Revolution erupts in Paris and Louis Philippe abdicates • Lamartine forms provisionary government • Universal suffrage is finally achieved and the French Republic proclaimed • Revolution spreads to Berlin, Budapest, Vienna, and throughout Europe • In Paris, during June insurrection, thousands of workers are killed on barricades. General Cavaignac quells uprisings and Louis Napoleon is elected president by popular vote • Famine strikes Europe • Failure of liberal movement in the German States forces many young men to emigrate • John Stuart Mill: *Principles of Political Economy* • Karl Marx: *Wage, Labour and Capital* • William Thackeray: *Vanity Fair* • Dickens: *Dombey and Son* • Death of Chateaubriand

1849 • Garibaldi, famed military adventurer, supports Mazzini's short-lived Roman republic • Marshal Oudinot, leading French army against Garibaldi's ''red-shirted'' troops, restores Rome to the Pope. Garibaldi escapes and immigrates to United States • Cholera epidemic in London results in increased public sanitation measures • Death of Poe

1850 • New French electoral law, directed at migratory radical workers, requires voters to reside in one place for three years • Clubs and public meetings are forbidden in France • Great Britain adopts free trade • Birth of Guy de Maupassant • Death of Balzac • Dickens: *The Personal History of David Copperfield*

1851 • In France, Second Republic ends • Louis Napoleon Bonaparte's coup d'état 2 December leads to his appointment as life-president. Troops repress workers' uprisings • Great Exhibition featuring England's industrial achievement and prosperity takes place in London's Crystal Palace. This first great structure made of iron, glass, and laminated wood rather than masonry influences design of European railway stations • Englishman Scott Archer invents ''wet'' collodion process, thereby facilitating mass production of photographic prints • London declared largest city in the world, 2.37 million; Paris 1.3 million

1852 • Second Empire proclaimed in France 2 December • Napoleon III begins huge program of public works with gift of Bois de Boulogne, which Baron Georges Haussmann transforms into park modeled after London's Hyde Park • Bon Marché in Paris, taken over by French merchant Aristide Boucicaut, becomes world's first department store • Death of Gogol • Turgenev: *A Sportsman's Sketches*

1853 • Napoleon III marries Spanish Comtesse Eugénie de Montijo • Baron Haussmann takes office as prefect of the Seine and begins transformation of the city layout • Death of Arago • Dickens: *Bleak House* • Hugo: *Les Châtiments* • Sand: *Les Maîtres sonneurs*

1848 • Couture: *The Enlistment of the Volunteers* • Daumier and Millet, among others, participate in contest to select symbol of Second Republic • William Holmon Hunt, John Everett Millais, Dante Gabriel Rosetti form the Pre-Raphaelite Brotherhood • Salon exhibitions are held for first time in the Louvre. Jury is abolished and Salon opened to all artists. Louvre is reorganized and galleries rearranged historically • Salon accepts all ten of Courbet's entries

1849 • Death of Granet • Millet moves to Barbizon • First Pre-Raphaelite exhibition takes place in London • Corot: *View of the Coliseum* • Charles Blanc, Thoré, Jeanron dominate in government councils • Salon jury system reestablished and members chosen by election (not appointment) • Salon accepts Courbet's *After Dinner at Ornans* and six other works, rejects four

1850 • Salon officially opened to public 3 January • Millet's *The Sower* acclaimed by republican colleagues • Daumier: *Ratapoil*

1851 • Hiram Powers's sculpture *The Greek Slave* (completed in 1843) exhibited at London World's Fair • Death of Turner • Delacroix finishes ceiling of Galerie d'Apollon in the Louvre, and begins work on Salon de la Paix at Hôtel de Ville • Corot: *Morning, the Dance of the Nymphs* • Salon accepts all nine of Courbet's paintings, including *The Stonebreakers* and *The Burial at Ornans*

1852 • Gustave Moreau: *Piéta* • Millet, commissioned by state, begins *Hagar and Ishmael*, but sends *The Hay-Makers' Rest* • Salon accepts Courbet's *Young Women of the Village*, rejects two others

1853 • Birth of Vincent van Gogh • Millet exhibits *The Harvesters Resting* and *A Sheep Shearer*, receives second-class medal

1848 • Birth of Jules Bastien-Lepage, Caillebotte, Casile • Probably Feyen-Perrin's first Salon • Rosa Bonheur exhibits eight works and receives first-class medal. Receives state commission • Brion serves in National Guard • Cals meets art dealer Père Martin • Jeanron, appointed director of National Museums, works for reforms in museums. Salon held in Louvre for first time. Reorganization of collections brings about rediscovery of past masters: Chardin and the Le Nains • Jongkind's first Salon • Adolphe Leleux paints scenes of February Revolution • Meissonier's *Souvenir of the Civil War* receives first-class medal • Philippe Rousseau wins first-class medal

1849 • Birth of Carrière, Lebourg • Rosa Bonheur exhibits state commission *Plowing at Nivernais*, which enters Luxembourg Museum • Breton studies with Drolling in Paris; first Salon: *Misery and Despair* • Flers receives Légion d'honneur • Hervier's first Salon • Pils exhibits *Rouget de Lisle Singing the Marseillaise* • Troyon receives Légion d'honneur

1850 • Birth of Raffaelli • Colin studies law in Paris • Fantin-Latour studies with Lecoq de Boisbaudran at Petite Ecole de Dessin • 1850/51 Salon marks official beginning of Realist movement • Antigna exhibits seven works, including *The Fire*, and receives first-class medal • Brion arrives in Paris, probably studies with Drolling • Gautier moves to Paris aided by stipend from city of Lille • Pils exhibits *The Death of a Sister of Charity* • Tassaert exhibits *An Unfortunate Family* or *The Suicide*, his most famous work • Antoine Vollon studies at Ecole des Beaux-Arts in Lyon

1851 • Birth of Julien Dupré • François Bonvin receives second-class medal for *The Girls' School* • Legros studies with Belloc and Lecoq de Boisbaudran at Petite Ecole de Dessin, meets Fantin-Latour, Lhermitte, and Cazin • Ribot returns to Paris after stay in Algeria

1852 • Birth of Dagnan-Bouveret • Gautier studies with Léon Cogniet • Jongkind receives first award, a third-class medal • Pils exhibits *Soldiers Distributing Bread to the Poor*

1853 • Bonnat returns to Bayonne with family and receives city stipend to study in Paris • Rosa Bonheur's Salon entry *Horse Fair* brings her success • Breton exhibits first of a series of rural scenes: *The Return of the Harvesters*. Paints *The Little Gleaner* • Brion exhibits three works and receives second-class medal for *The Potato Harvest during the Flooding of the Rhine in 1852* • Pils's exhibit *The Prayer in the Hospice* purchased by Napoleon III

1854 • Crimean War begins 28 March with France and England allied against Russia • Florence Nightingale takes thirty-four London nurses to Crimea • Egypt grants Suez Canal concession to French engineer Ferdinand de Lesseps • *Le Figaro* begins publication in Paris • Dickens: *Hard Times*

1855 • Russia's Nicholas I dies and his son, Alexander II, initiates liberal reforms • Italy joins France and England in Crimean War • Frenchman Constantin Guys's on-the-spot drawings and Englishman Robert Fenton's photographs of the Crimean War are reproduced as wood engravings in *Illustrated London News* • Russian forces abandon Sebastopol 11 September • London's sewer system modernized following cholera outbreak • Paris International Exhibition demonstrates France's technological and economic progress • The new Magasins du Louvre attract shoppers in Paris

1856 • Crimean War ends 1 February. Congress of Paris declares the Black Sea neutral in March • Seizure of Canton by British and French forces precipitates new Anglo-Chinese war • Fossil remains of Neanderthal man found in West Germany • Death of Robert Schumann and Heinrich Heine

1857 • Garibaldi founds Italian National Association to unify Italy's separate states • Crinoline becomes fashionable • Death of Alfred de Musset • Gustave Flaubert wins acquittal of immorality charges for writing *Madame Bovary* • Charles Baudelaire's *Les Fleurs du mal* condemned as obscene • Dickens: *Little Dorrit*

1858 • Italian patriot Orsini is executed after attempted assasination of Napoleon III—an act that influences Napoleon to intervene against Austria in favor of Italian unification • Treaty of Tientsin ends the two-year Anglo-Chinese war • Death of French social philosopher and reformer Charles Fourier

1859 • France acquires Magenta and Solferino in Italian war against Austria. Austria's shortage of funds and revolution in Hungary force a settlement at Villafranca • Metternich dies in England, where he fled after the 1848 revolutions • Abolitionist John Brown's raid on federal arsenal at Harper's Ferry stirs passions throughout the United States • Suez Canal construction finally begins • Birth of Pierre Curie, Henri Bergson • Hugo, writing *La Légende des siècles* while living on isle of Guernsey, opposes Napoleon III and refuses amnesty • Charles Darwin: *On the Origin of Species* • Dickens: *A Tale of Two Cities*

1860 • Garibaldi and his army of "Red Shirts" take Palermo, Naples, and support efforts of Victor Emmanuel II of Piedmont to become king of Italy • England and France sign free trade treaty • Napoleon III relinquishes power to the French parliament in an effort to regain support lost because of Italian campaign and free trade treaty • Abraham Lincoln elected President • French railway extends 5918 miles

1854 • Millet: *The Reaper* • Ingres: *Joan of Arc at the Coronation of Charles VII in the Cathedral of Reims* and *The Virgin and the Host* • Salon postponed

1855 • Death of Rude • Baudelaire writes the eulogy of Delacroix • Constantin Guys returns to Paris • Whistler arrives in Paris • Manet studies with Couture at Ecole des Beaux-Arts • Degas gives up law studies to enter Ecole des Beaux-Arts and makes trips to south of France and Italy • Annual Salon combines with Universal Exhibition. Ten paintings by Corot exhibited, but Courbet's entries: *The Burial, The Portrait of Champfleury,* and *The Atelier* rejected. Courbet exhibits at his own Pavillon du Réalisme

1856 • Death of Chassériau, Delaroche • Ingres: *The Source* • Couture receives commission for the *Baptism of the Imperial Prince* • Courbet goes to Belgium • No Salon

1857 • Millet: *The Gleaners* • Félix Bracquemond discovers Hokusai's *Manga* • Delacroix elected to Institut de France • Manet leaves Couture's studio to travel extensively • Degas travels to Italy • Renoir apprentices as a porcelain painter • Sisley studies commercial art in England • Salon regulations changed

1858 • Death of Ary Scheffer • Courbet travels to Brussels and Frankfurt • No Salon

1859 • Delacroix begins decoration of Chapel of the Angels in Saint Sulpice • Millet: *The Angelus* • Ingres: *The Turkish Bath* • Whistler moves to London • Degas works in Rome and Sienna, paints portrait of the *Belleli Family* and visits Pisa • Pissarro studies at Académie Suisse • Cézanne studies law but wants to paint • Renoir chooses painting as a career • Sisley remains in London • Courbet exhibits in Le Havre and London • Salon accepts Boudin for first time, rejects Manet despite Delacroix's support. Pissarro exhibits landscapes, and works at Académie Suisse • Baudelaire reviews Salon

1860 • Death of Raffet, Decamps • The newspaper *Charivari* fires Daumier • Large exhibition of paintings by Delacroix, Millet • Manet: *The Spanish Guitar Player* • Degas: *Young Spartans Exercising,* and travels in Italy • Pissarro works near Paris and meets Chintreuil • Bazille studies medicine in Montpellier • No Salon

1854 • Birth of Emile Bastien-Lepage, Goeneutte • Bonnat studies with Léon Cogniet in Paris • Colin studies with Ary Scheffer, then Couture • Jean Antoine Bail's first regional Salon in Lyon, exhibits *Interior of a Studio* • Gautier travels with his friend Dr. Paul Gachet to Jura during cholera epidemic

1855 • Rosa Bonheur's last Salon • Antigna exhibits sixteen works and receives third-class medal for *The Forced Halt* • Breton exhibits *The Gleaners,* receives third-class medal • Pierre Edouard Frère receives Légion d'honneur. His popularity grows in England, where Ruskin writes about his work • Henner returns to Alsace • Legros enters Ecole des Beaux-Arts • Adolphe Leleux receives Légion d'honneur • Meissonier receives Légion d'honneur at Universal Exhibition • Théodore Rousseau buys Millet paintings • Du Camp: *Les Beaux-Arts à l'Exposition Universelle de 1855. Peinture, sculpture*

1856 • Birth of Maurin • Duranty begins publication of the review *Le Réalisme* • Père Martin organizes sale to help Jongkind

1857 • Bonnat's first Salon, exhibits portraits. Receives second place in Prix de Rome and studies in Rome • Colin's first recorded Salon entry • Antigna exhibits scene showing "official" Realism: *Napoleon III Visiting Flood Victims* • Breton's exhibit *The Blessing of the Wheat Fields* receives second-class medal and is purchased by the state • Gautier's exhibit *The Madwomen of the Salpêtrière* establishes his place in Realist circle • Henner returns to Paris and studies with Picot • Legros's first Salon: *Portrait of the Artist's Father* • Champfleury: *Le Réalisme*

1858 • Boudin paints Brittany subjects • Count Doria meets Cals and becomes his patron • Henner wins Prix de Rome for *Adam and Eve Discovering the Body of Abel,* and studies in Rome • Antoine Vollon exhibits paintings in Lyon

1859 • Fête du Réalisme held in Courbet's studio • Fantin-Latour's first Salon entry rejected and he makes first trip to England • François Bonvin holds "Exposition des Refusés" in his studio: exhibits works by Fantin-Latour, Legros, Théodule Ribot, Whistler • Carolus-Duran wins stipend from city of Lille to study in Paris • Colin's Salon entry records Basque region • Firmin-Girard's first Salon • Boudin's first Salon • Breton exhibits *The Recall of the Gleaners, Dedication of a Calvary,* and *The Seamstress* • Troyon's last Salon • Astruc: *Les 14 Stations du Salon, 1859*

1860 • Léon Bonvin paints water colors • Père Martin with Count Doria organizes sale for Jongkind • Armand Leleux receives Légion d'honneur • Death of Monanteuil

1861 • Italy unites as single kingdom 17 March under Victor Emmanuel II, and Nice and Savoy are ceded to France • Under growing political opposition, Napoleon III extends financial powers of parliament and starts grandiose program of public works • Prince Albert dies • American Civil War begins • Czar Alexander II completes emancipation of Russian serfs • Parisian Pierre Michaux invents the world's first true bicycle • Dickens: *Great Expectations* • The Goncourt brothers: *Soeur Philomène*

1861 • Corot: *Le Repos*, and works at Fontainebleau • Manet exhibits at Martinet's Gallery, meets Baudelaire and Duranty • Degas paints historical subjects • Pissarro meets Cézanne • Cézanne quits law, visits Paris, and returns to Aix to work in father's bank • Manet completes military service in Algiers • Salon rejects Millet's *Death and the Woodcutter*, rejects Pissarro. Salon proves great success for Manet

1861 • Bonnat's exhibit *Death of Abel* receives second-class Salon medal, and he returns to France • Antigna receives Légion d'honneur • Jean Antoine Bail's first Paris Salon • Breton receives first-class medal and Légion d'honneur for *The Colzas* • Gautier receives honorable mention for *Portrait of Doctor Gachet* • Herlin's first Salon • Legros exhibits *The Ex-Voto* • Meissonier elected to Institut de France • Pils's exhibit *The Battle of Alma* wins grand medal • Ribot's first Salon: several compositions of cooks • Théophile Gautier recognizes Philippe Rousseau as member of Realist movement • Exhibition at Martinet's Gallery

1862 • Second London Great International Exhibition spurs demand for Japanese goods • Liberty's shop opens in London • Birth of Debussy, Maeterlinck, Briand • Hugo's *Les Misérables* depicts injustice of French society • Dostoyevsky: *House of Death* • Turgenev: *Fathers and Sons* • Flaubert: *Salammbô* • Georgina Rossetti's *Goblin Market and Other Poems* gives Pre-Raphaelites first great literary success

1862 • Universal Exhibition in London displays Japanese arts and crafts • Courbet opens his studio for students • Millet: *Potato Planters* • Degas and Manet meet • Manet: *Concert in the Tuileries Gardens* • Baudelaire praises Manet • Degas paints horses and racing themes, becomes friends with Duranty • Cézanne leaves his father's bank, returns to Paris to paint • Renoir studies with Gleyre at the Ecole des Beaux-Arts • Bazille moves to Paris, continues study of medicine, and enrolls in Gleyre's studio

1862 • Birth of Joseph Bail • Duranty sponsors marionette plays in Tuileries Garden • Cazin studies with Lecoq de Boisbaudran • Fantin-Latour joins Société des Aquafortistes • Brion illustrates *Les Misérables*

1863 • Emancipation Proclamation frees nearly 4 million United States slaves • Battle of Gettysburg • French forces occupy Mexico City • Mexican leaders meeting under French auspices adopt imperial form of government • La Villette, central hygienic slaughterhouse designed by Haussmann, opens in Paris • Photographer Nadar, surveying from a balloon, takes aerial views of Paris • Death of Alfred de Vigny, Thackeray

1863 • Death of Delacroix, Horace Vernet • Birth of Signac, Munch • Ecole des Beaux-Arts reorganized • Salon des Refusés • Manet's *Luncheon on the Grass* creates a furor at Salon des Refusés, but he shows many paintings at Martinet Gallery • Millet: *Man with a Hoe* • Baudelaire writes study on Guys • Courbet's *Return from the Conference* rejected at both Salon and Salon des Refusés

1863 • Brion receives first-class medal and Légion d'honneur • Flers's last Salon • Colin, Gautier, Jongkind, Legros, Vollon participate in Salon des Refusés • Castagnary praises Gautier • Jongkind meets Boudin at Honfleur • Legros leaves for England • Lhermitte studies with Lecoq de Boisbaudran at Ecole Impériale de Dessin • Tassaert, poverty-stricken, sells contents of his studio to Père Martin

1864 • Austria's Archduke Maximilian accepts throne of Mexico • Polish insurrection spreads to Lithuania and White Russia, and autonomy is abolished in Poland • Napoleon III acknowledges right to strike and rescinds ban on workers' associations • Red Cross is established by Geneva Convention • International Working Men's Association, known as the first International, meets in London • European immigrants respond to United States's Homestead Act of 1862 • The Goncourt brothers: *Renée Mauperin*

1864 • Birth of Toulouse-Lautrec, Sérusier • Gleyre closes his studio • Manet: *The Dead Toreador* • Fantin-Latour: *Homage to Delacroix* • Bazille gives up medicine for art • Courbet: *Portrait of Pierre Joseph Proudhon in 1853* • Millet wins first-class Salon medal • Salon rejects Rodin's *Man with a Broken Nose*

1864 • First Salon success for Fantin-Latour: *Homage to Delacroix* • Feyen-Perrin exhibits *The Anatomy Lesson of Doctor Velpeau* • Lhermitte's first Salon: a drawing • Pils named professor at Ecole des Beaux-Arts • Vollon's first Salon

1865 • American Civil War ends • President Lincoln assassinated • Mendel's law on heredity published • The Printemps department store opens in Paris • Death of Proudhon and posthumous publication of his *Principe de l'Art* • Dickens: *Our Mutual Friend* • The Goncourt brothers: *Germinie Lacerteux* and *Manette Salomon*

1865 • Death of Devéria • Zola visits Courbet • Degas exhibits medieval war scene at Salon • Manet's paintings receive acclaim at Martinet Gallery, but he is criticized at Salon for *Olympia*

1865 • Death of Troyon • Birth of Adler, Alexis Vollon • Bonnat opens own studio, begins collecting art • Duplessy's first Salon • Rosa Bonheur receives Légion d'honneur • Ribot shows in Amsterdam. His Salon exhibit *Saint Sebastian* purchased by state • Cazin's first Salon • Almost blind, Tassaert spends time at home of his friend and patron Bruyas in Montpellier • Vollon's exhibit *Kitchen Interior* receives first Salon award

1866 • United States refuses to recognize Emperor Maximilian and demands withdrawal of French troops • Austro-Hungarian Empire is formed • Italy joins Prussia in war against Austria. Prussians defeat Austria at Sadowa • Swedish engineer Nobel invents dynamite • Hugo: *Les Travailleurs de la mer* • First installment of Tolstoy's *War and Peace* published • Dostoyevsky: *Crime and Punishment* and *The Gambler*

1866 • Corot and Daubigny elected to Salon jury • Zola dedicates *Mon Salon* to Cézanne • Birth of art dealer Vollard • Mary Cassatt goes to Paris • Manet meets Zola, Cézanne, Monet • Salon rejects Cézanne in spite of Daubigny's intervention • Salon rejects Manet's *The Fifer* • Salon rejects Renoir despite Corot's and Daubigny's intervention • Monet's *Camille* acclaimed at Salon • Courbet exhibits *Woman with the Parrot*

1866 • Léon Bonvin commits suicide • Carolus-Duran returns to Paris, and his exhibit *The Assassination* receives Salon medal. Travels to Spain • Courbet paints Gautier's portrait • Lhermitte's first Salon • Zola writes about Realism in *L'Evénement*

1867 • United States purchases Alaska from Russia • Mexico's Emperor Maximilian surrenders and is executed—ending Napoleon III's dream of extending his empire to Latin America • Meiji Emperor Mutsuhito ascends throne in Japan • Prussia's Count von Bismarck organizes North German Confederation • Karl Marx: *Das Kapital* • World's Fair in Paris • Death of Baudelaire • Zola: *Thérèse Raquin*

1867 • Death of Théodore Rousseau, Ingres, Baudelaire • Universal Exhibition in Paris. Courbet exhibits only four paintings • Manet exhibits his works at separate pavilion with little success. His *The Execution of Maximilian* barred from exhibition • Japanese art and *ukiyo-e* prints become popular • Courbet holds separate one-man show • Courbet sends no paintings to Salon • Zola's writings mock Salon jury • Salon rejects Pissarro • Renoir, Sisley, Bazille petition for another Salon des Refusés

1867 • François Bonvin's first trip to Low Countries • Breton exhibits ten works at Universal Exhibition and wins first-class medal. Made commander of the Légion d'honneur • Brion exhibits *Vosges Peasants Fleeing before the Invasion* at Universal Exhibition • Fouace receives stipend from city of Cherbourg and studies with Adolphe Yvon in Paris • Meissonier receives medal of honor at Universal Exhibition • Pils receives Légion d'honneur • Philippe Rousseau exhibits *Chardin and His Models*, a testimonial of his admiration for Chardin • Du Camp: *Les Beaux-Arts à l'Exposition Universelle et aux Salons de 1863, 1864, 1865, 1866 et 1867*

1868 • Revolution in Japanese life and government (Meiji Restoration) ends feudal rule that had continued since 1185 • Cro-Magnon man discovered in French cave near Périgueux • Birth of Gorki

1868 • Birth of Vuillard • Manet paints portrait of Duret, makes trip to England • Pissarro forced to accept commercial jobs • Monet paints at Etretat, and is dispossessed by creditors • Millet receives Légion d'honneur • Salon finally accepts Pissarro with help of Daubigny. Salon accepts Manet's *Portrait of Zola*. Zola again reviews Salon, praises Manet and Pissarro

1868 • Death of Flers • Jules Bastien-Lepage studies with Cabanel • Carolus-Duran's career established, marries fellow artist • Cazin becomes director of Ecole de Dessin and curator of museum in Tours • Pierre Edouard Frère exhibits at Royal Academy • Publication of Thoré's "Nouvelles Tendances de l'Art," the preface to *Salons de Th. Thoré, 1844, 1845, 1846, 1847, 1848*, advocates "art for man"

1869 • Suez Canal opens • Connection of Union Pacific and Central Pacific in Utah extends United States railway from coast to coast • Cable connection between France and United States is completed at Duxbury, Mass. • Samaritaine department store opens in Paris • Death of Lamartine • Flaubert: *L'Education sentimentale* • Dostoyevsky: *The Idiot* • Hugo: *The Man Who Laughs* • The Goncourt brothers: *Madame Gervaisais*

1869 • Death of Paul Huet • Birth of Matisse • Manet and friends gather at Café Guebois. Eva Gonzales studies with Manet. He exhibits *The Balcony* and *The Luncheon in The Studio* • Creditors seize Monet's paintings, and Renoir comes to his aid • Courbet goes to Munich • Salon rejects Monet

1869 • Death of Thoré-Bürger • Caillebotte receives law degree • Carolus-Duran exhibits first real success, *Lady with a Glove,* which receives second-class medal and is purchased by Luxembourg Museum • Dagnan-Bouveret studies with Cabanel, then Gérôme at Ecole des Beaux-Arts • First Salon for Desboutin, Victoria Dubourg, and Rozier • Théodule Ribot exhibits in Munich

1870 • German-American businessman Heinrich Schliemann begins archaeological excavations of Ancient Troy • Isabella of Spain abdicates. Offer of Spanish crown to Hohenzollern Prince Leopold precipitates Franco-Prussian War • Prussians humiliate France at Sedan • Second Empire falls • Italian troops enter Rome after French withdraw and finally complete unification of Kingdom of Italy under Victor Emmanuel II • First Vatican Council establishes doctrine of papal infallibility • Léon Gambetta pioneers air travel as he escapes from besieged Paris by balloon • French citizens subscribe 40 million francs for erection of Sacré Coeur as symbol of hope to commemorate Napoleon III's defeat at Sedan • Paris starves as two German armies begin a 135-day siege of city • Death of Prosper Mérimée, Dickens, Alexandre Dumas • Birth of Lenin

1870 • Courbet and Daumier refuse Légion d'honneur • Millet, Manet, Courbet, and Daumier rejected as candidates on Salon jury • Daubigny and Corot resign from Salon jury • Fantin-Latour exhibits *Studio in the Batignolles* with Manet as central figure • Degas enlists in the infantry • Fantin-Latour becomes officer in National Guard • Pissarro flees to England and marries mother of his children • Monet leaves for England • Renoir is drafted • Bazille is killed in action • Courbet elected president of Commission des Arts, works to save works of art

1870 • Jules Bastien-Lepage's first Salon. He joins the army and is wounded • First Salon for Bergeret and Butin • Butin studies with Picot and Pils at Ecole des Beaux-Arts • Caillebotte called into Garde Mobile de la Seine • Carolus-Duran joins National Guard • François Bonvin moves to London. Receives Légion d'honneur • Fouace's first Salon: two portraits, including *Portrait of Thomas Henry*, (founder of Cherbourg museum) • Gautier's works destroyed by Prussians • Death of Lepoittevin • Meissonier paints *The Ruins of the Tuileries* • Pils records Franco-Prussian War in water color • Raffaelli's first Salon • Ribot's studio and paintings destroyed by Prussians in Argenteuil

1871 • United German Empire is proclaimed • Paris capitulates 28 January and French Assembly accepts peace treaty, ceding Alsace and parts of Lorraine to Germany • Napoleon III, formally deposed 1 March, goes into exile in England • Louis Adolphe Thiers elected president of Third Republic in February • Paris Commune established in March and defeated in "Bloody Week" at end of May. Tuileries Palace in Paris consumed by fire • Birth of Marcel Proust • Dostoyevsky: *The Possessed* • Nietzsche's first book: *The Birth of Tragedy* • Zola: *La Fortune des Rougon*

1871 • Death of Henri Regnault, Paul Guigou • Courbet, elected president of the Commune Art Commission, is involved in destruction of Vendome Column, imprisoned, and condemned • Manet goes to Bourdeaux during Commune • Pissarro's work left at Louveciennes are destroyed • In London, Durand-Ruel meets Monet and exhibits his paintings

1871 • Cazin joins Legros in England • Gautier and Courbet elected to Fédération des Artistes. After Commune, Gautier arrested, then acquitted, but continues friendship with Courbet • Laperlier meets Lebourg, offers him teaching position in Algiers • Lhermitte goes to London, where Legros assists him and introduces him to Durand-Ruel • Raffaelli studies for only three months with Gérôme at Ecole des Beaux-Arts

1872 • France struggles to make reparations to Germany • Triple Alliance joins Germany, Russia, and Austria-Hungary • Louis Pasteur publishes classic paper on fermentation • Death of Théophile Gautier • Hugo: *L'Année terrible*

1873 • German occupation forces evacuate France • Thiers falls from power • MacMahon elected president of France • Death of Napoleon III • Financial panic strikes Vienna in May and spreads to other European money centers and the United States • First Spanish republic proclaimed • Hugo: *Quatre-Vingt-Treize*

1874 • Death of Jules Michelet • Thomas Hardy: *Far from the Madding Crowd* • Flaubert: *La Tentation de Saint Antoine* • Zola: *La Curée* and *Le Ventre de Paris*

1875 • Suez Canal comes under British control • United States Civil Rights Act guarantees blacks equal rights in public places • Photoengraving process patented by German-American photographer David Bachrach • Paris Opéra, completed by Jean Louis Charles Garnier, opens in Paris • Zola: *La Conquête de Plassans* and *La Faute de l'Abbé Mouret*

1876 • Bell demonstrates telephone at United States Centennial Exhibition in Philadelphia • Queen Victoria named Empress of India • Famine kills millions in China and India • Death of George Sand, anarchist Bakunin • Zola: *Son Excellence Eugène Rougon*

1877 • Russia declares war on Turkey • Crisis on 16 May threatens France's survival as republic • Edison invents phonograph • Tolstoy: *Anna Karenina*

1878 • King Victor Emmanuel of Italy dies, and is succeeded by son Umberto I • Ottoman forces capitulate at Shipka Pass and ask Russia for armistice • Berlin Congress • Russia withdraws from Triple Alliance • World's Fair in Paris • Death of Claude Bernard • Thomas Hardy: *The Return of the Native* • Edmond de Goncourt: *La Fille Elisa* • Zola: *L'Assommoir*

1872 • Artists protest nomination of Salon jury by new Fine Arts Administration • Durand-Ruel exhibits Impressionist works in London • Courbet completes prison term • Manet sells many paintings to Durand-Ruel and travels to Holland • Degas meets Durand-Ruel and travels to New Orleans • Renoir lives in Paris, paints Pont-Neuf and other urban landscapes • Gauguin, a successful bank agent, paints only occasionally • Whistler: *The Artist's Mother* • Jongkind, Pissarro, Renoir, and Manet petition for new Salon des Refusés

1873 • Death of Chintreuil • New Salon des Refusés • Durand-Ruel exhibits Impressionist works in London • Courbet flees to Switzerland • Manet's *Bon Bock* receives acclaim at Salon • Degas paints scenes in New Orleans, and returns to France • Monet uses boat on Seine as studio • Renoir meets Durand-Ruel, and sales enable him to take large studio

1874 • First Impressionist Exhibition at Nadar's studio • Durand-Ruel also exhibits Impressionist works in London • Vincent van Gogh visits Paris • Death of Gleyre • Manet refuses to exhibit with Impressionists • Cézanne admitted to Impressionist Exhibition on Pissarro's insistence • Renoir helps organize Impressionist show • Millet commissioned to paint the chapel at the Panthéon

1875 • Death of Corot, Millet, Barye, Carpeaux • Durand-Ruel closes gallery in London • Manet's *Boating at Argenteuil* causes scandal at Salon • Pissarro participates in founding of artists' Union • Monet, in great financial difficulties, paints scenes in Argenteuil • Gauguin continues to draw and paint in spare time • Zola reviews Salon for Russian periodical

1876 • Death of Fromentin, Diaz • Second Impressionist Exhibition: nineteen artists • Duranty: *La Nouvelle Peinture* • Salon rejects Manet, and he holds exhibition for public in his own studio • Monet begins the first of his Gare St. Lazare series • Renoir: *The Swing* and *Moulin de la Galette* • Gauguin exhibits landscapes at Salon, and begins to collect Impressionist paintings

1877 • Death of Courbet • Third Impressionist Exhibition: eighteen artists • Manet: *Nana* • Degas active in organizing Impressionist Exhibition • A lottery is held to help Pissarro and Sisley • Gauguin meets Pissarro

1878 • Death of Daubigny • Tiffany, in New York, specializes in glass work • Paris Universal Exhibition. Durand-Ruel shows three hundred Barbizon paintings • Zola reviews art section of Universal Exhibition for Russian periodical • Duret: *Les Impressionnistes* • Degas paints circus scenes, and Pau museum acquires his *Cotton Exchange Office* • Zola helps Cézanne financially • Renoir: *Portrait of Mme Charpentier*

1872 • Caillebotte studies with Bonnat • Carolus-Duran receives Légion d'honneur and opens teaching studio that attracts American painters • Desboutin returns ruined to Paris after seventeen years in Italy • Goeneutte studies with Pils at Ecole des Beaux-Arts • Lebourg teaches in Algiers • Lhermitte exhibits *Oxen Plowing* at Royal Academy

1873 • Bergeret receives third-class medal • Caillebotte enters Ecole des Beaux-Arts • Cals moves to Honfleur to paint with Jongkind • Fouace exhibits two still lifes at Paris Salon • Gilbert's first Salon • Lhermitte enters first annual Black and White exhibition in London

1874 • Emile Bastien-Lepage studies architecture at Ecole des Beaux-Arts • Jules Bastien-Lepage exhibits first critical success, *Portrait of My Grandfather* • Bonnat's portrait of *Madame Pasca* acclaimed by critics • Butin's visit to Villerville inspires him to paint seascapes and life of fishermen • Caillebotte and Boudin exhibit in first Impressionist show • Lhermitte receives first award, a third-class medal for *The Harvest*, purchased by the state and the first of his scenes of Brittany • Tassaert commits suicide

1875 • Death of Pils • Jules Bastien-Lepage competes for Prix de Rome • Butin receives third-class medal • Caillebotte, rejected at Salon, abandons official art system • Cazin returns to France • Maurin studies at Académie Julian

1876 • *The Floor Scrapers* and other entries at Second Impressionist Exhibition bring Caillebotte notoriety. Collects Impressionist paintings • Cazin exhibits *The Boatyard*, his first important Salon entry • Dagnan-Bouveret receives second Prix de Rome • Degas uses Desboutin as model for his *Absinthe Drinkers* • Julien Dupré's first Salon: *Harvest in Picardie* • Fantin-Latour marries the artist Victoria Dubourg • Goeneutte's first Salon: *The Boulevard de Clichy under Snow* • Legros appointed Slade Professor at Slade School of Art

1877 • Death of Brion, Jeanron • Bergeret receives second-class medal • Carrière leaves Cabanel's studio • Goeneutte exhibits *The Assembly of the Road-Sweepers* • Lebourg returns to France • Raffaelli exhibits *The Family of Jean-le-Boiteux* • Philippe Rousseau's last Salon

1878 • Death of Antigna • Joseph Bail's first Salon • Jules Bastien-Lepage exhibits *The Haymakers Resting* • Butin receives second-class medal for *Burial of a Sailor at Villerville* • Dagnan-Bouveret leaves Ecole des Beaux-Arts, travels to Franche-Comté • Cabat becomes director of French Academy in Rome • Fouace starts work on wall paintings in church at Montfarville • Meissonier helps organize Société Nationale des Beaux-Arts, becomes that group's first president • Ribot receives Légion d'honneur and third-class medal at Universal Exhibition • Antoine Vollon made officer of Légion d'honneur

1879 • Edison invents practical incandescent lamp • Birth of Stalin, Trotsky, Einstein

1879 • Death of Daumier, Couture • Fourth Impressionist Exhibition • Huysmans reviews Salon • Zola writes Salon review for Russian periodical reproaching Impressionists for "insufficient technique" • Pissarro invites Gauguin to show with Impressionist group • Monet, following Renoir's example, exhibits at Salon • Renoir's *Portrait of Mme Charpentier* a Salon success. *La Vie Moderne* organizes one-man show of his works • Gauguin exhibits sculpture with Impressionist group, but not listed in catalog

1879 • Death of Hervier • Carolus-Duran receives medal of honor • Carrière exhibits *Maternity*, establishing his interest in family life • Casile's first Salon: *A Cliff in Normandy* • Dagnan-Bouveret exhibits *A Wedding in the Photographer's Studio* • Lebourg exhibits with Impressionists • Huysmans reviews the Salon

1880 • French Socialist Party is formed • First photographic reproduction appears in *New York Daily Graphic* • Dostoyevsky: *Brothers Karamazov* • Zola: *Nana*

1880 • Fifth Impressionist Exhibition: eighteen artists • Huysmans attacks the Impressionists • Zola publishes new art criticism in *Le Voltaire* • Durand-Ruel recovers from financial crisis • Manet's *Execution of Maximilian* exhibited in Boston • *La Vie Moderne* organizes one-man shows for Manet and Monet • Degas travels to Spain • Manet accuses Impressionists of not being selective enough about whom they accept for the exhibition • Renoir accepted at Salon. Paints *Place Clichy* • Gauguin exhibits with Impressionists

1880 • Death of Duranty, Cals • Emile Bastien-Lepage receives diploma in architecture • Jules Bastien-Lepage exhibits *Joan of Arc*. Visits London • Butin exhibits *The Ex-Voto* • Carrière starts working at Sèvres • Casile goes to Paris • Cazin receives first-class medal for *Ishmael* • Dagnan-Bouveret's exhibit *An Accident* receives first-class medal • Jules Breton publishes *Les Champs de la mer* • Gilbert, specialist on Les Halles themes, exhibits *A Corner of the Fish Market: Morning* • Goeneutte exhibits *The Morning Soup-Kitchen* and continues painting scenes from Parisian life • Lhermitte receives second-class medal • Gallery of *L'Art* exhibits Ribot's work • Huysmans reviews the Salon

1881 • Assassination of Russia's Alexander II causes new czar, Alexander III, to tighten control and repress minorities, especially Jews • Meyer Guggenheim at sixty years of age begins mining and smelting refineries • Clémenceau writes for *La Justice* • Death of Carlyle, Disraeli, Dostoyevsky • Anatole France: *The Crime of Sylvestre Bonard* • Flaubert: *Bouvard and Pécuchet*

1881 • Birth of Picasso • Sixth Impressionist Exhibition: thirteen artists • French government abandons control of the arts • Société des Artistes Français founded • Durand-Ruel again buys Impressionist works • Manet wins second-class medal • Proust, as Fine Arts Minister in Gambetta's government, proposes Manet, now seriously ill, for Légion d'honneur • Monet never again sends works to Salon • Renoir travels to Italy • Gauguin exhibits at Impressionist Exhibition and is praised by Huysmans

1881 • Jules Bastien-Lepage's Salon exhibit *The Beggar* well received • Bonnat elected to Institut de France • Butin receives Légion d'honneur • Gilbert exhibits two other Les Halles scenes • Lhermitte exhibits *The Tavern*, the first of his series on life of agricultural workers

1882 • Electricity illuminates parts of London and New York • Insurrection in Tonkin leads to full-scale colonial war against French in Indo-China • Robert Koch discovers tuberculosis bacillus • Vienna physician Joseph Breuer pioneers psychoanalysis • Death of Garibaldi, Gambetta, Darwin • Mark Twain: *The Prince and the Pauper* • Edmond de Goncourt: *La Faustin*

1882 • Durand-Ruel organizes Seventh Impressionist Exhibition: eight artists • Competitor Georges Petit founds Exposition Internationale • Courbet retrospective at Ecole des Beaux-Arts • Birth of Braque • Manet exhibits *The Bar at the Folies-Bergères* • Cézanne admitted to Salon • Gauguin takes active part in organizing Impressionist Exhibition

1882 • Jules Bastien-Lepage exhibits *The London Bootblack, Pas Mêche, Going to School* • Caillebotte's last Impressionist show • After ceramic exhibition at Union Centrale, Cazin receives Légion d'honneur • Dagnan-Bouveret exhibits regional themes depicting Franche-Comté • Lhermitte's *Payday for the Harvesters* achieves general fame and is purchased by the state • Maurin's first Salon

1883 • First transcontinental train, the Orient Express, leaves Paris for Constantinople 4 October • Ferdinand de Lesseps begins construction of Panama Canal • League of Struggle for Emancipation of Labor founded in Switzerland by Russian emigrant Plekhanov • Death of Marx, Turgenev • Birth of Mussolini, Gropius, Kafka • Nietzsche: *Thus Spoke Zarathustra*

1883 • Death of Manet, Gustave Doré • Huysmans: *L'Art moderne* • Louis Gonse: *L'Art japonais* • Durand-Ruel organizes series of one-man shows by Pissarro, Monet, and Renoir, and exhibits Impressionist works in London, Berlin, and Rotterdam • Degas refuses to show at Durand-Ruel's gallery • Whistler shows *The Artist's Mother* at Salon • Pissarro, Monet, and Renoir have one-man shows at Durand-Ruel • Gauguin loses bank job, and joins Pissarro in Rouen

1883 • Death of Butin • Casile exhibits *The Bank of the Rhône at Avignon* • Durand-Ruel organizes retrospective exhibition of Boudin's work • Lebourg's first Salon

1884 • Invention of Linotype in United States revolutionizes newspaper publishing • Trade unions legalized in United States • Mark Twain: *The Adventures of Huckleberry Finn* • Karl Huysmans: *A Rebours* • Tolstoy: *The Death of Ivan Ilyich* • Edmond de Goncourt: *Chérie*

1884 • Société des Vingt (Les XX) founded in Brussels • Groupe des Artistes Indépendants founded in Paris. Proposes to mount shows without jury and awards • Manet retrospective at Ecole des Beaux-Arts, with catalog introduction by Zola • Gauguin sends paintings to Oslo, and tries unsuccessfully to represent commercial firms • Seurat's *Bathers at Asnières* rejected at Salon. Participates in founding of Groupe des Artistes Indépendants

1884 • Death of Jules Bastien-Lepage • Adler meets Gigoux • Carrière receives first award, an honorable mention • Meissonier retrospective at Georges Petit's Gallery • Raffaelli publishes *Etude des mouvements de l'art moderne et du beau caractériste*

1885 • World's first successful gasoline-driven motor vehicle attains speed of nine miles per hour in Germany • Death of Victor Hugo • Kropotkin: *Memoirs of a Revolutionist* • Zola: *Germinal* • Guy de Maupassant: *Bel Ami* and *Contes et nouvelles* • Karl Marx: *Das Kapital* (vol. 2 published posthumously)

1886 • Agitation by labor for eight-hour day leads to violent Haymarket Square Riot in Chicago • Statue of Liberty, gift of France to United States, dedicated 28 October • Kropotkin: *La Conquête du pain* • Zola: *L'Oeuvre*

1887 • Germany's Prince Otto von Bismarck predicts European war • Triple Alliance of 1882 renewed for another five years • Italian-Ethiopian War begins • France's President Jules Grévy forced to resign and Sadi Carnot is elected • English photographer E. Muybridge creates portfolio on animal locomotion • Death of industrialist A. Krupp

1888 • With the death of Wilhelm I and his successor Friedrich Wilhelm, Wilhelm II ascends German throne • Nationalist movement precipitated by General Boulanger's agitation for revenge on Germany reaches peak • Société des Droits de l'Homme founded in France • Pasteur Institute founded in Paris • Zola: *La Terre*

1889 • Second International in Paris declares 1 May workers' holiday • Completion of Eiffel Tower, designed by French engineer, marks opening of Universal Exhibition 6 May • New York's first skyscraper completed at 50 Broadway • Moulin Rouge cabaret opens in Montmartre • Bergson: *Time and Free Will* • Huysmans: *Certains* • Kipling: *The Ballad of East and West*

1890 • Bismarck forced to resign as prime minister • London's first electric underground railway opens • Knut Hamsun: *Hunger*

1891 • Germany puts into effect world's first old-age pension plan • General Boulanger commits suicide in Brussels • Huysmans: *Là-bas*

1885 • Duret: *Critique d'avant-garde* • Delacroix retrospective at Ecole des Beaux-Arts • Death of Constantin Guys • Pissarro meets Signac, and is influenced by Guillaumin and Seurat's theories • Monet paints at Giverny, and participates in fourth Exposition Internationale at Georges Petit's Gallery • Gauguin's exhibition in Copenhagen fails • Gauguin quarrels with Degas • Rodin: *The Kiss* • Van Gogh: *The Potato Eaters* • Sérusier enters Académie Julian

1886 • Eighth and last Impressionist Exhibition: seventeen artists • Van Gogh arrives in Paris • Durand-Ruel achieves his first success in America • Georges Petit holds fifth Exposition Internationale, and invites Monet and Renoir • Zola: *L'Oeuvre* • Fénéon: *Les Impressionnistes en 1886*. Becomes correspondent for *L'Art Moderne* (published by Les XX) • Large Whistler exhibition at Georges Petit • Pissarro exhibits first divisionist canvas. Meets van Gogh • Durand-Ruel exhibits Pissarro's work in New York • Cézanne, offended by *L'Oeuvre*, breaks with Zola. Inherits fortune after father's death • Monet refuses to show with Impressionists because of Pissarro's insistence that Signac and Seurat participate, and joins Renoir in exhibits at Georges Petit and with Les XX • Gauguin paints in Brittany and exhibits with Impressionists. Meets van Gogh • Seurat's *Grand Jatte* creates scandal at Impressionist exhibition

1887 • Van Gogh: *Moulin de la Galette* • Gauguin paints in Martinique. Paints *The Vision after the Sermon* in Brittany • Millet retrospective at Ecole des Beaux-Arts • Exhibition of Japanese art at Union Centrale des Arts

1888 • Van Gogh leaves Paris for Arles • Gauguin joined by Bernard at Pont Aven • Gauguin joins van Gogh in Arles • Sérusier: *The Talisman*. Sérusier's first Salon exhibit *The Weaver* receives honorable mention • Founding of Nabis group • Rodin: *The Thinker* • Bing's shop exhibits Japanese art in conjunction with publication of *Artistic Japan*

1889 • Van Gogh, at Arles, paints *Portrait with Bandaged Ear* • Universal Exhibition takes place in Paris • Monet and Rodin retrospectives at Georges Petit

1890 • Death of van Gogh • La Gravure Japonaise exhibition at Ecole des Beaux-Arts • First exhibition of Société Nationale des Beaux Arts (founded as alternative to Salon des Artistes Français)

1891 • Death of Seurat • Gauguin leaves for Tahiti • *Revue Blanche* is founded by Natanson • First exhibition of Les Peintres Impressionnistes et Symbolistes at Le Barc de Boutteville • First Nabis exhibition at Saint-Germain-en-Laye

1885 • Death of Armand Leleux • Joseph Bail receives first award, an honorable mention • Casile's exhibit *View of Paris—L'Estacade* receives third-class medal • Dagnan-Bouveret exhibits *Horses at the Watering Trough*, receives Légion d'honneur, and makes first trip to Brittany • Fouace exhibits *The Stonebreaker's Lunch* • Raffaelli lectures and publishes *Le Laid dans l'Art* • Alexis Vollon's first Salon, wins honorable mention

1886 • Death of Frère

1887 • Death of François Bonvin, Philippe Rousseau • Dagnan-Bouveret elected to Salon jury • Lhermitte exhibits for first time with Société des Aquarellistes Français • Maurin's first Salon des Indépendants • Ribot exhibits at Bernheim Jeune, and is made officer of the Légion d'honneur

1888 • Death of Feyen-Perrin

1889 • Adler's first Salon • Joseph Bail receives silver medal at Universal Exhibition • Bergeret receives medal of honor at Universal Exhibition • Carrière receives first-class medal at Universal Exhibition and is appointed Chevalier of the Légion d'honneur • Henner elected to Institut de France • Meissonier becomes first artist to receive Grand Cross of Légion d'honneur • Raffaelli illustrates *Les Types de Paris*

1890 • Desboutin is one of founding members of Société Nationale des Beaux-Arts • Breton publishes *La Vie d'un artiste—Art et nature* • Lhermitte serves as charter member and juror of Société Nationale des Beaux-Arts • Ribot exhibition at Bernheim Jeune

1891 • Death of Jongkind, Adolphe Leleux, Meissonier, Théodule Ribot • Fouace receives gold medal, highest award • Goeneutte meets Doctor Gachet and paints his portrait. Settles at Auvers-sur-Oise

1892 • Panama Canal scandal rocks France • French anarchist Ravachol arrested and executed • Death of Tennyson, Ernest Renan • Zola: *La Débacle*

1893 • Laos becomes French protectorate as France begins new colonial empire in Indo-China • Anti-Semitism mounts in France as Jews are blamed for collapse of Panama Canal Company • First Ford motorcar road-tested in United States in April • World's Fair in Chicago features many works by Degas, Manet, Monet owned in United States

1894 • Economic depression continues in United States • French Army Captain Alfred Dreyfus, courtmartialed for passing military information to German agents, provokes increased anti-Semitism in France. Viennese journalist Theodore Herzl witnesses the trial and lays foundation for political Zionism • Italian anarchist Santo Caserio assassinates French President Sadi Carnot • Russia's Alexander III dies, succeeded by son Nicholas II

1895 • Sigmund Freud publishes his studies on hysteria in collaboration with Joseph Breuer • Pneumatic tires are used on motorcars for first time by France's André Michelin • First theater showing of motion pictures in Paris • Huysmans: *En route* • Thomas Hardy: *Jude the Obscure* • H. G. Wells: *The Time Machine*

1896 • First underground rail service on European continent begins in Budapest • World's first permanent wireless installation established by Marconi in England

1897 • Matthieu Dreyfus demands new trial for his brother • André Gide: *Fruits of the Earth* • H. G. Wells: *The Invisible Man* • Kipling: *Captains Courageous*

1898 • Italian anarchist Luigi Luccheni stabs Austrian Empress Elisabeth • Captain Dreyfus's unjust imprisonment because of anti-Semitic plot is revealed. French novelist Emile Zola agitates for retrial • Photographs taken with artificial light produced for first time • Death of Mallarmé • H. G. Wells: *The War of the Worlds*

1899 • United Sates proposes "open-door" policy with China • Boer War begins in South Africa

1900 • Boxer uprisings rock foreign interests in China • Italy's Umberto I assassinated, succeeded by son Emmanuel III • Russian revolutionist Vladimir Ilyich Lenin completes three-year exile and immigrates to Switzerland • Freud: *The Interpretation of Dreams* • Paris Metro underground rail service begins operations • Trans-Siberian Railway opens • World's Fair in Paris

1892 • Aurier writes "Les Peintres Symbolistes" in *Revue Encyclopédique* • First Salon de la Rose-Croix at Durand-Ruel • Van Gogh exhibition at Le Barc de Boutteville

1893 • Death of Père Tanguy • Vollard opens gallery • Utamaro and Hiroshige exhibition with catalog preface by Bing • Peintres Néo-Impressionistes exhibition at Galerie Laffitte

1894 • Caillebotte dies, leaving his Impressionist collection to the state. Retrospective at Durand-Ruel

1895 • First Venice Biennale opens • Death of Berthe Morisot • Rodin: *The Burghers of Calais* • Bing holds first Salon of Art Nouveau at 22 rue de Provence

1896 • Morisot retrospective at Durand-Ruel • Constantin Meunier and Eugène Carrière exhibit at Bing's shop

1897 • Part of Caillebotte's bequest exhibited at Luxembourg Museum

1898 • Glasgow's Mackintosh School of Art is founded • Gustave Moreau dies, leaving house and some 8000 paintings and drawings to French nation • Death of Puvis de Chavannes

1899 • Death of Sisley

1900 • Universal Exhibition • Exposition centennale de l'Art français, 1800-1900 • Exposition décennale des Beaux-Arts, 1889-1900

1892 • Adler receives first commission for large painting: *Transfusion of Goat Blood by Dr. Bernheim* • Maurin's first exhibition with the Rose-Croix • Castagnary: *Salons 1857-70*

1893 • Death of Cabat, Germain Ribot • Adler's exhibit *The Street*, his first Salon success, receives honorable mention

1894 • Death of Gautier, Gigoux, and Goeneutte

1895 • Death of Fouace • Adler's exhibit *On the Faubourg Saint-Denis, in the Morning* receives third-class medal • Desboutin receives Légion d'honneur in recognition of total work • Breton writes *Un Peintre paysan* • Lhermitte: *Les Halles*

1897 • Adler exhibits *The Weary*, influenced by Zola's *L'Assommoir* • Antoine Vollon elected to Institut de France

1898 • Death of Boudin • Adler receives second-class medal • Carolus-Duran and Antoine Vollon appointed commanders of Légion d'honneur

1899 • Death of Rosa Bonheur

1900 • Death of Antoine Vollon, Herlin • Adler's exhibit *The Strike at Le Creusot* shows his dedication to the cause of workers • Joseph Bail receives gold medal at Universal Exhibition • Bergeret receives medal of honor at Universal Exhibition • Bonnat and Carolus-Duran are appointed grand officers of Légion d'honneur • Dagnan-Bouveret receives first prize at Universal Exhibition, elected to Institut de France

Selected Bibliography

The following libraries and archives played an essential role in the location of documentary material on many of the artists in the exhibition:

PARIS
Archives de Paris et de l'ancien département de la Seine
Archives Nationales
Bibliothèque de l'Arsenal
Bibliothèque d'Art et d'Archéologie
Bibliothèque des Arts Décoratifs
Bibliothèque Nationale:
 Cabinet des Estampes
 Département des Imprimés
 Département des Périodiques
Bibliothèque de la Ville de Paris
Institut Néerlandais
Musée du Louvre:
 Archives du Louvre
 Bibliothèque du Louvre
 Cabinet des Dessins
 Documentation

PROVINCES
Institut de France, Fonds Lovenjoul, Chantilly
Bibliothèque Municipale, Bayonne
Bibliothèque Municipale, Lyon
Bibliothèque Municipale, Montpellier
Bibliothèque du Musée des Beaux-Arts, Strasbourg

ENGLAND
Library of the British Museum, London
Library of the Victoria and Albert Museum, London
The Witt Library, Courtauld Institute, London

HOLLAND
The Rijksbureau, The Hague

UNITED STATES
The Cleveland Museum of Art Library
Firestone Library, Princeton University
Freiberger Library, Case Western Reserve University, Cleveland
The Frick Art Reference Library, New York City
The Library of Congress, Washington, D.C.
New York Public Library
Peabody Library, Peabody Institute, Baltimore

It is not possible or necessary to cite all of the French newspapers consulted. The following, however, are valuable sources for information on the nineteenth century. They were consulted at the Bibliothèque Nationale, Paris.

Le Constitutionnel, L'Evénement, Le Globe, Le Journal des Débats, La Liberté, La Presse, La Réforme, La République Française, Le Siècle, and *Le Temps.*

A. M. "Charles Cazin." *Le Bulletin de l'art ancien et moderne,* no. 93 (30 March 1901).

About, Edmond. *Voyage à travers l'exposition des beaux-arts (peinture et sculpture).* Paris: Hachette et Cie., 1855.

_____. *Nos artistes au Salon de 1857.* Paris: Hachette et Cie., 1858.

_____. *Salon de 1864.* Paris: Hachette et Cie., 1864.

_____. *Salon de 1866.* Paris: Hachette et Cie., 1867.

_____. "Le Salon de 1869." *Revue des deux mondes,* 1 June 1869.

Adhémar, Jean. "Les Lithographies de paysage en France à l'époque romantique." *Archives de l'art français,* n.s. XIX (1935-37): 189-346.

_____. *Honoré Daumier.* Paris: P. Tisné, 1954.

_____, and Cachin, Françoise. *Degas: The Complete etchings, lithographs, and monotypes.* Translated by Jane Breton. New York: Viking Press, 1974.

Alauzen, André M. *La Peinture en Provence du XVIème siècle à nos jours.* Lausanne: Editions La Savoisienne, 1962.

Alexandre, Arsène. *Honoré Daumier: L'Homme et l'oeuvre.* Paris: H. Laurens, 1888.

_____. *A. F. Cals, ou le bonheur de peindre.* Paris: Georges Petit, 1900.

_____. "Artistes contemporains—Carolus-Duran." *La Revue de l'art ancien et moderne* XIV (1903): 185-200, 289-304.

_____. *31 Peintures par J.-Ch. Cazin,* sale cat. Galerie Georges Petit, Paris, 1908.

_____. *J.-F. Raffaëlli, peintre, graveur et sculpteur.* Paris: H. Floury, 1909.

Allemagne, Henry-René d'. *Le Noble jeu de l'oie en France, de 1640 à 1950: Quarante-huit tableaux et notices, la vie quotidienne à Paris de 1820 à 1824.* Paris: Librairie Gründ, 1950.

Amand-Durand, and Sensier, Alfred. *Th. Rousseau, études et croquis.* Paris: Amand-Durand/Goupil, 1876.

Amic, Henri. *Jules Bastien-Lepage: Lettres et souvenirs.* Paris: Imprimé par l'auteur, 1896.

Amiel, Joseph Henri. "Le Réalisme de la 'sincérité dans l'art,' Courbet, Champfleury, Duranty, Buchon, le journal Réalisme." Ph.D. diss., Urbana, Ill.: University of Illinois, 1939.

_____. "Un Précurseur du réalisme: Max Buchon." *Modern language quarterly* III (September 1942): 379-90.

Anderson, R. D. *Education in France, 1848-1870.* Oxford: Clarendon Press, 1975.

Angrand, Pierre. "L'Etat-mécène, période autoritaire du Second Empire (1851-1860)." *Gazette des beaux-arts* LXXVII (1968): 303-48.

Aragon, Louis. *L'Exemple de Courbet.* Paris: Cercle d'Art, 1952.

Argencourt, Louise d', and Druick, Douglas. *The Other nineteenth century: Paintings and sculpture in the collection of Mr. and Mrs. Joseph M. Tanenbaum,* exh. cat. Ottawa: National Gallery of Canada, 1978.

Ariès, Philippe. *Centuries of childhood: A Social history of family life.* Translated by Robert Baldick. New York: Alfred A. Knopf, 1962.

_____. "The Family and the city." *Daedalus* CVI (1977): 227-35.

Armelhaut, J., and Boucher, E. *L'Oeuvre de Gavarni: Catalogue raisonné.* Paris: Librairie des Bibliophiles, 1873.

Arrouye, Jean. "La Notion du travail créateur dans l'art." In *Travail.* Paris: Bréal. 1978.

_____. "Sémiotique de l'Ex-Voto." Communication au 1er congrès de la Société des Sciences de l'Information et de la Communication, Compiègne, May 1978.

Astruc, Zacharie. *Les 14 Stations du Salon, 1859—Suivies d'un récit douloureux.* Paris: Poulet-Malassis et De Broise, 1859.

_____. *Le Salon, 14 May 1863.* Paris: Cadart, 1863.

_____. *Le Salon: Feuilleton quotidien paraissant tous les soirs pendant les deux mois de l'exposition.* Paris: Cadart, 1863.

Aubert, Maurice. *Souvenirs du Salon de 1859.* Paris: J. Tardieu, 1859.

Audiganne, Armand. *Les Populations ouvrières et les industries de la France dans le mouvement social du XIXe siècle.* 2 vols. Paris: Capelle, 1854.

Austin, Lloyd James. "Mallarmé and the visual arts." In *French 19th century painting and literature.* Edited by Ulrich Fincke. Manchester: Manchester University Press, 1972.

Auvray, Louis. *Exposition des beaux-arts: Salon de 1857.* Paris: Bureau de l'Europe artiste, 1857.

_____. *Exposition des beaux-arts: Salon de 1859.* Paris: A. Taride, 1859.

_____. *Exposition des beaux-arts: Salon de 1861.* Paris: Bureaux de la "Revue artistique," 1861.

_____. *Exposition des beaux-arts: Salon de 1863.* Paris: A. Lévy, 1863.

_____. *Exposition des beaux-arts: Salon de 1864.* Paris: A. Lévy, 1864.

Avenel, Henri. *Histoire de la presse française, depuis 1789 jusqu'à nos jours, rapport au Ministère du Commerce (Exposition universelle de 1900).* Paris: E. Flammarion, 1900.

Bacon, Henry. "Edouard Frère." *Art journal* VI (November 1886): 321-24.

Bacou, Roseline. *Millet dessins.* Paris: Bibliothèque des Arts, 1975.

Baignères, A. "Journal du Salon de 1866." *Revue contemporaine* (1866): 353.

Bailly-Herzberg, Janine. *L'Eau-forte de peintre au dix-neuvième siècle: La Société des aquafortistes 1862-1867.* Paris: Léonce Laget, 1972.

_____. "Marcellin Desboutin and his world." *Apollo* XCV, no. 124 (June 1972): 496-500.

Balch, Emily Greene. *Public assistance of the poor in France.* Nashville, Tenn.: American Economic Association, 1893.

Balzac, Honoré de. *Les Paysans*. Paris: J. H. Donnard, 1964.

Bantens, Robert James. "Eugène Carrière: His work and his influence." Ph.D. diss., University of Michigan, 1976.

Barbedette, L. *Le Peintre Jules Adler*. Besançon: Editions Séquania, 1938.

Barron, Louis. *Paris pittoresque 1800-1900: La Vie—les moeurs—les plaisirs*. Paris: Société Française d'Editions d'Art, 1900.

Baudelaire, Charles. "Le Vin des chiffonniers." In *Les Fleurs du mal et poésies diverses*. Paris: Bibliothèque Larousse, 1927.

————. *Oeuvres complètes*. Edited and annotated by Y. G. Le Dantec; rev. ed. edited by C. Pinchois. Paris: Bibliothèque de La Pléiade, 1961.

————. *Art in Paris 1845-1862: Reviews of Salons and other exhibitions*. Translated and edited by J. Mayne. London: Phaidon, 1965.

Bauduin, Annie. "Recherches sur la vie et l'oeuvre du peintre français Adolphe Hervier (1819-1879) avec le catalogue des oeuvres peintes et dessinées." Mémoire de maîtrise [thesis], Université de Lille, 1972.

Beaud, Marie-Claude. *Fantin-Latour: Une Famille de peintres au XIXe siècle*, exh. cat. Grenoble: Musée de Grenoble, 1977.

Becq de Fouquières, L. *Catalogue de tableaux, études, esquisses, aquarelles, dessins par I. Pils*. Paris: Hôtel Drouot (March), 1876.

————. *Exposition des oeuvres de Pils à l'Ecole des beaux-arts*. Paris: Typographie Lahure, 1876.

————. *Isidore Alexandre Auguste Pils: Sa vie et ses oeuvres*. Paris: Charpentier et Cie., 1876.

Begemann, E. Haverkamp, and Logan, Anne-Marie. *European drawings and watercolors in the Yale University art gallery*. New Haven: Yale University Press, 1970.

Bellessort, André. *La Société française sous Napoléon III*. Paris: Perrin, 1932.

Belloy, Marquis de. "Le Salon de 1859." *L'Artiste*, 24 April 1859, pp. 5-6; 1 May 1859, p. 59.

Bénédite, Léonce. *Le Musée National du Luxembourg: Catalogue raisonné et illustré des peintures, sculptures, dessins, gravures en médailles et sur pierres fines et objets d'art divers des écoles contemporaines*. Paris: Librairies-Imprimeries Réunies, 1896.

————. *L'Art au XIXe siècle, 1800-1900*. Paris: Librairie Centrale des Beaux-Arts, 1900.

————. "A. Legros." *Revue de l'art ancien et moderne* VII (1900): 335-58.

————. "Jean Charles Cazin." *Revue de l'art ancien et moderne* X (1901): 1-32,73-104.

————. "Un tableau de Fantin-Latour." *Revue de l'art ancien et moderne* XII (1902): 95-101.

————. "A. Legros, painter and sculptor." *Studio* XXIX (June 1903): 3-22.

————. *The Drawings of Jean-François Millet*. London: William Heinemann, 1906.

————. "Artistes contemporains: J. J. Henner." *Gazette des beaux-arts*, 3d ser. XXXVIII (1907): 315-32.

————. "Madame Marie Gautier." *Art et décoration* XXIII (1908): 137-44.

————. *Albert Lebourg*. Paris: Editions Galeries Georges Petit, 1923.

————. "Jean-Charles Cazin." *Les Artistes de tous les temps*. Sér. D: Le XXe siècle. Paris, n.p.

Béraldi, Henri. *Les Graveurs du XIXe siècle*. 12 vols. Paris: Conquet, 1885-92.

Berger, Klaus. *Géricault et son oeuvre*. Paris: Flammarion, 1968.

Bermingham, Peter. *American art in the Barbizon mood*, exh. cat. Washington, D.C.: Smithsonian Institution, National Collection of Fine Arts, 1975.

Bertault, Philippe. *Balzac and the human comedy*. Translated by Richard Monge. New York: New York University Press, 1963.

Bertin, Louise. *Glanes*. Paris: A. René et Cie., 1842.

Bird, Elizabeth. "International Glasgow." *Connoisseur* CLXXXIII (August 1973): 248-57.

Bixiou [Champfleury]. "Salon de 1849." *La Silhouette*, 22 July 1849.

Blanc, Charles. *Histoire des peintres français au XIXe siècle*. Paris: Cauville Frère, 1845.

————. "De la gravure à l'eau-forte et des eaux-fortes de Jacque." *Gazette des beaux-arts*, 1st ser. IX (1861): 193-208.

Blanche, J. E. *Portraits of a lifetime; the late Victorian era, the Edwardian pageant, 1870-1914*. Translated and edited by Walter Clement. New York: Coward-McCann, 1938.

Bloch, Marc. *French rural history: An Essay on its basic characteristics*. Berkeley and Los Angeles: University of California Press, 1966.

Blum, Jerome, *The End of the old order in rural Europe*. Princeton: Princeton University Press, 1978.

Boggs, Jean Sutherland. *Drawings by Degas*, exh. cat. St. Louis: City Art Museum, 1967.

Boime, Albert. *The Academy and French painting in the nineteenth century*. London and New York: Phaidon, 1971.

————. *Thomas Couture: Drawings and some oil sketches*, exh. cat. New York: Shepherd Gallery, 1971.

————. *Strictly academic: Life drawing in the nineteenth century*, exh. cat. Binghamton: State University of New York, 1974.

————. "Entrepreneurial patronage in nineteenth-century France." In *Enterprise and entrepreneurs in nineteenth and twentieth century France*. Baltimore and London: Johns Hopkins University Press, 1976.

————. "The Teaching reforms of 1863 and the origins of modernism in France." *Art quarterly* I (1977): 1-39.

————. "Thomas Couture's drummer boy beating a path to glory." *Bulletin of The Detroit Institute of Arts* LVI, no. 2 (1978), 108-31.

Bonnat, Léon. "Velasquez." *Gazette des beaux-arts*, 3d ser. XIX (1898): 177-82.

Bonnemère, Eugène. *Histoire des paysans, depuis la fin du Moyen-Age jusqu'à nos jours, 1200-1850*. Paris: F. Chamerot, 1856.

Boon, H. N. *Rêve et réalité dans l'oeuvre économique et sociale de Napoléon III*. La Haye: M. Nijhoff, 1936.

Bouchardon, Edmé. *Etudes prises dans le bas peuple; ou, les cris de Paris*. 5 vols. Paris: Foullain, 1737-46.

Bouchot, Henri. *Les Livres à vignettes du XIXe siècle*. Paris: Bibliothèque des Connaissances Utiles aux Amis des Livres, 1891.

————. *La Lithographie*. Paris: Librairies Imprimeries Réunies, 1895.

Bouguereau, W. "Notice sur M. Pils." In *Institut de France, Académie des beaux-arts, 27 January 1877*. Paris: Firmin-Didot, 1877.

Bouillon, Jean Paul. "La Correspondance de Félix Bracquemond: Une Source inédite pour l'histoire de l'art français dans la seconde moitié du XIXe siècle." *Gazette des beaux-arts*, 6th ser. LXXXII (1973): 351-86.

————. "Manet vu par Bracquemond." *Revue de l'art* XXVII (1975): 37-45.

————. "Félix Bracquemond, les années d'apprentissage." *Nouvelles de l'estampe*, no. 48 (December 1979): 12-17.

Bouret, Jean. *L'Ecole de Barbizon, et le paysage français au XIXe siècle*. Neuchâtel: Editions Ides et Calendes, 1972.

Bouvier, Emile. *La Bataille réaliste 1844-1857*. Paris: Fontméry and Cie., 1913.

Bownell, W. C. *French art, classic and contemporary painting and sculpture*. New York: n.p., 1901.

Bready, J. Wesley. *Lord Shaftesbury and social-industrial progress*. London: Allen & Unwin, 1926.

Bredius, Abraham. *Rembrandt: The Complete edition of the paintings*. London and New York: Phaidon, 1969.

Breton, Boniface. *Le Village: Histoire morale, politique et pittoresque de Courrières*. Arras: J. Degeorge, 1837.

Breton, Jules. *La Vie d'un artiste: Art et nature*. Paris: Lemerre, 1890.

————. *Un Peintre paysan: Souvenirs et impressions*. Paris: Lemerre, 1896.

————. *Nos peintres du siècle*. Paris: Société d'Edition Artistique, 1899.

Brière, G. *Ecole française: Catalogue des peintures exposées dans les galeries*. 3 vols. Paris: Musées Nationaux, 1922-26.

Briffault, Eugène. *Paris à table, Paris marié, Paris dans l'eau*. Paris: J. Hetzel, 1846.

Brion, Marcel. *Art of the romantic era: Romanticism, classicism, realism*. London and New York: Praeger, 1966.

Brochon, Pierre. *Le Livre de colportage en France depuis le XVIe siècle*. Paris: Grün, 1954.

————. *La Chanson française: Le Pamphlet du pauvre 1834-1851, du socialisme utopique à la révolution de 1848*. Paris: Editions Sociales, 1957.

Brookner, Anita. *The Genius of the future—Studies in French art criticism: Diderot, Stendhal, Baudelaire, Zola, the Brothers Goncourt, Huysmans*. London: Phaidon, 1971.

Bruyas, Alfred. *Explication des oeuvres de peinture du cabinet Alfred Bruyas*. Montpellier: n.p., 1854.

Buchon, Max. *Le Réalisme: Discussions esthétiques, recueillies et commentées*. Neuchâtel: J. Attinger, 1856.

————. *Poésies fran-comtoises: Tableaux domestiques et champêtres*. Salins: Duvernois et Billet, 1862.

————. *Oeuvres choisies: Notice biographique par Champfleury, portrait d'après Courbet, eaux-fortes par F. Régamey*. Paris: Sandoz et Fischbacher, 1878.

Buisson, J. "Le Salon de 1881." *Gazette des beaux-arts*. 2d ser. XXIV (1881): 29-81.

Buret, Eugène. *De la misère des classes laborieuses en Angleterre et en France: De la nature de la misère, de son existence, de ses effets, de ses causes, et de l'insuffisance des remèdes qu'on lui a opposés jusqu'ici, avec les moyens propres à en affranchir les sociétés*. 2 vols. Paris: Paulin, 1840.

Burty, Philippe. "Nouvelles du jour: Mort de Troyon." *La Presse*, 22 March 1865.

————. "Nouvelles du jour: Funérailles de Troyon." *La Presse*, 23 March 1865.

————. "Le Salon de 1874." *La République française*, 28 May 1874.

_____. "Le Salon de 1876." *La République française*, 17 May 1876.
_____. *Maîtres et petits maîtres*. Paris: Charpentier, 1877.

Cabanis, Pierre. *Rapports du physique et du moral de l'homme*. Paris: Crapart, Caille et Ravier, 1802.
Callias, H. de. "Salon de 1861." *L'Artiste*, 15 May 1861, p. 223.
Camp, Maxime du. *Les Beaux-arts à l'Exposition Universelle de 1855, peinture—sculpture*. Paris: Librairie Nouvelle, 1855.
_____. *Le Salon de 1857*. Paris: Librairie Nouvelle, 1857.
_____. *Le Salon de 1859*. Paris: Librairie Nouvelle, 1859.
_____. *Le Salon de 1861*. Paris: Librairie Nouvelle, 1861.
_____. *Les Beaux-Arts à l'Exposition Universelle et aux Salons de 1863, 1864, 1865, 1866, et 1867*. Paris: Jules Renouard, 1867.
_____. *Paris, ses organes, ses fonctions et sa vie*. Paris: Librairie Hachette et Cie., 1874.
_____. *Paris bienfaisant*. Paris: Librairie Hachette, 1888.
Cantrel, E. "Voyage en zig-zag à travers l'exposition." *L'Artiste*, 26 June 1859, p. 132.
Cartier, Karl. "Silhouettes d'artistes: Julien Dupré, peintre." *Le Journal des arts*, 9 May 1903.
Cartwright, Julia. "Jules Bastien-Lepage." *Portfolio* (1894): 22-23.
_____. *Jules Bastien-Lepage*. London: Seeley & Co., 1894.
_____. *Jean-François Millet: His life and letters*. London: S. Sonnenschein, 1896.
Cassagne, Armand. *La Théorie de l'art pour l'art en France chez les derniers romantiques et les premiers réalistes*. Paris: Dorbon, 1959.
Cassou, Jean. *Le Quarante-huitard*. Paris: Presses Universitaires de France, 1948.
Castagnary, Jules-Antoine. *Philosophie du Salon de 1857*. Paris: Poulet-Malassis et de Broise, 1858.
_____. *Les Artistes au XIXe siècle: Salon de 1861, gravures par H. Linton*. Paris: Librairie Nouvelle, 1861.
_____. *Salons (1857-1870)*. 2 vols. Paris: Bibliothèque Charpentier, 1892.
Catalogue de la Galerie Bruyas. Montpellier: Jean Martel Aîné, 1868.
Catalogue des oeuvres de M. Dagnan-Bouveret (peintures). Paris: Maurice Rousseau, 1930.
Catalogue E. Boulard, 1863-1943, exh. cat. L'Isle-Adam: Musée Louis-Senlecq, 1979.
Cate, Phillip Dennis. *Charles Maurin 1856-1914,* exh. cat. New York: Lucien Goldschmidt Gallery, 1978.
Caw, Sir James L. *Sir James Guthrie, P.R.S.A., LL.D., a biography*. London, 1932.
Chaldecott, J. A. "The Zograscope or optical diagonal machine." *Annals of science* IX (December 1953): 315-22.
Challamel, Augustin. *Les Amuseurs de la rue*. Paris: Librairie Ducrocq, 1875.
Chamboredon, Jean-Claude. "Peinture des rapports sociaux et invention de l'éternel paysan: Les Deux manières de Jean François Millet." *Actes de la recherche en sciences sociales*, nos. 17-18 (November 1977): 8-28.
Champa, Kermit. *Studies in early Impressionism*. New Haven: Yale University Press, 1973.
Champfleury [Jules Fleury]. *Essai sur la vie et l'oeuvre des Lenain peintres laonnois*. Laon: E. Fleury et A. Chevergny, 1850.

_____. "Du Réalisme: Lettre à Madame Sand." *L'Artiste*, 5th ser. XVI, no. 1 (2 September 1855): 1-5.
_____. *Le Réalisme*. Paris: Michel Lévy Frères, 1857.
_____. *Les Amis de la nature*. Paris: Poulet-Malassis, 1859.
_____. *Souvenirs des funambules*. Paris: Michel Lévy Frères, 1859.
_____. *Chien-Caillou*. New edition. Paris: Michel Lévy Frères, 1860.
_____. *Grandes figures d'hier et d'aujourd'hui: Balzac, Gérard de Nerval, Wagner, Courbet*. Paris: Poulet-Malassis et de Broise, 1861.
_____. *Histoire de l'imagerie populaire*. Paris: E. Dentu, 1869.
_____. *Souvenirs et portraits de jeunesse*. Paris: E. Dentu, 1872.
_____. *Les Enfants*. Paris: J. Rothschild, 1873.
_____. *Les Aventures de Mademoiselle Mariette*. Paris: E. Dentu, 1879.
_____. *Les Vignettes romantiques: Histoire de la littérature et de l'art, 1825-40*. Paris: E. Dentu, 1883.
_____. *Oeuvres posthumes: Salons 1846-51*. Paris: A. Lemerre, 1894.
_____. *Le Réalisme: Textes choisis et présentés par Geneviève et Jean Lacambre*. Paris: Collection Savoir-Hermann, 1973.
Champier, Victor. "Nécrologie-Antigna," *L'Année artistique 1878*. Paris: A. Quantin, 1879, p. 475.
Chardon, Lucien de. *Damvillers et son canton, vingt siècles d'histoire*. Verdun-sur-Meuse: Cogerex, 1973.
Chassé, Charles. *Les Nabis et leur temps*. Paris: La Bibliothèque des Arts, 1960.
Chaumelin, Marius. *L'Art contemporain*. Paris: Librairie Renouard, 1873.
_____. *Portraits d'artistes: E. Meissonier, J. Breton*. Paris: n.p., 1887.
Chesneau, Ernest. *Le Salon de 1859*. Paris: n.p., 1859.
Chesney, Kellow. *The Victorian underworld*. London: Pelican Books, 1970.
Chevalier, Louis. *Les Paysans, étude d'histoire et d'économie rurales*. Paris: Société des Editions Denoël, 1947.
_____. *La Formation de la population parisienne au XIXe siècle*. Paris: Presses Universitaires de France, 1950.
_____. *Classes laborieuses et classes dangereuses à Paris pendant la première moitié du XIXe siècle*. Paris: Librairie Plon, 1958.
_____. *Laboring classes and dangerous classes in Paris during the first half of the nineteenth century*. Translated by Frank Jellinek. New York: H. Fertig, 1973.
Chevallier, E. *De l'assistance dans les campagnes: Indigence, prévoyance, assistance*. Paris: A. Rousseau, 1899.
Chevassus. *Max Buchon: Sa vie, son oeuvre*. Paris: n.p., 1884.
Chiego, William J. "Two Paintings by Fantin-Latour." *Museum News* (Toledo Museum of Art) XVII (1974): 27-39.
Chu, Petra T.D. *French realism and the Dutch masters: The Influence of Dutch seventeenth-century painting on the development of French painting between 1830 and 1870*. Utrecht: Haentjens, Dekker and Gumbert, 1974.
_____, ed. *Courbet in Perspective*. Englewood Cliffs, N.J.: Prentice-Hall, 1977.
Claretie, Jules. *Peintres et sculpteurs contemporains*. Paris: Charpentier, 1873.

_____. "Chronique: Un Peintre indépendant, M. Raffaëlli." *Le Temps*, 21 July 1880.
_____. *Peintres et sculpteurs contemporains*. 2 vols. Paris: Librairie des Bibliophiles, 1882-84.
_____. "Carolus-Duran." In *Peintres et sculpteurs contemporains*. 2 vols. Paris: Librairie des Bibliophiles, 1884.
Clark, T.J., "A Bourgeois dance of death: Max Buchon on Courbet." *Burlington magazine* CXI (1969): 208-12, 286-90.
_____. *The Absolute bourgeois: Artists and politics in France, 1848-1851*. London: Thames and Hudson, 1973.
_____. *Image of the people: Gustave Courbet and the Second French Republic, 1848-1851*. Greenwich, Conn.: New York Graphic Society, 1973.
Clifford, Jane. "French Drawings." *Arts review*, XXVII (7 March 1975): 121.
Cloche, M. "Un Grand éditeur du XIXe siècle, Léon Curmer." *Arts et métiers graphiques* XXXIII (1933): 28-36.
Cluit, F.E. "The Art of Jules Breton." *Brush and pencil* XVIII (1906): 106-10.
Colin, Gustave. "C. Corot." *L'Evénement*, 23 March 1875, pp. 1-2.
Colin, Paul. *Edouard Manet*. Paris: Librairie Floury, 1932.
Collins, Irene. *The Government and the newspaper press in France, 1814-1881*. Oxford: Oxford University Press, 1959.
Colombier, Pierre du. *Decamps*. Paris: Les Editions Rieder, 1928.
Colvin, Sidney. "English painters, George H. Boughton." *Portfolio* (1871): 67-70.
Considérant, Nestor. *Du travail des enfants dans les manufactures et dans les ateliers de la petite industrie*. Brussels: A. Lacroix, 1863.
Considérant, Victor Prosper. *Destinée sociale*. 2 vols. Paris: Phalangé, 1838.
_____. *Le Socialisme devant le vieux monde, ou le vivant devant les morts*. Paris: Librairie Phalanstérienne, 1838.
_____. *Principes du socialisme; manifeste de la démocratie au XIXe siècle: Suivi du procès de la démocratie pacifique*. Paris: Librairie Phalanstérienne, 1847.
Conway, W. D. "Edouard Frère, and sympathetic art in France." *Harper's new monthly magazine* XLIII (November 1871): 801-14.
Coppier, André-Charles. "Regards sur l'oeuvre de Dagnan." In *Catalogue des oeuvres de M. Dagnan-Bouveret (peintures)*. Paris: Maurice Rousseau, 1930.
Courbet, Gustave. *Exhibition et vente de 38 tableaux et 4 dessins de l'oeuvre de M. Gustave Courbet, catalogue rédigé par l'artiste et précédé de: Le Réalisme*. Paris: Morris, 1855.
Courbet and the naturalistic movement; Essays read at The Baltimore Museum of Art, 16, 17, 18 May 1938. Edited by George Boas. Baltimore: Johns Hopkins University Press, 1938.
Courthion, Pierre. *Courbet raconté par lui-même et par ses amis*. Genève: Pierre Cailler, 1950.
Crépin-Leblond, Marcellin. "Sur Marcellin Desboutin." *Bulletin-revue de la Société d'émulation et des beaux-arts du Bourbonnais* (1902): 120-36.
Crespelle, J. P. *Les Maîtres de la belle époque*. Paris: Hachette, 1966.
Crouzet, Marcel. *Un Méconnu du réalisme: Duranty (1833-1880): L'Homme, le critique, le romancier*. Paris: Librairie Nizet, 1964.

Cunningham, Charles C. *Jongkind and the pre-Impressionists: Painters of the Ecole Saint-Simeon,* exh. cat. Williamstown, Mass.: Sterling and Francine Clark Art Institute and Smith College Museum, 1977.

Dampt, J. "P. A. J. Dagnan-Bouveret, 1852-1929." In *Catalogue des oeuvres de M. Dagnan-Bouveret (peintures).* Paris: Maurice Rousseau, 1930.

Dansette, Adrien. *Louis-Napoléon à la conquête du pouvoir.* Paris: Hachette, 1961.

Darmon, Jean-Jacques. *Le Colportage de librairie en France sous le Second Empire.* Paris: Plon, 1972.

Daulte, François. *L'Aquarelle française au XIXe siècle.* Paris: Bibliothèque des Arts, 1969.

_____. *Auguste Renoir: Catalogue raisonné de l'oeuvre peint.* Lausanne: Editions Durand-Ruel, 1971.

Daumard, Adeline. *La Bourgeoisie parisienne de 1815 à 1848.* Paris: S.E.V.P.E.N., 1963.

David, H. *Le Musée de Dijon et le romantisme.* Dijon: n.p., 1930.

David-Sauvageot, A. *Le Réalisme et le naturalisme dans la littérature et dans l'art.* Paris: Calmann Lévy, 1889.

Davies, Martin. *French school: Early 19th century Impressionists, Post-Impressionists.* Revised edition. London: National Gallery, 1970.

Day, Barclay. "The Atelier-Bonnat." *Magazine of art* V (1882): 138-40.

Decamps, Louis. "Exposition d'oeuvres d'art exécutées en noir et blanc." *L'Art* (1876): 199, 202.

Degrully, Paul. *Le Droit de glanage, grapillage, ratelage, chaumage, et sarclage patrimoine des pauvres.* Paris: V. Giard et E. Brière, 1912.

Delécluze, Etienne-Jean. *Exposition des artistes vivants, 1850.* Paris: Comon, 1851.

Delord, Taxile. *Histoire du Second Empire (1848-1869).* 6 vols. Paris: G. Baillère, 1869-75.

Delort, Joseph. *Mes voyages aux environs de Paris.* Paris: Picard-Dubois, 1821.

Delouche, Denise. *Peintres de la Bretagne: Découverte d'une province.* Paris: Librairie C. Klincksieck, 1977.

Delvau, Alfred. *Histoire anecdotique des cafés et cabarets de Paris: Avec dessins et eaux-fortes de Gustave Courbet, Léopold Flameng et Félicien Rops.* Paris: E. Dentu, 1862.

Delzons, Louis. *La Famille française et son évolution.* Paris: A. Colin, 1913.

Denis, Maurice. *Paul Sérusier: ABC de la peinture.* Paris: Librairie Floury, 1942.

Dergny, Dieudonné. *Usages, coutumes et croyances ou livre des choses curieuses; costumes locaux de France.* 2 vols. Abbeville: E. Winckler-Hiver, 1885-88.

Desjardins, Paul. "En mémoire de Jean-Charles Cazin." *Gazette des beaux-arts,* 3d ser. XXVI (1901): 176-91.

_____. "Artistes contemporains: Eugène Carrière." *Gazette des beaux-arts,* 3d ser. XXXVIII (1907): 13-26.

Les Dessins de la collection Léon Bonnat au Musée de Bayonne, exh. cat. Paris: n.p., 1925.

Droz, Edmond. *P.-J. Proudhon (1809-1865).* Paris: n.p., 1909.

Duchartre, Pierre Louis, and Saulnier, René. *L'Imagerie populaire: Les Images de toutes les provinces françaises du XVe siècle au Second Empire, les complaintes, contes, chansons, légendes qui ont inspiré les imagiers.* Paris: Librairie de France, 1925.

Duchemin, Jacques. *Pardons bretons du temps passé.* Brussels: S.P.R.L. Sadim, 1978.

Ducourau, Vincent, and Sérullaz, Maurice. *Dessins français du XIXe siècle du Musée Bonnat à Bayonne,* exh. cat. Paris: Musée du Louvre, Cabinet des Dessins, 1979.

Ducpétiaux, Edouard. *De la condition physique et morale des jeunes ouvriers et des moyens de l'améliorer.* 2 vols. Brussels: Méline, Cans et Cie., 1843.

Dumas, Alexandre (Père). *L'Art et les artistes contemporains au Salon de 1859.* Paris: Librairie Nouvelle, 1859.

Dumesnil, Henri. *Aimé Millet: Souvenirs intimes.* Paris: A. Lemerre, 1891.

Dumesnil, René. *Le Réalisme.* Paris: J. de Gigord, 1936.

_____. *L'Epoque réaliste et naturaliste.* Paris: Editions Jules Tallandier, 1945.

_____. *Le Réalisme et le naturalisme.* Paris: Del Duca et de Gigord, 1955.

Du Pays, A. J. "Le Salon de 1852." *L'Illustration,* 22 May 1852, p. 346.

_____. "Exposition Universelle des Beaux-Arts: Réalisme." *L'Illustration,* 28 July 1855, p. 74.

Dupont, Paul. *Histoire de l'imprimerie.* 2 vols. Paris: P. Dupont, 1854.

Dupont, Pierre. *Le Chant des ouvriers.* Paris: L'Auteur, 1848.

_____. *Le Chant du pain.* Paris: L'Auteur, 1849.

_____. *Chants et chansons, poésie et musique.* 4 vols. Paris: Houssiaux, 1852-59.

Durand-Greville, E. "La Peinture aux Etats-Unis." *Gazette des beaux-arts,* 2d ser. XXXVI (July 1887): 65-75.

Duranty, Edmond. "Réalisme." *Réalisme,* 15 November 1856, p. 1.

_____. "Réflexions d'un bourgeois sur le Salon de peinture." *Gazette des beaux-arts,* 2d ser. XV (1877): 546-81.

_____. *La Nouvelle peinture.* New edition. Paris: M. Guérin, 1946.

Duret, Théodore. *Histoire d'Edouard Manet et de son oeuvre.* Paris: H. Floury, 1902.

Duval, Georges. "Bastien-Lepage intime." *L'Evénement,* 13 December 1884.

Duveau, Georges. *La Vie ouvrière en France sous le Second Empire.* Paris: Gallimard, 1946.

Egbert, Donald Drew. *Social radicalism and the arts: Western Europe.* New York: Alfred A. Knopf, 1970.

Engels, Friedrich. *The Condition of the working class in England.* Moscow: Progress Publishers, 1973.

Escholier, Raymond. *Daumier: Peintre et lithographe.* Paris: H. Floury, 1923.

Escudier, Gaston. *Les Saltimbanques leur vie, leurs moeurs.* Paris: Michel Lévy Frères, 1875.

Estignard, A. *Jean Gigoux: Sa vie, ses oeuvres, ses collections.* Besançon: Delagrange-Louys, 1895.

Eudel, Paul. *L'Hôtel Drouot et la curiosité.* 9 vols. Paris: Charpentier, 1882-91.

Evrard, Michelle, and Le Nouëne, Patrick. *La Représentation du travail: Mines, forges, usines,* exh. cat. Le Creusot: Ecomusée, 1978.

Exposition des oeuvres de Jules Bastien-Lepage, exh. cat. Paris: Ecole nationale des beaux-arts, Hôtel de Chimay, 1885.

Fantin-Latour, Mme. [Victoria Dubourg]. *Catalogue de l'oeuvre complet de Fantin-Latour.* Paris: H. Floury, 1911.

Faré, Michel. *La Nature morte en France: Son histoire et son évolution du XVIIe au XXe siècle.* Genève: P. Cailler, 1962-63.

Feldman, William Steven. "The Life and work of Jules Bastien-Lepage, 1848-1884." Ph.D. diss., New York University, 1973.

Fernier, Robert. *La Vie et l'oeuvre de Gustave Courbet.* 2 vols. Lausanne and Paris: Bibliothèque des Arts, Fondation Wildenstein, 1977-78.

Fidell-Beaufort, Madeleine. " 'Fire in a Haystack' by Jules Breton." *Bulletin of The Detroit Institute of Arts* LVII, no. 2 (1979): 54-63.

Fields, Barbara Schinman. "Jean-François Raffaelli (1850-1924): The Naturalist artist." Ph.D. diss., Columbia University, 1978.

Flaubert, Gustave. *Madame Bovary.* Translated by Francis Steegmuller. New York: Random House, 1957.

Fleischmann, Benno. *Honoré Daumier: Gemälde und Graphik.* Wien: O. Lorenz, 1938.

Flescher, Sharon. *Zacharie Astruc: Critic, artist and japoniste.* New York: Garland Publishing, 1978.

Fleuret, Fernand. *Les Colporteurs de la bibliothèque bleue.* Paris: n.p., 1928.

Focillon, Henri. *La Peinture aux XIXe et XXe siècles: Du Réalisme à nos jours.* Paris: Librairie Renouard, 1928.

Forster-Hahn, Françoise. "Authenticity into ambivalence: The Evolution of Menzel's drawings." *Master Drawings* XVI (1978): 255-83.

Fouquier, Achille. *L. Bonnat, première partie de sa vie et de ses oeuvres.* N.p., 1879.

Fourcaud, Louis de. "Le Salon de 1884." *Gazette des beaux-arts,* 2d ser. XXIX (1884): 50-63, 105-21, 464-92.

_____. "Artistes contemporains, Jules Bastien-Lepage." *Gazette des beaux-arts,* 2d ser. XXXI (1885): 105-20.

_____. "Exposition des oeuvres de Bastien-Lepage à l'Hôtel de Chimay." *Gazette des beaux-arts,* 2d ser. XXXI (1885): 250-67.

_____. *Théodule Ribot: Sa vie et ses oeuvres.* Paris: L. Baschet, 1885.

Fournel, Victor. *Ce qu'on voit dans les rues de Paris.* Paris: A. Delahays, 1858.

_____. *Tableau du vieux Paris: Les Spectacles populaires et les artistes des rues.* Paris: E. Dentu, 1863.

_____. *Paris nouveau et Paris futur.* Paris: J. Lecoffre, 1865.

_____. *Les Rues du vieux Paris: Galerie populaire et pittoresque.* Paris: Firmin-Didot et Cie., 1879.

_____. *Les Cris de Paris.* Paris: Firmin-Didot et Cie., 1889.

Fournier, Edouard. *Histoire du Pont Neuf.* 2 vols. Paris: E. Dentu, 1862.

Fraipont, G. *L'Art de prendre un croquis et de l'utiliser.* Paris: H. Laurens, 1899.

Les Français peints par eux-mêmes. Paris: L. Curmer, 1840.

Frantz, Henri. "A Great French landscape painter: Jean Charles Cazin." *Studio* LIV (1911): 3-17.

Frégier, H. A. *Des Classes dangereuses de la population dans les grandes villes, et des moyens de les rendre meilleures.* 2 vols. Paris: J.-B. Baillère, 1840.

Frémine, Charles. "Feyen-Perrin à l'Ecole des beaux-arts." *Le Rappel,* 10 March 1889.

_____. *Promenades et rencontres.* Paris: Librairie Générale, 1905.

Fusco, Peter, and Janson, H. W. *The Romantics to Rodin. French nineteenth-century sculpture from North American collections,* exh. cat. Los Angeles: Los Angeles County Museum of Art in Association with George Braziller, 1980.

Fyot, E. "Le Portrait du père de A. Legros." *La Revue de Bourgogne* (1922): 132-35.

Gabriel-Ferrier, M. *Notice sur la vie et les travaux de M. Jules Breton.* Read at the meeting of the Academy des Beaux-Arts, 12 December 1900. Paris: n.p., 1910.

Gachet, Paul. *Lettres du peintre Amand Gautier à son ami le Dr. P. F. Gachet.* Auvers: n.p., 1940.

Gaudillot, J. M. "Un Aspect peu connu de Millet." *Art de Basse-Normandie* V (1957): 33-35.

Gautier, Théophile. "Salon de 1844." *La Presse,* March 1844.

———. *Les Beaux-arts en Europe, 1855.* 2 vols. Paris: Lévy Frères, 1856.

Geddes, Patrick. *Every man his own art critic,* exh. cat. Edinburgh: W. Brown, 1888.

Geffroy, Gustave. "Exposition des artistes indépendants." *La Justice,* 19 April 1881.

———. *Daumier.* Paris: Librairie de L'Art Ancien et Moderne, 1901.

———. *L'Oeuvre de E. Carrière.* Paris: Edition d'Art, 1902.

———. *La Vie artistique.* Paris: E. Dentu, 1892-1903.

———. "Jean-François Raffaëlli, 1850-1924." *Gazette des beaux-arts,* 5th ser. X (1924): 167-96.

Geiger, Monique. "Alphonse Legros, l'Ex-Voto: Etude radiographique." *Annales du Laboratoire de recherches des musées de France* (1971): 19-23.

Gensel, Walter. *Corot und Troyon.* Bielefeld and Leipzig: Velhagen und Klasing, 1906.

Geoffroy, Louis de. *Le Salon de 1850.* Paris: n.p., 1850.

———. "Le Salon de 1850." *La Revue des deux mondes* XII (1851): 938.

Gibson, Frank. *The Art of Fantin-Latour: His life and work.* London: Drane's, 1924.

Gigoux, Jean. *Causeries sur les artistes de mon temps.* Paris: M. Lévy, 1885.

Gillet, Louis. *Les Trésors des musées de province.* Paris: Firmin-Didot, 1934.

Giram, M. *Examen critique des principaux ouvrages en peinture et sculpture de l'exposition de 1852.* Paris: Chaumerot, 1852.

Gogh, Vincent van. *The Complete letters.* Greenwich, Conn.: New York Graphic Society, 1959.

Goldman, B. "Realist iconography: Intent and criticism." *Journal of aesthetics and art criticism* XVIII (1959): 183-92.

Goncourt, Edmond de, et Goncourt, Jules de. "Salon de 1852." *Etudes d'art* (1852).

Gonse, Louis. "Exposition de Pils à l'Ecole des beaux-arts." *Chronique des arts* (1876).

———. "Manet." *Gazette des beaux-arts,* 2d ser. XXIX (1884): 133-52.

Gounot, Roger. *Charles Maurin, 1856-1914,* exh. cat. Le Puy: Musée Crozatier, 1978.

Graña, César. *Bohemian versus bourgeois: French society and the French man of letters in the nineteenth century.* New York and London: Basic Books, 1964.

Grate, Pontus. "Deux critiques d'art de l'époque romantique: Gustave Planche et Théophile Thoré." *Figura* XI-XII (1959): 1-281.

Grayson, Marion L. *Paris in the belle epoque: People and places,* exh. cat. St. Petersburg, Fla.: Museum of Fine Arts, 1980.

Gréard, Octave. *Jean-Louis-Ernest Meissonier: Ses souvenirs, ses entretiens.* Paris: Hachette et Cie., 1897.

Green, Frederick C. *French novelists, from the Revolution to Proust.* New York: Frederick Ungar Publishing Co., 1964.

Grün, Alphonse. *Salon de 1852.* Paris: Panckoucke, 1852.

Guicheteau, Marcel, and Boutaric, Paule Henriette. *Paul Sérusier.* Paris: Editions Side, 1976.

Guiffrey, J. J. *L'Oeuvre de Ch. Jacque: Catalogue de ses eaux-fortes et pointes sèches.* Paris: Lemaire, 1866.

Guignebert, Charles. *A Short history of the French people.* London: George Allen and Unwin, 1930.

Guinard, Paul, and Mesuret, R. "Le Goût de la peinture espagnole en France." In *Trésors de la peinture espagnole,* exh. cat. Paris: Musée des Arts Décoratifs, 1963.

Gusman, Pierre. *La Gravure sur bois en France au XIXe siècle.* Paris: Editions Albert Morancé, 1929.

Halton, E. G. "The Staats Forbes Collection." *Studio* XXXVI (1906): 218-32.

Hamel, Mary Michele. *Léon Lhermitte,* exh. cat. Oshkosh, Wisc.: Paine Art Center, 1974.

———. "A French artist: Léon Lhermitte, 1844-1925." Ph.D. diss., St. Louis, Washington University, 1974.

Hamerton, Philip Gilbert. *The Present state of the fine arts in France.* London: Seeley & Co., 1892.

Hamilton, George Heard. *Manet and his critics.* New Haven, Conn.: Yale University Press, 1954.

Hanotaux, Gabriel. Preface to *Exposition rétrospective: Bastien-Lepage, 1848-1884; Louise Breslau, 1854-1927; Marie Bashkirtseff, 1860-1884.* Nice: n.p., 1939.

Hanson, Anne Coffin. *Edouard Manet: 1832-1883,* exh. cat. Philadelphia, Pa.: Philadelphia Museum of Art, 1966.

———. "Manet's subject matter and sources of popular imagery." *Chicago Art Institute Studies* III (1968): 63-80.

———. *Manet and the modern tradition.* New Haven, Conn.: Yale University Press, 1977.

Harris, J. C. *Edouard Manet: Graphic works.* New York: Collectors Editions, 1970.

Haug, Hans. "Un Peintre alsacien sous le Second Empire: Gustave Brion, 1824-1877." In *La Vie en Alsace.* Strasbourg: n.p., 1925.

———. *L'Art en Alsace.* Paris: Arthaud, 1962.

Hautecoeur, Louis. "Le Sentimentalisme dans la peinture française: De Greuze à David. I: Les Origines." *Gazette des beaux-arts,* 4th ser. I (1909): 159-76.

———. "Le Sentimentalisme dans la peinture française: De Greuze à David. II: Les Thèmes sentimentaux." *Gazette des beaux-arts,* 4th ser. I (1909): 269-86.

———. *Littérature et peinture en France.* Paris: A. Colin, 1942.

Heath, Richard. "Jules Breton, painter and poet." *Art journal* X (1884): 289-92.

Hefting, Victorine. *Jongkind, d'après sa correspondance.* Utrecht: Haentjens, Dekker and Gumbert, 1969.

———. *Jongkind: Sa vie, son oeuvre, son époque.* Paris: Arts et Métiers, 1975.

Hélias, Pierre-Jakez. *The Horse of pride, life in a Breton village.* New Haven and London: Yale University Press, 1978.

Hemmings, F. W. J., and Niess, Robert J. *Emile Zola: Salons.* Geneva: Librairie Droz, 1959.

———. *Culture and society in France 1848-1898: Dissidents and philistines.* London: B. T. Batsford, 1971.

Henley, William Ernest. *A Century of artists: A Memorial of the collection of painting and sculpture at the Glasgow International Exhibition.* Glasgow: J. MacLehose & Sons, 1889.

Henriet, Frédéric. "Le comte de Nieuwerkerke." *Journal des arts,* 21 and 25 January 1893.

———. "Au Musée de Reims." *Journal des arts,* 11 November 1899.

———. *Les Eaux-fortes de Léon Lhermitte.* Paris: Alphonse Lemerre, 1905.

Herbert, Robert L. *Barbizon revisited,* exh. cat. Boston, Mass.: Museum of Fine Arts, 1962.

———. "Millet reconsidered." *Museum Studies* I (1966): 29-65.

———. *Jean-François Millet,* exh. cat. Paris: Editions des Musées Nationaux, 1975.

———. "City vs. country, the rural image in French painting from Millet to Gauguin." *Artforum* VIII (February 1970): 44-55.

———. *Millet's gleaners,* exh. cat. Minneapolis, Minn.: Minneapolis Institute of Arts, 1978.

Hird, Frank. *H. M. Stanley: The Authorized life.* London: S. Paul and Co., 1935.

Hodder, Edwin. *The Life and work of the seventh earl of Shaftesbury, K.G.* 11 vols. London: Cassell & Co., 1886.

Holt, Elizabeth Gilmore, ed. *The Triumph of art for the public—The Emerging role of exhibitions and critics.* Garden City, N.Y.: Anchor Books, 1979.

Houssaye, Arsène. *Les Confessions, souvenirs d'un demi-siècle, 1830-1880.* 4 vols. Paris: E. Dentu, 1885-88.

Hufton, Olwen H. *The Poor of eighteenth-century France 1750-1789.* Oxford: Clarendon Press, 1974.

Hugo, Victor. *L'Année terrible.* Paris: J. Hetzel, 1872.

———. *The Hunchback of Notre Dame.* New York: A. L. Burt, n.d.

———. *Les Misérables;* illustrés de deux cents dessins par Brion gravures de Yon et Perrichon. Paris: J. Hetzel et A. Lacroix, n.d.

Hungerford, Constance J. C. "The Art of Jean-Louis-Ernest Meissonier: A Study of the critical years 1834 to 1855." Ph.D. diss., University of California at Berkeley, 1977.

———. "Meissonier's Souvenir de guerre civile." *Art bulletin* LXI (June 1979): 277-88.

———. "Ernest Meissonier's first military paintings: I: 'The Emperor Napoleon at the Battle of Solferino' and II: '1814, The Campaign of France.'" *Arts magazine* LIV (January 1980): 89-107.

Hunt, Herbert James. *Le Socialisme et le romantisme en France: Etude de la presse socialiste de 1830 à 1848.* Oxford: Clarendon Press, 1935.

Hustin, A. "Jules Breton." *L'Estafette,* 1 November 1888.

Huysmans, Joris Karl. *Oeuvres complètes de J. K. Huysmans.* 18 vols. Paris: G. Crès et Cie., 1928-34.

Irwin, David, and Irwin, Francina. *Scottish painters at home and abroad, 1700-1900.* London: Faber and Faber, 1975.

Isaacson, Joel. *The Crisis of impressionism, 1878-1882,* exh. cat. Ann Arbor, Mich.: University of Michigan Museum of Art, 1979-80.

Isnard, Guy. *Barbizon au temps de J. F. Millet, 1849-1875,* exh. cat. Barbizon: La Municipalité, 1975.

Jammes, André. *Charles Nègre photographe, 1820-1880.* Paris: L'Auteur, 1963.

Jamot, Paul, and Wildenstein, Georges. *Manet.* 2 vols. Paris: Les Beaux-Arts, 1932.

Janin, Jules. *Le Diable à Paris: Paris et les parisiens.* Paris: J. Hetzel, 1845.

_____. *Un Hiver à Paris.* Paris: L. Janet, 1847.

Jeanpierre, H. *Bonnat et l'art moderne.* Bayonne: Société des Sciences, Lettres et Arts de Bayonne, 1973.

Johnson, Jill. *Charles Parsons: Collection of paintings.* St. Louis: Washington University, 1977.

Jones, Gareth Stedman. *Outcast London: A Study in the relationship between classes in Victorian society.* London: Penguin Books, 1976.

Jouan, Andrée. "Notes sur quelques radiographies." *Bulletin du Laboratoire du Musée du Louvre* XI (1966): 20.

Joubin, André. "Les Dix-sept portraits d'Alfred Bruyas ou 'chacun sa vérité.'" *La Renaissance de l'art français* IX (1926): 547-57.

Jouin, Henry. *Jean Gigoux, artistes et gens de lettres de l'époque romantique.* Paris: Aux Bureaux de l'Artiste, 1895.

Jourdan, Louis. *Les Peintres français: Salon de 1859.* Paris: Librairie Nouvelle, 1859.

Jouy, Etienne. *Oeuvres complètes d'Etienne Jouy.* 27 vols. Paris: Jules Didot Aîné, 1823.

_____. *Les Hermites en liberté.* Paris: Ladvocat, 1824.

Jowell, Frances Suzman. *Thoré-Burger and the art of the past.* New York: Garland Publishing, 1977.

Kahn, Gustave. *Fantin-Latour.* Paris: F. Rieder, 1926.

Karageorgevitch, Bojidar, Prince. "Personal reminiscences of Jules Bastien-Lepage." *Magazine of art* XIII (1890): 88.

Klingender, Francis Donald. *Art and the Industrial Revolution.* New York: Schocken Books, 1970.

Klumpke, Anna. *Rosa Bonheur: Sa vie, son oeuvre.* Paris: E. Flammarion, 1908.

Knyff, Gilbert de. *Norbert Goeneutte: Sa vie et son oeuvre ou l'art libre au XIXe siècle.* Paris: Editions Mayer, 1979.

Kraemer, Erik V. "Le Type du faux mendiant dans les littératures romanes depuis le moyen âge jusqu'au XVIIe siècle." Ph.D. diss., Université de Helsinki, 1944.

Kunstler, Charles. "Camille Pissarro." *La Renaissance de l'art français* XI (December 1928): 497-508.

_____. *Camille Pissarro.* Milan: Fratelli Fabbri, 1972.

La Bédollière, Emile Gigault de. *Les Industriels: Métiers et professions en France.* Paris: L. Janet, 1842.

Labracherie, P. *Napoleon III et son temps.* Paris: Julliard, 1967.

Lacambre, Geneviève. *Le Musée du Luxembourg en 1874,* exh. cat. Paris: Grand Palais, 1974.

Lachaise, Claude. *Topographie médicale de Paris, ou examen général des causes qui peuvent avoir une influence marquée sur la santé des habitans de cette ville.* Paris: J.-B. Baillère, 1822.

Lacombe, Paul. *Parisien: Bibliographie parisienne; tableaux de moeurs (1600-1880).* Paris: P. Rouquette, 1887.

Lafenestre, Georges. *L'Art vivant: La Peinture et la sculpture aux Salons de 1868 à 1877.* Paris: G. Fischbacher, 1881.

_____. "Salon de 1888." *Revue des deux mondes* LXXXVII (1 June 1888).

_____. "L'Exposition d'études, dessins et pastels de M. Dagnan-Bouveret, à la Société nationale des beaux-arts." *Gazette des beaux-arts,* 4th ser. I (1909): 465-80.

La Fizelière, Albert A. de. *Exposition Nationale: Salon de 1850-51.* Paris: Passard, 1851.

_____. "Salon de 1864." *L'Union des arts,* no. 23 (2 July 1864).

Lagrange, Léon. "Salon de 1861." *Gazette des beaux-arts,* 1st ser. XI (1861): 48-73.

_____. "Salon de 1864." *Gazette des beaux-arts,* 1st ser. XVI (1864): 501-36.

Lalo, Charles. *L'Art et la vie sociale.* Paris: Octave Doin et Gaston Doin, 1921.

Larkin, Oliver. *Daumier: Man of his time.* New York, Toronto, and London: McGraw-Hill, 1966.

Larroumet, Gustave. *Discours prononcé à l'inauguration de la statue de Jules Bastien-Lepage à Damvillers, le 29 septembre 1889.* Paris: Quantin, 1889.

_____. *Catalogue des oeuvres de Guillaume R. Fouace exposées à l'Ecole nationale des beaux-arts.* Paris: n.p., 1895.

La Rue, Abbé Gervais de. *Essais historiques sur les bardes, les jongleurs et trouvères normands et anglo-normands.* 3 vols. Caen: Mancel, 1834.

La Sicotière, Léon de. *Monanteuil, dessinateur et peintre.* Caen: F. Le Blanc-Hardel, 1865.

Laurent, Pierre. "Les Conseillers municipaux." *Les Beaux-arts illustrés* XI (1879): 83.

Lavery, John. *The Life of a painter.* London: Cassell & Co., 1940.

Laviron, Gabriel, and Galbacio, B. *Le Salon de 1833.* Paris: Librairie Abel Ledoux, 1833.

Laviron, Gabriel. *Le Salon de 1834.* Paris: Librairie de Louis Janet, 1834.

Léaud, Alexis, and Glay, Emile. *L'Ecole primaire en France: Ses origines, ses différents aspects au cours des siècles, ses luttes, ses victoires, sa mission dans la démocratie.* 2 vols. Paris: La Cité Française, 1934.

Le Bot, Marc. *Peinture et machinisme.* Paris: Klincksieck, 1973.

Lecomte, Georges. "L'Oeuvre de J.-F. Raffaëlli." *La Grande revue* XLV (September 1907): 458, 471.

Lecoq de Boisbaudran, Horace. *L'Education de la mémoire pittoresque et la formation de l'artiste.* Paris: H. Laurens, 1913.

Le Creusot, usine, ville et environ: Guide du visiteur. Creusot: G. Martet, n.d.

Lefort, Paul. "Les Artistes contemporains: Th. Ribot." *Gazette des beaux-arts,* 3d ser. VI (1891): 298-309.

_____. *Les Chefs-d'oeuvre de l'art au XIXe siècle.* Vol. 3: *La Peinture française actuelle.* Paris: Librairie Illustrée, 1891.

Leiris, Alain de. *The Drawings of Edouard Manet.* Berkeley and Los Angeles: University of California Press, 1969.

_____, and Smith, Carol Hynning. *From Delacroix to Cézanne, French watercolor landscapes of the nineteenth century,* exh. cat. College Park, Md.: University of Maryland, 1977.

Le Jeune, Jean. *Guillaume Fouace, 1837-1895.* Coutances: Editions OCEP, 1976.

Lemoisne, P.-A. *Degas et son oeuvre.* 2 vols. Paris: Paul Brame and C. M. Hanker, 1946-49.

Lepage, Jean. *"Ex-Voto, marins du ponant,"* offerts à Dieu et à ses Saints par les gens de la Mer du Nord, de la Manche et de l'Atlantique, exh. cat. Paris: Musées de la Marine, 1975.

Lépine, Olivier. *Equivoques, peintures françaises du XIXe siècle,* exh. cat. Paris: Musée des Arts Décoratifs, 1973.

Lepoittevin, Lucien. *Les Ouvriers des deux mondes: Etude sur les travaux, la vie domestique et la condition morale des populations ouvrières des diverses contrées.* 5 vols. Paris: n.p., 1857-75.

Lepoittevin, Lucien. "J. F. Millet, mythe et réalité." *L'Oeil* (November 1964): 28-35.

_____. *Jean-François Millet.* Vols. 1, 2. Paris: Léonce Laget, 1971-73.

Le Roux, Hugues, and Garnier, Jules. *Acrobats and mountebanks.* Translated by A. P. Morton. London: Chapman and Hall, 1890.

Leroy, Paul Auguste. *Alexandre Antigna, peintre.* Orléans: H. Herluison, 1892.

Leroy-Beaulieu, Paul. *La Question ouvrière au XIXe siècle.* Paris: Charpentier et Cie., 1872.

Less, Frederic. "The Artist in Paris: The Work of Léon Lhermitte." *Artist,* 1 October 1898, pp. 84-89.

Lestocquoy, Jean. *La Vie religieuse en France du VIIe au XIXe siècles.* Paris: A. Michel, 1964.

Lethève, J. *La Vie quotidienne des artistes français au XIXe siècle.* Paris: Hachette, 1968.

Levin, Harry. *The Gates of horn: A Study of five French realists.* New York: Oxford University Press, 1963.

Lhéritier, Andrée. *Les Physiologies 1840-1845.* Paris: Service International de Microfilms, 1966.

Lhermitte, Léon. "Notice sur la vie et les travaux de J. J. Henner membre de l'Institut." In *Musée J. J. Henner,* Paris: n.p.

Lindsay, Jack. *Gustave Courbet: His life and art.* New York: Somerset, Adams and Dart, 1973.

Lioult, Claude. *Artistes ornais du XIXe siècle,* exh. cat. Alençon: Musées d'Alençon, 1977.

Lora, L. de. "Le Peintre Antigna." *Journal du Loiret,* 1 March 1878.

Lostalot, Alfred de. "Expositions diverses à Paris: Oeuvres de M. J.-F. Raffaëlli." *Gazette des beaux-arts,* 2d ser. XXIX (1884): 334-42.

Loudun, Eugène [Balleyguier, Eugène]. Preface to *Catalogue de la vente qui aura lieu par suite du décès de Antigna, ses tableaux, études et croquis.* Paris: n.p., 1878.

_____. *Exposition universelle des beaux-arts: Le Salon de 1855.* Paris: n.p., 1855.

Lovie, Jacques. *La Savoie dans la vie française de 1860 à 1875.* Paris: Presses Universitaires de France, 1963.

Lucie-Smith, Edward. *Fantin Latour.* Oxford: Phaidon Press, 1977.

_____, and Dars, Celestine. *Work and struggle: The Painter as witness, 1870-1914.* London and New York: Paddington Press, 1977.

Lukács, György. *Balzac et le réalisme français.* Translated from German by Paul Laveau. Paris: F. Maspero, 1967.

Maas, Jeremy. *Gambart: Prince of the Victorian art world*. London: Barrie and Jenkins, 1975.

Mace, Charles de. "La Jeunesse de Bastien-Lepage d'après sa correspondance inédite." *Le Figaro*, 17 December 1884, pp. 81-82.

Madeleine, H. de la. *Salon de 1853*. Paris: n.p., 1853.

Magnitot, M. A. de. *De l'assistance et de l'extinction de la mendicité*. Paris: Firmin-Didot Frères, 1856.

Maison, K. E. *Honoré Daumier: Catalogue raisonné of the paintings, watercolors and drawings*. 2 vols. Greenwich, Conn.: New York Graphic Society, 1968.

Malassis, P.-E.-A. Poulet. *M. Alphonse Legros au Salon de 1875; note critique et biographique*. Paris: P. Rouquette, 1875.

Mallarmé, Stéphane. "Types de la Rue." In *Les Types de Paris*. Paris: Figaro, Plon, Nourrit et Cie., 1889.

_____. *Correspondance*. Edited by Henri Mondor and Lloyd James Austin. 4 vols. Paris: Gallimard, 1973.

Manceau, Henri. *Gens et métiers d'autrefois*. Mézières: Editions de la Société d'Etudes Ardennaises, 1957.

Mandrou, Robert. *De la culture populaire aux 17e et 18e siècles*. Paris: Stock, 1965.

Mantz, Paul. *Salon de 1847*. Paris: Ferdinand Sartorius, 1847.

_____. "Le Salon, MM. Adolphe Leleux, Eugène Lacoste et Breton." *L'Evénement*, 12 February 1851.

_____. "Feuilleton de l'Evénement: Le Salon." *L'Evénement*, 15 February 1851.

_____. "Salon de 1859." *Gazette des beaux-arts*, 1st ser. II (1859): 271-99.

_____. "Le Salon de 1863." *Gazette des beaux-arts*, 1st ser. XIV (1863): 481-506.

_____. "Salon de 1865." *Gazette des beaux-arts*, 1st ser. XIX (1865): 5-42.

_____. "Salon de 1869." *Gazette des beaux-arts*, 2d ser. I (1869): 489-501.

_____. "Bastien-Lepage." *Le Temps*, 23 December 1884.

_____. "La Peinture française." *Gazette des beaux-arts*, 3d ser. II (1889): 345-67.

Marcel, Henry. *La Peinture française au 19e siècle*. Paris: A. Picard et Kaan, 1905.

Marchal, Charles [Bussy, Charles de]. *Les Forains à travers les âges*. Paris: n.p., 1930.

Marlet, Jean Henri. *Tableaux de Paris*. Paris: Marlet, 1821.

Martin, Etienne. *Antoine Vollon: Peintre, 1833-1900*. Marseille: Au Siège de l'Académie, 1923.

Martino, Pierre. *Le Roman réaliste sous le Second Empire*. Paris: Hachette et Cie., 1913.

_____. *Le Naturalisme français 1870-1895*. Paris: A. Colin, 1923.

Marx, Karl. "The Class struggle in France (1848-1850)." In *Selected Works, Karl Marx and Frederick Engels*, vol. 1. Moscow: n.p., 1962.

Marx, Roger. *Exposition centennale de l'art français, 1800-1900*. Paris: E. Lévy, 1903.

Mauclair, Camille. *L'Impressionnisme: Son histoire, son esthétique, ses maîtres*. Paris: Librairie de l'Art Ancien et Moderne, 1904.

[Maus, Octave]. "Les Vingt: 3e article." *L'Art moderne*, 22 February 1885, p. 58.

Mayaud, Jean Luc. *Les Paysans du Doubs au temps de Courbet*. Besançon: Les Belles-Lettres, 1979.

Mayhew, Henry. *London labour and the London poor*. 4 vols. London: Cass, 1967.

Maynial, Edouard. *Anthologie des romanciers du XIXe siècle*. Paris: Hachette, 1931.

McConkey, Kenneth. "The Bouguereau of the naturalists: Bastien-Lepage." *Art history* III (September 1978): 371-79.

McCoubrey, John W. "Studies in French still-life painting, theory and criticism: 1660-1860." Ph.D. diss., New York University, 1958.

_____. "The Revival of Chardin in French still-life painting, 1850-1870." *Art bulletin* XLVI (March 1964): 39-53.

Meier-Graefe, Jules. *Entwicklungsgeschichte der modernen Kunst*. 3 vols. Stuttgart: J. Hoffmann, 1904.

_____. *Edouard Manet*. Munich: R. Piper, 1912.

Meltzoff, Stanley. "The Revival of the Le Nains." *Art bulletin* XXIV (September 1942): 259-86.

Ménard, René. *L'Art en Alsace-Lorraine*. Paris: Baulle et Delagrave, 1876.

_____. *Le Monde vu par les artistes, géographie artistique*. Paris: C. Delagrave, 1881.

Mercier, Louis Sébastien. *Tableau de Paris*, 8 vols. Amsterdam: n.p., 1782-83; new edition, 12 vols. Amsterdam: n.p., 1782-88.

Mercier, Roger. *L'Enfant dans la société au 18e siècle; Avant l'Emile*. Paris: n.p., 1962.

Meunier, P.-A. *La Vie et l'art de Jean-Jacques Henner*. Paris: n.p., 1927.

Meyer, Julius. *Geschichte der modernen französischen malerei seit 1789, zugleich in ihrem verhältniss zum politischen leben, zur gesittung und literatur*. Leipzig: C. A. Seemann, 1867.

Michel, Ernest. *Galerie Bruyas*. Montpellier: n.p., 1878.

Michelet, Jules. *Le Peuple*. Paris: Hachette et Paulin, 1846.

Mistler, Jean. *Epinal et l'imagerie populaire*. Paris: Hachette, 1961.

Montifaud, M. de. "Salon de 1867 et Exposition Universelle." *L'Artiste*, 1 May 1867.

Montigny, L. *Le Provincial à Paris, esquisses des moeurs parisiennes*. 3 vols. Paris: Ladvocat, 1825.

Montrosier, Eugène. "Le Musée du Luxembourg." In *Les Chefs-d'oeuvre d'art au Luxembourg*. Paris: L. Baschet, 1881.

_____. *Les Artistes modernes*. 4 vols. Paris: H. Launette, 1881-84.

_____. *Salon de 1888*. Paris: Baschet, 1888.

Moore, George. *Modern Painting*. London: Walter Scott, 1893.

Morancé, A. "Notice biographique sur Alexandre Antigna." *L'Avenir du Loiret*, no. 211 (6 September 1882).

Moreau-Nélaton, Etienne. *Manet: Graveur et lithographe*. Paris: L. Delteil, 1906.

_____. *Jongkind raconté par lui-même*. Paris: H. Laurens, 1918.

_____. *Millet, raconté par lui-même*. 2 vols. Paris: H. Laurens, 1921.

_____. *Manet raconté par lui-même*. Paris: H. Laurens, 1926.

_____. *Bonvin raconté par lui-même*. Paris: Henri Laurens, 1927.

Mosby, Dewey F. *Alexandre-Gabriel Decamps, 1803-1860*. New York and London: Garland Publishing, 1977.

_____. *The Figure in nineteenth-century French painting*, exh. cat. Detroit, Mich.: Detroit Institute of Arts, 1979.

Mourey, Gabriel. "Jules Breton, 1827-1906." *Les Arts* V (December 1906): 30-36.

Muel, Francine. "Les Instituteurs, les paysans et l'ordre républicain." *Actes de la recherche en sciences sociales*, nos. 17-18 (November 1977): 37-61.

Muntz, Eugène. "Exposition internationale de Munich." *Gazette des beaux-arts*, 2d ser. II (1869): 301-31.

Murger, Henry. *Scènes de la vie de bohème*. Paris: Larousse, 1914.

Muther, Richard. *The History of modern painting*. London: Henry & Co., 1896.

Nash, Steven. *Painting and sculpture from antiquity to 1942: Collection of the Albright-Knox art gallery*. New York: Rizzoli, 1980.

"Nécrologie: Jean Jacques Henner." *Chronique des arts* (1905): 222.

Nède, André. "Nécrologie, Gustave Colin." *Le Figaro*, 30 December 1910.

Nettement, Alfred. *Poëtes et artistes contemporains*. Paris: Lecoffre, 1862.

Newhall, Beaumont. *The History of photography from 1839 to the present day*. New York: Museum of Modern Art, 1964.

Niess, Robert J. *Zola, Cézanne and Manet: A Study of 'L'Oeuvre.'* Ann Arbor, Mich.: University of Michigan Press, 1968.

Nisard, Charles. *Histoire des livres populaires ou de la littérature de colportage depuis l'origine de l'imprimerie jusqu'à l'établissement de la Commission d'examen des livres de colportage*. Paris; Amyot, 1854.

Nochlin, Linda. *Realism and tradition in art, 1848-1900: Sources and documents*. Englewood Cliffs, N.J.: Prentice-Hall, 1966.

_____. "Gustave Courbet's meeting: A Portrait of the artist as a wandering Jew." *Art bulletin* XLIX (September 1967): 209-22.

_____. "Gustave Courbet's 'Toilette de la mariée.'" *Art quarterly* XXXIV (1971): 31-54.

_____. *Realism*. Baltimore: Penguin Books, 1971.

_____. *Gustave Courbet: A Study of style and society*. New York and London: Garland Publishing, 1976.

_____. "Van Gogh, Renouard and the weavers' crisis in Lyon: The Status of a social issue in the art of the later 19th century." in *Essays in honor of H. W. Janson*. New York: Prentice-Hall, forthcoming.

Nouëne, Patrick le. "'Les Soldats de l'Industrie,' de François Bonhommé: L'Idéologie d'un projet." In *Histoire et critique des arts*, May 1978, pp. 35-61.

Novak, Barbara. *American painting of the nineteenth century: Realism, idealism and the American experience*. New York: Praeger, 1969.

Ojalvo, David. *Jean Pierre Alexandre Antigna*, exh. cat. Orléans: Musée des Beaux-Arts, 1979.

Ollivier, Emile. *L'Empire libéral, études, récits, souvenirs*. 18 vols. Paris: Garnier Frères, 1895-1918.

Onyx [Fyot]. "'L'Ex-voto' d'A. Legros." *La Revue de Bourgogne* (1911): 96-98.

Oursel, Hervé. *Gustave Colin, 1828-1910*, exh. cat. Arras: Musée d'Arras, 1967.

Parry, Elwood C. "'The Gross Clinic' as anatomy lesson and memorial portrait." *Art quarterly* XXXII (1969): 373-91.

Peisse, M. I. "Feuilleton du Constitutionnel: Salon de 1850." *Le Constitutionnel*, 1 April 1850.

Pelloquet, Théodore. *Dictionnaire de poche des artistes contemporains: Les Peintres*. Paris: A. Delahays, 1858.

Pelloutier, Fernand, and Maurice Pelloutier. *La Vie ouvrière en France*. Paris: Schleicher Frères, 1900.

Perrier, Ch. "Exposition Universelle des beaux-arts." *L'Artiste*, 20 May 1855, p. 30; July 1855, p. 133.

Personnaz, Antonin. "Léon Bonnat." *Notice de la Société des Amis du Louvre*. Paris: n.p., 1923.

Phillips, C. S. *The Church in France: 1848-1907*. London: Society for Promoting Christian Knowledge, 1936.

Pickvance, Ronald. *Degas 1879*, exh. cat. Edinburgh: National Gallery of Scotland, 1979.

Pieske, Christa. *Burgerliches Wandbild, 1840-1920: Populare druckgraphik aus Deutschland, Frankreich und England*, exh. cat. Göttingen Städtisches Kunstinstitut, 1975.

Pillement, Georges. *Les Pré-Impressionnistes*. Zoug: Les Clefs du temps, 1974.

Pissarro, Ludovic R., and Venturi, Lionello. *Camille Pissarro: Son art, son oeuvre*. Paris: P. Rosenberg, 1939.

Planet, L. de. *Souvenirs de travaux de peinture avec M. Eugène Delacroix*. Paris: A. Colin, 1929.

Plasse, Bernard. *42 Oeuvres du peintre A. Casile, 1848-1909*, exh. cat. Paris: Galerie Jean Saint-Georges, 1964.

Pommier, Jean. *Les Ecrivains devant la révolution de 1848: Lamartine, Hugo, Lamennais, George Sand, Michelet, Béranger*. Paris: Presses Universitaires de France, 1948.

Pool, Phoebe. "Some early friends of Edgar Degas." *Apollo* LXXIX (1964): 391-94.

Privat, Louis de Gonzague. *Place aux jeunes: Causeries critiques sur le Salon de 1865*. Paris: F. Cournol, 1865.

Privat d'Anglemont, A. *Paris inconnu, précédé d'une étude sur sa vie par Alfred Delvau*. Paris: Adolphe Delahays, 1875.

Prost, Bernard. *Artistes modernes: Octave Tassaert, notice sur sa vie et catalogue de son oeuvre*. Paris: L. Baschet, 1886.

Proudhon, Pierre-Joseph. *Du Principe de l'art et de sa destination sociale*. Paris: A. Lacroix, 1875.

Proust, Antonin. *Edouard Manet: Souvenirs*. Paris: A. Barthélemy et H. Laurens, 1913.

Quarré, P. "L'Art en Bourgogne." In *Visages de la Bourgogne*. Paris: n.p., 1963.

Quick, Michael; Ruhmer, Eberhard; and West, Richard, *Munich and American realism in the 19th century*, exh. cat. Sacramento, Calif.: E.B. Crocker Art Gallery, 1978.

Raffaëlli, Jean-François. "Etude des mouvements de l'art moderne et du beau caractériste." In *Catalogue illustré des oeuvres de J. F. Raffaëlli exposées 28 bis, avenue de l'Opéra, 15 mars au 15 avril 1884*. Paris: n.p., 1884.

———. "Caractère des lignes." *La Revue indépendante* VI (February 1888): 176-77.

———. "L'Art dans une démocratie." *La Nouvelle revue*, 15 October 1896.

———. *Mes Promenades au musée du Louvre*. 2d edition, revised. Paris: Editions d'Art et de Littérature, 1913.

———. *Conférence faite par M. J. F. Raffaëlli au Palais des beaux-arts de Bruxelles, au Salon annuel des XX, le 7 février 1885*. Poissy: S. Lejay, n.d.

Ralston, W. R. S. "The Poor of Paris." *Contemporary review* VIII (1868): 234-45.

Rambaud, Yveling. "Joseph Bail." *Le Journal*, 17 July 1894.

———. "Victor Gilbert." *Le Journal*, 7 August 1898.

Randall, Lillian M. C. *The Diary of George A. Lucas: An American art agent in Paris, 1857-1909*. 2 vols. Princeton, N.J.: Princeton University Press, 1979.

Réau, Louis. "La Peinture française de 1848 à nos jours." In A. Michel, *Histoire de l'art*, vol. 8, pt. 2. Paris: A. Colin, 1926.

Rebeyrol, Philippe. "Art historians and art critics. I: Théophile Thoré." *Burlington magazine* XCIV (1952): 196-200.

Reff, Theodore. "Copyists in the Louvre, 1850-1870." *Art bulletin* XLVI (1964): 552-59.

———. "Manet's sources: A Critical evaluation." *Artforum* VIII (September 1969): 40-48.

———. "Degas and the literature of his time." *Burlington magazine* CXII (September 1970): 575-89; (October 1970): 674-88.

———. *Degas: The Artist's mind*. New York: Harper and Row, Metropolitan Museum of Art, 1976.

———. *Manet: Olympia*. London: Allen Lane and Penguin Books, 1976.

———. *The Notebooks of Edgar Degas*. Oxford: Clarendon Press, 1976.

Régamey, Félix. *H. Lecoq de Boisbaudran et ses élèves*. Paris: Champion, 1903.

Reveillez, H. "Le Peintre Jean-Charles Cazin." *Revue de Boulogne-sur-mer* (n.d.).

Rewald, John. *The History of Impressionism*. New York: Museum of Modern Art, 1961.

———. *Post-Impressionism from Van Gogh to Gauguin*. New York: Museum of Modern Art, 1962.

———. *Camille Pissarro*. New York: Harry N. Abrams, 1963.

Rhodes, Albert. "The Ragpickers of Paris." *Galaxy* XVIII (1874): 194-95.

Ricaud, Th. "Le Musée de peinture et sculpture de Bordeaux de 1830 à 1870." *Revue historique de Bordeaux* (April-June 1937): 84-85.

Riotor, Léon. "Les Artistes de l'Ile Saint Louis." *Bulletin de la Ville de Paris* VIII-IX (n.d.): 445-50.

Ris, L. Clément de. "Le Salon de 1851." *L'Artiste*, February 1851, p. 6.

———. "Musées de province, Musée de Bordeaux." *Revue universelle des arts* XII (1860): 32.

Robert, H. "Salon de 1841, Portrait: Oublis." *Le National*, 20 April 1841.

Roberts, Warren. *Morality and social class in eighteenth-century French literature and painting*. Toronto: University of Toronto Press, 1974.

Roche, A. "Of finish in art." *Transactions of the national association for the advancement of art*. Edinburgh meeting, 28 October—November 1889. London: n.p., 1890, p. 339.

Rocheblave, Samuel. "La Jeunesse d'Henner." *Revue de l'art ancien et moderne* (1906): 161-76.

———. "Louis de Fourcaud et le mouvement artistique de 1875 à 1914." *Publication de la Faculté des lettres de Strasbourg*, 20th ser. fasc. 1. Strasbourg: Les Belles Lettres, 1926.

———. "Les Salons de Louis de Fourcaud." *Gazette des beaux-arts*, 5th ser. XIII (1926): 37-59.

———. *L'Art et le goût en France de 1600 à 1900*. Paris: A. Colin, 1930.

Rodee, Howard David. "Scenes of rural and urban poverty in Victorian painting and their development, 1850-1890." Ph.D. diss., Columbia University, 1975.

———. "Dreary landscape as a background for scenes of rural poverty in Victorian paintings." *Art journal* XXXVI (Summer 1977): 307-13.

Roger-Milès, L. *Rosa Bonheur: Sa vie, son oeuvre*. Paris: Société d'Edition Artistique, 1900.

———. "Léon Lhermitte." *Le Figaro Illustré* XVIII (1907): 145-64.

Rogers, Meyric R. "The Two sisters." *Bulletin of the City Art Museum of Saint Louis* XXII (April 1937): 14-16.

The Romantics to Rodin: French nineteenth-century sculpture from North American collections, exh. cat. Los Angeles: Los Angeles County Museum of Art in association with George Braziller, 1980.

Romieu, Mme. Auguste. *Des paysans et de l'agriculture au XIXe siècle*. Paris: Bouchaud-Huzaud, 1865.

Rookmaaker, H. R. *Synthetist art theories. Genesis and nature of the idea on art of Gauguin and his circle*. Amsterdam: Sweets and Zeitlinger, 1959.

Rosenberg, Pierre. *Chardin*, exh. cat. Paris: Editions de la Réunion des Musées Nationaux, 1979.

Rosenthal, Léon. "Du romantisme au réalisme: Les Conditions sociales de la peinture sous la Monarchie de Juillet." *Gazette des beaux-arts*, 4th ser. III (1910): 93-114, 217-41, 332-54.

———. "La Genèse du réalisme avant 1848." *Gazette des beaux-arts*, 4th ser. X (1913): 169-90, 302-27.

———. *Du romantisme au réalisme: Essai sur l'évolution de la peinture en France de 1830 à 1848*. Paris: H. Laurens, 1914.

Roskill, Mark W. "On Realism in nineteenth century art." *New Mexico studies in the fine arts* III (1978)).

Rothenstein, John. *Modern foreign pictures in The Tate Gallery*. London, 1947.

Rouart, Denis, and Wildenstein, Daniel. *Edouard Manet: Catalogue raisonné*. Lausanne: La Bibliothèque des Arts, 1975.

Rousseau, Madeleine. "La Vie et l'oeuvre de Philippe Auguste Jeanron, peintre, écrivain, directeur des musées nationaux, 1808-1877." Thesis, Ecole du Louvre, 1935.

Roy, Joseph-Antoine. *Histoire de la famille Schneider et du Creusot*. Paris: Marcel Rivière et Cie., 1962.

Sadleir, Michael. *Daumier: The Man and the artist*. London: Halton and Truscott Smith, 1924.

Saint-Geours, Yvonne; Sainte-Fare-Garnot, Nicolas; and Simon, Nadine. *Trésors et chefs-d'oeuvre de l'Assistance publique*, exh. cat. Paris: n.p., 1977.

Saint-Girons, Simone. *Les Halles: Guide historique et pratique*. Paris: Librairie Hachette, 1971.

Saint-Victor, Paul de. "Variétés: Salon de 1863." *La Presse*, 13 June 1863.

Saldern, Axel von. *Triumph of realism: An Exhibition of European and American realist paintings, 1850-1910*, exh. cat. Brooklyn, N.Y.: Brooklyn Museum of Art, 1967.

Sambi, Margaret Ann. "Jean-François Millet and mid-nineteenth century revivals." M.A. thesis, University of Cincinnati, 1974.

Sand, George. *François de Champi*. Paris: M. Lévy, 1852.

———. *Les Maîtres sonneurs*. Paris: M. Lévy, 1869.

———. *La Mare au diable*. Paris: M. Lévy, 1869.

———. *Questions d'art et de littérature*. Paris: Calmann Lévy, 1878.

———. *Indiana*. Paris: M. Lévy, 1888.

———. *Le Meunier d'Angibault*. Paris: M. Lévy, 1888.

———. *Le Compagnon du tour de France*. Paris: Editions Montaigne, 1928.

Sanson, William. *Victorian life in photographs*. London: Thames & Hudson, 1974.

Sarcey, Francisque. *Le Mot et la chose*. Paris: Société d'Editions Littéraires et Artistiques, 1900.

Sartor, Mme. M. *Musée de Reims. Catalogue sommaire de la collection Henry Vasnier*. Reims: Au Musée, 1913.

Savigny, M. de. *Le Magasin des écoliers, encyclopédie illustrée*. Paris: Didier, n.d.

Schapiro, Meyer. "Courbet and popular imagery." *Journal of the Warburg and Courtauld institutes* IV (1941): 164-91.

Scharf, Aaron. "Painting, photography and the image of movement." *Burlington magazine* CIV (1962):1864-95.

———. *Art and photography*. Baltimore: Penguin Books, 1974.

Schmit, Robert. *Eugène Boudin: 1824-1898*. 3 vols. Paris: Imprimerie Union, 1973.

Schnerb, J. F. "François Bonhommé." *Gazette des beaux-arts*, 4th ser. I (1913): 11-25.

Schulze, Franz. "A Consistently discriminating connoisseurship." *Art news* LXXVI (April 1977): 64-67.

The Second Empire: 1852-1870—Art in France under Napoleon III, exh. cat. Philadelphia: Philadelphia Museum of Art, 1978.

Seltzer, Alexander. "Alphonse Legros: The Development of an archaic visual vocabulary in 19th century art" Ph.D. diss., State University of New York at Binghamton, 1980.

Sensier. Alfred. *Jean-François Millet, peasant and painter*. Translated by Helena De Kay. Boston: J. R. Osgood & Co., 1881.

Sertat, Raoul. *Exposition Th. Ribot au Palais national de l'Ecole des beaux-arts*, exh. cat. Paris: Imprimerie de l'Art, 1892.

———. "Littérature et beaux-arts." *Revue encyclopédique* II, 1 August 1892: 1111-12.

———. "Théodule Ribot." *Revue populaire des beaux-arts*, 18 February 1899.

Sheon, Aaron. "Tassaert's social themes." Paper read at the 66th Annual Meeting of the College Art Association of America, 25-28 January 1978, at New York City.

———. "Courbet, French realism and the discovery of the unconscious." *Art quarterly*, n.s. (1980), in press.

Shikes, Ralph E., and Harper, Paula. *Pissarro. His life and work*. New York: Horizon Press, 1980.

Simond, Charles. *Paris de 1800 à 1900 d'après les estampes et les mémoires du temps*. 3 vols. Paris: E. Plon, Nourrit et Cie., 1900.

Sloane, Joseph. *French painting between the past and the present: Artists, critics and traditions from 1848-1870*. Princeton, N.J.: Princeton University Press, 1951.

Smith, Karen W. *The Crimean war drawings of Constantin Guys*, exh. cat. Cleveland, Ohio: Cleveland Museum of Art, 1978.

Soubies, Albert. *J. J. Henner (1829-1905), notes biographiques*. Paris: Flammarion, 1905.

Soullié, Louis. *Les Grands peintres aux ventes publiques*. Vol. 1: *Peintures, pastels, aquarelles, dessins de Constant Troyon relevés dans les catalogues de ventes de 1833 à 1900*. Paris: L. Soullié 1900.

———. *Les Grands peintres aux ventes publiques*. Vol. 2: *Peintures, aquarelles, pastels, dessins de Jean-François Millet relevés dans les catalogues de ventes de 1849 à 1900*. Paris: L. Soullié, 1906.

Stanley, Dorothy. "Bastien-Lepage in London." *Art journal* LIX (1897): 53-54.

Starkie, Enid. *Flaubert: The Making of the master*. London: Penguin Books, 1971.

Steegmuller, Francis. *Flaubert and Madame Bovary*. Chicago: University of Chicago Press, 1977.

———. trans. and ed. *The Letters of Gustave Flaubert, 1830-1857*. Cambridge, Mass.: Belknap Press of Harvard University Press, 1980.

Steinitz, Wolfgang. *Les Cris de Paris*. Salzburg: Verlag Galerie Welz, 1971.

Sterling, Charles, and Adhémar, Hélène. *La Peinture au musée du Louvre: L'Ecole française le XIXe siècle*. 4 vols. Paris: Editions des Musées Nationaux, 1961.

———, and Salinger, M. M. *French paintings: A Catalogue of the collection of the Metropolitan Museum of Art*. 3 vols. New York: Metropolitan Museum of Art, 1966-67.

Stillpass, Andrew J. "Eugène Carrière: Symbolist of family life." M.A. thesis, University of Cincinnati, 1974.

Stromberg, Roland N. *Realism, naturalism, and symbolism: Modes of thought and expression in Europe, 1848-1914*. New York: Harper and Row, 1968.

Sue, Eugène. *Le Juif errant*. Illustrated by Gavarni. Paris: Paulin, 1845.

———. *Les Mystères du peuple, ou histoire d'une famille de prolétaires à travers les ages*. Brussels: n.p., 1850-52.

———. *The Mysteries of Paris*. New York: Thomas Y. Crowell, n.d.

Sutton, Denys. "Carrière and the symbolists at the Orangerie." *Burlington magazine* XCII (1950): 81.

———. "The Baudelaire exhibition." *Apollo* LXXXIX (1969): 174-83.

Tabarant, A. *La Vie artistique du temps de Baudelaire*. 2d ed. Paris: Mercure de France, 1963.

Tennant, Dorothy. *London street Arabs*. London: Cassell & Co., 1890.

Ternois, René. *Zola et son temps*. Lourdes and Paris: Les Belles Lettres, 1961.

Theuriet, André. "Jules Bastien-Lepage." *Catalogue des tableaux, esquisses, etc., laissés dans son atelier*. Paris: n.p., 1885.

———. "Jules Bastien-Lepage, l'homme et l'artiste." *Revue des deux mondes*, 15 April 1885.

———. *La Vie rustique*. Paris: Librairie Artistique, H. Launette et Cie., 1888.

———. *Jules Bastien-Lepage and his art: A Memoir*. London: T. Fisher Unwin, 1892.

Thomson, David C. *The Barbizon school of painters: Corot, Rousseau, Diaz, Millet, Daubigny, etc.* London: Chapman and Hall, 1902.

Thoré, Théophile. *Journal du Peuple*, 1 April 1838.

———. "Peintres modernes: M. Jean Gigoux." *L'Artiste*, 2d ser. II (1839): 204.

———. *Le Salon de 1844, précédé d'une lettre à Théodore Rousseau*. Paris: Alliance des Arts et chez M. Masgana, Galerie de l'Odéon, 1844.

———. *Le Salon de 1845, précédé d'une lettre à Béranger*. Paris: Alliance des Arts et chez M. Masgana, Galerie de l'Odéon, 1845.

———. *Le Salon de 1846, précédé d'une lettre à George Sand*. Paris: Alliance des Arts, 1846.

———. *Le Salon de 1847*. Paris: n.p., 1847.

———. "Nouvelles tendances de l'art." In *Salons de Th. Thoré, 1844-48*. Paris: Librairie Internationale, 1868.

———. *Salons de T. Thoré: 1844, 1845, 1846, 1847, 1848*, with a preface by W. Bürger. Paris: Librairie Internationale, 1868.

———. *Salons de W. Bürger: 1861 à 1868*, with a preface by T. Thoré. 2 vols. Paris: J. Renouard, 1870.

Thorlby, A. *Gustave Flaubert and the art of realism*. New Haven: Yale University Press, 1957.

Tillot, Charles. "Exposition de 1853: Revue du Salon." *Le Siècle*, 25 May 1853, pp. 1-2.

Toussaint, Hélène. *Le Romantisme dans la peinture française*. Moscow: n.p., 1968.

———. "Collection Henry Vasnier: Peintures et dessins." Xerox copy of thesis, Ecole du Louvre, 1969.

———. *Gustave Courbet (1819-1877)*, exh. cat. Paris: Editions des Musées Nationaux, 1977.

Trapp, Frank A. "Fantin-Latour at Smith College." *Burlington magazine* CVIII (1966): 393-94.

Troubat, Jules. *Une Amitié à la d'Arthez: Champfleury, Courbet, Max Buchon, suivi d'une conférence sur Sainte-Beuve*. Paris: L. Duc, 1900.

———. *Souvenirs sur Champfleury et le réalisme conférence faite le 23 novembre 1905, à l'Association polytechnique*. Paris: Librairie de la Province, 1905.

Trudgian, Helen. *L'Esthétique de J.-K. Huysmans*. Paris: Louis Conrad, 1934.

Tschudi, H. von. *Edouard Manet*. Berlin: B. Cassirer, 1902.

Twyman, Michael. *Lithography: 1800-1850*. London: Oxford University Press, 1970.

Unpublished correspondance of Henri de Toulouse-Lautrec in the collection of Herbert Schimmel. New York: Phaidon, 1969.

Vachon, Marius. *Jules Breton*. Paris: A. Lahure, 1899.

Vaillat, Léandre. "Vingt toiles de Millet dans un grenier." *L'Illustration*, 11 March 1922.

Valentiner, W.R. *Catalogue of a collection of paintings and some art objects: German, French, Spanish and English paintings and art objects*. Vol. 3: *Modern paintings*. Philadelphia, John G. Johnson, 1914.

Valéry, Paul. *Degas, Manet, Morisot*. Translated by David Paul. London: Routledge and Kegan Paul, 1960.

Valléry-Radot, Pierre. "Chroniques, en l'honneur de l'internat et de l'hôpital Saint-Louis quelques anniversaires." *La Presse médicale*, 3 December 1952: 1657-58.

Vallès, Jules. *La Rue*. Paris: A. Faure, 1866.

———. *Le Cri du peuple, février 1848 à mai 1871*, with a preface and notes by Lucien Scheler. N.p., 1953.

Vallet, E. *Nouvelle édition du catalogue*. Bordeaux: n.p., 1894.

Valmy-Baysse, Jean. "Joseph Bail." In *Peintres d'aujourd'hui*, no. 10. Paris: n.p., 1910.

Vandam, Albert. "The Paris market-women." *Fortnightly review* LXII (1899): 683-95.

Varnedoe, J. Kirk T., and Lee, Thomas P. *Gustave Caillebotte: A Retrospective exhibition*, exh. cat. Houston: Museum of Fine Arts and the Brooklyn Museum, 1976-77.

Vaudoyer, J. L. *Jean Béraud, peintre de la vie parisienne*, exh. cat. Paris: Musée Carnavalet, 1936.

Vergne, Paul. "J. F. Millet au Musée national des beaux-arts d'Alger." *Etudes d'art* VI (1951): 113-24.

Vergnet-Ruiz, J., and Laclotte, Michel. *Petits et grands musées de France*. Paris: Musée du Louvre, 1962.

Vernet, Carle. *Cris de Paris, dessinés d'après nature*. Paris: Delpech, 182?.

Véron, Théodore. *Dictionnaire Véron, ou mémorial de l'art et des artistes contemporains: Le Salon de 1875*. Paris: n.p., 1875-81.

_____. *Dictionnaire Véron, ou mémorial de l'art et des artistes de mon temps: Le Salon de 1877* [1878] 3e [4e] annuaire. Paris-Poitiers: L'Auteur, 1877-78.

Vexliard, Alexandre. *Introduction à la sociologie du vagabondage*. Paris: Marcel Rivière et Cie., 1956.

Viallefond, Geneviève. *Le Peintre Léon Riesener 1808-1878: Sa vie, son oeuvre avec des extraits d'un manuscrit inédit de l'artiste*. Villeneuve-Saint-Georges: Albert Moranée, 1955.

Vignon, Claude. *Salon de 1850-51*. Paris: Garnier Frères, 1851.

_____. *Salon de 1852*. Paris: Dentu, 1852.

Villeneuve-Bargemont, Le Vte Alban de. *Economie politique chrétienne, ou recherches sur la nature et les causes du paupérisme en France et en Europe et sur les moyens de le soulager et de le prévenir*. 2 vols. Paris: Paulin, 1834.

Vincent, Howard P. *Daumier and his world*. Evanston, Ill.: Northwestern University Press, 1968.

Viollet-le Duc, Eugène. *Réponse à M. Vitet à propos de l'enseignement des arts du dessin*. Paris: A. Morel, 1864.

Waldmann, Emil. *Die Kunst des realismus und des impressionismus im 19 Jahrhundert*. Berlin: Propyläen-Verlage, [1927].

Wallon, J. *La Presse de 1848, ou revue critique des journaux publiés à Paris depuis la révolution de février jusqu'à la fin de décembre*. Paris: Pillet, 1849.

Weber, Eugen. *Peasants into Frenchmen: The Modernization of rural France, 1870-1914*. Stanford, Calif.: Stanford University Press, 1976.

Wechsler, Judith. "An Aperitif to Manet's *Déjeuner sur l'herbe*." *Gazette des beaux-arts*, 6th ser. XCI (1978): 32-34.

Wegener, Hertha. "French Impressionist and Post-Impressionist paintings in the Brooklyn Museum." *Bulletin of the Brooklyn Museum* XVI (Fall 1954): 7-8.

Weill, Georges. *Histoire de l'enseignement secondaire en France, 1802-1920*. Paris: Payot, 1921.

Weinberg, Bernard. *French realism: The Critical reaction, 1830-70*. New York: Modern Language Association of America, 1937.

Weisberg, Gabriel P. "François Bonvin and an interest in several painters of the seventeenth and eighteenth centuries." *Gazette des beaux-arts*, 6th ser. LXXVI (1970): 364-66.

_____. "Philippe Burty: A Notable critic of the nineteenth century." *Apollo* XCI (1970): 296-300.

_____. *The Etching renaissance in France: 1855-1880*, exh. cat. Salt Lake City: University of Utah, Museum of Fine Arts, 1971.

_____. *Social concern and the worker: French prints from 1830-1910*. Salt Lake City: University of Utah, Museum of Fine Arts, 1973.

_____. "François Bonvin and the critics of his art." *Apollo* C (1974): 306-11.

_____ et al, *Japonisme: Japanese influence on French art 1854-1910*, exh. cat. Cleveland, Ohio: Cleveland Museum of Art, 1975.

_____. "Théodule Ribot: Popular imagery and *The Little Milkmaid*". *Bulletin of The Cleveland Museum of Art* LXIII (1976): 253-63.

_____. "Fantin-Latour and still-life symbolism in the 'Studio in the Batignolles.'" *Gazette des beaux-arts*, 6th ser. XC (1977): 205-15.

_____. "A Still life by Antoine Vollon, painter of two traditions." *Bulletin of The Detroit Institute of Arts* LVI, no. 4 (1978).

_____. "The Traditional realism of François Bonvin." *Bulletin of The Cleveland Museum of Art* LXV (1978): 281-98.

_____. *Bonvin: La Vie et l'oeuvre*. Paris: Geoffroy-Dechaume, 1979.

_____ with William S. Talbot. *Chardin and the still-life tradition in France*, exh. cat. Cleveland, Ohio: Cleveland Museum of Art, 1979.

_____. "François Bonhommé and early realist images of industrialization, 1830-1870." *Arts magazine* L (April 1980): 132-35.

_____. "Léon Bonvin and the Pre-Impressionist Innocent Eye." *Arts magazine* LIV (June 1980): 120-24.

_____. "French realism and past traditions." In *Proceedings of a symposium on realism*. Edited by Klaus Herding. Frankfurt am Main: Städelschen Kunstinstitut, forthcoming.

_____. "In search of state patronage: Three French realists and the Second Empire, 1851-1871." In *Essays in honor of H. W. Janson*. New York: Prentice-Hall, forthcoming.

_____. *The Drawings and Water Colors of Léon Bonvin*, exh. cat. Cleveland, Ohio: Cleveland Museum of Art, 1980.

Wilhelm, Jacques. "Les Principales acquisitions du Musée Carnavalet de 1941 à 1972." *Bulletin du Musée Carnavalet* XXVI, nos. 1-2 (1973): 1-116.

_____. "Life in Paris under the Second Empire and the Third Republic." *Apollo* CVI (1977): 491-99.

Woodcock, George. *Pierre-Joseph Proudhon, a biography*. London: Routledge and Paul, 1956.

Yriarte, Charles. *Paris grotesque: Les Célébrités de la rue Paris, 1815 à 1863*. Paris: Librairie Parisienne, 1864.

Zeldin, Theodore. *France: 1848-1945*. Vol.1: *Ambition, love and politics*. Oxford: Clarendon Press, 1973.

_____. *France: 1848-1945*. Vol. 2: *Intellect, taste and anxiety*, Oxford: Clarendon Press, 1977.

Zola, Emile. *L'Evénement*, 11 May 1866.

_____. *Edouard Manet: Etude biographique et critique*. Paris: Dentu, 1873.

_____. *Edouard Manet: Etude biographique et critique*. Paris: Dentu, 1873.

_____. *Le Ventre de Paris*. Paris: n.p., 1873.

_____. *Le Bon combat: De Courbet aux impressionistes: Anthologie d'écrits sur l'art*. Présentation et préface de Gaëtan Picon: éd. critique, chronologie, bibliographie et index par Jean-Paul Bouillon. Paris: Hermann, 1974.

_____. *L'Assommoir*. Paris: Charpentier, 1877.

_____. *L'Oeuvre*. Paris: G. Charpentier et Cie., 1886.

_____. *Germinal*. Paris: G. Charpentier et Cie., 1890.

_____. *Pot-bouille*. Paris: G. Charpentier, 1905.

Exhibitions

AGEN

1958. Romantiques et Réalistes, exposition circulante. (Also in Grenoble and Nancy)

ALENÇON

1977, Maison d'Ozé. Artistes ornais du XIXe siècle.

AMSTERDAM

1937, Galerie François Buffa et Fils. Exposition des oeuvres du peintre Théodule Ribot (1823-1891).

ARRAS

1954, Musée d'Arras. C. Corot, C. Dutilleux, leurs amis et leurs élèves.

1967, Musée d'Arras, Ancienne Abbaye Saint-Vaast. Gustave Colin, 1828-1910.

1976/77, Musée des Beaux-Arts. Jules et Emile Breton: Peintres de l'Artois.

BALTIMORE

1965, Baltimore Museum of Art. The George A. Lucas Collection.

BESANÇON

1928, Musée des Beaux-Arts. Cinquantième anniversaire de la mort de Courbet.

CHERBOURG

1964, Musée Thomas Henry. Jean-François Millet.

1971, Musée Thomas Henry. Jean-François Millet.

1975, Musée Thomas Henry. Jean-François Millet et le thème du paysan dans la peinture française du XIXe siècle.

COLOMBES

1934, Hôtel de Ville. Exposition rétrospective Th. Ribot—Peintre et aquafortiste.

DIJON

1957, Musée des Beaux-Arts. A. Legros peintre et graveur.

GRENOBLE

1936, Musée-Bibliothèque de Grenoble. Centenaire de Henri Fantin-Latour.

JARVILLE

1976, Musée du Fer. François Bonhommé dit le Forgeron.

LAREN

1962, Singer Museum. Vier Franse Meesters: Bonvin—Ribot—Rousseau—Vollon.

LE PUY

1978, Musée Crozatier. Charles Maurin 1856-1914.

LILLE

1865, Salles de l'Hôtel de Ville. Exposition des oeuvres de M. Amand Gautier.

LONDON

1901, The Goupy Gallery. Pictures, Pastels and Drawings by Léon Lhermitte.

1921, Leicester Galleries. Jean-François Millet, Drawings and Studies.

1969, Hazlitt. A.-F. Cals 1810-1880.

1969, Wildenstein, J. F. Millet.

NEW YORK

1887, F. Keppel Gallery. A Complete Collection of the Etchings and Other Prints by Jean-François Millet.

1919, Metropolitan Museum of Art. Works of Gustave Courbet.

1971, Wildenstein & Company. From Realism to Symbolism, Whistler and His World.

1978, Lucien Goldschmidt, Inc. Charles Maurin, 1856-1914.

1980, The Shepherd Gallery. Christian Imagery in French Ninteenth Century Art 1789-1906.

NICE

1939, Musée Jules Chéret. Exposition rétrospective—Bastien-Lepage 1848-1884; Louise Breslau, 1854-1927; Marie Bashkirtseff, 1860-1884.

NOGENT-LE-ROTROU

1961, Peintres percherons.

NORTHAMPTON (MASS.)

1966, Smith College Museum of Art. Henri Fantin-Latour, 1836-1904.

ORLÉANS

1978, Musée des Beaux-Arts d'Orléans. Jean-Pierre Alexandre Antigna (Orléans 1817—Paris 1878).

OSHKOSH

1974, The Paine Art Center and Arboretum. Léon Lhermitte.

PARIS

1855, Av. Montaigne, Champs-Elysées. Exhibition et vente de 40 tableaux et 4 dessins de l'oeuvre de M. Courbet.

1867, Rond-Point de l'Alma, Champs Elysées. Exposition des oeuvres de M. G. Courbet.

1876, Ecole des Beaux-Arts. Exposition des oeuvres de Pils à l'Ecole des Beaux-Arts.

1878, Hôtel Drouot. Catalogue de la vente qui aura lieu par suite du décès de Antigna, ses tableaux, études et croquis.

1880, Galeries de l'Art. Th. Ribot, Exposition générale de ses oeuvres dans les Galeries de l'Art.

1882, Ecole des Beaux-Arts. Exposition des oeuvres de G. Courbet.

1884, 28 bis Avenue de l'Opéra. Exposition des oeuvres de Jean-François Raffaëlli.

1885, Ecole Nationale des Beaux-Arts, Hôtel de Chimay. Exposition des oeuvres de Jules Bastien-Lepage.

1885, Galerie Georges Petit. Exposition O. Tassaert au bénéfice de la Société des Artistes, peintres, sculpteurs, graveurs.

1886, Galerie D. Rothschild. Exposition de tableaux et dessins par F. Bonvin.

1887, Ecole des Beaux-Arts. Exposition J. F. Millet.

1887, Galerie Bernheim Jeune. Exposition T. Ribot—Catalogue raisonné des oeuvres exposées.

1889, Ecole des Beaux-Arts. Exposition des oeuvres de Feyen-Perrin.

1892, Palais National de l'Ecole des Beaux-Arts. Exposition Th. Ribot.

1894, Galerie Berne-Bellecour. Exposition d'oeuvres de Adolphe-Félix Cals.

1895, Ecole Nationale des Beaux-Arts. Exposition des oeuvres de Guillaume R. Fouace.

1895, Ecole Nationale des Beaux-Arts. Exposition de tableaux, dessins, pastels, eaux-fortes de Norbert Goeneutte.

1897, Galerie J. Mancini. Exposition Gustave Colin.

1901, Galerie Georges Petit. Exposition rétrospective des oeuvres de Cals.

1901, Galerie Georges Petit. Exposition de tableaux par Gustave Colin.

1902, Ecole Nationale des Beaux-Arts. Oeuvres de Marcellin Desboutin. Peintre et graveur.

1903, Galerie Rosenberg. Exposition d'une centaine d'oeuvres de A. Lebourg.

1905, Tempelaere. Exposition de l'Atelier de Fantin-Latour.

1906, Palais de l'Ecole Nationale des Beaux-Arts. Exposition de l'oeuvre de Fantin-Latour.

1906, Salon d'Automne. Rétrospective Courbet.

1907, Ecole des Beaux-Arts. Exposition de l'oeuvre d'Eugène Carrière.

1907, Cercle artistique et littéraire. Exposition d'oeuvres de J. J. Henner.

1909, Galerie Georges Petit. Exposition J. F. Raffaëlli.

1911, Bernheim Jeune et Cie. Exposition Ribot.

1912, Galerie Chaîne et Simonson. L'Oeuvre de Gustave Colin.

1918, Salon d'Automne. Exposition rétrospective des oeuvres de François Bonhommé.

1920, Galeries J. Allard. Pastels de Léon Lhermitte: Exposition du 2 au 31 mars 1920.

1925, Les Dessins de la Collection Léon Bonnat au Musée de Bayonne.

1929, Petit Palais. Gustave Courbet.

1936, Salon de la Nationale. Exposition rétrospective de l'oeuvre de Jean Béraud.

1936/37, Musée Carnavalet. Jean Béraud—Peintre de la vie parisienne.

1937, Galerie Raphaël Gérard. Antoine Vollon (1833-1900).

1955, Musée du Petit Palais. G. Courbet.

1960, Cabinet des Dessins, Musée du Louvre. Dessins de Jean-François Millet.

1964, Galerie Jean Saint-Georges. Alfred Casile, 1848-1909.

1964, Musée Jacquemart-André. J.-F. Millet, le portraitiste et le dessinateur.

1966, Galerie M. Bénézit. Hommage de Paul Gadala à Antoine Vollon.

1976, Galerie Schmidt. Exposition Jongkind.

1976, Grand Palais. Jean-François Millet.

1977/78, Grand Palais. Gustave Courbet 1819-1877.

1978/79, Mairie Annexe du XVIe Arrondissement. Musée Carnavalet, Mairie Annexe du Ve Arrondissement. Un Témoin de la Belle Epoque—Jean Béraud (1849-1935). Collections du Musée Carnavalet.

SANTA BARBARA

1976/77, Louis Eugène Boudin: Precursor of Impressionism. (Also in Corpus Christi, St. Petersburg, Columbus, and San Diego)

SEOUL, KOREA

1972, Musée du Palais Duksoo. Millet et les peintres de la vie rurale en France au 19e siècle.

STRASBOURG

1964, Château de Rohan. Exposition Eugène Carrière.

TOULOUSE

1949, Musée des Augustins. Exposition du centenaire d'Eugène Carrière.

Acknowledgments

MUSEUM PROFESSIONALS
Canada and the United States

Gerald D. Bolas, Washington University Gallery of Art
Michael Botwinick, The Brooklyn Museum
James D. Burke, The St. Louis Art Museum
Victor Carlson, The Baltimore Museum of Art
Shelby White Cave, Corcoran Gallery of Art
William J. Chiego, The Portland Art Museum
Van Deren Coke, San Francisco Museum of Modern Art
Jack Cowart, The St. Louis Art Museum
Felicia Cukier, The Montreal Museum of Fine Arts
Frederick J. Cummings, The Detroit Institute of Arts
Sarah Faunce, The Brooklyn Museum
Linda S. Ferber, The Brooklyn Museum
Jay Fisher, The Baltimore Museum of Art
Mary L. Gonos, The St. Louis Art Museum
Catherine Grimshaw, The Brooklyn Museum
Helen Hall, Museum of Fine Arts, Boston
Sona Johnston, The Baltimore Museum of Art
William R. Johnston, The Walters Art Gallery
Irene Konefal, Philadelphia Museum of Art
John R. Lane, Carnegie Institute, Pittsburgh
Roger Mandle, The Toledo Museum of Art
Thomas N. Maytham, The Denver Art Museum
Katherine H. Mead, Santa Barbara Museum of Art
Ross Merrill, The Cleveland Museum of Art
Kate Miller, The Baltimore Museum of Art
Dewey F. Mosby, The Detroit Institute of Arts
Steven Nash, Albright-Knox Art Gallery
Jane E. Nitterauer, Albright-Knox Art Gallery
Edward J. Nygren, Corcoran Gallery of Art
Anne Poulet, Museum of Fine Arts, Boston
Richard Randall, The Walters Art Gallery
Louise S. Richards, The Cleveland Museum of Art
Brenda Richardson, The Baltimore Museum of Art
Joseph Rishel, Philadelphia Museum of Art
Myra N. Rosenfeld, The Montreal Museum of Fine Arts
Edith Seanor, The High Museum of Art
Karen A. Serota, The Detroit Institute of Arts
Barbara A. Shapiro, Museum of Fine Arts, Boston
Alan Shestack, Yale University Art Gallery
Evelyn Stacy, The St. Louis Art Museum
William S. Talbot, The Cleveland Museum of Art
Linda Thomas, Museum of Fine Arts, Boston
Georgina Gy. Toth, The Cleveland Museum of Art
Jean Trudel, The Montreal Museum of Fine Arts
Gudmund Vigtel, The High Museum of Art
John Walsh, Jr., Museum of Fine Arts, Boston
Patricia J. Whitesides, The Toledo Museum of Art
James N. Wood, Chicago Art Institute
Suzanne Zolper, The Walters Art Gallery

England, Ireland, and Scotland

Alasdair A. Auld, Glasgow Museums and Art Galleries
Sue Aylwin, The Tate Gallery
Robert Breen, The Scottish Arts Council
Hugh Brigstocke, National Gallery of Scotland
Stephen Calloway, Victoria and Albert Museum
H. F. Constantine, Graves Art Gallery
Bryan Crossling, The Bowes Museum, Barnard Castle
Anne Donald, Art Gallery and Museum Kelvingrove
Richard Green, York Art Gallery
Judith Jeffreys, The Tate Gallery
Christopher J. M. Johnstone, National Gallery of Scotland
C. M. Kauffmann, Victoria and Albert Museum
Michael Kirkby, The Bowes Museum, Barnard Castle
Michael Levey, The National Gallery, London
Hugh Macandrew, National Gallery of Scotland
Carolyn Oppenheimer, Victoria and Albert Museum
Niamh O'Sullivan, National Gallery of Ireland
Julian Spaldin, Graves Art Gallery
Margaret Stewart, The National Gallery, London
John M. Sutherland, National Gallery of Scotland
Colin Thompson, National Gallery of Scotland
Angela Weight, City of Aberdeen Art Gallery and Museums
James White, National Gallery of Ireland
Michael Wilson, The National Gallery, London
Michael Wynne, National Gallery of Ireland

France, Holland, and Switzerland

Françoise Amanieux, Musée du Haubergier, Senlis
Jean Aubert, Musées d'Art et d'Histoire de Chambéry
Mme. Aude, Conservatoire National des Arts et Métiers
Jacques Beauffet, Musée d'Art et d'Industrie, Saint-Etienne
Irène Bizot, Réunion des Musées Nationaux, Paris
Yvonne Brunhammer, Musée des Arts Décoratifs, Paris
C. J. de Bruyn Kops, Rijksmuseum, Amsterdam
Adeline Cacan de Bissy, Musée du Petit Palais, Paris
M. Cazin, Conservatoire National des Arts et Métiers
Bernard Ceysson, Musée d'Art et d'Industrie, Saint-Etienne
Jean Chabert, Direction des Musées de France, Paris
Philippe Chabert, Musée des Beaux-Arts, St. Omer (now at Troyes)
Pierre Chanel, Musée de Lunéville
Georges Cheyssial, Musée National J. J. Henner, Paris
Philippe Comte, Musée des Beaux-Arts, Pau
Claire Constant, Musée National du Château de Versailles
Françoise Debaisieux, Musée des Beaux-Arts, Caen
Xavier Dejean, Musée Fabre, Montpellier

Mlle. France Dijoud, Ateliers de Restauration du Louvre, Paris
Jean Fénelon, Service du Matériel, Sénat, Paris
Marie-Pierre Foissy, Musée Fabre, Montpellier
Jean Forneris, Musée des Beaux-Arts Jules Chéret, Nice
Pierre Gaudibert, Musée de Peinture et de Sculpture, Grenoble
Monique Geiger, Musée des Beaux-Arts, Dijon
Pierre Georgel, Musée des Beaux-Arts, Dijon
Françoise Guéroult, Musée Thomas Henry, Cherbourg
Marguerite Guillaume,Musée des Beaux-Arts, Dijon
Sophie Guillot de Suduiraut, Musée des Beaux-Arts, Tours
J. Guillouet, Musée Municipal, Douai
R. Hamon, Musée Baron-Gérard, Bayeux
Mr. Van der Kemp, Musée National du Château de Versailles
Isabelle Klinka, Musées du Mans, Le Mans
Michel Laclotte, Département des Peintures, Musée du Louvre
Hubert Landais, Direction des Musées de France, Paris
Jean Langle, Service Technique du Mobilier à l'Administration Centrale des Finances, Paris
Claude Lapaire, Musée d'Art et d'Histoire, Geneva
Marielle Latour, Musées des Beaux-Arts, Marseille
Annette Laumon, Musée du Fer, Jarville
Pascal de La Vaissière, Musée Carnavalet, Paris
l'Abbé Lelegard, Abbaye de la Lucerne, La Haye-Pensel
Pierre Lemoine, Musée National du Château de Versailles
Claude Lioult, Musées d'Alençon
Georges de Löye, Musée Calvet, Avignon
Marie-Claude Maillant, Service de la Création Artistique, Paris
Françoise Maison, Musée des Beaux-Arts, Arras (for sharing her work on Jules Breton)
Mme. M. F. Marchand-Marrec, Musée de l'Histoire du Fer, Jarville
Gilberte Martin-Méry, Musée et Galerie des Beaux-Arts, Bordeaux
François Mathey, Musée des Arts Décoratifs, Paris
Denis Milhau, Musée des Augustins, Toulouse
Geneviève Monnier, Cabinet des Dessins, Musée du Louvre, Paris
Bernard de Montgolfier, Musée Carnavalet, Paris
Jean-Marie Moulin, Musée National du Château de Compiègne
Alain Mousseigne, Musée des Augustins, Toulouse
Jacques Nicourt, Musée National des Arts et Traditions Populaires, Paris
J. W. Niemeijer, Rijksmuseum, Amsterdam
M. Nikitine, Musées du Mans, Le Mans
David Ojalvo, Musée des Beaux-Arts, Orléans
Hervé Oursel, Musée des Beaux-Arts, Lille
Gabriel Pallez, Assistance Publique, Paris
Maurice Pianzola, Musée d'Art et d'Histoire, Genève
F. Pomarede, Musée Saint-Denis, Reims
Marie-Noëlle Pinot de Villechenon, Musée des Beaux-Arts, Tours
Joëlle Pontefract, Musée Historique, Palais Granvelle, Besançon
M. R. Quarré, Musée des Beaux-Arts, Dijon
Marguerite Rebois, Réunion des Musées Nationaux, Paris
Pauline Reverchon, Musée Municipal, Cognac
Françoise Reynaud, Musée Carnavalet, Paris
Jean-Paul Richard, Service du Matériel, Sénat, Paris
Yvonne Saint-Geour, Musée de l'Assistance Publique, Paris
Nicolas Sainte-Fare-Garnot, Musée de l'Assistance Publique, Paris
Annie Scottez, Musée des Beaux-Arts, Lille
Claude Seillier, Musée Municipal, Boulogne-sur-Mer
Arlette Sérullaz, Cabinet des Dessins, Musée du Louvre, Paris
Maurice Sérullaz, Cabinet des Dessins, Musée du Louvre, Paris
Nadine Simon, Musée de l'Assistance Publique, Paris
Françoise Soulier-François, Musée des Beaux-Arts, Besançon

Claude Souviron, Musée des Beaux-Arts, Nantes
P. J. J. van Thiel, Rijksmuseum, Amsterdam
Germaine Tureau, Service Photographique des Musées Nationaux, Paris
Gérard Turpin, Direction des Musées de France, Paris
Marcel Xavier, Service du Matériel, Sénat, Paris

PRIVATE INDIVIDUALS AND GALLERIES

Hélène Adhémar, Jean Adhémar (for his advice and interest in my research over the years), Pierre Angrand (who enabled us to master the secrets of the Archives Nationales), Mme. Robert Antoine, J. M. F. Baer, Joseph Baillio, Louis Ball, Mme. Pierre Balley, Annie Bauduin (for sharing her work on Adolphe Hervier), Marie-Claude Beaud, Gérard Becq de Fouquières, Pasteur Philippe Bertrand, Helen O. Borowitz, M. et Mme. Alain Bourrut-Lacouture, Philippe Brame, Andrew T. Chakalis, Colin Clark, Etienne Dailly, Marianne Doezema, Henri Dorra, l'Abbé Fiche, Gallery Fischer-Kiener, André Gadaud, Mme. A. Goeneutte-Castillon, Elizabeth G. Holt, Mark M. Johnson, Betty Joseph, Mr. and Mrs. Pierre Leberruyer, M. J. Le Jeune (author of a book on Fouace), Robert Lepeltier, François Lhermitte, Emmanuel Lhermitte, Martin Linsey, Stefanie Maison, Margaret Mallory, Nicole Maritch-Haviland, Mr. and Mrs. Claude Médard de Chardon, N. Ner, Linda Nochlin, Mme. de Peyret, Ronald Pickvance, Général Richter, Mr. and Mrs. Lucien Sagot, Mr. and Mrs. Herbert D. Schimmel, Mrs. Charles Schneider, Shepherd Gallery, H. Shickman Gallery, Robin Spencer, A. Stalter, Norman Sugarman, James Thompson, John Tillotson, J. Kirk Varnedoe, Mme. Verdilhan, André Watteau, Daniel Wildenstein and Jo Zuppan.

List of Figures

Photographic Credits

Figure 47. Millet. *Twilight,* black crayon and pastel, 20-1/8 x 15-3/8 inches (51 x 39 cm.), ca. 1858-59. Museum of Fine Arts, Boston, Shaw Collection.

Figure 48. Gustave Courbet. *Seated Girl,* pencil and charcoal, 14-9/16 x 9-1/16 inches (37 x 23 cm.), 1865. Private Collection.

Figure 49. Edouard Manet. *Portrait of a Lady,* charcoal, 21-1/2 x 16-1/8 inches (54.5 x 41 cm.), ca. 1859. National Museum Vincent van Gogh, Amsterdam.

Figure 50. Edgar Degas. *Portrait of Madame Julie Bertin,* graphite pencil with touches of chalk, 14-1/4 x 10-3/4 inches (36. 1 x 27.2 cm.), ca. 1863. Fogg Art Museum, Cambridge, Mass., Meta and Paul J. Sachs Collection.

Figure 51. Degas. *Portrait of Marguerite Degas in Confirmation Dress,* pencil, 12-13/16 x 9-3/8 inches (32.5 x 23.7 cm.), 1854. Photo courtesy of Archives E. V. Thaw & Co.

Figure 52. Hans Holbein the Younger. *Portrait of Dorothea Kannengieser* (study for the *Madonna of Darmstadt),* colored chalks, 15-9/16 x 11-1/8 inches (39.5 x 28.2 cm.), 1525-26. Oeffentliche Kunstsammlung, Basel, Kupferstichkabinett.

Figure 53. Rembrandt van Rijn. *Bearded Man in Furred Oriental Cap and Robe,* etching, 5-3/4 x 5-1/8 inches (14.6 x 13 cm.), 1631. Rijksmuseum, Amsterdam, Prentenkabinet.

Figure 54. Léon Lhermitte. *Market Day,* charcoal, 17-3/4 x 21-3/4 inches (45.1 x 55.2 cm.), ca. 1878. Metropolitan Museum of Art, Bequest of Katherine S. Dreier.

Figure 55. Jean-Jacques Henner. *Académie,* charcoal. Musée J. J. Henner, Paris.

Catalog numbers are shown in boldface type, comparative figure numbers in normal type.

A.C.L., Brussels 189b
Art et Photo, Bordeaux **166**
Mlle. Suzeline Ball **50A, 50B, 56, 89A, 145, 162, 185;** 89a
Photo Borel, Marseille **11**
Photographie Bulloz, Paris **15, 24, 140, 153;** 45
Vincent Cazin, Bayeux **193**
I. W. Charles, National Galleries of Scotland **181**
Jean-Loup Charmet **23, 42, 44, 65, 66, 79A, 81, 81A, 90, 96, 98, 98A, 102, 103, 104, 105, 106, 107, 109, 132, 138, 139, 146, 147, 168, 171, 172, 173, 180, 186, 188, 220, 222, 224, 226, 227, 234;** 13, 21, 26, 27, 28, 29, 55, 80a, 206a, 221a
Foto-Commissie, Rijksmuseum, Amsterdam **72;** 53
Fondation Custodia (Coll. F. Lugt), Institut Néerlandais, Paris 32
Alain Danvers, Bordeaux **25, 99, 191, 208, 216**
Devos, Boulogne-sur-mer **1**
Jerome Drown, Atlanta **114**
Dumont-Babinot, Reims **10, 62, 115, 164**
Faerber and Maison, Ltd., London **215**
Fontana-Thomasset, Chambéry **202**
Frequin-Photos, Rotterdam 46
Studio Gérondal, Lille **160, 179,** 189, 190, 214, **218, 236;** 19
Photographie Giraudon, Paris **120, 205**
Greenberg-May Prod., Inc. **14**
Photo Hutin, Compiègne **108**
Photo Jacques, Orléans **92**
Laurent Sully Jaulmes, Musée des Arts Décoratifs, Paris **170**
Photo Leroy, Arras **52**
Martin Linsey, Cleveland **6, 78A, 176, 199;** 6, 7, 9, 9a, 10, 11, 24, 25, 113a
Photo-Studio Madec, Nantes **48, 94, 111**
Ross Merrill, Cleveland **117, 211**
Claude O'Sughrue, Montpellier **5, 8, 63, 85, 137, 196**
Marie Louise Pérony, Pau **91**
Photopress, Grenoble **142, 212, 230**
Studio Piergil, Deauville **3, 4, 92A, 93**
Photo Prism, Chalon-sur-Saône **43**
Nathan Rabin, New York **174**
Documentation Photographique, Réunion des Musées Nationaux, Paris **28, 29, 78B, 82, 97, 127, 144, 158, 169, 206;** 20, 31, 40
Photo Routhier, Paris **70**
Score Photographers, Cleveland **30A, 54, 79B, 80, 101, 113, 116, 135, 141, 154, 223, 225**
Tom Scott, Edinburgh **163**
Seligmann cliché, Paris **51,** 151a
Baron Erik Spafford, Santa Barbara **7**
Yan Thibault, Le Rove **36, 237**

F. Bonvin, p. 273
J. Gigoux, p. 293
J. J. Henner, p. 295
E. Lepoittevin, p. 301
J. L. E. Meissonier, p. 304
J. F. Millet, p. 304
P. Rousseau, p. 310
C. Troyon, p. 311

List of Color Plates

Works Exhibited
at Only Certain Locations

The following works will be exhibited only in
Cleveland

70 Breton, *The Seamstress*
108 Meissonier, *The Ruins of the Tuileries*
121 Pissarro, *Still Life*

The following works will be exhibited only in
Cleveland and Brooklyn

22 Antigna, *The Forced Halt*
153 Feyen-Perrin, *The Anatomy Lesson of
Doctor Velpeau*

The following works will be shown only in
Cleveland and Glasgow

72 François Bonvin, *Woman at the Spinet*
110 Philippe Rousseau, *The Fish Market*
155 Philippe Rousseau, *A Valley*
181 Jules Bastien-Lepage, *Nothing Doing*
232 Goeneutte, *The Boulevard de Clichy under
Snow*

The following works will be exhibited only in
Cleveland, Brooklyn, and St. Louis

7 Jongkind, *Bathhouses and Wash-Boat on the
Seine*
14 Daumier, *The Waiting Room*
21 Millet, *The Wanderers*
32 Millet, *The Quarriers*
33 François Bonvin, *Woman Ironing*
68 Frère, *Children Looking at Perspective Prints*
69 Frère, *The Little Cook*
76 Frère, *Preparing Dinner*
82 Breton, *Dedication of a Calvary*
118 François Bonvin, *Still Life with Oysters*
160 Breton, *Farmyard at Souchez*
167 Caillebotte, *Standing Man in Derby*
198A Cazin, *Ernest-Alexandre-Honoré Coquelin*
236 Colin, *The Castillo and the Inlet of Pasages
at High Tide*

Index

The index consists of works of art and artists discussed in the essays and the catalog entries. Catalog numbers are given in square brackets. Page references to illustrations are given in italics. Page references to catalog entries, when different from the illustration, are given in regular type.

Prepared by Jack Perry Brown, Librarian
The Cleveland Museum of Art